The Hirshhorn

MUSEUM & SCULPTURE GARDEN

Foreword by

S. Dillon Ripley SECRETARY, SMITHSONIAN INSTITUTION

Edited and with an Introduction by

Abram Lerner DIRECTOR, THE HIRSHHORN MUSEUM & SCULPTURE GARDEN

Essays by

Linda Nochlin
Alfred Frankenstein
John I. H. Baur
Milton W. Brown
Irving Sandler
Dore Ashton

The

M U S E U M & SC

Hirshhorn

SCULPTURE GARDEN

SMITHSONIAN INSTITUTION

Harry N. Abrams, Inc., Publishers, New York

ELLEN SHULTZ *Editor*
MARGARET L. KAPLAN *Managing Editor*
DIRK J. v O. LUYKX *Book Design*
NAI Y. CHANG *Vice-President, Design*

Library of Congress Cataloging in Publication Data
Main entry under title:

The Hirshhorn Museum and Sculpture Garden, Smithsonian
Institution.

Includes bibliographies.
1. Joseph H. Hirshhorn Museum and Sculpture Garden.
2. Art, Modern—20th century—Washington, D.C.—
Catalogs. I. Nochlin, Linda.
N6487.W3J664 1974 709'.04'0740153 74–5454
ISBN 0-8109-0165-X
ISBN 0-8109-9011-3 (pbk.)

Foreword

by S. Dillon Ripley

SECRETARY, SMITHSONIAN INSTITUTION

IN THIS PUBLICATION the reader will find a delineation of a part of the collection of Joseph H. Hirshhorn. But it also records an answer to prayer a long time arriving. For it was some thirty-six years ago that the United States Congress enacted legislation designed to create on the Mall in Washington a museum to illustrate trends in contemporary art and to encourage thereby the growth as well as public understanding of such art.

The past has become as usual a prologue to the present. In the ensuing years of war and controversy in the affairs of mankind the Smithsonian has been beleaguered at times in its legitimate attempts to provide our citizens with an appropriate panorama of the history of creativity in all its aspects. But the acquisition of the vast Hirshhorn collection of sculpture and painting in 1966 has been an earnest of keeping the faith on this Institution's part as well as an act of faith on the part of the donor. It has served to add a capstone to the wealth of galleries in our capital, to complete a chain stretching across the years from the origins of the Institution itself and its mandate "for the increase and diffusion of knowledge among men."

Whatever the future holds, Washington can take satisfaction in having here on the Mall, and in adjacent sites close by, perhaps as significant a sampling of human creativity over the centuries as has been assembled in one place. And this is true of all the arts, including the art

of politics, for from Archives to Congressional Library, to the great galleries and museums, it is, appropriately enough, *all* here for those who seek to find.

The Hirshhorn Museum and Sculpture Garden has its aesthetic roots in the mercurial, sometimes quixotic art of the twentieth century. The building reflects the kaleidoscopic taste patterns of the years themselves, contrasting with the 1879 fantasy of the Arts and Industries building next to it, the tessellated 1852 Smithsonian towers beyond, and the cool austerity of the 1921 Freer neoclassicism beyond that. Now an additional functionalist statement is rising on its other side, the National Air and Space Museum, which is to be completed in 1976. In another place I have called them "figures from a tapestry." In addition, the Hirshhorn has its own garden and ample space for the outdoor display of its collections. And these collections cover not only a spectrum of the diversity of the present, but are a kind of ethnoaesthetics, straying among the progenitors of the past.

The selected works of art in this inaugural publication of the Hirshhorn Museum and Sculpture Garden represent merely a part of the Museum's holdings, but they do attest to the range and taste of our donor. The inaugural exhibition, for which this book serves as a catalogue and guide, will reveal some of the highlights of the collection as it overflows the museum building onto the plaza and Sculpture Garden, bringing monumental bronzes and stone pieces into the open air. It is to be hoped that the Sculpture Garden will become one of the most popular spots in Washington, a special magnet among these other magnets on the Mall, an outdoor *"galleria"* for all to enjoy and share. This synthesis of art and environment is an ancient ideal, as valid and desirable today as it was in the Rome of Pope Sixtus, or as it still survives in the noble Piazza della Signoria in Florence, where the citizenry sip their espresso in the company of Giambologna, Michelangelo, and Cellini.

The Hirshhorn Museum and Sculpture Garden was created by an

Act of Congress on November 7, 1966, which accepted Mr. Hirshhorn's gift to the nation and approved a site on the Mall for a building in which to house the gift. Construction began in March 1970, and the completed museum now joins the family of museums here, dedicated to serving the public. In this cause a schedule of activities and changing exhibitions will add vitality to our nation's capital.

In bringing the Hirshhorn collection to Washington we must give full credit for the necessary vision not only to our friends the donor and his wife, but also to the late President Lyndon B. Johnson and his imaginative widow, Lady Bird Johnson. President Johnson's then Advisor on the Arts, Roger L. Stevens, and Special Counsel to the President, Harry C. McPherson, Jr., played an instrumental part in helping the Smithsonian. To them the Board of Regents, who, led by our then Chancellor, former Chief Justice Earl Warren, firmly backed the proposal from the beginning, and I myself owe a great debt of gratitude, as we do also to the members of the Congressional Committees involved with the legislation, Senator Jennings Randolph, Congressman Ken Gray, Senator Claiborne Pell, Congressman Frank Thompson, and the annual fiscal and moral support of our Appropriations Chairmen, Senator Alan Bible and Congresswoman Julia Butler Hansen. Without the help of all these persons, this volume would not be in print.

Thus the reader will find here enlightening and appealing texts, replete with illustrations, which, together with the scholarly catalogue, mirror the Museum's collections and the changing art of our time. The volume is also a souvenir of the persistence and dedication of many persons in bringing this eclectic museum into existence.

Contents

Introduction

by Abram Lerner

DIRECTOR, THE HIRSHHORN MUSEUM & SCULPTURE GARDEN

SELECTING A THOUSAND WORKS OF ART from a large museum collection is a fascinating if risky exercise in critical judgment. It must be made with the awareness that future opinion will find in it the seeds of contemporary bias and critical parochialism. This is especially true of published works in which reproductions and text seek to distill the spirit of more than a hundred years of art. And yet, despite the inherent risks involved, this procedure may yield a surprising and revealing result—a heady mixture of works of art which might otherwise never be seen in such audacious contrast.

In our inaugural exhibition and in this book it has been our purpose to indicate the nature and scope of our collection in a manner that would delight and inform. We have chosen to summarize its essential character and profile, to reveal the influence of its creator, and to set it into a meaningful framework. Without attempting an encyclopedic approach, we have divided our selection into periods or epochs which we hope will add interest and structure to a variety of works too often seen out of their historical context. Our determination to retain the historicity of artistic production allows artists to appear and reappear in relation to their contemporaries within each epoch. The contrasts created by such confrontations are intended to reduce the homogeneity which frequently accompanies large surveys—and may even result in the discovery of unexpected similarities, differences, and influences hitherto unnoticed.

Each section is supplemented by an essay which offers the reader insight and historical perspective. To allow for the widest interpretive latitude, the essayists were free to make references to art and artists not represented in our collection.

The Hirshhorn Museum, like most other museums, has lacunae which will be reduced in time. However, Joseph Hirshhorn's catholicity has provided us with an unusual record of American painting from about 1870 on, European and American sculpture from the middle of the nineteenth century on, and European painting of the past three decades. These constitute the major categories of our inaugural exhibition and of this book, which will serve as an introduction to the Museum.

Although painting and sculpture from Mr. Hirshhorn's collection had frequently appeared in important national and international exhibitions since the 1940s, and his activities were well known in the art world, it was a major show of 444 sculptures at The Solomon R. Guggenheim Museum in New York, in 1962, that focused sudden public interest on the collector and his collection. That exhibition also dramatized the development and importance of sculpture in the twentieth century. Mr. Hirshhorn's sculpture collection became famous, and, as Herbert Read noted: "I have seen many [sculpture] collections, but never one that can rival yours in completeness, in quality, and in display. It is a great achievement and I hope it will remain intact, for the enjoyment of generations to come."

Mr. Hirshhorn's career as art collector spans a period of forty years. Part of that journey in art can be traced from records, and reconstructed, but much of it has disappeared together with artists, dealers, and friends who are no longer alive. The private collector rarely pays attention to the minutiae of acquisition; bills of sale are mislaid and never recovered, correspondence disappears. The history of his relationships with art and artists, the chronicle of his growth and self-education fade into the past except for fragments recalled long after the event.

Mr. Hirshhorn recollects that his interest in art began when, as a boy, he discovered reproductions of popular Salon masters in an insurance company calendar. He pasted them on his bedroom wall and spent hours studying their colors and edifying sentiments. This fateful experience remained etched in his memory and, perhaps because of it, the first paintings he acquired as a successful young businessman were by William-Adolphe Bouguereau, Joseph Israels, Edwin Henry Landseer, and Jean-Jacques Henner. Apparently paintings of this kind, rather than works which paralleled his own life-style and personality, were identified in his mind with traditional values of beauty and lofty sentiment. But an unrelenting curiosity, strengthened by visits to museums and galleries, inevitably led to the discovery that, as he puts it: "I was in the wrong pew." The revelation of modern art was a liberating experience and it ended his quest for the past. By natural temperament a man of the present, he found that modern art touched him deeply and yielded aesthetic experiences which he had not previously known.

Visits to art museums and galleries, The Museum of Modern Art and the Whitney Museum of American Art in particular, were decisive in directing his enthusiasm and increasing his comprehension of the "new" art. He once told me that a visit to a museum was a little like a religious experience in which evangelism, faith, humility, and devotion ultimately lead to conversion. The process of education and assimilation is one of the imperatives of informed art collecting. In a way it parallels the aims of formal education, which endeavors to extend our knowledge and perception, broaden our vision, and encourage our imagination. It forces the collector to adopt the habits of a student. He must know what he is about, where to seek information, how to select the proper guides and authorities, what to read, and, above all, how to look carefully with an unbiased, serene, and discerning eye.

By the late 1930s Mr. Hirshhorn had disposed of his Salon heroes and substituted such modern painters as Monet, Cézanne, Degas, Renoir, Chagall, Rouault, Jules Pascin, and André Masson. As his edu-

13

cation and experience increased, he began to comprehend more clearly the perimeters of his interests and responses. He turned decisively to the contemporary scene, and eventually gave up his Impressionist and School of Paris works. This action can be understood in retrospect as a change of emphasis, for Renoir, Degas, Matisse, and Picasso are represented in the collection by sculpture, and paintings by Pascin and Masson have, happily, been reinstated.

It has been said that such changes of heart and direction constitute the unique privilege of the collector to make his own decisions, modified only by his means. In a more critical spirit, it has also been said that most private collections, formed without the advice and consent of museum directors, curators, and historians, at best reflect the quixotic taste of the collector. If that is true, it would tend to confirm at least one interesting similarity between museums and private collections: that museums and their benefactors are equally disposed to quixotic decisions of taste and policy and will occasionally succumb to the dictates of fashion and the worldliness of the marketplace. Eminence is too often confused with infallibility. In the end, the score is about even—the successes are celebrated and the mistakes are hidden from public view.

In any case, the collector has some unique advantages. He can make quick decisions, and he enjoys the unrestricted privilege of concentrating on a few artists or compiling a survey of a particular period or style, as the spirit moves him. He may even acquire unpopular artists for reasons unstated and subtle, or artists he believes to have been overlooked by Establishment opinion. But the motivating force behind all this is the desire to possess, to establish the intimacy of relationship which ownership can provide.

The 1930s and 1940s appear to have been decisive years in Mr. Hirshhorn's collecting career. His earlier taste for the past and its reassuring nostalgia was subtly challenged by the realities of the Depression years. In many ways it was a time of remarkable contrasts; side by

side with poverty and social upheaval there was an awakening public interest in the arts, created in part by the very Depression that had destroyed the economic base which normally supports the arts—the collectors, dealers, patrons, and museums. The Government filled the gap with a program of art patronage so audacious for its time that some people have not yet recovered from the shock. The various federal projects paid artists for producing paintings, murals, sculpture, plays, exhibitions, books, and concerts. Classes in art and art appreciation created a generation of future artists, art historians, collectors, and informed art lovers. In this lively atmosphere it was difficult for anyone with even a modest curiosity about art not to become involved in the contemporary art scene. From visits to galleries and museums, and friendships formed with artists, Mr. Hirshhorn began to develop that inspired greed for art which has dominated so much of his life. He would leave a business meeting and rush to an exhibition or an artist's studio, or would suddenly descend on a gallery and buy several works with a certainty and speed rarely encountered by dealers accustomed to endless deliberation and reflection. In the early forties, together with a small group of fellow collectors, he would spend every Saturday visiting the galleries on Fifty-seventh Street in New York. His enthusiasm, decisiveness, and bargaining skill became legendary.

It was on one of his visits to the ACA Gallery in New York, in 1945, that I first met Mr. Hirshhorn. I had been working in the gallery for a very short time. It was summer, and there were few visitors. Suddenly a man hurried in, scanned the exhibition, and inquired about several paintings. He bought four works in short order and departed as suddenly as he had entered. I immediately called the director and told him that a short, stocky apparition had just bought four paintings and that I was at a loss since I had been unable to get his address or phone number. I was sure it was a prank. The director laughed. "No need to worry," he said. "That was Joseph Hirshhorn. He's the most dynamic collector in New York."

After this initial encounter I saw him often. Frequently I accompanied him to galleries and found myself happily involved in the excitement these visits generated. I ventured to suggest particular exhibits for him to see and was pleased when he acquired something I had praised. He never bought what he did not personally respond to, no matter who recommended it. If anything, "expert" advice seemed to turn him off. He would listen, and perhaps it might have its effect later, but for the moment he would trust his own feelings. We found we shared an interest in certain artists. For example, Mr. Hirshhorn was very enthusiastic about the American painter Louis Eilshemius, who was essentially neglected and constantly being "rediscovered." I shared this feeling only to a degree, but it was enough to create a sympathy between us. Though we frequently disagreed on individual artists or works of art, over the next twenty-five years our differences were insignificant in the face of his general ardor and responsiveness. I was particularly taken by his enthusiasm for the young artists, his faith in their talent, and his ability to adjust quickly to their vision of the world. What seemed to matter most was their ability to excite his interest and admiration.

During the late 1930s he acquired his first work of sculpture, a stone carving by the American John Flannagan. Although he did not begin to buy sculpture avidly until almost a decade later, this initial purchase must have been rooted in a fertile, if still dormant, appreciation of structural form and concrete imagery. What began casually in the thirties became a passion in the forties and has remained so to the present. This interest in sculpture inevitably led him to the Curt Valentin Gallery, where exciting examples of the finest modern sculpture were always on view. There he was to discover Moore, Rodin, Lipchitz, Daumier, and others. Simultaneously, he was also acquiring paintings by Milton Avery, Arshile Gorky, Stuart Davis, Lyonel Feininger, and Philip Evergood.

By the late 1950s the nature of the collection had been deter-

mined. The paintings were primarily American, with a broad sampling of European art of the past three decades, while the sculpture was international and covered a greater time span.

Warehouse space became indispensable for the overflow from Mr. Hirshhorn's home and office in New York, and his house, office, and hotel suite in Canada. Art works moved frequently between these places, and increasing requests for loans made it difficult to keep track of what he owned and where it was. By the fifties, the collection had in a sense taken over, its incredible growth creating inevitable problems.

In 1956 I was appointed full-time curator, and I established headquarters in Mr. Hirshhorn's New York office at 165 Broadway. It was a fascinating combination of business office, gallery, and warehouse. Paintings covered the walls, and sculpture occupied tables and floor. Steel bins held the overflow in a separate room. A large table facing Mr. Hirshhorn's desk was crowded with sculpture. Every so often he would peek out into the waiting room to see whether a visitor had dared to hang his hat on a piece of sculpture, in which case the offender would receive a short but colorful lecture on the sanctity of art. When it became evident that I required separate quarters, I found space in a charming building at the corner of Sixty-seventh Street and Madison Avenue (now replaced by a faceless office building). The "art office," as Mr. Hirshhorn referred to it, had many functions, among them the usual ones of cataloguing, handling correspondence and requests for loans, overseeing storage facilities, clearing foreign shipments, maintaining proper insurance levels, and so forth. But it was also a halfway house between Mr. Hirshhorn's business office and the art galleries. Here he could pause to look at his most recent acquisitions, examine new paintings and sculpture which I had gathered for his consideration, set up meetings with artists and dealers, and schedule visits to galleries. It was an exciting situation and it encouraged him to even greater efforts in collecting. Within a short time the office was packed with new acquisitions, and one had to tread carefully for fear of bump-

1. View from Joseph H. Hirshhorn's
desk at his business office at
165 Broadway, New York, in 1956

ing into a canvas or toppling a piece of sculpture. This office was followed by a somewhat larger one on Sixty-eighth Street which also filled very quickly, despite the fact that we were constantly shipping items to the warehouse, where we now occupied considerable space. I would spend one or two days a week at the warehouse, trying desperately to maintain order among the new arrivals from galleries in New York, Los Angeles, Toronto, Paris, London, Zurich, and Rome. Every so often Mr. Hirshhorn would accompany me to the warehouse. He always seemed a little surprised by the quantity of objects, but delighted in pulling paintings out of bins, handling the sculpture, and excitedly discussing individual works.

In 1961 Mr. Hirshhorn established a residence in Greenwich, Connecticut. The commodious scale of this country estate seemed to encourage and even accelerate his art buying. The spacious house—surrounded by inviting areas of flower beds, lawns, and stone walks—was quickly inundated with paintings and small sculpture. He placed large bronzes in the garden and on the lawns, and kept adding pieces for variety and contrast. His garden became one of the most exciting places in the United States in which to see modern sculpture. Over the years thousands of people have visited Greenwich, usually in groups organized by charitable and educational institutions.

Although Mr. Hirshhorn's original interest was contemporary painting, a growing awareness of American art of the recent past led him back to the work of The Eight, and ultimately to Thomas Eakins. The first paintings by members of The Eight were acquired in 1954, although Mr. Hirshhorn had known their work much earlier, had visited John Sloan in his studio, and had purchased an Ernest Lawson in the 1930s. Now he acquired major works by Maurice Prendergast, Sloan, and Robert Henri. I remember well the sense of excitement that accompanied these purchases, the joy of rediscovery. From then on, given Mr. Hirshhorn's curiosity and appetite, it was inevitable that their precursors be traced, and that the chain of styles and influences

be explored and represented in the collection. The return to an earlier art in no way displaced his enthusiasm for the present. One might say that Mr. Hirshhorn was unwilling or incapable of confining his acquisitions to a particular style or school; the breadth and variety of art was too appealing to be channeled into a specialty. Awareness of the past was never allowed to alter the pattern of collecting he had established from the beginning, which relied on his own sensibility and judgment to direct him to works of quality and interest. Between 1957 and 1960 additional distinguished works by members of The Eight were added, including fifteen by Arthur B. Davies.

The late forties and fifties marked a profound change in American art and collecting. The prosperous years that followed World War II produced a new breed of collectors for whom modern, innovative art created no dilemmas, who had no inhibitions stemming from past allegiances or traditions. They accepted the avant-garde as daring liberators manifesting the nation's sense of destiny, of leadership in the arts, politics, and technology. For the older collectors the new art rep-

resented a challenge to all the aesthetic assumptions that had formed their tastes. It was not until the late fifties, a decade after the new art had first appeared, that Mr. Hirshhorn acquired his first paintings by the New York School. But if he found Abstract Expressionism difficult, he savored color-field painting from its beginning and acquired a group of Kenneth Nolands and Morris Louises from Clement Greenberg's now historical exhibition at French & Company in New York, in 1959. That same year, with typical freewheeling ebullience, he purchased major works by Balthus, Mary Cassatt, Walt Kuhn, and Matisse, among others.

Variety and scope were maintained, but, more significantly, the purchase of an artist's works did not cease once he was represented in the collection. On the contrary, a positive reaction almost always guaranteed a sustained interest in an artist and the acquisition of additional works. This has provided important in-depth representation, making the collection extremely valuable for research and study. Mr. Hirshhorn acquired his first Henry Moore, *The Rocking Chair,* in 1951, and he added Moores to the collection almost every year after that. The same has been true of works by Eakins, Daumier, Rodin, Matisse, Manzù, David Smith, de Kooning, and a host of others. An interesting instance of this continuing enthusiasm is exemplified by the Eakins acquisitions. The first paintings by this master were purchased in 1957, a group of four which included the study for *The Violinist.* Between 1957 and 1959, thirteen Eakins paintings and one bronze were added. In 1961, it became possible to acquire a large group of Eakins's paintings and sculpture which had formerly been in the Joseph Katz Collection. In 1965, Mr. Hirshhorn acquired another remarkable group of Eakins works from the former collection of the sculptor Samuel Murray. Besides the paintings and sculpture, these important collections added an archive of letters, documents, photographs, and miscellaneous memorabilia which are indispensable for the scholarly study of Eakins's life and work.

2

2. Office of The Joseph H. Hirshhorn
Collection at 24 East
Sixty-seventh Street, New York,
in 1958

3. Entrance hall of
The Hirshhorn Museum offices
at 11 East Sixty-eighth Street,
New York, in 1968

3

It was fascinating to participate in this constant seesaw between modern and older works. The purchase of a Winslow Homer would be followed by the acquisition of a David Smith, sometimes on the very same day. I recall the excitement created by the acquisition of our first Benin bronze, in 1957, which was the signal for the beginning of a collection of these magnificent African pieces which now totals twenty-four. These bronzes were, in a manner of speaking, side acquisitions, motivated by the discovery of some uniquely beautiful work and by a growing awareness of comparable expressive forms in ancient, primitive, and modern art. It was a rewarding experience to compare the affinities between a South Arabian work of the first century and a modern sculpture.

It is difficult to say just when Mr. Hirshhorn realized that his collection had outgrown its private status. The question of its future was often raised between us, and it became clear that he felt its size and importance imposed a special responsibility on him to preserve it intact and to eventually give it to the public. Fate intervened in 1964, when official representations were made by the British Government to establish a museum for the collection in London. Several meetings

were held between Mr. Hirshhorn and British officials, and a site in Regent's Park was suggested. The offer was tempting for a variety of reasons, especially the prospect of establishing a museum which would in large part consist of twentieth-century American painting and sculpture, the first representation of its kind in a foreign capital. Its effect on the dissemination and appreciation of American art abroad could not be overestimated, a fact that was not lost on Mr. Hirshhorn. At about the same time, representations were also made from official quarters in Zurich, Florence, and Tel Aviv. In New York, Governor Nelson A. Rockefeller suggested that the collection be housed in its own museum on the campus of the State University at Purchase, where it would serve the student body and the visiting public.

All these overtures were carefully considered. Then, late in 1964, Mr. Hirshhorn was approached by Dr. S. Dillon Ripley, Secretary of the Smithsonian Institution, who suggested that Mr. Hirshhorn present his collection to the United States, under the aegis of the Smithsonian. A site on the Mall in Washington, D.C., was suggested for a museum building and sculpture garden. The intercession of President Lyndon B. Johnson made Mr. Hirshhorn's choice inevitable. In 1966 an agreement was reached between Mr. Hirshhorn and the Smithsonian, and that same year Congress enacted legislation creating the Hirshhorn Museum and Sculpture Garden.

In his address at ceremonies in the White House on May 17, 1966, President Johnson said, in part: "Washington is a city of powerful institutions—the seat of government for the strongest nation on earth, the place where democratic ideals are translated into reality. It must also be a place of beauty and learning. Its buildings and thoroughfares, its schools, concert halls, and museums should reflect a people whose commitment is to the best that is within them to dream.

"In the National Gallery collection, in the Freer and the Corcoran galleries, in the museums of the Smithsonian, in the Kennedy Center that is to come, in the Pennsylvania Avenue plan—and now, in the

5. *Left to right:* Chief Justice Earl Warren; S. Dillon Ripley, Secretary, Smithsonian Institution; Joseph H. Hirshhorn; and President Lyndon B. Johnson at groundbreaking ceremonies for The Hirshhorn Museum and Sculpture Garden, Washington, D.C., January 8, 1969

Hirshhorn Museum and Sculpture Garden—we have the elements of a great capital of beauty and learning, no less impressive than its power."

It is our intention to contribute to this high purpose and to make our museum a vital force in the cultural life of our capital and our nation. Since its creation in 1846, the Smithsonian Institution has followed its founder's expressed wish that it serve as "an establishment for the increase and diffusion of knowledge among men." What has been referred to as the nation's "attic" is, in fact, the world's largest museum complex, including six art museums, four history and science museums, a national zoological park, and other facilities which reach out across the nation and the world. The Hirshhorn Museum and Sculpture Garden is proud to be a part of this distinguished establishment.

The 19th Century:

FRENCH NINETEENTH-CENTURY SCULPTURE

AND AMERICAN ART *by Linda Nochlin*

6. JEAN-ANTOINE HOUDON. *Sabine Houdon*. c. 1791. Marble, $17 \times 13\frac{1}{2} \times 8''$

I. French Nineteenth-Century Sculpture[1]

The sheer range and variety of nineteenth-century sculpture in the Hirshhorn Museum does much to gainsay Baudelaire's contention that sculpture, tiresome at best, had reached a truly pitiable state in his own time. Admittedly, he was writing about sculpture in 1846, before the advent of Rodin, yet even so, anyone but a great poet might hesitate to make such a sweeping statement. Although, apart from Rodin's achievement, it would be rash to assert that sculpture was a major or innovating force in the art of the nineteenth century, it is nevertheless a peculiarly appropriate area for investigation today, at a moment when the very categories of the major and the minor, the important and the unimportant, are being revised and questioned. Moreover, it was within the area of sculpture, whether it was major or minor, that many basic issues—the fruitful contradictions of nineteenth-century aesthetics or of art in general—were raised. They included such questions as whether art was to be basically public or private; whether it should deal with elevated, traditional themes or personal, ordinary, experienced ones; whether high finish was the mark of the completed work; how essential the testimony of the actual touch or handiwork of the artist himself was to the power and con-

1. I should like to express my gratitude to friends and colleagues who, in conversation or publication, have helped guide me in the field of nineteenth-century sculpture. These include Ruth Butler Mirolli, Albert Elsen, Fred Licht, Athena Tacha Spear, and Sidney Geist.

27

7

7. Atelier of Claude Michel called CLODION. *Female Satyr Group*. c. 1780. Terra-cotta, $17 \times 12 \times 9\frac{3}{4}''$

8. Atelier of Claude Michel called CLODION. *Male Satyr Group*. c. 1780. Terra-cotta, $18\frac{1}{8} \times 12 \times 11''$

viction of his oeuvre; and the problem of scale in relation to subject. All these issues, crucial to the nineteenth century and not absolutely irrelevant to our own, are raised by the sculpture of the French mainstream. Above all, consideration of these works brings up the little discussed question of the relation of the sign to the signified—the central issue of the nature of sculptural language itself.

While the term "sculpture" generally is traditionally associated with the large-scale, highly wrought, essentially public monumental style characteristic of Western art from the time of the Parthenon, or even the pyramids, down through the grand sculptural complexes of Michelangelo and Bernini, and while such grandiose public monuments were certainly not lacking in nineteenth-century France, it is significant that two of the most successful groups of nineteenth-century sculptural works are neither large-scale nor monumental, are rough and sketchy rather than smooth and polished, and were not intended for public exhibition in the official Salon or for the permanence en-

28

8

dowed by bronze casting; instead they were conceived in almost deliberately ephemeral materials—wax or clay—and, perhaps even more important, were not the work of sculptors but the private productions of the painters and draftsmen Daumier and Degas. Indeed, their sculptural groups cannot even be considered "complexes" in the traditional sense of various statues organized or interrelated, generally in an architectural context, around some significant theme or narrative, such as the Medici tomb or *The Ecstasy of Saint Theresa;* rather, they should be thought of as constituting a more modern category: the series.

In the case of Daumier's series of "celebrities," busts portraying politicians of the *juste milieu* in Louis-Philippe's government in the 1830s, many of the most striking qualities of the statuettes—the small scale, the bold handling, the ephemeral nature of their original medium, the expressive exaggeration of features—must be attributed to the fact that they were probably intended as working models for lithographs to be published in Charles Philipon's satiric journal *La Carica-*

9

ture rather than as "pure art" destined for Salon exhibition. Paradoxically, the political-satiric function of these works may have freed Daumier from the constrictions governing purely artistic works in his time.

The originals of these busts—plain, unfired, fragile clay roughly painted by the artist—were intended as trenchant political criticism. They were *portraits-charges,* literally "charged" or "loaded" portraits, savagely satirizing the various types of venality, hypocrisy, and obtuseness characteristic of the bourgeois monarch's government. The bronze versions of the series, cast about one hundred years after their creation, are much more generalized and abstractly expressive, in the modern sense of the term, than the down-to-earth, unpretentious, and even amateurish-looking hand-painted originals. To taste that is conditioned to associate sculptural quality with colorless neutrality of surface, the painted clay models tend to be a little disappointing—closer to the ephemera of the souvenir shop than to the timelessness of ob-

9. JEAN-BAPTISTE LEMOYNE.
Noël-Nicolas Coypel. c. 1730.
Terra-cotta, $24\frac{1}{2} \times 15\frac{3}{4} \times 14\frac{1}{4}''$

10. JEAN-ANTOINE HOUDON.
Jean Louis Leclerc, Comte de Buffon. 1782.
Tinted plaster, $23\frac{3}{4} \times 11\frac{1}{4} \times 10\frac{3}{4}''$

11. CHRISTOPHE-GABRIEL ALLEGRAIN.
Venus Entering the Bath. After 1767.
Bronze, $31\frac{1}{2} \times 10\frac{1}{4} \times 11\frac{7}{8}''$

10

11

jects in the museum. It is the bronze casts that attain the status of sculpture.

This very transformation of expressive and associational values brings out the centrality of the issue of the medium, in the nineteenth century and after, as a self-conscious property of sculptural style, at a time when, as Ruth Butler Mirolli points out in her admirable catalogue introduction for the J. B. Speed Art Museum,[2] sculptors could see their works carried out in a wide range of materials and sizes, in a variety of "editions." It is in the bronze versions that what might be called the more purely sculptural qualities of Daumier's achievement emerge without the distraction occasioned by the painted surfaces of the clay originals. In bronze, the boldness and inventiveness of Daumier's actual modeling stand out: no wonder that Rodin expressed admiration for Daumier's sculpture! Indeed, it is Rodin's powerful expressiveness and knowing manipulation of concave and convex to produce effects quite apart from the literal delineation of specific features that Daumier's style most brings to mind.

Yet, unlike most of Rodin's, Daumier's are small-scale works, many of them not much over five inches in height, so that their formal daring and expressive condensation are carried out within definite restrictions: to imagine them life-size or on the scale of Rodin's or Jean-Baptiste Carpeaux's portrait busts is to translate trenchant satire into nightmare grotesquerie. As it is, there is something of Goya's evocation of unspeakable menace lurking beneath superficial banality in a work such as *Comte de Kératry (The Obsequious)*, with the modestly lowered eyelids and obsequious grin (plate 28). The incisiveness of this caricature reminds us of the popularity of physiognomy, the art—or pseudoscience—of judging character from the facial features, and of the general interest in cataloguing human and social types in the art

2.　　See Ruth Butler Mirolli, *Nineteenth Century French Sculpture: Monuments for the Middle Class,* Louisville, Kentucky, J. B. Speed Art Museum, 1971, p. 21.

and literature of the nineteenth century. In the Kératry bust, the treatment of the head is both extremely broad and yet subtly nuanced at the same time, with the flattened skull, the broadly accented cheekbones and the wide, wavering slit of the grinning mouth, the wisps of hair about the flattened cranium, the carefully delineated teeth, the delicate wrinkles around the drooping eyelids. Daumier obviously envisioned the Count as the stereotype of the hypocritical, obsequious courtier.

In style, these busts may range from the sober, Balzacian delineation of sags, wrinkles, slack jaws, and bulbous nose in the senile *Harlé Père* (*The Old Fool*) (plate 32), "one of the most remarkable fossils of the Center,"[3] to the extremes of inventive exaggeration characteristic of *Lefebvre* (*The Fine, Trenchant Spirit*), where the distance from the tip of the preposterous beak to the crest of hair above the almost horizontal extension of the forehead is extravagantly extended (plate 25). This stretched-out physiognomic landscape is played against the prissy contraction of the vertical distances: mouth, chin, and upper lip together are hardly longer than the nostril overhanging them! Unlike the twentieth-century sculptor Giacometti, who was racked with metaphysical despair when confronting the Sahara-like distance between one wing of his model's nose and the other, Daumier hardly seems to have been perturbed by the infinitude of sculptural spaces or, in any case, he saw them as a plastic, rather than an existential, problem.

Like Daumier, Degas created his small sculptures for himself, in order to work out problems arising from his primary commitment to the two-dimensional arts. Yet the little studies, so carelessly left around in Degas's studio, often in complete disrepair, obviously became ends in themselves rather than mere exercises. In these truly private art works— the small horses, dancers, and bathers—one senses immediately the artist's personal touch, his own particular way of seeing and creating

3. This was the view of both Daumier and his editor, Charles Philipon. See Jeanne L. Wasserman et al., *Daumier Sculpture: A Critical and Comparative Study,* Cambridge, Massachusetts, Fogg Art Museum, Harvard University, 1969, cat. no. 18, p. 99.

HONORÉ DAUMIER.

12. *Ratapoil.*
c. 1850, cast 1925.
Bronze, $17\frac{3}{8} \times 6\frac{1}{2} \times 7\frac{1}{4}''$

13. *The Lover.*
c. 1840–62, cast after 1930.
Bronze, $7\frac{1}{8} \times 2\frac{3}{8} \times 2\frac{1}{2}''$

14. *The Listener.*
c. 1840–62, cast after 1930.
Bronze, $6\frac{1}{8} \times 2\frac{3}{4} \times 2\frac{3}{4}''$

15. *The Visitor.*
c. 1840–62, cast after 1930.
Bronze, $6\frac{5}{8} \times 2\frac{1}{2} \times 2\frac{1}{2}''$

16. *Small-Fry Landlord.*
c. 1840–62, cast after 1930.
Bronze, $6\frac{3}{4} \times 3\frac{1}{8} \times 2\frac{3}{4}''$

17. *The Reader.*
c. 1840–62, cast after 1930.
Bronze, $6\frac{3}{4} \times 2\frac{1}{2} \times 3\frac{3}{4}''$

18. *The Confidant.*
c. 1840–62, cast after 1930.
Bronze, $7\frac{3}{8} \times 2\frac{3}{8} \times 2\frac{3}{8}''$

19. *The Scavenger.*
c. 1840–62, cast after 1930.
Bronze, $5\frac{3}{4} \times 2\frac{3}{8} \times 2\frac{1}{8}''$

20. *The Representative Knotting His Tie.* c. 1840–62, cast after 1930. Bronze, $7 \times 2\frac{3}{4} \times 2\frac{5}{8}''$

21. *The Parisian Janitor.*
c. 1840–62, cast after 1930.
Bronze, $6\frac{1}{4} \times 2\frac{1}{2} \times 3\frac{1}{4}''$

13

14

15

16

17

18

19

20

21

22

23

24

28

29

30

36

34

35

25

26

27

31

32

33

HONORÉ DAUMIER.

22. *Dupin* (The Orator). c. 1832–35, cast 1929–52. Bronze, $5\frac{7}{8} \times 5\frac{1}{2} \times 3\frac{3}{4}''$

23. *Dr. Prunelle* (The Scornful). c. 1832–35, cast 1929–52. Bronze, $5\frac{3}{4} \times 5\frac{3}{4} \times 4''$

24. *Royer-Collard* (The Sly Old Man). c. 1832–35, cast 1929–52. Bronze, $5\frac{1}{4} \times 4 \times 3\frac{1}{2}''$

25. *Lefebvre* (The Fine, Trenchant Spirit). c. 1832–35, cast 1929–52. Bronze, $7\frac{3}{4} \times 4\frac{1}{2} \times 5''$

26. *Podenas* (The Malicious Man of Importance). c. 1832–35, cast 1929–52. Bronze, $8\frac{1}{8} \times 7\frac{7}{8} \times 5''$

27. *Gaudry* (Sorrowful unto Death). c. 1832–35, cast 1929–52. Bronze, $6\frac{1}{4} \times 4\frac{1}{2} \times 5''$

28. *Comte de Kératry* (The Obsequious). c. 1832–35, cast 1929–30. Bronze, $4\frac{7}{8} \times 5\frac{1}{4} \times 3\frac{5}{8}''$

29. *Comte de Falloux* (A Sly One). c. 1832–35, cast 1929–52. Bronze, $9 \times 5\frac{3}{8} \times 5\frac{1}{8}''$

30. *Girod de l'Ain or Admiral Verhuel?* (The Simpleton). c. 1832–35, cast 1929–52. Bronze, $5 \times 4\frac{3}{8} \times 3\frac{5}{8}''$

31. *Comte d'Argout* (Spiritual and Malignant). c. 1832–35, cast 1929–52. Bronze, $5 \times 6\frac{1}{2} \times 3\frac{3}{4}''$

32. *Harlé Père* (The Old Fool). c. 1832–35, cast 1929–52. Bronze, $4\frac{5}{8} \times 5\frac{1}{2} \times 4\frac{1}{4}''$

33. *Unknown* (Toothless Laughter). c. 1832–35, cast 1929–52. Bronze, $6\frac{1}{8} \times 4\frac{3}{8} \times 3\frac{5}{8}''$

34. *Fulchiron* (The Hypocrite). c. 1832–35, cast c. 1929–30. Bronze, $6\frac{1}{2} \times 5 \times 4\frac{1}{8}''$

35. *Pelet de la Lozère?* (Man with a Flat Head). c. 1832–35, cast 1929–52. Bronze, $5\frac{1}{2} \times 4\frac{1}{2} \times 3\frac{1}{2}''$

36. FRANÇOIS RUDE. *Head of an Old Warrior.*
c. 1833–36. Terra-cotta, 25¼ × 15 × 13¼"

37. JEAN-BAPTISTE CARPEAUX. *The Negress.*
1868. Plaster, 24⅛ × 18¼ × 14"

38. DANTAN LE JEUNE.
Caricature of Auguste Vestris. 1834,
cast 1961. Bronze, 11½ × 3⅞ × 6½"

39. HIRAM POWERS. *Proserpine.*
c. 1849–50. White marble, 25 × 18¼ × 10"

40. JEAN-BAPTISTE CARPEAUX. *Jean-Léon
Gérôme.* 1871. Plaster, 23¾ × 10 × 10"

41. JEAN-BAPTISTE CARPEAUX. *Alexandre
Dumas Fils.* 1873. Bronze, 31½ × 22½ × 17⅝"

42. JEAN-BAPTISTE CARPEAUX. *Charles Gounod.*
1872. Terra-cotta, 25½ × 17⅞ × 15¼"

37

36

40

38

39

41

42

43

43. ANTOINE-LOUIS BARYE. *Tiger Devouring an Antelope*. c. 1830. Bronze, $13\frac{1}{2} \times 20\frac{5}{8} \times 11''$

44. ANTOINE-LOUIS BARYE. *Theseus Slaying the Centaur Bianor*. 1850. Bronze, $50 \times 43 \times 17\frac{3}{4}''$

form as a single operation, his rejection of all the preconceptions and conventions of sculptural imagery.

While it is perhaps unfair to compare a private sketch, rough and spontaneous, such as Degas's *Dancer at Rest, Hands Behind Her Back, Right Leg Forward* (plate 79), with a polished, public offering such as Jean-Léon Gérôme's *"Boules" Player* (plate 140), done after 1901, the comparison is nevertheless instructive, especially in the light of Baudelaire's useful distinction between works which are "complete" and which are merely "finished." Despite the aggressive realism underlying its conception, Degas's *Dancer* is, paradoxically, at the same time an exemplar of the romantic notion—ultimately modern in its implications—that the spontaneous, incomplete, roughly adumbrated form is by nature more expressive of and appealing to the powers of the imagination, in that it at once reveals the specific properties of the medium as well as the quality of art as process rather than completed object. The very tentativeness of the unfinished work suggests the notion of the coming into being of the work of art in the mutual interaction between work and spectator.

Both Gérôme and Degas are, like most nineteenth-century sculptors, modelers rather than carvers, and both are best known as painters. Yet in Degas's statuette a rich sense of volume and the relation of form to surrounding space seem to be a natural corollary to the process of capturing the pose of the dancer's body in a malleable medium. The urgency of the sculptor's vision demands anatomical simplifications and elisions, which at the same time create a sense of plastic volume: the summarized thrusts and counterweights of the pose of the dancer's trained body define an energized area of surrounding space, forcefully asserting the shape and direction of the empty spaces in crucial areas like the nape of the backward-thrust head and the openings between back and bent arm and between out-thrust and weight-bearing leg. Thus dancer and nondancer—the body's volumes and the spatial areas related to them—form a significant unity in Degas's work.

45

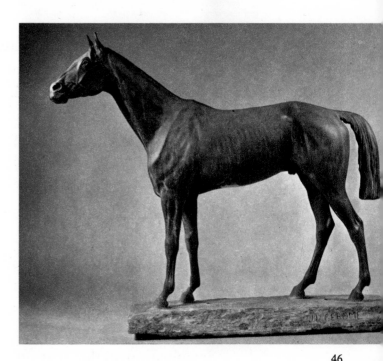

46

45. ALEXANDRE FALGUIÈRE. *Head of Diana.*
c. 1882. Bronze, $17 \times 15\frac{3}{4} \times 10\frac{1}{4}''$

46. JEAN-LÉON GÉRÔME. *Horse.*
c. 1890. Bronze, $26 \times 6\frac{3}{4} \times 28\frac{7}{8}''$

47. ERNEST MEISSONIER. *A Horseman in a Storm.* c. 1880–85. Bronze, $18\frac{3}{4} \times 23 \times 8\frac{1}{2}''$

While smallness of scale lends it intimacy, one of the essential properties of *Dancer,* it is at the same time sculptural in the fullest sense of the word.

Not so Gérôme's work, which functions rather on the level of *bijouterie*—jewel-like, highly wrought, and smoothly polished. In his unswerving dedication to naturalistic minutiae of detail and smoothness of surface, Gérôme has managed to achieve a perfectly nonsculptural sculpture. In *"Boules" Player* he has done precisely the opposite of Degas on every count: the pose is a collection of static details, the body an assemblage of nipples, tendons, and satiny slither; no direction of movement either reinforces or works against any other; and space is simply where the polished bronze is not, unshaped and undefined. Yet its smallness saves it: on that scale, one is able to react to the charms of the parted lips, the provocatively uptilted breasts, the elegant richness of the base. One appreciates the *"Boules" Player* as a precious object rather than as a piece of sculpture.

47

The relative rise in importance of small-scale, intimate sculpture does not mean that monumental public art ceased, or even ceased to achieve high quality, during the nineteenth century. Nevertheless, something did happen to the large-scale public monument, and in the context of the history of Western civilization this something can only be understood only as attrition, loss of power, or failure of nerve. By its very nature, large-scale sculpture seems to demand a situation of continuity, permanence, and a solid belief that what was here yesterday and is here today will endure into the future, accompanied by an expressed or unspoken assumption of the value of that endurance. In previous centuries, while the particular king or pope might change, the belief in the authority of the kingship or the papacy as an institution continued and, with it, the need to make visible, in monuments of suitable magnificence, the signs and substance of that authority. Sculpture is particularly vulnerable to sudden shifts of faith and power, stylistic or political. While painting may be consigned to the attic or

48

44

49

50

51

THOMAS EAKINS.

48. *Margaret*. 1871.
Oil on canvas, 18¼ × 15″

49. *Girl in a Big Hat*. c. 1888.
Oil on canvas, 24 × 20″

50. *Spinning*. 1882–83.
Bronze relief, 18¼ × 14½″

51. *Knitting*. 1882–83.
Bronze relief, 18¼ × 14¾″

52

52. JOHN TWACHTMAN.
Hemlock Pool (A Waterfall). c. 1895.
Oil on canvas, $30\frac{1}{8} \times 25\frac{1}{8}''$

53. ALBERT BIERSTADT. *Shady Pool,*
White Mountains, New Hampshire. c. 1869.
Oil on paper mounted on canvas, $22\frac{1}{2} \times 30''$

53

basement and architecture refurbished or given a new function—the Pantheon is a case in point—monumental sculpture is peculiarly unadapted to political revision and peculiarly susceptible to mob violence and establishment vindictiveness, and the nineteenth century was, in France, a period of unparalleled social and political upheaval. While each successive new government might well be sympathetic to—even enthusiastic about—sculptural self-commemoration, the maquettes were hardly selected, the commissions granted, before a new set of personages and ideals demanded immortalization.

The sculptural history of the Place Vendôme in Paris, admirably summarized by Ruth Butler Mirolli,[4] offers an example. The Place Vendôme was originally planned as a setting for François Girardon's equestrian figure of Louis XIV under the Old Régime, but the statue was torn down in 1792 to make room for a projected column honoring the heroes of the *département*; the column was in turn converted to commemorate the Battle of Austerlitz and was crowned with a colossal statue of Napoleon. The latter statue was removed after the dictator's abdication, and was replaced by still another figure of Napoleon after the Revolution of 1830, which in turn—this time for more or less stylistic reasons—Napoleon III replaced with a replica of the original Napoleon, during the Second Empire; the entire column was torn down under the Commune and then re-erected under the Third Republic. Obviously, the situation for the creator of monumental public art in the grand tradition was not particularly encouraging in nineteenth-century France!

Nevertheless, as the Hirshhorn Museum reveals, monumental sculpture *was* commissioned and executed during this period, and some of it was excellent. Even Antoine-Louis Barye, the popular *animalier* for the bourgeois drawing room, at times rose to the scale of the monumental with considerable *éclat*, executing the *Walking Lion* for

4. *Op. cit.*, pp. 10–11.

54

55

57

THOMAS EAKINS.

54. Study for *The Crucifixion*. 1880.
Oil on canvas, 22 × 18″

55. *A Youth Playing the Pipes*. 1883.
Bronze relief, 19⅞ × 11″

56. *Arcadia*. 1883. Plaster relief, 11⅛ × 24″

57. *The Continental Army Crossing the Delaware*.
1893, cast 1969. Bronze relief, 55 × 94″

58. *The Opening of the Fight*. 1893,
cast 1969. Bronze relief, 55 × 94″

56

58

59

60

the July Column in the 1830s, several groups of sculptural decorations for the Louvre under Napoleon III, as well as *Theseus Slaying the Centaur Bianor* (plate 44), originally exhibited at the Salon of 1850. Indeed, many of the sculptures in the Hirshhorn Museum were originally intended as studies for—or were in some way related to—more grandiose sculptural monuments: Aimé-Jules Dalou's *The Revolutionary* and *Wisdom Supporting Freedom* (plates 75, 76) are studies for larger projects;[5] François Rude's impassioned *Head of an Old Warrior* (plate 36) is related to its counterpart in his monumental group for the Arc de Triomphe; the wonderfully expressive head of a Negress by Carpeaux is obviously related to Africa, one of the four allegorical figures supporting the globe of the Fontaine de l'Observatoire; and Émile-Antoine

5. *The Revolutionary* is obviously related to Dalou's monumental bronze high relief *Mirabeau Répondant à Dreux-Brézé,* commissioned in 1883.

59. SAMUEL MURRAY.
Portrait Bust of Thomas Eakins. 1894.
Painted plaster, $21\frac{1}{2} \times 8 \times 9\frac{3}{4}''$

60. SAMUEL MURRAY.
Portrait Bust of Benjamin Eakins. 1894.
Plaster, $24 \times 13 \times 9\frac{5}{8}''$

61. JOHN FREDERICK PETO.
Mug, Pipe and Match. c. 1887.
Oil on board, $6 \times 9''$

62. JOHN FREDERICK PETO.
*Mug, Book, Pipe, Matchstick and
Biscuit on a Brown Ledge*. c. 1887.
Oil on board, $5\frac{3}{4} \times 8\frac{3}{4}''$

Bourdelle's mighty *The Great Warrior of Montauban* (plate 118) was intended to be part of the grandiose monument honoring the defenders of 1870–71. And of course Rodin, the greatest of all nineteenth-century sculptors, created works on the grand scale, managing to infuse the public monument with the profoundly personal vision and original formal language characteristic of private expression. Rodin, and Rodin alone, synthesized the personal expressivity and formal daring that distinguished the small-scale private work of the nineteenth century with the grandeur of scale and conception associated with the traditional public monument. Indeed, aside from his portraits, few of his individual sculptures exist unrelated to more ambitious complexes, an incredible number of them in some way involved with one of the most richly figured of all sculptural compositions: *The Gates of Hell*.

Rodin's work is interesting because it raises so openly a major issue of sculpture as an art form: that of the nonidentity of sign and

63

63. THOMAS EAKINS.
Miss Anna Lewis. c. 1898.
Oil on canvas, 33 × 28″

64. SAMUEL MURRAY.
Full-Length Figure of Mrs. Thomas Eakins. 1894.
Plaster, $24\frac{3}{4} \times 8\frac{5}{8} \times 9\frac{3}{4}$″

65. THOMAS EAKINS.
William Merritt Chase. c. 1899.
Oil on canvas, 24 × 20″

64

66

67

66. *Army Boots*. 1865. Oil on canvas, 14 × 18″

67. *The Houses of Parliament*. 1881. Watercolor on paper, 12½ × 19½″

signified in the three-dimensional work of art.[6] His sculptures are tangible assertions of the nonliteralness of sculptural marks, of the vital inventiveness of plastic equivalences. While much has been made of the relation between pictorial language and its objects in discussions of the schemata, conventions, and notational systems of painting, far less has been said about similar features in the language of sculpture. In the case of painting, even the most naive accept the relative arbitrariness of the sign system as part of the necessary abstractness of a medium which must, no matter how naturalistic in style, transpose the three-dimensional world of experienced reality onto the two-dimensional surface of the support. No such transformation is demanded of the sculptor's object by the sculptural medium, since *both* are three-dimensional and exist in the same kind of actual, rather than virtual, space. The story of Pygmalion—marble metamorphosed into flesh by desire—offers a charming paradigm of the naive view of the relation between subject and sculpture: while reversing the usual relation be-

6. The terminology used in this discussion of the relation between the thing existing in the world and the sculptured equivalent—or "sign"—for it is roughly based on Ferdinand de Saussure's well-known model for language (from his *Course in General Linguistics,* trans. by W. Baskin, New York, McGraw-Hill, 1959, pp. 65–70), suitably modified to fit the demands of a sculptural rather than a verbal language system. For example, in sculpture the sculptured sign or equivalent *can* be a near-exact replica of the thing it stands for (i.e., in the case of the waxwork) in a way that the linguistic sign can *never* be an exact replica of the concept—plus sound—image it bodies forth. The relation between the linguistic sign and what it transmits *must* be both more complex *and* more arbitrary than that between the sculptural sign and its object.

Two possible adaptations of Saussure's linguistic model to the language of sculpture are suggested in the following diagrams:

	Saussure's Linguistic Model		Complex Sculptural Model		Simplified Sculptural Mode	
SIGNIFIED	Concept	↑ arbitrary ↓ relation	Form of object model (i.e., breast, wrinkle, etc.)	↑ relatively arbitrary ↓ relation	Form or shape of object-model	
SIGNIFIER	Sound-image	⎤ arbitrary ⎦ relation	Shape-image (modalities of material: concavities convexities, etc.)	↑ relatively arbitrary ↓ relation		relatively arbitrary relation
SIGN	Linguistic sign		Sculptural sign		Sculptural sign or equivalence	

tween model and statue, it mythologizes the all-important notion of an absolute formal identity between the thing in the world and the art object.[7] Yet, in actuality, it is precisely in their divergence from mere duplication of individual concavities and convexities, from the exact reiteration of the model's bulges and wrinkles, that the strategies of sculpture differ from those of the waxwork, where such literal fidelity to the facts is of the essence.

So-called primitive styles are based upon a traditional semeiology of stylization and abstraction. In the case of more naturalistic sculpture, the second-rate artist may resort to shopworn conventions of representation in order to diverge from literal reproduction of form. The truly innovating sculptor, like Rodin, on the other hand, asserts the divergence from literalness by daringly adjusted plastic summaries of—or equivalences for—experienced form, felt qualities of surface that may *in themselves* be totally unlike that form or even constitute a metaphor of the sculptor's reaction to it.

It is not merely a case, in Rodin's work, of a painterly or baroque-illusionistic style as opposed to a more classical-tactile one. If we compare the quite free and painterly portrait busts by Carpeaux, *Jean-Léon Gérôme,* for example, or *Alexandre Dumas Fils* (plates 40, 41)—both ultimately relatable to the Bernini tradition of bravura portraiture, their naturalism transmuted by the finesse and nervous *brio* characteristic of the best eighteenth-century French portrait sculpture—with Rodin's *Head of Baudelaire or Monument to Balzac* (plates 91, 120), we see that the difference is not a mere Wölfflinian opposition between the linear and the painterly. On the contrary, if we consider only Rodin's *Baudelaire* in relation to Carpeaux's *Dumas Fils,* the Rodin head is far *less* painterly, far more sculptural, simplified, and reduced to plastic essentials than the Carpeaux. In *Baudelaire* the bronze is modeled in

7. One shudders to think of one of Rodin's works, for example his *Balzac,* suddenly becoming flesh, with all the "lumps and holes" literally reduplicated!

68

70

69

68. EASTMAN JOHNSON.
Mrs. Eastman Johnson. 1887.
Oil on canvas, $55\frac{1}{4} \times 42''$

69. LOUIS COMFORT TIFFANY.
Italian Landscape. c. 1878.
Oil on canvas mounted on board, $21\frac{3}{8} \times 16\frac{1}{4}''$

70. EASTMAN JOHNSON.
Self-Portrait. 1891.
Oil on canvas, $72 \times 36''$

71. FRANK BOGGS. *New York: Entering the Harbor.*
1887. Oil on canvas, 20 × 26"

72. ALBERT BIERSTADT. *Coast Scene* (West Indies).
c. 1880–93. Oil on paper mounted on Masonite, 13½ × 18½"

large, summarized sculptural masses. The shift in direction of the planes above the eyebrows and those beneath the eyes contrasts sharply with the areas immediately adjacent; one senses the bronze shell of the cranium both as a volume bulging with the force of inward pressures and, at the same time, as a poured substance still volatile in its molten flow. In Carpeaux's *Dumas Fils* we are given much more of the actual visual appearance of this lively literary personality: we know more about his wrinkles, his eyebrows, the texture of his hair. The planes of the skull, cheekbones, and eye sockets are less simplified, and far more numerous and complex; form faithfully follows, or creates, an illusion of surface like a diligent if witty and efficient servant. Rodin's modeling, on the contrary, is both less literal *and* less illusionistic, faithful to the conditions of the sculptor's vision and the possibilities inherent in the medium. In *Baudelaire,* a purely sculptural expression of extreme intensity is generated by the opposition of roughly molten and tautly compressed areas. A kind of moral victory of spiritual energy

over the pull of gravity is asserted throughout by even so minor, yet so telling, a touch as the delicate diagonal ledge, shining out in relief, subtended beneath the left nostril. The unsmiling, undercut ripple of the upper lip is played against the compressed irregular bulges of the lower to create a mouth at once sensitive and sullen, the quintessential poet's mouth. All this is done in terms of sculptural values: outward pressures versus gravitational pull; planes, relief, and intaglio in relation to surrounding space. It is Carpeaux's bust—with its play of light and shade on surface calculated to produce *effects* of form, texture, and expression—which is undeniably more pictorial in style. The same contrast might be drawn between the witty, volatile immediacy of Carpeaux's bust of Gérôme and the ponderous protrusions and shadowy concavities of the mighty *Balzac*. The difference between them lies in the difference in the relation of the sculptural sign to that which it signifies, a problem fundamental to sculpture but particularly crucial in the nineteenth century, when many of the old conventions had been

dropped, an extreme vulgarized reduplicative naturalism tended to substitute for them, and consciousness of purely *abstract* values was not yet an issue.

It is not merely that Rodin's surfaces are so boldly modeled, that his volumes are summarized so masterfully, that he has taken such serious account of the pull of gravity, but that these discoveries work so well as formal and expressive strategies. Whereas in waxworks, and in much of the successful sculpture of Rodin's time, convexities, concavities, and directions of movement often served merely to mirror their corresponding parts in the living model (or, in more painterly styles, to create *illusions* of them), in a work like *She Who Was Once the Helmet-Maker's Beautiful Wife* (plate 87) every lump, hole, thrust, and facet counts in transforming the model-idea into an emphatic sculptural statement. There is nothing in this bronze that merely describes: everything signifies. Even such a seemingly fortuitous detail as the indented, saucer-like concavity of the flaccid right breast, the nipple floating passively in its depths, has a metaphoric as well as an anatomical or merely descriptive significance, connoting in purely plastic terms, by reversing the usual relation between firm, convex globe and crowning button, the ravages wrought by the ruthless fingers of time on a once beautiful body. The deeply undercut ridges of sagging bronze at waist and belly convey the same message of brutal mortality, as do the shallower and more open gouges of the rib cage, its hollowness emphasized by the play of light and shadow over the fretted surface of the bronze. Forms bulge and sag where, in terms of classical ideals of beauty, they should be taut and out-thrust; that which is normally convex is sunken, and what should be smooth is rough. It is thus that Rodin creates a sculptural equivalence in plastic metaphors for the alchemy of age. While one *thinks* of this as a horrifically naturalistic depiction of an old woman, and indeed it is from this sense of accuracy that the sculpture's power to convince arises, its force and pathos spring not from the duplication of the wrinkles and sags of an aged

body, but from the invention of sculptural signs for the felt quality of the depredations of time on beauty.

The most extreme example of pictorial style in sculpture is the work of Medardo Rosso toward the end of the nineteenth century. Small-scale, intimate, evocative, Rosso's little works have often been incorrectly related to the style of Rodin, mainly, it would seem, because of the apparent spontaneity of their execution and the concomitant roughness of their surfaces. Yet, in actuality, Rosso's style is a continuation—in fact, the *ne plus ultra*—of the painterly Baroque style, exaggerated by the translation of Impressionist pictorial techniques into sculpture. Rosso's themes, like those of the Impressionists, are taken from the passing experiences of daily life, and deprived quite deliberately of the weighty, atemporal significance characteristic of most sculptural works. And unlike most sculpture, but like painting, they are situated not so much in the spatial context shared with the spectator but in a sketchy ambience of their own—a vaguely adumbrated garden, a piece of land, or at times a curious atmospheric integument, a transparent membrane or web encasing the forms as though with a veil of shaped air. The malleable medium—generally wax—ductile yet frangible at the same time, is used as the Impressionists used their pigments: to suggest the dissolution of solid form through the activity of light and atmosphere by emphasizing the consistency and physical texture— lumpiness, granularity, viscousness—of the material itself. Rosso's is indeed pictorial sculpture carried to its absolute. Only rarely, in a few points of emphasis, do actual forms assert themselves as defined, literally imitative sculptural shapes: the left arm of *The Bookmaker* (plate 98), for example, or the opened mouth of the crying child in *The Golden Age* (plate 95). Otherwise such major protuberances or cavities are deliberately avoided insofar as they interrupt and actually interfere with one's response to the Impressionistic illusion created by the all-over play of light and shadow on constantly shifting or even flowing surfaces, rough or smooth as the occasion may demand. Noncorrespon-

AIMÉ-JULES DALOU.

73. *Fall of Lucifer*. n.d.
Bronze, $5\frac{1}{2} \times 3\frac{1}{2} \times 4\frac{3}{4}''$

74. *Study of a Nude*. c. 1896, cast 1902–5.
Bronze, $20\frac{1}{2} \times 7\frac{3}{8} \times 9''$

75. *The Revolutionary*. n.d.
Bronze, $21 \times 10\frac{1}{2} \times 7''$

76. *Wisdom Supporting Freedom*. 1889.
Bronze on a base, $24 \times 10\frac{1}{4} \times 10\frac{1}{4}''$

74

73

75

76

dence between form and sculptural equivalence is almost complete, and the result is a kind of anti-sculpture which, while often evocative and moving, may simply dissolve into palpitating blobs under adverse conditions of illumination.

Neither Rodin nor Rosso represents the future direction of the sculpture in the Hirshhorn Museum; rather, such portents may be found in the late-nineteenth-century work of Bourdelle, Maillol, and Gauguin. All three of their styles would seem to constitute significant rejections, at least in part, of the style and expressive qualities of Rodin's work. In the case of Bourdelle, this reaction is modified by overt dependence on the older master: both the self-conscious stiffness of archaistic stylization and the intensification of baroque surface treatment and gesture, as well as the constriction of space into a virtual relief plane, can be viewed as reactions to Rodin's style. In Maillol, the self-conscious simplification of form and content, the coolly abstract "Mediterranean" classicism of his approach, may again be interpreted as a specific kind of antithesis to the art of Rodin. But it is Gauguin, with his search for primitive authenticity of form and feeling in the art of barbaric and exotic cultures far from the monumental mainstream of the Western sculptural tradition, whose rejection of Rodin is most unconditional, whose search for a sculpture of formal abstraction and direct, mythic expressive intensity most closely predicts the state of sculpture to come.

Yet, looked at from another point of view, understood at a deeper level, Rodin's achievement can be seen as one of the generative forces behind twentieth-century sculpture in its insistence on the independent properties of the language of sculpture itself. In this way, he may be seen as a major impulse behind the important sculptural experiments not only of Matisse, where the filiation is quite obvious, but of those of the Cubists, the Futurists, the Expressionists, or even of Brancusi, who perhaps carried this aspect of Rodin's style to its ultimate conclusion.

64

77

77. JOHN SINGER SARGENT.
Catherine Vlasto. 1897.
Oil on canvas, $58\frac{1}{2} \times 33\frac{3}{4}''$

78. WILLIAM MERRITT CHASE.
Artist's Daughter in Mother's Dress
(Young Girl in Black). c. 1899.
Oil on canvas, $60 \times 36''$

79

80

II. American Art

The reliefs of Thomas Eakins serve as a natural bridge between two national traditions in art—French and American—and two disparate media, painting and sculpture, in addition to existing as art objects in their own right. While directing his major energies toward painting, Eakins had early supplemented more traditional art training at The Pennsylvania Academy of the Fine Arts with direct study of the human body in anatomy classes at Philadelphia's Jefferson Medical College and in Paris, where, although he primarily studied painting under Gérôme, he managed to receive instruction in sculpture as well, from a minor academician, Augustin-Alexandre Dumont.[8]

8. For further information see Moussa Domit, *The Sculpture of Thomas Eakins,* Washington, D.C., The Corcoran Gallery of Art, May–June 1969.

EDGAR DEGAS.

79. *Dancer at Rest, Hands Behind Her Back, Right Leg Forward.* c. 1882–95, cast 1919–21. Bronze, $17\frac{3}{8} \times 4\frac{7}{8} \times 10''$

80. *Dancer Moving Forward, Arms Raised.* c. 1882–95, cast 1919–21. Bronze, $13\frac{3}{4} \times 6\frac{1}{8} \times 6\frac{3}{8}''$

81. *Dancer Moving Forward, Arms Raised, Right Leg Forward.* c. 1882–95, cast 1919–21. Bronze, $25\frac{3}{8} \times 12\frac{5}{8} \times 8\frac{1}{2}''$

82. *Dancer, Arabesque over Right Leg, Left Arm in Line.* c. 1882–95, cast 1919–21. Bronze, $11\frac{7}{8} \times 17\frac{1}{8} \times 3\frac{3}{4}''$

81

82

83

EDGAR DEGAS.

83. *Prancing Horse.* c. 1865–81, cast 1919–21. Bronze, $10\frac{3}{8} \times 10\frac{3}{4} \times 5''$

84. *Picking Apples.* c. 1865–81, cast 1919–21. Bronze relief, $17\frac{5}{8} \times 18\frac{3}{4} \times 2\frac{3}{4}''$

84

Eakins's relatively rare sculptural works offer a problematic fusion, or alternation, of directness and reticence, vivid freshness and academic rigidity. His classicizing reliefs, such as the bronze *Youth Playing the Pipes* of 1883[9] or *Arcadia* of the same year (plates 55, 56), embody an ambiguous attitude toward the naked human form, an attitude exhibited not merely in relief sculpture, where classical nostalgia—a vague reminiscence of the Parthenon frieze or even, in the case of the *Youth,* a subdued reference to Donatello's *Cantoria*—is understandable but, less comprehensibly, given Eakins's general forthrightness and penchant for scientific exactitude, in the classicizing "effects" of his paintings and even his photographs of the nude. It is as though, for even this most self-determined of nineteenth-century American artists, the idiosyncratic response to the naked human body had to be mediated by the penumbra of Arcadian vision, and possible audacities of deep personal feeling legitimized by classical generalization. No such ambiguities mark Eakins's modest oval fireplace decorations of craftswomanly activities, commissioned in 1882 but later rejected as too expensive. *Spinning* and *Knitting* (plates 50, 51), both related to earlier watercolors, are based on careful, indeed fanatically painstaking preparation. Eakins even required the model for *Spinning* to take lessons in the art in order to make her pose more relaxed and convincing. In both cases the costumes are a tactful adaptation of Early American garb to classical generalization, and details, while authentic, are neither fussy nor obtrusive.

Yet it is as a painter of portraits that Eakins is rightly most esteemed. References to Velázquez, Rembrandt, and Ribera appear repeatedly in the notes he took during his trip to Spain in 1869 and 1870, following his stint in Gérôme's studio in Paris. In his portrait of his favorite sister, *Margaret,* of 1871 (plate 48), there is a strong flavor of

9. Erroneously dated on the bronze 1888, original plaster dated 1883. Domit, *op. cit.,* no. 17, p. 23.

85

87

86

AUGUSTE RODIN.

85. *Mask of the Man with the Broken Nose.*
1864. Bronze, $12\frac{1}{2} \times 7\frac{1}{2} \times 6\frac{1}{2}''$

86. Third architectural model for *The Gates of Hell*. 1880. Plaster, $39\frac{1}{2} \times 25 \times 7\frac{1}{4}''$

87. *She Who Was Once the Helmet-Maker's Beautiful Wife* (The Old Courtesan). 1885. Bronze, $19\frac{7}{8} \times 9\frac{1}{4} \times 12''$

88. *Head of St. John the Baptist.* 1887. Bronze relief, $10\frac{1}{4} \times 8\frac{1}{4} \times 5\frac{1}{2}''$

89. *The Crouching Woman.* 1882, cast 1962. Bronze, $37\frac{1}{2} \times 26 \times 21\frac{3}{4}''$

88

89

Velázquez in the openness of the brushwork (although this may be attributable to academic sketch practice of the time), but even more significant, a parallel tendency on the part of the American artist to grant priority to the individual's identity over flattering generalization or softening sentiment. The air of inwardness, of the subject caught in the web of her own reverie, is perhaps Rembrandtian; the closeness of the image and its romantic poignancy more generally nineteenth century. Yet the study as a total work is Eakins at his purest. It is direct, unpretentious, particularizing, objective in its major impact and intensely moving in its sense of suspended vitality, of the impenetrability of even the most loved, hardly probed human presence. Eakins's female sitters are rarely beautiful in any conventional sense of the term. How far are his *Girl in a Big Hat* or *Miss Anna Lewis* (plates 49, 63) from the high-toned elegance and classy pyrotechnics of John Singer Sargent's *Catherine Vlasto* or *Mrs. Kate A. Moore* (plates 77, 103), or even the comfortable Impressionist unity of form and feeling of

AUGUSTE RODIN.

90. *Iris, Messenger of the Gods.* 1890–91.
Bronze, 32 × 36 × 24″

91. *Head of Baudelaire.* 1898. Bronze, 9 × 7⅜ × 8″

92. *Half-Length Portrait of Balzac.* 1892.
Bronze, 18½ × 14¼ × 12¼″

90

Mary Cassatt's admirable *Portrait of an Italian Lady* (plate 104)! A common inner anxiety, an air of long-sufferingness, a veiled appeal tinged with self-withdrawal seem to characterize all of Eakins's female sitters, marking them off clearly as unique human subjects who differ from the usual charming feminine objects of fashionable portraiture. The same half-conscious awareness of time and its depredations—the past for the mature, the future for the young sitters—scars them all, holds them in wistful yet uneasy bondage. This sense of profound human unease in Eakins's best portraits may, of course, arise from the fact that, as a declared realist, he simply is recording the natural discomfort and self-consciousness concomitant with sitting for one's portrait or, indeed, in those days, for one's photograph, both of which in Eakins's oeuvre share this sense of profound isolation—a sense, perhaps, particularly acute in the reserved, well-bred women, unhabituated to direct observation, who sat for him.

But in some cases, such as the remarkable *Miss Anna Lewis,* Ea-

<p style="text-align:center">91 92</p>

kins has pushed Velázquez's natural rhetoric of incongruity—characteristic of the latter's Infanta portraits—between splendor of feminine costume and ostentatious plainness of the wearer to a disequilibrium at once more moving and more factual. In the Lewis portrait a remarkable sense of gravity arises from the contrast between the diaphanous, beribboned gray party dress, portrayed with such elegant sprightliness and *brio,* and the ponderous fleshiness of the sitter's face and hand, her glazed yet haunted eyes, treated so much more soberly in terms of the very brushwork itself.

It is, however, in the painting of landscape that the idiosyncratic qualities of American vision emerge most fully in nineteenth-century painting. While the range of individual expression is broad and variegated, most nineteenth-century American landscape painting is shaped by the notion of the New World as a kind of primeval paradise, a pure and special case of the international romantic adulation of nature and the primitive, the virgin beauty of the New World offering itself up as

the ideal subject for the morally as well as the visually pure "Emersonian eye" of the American artist. Then, too, there was a tendency, particularly pronounced at mid-century and specifically iterated by the French Realists, to equate landscape painting with democratic art, an art open to the delectation of Everyman, or anyone who had his proper feelings and senses about him. Landscape was viewed as "art for Man," to borrow the words of that staunch apologist for the Realist outlook and democratic art critic par excellence, Théophile Thoré, as opposed to the outworn splendors and learned conventions of art for kings, princes, or aristocrats. In actuality, the general run of American landscapists settled for a kind of popularizing compromise between conventional idealization of composition and meticulous realism of detail, "idealizing in composition and materializing in detail," to paraphrase the contemporary American art lover James Jackson Jarves in his critique of the Hudson River School.[10]

Yet such compromise may, of course, be of the essence for an art that is democratic in the literal sense of the word and for a nation with neither a firmly established tradition of production of, or response to, art, nor an avant-garde to rebel constructively against such tradition. In this sense alone, an artist such as Albert Bierstadt, while European by birth and training, is certainly American in his grandiose panoramas of American natural splendor. While it has become *de rigueur* for sophisticated critics to scoff at Bierstadt's wide-screen evocations of the glories of the West as sentimentally inflated picture postcards, it must be admitted by even the most critical person that, in the face of the conversion of natural American beauty to tract housing or garbage dumps, the sheer emotional pull of such large-scale, richly detailed commemorations, their gorgeous depths magnetic with pristine light and unpolluted air, has offered at least one

10. See Barbara Novak, *American Painting of the Nineteenth Century: Realism, Idealism, and the American Experience,* New York, Praeger, 1969, especially pp. 80 ff., for a more extended discussion of the "hybrid aesthetic" of the Hudson River School.

ALBERT PINKHAM RYDER.

93. *Mending the Harness.* n.d.
Oil on panel, $7\frac{1}{2} \times 8''$

94. *Pegasus.* n.d.
Oil on wood, $7 \times 9''$

93

94

95

96

97

MEDARDO ROSSO.

95. *The Golden Age*. 1886.
Wax over plaster, $16\frac{5}{8} \times 20\frac{1}{2} \times 11''$

96. *Man in Hospital*. 1889.
Plaster, $9 \times 10\frac{3}{4} \times 11\frac{3}{4}''$

97. *Child in the Poorhouse*
(Baby Chewing Bread). 1893.
Wax over plaster, $17\frac{1}{2} \times 19 \times 6''$

98. *The Bookmaker*. 1894.
Bronze, $18 \times 13\frac{1}{8} \times 13\frac{1}{2}''$

98

viewer the overwhelming temptation—physically possible in terms of sheer scale—to walk through the canvas like Alice through the looking glass, into a bygone realm of vanished awesomeness and innocence. And the artist's smaller, less ambitious works are convincing in more usual artistic terms: *Shady Pool, White Mountains, New Hampshire* (plate 53) comes close to some of Courbet's similar studies of "uncomposed" forest interiors in the unassuming accuracy and directness of its approach to a well-known and freshly observed landscape motif.

At the opposite pole of the American nineteenth-century landscape sensibility lie the highly evocative, poetic, interiorized works of the mysterious Ralph Blakelock. In some ways a *retardataire* yet idiosyncratic revenant from the late-eighteenth-century realm of the sublime and the picturesque, obviously affected, indirectly at least, by the pantheistic nature worship of the Barbizon School, Blakelock is nevertheless a characteristic example of the American artist as loner, making up for a certain provinciality or narrowness of range by sheer intensity of vision. For Blakelock, the natural motif, distilled to its essence by a rich technique of built-up glazes and impasto, seems to have served merely as a catalyst for the artist's inner vision rather than as an end in itself.

Far more dependent on the objective realities of the contemporary American scene are the landscape and genre paintings of Winslow Homer. His compositions of figures in a natural, outdoor setting can indeed be compared with contemporary efforts on the part of the French Impressionists, whose early work, as well as that of the Realists, Homer may well have seen during his trip to Paris in 1867. Yet while close to some of Monet's works of the late sixties and early seventies in its casualness and *plein air* brightness—in part, at least, attributable to the watercolor medium—a painting like Homer's *Scene at Houghton Farm* (plate 107), c. 1878, is stiffer, more graphic, and more attached to the integrity of known silhouettes and objects than the works of the Impressionists, and of course his genre scenes, in their

99

101

99. PAUL GAUGUIN.
Torso of a Tahitian Woman. c. 1893,
cast c. 1955. Bronze, $11\frac{1}{2} \times 5\frac{3}{8} \times 6''$

100. PAUL GAUGUIN.
Mask of a Woman. c. 1893–95.
Bronze, $14\frac{3}{8} \times 9\frac{3}{8} \times 4''$

101. ARISTIDE MAILLOL.
Bather with Raised Arms. 1898.
Bronze, $10\frac{1}{2} \times 4\frac{5}{8} \times 4\frac{3}{8}''$

100

subjects alone, ring a sharply and unequivocally American note. While *Army Boots* (plate 66), of 1865, may have quite overt narrative implications, with its combination of hopeful blacks and military accoutrements, even such an apparently "objective" depiction of ordinary Americana as *The Country Store* (plate 106) has heavy overtones of national pride in homespun virtue, an implicit assertion of the superiority of rural simplicity over urban sophistication, a kind of moral *parti pris* quite foreign to Degas's quite similar and exactly contemporary *The Cotton Market, New Orleans* (Musée des Beaux-Arts, Pau, France).

A summarizing and perhaps prophetic statement of the American artist's attitude toward his native landscape is George Inness's *Niagara* (plate 112), of 1893, painted near the end of the artist's life, when the Barbizon explicitness of his earlier style had been transmuted by spiritual beliefs into an imagery more atmospheric, abstract, and evocative.[11] In a composition as "aesthetic" as any of Whistler's, Inness nevertheless creates a compelling image of the prototypical American motif of landscape-as-power, distilling the elements of industrial might, natural energy, and fragile human witness into a simplified tripartite horizontal system, each division separate from, yet merging with, the next. The presence of the four elements—earth, air, fire, and water—amplifies the statement with more universal cosmic resonances. While it is perhaps pushing the point, it may be worth considering a work like *Niagara,* in its emphasis upon nature as process rather than material fact, its hallowing of the dynamism and power of American experience, its vision of American motif as vital energy, its unique combination of the mythic, the natural, and the self-consciously national, as a spiritual ancestor of that apotheosis of the American abstract-sublime, the Abstract Expressionism of the twentieth century.

11. For a discussion of the impact of Swedenborgianism on Inness's style, see Nicolai Cikovsky, Jr., *George Inness,* New York, Praeger, 1971, especially pp. 46-47, 57–59.

102. ALBERT BIERSTADT. *Scene in the Tyrol*. 1854.
Oil on panel, $9\frac{1}{2} \times 13''$

103

104

103. JOHN SINGER SARGENT. *Mrs. Kate A. Moore*. 1884. Oil on canvas, 70 × 44″

104. MARY CASSATT. *Portrait of an Italian Lady*. c. 1879. Oil on canvas, 32 × 23½″

84

105. THOMAS EAKINS. *Mrs. Thomas Eakins.* c. 1899. Oil on canvas, $20 \times 16''$

106. WINSLOW HOMER. *The Country Store.* 1872. Oil on board, $11\frac{1}{2} \times 18''$

107. WINSLOW HOMER. *Scene at Houghton Farm.* c. 1878. Watercolor on paper, $7\frac{1}{4} \times 11\frac{1}{4}''$

107

1

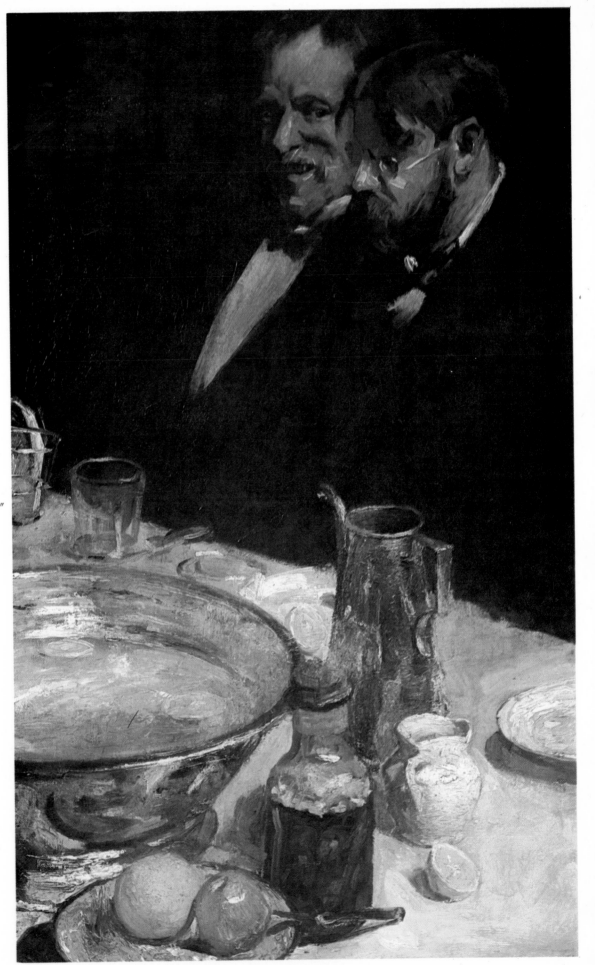

108. RALPH BLAKELOCK.
The Wounded Stag.
c. 1880. Oil on canvas
mounted on wood, 20¾ × 39″

109. RALPH BLAKELOCK.
The Three Trees. c. 1885.
Oil on canvas, 22 × 30″

110. CHARLES HAWTHORNE.
The Story (Two Men at
Table). c. 1898.
Oil on canvas, 48 × 30″

111

112

111. JOHN TWACHTMAN.
The Waterfall. 1890s.
Oil on canvas, 22 × 30″

112. GEORGE INNESS.
Niagara. 1893.
Oil on canvas, 45 × 70″

113. WILLARD METCALF.
Sunset at Grez. 1885.
Oil on canvas, $33\frac{3}{4} \times 43\frac{1}{2}$″

114. CHILDE HASSAM.
Vesuvius. 1897.
Oil on canvas, $25\frac{3}{8} \times 30\frac{7}{8}$″

113

114

115

115. LOUIS EILSHEMIUS. *Figure Seated*. 1890. Oil on canvas, 16 × 12″
116. LOUIS EILSHEMIUS. *Mother Bereft*. c. 1890. Oil on canvas, 20½ × 14½″

117. WILLIAM MERRITT CHASE.
Interior: Young Woman Standing at Table. c. 1898.
Pastel on paper, 22 × 28″

118. ÉMILE-ANTOINE BOURDELLE.
The Great Warrior of Montauban. 1898.
Bronze, $71\frac{1}{2} \times 63 \times 20''$

119. AUGUSTE RODIN.
The Burghers of Calais. 1886.
Bronze, $82\frac{1}{2} \times 95 \times 78''$

94

120. AUGUSTE RODIN.
Monument to Balzac.
1898. Bronze,
8'10" × 3'6½" × 4'2"

1900–1913

by Alfred Frankenstein

121. EDGAR DEGAS.
The Masseuse.
c. 1896–1911, cast 1919–21.
Bronze, $16\frac{1}{2} \times 17 \times 13\frac{3}{4}''$

121

The art of 1900 to 1913 is represented in the Hirshhorn Museum in a very unusual way: nearly all the painting is American and nearly all the sculpture is European. Furthermore, most of the sculpture is by artists who are best known as painters—Degas, Matisse, Picasso, Modigliani. Over much of the sculpture broods the spirit of one who, to be sure, was primarily a maker of three-dimensional images but who was surely the most painterly sculptor who ever lived: Auguste Rodin. And so the paradox of the sculpture in the collection comes full circle.

Most of the sculpture by Edgar Degas was created in the late 1890s; the figures were originally modeled in wax and were not cast in bronze until after the artist's death in 1917. Modeling in soft materials like wax or clay, with the fingers as the artist's principal tool, is likely to recommend itself to painters because the modeled object can be readily changed and added to or partially erased, like a painting; carving wood or stone is precisely the opposite of the modeling process, and it is not surprising that painters generally avoid it.

In a letter to George Moore, Degas described the prevailing subject of his sculptures as "the human beast occupied with herself, a cat licking herself. Until now, the nude has always been represented in poses that presuppose an audience. But my women are simple, honest

122

123

124

125

126

127

EDGAR DEGAS.

122. *Woman Arranging Her Hair*. c. 1896–1911,
cast 1919–21. Bronze, $18\frac{1}{4} \times 10\frac{3}{8} \times 6\frac{5}{8}''$

123. *Woman Rubbing Back with a Sponge, Torso*. c. 1896–1911,
cast 1919–21. Bronze, $17 \times 10\frac{1}{4} \times 7''$

124. *Dancer Putting on Her Stockings*. c. 1896–1911,
cast 1919–21. Bronze, $18\frac{1}{4} \times 8\frac{3}{4} \times 7\frac{1}{2}''$

125. *Woman Getting Out of the Bath*. c. 1896–1911,
cast 1919–21. Bronze, $16\frac{5}{8} \times 5\frac{1}{4} \times 5\frac{1}{4}''$

126. *Dancer Holding Her Right Foot in Her Right Hand*. c. 1896–1911,
cast 1919–21. Bronze, $20\frac{1}{8} \times 10\frac{1}{2} \times 13\frac{1}{4}''$

127. *Woman Stretching*. c. 1896–1911,
cast 1919–21. Bronze, $14\frac{1}{4} \times 8 \times 8''$

people who have no other thought than their physical activity." When Rodin asked Degas why he refused to let his wax sculptures be cast in bronze, the latter replied, "It's too great a responsibility. Bronze is for eternity. You know how I like to work these figures over and over. When one crumbles, I have an excuse for beginning again."

Taken together, these two observations provide an almost complete definition of the painterly/Impressionistic style. Nothing is for eternity. The passing moment crumbles from the moment before it and into the next, and the subject matter is as far from heroic as can be. In addition—and it is an extremely important addition—the kneaded, pitted, knobby, sometimes scarified-looking surfaces of these sculptures are traps for light and shadow, and as such they are totally transformed by changes in illumination; they achieve those changes of aspect through changes of light at which Impressionistic painting forever hints but cannot, because of the nature of that medium, attain.

The fragmentary form of some figures by Degas is worthy of comment as well. To be sure, the headless, armless torso is a well-established convention of nineteenth-century sculpture, but how many conventional sculptors of the nineteenth century would have given us a figure in vigorous motion, bending forward with one leg raised, yet without feet or arms, as does Degas in the *Woman Getting Out of the Bath* (plate 125)? One is reminded of Leo Steinberg's remark about Rodin's fragmented *Flying Figure*: "Rodin has not so much modeled a body in motion as clothed a motion in a body, and in no more body than it wants to fulfill itself."

Bathing, massaging, drying one's self, and starting to dress, as do the women of Degas in these sculptures, are things that come naturally in the nude. Bowling in the nude, however, is something else; the nude lady bowler of the academic painter/sculptor Jean-Léon Gérôme emphasizes, even in subject matter, the artificiality of the nineteenth-century academic tradition. Everything in the *"Boules" Player* (plate 140) is as slick and smooth as can be; the golden tone of the

bronze turns the statuette into a bibelot, and there is a sexiness about the whole performance which suggests that the model's nudity has been attained through a knowing and provocative striptease.

Rodin's view was quite different. "The human body is a temple that marches," he said, and nothing exemplifies that idea so well as his *Walking Man* (plate 221). The figure was originally modeled in 1878, but it was enlarged in 1905 and given a more rugged, battered surface. "No sculptor before Rodin had made such a basic, simple event as walking the exclusive focus of his art and raised it to the level of high drama," says Albert Elsen. To this Steinberg adds, "*The Walking Man* is not really walking. He is staking his claim on as much ground as his great wheeling stride will encompass. Though his body's axis leans forward, his rearward left heel refuses to lift. In fact, to hold both feet down on the ground, Rodin made the left thigh (measured from groin to patella) one-fifth as long again as its right counterpart. The resultant stance is profoundly unclassical, especially in the digging-in conveyed by the pigeon-toed stride and the rotation of the upper torso."

Rodin's *Head of Sorrow* (plate 154) is also a reworking, about 1905, of an earlier sculpture. The same head had appeared as part of several of Rodin's male figures, but in this version it is transformed into a portrait of Eleonora Duse, the famous tragedienne; tragedy, it would appear, is not the exclusive possession of either sex.

Every European sculptor of the early twentieth century came under Rodin's influence, if only to react against it. Few, however, share with him that sense of flux, of endless organic transition and fluidity, which is the essential impressionistic insight, whether in painting or sculpture. One artist who did share that insight is Medardo Rosso, in his *Behold the Boy* (plate 142); but where Rodin is heroic, melodramatic, often tortured, and frequently immense in scale, Rosso speaks with the proverbial still, small voice. His is a genius for pathos rather than tragedy. In his sculpture in wax Rosso is soft and delicate in his touch, and dependent on the white translucency of his material.

129

130

131

132

Charles Despiau and Émile-Antoine Bourdelle both worked in Rodin's studio as technical assistants; both came from a long line of craftsmen, and their employment by Rodin was in that old tradition whereby the sculptor entrusted the labor of realizing his works to others. In their own work, however, neither artist was a pale follower of the celebrated master. Despiau is especially well known for his quietly elegant portrait heads, such as *Paulette* (plate 141), which are reminiscent of the sculptured portraits by Francesco Laurana, Desiderio da Settignano, and other fifteenth-century Florentines. Bourdelle could stand close to Rodin in the ruggedness of his surfaces, as in *Bust of Ingres* (plate 153), and depart from him dramatically in his rejection of the pitted, kneaded surface, as in *Torso of the Figure Called Fruit* (plate 155).

"Sculpture is the art of the lump and the hole," said Rodin, but

131. JOHN SINGER SARGENT.
Betty Wertheimer Salaman
(Mrs. Arthur Ricketts). Before 1906.
Watercolor on paper, $13\frac{7}{8} \times 9\frac{7}{8}''$

132. JOHN SINGER SARGENT.
The Redemption. 1900.
Bronze, $28\frac{1}{2} \times 20 \times 2\frac{1}{4}''$

133. MARY CASSATT.
Baby Charles. 1900.
Pastel on paper, $12\frac{1}{2} \times 9\frac{1}{4}''$

133

there were those of his contemporaries who rejected this idea in favor of smooth surfaces and rounded forms. They scorned the impressionism of kneaded clay, especially when it was cast in bronze; for them, metal had its own virtues and values. Hence the strong, clear surfaces, untormented modeling, and simple, natural poses of Aristide Maillol. "The female form was Maillol's haystack," says Lincoln Rothschild, referring to Claude Monet's repeated depiction of haystacks under different conditions of light and atmosphere. It is scarcely surprising that all the Maillols in the Hirshhorn Museum are female figures.

Related to this post-Rodin group of sculptors is Constantin Meunier, who was older than Despiau, Bourdelle, and Maillol, but shared some stylistic traits with them. Meunier was a Belgian who came from a family of laborers and devoted his entire career to celebrating the dignity of labor in bronze, as in *The Coal Miner* (plate 152).

135

ARISTIDE MAILLOL.

134. *Youth.* 1910, cast c. 1925.
Bronze, $39\frac{7}{8} \times 16\frac{5}{8} \times 13''$

135. *Standing Nude.* 1910.
Terra-cotta, $10\frac{3}{8} \times 3\frac{3}{4} \times 2\frac{3}{4}''$

136. *Kneeling Nude.* c. 1900.
Bronze, $33 \times 16\frac{5}{8} \times 21\frac{3}{8}''$

136

137

139

138

140

141

137. PIERRE BONNARD.
Girl Bathing. c. 1900–1906.
Bronze, $10\frac{3}{4} \times 4 \times 4\frac{5}{8}''$

138. PIERRE BONNARD.
Bather (La Femme aux rochers).
c. 1900–1906. Bronze, $6\frac{1}{2} \times 5\frac{1}{4} \times 3''$

139. FÉLIX VALLOTTON.
The Bather. 1904.
Bronze, $13 \times 3 \times 3\frac{1}{4}''$

140. JEAN-LÉON GÉRÔME.
"Boules" Player. After 1901.
Bronze, $10\frac{3}{4} \times 5 \times 3\frac{1}{4}''$

141. CHARLES DESPIAU.
Paulette. 1907.
Plaster, $12\frac{7}{8} \times 8\frac{5}{8} \times 7''$

Wilhelm Lehmbruck was another Northerner on the periphery of the Rodin circle. He greatly admired the simplifications of Maillol. His lyric sense was extremely strong, and as his career progressed, his figures grew more gaunt, Gothic, and tormented. He committed suicide in Berlin during World War I. Andrew Ritchie quotes him as declaring that measure, proportion, and just relationship are all that matter in art. In this he reflects the German notion of Greek aesthetics preached from the eighteenth century onward, but there may be less justice of proportion in his own work than his philosophy would indicate.

The Greek ideal is better—or at least more obviously—realized by Elie Nadelman than by any other artist under discussion here. For one thing, his *Classical Head* and *Classical Figure* (plates 143, 144) are made of the classical material, marble. They also capture classical serenity, classical facial types, and, in the nude figure, a classical pose, with the right leg slightly forward. Nadelman's *Standing Female Nude* (plate 146), with its strangely sinuous, rubbery limbs, is decidedly unclassical, however; it represents a very early phase of his career, as do two of his drawings in the Museum. Born in Poland and trained in Paris, Nadelman came to the United States in 1914 and lived here until his death in 1946; he is often listed, therefore, as an American artist, but the works considered here were all done in his Paris days, when his discovery of American folk sculpture in painted wood was still in the distant future.

Michelangelo had a broken nose; one of the most celebrated works by Rodin is *Mask of the Man with the Broken Nose* (plate 85); Gauguin did a portrait of himself emphasizing the brokenness of his nose; and Picasso joined the procession with his *Mask of a Picador with a Broken Nose,* dated 1903 (plate 178). Among the great painter/sculptors Picasso alone was as ceaselessly productive and inventive in three dimensions as in two. Picasso's very early sculpture, which falls into the period under discussion, is more traditional in medium and

142

144

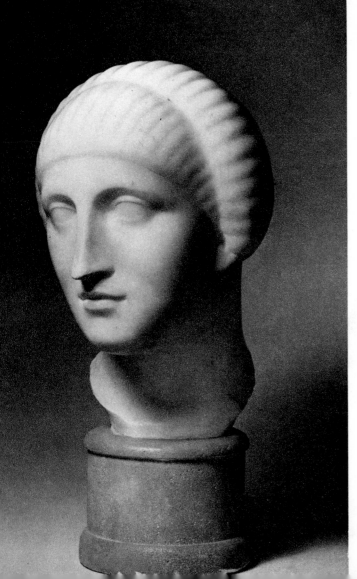

142. MEDARDO ROSSO. *Behold the Boy*.
1906–7. Wax over plaster, $17\frac{1}{4} \times 13\frac{1}{2} \times 9''$

143. ELIE NADELMAN. *Classical Head*.
c. 1909–11. Marble, $12\frac{3}{8} \times 9 \times 11\frac{1}{2}''$

144. ELIE NADELMAN. *Classical Figure*.
c. 1909–11. Marble, $34\frac{3}{4} \times 15\frac{3}{8} \times 13\frac{5}{8}''$

146

145

147

ELIE NADELMAN.

145. *Head of a Man.* c. 1913. Bronze, $15\frac{1}{2} \times 8 \times 11''$

146. *Standing Female Nude.* c. 1909. Pen and ink, and pencil on paper, $21\frac{3}{4} \times 8\frac{3}{4}''$

147. *Standing Male Nude.* c. 1909. Pen and ink, and pencil on paper, $21 \times 9\frac{1}{2}''$

148. *Standing Female Nude.* c. 1909. Bronze, $26 \times 7\frac{1}{2} \times 7\frac{1}{4}''$

148

method than his later sculpture, but is no less characteristic of his work.

Head of a Jester (plate 222), with its powerfully modeled volumes and richly rhythmical crown, reflects the absorption with theater and circus figures that marks Picasso's painting of the same period, c. 1905. *Head of Fernande* (plate 181)—actually a portrait of the artist's mistress—with its fully modeled nose and mouth and flattened-out eyes and peripheral areas, suggests a distant passing interest in the style of Medardo Rosso. *Head of a Man* and *Kneeling Woman Combing Her Hair* (plates 177, 182) were both conceived and originally executed as ceramics, which is rather strange in view of their intensely tragic and highly archaic feeling, since at the time that these works were created ceramic sculpture was almost universally regarded as a lightweight, purely decorative medium. I cannot agree with Werner Spies when, in his book on Picasso's sculpture, he asserts that in turning to the Degas-like subject of a woman combing her hair Picasso retreats from inward, spiritual concerns for the factual, purely plastic statement of "gestures which express virtually nothing about the human psyche or its social predicament." Far from "paving the way for the abandonment of the psychological," as Spies puts it, Picasso here seems to suggest tragic depths of the psyche through the gestures of every day, thereby paralleling the insights of modern depth psychology which were being formulated by Freud and others at the time.

The bronze relief *Head of a Woman,* of 1906 (plate 175), was Picasso's first work in metal. The profile treatment of the nose in the slightly averted face forecasts the days when Picasso would combine two and three perspectives of the same head in a single painting. The full, protruding lips suggest that interest in primitive art which was ultimately to become so pronounced a theme in all of Picasso's work. Spies suggests, however, that the artist had not yet begun to examine the sculpture of tropical Africa and that the source is to be found at one remove: it is Oceanic art as filtered through Gauguin.

149

150

151

LOUIS EILSHEMIUS.

149. *Coney Island.* c. 1909.
Oil on paper mounted on
Masonite, $13\frac{5}{8} \times 21\frac{1}{2}''$

150. *Gas Tanks at End of 23rd
Street, New York.* 1909.
Oil on board, $16\frac{5}{8} \times 24\frac{5}{8}''$

151. *The Flood.* c. 1910–11.
Oil on cardboard, $17\frac{7}{8} \times 21\frac{3}{8}''$

15.

152

152. CONSTANTIN MEUNIER. *The Coal Miner.*
c. 1903. Bronze, $21\frac{1}{4} \times 7\frac{1}{2} \times 5\frac{3}{4}''$

153. ÉMILE-ANTOINE BOURDELLE. *Bust of Ingres.*
1908. Bronze, $22\frac{3}{8} \times 16\frac{1}{2} \times 12\frac{1}{4}''$

154. AUGUSTE RODIN. *Head of Sorrow.*
1905. Bronze, $9\frac{1}{4} \times 8\frac{1}{4} \times 10\frac{1}{2}''$

155. ÉMILE-ANTOINE BOURDELLE. *Torso of the Figure
Called Fruit.* 1911. Bronze, $39 \times 24\frac{1}{4} \times 14''$

154

Head of a Woman (plate 176)—round, bulky, with a great horn of a nose and a tiny mouth—again suggests the primitive, as does *Mask of a Woman,* of 1908 (plate 180). The latter was originally executed in terra-cotta, and the brusque, deep cutting in its modeling is well-adapted to that medium. Both of these heads represent an abstracting or universalizing of their theme; they are the heads of all women and of no woman, and as such they provide an instructive contrast to the head of Fernande, which particularizes, as a portrait, the uniqueness of one woman in bronze.

The two heads just described may be categorized as proto-Cubist; Cubist sculpture bursts into full flower in the *Head of a Woman,* of 1909 (plate 179), which is one of the key masterpieces of modern art and one of the most influential pieces of sculpture ever created. The whole sculptural work of artists such as Roger de La Fresnaye and Alexander Archipenko depends on that revelation of sculptural Cubism by Picasso; it was also to have tremendous influence on the sculpture of the Italian Futurists, and in a sense its influence is working still.

What makes the work Cubist is, of course, the imposition on the head of sharply defined planes and deeply cut ridges, the use of voids and hollows where following the natural form would dictate convexities (especially in the cheeks and forehead), and its general air of having been generated in a matrix of intersecting straight lines. That it was not generated in this way is obvious, however: the curve of the neck upholds the head and counterbalances its grave nod; the hair consists entirely of rounded forms quite devoid of the sharpness of edge elsewhere in the work; and the surface is as nervous and rich as if it had been created by Rodin himself. Picasso was to do many incredible things in sculpture henceforth; nothing he was ever to do in this medium, however, would have so seminal an influence as this *Head of a Woman,* of 1909.

Henri Matisse began his career as a sculptor with humble tribute to Rodin in his statue called *The Serf* (plate 161). Rodin's *Walking*

156. ABBOTT H. THAYER. *Study for Seated Angel.* 1899–1900. Oil on canvas, $37\frac{1}{2} \times 29\frac{1}{2}''$

157. ARTHUR B. DAVIES. *Valley's Brim*. Before 1910. Oil on canvas, 18 × 30″

158. EVERETT SHINN. *Nude Bathers*. 1910. Oil on canvas, 25 × 30″

Man is, of course, recalled in the stance of this figure, but *The Serf* lacks the violence, the dynamism, and the sweeping movement of the older sculptor's work, and it is less than half as big. In place of the juggernaut-thrust of the Rodin, it offers us "a glittering succession of integrated planes," as Herbert Read described it. This quality of intensely animated surface was to remain the sign manual of Matisse's sculpture throughout the rest of his life.

The Serf, with its overtones of tragic feeling and its relatively stolid pose, stands apart from Matisse's sculpture as a whole. The artist himself insisted on the term "arabesque" as most suited to his sculpture, and its appropriateness is clear enough in the *Decorative Figure* (plate 159)—in its sinuous outline, the placement of the arms away from the body to create voids in the composition and thus emphasize its silhouette, and in the twist of the pose, which adds thrust and great variety of shape from the waist down. The pursuit of the arabesque is carried much further in *La Serpentine* (plate 243), where the figure forms part of a closed linear system completed by the stele on which it leans; also, in the interests of line and silhouette, the body and arms of *La Serpentine* are reduced to long, slender rolls, and the thighs are thicker than the torso because they carry the weight of the figure down to the base from which its energy returns, via the stele, to the upper part.

The arabesque and the silhouette are also emphasized in the *Reclining Nude* (plate 160); the outline of this work obviously pleased Matisse exceptionally, since the figure recurs as a still-life object in many of his paintings, as well as in paintings of the nude, with the characteristic up-thrust hip and weighty arm bent over the head. The most celebrated of these paintings, the *Blue Nude* (The Baltimore Museum of Art), was created at the same time as the sculptured version. There is always interaction between sculpture and painting for artists who work in both media, but the relationship is seldom so close as in this instance.

159

HENRI MATISSE.

159. *Decorative Figure*. 1908.
Bronze, $28\frac{1}{4} \times 20 \times 12''$

160. *Reclining Nude I*. c. 1907.
Terra-cotta, $12\frac{5}{8} \times 19 \times 10\frac{1}{2}''$

161. *The Serf*. 1900–1903.
Bronze, $36 \times 13\frac{7}{8} \times 12\frac{1}{4}''$

160

161

162

163

164

166

165

162. RAYMOND DUCHAMP-VILLON.
Maggy. 1912.
Bronze, $28\frac{1}{2} \times 13\frac{1}{8} \times 15\frac{7}{8}''$

163. RAYMOND DUCHAMP-VILLON.
Decorative Basin. 1911.
Bronze, $23\frac{1}{2} \times 7 \times 8\frac{3}{4}''$

164. FRANÇOIS POMPON.
Sleeping Rooster. 1923.
Bronze, $9 \times 12\frac{1}{8} \times 4\frac{7}{8}''$

165. ROGER DE LA FRESNAYE.
The Italian Girl. 1912.
Bronze, $24 \times 12\frac{3}{4} \times 6\frac{1}{2}''$

166. ROGER DE LA FRESNAYE.
The Italian Girl. Detail

Rather curiously, the *Two Negresses* (plate 207) exhibit no Negroid traits. It was Matisse who "discovered" African sculpture for the School of Paris, and its influence on the works of Picasso and others, such as Modigliani's stone *Head* (plate 200), was profound, but Matisse avoided the African note in his own oeuvre.

Matisse's famous remark that he wanted his art to soothe and mollify those who came into contact with it is belied by most of his works, but by none so dramatically as the series of four huge bronze reliefs, each called simply *Back*. One would have to look to the great winged bulls that guarded the gates of ancient Assyrian towns to find anything to equal their monumentality and power. As is the case with other sculptural series by Matisse, such as the five heads entitled *Jeannette* in the Hirshhorn Museum, the four *Backs* are increasingly abstract in their succession. *Back I* (plate 208), for its immensity and power, is relatively naturalistic. In *Back II* (plate 209) the forms are somewhat geometrized, as if Matisse had been looking at the Cubist sculpture of his friend Picasso. The last two sculptures in the series lie outside the scope of this essay, since they were completed after 1913.

Alexander Archipenko was one of the most prolific of all the Cubist sculptors; his *Head: Construction with Crossing Planes* (plate 170) is especially important. Except for this one work, all the Cubist sculpture under discussion here maintains some allegiance to the "normal" appearance of things; here, Cubist deformation leads to a highly formalized construction which breaks completely with the normal aspect of its ostensible subject. Totally abstract sculpture is just around the corner from this bronze by Archipenko, and Archipenko himself was among the first to turn that corner.

The idea that modern art must abandon the accumulated tradition and anti-tradition of centuries and return to first principles and basic forms is one that is constantly reiterated, but few artists have embodied it—or seemed to embody it—in their work so dramatically as Constantin Brancusi. Brancusi's forms are not, of course, Platonic

essences; they are his own inventions, but inventions of such purity and lyric simplicity that they seem to have attained the ultimate, irreducible distillation of form.

Brancusi's *Sleeping Muse* (plate 197) is in marble, like the *Classical Head* of Elie Nadelman. Although Nadelman, who exhibited in Paris about the time Brancusi began *Sleeping Muse,* may well have influenced Brancusi in many ways, in actuality *Sleeping Muse* was abstracted from the features of Brancusi's friend Baroness Renée Frachon. As Sidney Geist puts it, "The facial features [of the *Sleeping Muse*] compose a formal declension as brow converges to nose, which drops to upper lip, itself separated from the slight elevation of the lower lip by a shallow, open groove; between cheek and brow the eyes are a gentle modulation governed by the large tapering ovoid of the head." It is as if the entire head, hair included, were encased by a smooth, flawless skin; we are as far as can be from the knobby, kneaded surfaces of the Rodin tradition. An even more radical reduction of the form of the head occurs with Brancusi's *Prometheus* (plate 199), where facial features are eliminated and the entire meaning of the work resides in its orb-like shape.

The Brancusian sense of essential form is clearly perceptible also in two major sculptures by Raymond Duchamp-Villon. Duchamp-Villon is commonly pigeonholed as a Cubist, and the Cubist emphasis on sharp planes and geometrized forms is most evident in *Maggy* (plate 162), where the voids, hollows, and protuberances of the face come close to caricature. There is no caricature, however, in Duchamp-Villon's *Head of Baudelaire* (plate 194). In addition to giving the face a serious, even grim-lipped mien, the sculptor has endowed the great poet with an enormous cranium, as if to call him a "brain proprietor" (the term which Beethoven applied to himself when his little brother put on airs as a "land proprietor").

An American sculpture, *The Redemption* (plate 132), by John Singer Sargent returns us to the theme of sculpture by painters. It was

167

167. WILHELM LEHMBRUCK. *Bowing Female Torso*.
1913. Cast stone, $36 \times 11\frac{5}{8} \times 18''$

168. WILHELM LEHMBRUCK. *Torso*.
1910–11. Bronze, $26\frac{1}{2} \times 9 \times 8''$

169. ALEXANDER ARCHIPENKO. *Sorrow*.
1909. Painted wood, $9\frac{1}{2} \times 2\frac{1}{4} \times 1\frac{7}{8}''$

170. ALEXANDER ARCHIPENKO. *Head: Construction with Crossing Planes*. 1913, reconstructed c. 1950, cast 1957. Bronze, $15 \times 11\frac{1}{2} \times 11''$

171. MANOLO. *Seated Nude*. 1913.
Stone relief, $14 \times 17\frac{1}{4} \times 4\frac{1}{8}''$

168

169

170

171

174

172. RAYMOND DUCHAMP-VILLON.
Torso of a Young Man. 1910.
Plaster, $23\frac{7}{8} \times 13\frac{1}{4} \times 13\frac{1}{8}''$

173. HENRI GAUDIER-BRZESKA.
Wrestler. 1912.
Lead, $26 \times 14\frac{3}{4} \times 14\frac{1}{4}''$

174. RAYMOND DUCHAMP-VILLON.
Head of Baudelaire. 1911.
Bronze, $15\frac{3}{4} \times 8\frac{3}{4} \times 9\frac{3}{8}''$

173

175

176

I34

177

PABLO PICASSO.

175. *Head of a Woman.* 1906. Bronze relief, $4\frac{7}{8} \times 2\frac{1}{2}''$

176. *Head of a Woman.* 1906. Bronze, $4\frac{1}{2} \times 3\frac{1}{4} \times 3\frac{3}{8}''$

177. *Head of a Man.* c. 1905. Bronze, $6\frac{5}{8} \times 8\frac{3}{4} \times 4\frac{1}{8}''$

178. *Mask of a Picador with a Broken Nose.* 1903. Bronze, $7\frac{1}{4} \times 5\frac{5}{8} \times 4\frac{1}{2}''$

178

made originally as part of Sargent's decorative scheme for the Boston Public Library, which was based on religious themes and involved painting merging at points with sculpture in low relief. The nervous, elongated strokes in this sculpture point to its painterly origins.

As pointed out above, all but one of the sculptures of the period 1900–13 discussed in this essay are European; conversely, all but three of the paintings are American. Three of the American painters—James Abbott McNeill Whistler, Thomas Eakins, and John Singer Sargent—really belong with the nineteenth century so far as the main thrust and meaning of their work is concerned, but the pictures under discussion here are very late productions, painted after 1900.

Whistler, who died in 1903, is represented by *Girl in Black* (plate 216), created in the last year of his life. Black was one of Whistler's two

180

179

PABLO PICASSO.

179. *Head of a Woman*. 1909,
cast 1960. Bronze, $16\frac{3}{4} \times 10 \times 10\frac{1}{2}''$

180. *Mask of a Woman*. 1908.
Bronze, $7\frac{1}{4} \times 6\frac{1}{4} \times 4\frac{1}{4}''$

181. *Head of Fernande*. 1905.
Bronze, $14\frac{1}{4} \times 9\frac{1}{2} \times 9''$

182. *Kneeling Woman Combing Her Hair*.
1905–6. Bronze, $16\frac{3}{8} \times 11\frac{1}{2} \times 13\frac{1}{4}''$

181

182

183. LOUIS EILSHEMIUS. *Fairy Tale*. 1901. Oil on canvas, $14\frac{1}{2} \times 20\frac{1}{2}''$

favorite colors, and blue was the other; in other words, his painting was largely an exercise in subtle tonalism at the cool end of the spectrum. The artist's own remarks about his portrait style are well worth recalling here:

As the light fades and the shadows deepen, all petty and exacting details vanish, everything trivial disappears, and I see things as they are in great, strong masses. The buttons are lost but the sitter remains; the garments are lost, but the sitter remains; the sitter is lost, but the shadow remains; the shadow is lost, but the picture remains. And that, night cannot efface from the painter's imagination.

Eakins is sometimes played off against Whistler as a stay-at-home realist and psychologist in contrast to an expatriate Impressionist and optical sensualist. Actually, there is more realism in Whistler and more Impressionism in Eakins than this view of the two men admits.

Realist and psychologist though he doubtless was, Eakins delighted in the revelation of broad masses in a twilit atmosphere to the same degree as his expatriate colleague, but he respected the third dimension more sedulously and had a genius for the telling detail—furniture, drapery, or still-life accessory—that nails a portrait to its place and time. The major Eakins painting to be considered within the framework of this essay, the portrait of Robert C. Ogden (plate 128), who is shown life-size and seated, recalls, as do so many of the portraits by Eakins, the pictures of seventeenth-century Spanish grandees which he admired so much as a student in Europe. The bearded man, sixty-eight years old, is as severe in appearance as any grand duke, and the crepuscular tone of the whole canvas adds to its majestic quality. The work is unusual for Eakins in that it portrays a person of great wealth and influence. Robert C. Ogden was a partner of John Wanamaker in his merchandising ventures and the founder of the Wanamaker store

in New York City; he was also the prime mover and prime financier of the so-called "Ogden movement" for the improvement of education in the Southern states.

Philadelphia society in general did not like Eakins because of his realism—witness the unfinished state of the portrait of Mrs. Joseph H. Drexel (plate 129). Mrs. Drexel was a society lady who collected fans, as indicated by the fans in the picture, but she was too busy with her social obligations and her fans to pose as often as Eakins, who was rigorously demanding of his sitters, desired. When she started sending her maid to Eakins's studio as a stand-in, the artist gave up.

Another unfinished Eakins painting—though doubtless unfinished for other reasons than those responsible for the incompleteness of *Mrs. Joseph H. Drexel*—is the portrait of Dr. Edward Anthony Spitzka (plate 215), who was an anatomist and brain specialist. The portrait of Frank B. A. Linton (plate 214) reflects the fine intellectualism of Eakins's own circle, and *The Violinist* (plate 130) conveys that sense of the tragic and the inward that suffuses every stroke that Eakins placed on canvas.

The third holdover from the nineteenth century among the American painters to be considered here—John Singer Sargent—was one of the most versatile artists who ever lived. We have already touched on him as a sculptor, but he was also a watercolorist, in that brilliant, dashing, calligraphic, quasi-Oriental style in which watercolor came into its own as an independent medium. Winslow Homer was the pioneer of this development, which was without much question the foremost technical advance registered by American artists before the development of Abstract Expressionism in the 1940s. *Boats on Lake Garda* (plate 212) is somewhat in the Winslow Homer tradition if only in its subject; *Betty Wertheimer Salaman* (plate 131), with its billowing, reiterated oval forms, belongs to a long series of portraits of members of a wealthy London merchant's family which Sargent painted, mostly in oil.

184. OSKAR KOKOSCHKA. *Frau K.*
1912. Oil on canvas, $39\frac{1}{2} \times 29\frac{1}{8}''$

185. ROBERT HENRI. *Blind Singers.*
1913. Oil on canvas, $33 \times 41''$

184

185

141

186

187

188

186. JEROME MYERS. *Street Scene*. 1904.
Oil on canvas, $22\frac{5}{8} \times 28\frac{1}{4}''$

187. JOHN SLOAN. *Rain, Rooftops, West 4th Street*.
1913. Oil on canvas, $20 \times 24''$

188. GEORGE BELLOWS. *Hudson River: Coming Squall*
(*A Cloudy Day*). 1908. Oil on panel, $30 \times 38\frac{1}{2}''$

189

The work and the world of Mary Cassatt balance on a knife edge
between the nineteenth century and the twentieth. A friend and dis-
ciple of the French Impressionists, notably Degas, she resolutely re-
fused to subscribe to the term "Impressionism" and called herself an
Independent all her life. As the group of pictures in the Hirshhorn
Museum indicates, she combined the bright, glowing pastel technique
of Degas with a firm anatomical realism in order to portray an ex-
tremely elegant world of women. Her emphasis on the mother-and-
child motif has been exaggerated, although, as *Baby Charles* (plate
133) demonstrates, she was as successful with her portraits of children
as with her portraits of ladies. Such a title as *Woman in Raspberry
Costume Holding a Dog* (plate 211) exemplifies the fact that she
thought of her pictures largely as genre studies and not as portraits;
thus her sitters are seldom identified.

A case could be made for the start of twentieth-century art in
America with The Eight, a group of painters who exhibited together

189. ERNEST LAWSON. *Wet Night, Gramercy Park* (After Rain;
Nocturne). 1907. Oil on canvas, 26 × 29"

190. J. ALDEN WEIR. *The Bridge: Nocturne* (Nocturne:
Queensboro Bridge). 1910. Oil on canvas, 29 × 39½"

briefly in 1908 and who have been held together by a group label ever since. The group is often said to have placed its primary emphasis on social realism. In its own time it was called the Ashcan School, but that label is almost totally false. What held The Eight together was opposition to the entrenched conservatism of the National Academy of Design, not criticism of American society.

There is, to be sure, some social realism in the subject of a painting such as Robert Henri's *Blind Singers* (plate 185), but there is no trace of it in the other two Henris included here. Henri was the central figure of The Eight and was always talking about redeeming art in the mainstream of life, but a portrait like his *John Butler Yeats* (plate 226) is as bluff and brilliant and unrealistic as anything by Sargent, and much the same is to be said of his *Woman in White* (plate 224).

Everett Shinn did paint some drastic criticisms of society when he was in Paris about 1900: the name Ashcan School was inspired by a pastel by Shinn showing a beggar and a starving cat scrounging for food among the ashcans of Paris. But Shinn's *The Door, Paris* (plate 219) comes directly from Whistler's delicate little notations of doorways and fruit shops in the byways of London, and the social note is no more apparent in *The Door, Paris* than in Shinn's dainty group of nude bathers and their fully clothed companions, which foreshadows the endearing studies of vaudeville and the ballet for which he is especially well known.

Nineteenth-century Americans glorified the wilderness; twentieth-century Americans discovered the city—as atmosphere and as intellectual, spiritual, and social matrix. This discovery is really the watershed between the two centuries in American life. When America gave up its bucolic dreams and recognized the fact that its civilization is urban, American art came into its own, and into the modern arena.

The work of John Sloan signals that discovery, although Whistler had predicted it in London. As in *Rain, Rooftops, West 4th Street* (plate 187), Sloan deals with the Greenwich Village area of New York, its

191. EDWARD HOPPER. *Tramp Steamer*. 1908. Oil on canvas, 20 × 29″

old red-brick buildings, the deep space of its vistas, and the smoky, misty atmosphere that often envelops it. Sloan is the only one of The Eight who consistently painted the city as a motif in itself, apart from the people who inhabit it; in this he gives the cue to such later painters as Edward Hopper, Charles Burchfield, and—although the spirit of his work is totally different—Charles Sheeler. But life on the streets of New York—ordinary life, common life—is also a main theme with Sloan, as it was with other members of The Eight. *Carmine Theater* (plate 229), with its fat deaconess, dogs, and "wistful little customers hanging around a small movie show," as Sloan put it, is a beautiful example of that interest.

The city translated into dissolving veils of color, with space flat-

192. WILLIAM MERRITT CHASE. *Good Friends*. c. 1909. Oil on panel, $22\frac{1}{8} \times 30\frac{7}{8}''$
193. MAURICE PRENDERGAST. *A Dark Day*. c. 1910. Oil on canvas, $21 \times 27''$
194. MAURICE PRENDERGAST. *Seated Girl*. c. 1912–14. Oil on canvas, $24 \times 18\frac{1}{2}''$

193

194

149

tened and silhouettes just indicated, is seen in Ernest Lawson's *Wet Night, Gramercy Park* (plate 189). Lawson was the one member of The Eight who came directly under the influence of Claude Monet and French landscape Impressionism in general. He remains among the very finest of the American landscape Impressionists—a school that is staging a remarkable revival at the present time—but places like Gramercy Park, in the heart of old New York, are unusual subjects for him. He was particularly fascinated with the upper reaches of Manhattan, with the Harlem River and its bridges, and the Hudson River around Fort Tryon Park, as well as with rural subject matter in general.

The work of Arthur B. Davies takes us into a world of mysticism, sex, and a kind of sensual classicism which was very much his own invention. His somnambulistic nudes wandering through beautifully ordered landscapes, as in *Valley's Brim* (plate 157), suggest a parallel with the beginnings of the modern dance and Isadora Duncan, whose world of the theater was quite like the world Davies placed on canvas at about the same time. Davies's nude, full-breasted *Madonna of the Sun* (plate 220) is a paean to love.

Maurice Prendergast was the major modernist of The Eight. He loved fiestas, regattas, Sunday afternoons in Central Park, and every other type of situation where large groups of people had a good time. *A Dark Day* and *Beach at Saint-Malo* (plates 193, 238) predict the modernist assault on the third dimension that Prendergast was to lead among American painters. All three of the Prendergasts under consideration exploit that rich, mosaic-like, tapestry-like paint application which is so characteristic of his style, whether in oil or in watercolor. *Beach at Saint-Malo* also suggests the Post-Impressionist use of a wiry contour line around shapes, restoring the edges of objects after a generation of Impressionist shimmer. Prendergast is sometimes classified with the Impressionist school, but he is actually an anti-Impressionist; he belongs not with Monet but with Gauguin and Van Gogh.

195

195. ABRAHAM
WALKOWITZ.
The Road, Paris.
1906. Watercolor
and graphite on
paper, $10\frac{3}{4} \times 16''$

196. MAN RAY.
The Hill. 1913.
Oil on canvas,
$20 \times 24''$

196

197

198

199

197. CONSTANTIN BRANCUSI.
Sleeping Muse. 1909–11.
Marble, $7 \times 11 \times 8''$

198. CONSTANTIN BRANCUSI.
Reclining Head (The First Cry). 1915.
Gouache on paper, $15 \times 21''$

199. CONSTANTIN BRANCUSI.
Prometheus. 1911.
Polished bronze, $5\frac{1}{2} \times 6\frac{7}{8} \times 5\frac{1}{2}''$

200. AMEDEO MODIGLIANI.
Head. 1911–12.
Stone, $19\frac{3}{4} \times 7\frac{5}{8} \times 8\frac{1}{4}''$

The *Seated Girl* (plate 194) is a very unusual subject for him; he seldom confronted the human figure directly, and most often used it as an impersonal element of energy and movement shown from the back, as in the scenes of St. Mark's Square by Canaletto and Guardi whose Venice gave Prendergast the most important subject of his early career.

Impressionism à la Whistler, with great emphasis on New York at night, forms the theme of two cityscapes by J. Alden Weir (plates 190, 230). A high-keyed Impressionism, more in the French manner, with remarkably solid forms, is apparent in *The East Window* (plate 232) by Childe Hassam. Jerome Myers's delight in ordinary life in New York parallels Sloan and Shinn. Alfred H. Maurer and William Merritt Chase follow Whistler, as Thomas Anshutz follows Eakins; that Maurer would develop into one of the most challenging of American modernists is not even faintly suggested in an early work represented in the Hirshhorn Museum. Another very early work, but one that does to some degree predict the solid realism of later achievement, is Edward Hopper's *Tramp Steamer* (plate 191).

Three paintings by George Bellows and one by Glenn O. Coleman sum up American realism. Coleman's *Queensboro Bridge, East River* (plate 231) parallels Glackens in its feeling for the city and in its sympathetically limned cast of characters. *The Sea* (plate 237), by Bellows, recalls Winslow Homer and his epic of the coast of Maine. The loneliness and emptiness of *Bethesda Fountain* (plate 228), where the human figure is dominated by an artifact, looks ahead to Hopper. *Hudson River: Coming Squall* (plate 188) involves a theme of which Bellows was especially the master; the Hudson was his special province, as Greenwich Village was Sloan's.

The fantastic, eccentric, unpredictable Louis Eilshemius is represented in this volume by nine works. The essential primitivism of his style is apparent in *The Flood* (plate 151), which might well have been developed from a newspaper photograph. Its totally linear treatment, emphasis upon a sensational subject, strangely weak and undramatic

handling of a boat with a figure in it, and its odd framing in paint, all point toward the Sunday artist, as does the romanticism of *Fairy Tale* (plate 183), with its stiff Rhine maidens and seemingly wooden waves. *Mountain Stream* (plate 217) is somewhat more effective in its figures and infinitely more effective in its treatment of mountains and trees, which do not suggest the primitive at all; here Eilshemius parallels the greatest of American romanticists, Albert Pinkham Ryder. Eilshemius also painted the views of New York which were all but mandatory for every American artist of his time—somewhat impressionistically in *East Side, New York* (plate 218), and rather more geometrically, with Surrealistic overtones in its small figures, in *Gas Tanks at End of 23rd Street, New York* (plate 150).

The beginnings of American modernism can be seen in two paintings by Max Weber and Man Ray. Weber's *Bather* (plate 223) is pure, orthodox Analytical Cubism, directly and unashamedly after Picasso. *The Hill* by Man Ray (plate 196) seems rather to stem from German Expressionism. At all events, neither style was to provide a road of development for either painter.

Expressionism is, however, the word for three European paintings of our period in the Hirshhorn Museum. The intensity of feeling is, of course, the element that gives the style its name. That it also permits magnificent portraiture is indicated by Oskar Kokoschka's *Frau K.* and his *Egon Wellesz* (plates 184, 225); Wellesz, composer and musicologist, was a disciple of Arnold Schoenberg, whose portrait Kokoschka would do in later years and who would himself produce some eminently Kokoschka-like paintings.

Describing Kokoschka's portraits, John Russell writes,

Although no one could be more contemptuous of psychoanalysis than Kokoschka, these portraits [all the portraits of Kokoschka, c. 1912] are recognizably the contemporaries of Freud and Jung. As much as they, although from a completely different point of

201

203

202

204

205

HENRI MATISSE.

201. *Head of Jeannette I*. 1910–13. Bronze, $12\frac{1}{2} \times 7\frac{1}{2} \times 10''$

202. *Head of Jeannette II*. 1910–13. Bronze, $10\frac{5}{8} \times 8\frac{1}{4} \times 9''$

203. *Head of Jeannette III*. 1910–13. Bronze, $23\frac{1}{2} \times 8\frac{1}{2} \times 9\frac{1}{2}''$

204. *Head of Jeannette IV*. 1910–13. Bronze, $24 \times 9\frac{1}{2} \times 10\frac{1}{2}''$

205. *Head of Jeannette V*. 1910–13. Bronze, $23 \times 8 \times 11\frac{1}{2}''$

158

206

207

208

209

HENRI MATISSE.

206. *Seated Nude, Olga*. 1910. Bronze, $17 \times 9\frac{3}{8} \times 12\frac{3}{8}''$

207. *Two Negresses*. 1908. Bronze, $18\frac{1}{4} \times 9\frac{5}{8} \times 7\frac{1}{4}''$

208. *Back I*. 1909. Bronze relief, $74\frac{3}{8} \times 46 \times 7''$

209. *Back II*. 1913. Bronze relief, $74\frac{3}{8} \times 47 \times 8''$

view, he was trying at this stage of his career to reconcile those extremes and opposites which make it so difficult to say what any given human being is "like." His sitters have described the sense of desperation with which he went about the work: scratching at the paint with his fingers, flattening himself on the floor if his subject happened to bend down, and remarking that the artist would be justified in using even a hammer or a crowbar if in so doing he got nearer to the final, the perfectly convincing result. Like most paintings in which a new sort of beauty is revealed, these portraits displeased more often than not: only later did they reveal themselves as almost embarrassingly faithful not only to individual sitters but to the collective spirit of their day. Politeness plays no part in them: they are works in which everything is said. But works also in which everything is forgiven, and the idea of pain or "offense" seems ridiculous. Kokoschka pushes his sitters to that far edge of human experience from which we are lucky to come back alive and intact.

Edvard Munch was older than Kokoschka, and was one of the first of the Northern Expressionists, but his *Kneeling Nude* (plate 227) was painted a little later than either of the above-mentioned Kokoschkas. "No more interiors with men reading and women knitting should be painted," said Munch. "They must be living men, breathing, feeling, suffering, and loving. I am going to paint a series of these pictures. Their holiness must be recognized and people must doff their hats before them as they would in church." Here Munch emphasizes that ethical strain which is so important a component of Expressionism wherever it may be found. Perhaps Munch's words are applicable to all significant art.

210. EDGAR DEGAS. *Seated Woman Wiping Her Left Side.* c. 1896–1911,
cast 1919–21. Bronze, $14 \times 13\frac{1}{4} \times 9''$

211. MARY CASSATT.
*Woman in Raspberry Costume
Holding a Dog.* c. 1901.
Pastel on paper mounted
on canvas, $29 \times 23\frac{3}{4}''$

212. JOHN SINGER SARGENT.
Boats on Lake Garda. 1913.
Watercolor on paper, $15\frac{5}{8} \times 21''$

213. THOMAS ANSHUTZ.
*Portrait of a Girl in
a White Dress.* c. 1905.
Oil on canvas, $64\frac{1}{8} \times 40''$

211

212

214

214. THOMAS EAKINS.
Frank B. A. Linton. 1904.
Oil on canvas, $24 \times 20\frac{1}{4}''$

215. THOMAS EAKINS.
Dr. Edward Anthony Spitzka.
c. 1913. Oil on canvas,
$30 \times 25''$

216. JAMES ABBOTT MCNEILL
WHISTLER. *Girl in Black*
(Pouting Tom). 1902–3.
Oil on canvas, $20\frac{3}{8} \times 12\frac{1}{2}''$

215

216

217

166

218

219

217. LOUIS EILSHEMIUS. *Mountain Stream* (Three Nudes at a Mountain Creek). 1900. Oil on canvas, $27\frac{1}{2} \times 19\frac{1}{8}''$

218. LOUIS EILSHEMIUS. *East Side, New York*. c. 1908. Oil on board, $15 \times 13\frac{5}{8}''$

219. EVERETT SHINN. *The Door, Paris*. 1900. Watercolor and charcoal on paper, $10 \times 13\frac{3}{4}''$

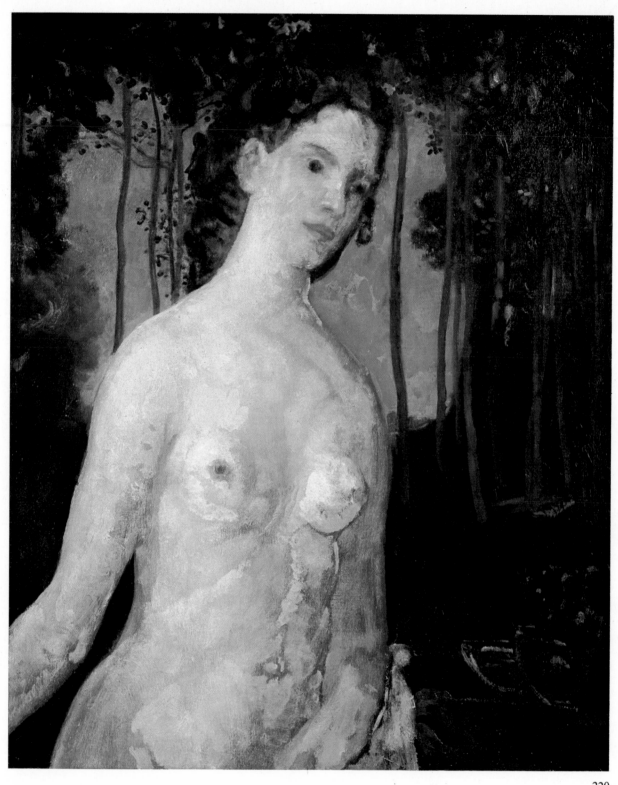

220

220. ARTHUR B. DAVIES. *Madonna of the Sun.* c. 1910.
Oil on canvas, 28 × 23″

221. AUGUSTE RODIN. *Walking Man.* 1905, cast 1962.
Bronze, 83 × 61 × 28″

221 ▶

222. PABLO PICASSO.
Head of a Jester. 1905.
Bronze, $16\frac{1}{4} \times 14\frac{1}{8} \times 9''$

223. MAX WEBER.
Bather. 1913.
Oil on canvas, $60\frac{1}{2} \times 24\frac{1}{4}''$

225

226

224. ROBERT HENRI.
Woman in White (Morelle
in White). 1904.
Oil on canvas, 77 × 38″

225. OSKAR KOKOSCHKA.
Egon Wellesz. 1911.
Oil on canvas, $29\frac{1}{2} \times 27\frac{1}{4}''$

226. ROBERT HENRI.
John Butler Yeats. 1909.
Oil on canvas, 32 × 26″

227. EDVARD MUNCH.
Kneeling Nude. c. 1913.
Oil on canvas, $32\frac{1}{2} \times 31''$

227

228. GEORGE BELLOWS.
Bethesda Fountain (Fountain in Central Park). 1905.
Oil on canvas, $20\frac{1}{4} \times 24\frac{1}{4}''$

229. JOHN SLOAN.
Carmine Theater. 1912.
Oil on canvas, $25 \times 31''$

230. J. ALDEN WEIR.
The Plaza: Nocturne. 1911.
Oil on canvas, $28\frac{7}{8} \times 39\frac{3}{8}''$

231. GLENN O. COLEMAN.
Queensboro Bridge, East River.
c. 1910. Oil on canvas, $30 \times 38''$

228

229

230

231

232

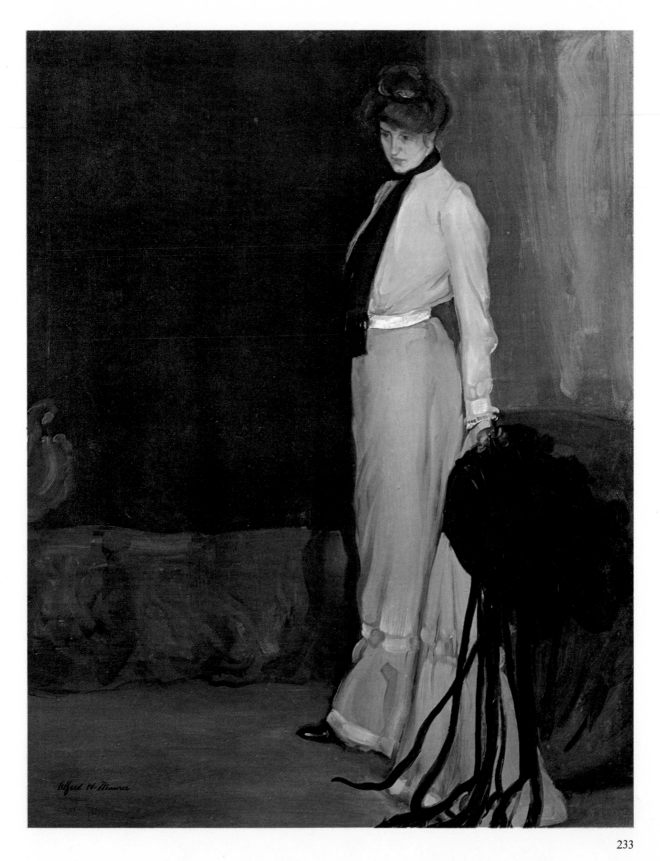

233

232. CHILDE HASSAM. *The East Window*. 1913. Oil on canvas, 55×45″

233. ALFRED H. MAURER. *The Model*. c. 1902. Oil on canvas, 36×29″

234

235

234. JEROME MYERS.
Children Dancing. 1903.
Oil on canvas, $16\frac{1}{4} \times 22\frac{1}{4}''$

235. ROCKWELL KENT.
The Seiners. 1910–13.
Oil on canvas, $34 \times 43''$

236. EDWARD POTTHAST.
Enchanted. n.d. Watercolor
on paper, $21\frac{5}{8} \times 25\frac{7}{8}''$

237. GEORGE BELLOWS.
The Sea. 1911.
Oil on canvas, $33 \times 44''$

236

238

238. MAURICE PRENDERGAST.
Beach at Saint-Malo. 1909.
Watercolor on paper, $13\frac{1}{2} \times 19\frac{5}{8}''$

239. ABRAHAM WALKOWITZ.
In the Street. 1909.
Oil on board, $13\frac{1}{2} \times 10\frac{1}{2}''$

240. E. AMBROSE WEBSTER.
The Bridge. c. 1912.
Oil on canvas, $26 \times 30\frac{1}{8}''$

241. MAURICE PRENDERGAST.
Beach at Gloucester. c. 1912–14.
Oil on canvas, $30\frac{5}{8} \times 43''$

239

240

241

242. HENRI MATISSE. From left to right:
Back I. 1909. Bronze relief, $74\frac{3}{8} \times 46 \times 7''$; *Back II*. 1913. Bronze relief, $74\frac{3}{8} \times 47 \times 8''$;
Back III. 1916–17. Bronze relief, $74 \times 45 \times 6''$; *Back IV*. 1930. Bronze relief, $74\frac{1}{2} \times 45 \times 7''$

243. HENRI MATISSE.
La Serpentine. 1909.
Bronze, $22 \times 11\frac{1}{2} \times 7\frac{1}{2}''$

243

1914–1929

by John I. H. Baur

244. RAYMOND DUCHAMP-VILLON.
Head of Professor Gosset.
1917. Bronze, large version, 12 × 9 × 8″

Like two rocks dropped simultaneously into a pond, Cubism and Fauvism generated sometimes separate, sometimes overlapping waves which spread in the fifteen years from 1914 to 1929 through the art of the entire Western world. In France Analytic Cubism yielded to Synthetic Cubism and spawned the related movements of Purism and Orphism. In Italy there was Futurism, in Russia Suprematism and Constructivism, in Holland de Stijl, in Germany the Blaue Reiter and the Bauhaus.

Equally important, perhaps, was the attendant concept of modern art as a revolution, an avant-garde, an agent of radical change. This idea exercised its influence on each succeeding generation of artists and stimulated the recurring search for new forms of expression which has proved so characteristic of our century. Even the decade and a half covered by this essay saw the formal preoccupations of Cubism and Fauvism challenged by Dada, and Dada itself supplanted by Surrealism.

In America the polarities of "modern" and "traditional" existed during this period but, with some exceptions, on a less intense level. Despite the shock of the Armory Show, modernism established itself more slowly here and often sought compromises with the long Realist tradition of American art which was still producing paintings of more than academic merit.

245

In the Hirshhorn Museum, for example, at least three vigorous strands of native Realism can be identified in works of this period. The most prevalent is the "dark" Impressionism of the old Munich School of the 1870s, still lively in William Merritt Chase's *Still Life with Fish and Brown Vase* (plate 367) and Abbott H. Thayer's penetrating *Self-Portrait* (plate 306), and in the figures of John Sloan—such as *Efzenka the Czech* (plate 369)—and Edwin Dickinson's *Antoinette* (plate 374). This style, which was adopted by Sloan in *McSorley's Saturday Night* (plate 287), and by George Luks, William Glackens, and Everett Shinn for their pictures of life in New York City, seemed to contemporary critics revolutionary in 1908; much later it became known as the Ashcan School.

A second strand of Realism, the sunlit or "light" Impressionism of French art, had been domesticated in the United States before 1900 by Theodore Robinson, John Twachtman, and Childe Hassam, and by 1920 it had been adopted by many other American painters. The

RAYMOND DUCHAMP-VILLON.

245. *Head of a Horse*. 1914.
Bronze, 18¼ × 19⅜ × 15⅞"

246. *Horse*. 1914.
Bronze, 18¼ × 18½ × 8½"

246

still fresh variety of its forms is visible in Edward Potthast's *Beach Scene* (plate 289), Hassam's *The Union Jack, New York, April Morn* (plate 363), Frederick Frieseke's *La Chaise Longue* (plate 362), and Ernest Lawson's *High Bridge* (plate 269).

A third and somewhat less robust art style, also with roots in the past, might be called "decorative fantasy." It was not really a movement, since the artists involved—Arthur B. Davies with his tapestry-like friezes of figures, apparent in *A Thousand Flowers* (plate 366); "Pop" Hart playing rather uncharacteristically with a classical theme, as in *Centaurs and Nymphs* (plate 364); and Joseph Stella with his very Italianate fantasies on medieval themes, such as *La Fontaine* (plate 378), and tropical subjects, for example, *The Palm* (plate 318)—were very different from each other. They all shared, however, a nostalgia for the past and an inclination toward decoration which skirted senti-mentality, though sometimes by a narrow margin.

But even these painters (and other traditionists like them) were af-

189

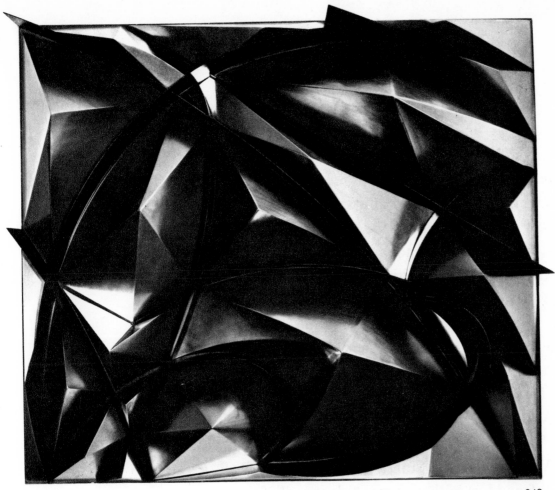

248

GIACOMO BALLA.

247. *Line of Speed and Vortex.* 1913–14, reconstructed 1968. Chromed brass on painted metal base, $78 \times 49 \times 12\frac{1}{2}''$

248. *Plastic Construction of Noise and Speed.* 1914–15, reconstructed 1968. Aluminum and steel relief, $40 \times 47 \times 8''$

249. *Boccioni's Fist—Lines of Force II.* 1915, reconstructed 1955/68. Brass construction, $31\frac{1}{2} \times 30 \times 10''$

fected to some degree by the modernist revolution. Stella turned out to be the one significant American Futurist. Davies tried to graft Cubism onto his decorative style, as in *Dust of Color* (plate 365), and produced a hybrid art of some charm if not great profundity. Alfred H. Maurer, who started in the Chase tradition, ended closer to Modigliani with *Two Sisters* (plate 375).

At the same time a younger generation embraced modernism more wholeheartedly—particularly those artists who found themselves in Paris during World War I, or shortly after. The group included Arthur G. Dove, Max Weber, Abraham Walkowitz, Henry Lee Mc-Fee, John Marin, Joseph Stella, Marsden Hartley, Preston Dickinson, Morton L. Schamberg, Charles Sheeler, Patrick Henry Bruce, Georgia O'Keeffe, William Zorach, Stuart Davis, and Arthur B. Carles—to name only a few. Most of them were students; all of them were powerfully attracted either to Cubism and its variants or to the Fauvism of Henri Matisse. Some went on to Germany and contributed to the development of Expressionism there.

As one tries to sort out this often confused activity certain dominant lines of stylistic development emerge. Cubism had a few direct converts, among them Henry Fitch Taylor, who was painting orthodox Cubist compositions such as *Figure with Guitar I* (plate 344) as early as 1914. It could also claim several European-born artists who later came to the United States, where they exerted great influence. Chief among them were Jacques Lipchitz, with his *Still Life* (plate 351), and Alexander Archipenko, whose Cubist works include *Seated Nude* and *Composition* (plates 256, 349). The pure geometric abstraction which grew out of Cubism in Russia, The Netherlands, and at the Bauhaus in Germany had one of its greatest practitioners—and teachers—in Josef Albers, as seen in his *Fugue II* (plate 338). The later phases of Synthetic Cubism influenced Patrick Henry Bruce's *Forms #12* (plate 377) and Stuart Davis's *Rue des Rats No. 2* (plate 376).

Orphism, that more dynamic variant of Cubism launched by Rob-

250. MORGAN RUSSELL.
Synchromy. 1914–15.
Oil on canvas, 32 × 10″

ert Delaunay and Franz Kupka, had a more immediate appeal to the Americans than Cubism and produced the rival movement of Synchromism, initiated by Stanton Macdonald-Wright and Morgan Russell in 1912–13. While artists in both movements sometimes used recognizable elements of nature, as the Cubists had—for instance, Delaunay in his painting *Eiffel Tower* (plate 397)—they also explored complete abstraction, employing discs, triangles, and squares in brilliant colors to set up spatial tensions based on the illusion that the shapes recede or advance in accordance with the recessive qualities of the colors used. Representative paintings are Macdonald-Wright's *Conception Synchromy* (plate 345) and Russell's *Synchromy* of 1914–15 and of 1915–17 (plates 250, 346).

In general, however, the Americans were not directly attracted by the austerity of Analytical Cubism or by the demanding and alien aesthetics of pure geometrical abstraction. They preferred the strong color and expressive dislocations of Fauvism, as is evident in Ben Benn's *Suggestive Portrait (Walkowitz)* and in Arthur B. Carles's *The Lake, Annecy* and *Nude* (plates 262, 329, 384). They also responded to the more violent color and the more angular distortions of the German Expressionists. The young Marsden Hartley did some of his finest work, such as *Painting No. 47, Berlin* (plate 353), while briefly under this influence. It formed Oscar Bluemner's style for life, as is apparent in *Old Canal, Red and Blue* and *Morning Light (Dover Hills, October)* (plates 263, 347). The subtler and more acid distortions of George Grosz, Germany's most brilliant caricaturist, had little influence on Americans, either at this time or later when he moved to the United States. Perhaps his work—for example, *Café, Circe,* and *A Man of Opinion* (plates 354–56)—was too strongly rooted in a perception of decadence to appeal to American minds.

Surrealism, too, had few American followers in its early years. Announced in Paris by André Breton in 1924 and defined as "pure psychic automatism . . . all exercise of reason and every esthetic or

251

252

251. MAX WEBER.
Spiral Rhythm. 1915,
enlarged and cast 1958–59.
Bronze, $24 \times 13\frac{3}{4} \times 13\frac{1}{4}''$

252. JOHN STORRS.
The Abbot. 1920.
Bronze, $17\frac{1}{8} \times 7\frac{3}{8} \times 12\frac{5}{8}''$

253

254

ALEXANDER ARCHIPENKO.

253. *Flat Torso*. 1915.
Marble on alabaster base,
18¾ × 4½ × 4½″

254. *Vase Figure*. 1918.
Terra-cotta, 18 × 3 × 3¼″

255. *Gondolier*. 1914, reconstructed
c. 1950, enlarged and cast 1957.
Bronze, 64 × 26 × 16″

255

256

moral preoccupation being absent," it released in Europe a spate of fantastic imagery as different as that of Joan Miró's *Circus Horse* (plate 399) and Max Ernst's *The Sun and the Sea* (plate 394). Only one American, Man Ray—whose *Composition (Marchand de couleurs)* is in the Hirshhorn Museum (plate 330)—took part in the initial development of Surrealism, but he had been associated with the preceding Dada movement and was hence no stranger to the irrational spirit.

For most Americans, however, it was a long enough leap from Realism into the formal aesthetics of Cubism and Expressionism; they were not about to leap backward into a self-proclaimed anti-aestheticism, which was also offensive to the strong puritanical strain in American art. Instead, the 1920s saw two broad movements, both aimed at acclimatizing modernism in America. One modified Cubism, the other Fauvism, in the direction of greater realism and the accommodation of American subject matter.

Precisionism—as the wedding between Cubism and Realism be-

257

came known in America—was based on the similarity of some abstract art to machines, particularly in the precision of their parts and their apparently (at least) functional relations. The appreciation of the inherent beauty in machines can be traced as far back as Horatio Greenough in the early nineteenth century, but it was probably Fernand Léger, with *Still Life, King of Diamonds* and *Nude on a Red Background* (plates 395, 396), and the Purists who had a more immediate impact on the young Americans. Légar began to use machine forms about 1910, and during the next decade the Purists developed a machine aesthetic based on Le Corbusier's concept of architecture as a machine for living.

Early in the 1920s several American artists began to paint American scenes as compositions of equally simplified forms, sharply outlined and smoothly modeled. The subjects selected generally lent themselves to such treatment. The city, with its industrial forms and its severe skyscrapers, was the choice of Charles Demuth in *Flour Mill*

258. HENRI LAURENS. *Head of a Woman*. 1925.
Bronze, $16\frac{1}{2} \times 7\frac{1}{2} \times 6\frac{1}{2}''$

259. HENRI LAURENS. *Man with Clarinet*. 1919.
Stone, $23\frac{5}{8} \times 8\frac{7}{8} \times 6\frac{3}{8}''$

260. JACQUES LIPCHITZ. *Girl Reading*. 1919.
Bronze, $30 \times 11\frac{1}{4} \times 9\frac{3}{4}''$

261. JACQUES LIPCHITZ. *Bather*. 1915.
Bronze, $31\frac{1}{4} \times 7\frac{1}{2} \times 4\frac{1}{2}''$

259

258

260

261

262

262. BEN BENN.
Suggestive Portrait (Walkowitz).
1917. Oil on canvas, 38 × 30″

263. OSCAR BLUEMNER.
Old Canal, Red and Blue. 1915.
Oil on canvas, $14\frac{1}{4} \times 20''$

(Factory) (plate 357), George C. Ault in *The Propeller* (plate 315), Louis Lozowick in *Minneapolis* (plate 324), and Niles Spencer in *Edge of the City* (plate 504). Charles Sheeler preferred the austere simplicity of Shaker architecture and crafts, as in *Staircase, Doylestown* (plate 388). Georgia O'Keeffe developed the style as a very personal art of flower and landscape painting, while Preston Dickinson adapted it to the conventional still life, as in the painting *Still Life with Navajo Blanket* (plate 382). Joseph Stella, that chameleon of art, used it sporadically to depict factories and sun-drenched Italian landscapes such as *Cypress Tree* (plate 317).

While all these artists maintained a strong semi-abstract structure in their paintings (at least prior to 1930), others were drawn further toward Realism and bear witness to the effects of Cubism on their art only in a kind of simplifying process, the suppression of detail, and the harmony of volumes simply related. Rockwell Kent in *The Seiners* (plate 235) and Guy Pène du Bois in *The Lawyers* (plate 286) were among the first to jettison detail; indeed, they preceded the Precisionists in this respect, though they did not go as far as the latter and their synthesis of Realism and abstraction was more superficial. Many others followed for a time the same rather uncertain route, among them Maurice Sterne with *Giovanina* (plate 326), Henry Lee McFee in *Still Life with Yellow Flowers* (plate 381), Leon Kroll in *Mary at Breakfast* (plate 325), George Luks in *Girl in Green* and *Girl in Orange Gown* (plates 288, 368), and Edwin Dickinson in *Nude (Helen)* (plate 304).

Expressionism in America, whether related to French or German sources, went through an acclimatization somewhat similar to that of Cubism, although the process did not produce any movement as widespread or strong as Precisionism. It did, however, give us an artist of great distinction in John Marin, whose shorthand distortions, though owing something to Cézanne and Cubism, were basically Expressionist. Just as Delaunay in certain of his Eiffel Tower pictures and in Study for *Portrait of Philippe Soupault* (plate 398) fragmented Cubist

264. CHARLES DEMUTH.
Circus. 1917. Watercolor and
pencil on paper, $8 \times 17''$

265. CHARLES DEMUTH.
*Sailor, Soldier and
Policeman.* 1916. Watercolor
on paper, $10\frac{1}{2} \times 8''$

266. ABRAHAM WALKOWITZ.
Isadora Duncan: Seven Studies.
n.d. Pen and ink and watercolor
on paper, each $6\frac{3}{4} \times 2\frac{5}{8}''$

267. ABRAHAM WALKOWITZ.
New York Improvisation. 1915.
Watercolor and charcoal
on paper, $23 \times 16\frac{1}{8}''$

266

267

205

268

269

268. FRANK A. NANKIVELL.
Children on Rocks by Sea. n.d.
Oil on canvas, $17\frac{1}{2} \times 25\frac{1}{2}''$

269. ERNEST LAWSON.
High Bridge. 1928.
Oil on canvas, $30 \times 36''$

270. CHARLES HAWTHORNE.
Woman with Raised Arms
(verso of plate 361). c. 1920.
Oil on canvas, $38\frac{1}{8} \times 40''$

270

forms to create an essentially Fauvist dynamism, so Marin tipped the Woolworth Building askew, and agitated rocks and sea in an equally romantic spirit, as in *Green Head, Deer Isle, Maine* (plate 350). In *New York Improvisation, Metropolis #2,* and *Italian Improvisation* (plates 267, 359, 360), Abraham Walkowitz attempted similar improvisations on nature and New York but seldom achieved Marin's authority.

Another artist who owed a clear debt to French painting was the young Walt Kuhn, whose early work, such as *The Tragic Comedians* (plate 385), was influenced by Degas and Toulouse-Lautrec. Charles Demuth and the French-born American painter Jules Pascin developed parallel and oddly similar styles in drawing and watercolor; both used subtle linear distortions and delicate washes of color to create an aura of perfumed decadence, as in Demuth's *Circus* (plate 264), *Soldier, Sailor and Policeman* (plate 265), and *Vaudeville: "Many Brave Hearts Are Asleep in the Deep"* (plate 358) and Pascin's *"Salon" at Marseilles* (plate 303). Pascin's influence on a whole generation of

271

American artists was immense. Yasuo Kuniyoshi, in *Child Frightened by Water* and *Nude* (plates 327, 383), was one of many who responded to Pascin's eroticism and his technical virtuosity.

A figure quite apart from these Expressionists was Thomas Hart Benton, whose personal brand of Expressionism, evident in *The Cliffs* and *People of Chilmark* (plates 331, 387), was derived from old masters such as Tintoretto and El Greco and from a determination to create an art of militant Americanism. Although he had dabbled with Synchromism as a young man, he turned against abstraction in the 1920s and, with John Steuart Curry and Grant Wood, became a vocal leader of the widespread revolt against European modernism that culminated in the 1930s.

Between 1914 and 1929 sculpture followed similar lines of development, although the innate characteristics of sculpture opened up new

272

271. ROBERT LAURENT.
Bust of a Woman. 1920–21.
Caen stone, $10\frac{7}{8} \times 8\frac{5}{8} \times 8\frac{1}{8}''$

272. WILLIAM ZORACH.
The Spirit of Silk. 1925.
Bronze, $20\frac{1}{4} \times 4\frac{3}{8} \times 4\frac{5}{8}''$

273. CHARLES DESPIAU.
Eve. c. 1925.
Bronze, $31\frac{1}{4} \times 10\frac{1}{4} \times 6\frac{7}{8}''$

273

274

275

276

277

PIERRE-AUGUSTE RENOIR.

274. *Dancer with a Tambourine I.* 1918.
Bronze relief, $23\frac{3}{4} \times 16\frac{7}{8} \times 1\frac{1}{4}''$

275. *Boy with a Flute* (Pipe Player).
1918. Bronze relief, $24 \times 17\frac{1}{4} \times 2''$

276. *Head of a Woman.* c. 1918.
Bronze, $12\frac{1}{2} \times 8\frac{1}{2} \times 13\frac{1}{2}''$

277. *Mme Renoir.* 1916.
Bronze, $23\frac{5}{8} \times 19\frac{5}{8} \times 13\frac{1}{2}$

278. *Small Venus Victorious,* with
base showing *The Judgment of Paris.*
1913, base 1915. Bronze,
figure $23\frac{3}{4} \times 12\frac{1}{4} \times 7\frac{3}{4}''$; base $9\frac{1}{2} \times 9 \times 9\frac{1}{2}''$

279

280

ARTHUR B. DAVIES.

279. *Head with Cape*. Early 1920s.
Bronze relief, $7\frac{1}{4} \times 4 \times 2\frac{1}{8}''$

280. *Standing Nude, Right Arm
on Shoulder*. Early 1920s.
Bronze relief, $7\frac{1}{2} \times 3\frac{1}{4} \times \frac{1}{2}''$

281. *Beauty and Good Fortune*.
Early 1920s. Bronze relief,
$5\frac{1}{2} \times 5\frac{5}{8} \times \frac{1}{8}''$

282. *Nude*. Early 1920s.
Bronze relief, $6 \times 2 \times \frac{5}{8}''$

283. *Mirror of Venus*. Early 1920s.
Bronze relief, $15\frac{1}{4} \times 5\frac{3}{8} \times \frac{7}{8}''$

284. *Maenad*. Early 1920s.
Bronze relief, $15\frac{1}{2} \times 4\frac{3}{8} \times 2\frac{3}{4}''$

285. *Pillars of Ialysos*.
Early 1920s. Bronze relief,
$13\frac{1}{2} \times 11\frac{5}{8} \times 1\frac{1}{8}''$

281

282

283

284

285

286

286. GUY PÈNE DU BOIS. *The Lawyers*.
1919. Oil on panel, 20 × 15″

287. JOHN SLOAN. *McSorley's Saturday
Night*. 1929. Oil on canvas, 30 × 36″

288. GEORGE LUKS. *Girl in Green*.
Late 1920s. Oil on canvas, 42 × 34″

289. EDWARD POTTHAST. *Beach Scene*.
c. 1916–20. Oil on canvas, 24 × 30″

287

288

289

spatial and technical possibilities and raised problems which painting did not share.

Two traditional movements dominated sculpture well into the twentieth century. The work of Rodin, such as *Étienne Clémentel* (plate 310), guided the Impressionists, most of whom preferred to model in clay rather than to carve. Rodin was joined in sculpture by the painters Degas and Renoir; *Boy with a Flute (Pipe Player)*, *Head of a Woman*, and *Mme Renoir* (plates 275–77) are among the latter's works in the Hirshhorn Museum. In their various ways they broke up the surface of sculpture to create an animated play of light and shade analogous to the glittering effects and the suggestion—rather than the delineation—of form found in Impressionist painting. John Singer Sargent did somewhat the same thing in America in his Study for *The Conflict Between Victory and Death* (plate 309). Rodin's assistant and direct follower, Émile-Antoine Bourdelle, carried the style in the direction of Expressionism in *Portrait Bust of Vincent d'Indy*, *Head of Beethoven with Architecture*, and Study for *Monument to Daumier* (plates 312–14).

The other movement from the past which continued to exert some force in these years was the French classical tradition, which Aristide Maillol devoted his life to reviving and purging of neo-classical eclecticism. This style was the opposite of Rodin's Impressionism in every way. Simple volumes, clear contours, monumental structure, and a sense of timelessness were its characteristics. Often a work was carved rather than modeled, but even when modeled the clay was smoothed out so it retained no signs of its manipulation. In Charles Despiau's work, such as *Mme Derain* (plate 333), the style had an adherent of great sensitivity—if of less force—than Maillol and his *Standing Nude* (plate 135), while Renoir was occasionally seduced into the classical camp, as in his *Small Venus Victorious* with its charming bas-relief of *The Judgment of Paris* on the base (plate 278). In America the little-known sculpture of Arthur B. Davies reveals him as a classicist of

290

290. ELIE NADELMAN.
Horse. c. 1914.
Bronze, $12\frac{1}{2} \times 11\frac{3}{4} \times 3\frac{1}{4}''$

291. RENÉE SINTENIS.
Donkey of Selow. 1927.
Bronze, $30\frac{1}{4} \times 27 \times 8\frac{1}{2}''$

291

292

293

294

GASTON LACHAISE.

292. *Eternal Force*. 1917.
Bronze, $13 \times 6\frac{5}{8} \times 3\frac{1}{4}''$

293. *Woman on a Couch*. 1918–23,
cast 1928. Bronze, $9\frac{1}{2} \times 16 \times 10\frac{1}{2}''$

294. *Egyptian Head*. 1923.
Bronze, $13\frac{1}{8} \times 8\frac{1}{2} \times 9''$

295. *The King's Bride* (Garden
Figure). c. 1927. Cast cement,
$79\frac{1}{2} \times 27\frac{1}{2} \times 17''$

295

296

296. GASTON LACHAISE.
*Reclining Woman with
Arm Upraised* (Woman
in a Chair). 1924.
Bronze, 13¾ × 9⅜ × 14¼″

297. ELIE NADELMAN.
Host. c. 1920–23. Painted
cherry wood and iron,
28⅞ × 15½ × 14½″

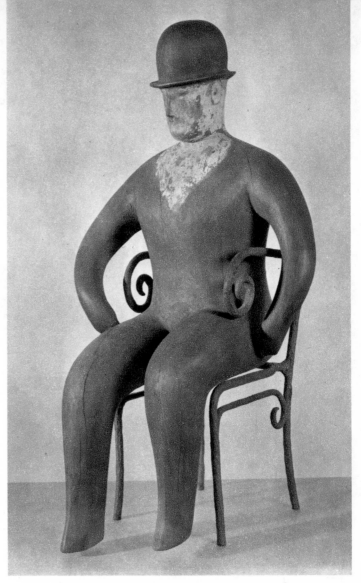

297

much greater strength than his rather mannered paintings suggest. The rich collection of his bronzes in the Hirshhorn Museum ranges from monumental figures—despite their small size—such as *Standing Nude, Right Arm on Shoulder* (plate 280), to elaborate compositions of interweaving forms. Another unexpected revelation in the Hirshhorn Museum collection is the quality of Henry Fitch Taylor's classical carving *Head of a Woman (Cressida?)* (plate 308), apparently done at the same time as his Cubist paintings.

As in painting, the traditional forms of sculpture were disrupted by the advent of Cubism and Fauvism. One of the first sculptors to embark on a systematic exploration of Cubist possibilities in three dimensions was Archipenko, who had created pierced figures and utilized voids as early as 1912, and had translated Cubist collage into relief

298. SIR JACOB EPSTEIN. *First Marble Doves* (Second Group of Birds). 1914. Marble, 13¾ × 19½ × 7¼″

299. JOSÉ DE CREEFT. *Bird.* 1927. Found objects, 11¾ × 13⅜ × 3½″

300. FRANÇOIS POMPON. *Carrier Pigeon.* 1926. Bronze, 12 × 10¾ × 4½″

301. HUGO ROBUS. *The General.* 1922. Bronze, 18⅝ × 19⅜ × 9″

300

301

302

303

304

302. JULES PASCIN. *The Brunette*.
1921. Oil on canvas, $31\frac{7}{8} \times 25\frac{1}{2}''$

303. JULES PASCIN. *"Salon" at
Marseilles*. c. 1929. Watercolor and
pen and ink on paper, $17\frac{1}{2} \times 22\frac{3}{8}''$

304. EDWIN DICKINSON. *Nude* (Helen).
1925. Oil on beaverboard, $36 \times 30''$

305. PRINCE PAUL TROUBETZKOY.
Seated Woman. 1926.
Bronze, $15 \times 8\frac{3}{4} \times 12''$

305

306

308

307

306. ABBOTT H. THAYER. *Self-Portrait.*
1919. Oil on wood panel, $35\frac{1}{4} \times 24\frac{1}{8}''$

307. PAVEL TCHELITCHEW. *Untitled Portrait.*
c. 1926. Oil on canvas, $39\frac{3}{8} \times 31\frac{5}{8}''$

308. HENRY FITCH TAYLOR. *Head of a
Woman* (Cressida?). 1912–15. Marble,
$14\frac{3}{8} \times 7\frac{1}{2} \times 10\frac{5}{8}''$

constructions by 1913–14. His work had an abstract elegance, apparent in *Vase Figure* and *Gondolier* (plates 254, 255), which may have helped to make Cubism acceptable. Archipenko's interest in Cubism was soon shared by other sculptors with a stronger formal sense. Raymond Duchamp-Villon came close to total abstraction in his *Head of a Horse* and *Horse* (plates 245, 246), both done in 1914, although his later *Head of Professor Gosset* (plate 244) modifies Cubism in the direction of a totemistic mask. Jacques Lipchitz made one of the strongest of all contributions to Cubist sculpture in a long series of works done between 1914 and about 1928, including *Girl Reading, Bather, Head,* and *Reclining Nude with Guitar* (plates 260, 261, 332, 390). In these he explored the Cubist principles of simultaneity, voids and volumes, and tipped perspective and controlled space with an authority which makes them seem the natural domain of sculpture. The works of Henri Laurens, *Man with Clarinet* and *Guitar and Clarinet* (plates 259, 352), and such as the sculpture of Ossip Zadkine, for example, *Mother and Child (Forms and Light)* (plate 392), seem decorative by comparison. Two Americans, Max Weber and the long-neglected John Storrs, made considerable contributions to the movement in terms of merit, though certainly not in terms of influence. During Weber's brief Cubist period as a painter he turned out several sculptures, including *Spiral Rhythm* (plate 251), which are totally abstract, while Storrs moved from Cubist figures of great originality, such as *The Abbot* (plate 252), to works which are also completely abstract, though perhaps related to skyscrapers and industrial shapes, among them *Study in Form (Forms in Space)* and *Study in Pure Form (Forms in Space, No. 4)* (plates 335, 336).

While Picasso had made Cubist constructions in 1912–13, neither he nor Georges Braque, the principal founders of Cubism, had much to do with the development of abstract sculpture in these years. Constantin Brancusi, on the other hand, developed his progressively more radical simplifications of natural forms to a point approaching pure abstraction, as in *Torso of a Young Man* (plate 400), and exercised a

309. JOHN SINGER SARGENT. Study for
The Conflict Between Victory and Death.
1921–22. Bronze, $12 \times 6\frac{3}{8} \times 9\frac{1}{2}''$

310. AUGUSTE RODIN. *Étienne Clémentel.*
1916. Bronze, $21\frac{1}{2} \times 15\frac{1}{8} \times 11\frac{5}{8}''$

311. PAUL PAULIN. *Auguste Rodin.* 1917.
Bronze, $14\frac{1}{4} \times 11 \times 13\frac{1}{4}''$

312. ÉMILE-ANTOINE BOURDELLE. *Portrait Bust of
Vincent d'Indy.* 1927. Bronze, $25\frac{1}{2} \times 11\frac{5}{8} \times 11\frac{3}{8}''$

313. ÉMILE-ANTOINE BOURDELLE. *Head of Beethoven
with Architecture.* 1925. Bronze, $16 \times 9\frac{1}{4} \times 12\frac{5}{8}''$

314. ÉMILE-ANTOINE BOURDELLE. Study for
Monument to Daumier. 1925. Bronze, $45 \times 23\frac{1}{2} \times 14\frac{1}{2}''$

310

309

311

312

314

313

315

315. GEORGE C. AULT.
The Propeller. 1922.
Oil on cardboard, 20 × 16″

316. YUN GEE.
Chinese Musicians. 1926–27.
Oil on canvas, 19 × 14″

317. JOSEPH STELLA.
Cypress Tree. c. 1927.
Gouache on paper, 41 × 27″

318. JOSEPH STELLA.
The Palm. c. 1928.
Pastel on paper, 44 × 32¾″

316

317

318

319. JOHN FLANNAGAN. *Lady with Death Mask*. 1926. Mahogany, $12\frac{1}{2} \times 7\frac{7}{8} \times 14\frac{3}{4}$"

320. ERNST BARLACH. *The Avenger*. 1914. Bronze, $17\frac{1}{4} \times 23 \times 8\frac{1}{4}$"

319

pervasive influence on many later sculptors. In Russia Antoine Pevsner and his brother Naum Gabo were leading figures in the Constructivist movement; not only did they "build" their sculpture (rather than model or carve it) but they were also among the first to use transparent plastics, which allowed the various planes to be seen through each other and the total structure to be revealed, as in Pevsner's *Head of a Woman* (plate 389). Piet Mondrian's followers also produced constructions, though these tended—as in César Domela's *Construction* (plate 337)—to be two-dimensional. In Italy Umberto Boccioni published his *Technical Manifesto of Futurist Sculpture* in 1912, and between then and his death in 1916 he produced the most dynamic abstract sculpture of the period. Less well known is the sculpture of his fellow Futurist, Giacomo Balla, who, in 1968, reconstructed a lost piece done in 1915 named, in honor of his friend, *Boccioni's Fist—Lines of Force II* (plate 249). Boccioni's influence seems to have been felt briefly by the American Hugo Robus, whose *General* (plate 301) is remarkably similar to

320

the Italian sculptor's *Unique Forms of Continuity in Space* (The Museum of Modern Art, New York).

Fauvism did not as immediately give rise to sculpture as did Cubism, although Matisse himself produced a large body of bronzes. While the influence of Rodin is apparent in his early work, Matisse soon developed free and expressive distortions of form which carried him sometimes toward Cubism, as in *Back III* (plate 339), but more often in the direction of those sinuous shapes and pagan rhythms which inform his paintings, as, for instance, *Reclining Nude III* (plate 340).

Eventually Expressionist sculpture spread to many countries and developed into a wide variety of forms. In England the American-born sculptor Jacob Epstein tortured clay into pitted surfaces and dark cavities which, as in *Joseph Conrad* and *The Visitation* (plates 321, 323), suggest the mortality of human flesh. In Germany Ernst Barlach translated his love of German Gothic into an angular Expressionism of

SIR JACOB EPSTEIN.

321. *Joseph Conrad.* 1924.
Bronze, $16\frac{1}{2} \times 11\frac{3}{4} \times 10''$

322. *The Duchess of Hamilton.* 1915.
Bronze, $25\frac{1}{2} \times 20\frac{3}{4} \times 10\frac{3}{4}''$

323. *The Visitation.* 1926, cast 1955.
Bronze, $66 \times 19 \times 17\frac{1}{2}''$

321

322

323

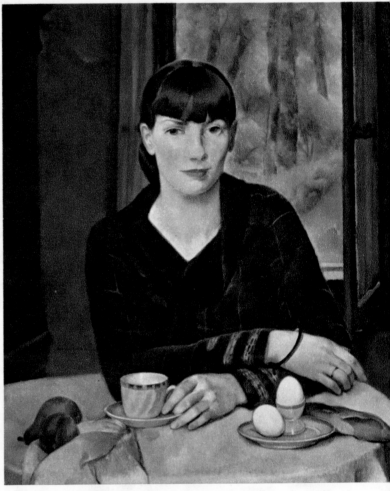

324

324. LOUIS LOZOWICK. *Minneapolis*.
1926–27. Oil on canvas, $30 \times 22\frac{1}{4}''$

325. LEON KROLL. *Mary at Breakfast*
1924. Oil on canvas, $30 \times 25\frac{3}{4}''$

326. MAURICE STERNE. *Giovanina*.
1925. Oil on canvas, $33\frac{3}{4} \times 27\frac{3}{4}''$

326

considerable force. In Paris Lipchitz began about 1925 to break away from Cubism and to search for a more romantic and personally expressive style. *Figure* (plate 391), with its heavy totemic presence, marked a first step in this direction; after 1930 Lipchitz developed a baroque, curvilinear style of even greater Expressionist energy.

The fantastic imagery of Surrealism was not evident in much sculpture before 1930, but one artist, Alberto Giacometti, began in the late 1920s to create strange and sometimes erotic figures, such as *Man and Woman, Man, Woman,* and *Reclining Woman Who Dreams* (plates 341, 342, 343, 401), which appear to have been inspired by the Surrealists. The last of the above pieces particularly forecasts those open constructions of figures in settings with which the artist, at a later date, created a more powerful sense of strangeness and mystery. Although not a Surrealist, José de Creeft produced in these same years several fanciful and often humorous figures made with found objects, such as a picador constructed principally from old stovepipes and the *Bird*

237

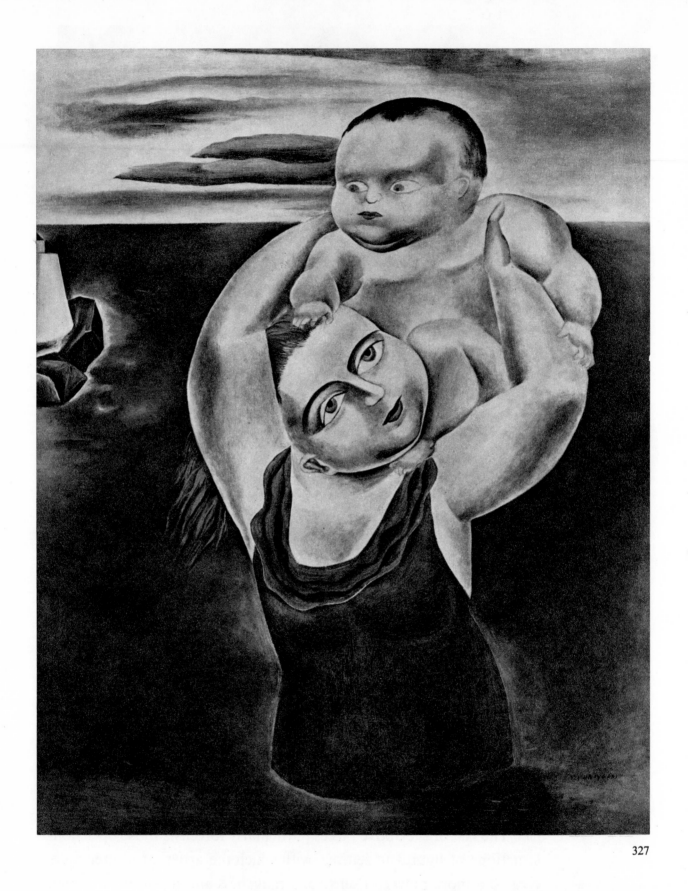

327. YASUO KUNIYOSHI. *Child Frightened by Water.* 1924. Oil on canvas, $30\frac{1}{8} \times 24''$

328. ARSHILE GORKY. *Portrait of Myself and My Imaginary Wife.* 1923.
Oil on cardboard, $8\frac{1}{2} \times 14\frac{1}{4}''$

329. ARTHUR B. CARLES. *The Lake, Annecy.* c. 1920. Oil on canvas, $24\frac{1}{4} \times 29\frac{3}{8}''$

328

329

330

331

333

332

330. MAN RAY. *Composition* (Marchand
de couleurs). 1929. Oil on canvas, $21\frac{1}{4} \times 28\frac{3}{4}''$

331. THOMAS HART BENTON. *The Cliffs*.
1921. Oil on canvas, $29\frac{1}{8} \times 34\frac{1}{2}''$

332. JACQUES LIPCHITZ. *Head*. 1915.
Bronze, $24 \times 7\frac{1}{8} \times 7\frac{3}{4}''$

333. CHARLES DESPIAU. *Mme André Derain*.
1926. Stone, $15\frac{7}{8} \times 9 \times 6\frac{3}{4}''$

334. PABLO GARGALLO. *Kiki of
Montparnasse*. 1928. Polished bronze, $9 \times 6\frac{5}{8} \times 5\frac{5}{8}''$

334

335

242

336

335. JOHN STORRS. *Study in Form*
(Forms in Space). 1924.
Bronze, 19⅞ × 12 × 2⅛″

336. JOHN STORRS. *Study in Pure Form*
(Forms in Space, No. 4). c. 1924. Stainless
steel, copper, and brass, 12¼ × 3 × 1½″

337. CÉSAR DOMELA. *Construction.*
1929. Glass and polychromed metal
on board, 35⅜ × 29½ × 1¾″

338. JOSEF ALBERS. *Fugue II.* 1925.
Sandblasted and painted glass, 6¼ × 22¾″

337

338

HENRI MATISSE.

339. *Back III*. 1916–17.
Bronze relief, 74 × 45 × 6″

340. *Reclining Nude III*. 1929.
Bronze, 7¼ × 18¼ × 5¼″

340

(plate 299). While Marcel Duchamp's ready-mades were the ancestors of this kind of art, de Creeft and Alexander Calder with his *Circus* (Collection the artist) were among the first to explore the aesthetic possibilities of the *objet trouvé*.

One other movement, peculiar to sculpture because of its nature, flourished in this period. It was known as "direct carving," and it grew out of a reaction against the Rodin tradition of modeled clay and the academic technique of translating clay images into stone by means of the pointing machine (often with the aid of hired carvers). Instead, a number of artists, both here and abroad, set out to return sculpture to its first principles, which they felt had been lost in the illusionism of the nineteenth century. They proposed to do their own carving, to let the shape of the rough wood or stone suggest the form and remain inherent in the finished piece, to leave the marks of chisel and point and bushhammer visible whenever appropriate—in short, to make the material and the technique of carving a part of the sculpture's aesthetic.

245

341

ALBERTO GIACOMETTI

341. *Man and Woman*. 1928.
Bronze, $12\frac{1}{2} \times 7\frac{7}{8} \times 5\frac{1}{4}''$

342. *Man*. 1929.
Bronze, $16 \times 11\frac{3}{4} \times 3\frac{1}{2}''$

343. *Woman*. 1927–28, cast 1929.
Bronze, $16\frac{1}{4} \times 14\frac{7}{8} \times 3\frac{5}{8}''$

342

343

Epstein, in England, was one of the first to do this; when he turned from modeling to stone he adopted the blocky simplifications of primitive sculpture, as in *First Marble Doves (Second Group of Birds)* (plate 298). In America the pioneers in the movement were William Zorach, Robert Laurent, and John Flannagan, whose *Lady with Death Mask* (plate 319) is in the Hirshhorn Museum. Zorach and Laurent were both influenced to some degree by the simplicity of American folk art. In France, Henri Laurens, moving away from Cubism, adopted a similar aesthetic, for instance in *Reclining Woman* and *Head of a Woman* (plates 257, 258).

While direct carving was one road toward a fusion of Realism and abstraction, a more deliberate and intellectual step in the same direction was taken by Elie Nadelman at a much earlier date. The essentially Cubist head which he created about 1907 (now lost) preceded, and perhaps influenced, Picasso's Cubist *Head* of 1909 (The Museum of Modern Art, New York). But Nadelman's taste was too strongly

247

formed by the classical sculpture of antiquity for him to pursue Cubism long or to move into pure abstraction. Instead he embarked on a rigorous analysis of the body in terms of its curving silhouettes and its rounded volumes, as in *Horse, Host,* and *The Hostess* (plates 290, 297, 370). His style was a rather mannered one, often informed by wit, but it had a sinuous strength rooted in the structure underlying the sleek surfaces. "I employ no other line than the curve," he once wrote Alfred Stieglitz. "The subject of any work of art is for me nothing but a pretext for creating significant form" (*Camera Work,* 32, 1910, p. 41).

Gaston Lachaise, born in the same year as Nadelman (1882), developed in a parallel direction. Although less intellectual and more sensual than Nadelman, Lachaise too evolved a style of flowing contours, rather mannered poses, and swelling volumes—generally those of the female figure—exemplified by *Eternal Force, The King's Bride (Garden Figure), Reclining Woman with Arm Upraised,* and *Torso ("Ogunquit" Torso)* (plates 292, 295, 296, 371). His debt to the classical tradition is apparent in much work of this period, including *Egyptian Head* and *Walking Woman* (plates 294, 372), but at times he pushed his stylized forms toward almost pure abstraction, as in *Woman on a Couch* (plate 293). Above all, there is a bounding vitality in Lachaise's sculpture, and it is this quality which differentiates it most markedly from Nadelman's cool detachment. Yet the two men remain bracketed as mannerists (in the best sense of the word) and stylists who found similar ways of reconciling sculptural tradition with the new vision created by Cubism. That they happened to be the same age, European born, and Paris trained, and that they emigrated to the United States within eight years of each other (Lachaise in 1906, Nadelman in 1914), were accidents that simply underline the parallels. It was no accident, however, that they became, with William Zorach, the most important American sculptors in the first three decades of the twentieth century.

344. HENRY FITCH TAYLOR. *Figure with Guitar I*. 1914.
Oil on canvas, 36 × 26¼″

345. STANTON MAC DONALD-WRIGHT.
Conception Synchromy. 1914.
Oil on canvas, $36\frac{1}{4} \times 30\frac{1}{4}''$

346. MORGAN RUSSELL.
Synchromy. 1915–17. Oil on
canvas mounted on board, $12\frac{3}{4} \times 10\frac{5}{8}''$

347. OSCAR BLUEMNER. *Morning
Light* (Dover Hills, October).
c. 1916. Oil on canvas, $20 \times 30''$

346

347

348

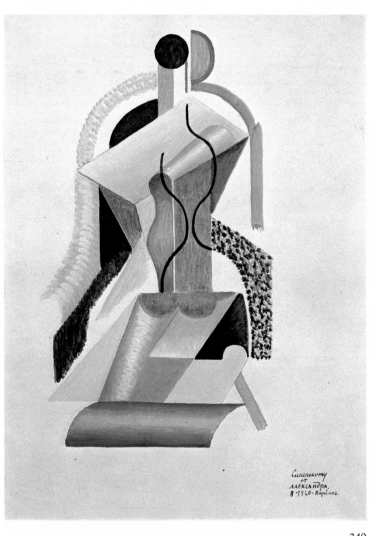

348. ALEXANDER ARCHIPENKO.
Woman with Fan. 1915. Painted
wood relief, $19\frac{1}{4} \times 15\frac{3}{4} \times 1\frac{5}{8}''$

349. ALEXANDER ARCHIPENKO.
Composition. 1920. Gouache and
watercolor on paper, $12\frac{1}{2} \times 9\frac{1}{2}''$

350. JOHN MARIN. *Green Head,
Deer Isle, Maine.* 1921. Watercolor
on paper, $16\frac{1}{2} \times 19\frac{1}{2}''$

349

350

351. JACQUES LIPCHITZ. *Still Life*. 1919.
Gouache and sand on cardboard, 18 × 23″

352. HENRI LAURENS. *Guitar and Clarinet*. 1920.
Polychromed stone, $12\frac{5}{8} \times 14\frac{1}{2} \times 3\frac{1}{2}$″

353. MARSDEN HARTLEY.
Painting No. 47, Berlin. 1914–15.
Oil on canvas, $39\frac{1}{4} \times 31\frac{1}{2}''$

354. GEORGE GROSZ.
Café. 1915.
Oil on canvas, $24 \times 16''$

355. GEORGE GROSZ.
Circe. c. 1925.
Watercolor on paper, $24\frac{1}{8} \times 19\frac{1}{8}''$

356. GEORGE GROSZ.
A Man of Opinion. 1928.
Watercolor on paper, $24\frac{1}{2} \times 18\frac{1}{2}''$

354

355

356

357. CHARLES DEMUTH. *Flour Mill* (Factory). 1921. Tempera on composition board, $18\frac{1}{2} \times 15\frac{7}{8}''$

358. CHARLES DEMUTH. *Vaudeville: "Many Brave Hearts Are Asleep in the Deep."*
1916. Watercolor on paper, $13 \times 8''$

359. ABRAHAM WALKOWITZ. *Metropolis—No. 2.* 1923. Watercolor on paper, $30 \times 22''$

360. ABRAHAM WALKOWITZ. *Italian Improvisation.* 1914. Watercolor on paper, $14 \times 21''$

358

359

360

361

363

361. CHARLES HAWTHORNE. *Evening* (recto of plate 270).
c. 1920. Oil on canvas, 40 × 38⅛″

362. FREDERICK FRIESEKE. *La Chaise Longue*.
1919. Oil on canvas, 39⅝ × 60½″

363. CHILDE HASSAM. *The Union Jack, New York, April Morn.*
1918. Oil on canvas, 37 × 20″

364. "POP" HART.
Centaurs and Nymphs. 1921.
Watercolor and pencil
on paper, 26 × 19″

365. ARTHUR B. DAVIES.
Dust of Color. c. 1915–20.
Oil on canvas, 28¼ × 23¼″

366. ARTHUR B. DAVIES.
A Thousand Flowers. c. 1922.
Oil on canvas, 33½ × 64″

365

366

367

368

367. WILLIAM MERRITT CHASE. *Still Life with Fish and Brown Vase*
(Venetian Fish). 1914. Oil on canvas, 29 × 36″

368. GEORGE LUKS. *Girl in Orange Gown*. Late 1920s. Oil on canvas, 30 × 36″

369. JOHN SLOAN. *Efzenka the Czech*. 1918. Oil on canvas, 32½ × 19¾″

370. ELIE NADELMAN.
Hostess. c. 1918–20. Painted
cherry wood, $32\frac{1}{2} \times 9\frac{1}{4} \times 13\frac{1}{2}''$

371. GASTON LACHAISE.
Torso ("Ogunquit" Torso;
"Classic" Torso). 1928, cast 1946.
Polished bronze, $10\frac{3}{8} \times 6\frac{3}{8} \times 4\frac{3}{8}''$

372. GASTON LACHAISE.
Walking Woman. 1919.
Bronze, $17 \times 10\frac{3}{4} \times 7\frac{1}{2}''$

371

370

372

l'Embarquement pour les Îles

373. JULES PASCIN.
Embarkation for the Islands
(Homage to MacOrlan). c. 1924.
Oil, gouache, charcoal, and
pastel on paper mounted
on canvas, $67\frac{1}{2} \times 62''$

374. EDWIN DICKINSON.
Antoinette. 1919.
Oil on canvas, $32 \times 26''$

375. ALFRED H. MAURER.
Two Sisters. c. 1924.
Oil on board, $30 \times 19\frac{3}{4}''$

375

374

269

376. STUART DAVIS. *Rue des Rats No. 2*. 1928. Oil and sand on canvas, 19¾ × 28¾″

377. PATRICK HENRY BRUCE. *Forms #12*. 1927. Oil on canvas, 35 × 45¾″

378. JOSEPH STELLA. *La Fontaine*. c. 1925. Oil on canvas, 43 × 37″

379. JOAQUÍN TORRES-GARCÍA.
New York Street Scene. 1920.
Oil on paper mounted on panel, $18\frac{1}{2} \times 26\frac{1}{4}$″

380. LOUIS EILSHEMIUS.
Statue of Liberty. c. 1913.
Oil on Masonite, $13\frac{7}{8} \times 10$″

381. HENRY LEE MC FEE.
Still Life with Yellow Flowers
(Bouquet of Yellow Flowers). c. 1925–28.
Oil on canvas, $30\frac{1}{4} \times 24\frac{1}{4}$″

382. PRESTON DICKINSON.
Still Life with Navajo Blanket. 1929.
Oil on canvas, 20×20″

381

382

273

383

384

383. YASUO KUNIYOSHI.
Nude. 1929. Oil on
canvas, 30 × 40″

384. ARTHUR B. CARLES.
Nude. 1922. Oil on
canvas, $28\frac{1}{4} \times 34\frac{1}{2}″$

385. WALT KUHN.
The Tragic Comedians.
c. 1916. Oil on canvas,
$95\frac{7}{8} \times 45″$

386

387

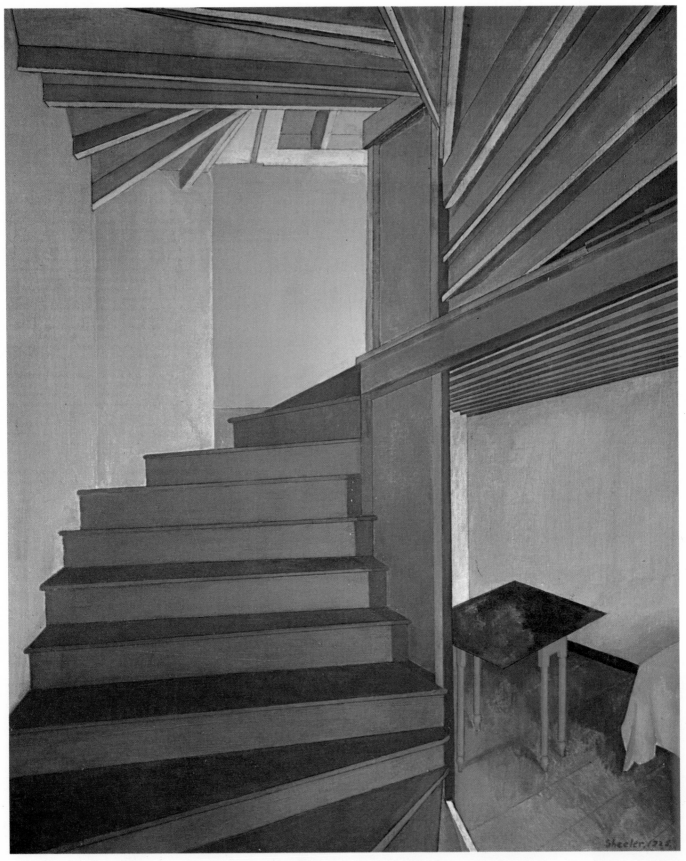

388

386. C. S. PRICE. *Coastline*. c. 1924. Oil on canvas, 40 × 50¼"

387. THOMAS HART BENTON. *People of Chilmark* (Figure Composition).
1920. Oil on canvas, 65½ × 77½"

388. CHARLES SHEELER. *Staircase, Doylestown*. 1925. Oil on canvas, 24 × 20"

389

389. ANTOINE PEVSNER.
Head of a Woman. 1923.
Plastic construction on wood
panel, $14\frac{1}{4} \times 9\frac{1}{4} \times 3\frac{1}{4}$"

390. JACQUES LIPCHITZ.
Reclining Nude with Guitar.
1928. Bronze, $16 \times 29\frac{3}{4} \times 13$"

391. JACQUES LIPCHITZ.
Figure. 1926–30.
Bronze, $87\frac{1}{2} \times 38\frac{1}{2} \times 28\frac{1}{2}$"

392. OSSIP ZADKINE. *Mother and Child* (Forms and Lights).
1918. Marble, $23\frac{3}{4} \times 16\frac{1}{2} \times 7\frac{1}{2}''$

393. JOSEF ALBERS. *Untitled Glass Assemblage.*
1921. Light box, wood, glass, and wire, $23 \times 21\frac{3}{4} \times 7\frac{1}{4}''$

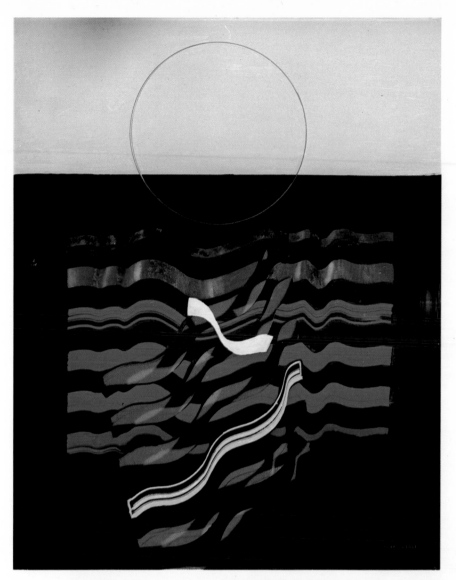

394

394. MAX ERNST.
The Sun and the Sea.
c. 1926–29. Oil paint
on glass, $21\frac{1}{4} \times 17\frac{3}{4}''$

395. FERNAND LÉGER.
*Still Life, King of
Diamonds.* 1927. Oil
on canvas, $36 \times 26''$

396. FERNAND LÉGER.
Nude on a Red Background.
1927. Oil on canvas,
$51 \times 32''$

395

396

397. ROBERT DELAUNAY. *Eiffel Tower*. 1924–26. Oil on canvas, $63\frac{1}{4} \times 47\frac{1}{4}''$

398. ROBERT DELAUNAY. Study for *Portrait of Philippe Soupault*. 1922.
Watercolor and black chalk on paper mounted on canvas, $76\frac{1}{2} \times 51''$

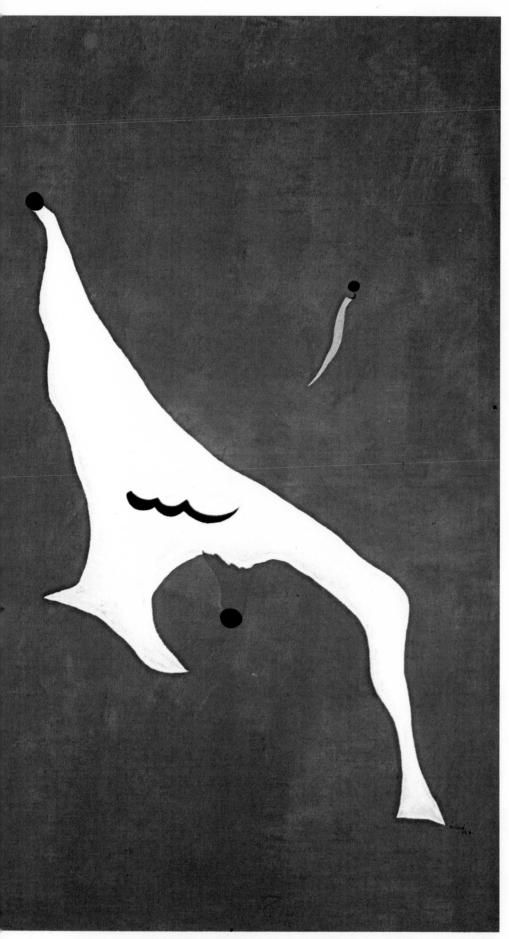

399. JOAN MIRÓ.
Circus Horse. 1927.
Oil on canvas, $6'4\frac{3}{4}'' \times 9'2\frac{1}{4}''$

400

400. CONSTANTIN BRANCUSI.
Torso of a Young Man. 1924.
Polished bronze on original stone
and wood base, $18 \times 11 \times 7''$;
height of base $40\frac{3}{8}''$

401. ALBERTO GIACOMETTI.
Reclining Woman Who Dreams.
1929, cast c. 1959. Bronze
painted white, $9\frac{1}{2} \times 16\frac{1}{2} \times 5''$

401

1930-1945

by Milton W. Brown

402

402. HENRI MATISSE. *Back IV*. 1930.
Bronze relief, $74\frac{1}{2} \times 45 \times 7''$

403. PABLO GARGALLO. *The Prophet*
(St. John the Baptist). 1933.
Bronze, $92\frac{1}{4} \times 29\frac{3}{4} \times 18\frac{1}{8}''$

404. ALBERTO GIACOMETTI. *Cubist Head*.
1934–35. Painted plaster, $7 \times 7\frac{3}{4} \times 8\frac{1}{2}''$

403

404

The years between the stock-market crash of 1929 and the end of World War II were perhaps the most critical of the twentieth century. The economic depression which hit the United States was worldwide in scope, driving countries to the brink of bankruptcy and revolution. In most, the struggle between communism and fascism as alternatives to capitalism in crisis became an overriding issue. With the end of the 1920s, the short interlude of apparent peace, stability, and prosperity—at least for the great powers who had been victorious in World War I—came to an end. The political and military aggression of the "have not" nations began to unsettle the balance and eventually led to war. The tragic series of events opened with the invasion of Manchuria by Japan in 1931. Then, out of a miasma of economic depression, uncertainty, and fear, haunted by the specter of communism, the German nation in 1933 gave birth to Nazism. Emboldened by the course of events, Italy invaded Ethiopia in 1935. Germany reoccupied the Rhineland without opposition in 1936 and Spanish Falangism, with the blessings and military support of Hitler and Mussolini, attacked the newly established republican government of Spain. The organization of the liberal forces of Europe against this concerted thrust of fascism was too little and too late. After a period of hysterical political maneuvers, which included the Munich agreement, the surrender of Czechoslovakia by the Allied nations, and the unexpected Nazi-So-

GEORGES BRAQUE.

405. *Little Horse* (Gelinotte).
1939, cast 1955.
Bronze, $7\frac{3}{8} \times 7\frac{3}{8} \times 2''$

406. *Little Horse*. 1939, cast 1955.
Bronze, $8\frac{3}{8} \times 6\frac{7}{8} \times 2\frac{1}{8}''$

407. *Hesperis*. 1939, cast 1955.
Bronze, $16\frac{1}{4} \times 8\frac{3}{4} \times 3\frac{1}{2}''$

405

viet Pact, the Germans invaded Poland in 1939 and World War II began.

During these years of crisis, culture was riven by unprecedented economic, ideological, and aesthetic stresses. There has been no time in recent memory, at least in the United States, when the artist was so affected by sheer physical need, so involved in economic action, so moved to political expression and organization, so caught up in aesthetic debate. It was a time of intellectual ferment, questioning, daring; a time of economic solidarity as well as acrimonious ideological factionalism. The Depression in the United States produced a unique social and cultural configuration, quite unlike those in Europe. In the first place, there was an inevitable drawing back from international affairs and a concentration on internal problems of survival. The United States was, thus, somewhat more removed than normally from the political convulsions that were gripping Europe, though the echoes of the epochal struggle were felt in America and even dominated the thinking and feeling of some segments of the population, especially in the East and in intellectual circles.

406

407

Although nationalism in American art had increased during the post–World War I era, it reflected in part a sincere, essentially non-chauvinistic effort of American artists to establish themselves in the face of competition from their more famous European colleagues and to fight their way clear of dependence on international modernism. Actually, the position of art in America was bolstered in the 1930s—by the founding of The Museum of Modern Art in 1929 and the opening of the Whitney Museum of American Art in 1931, which led to expanded and consistent exhibition, research, and publication in both modern and American art. Then, a national cultural consciousness was fostered inadvertently and on an unprecedented scale by emergency governmental support of the arts under a series of agencies, especially the Works Project Administration (WPA), from 1935 to 1943. As part of the Roosevelt administration's effort to cope with unemployment and economic stagnation, qualified individuals on relief rolls were assigned to cultural projects—music, theater, dance, writing, the fine arts, and crafts. In this "golden age" of cultural activity, the creative forces of the nation were mobilized under the guise of make-work proj-

ects to spread and popularize the arts through performance, exhibition, and instruction. Never in American history had so many artists of all kinds been gainfully employed in the democratic occupation of bringing art to the people. The numbers involved in the entire process of creation and consumption are incalculable; under the Federal Art Project (FAP) alone, an estimated 3,600 artists produced 16,000 works shown in 1,000 cities and towns in the United States. Under the umbrella of the WPA and its generally enlightened policy of noninterference, not only was art kept alive but artists of all political or artistic persuasions were given an opportunity to work consistently and relatively unhampered as professionals. Aside from what was produced —and until recently there has been an unfortunate and continuing tendency to denigrate its achievements—the FAP served as a mass training ground for a generation of artists, raised the entire level of professional competence among them, and in throwing them together helped foster a consciousness of art and artists as a function of society. The times were not easy. Being on the dole was demeaning. Existence was snarled and time consumed by red tape and petty annoyances, as well as by larger uncertainties and by union actions and factional hassles. But the vitality that permeated the art scene, the camaraderie among artists—which can almost be called *esprit de corps*—was unique in American history.

Although American art had previously taken its leads somewhat belatedly from Europe, it veered off during the 1930s on an independent course, at variance from the reigning international mode of modernism. European art was still dominated by the "old masters" of the modern movement which had begun early in the century, but the constellations of artistic relevance had now shifted. The generative energies of Fauvism-Expressionism and Cubism had waned. And if their influence persisted in the personalities of Matisse, Picasso, or Braque, the vocabularies had undergone transformation. It was now Surrealism that held center stage, and even Picasso turned from the cool per-

408

410

409

408. ANDRÉ DERAIN. *The Old Gaul.*
1939–54. Bronze, $15\frac{1}{2} \times 4\frac{1}{4} \times 7\frac{1}{4}''$

409. ROBERT DELAUNAY. *Relief.* 1936–37,
cast 1962. Bronze, $51\frac{1}{4} \times 38 \times 6''$

410. JULIO GONZÁLEZ. *Woman with Bundle
of Sticks.* 1932. Welded iron, $14\frac{3}{8} \times 5\frac{3}{4} \times 4''$

411

411. JULIO GONZÁLEZ.
Head Called "Hooded."
1934–35. Bronze,
$5\frac{1}{4} \times 8\frac{5}{8} \times 7\frac{1}{8}''$

412. JULIO GONZÁLEZ.
*Head of "The
Montserrat II."* 1941–42.
Bronze, $12\frac{3}{4} \times 6\frac{1}{8} \times 10\frac{1}{4}''$

413. JULIO GONZÁLEZ.
*Mask of Montserrat
Crying.* 1936–37.
Bronze, $11 \times 6 \times 5''$

414. JOHN FLANNAGAN.
Triumph of the Egg I.
1937, cast 1941.
Cast stone, $12 \times 15\frac{1}{4} \times 8\frac{7}{8}''$

415. JOHN FLANNAGAN.
The Lamb. 1939.
Carved limestone,
$11 \times 19\frac{1}{2} \times 8\frac{3}{4}''$

412

413

414

415

416

416. GUY PENE DU BOIS.
Night Club. 1933.
Oil on canvas, 29 × 36″

417. EVERETT SHINN.
Acrobat Falling. 1930.
Oil on canvas, 36 × 26⅛″

417

mutations of Cubism to investigate the intricacies and fascinating mysteries of the subconscious. Responding to the growing tensions of the period and the horrors of the Spanish Civil War, he unleashed an unequaled emotional violence and mythopoetic iconography which had a profound and lasting effect on Western art. On the whole, however, if European art, steeped in a long tradition of art for art's sake, did not react directly to the social and political tensions of the time, there was a good deal of intellectual concern with the course of events and a growing political polarization among artists and writers. T. S. Eliot had serious misgivings about the crisis of civilization, though his conservative inclinations led him to espouse a theocratic solution, while many younger writers in England and on the Continent turned toward the political left. Surrealism made an abortive gesture toward communism, but Louis Aragon deserted the movement in 1936 because it backed off from political commitment. Picasso, in his *Dream and Lie of Franco* and *Guernica,* was almost alone in responding artistically to what he considered the imperatives of political reality. The Nazi threat, its cultural hoodlumism, book burnings, the harassment of intellectuals, the labeling of avant-garde art as degenerate and Jewish rallied the international cultural community to an anti-fascist solidarity, even if it failed, unfortunately, to stem the course of historic events. Finally, the European cultural world was disrupted, and many artists, refugees from the war and Nazism, found temporary asylum in the United States, where they played a decisive role in the evolution of American art.

During these years American artists reacted much more directly to the exigencies of social and economic pressures; they were in a sense forced both economically and ideologically into social responsibility. In accepting support from public funds, they were impelled to respond to public sentiment and taste. Faced by an unprecedented social crisis, they were led to reconsider the social role of art. At the same time, the more politically radical artists were influenced by the Marxist theory of

420

418. GEORGIA O'KEEFFE.
Soft Gray, Alcalde Hill
(Near Alcalde, New Mexico).
1929–30. Oil on canvas,
10 × 24"

419. ERNEST LAWSON.
Wild Birds' Roost. 1939.
Oil on canvas, 25⅛ × 30"

420. ARTHUR G. DOVE.
Haystack. 1931. Oil on
canvas, 18⅛ × 29"

421. ARTHUR G. DOVE.
City Moon. 1938. Oil and
wax emulsion on canvas,
35 × 25"

421

422

art as an instrument of the class struggle and the Soviet artistic dogma of Socialist Realism.

All in all, American art during the 1930s was preponderantly representational (though not necessarily naturalistic), communicative, and popular. It dealt with contemporary American life and, especially in the mural projects, American history, and was thus a continuation of a native tradition of genre and, to a more limited extent, historical painting. Within this parameter, there existed a broad range of political and social attitudes and artistic variations from revolutionary propaganda to patriotic nationalism, from naturalism to surrealism.

The Ashcan tradition had resurfaced in the 1920s with the return of John Sloan to urban genre and was recalled with nostalgic sentiment by artists like Glenn O. Coleman. But the most vital continuation of the realist tradition was to be found in the work of Edward Hopper, who belonged to a younger generation of Ashcan painters, students of Robert Henri—who included Coleman, Guy Pène du Bois, Stuart Davis—and whose aesthetic moorings had been disrupted by the Armory Show of 1913; it was also apparent in the art of Charles Burch-

field, who came from the small-town and rural Midwest. These artists broadened the urban base of genre painting and helped establish what was then called American Scene painting. Out of this in the 1930s were to develop three related though divergent tendencies—urban genre, Social Realism, and Regionalism.

Regionalism had had its beginnings in the mid–1920s with the programmatic ambition of Thomas Hart Benton to paint the American epic. Rejecting what he thought of as the alien and hothouse art of the effete East and his own earlier involvement with modernism, Benton projected a return to the grass roots of rural America and an agrarian past. The somewhat later emergence of Grant Wood from Iowa and John Steuart Curry from Kansas reinforced the appearance of a new Western and rural current in American art. The Regionalists turned for their subject matter to Western farm and ranch life and, though Curry was essentially a romantic genre and landscape painter, both Benton and Wood exhibited an early penchant toward a satirical treatment of the fabled West as well as of rustic and small-town mores. They all were eventually converted to a more sentimental, nostalgic, and mythic image of the subject, spawning a host of imitators who produced not much more than popular illustration, but they also spurred a growing interest in local landscape and genre, a tendency strengthened through the diffusion of federal art projects across the country.

Benton's early interest in an American epic led him to the monumental mural form for which there was little native tradition or demand. He may have been influenced by the great Mexican muralists—Diego Rivera, José Clemente Orozco, David Alfaro Siqueiros—who had lost governmental support at home and were working in the United States during the late 1920s and early 1930s. Rivera was active on the Ford murals at The Detroit Institute of Arts; then at Rockefeller Center, where the work was destroyed because of its revolutionary content; and later in the loft headquarters of a Communist Party splinter group, on a history of the United States in which he was assisted by

424

424. DAVID SMITH. *Aerial Construction*. 1936. Painted iron, $10 \times 30\frac{1}{2} \times 9\frac{1}{8}''$

425. JOSEF ALBERS. *Six and Three*. 1931. Gouache on paper, $20\frac{3}{4} \times 10\frac{1}{2}''$

426. ALEXANDER CALDER. *Crank-Driven Mobile*. 1931–32.
Wood, wire, and sheet metal, $23 \times 24\frac{1}{2}''$

425

426

Ben Shahn and which was paid for by the Rockefeller financial settlement. Orozco executed murals first at Pomona College in Claremont, California; then at the New School for Social Research in New York City; and after that, the *Epic of American Civilization* at Dartmouth College. Benton, as the native counterpart of Orozco, was given the opportunity to execute a mural series by the New School in 1930, and two years later did a comparable series for the new Whitney Museum of American Art. This concerted mural activity aroused public interest and may in effect have influenced the development of the extensive Treasury Department program (TRAP) for decorating public buildings. In any case, the confluence of events created a new artistic climate. Many artists who had been involved in what was small-scaled, private, and personal in expression turned eagerly to the new and demanding discipline of a monumental, public, communicative art—though not always with the happiest results. Lacking background or training in that area, many fell back on the formal and ideological banalities of an outworn academic tradition. The walls of untold public buildings—post offices, customhouses, schools, libraries—were covered with genre scenes overblown to heroic proportions or charades of textbook history. But for many the experience was crucial. They found an excitement in the investigation of different media and techniques, a challenge in the problem of scale, a sense of importance in moving out of the isolation of the studio into the larger world of public activity. The mural renaissance may have died with the WPA, but its influence on American art was felt in an increased competence, confidence, and boldness.

Urban genre painting remained more intimate, within the tradition of the Ashcan School. The most prominent artists in this manner worked in New York City; most had studios in the vicinity of Union Square and painted the colorful and crowded life of that lower-class commercial area adjoining the bohemia of Greenwich Village. Kenneth Hayes Miller, perhaps the most influential teacher of the period,

427

427. JOAQUÍN TORRES-GARCÍA. *Composition.* 1932.
Oil on canvas, 28½ × 23½"

428. JOAQUÍN TORRES-GARCÍA. *Untitled.* 1931.
Wood relief, 30⅛ × 7⅜ × 2¼"

429. ARSHILE GORKY. *Portrait of a Young Man.* 1924–42.
Oil on canvas, 20 × 16"

430. ARSHILE GORKY. *Portrait of Vartoosh.* c. 1932.
Oil on canvas, 20⅛ × 15¼"

431. ARSHILE GORKY. *Personage.* 1936. Oil on board, 10 × 8"

428

429

431

430

307

developed the "shopping" theme so popular among the urban realists; one of his students, Isabel Bishop, treated the working girl in characteristic activity with sensitivity and sympathy, and Edward Laning, another student, adapted the genre to mural size. The Soyers—Raphael, Moses, and Isaac—recording the lives of the workers, artists, students, and derelicts who mingled in that area, projected a note of sadness and empathy with the ordinary. Reginald Marsh, whose locale was more extensive, found his interest in the bizarre spectacles of New York's more raffish side—the Bowery, Coney Island, and the honky-tonk entertainment palaces. The interest of such artists was in the life of the city and its streets, in the lower classes, in the recognizable activities and amusements of ordinary people—all seen with unpretentious realism, in the Ashcan manner, as life rather than art. Their work seemed in those days to carry more social comment than it had, though some was certainly implied.

Social Realism, so-called, had much in common with urban realism, except that the social comment was conscious and pointed, and the formal expression often moved beyond the confines of naturalism into a wider range of symbolism, expressionism, or even surrealism. Although Social Realism did not dominate the art of the period, it was for a time at least the eye of a storm of controversy that attracted public attention. It polarized artistic attitudes, ideologically and aesthetically, by postulating the premises of social relevance and communication as requisite for art. The more radical, Marxist-oriented artists saw all art as an expression of class struggle, from which it followed that the conscious artist had to accept the consequences of his social and political allegiance. And since art was a weapon in the struggle, to be most effective it had to be communicative on the broadest levels. Of course, many artists did not accept the political convictions or the philosophical arguments of the Social Realists, and many who did refused to equate art and propaganda. The Social Realists attacked the Regionalists for what they considered to be reactionary social attitudes,

432

433

wrote off the majority of artists for their political obtuseness or lack of commitment at a time of world crisis, and inveighed against abstraction and avant-garde art in general as social and cultural obfuscation. It must be said that the polemics were not one-sided. The Regionalists reviled the Social Realists and modernists both as equally alien, effete, and subversive of native traditions. And the modernists dismissed representationalism in art as irrelevant and, more specifically, Regionalism as illustration and Social Realism as propaganda. The heat of the arguments was symptomatic of the social climate and the need of artists to come to terms with reality and/or society. There was much discussion of the connection between art and reality and about the role of art and artist in society. These were questions of profound significance and, in the face of mounting international tensions, it is not surprising that artists of various persuasions rallied to support the First American Artists' Congress in 1936. For a time at least, external circumstances had forced a sense of unity on the artistic community. In the words of Lewis Mumford, addressing the Congress, "The time has come for the people who love life and culture to form a united front

434

310

435

434. ERNST BARLACH.
Two Monks Reading. 1932.
Bronze, 23 × 17¼ × 15″

435. ERNST BARLACH.
Old Woman Laughing. 1937.
Bronze, 8¼ × 4⅝ × 12¼″

436. KÄTHE KOLLWITZ.
Self-Portrait. 1936.
Bronze, 15¼ × 8⅝ × 11⅜″

437. KÄTHE KOLLWITZ.
Mother and Child. c. 1917, cast
after 1954. Bronze, 28½ × 18 × 19″

436

437

against them [war and fascism], to be ready to protect, and guard, and if necessary, fight for the human heritage which we, as artists, embody."

Historical circumstances appeared to be vindicating the political and, by inference, the artistic position of the left-wing artists while enhancing the status of Social Realism. Some, for whom it had not been usual, now turned to social comment in their art—Max Weber, Peter Blume, Philip Guston, to name but a few. There were others who made a passing stab at social art at one time or another, and many were listed in the ranks of Social Realism because their work seemed to imply social intentions. This was especially true of some of the urban realists. However, the major artists identified with Social Realism were Ben Shahn, Philip Evergood, William Gropper, Jack Levine, Jacob Lawrence, Robert Gwathmey, Joseph Hirsch. Others achieved recognition as Social Realists—Anton Refregier, Charles White, Mervin Jules, Harry Sternberg, Honoré Sharrer, Harry Gottlieb, Walter Quirt

438. BEN NICHOLSON. *White Relief* (version I). 1938.
Painted wood relief, 47½ × 72 × 3″

—but faded from view as the movement declined and tastes changed. Some shifted artistic allegiances and later reappeared in different camps. For a time, Social Realism had widespread impact, extending beyond the Eastern seaboard to the West and weaning a younger generation of artists away from Regionalism—Joe Jones, James Turnbull, Mitchell Siporin, Edward Millman. The Social Realists all shared a desire to use their art for social ends and were drawn together around the John Reed Club, the Artists' Union, and the American Artists' Congress, but there was no expressive or aesthetic consensus among them. Their art ranged from the heroic to the ironic, from the satiric to the sentimental, from the passionate to the cerebral, from cliché to fantasy, from the fringes of Cubism to those of Surrealism, from naturalism to symbolism, covering a gamut of styles that included all the current modes just this side of abstraction.

Social Realism as a force in American art did not outlive the 1930s, though individual artists remained loyal to its precepts and continued to work in that vein beyond World War II in spite of the political atmosphere of the Cold War and a hostile artistic environment. The decline of the movement was the result of a variety of factors: the political debacle of the left following the Nazi-Soviet Pact and the attendant disillusionment of many artists with political commitment as such, which led to the collapse of the American Artists' Congress; the easing of the Depression and the phasing out of the WPA; the impact of European avant-garde art fostered by an influx of refugees from Hitler and World War II; and finally the war itself, which, by its anti-fascist character, blunted criticism from the left. With the war, the American Social Realists suddenly found themselves in a position comparable to that of the Russian Socialist Realists—as propagandists for, rather than against, the status quo.

Located somewhere between Realism and Surrealism, neither prosaic enough for the former nor mad enough for the latter, was an ill-defined and rather minor movement called Magic Realism, which

DAVID SMITH.

439. *Medal for Dishonor: War Exempt Sons of the Rich.* 1939–40.
Bronze relief, $10 \times 8\frac{7}{8} \times \frac{3}{8}''$

440. *Medal for Dishonor: Propaganda for War.* 1939–40.
Bronze relief, $9\frac{1}{2} \times 11\frac{3}{8} \times \frac{7}{8}''$

441. *Medal for Dishonor: Death by Gas.* 1939–40.
Bronze relief, $10\frac{1}{2} \times 11\frac{1}{8} \times 1\frac{1}{4}''$

439

440

441

315

442. PHILIP EVERGOOD.
Juju as a Wave. 1935–42.
Oil on canvas, 69 × 43¼″

443. KENNETH HAYES MILLER.
Looking and Pricing. 1938.
Oil on canvas, 28 × 23″

443

had much in common with German Neue Sachlichkeit and French Neo-Romanticism without being a direct counterpart of either. It was unmistakably American, its subject matter native and popular, prefiguring Pop Art in its fascination with iconic trivia. A compulsive concern with *trompe l'oeil* distinguishes it from its European parallels, though it shared with them a pervasive sense of nostalgia. The Museum of Modern Art exhibition *American Realists and Magic Realists* in 1943 brought the tendency (it was in no sense a cohesive movement) to public attention and at the same time confused the situation by giving it an exclusively American ancestry and by including a disparate variety of representational modes from straightforward naturalism to surrealist fantasy, from the precisionist structuralism of Edmund Lewandowski and Louis Lozowick to the obsessive morbidity of Ivan Le Lorraine Albright, from the brooding asceticism of Andrew Wyeth to the social symbolism of Peter Blume, from the frenetic satire of Paul Cadmus to the unsettling ambiguities of Jared French. If anything, Magic Realism was an eccentric realism, finding the unexpected in the expected, fantasy in the usual, the undecipherable in the apparent. It

317

444. BEN SHAHN.
Supreme Court of California: Mooney Series. 1932. Gouache on paper mounted on Masonite, 16 × 24″

445. WILLIAM GROPPER.
Tailor. 1940.
Oil on canvas,
20 × 26¾″

444

445

called a change in American-subject painting by inverting accepted notions of significance and, for a short period, offered representational painters who were dissatisfied with the limitations of Regionalism, urban genre, or Social Realism the possibility of philosophic or psychological meaning beyond the explicit.

Despite the controversy and publicity that surrounded Regionalism and Social Realism, prestige in the art market, museums, and exhibitions remained with the older, established artists. Conservative, academic painters such as Eugene Speicher, Leon Kroll, and Alexander Brook still loomed large, though the focus of interest had already swung over to those first American modernists who had matured after the Armory Show—John Marin, Max Weber, Arthur G. Dove, Georgia O'Keeffe, Charles Sheeler, Charles Demuth, Marsden Hartley, Stuart Davis, Yasuo Kuniyoshi. They had converted the influences of Fauvism and Cubism into something recognizably American, if more conservative, and as America's own modern masters they enjoyed a growing esteem. They were, perhaps, too frequently and naively compared by museums and critics with their European contemporaries—to their disadvantage. But it was their dominance in the art world that obscured the rise of a younger generation of avant-garde artists.

The American art world expanded phenomenally in spite of the economic crisis. The number of galleries exhibiting modern and American art increased, museums assumed more liberal policies toward contemporary art, and the WPA initiated art centers throughout the country. It was then, also, that the artistic power structures began to tip in the direction of modernism; The Museum of Modern Art, under the brilliant direction of Alfred H. Barr, Jr., became the vital tastemaker, achieving an almost dictatorial hold on artistic opinion. The status of avant-garde art was bolstered by the addition of A. E. Gallatin's collection, The Gallery of Living Art, housed at New York University at Washington Square; The Museum of Non-Objective Painting; and a growing number of important commercial galleries ex-

446

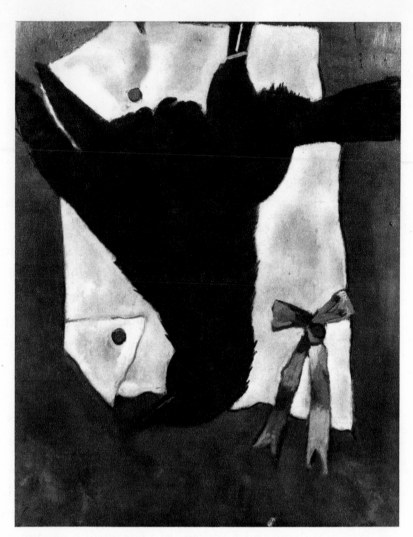

447

hibiting European modern art, climaxed during World War II with the opening of Peggy Guggenheim's museum-gallery, Art of This Century. The impact of modernization became evident in the changing composition of the Whitney Museum annuals, even had its effect on so conservative an institution as The Metropolitan Museum of Art, and was eventually felt throughout the nation. Though avant-garde artists found the pace of change too slow and the acceptance of American manifestations too grudging, the actual conversion of taste was profound and extensive. Never before had European contemporary art been presented to the American public and artists with such consistency, coherence, and immediacy. Once again European developments began to intrigue American artists. In comparison with the richness and variety of style and experimentation abroad, the older American modernists appeared tame and rather bloodless to the younger generation. Instead of continuing along already charted native lines, the latter began to pick up the threads of newer European modes. Only

320

446. JEAN CHAUVIN.
An Island in the Night. 1932.
Wood, $19\frac{5}{8} \times 7\frac{5}{8} \times 7\frac{3}{8}''$

447. MARSDEN HARTLEY.
Crow with Ribbons. 1941–42.
Oil on Masonite, $28 \times 22''$

448. ABRAHAM RATTNER.
The Bride. 1944.
Oil on canvas, $36\frac{1}{2} \times 32''$

449. GREGORIO PRESTOPINO.
Supper in Bethlehem. 1945.
Oil on canvas, $32\frac{3}{8} \times 43\frac{1}{2}''$

448

449

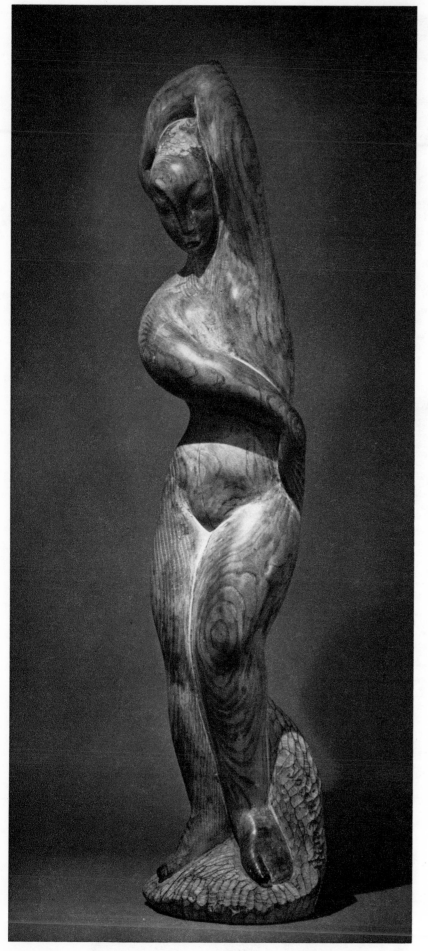

450. JOSÉ DE CREEFT. *Dancer*.
1943–54. Chestnut, $58 \times 13\frac{3}{4} \times 12\frac{1}{4}''$

451. ÉMILE BRANCHARD. *Burlesk Queen*. n.d.
Oil on canvas mounted on board, $13 \times 8\frac{1}{2}''$

452. VINCENT CANADÉ. *Self-Portrait #28*.
c. 1937. Oil on canvas mounted
on board, $13 \times 8\frac{3}{4}''$

453. JOHN KANE. *My Daughter and
Grandchild*. c. 1931–32. Oil on canvas,
$23\frac{1}{2} \times 27\frac{1}{4}''$

454. STUART DAVIS. *The Terminal*. 1937.
Oil on canvas, $30 \times 40''$

450

451

452

453

454

455

Stuart Davis with his freewheeling translation of Cubism into an American idiom seemed able to bridge the generations, continuing to work in his own manner yet still able to interest and influence his younger contemporaries, though he remained always somewhat apart.

Beginning with the arrival in the United States of George Grosz and Hans Hofmann in the early 1930s, the migration of major European artists mounted steadily after Hitler came to power and the threat of war increased. Their presence added a new dimension to the relationships within Western art. It both strengthened the influence of European art and at the same time seemed to give the Americans an unexpected independence vis-à-vis the fabled European mentors, who appeared in the flesh but out of their native habitat. The dissolution of the Bauhaus brought Walter Gropius, Marcel Breuer, László Moholy-Nagy, Josef Albers, Lyonel Feininger. Through the 1930s individual artists arrived as visitors or refugees—Fernand Léger, Salvador Dalí, Joan Miró, Matta, Marc Chagall, Piet Mondrian, Amédée Ozenfant,

455. GIACOMO MANZÙ.
*Self-Portrait with Model
at Bergamo*. 1942.
Bronze high relief, 50 × 37 × 10″

456. CHAIM GROSS.
Strong Woman (Acrobats). 1935.
Lignum vitae, 48¾ × 11⅝ × 8″

457. MARINO MARINI.
Susanna. 1943. Bronze,
28¼ × 21 × 9⅝″

458. HENRI LAURENS.
Maternity. 1932.
Bronze, 21 × 55 × 23″

457

458

459. SAUL BAIZERMAN.
The Miner. 1939–45.
Hammered copper,
$82\frac{1}{2} \times 46 \times 32''$

Jean Hélion, Eugene Berman, Pavel Tchelitchew. And, with the outbreak of war, the Surrealists came en masse—André Breton, Max Ernst, André Masson, Yves Tanguy, Kurt Seligmann. Quite a few became teachers either at academic institutions or art schools. Gropius and Moholy-Nagy in architecture and design, and Hofmann and Albers in painting trained a generation of artists, most of whom reached maturity after the war.

A small group of young artists, working their way through the post-Cubist abstraction of Purism, Constructivism, and Neo-Plasticism, found some encouragement in The Museum of Modern Art exhibition *Cubism and Abstract Art* in 1936 and an exhibition of American "abstract" art at the Whitney Museum the preceding year, though the latter was confined to the older generation of modernists. With the return in the mid-1930s of Alexander Calder and other Americans who had belonged to the Cercle et Carré and Abstraction-Création groups in Paris and the addition of the émigrés Albers and Fritz Glarner, the hard-edge, geometric abstractionists attained a more noticeable profile. The Abstract American Artists, founded in 1936, was dominated by them but eventually included such diverse artists as Albers and Glarner; Carl Holty and John Ferren, just back from Europe; Burgoyne Diller, the first of Mondrian's American disciples, Ilya Bolotowsky, and I. Rice Pereira; Balcomb Greene and Ad Reinhardt; Ibram Lassaw and David Smith. It was they who spearheaded the attack on "realism" in American art and began to pressure the museums to recognize American avant-garde styles.

"Classical" Surrealism had only a limited influence among American artists; aside from Federico Castellón, and later Kay Sage and Dorothea Tanner, there were few who answer that description. Others, such as Morris Graves, Stephen Green, or Edwin Dickinson, responded very personally and idiosyncratically. However, the alternatives Surrealism presented started a chain reaction that proved revolutionary. It had an obvious though superficial effect on the Magic Realists and a

460

more profound one on socially oriented artists such as Peter Blume,
Louis Guglielmi, Walter Quirt, and David Smith, who attempted to
adapt Surrealist assumptions to their own intentions. But its major im-
pact was to offer some of the younger abstractionists an avenue of
escape from the tight intellectual prescriptions of "purism." The "ab-
stract" wing of Surrealism—Miró, Masson, Matta, Arp, and to a
certain extent, Ernst—offered a kind of liberation, extending the range
of abstraction to encompass "psychic automatism"; biomorphic and
amorphic form; symbolism, most frequently sexual, read as subcon-
scious universality or Jungian racial memory; the dialectic of the creative
process; and the relevance of accident. It was, in a sense, a return to
the radical early work of Kandinsky and what he had called "abstract
expressionism." Like their socially directed colleagues, most of the
young artists dedicated to abstraction, whether "purist" or "expres-
sionist," were raised under the WPA and indoctrinated by the ideo-
logical battles of the period. They could no longer view art as simply
the making of objects or commodities, but as the deepest kind of
personal, philosophic, or social commitment.

Pivotal to the transformation of American abstractionism from a

328

461

462

463. MAX BILL. *Construction.*
1937, executed 1962.
Granite, 39 × 31¼ × 30¾"

464. NAUM GABO. *Linear Construction
No. 1* (smaller version). 1942–43.
Plastic construction with nylon
thread, 12¼ × 12¼ × 2½"

465. ANTOINE PEVSNER. *The Black
Lily* (Spiral Construction). 1943.
Bronze, 20½ × 16¼ × 14¾"

464

465

467

466. ELIE NADELMAN.
Head of Baudelaire. c. 1940–45.
Marble, $17\frac{1}{2} \times 8\frac{3}{8} \times 12\frac{1}{8}''$

467. JEAN DUBUFFET. *Masks.* 1935.
left: *René Pontier.*
Painted papier-mâché, $11\frac{1}{4} \times 6\frac{7}{8}''$;
center: *André Claude.*
Painted papier-mâché, $9\frac{1}{8} \times 6''$;
right: *Robert Polguère.*
Painted papier-mâché, $9\frac{3}{4} \times 7\frac{1}{8}''$

468. REUBEN NAKIAN.
Head of Marcel Duchamp. 1943,
cast 1961. Bronze, $22 \times 6 \times 10\frac{1}{2}''$

468

minor reflection of European innovations, already dated, to an original style that eventually became dominant in Western art were Arshile Gorky, Jackson Pollock, and Willem de Kooning, but the flowering of Abstract Expressionism did not occur until after World War II. All three artists seem to have been deeply impressed, as were so many others, by the great Picasso exhibition at The Museum of Modern Art in 1939, and they were inspired, each in his own way, to move toward a more vigorous and expressive manner. However, it was only in the early 1940s that the contact with Surrealism freed them to shed the last remnants of formalism and to seek the wells of creativity in the subconscious. Stuart Davis, as well as Mark Tobey and Arthur B. Carles, who had little influence at the time, were native precursors, but it was Gorky who pioneered the movement. He was followed shortly by Pollock. De Kooning continued to be committed to figurative painting until about 1945.

During the first four decades of the twentieth century sculpture could not match the profligate variety and richness of invention that characterized painting; in fact, it took most of its cues from the latter. Major sculptors were fewer and developments less concerted and intensive. Of the transitional masters, Aristide Maillol was still working in the 1930s, but younger and more radical men had already achieved prominence—Constantin Brancusi, the undisputed giant among early modern sculptors; the Cubists Alexander Archipenko, Henri Laurens, Jacques Lipchitz, and Ossip Zadkine; the Russian Constructivists Antoine Pevsner and Naum Gabo; and in England, Jacob Epstein, who had, however, by that time become rather conservative. At the very beginning of the 1930s a vital ingredient was added when Picasso's interest in sculpture revived. The wildly extravagant plasters and innovative iron-rod constructions conceived and executed with the collaboration of Julio González infused new blood into the medium. González himself, moving from abstraction to Surrealism and back to realism, played an interesting if unpublicized role in the development

334

469

470

HENRY MOORE.

469. *Composition*. 1934, cast 1961.
Bronze, $8 \times 17 \times 8''$

470. *Miners*. 1942. Ink, black crayon,
and white chalk on paper, $12\frac{1}{2} \times 21\frac{1}{2}''$

471. *Carving*. 1935. Cumberland
alabaster, $13\frac{1}{2} \times 11\frac{1}{2} \times 7''$

471

472. DAVID SMITH. *Big Rooster*. 1945. Steel, $16\frac{1}{2} \times 23\frac{1}{4} \times 14\frac{3}{4}''$
473. DAVID SMITH. *Steel Drawing I*. 1945. Steel, $22\frac{1}{4} \times 26 \times 6''$

of modern sculpture. At the same time, Lipchitz abandoned Cubism for the baroque expressionism of his mature style. As in painting, Surrealism had a germinal influence. Alberto Giacometti created a series of remarkably inventive sculptures before moving into the elongated figurative style for which he is noted. Max Ernst turned to sculpture and produced some of the most imaginative objects of that period, and Jean Arp evolved from cut-out reliefs to the "concretions" of his later style. In England, Henry Moore and Barbara Hepworth, influenced by Brancusi, were both beginning to work in a manner similar to Arp's. This is not a large roster, but the quality of the work produced was high and the climate was being prepared for a renaissance of the sculptural arts after World War II.

In the United States the sculpture lag was even more pronounced. Before the 1930s, there were only two modern sculptors of any consequence, and they were foreigners—Gaston Lachaise and Elie Nadelman. Both had a polished elegance characteristic of L'Art Décoratif rather than the more radical phases of modern art. Nadelman's camp

"classicism" is at once frivolous and faintly ironic. Lachaise's art is comparable to Nadelman's in some respects, but he was more profound and more impressive in sculptural terms, his obsessive eroticism transforming the polished forms into monstrous images. Of about the same generation, Saul Baizerman, who worked in a rather muted, sensitive manner, owed artistic allegiance to the memory of Rodin, though he is more often reminiscent of Émile-Antoine Bourdelle. All three of these American sculptors belonged to an earlier era, but the sheer vitality of Lachaise makes him appear more contemporary.

Most of the American sculptors active in the 1930s, while conscious of changing modes, remained *retardataire,* attached to the tradition of Rodin, Bourdelle, Maillol, Despiau, Lehmbruck. They were figurative sculptors and fine craftsmen; many of them—William Zorach, José de Creeft, John Flannagan, Robert Laurent, Hugo Robus, Chaim Gross—worked directly in stone and wood, utilizing a limited form of stylization which, in the context of American art of the period, appeared passably modern. It would be difficult to find equivalents in

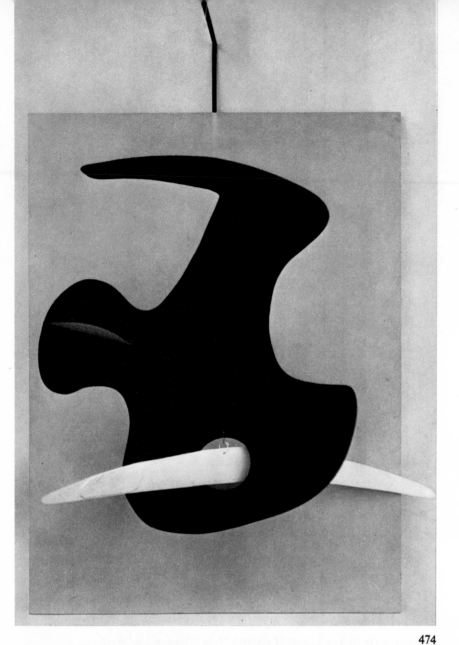

474. ALEXANDER CALDER.
Form Against Yellow. 1936.
Painted sheet metal and wood,
$42 \times 40 \times 30''$

475. JOSEF ALBERS.
Vice Versa B. 1943.
Oil on Masonite, $13\frac{7}{8} \times 28\frac{1}{8}''$

476. JOSEF ALBERS.
Proto-Form B (Protean Form B).
1938. Oil on Masonite, $28 \times 24''$

477. JOSEF ALBERS.
Bent Black. 1940.
Oil on Masonite, $26 \times 19\frac{1}{4}''$

478. ALEXANDER CALDER.
Constellation. 1943.
Painted and unpainted wood
and wire, $21\frac{3}{4} \times 28 \times 24''$

474

475

476

477

478

479

479. JEAN ARP. *Alu with Claws.* 1942.
Polished bronze, $22\frac{1}{2} \times 17 \times 10''$

480. MAX ERNST. *Moonmad.* 1944.
Bronze, $36\frac{1}{2} \times 11\frac{3}{4} \times 12''$

481. JACQUES LIPCHITZ,
Rape of Europa, II,
1938. Bronze, $16 \times 24 \times 12\frac{3}{4}''$

482. MAX ERNST. *The Table is Set.*
1944. Bronze, $12 \times 23\frac{1}{2} \times 21\frac{7}{8}''$

480

481

482

sculpture of comparable stature to Regionalist, urban genre, or Social Realist painting perhaps because sculpture does not lend itself easily to the transient or the illustrative, to genre, anecdotal, or social themes.

Of those who were later to be among the leading American abstract sculptors, some who were of age in the 1930s had either not surfaced artistically or were still working in more traditional forms—Louise Nevelson, Reuben Nakian, José de Rivera, Seymour Lipton, Herbert Ferber. Only a handful had by then taken the decisive avant-garde step toward either abstraction or Surrealism. Early in the 1930s, Joseph Cornell, apparently already aware of Dada and Surrealist experiments, was manufacturing those magical boxes of nostalgic debris, full of enigmatic historical allusions which recalled the *trompe l'oeil* paintings of William Harnett and John Frederick Peto and tantalized with the hint of deeper subconscious meanings. Isamu Noguchi had been in Paris, where he had worked with Brancusi and had met Calder and Giacometti; upon his return to the United States he began unobtrusively and independently the development of an organic abstraction delicately balanced between natural and man-made objects, between the ancient and time-worn and the machine-made. Except for isolated experiments by American Neo-Plasticists such as Burgoyne Diller and Harry Holtzman, Theodore J. Roszak was almost alone in the creation of elegant Constructivist machines, an interest he abandoned after World War II for a more popular, corrosive expressionism. The major figures of modern sculpture in America in the 1930s were Calder, who came to prominence then, and David Smith, who was just beginning a brilliant career. Calder's early work in Paris during the 1920s had been in the Dada spirit, though American in character, playful and gimmicky. Greatly impressed with Mondrian and influenced by the Constructivism of Gabo, he began to experiment in the early 1930s with hand- and motor-driven mobiles. It was only later that he evolved the free-winging wind mobile and turned from Neo-

483

483. ANDRÉ MASSON.
Elk Attacked by Dogs.
1945. Oil on canvas,
20 × 25"

484. YVES TANGUY.
Naked Water. 1942.
Oil on canvas, 36¼ × 28"

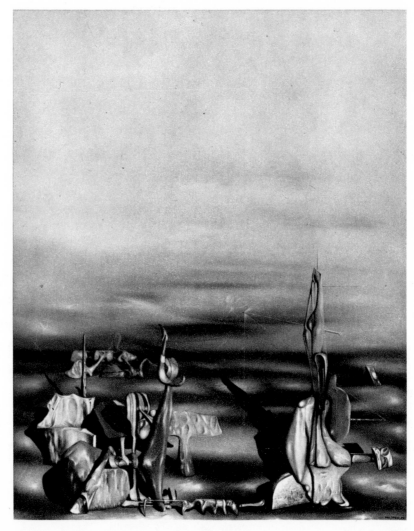

484

Plastic geometry to the organic forms of Miró and Arp. When Calder returned to the United States in the mid-1930s his reputation was international and he was from then on a major force in American art. Smith, on the other hand, in developing his plastic vocabulary was oscillating between Surrealism and the abstract wire constructions of Picasso and González. Toward the end of the 1930s, stirred by a sense of impending holocaust, he executed a series of reliefs entitled *Medals for Dishonor* in which he expressed his social rage, as Picasso had in the *Guernica,* but in Surrealist terms. Smith moved out of expressionist Surrealism toward abstraction, and both his and Calder's work became increasingly monumental. It was around these pioneers of modernism in the 1930s that the remarkable resurgence of sculpture in America occurred after World War II.

There is at present a revival of interest in the 1930s, sparked in part by nostalgia and in part by a more serious search for origins. In any case, it is a period still too recent for truly objective judgment; those who lived through it have indelible if sometimes clouded memories, and those who did not see it through the distorting lenses of their own preoccupations. What once seemed crucial now seems inconsequential, what now seems revelatory was then hardly noticed. One expects that time will eventually temper our vision to recognize what happened, not only in relation to ourselves, but to history. We will someday, perhaps, see the period not only as a preparation for a later age, or as the culmination or decline of a previous one, but as a response to its own historical necessities and within its own context. It was withal a coherent period which tied together many diverse strands and wove a pattern that had its own particular and inimitable color—serious, committed, idealistic, naive, contentious, and perhaps even deluded. What came later, whatever its indebtedness, occurred under totally different auspices.

485. ALBERTO GIACOMETTI. *Standing Man.* 1930. Polychromed plaster, 26¾ × 19¼ × 7⅜″

485

487

486. ARISTIDE MAILLOL. *Nymph*. 1936–38. Bronze, $60\frac{1}{2} \times 24\frac{1}{2} \times 18''$

487. PAVEL TCHELITCHEW. *Maude Stettiner*. 1931. Oil on canvas, $51\frac{1}{8} \times 35''$

488

489

488. REGINALD MARSH. *George C. Tilyou's Steeplechase Park*. 1936.
Egg tempera on wood panel, 36 × 48″

489. WALT KUHN. *Still Life with Apples*. 1939.
Oil on canvas, 24⅝ × 29½″

490. OSKAR KOKOSCHKA. *Santa Margherita*. c. 1930.
Oil on canvas, 29¼ × 36¼″

491

492

491. ARTHUR G. DOVE.
Sunrise IV. 1937.
Oil and wax emulsion
on canvas, 10 × 14″

492. GEORGIA O'KEEFFE.
Goat's Horn with Red.
1945. Pastel on paper,
$31\frac{3}{8} \times 27\frac{5}{8}''$

493. PATRICK HENRY BRUCE.
Vertical Beams. c. 1932.
Oil on canvas, $31\frac{7}{8} \times 51\frac{1}{4}''$

494. BURGOYNE DILLER.
Construction. 1934.
Painted wood and Masonite
relief, 24 × 24 × 2″

ARSHILE GORKY.

495. *Waterfall.* c. 1943.
Oil on canvas, 38 × 25″

496. *Woman's Head.* 1933?
Oil on canvas, 12 × 9″

497. *Composition.* c. 1938–40.
Oil on canvas, 34 × 56″

496

497

498

498. JOAQUÍN TORRES-GARCÍA. *Untitled.* 1931.
Wood relief, $21 \times 8\frac{1}{2} \times 3\frac{1}{2}''$

499. ARTHUR B. CARLES. *Abstraction* (Last Painting). 1936–41.
Oil on board, $41\frac{1}{4} \times 58\frac{3}{8}''$

500. JEAN XCERON. *Still Life No. 116.* 1934.
Oil on canvas, $23\frac{1}{2} \times 28\frac{5}{8}''$

499

500

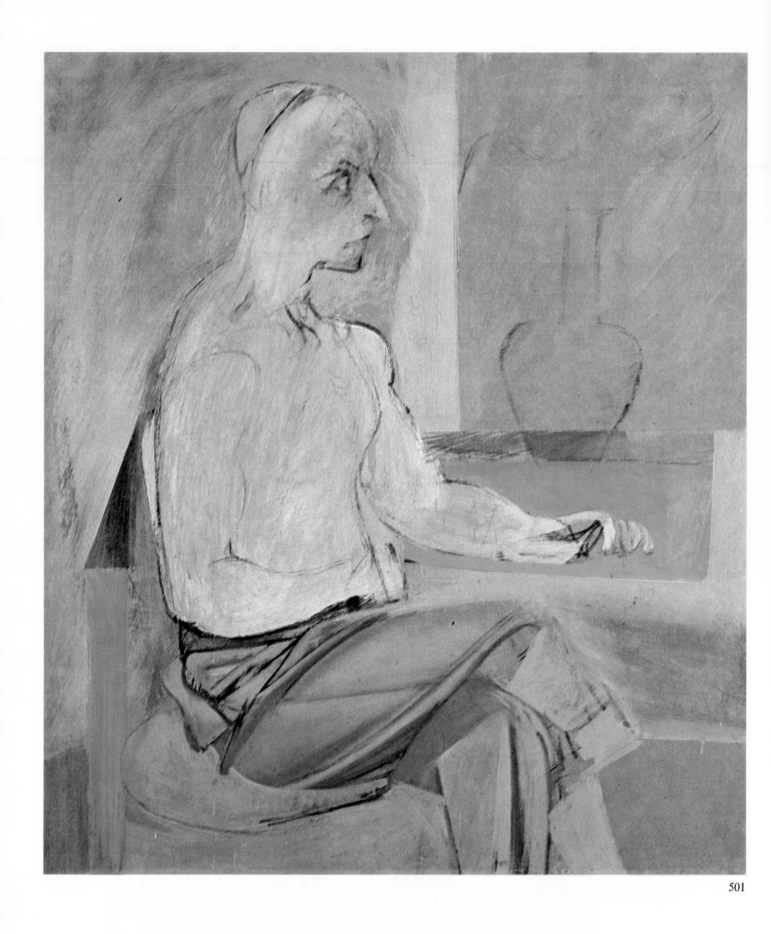

501. WILLEM DE KOONING. *Seated Man.* c. 1939. Oil on canvas, $38\frac{1}{8} \times 34\frac{1}{8}''$

502. WILLEM DE KOONING. *Queen of Hearts.* 1943–46. Oil and charcoal on composition board, $46 \times 27\frac{1}{2}''$

503

503. PIET MONDRIAN. *Composition with Blue and Yellow*. 1935.
Oil on canvas, 28½ × 27¼″

504. NILES SPENCER. *Edge of the City*. 1943.
Oil on canvas, 25 × 29″

505. BEN NICHOLSON. *Painting*. 1937.
Oil on canvas, 16¼ × 22″

504

505

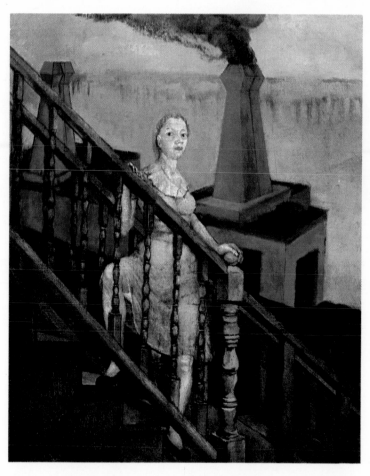

506

506. PHILIP EVERGOOD.
Turmoil. 1941.
Oil on canvas, $24\frac{1}{4} \times 20\frac{1}{4}''$

507. MILTON AVERY.
Interior with Figure. 1938.
Oil on canvas, $31\frac{7}{8} \times 40''$

508. PHILIP EVERGOOD.
Nude by the El. 1934.
Oil on canvas, $38 \times 43''$

509. DAVID ALFARO SIQUEIROS. *Zapata*. 1931. Oil on canvas, $53\frac{1}{4} \times 41\frac{1}{2}''$

510. THOMAS HART BENTON. *Field Workers* (Cotton Pickers). 1945.
Oil on parchment paper, $8\frac{3}{4} \times 13\frac{1}{2}''$

511. MAX WEBER. *Reading*. 1935. Oil on canvas, $31\frac{1}{2} \times 47\frac{1}{4}''$

510

511

513

512. MARSDEN HARTLEY.
Christ Held by Half-Naked Men.
1940–41. Oil on Masonite,
$39\frac{7}{8} \times 29\frac{7}{8}''$

513. BERNARD KARFIOL.
The Models. 1932.
Oil on canvas, $24 \times 30''$

514. ELIE NADELMAN.
Two Acrobats. 1934.
Polychrome-glazed ceramic,
$10\frac{3}{4} \times 9\frac{1}{2} \times 6\frac{1}{4}''$

514

515

516

517

515. JOHN MARIN. *A Composing, Cape Split, No. 2.* 1943.
Watercolor on paper, $15 \times 20\frac{5}{8}''$

516. MARSDEN HARTLEY. *Mt. Katahdin.* 1941.
Oil on Masonite, $22 \times 28''$

517. MORRIS GRAVES. *Colossal Owls and Eagles of the Inner Eye.* 1941.
Oil and gouache on paper, $20\frac{7}{8} \times 36\frac{1}{2}''$

519

518. DAVID BURLIUK. *Dreams About Travel*. 1943.
Oil on canvas, 41 × 36″

519. HORACE PIPPIN. *Holy Mountain III*. 1945.
Oil on canvas, 25 × 30″

369

520. EUGENIE BAIZERMAN. *Setting Sun*. 1944. Oil on canvas, two panels, each 54 × 43″

522

521. HENRY MOORE.
Mother and Child. 1931.
Cumberland alabaster,
$17\frac{3}{4} \times 8\frac{1}{4} \times 6\frac{1}{8}''$

522. ALEXANDER CALDER.
Fish Mobile. 1940.
Glass, metal, wire,
and cord, $16\frac{1}{4} \times 46 \times 3''$

523. ISAMU NOGUCHI.
Lunar Landscape.
c. 1944. Magnesite
cement, cork, fishing
line, and electric
lights, $33\frac{1}{4} \times 24 \times 7''$

523

524

525

524. YVES TANGUY.
The Doubter. 1937.
Oil on canvas,
23¾ × 32″

525. ANDRÉ MASSON.
Légende. 1945.
Tempera on canvas,
26 × 20″

526. JACKSON POLLOCK.
Water Figure. 1945.
Oil on canvas,
71¾ × 29″

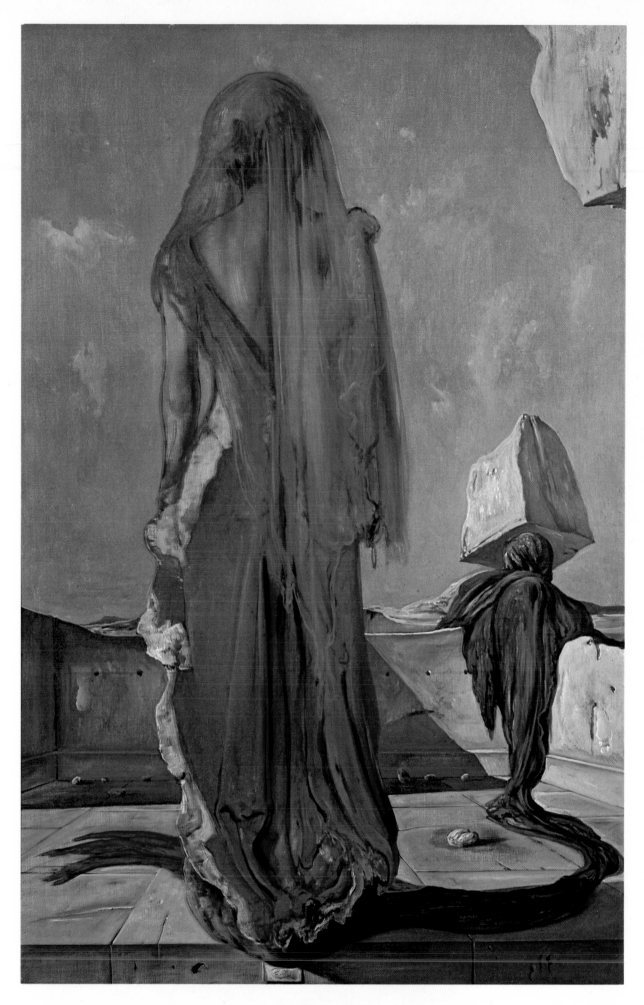

527. EUGENE BERMAN. *Nike*. 1943. Oil on canvas, $58\frac{5}{8} \times 38\frac{1}{2}''$

1946-1960

by Irving Sandler

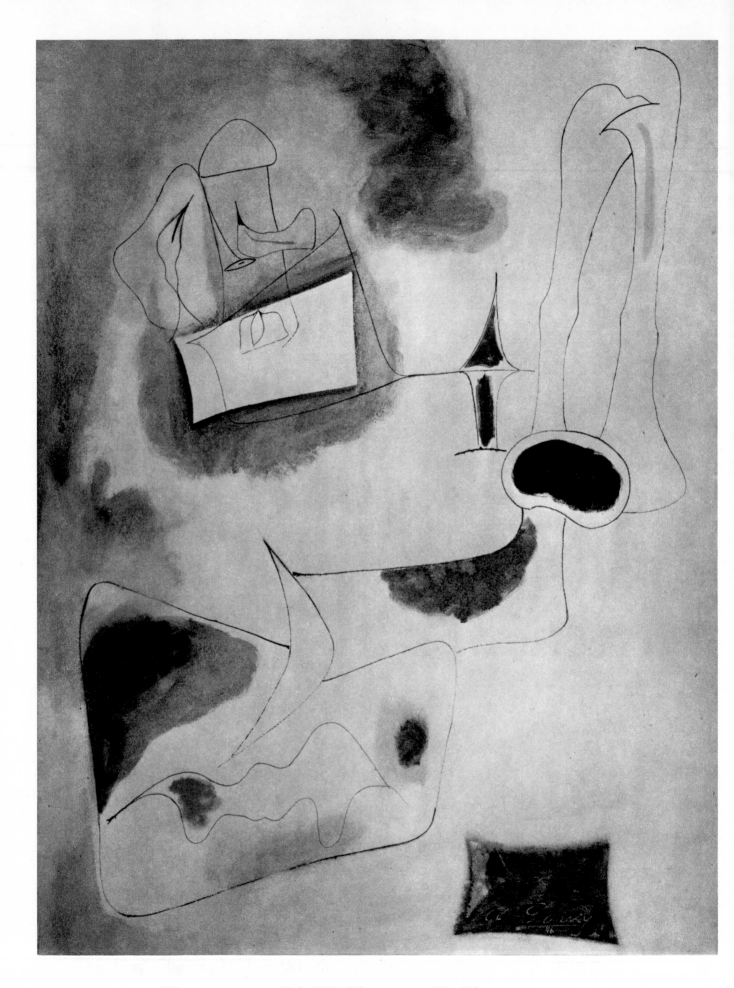

528. ARSHILE GORKY. *Nude*. 1946. Oil on canvas, $50\frac{1}{8} \times 38''$

When a mass-media magazine labeled Jackson Pollock "Jack the Dripper" and Willem de Kooning "Willem the Walloper" it typified a point of view, common during the 1940s and 1950s, which regarded vanguard artists as brutes. Even some friends of the new art—generally called Abstract Expressionism—considered the painters to be primitive but inspired, and this attitude was fostered by many of the artists themselves, who claimed not to know what they were doing while painting. In fact, however, the Abstract Expressionists did understand and articulate the value of unpremeditated creation and the thrust of modern thought that gave rise to it. They were, in a word, intellectuals, who absorbed and used any information that illuminated their condition as men and artists. Indeed, had they not been alive to changing values in all of contemporary culture, rejecting what was no longer pertinent to their experience, they could not have achieved the most significant and vital art of their time.

For much of the period from 1946 to 1960 the intellectual matrix of vanguard art was Existentialism; it had been introduced into America from France shortly after World War II and was the latest manifestation of the Romanticist spirit. Surrealism, which had been influential earlier, in the war years, was equally Romanticist. Interest in both movements developed partly as a reaction against the ideologies that motivated artists during the 1930s, the decade of the Great

529. ADOLPH GOTTLIEB.
Pictogenic Fragments.
1946. Oil on canvas,
36 × 30″

530. FRANZ KLINE.
Painting (Untitled).
1948. Oil and collage
on panel, 28 × 22¼″

529

Depression: Marxism, Nationalism, and Utopianism, which provided the rationales, respectively, for Social Realism, Regionalism, and geometric abstraction.

Although Social Realism and Regionalism were politically antithetical, both aimed to communicate social dogmas to a mass audience and consequently took the form of an easily understood figuration—literary, illusionistic, and retrogressive—although there were realist artists who rose above clichés, such as Edwin Dickinson, Edward Hopper, and John Marin. In opposition to Social Realism and Regionalism, which were the dominant styles of the period, a small vanguard embraced geometric abstraction, painting pictures composed of clearly defined forms in clear, flat colors, which stressed nonobjective, structural, and pictorial values. Often explicit—or, at least, implicit—in the thinking of geometric abstractionists were neo-Platonic and utopian attitudes. The Neo-Plasticists, Constructivists, and Bauhaus associates

530

proposed that art become the blueprint of brave new worlds. Believing that man (and society) was perfectible, that his irrationality was a passing aberration whose signs should be suppressed in their works, they called for an art in keeping with man's future: rational and idealistic, constructivist and collectivist, aspiring to the suprapersonal.

Mondrian's Neo-Plasticism can be considered the prototype of geometric abstractionist thought, and it strongly influenced many Americans, among them Burgoyne Diller, Fritz Glarner, Ad Reinhardt, and Albert Swinden, and Europeans such as Ben Nicholson. Neo-Plasticism, according to Mondrian, conceived of "an evolution from the individual towards the universal, of the subjective towards the objective; towards the essence of things and of ourselves." Art was to reveal the underlying laws which governed man's progress to his highest state of individual and social being. Indeed, in the future, a work of art would no longer be a thing apart from its environment. "Painting

531

532

382

531. WILLEM DE KOONING.
Special Delivery. 1946.
Oil, enamel, and charcoal
on paper mounted on
cardboard, $23\frac{3}{8} \times 30''$

532. WILLEM DE KOONING.
above: *Woman* (recto). 1948.
Oil and enamel on
composition board, $53\frac{1}{2} \times 44\frac{1}{2}''$;
below: *Untitled* (verso)

533. THEODORE J. ROSZAK.
Invocation I. 1947.
Steel, $30\frac{1}{2} \times 21\frac{1}{2} \times 14''$

534. BYRON BROWNE.
Icon. 1949. Oil and collage
on canvas, $25\frac{1}{2} \times 19\frac{1}{4}''$

535. KARL KNATHS.
Pineapple. 1951.
Oil on canvas, $36 \times 27''$

533

534

535

536

536. WILLIAM ZORACH. *Setting Hen*. 1946.
Maine granite, $14\frac{1}{4} \times 16 \times 13''$

537. MILTON AVERY. *Morning Call*. 1946.
Oil on canvas, $54 \times 34''$

538. WALT KUHN. *Acrobat in White
and Blue*. 1947. Oil on canvas, $30 \times 25''$

539. BEN SHAHN. *Song*. 1950. Tempera
on canvas mounted on board, $31 \times 52''$

540. SAUL BAIZERMAN. *Espérance*.
1953–56. Hammered copper, $23 \times 10\frac{1}{2} \times 13\frac{1}{2}''$

541. YASUO KUNIYOSHI. *Look, It Flies!*
1946. Oil on canvas, $39\frac{3}{4} \times 30\frac{3}{8}''$

539

540

541

542

HENRY MOORE.

542. *Family Group*. 1946. Bronze, $17\frac{1}{2} \times 13\frac{1}{4} \times 8\frac{5}{8}''$

543. *Rocking Chair No. 2*. 1950. Bronze. $11 \times 12 \times 3\frac{1}{2}''$

544. *Reclining Figure No. 4*. 1954–55. Bronze, $14 \times 23\frac{1}{4} \times 12\frac{1}{2}''$

545. *Mother and Child on Rocking Chair* (verso). 1948.
Watercolor, gouache, and wax crayon on paper, $11\frac{1}{4} \times 9\frac{1}{4}''$

546. *Reclining Figures* (recto of plate 545).

543

545

546

544

ALBERTO GIACOMETTI.

547. *Tall Figure.* 1947. Bronze, $80 \times 6 \times 5''$

548. *Walking Man.* 1947–48. Bronze, $26\frac{1}{2} \times 11\frac{1}{2} \times 5''$

549. *The Nose.* 1947. Bronze,
head $16\frac{3}{8} \times 3\frac{3}{8} \times 26''$; cage $32 \times 14\frac{5}{8} \times 18\frac{1}{8}''$

550. *Three Figures and a Head* (La Place).
1950. Bronze, $22 \times 21\frac{1}{2} \times 16\frac{1}{2}''$

388

547

548

549

550

and sculpture will not manifest themselves as separate objects, nor as 'mural art' which destroys architecture itself, nor as 'applied' art, but *being purely constructive* will aid the creation of a surrounding not merely utilitarian or rational but also pure and complete in its beauty."

Mondrian wrote of two main impulses of art, "diametrically opposed to each other. . . . One aims at the *direct creation of universal beauty,* the other at the *aesthetic expression of oneself.*"[1] With the outbreak of World War II, the American vanguard changed its attitude from the one to the other, which was a Romanticist point of view. Considering Chaim Soutine a major progenitor of the new outlook, Jack Tworkov contrasted him to those artists "whose standpoint is that the picture is an object, a system of balances, creating an order which is its own end. . . . This position concludes that . . . the painter ought to stand beside the architect, the industrial designer and the decorator . . . [as] willing servants. . . . Soutine is different. . . . He represents the deracinated intellectual—the bohemian who rejects membership in any class, especially in the capacity of a servant."

Tworkov went on to say that Soutine is indifferent to the "improvement of the environment, to make it more efficient, hence, more beautiful," and to the concomitant "concern with careful workmanship and precise appearances." His "passion is not for the picture as a thing, but for the creative process itself. . . . This struggle on the part of the artist to capture the sequence of ephemeral experience is not only the heart of Soutine's method, but also expresses his tragic anxiety, his constant brooding over being and not being, over bloom and decay, over life and death."[2]

The new vanguard rejected not only the attitudes but also the attributes of geometric abstraction: uninflected surfaces from which all signs of the artist's personal touch had been removed; cleanly lined,

1. Piet Mondrian, *Plastic Art and Pure Plastic Art*, New York, Wittenborn, 1945, pp. 50–63.

2. Jack Tworkov, "The Wandering Soutine," *Art News,* 49, part 1, November 1950, pp. 33, 62.

551. WIFREDO LAM.
The Siren of the Niger. 1950.
Oil and charcoal on canvas, 51 × 38″

552. MAN RAY.
Shakespearean Equation:
"Twelfth Night." 1948.
Oil on canvas, 34 × 30″

551

552

391

553

554

PABLO PICASSO.

553. *Woman with Baby Carriage.* 1950.
Bronze, after found objects, $80 \times 57 \times 23\frac{5}{8}''$

554. *Head of a Woman.* 1951.
Bronze, $21\frac{1}{8} \times 7\frac{3}{8} \times 13\frac{3}{4}''$

555. *Pregnant Woman.* 1950.
Bronze, $41\frac{3}{8} \times 11\frac{1}{2} \times 10''$

555

closed forms that looked as if they were ruled with mechanical devices;
synchronous, streamlined design; and "unpsychological" colors—all
of which looked impersonal, often calling to mind modern technology.
Instead, the advanced artist favored ambiguous, dynamic, open, and
"unfinished" forms—directly exploiting the expressiveness of the
painting medium to suggest his own particular temperament with pas-
sion and drama.

There were compelling causes of the rebirth of Romanticism. The
very fact of the war—aggravated by the existence of dictatorship, con-
centration camps, genocide, atomic holocaust, and the Cold War—
called into question utopian and universalist ideologies. Instead, there
was a growing realization that the irrational side of man was inherent
in his being and had to be expressed in any art that aimed to feel real.
It was this reality that vanguard artists would attempt to embody in
their art, and the difficulty of doing so prompted them to think that
they faced "a crisis in subject matter" (their term for content). The
optimistic, ready-made dogmas of modern "isms" could no longer
shelter the artists from the tragic realities of their condition. Grasping
the central impulse of Romanticism, they felt the only guides they
could trust and accept were themselves—their subjective, vulnerable,
and fallible private experiences and visions. To be sure, the painters of
the 1940s did believe that if each dared to probe into his idiosyncratic
experience deeply enough, he would reach a stratum of being shared
by all men. Thus, self-exposure would become intrasubjective—ca-
pable of being communicated.

Romanticist art in America developed in two main directions. A
number of artists intended to provide insights into the world; for ex-
ample, de Kooning's abstractions of the middle 1950s often feel as *real*
as a walk down New York's Tenth Street. The other group—Clyfford
Still, Mark Rothko, Barnett Newman, Jackson Pollock, and to a de-
gree Adolph Gottlieb—sought to suggest their private visions of the
sublime, conceiving of their pictures as incantations to a transcenden-

tal state—in Newman's words, as cathedrals made "out of ourselves, out of our own feelings."[3]

During the early and middle 1940s, these artists (with the exception of Still), intent on expressing human irrationality, were attracted to such Surrealists as Salvador Dali, Max Ernst, Wifredo Lam, René Magritte, Matta, Pavel Tchelitchew, and particularly Joan Miró, the most masterly of the group. Moreover, a number of leading Parisian Surrealists, among them Ernst and Matta, who fled to New York when France was invaded by the Nazis, exerted a personal influence on New York artists. The American Abstract Expressionists adopted Surrealism's central technique, that of automatic drawing and painting as a means of exploring psychic depths to discover fresh images—biomorphic rather than geometric—which suggested life's processes in all of their rich variety. The European Surrealists (who, in New York, in-

3. Barnett Newman, "The Sublime Is Now," *The Tiger's Eye,* 1, October 1949, pp. 51–53.

557. JACKSON POLLOCK. *Number 25, 1950.* 1950.
Encaustic on canvas, $10 \times 37\frac{7}{8}''$
558. MARINO MARINI. *Horse and Rider.* 1952–53.
Bronze, $82 \times 81 \times 46\frac{1}{2}''$

557

cluded Arshile Gorky and Robert Motherwell in their circle), under
the influence of Freud, tried to depict psychological experiences such
as dreams and hallucinations.

In contrast, the Americans generally used automatism to reveal
what they believed to be the residues of universal myths that "lived"
in the collective unconscious, an approach anticipated by Jung. Gott-
lieb and Rothko (with the collaboration of Newman) wrote in a now
famous letter to *The New York Times* in 1943 that they "are concerned
with primitive myths and symbols that continue to have meaning
today . . . only that subject matter is valid which is tragic and time-
less. That is why we profess kinship with primitive and archaic art."[4]
This outlook was shared by William Baziotes and Theodoros Stamos.
Exemplifying 1940s mythmaking was Gottlieb's series of pictographs,

4. Adolph Gottlieb and Mark Rothko (in collaboration with Barnett Newman), "Letters to the
Editor," *The New York Times,* June 13, 1943, sec. 2, p. 9.

558 ▶

MARINO MARINI.

559. *Juggler* (Dancer; Acrobat). 1954.
Bronze, 65 × 23 × 16″

560. *Juggler*. Detail

561. *Little Horse and Rider*. 1949.
Polychromed bronze, 17¾ × 16¾ × 8¼″

562. *Bull*. 1953.
Bronze, 32 × 26¾ × 15″

560

398

559

561

562

563. MAX BILL. *Endless Ribbon from a Ring I*. 1947–49, executed 1960. Gilded copper on crystalline base, $14\frac{1}{2} \times 27 \times 7\frac{1}{2}''$

564. ALBERT SWINDEN. *Triangular Movement*. 1946. Oil on canvas, $40 \times 30''$

565. PIERO DORAZIO. *Eye Numerator*. 1953. Wood and plastic box construction, $28\frac{3}{4} \times 15\frac{3}{4} \times 3\frac{3}{8}''$

563

564

565

each sectioned into rectangular compartments in which were placed enigmatic images, ranging from schematic anatomical segments, fish, reptiles, birds, and animals to abstract signs—subjects often reminiscent of Northwest Coast American Indian painting—meant to recollect man's prehistoric past.

During the late 1940s, Pollock, Still, Rothko, and Newman began to try with greater *immediacy* to evoke what Rothko termed "the Spirit of Myth, which is generic to all myths of all times."[5] "Directed by a ritualistic will towards metaphysical understanding," as Newman wrote,[6] they would transcend the particular, reaching beyond the known world and familiar art to create an abstract art of the sublime. There was a religious impulse in their seeking to reveal (in the sense of revelation) their infinite yearnings, even though it was not related to any organized religion.

Such thinking had a source in Surrealism. André Breton had declared in the second Surrealist Manifesto "that there exists a certain point of the mind at which life and death, the real and the imagined, past and future, the communicable and the incommunicable . . . cease to be perceived as contradictions. Now, search as one may one will never find any other motivating force in the activities of the Surrealists than the hope of finding and fixing this point."[7] To achieve this visionary state of consciousness, artists would need to reject outworn imagery that had become too commonplace and finite to suggest the illimitable. This the European Surrealists did not do, but the Americans abandoned their automatist, calligraphic, quasi-figurative, mythic symbols and started to search for pictorial means that would directly and freshly express transcendental experience.

5. Mark Rothko, quoted in Sidney Janis, *Abstract and Surrealist Art in America,* New York, Reynal and Hitchcock, 1944, p. 118.

6. Barnett Newman, *The Ideographic Picture,* New York, Betty Parsons Gallery, 1947, n.p.

7. André Breton, *Manifestoes of Surrealism,* trans. Richard Seaver and Helen R. Lane, Ann Arbor, The University of Michigan, 1969, pp. 123–124.

566. MATTA.
The Clan. 1958.
Bronze and iron, $28\frac{1}{2} \times 29 \times 22\frac{3}{4}''$

567. MATTA.
The Three. 1951.
Oil on canvas, $34 \times 48\frac{1}{4}''$

568. WOLS.
Adversity of the Winds. 1950.
Watercolor on paper, $7\frac{5}{8} \times 6\frac{1}{8}''$

569. AARON BOHROD.
The Shepherd Boy. 1957.
Oil on panel, $12 \times 9''$

570. CARROLL CLOAR.
Day Remembered. 1955.
Casein and tempera on
Masonite, $28 \times 40''$

566

568

569

570

573

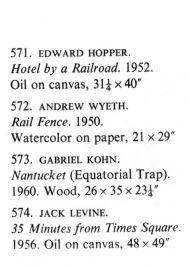

571. EDWARD HOPPER.
Hotel by a Railroad. 1952.
Oil on canvas, $31\frac{1}{4} \times 40''$

572. ANDREW WYETH.
Rail Fence. 1950.
Watercolor on paper, $21 \times 29''$

573. GABRIEL KOHN.
Nantucket (Equatorial Trap).
1960. Wood, $26 \times 35 \times 23\frac{1}{4}''$

574. JACK LEVINE.
35 Minutes from Times Square.
1956. Oil on canvas, $48 \times 49''$

574

575

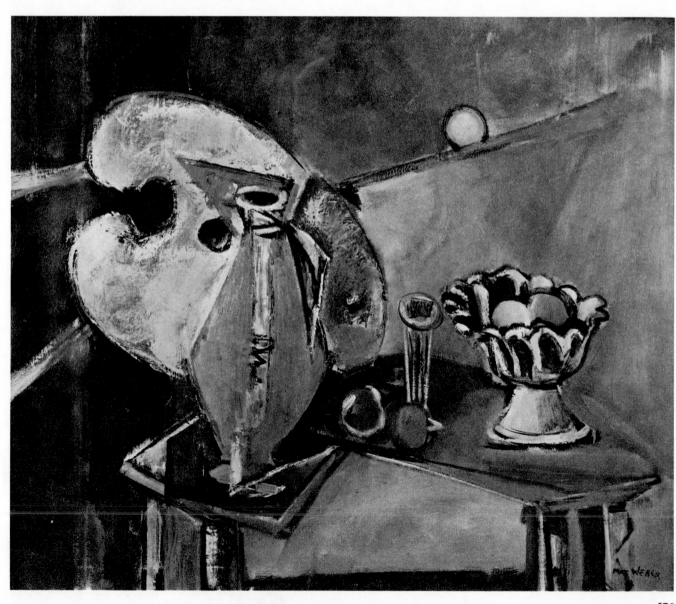

576

575. JOSEPH SOLMAN. *Studio Interior with Statue*. 1950. Oil on canvas, 15¾ × 23⅝"

576. MAX WEBER. *Still Life with Palette*. 1947. Oil on canvas, 30 × 36"

577. SEYMOUR LIPTON. *Mandrake*. 1958. Nickel Silver on Monel Metal, 36 × 34 × 16½"

577

Of great use to them in this venture were writings on the sublime, particularly those of Edmund Burke, the eighteenth-century philosopher. Among the attributes of the sublime Burke listed "the effect of infinity,"[8] an effect that Still, Rothko, and Newman began to achieve by limiting themselves to large, simple areas of color that so inundate the eye as to appear vast and boundless. At the same time, the colors are made to express (to paraphrase Van Gogh) the vast intense things that rise up in the artist, these things of color, these infinite things.

The sense of boundlessness is intensified when the areas of color are close in value and evenly painted, and when they are not sharply delineated, making it possible, as Burke remarked, "to continue that uninterrupted progression which alone can stamp on bounded objects the character of infinity." To create chromatic fields, each graspable

8. This and other of Burke's quotations are from Edmund Burke, *A Philosophical Enquiry into the Origin of Our Ideas of the Sublime and the Beautiful* (1757), New York, Columbia University, 1958.

578

579

582

583

580

581

584

578. ROBERT GWATHMEY.
Portrait of a Farmer's Wife. 1951.
Oil on canvas, $44\frac{1}{8} \times 33\frac{7}{8}''$

579. EARL KERKAM.
Self-Portrait. 1953.
Oil on canvas mounted on
cardboard, $23\frac{1}{4} \times 19''$

580. JOSÉ LUIS CUEVAS.
Assaulted Woman VII. 1959.
Gouache on paper, $40 \times 26''$

581. MOSES SOYER.
Phyllis. 1954.
Oil on canvas, $30 \times 25''$

582. PHILIP EVERGOOD.
American Shrimp Girl. 1954.
Oil on canvas mounted on
board, $46\frac{1}{2} \times 32\frac{3}{8}''$

583. CHARLES WHITE.
The Mother. 1952.
Sepia ink on paper, $28\frac{3}{8} \times 19''$

584. EDWIN DICKINSON.
Self-Portrait. 1954.
Oil on canvas, $26\frac{1}{4} \times 24\frac{1}{4}'$

585

586

587

585. LAURA ZIEGLER. *Eve.* 1958.
Bronze, $70 \times 23\frac{1}{2} \times 24''$

586. SAUL BAIZERMAN. *Nereid.* 1955–57.
Hammered copper, $47\frac{3}{4} \times 18 \times 10''$

587. CHAIM GROSS. *Playful Sisters*
(Family of Three). 1949.
Mexican tulipwood, $54 \times 16\frac{1}{2} \times 13\frac{3}{4}''$

588. FRITZ WOTRUBA. *Figure with Raised
Arms.* 1956–57. Bronze, $75\frac{1}{4} \times 19\frac{1}{2} \times 15''$

589. RICHARD STANKIEWICZ. *Figure.*
1955. Iron, $80 \times 20\frac{1}{2} \times 19\frac{1}{4}''$

588

589

590. REUBEN NAKIAN.
Europa. 1959–60.
Terra-cotta, $10\frac{1}{2} \times 13\frac{3}{8} \times 3\frac{7}{8}''$

591. WILLEM DE KOONING.
Woman. 1953. Oil and
charcoal on paper mounted
on canvas, $25\frac{1}{2} \times 19\frac{5}{8}''$

592. JEAN DUBUFFET.
Oberon. 1960. Papier-mâché,
$34 \times 14\frac{1}{2} \times 12\frac{1}{4}''$

593. PABLO PICASSO.
The Arm. 1959. Bronze,
$22\frac{3}{4} \times 6\frac{1}{2} \times 6\frac{1}{4}''$

594. JEAN DUBUFFET.
Limbour as a Crustacean. 1946.
Oil on canvas, $45\frac{5}{8} \times 35''$

590

412

591

592

593

594

595

all at once in its entirety, Still, Rothko, and Newman—who have come to be called color-field painters—avoided crisscrossing elements to create relational structures of finite forms which force the viewer slowly to read a picture from part to part to whole.

Desiring to augment the sensation of enveloping colors, the color-field painters worked on a larger and larger scale so that "the mind is so entirely filled with its object that it cannot entertain any other"—this, according to Burke, provoking astonishment and leading to transcendental experience. Moreover, "greatness of dimension is a powerful cause of the sublime."

Before Still, Rothko, and Newman had executed their extreme open-field abstractions, Pollock had achieved an unprecedented effect of boundlessness in the "drip" paintings he began in 1947. Earlier, like the three color painters, he had painted mythic pictures that often alluded to legends recounted in Jung's writings, to animal sexuality, and to nocturnal rites—violent themes which are embodied in tem-

597

595. MAX ERNST. *Daughter and Mother.* 1959.
Bronze, $17\frac{5}{8} \times 10\frac{3}{8} \times 11\frac{1}{2}''$

596. MAX ERNST. *The Parisian Woman.* 1950.
Bronze, $31\frac{1}{2} \times 7\frac{1}{4} \times 5\frac{1}{2}''$

597. JOAN MIRÓ. *Woman* (Personnage). 1953.
Black marble, $38\frac{1}{4} \times 27\frac{3}{4} \times 28''$

596

598

JOSEPH CORNELL.

598. *Hôtel goldene Sonne*. c. 1955–57.
Box construction, $12\frac{7}{8} \times 9\frac{1}{2} \times 4''$

599. *Shadow Box*. Mid-1950s.
Box construction, $5\frac{3}{4} \times 8\frac{7}{8} \times 3\frac{1}{4}''$

600. *Hotel Boule-D'Or*. c. 1957.
Box construction, $17\frac{1}{8} \times 10\frac{1}{4} \times 4\frac{5}{8}''$

601. *Boötes*. Mid-1950s.
Box construction, $8\frac{1}{4} \times 13 \times 3\frac{1}{2}''$

602. *Sand Fountain*. Late 1950s.
Box construction, $10\frac{3}{4} \times 7\frac{7}{8} \times 3\frac{1}{2}''$

603. *T. Lucretii*. Mid-1950s.
Box construction, $10 \times 15\frac{3}{4} \times 3\frac{1}{2}''$

602

600

601

603

417

604

605

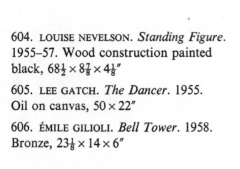

604. LOUISE NEVELSON. *Standing Figure.*
1955–57. Wood construction painted
black, 68½ × 8⅞ × 4⅛″

605. LEE GATCH. *The Dancer.* 1955.
Oil on canvas, 50 × 22″

606. ÉMILE GILIOLI. *Bell Tower.* 1958.
Bronze, 23⅛ × 14 × 6″

606

pestuous painting. In time, Pollock increasingly suppressed literal references, eliminating recognizable symbols and signs, and concentrated on the spontaneous process of painting, it seems, as a ritualistic act. It was as if Pollock discovered for himself the primitive common denominator of art and ritual—"the desire . . . to give out a strongly felt emotion," as Jane Harrison has written.[9] Perhaps, too, Pollock thought, as Meyer Schapiro has remarked, that Surrealism "proposed as its chief image the minotaur, the man-beast in the labyrinth,"[10] and attempted to enact that drama directly, employing automatism to an extreme far beyond which any Surrealist would venture.

The abstractions that resulted, many of them wall-size, were composed of dribbled, poured, and flung marks of paint interlaced to form

9. Jane Harrison, quoted in Herbert Read, *Icon and Idea,* Cambridge, Massachusetts, Harvard University, 1955, p. 57.

10. Meyer Schapiro, "The Younger American Painters of Today," *The Listener,* 60, January 26, 1956, p. 147.

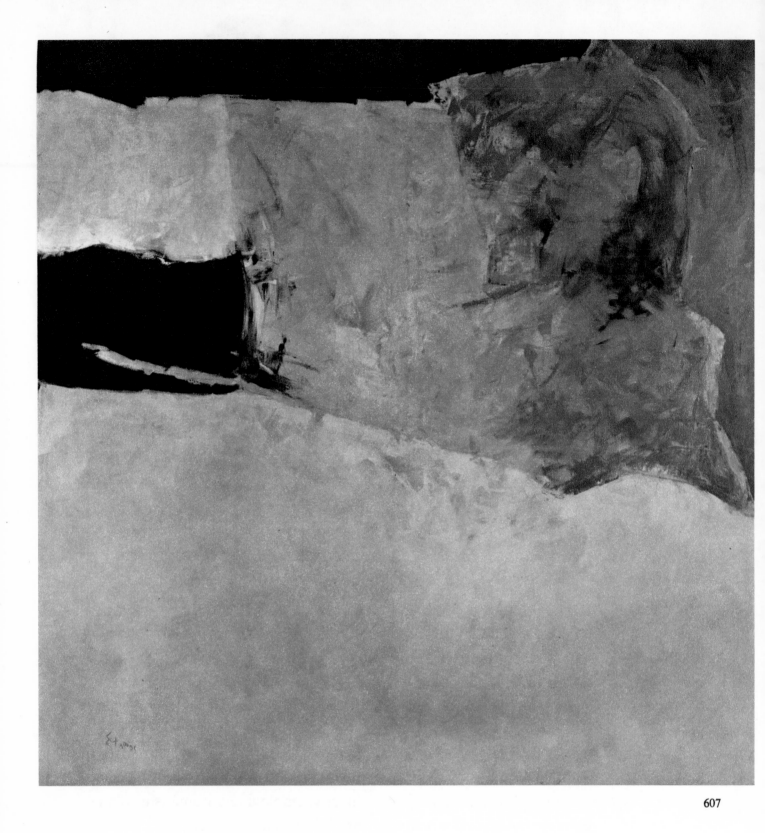

607. THEODOROS STAMOS. *Byzantium II*. 1958.
Oil on canvas, $69 \times 68''$

608. MARK TOBEY. *Saints and Serpents*. 1953.
Gouache on paper, $22\frac{1}{2} \times 25\frac{1}{2}''$

608

an all-over single image lacking focal points. The paintings were charged with energy, so much so as to seem to expand beyond the picture limits into infinity. This prompted Robert Rosenblum to write that before Pollock's "gyrating labyrinths" we were "immediately plunged into divine fury . . . we are almost physically lost in this boundless web of inexhaustible energy. . . . Pollock invariably evokes the sublime mysteries of nature's untamable forces."[11]

Summing up, Schapiro wrote that such painters as Pollock, on the one hand, and Still, Rothko, and Newman, on the other, seek "an absolute in which the receptive viewer can lose himself, the one in compulsive movement, the other in an all-pervading . . . sensation of a dominant colour. The result in both is a painted world with a powerful, immediate impact."[12]

11. Robert Rosenblum, "The Abstract Sublime," *Art News,* 59, February 1961, p. 56.

12. Schapiro, "The Younger American Painters," p. 146.

609

611

612

ALEXANDER CALDER.

609. *Zarabanda*. 1955. Mobile, painted sheet metal, metal rods, and wire, $33 \times 89\frac{1}{2} \times 21\frac{1}{2}''$

610. *Mobile*. 1958. Painted sheet metal, metal rods, and wire, $3'5'' \times 8'4'' \times 4'10''$

611. *Twenty-Nine Circles*. 1958. Painted sheet metal and wire, $47\frac{1}{2} \times 30 \times 22''$

612. *Little Long Nose*. 1959. Painted sheet metal, $66 \times 66 \times 47''$

613. *Orange and Black Composition*. 1956. Gouache and ink on paper, $29 \times 40''$

614. JIMMY ERNST. *Papageno*. 1960.
Oil on canvas, 54 × 72″

615. FRITZ GLARNER. *Relational Painting No. 83*. 1957.
Oil on canvas, 45¼ × 43¼″

615

616. JAMES ROSATI. *Hamadryad*. 1957–58. Marble, $35\frac{1}{4} \times 8\frac{3}{4} \times 7''$

617. ISAMU NOGUCHI. *Endless Coupling*. 1957.
Cast iron, in three parts, $58\frac{1}{2} \times 13 \times 9\frac{3}{4}''$

616

617

Pollock, Still, Rothko, and Newman extended Surrealist ideas in such unprecedented directions that their pictures could not be called Surrealist. Other Abstract Expressionists were also turning from the psychoanalytic orientation of Surrealism toward Existentialism, which in the late 1940s became the intellectual frame of reference. As early as the summer of 1946, Clement Greenberg noted, "What we have to do with here is an historical mood that has simply seized upon Existentialism to formulate and justify itself, but which has been gathering strength long before most of the people concerned had ever read Heidegger or Kierkegaard. . . . Whatever the affectations and philosophical sketchiness of Existentialism, it is esthetically appropriate to our age. . . . What we have to do with here, I repeat, is not so much a philosophy as a mood."[13] De Kooning's recollection corroborates Greenberg. He has said in conversation: We weren't influenced directly by Existentialism, but it was in the air, and we felt it without knowing too much about it. We were in touch with the mood. I read the books, but even if I didn't, I would probably be the same kind of painter. I live in my world.[14]

The leading American exponent of Existentialism, William Barrett, a friend of many Abstract Expressionists, has said that a cardinal premise agreed upon by all Existentialists was this: "Man exists and makes himself to be what he is; his individual essence or nature comes out of his existence. . . . Man does not have a fixed essence that is handed to him ready-made; rather, he makes his own nature out of his freedom and the historical conditions in which he is placed. . . . This is one of the chief respects in which man differs from things, which do have fixed natures or essences, which are once and for all what they are."[15]

13. Clement Greenberg, "Art," *The Nation,* 163, July 13, 1946, p. 54.

14. Willem de Kooning, conversation with the author, New York, June 16, 1959.

15. William Barrett, *Irrational Man,* New York, Doubleday, 1958, p. 90.

618

Consequently, the existentially minded artist avoided subjecting himself to fixed ideas, patterns, or standards. To partake authentically in the human adventure he had to embrace change, to live in a mood of expectancy. To do otherwise—that is, to stop becoming—would turn him into a thing. His art too had to remain open, to be constantly modified by new experiences which could not be foreseen. Summarizing this attitude, Motherwell wrote in 1950, "The process of painting . . . is conceived of as an adventure, without preconceived ideas on the part of persons of intelligence, sensibility and passion. Fidelity to what occurs between oneself and the canvas, no matter how unexpected, becomes central. . . . The major decisions in the process of painting are on the grounds of truth, not taste . . . no artist ends up with the style he expected to have when he began."[16]

16. Robert Motherwell, "The School of New York," Beverly Hills, California, Perls Gallery, 1951, n.p.

620

618. ANNE RYAN.
Collage #538. 1953.
Collage on cardboard,
$12\frac{1}{2} \times 9\frac{3}{4}''$

619. ANNE RYAN
Collage #534, 1953.
Collage on cardboard,
$12\frac{1}{2} \times 9\frac{3}{8}''$

620. HERMAN ROSE.
Skyline, New York. 1949.
Oil on canvas,
$24 \times 12''$

621

Thus, a number of artists who have been called gesture painters—Motherwell (in some of his work), de Kooning, Hans Hofmann, Bradley Walker Tomlin, Philip Guston, Franz Kline, Adja Yunkers, and Sam Francis (and in Europe Alfred Wols, Nicolas de Staël, Karel Appel, Pierre Alechinsky, and Antonio Saura)—in varying degrees executed pictures which, in Meyer Schapiro's words, "impress us as possessing the qualities not so much of things as of impulses, of excited movements, emerging and changing before our eyes." Schapiro goes on to say, "The consciousness of the personal and spontaneous . . . stimulates the artist to invent devices of handling, processing, surfacing, which confer to the utmost degree the aspect of the freely made. Hence the great importance of the mark, the stroke, the brush, the drip, the quality of the substance of the paint itself, and the surface of the canvas as a texture and field of operation—all signs of the artist's active presence." But the spontaneous was not all (and it was in this that the gesture painters differed from the automatist Surrealists):

623

624

625

626

623. WILLIAM KING. *Venus*. 1956. Bronze, $63 \times 18\frac{1}{2} \times 13\frac{1}{2}''$

624. GERHARD MARCKS. *Girl with Braids*. 1950. Bronze, $45\frac{1}{4} \times 14\frac{1}{2} \times 8\frac{7}{8}''$

625. REG BUTLER. *Manipulator*. 1956. Bronze, $66 \times 23\frac{1}{2} \times 21''$

626. REG BUTLER. *Girl*. 1954–56. Bronze, $88\frac{1}{4} \times 30 \times 25''$

433

627

628

629

627. DAME BARBARA HEPWORTH.
Head (Elegy). 1952.
Mahogany and string,
$16\frac{7}{8} \times 11 \times 7\frac{1}{2}''$

628. DAME BARBARA HEPWORTH.
Pendour. 1947.
Painted wood, $10\frac{3}{8} \times 27\frac{1}{4} \times 9''$

629. JEAN ARP.
Torso Fruit. 1960.
Marble, $29\frac{1}{2} \times 12 \times 11\frac{1}{2}''$

630. DAME BARBARA HEPWORTH.
Figure for Landscape. 1960.
Bronze, $8'10'' \times 4'2\frac{1}{2}'' \times 2'2\frac{1}{2}''$

630

"These elements of impulse which seem at first so aimless on the canvas are built up into a whole . . . a well-defined, personal class of forms and groupings. . . . [They are] submitted to critical control by the artist who is alert to the rightness or wrongness of the elements delivered spontaneously, and accepts or rejects them."[17]

It must be stressed that the gesture painters did not *illustrate* Existentialist concepts in their painting. Having rejected the ideological art of the Social Realists, Regionalists, geometric abstractionists, and academic Surrealists, they were not about to put their art in the service of any other "ism." Instead, the gesture painters considered painting to be an existential process, an unpremeditated "situation" (for they often used words borrowed from the terminology of Existentialism) in which a creatively "committed" artist "encountered" images of "authentic" being. All existentially minded artists were deeply aware of "alienation and estrangement; a sense of the basic fragility and contingency of human life; the impotence of reason confronted with the depths of existence; the threat of Nothingness, and the solitary and unsheltered condition of the individual before this threat."[18]

Indeed, leading artists in Europe, among them Jean Dubuffet and Francis Bacon, focused on this attitude in their paintings. As an originator of Art Brut (raw art), Dubuffet looked to the art of children, primitives, and the insane for subject matter, gouging savage figures in heavy impasto which resemble anonymous graffiti crudely scrawled on city streets and the walls of buildings. Bacon's image is man as monster, the inhabitant of the world of Hiroshima and Buchenwald. His brutalized figures are a metaphor for man as "a completely futile being" who "has to play out the game without reason." The American gesture painters were more optimistic, believing that the man—no

17. Meyer Schapiro, "The Liberating Quality of Avant-Garde Art," *Art News,* 56, Summer 1956, pp. 38–40.

18. Barrett, *Irrational Man,* p. 31.

436

631. GRAHAM SUTHERLAND.
Cynocéphale. 1952.
Oil on canvas, $52\frac{1}{8} \times 23\frac{5}{8}''$

632. FRANCIS BACON.
Study for *Portrait V*. 1953.
Oil on canvas, $60 \times 46''$

633. WILLIAM TURNBULL.
Head. 1957. Bronze on
stone base, $40 \times 29 \times 14''$

632

631

633

634

635

HENRY MOORE.

634. *Falling Warrior*. 1956–57. Bronze,
$23\frac{1}{4} \times 57\frac{3}{4} \times 30''$

635. *Interior-Exterior Reclining Figure*
(Working Model for Reclining Figure:
Internal and External Forms). 1951.
Bronze, $14 \times 21\frac{3}{8} \times 7\frac{1}{2}''$

636. *Draped Reclining Figure*. 1952–53,
cast 1956. Bronze, $41\frac{1}{2} \times 66\frac{1}{2} \times 34''$

637. *Upright Motive No. 1: Glenkiln Cross*.
1955–56. Bronze, $11' \times 3' \times 3'2''$

638. *Seated Woman*. 1956–57. Bronze, $57 \times 56 \times 41''$

639. *Three Motives Against Wall, No. 2*.
1959. Bronze, $18\frac{1}{2} \times 43\frac{1}{4} \times 16''$

636

637

638

639

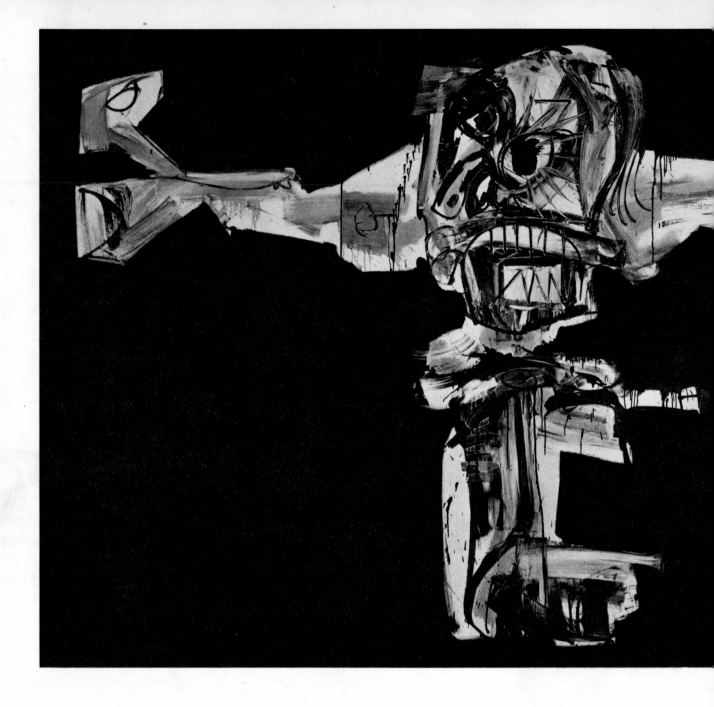

matter how alone and vulnerable—who *makes himself* is something of a hero.

The consummate statement of the Existentialist position was Harold Rosenberg's article "The American Action Painters," which generated great controversy during the 1950s. "At a certain moment the canvas began to appear to one American painter after another as an arena in which to act—rather than as a space in which to reproduce, re-design, analyze, or 'express' an object, actual or imagined. . . . The big moment came when it was decided to paint. . . . Just TO PAINT. The gesture on the canvas was a gesture of liberation, from Value—political, esthetic, moral. . . . On the one hand, a desperate recogni-

640. ANTONIO SAURA. *Crucifixion* (Triptych).
1959–60. Oil on canvas, 6'5" × 10'7"

tion of moral and intellectual exhaustion; on the other, the exhilaration of an adventure over depths in which he might find reflected the true image of his identity." Rosenberg also asserted, "A painting that is an act is inseparable from the biography of the artist. The painting itself is a 'moment' in the adulterated mixture of his life. . . . The act-painting is of the same metaphysical substance as the artist's existence. The new painting has broken down every distinction between art and life."[19] Thus the artist confronts his canvas without preconceptions

19. Harold Rosenberg, "The American Action Painters," *Art News,* 51, December 1952, pp. 22–23, 48.

641

643

644

645

GIACOMO MANZÙ.

641. *The Execution*. 1956. Bronze relief, $13\frac{1}{8} \times 8\frac{3}{4} \times \frac{5}{8}''$

642. *The Deposition*. 1956. Bronze relief, $13\frac{1}{2} \times 9\frac{1}{2} \times 1\frac{1}{4}''$

643. *Three Studies of Saint Sévérin*. 1958. Bronze relief, $21\frac{1}{2} \times 28\frac{3}{4}''$

644. *The Deposition*. c. 1953. Charcoal and gouache on wood, $86 \times 58\frac{1}{2}''$

645. *Large Standing Cardinal*. 1954. Bronze, $66\frac{1}{2} \times 23 \times 15\frac{3}{4}''$

646. *Praying Cardinal*. 1955. Gouache on paper mounted on Masonite, $40\frac{1}{4} \times 26\frac{1}{2}''$

646

GIACOMO MANZÙ.

647. *Bust of Inge, No. 2.* 1956.
Bronze, $23\frac{5}{8} \times 15\frac{3}{8} \times 12\frac{1}{4}''$

648. *Dancer with Skirt.* 1956.
Bronze, $79 \times 18\frac{1}{2} \times 15''$

649. *Young Girl on a Chair.* 1955.
Bronze, $44 \times 23\frac{3}{4} \times 43\frac{1}{4}''$

650. *Young Girl on a Chair.* Detail

647

648

and in the process of adding gesture to gesture, each dictated by his compulsion to make it, arrives at a picture of his own identity.

The so-called action painters had reservations about the extremeness of Rosenberg's conception, yet, like him, they considered the artist's existential experience as the mainspring of art, elevating it above any ideas imposed from without, received ideas, picture-making, or aesthetic performance. Exemplifying this gestural kind of painting are de Kooning's pictures in which open areas, composed of vehement, "unfinished" brushstrokes which generate energy are ceaselessly shifting, as if in a state of becoming. Indeed, it appeared as if his aim was to avoid the ruts of habit, atrophied mannerisms—in a word, stylization—in order to convey more nakedly than ever before a sense of his passionate creative struggle. His images look as if they germinate from—are *found* in—that direct and improvisational struggle. The painterly marks convey the burden of content. As Franz Kline has said, "If you meant it enough when you did it, it will mean that

651. MARIA ELÉNA VIEIRA DA SILVA. *Labyrinth*. 1956. Oil on canvas, $31\frac{1}{2} \times 31\frac{1}{2}''$

652. ÉTIENNE HAJDU. *The Bird, Uranus II*. 1957. Bronze, $39 \times 75 \times 10''$

653. RICHARD HUNT. *Construction*. 1958. Bronze and steel, $20\frac{1}{2} \times 18 \times 12''$

654. ÉTIENNE HAJDU. *Adolescence*. 1957. Marble, $35\frac{1}{2} \times 11\frac{7}{8} \times 2\frac{1}{4}''$

655. NAUM GABO. *Linear Construction No. 4*. 1959–61. Aluminum construction with stainless steel spring wire, $39 \times 29 \times 29''$

656. NAUM GABO. *Linear Construction No. 2* (smaller version). 1949. Plastic construction with nylon thread, $15 \times 11 \times 11''$

651

652

653

655

654

656

657

657. ROBERT MÜLLER. *Larkspur.* 1958
Iron, 47 × 29½ × 25″

658. WILLIAM ZORACH. *Eve.* 1951.
Pink granite, 26 × 7¾ × 7″

658

448

much."[20] Depending on the unique temperament of each artist, gesture painting is often violent, but much of it—that of Guston, Tomlin, Yunkers, and Francis—is quiet and lyrical (that is, nonaggressive). Moreover, although most of gesture painting is marked by anxiety, some, notably Hofmann's, is not. Indeed, Hofmann is *the* hedonist of Abstract Expressionism, high-spirited and extravagant.

Younger artists who emerged in the milieu of Abstract Expressionism during the early 1950s adopted the Existentialist stance of their elders, but in many cases only the rhetoric, and a few began to respond ironically to what Larry Rivers has called "ich-schmerz."[21] It was John Cage who launched the major assault on all Romanticist thinking—major, because of its effect on such younger artists as Robert Rauschenberg, Jasper Johns, and Allan Kaprow. Cage was influenced by Zen Buddhism and Dada—notably by Marcel Duchamp, the ultimate Dada, who had ceased producing art (so it was believed) but who remained active on the New York art scene. Cage considered Dada and Zen akin because they related art to everyday life in an unsentimental, shocking, and humorous fashion. Moreover, both repudiated "a rationalized hierarchy of values," as William Seitz has remarked, and instead called attention to "unsureness, accident, confusion, disunity and discontinuity . . . [releasing] a constellation of physical and intellectual energies through which an artist could (and still can) operate in a way that, at least in the West, was previously impossible."[22]

Cage had no sympathy for the Abstract Expressionists' aesthetic intentions, particularly their idea that an artist or his art deserves to constitute some center of special interest. Indeed, Cage challenged the importance of the artist's existential condition as a primary source of art. He denied the value of an artist struggling to forge his own identi-

20. Frank O'Hara, "Franz Kline Talking," *Evergreen Review,* 2, Autumn 1958, p. 63.

21. Thomas B. Hess, "U.S. Painting: Some Recent Directions," *Art News Annual,* 25, 1956, p. 196.

22. William C. Seitz, *The Art of Assemblage,* New York, The Museum of Modern Art, 1961, p. 37.

660

659. JAN LEBENSTEIN.
Axial Figure No. 90. 1960.
Oil on canvas, $57\frac{3}{4} \times 35\frac{5}{8}''$

660. ERNST WILHELM NAY.
Untitled. 1954.
Oil on canvas, $22\frac{7}{8} \times 31''$

661. ADJA YUNKERS.
Tarassa X. 1958.
Pastel on paper, $44 \times 31''$

661

662. NATHAN OLIVEIRA. *Man Walking*. 1958. Oil on canvas, $60\frac{1}{4} \times 48''$

663. LEONARD BASKIN. *The Guardian*. 1956. Limestone, $26 \times 9\frac{3}{8} \times 9\frac{5}{8}''$

664. HAROLD TOVISH. *Mechanical Gypsy*. 1955. Bronze, $22 \times 9\frac{3}{4} \times 9\frac{3}{4}''$

663

664

ty in the anxiety-provoking act of creation. Cage's antipathy to the image of an artist as a combination of existential hero or shaman and master painter is illustrated in the following two anecdotes. One: Cage told of a conversation with de Kooning, who said: We are different. . . . You don't want to be an artist whereas I want to be a great artist. Cage commented, "Now it was this aspect of wanting to be an artist . . . who has something to say, who wanted through his work to appear really great . . . which I could not accept."[23] Two: As recollected by Morton Feldman, a visitor to Cage's home in Stony Point was praising the contribution the composer had made to music. Walking over to the window and looking out into the woods, Cage said, "I just can't believe I am better than anything out there."[24]

Just as Cage denied the role of the artist as master, so he denied

23. John Cage, conversation with the author, New York, 1966. Unless otherwise indicated, all of Cage's quotes are from this conversation.

24. Morton Feldman, "The Anxiety of Art," mimeographed typescript, 1965, p. 5.

665

the conception of the work of art as masterpiece. Of a lecture entitled "Sand Painting," delivered in 1949 to an audience composed largely of Abstract Expressionist artists, Cage said, "I was promoting the notion of impermanent art . . . something that, no sooner had it been used, was so to speak discarded. I was fighting . . . the notion of art itself as something which we preserve."

Uninterested in the confession of the private aspects of an artist's life and of its emotional qualities, Cage focused instead on what was experienced through the senses. The "use" of art was to open up one's eyes to "just seeing what there was to see," and one's ears to attend to the activity of sounds.[25] The ability of art to do so was confirmed by E. H. Gombrich: "Contemporary artists such as Rauschenberg have become fascinated by the patterns and textures of decaying walls with

25. John Cage, *Silence: Lectures and Writings,* Cambridge, Massachusetts, and London, Massachusetts Institute of Technology, 1967, p. 10.

666

665. ELMER BISCHOFF.
*Woman with Dark
Blue Sky*. 1959. Oil
on canvas, 68 × 68″

666. NICOLAS DE STAËL.
La Seine. 1954. Oil
on canvas, 35 × 51⅜″

667. SERGE POLIAKOFF.
Untitled. 1958. Oil
on canvas, 28¾ × 36¼″

667

668. FRANCESCO SOMAINI. *Large Bleeding Martyrdom.* 1960. Lead, 51½ × 26 × 22½"

669. EDUARDO CHILLIDA. *Ikaraundi* (The Great Tremor). 1957. Bronze, 23 × 58 × 26½"

their torn posters and patches of damp. Though I happen to dislike Rauschenberg, I notice to my chagrin that I cannot help being aware of such sights in a different way since seeing his paintings."[26]

In order to hear and see what existed, Cage denied any hierarchy of sounds in music, or materials, forms, or colors in the visual arts. Each was to exist only for itself "rather than being exploited to express sentiments or ideas of order."[27] Each sound or material *is* art—a conception of particular importance to Rauschenberg in the development of his "combine-paintings." And Johns not only chose commonplace subjects and tried to make the visually exhausted visible again but, with seeming detachment, he made or crafted his surfaces to resemble gesture paintings—striking at the very ethic of the Abstract Expressionist approach, a reason that his pictures provoked shock when they were first shown in 1958.

26. E. H. Gombrich, "Visual Discovery Through Art," *Arts,* November 1965.

27. Cage, *Silence,* p. 69.

670. JEAN IPOUSTÉGUY. *The Crab and the Bird*. 1958. Bronze, $25\frac{1}{2} \times 61\frac{1}{4} \times 20''$

671. LEONARDO CREMONINI. *Bathers Amongst the Rocks*. 1955–56. Oil on canvas, $35 \times 57\frac{1}{2}''$

672. MORRIS BRODERSON. *Angel and Holy Mary, after Leonardo da Vinci.*
1960. Oil on canvas, $50 \times 72''$

673. JEAN IPOUSTÉGUY. left: *David*. 1959. Bronze, $47 \times 24\frac{1}{2} \times 24''$;
right: *Goliath*. 1959. Bronze, $30\frac{1}{2} \times 56 \times 35''$

672

673

Cage has asserted, "I wanted to change my way of seeing, not my way of feeling. I was perfectly happy about my feelings." But becoming alive to one's actual environment would lead to happiness. "I prefer laughter to tears [of Abstract Expressionism]. . . . If art was going to be of any use, it was . . . not with reference to itself but . . . to the people who used it, and they would use it not in relation to art itself but . . . to their daily lives . . . [which] would be better if they were concerned with enjoyment rather than misery."

The Existentialist attitude also came under growing attack from artists and critics who, taking their cues from Roger Fry and Clive Bell, espoused a "purist" or "art for art's sake" aesthetic—notably Clement Greenberg and Ad Reinhardt. The purist position was strongly opposed to the Duchamp-Cage aesthetic, and during the 1960s both vied for hegemony.

Greenberg was among the earliest art critics to acclaim the Abstract Expressionists, yet his aesthetic, which may be termed formalist, had little in common with their Romanticist attitude. He believed that the primary ambition of *modernist* artists, aside from creating works of quality, was to develop what was unique in the nature of their mediums. As early as 1940, he asserted that in each of the arts there existed an urge to disassociate itself from the others—to become pure. Purism was "the terminus of a salutary reaction against the mistakes of painting and sculpture in the past several centuries."[28] The major "mistakes" were literary subject matter, representation, and illusionism, produced in the main by the contrast of light and dark values, which destroys the flatness of the canvas plane.

Greenberg wrote, "Purity in art consists in the acceptance, willing acceptance, of the limitations of the medium of the specific art. . . . The purely plastic or abstract qualities of the work of art are the only

28. Clement Greenberg, "Towards a Newer Laocoön," *The Partisan Review,* 7, July–August 1940, p. 296.

674. KAREL APPEL. *Beach Life*. 1958. Oil on canvas, 63¾ × 51″

675

676

675. ALICIA PENALBA.
The Sparkler. 1957.
Bronze on carved stone
base, $47 \times 27\frac{3}{4} \times 25''$; height of base 20"

676. GERMAINE RICHIER.
Grain. 1955.
Bronze, $57 \times 13\frac{1}{2} \times 12''$

ones that count. Emphasize the medium and its difficulties, and at once the purely plastic, the proper values of visual art come to the fore. Overpower the medium to the point where all sense of resistance disappears, and the adventitious uses of art become important."[29]

Therefore, as Greenberg saw it, changes in style issued from the progressive elimination of impurities which deny the medium and from the concomitant exploitation of its expressive resources. Style changes also resulted from critical reactions against the formal solutions in the art of the recent past which had become outworn through repetition. The modernist artist "cannot resort to the means of the past, for they have been made stale by overuse, and to take them up again would be to rob his art of its originality and real excitement."[30]

From the late 1950s on, Greenberg championed the color painting of Morris Louis, Kenneth Noland, and Jules Olitski. It continued the Romanticist spirit of Abstract Expressionism, if in a more hedonistic vein, but Greenberg's treatment of it was primarily formalist. Painting, in its will to its own definition, was now to be based on the optical qualities of color that are purely visual or pictorial. To be suppressed were tactile qualities that make an appeal to touch and therefore belong to sculpture.

Early in the 1950s, Ad Reinhardt had espoused an uncompromising purist position, but it was not taken seriously (although his painting always was) until near the end of the decade. Reinhardt consciously renounced all extra-aesthetic associations in art, in an effort to define what art ought to be. As he wrote, "The one thing to say about art is that it is one thing. Art is art-as-art and everything else is everything else." Therefore, he attempted "to present art-as-art and as nothing else; to make it into the one thing it is only, separating and defining it more and more, making it purer and emptier, more absolute and more

29. Greenberg, "Towards a Newer Laocoön," p. 305.
30. Clement Greenberg, "Art," *The Nation,* 152, April 19, 1941, p. 482.

677

679

678

ALBERTO GIACOMETTI.

677. *Bust of a Man* (Diego). 1954.
Bronze, $11\frac{1}{2} \times 6\frac{3}{4} \times 5\frac{1}{4}''$

678. *Bust of Diego*. 1957.
Bronze, $24\frac{1}{4} \times 10\frac{1}{4} \times 5\frac{3}{4}''$

679. *Bust of Diego on a Stele* (Stele II).
1958. Bronze, $65 \times 8\frac{1}{8} \times 3''$

680. *Dog*. 1951, cast 1957.
Bronze, $17\frac{1}{4} \times 36\frac{1}{4} \times 6\frac{1}{8}''$

exclusive—non-objective, non-representational, non-figurative, non-imagist, non-expressionist, non-subjective. The only and one way to say what abstract art or art-as-art is, is to say what it is not."[31]

To Reinhardt, the antithesis of art-as-art was art-as-life, and to distill the artness of art as exclusively and directly as he could, he programmatically purged painting of all signs of life: at first, of varied shapes, colors, and textures; later, of most of color and of line until the surfaces of his "black" paintings appeared to be a homogenous, matte gray. (However, his intentions notwithstanding, his pictures emanate a dark atmosphere that evokes a contemplative mood and look haunting rather than purist.)

Reinhardt insisted, "Any combining, mixing, adding, adulterating, diluting, exploiting, vulgarizing or popularizing of abstract art deprives art of its essence and truth, and is a corruption of the artist's ar-

31. Ad Reinhardt, "Art-as-Art," *Art International,* December 1962.

681. ALEXANDER CALDER. *The Red Mobile*. 1958.
Painted sheet metal and wire, 27 × 78″

tistic conscience."[32] To him, the worst sinners were the Abstract Expressionists (although he is generally numbered as one), and he castigated them mercilessly. They, of course, reciprocated in kind, and Reinhardt was the butt of ridicule. However, toward the end of the 1950s, a younger generation, inclined to an impassive conceptual art whose forms are predetermined and schematic, geometric and repetitive, assumed his anti-Romanticist, anti-angst stance, as is clear in the following statement by Frank Stella, a germinal artist of the 1960s: "My painting is based on the fact that only what can be seen there *is* there. . . . If the painting were lean enough, accurate enough, or right enough, you would just be able to look at it. All I want anyone to get out of my painting, and all I ever get out of them, is the fact that you can see the whole idea without any confusion. . . . What you see is what you see."[33]

Stella's statement points to the aesthetic that powerfully impressed artists of the 1960s, both abstract and figurative, an aesthetic that rejected all extra-aesthetic interpretations—subjective, psychological, social—and aimed instead at literalness or specificity or factuality (key words in the art talk of the decade). Rather than stressing the personalized process of the making of art, they prized the novel *idea* in art. For example, the central concept of Minimal Art was to create objects that would be seen as objects—for their own sake. The intention was to effect an instantaneous and total comprehension of a work, so that it would be seen all at once and not part by part. Such artists as Donald Judd and Robert Morris favored simple geometric volumes in their sculpture—because they did not look "anthropomorphic," that is, they were not reminiscent of bodily parts and movements—in order to direct attention to the autonomous and literal nature of sculpture, to its irreducible limits as things—indivisible, massive, tactile, and stable.

32. Ad Reinhardt, conversation with the author, "In the Art Galleries," *The New York Post,* August 12, 1962.

33. Bruce Glaser, "Questions to Stella and Judd," *Art News,* 65, September 1966, pp. 55–61.

683

DAVID SMITH.

682. *Auburn Queen*. 1951–52.
Bronze, $87\frac{1}{4} \times 37 \times 18''$

683. *Raven IV*. 1957.
Steel, $29 \times 33 \times 13\frac{1}{2}''$

684. *Animal Weights*. 1957.
Steel, $21 \times 46 \times 7\frac{1}{8}''$

685. *Sentinel II*. 1956–57.
Stainless steel, $70\frac{3}{4} \times 10\frac{3}{4} \times 7\frac{1}{4}''$

686. *Agricola I*. 1951–52.
Painted steel, $73\frac{3}{4} \times 54\frac{3}{4} \times 23\frac{3}{4}''$

682

684

685

686

In a related vein, figurative artists (despite crucial differences among them)—including Pop artists Andy Warhol and Roy Lichtenstein, who duplicated advertisements and comic strips; Photo Realists Malcolm Morley and Richard Estes, who painted copies of photographs; and Philip Pearlstein, who depicted live models as accurately as he could—all avoided interpretation, intending only to render what they could observe. Although they were not influenced by his thinking, their aesthetic seems best summed up by Alain Robbe-Grillet: "But the world is neither meaningful nor absurd. It quite simply *is*. And that, in any case, is what is most remarkable about it. . . . All around us, defying our pack of animistic or domesticating adjectives, things *are there*. Their surface is smooth, clear and intact, without false glamour, without transparency. The whole of our literature has not yet managed even to begin to penetrate them, to alter their slightest curve."[34]

Thus, the Romanticist attitudes underlying Abstract Expressionism were undermined by the conflicting rationales of pure and impure art, which were to provide the intellectual basis of much of the provocative art of the 1960s.

In general, the attitudes of sculptors during the years from 1946 to 1960 were similar to those of painters. However, sculptors tended to be more concerned with Humanism, the tradition of carved and modeled, monolithic, figurative sculpture. A vital question for them was what part of this grand manner, in which man was believed to be at the center of the universe, could be saved in the face of new or modern conceptions of man and space.

A considerable number of sculptors, the most important of whom were Jacques Lipchitz and Henry Moore, tried to extend the tradition

34. Alain Robbe-Grillet, *Snapshots and Towards a New Novel*, London, Calder and Boyars, 1965, p. 53.

687. FRANZ KLINE. *Delaware Gap*. 1958. Oil on canvas, 6′6″ × 8′10″

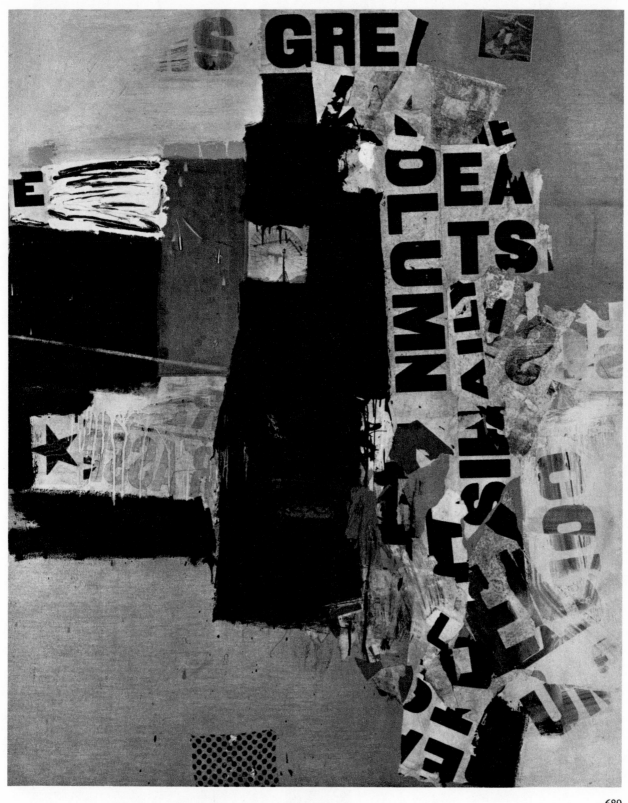

688. AD REINHARDT. *Number 119, 1958 (black)*.
1958–62. Oil on canvas, 84 × 75″

689. ROBERT RAUSCHENBERG. *Dam*. 1959.
Combine painting on canvas, 75½ × 61½″

690. CÉSAR.
Marseille. 1960, cast 1963.
Bronze, 99 × 54 × 25¼″

691. VICTOR VASARELY.
Mizzar. 1956–60.
Oil on canvas, 76⅞ × 44⅞″

692. JULIUS BISSIER.
12. Febr 60 malade. 1960.
Oil on canvas, 6¾ × 8⅛″

691

692

693. JASPER JOHNS. *Flag*. 1960. Bronze relief, $12\frac{3}{8} \times 18\frac{3}{4} \times \frac{1}{4}''$

694. FRANK STELLA. *Arundel Castle*. 1959. Oil on canvas, $10'1'' \times 6'1''$

of the figurative monument by verging toward abstraction and by introducing volumes of space as positive elements, making forms of them. Others, Surrealist in outlook—notably Jean Arp—invented new figures in marble and bronze, biomorphic abstractions spawned in private fantasy worlds. Alberto Giacometti, who early in his career had been a Surrealist, came to envisage man as ravaged by space. In his solitary, attenuated figures he fully embodied the Existentialist vision of man: alone and vulnerable.

As the twentieth century progressed, sculptors increasingly turned away from carving and modeling massive pieces in the belief that working in this vein was outworn. Instead, they took their cues from Cubist collage and relief, and began to construct their sculptures from welded metal, plastics, and other new materials, employing space itself as the primary element. Many even thought of their open constructions in space as *the* art of a new and revolutionary space age.

Most of the artists who theorized in this fashion—among them

694

695. MORRIS LOUIS. *Where*. 1960.
Acrylic on canvas, 7'10" × 11'11½"

696. ROBERT MOTHERWELL. *Black
and White Plus Passion*. 1958.
Oil on canvas, 50 × 80"

Max Bill, Naum Gabo, and Antoine Pevsner—embraced attitudes akin to Mondrian's integrated conception of the arts and society. Indeed, their rigidly polished constructions glorified the rationality of technological civilization, elevating it to an absolute.

Other sculptors of abstract constructions reacted against the impersonality of utopian visions and adopted a Romanticist outlook. David Smith transmuted iron and steel into mechanomythological creatures, often fanciful and witty but fundamentally as hard as the stubborn materials and precise forms that he used. Alexander Calder also preferred strict forms, which he put into motion; his mobiles capture the movement of natural phenomena. Reuben Nakian pieced together vigorously modeled sheets of plaster to create abstract mythological personages. Louise Nevelson assembled room-size enclosures from discarded mill ends, inviting the spectator to enter physically a shadowy realm of her imagination.

Seymour Lipton, Theodore J. Roszak, Richard Stankiewicz, and

Richard Hunt, among other construction sculptors, were related to the gesture painters in that they looked to the improvisational process of working—in their cases, with welded metal—as a major source of images, generally biomorphic and suggestive of the natural processes of germination and growth, decay and death.

Throughout the modern era, sculpture has been secondary to painting—but no longer. Responsible in part for its renewal has been the introduction of an astonishing variety of materials and techniques, opening up rich and challenging possibilities whose development has attracted a significant number of the best of contemporary artists. It is noteworthy that the Hirshhorn Museum has been sensitive to the changed status of three-dimensional art, for the museum's extensive sculpture collection constitutes one of its greatest strengths.

697. MARK ROTHKO. *Number 24*. 1949. Oil on canvas, 88 × 57½″

699

698. JACKSON POLLOCK.
Number 3, 1949. 1949. Oil and
aluminum paint on canvas
mounted on Masonite, $62 \times 37\frac{1}{8}''$

699. WILLEM DE KOONING.
Secretary. 1948. Oil and
charcoal on composition
board, $24\frac{1}{2} \times 36\frac{1}{2}''$

700. ROBERT MOTHERWELL.
Blue Air. 1946. Oil on
cardboard, $41\frac{1}{2} \times 27\frac{7}{8}''$

700

701

484

702

701. JACOB LAWRENCE.
Cabinet Makers. 1946.
Gouache on paper, 22 × 30″

702. BEN SHAHN.
Brothers. 1946.
Tempera on Masonite, 39 × 26″

703. BALTHUS.
The Room. 1947–48.
Oil on canvas, 75 × 63″

704. BALTHUS.
The Golden Days. 1944–46.
Oil on canvas, $58\frac{3}{8} × 78\frac{1}{2}$″

703

704

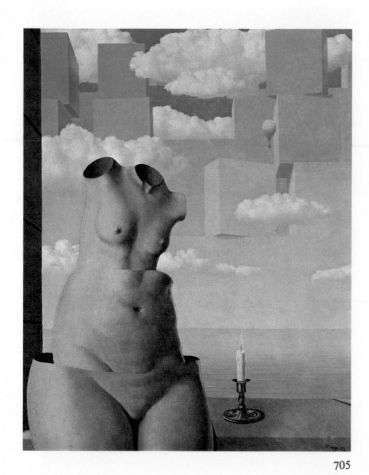

705

705. RENÉ MAGRITTE. *Delusions of Grandeur*.
1948. Oil on canvas, 39 × 32″

706. MARINO MARINI. *Red Horse*. 1952.
Oil on canvas, 39⅜ × 29¼″

707. JACKSON POLLOCK. *Collage and Oil*. 1951.
Collage, oil, and string on board, 41 × 31″

708. BARNETT NEWMAN. *Covenant*. 1949.
Oil on canvas, 48 × 60″

709. AD REINHARDT. *Number 88, 1950 (blue)*.
1950. Oil on canvas, 6′3″ × 12′

707

706

708

709

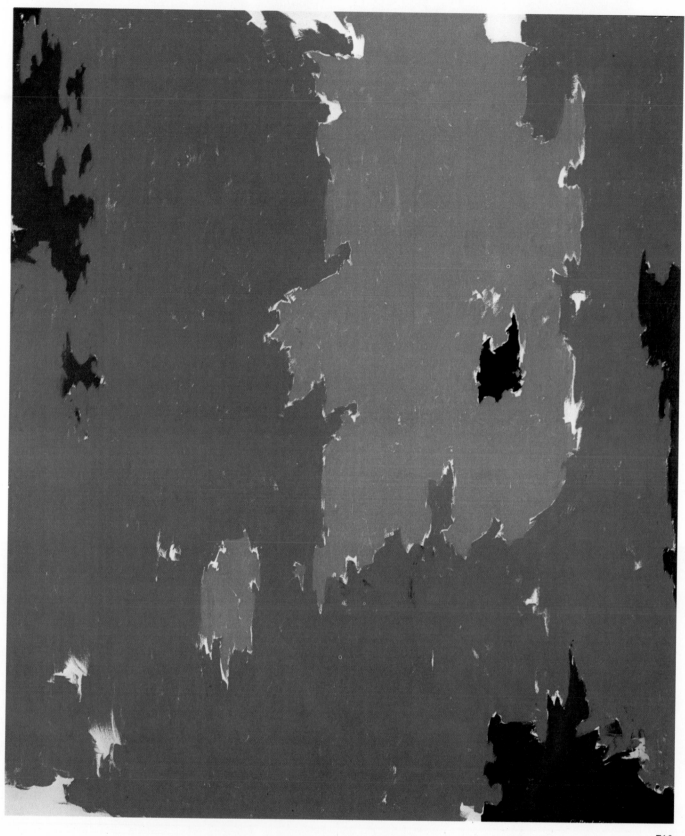

710. CLYFFORD STILL. *1950–A No. 2*. 1950. Oil on canvas, 9'1" × 7'9"

711. FRITZ GLARNER. *Relational Painting Tondo #20*. 1951–54. Oil on Masonite, diameter 47⅜"

712. WOLS. *A Root*. 1949. Pen and ink, and watercolor on paper, 7⅝ × 4¾"

713. MATTA. *Untitled*. c. 1949. Chalk and pastel on paper mounted on canvas, 39½ × 59½"

711

712

713

489

714

71

714. JOHN MARIN.
*Movement: Boat and Sea
in Greys.* 1952.
Oil on canvas, 22 × 28″

715. PAVEL TCHELITCHEW.
Interior Landscape. c. 1949.
Watercolor and gouache
on paper, 20 × 18½″

716. CHARLES BURCHFIELD.
Midsummer Afternoon. 1952.
Watercolor on paper, 40 × 30″

717. EDWARD HOPPER.
First Row Orchestra. 1951.
Oil on canvas, 31 × 40″

718. EDWARD HOPPER.
City Sunlight. 1954.
Oil on canvas, 28 × 40″

716

717

719

721

720

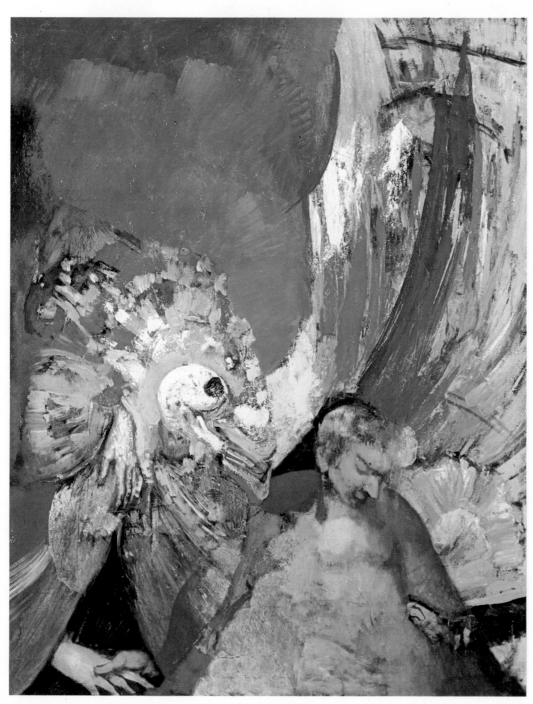

722

719. REGINALD MARSH.
Hudson Burlesk Chorus
(recto).
1948. Egg tempera on
Masonite, 27 × 48″

720. REGINALD MARSH.
Hudson Burlesk Chorus
(verso of plate 719)

721. JACK LEVINE.
Reception in Miami.
1948. Oil on canvas,
50 × 56″

722. HYMAN BLOOM.
Apparition of Danger.
1951. Oil on canvas,
$54\frac{1}{4} \times 43\frac{1}{4}″$

493

723

724

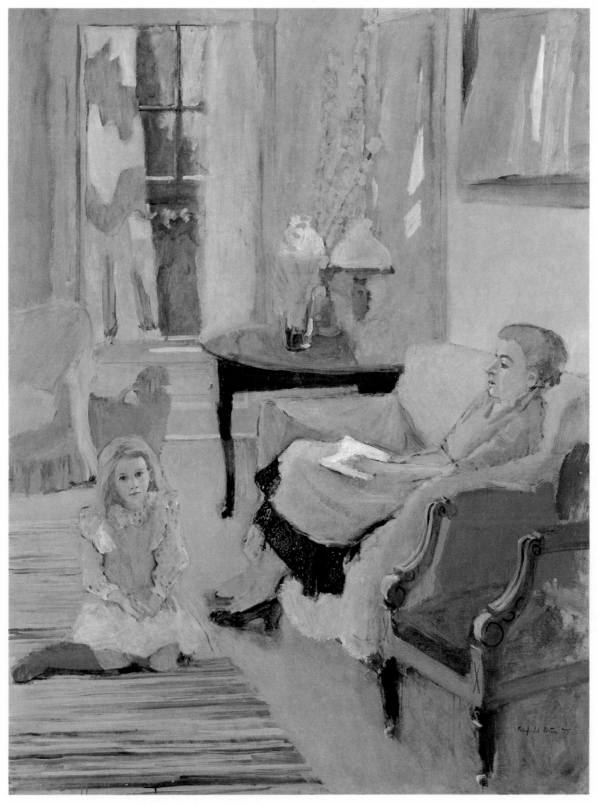

726

723. JAN MÜLLER. *St. George and Walpurgis Night* (recto). 1956.
Oil on wood, reversible triptych, $9\frac{7}{8} \times 23\frac{1}{2}''$

724. JAN MÜLLER. *St. George and Walpurgis Night* (verso of plate 723)

725. MAX BECKMANN. *Still Life with Musical Instruments*. 1950. Oil on canvas, $36 \times 55''$

726. FAIRFIELD PORTER. *Katie and Anne*. 1955. Oil on canvas, $80\frac{1}{4} \times 62\frac{1}{8}''$

727

727. WILLEM DE KOONING. *Two Women in the Country*. 1954. Oil, enamel, and charcoal on canvas, 46 × 41″

728. PABLO PICASSO. *Little Owl*. 1953. Painted bronze, 10¼ × 7 × 5¼″

729. FERNAND LÉGER. *Sunflower*. c. 1954. Glazed ceramic and stone mosaic, 56¾ × 46¾ × 3½″

730. JEAN DUBUFFET. *Landscape with Three Trees*. 1959. White mullein, vine, wild sorrel, spinach, and beet on cardboard, 23½ × 22½″

731. REUBEN NAKIAN. *Europa and the Bull*. 1949–50. Terra-cotta, 26½ × 24¾ × 21″

728

729

730

731

732

732. JOSEPH CORNELL. *Suite de la longitude*. c. 1957. Box construction, $13\frac{1}{8} \times 19\frac{3}{4} \times 4\frac{3}{8}''$

733. MAX ERNST. *Belle of the Night*. 1954. Oil on canvas, $51 \times 35''$

734. JOAN MIRÓ. *Woman and Little Girl in Front of the Sun*. 1946. Oil on canvas, $56\frac{1}{2} \times 44\frac{7}{8}''$

733

735

736

735. WILLIAM BAZIOTES.
Green Night. 1957.
Oil on canvas, 36 × 48″

736. MILTON AVERY.
Sandbar and Boats. 1957.
Oil on canvas, 40 × 50″

737. HANS HOFMANN.
Composition No. III. 1953.
Oil on canvas, 36 × 48″

738. HANS HOFMANN.
Flowering Swamp. 1957.
Oil on wood panel, 48 × 36″

739. HANS HOFMANN.
Oceanic. 1958.
Oil on canvas, $60\frac{1}{4} × 48\frac{1}{4}″$

737

738

739

740

740. CLYFFORD STILL.
Untitled Painting. 1953.
Oil on canvas, 9'2" × 7'8"

741. BRADLEY WALKER TOMLIN.
Number 2. 1952–53.
Oil on canvas, 23 × 32⅛"

742. SAM FRANCIS.
Blue Out of White. 1958.
Oil on canvas, 78 × 90"

741

742

743

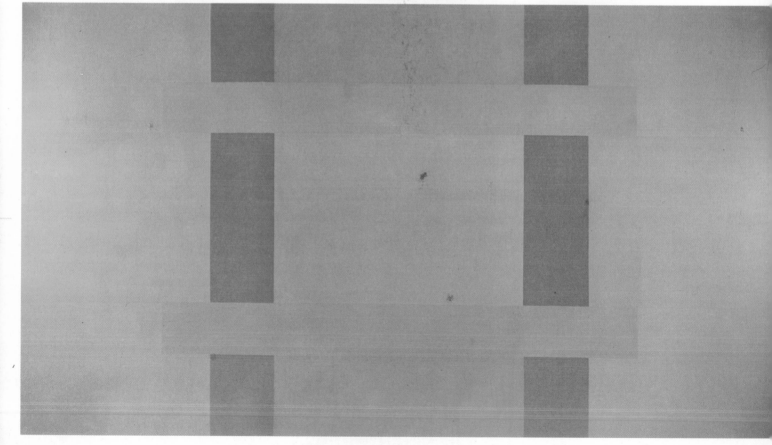

744

743. BURGOYNE DILLER.
No. 2, First Theme. 1955–60.
Oil on canvas, 60 × 48″

744. AD REINHARDT.
Number 90, 1952 (red).
1952. Oil on canvas, 11 × 20′

745. LOREN MACIVER
Skylight Moon. 1958.
Oil on canvas, 50 × 39¾″

746. ALEXANDER CALDER.
Mobile-Stabile. 1950.
Painted sheet metal and
metal rods, 12 × 16′

745

746

747

747. BEN NICHOLSON. *Still Life June 4, 1949* (Diagonal). 1949. Oil on board, $23\frac{3}{4} \times 18\frac{1}{4}''$

748. RAPHAEL SOYER. *Farewell to Lincoln Square* (Pedestrians). 1959. Oil on canvas, $60\frac{1}{4} \times 55''$

749. JEAN ARP. *Human Lunar Spectral* (Torso of a Giant). 1957. Bronze, $45 \times 32 \times 26''$

750. JEAN ARP. *Six White Forms and One Gray Make a Constellation on a Blue Ground.* 1953. Painted wood relief, $28\frac{5}{8} \times 23\frac{3}{8}''$

751. FRANCIS BACON. Study for *Portrait of Van Gogh III.* 1957. Oil on canvas, $78 \times 55\frac{3}{4}''$

748

749

750

751

752. HENRY MOORE.
King and Queen. 1952–53.
Bronze, $63\frac{1}{2} \times 59 \times 37\frac{1}{2}''$

753. PIETRO CONSAGRA.
Little Colloquy. 1955.
Bronze, $29\frac{1}{2} \times 29\frac{3}{4} \times 3''$

754. SALVADOR DALI.
Skull of Zurbarán. 1956.
Oil on canvas, $39\frac{1}{2} \times 39\frac{1}{2}''$

753

754

509

◄ 752

755

755. I. RICE PEREIRA.
Two Becomes One. 1951. Front plane:
mixed media on glass; back plane:
casein on gesso panel, $22\frac{3}{8} \times 18\frac{5}{8}''$

756. PIERRE ALECHINSKY.
Seize the Day. 1958.
Oil on canvas, $6'6\frac{3}{4}'' \times 9'10''$

757. GIACOMO MANZÙ.
Monumental Standing Cardinal. 1958.
Bronze, $12'6\frac{1}{2}'' \times 3' \times 1'10\frac{1}{2}''$

758. ANTOINE PEVSNER.
Column of Peace. 1954.
Bronze, $52 \times 33 \times 17\frac{1}{4}''$

756

757

758

759

759. RICHARD DIEBENKORN. *Man and Woman in Large Room*. 1957. Oil on canvas, 71 × 62½″

760. STUART DAVIS. *Rapt at Rappaport's*. 1952. Oil on canvas, 52⅜ × 40⅜″

761. STUART DAVIS. *Tropes de Teens*. 1956. Oil on canvas, 45 × 60″

760

762

76.

762. ALBERTO GIACOMETTI. *Monumental Head*. 1960.
Bronze, $37\frac{1}{2} \times 12 \times 15''$

763. DONALD HAMILTON FRASER. *Landscape, Sea and Wind*. 1957.
Oil on canvas, $48 \times 36''$

764. PHILIP GUSTON. *Oasis*. 1957.
Oil on canvas, $62 \times 68''$

764

765. MORRIS LOUIS.
Point of Tranquility.
1958. Acrylic on canvas,
$8'5\frac{3}{8}'' \times 11'3''$

517

766

767

766. ZOLTAN KEMENY.
Visualization of the Invisible.
1960. Brass, $6'\frac{1}{2}'' \times 8'10'' \times 11\frac{1}{2}''$

767. MARK TOBEY.
Plains Ceremonial. 1956.
Gouache on paper, $23\frac{1}{4} \times 35\frac{1}{2}''$

768. JULIUS BISSIER.
Tamaro. M 18.3.61. 1961.
Watercolor on paper, $6\frac{5}{8} \times 8\frac{3}{8}''$

769. FRANK STELLA.
Pagosa Springs. 1960. Copper
paint on shaped canvas, $99\frac{1}{4} \times 99\frac{1}{4}''$

768

769

770. KENNETH NOLAND.
Beginning. 1958.
Acrylic on canvas,
90 × 96″

771. CLYFFORD STILL.
1960–R. 1960.
Oil on canvas, 9′ × 7′8″

770

771

1961 to the Present

by Dore Ashton

772. FRANZ KLINE. *Palladio*. 1961. Oil on canvas, 8'8¾" × 6'4¼"

Goethe thought it was "impossible to contemplate an epoch from a standpoint within that epoch." I agree with him. Certainly a handful of years does not represent an epoch. I wonder if it even represents a legitimate point of departure for the practice of art history. The tendency to mark off decades, to analyze them as if there were a possibility of scientific classification, has increased in the twentieth century, but I doubt that it is salubrious. Often the marked interest in defining periods and in classification obscures rather than illuminates the basic character of an epoch. Premature attempts to force works of art to reflect a *Weltbild* impose on art itself unnatural obligations. The late Pierre Francastel was right, I think, in attacking György Lukács's theory of the "echo-role" of the artist. Artists, in such historical schema, become mere "transcribers of messages" and are not free and unpre ictable agents of change.

History, to my mind, is ineffably retrospective. The viewpoint from within a living experience can never be legitimately historical. On the other hand, it is important to put order into one's responses to the events of one's lifetime. But such ordering is a speculative activity. It should never be confused with writing history, and especially not art history. To elicit the full and vivid response, untrammeled by historical theory or compulsive classification, the French have a useful approach: the art critic functions as a "witness" of his time. Everyone

773

774

775

DAVID SMITH.

773. *Voltri V*. 1962. Steel, $85\frac{3}{4} \times 36 \times 25''$

774. *Voltri I*. 1962. Steel, $93 \times 21\frac{1}{4} \times 18\frac{3}{4}''$

775. *Voltri IX*. 1962. Steel, $78\frac{1}{2} \times 32 \times 12''$

776. *Voltri XXI*. 1962. Steel, $51 \times 28 \times 24''$

777. *Voltri XV*. 1962. Steel, $90 \times 77 \times 2\frac{1}{2}''$

776

777

778

7

526

780

781

778. ALBERTO GIACOMETTI.
Annette. 1961. Oil on
canvas, $21\frac{5}{8} \times 18\frac{1}{8}''$

779. ALBERTO GIACOMETTI.
Head of a Man. 1961.
Oil on canvas, $21\frac{5}{8} \times 15\frac{1}{8}''$

780. RAOUL HAGUE.
Sculpture in Walnut. 1962.
Walnut, $33\frac{1}{2} \times 58 \times 33''$

781. JOAN MITCHELL.
Lucky Seven. 1962.
Oil on canvas, $79 \times 74\frac{3}{8}''$

782. CONRAD MARCA-RELLI.
The Picador. 1956. Oil and
canvas collage, $47\frac{1}{4} \times 53''$

783

784

783. REUBEN NAKIAN.
Olympia. 1960–62.
Bronze, $71\frac{1}{2} \times 67 \times 25''$

784. SOREL ETROG.
The Source. 1964.
Bronze, $35\frac{1}{2} \times 79 \times 28\frac{1}{4}''$

785. JOSÉ DE RIVERA.
Construction #76. 1961.
Bronze forged rod, $6\frac{1}{4} \times 9\frac{1}{2} \times 7\frac{3}{4}''$

786. SOREL ETROG.
Mother and Child. 1962–64.
Bronze, $9'4'' \times 3'4\frac{1}{2}'' \times 3'2''$

785

786

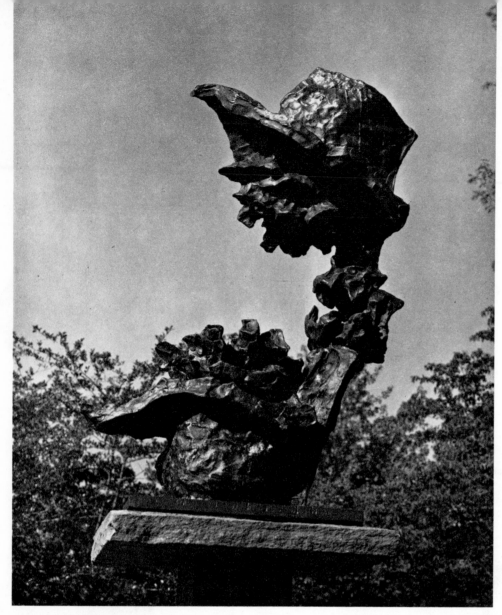

787

787. JEAN-PAUL RIOPELLE.
Don Quixote. 1961.
Bronze, 30 × 22 × 10″

788. HENRY MOORE.
*Three-Piece Reclining
Figure No. 2: Bridge Prop.*
1963. Bronze, 41½ × 99 × 44½″

789. HENRY MOORE.
*Working Model for Standing
Figure: Knife Edge.* 1961.
Bronze, 64 × 25 × 13½″

790. GIACOMO MANZÙ.
Study for *The Opening of the
Ecumenical Council* (Pope John XXI
and Cardinal Rugambwa). 1962.
Bronze relief, 27⅜ × 25½ × ⅞″

791. HENRY MOORE.
*Working Model for Three-Way
Piece No. 2: Archer.* 1964.
Bronze, 31 × 31½ × 21″

788

789

790

791

792

792. MARY BAUERMEISTER.
Pst . . . Who Knows Wh 1966.
Construction of glass, lenses,
drawings, and wooden spheres,
$47 \times 37\frac{1}{4} \times 4''$

793. JEAN DUBUFFET.
Actor in a Ruff. 1961.
Oil on canvas, $45\frac{1}{4} \times 35\frac{1}{8}''$

794. WILLEM DE KOONING.
Untitled. 1963.
Oil on canvas, $80 \times 70''$

793

794

795

795. PABLO SERRANO.
*A Contradictory Duality in
Man Between His Inner Ambit
and His Outer Configuration.* 1964.
Bronze, 52 × 41½ × 43″

796. RAYMOND MASON.
Big Midi Landscape. 1961.
Bronze relief, 41⅛ × 78¾ × 4″

797. PHILLIP PAVIA.
Horsetail. 1961.
Bronze, 73 × 12 × 13″

798. SARAH JACKSON.
Dancer. 1961–62.
Bronze, 94¾ × 62 × 27″

796

797

798

799. ROMARE BEARDEN.
*The Prevalence of Ritual:
Baptism*. 1964. Collage on
composition board, 9 × 12″

800. GEORGE SEGAL.
Bus Riders. 1964. Plaster,
metal, and vinyl, 69 × 40 × 76″

799

knows the psychological shortcomings of witnesses and their frequent inaccuracies, but still they are necessary to society, which must form judgments on the basis of numerous eyewitness accounts. The sympathetic witness is by far the most valuable resource for the subsequent historian.

Any account of the period I have under consideration would have to stress the extreme interest in documentation—in the accumulation of data that are predestined to be entered into historical ledgers. After World War II historicity became a noticeable mania. As a witness, I have been increasingly aware of the insistently historical categories within which the artist has been expected to perform. The imperative for change—a modern necessity, and one of the few supposed characteristics of our epoch I can accept without skepticism—became institutionalized. Commentators have looked back to the origins of the modern era and have found that self-conscious change was implicit in the actions of its artists. The Impressionists, for instance, were articulate

536

800 ▶

801. PABLO SERRANO.
Portrait of Joseph H. Hirshhorn. 1967.
Plaster, $12\frac{1}{4} \times 10\frac{1}{2} \times 12\frac{1}{4}''$

802. MARINO MARINI.
Portrait of Henry Miller. 1961.
Bronze, $11\frac{3}{8} \times 6\frac{1}{4} \times 8\frac{1}{2}''$

803. ELISABETH FRINK.
Fallen Bird Man. 1961.
Bronze, $20 \times 63 \times 34''$

804. ITZHAK DANZIGER.
"The Lord Is My Shepherd" (Negev Sheep).
1964. Bronze, $2'10'' \times 8'8\frac{1}{2}'' \times 6'9\frac{1}{2}''$

802

801

803

804

805

about their need to be wholly different from the artists of the four preceding centuries. Their rejection of Renaissance perspective was programmatic. Contemporary critics, concluding that radical change is the paradigmatic mark of the era, have increasingly limited their activity to the discernment of—and often the propagation of—total change. In such an approach, the artist is conveniently seen best in his "echo-role." The ways in which the artist has accommodated the view that he has an "echo-role" would make a sociological commentary of some significance. What I want to stress here, though, is that the apparent characteristics of the decade I'm discussing, from an absurdly close vantage point, have been determined (prematurely, of course) at least as much by the documentarians as by the artists themselves.

Much of what can be discerned about the 1960s seems contingent upon the prosperity that marked the reorganization of the world after World War II. Europe and the United States—and the countries with which they were allied, such as Japan—had known unprecedented eco-

807

806

805. BOB THOMPSON.
LeRoi Jones and His Family. 1964.
Oil and pastel on canvas, 36 × 48″

806. PAUL SUTTMAN.
Resting. 1965.
Bronze, 65 × 27¼ × 23⅜″

807. LELAND BELL.
Self-Portrait. 1961.
Oil on canvas, 29 × 21½″

541

808

810

809

8

812

808. LOUIS LE BROCQUY. *Willendorf Venus*. 1964.
Oil on canvas, $25\frac{5}{8} \times 19\frac{5}{8}''$

809. CÉSAR. *Venus of Villetaneuse*. 1960.
Bronze, $40\frac{3}{4} \times 10\frac{3}{4} \times 13\frac{1}{2}''$

810. JEAN IPOUSTÉGUY. *The Earth*. 1962.
Bronze, $69\frac{1}{2} \times 25\frac{1}{2} \times 20\frac{1}{4}''$

811. EUGÈNE DODEIGNE. *Pregnant Woman*. 1961.
Belgian limestone, $50 \times 14 \times 14''$

812. JEAN IPOUSTÉGUY. *Man Pushing the Door*
(front view). 1966. Bronze, $77\frac{1}{2} \times 51 \times 46''$

813. JEAN IPOUSTÉGUY. *Man Pushing the Door*
(back view of plate 812)

813

814

815

814. Larry Rivers and his stepson Joseph, at work on the *First New York Film Festival Billboard* (see plate 977) at Lincoln Center for the Performing Arts, New York, 1963

815. The *Billboard*, in progress

816. HAROLD TOVISH. *Interior I*. 1962. Bronze and wood, $30\frac{1}{2} \times 35\frac{3}{4} \times 7''$

817. ERNEST TROVA. *Study: Falling Man* (Carman). 1965. Polished silicone bronze and enamel, $20\frac{1}{4} \times 78 \times 30\frac{3}{4}''$

816

817

818

819

818. POL BURY. *1053 White Dots*. 1964. Motorized construction of nylon wires in wood panel, $54\frac{1}{2} \times 27\frac{1}{8} \times 7''$

819. MARK TOBEY. *White World*. 1969. Oil on canvas, $60 \times 36\frac{1}{4}''$

820. HARRY BERTOIA. *Untitled*. 1965. Stainless steel wires on concrete base, $48 \times 46 \times 40''$

821. LUCAS SAMARAS. *Untitled*. 1962. Wood, cloth, plastic, metal pins, and woolen glove, $13\frac{1}{2} \times 15 \times 10\frac{1}{2}''$

820

821

822. JACK ZAJAC.
Big Skull II. 1964.
Bronze, 30 × 42 × 20″

823. ANDREA CASCELLA.
I Dreamed My Genesis. . . .
1964. Granite,
3′10″ × 9′1″ × 3′

824. ANDREA CASCELLA.
Geronimo. 1964.
Black Belgian marble,
15⅝ × 33⅝ × 14¼″

825. DIMITRI HADZI.
Helmet V. 1959–61.
Bronze, 76¾ × 42½ × 29½″

826. JACK ZAJAC.
Falling Water II. 1965–67.
Bronze, 94 × 29 × 20″

822

823

824

825

826

827

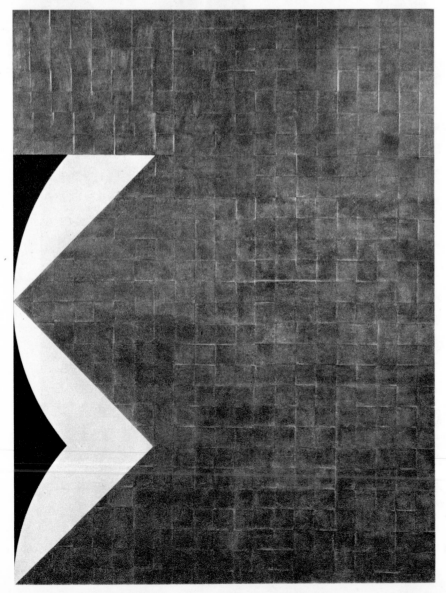

827. YVARAL.
Acceleration No. 18, Series B.
1962. Wood and plastic,
$24\frac{1}{4} \times 23\frac{3}{4} \times 3\frac{1}{8}''$

828. GOTTFRIED HONEGGER.
Tableau-Relief. Z–470.
1963–67. Collage and acrylic
on canvas, $78\frac{1}{2} \times 59''$

829. FRANCISCO SOBRINO.
Unstable Displacement. 1968.
Plexiglas, $37\frac{1}{4} \times 15\frac{7}{8} \times 2\frac{3}{4}''$

830. MAX FINKELSTEIN.
Square Plus 300. 1967.
Aluminum, $36 \times 32 \times 1''$

828

829

830

nomic expansion during the previous decade (a controversial period called by I. F. Stone "the haunted Fifties"), and such prosperity, as always, spilled over into the arts. By the end of the 1950s people spoke about the "culture explosion," by which they usually meant the enormous increase in such international activities as Biennales, transcontinental traveling exhibitions, symposia, and the copious documentation of these activities. Museums, art dealers, collectors, and increasing numbers of aficionados shared with the artists a driving need to establish the contemporary visual arts as epoch-making historical facts. In addition, the greatly increased availability of higher education during the postwar period provided a new class of consumer as well as a new source of practitioner, trained as they had never been before in the academic (usually Aristotelian) system of intellectual inquiry.

This generation, in Europe as well as in America, was generally recognized as consciously opposed to the assumptions that had satisfied

831

832

833

831. AGNES MARTIN. *Play*. 1966.
Acrylic on canvas, 72 × 72″

832. DEBORAH DE MOULPIED. *Palamos*. 1965–67.
Plexiglas, $32\frac{3}{4} \times 47\frac{1}{2} \times 35\frac{1}{4}$″

833. MON LEVINSON. *The Edge I*. 1965.
Front panel: acetate ink on Plexiglas;
back panel: moiré paper, 30 × 30″

834. JOHN CUNNINGHAM, JR. *Rock Candy Mountain*.
1971. Plexiglas, $25\frac{3}{8} \times 16 \times 1\frac{3}{8}$″

834

835

835. RALSTON CRAWFORD. *Torn Signs #2*. 1967–68.
Oil on canvas, 60 × 45″

836. ROBERT MURRAY. *Marker*. 1964–65.
Steel painted white, ·84 × 34¾ × 21″

837. ANTHONY BENJAMIN. *Nimbus V*. 1970.
Chrome and plastic, 24 × 19¾ × 13″

838. ALLAN D'ARCANGELO. *Number One of Road
Series 2*. 1965. Acrylic on canvas, 6′9″ × 8′6″

837

838

839

839. PIETRO CONSAGRA. *Transparent Turquoise Iron*. 1966.
Painted iron, $99\frac{1}{2} \times 65\frac{1}{2} \times 18''$

840. GIÒ POMODORO. *Matrix I*. 1962. Bronze, $62\frac{1}{2} \times 36 \times 28''$

841. ARNALDO POMODORO. *The Traveler's Column*.
1962. Bronze, $99\frac{1}{2} \times 15 \times 15''$

842. ARNALDO POMODORO. *Sphere Number 6*.
1963–65. Bronze, diameter $47\frac{1}{2}''$

843. ARNALDO POMODORO. *Homage to a Cosmonaut*.
1962. Bronze, $62\frac{1}{2} \times 62\frac{1}{2} \times 18''$

840

841

842

843

844

845

844. GEORGE RICKEY. *Summer III*. 1962–63.
Stainless steel kinetic construction, height 13′

845. GEORGE RICKEY. *Three Red Lines*. 1966.
Lacquered stainless steel kinetic construction, height 37′

846. GEORGE RICKEY. *Joe's Silver Vine*. 1964.
Steel and sterling silver kinetic construction, $28\frac{1}{2} \times 11 \times 10''$

847. ALEXANDER CALDER. *Stainless Stealer*. 1966.
Painted stainless steel and aluminum, $10 \times 15 \times 15'$

847

846

the artists of the 1950s. The Abstract Expressionists in the United States, the informalists of Europe, and the corresponding groups in Japan had romanticized their function and emphasized the emotional import of their work. But the decade of 1960s brought to the fore a programmatic interest in what was called objectivity: in facts, in documents, and in information, as opposed to the vagaries of intuition and emotion. Nearly all the so-called movements of the 1960s (so quickly classified by the well-trained Aristotelians) were based on skepticism and irony and a very conscious rejection of the modern myth of the alienated artist. For whatever reasons—jet travel, mass media, and so on—this occurred on an international scale.

Any tendency that becomes pronounced has to be present in the first place. When the documentarians announced a movement they called "Minimalism" they tried to distinguish it from previous reductive modes by describing the attitudes of the artists as "factual," "unromantic," "matter-of-fact," "cool," and "objective." All the same,

850

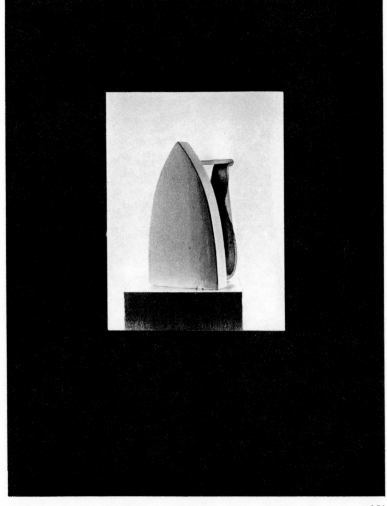

MAN RAY.

848. *Chess Set*. Detail of plate 984

849. *New York 17*. 1966. Bronze replica of 1917 mixed-media object, $17\frac{5}{8} \times 9\frac{3}{8} \times 9\frac{3}{8}''$

850. *Puericulture II: Dream, January 1920*. 1964. Bronze, $11 \times 4\frac{1}{2} \times 4''$

851. *Red Hot Iron*. 1965. Painted steel, $4\frac{1}{4} \times 3\frac{5}{8} \times 6''$; illuminated box, $20 \times 15\frac{7}{8} \times 7''$

849

851

852. CÉSAR. *César's Thumb*. 1967.
Bronze, $34\frac{1}{2} \times 20 \times 14\frac{1}{4}''$

853. MAX ERNST. *Under the Bridges of Paris*. 1961.
Bronze, $58\frac{3}{8} \times 10\frac{5}{8} \times 10\frac{5}{8}''$

854. JOAN MIRÓ. *Lunar Bird*. 1966.
Bronze, $90\frac{1}{8} \times 81\frac{1}{4} \times 59\frac{1}{8}''$

852

853

854

855

855. ARMAN. *To Hell with Paganini*. 1966.
Burned violin in polyester; $29\frac{1}{2} \times 10 \times 3\frac{3}{8}''$

856. RENÉ MAGRITTE. *The Therapeutist*. 1967.
Bronze, $59 \times 51\frac{3}{4} \times 35''$

857. RENÉ MAGRITTE. *Delusions of Grandeur*. 1948.
Oil on canvas, $39 \times 32''$

858. RENÉ MAGRITTE. *Delusions of Grandeur*. 1967.
Bronze, $61\frac{1}{2} \times 48 \times 32\frac{1}{2}''$

856

857

858

859. ANTONIO SEGUÍ. *Fat Luisa in the Bordello.*
1963. Oil and collage on board, 69 × 39″

860. TOMONORI TOYOFUKU. *Water.* 1964.
Wood, $80\frac{1}{2} \times 16 \times 8\frac{1}{2}$″

861. GYÖRGY KEPES. *Amethyst Stain.* 1970.
Oil and sand on canvas, 48 × 48″

859

860

certain of the precursors, still active in the 1960s, were anything but cool. Barnett Newman, who was claimed for the Minimalists because of his interest in the whole color surface, and his vision of a unitarian space, actually functioned as a metaphysician in terms of his attitude toward painting. The same could be said of Ad Reinhardt, who also stepped into prominence during the 1960s partly because of his renunciation of informal details (he produced perfectly square, black paintings exclusively for the last few years of his life) and partly because of his spirited opposition to the canons of his confreres, the Abstract Expressionists. Josef Albers, who like Reinhardt enjoyed new prominence during the 1960s because he had reduced his painting vehicle to the square (but in his case, in order to stress the lyrical and infinite possibilities of color), was also forced to be a precursor, although his attitudes are more nearly consistent with the abstract lyricists of earlier generations. These older members of the painting community provided an artificial base for those who wished to shape movements and to

862

862. LOUISE NEVELSON. *Silent Music IX*. 1964. Wood construction with mirrors, Formica, and Plexiglas, $33\frac{1}{8} \times 30 \times 14''$

863. LOUISE NEVELSON. *Black Wall*. 1964. Wood construction painted black, $64\frac{3}{4} \times 39\frac{1}{2} \times 10\frac{1}{8}''$

864. DAVIDE BORIANI. *Magnetic Surface*. 1962. Magnetized metal and glass (motorized), $40 \times 40 \times 6\frac{3}{4}''$

865. ROBERT INDIANA. *Love*. 1966–67. Aluminum, $12 \times 12 \times 6''$

866. JOSEF ALBERS. *Homage to the Square: Glow*. 1966. Oil on Masonite, $48 \times 48''$

867. ROBERT INDIANA. *The Beware-Danger American Dream #4*. 1963. Oil on canvas, $8'6'' \times 8'6''$

863

864

865

866

867

868

869

870

871

868. CY TWOMBLY. *August Notes from Rome.*
1961. Oil and pencil on canvas, 65 × 79″

869. KENNETH PRICE.
Orange. 1961.
Glazed ceramic on wooden base, $7\frac{1}{2} \times 5\frac{3}{4} \times 5\frac{3}{4}″$

870. KENNETH PRICE.
D. Black. 1961.
Glazed ceramic on wooden base, $9\frac{1}{4} \times 5\frac{1}{4} \times 5\frac{3}{4}″$

871. JOSEPH CORNELL.
The Uncertainty Principle. 1966.
Collage, $7\frac{1}{2} \times 9\frac{1}{2}″$

872. JOSEPH CORNELL.
Sorrows of Young Werther. 1966.
Collage, $8\frac{1}{4} \times 11\frac{1}{4}″$

873. GIANFRANCO BARUCHELLO.
*Unavoidable Difficulties in
the Garden of Eden.* 1964.
Paint on Plexiglas, 18 × 22″

872

873

571

874

875

876

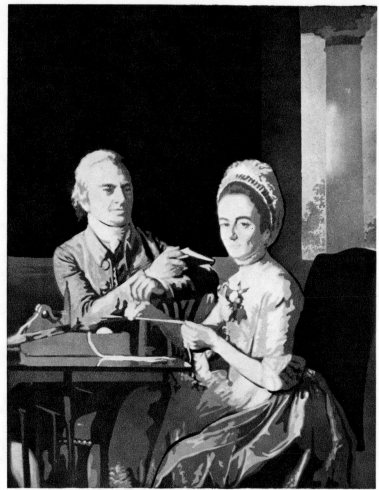

877

874. JAMES MC GARRELL.
Veracity. 1969.
Oil on canvas, $61\frac{1}{8} \times 71''$

875. FERNANDO BOTERO.
Camera degli Sposi II. 1961.
Oil on canvas, $7'7\frac{1}{8}'' \times 8'6\frac{1}{2}''$

876. LARRY RIVERS.
The Greatest Homosexual. 1964.
Oil and collage on canvas, $80\frac{1}{8} \times 61''$

877. JOHN CLEM CLARKE.
*Copley—Governor and
Mrs. Thomas Mifflin*. 1969.
Oil on canvas, $8'8'' \times 6'10''$

878. ANDREW WYETH.
Waiting for McGinley. 1962.
Watercolor on paper, $14\frac{3}{4} \times 21\frac{3}{4}''$

878

879

880

881

882

879. DOMENICK TURTURRO.
Water. 1967.
Oil on canvas, $62\frac{1}{2} \times 72\frac{5}{8}$″

880. REG BUTLER.
Musée Imaginaire. 1963. Thirty-nine
bronze figures in wooden case, $30\frac{1}{2} \times 48\frac{1}{2} \times 5$″

881. CLIVE BARKER.
Spill. 1967.
Chromed steel, $30\frac{3}{8} \times 20\frac{1}{4} \times 3\frac{1}{2}$″

882. PAUL SUTTMAN.
Big Table No. 2. 1968.
Bronze, $32 \times 17 \times 18$″

883. PETER AGOSTINI.
Open Box. 1963.
Plaster, $37\frac{3}{4} \times 28\frac{1}{2} \times 26$″

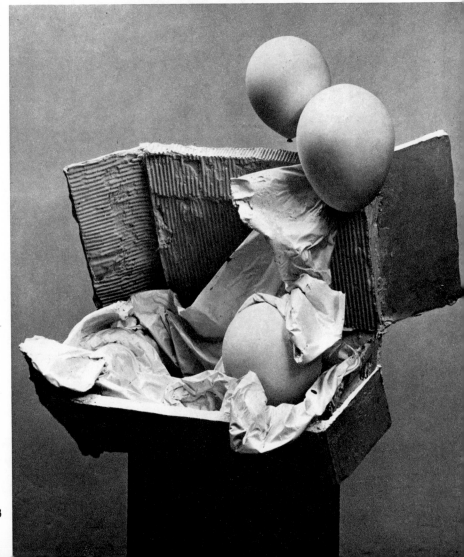

883

884. PETER BLAKE. *Coco Chanel*. 1967.
Acrylic on Masonite, 14 × 11″

885. MEL RAMOS. *Kar Kween*. 1964.
Oil on canvas, 60 × 48″

886. RED GROOMS. *Hollywood*. 1965.
Painted wood, 27¾ × 37 × 15″

884

885

886

classify. A spate of new terms appeared, such as "color-field" painting, used to describe those artists (first among them Newman of course) who worked within circumscribed pictorial limits and refused illusion as nearly as possible. "Hard-edge" painting characterized those works in which unique forms still appeared but were no longer ambiguous in their lineaments as Abstract Expressionist paintings had been. Toward the mid-1960s came "serial" painting and "shaped-canvas" painting. Sometimes, as in the case of Frank Stella, all these terms applied. Sometimes, as in the case of Morris Louis, only one or two were pertinent, but always these painters were grouped—together with others such as Ellsworth Kelly, Kenneth Noland, and Richard Smith—under the Minimalist rubric.

Sculpture too was freighted with new terminology to cover the renewed interest in the quasi-geometrical abstract sculpture that actually had made its appearance long before in the century. The leading American sculptor David Smith was celebrated for his "Cubi" series, in

577

887

888

889

887. COSTANTINO NIVOLA. *Seascape Plaque*. 1963. White terra-cotta relief, $12\frac{1}{2} \times 9\frac{7}{8} \times 3\frac{5}{8}$"

888. MARY FRANK. *Untitled*. 1967. Unglazed terra-cotta, $6\frac{3}{4} \times 9\frac{5}{8} \times 10$"

889. WARREN BRANDT. *The Morning Paper*. 1966. Oil on canvas, 60×70"

890. IRVING BLOCK. *Interior with Candle*. 1963. Oil on canvas, $16\frac{1}{8} \times 20\frac{1}{8}$"

891. JANE WILSON. *January: Tompkins Square*. 1963. Oil on canvas, $59\frac{7}{8} \times 75\frac{5}{8}$"

890

891

892

892. MARK DI SUVERO.
The "A" Train. 1965. Wood and
painted steel, 13' × 11'11" × 9'7"

893. SAUL STEINBERG.
Still Life with Golem. 1965.
Pen, ink, pencil, and collage
on paper, 20 × 30"

894. WILFRID ZOGBAUM.
Bird in 25 Parts. 1962.
Painted steel, 6'10" × 8'6" × 4'8"

893

894

895. LEE BONTECOU. *Untitled*. 1967.
Cloth and wood, $55\frac{1}{2} \times 22\frac{3}{8} \times 22\frac{3}{8}''$

896. DAVID VON SCHLEGELL. *Leda*. 1963.
Cedar, oak, aluminum, and steel, $78 \times 38\frac{1}{2} \times 18''$

895

896

which the rectilinearity seemed to reflect the form will of the time (this despite the fact that Smith had often happened upon rectilinear structures before and had usually worked freely in a variety of modes). The British sculptor Anthony Caro was equally praised for his large welded steel sculptures, in which he frequently used I-beams as the basic unit and in which the reductions to severe profiles seemed "minimal" to his commentators. At the time, there was a strong interest in insisting on the utter novelty of the new sculpture. More recently critics have relaxed a bit and have been willing to see these large steel sculptures as consistent with a steady line of development in twentieth-century sculpture that began with the Russian Constructivists. Others, sculptors of the 1960s such as Donald Judd, emerged with stern forms which they ranged in series, and in which a modular scheme was essential. The prevalence of "fabricated" sculpture, done to specifications in a factory, seemed to emphasize the sharp change in sculptural practices and certainly confirmed the fact that economic prosperity had helped to shape new attitudes.

Another sign of the consuming interest in the factual data of the art object—in the facts of perception itself—during the 1960s was the prominence of works by Victor Vasarely, Yaacov Agam, Richard Anuszkiewicz, Bridget Riley, and Larry Poons, all of whom were categorized under the hastily manufactured term "Op Art." The strongest impetus came from Europe, where the precepts of the Bauhaus had been adapted to modern technological needs. Vasarely's conviction that romanticism, anecdotalism, and all the old associations with painting had to be expunged, and that art had to be apposite in an age of mass production, led him to emphasize the physical properties of color and the inherent dynamics of geometric design. He called his own painting "cinematic" and encouraged scores of younger artists to see their task as the visual activation of their environment. His efforts in painting were paralleled by sculptors in France, particularly Nicholas Schöffer, who used technological inventions to set his forms in motion,

897. RAOUL UBAC. *The Tree: Stele.* 1961. Carved slate on wooden pedestal, $65 \times 38\frac{1}{2} \times 2\frac{1}{4}''$

898. SERGIO DE CAMARGO. *Column.* 1967–68. Marble, $55\frac{3}{4} \times 11 \times 9''$

899. SERGIO STOREL. *Caryatid.* 1964. Hammered copper, $40\frac{1}{2} \times 14 \times 6\frac{1}{4}''$

900. ANTOINE PONCET. *Cororeol.* 1966. Aluminum, $80\frac{1}{4} \times 41 \times 13''$

897

899

900

901

902

901. MASAYUKI NAGARE. *Wind Form*. 1965.
Polished Italian travertine marble, $31\frac{3}{8} \times 10\frac{1}{4} \times 9''$

902. REINHOUD. *Hopscotch*. 1965.
Hammered and brazed brass sheets, $57\frac{3}{4} \times 28 \times 37''$

903. PHILIPPE HIQUILY. *Buccaneer*. 1963.
Sheet metal in five movable parts, $68\frac{1}{2} \times 38 \times 30''$

904. VJENCESLAV RICHTER. *Rasver III*. 1968.
Aluminum, $59\frac{1}{4} \times 14\frac{1}{8} \times 15\frac{5}{8}''$

903

904

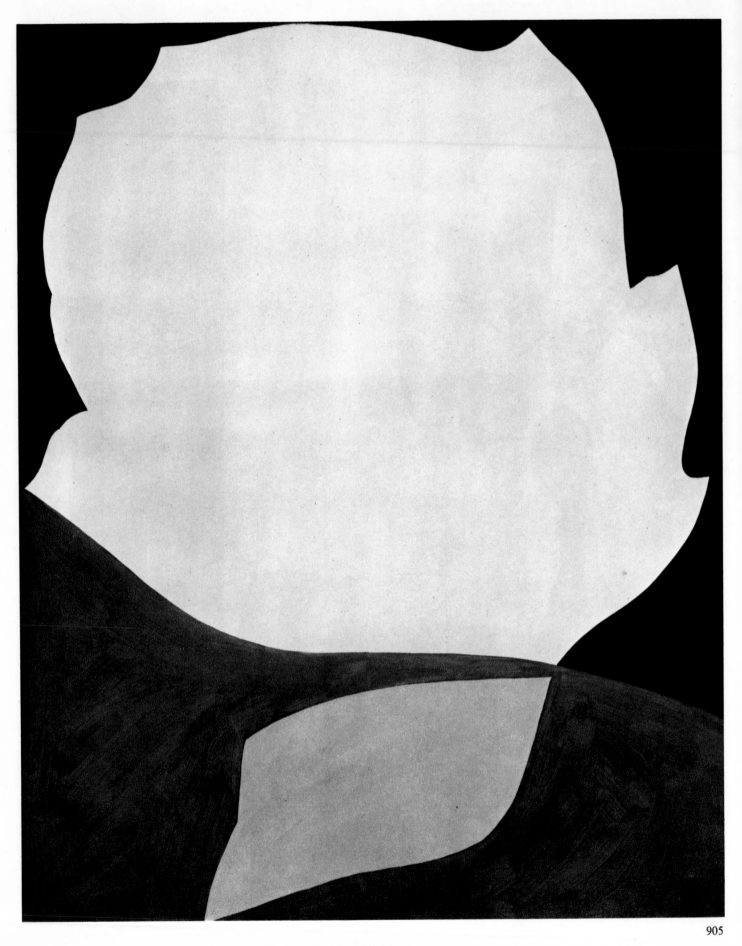

905. JACK YOUNGERMAN. *September White*. 1967. Acrylic on canvas, 9′ × 7′3″

906. TOM WESSELMANN. *Study for First Illuminated Nude*. 1965. Acrylic on canvas, 46 × 43″

906

worked closely with scientists, and was trying to incorporate auditory experiences in his work as well. The rhetoric accompanying the Op works in painting and the kinetic works in sculpture almost always aimed at the desanctification of art. These artists were determinedly opposed to Salon art, art for the bourgeois interior, art for the elite. By insisting on the "objective" value of their works, they hoped to reach into the mass society and accompany its technological revolution.

While they were still deeply committed to art—albeit an enlarged concept of its function—the other desanctifiers who came to be called Pop artists often indicated an impatience with the very idea of art. In the United States there had been a definite rebellion against the romantic idealism of the 1950s, led by such artists as Robert Rauschenberg and Jasper Johns. Both of them incorporated into their paintings actual objects of everyday life, as well as commonplace signs of their urban environment, with the avowed purpose of de-emphasizing the importance of painting. The cultural denigration of painting that was discernible throughout the 1960s, both in Europe and the United States,

907

908

909

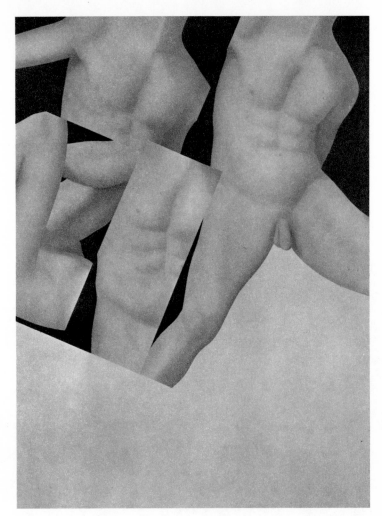

910

907. PHILIP PEARLSTEIN.
*Male and Female Nudes
with Red and Purple Drape.*
1968. Oil on canvas,
$75\frac{1}{4} \times 75\frac{5}{8}''$

908. SIDNEY TILLIM.
Furniture War. 1966.
Oil on canvas, $36 \times 50\frac{1}{4}''$

909. LEONARD BASKIN.
Hephaestus. 1963,
cast 1965. Bronze,
$64\frac{1}{2} \times 27\frac{1}{2} \times 23\frac{1}{2}''$

910. PAUL WALDMAN.
Untitled. 1967. Oil on
Masonite, $48\frac{1}{4} \times 36''$

911. ROBERT GRAHAM.
Girl with Towel. 1968.
Wax, balsa wood, paper,
and Plexiglas, $11 \times 20 \times 20''$

911

912

913

914

912. ISAAC WITKIN.
Vermont IV (Spring).
1965. Stainless steel and iron, $8'9'' \times 6'8\frac{1}{2}'' \times 4'2''$

913. EDUARDO PAOLOZZI. *Basla*. 1967.
Stainless steel, $8'4'' \times 5'2'' \times 1'\frac{1}{4}''$

914. RICHARD SMITH. *Revolval 2 & 3*. 1966.
Acrylic on shaped canvas, two panels,
each $73 \times 37 \times 11''$

915. ILYA BOLOTOWSKY. *Trylon: Blue,
Yellow and Red*. 1967. Polychromed wood,
$94\frac{3}{4} \times 9 \times 9''$

916. ILYA BOLOTOWSKY. *White Diamond*.
1968. Oil on canvas, $48 \times 48''$

593

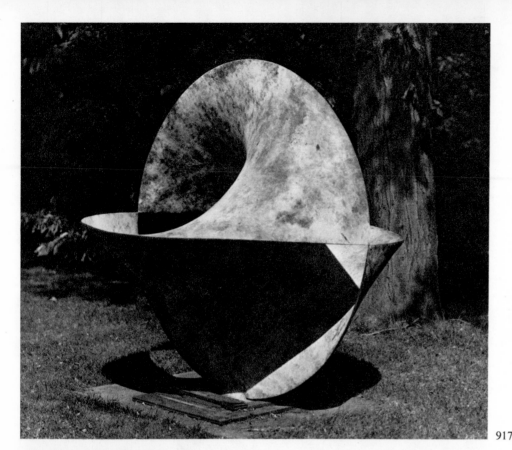

917

917. ROBERT ENGMAN.
Untitled. 1969.
Bronze, $59\frac{1}{2} \times 59\frac{1}{2} \times 59\frac{1}{2}''$

918. NORBERT KRICKE.
Space Sculpture. 1963.
Stainless steel, $58 \times 83 \times 89''$

919. HEINZ MACK. *Relief Stele:*
Lumen et Luxuria. 1967.
Aluminum on wood, $9'10'' \times 1'1\frac{1}{2}'' \times 1\frac{1}{4}''$

918

919

920. ANTHONY CARO. *Rainfall*. 1964. Steel painted green, 48 × 99 × 52″

921. NAUM GABO. *Vertical Construction No. 1*. 1964–65. Brass construction with stainless steel spring wire, 39¼ × 9 × 7″

920

921

was given great impetus by the extreme vitality of the popularizers of Pop Art. The appearance of recognizable imagery, coupled with the imitation of mass-media techniques by the painters, made their work accessible on a broad social scale. The popular news media were delighted to talk about Jim Dine's overcoats and neckties, James Rosenquist's automobiles and hair dryers, and Andy Warhol's multiple images of Marilyn Monroe. In Europe, the confections of Martial Raysse and a whole group of artists called New Realists found similar attention. On the other hand, certain art critics, bestirred by the convulsive social and political events of the 1960s, felt justified in seeking in Pop imagery an antidote to what they called elitism. Since Pop artists tended to imitate the industrial processes—Lichtenstein with his Benday dots and Rosenquist with his billboard techniques—they seemed heralds of a new populist era. They were joined by others, who began to make extensive use of photographic imagery, either in photomontages

922

923

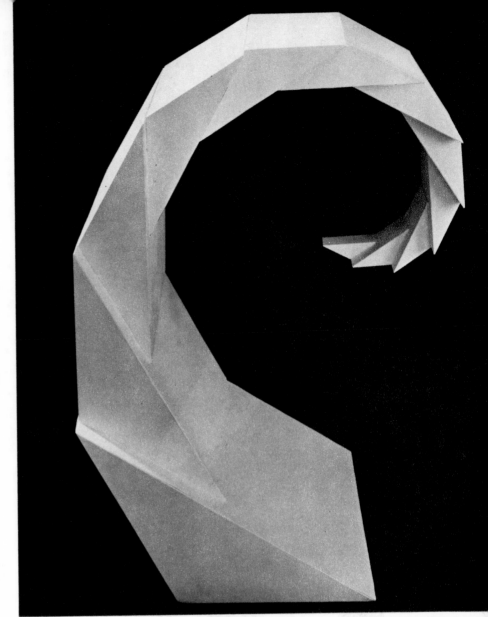

926

922. TIM SCOTT. *Quali I*. 1967.
Painted steel tube and acrylic sheet, 4'10" × 15'1" × 9'1"

923. HARRY SEAGER. *Opus 29*. 1965.
Glass and iron, $23\frac{1}{4} \times 25 \times 25\frac{1}{2}$"

924. MIGUEL BERROCAL. *Caryatid*. 1966.
Bronze, twenty-two separable parts, $14\frac{3}{4} \times 6\frac{1}{2} \times 3\frac{1}{4}$"

925. PAUL WUNDERLICH. *Chair-man*. 1968.
Chromed metal, $53\frac{1}{4} \times 17\frac{3}{4} \times 18$"

926. ROBERT SMITHSON. *Gyrostasis*. 1968.
Painted steel, $73 \times 57 \times 40$"

925

◀ 924

927

928

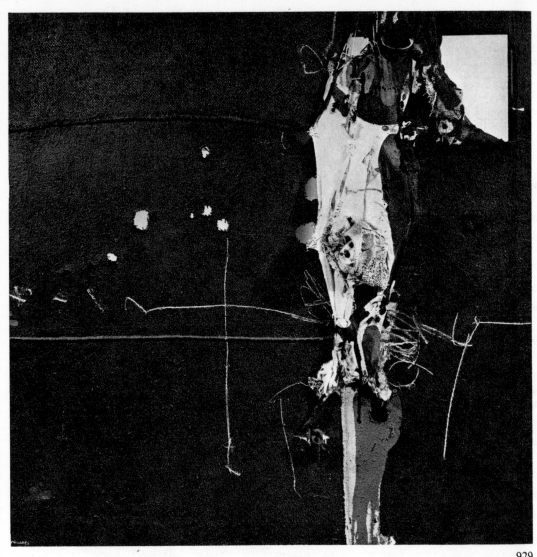

929

927. JUAN GENOVÉS.
The Prisoner. 1968. Acrylic
and oil on canvas, $78\frac{3}{4} \times 59\frac{1}{8}''$

928. JOHN WALKER.
Blackwell. 1967.
Acrylic on canvas, $8'9'' \times 17'$

929. MANOLO MILLARES.
Painting. 1965. Oil and
collage on canvas, $63\frac{3}{4} \times 63\frac{3}{4}''$

930. JOHN CHAMBERLAIN.
Beezer. 1964. Auto lacquer,
metal flake, and chrome on
Masonite, $48\frac{1}{4} \times 48\frac{1}{4} \times 3\frac{1}{2}''$

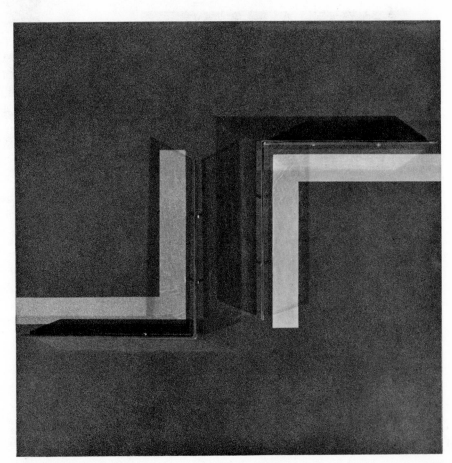

930

931. CHRYSSA. *Study for the Gates #15* (Flock of Morning Birds from "Iphigenia in Aulis" by Euripides). 1967. Black glass neon tubing with timer, $62 \times 35\frac{1}{2} \times 29\frac{3}{8}''$

932. DONALD JUDD. *Untitled*. 1969. Brass and red Plexiglas, ten units, each $6 \times 27 \times 24''$

933. FLETCHER BENTON. *Synchronetic C–637–S*. 1968. Plexiglas, Formica, and steel, with electric circuitry, $28 \times 28 \times 8\frac{1}{8}''$

931

932

933

or in the specific imitation of photographic light and shade. These artists' interests ranged from political commentary, as in the case of Juan Genovés, to cultural spoofing, as is true of Malcolm Morley and John Clem Clarke. Sculptors too were engaged in a desanctification process, among them Arman, whose assembled objects were chosen mainly from the sources of mass production, Eduardo Paolozzi, who was one of the British progenitors of the Pop movement, and César, celebrated for his reductions of real automobiles.

All of these willfully grouped phenomena of the 1960s must be seen as initiatives for change, but they should not be seen as the total art history of the period. No decade can be characterized neatly, for there are always scores of artists, often older artists, whose individuality cannot be accounted for, or whose significance overbridges the temporary categories imposed on them by historians. Strong personalities such as Jean Dubuffet in France, Francis Bacon in England, and at least half a dozen painters in the United States produced works in the

934

935

934. CHARLES GINNEVER.
Untitled. 1968. Cor-Ten
steel, 8'2" × 9'1¼" × 6"

935. PETER FORAKIS.
Double Exeter III
(Mirror Image Series).
1968. Painted cold-rolled
steel, 2'10" × 10'4" × 3'

936. CHARLES MATTOX.
Opposing V's. 1966.
Wood and Fiberglas
construction, electrically
wired, 60½ × 73 × 16½"

937. JACK KRUEGER.
Chuck Around. 1967.
Acrylic and lacquer on
steel tubing, 7'10" × 15' × 2'5"

936

937

938. GASTÓN ORELLANA. *Train in Flames.*
1970. Oil on canvas, three panels,
each 98 × 88″

939. EDWARD RUSCHA. *The Los Angeles
County Museum on Fire.* 1968.
Oil on canvas, 4′6″ × 11′

939

1960s that may be reckoned, finally, as their most significant. Bacon's powerful triptychs, for instance, made a tremendous impact when they were exhibited widely, and even the French, so traditionally indifferent both to Expressionism and British painting, bowed to him in the early 1970s. In the United States, Mark Rothko (before his death in 1970) had completed three cycles of murals within a decade: the first, intended for the Seagram Building in New York but never installed there; the second, for the Holyoke Center at Harvard; the third, for the chapel commissioned by the John de Menil family in Houston. These ensembles of huge paintings, even at the time they were produced, had already assumed an importance that could be called transhistorical. Young artists who had never even seen them, but who had heard reports of Rothko's projects, rallied precisely because Rothko had aspired to a condition of not belonging to the moment. The psychological distancing had already begun, but the classifiers could not find the right category in the formations of the 1960s in which to imprison Rothko.

The same could be said for several other painters of Rothko's

940

941

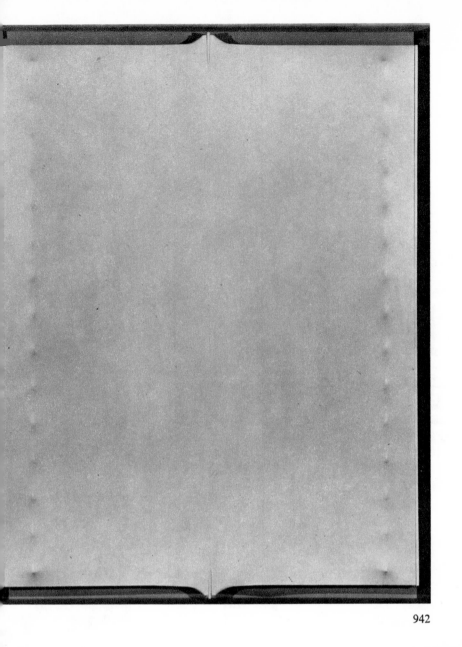

942

940. ROY LICHTENSTEIN.
*Modern Sculpture with
Black Shaft*. 1967. Aluminum
and glass, $81 \times 53\frac{1}{2} \times 18''$

941. GIÒ POMODORO.
Opposition. 1968. Fiberglas
with metallic paint, $6'6\frac{5}{8}'' \times 12'5\frac{1}{2}'' \times 1'5''$

942. ENRICO CASTELLANI.
White Surface 2. 1962. Oil on
shaped canvas, $74 \times 55\frac{1}{2}''$

943. TONY DELAP.
Zingone. 1969. Wood,
Fiberglas, lacquer, and
anodized aluminum, $22\frac{1}{8} \times 22 \times 4\frac{1}{2}''$

943

944

945

944. OLLE BAERTLING. *XYH*. 1967. Steel, 9'11" × 13'8" × 2"

945. DAVID VON SCHLEGELL. *Untitled*. 1969. Stainless steel, 8' × 18'2" × 8'3½"

946. KENNETH SNELSON. *Lorraine* (Crane Booms). 1968.
Painted steel and stainless steel cable, 11'9" × 16'10" × 17'2"

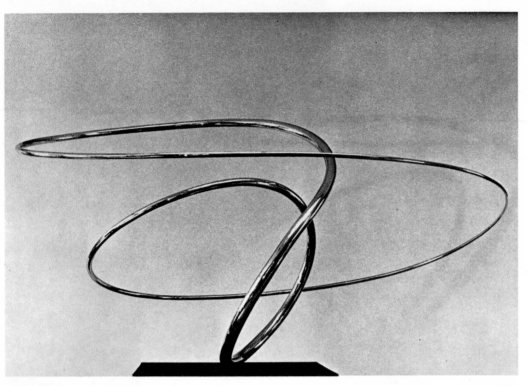

947. JOSÉ DE RIVERA.
Construction #107. 1969.
Stainless steel forged
rod, $21\frac{1}{2} \times 41 \times 41''$

948. ULI POHL.
PX 11/3010. 1959–64.
Plexiglas on steel base,
$27\frac{1}{2} \times 16\frac{5}{8} \times 12''$

949. JULIO LE PARC.
Instability. 1963. Wood,
plastic, and aluminum
mobile, $31\frac{3}{8} \times 31\frac{3}{8} \times 3\frac{7}{8}''$

950. RONNIE LANDFIELD.
Rain Dance III. 1969–70.
Acrylic on canvas, $9' \times 7'8\frac{1}{4}''$

951. PAT ADAMS.
Mortarless. 1965. Acrylic
on canvas, $69 \times 46''$

952. PAT LIPSKY.
Yaqui. 1969. Acrylic
on canvas, $6'8\frac{3}{4}'' \times 9'9\frac{1}{4}''$

947

948

94

950

951

952

generation, including Robert Motherwell, whose paintings of the 1960s also assumed mural proportions, and Philip Guston, whose political allusions in his later works escaped category. Others, such as Mark Tobey and to some extent Willem de Kooning, seemed to move within the modes they had long ago established, but they moved depthward. De Kooning's important modifications of his style were paradoxically subtle and escaped the attention of most commentators. The distinction, presumably, will be seen later.

Among sculptors whose most powerful works were created in the 1960s and early 1970s I can think of Miró and his masterpiece *Lunar Bird* (plate 854); Henry Moore and his monumental bronzes, particularly those of reclining figures rendered in grouped but isolated forms; Louise Nevelson, whose work branched out into towering steel compositions; and younger artists such as Lee Bontecou or Peter Agostini, both of whom work in idioms so personal that they could not justifiably be labeled as specimens of the decade.

No speculative attempt to deal with this period can legitimately ignore the pronounced movement away from painting and sculpture on the part of individuals all over the world who still consider themselves artists. This movement includes those who develop the idea of ephemeral events, such as happenings, and those who have slipped over into a *terrain vague* loosely identified as "Conceptual Art." Conceptualists vary in their expressions of dissatisfaction with orthodox artistic categories, but in general they hold that the art object is obsolete. At the extremes, the Conceptualists content themselves with sending messages, sometimes messages in which the language of the sciences is stressed. In more modified demonstrations of Conceptualist positions the artist appears, performs a "work," and becomes a part of his work in an ephemeral context. In general, the Conceptual artist hovers near the sources of linguistic scientism and expresses yet again the deep suspicion of certain modern artists (a century-old suspicion) that the myths generated by works of art have become impotent. The

953. ROBERT GROSVENOR.
Niaruna. 1965. Painted
aluminum and cables,
3′1″ × 24′7″ × 6′9″

954. BEVERLY PEPPER.
Fallen Sky. 1968.
Stainless steel,
4′10″ × 15′1″ × 8′9½″

957

955. YAACOV AGAM.
Transparent Rhythms II.
1967–68. Oil on aluminum
relief, 9'10⅛" × 13'1½"

956. MENASHE KADISHMAN.
Segments. 1968. Painted
metal and glass, 5' × 14'6" × 1'

957. MENASHE KADISHMAN.
Wave. 1969. Stainless steel
and glass, 5'1" × 10'10½" × 2'11½"

958. MENASHE KADISHMAN.
Open Suspense. 1968. Cor-Ten
steel, 9'8¼" × 7'3" × 1'3"

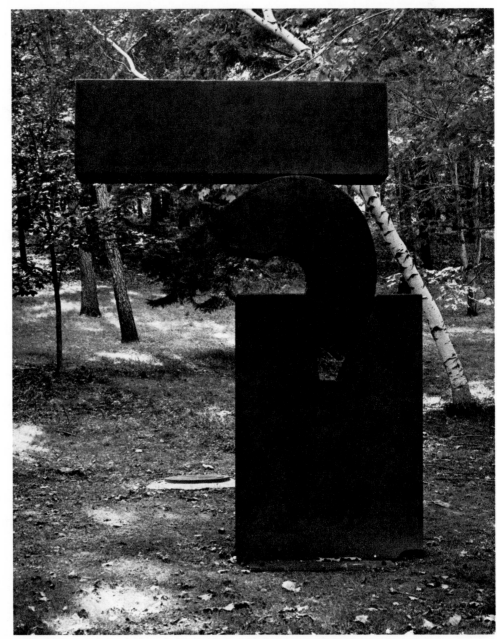

958

existence, throughout the world, of Conceptualists who no longer honor painting or sculpture as the primary expressions of visual sensibilities, and who discuss their work in terms of communication (as opposed to the old romantic idea of communion), undoubtedly reflects a profound cultural change. But an honest witness would have to concede that Conceptualism has not succeeded in displacing the more orthodox conceptions of art. On the contrary, its predominance in international exhibitions provides a false picture statistically. At the very moment when Conceptualism was thrust into the foreground there was an apparent upsurge in conventional painting. Conventional, that is, in that the young artists of the late 1960s and early 1970s seem content with traditional formats and paint on canvas.

Many seemingly looked back a decade, reassessed the informal tendencies, and found themselves comfortable with what they generally refer to as lyrical abstraction. New techniques, such as sprayed surfaces, and new materials have altered the appearance of these canvases, but essentially the artists have retained the freely informal attitudes of the 1950s.

Still more conventional, in a sense, is the new interest in representational painting. Admirers of the painter Philip Pearlstein speak of his originality in terms of his perceptual point of view, but they are quick to point out that Pearlstein's grouped figures are traditional in that they are posed and painted in the studio. This new tolerance for a time-honored painting practice has opened the field to a great many painters of relatively traditional convictions. The extraordinary success in the United States of Richard Estes, whose painstakingly detailed paintings of city scenes reveal a fine academic eye, and of others who unabashedly aim for photographic realism, indicates the degree to which the hunger for traditional painting lingers. Whether the light of history will confirm these artists as significant in their period is problematical. But the profusion of expressions and modes visible between 1961 and 1973 refuses temporary historicizing.

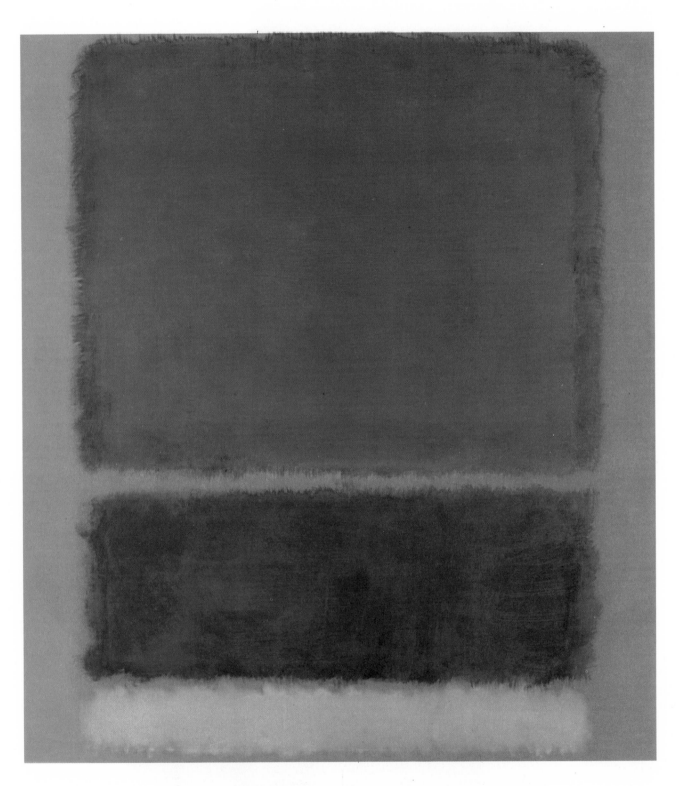

959. MARK ROTHKO. *Blue, Orange, Red*. 1961. Oil on canvas, 90¾ × 81″

960

960. **ALBERTO GIACOMETTI.**
The Studio. 1961.
Oil on canvas, $36\frac{1}{8} \times 28\frac{3}{4}''$

961. **PAUL JENKINS.**
Phenomena Reverse Spell. 1963.
Acrylic on canvas, $6'5'' \times 9'7\frac{3}{4}''$

962. **PETER GOLFINOPOULOS.**
Number 4. 1963.
Oil on canvas, $79\frac{1}{2} \times 84''$

961

962

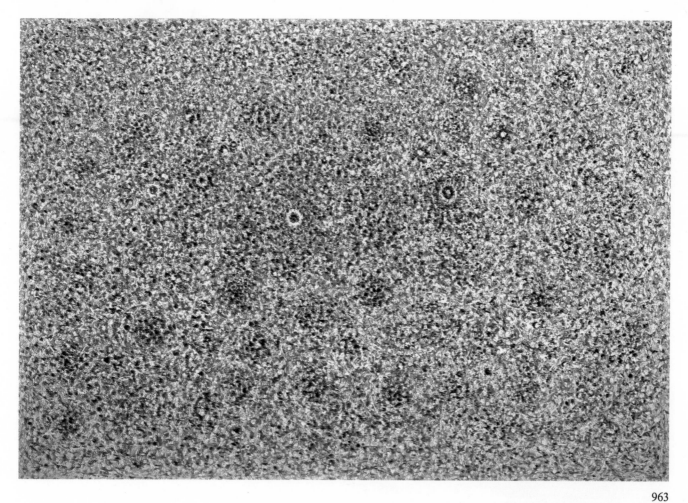

963

963. RICHARD POUSETTE-DART.
Cavernous Earth with 27 Folds of Opaqueness.
1961–64. Oil on canvas, 6′7½″ × 9′7″

964. ANDY WARHOL.
Marilyn Monroe's Lips. 1964.
Acrylic and silkscreen enamel on canvas
(left panel of diptych), 82⅞ × 80¾″

965. ANDY WARHOL.
Marilyn Monroe's Lips.
(Right panel of diptych), 82⅞ × 82⅜″

966. JEAN-PAUL RIOPELLE.
Large Triptych. 1964.
Oil on canvas, 9 × 21′

964

965

966

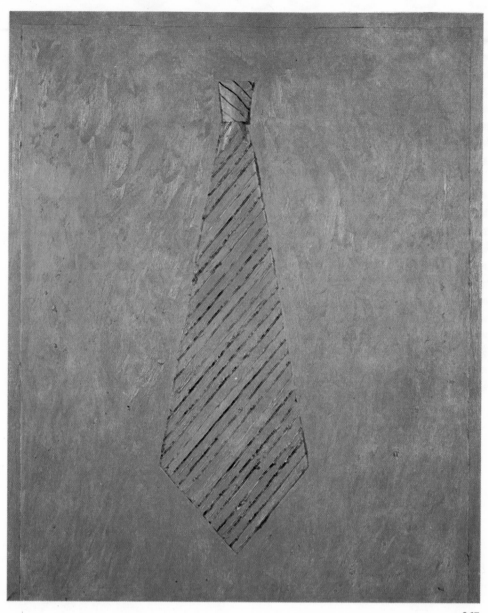

967

967. JIM DINE. *Flesh Striped Tie*. 1961.
Oil and collage on canvas, $60\frac{1}{4} \times 50''$

968. JAMES ROSENQUIST. *The Light That Won't Fail, I*. 1961.
Oil on canvas, $72 \times 96''$

968

969

969. DAVID SMITH. *Cubi XII*. 1963.
Stainless steel, 9'1½" × 4'1" × 2'2"

970. ALEXANDER CALDER. *Two Discs*. 1965.
Painted steel plate, 25'6" × 27'4" × 17'4"

970

971

971. WILLEM DE KOONING. *Woman, Sag Harbor*. 1964.
Oil on wooden door, 80 × 36″

972. JEAN DUBUFFET. *Glass of Water II*. 1966.
Cast polyester resin, 94¼ × 42⅛ × 4″

973. ADOLPH GOTTLIEB. *Two Discs*. 1963.
Oil on canvas, 7′6″ × 9″

972

973

974

975

974. ROMARE BEARDEN.
Watching the Good Train Go By:
Cotton. 1964. Collage on composition
board, 11 × 14″

975. JACK LEVINE.
The Last Waltz. 1962.
Oil on canvas, 78 × 48″

976. RICHARD LINDNER.
New York City IV. 1964.
Oil on canvas, 69¾ × 60″

977. LARRY RIVERS.
Billboard for the First New York
Film Festival. 1963. Oil on
canvas, 9′6″ × 15′

976

977

978

979

978. VICTOR VASARELY.
Arcturus II. 1966.
Oil on canvas,
$63 \times 63''$

979. VICTOR VASARELY.
Orion. 1956–62.
Collage maquette on
wood, $82\frac{1}{2} \times 78\frac{3}{4}''$

980. NICOLAS SCHÖFFER.
Spatiodynamique 17. 1968.
Chromed metal with motor,
$17'6'' \times 7'11\frac{1}{2}'' \times 7'9\frac{1}{4}''$

980 ▶

981

982

632

981. ALEXANDER CALDER.
Effect of Red. 1967.
Painted sheet metal, metal
rods, and wire, $34\frac{1}{2} \times 65''$

982. MAN RAY.
Blue Bred (Pain peint). 1960.
Blue plastic, $3 \times 29''$;
Lucite base, $10\frac{1}{2} \times 36''$

983. ARMAN.
Voyage en France. 1963. Metal
sealers from wine bottles
in polyester, $68\frac{1}{2} \times 48 \times 2\frac{3}{4}''$

984. MAN RAY.
Chess Set. 1962. Thirty-two
pieces: bronze, from $1\frac{3}{4}$ to
$3\frac{1}{2}''$ high; enameled brass on
wood board, $3\frac{7}{8} \times 39 \times 22\frac{1}{2}''$

983

984

633

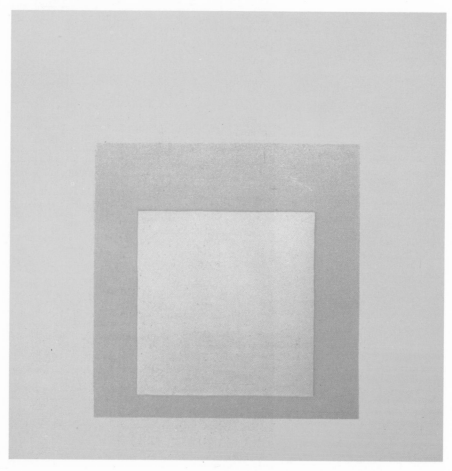

985

985. JOSEF ALBERS. *Homage to the Square: Chosen*. 1966.
Oil on Masonite, 48 × 48"

986. RICHARD ANUSZKIEWICZ. *Sol I*. 1965.
Acrylic on canvas, 84 × 84"

986

987

987. ROBERT RAUSCHENBERG. *Fossil for Bob Morris, N.Y.* 1965.
Combine painting on canvas, $84\frac{7}{8} \times 60\frac{5}{8} \times 10''$

988. JASPER JOHNS. *Numbers 0 to 9*. 1961.
Oil on canvas, $54 \times 41\frac{3}{8}''$

989. JOSEPH CORNELL. *Rapport de Contreras* (Circe). c. 1965. Collage, $8\frac{1}{2} \times 11\frac{1}{2}''$

990. MARTIAL RAYSSE. *Made in Japan*. 1964. Mixed media on canvas, $4'3'' \times 8'9''$

991. WAYNE THIEBAUD. *French Pastries*. 1963. Oil on canvas, $16 \times 24''$

992. MALCOLM MORLEY. *Beach Scene*. 1968. Acrylic on canvas, $9'2'' \times 7'6''$

989

990

991

993.

993. DAVID HOCKNEY.
Cubist (American) Boy with Colourful Tree. 1964.
Acrylic on canvas, $65\frac{3}{4} \times 65\frac{3}{4}''$

994. DAVID LEVINE.
Coney Island Bathing. 1965.
Watercolor on paper, $19 \times 25''$

995. RED GROOMS.
Loft on 26th Street. 1965–66.
Mixed media, $30\frac{1}{4} \times 70 \times 35\frac{1}{4}''$

996. ROBERT BEAUCHAMP.
Yellow Bird. 1968.
Oil on canvas, $5'6\frac{3}{4}'' \times 13'4\frac{3}{4}''$

995

996

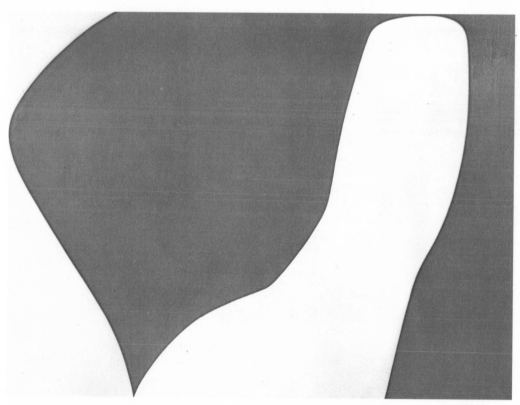

999

997. LARRY POONS. *Via Regia*. 1964. Acrylic on canvas, 6'⅜" × 12'

998. LARRY POONS. *Sicilian Chance*. 1964. Acrylic on canvas, 6' × 12'¼"

999. ELLSWORTH KELLY. *Red White*. 1961. Oil on canvas, 62¾ × 85¼"

1000. HELEN FRANKENTHALER. *Indian Summer*. 1967. Acrylic on canvas, 93½ × 93½"

998

1000

1001

1002

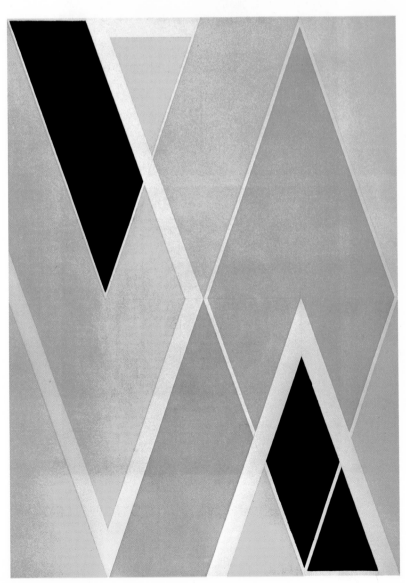

1001. RICHARD SMITH.
Soft Pack. 1963.
Oil on canvas, 8'6" × 5'8"

1002. KENNETH NOLAND.
Bend Sinister. 1964.
Acrylic on canvas, 7'8¾" × 13'5¾"

1003. LARRY ZOX.
Diamond Drill Series—Trobriand. 1967.
Acrylic and epoxy on canvas, 9'4¼" × 6'8"

645

1003

1004. GREGORIO VARDÁNEGA.
Chromatic Variations. 1964.
Wood and plastic box construction
with light and motor, five views,
$31\frac{3}{4} \times 35\frac{1}{8} \times 7\frac{3}{4}''$

1005. JOHN FERREN.
*Construction in Wood: Daylight
Experiment* (Facade). 1968.
Painted wood, $72\frac{1}{2} \times 48 \times 14''$

1006. JESUS RAFAEL SOTO.
Two Volumes in the Virtual. 1968.
Painted metal, Masonite, and wood,
$9'10\frac{1}{2}'' \times 6'6\frac{3}{4}'' \times 6'6\frac{3}{4}''$

1006

1005

1007

1007. FRANCIS BACON.
Triptych. 1967.
Oil and pastel on canvas,
three panels, each 78 × 58″

1008. PAUL WUNDERLICH.
Angel with Forefinger. 1967.
Oil on canvas, $63\frac{3}{4} \times 51\frac{1}{4}''$

1008

1009

1009. GREGORY GILLESPIE.
Exterior Wall with Landscape. 1967.
Mixed media, $38\frac{1}{4} \times 23\frac{3}{4} \times 4''$

1010. FRANK STELLA.
Darabjerd III. 1967.
Fluorescent acrylic on canvas, $10 \times 15'$

1011. ROY LICHTENSTEIN.
Modern Painting with Clef. 1967.
Oil and acrylic on canvas, $8'4'' \times 15'$

1012. DAN CHRISTENSEN.
Grus. 1968.
Acrylic on canvas, $10'10'' \times 8'3''$

1010

1011

1012

1013. LUCIO FONTANA.
Spatial Concept. 1967.
Lacquered wood, four
plaques, each $68\frac{1}{4} \times 28\frac{1}{4}''$

1014. DONALD KAUFMAN.
Plink II. 1968.
Acrylic on canvas,
$5'8\frac{1}{4}'' \times 8'9''$

1015. WILLIAM PETTET.
Slip Rent. 1969.
Acrylic on canvas,
$7'4'' \times 16'11''$

1013

652

1014

1015

1016

1016. JOHN SEERY. *Wind and Bone Eclipse*. 1970. Acrylic on canvas, 8'10¼" × 6'10¾"

1017. CARLO BATTAGLIA. *Libra*. 1969. Oil and tempera on canvas, 9'10¼" × 4'3⅛"

1018. JULES OLITSKI. *Bad Bugaloo*. 1968. Acrylic on canvas, 3'7¼" × 9'9¼"

1017

1018

655

1019. NICHOLAS KRUSHENICK. *Measure of Red.* 1971.
Acrylic on canvas, 90 × 70″

Catalogue

The catalogue provides selective documentation of the works of art included in this volume.

Dimensions are given in inches, with height preceding width, and, in the case of sculpture, depth.

Four traveling exhibitions of works from the collections are abbreviated in the catalogue entries.

Their full itineraries were:

The National Gallery of Canada, Ottawa, *Some American Paintings from the Collection of Joseph H. Hirshhorn,* January 10–31, 1957; toured to Montreal Museum of Fine Arts, March 20–31; Art Gallery of Toronto, April 12–May 26; Stratford Arena, Ontario, July 1–August 31; The Winnipeg Art Gallery, Manitoba, October 6–November 3.

American Federation of Arts tour, 1959–60, *Ten Modern Masters of American Art: 30 Works Selected from The Joseph H. Hirshhorn Collection;* toured to Coe College, Cedar Rapids, Iowa, January 1–21, 1959; Quincy Art Club, Illinois, February 2–22; Des Moines Art Center, Iowa, March 6–26; E. B. Crocker Gallery, Sacramento, California, April 8–28; Nashville Artists' Guild, Tennessee, May 10–30; Roanoke Fine Arts Center, Virginia, June 15–July 15; Time, Inc., New York, July 28–August 17; Columbia Museum of Art, South Carolina, September 1–21; Joslyn Art Museum, Omaha, Nebraska, October 5–25; William Rockhill Nelson Gallery of Art, Kansas City, Missouri, November 4–24; Fort Lauderdale Art Center, Florida, December 7–27; John Herron Art Institute, Indianapolis, Indiana, January 10–30, 1960.

The Detroit Institute of Arts, *Sculpture in Our Time: Collected by Joseph H. Hirshhorn,* May 5–August 23, 1959; toured to Milwaukee Art Center, September 10–October 11; Walker Art Center, Minneapolis, October 25–December 6; William Rockhill Nelson Gallery of Art, Kansas City, Missouri, December 20–January 31, 1960; The Museum of Fine Arts, Houston, March 1–27; Los Angeles County Museum of History, Science and Art, April 11–May 15; M. H. de Young Memorial Museum, San Francisco, May 29–July 10; Colorado Springs Fine Arts Center, Colorado, July 24–September 4; Art Gallery of Toronto, September 30–October 31.

American Federation of Arts tour, 1962–65, *Paintings from the Joseph H. Hirshhorn Foundation Collection: A View of the Protean Century;* toured to M. Knoedler & Co., New York, October 31–November 24, 1962; Currier Gallery of Art, Manchester, New Hampshire, December 16–January 12, 1963; Carnegie Institute, Pittsburgh, January 30–February 26; Evansville Museum of Arts and Science, Indiana, March 16–April 12; Munson-Williams-Proctor Institute, Utica, New York, April 30–May 27; J. B. Speed Art Museum, Louisville, Kentucky, June 13–July 10; The Minneapolis Institute of Arts, July 30–August 25; Seattle Art Museum, September 11–October 8; San Francisco Museum of Art, September 26–November 23; Colorado Springs Fine Arts Center, Colorado, December 11–January 7, 1964; Dallas Museum of Fine Arts, January 26–February 23; Oklahoma Art Center, Oklahoma City, March 12–April 8; Brooks Memorial Art Gallery, Memphis, April 25–May 23; Atlanta Art Association, Georgia, June 10–July 7; Saginaw Art Museum, Michigan, July 25–August 22; Montreal Museum of Fine Arts, September 8–October 6; Allentown Art Museum, Pennsylvania, October 24–November 21; Museum of Fine Arts, Boston, December 9–January 10, 1965; The Brooklyn Museum, New York, February 8–April 5.

PAT ADAMS (b. 1928)

Patricia Adams, born Stockton, California, July 8, 1928. Studied: University of California, Berkeley, 1945–49; School of The Art Institute of Chicago, 1949; The Brooklyn Museum Art School, New York, with Max Beckmann, John Ferren, and Reuben Tam, 1950–51. First one-man show, Haggin Art Gallery, Stockton, 1950. Lived in Florence, 1951–52. Received: Yaddo Fellowship, Saratoga Springs, New York, summers, 1954, 1964, 1969, 1970; Fulbright Grant, to France, 1956–57; MacDowell Colony Fellowship, Peterborough, New Hampshire, 1968. Included in: Whitney Annual, 1956, 1961; "The New Landscape in Art and Science," American Federation of Arts, Circulating Exhibition, 1958–59. One-man shows: Zabriskie Gallery, New York, from 1956; Kanegis Gallery, Boston, 1959; Wheaton College, Norton, Massachusetts, 1959; Windham College, Putney, Vermont, 1967. Guest lecturer, Yale University, New Haven, Connecticut, 1972. Included in "Women Choose Women," The New York Cultural Center, 1973. Has lived and taught at Bennington College, Vermont, since 1964.

Mortarless. 1965.
Acrylic on canvas, 69 × 46 inches
Signed and dated on back: "Pat Adams/1965"

PROVENANCE:
Zabriskie Gallery, New York, 1965

EXHIBITIONS:
Zabriskie Gallery, New York, November 23–Decembe, 11, 1965, *Pat Adams,* cat.
Windham College, Putney, Vermont, April 16–30, 1967r *Pat Adams, Paintings,* cover ill.

YAACOV AGAM (b. 1928)

Yaacov Gipstein, born Rishon le Zion, Palestine, May 11, 1928. Studied: Bezalel Academy of Arts and Design, Jerusalem, 1947–48; with Johannes Itten, and Siegfried Giedion, Zurich, 1950–51. Settled in Paris, 1951. One-man shows: Galerie Craven, Paris, 1953; Galerie Denise René, Paris, 1956, 1958; Tel-Aviv Museum, Israel, 1958; Galerie Suzanne Bollag, Zurich, 1959, 1962. Included in: Salon des Réalités Nouvelles, Paris, 1954–56; "Mouvement I," Galerie Denise René, 1955; Pittsburgh International, 1958, 1961, 1964, 1972; I^e Biennale de Paris,

1959; "Bewogen Beweging," Stedelijk Museum, Amsterdam, and tour, 1961; VII São Paulo Bienal, 1963 (International Prize for Artistic Research); "Art Israel," The Museum of Modern Art, New York, 1964; "The Responsive Eye," The Museum of Modern Art, and tour, 1965–66; "Plus by Minus: Today's Half-Century," Albright-Knox Art Gallery, Buffalo, New York, 1968. Designed multiple-scene theater, IX^e Festival des Nuits de Bourgogne, Dijon, France, 1962. Commissions: *Jacob's Ladder,* National Convention Center, Jerusalem, 1965; *3 × 3 Interplay,* The Juilliard School, Lincoln Center for the Performing Arts, New York, 1971; *Wake Fire Fountain,* City of St. Louis, Missouri, 1971. One-man shows: Marlborough-Gerson Gallery, New York, 1966; Galerie Denise René, New York, 1971; Musée National d'Art Moderne, Paris, 1972. Lives in Paris.

Transparent Rhythms II. 1967–68.
Oil on aluminum relief, 9 feet 10½ inches × 13 feet 1½ inches

PROVENANCE:
The artist, Paris, 1968

EXHIBITIONS:
National Gallery of Art, Washington, D.C., February 17–March 17, 1968, *Painting in France, 1900–1967* (sponsored by the International Exhibitions Foundation), no. 45, ill. p. 108; toured to The Metropolitan Museum of Art, New York, April 1–May 5; Museum of Fine Arts, Boston, May 18–June 23; The Art Institute of Chicago, July 13–August 18; Musée d'Art Contemporain, Montreal, September 14–October 20; The Detroit Institute of Arts, November 18–December 29
Musée National d'Art Moderne, Paris, October 6–December 4, 1972, *Yaacov Agam,* checklist

REFERENCES:
Colten, Joel G. *Great Ages of Man: Twentieth Century,* New York, Time-Life Books, 1968, colorplate pp. 156–57
Gautier, Blaise. "Peinture en France," *Art International,* 12, February 1968, ill. p. 62
Leymarie, Jean, et al. *Agam,* Paris, Centre National d'Art Contemporain, and Musée National d'Art Moderne, 1972, front and back endpapers
Stevens, Elizabeth. "Sixty-Seven Years of French Painting," *Arts,* 42, April 1968, pp. 33, 35, colorplate p. 33

Unsigned. "Hélas pour la Grandeur," *Time,* 91, April 12, 1968, p. 76, colorplate p. 77

PETER AGOSTINI (b. 1913)

Born New York, February 13, 1913. Studied, Leonardo da Vinci Art School, New York, 1935–36. One-man shows, New York: Galerie Grimaud, 1959; Stephen Radich Gallery, 1960, 1962–64, 1966. Received Longview Foundation Grant, 1960–62. Included in: "Aspects de la Sculpture Américaine," Galerie Claude Bernard, Paris, 1960; 65th American Exhibition, The Art Institute of Chicago, 1962; "Sculpture in the Open Air," Battersea Park, London, 1963; "Sculptors of Our Time," Washington [D.C.] Gallery of Modern Art, 1963; VII São Paulo Bienal, 1963; "Recent American Sculpture," The Jewish Museum, New York, 1964; New York State Pavilion, New York World's Fair, Flushing Meadows, 1964; Whitney Annual, 1964, 1966, 1968, 1970; "American Sculpture of the Sixties," Los Angeles County Museum of Art, and Philadelphia Museum of Art, 1967; Guggenheim International, 1967–68. Taught, Columbia University, New York, 1961–66. Received: Brandeis University Creative Arts Award Citation, 1964; Guggenheim Foundation Fellowship, 1966; National Council on the Arts Grant, 1968. One-man shows: University of North Carolina at Greensboro, 1969; Zabriskie Gallery, New York, 1971. Has taught, University of North Carolina at Greensboro, since 1966. Lives in Greensboro, and in New York.

Open Box. 1963.
Plaster, 37½ × 28½ × 26 inches

PROVENANCE:
Stephen Radich Gallery, New York, 1963

EXHIBITIONS:
Stephen Radich Gallery, New York, April 3–May 18, 1963, *Peter Agostini*

REFERENCES:
Roberts, Colette. "Lettre de New York," *Aujourd'hui, Art et Architecture,* 8, October 1963, p. 201, ill. p. 200
Rose, Barbara. "New York Letter," *Art International,* 7, May 25, 1963, p. 57, ill. p. 55
Sandler, Irving. "Agostini: High Speed Plaster," *Art News,* 62, Summer 1963, ill. p. 29

JOSEF ALBERS (b. 1888)

Born Bottrop, Westphalia, Germany, March 19, 1888. Teacher's certificate, Lehrerseminar, Büren, Westphalia, 1908. Taught, elementary school, Bottrop, 1908–13, 1916–19. Studied, Germany: Kunstakademie, Berlin, 1913–15; Kunstgewerbeschule, Essen, 1916–19; Bauhaus, Weimar, 1920–23. Taught, Bauhaus: Weimar, 1923–25; Dessau, 1925–32; Berlin, 1932–33. Included in Bauhaus group exhibition, with Lyonel Feininger, Wassily Kandinsky, Paul Klee, and Oskar Schlemmer, Kunsthalle, Basel, 1929. Member, Association Abstraction-Création, Paris, 1933–46. Emigrated to the U.S., 1933; citizen, 1939. Taught: Black Mountain College, North Carolina, 1933–49; Yale University, New Haven, Connecticut, 1950–60. One-man shows: J. B. Neumann's New Art Circle, New York, 1936, 1938, 1945; The Artists' Gallery, New York, 1938; San Francisco Museum of Art, 1939–40, 1953, 1964; The Baltimore Museum of Art, 1942; Egan Gallery, New York, 1946, 1949; Memphis Academy of Arts, Tennessee, 1947; Sidney Janis Gallery, New York, 1949, 1952, 1955, 1958, 1959, 1961, 1963, 1964, 1968, 1970; The Museum of Modern Art, New York, International Circulating Exhibition, 1964–67; Kestner-Gesellschaft, Hanover, 1968; Kunsthalle, Hamburg, 1970. Member, Abstract American Artists, New York, since 1938. Mural commissions: Harvard University Graduate Center, Cambridge, Massachusetts, 1950; Corning Glass Building, New York, 1958; Time & Life Building, New York, 1961; Pan American World Airways Building, New York, 1963. Retrospectives: Yale University Art Gallery, 1956; Stedelijk Museum, Amsterdam, 1961; Städtische Kunsthalle, Düsseldorf, 1970; The Art Museum, Princeton University, New Jersey, 1971; The Metropolitan Museum of Art, New York, 1971. Received: Ford Foundation Fellowship, 1959; Graham Foundation Fellowship, 1962. Honorary Doctor of Fine Arts, Yale University, 1962. Sculpture commissions: Art and Architecture Building, Yale University, 1964; Science Building, Rochester Institute of Technology, New York, 1967; Landesmuseum für Kunst und Kulturgeschichte, Münster, Germany, 1971. Awarded: American Institute of Graphic Arts Medal, 1964; Grosses Verdienstkreuz, Federal Republic of Germany, 1968. Member, The National Institute of Arts and Letters, 1968. Benjamin Franklin Fellow, Royal Society of Arts, London, 1970. Received Distinguished Teaching of Art Award, College Art Association of America, 1973. Books include: *Poems and Drawings* (New York, Wittenborn), 1961; *Interaction of Color* (New Haven, Yale), 1963; *Search Versus Re-Search . . .* (Hartford, Connecticut, Trinity), 1969. Lives in Orange, Connecticut.

Untitled Glass Assemblage. 1921.
Light box, wood, glass, and wire, 23 × 21¾ × 7¼ inches
Signed and dated twice l. r.: "Albers/1921"

PROVENANCE:
The artist, Orange, Connecticut, 1968

EXHIBITIONS:
Addison Gallery of American Art, Phillips Academy, Andover, Massachusetts, April 10–May 8, 1938, *Bauhaus: How It Worked* (The Museum of Modern Art, New York, Circulating Exhibition), cat.; toured to nine U.S. cities

"In 1921, at the Bauhaus in Weimar, after having absorbed the obligatory Introductory Course, I applied for the study of glass painting.
The glass workshop, then without students, had just been closed. Thus, the conference of the Bauhaus masters accepted me in the workshop on wall painting, arguing that glass painting was a branch of wall painting.
Disagreeing with this—to me wall painting deals with color as reflected light, but glass painting with color as direct light—I decided to study on my own, as a freelance apprentice. And then, with the worst inflation possible—a postage stamp for a letter cost several billion German Marks—no artists' materials or tools were obtainable. Thus, with knapsack and hammer I went to the dumping grounds and broke glass bottles in order to find glass shards of all colors possible.
Then, at my studio, I ordered and juxtaposed such shards to related size, shape, [and] color, and arrived at various groupings, assemblages, or compositions.
Such results I mounted (beginning as a dilettante) on tin sheets or wire screens. At the end of the semester, when every student had to exhibit his work, I hung my trials close together (independent of any workshop) at the window of a stairwell, expecting that this would be my swan song at the Bauhaus.
Instead, the conference of the masters informed me that I could continue my studies at the Bauhaus, and soon asked me to install a new glass workshop.
The glass assemblage here on exhibit is one of my very first trials toward some glass pictures. It was shown a second time seventeen years later, at the first Bauhaus exhibition at The Museum of Modern Art in New York in 1938, thirty-four years ago."

Statement by the artist, 1972

Fugue II. 1925.
Sandblasted and painted glass, 6⅛ × 22⅜ inches
Signed and dated on back: "Albers 1925"

PROVENANCE:
Sidney Janis Gallery, New York, 1968

Six and Three. 1931.
Gouache on paper, 20⅛ × 10¼ inches
Signed and dated l. r.: "Albers 31"

PROVENANCE:
Robert Elkon Gallery, New York, 1964

Proto-Form B (Protean Form B). 1938.
Oil on Masonite, 28 × 24 inches
Signed and dated with monogram l. r.: "A 38"

PROVENANCE:
J. B. Neumann's New Art Circle, New York; Bertha Schaefer Gallery, New York, 1945; Parke-Bernet Galleries, New York, Sale 2211, October 9, 1963, no. 90

EXHIBITIONS:
The Artists' Gallery, New York, December 6–31, 1938, *Josef Albers*, no. 11
San Francisco Museum of Art, December 1939–January 1940, *Josef Albers*
Galerie Herrmann, Stuttgart, July–August 1948, *Josef Albers, Hans Arp, Max Bill*, cat., ill.

Bent Black. 1940.
Oil on Masonite, 26 × 19⅛ inches
Signed and dated on back: "Albers, 1940"

PROVENANCE:
G. David Thompson, Pittsburgh; Galerie Semiha Huber, Zurich, 1963

EXHIBITIONS:
University of North Carolina at Chapel Hill, November 2–29, 1941, *Annual Exhibition of North Carolina Artists;* toured to Wilmington Museum of Art, North Carolina; Woman's College of the University of North Carolina, Greensboro; Raleigh Art Center, North Carolina
Kunstmuseum der Stadt, Düsseldorf, December 14, 1960–January 29, 1961, *Sammlung G. David Thompson,* no. 3; toured to Gemeentemuseum, The Hague, February 17–April 9; The Solomon R. Guggenheim Museum, New York, May–August; Museo Civico di Torino, October–November

Vice Versa B. 1943.
Oil on Masonite, 13¾ × 28⅛ inches
Signed and dated l. r.: "A 43"

PROVENANCE:
Sidney Janis Gallery, New York, 1968

EXHIBITIONS:
Memphis Academy of Arts, Tennessee, January 15–28, 1947, *Twenty-Five Paintings by Josef Albers,* no. 2
California Palace of the Legion of Honor, San Francisco, September 1947, *Josef Albers*
Cincinnati Art Museum, Ohio, October 1949, *Albers,* no. 12
Allen R. Hite Art Institute, University of Louisville, Kentucky, April 17–May 27, 1950, *Josef Albers,* cat.

REFERENCES:
Gomringer, Eugen. *Josef Albers: His Work as a Contribution to Visual Articulation in the Twentieth Century,* New York, Wittenborn, 1968, no. 110, ill. p. 110
Spies, Werner. *Albers,* New York, Abrams, 1970, p. 68, ill. p. 34

Homage to the Square: Chosen. 1966.
Oil on Masonite, 48 × 48 inches
Signed l. r.: "A 66"

PROVENANCE:
Galerie Denise René, Paris, 1967

EXHIBITIONS:
Sidney Janis Gallery, New York, October 5–31, 1970, *Paintings by Josef Albers*
The Art Museum, Princeton University, New Jersey, January 5–25, 1971, *Albers: Paintings and Graphics, 1917–1970,* no. 33
Royal Dublin Society, Ireland, October 24–December 29, 1971, *ROSC '71: An International Art Exhibition,* no. 4, ill. p. 206

Homage to the Square: Glow. 1966.
Oil on Masonite, 48 × 48 inches
Signed and dated l. r.: "A 66"

PROVENANCE:
Galerie Denise René, Paris, 1967

EXHIBITIONS:
Sidney Janis Gallery, New York, October 5–31, 1970, *Paintings by Josef Albers*
Royal Dublin Society, Ireland, October 24–December 29, 1971, *ROSC '71: An International Art Exhibition,* no. 3, ill. p. 23

PIERRE ALECHINSKY (b. 1927)

Born Brussels, October 19, 1927. Studied typography and book illustration, Institut National Supérieur d'Architecture et des Arts Visuels, Brussels, 1944–48. First one-man show, Galerie Lou Cosyn, Brussels, 1947. Member, La Jeune Peinture Belge; exhibited with group, Palais des Beaux-Arts, Brussels, 1947, 1950. Participated in "Les Mains Éblouies," Galerie Maeght, Paris, 1948, 1950. Member of CoBrA, 1949–51; included in CoBrA exhibitions: Stedelijk Museum, Amsterdam, 1949; Galerie Geert van Bruaene, Brussels, 1950; Musée des Beaux-Arts de la Ville de Liège, Belgium, 1951. Received: Hélène Jacquet Painting Prize, La Louvière, Belgium, 1950; Bourse d'Étude du Gouvernement Français, to study etching, Paris, 1951. Studied engraving, S. W. Hayter's Atelier 17, Paris, 1952. One-man shows: Galerie Apollo, Brussels, 1953; Galerie Nina Dausset, Paris, 1954; Palais des Beaux-Arts, Brussels, 1955. Traveled to Far East; made film, *Calligraphie japonnaise,* Tokyo and Kyoto, 1955. Included in: Pittsburgh International, 1952–70; I and V São Paulo Bienal, 1953, 1959; "European Art Today," The Minneapolis Institute of Arts, and tour, 1959–60; Venice Biennale, 1960; Fifth International Hallmark Art Award, Wildenstein & Co., New York, 1960 (first prize); Documenta III, Kassel, 1964; ROSC '67, Dublin, 1967. Exhibited with Reinhoud, Stedelijk Museum, and tour, 1961. One-man shows: Galerie van de Loo, Munich, 1961; Carnegie Institute, Pittsburgh, 1961; Galerie de France, Paris, 1962; Lefebre Gallery, New York, from 1962; Stedelijk van Abbemuseum, Eindhoven, The Netherlands, 1963; The Arts Club of Chicago, and tour, 1965; The Museum of Fine Arts, Houston, 1967. Illustrated *Le Tout venant* (Paris, Galerie de France), 1967; wrote *Roue libre* (Geneva, Skira), 1971. Retrospective, Palais des Beaux-Arts, Brussels, and tour, 1969. One-man show, Venice Biennale, 1972. Lives in Bougival, France.

Seize the Day (Prendre Jour). 1958.
Oil on canvas, 6 feet 6⅜ inches × 9 feet 10 inches
Signed and dated l. r.: "Alechinsky VII 1958"

PROVENANCE:
Jon N. Streep, New York, 1964

EXHIBITIONS:
The Minneapolis Institute of Arts, September 23–October 25, 1959, *European Art Today,* no. 4; toured to Los Angeles County Museum of Art, November 11–December 20; San Francisco Museum of Art, January 6–February 8, 1960; North Carolina Museum of Art, Raleigh, February 28–April 3; The National Gallery of Canada, Ottawa, April 20–May 24; French & Company, New York, June 7–August 13; The Baltimore Museum of Art, September 18–October 16
The Arts Club of Chicago, February 26–March 27, 1965, *Pierre Alechinsky,* no. 1; toured to University of Minnesota, Minneapolis, April 7–May 4; The Jewish Museum, New York, May 15–June 15

REFERENCES:
Putnam, Jacques. *Alechinsky.* Milan, Fratelli Fabbri, 1967, ill. 45

CHRISTOPHE-GABRIEL ALLEGRAIN (1710–1795)

Born Paris, October 8, 1710; son of landscape painter Gabriel Allegrain (1679–1748). Married sister of sculptor Jean-Baptiste Pigalle, 1733. Académie Royale de Peinture et de Sculpture, Paris: academician, 1751; professor, 1759; director, 1783. Patrons included Madame de Pompadour and Madame Du Barry. Died Paris, October 8, 1795. Included in "France in the Eighteenth Century," Royal Academy of Arts, London, 1968.

Venus Entering the Bath (Venus Entrant au Bain). After 1767.
Bronze, 31½ × 10¼ × 11¾ inches
Markings: l. top of base "Allegrain"
r. front of base "A^te Lemaire"

PROVENANCE:
Private collection, London; Bernard Black Gallery, New York; Parke-Bernet Galleries, New York, Sale 2932, November 14, 1969, no. 135, ill.

REFERENCES:
Bernard Black Gallery, New York, *Apollo,* 89, May 1969, ill. p. ciii (adv.)

This bronze version of *Venus Entering the Bath* is a reduction of the life-size marble commissioned by Madame Du Barry for the Château de Louvecienne, situated outside of Paris. The marble (now, Musée du Louvre) was executed in 1766 and exhibited at the Salon of 1767, where it was highly praised by Denis Diderot.

THOMAS ANSHUTZ (1851–1912)

Thomas Pollock Anshutz, born Newport, Kentucky, October 5, 1851. Studied: National Academy of Design, New York, 1871–75; with Thomas Eakins, Philadelphia Sketch Club, 1875–76, and The Pennsylvania Academy of the Fine Arts, Philadelphia, 1876–81; Académie Julian, Paris, with William-Adolphe Bouguereau and Henri-Lucien Doucet, 1892–93. Worked with Eadweard Muybridge and Eakins on their photographic experiments, University of Pennsylvania, Philadelphia, early 1880s. Taught, Pennsylvania Academy, 1881–91, 1893–1912, initially as Eakins's assistant, then head of faculty, 1909–12; his students included A. Stirling Calder, Arthur B. Carles, Charles Demuth, William Glackens, Robert Henri, John Marin, Everett Shinn, John Sloan, and Henry O. Tanner. Co-founded Darby School of Painting, Darby (later Fort Washington), Pennsylvania, with Hugh Breckenridge, 1898. Awarded: Silver Medal, St. Louis International Exposition, Missouri, 1904; Gold Medal of Honor, and Lippincott Prize, Pennsylvania Academy, 1909; Gold Medal, Buenos Aires International Exposition, 1911. Included in: Pennsylvania Academy Annual, 1894–1912; City Art Museum of St. Louis Annual, 1906–12; Panama-Pacific International Exposition, San Francisco, 1915. Associate, National Academy of Design, 1910. Died Fort Washington, June 16, 1912. Memorial exhibition, Philadelphia Art Alliance, 1912. Retrospectives: James Graham and Sons, New York, 1963; Pennsylvania Academy, 1973.

Portrait of a Girl in a White Dress. c. 1905.
Oil on canvas, 64¼ × 40 inches
Signed l. r.: "Thos. Anshutz"

PROVENANCE:
Estate of the artist; James Graham and Sons, New York, 1963

EXHIBITIONS:
The Pennsylvania Academy of the Fine Arts, Philadelphia, January 22–March 3, 1906, *One Hundred and First Annual Exhibition,* no. 343
James Graham and Sons, New York, February 19–March 16, 1963, *Thomas Anshutz: A Retrospective Exhibition,* no. 44

REFERENCES:
Bowman, Ruth. *Thomas Pollock Anshutz: 1851–1912,* M.A. thesis, New York University, 1971, pp. 43, 44, ill. 56

RICHARD ANUSZKIEWICZ (b. 1930)

Richard J. Anuszkiewicz, born Erie, Pennsylvania, May 23, 1930. Studied: Cleveland Institute of Art, B.F.A., 1953; Yale University, New Haven, Connecticut, with Josef Albers, M.F.A., 1955; Kent State University, Ohio, B.S.Ed., 1956. Received Pulitzer Traveling Scholarship, National Academy of Design, 1953. One-man shows: Butler Institute of American Art, Youngstown, Ohio, 1955; The Contemporaries, New York, 1960, 1961, 1963. Traveled to Europe, and North Africa, 1958. Included in: "Geometric Abstraction in America," Whitney Museum of American Art, New York, 1962; "Americans 1963," The Museum of Modern Art, New York, 1963; "Formalists," Washington [D.C.] Gallery of Modern Art, 1963; Whitney Annual, 1963–72; Pittsburgh International, 1964, 1967, 1970; "The Responsive Eye," The Museum of Modern Art, and tour, 1965–66; "Plus by Minus: Today's Half-Century," Albright-Knox Art Gallery, Buffalo, New York, 1968; Documenta 4, Kassel, 1968. One-man shows: Sidney Janis Gallery, New York,

from 1965; The Cleveland Museum of Art, 1966; Hopkins Art Center, Dartmouth College, Hanover, New Hampshire (while artist-in-residence), 1967. Visiting artist, Cornell University, Ithaca, New York, 1968. One-man shows: The J. L. Hudson Gallery, Detroit, 1968, 1971; DeCordova and Dana Museum and Park, Lincoln, Massachusetts, 1972. Lives in Frenchtown, New Jersey.

Sol I. 1965.
Acrylic on canvas, 84 × 84 inches

PROVENANCE:
Sidney Janis Gallery, New York; Carnegie Institute, Pittsburgh, 1967

EXHIBITIONS:
Sidney Janis Gallery, New York, November 3–27, 1965, *New Paintings by Anuszkiewicz*, no. 32
Whitney Museum of American Art, New York, December 8, 1965–January 30, 1966, *1965 Annual Exhibition of Contemporary American Painting*, no. 3, ill.
Carnegie Institute, Pittsburgh, October 27, 1967–January 7, 1968, *1967 Pittsburgh International Exhibition of Contemporary Painting and Sculpture*, no. 242.

REFERENCES:
Hruby, Frank. "Pittsburgh Show Displays The Latest Works In Art," *Cleveland Press*, November 4, 1967
Lunde, Karl. *Richard Anuszkiewicz*, New York, Abrams, forthcoming, ill.

KAREL APPEL (b. 1921)

Born Amsterdam, April 25, 1921. Studied, Rijksakademie van Beeldende Kunsten, Amsterdam, 1940–43. First one-man show, Beerenhuis, Groningen, The Netherlands, 1946. Co-founded CoBrA, with Corneille (Cornélis van Beverloo), Asger Jörn, and Christian Dotremont, 1948; included in CoBrA exhibitions: Stedelijk Museum, Amsterdam, 1949; Librairie 73, Paris, 1950; Galerie Pierre, Paris, 1951; Musée des Beaux-Arts de la Ville de Liège, Belgium, 1951. Included in: Salon de Mai, Paris, 1949–57; Pittsburgh International, 1952–67; I and V São Paulo Bienal, 1953, 1959 (Painting Prize); Venice Biennale, 1954; "Younger European Painters," The Solomon R. Guggenheim Museum, New York, 1954; "The New Decade," The Museum of Modern Art, New York, 1955; Documenta II and III, Kassel, 1959, 1964; "New Images of Man," The Museum of Modern Art, and The Baltimore Museum of Art, 1959–60; Guggenheim International Award, 1960; ROSC '67, Dublin, 1967. Moved to Paris, 1950. Mural commissions: auditorium foyer, and garden hall, Stedelijk Museum, 1951, 1956; UNESCO Building, Paris, 1958; Congress House, The Hague, 1967. One-man shows: Palais des Beaux-Arts, Brussels, 1953; Galerie Paul Facchetti, Paris, 1954; Martha Jackson Gallery, New York, from 1954; Gimpel Fils, London, 1959–62; Gimpel & Hanover Galerie, Zurich, and tour, 1963–64; Centre National d'Art Contemporain, Paris (sculpture), 1968; Centraal Museum der Gemeente, Utrecht, The Netherlands, 1970; Galleria Schubert, Milan, 1971. Retrospectives: West Coast tour, organized by Pasadena Art Museum, California, and Esther-Robles Gallery, Los Angeles, 1961–62; Stedelijk Museum, 1965; Gemeentemuseum, The Hague, 1969; Musée d'Art Contemporain, Montreal, and tour, 1972–73. Lives near Auxerre, France, and in New York.

Beach Life. 1958.
Oil on canvas, 63¾ × 51 inches
Signed and dated l. r.: "Appel '58"

PROVENANCE:
Gimpel Fils, London, 1959

EXHIBITIONS:
San Francisco Museum of Art, June 23–July 23, 1961, *Karel Appel: West Coast Exhibition*, no. 12; toured to Pasadena Art Museum, California, August; Phoenix Art Museum, Arizona, November; Santa Barbara Museum of Art, California, December; Seattle Art Museum, Washington, January 1962; La Jolla Museum of Art, California, February

ALEXANDER ARCHIPENKO (1887–1964)

Born Kiev, Russia, May 30, 1887. Studied, Kiev Art School, 1902–5. Lived in Moscow, 1906–8. Worked in sculpture studio, Paris, with Amedeo Modigliani, and Henri Gaudier-Brzeska, 1908. Exhibited, Paris: Salon de la Société des Artistes Indépendants, 1910–14; Salon d'Automne, 1911–13, 1919; Salon de "La Section d'Or," Galerie La Boétie, 1912–14. Exhibited with Henri Le Fauconnier, Museum Folkwang, Hagen, Germany, 1912. One-man show, Galerie der Sturm, Berlin, 1913. Included in: the Armory Show, 1913; Erster Deutscher Herbstsalon, Galerie der Sturm, 1913; Cubist exhibition, Mánes Society, Prague, 1914. Lived in Nice, 1914–18; moved to Germany, 1918. One-man shows: Venice Biennale, 1920; Kunsthaus, Zurich, 1920; Société Anonyme, New York, 1921. Retrospective, Galerie der Sturm, 1921. Directed his own art school, Berlin, 1921–23. Emigrated to the U.S., 1923; citizen, 1928. Founded: art school, New York, 1923; summer school, Woodstock, New York, 1924. One-man show, The Anderson Galleries, New York, 1928. Taught: Mills College, Oakland, California, summer, 1933; Chouinard School of Art, Los Angeles, 1933; University of Washington, Seattle, summers, 1935–36; The New Bauhaus, Chicago, 1937. Included in "Cubism and Abstract Art," The Museum of Modern Art, New York, 1936. Works in German museums confiscated by Nazis and included in "Entartete Kunst (Degenerate Art)," Munich, and tour, 1937. One-man shows: Nierendorf Gallery, New York, 1944; Associated American Artists Galleries, New York, 1948, 1954; Museu de Arte Moderna de São Paulo, 1952; Kunsthalle, Darmstadt, Germany, and tour, 1955–56; Perls Galleries, New York, 1957, 1959, 1962. Retrospectives: Städtisches Karl-Ernst-Osthaus-Museum, Hagen, 1960; Palazzo Barberini, Rome, and tour (organized by the Ente Premi Roma), 1963–64. Member, The American Academy of Arts and Letters, 1962. Died New York, February 25, 1964. Retrospectives: The Art Galleries, University of California at Los Angeles, and tour, 1967–69; National Collection of

Fine Arts, Smithsonian Institution, Washington, D.C., and international tour, 1968–69.

Sorrow (La Tristesse). 1909.
Painted wood, 9½ × 2¼ × 1¾ inches

PROVENANCE:
The artist, Paris, 1921; Mme Jean G. Verdier, Cannes, 1966

EXHIBITIONS:
Museum Folkwang, Hagen, Germany, December 1912, *Le Fauconnier, Alexander Archipenko*

Head: Construction with Crossing Planes. 1913, reconstructed c. 1950, cast 1957.
Bronze, 15 × 11½ × 11 inches
Markings: 1. top of base "Archipenko 1913 2/6"

PROVENANCE:
Perls Galleries, New York; Ernst Anspach, New York; Perls Galleries, 1965

EXHIBITIONS:
Perls Galleries, New York, September 29–October 24, 1959, *Alexander Archipenko Bronzes*, no. 7, ill.

REFERENCES:
Giedion-Welcker, Carola. *Contemporary Sculpture: An Evolution in Volume and Space*, 3rd rev. ed., New York, Wittenborn, 1960, p. 84, ill.
Raynor, Vivien. "4,000 Paintings and 1,500 Sculptures," *The New York Times Magazine*, November 27, 1966, ill. p. 55

The *Head: Construction with Crossing Planes* was originally executed in wood and plaster as a study for a large painted wood relief, *Woman in Front of a Mirror*, 1914 (now destroyed). Archipenko reconstructed the original work c. 1950, and the bronze was cast in 1957.

Gondolier, 1914, reconstructed c. 1950, enlarged and cast 1957.
Bronze, 64 × 26 × 16 inches
Markings: front r. top of base "Archipenko
1914 2/6"
rear l. l. base "Modern Art Foundry
New York, N.Y."

PROVENANCE:
Perls Galleries, New York, 1964

EXHIBITIONS:
Perls Galleries, New York, September 29–October 24, 1959, *Alexander Archipenko Bronzes*, no. 8, ill.
The Baltimore Museum of Art, October 6–November 15, 1964, *1914: An Exhibition of Paintings, Drawings and Sculpture*, no. 2

Gondolier, originally conceived as a wood construction, was one of the most celebrated works at the Salon de la Société des Artistes Indépendants of 1914. This bronze version was enlarged and cast in 1957 from a reconstruction made by Archipenko c. 1950.

Flat Torso. 1915.
Marble on alabaster base, 18½ × 4½ × 4½ inches
Markings: back of base at bottom "Archipenko"

PROVENANCE:
Galerie des Arts Anciens et Modernes, Schaan, Liechtenstein; Sotheby and Co., London, Sale, December 11, 1957, no. 67; Marlborough Fine Art, London, 1958

EXHIBITIONS:
Marlborough Fine Art, London, Summer 1958, *Nineteenth and Twentieth Century European Masters*, no. 81, ill. p. 106
The Detroit Institute of Arts, 1959, *Sculpture in Our Time*, no. 40, ill. p. 24
The Solomon R. Guggenheim Museum, New York, October 3, 1962–January 6, 1963, *Modern Sculpture from the Joseph H. Hirshhorn Collection*, no. 4, ill. p. 61

REFERENCES:
Daubler, Theodor, and Goll, Ivan. *Archipenko Album*, Potsdam, Germany, Gustav Kiepenheuer, 1921, p. 15, plate 1
Hildebrandt, Hans. *Alexander Archipenko*, Berlin, Ukrainske Slowo, 1923, p. 13, plate 20
Schwartz, Marvin D. "News and Views from New York," *Apollo*, 70, September 1959, ill. p. 62

Flat Torso is the only known marble version of a plaster original dated 1914.

Woman with Fan. 1915.
Painted wood relief, 19½ × 15¾ × 1¼ inches
Markings: l. r. corner "Archipenko 1915 Nice"

PROVENANCE:
The artist, Paris; Mme Jean G. Verdier, Cannes, 1964

Vase Figure. 1918.
Terra-cotta, 18 × 3 × 3¼ inches
Markings: l. l. base "Archipenko"

PROVENANCE:
The artist, Paris; Mme Jean G. Verdier, Cannes; Gabriel Garcin, Cannes, 1968

Seated Nude. c. 1919–20.
Oil on canvas, 12¾ × 9¾ inches
Signed l. r.: "Archipenko"

PROVENANCE:
Mme Jean G. Verdier, Cannes, 1965

Composition. 1920.
Gouache and watercolor on paper, 12½ × 9½ inches
Signed and dated in Russian inscription l. r.: "To Sinensky from Alexander/ 8/1920, Paris"

PROVENANCE:
Mme Jean G. Verdier, Cannes, 1966

ARMAN (b. 1928)

Armand Fernandez, born Nice, France, November 17, 1928. Studied: École Nationale d'Art Décoratif de Nice, 1946–49; École du Louvre, Paris, 1949–51. One-man shows: Galerie Haut Pavé, Paris, 1956; P.E.G. Gallery, London, 1956; Galerie Iris Clert, Paris, 1958,

1960; Galerie Alfred Schmela, Düsseldorf, 1960, 1963; Cordier-Warren Gallery, New York, 1961; Galleria Schwarz, Milan, 1961, 1963, 1968, 1969; Dwan Gallery, Los Angeles, 1962. Included in: "The Art of Assemblage," The Museum of Modern Art, New York, and tour, 1961–62; Pittsburgh International, 1964, 1967; Documenta III and 4, Kassel, 1964, 1968; "Dada, Surrealism, and Their Heritage," The Museum of Modern Art, and tour, 1968; Venice Biennale, 1968; "Pop Art (Nouveau Réalisme)," Casino Communal, Knokke-le-Zoute, Belgium, 1970. One-man shows: Sidney Janis Gallery, New York, 1963, 1964, 1968; Walker Art Center, Minneapolis, 1964; Stedelijk Museum, Amsterdam, 1964, 1969; Museum Haus Lange, Krefeld, Germany, 1965; Palais des Beaux-Arts, Brussels, 1966; Nationalmuseum, Stockholm, 1970; Lawrence Rubin Gallery, New York, 1970, 1971; The J. L. Hudson Gallery, Detroit, 1972. Taught, University of California at Los Angeles, 1967–68. Retrospective, The Museum of Fine Arts, Houston, and tour, 1973. Lives in Vence, France, and in New York.

Voyage en France. 1963.
Metal sealers from wine bottles in polyester, 68½ × 48 × 2¾ inches
Markings: l. l. "Arman 1963"

PROVENANCE:
The artist, New York, 1964

REFERENCES:
Martin, Henry. *Arman*, New York, Abrams, 1973, colorplate 92

To Hell with Paganini. 1966.
Burned violin in polyester, 29½ × 10 × 3¾ inches
Markings: back l. r. "Arman 66"

PROVENANCE:
The artist, New York, 1966

"The destruction of an object as typical as a violin, with a content both emotional and sentimental, leads to a completely different aspect in the composition. The main consideration is that through the partial destruction (burning, breaking, and/or slicing) an object with a strong identity endures the different transformations with enough puissance to survive the accident. This points to a contrast between an ancient handmade object and a manufactured and/or mass-produced object. The first one keeps its identity even through transformation, whereas the other, not strong enough to attain its identity in a mass, can be considered more as a biological extension (fingernails, hair, etc.), and can be used, discarded, and recycled indefinitely."

Statement by the artist, 1972

JEAN ARP (1887–1966)

Hans Arp, born Strasbourg, German Alsace, September 16, 1887. Studied: Kunstgewerbeschule, Strasbourg, 1904; Kunstschule, Weimar, Germany, 1905–7; Académie Julian, Paris, 1908. Visited Wassily Kandinsky, Munich, 1911. Included in: second exhibition of Der Blaue Reiter, Galerie Neue Kunst, Munich, 1912; Erster Deutscher Herbstsalon, Galerie der Sturm, Berlin, 1913. In Paris, 1914: associated with Robert and Sonia Delaunay, Max Jacob, Amedeo Modigliani; met Pablo Picasso, and Guillaume Apollinaire. Moved to Zurich, 1915: one-man show, Galerie Tanner (collages and tapestries); met Sophie Taeuber. Co-founded Dada movement, with Hugo Ball, Tristan Tzara, and Richard Huelsenbeck, Zurich, 1916; contributed to Dada magazine *Cabaret Voltaire*. In Cologne, 1919–20: worked with Max Ernst; contributed to Cologne Dada publications *Die Schammade* and *Dada*; participated in exhibition at Brauhaus Winter, closed by police, 1919. Moved to Berlin, 1920: met El Lissitzky, and Kurt Schwitters; included in Erste Internationale Dada-Messe. Returned to Paris, 1922: included in "Salon Dada," Galerie Montaigne. With Lissitzky, edited survey of modernist art movements, *Kunstism 1914–24* (Zurich, Erlenbach), 1925. Included in "Exposition, La Peinture Surréaliste," Galerie Pierre, Paris, 1925. Settled in Meudon, outside of Paris, 1926. One-man show, Galerie Goemans, Paris, 1929. Joined Cercle et Carré, founded by Michel Seuphor, and Joaquín Torres-García, Paris, 1930; exhibited with group, Galerie 23, 1931. Joined Association Abstraction-Création, Paris, 1932; exhibited, Galerie Abstraction-Création, 1933. Co-published review *Plastique* (Paris, and New York), with wife Sophie Taeuber-Arp, and César Domela, 1937. Included in "Cubism and Abstract Art," and "Fantastic Art, Dada, Surrealism," The Museum of Modern Art, New York, 1936, 1936–37. Lived in Switzerland, 1942–46; returned to Meudon. Visited the U.S., 1949: one-man show, Buchholz Gallery, New York. Sculpture commissions: Harvard University Graduate Center, Cambridge, Massachusetts, 1949–50; UNESCO Building, Paris, 1957; Hochschule für Wirtschafts-und Sozialwissenschaften, St. Gallen, Switzerland, 1963. Retrospectives: The Museum of Modern Art, 1958; Musée National d'Art Moderne, Paris, and tour, 1962; "Jean Arp–Sophie Taeuber-Arp," Galerie Denise René, Paris, 1962. Chevalier, Légion d'honneur, 1960. Awarded: Grand Prix National des Arts, Paris, 1963; Grosses Verdienstkreuz mit Stern, Federal Republic of Germany, 1965. Died Basel, June 7, 1966. Retrospective, The Art Galleries, University of California at Los Angeles, and tour, 1969. Collected editions of his poems and essays published: *Jours éffeuillés: Poèmes, essais, souvenirs 1920–1965* (Paris, Gallimard), 1966; *Gesammelde Gedichte, I* (Zurich, Der Arche), 1967; *Arp on Arp: Poems, Essays, Memories* (New York, Viking), 1972.

Alu with Claws (Alou aux Griffes). 1942.
Polished bronze, 22½ × 17 × 10 inches

PROVENANCE:
Sidney Janis Gallery, New York, 1956

EXHIBITIONS:
The Detroit Institute of Arts, 1959, *Sculpture in Our Time*, no. 44
Galerie Chalette, New York, October–November 1960, *Jean Arp and Sophie Taeuber-Arp*, no. 50.
The Solomon R. Guggenheim Museum, New York,

October 3, 1962–January 6, 1963, *Modern Sculpture from the Joseph H. Hirshhorn Collection,* no. 12, ill. p. 104

Six White Forms and One Gray Make a Constellation on a Blue Ground. 1953.
Painted wood relief, 28⅛ × 23½ inches
Signed on label on back: "Arp"

PROVENANCE:
Rose Fried Gallery, New York; Leo Castelli Gallery, New York; Private collection, New York; Harold Diamond, New York, 1962

Human Lunar Spectral (Torso of a Giant). 1957.
Bronze, 45 × 32 × 26 inches
Markings: l. r. side "△▽△"

PROVENANCE:
The artist; Pierre Loeb, Paris; William S. Rubin, New York; Leo Castelli Gallery, New York, 1961

EXHIBITIONS:
The Solomon R. Guggenheim Museum, New York, October 3, 1962–January 6, 1963, *Modern Sculpture from the Joseph H. Hirshhorn Collection,* no. 14, ill p. 105

REFERENCES:
Arnason, H. Harvard. *History of Modern Art: Painting, Sculpture, Architecture,* New York, Abrams, 1968, p. 346, ill.
Kaufman, Betty. "Hirshhorn: The Collector's Art," *Commonweal,* 77, November 9, 1962, p. 182
Raynor, Vivien. "4,000 Paintings and 1,500 Sculptures," *The New York Times Magazine,* November 27, 1966, ill. p. 52
Rubin, William S. *Dada and Surrealist Art,* New York, Abrams, 1969, no. 243, p. 479, ill. p. 248

Torso Fruit. 1960.
Marble, 29½ × 12 × 11½ inches

PROVENANCE:
The Hanover Gallery, London, 1961

EXHIBITIONS:
The Solomon R. Guggenheim Museum, New York, October 3, 1962–January 6, 1963, *Modern Sculpture from the Joseph H. Hirshhorn Collection,* no. 16, ill. p. 105
The Art Galleries, University of California at Los Angeles, November 10–December 15, 1968, *Jean Arp (1886–1966): A Retrospective Exhibition;* toured to Des Moines Art Center, Iowa, January 11–February 23, 1969; Dallas Museum of Fine Arts, March 19–April 20; The Solomon R. Guggenheim Museum, New York, May 16–June 29

REFERENCES:
Kaufman, Betty. "Hirshhorn: The Collector's Art," *Commonweal,* 77, November 9, 1962, p. 182
Read, Herbert. *The Art of Jean Arp,* New York, Abrams, 1968, no. 128, p. 207, ill. p. 105

GEORGE C. AULT (1891–1948)

George Christian Ault, born Cleveland, October 11, 1891. Lived in England; made frequent trips to France, 1899–1911. Studied, London: University College School, 1907–8; Slade School of Fine Art, with Henry Tonks and Wilson Steer, 1909; St. John's Wood School of Art, with William Orchardson and George Clausen. Exhibited, St. John's Wood School of Art, 1908. Moved to New York, 1911. Adopted "Copeland" as middle name. Exhibited with: Society of Independent Artists, New York, 1920; Salons of America, New York, 1921–34. One-man shows: Sea Chest Gallery, Provincetown, Massachusetts, 1922; Bourgeois Galleries, New York, 1923; J. B. Neumann's New Art Circle, New York, 1927; The Downtown Gallery, New York, 1927, 1928. Included in: "33 Moderns," Grand Central Art Galleries, New York, 1930; Whitney Biennial, 1932–33, 1934–35; "Abstract Painting in America," Whitney Museum of American Art, New York, 1935; Carnegie Annual, 1941–48; Pennsylvania Academy of Fine Arts Annual, 1944, 1946, 1949; National Academy of Design Annual, 1945. Moved to Woodstock, New York, 1937; one-man show, The Little Gallery, 1943. Died Woodstock, December 30, 1948. Memorial exhibitions: Woodstock Art Gallery, 1949; The Milch Galleries, New York, 1950; The Mint Museum of Art, Charlotte, North Carolina, 1951. One-man shows, Zabriskie Gallery, New York, 1957, 1963 (drawings), 1969. Included in "The Precisionist View in American Art," Walker Art Center, Minneapolis, and tour, 1960–61.

The Propeller. 1922.
Oil on cardboard, 20 × 16 inches
Signed and dated l. l.: "G. C. Ault '22"

PROVENANCE:
Estate of the artist; Zabriskie Gallery, New York, 1961

EXHIBITIONS:
Sea Chest Gallery, Provincetown, Massachusetts, August 2–16, 1922, *Exhibition of Water Colors, Oils and Monotypes by George C. Ault,* no. 12

MILTON AVERY (1893–1965)

Milton Clark Avery, born Altmar, New York, March 7, 1893. Youth spent in Hartford, Connecticut; worked night shift, United States Tire and Rubber Company, Hartford, 1913. Studied, Connecticut League of Art Students, Hartford, with Charles Noel Flagg, c. 1913. Moved to New York, 1925. First one-man show, Opportunity Gallery, New York, 1928. Awarded: Atheneum Prize, Connecticut Academy of Fine Arts, Hartford, 1930; Logan Medal, International Watercolor Exhibition, The Art Institute of Chicago, 1931. One-man shows: Gallery 144, New York, 1932; Valentine Gallery, New York, 1935, 1936, 1938; The Phillips Memorial Gallery, Washington, D.C., 1943, 1944, 1952; Paul Rosenberg & Co., New York, 1943–46; Durand-Ruel Galleries, New York, 1945–49; Portland Art Museum, Oregon, 1947; Grace Borgenicht Gallery, New York, from 1951; The Waddington Galleries, London, from 1962. First graphics, 1933. First trip to Europe, 1952. Retrospectives: The

Baltimore Museum of Art, and tour, 1952–53; American Federation of Arts tour, 1959–60. Awarded second prize, Boston Arts Festival, 1958. Received Ford Foundation Grant, 1960. Included in: Pittsburgh International, 1964; "Painting and Sculpture of a Decade, 54–64," The Tate Gallery, London, 1964. Died New York, January 3, 1965. Memorial exhibitions: The Museum of Modern Art, New York, Circulating Exhibition, 1965–66; Sheldon Memorial Art Gallery, University of Nebraska, Lincoln, 1966. Retrospectives: National Collection of Fine Arts, Smithsonian Institution, Washington, D.C., and tour, 1969–70; The Corcoran Gallery of Art, Washington, D.C., and tour (prints), 1972–73.

Interior with Figure. 1938.
Oil on canvas, 31¼ × 40 inches
Signed l. l.: "Milton Avery"

PROVENANCE:
The artist, New York, c. 1942

EXHIBITIONS:
American Federation of Arts tour, 1959–60, *Ten Modern Masters of American Art,* no. 1
American Federation of Arts tour, 1962–65, *Paintings from the Joseph H. Hirshhorn Foundation Collection: A View of the Protean Century,* no. 5, ill. p. 32
Durand-Ruel Galleries, New York, February 4–March 1, 1947, *"My Daughter, March" by Milton Avery,* no. 3

Russian Woman c. 1940.
Oil on canvas mounted on board, 24 × 18 inches
Signed l. l.: "Milton Avery"

PROVENANCE:
The artist, New York, c. 1942

EXHIBITIONS:
Marquié Gallery, New York, October 17–November 4, 1942, *Group Exhibition*

REFERENCES:
Unsigned. "Varied Moderns," *Art Digest,* 17, October 15, 1942, p. 22, ill.

Morning Call. 1946.
Oil on canvas, 54 × 34 inches
Signed and dated l. l.: "Milton Avery 1946"

PROVENANCE:
Durand-Ruel Galleries, New York, 1947

EXHIBITIONS:
Durand-Ruel Galleries, New York, February 4–March 1, 1947, *"My Daughter, March" by Milton Avery,* no. 9, ill.
Durand-Ruel Galleries, New York, April 18–May 14, 1949, *Milton Avery*
The Baltimore Museum of Art, December 9, 1952–January 18, 1953, *Paintings by Milton Avery: 1928–1952,* no. 50; toured to Institute of Contemporary Art, Boston; The Joe and Emily Lowe Art Gallery, University of Miami, Coral Gables, Florida; The Phillips Memorial Gallery, Washington, D.C.; Wadsworth Atheneum, Hartford, Connecticut
American Federation of Arts tour, 1959–60, *Ten Modern Masters of American Art,* no. 3, ill.
The Phillips Collection, Washington, D.C., May 17–June 28, 1965, *Milton Avery* (The Museum of Modern Art, New York, Circulating Exhibition); toured to eleven U.S. cities
National Collection of Fine Arts, Smithsonian Institution, Washington, D.C., December 12, 1969–January 25, 1970, *Milton Avery,* no. 38, ill.; toured to The Brooklyn Museum, New York, February 17–March 29; The Columbus Gallery of Fine Arts, Ohio, April 24–May 31

REFERENCES:
Breeskin, Adelyn Dohme. *Milton Avery,* Greenwich, Connecticut, New York Graphic Society, 1969, no. 38, ill.
Kramer, Hilton. *Milton Avery, Paintings 1930–1960,* New York, Yoseloff, 1962, p. 25, colorplate 11
Ritter, Chris. "A Milton Avery Profile," *Art Digest,* 27, December 1, 1952, ill. p. 11
Unsigned. "Reviews and Previews: Milton Avery," *Art News,* 45, February 1947, p. 42, ill.
Wolf, Ben. "Two Averys Grow," *Art Digest,* 21, February 15, 1947, p. 11, ill.

Sandbar and Boats. 1957.
Oil on canvas, 40 × 50 inches
Signed and dated l. r.: "Milton Avery, 1957"

PROVENANCE:
Grace Borgenicht Gallery, New York; Ethel Steuer Epstein, New York; Parke-Bernet Galleries, New York, Sale 2531, March 16, 1967, no. 104, ill.

EXHIBITIONS:
Grace Borgenicht Gallery, New York, October 28–November 16, 1957, *Milton Avery*

REFERENCES:
Goossen, Eugene C. "In the Galleries: Milton Avery," *Arts,* 32, November 1957, p. 52

FRANCIS BACON (b. 1909)

Born Dublin, of English parents, October 28, 1909. Moved to London, 1925. Lived in Berlin, and Paris, 1926–28. Returned to London, 1928; worked as interior decorator. Self-taught as an artist. First exhibited in his studio, with Roy de Maistre, London, 1930. Group exhibitions, London: "Art Now," The Mayor Gallery, 1933; "Young British Painters," Thomas Agnew and Sons, 1937. First one-man show, Transition Gallery, London, 1934. Medical exemption from military service, World War II. Destroyed most of his earlier work, 1944. One-man shows: The Hanover Gallery, London, 1949–57, 1959; Durlacher Brothers, New York, 1953; Galerie Rive Droite, Paris, 1957; Marlborough Fine Art, London, 1960, 1963, 1967, 1968. Included in: Pittsburgh International, 1950, 1958, 1964, 1967 (painting award), 1970; Venice Biennale, 1954; "The New Decade," The Museum of Modern Art, New York, 1955; V São Paulo Bienal, 1959; Documenta II and III, Kassel, 1959, 1964; "New Images of Man," The Museum of Modern Art, and The Baltimore Museum of Art, 1959–

60; "Francis Bacon–Hyman Bloom," The Art Galleries, University of California at Los Angeles, 1960; ROSC '67, Dublin, 1967. Retrospectives: Institute of Contemporary Arts, London, 1955; Galatea Galleria d'Arte, Turin, and tour, 1958; The Tate Gallery, London, and tour, 1962–63; The Solomon R. Guggenheim Museum, New York, and The Art Institute of Chicago, 1963–64. Awarded Rubens Prize, Siegen, Germany, 1967. One-man show, Marlborough-Gerson Gallery, New York, 1968. Retrospective, Grand Palais, Paris, and Städtische Kunsthalle, Düsseldorf, 1971–72. Lives in London.

Study for **Portrait V.** 1953.
Oil on canvas, 60 × 46 inches

PROVENANCE:
The Hanover Gallery, London; Durlacher Brothers, New York; Mr. and Mrs. Stanley J. Wolf, Great Neck, New York; The Alan Gallery, New York, 1955

EXHIBITIONS:
Durlacher Brothers, New York, October–November 1953, *Francis Bacon,* no. 3
Brandeis University, Waltham, Massachusetts, June 1–17, 1955, *Three Collections,* no. 2
The Tate Gallery, London, May 24–July 1, 1962, *Francis Bacon Retrospective,* no. 28; toured to Städtische Kunsthalle, Mannheim, Germany, July 18–August 26; Museo Civico di Torino, September 11–October 14, no. 29, ill. p. 87; Kunsthaus, Zurich, October 27–November 25; Stedelijk Museum, Amsterdam, January 11–February 18, 1963, no. 19, ill.
The Brooklyn Museum, New York, February 8–April 5, 1965, *Paintings from the Joseph H. Hirshhorn Foundation Collection: A View of the Protean Century,* no. 76

REFERENCES:
Fitzsimmons, James. "Art: Paintings of Apes and Madmen," *Arts & Architecture,* 71, January 1954, p. 30, ill.
Hunter, Sam. "Francis Bacon: An Acute Sense of Impasse," *Art Digest,* 28, October 15, 1953, p. 16, ill.
Menna, F. "Modern European Art," *New Catholic Encyclopedia,* I, New York, McGraw-Hill, 1967, p. 911, ill. p. 907
Preston, Stuart. "A Collector's Eye-View," *The New York Times,* February 28, 1965, sec. 2, p. 19
Rothenstein, John, and Alley, Ronald. *Francis Bacon,* London, Thames and Hudson, 1964, no. 63
Seckler, Dorothy Gees. "Reviews and Previews: Francis Bacon," *Art News,* 52, part 1, November 1953, p. 43
Spender, Stephen. "English Artists vs. English Painting," *Art News,* 52, November 1953, p. 48, ill. p. 14
Unsigned. "Snapshots from Hell," *Time,* 62, October 19, 1953, ill. p. 63

The study for *Portrait V* is the fifth in a series of eight studies based on Diego Velázquez's three-quarter-length portrait of Pope Innocent X painted in 1650 (Galleria Doria-Pamphili, Rome).

Study for **Portrait of Van Gogh III.** 1957.
Oil on canvas, 78 × 55¾ inches

PROVENANCE:
The Hanover Gallery, London, 1957

EXHIBITIONS:
The Hanover Gallery, London, March 21–April 26, 1957, *Francis Bacon,* no. 13
The Museum of Modern Art, New York, September 30–November 29, 1959, *New Images of Man,* no. 15, colorplate p. 33; toured to The Baltimore Museum of Art, January 9–February 7, 1960
The Art Galleries, University of California at Los Angeles, October 30–December 11, 1960, *Francis Bacon–Hyman Bloom,* no. 9
The Tate Gallery, London, May 24–July 1, 1962, *Francis Bacon Retrospective,* no. 59, ill.; toured to Städtische Kunsthalle, Mannheim, Germany, July 18–August 26, no. 47; Museo Civico di Torino, September 11–October 14, no. 50; Kunsthaus, Zurich, October 27–November 25, no. 45; Stedelijk Museum, Amsterdam, January 11–February 18, 1963
The Solomon R. Guggenheim Museum, New York, October 18, 1963–January 12, 1964, *Francis Bacon,* no. 39, ill. p. 54; toured to The Art Institute of Chicago, January 24–February 23
Providence Art Club, Rhode Island, March 31–April 24, 1965, *Critics' Choice: Art Since World War II,* no. 4, ill. p. 19
Marlborough-Gerson Gallery, New York, April–May 1968, *International Expressionism Part I,* no. 2, ill.

REFERENCES:
Alloway, Lawrence, "Art News from London," *Art News,* 56, May 1957, p. 48, ill. p. 58
Fried, Michael. "Bacon's Achievement," *Arts,* 36, September 1962, p. 28
Hoctin, Luce. "Francis Bacon et la hantise de l'homme," *XX Siècle,* no. 11, Noël 1958, p. 53, colorplate p. 55
Lynton, Norbert. "London Letter," *Art International,* 6, October 25, 1962, ill. p. 69
Roskill, Mark. "Francis Bacon as a Mannerist," *Art International,* 7, September 25, 1963, p. 47
Rothenstein, John, and Alley, Ronald. *Francis Bacon,* London, Thames and Hudson, 1964, no. 13, colorplate p. 111
Russell, John. *Francis Bacon,* London, Methuen, 1964, ill.
———. "Peer of the Macabre, Francis Bacon," *Art in America,* 51, October 1963, colorplate p. 100
Unsigned. "Weird Wonder," *MD,* 15, May 1957, p. 140, colorplate p. 138

This study is one of a series that Bacon based on Vincent Van Gogh's *The Painter on the Road to Tarascon* of 1888 (destroyed during World War II).

Triptych. 1967.
Oil and pastel on canvas, three panels, each 78 × 58 inches

PROVENANCE:
Marlborough-Gerson Gallery, New York, 1968

EXHIBITIONS:
Marlborough-Gerson Gallery, New York, November–

December 1968, *Francis Bacon—Recent Paintings,* no. 10, colorplate p. 41

Grand Palais, Paris, October 26, 1971–January 10, 1972, *Francis Bacon Retrospective,* no. 75, colorplate 335; toured to Städtische Kunsthalle, Düsseldorf, March 7–May 7

REFERENCES:
Gibson, Michael. "Art in Paris: The Ambiguous Appeal of Francis Bacon's Work," *International Herald Tribune,* October 30–31, 1971, p. 7, ill.
Gowing, Lawrence. "Pigment Figment," *Art News,* 67, December 1968, p. 43, ill. p. 45
Hobhouse, Janet. "Francis Bacon," *Arts,* 46, February 1972, p. 38, ill.
Peppiatt, Michael. "Francis Bacon's New Paintings," *Art International,* 12, December 1968, pp. 36–38, ill. p. 36, colorplate p. 37
Schwartz, Barry. *Humanism in Twentieth Century Art,* New York, Praeger, forthcoming, ill.
Unsigned. "Prelude to Butchery," *Time,* 92, November 29, 1968, p. 82, ill.

T. S. Eliot's *Sweeney Agonistes* (London, Faber & Faber), 1932, was the source of inspiration for this painting.

OLLE BAERTLING (b. 1911)

Born Halmstad, Sweden, December 6, 1911. Moved to Stockholm, 1928. Studied, with Fernand Léger and André Lhote, Paris, 1948. One-man shows: Galerie Samlaren, Stockholm, 1949, 1955, 1957, 1960, 1964, 1966; Galerie Birch, Copenhagen, 1952; Galerie Denise René, Paris, 1955, 1958, 1962, 1972. Included in Salon des Réalités Nouvelles, Paris, 1950–58. Mural commission, City Center, Stockholm, 1959–60. Included in: V and VII São Paulo Bienal, 1959, 1963; "Konstruktivisten," Städtisches Museum Schloss Morsbroich, Leverkusen, Germany, 1962; Guggenheim International, 1964. One-man shows: Columbia University, New York, 1964; New York University, 1964; Rose Fried Gallery, New York, 1965, 1967, 1968, 1970; North Carolina State University at Raleigh, 1966; Allen Memorial Art Museum, Oberlin College, Ohio, 1966; University of Minnesota, Minneapolis, 1966; Sundsvalls Museum, Sweden, 1966; Jönköpings Läns Museum, Sweden, 1966; Galleri Löwendahl, Uppsala, Sweden, 1967. Included in: "Kinetika-Bewegte Kunst," Museum des 20. Jahrhunderts, Vienna, 1967; "Plus by Minus: Today's Half-Century," Albright-Knox Art Gallery, Buffalo, New York, 1968. Retrospective, Royal Academy of Fine Arts, Stockholm, and tour, 1969. Lives in Stockholm.

XYH. 1967.
Steel, 9 feet 11 inches × 13 feet 8 inches × 2 inches

PROVENANCE:
Gift of Rose Fried, New York, 1968

EXHIBITIONS:
Rose Fried Gallery, New York, May 14–June 8, 1968, *The Angles of Baertling*

REFERENCES:
Rickey, George, et al. *Baertling: Creator of Open Form,* Stockholm, Åke Nyblom, 1969, ill p. 47

EUGENIE BAIZERMAN (1899–1949)

Eugenie Silverman, born Warsaw, October 14, 1899. Youth spent in Bessarabia (on Polish-Russian border), and in Odessa, Russia. Studied art privately, and at Odessa Art School. Emigrated to New York, 1913. Studied, New York: Educational Alliance Art School, 1913–c. 1917; National Academy of Design, 1917–20. Married sculptor Saul Baizerman, 1920. Exhibited with Salons of America, New York, 1934. The Artists' Gallery, New York: one-man show, 1938; exhibited with husband, 1948. Died New York, December 30, 1949. Memorial exhibition, The Artists' Gallery, 1950. Posthumous one-man shows, New York: The New Gallery, 1953; The Artists' Gallery, 1961; Oscar Krasner Gallery, 1962, 1964, 1965; Zabriskie Gallery, 1969. Included in "Baizerman-Baizerman: Painting and Sculpture," American Federation of Arts, Circulating Exhibition, 1962–63.

Setting Sun. 1944.
Oil on canvas, two panels, each 54 × 43 inches
Signed and dated u. r. left panel and u. l. right panel: "Eugenie Baizerman 44"

PROVENANCE:
Oscar Krasner Gallery, New York, 1961

EXHIBITIONS:
Oscar Krasner Gallery, New York, January 2–27, 1962, *Paintings by Eugenie Baizerman,* no. 16
Des Moines Art Center, Iowa, October 5–November 4, 1962, *Baizerman-Baizerman: Painting and Sculpture* (American Federation of Arts, Circulating Exhibition), no. 12

SAUL BAIZERMAN (1889–1957)

Born Vitebsk, Russia, December 25, 1889. Studied, Imperial Art School, Odessa, 1904. Emigrated to New York, 1910. Studied, New York: Educational Alliance Art School; National Academy of Design, 1911; Beaux-Arts Institute of Design, 1911–20. Won (but later rejected) commission for Civil Liberty Monument, Grant's Tomb, New York, 1918. Married painter Eugenie Silverman, 1920. One-man show, Dorien Leigh Galleries, London, 1924. Included in Salon des Indépendants, Paris, 1925. One-man shows, New York: Eighth Street Gallery, 1933; The Artists' Gallery, 1938. Directed his own art school at the Educational Alliance, 1934–40. Exhibited with wife, The Artists' Gallery, 1948. Included in: Whitney Annual, 1940, 1949–54; 1st Middelheim Biënnale, Antwerp, 1951; I São Paulo Bienal, 1951. One-man show, Philadelphia Art Alliance, 1949. Taught, University of Southern California, Los Angeles, summer, 1949. Awarded: honorable mention, Pennsylvania Academy Annual, 1949; Steel Memorial Prize, Pennsylvania Academy Annual, 1950. Received: grant, The National Institute of Arts and Letters, and The American Academy of Arts and Letters, 1951; Guggenheim Foundation Fellowship, 1952. One-man shows, The New Gallery, New York, 1952, 1954. Retrospective, Walker

Art Center, Minneapolis, and tour, 1953. Died New York, August 30, 1957. Memorial exhibitions: The Artists' Gallery, 1957; Institute of Contemporary Art, Boston, and tour, 1958; Heckscher Museum, Huntington, New York, 1961; "Baizerman-Baizerman: Painting and Sculpture," American Federation of Arts, Circulating Exhibition, 1962–63.

The Miner. 1939–45.
Hammered copper, 82½ × 46 × 32 inches
Markings: l. l. side "S Baizerman"

PROVENANCE:
Estate of the artist; Zabriskie Gallery, New York, 1968

EXHIBITIONS:
The Artists' Gallery, New York, September 1–October 1, 1948, *Baizerman: An Exhibition of Paintings by Eugenie Baizerman and Sculptures by Saul Baizerman,* checklist no. 13
Philadelphia Art Alliance, October 6–30, 1949, *Saul Baizerman Sculpture,* no. 21
Walker Art Center, Minneapolis, January 25–March 8, 1953, *The Sculpture of Saul Baizerman,* no. 23; toured to Des Moines Art Center, Iowa, April 5–May 3; San Francisco Museum of Art, August 19–September 13
Zabriskie Gallery, New York, November 14–December 9, 1967, *Saul Baizerman,* no. 3, ill. p. 7

REFERENCES:
Kramer, Hilton. "A Lost World," *The New York Times,* November 26, 1967, sec. 2, p. 23
———. *The Art of the Avant-Garde,* New York, Farrar, Straus and Giroux, 1973, p. 308
Messer, Thomas M., foreword. *Saul Baizerman,* Boston, Institute of Contemporary Art, 1958, p. (17)
Unsigned. "Hammered Statues," *Life,* 25, October 4, 1948, p. 157, ill.

Baizerman employed the *repoussé* technique, hammering out his forms from large flat copper sheets. The shapes were worked from the back by beating the copper into a frontal high relief, without sealing the back or disguising the nature of the original material.

Espérance. 1953–56.
Hammered copper, 23 × 10½ × 13½ inches
Markings: r. and l. sides "S. Baizerman 100"

PROVENANCE:
The artist, New York, 1957

EXHIBITIONS:
The Detroit Institute of Arts, and tour, 1959–60, *Sculpture in Our Time,* no. 48
Des Moines Art Center, Iowa, October 5–November 4, 1962, *Baizerman-Baizerman: Painting and Sculpture* (American Federation of Arts, Circulating Exhibition), no. 29
World House Galleries, New York, January 22–February 23, 1963, *Saul Baizerman,* no. 18
Zabriskie Gallery, New York, April 28–May 23, 1970, *Saul Baizerman,* no. 14

REFERENCES:
Messer, Thomas M., foreword. *Saul Baizerman,* Boston, Institute of Contemporary Art, 1958, p. (17)

Nereid. 1955–57.
Hammered copper, 47¾ × 18 × 10 inches

PROVENANCE:
The artist, New York, 1957

EXHIBITIONS:
The Detroit Institute of Arts, and tour, 1959–60, *Sculpture in Our Time,* no. 49
The Solomon R. Guggenheim Museum, New York, October 3, 1962–January 6, 1963, *Modern Sculpture from the Joseph H. Hirshhorn Collection,* no. 21

REFERENCES:
Messer, Thomas M., foreword. *Saul Baizerman,* Boston, Institute of Contemporary Art, 1958, p. (17)

GIACOMO BALLA (1871–1958)

Born Turin, August 18, 1871; son of a chemist and amateur photographer. Studied design briefly, Accademia Albertina di Belle Arte e Liceo Artistico, Turin. Worked in lithography studio. Moved to Rome, 1895. Included in Venice Biennale, 1899. Studied painting, Paris, 1900. Included in Esposizione Internazionale di Belle Arti, Rome, 1900–1911. Issued *Manifesto dei pittori futuristi* and *Manifesto tecnico della pittura futurista,* with Umberto Boccioni, Carlo Carrà, Luigi Russolo, and Gino Severini, 1910. Exhibited with Futurists: Galerie Bernheim-Jeune, Paris, and European tour, 1912; Erster Deutscher Herbstsalon, Galerie der Sturm, Berlin, 1913; Panama-Pacific International Exposition, San Francisco, 1915. Participated in first and second Futurist evening performances, Teatro Costanzi, Rome, 1913. First sculptures exhibited, "Prima Esposizione linea futurista," Galleria Sprovieri, Rome, 1914. One-man shows, Rome: Sala d'Arte A. Angelelli, 1915; Casa d'Arte Bragaglia, 1918. Co-authored: with Fortunato Depero, *Ricostruzione futurista dell' universo,* 1915; with Remo Chiti, Bruno Corra, Arnaldo Ginna, Filippo Tommaso Marinetti, and Emilio Settimelli, *La Cinematografia futurista,* 1916. Wrote *Manifesto del colore,* 1918. Included in: Venice Biennale, 1926, 1950; I Quadriennale Nazionale d'Arte, Rome, 1931; "Futurismo-Pittura Metafisica," Kunsthaus, Zurich, 1950; "Exposición de Arte Italiano Contemporáneo," Palacio del Retiro, Madrid, 1955. One-man shows: Galleria Bompiani, Milan, 1951; Galleria d'Arte Contemporanea, Florence, 1952; Galerie Cahiers d'Art, Paris, 1957. Died Rome, March 1, 1958. Retrospectives: Museo Civico di Torino, 1963; Venice Biennale, 1968; Galleria dell'Obelisco, Rome (sculpture), 1968, 1971.

Line of Speed and Vortex (Linea di velocità e vortice). 1913–14, reconstructed 1968.
Chromed brass on painted metal base (1/9), 78 × 49 × 12½ inches

PROVENANCE:
Estate of the artist; Galleria dell'Obelisco, Rome, 1968

EXHIBITIONS:
Galleria dell'Obelisco, Rome, May–June 1968, *Balla sculture 1913–15*

REFERENCES:
Dell'Arco, Maurizio Fagiolo. *Futur Balla,* Rome, Mario Bulzoni, 1970, p. 71
Dorazio, Virginia Dortch. *Giacomo Balla: An Album of His Life and Work,* New York, Wittenborn, 1970, no. 136, ill.
Galleria dell'Obelisco. *Balla 1871–1958: tutte le sculture,* Rome, 1971, no. 5, ill.

In 1914, dissatisfied with the possibilities for rendering dynamic movement in painting alone, Balla began making three-dimensional constructions ("complessi plastici") from such materials as colored string, cardboard, and tinfoil. "We shall give flesh and bones to the invisible, the impalpable," he wrote in *Ricostruzione futurista dell'universo,* "and then we shall combine them in plastic constructions." In the 1950s, with the assistance of a Maserati technician, Armando Ricci, Balla made metal reconstructions of the original sculptures. Ricci executed another series of reconstructions in 1968.

Plastic Construction of Noise and Speed (Complesso plastico di frastuono e velocità). 1914–15, reconstructed 1968.
Aluminum and steel relief, 40 × 47 × 8 inches
Markings: u. l. artist's stamp, "1/9"

PROVENANCE:
Estate of the artist; Galleria dell'Obelisco, Rome, 1968

EXHIBITIONS:
Galleria dell'Obelisco, Rome, May–June 1968, *Balla sculture 1913–15*

REFERENCES:
Dorazio, Virginia Dortch. *Giacomo Balla: An Album of His Life and Work,* New York, Wittenborn, 1970, no. 164, ill.
Galleria dell'Obelisco, *Balla 1871–1958: tutte le sculture,* Rome, 1971, no. 2, ill.

Boccioni's Fist—Lines of Force II (Linee—forza del pugno di Boccioni II). 1915, reconstructed 1955/68.
Brass construction, 31½ × 30 × 10 inches
Markings: beneath center strut, artist's stamp, "G. B. 1/9"

PROVENANCE:
Estate of the artist; Galleria dell'Obelisco, Rome, 1968

EXHIBITIONS:
Galleria dell'Obelisco, Rome, May–June 1968, *Balla sculture 1913–1915*

REFERENCES:
Dell'Arco, Maurizio Fagiolo. *Futur Balla,* Rome, Mario Bulzoni, 1970, p. 77
Galleria dell'Obelisco. *Balla 1871–1958: tutte le sculture,* Rome, 1971, no. 1, ill.

The Italian painter and sculptor Umberto Boccioni (1882–1916), for whom this work is named, was a founder and leading theorist of Futurism.

A drawing for Balla's construction, appearing on the masthead of the magazine *Futurismo,* became an emblem for the group, as well as a monogram used later by the artist.

BALTHUS (b. 1908)

Balthasar Klossowski de Rola, born Paris, February 29, 1908; son of Polish emigré painters, who provided his only art training. Father, Erich Klossowski, author of a standard monograph on Honoré Daumier, 1908. During World War I, moved with family to Geneva; returned to Paris, 1924. Traveled to Italy, 1926; copied frescoes by Piero della Francesca, Church of S. Francesco, Arezzo. Served, French Army, Morocco, 1929–30. Executed series of drawings, based on Emily Brontë's *Wuthering Heights,* 1933. One-man shows: Galerie Pierre, Paris, 1934; Pierre Matisse Gallery, New York, 1938, 1949, 1957, 1962, 1966, 1967; Galerie Georges Moos, Geneva, 1943. Included in: "Art in Our Time," The Museum of Modern Art, New York, 1939; "Exposition d'Art Contemporain," Palais des Papes, Avignon, France, 1947. Mobilized, 1939–40. Moved to Switzerland; returned to Paris, 1945. One-man shows: Wildenstein et Cie., Paris, 1946, 1956; Galerie des Beaux-Arts, Paris, 1946, 1956; The Lefevre Gallery, London, 1952. Retrospectives: The Museum of Modern Art, 1956–57; Museo Civico di Torino, 1961; The New Gallery, Hayden Library, Massachusetts Institute of Technology, Cambridge, 1964; The Arts Club of Chicago, 1964; Musée des Arts Décoratifs, Paris, and Casino Communal, Knokke-le-Zoute, Belgium, 1966; The Tate Gallery, London, 1968. Director, Académie de France à Rome, since 1961. One-man shows: Galerie Claude Bernard, Paris, 1971, 1972; Musée Cantini, Marseilles, France, 1973. Lives in Rome, and in Château-de-Chassy, Nièvre, France.

The Golden Days (Les Beaux Jours). 1944–46.
Oil on canvas, 58⅜ × 78½ inches

PROVENANCE:
Pierre Matisse Gallery, New York, 1959

EXHIBITIONS:
Palais des Papes, Avignon, France, June–September 1947, *Exposition d'Art Contemporain*
Pierre Matisse Gallery, New York, March 8–April 2, 1949, *Balthus,* no. 19
The Museum of Modern Art, New York, December 19, 1956–February 3, 1957, *Balthus,* no. 16, ill. p. 23
American Federation of Arts tour, 1962–65, *Paintings from the Joseph H. Hirshhorn Foundation Collection: A View of the Protean Century,* no. 7, ill. p. 16
Musée des Arts Décoratifs, Paris, May 12–June 27, 1966, *Balthus,* no. 13, ill. p. 25; toured to Casino Communal, Knokke-le-Zoute, Belgium, July–September
The Tate Gallery, London, October 4–November 10, 1968, *Balthus,* no. 23

REFERENCES:
Char, René. "Balthus, ou le Dard dans la fleur," *Cahiers d'Art,* 20–21 année, 1946, ill. p. 199
Clark, Eliot. "New York Commentary," *Studio,* 153, June 1957, p. 185

Feldman, Edmund Burke. *Varieties of Visual Experience,* New York, Abrams, 1972, ill. p. 325
Herman, William R. "Photographic Naturalism and Abstract Art," *College Art Journal,* 19, Spring 1960, pp. 237–38, ill. 4
Monro, Eleanor C. "Twentieth Century," *The Golden Encyclopedia of Art,* New York, Golden Press, 1961, colorplate p. 255
Reed, Judith Kaye. "Symbolic Realism and Haunting Victims," *Art Digest,* 23, April 1, 1949, p. 16, ill.
Russell, John, intro. *Balthus,* London, The Tate Gallery, 1968, p. 12
Soby, James Thrall. "Balthus," *Bulletin of The Museum of Modern Art,* New York, 24, 1956–57, pp. 7–8, ill. p. 23
Zervos, Christian. "Exposition d'Art Contemporain," *Cahiers d'Art,* 22, 1947, ill. p. 301

The Room (La Chambre). 1947–48.
Oil on canvas, 75 × 63 inches
Signed and dated l. l.: "Balthus 1947–8"

PROVENANCE:
Pierre Matisse Gallery, New York, 1959

EXHIBITIONS:
Pierre Matisse Gallery, New York, March 8–April 2, 1949, *Balthus,* no. 21
The Museum of Modern Art, New York, December 19, 1956–February 3, 1957, *Balthus,* no. 17, ill. p. 31
The New Gallery, Hayden Library, Massachusetts Institute of Technology, Cambridge, February 10–March 2, 1964, *Balthus Retrospective,* no. 13, ill.
The Arts Club of Chicago, September 21–October 28, 1964, *Balthus,* no. 12
The Brooklyn Museum, New York, February 8–April 5, 1965, *Paintings from the Joseph H. Hirshhorn Foundation Collection: A View of the Protean Century,* no. 79
Musée des Arts Décoratifs, Paris, May 12–June 27, 1966. *Balthus,* no. 14; toured to Casino Communal, Knokke-le-Zoute, Belgium, July–September
The Tate Gallery, London, October 4–November 10, 1968, *Balthus,* no. 26

REFERENCES:
Clark, Eliot. "New York Commentary," *Studio,* 153, June 1957, p. 185
Hess, Thomas B. "Spotlight on Balthus," *Art News,* 48, March 1949, p. 38, ill.
Preston, Stuart. "A Collector's Eye-View," *The New York Times,* February 28, 1965, sec. 2, p. 19
Reed, Judith Kaye. "Symbolic Realism and Haunting Victims," *Art Digest,* 23, April 1, 1949, p. 16
Soby, James Thrall. "Balthus," *Bulletin of The Museum of Modern Art,* New York, 1956–57, p. 8, ill. p. 24

CLIVE BARKER (b. 1940)

Born Luton, Bedfordshire, England, August 29, 1940. Studied, Luton College of Technology and Art, 1957–59. Included in: "Young Contemporaries," F.B.A. Gallery, London, 1962; "About Around," University of Leeds, Yorkshire, England, 1964; "118 Show," Kasmin Gallery, London, 1964. Taught, Maidstone College of Art, Kent, England, 1965. Included in: "New Idioms," Robert Fraser Gallery, London, 1966; Salon de la Jeune Peinture, Paris, 1967; "Young British Artists," The Museum of Modern Art, New York, Circulating Exhibition, 1968; "Contemporary British Painters and Sculptors," Museum of Modern Art, Oxford, England, 1968. One-man shows, London: Robert Fraser Gallery, 1968; The Hanover Gallery, 1969. Included in: "Pop Art," Hayward Gallery, London, 1969; "New Multiple Art," Whitechapel Art Gallery, London, 1970; "Metamorphose de l'Objet," Palais des Beaux-Arts, Brussels, 1971; "Künstler Aus England," Baukunst, Cologne, 1973. Visiting lecturer, Croydon College of Art, London, since 1972. Lives in London.

Spill. 1967.
Chromed steel, 30⅜ × 20¼ × 3½ inches

PROVENANCE:
Robert Fraser Gallery, London, 1968

EXHIBITIONS:
Robert Fraser Gallery, London, January 1968, *Clive Barker: Recent Works,* no. 5

ERNST BARLACH (1870–1938)

Born Wedel, near Hamburg, January 2, 1870. Studied: Kunstgewerbeschule, Hamburg, 1888–91; Kunstakademie, Dresden, 1891–95; Académie Julian, Paris, 1895–96. Moved to Berlin, 1907; met dealer Paul Cassirer. Included in Berliner Sezession, 1907, 1908. Received Villa Romana Prize, to work in Florence, 1909. Settled in Güstrow, Mecklenburg, Germany, 1910. Traveled in The Netherlands, with Cassirer and Tilla Durieux, 1912. Published first play, *Der tote Tag (The Dead Day),* with his own illustrations, 1912; play produced, Neuen Volkstheater, Berlin, 1923. Served, German Army, 1915–16. First major exhibition, Galerie Paul Cassirer, Berlin, 1917. Member, Preussische Akademie der Künste, Berlin, 1919. Play *Der arme Vetter (The Poor Cousin)* produced, Staatstheater, Munich, 1923. Awarded Kleist Prize, for play *Die Sündflut (The Flood),* 1924. Commissions, war memorials, Germany: Cathedral, Güstrow, 1927; University Church, Kiel, 1928; Cathedral, Magdeburg, 1929; city of Hamburg, 1932. One-man shows, Germany, 1930: Preussische Akademie; Museum Folkwang, Essen; Kunsthalle, Kiel; Galerie Alfred Flechtheim, Berlin. Appointed to Der Orden Pour le Mérite für Wissenschaften und Künste, 1933. Memorials removed: from Cathedral, Magdeburg, 1934; from Cathedral, Güstrow, 1937. Nazis removed his works from anniversary exhibition, Preussische Akademie, 1936. Included in Nazi exhibition "Entartete Kunst (Degenerate Art)," Munich, and tour, 1937. Forced to resign from Preussische Akademie, 1937. Died Rostock, Mecklenburg, October 24, 1938. Retrospectives: Buchholz Gallery, New York, 1938; Kunsthalle, Hamburg, 1948; Akademie der Künste, Berlin, 1951–52; Städtische Galerie im Lenbachhaus, Munich, 1959. Collected literary works, *Dichterische*

Werk, published in three volumes (Munich, Piper), 1956–59. Retrospective, Smithsonian Institution, Washington, D.C., Traveling Exhibition Service (sculpture, graphics, drawings), 1962–63.

The Avenger (Der Rächer). 1914.
Bronze, 17¼ × 23 × 8¼ inches
Markings: r. top of base "E. Barlach"
r. side of base "H. Noack Berlin"

PROVENANCE:
Estate of the artist; Galerie Alex Vömel, Düsseldorf; Jane Wade, New York, 1956

EXHIBITIONS:
The Detroit Institute of Arts, and tour, 1959–60, *Sculpture in Our Time,* no. 51, ill. p. 29
The Solomon R. Guggenheim Museum, New York, October 3, 1962–January 6, 1963, *Modern Sculpture from the Joseph H. Hirshhorn Collection,* no. 23
Dallas Museum of Fine Arts, May 12–June 13, 1965, *Sculpture Twentieth Century,* no. 6
Hopkins Center Art Galleries, Dartmouth College, Hanover, New Hampshire, May 25–July 9, 1967, *Sculpture in Our Century: Selections from the Joseph H. Hirshhorn Collection,* no. 5, ill. p. 10

REFERENCES:
Getlein, Frank. "Angel of Justice," *Country Beautiful,* 2, October 1962, ill. p. 47
Rogers, L. R. "Western Sculpture," *Encyclopedia Americana,* rev. ed., forthcoming, ill.
Werner, Alfred. "Barlach: Genius Out of Step," *Auction,* 2, February 1969, ill. p. 23

Two Monks Reading (Die lesende Mönche). 1932.
Bronze, 23 × 17½ × 15 inches
Markings: r. front of base "E Barlach 1932
H Noack Berlin"

PROVENANCE:
Estate of the artist; Galerie Alex Vömel, Düsseldorf; Fine Arts Associates, New York, 1957

EXHIBITIONS:
Galerie Alex Vömel, Düsseldorf, October 1951, *Barlach*
Fine Arts Associates, New York, October–November 1956, *Rodin to Lipchitz, Part II,* no. 1, ill.
The Detroit Institute of Arts, and tour, 1959–60, *Sculpture in Our Time,* no. 53
The Solomon R. Guggenheim Museum, New York, October 3, 1962–January 6, 1963, *Modern Sculpture from the Joseph H. Hirshhorn Collection,* no. 25, ill. p. 48

REFERENCES:
Saarinen, Aline B. *The Proud Possessors,* New York, Random House, 1958, ill. following p. 200
Sontag, Raymond J. *A Broken World 1919–1939,* New York, Harper & Row, 1971, ill. 36

Old Woman Laughing (Lachende Alte). 1937.
Bronze, 8½ × 4⅝ × 12¼ inches
Markings: back, l. l. "E Barlach"
back, l. r. "H. Noack Berlin"

PROVENANCE:
Buchholz Gallery, New York, 1948

EXHIBITIONS:
Gallery of Contemporary Art, Toronto, September, 1957, *Contemporary European Loan Exhibition*
The Solomon R. Guggenheim Museum, New York, October 3, 1962–January 6, 1963, *Modern Sculpture from the Joseph H. Hirshhorn Collection,* no. 26
Marlborough-Gerson Gallery, New York, November–December 1963, *Artist and Maecenas: A Tribute to Curt Valentin,* no. 60, ill. p. 19

REFERENCES:
Schult, Friedrich. *Ernst Barlach: das plastische Werk,* I, Hamburg, Hauswedell, 1960, no. 483, p. 252, ill.
Unsigned. "A Collector's Secret," *Toronto Globe & Mail,* September 14, 1957, ill.

GIANFRANCO BARUCHELLO (b. 1924)

Born Livorno, Italy, August 29, 1924. Studied, Rome. First paintings, 1959. Included in: "The New Realists," Sidney Janis Gallery, New York, 1962; IV and VI San Marino Biennale, 1963, 1967; "European Drawings," The Solomon R. Guggenheim Museum, New York, 1967; Pittsburgh International, 1967; Salon de Mai, Paris, 1968. One-man shows: Galleria La Tartaruga, Rome, 1963; Cordier & Ekstrom, New York, 1964, 1966; Galleria Schwarz, Milan, 1965, 1966, 1968, 1970; Galleria Il Punto, Turin, 1966; Palais des Beaux-Arts, Brussels, 1967; Galerie Alfred Schmela, Düsseldorf, 1967; Galerie Lauter, Mannheim, Germany, 1969. Collaborated on film *La Verifica incenta,* with Alberto Griffi, 1963–64; shown, Festa della Nuova Musica, Palermo, Italy, 1965. Lives in Rome.

Unavoidable Difficulties in the Garden of Eden. 1964.
Paint on Plexiglas, 18 × 22 inches
Signed and dated on back: "Baruchello 1964"

PROVENANCE:
Cordier & Ekstrom, New York, 1964

EXHIBITIONS:
Cordier & Ekstrom, New York, March 31–April 25, 1964, *Gianfranco Baruchello*

ANTOINE-LOUIS BARYE (1796–1875)

Born Paris, September 24, 1796; son of a goldsmith. Apprenticed to metal engraver Fourier, 1810. Studied, Paris: with sculptor François-Joseph Bosio, 1816; with painter Baron Antoine-Jean Gros, 1817; École des Beaux-Arts, 1818–24. Received second prize, competition for Prix de Rome, 1820. Worked for goldsmith Jacques-Henri Fauconnier, 1823–31. Exhibited, the Salon, Paris, 1831–37, 1850–75. Légion d'honneur: chevalier, 1833; officier, 1855. Public commissions, Paris, 1836: *Walking Lion,* July Column, Place de la Bastille; *Seated Lion,* Jardin des Tuileries. Curator of plaster replicas, Musée du Louvre, 1848–50. Professor of zoological drawing, Musée d'Histoire Naturelle, Paris, 1854–75. Awarded Grande Médaille d'Honneur, Exposition

Universelle de 1855, Paris. Commissions, 1860–63: reliefs, *Two Rivers* and *Napoleon III,* Musée du Louvre; *Equestrian Monument of Napoleon I,* Ajaccio, Corsica. President, Union Centrale des Arts Appliqués à l'Industrie, 1863. Member, Académie des Beaux-Arts, 1868. Died Paris, June 25, 1875. Memorial retrospective, École des Beaux-Arts, 1875–76. Retrospective, Musée du Louvre, 1956–57.

Tiger Devouring an Antelope. c. 1830.
Bronze, 13¼ × 20⅜ × 11 inches
Markings: back of base "Barye"

PROVENANCE:
George Bailey Wheeler; Alice Hoyt Dominick, New York; Parke-Bernet Galleries, New York, Sale 1625, November 17–19, 1955, no. 96, ill.; James Graham and Sons, New York, 1963

EXHIBITIONS:
The Alan Gallery, New York, December 4–31, 1961, *The Romantic Temperament,* no. 4

Theseus Slaying the Centaur Bianor. 1850.
Bronze, 50 × 43 × 17⅜ inches
Markings: front of base "A. L. Barye"
back of base, l. l. "A. L. Barye Paris 1850"
back of base, l. r. "F. Barbedienne, Fondeur, Paris"

PROVENANCE:
James Graham and Sons, New York, 1962

LEONARD BASKIN (b. 1922)

Born New Brunswick, New Jersey, August 15, 1922. Moved with family to Brooklyn, New York, 1929. Studied: Educational Alliance Art School, New York, with Maurice Glickman, 1937–39; New York University, 1939–41; Yale University, New Haven, Connecticut, 1941–43. Founded The Gehenna Press, Yale University, 1942. Sculpture exhibited: Glickman Studio Gallery, New York, 1939; Gallery, School of Architecture and Allied Arts, New York University, 1940. Served, U.S. Navy, 1943–46. Received: Louis Comfort Tiffany Foundation Fellowship, 1947; Guggenheim Foundation Fellowship, 1953. Studied: New School for Social Research, New York, B.A., 1949; Académie de la Grande Chaumière, Paris, 1950; Accademia di Belle Arti e Liceo Artistico, Florence, 1951. One-man show, Galleria Numero, Florence (prints), 1951. Taught, School of the Worcester Art Museum, Massachusetts, 1952–53. One-man shows: Boris Mirski Gallery, Boston, 1952–69; Grace Borgenicht Gallery, New York, 1953–69; Worcester Art Museum, 1956–57; The Museum of Modern Art, New York, International Circulating Exhibition, 1961–62. Included in: VI São Paulo Bienal, 1961; Venice Biennale, 1968. The National Institute of Arts and Letters, and The American Academy of Arts and Letters: grant, 1961; Gold Medal for Graphic Art, 1969. Retrospective, Bowdoin College Museum of Art, Brunswick, Maine, 1962. Illustrated books: Homer, *The Iliad* (University of Chicago), 1962; Dante Alighieri, *The Divine Comedy* (New York, Grossman), 1969; Jonathan Swift, *A Modest Proposal* (New York, Grossman), 1970. Awarded Medal of Merit, American Institute of Graphic Arts, 1965. One-man shows: Nationalmuseum, Stockholm, 1968; National Collection of Fine Arts, Smithsonian Institution, Washington, D.C., 1970; Kennedy Galleries, New York, 1971. Has taught, Smith College, Northampton, Massachusetts, since 1953. Director of The Gehenna Press, Northampton, since 1953. Lives in Northampton.

The Guardian. 1956.
Limestone, 26 × 9⅜ × 9⅜ inches

PROVENANCE:
Grace Borgenicht Gallery, New York, 1957

EXHIBITIONS:
Worcester Art Museum, Massachusetts, November 30, 1956–January 1, 1957, *Leonard Baskin: Sculpture, Drawings, Woodcuts,* no. 10, ill. p. 7
Grace Borgenicht Gallery, New York, January 28–February 16, 1957, *Leonard Baskin*
The Arts Club of Chicago, November 7–December 8, 1958, *Six American Sculptors: Baskin, Furr, Glasco, Lipton, Schmidt, Shor,* no. 5; toured to Milwaukee Art Center, December 18–January 20, 1959
The Detroit Institute of Arts, and tour, 1959–60, *Sculpture in Our Time,* no. 55
The Solomon R. Guggenheim Museum, New York, October 3, 1962–January 6, 1963, *Modern Sculpture from the Joseph H. Hirshhorn Collection,* no. 29

REFERENCES:
Morse, Samuel French. "Little Men in Big Business," *The New York Times Book Review,* March 19, 1961, p. 38, ill.
Saltmarche, Kenneth. "Notes on Special Exhibitions: 'Sculpture in Our Time,'" *The Art Quarterly,* 22, Winter 1959, p. 351
Young, Vernon. "In the Galleries: Leonard Baskin," *Arts,* 31, March 1957, p. 53

Hephaestus. 1963, cast 1965.
Bronze, 64½ × 27⅛ × 23⅛ inches
Markings: rear l. r. of base "Baskin 1963
Bedi-Rassy Foundry
3 of 4"

PROVENANCE:
Grace Borgenicht Gallery, New York, 1965

CARLO BATTAGLIA (b. 1933)

Born La Maddalena, Sardinia, Italy, January 28, 1933. Studied, Accademia di Belle Arti e Liceo Artistico, Rome; diploma in scenography, 1957. Lived in Paris, 1962; New York, 1967. One-man show, Galleria La Salita, Rome, 1964. Included in: "Arte Nuova," Konsthall, Lund, Sweden, 1964; "Nuove Proposte," Galleria Arco d'Alibert, Rome, 1966; "Works on Paper," The Art Institute of Chicago, 1971; "Progetto e immagine," Centro Culturale Nuova Dimensione, Pescara, Italy, 1972. One-man shows: Salone Annunciata, Milan, 1966,

1968, 1970, 1971; Galleria Arco d'Alibert, 1968; Qui Arte Contemporanea, Rome, 1969, 1972; Venice Biennale, 1971; Deson-Zaks Gallery, Chicago, 1971; Galleria Peccolo, Livorno, Italy, 1972; Deutsche-Italienische Vereinigung, Frankfort, 1972. Also works in theater and film. Lives in Rome.

Libra. 1969.
Oil and tempera on canvas, 9 feet 10½ inches × 4 feet 3⅛ inches
Signed on back: "Carlo Battaglia Libra 1969"

PROVENANCE:
The artist, Rome, 1969

MARY BAUERMEISTER (b. 1934)

Born Frankfort, September 7, 1934. Studied, Germany: Hochschule für Gestaltung, Ulm, 1954–55; Staatliche Werkkunstschule, Saarbrücken, 1955–56; Fereinkursen für Neue Musik, Darmstadt, with Karlheinz Stockhausen, 1961. First one-man show, opening with three-day performance of electronic music by Stockhausen, Stedelijk Museum, Amsterdam, 1962. Lived in New York, 1962–70. Included in: Whitney Annual, 1964, 1966, 1968; "1 + 1 = 3 (Retinal Art)," University Art Museum, University of Texas at Austin, 1964–65; Pittsburgh International, 1967; Contemporary American Exhibition, University of Illinois, Champaign-Urbana, 1969. One-man shows: Gemeentemuseum, The Hague, 1963; Galeria Bonino, New York, 1965, 1967, 1970; Galleria Schwarz, Milan, 1972; Staempfli Gallery, New York, 1972; Galería Bonino, Buenos Aires, 1972. Retrospective, Mittelrhein-Museum, Koblenz, Germany, 1972. Lives in Forsbach, near Cologne, and in Madison, Connecticut.

Pst . . . Who Knows Wh 1966.
Construction of glass, lenses, drawings, and wooden spheres, 47 × 37½ × 4 inches
Signed on back: "M Bauermeister 1966"

PROVENANCE:
Galeria Bonino, New York, 1966

EXHIBITIONS:
Whitney Museum of American Art, New York, December 6, 1966–January 29, 1967, 1966 Annual Exhibition of Contemporary Sculpture and Prints, no. 9
Galeria Bonino, New York, February 7–March 4, 1967, Bauermeister: Paintings and Constructions, no. 2, colorplate

"To describe the working process: I covered the background layer of writing and 'descendant objects' with a layer of glass, on which I glued optical lenses to distort the elements of the background. Images become doubled or reversed, black lines become colorful by defraction. I wanted to unfix what I did in the background, or make it more ambiguous. I then placed wooden spheres on top of that glass layer and partly copied what I now saw through the lenses, or I drew combinations of the elements. I finally added another layer of glass and lenses to further distort the background and the middle layer. I tried to reach a state where one cannot discern anymore what is a real drawing or a distortion, or a drawing of that distortion. What is illusion (color)—momentary or stable; or what is really there. Maybe the color is really there? Or in our eyes? Or that's it altogether? Maybe it's the only thing which is real?"

Statement by the artist, 1972

WILLIAM BAZIOTES (1912–1963)

Born Pittsburgh, June 11, 1912. Youth spent in Reading, Pennsylvania; worked for stained glass company, c. 1931–32. Moved to New York, 1933. Studied, National Academy of Design, New York, with Leon Kroll, 1933–36. WPA Federal Art Project, New York; teacher, 1936–38; Easel Division, 1938–41. Included in: "First Papers of Surrealism," 451 Madison Avenue, New York, 1942; Venice Biennale, 1948; "Twentieth Century Painters," The Metropolitan Museum of Art, New York, 1950; "15 Americans," The Museum of Modern Art, New York, 1952; "Four Abstract Expressionists," Walker Art Center, Minneapolis, 1953; II São Paulo Bienal, 1953; "The New Decade," Whitney Museum of American Art, New York, 1955; Documenta II, Kassel, 1959; "Vanguard American Painting," European tour, organized by The Solomon R. Guggenheim Museum, New York, for the U.S. Information Agency, 1961–62. One-man shows, New York: Peggy Guggenheim's Art of This Century, 1944; Kootz Gallery, 1946–58. Awarded Campania Memorial Prize, 58th American Exhibition, The Art Institute of Chicago, 1947–48. Co-founded Subjects of the Artist: A New Art School, New York, with Mark Rothko, Robert Motherwell, Barnett Newman, and David Hare, 1948. Taught, New York: The Brooklyn Museum Art School, and New York University, School of Education, 1949–52; People's Art Center, The Museum of Modern Art, 1950–52; Hunter College, 1952–62. Awarded Logan Medal, 64th American Exhibition, The Art Institute of Chicago, 1961. Died New York, June 5, 1963. Memorial exhibition, The Solomon R. Guggenheim Museum, and tour, 1965–66. Retrospective, Marlborough Gallery, New York, 1971.

Green Night. 1957.
Oil on canvas, 36 × 48 inches
Signed l. r.: "Baziotes"

PROVENANCE:
Kootz Gallery, New York, 1958

EXHIBITIONS:
Kootz Gallery, New York, February 18–March 8, 1958, Baziotes, no. 8
Fieldston School, Riverdale, New York, April 24–May 5, 1958, Second Annual Art Exhibition
Walker Art Center, Minneapolis, March–May 1960, Sixty American Painters 1960, no. 1, ill. p. 8
Galerie Würthle, Vienna, June 19–July 8, 1961, Vanguard American Painting (organized by The Solomon R. Guggenheim Museum, New York, for the U.S. Information Agency), no. 8, ill.; toured to nine European cities
Fine Arts Pavilion, Seattle World's Fair, April 21–

October 21, 1962, Art Since 1950, no. 2, ill. p. 16; toured to Rose Art Museum, Brandeis University, Waltham, Massachusetts, and Institute of Contemporary Art, Boston, November 21–December 23
The Solomon R. Guggenheim Museum, New York, February 5–March 21, 1965, William Baziotes: A Memorial Exhibition, no. 32, ill; toured to eleven U.S. cities

ROMARE BEARDEN (b. 1914)

Romare Howard Bearden, born Charlotte, North Carolina, September 2, 1914. Studied: New York University, B.S., 1935; The Art Students League of New York, with George Grosz, 1936–37; Université de Paris à la Sorbonne, 1950–51. Caseworker, New York City Department of Social Services, 1938–42, 1946–49, 1952–66. Included in: "The Art of the American Negro," Tanner Art Galleries, Chicago, 1940; "Paintings and Sculpture by American Negro Artists," Institute of Modern Art, Boston, 1943. One-man shows: studio of Ad Bates, New York, 1940; The G Place Gallery, Washington, D.C., 1944; Kootz Gallery, New York, 1945–47; Niveau Gallery, New York, 1948. Served, U.S. Army, 1942–45. Included in: Whitney Annual, 1945, 1946, 1955, 1969, 1972; "Advancing American Art," The Metropolitan Museum of Art, New York, and tour, 1946; "Introduction à la Peinture Moderne Américaine," Galerie Maeght, Paris (sponsored by the U.S. Information Agency), 1947. Member, ASCAP, 1951. One-man shows: Barone Gallery, New York, 1955; Michel Warren Gallery, New York, 1960; Cordier & Warren Gallery, New York, 1961; Cordier & Ekstrom, New York, from 1964; The Corcoran Gallery of Art, Washington, D.C., 1966; The J. L. Hudson Gallery, Detroit, 1967; Art Gallery, State University of New York at Albany, 1968. Included in: Pittsburgh International, 1961; "Afro-American Artists, New York and Boston," Institute of Contemporary Art, Boston, 1970; "10 Independents: An Artist-Initiated Exhibition," The Solomon R. Guggenheim Museum, New York, 1972. Art Director, Harlem Cultural Council, New York, from 1964. Received: grant, The National Institute of Arts and Letters, and The American Academy of Arts and Letters, 1966; Guggenheim Foundation Fellowship, 1970. Co-authored The Painter's Mind (New York, Crown), with Carl Holty, 1969. Retrospective, The Museum of Modern Art, New York, and tour, 1971–72. Mural, Our Festival Is in 980 Parks, commissioned by New York City Parks, Recreation, and Cultural Affairs Administration, for Times Square, 1972. Member, The National Institute of Arts and Letters, 1972. Lives in New York.

The Prevalence of Ritual: Baptism. 1964.
Collage on composition board, 9 × 12 inches
Signed l. l.: "romare bearden"

PROVENANCE:
Cordier & Ekstrom, New York, 1964

EXHIBITIONS:
Cordier & Ekstrom, New York, October 6–24, 1964, Romare Bearden
The Museum of Modern Art, New York, March 25–June 7, 1971, Romare Bearden: The Prevalence of Ritual, no. 9, colorplate p. 6; toured to National Collection of Fine Arts, Smithsonian Institution, Washington, D.C., July 16–September 12; University Art Museum, University of California, Berkeley, October 25–December 5; Pasadena Art Museum, California, December 20–January 30, 1972; High Museum of Art, Atlanta, Georgia, February 27–April 9

REFERENCES:
Ashton, Dore. "Romare Bearden Projections," Quadrum, 17, 1964, p. 101, ill.
Fine, Elsa H. The Afro-American Artist, New York, Holt, Rinehart & Winston, 1974, plate 18, p.164
Washington, M. Bunch. The Art of Romare Bearden: The Prevalence of Ritual, New York, Abrams, 1973, plate 7

"These works represent my attempt to find out about the lives and rituals of Black people. Those things that relate them to the great myths and rituals of the world. The continuance of the cleansing ritual of Baptism, then, comes down from ancient times, and finds expression in the Baptism I used to observe in the summer months in the South."

Statement by the artist, 1971

Watching the Good Train Go By: Cotton. 1964.
Collage on composition board, 11 × 14 inches

PROVENANCE:
Cordier & Ekstrom, New York, 1964

EXHIBITIONS:
Cordier & Ekstrom, New York, October 6–24, 1964, Romare Bearden

REFERENCES:
Washington, M. Bunch. The Art of Romare Bearden: The Prevalence of Ritual, New York, Abrams, 1973, plate 28

"When I was a young boy in the South, people would go to the depots to fraternize and to look at the trains go by. The good trains were the fast express and mail trains. By their ways of blowing the train whistles [we] knew what engineer was in the cab."

Statement by the artist, 1971

ROBERT BEAUCHAMP (b. 1923)

Born Denver, November 19, 1923. Studied, Colorado Springs Fine Arts Center, with Boardman Robinson, 1941, 1946–48. Served, U.S. Navy, 1942–46. Studied: Cranbrook Academy of Art, Bloomfield Hills, Michigan, 1948, 1950; University of Denver, 1949; Hans Hofmann School of Fine Art, New York, 1950–53. One-man shows, New York: Tanager Gallery, 1953, 1955; Great Jones Gallery, 1959, 1960; The Green Gallery, 1961, 1963. Included in: Pittsburgh International, 1958, 1961; "Recent Painting USA: The Figure," The Museum of Modern Art, New York, and tour, 1962–63; Whitney

Annual, 1963, 1965, 1967, 1969. Received: Fulbright Grant, to study in Rome, 1959; National Council on the Arts Grant, 1966. One-man shows, New York: James Graham and Sons, 1966, 1967, 1969; French & Company, 1972. Taught: University of Wisconsin, Madison, 1968; The Cooper Union for the Advancement of Science and Art, New York, 1969–70. Included in "10 Independents: An Artist-Initiated Exhibition," The Solomon R. Guggenheim Museum, New York, 1972. Received Guggenheim Foundation Fellowship, 1974. Lives in New York.

Yellow Bird. 1968.
Oil on canvas, 5 feet 6¾ inches × 13 feet 4½ inches
Signed and dated l. r.: "Robert Beauchamp 1/68"

PROVENANCE:
James Graham and Sons, New York, 1969

EXHIBITIONS:
James Graham and Sons, New York, October 8–30, 1969, Robert Beauchamp

REFERENCES:
Brown, Gordon. "In the Galleries: Robert Beauchamp," Arts Magazine, 44, November 1969, p. 58, ill.

"Red-eyed big yellow bird, a blue horned ape riding a red scorpion pulling—what? Wild horses dodging lassos, a speeding snake, poisonous jelly fish, a big-footed placid nude watching it all—comic, foreboding, intimidating, plastically inevitable—so it seems to me."

Statement by the artist, 1972

MAX BECKMANN (1884–1950)

Born Leipzig, February 12, 1884. Studied, Kunstschule, Weimar, Germany, with Carl Frithjof Smith, 1900–1903. Moved to Berlin, after brief stay in Paris, 1903–4. Included in: Künstlerbundausstellung, Weimar, 1906; Berliner Sezession, 1906–14. Received Villa Romana Prize, to work in Florence, 1907. Exhibited with: Georg Minne, Kunstgewerbemuseum, Weimar, 1907; Jules Pascin, Kunstverein, Hamburg, 1914. One-man shows, Galerie Paul Cassirer, Berlin, 1913, 1925. Moved to Frankfort, after medical discharge from Army Medical Corps, 1915. One-man shows: J. B. Neumann's Graphisches Kabinett, Berlin, 1917; Zinglers Kabinett, Frankfort, 1922. Included in: Venice Biennale, 1922, 1930; "Die Neue Sachlichkeit," Städtische Kunsthalle, Mannheim, Germany, with George Grosz, Otto Dix, and others, 1925; Carnegie International, 1929 (honorable mention); "German Painting and Sculpture," The Museum of Modern Art, New York, 1931. Wrote and illustrated play Ebbi (Vienna, Johannes Presse), 1924. Taught, Städelsches Kunstinstitut, Frankfort, from 1925; dismissed from faculty, by Nazi regime, 1933. One-man shows: J. B. Neumann's New Art Circle, New York, 1926, 1927; Kestner-Gesellschaft, Hanover, 1931; Galerie de la Renaissance, Paris, 1931. Retrospectives: Städtische Kunsthalle, Mannheim, 1928; Kunsthalle, Basel, and Kunsthaus, Zurich, 1930. Over five hundred works confiscated by Nazis; ten paintings included in "Entartete Kunst (Degenerate Art)," Munich, and tour, 1937. Moved to Amsterdam, 1937; never returned to Germany. One-man shows: Buchholz Gallery, New York, 1938, 1939–41, 1945–47, 1949, 1951; Stedelijk Museum, Amsterdam, 1945; Galerie Günther Franke, Munich, 1946; Städelsches Kunstinstitut, Frankfort, 1947. Awarded first prize, Contemporary European Section, Golden Gate International Exposition, San Francisco, 1939. Emigrated to the U.S., 1947. Taught: Washington University, St. Louis, Missouri, 1947–49; University of Colorado, Boulder, summer, 1949; The Brooklyn Museum Art School, New York, 1949–50; Mills College, Oakland, California, summer, 1950. Retrospective, City Art Museum of St. Louis, and tour, 1948. Awarded: first prize, Carnegie Annual, 1949; Grand Prize for Painting, Venice Biennale, 1950. Died New York, December 27, 1950. Memorial exhibition, Haus der Kunst, Munich, 1951. Max Beckmann Society founded, Munich, 1953. One-man show, Curt Valentin Gallery, New York, 1954. Retrospectives: The Museum of Modern Art, and tour, 1964–65; Musée National d'Art Moderne, Paris, and tour, 1968–69.

Still Life with Musical Instruments. 1950.
Oil on canvas, 36 × 55 inches
Signed and dated l. r.: "Beckmann N.Y. 50"

PROVENANCE:
Curt Valentin Gallery, New York, 1955

EXHIBITIONS:
XXV Biennale Internazionale d'Arte, Venice, June–September 1950, German Pavilion, no. 98, p. 312
Buchholz Gallery, New York, April 3–28, 1951, Max Beckmann, no. 1, ill.
Curt Valentin Gallery, New York, December 18, 1951–January 12, 1952, Contemporary Paintings and Sculpture, no. 6
Curt Valentin Gallery, New York, January 26–February 20, 1954, Max Beckmann, no. 23
Curt Valentin Gallery, New York, June 8–August 31, 1955, Closing Exhibition, no. 7
American Federation of Arts tour, 1962–65, Paintings from the Joseph H. Hirshhorn Foundation Collection: A View of the Protean Century, no. 9, ill. p. 18

REFERENCES:
The Museum of Modern Art, New York. Curt Valentin Gallery Photo Archives, vol. 3, p. 1

LELAND BELL (b. 1922)

Born Cambridge, Maryland, September 17, 1922. Moved to New York, 1940. Self-taught as an artist; encouraged by Karl Knaths. First one-man show, Jane Street Gallery, New York, 1946. Traveled: Iceland, 1946–47; France, 1950–51. Taught: Philadelphia Museum School of Art, 1951–52; Pratt Institute, Brooklyn, New York, 1953. One-man shows, New York: Hansa Gallery, 1955; Poindexter Gallery, 1957, 1959; Zabriskie Gallery, 1961; Robert Schoelkopf Gallery, from 1964. Traveled to France, 1962–63. Included in: "Five American Painters: Leland Bell, Nell Blaine, Robert de Niro, Louisa Matthiasdottir, Hyde Solomon," M. Knoedler & Co., New York, 1963; Pennsylvania Academy Annual, 1964.

Taught: New School for Social Research, New York, 1958–60; Yale University, New Haven, Connecticut, 1964; Indiana University, Bloomington, 1965; The University of Iowa, Iowa City, 1966; Kansas City Art Institute and School of Design, Missouri, 1966; New York Studio School, from 1964; The Cooper Union for the Advancement of Science and Art, New York, from 1971. Received grants: The National Council on the Arts, 1967; The National Institute of Arts and Letters, and The American Academy of Arts and Letters, 1970. Lives in New York.

Self-Portrait. 1961.
Oil on canvas, 29 × 21½ inches
Signed on back: "Leland Bell"

PROVENANCE:
Robert Schoelkopf Gallery, New York; M. Knoedler & Co., New York, 1963

EXHIBITIONS:
M. Knoedler & Co., New York, September 16–30, 1963, *Five American Painters: Leland Bell, Nell Blaine, Robert de Niro, Louisa Matthiasdottir, Hyde Solomon*, no. 6

REFERENCES:
Kramer, Hilton. "Notes on Painting in New York," *Arts Yearbook 7*, 1964, ill. p. 18

GEORGE BELLOWS (1882–1925)

George Wesley Bellows, born Columbus, Ohio, August 12, 1882. Studied: Ohio State University, Columbus, 1901–4; New York School of Art, with Robert Henri, 1904–6. First exhibited, Society of American Artists, New York, 1906. National Academy of Design, New York: awarded Second Hallgarten Prize, Annual, 1908; associate, 1909; academician, 1913; awarded Maynard Portrait Prize, Annual, 1914. Participated in: Original Independent Show, New York, 1908; Exhibition of Independent Artists, New York, 1910. Taught: The Art Students League of New York, 1910–11, 1917–19; Ferrer Center, New York, 1912, 1919; students included William Gropper, Moses Soyer, and Niles Spencer. One-man shows: Madison Gallery, New York, 1911; The Detroit Institute of Arts, 1913. Contributed to *The Masses* (John Sloan, art editor), 1912–17. Member, General Executive Committee, Association of American Painters and Sculptors, organizers of the Armory Show; fourteen of his works included, 1913. One-man shows: Montross Gallery, New York, 1914, 1921; Whitney-Richards Galleries, New York, 1915; The Milch Galleries, New York, 1917, 1918; M. Knoedler & Co., New York, 1918; Albright Art Gallery, Buffalo, New York, 1919; The Art Institute of Chicago, 1919. Awarded Gold Medal, Panama-Pacific International Exposition, San Francisco, 1915. First lithographs, 1916. Member, board of directors, Society of Independent Artists, New York, 1917. Summered, Woodstock, New York, 1920–24. Illustrated serialized stories: Donn Byrne's "The Wind Bloweth," *The Century Magazine*, 1921–22; H. G. Wells's "Men Like Gods," *The International Magazine*, 1922–23. Awarded: Beck Gold Medal, Pennsylvania Academy Annual, 1921; First Class Medal, Carnegie International, 1922; Corcoran Gold Medal, and First Clark Prize, Corcoran Biennial, 1924. Died New York, January 8, 1925. Memorial exhibition, The Metropolitan Museum of Art, New York, 1925. One-man shows: H. V. Allison & Co., New York, from 1941; Smithsonian Institution, Washington, D.C., Traveling Exhibition Service (prints and drawings), 1957–58; Hirschl & Adler Galleries, New York, 1971. Retrospectives: The Art Institute of Chicago, 1946; The National Gallery of Art, Washington, D.C., 1957; The Gallery of Modern Art, New York, 1966.

Bethesda Fountain (Fountain in Central Park). 1905.
Oil on canvas, 20¼ × 24¼ inches
Signed l. l.: "Geo. Bellows"

PROVENANCE:
The artist, New York; Colonel George Gerlach; M. Knoedler & Co., New York; John G. Lowe, New York; The Denver Art Museum; M. Knoedler & Co.; Zabriskie Gallery, New York, 1957

EXHIBITIONS:
Zabriskie Gallery, New York, June 17–July 21, 1957, *The City: 1900–1930*, no. 14
Temple B'nai Sholom, Rockville Centre, New York, March 31–April 3, 1963, *4th Annual Art Exhibit and Sale*, no. 1
Robert Schoelkopf Gallery, New York, June 2–30, 1964, *New York*

REFERENCES:
Devree, Howard. "Gallery Activity," *The New York Times*, June 23, 1957, sec. 2, part 1, p. 14

Emma Bellows, the artist's wife, is shown in Central Park, New York, seated beside Bethesda Fountain (which was named after the healing pool in Biblical Jerusalem [John 5:2]). In 1914 Bellows gave the painting as a wedding present to his cousin Colonel George Gerlach.

Hudson River: Coming Squall (A Cloudy Day). 1908.
Oil on panel, 30 × 38¼ inches
Signed l. l.: "Geo. Bellows"

PROVENANCE:
Whitney-Richards Galleries, New York; Montross Gallery, New York; The American Art Galleries, New York, Sale, *American Paintings Selected by Mr. N. E. Montross*, February 8, 1923, no. 20, ill.; R. C. & N. M. Vose Galleries, Boston; Mrs. Robert C. Vose, Sr., Boston; M. Knoedler & Co., New York; John Jacob Astor, New York; M. Knoedler & Co., 1957

EXHIBITIONS:
Whitney-Richards Galleries, New York, December 15–31, 1915, *Paintings and Drawings by George Bellows*
Montross Gallery, New York, December 3–31, 1921, *Paintings, Drawings and Lithographs by George Bellows*
Montross Gallery, New York, May 1922, *Paintings by American Artists*
R. C. & N. M. Vose Galleries, Boston, May–June 1923, *Group Exhibition*
Wilmington Society of the Fine Arts, Delaware Art Center, December 7–31, 1939, *Exhibition of Paintings and Watercolors*, no. 5
Joslyn Art Museum, Omaha, Nebraska, November 28–December 30, 1941, *10th Anniversary Exhibition of Masterpieces*
Wilmington Society of the Fine Arts, Delaware Art Center, January 7–25, 1942, *American Figure Painters of the Last Half Century*, no. 1
M. Knoedler & Co., New York, November 20–December 9, 1944, *American Painting of the 19th and 20th Century*, no. 19
M. Knoedler & Co., New York, January 28–March 1, 1957, *Twentieth Century American Painters*, no. 26
American Federation of Arts tour, 1962–65, *Paintings from the Joseph H. Hirshhorn Foundation Collection: A View of the Protean Century*, no. 11, ill. p. 10

REFERENCES:
Bellows, George. *Artist's Notebook A*, p. 47, courtesy H. V. Allison, New York
Sherburne, Ernest C. "Boston," *Art News*, 21, June 9, 1923, p. 9
Unsigned. "Americans of Varied Tendencies," *American Art News*, 20, May 13, 1922, p. 1
———. "$45,630 Is Realized For Montross Art," *Art News*, 21, February 17, 1923, p. 4
———. "George Bellows, His Personality," *American Art News*, 20, December 10, 1921, p. 2
———. "The George Bellows Show," *American Art News*, 14, December 18, 1915, p. 3
———. "Great Examples of American Painting in N. E. Montross Sale," *American Art News*, 11, January 27, 1923, p. 5

The Sea. 1911.
Oil on canvas, 33 × 44 inches
Signed l. l.: "Geo. Bellows"

PROVENANCE:
H. V. Allison & Co., New York; Robert Sterling Clark, New York; M. Knoedler & Co., New York, 1957

EXHIBITIONS:
The Pennsylvania Academy of the Fine Arts, Philadelphia, February 4–March 24, 1912, *One Hundred and Seventh Annual*, no. 669
The Toledo Museum of Art, Ohio, December 1912, *Special Exhibition*
The Detroit Institute of Arts, January 1–29, 1913, *Paintings by George Bellows*
The Art Association of Newport, Rhode Island, July 21–31, 1913, *Second Annual Exhibition of Pictures by American Painters*, no. 3
H. V. Allison & Co., New York, November 7–December 15, 1945, *Paintings by George Bellows*, cat.
American Federation of Arts tour, 1962–65, *Paintings from the Joseph H. Hirshhorn Foundation Collection: A View of the Protean Century*, no. 10, p. 5
The Rotunda, Asbury Park, New Jersey, May 2–31, 1965, *The Spell of the Sea* (sponsored by the Monmouth Museum), no. 58

REFERENCES:
Bellows, George. *Artist's Notebook A*, courtesy H. V. Allison, New York, p. 121
Braider, Donald. *George Bellows and the Ashcan School of Painting*, Garden City, New York, Doubleday, 1971, p. 73
Coffin, Charles Z., ed. *Pictures on Exhibit*, 1, November 1945, ill. p. 28
Devree, Howard. "George Bellows and Others," *The New York Times*, November 18, 1945, sec. 2, p. 7
Gibbs, Jo. "Some of the Greatness that Was Bellows," *Art Digest*, 20, November 15, 1945, p. 24
Morgan, Charles. *George Bellows*, New York, Reynal, 1965, p. 146

ANTHONY BENJAMIN (b. 1931)

Born Boarhunt, Hampshire, England, March 29, 1931. Studied: with Fernand Léger, Paris, 1951; The Polytechnic, London, 1951–54; S. W. Hayter's Atelier 17, Paris, 1958–59. Worked at artists' colony, St. Ives, Cornwall, England, 1956–58. Exhibited with Joe Tilson and Jeffrey Steele, City of Manchester Art Galleries, England, 1956. One-man shows: Institute of Contemporary Arts, London, 1966; Zwemmer Gallery, London, 1967; Museum of Modern Art, Oxford, England, 1967. Included in "British Sculpture," Coventry Cathedral, England, 1968. Taught: University of Calgary, Alberta, Canada, 1968–70; Hayward State College, Berkeley, California, summer, 1970; York University, Toronto, 1970–72; Ontario College of Art, Toronto, 1972–73. One-man shows, 1970: Gimpel & Weitzenhoffer, Ltd., New York; Comsky Gallery, Los Angeles. Lives in London.

Nimbus V. 1970.
Chrome and plastic, 24 × 19¾ × 13 inches

PROVENANCE:
Gimpel & Weitzenhoffer, Ltd., New York, 1970

BEN BENN (b. 1884)

Benjamin Rosenberg, born Kaminetz Podolsk, Ukraine, Russia, December 27, 1884. Emigrated with family to New York, 1894; U.S. citizen, 1938. Studied, National Academy of Design, New York, 1904–8. Studio a meeting place for artists, writers, and musicians, including Marsden Hartley, Eugene O'Neill, Joseph Stella, Charles Demuth, and Abraham Walkowitz, 1915–30. Exhibited, New York: "The Forum Exhibition of Modern American Painters," The Anderson Galleries, 1916; Society of Independent Artists Annual, 1917. First one-man show, J. B. Neumann's New Art Circle, New York, 1925. Included in: Whitney Biennial, 1932–33, 1934–35; "American Sources of Modern Art," The Museum of Modern Art, New York, 1933; "Abstract Painting in America," The Whitney Museum of American Art, New York, 1935. One-man shows, New York: Gallery 144, 1932, 1933; The Artists' Gallery, 1938, 1941, 1949; Hacker Gallery, 1950, 1952, 1953; Salpeter Gallery, 1956, 1957, 1959; Babcock Galleries, 1967, 1970. Awarded: Schiedt Memorial Prize, Pennsylvania Academy Annual, 1952; Beck Gold Medal, Pennsylvania Academy Annual, 1966;

Marjorie Peabody Waite Award, The National Institute of Arts and Letters, 1971. Retrospectives: Walker Art Center, Minneapolis, 1953; Babcock Galleries, 1963; The Jewish Museum, New York, 1965. Lives in New York.

Suggestive Portrait (Walkowitz). 1917.
Oil on canvas, 38 × 30 inches
Signed and dated l. l.: "Benn '17"

PROVENANCE:
Zabriskie Gallery, New York, 1961

EXHIBITIONS:
The Brooklyn Museum, New York, February 9–March 12, 1944, *One Hundred Artists and Walkowitz*, ill. p. 4
Whitney Museum of American Art, New York, February 27–April 14, 1963, *The Decade of the Armory Show*, no. 2; toured to City Art Museum of St. Louis, Missouri, June 1–July 14; The Cleveland Museum of Art, August 6–September 15; The Pennsylvania Academy of the Fine Arts, Philadelphia, September 30–October 30; The Art Institute of Chicago, November 15–December 29; Albright-Knox Art Gallery, Buffalo, New York, January 20–February 23, 1964

FLETCHER BENTON (b. 1931)

Born Jackson, Ohio, February 25, 1931. Studied, Miami University, Oxford, Ohio, B.F.A., 1956. First one-man show, Gump's Gallery, San Francisco, 1957. Taught, California: California College of Arts and Crafts, Oakland, 1959; San Francisco Art Institute, 1964–68; San Jose State College, 1968–69. Included in: Winter Invitational, California Palace of the Legion of Honor, San Francisco, 1961–64; "Directions in Kinetic Sculpture," University Art Museum, University of California, Berkeley, and Santa Barbara Museum of Art, California, 1966; Whitney Annual, 1966, 1968; "American Sculpture of the Sixties," Los Angeles County Museum of Art, and Philadelphia Museum of Art, 1967; Pittsburgh International, 1967; Whitney Biennial, 1973. One-man shows: California Palace of the Legion of Honor, 1964; San Francisco Museum of Art, 1965; Hansen Gallery, San Francisco, 1965, 1966; Esther-Robles Gallery, Los Angeles, 1966, 1967, 1972; San Francisco Art Institute, 1967; Galeria Bonino, New York, 1968, 1969; Landry-Bonino Galleries, New York, 1972; Bernard Danenberg Galleries, New York, 1972; Phoenix Art Museum, Arizona, 1973. Lives in San Francisco.

Synchronetic C-637-S. 1968.
Plexiglas, Formica, and steel, with electric circuitry, 28 × 28 × 8¼ inches

PROVENANCE:
Galeria Bonino, New York, 1968

EXHIBITIONS:
Galeria Bonino, New York, February 6–March 2, 1968, *Fletcher Benton: Kinetic Sculpture*, ill. p. 3

THOMAS HART BENTON (b. 1889)

Born Neosho, Missouri, April 15, 1889. Studied: School of The Art Institute of Chicago, with Frederick Oswald, 1907–8; Académie Julian, Paris, 1908–11. Moved to New York, 1912. Participated in Synchromist movement (founded by Stanton Macdonald-Wright and Morgan Russell, Paris, 1912), 1915–18. Included in "The Forum Exhibition of Modern American Painters," The Anderson Galleries, New York, 1916. Draftsman, U.S. Navy, Norfolk, Virginia, 1918–19. Taught, The Art Students League of New York, 1926–35; Jackson Pollock and Fairfield Porter among his pupils. Mural commissions: *America Today*, New School for Social Research, New York, 1928; *The Arts of Life in America*, library, Whitney Museum of American Art, New York, 1932 (now in New Britain Museum of American Art, Connecticut); panorama *Social Evolution of Indiana*, Indiana Room, Hall of States, Century of Progress Exposition, Chicago, 1933 (now at Indiana University, Bloomington); *Social History of the State of Missouri*, Missouri State Capitol, Jefferson City, 1936. Awarded Gold Medal for mural work, Architectural League of New York, 1933. Closely associated with Regionalists John Steuart Curry and Grant Wood, 1930s. Returned to Missouri, 1935. One-man shows: Ferargil Galleries, New York, 1935; The Lakeside Press Galleries, Chicago, 1937; Associated American Artists Galleries, New York, 1939. Director of Painting, Kansas City Art Institute and School of Design, Missouri, 1935–41. Artist-reporter: *Life*, 1937; *St. Louis Post-Dispatch, Kansas City [Mo.] Star*, and Abbott Laboratories, Chicago, 1942–44. Authored: *An Artist in America* (New York, McBride), 1937; *An American in Art* (Lawrence, University of Kansas), 1969. Member: The National Institute of Arts and Letters, 1942; The American Academy of Arts and Letters, 1962. Included in "Romantic Painting in America," The Museum of Modern Art, New York, 1943. Retrospectives: Joslyn Art Museum, Omaha, Nebraska, 1951; New Britain Museum of American Art, 1954; Museum of Art, University of Kansas, Lawrence, 1958; Indiana University Art Museum, Bloomington, 1966. Mural commission, *Independence and the Opening of the West*, Harry S. Truman Memorial Library, Independence, Missouri, 1961–62. One-man shows: James Graham and Sons, New York, 1968, 1970; Rutgers University Art Gallery, The State University of New Jersey, New Brunswick, 1972. Lives in Kansas City, Missouri, and in Martha's Vineyard, Massachusetts.

People of Chilmark (Figure Composition). 1920.
Oil on canvas, 65¾ × 77½ inches
Signed l. r.: "Benton"

PROVENANCE:
The artist, New York; Private collection, New York; Parke-Bernet Galleries, New York, Sale 2199, May 15, 1963, no. 85, ill.; James Graham and Sons, New York, 1964

EXHIBITIONS:
Rutgers University Art Gallery, The State University of New Jersey, New Brunswick, November 19–December 30, 1972, *Thomas Hart Benton: A Retrospective of His Early Years, 1907–1929*, no. 13, ill.

REFERENCES:
Baigell, Matthew. *Thomas Hart Benton,* New York, Abrams, forthcoming, colorplate
Benton, Thomas Hart. *An Artist in America,* Columbia, University of Missouri, 1968, p. 53
Canaday, John. "Young Artist en Route to the U.S.A.," *The New York Times,* December 10, 1972, sec. 2, p. 27, ill.

The Cliffs. 1921.
Oil on canvas, 29¼ × 34½ inches
Signed and dated l. r.: "Benton/21"

PROVENANCE:
The artist, New York; Ethel Whiteside, New York; Earle Horter, Philadelphia; Zabriskie Gallery, New York, 1964

EXHIBITIONS:
The Pennsylvania Museum of Art (now the Philadelphia Museum of Art), February 17–March 14, 1934, *The Earle Horter Collection;* extended loan until 1950
The Corcoran Gallery of Art, Washington, D.C., October 9–November 14, 1971, *Wilderness* (sponsored by The National Endowment for the Arts), no. 15
Rutgers University Art Gallery, The State University of New Jersey, New Brunswick, November 19–December 30, 1972, *Thomas Hart Benton: A Retrospective of His Early Years, 1907–1929,* no. 12, ill.

"*The Cliffs,* 1921, is of south beach Chilmark, Martha's Vineyard. This was a favorite bathing beach, and was (and is) approached by the cleft shown in the picture. I made many studies of the subject during the twenties."

Statement by the artist, 1972

Field Workers (Cotton Pickers). 1945.
Oil on parchment paper, 8¾ × 13½ inches
Signed l. r.: "Benton 45"

PROVENANCE:
Associated American Artists, New York; Mrs. Elinor Lewenthal, New York; Parke-Bernet Galleries, New York, Sale 2120, June 7, 1962, no. 107, ill. p. 27

EXHIBITIONS:
Art Collectors Place, New York, October–November 1961, *Group Moderns*

"Many paintings and drawings of workers in the cotton fields (and of related activities) were made between 1928 and 1945. This is the last of these, and the most complex in design."

Statement by the artist, 1972

EUGENE BERMAN (1899–1972)

Born St. Petersburg, Russia, November 4, 1899. Lived in Germany, Switzerland, and France, 1908–13; moved to Paris, 1919. Studied, Académie Ranson, Paris, with Maurice Denis, and Édouard Vuillard, 1919–22. Exhibited, Paris: Salon d'Automne, 1923–25; Salon des Tuileries, 1925–27. Exhibited with his brother Léonid, Pavel Tchelitchew, Christian Bérard, and others: "Neo-Romantic" exhibitions, Galerie Druet, Paris, 1926; Balzac Galleries, New York, 1931. One-man shows: Julien Levy Gallery, New York, 1932–47; Galerie Pierre Colle, Paris, 1937. First visit to New York, 1935. Included in: "Modern Works of Art," "Modern Painters and Sculptors as Illustrators," and "Art in Our Time," The Museum of Modern Art, New York, 1934–35, 1936, 1939; Carnegie International, 1935, 1939; "European Art of This Century," Toledo Museum of Art, Ohio, 1938. Designed sets and costumes, Ballets Russes de Monte Carlo, 1938–39. Emigrated to the U.S., 1940; citizen, 1944. Retrospective, Institute of Modern Art, Boston, 1941. Included in: Carnegie Annual, 1943–50; Whitney Annual, 1945–50, 1955. One-man shows: Decker & Flynn Galleries, Los Angeles, 1944; 67 Gallery, New York, 1944; Hugo Gallery, New York, 1946; The Museum of Modern Art, 1947; M. Knoedler & Co., New York, 1947–65; Phoenix Art Museum, Arizona, 1963; Larcada Gallery, New York, 1969–72. Received Guggenheim Foundation Fellowship, 1947–49. Member: Accademia Filarmonica Romana, Rome, 1949; The National Institute of Arts and Letters, 1964. Designed sets and costumes, New York City Ballet, and Metropolitan Opera, New York, 1951–63. Moved to Rome, 1958. Retrospective, American Academy in Rome, 1970. Died Rome, December 14, 1972.

Nike. 1943.
Oil on canvas, 58⅛ × 38¼ inches
Signed and dated l. c.: "E.B./1943"

PROVENANCE:
Julien Levy Gallery, New York; Larcada Gallery, New York, 1970

EXHIBITIONS:
Julien Levy Gallery, New York, November 4–30, 1943, *Eugene Berman*
Durand-Ruel Galleries, New York, January 4–22, 1944, *Art News' Ten Best of 1943,* no. 3
Carnegie Institute, Pittsburgh, October 12–December 10, 1944, *Painting in the United States,* 1944, no. 95
Louisiana State University, Baton Rouge, September 15–October 6, 1953, *The Classical Motif* (The Museum of Modern Art, New York, Circulating Exhibition); toured to twelve cities
Larcada Gallery, New York, January 3–21, 1971, *Early Works of Eugene Berman, 1929–1949*

REFERENCES:
Levy, Julien. *Eugene Berman,* New York, American Studio Books, 1946, ill. p. 42
Riley, Maude. "Berman's Mythology," *Art Digest,* 18, November 1, 1943, p. 7, ill.
———. "Carnegie Institute Opens Exciting Survey of American Paintings," *Art Digest,* 19, October 15, 1944, p. 6
Unsigned. "What They Say About Art News' Ten Best of 1943,'" *Art News,* 42, January 15, 1944, pp. 16–17, ill. p. 16

"In 1943 I was spending part of my time in Hollywood, California. In the two previous years I had painted what

I called 'Western Landscapes,' but missing the lasting fascination of Italian landscapes and architecture, which had been the leitmotifs of most of my earlier work, and not finding the Western desert themes quite adequate in the long run, I decided to return to the figure painting of my earliest years in Paris (1920–1923)—in a different way!

So, I painted between 1942 and 1946 many figure compositions with allegorical (mythological) titles, and several imaginary or fantasy-portraits of Ona Munson, who was to become my wife in 1950. I used her often as a model for these paintings, making many sketches and studies of her (and of other models), and using these sketches as a basis for various large figure compositions—either a single figure or several figures together, in desertlike landscapes, rock formations, or ruins. *Nike* is one of these single-figure compositions, very typical for this period of my work."

Statement by the artist, 1972

MIGUEL BERROCAL (b. 1933)

Miguel Ortiz Berrocal, born Villanueva de Algaidas, Spain, September 28, 1933. Studied, Madrid: Real Academia de Bellas Artes de San Fernando; Escuela Nacional de Artes Gráficas; Escuela de Artes Aplicadas y Oficios Artísticos. Moved to Italy, 1952. One-man shows: Galleria La Medusa, Rome, 1958; Galleria Apollinaire, Milan, 1958, 1960; Galerie Kriegel, Paris, 1962, 1965, 1969. Included in: "Three Sculptors: Berrocal, Ipoustéguy, Müller," Albert Loeb Gallery, New York, 1962; Venice Biennale, 1964; Documenta III, Kassel, 1964; 8th Middelheim Biënnale, Antwerp, 1965; 4ᵉ Biennale de Paris, 1965 (Sculpture Prize); Pittsburgh International, 1967. Taught, Staatliche Hochschule für Bildende Künste, Hamburg, 1966. One-man shows: Albert Loeb & Krugier Gallery, New York, 1965; Gimpel Fils, London, 1967; Stedelijk van Abbemuseum, Eindhoven, The Netherlands, 1967; Kunstmuseum, Lucerne, Switzerland, 1967; Palais des Beaux-Arts, Brussels, 1968; Galerie Krugier et Cie., Geneva, 1968; Albert Loeb & Krugier Gallery, 1969; Galerie der Spiegel, Cologne, 1969; Kestner-Gesellschaft, Hanover, 1969; Cortina Galleria d'Arte Contemporanea, Milan, 1970; Galerie Iolas-Velasco, Madrid, 1972. Lives in Negrar, near Verona, Italy.

Caryatid. 1966.
Bronze, twenty-two separable parts, 14½ × 6½ × 3¼ inches
Markings inside: "Berrocal 6/9"

PROVENANCE:
Albert Loeb & Krugier Gallery, New York, 1969

EXHIBITIONS:
Albert Loeb & Krugier Gallery, New York, April 15–May 10, 1969, *Berrocal*

REFERENCES:
Gimpel Fils. *Berrocal,* London, 1967, no. 23
Unsigned. "Berrocal," *Taurus,* New York, 10, April 1969, p. 11

HARRY BERTOIA (b. 1915)

Born San Lorenzo, near Udine, Italy, March 10, 1915. Emigrated with father to the U.S., 1930; citizen, 1946. Studied: Art School of the Society of Arts and Crafts, Detroit, 1936; Cranbrook Academy of Art, Bloomfield Hills, Michigan, 1937–38, and taught there, 1939–43. Monoprints included in "Loan Exhibition," Museum of Non-Objective Painting, New York, 1943. Worked with Charles Eames, Venice, California, 1943–44. Graphic designer, Point Loma Naval Electronics Laboratory, San Diego, California, 1947–49. One-man shows: Nierendorf Gallery, New York (graphics and jewelry), 1943, 1945, 1947; San Francisco Museum of Art (monoprints), 1945; Knoll Associates, New York (sculpture), 1951. Introduction of Bertoia chair for Knoll, 1952. Sculpture commissions: General Motors Technical Center, Warren, Michigan, 1953; Massachusetts Institute of Technology, Cambridge, 1955; U.S. Pavilion, Exposition Universelle et Internationale de Bruxelles, 1958; Dulles International Airport, Chantilly, Virginia, 1963; Princeton University, New Jersey, 1964; Rochester Institute of Technology, New York, 1968. Awarded Craftsmanship Medal, American Institute of Architects, 1956. One-man shows, sculpture: Fairweather-Hardin Gallery, Chicago, 1956, 1961, 1968; Staempfli Gallery, New York, from 1959. Received Graham Foundation Fellowship, Chicago, 1957. Included in: "Recent Sculpture, U.S.A.," The Museum of Modern Art, New York, and tour, 1959; "Sculpture in the Open Air," Battersea Park, London, 1963; "Sound Sculpture," Vancouver Art Gallery, British Columbia, Canada, 1973. Has lived in Barto, near Allentown, Pennsylvania, since 1950.

Untitled. 1965.
Stainless steel wires on concrete base, 48 × 46 × 40 inches

PROVENANCE:
Staempfli Gallery, New York, 1965

REFERENCES:
Nelson, June Kompass. *Harry Bertoia, Sculptor,* Detroit, Wayne State University, 1970, p. 42

ALBERT BIERSTADT (1830–1902)

Born Solingen, Germany, January 7, 1830. Emigrated with family to New Bedford, Massachusetts, 1832. Studied, Königlich Preussische Kunstakademie der Rheinprovinzen, Düsseldorf, with Emanuel Leutze, Carl Friedrich Lessing, and Andreas Achenbach, 1853–56. Toured Germany, Italy, and Switzerland, with Worthington Whittredge and others, 1856–57. Returned to New Bedford, 1857; moved to New York, 1860. National Academy of Design, New York: exhibited, Annual, 1858–60, 1863; academician, 1860. Joined expedition of Colonel Frederick W. Lander, chief engineer, Pacific Coast Railway Survey, over South Pass of Rocky Mountains, 1859; made sketches, stereographs, and photographs. Made many other "working trips" to the American West, Canada, Alaska, Nassau, and Europe.

Escaped military service in Civil War by paying exemption fee, but was permitted to sketch in Union Army camps. Built villa "Malkasten," Irvington-on-Hudson, New York, 1866; destroyed by fire, 1882. Chevalier, Légion d'honneur, Paris, 1867. Lived in Europe, 1867–69. Worked with photographer Eadweard Muybridge, Yosemite Valley, California, 1872–73. Included in: Centennial Exposition, Philadelphia, 1876; Royal Academy of Arts Annual, London, 1878; Royal Colonial Exhibition, London, 1882; World's Columbian Exposition, Chicago, 1893. Member, The National Institute of Arts and Letters, 1898. Died New York, February 18, 1902. Posthumous exhibitions, New York: Florence Lewison Gallery, 1963, 1964, 1968; M. Knoedler & Co., 1972. Retrospectives: Santa Barbara Museum of Art, California, 1964; Amon Carter Museum of Western Art, Fort Worth, Texas, and tour, 1972–73.

Scene in the Tyrol. 1854.
Oil on panel, 9½ × 13 inches
Signed with monogram and date l. r.: "AB 1854"
Inscribed on back "Mrs. B. P. Shillaber with the compliments of A. Bierstadt"

PROVENANCE:
The artist; Mrs. B. P. Shillaber; Unidentified collection; Robert S. Sloan Gallery, New York, 1964

REFERENCES:
Hendricks, Gordon. *Albert Bierstadt,* New York, Abrams, forthcoming, ill.

Shady Pool, White Mountains, New Hampshire. c. 1869.
Oil on paper mounted on canvas, 22½ × 30 inches
Signed l. r.: "A BIERSTADT"

PROVENANCE:
Count Ivan Podgoursky, Boston; Vose Galleries of Boston; Robert S. Sloan Gallery, New York, 1964

REFERENCES:
Hendricks, Gordon. *Albert Bierstadt,* New York, Abrams, forthcoming, ill.

Coast Scene (West Indies). c. 1880–93.
Oil on paper mounted on Masonite, 13½ × 18¼ inches
Signed l. l.: "A Bierstadt"

PROVENANCE:
John Nicholson Gallery, New York; H. C. Salles; Parke-Bernet Galleries, New York, Sale 2822, March 20, 1969, no. 66, ill. p. 75

EXHIBITIONS:
John Nicholson Gallery, New York, November–December 1946, *Exhibition of American Painting,* no. 22

REFERENCES:
Hendricks, Gordon. *Albert Bierstadt,* New York, Abrams, forthcoming, ill.

MAX BILL (b. 1908)

Born Winterthur, Switzerland, December 22, 1908. Studied: Kunstgewerbeschule der Stadt, Zurich, 1924–27; Bauhaus, Dessau, Germany, 1927–29. Exhibited with Albert Braun, Bauhaus, 1928. Established as architect, Zurich, 1929; worked also as painter, graphic artist, sculptor, journalist, and industrial designer. One-man shows: Atelier des Künstlers, Zurich, 1929; Kunstmuseum, Basel, 1939. Member, Association Abstraction-Création, Paris, 1932–36; exhibited, Galerie Abstraction-Création, 1933, 1934. Included in: "Bauhaus 1919–1928," The Museum of Modern Art, New York, 1938; "Konkrete Kunst," Kunsthalle, Basel, 1944; "Albers, Arp, Bill," Galerie Herrmann, Stuttgart, 1948. Awarded: Kandinsky Prize, Paris, 1949; First International Prize for Sculpture, I São Paulo Bienal, 1951. Editor: *Moderne Schweizer Architektur 1925–1945* (Basel, Werner), 1950; *Wassily Kandinsky* (Paris, Maeght), 1951. Retrospectives: Museu de Arte Moderna de São Paulo, 1950; Ulmer Museum, Ulm, Germany, and tour, 1956–57. Co-founder and dean, Hochschule für Gestaltung, Ulm, 1951–56. Author: *Form* (Basel, Werner), 1952; *Mies van der Rohe* (Milan, Il Balcone), 1955. Included in: 3rd–7th Middelheim Biënnale, Antwerp, 1955–63; "50 Ans d'Art Moderne," Palais des Beaux-Arts, Brussels, 1958; Expo '67, Montreal, 1967. One-man shows: Helmhaus, Zurich, 1957; Venice Biennale, 1958; Galerie Suzanne Bollag, Zurich, from 1958; Staempfli Gallery, New York, from 1963. Member, Swiss Federal Art Commission, 1961–68. Honorary Fellow, American Institute of Architects, 1964. Elected member, Swiss Parliament, 1967. Has taught environmental design, Staatliche Hochschule für Bildende Künste, Hamburg, since 1967. One-man shows: Kunsthalle, Bern, and Kestner-Gesellschaft, Hanover, 1968; Centre National d'Art Contemporain, Paris, 1969–70; San Francisco Museum of Art, 1970. Lives in Zurich.

Construction. 1937, executed 1962.
Granite, 39 × 31¼ × 30¾ inches

PROVENANCE:
Staempfli Gallery, New York, 1963

EXHIBITIONS:
Staempfli Gallery, New York, March 19–April 13, 1963, *Max Bill,* no. 17

REFERENCES:
Judd, Donald. "In the Galleries: Max Bill," *Arts Magazine,* 37, May 1963, p. 102, ill.
Rickey, George. *Constructivism: Origins and Evolution,* New York, Braziller, 1967, ill. p. 62
Unsigned. *Max Bill,* Hanover, Kestner-Gesellschaft, 1968, p. 7

Endless Ribbon from a Ring I. 1947–49, executed 1960.
Gilded copper on crystalline base, 14½ × 27 × 7½ inches

PROVENANCE:
Staempfli Gallery, New York, 1962

EXHIBITIONS:
The Solomon R. Guggenheim Museum, New York, October 3, 1962–January 6, 1963, *Modern Sculpture from the Joseph H. Hirshhorn Collection,* no. 33, ill. p. 94

REFERENCES:
Feldman, Edmund Burke. *Varieties of Visual Experience*, New York, Abrams, 1972, ill. p. 505
Myers, Bernard. *The Book of Art/How to Look at Art*, 10, New York, Grolier, 1965, p. 172, ill. p. 171
Read, Herbert. *A Concise History of Modern Sculpture*, New York, Praeger, 1964, no. 305, p. 288, ill. p. 252
Rickey, George. *Constructivism: Origins and Evolution*, New York, Braziller, 1967, p. 150, ill.

ELMER BISCHOFF (b. 1916)

Elmer Nelson Bischoff, born Berkeley, California, July 9, 1916. Studied, University of California, Berkeley, with Margaret Peterson, Erie Loran and John Haley; M.A., 1939. Served, U.S. Army Air Corps, England, 1942–46. Taught: California School of Fine Arts, San Francisco, 1946–52, 1956–63; Yuba College, Marysville, California, 1964. One-man shows: California Palace of the Legion of Honor, San Francisco, 1947; Paul Kantor Gallery, Los Angeles, 1955; San Francisco Museum of Art, 1956; Staempfli Gallery, New York, from 1960; M. H. de Young Memorial Museum, San Francisco, 1961. Included in: "Contemporary Bay Area Figurative Painting," The Oakland Museum, California, 1957; "Recent Painting USA: The Figure," The Museum of Modern Art, New York, and tour, 1962–63. Received: Ford Foundation Grant, 1959; grant, The National Institute of Arts and Letters, and The American Academy of Arts and Letters, 1963. Taught, Skowhegan School of Painting and Sculpture, Maine, summer, 1961. Awarded Harris Medal, 67th American Exhibition, The Art Institute of Chicago, 1964. Has taught, University of California, Berkeley, since 1963. Lives in Berkeley.

Woman with Dark Blue Sky. 1959.
 Oil on canvas, 68 × 68 inches
 Signed and dated on back: "Elmer Bischoff, 6–59, Woman with Dark Blue Sky"

PROVENANCE:
Staempfli Gallery, New York, 1960

EXHIBITIONS:
Staempfli Gallery, New York, January 5–23, 1960, *Elmer Bischoff, Recent Paintings*, cat.

JULIUS BISSIER (1893–1965)

Julius Heinrich Bissier, born Freiburg-im-Breisgau, Germany, December 3, 1893. Studied: Universität Freiburg-im-Breisgau, 1913; Staatliche Akademie der Bildende Künste, Karlsruhe, Germany, 1914. Military service, 1914–18. One-man shows: Kunstverein, Freiburg-im-Breisgau, 1920; Kunsthaus, Zurich, 1923; Augusteum, Oldenburg, Germany, 1929. Awarded first prize, Deutsche Künstlerbund, Kunstverein, Hanover, 1928. Taught, Universität Freiburg-im-Breisgau, 1929–33; nearly all his work destroyed by fire there, 1934. Traveled to Paris, 1930; met Constantin Brancusi and Oskar Schlemmer. Traveled to Italy, 1935–38. Designed tapestries and fabrics woven by his wife, Lisbeth Bissier, from 1939. First woodcuts, 1947; first color monotypes, 1947. One-man shows: Galerie Herrmann, Stuttgart, 1947; Galerie Ralfs, Braunschweig, Germany, 1951; Studio für Neue Kunst, Wuppertal, Germany, 1952; Théâtre Central, Zurich, 1953; Kunstverein, Freiburg-im-Breisgau, 1954; Gemeentemuseum, The Hague, 1959–60; Galerie Daniel Cordier, Paris, 1960; Gimpel Fils, London, 1960, 1963; Palais des Beaux-Arts, Brussels, 1961; Lefebre Gallery, New York, from 1961; Galerie Beyeler, Basel, 1962, 1963. Retrospectives: Kestner-Gesellschaft, Hanover, and tour, 1958; Kunstverein, Hamburg, and tour, 1962–63; Institute of Contemporary Art, Boston, and tour, 1963–64. Awarded Cornelius Prize, Düsseldorf, 1959. Included in: Venice Biennale, 1959, 1960 (São Paulo Museum Prize); Documenta II and III, Kassel, 1959, 1964; VI São Paulo Bienal, 1961 (Jubilee Prize); Pittsburgh International, 1961, 1964. Died Ascona, Switzerland, June 18, 1965. Retrospective, San Francisco Museum of Art, and The Solomon R. Guggenheim Museum, New York, and tour, 1967–69.

12. Febr 60 malade. 1960.
 Oil on canvas, 6⅜ × 8⅛ inches
 Signed, dated, and titled l. l.: "12. Febr 60 malade
 Jules Bissier"

PROVENANCE:
Lefebre Gallery, New York, 1961

EXHIBITIONS:
Lefebre Gallery, New York, November 7–December 2, 1961, *Bissier*, cat.
Park Lane Gallery, Buffalo, New York, January 14–February 10, 1962, *Paul Klee—Julius Bissier*, no. 2

Tamaro.M 18.3.61. 1961.
 Watercolor on paper, 6⅛ × 8⅛ inches
 Signed, dated, and titled l. l.: "Tamaro.M
 18.3.61
 Jules Bissier"

PROVENANCE:
Lefebre Gallery, New York, 1961

EXHIBITIONS:
Lefebre Gallery, New York, November 7–December 2, 1961, *Bissier*, cat.
Park Lane Gallery, Buffalo, New York, January 14–February 10, 1962, *Paul Klee—Julius Bissier*, no. 4

REFERENCES:
Johnson, Elaine. *Modern Drawings*, New York, Abrams, forthcoming, ill.

PETER BLAKE (b. 1932)

Peter Thomas Blake, born Dartford, Kent, England, June 25, 1932. Studied, Gravesend Technical College and School of Art, England, 1946–51. Served, Royal Air Force, 1951–56. Studied, Royal College of Art, London, 1953–56. Received Leverhulme Research Award, London, 1956; traveled to Holland, Belgium, France, Italy, Spain, 1956–57. Included in: "Five Painters," Institute of Contemporary Arts, London, 1958; "New Realists," Sidney Janis Gallery, New York, 1962. One-man shows, London: Portal Gallery, 1962; Robert Fraser Gallery,

1965, 1969; The Waddington Galleries, 1970. Traveled to the U.S., 1963. Three murals included in Shakespeare Exhibition, Stratford-on-Avon, England, 1964. Designed cover for Beatles album *Sgt. Pepper's Lonely Hearts Club Band*, 1967. Included in: Pittsburgh International, 1968; "British Painting and Sculpture, 1960–70," National Gallery of Art, Washington, D.C., 1970–71. Retrospective, City Art Gallery, Bristol, England, 1969. Has taught, Royal College of Art, since 1964. Lives in Willow Bath, England.

Coco Chanel 1967.
 Acrylic on Masonite, 14 × 11 inches
 Signed, dated, and titled l. r.: " 'Coco Chanel'
 Peter Blake 1967"

PROVENANCE:
Robert Fraser Gallery, London, 1968

REFERENCES:
Unsigned. "Chanel and Hepburn, Les Grandes Mam'-selles, Stars of 'Coco,' " *Vogue*, 154, December 1969, p. 192, colorplate p. 193

Coco Chanel (1883–1971), the Paris couturiere, was a major force in fashion design for more than sixty years. She was also the creator of the perfume which bears her last name and lucky number.

RALPH BLAKELOCK (1847–1919)

Ralph Albert Blakelock, born New York, October 15, 1847. Studied, Free Academy of the City of New York, 1864–66. Self-taught as an artist. National Academy of Design, New York: exhibited, Annual, 1867–73, 1878–88, 1894–98, 1910; associate, 1914; academician, 1916. Traveled to Kansas, Colorado, Wyoming, Utah, Nevada, California, Mexico, 1869–71; made second journey to Far West, 1872. Included in: Society of American Artists Annual, 1881, 1885, 1886, 1902; Pennsylvania Academy Annual, 1883, 1902, 1903; 2nd American Exhibition, The Art Institute of Chicago, 1889; World's Columbian Exposition, Chicago, 1893. Painter Harry W. Watrous became his friend and patron, c. 1885. First mental breakdown, 1891. Confined to Long Island Hospital, Kings Park, 1899–1901; Middletown State Hospital for the Insane, New York, 1901–16. Awarded honorable mention, Exposition Universelle de 1900, Paris. One-man shows: Lotos Club, New York, 1900, 1902; Worcester Art Museum, Massachusetts, 1913. Included in: Pan-American Exposition, Buffalo, New York, 1901; St. Louis International Exposition, Missouri, 1904; Inaugural Exhibition, Albright Art Gallery, Buffalo, 1905; Corcoran Biennial, 1907, 1908, 1910, 1916; Venice Biennale, 1909. Exhibitions to establish Blakelock Fund, 1916: Henry Reinhardt & Son, New York; M. Knoedler & Co., New York; J. W. Young, Chicago: money raised was never located. One-man show, R. C. and N. M. Vose Galleries, Boston, 1917. Committed to private sanitarium, New Jersey, 1918; returned to Middletown State Hospital, 1918; released July 1919. Died Elizabethtown, New York, August 9, 1919. Retrospectives: Whitney Museum of American Art, New York, 1947; University of California, Santa Barbara, 1969; M. Knoedler & Co., 1973.

The Wounded Stag. c. 1880.
 Oil on canvas mounted on wood, 20⅝ × 39 inches
 Signed l. r. in arrowhead: "Ralph Blakelock"

PROVENANCE:
Frederick S. Gibbs; American Art Association, New York, Sale, February 26, 1904, *Frederick S. Gibbs Collection*, no. 225, ill.; Lyman G. Bloomingdale, New York; American Art Association, New York, Sale, November 22, 1928, *Lyman G. Bloomingdale Collection*, no. 67, ill. p. 59; M. Knoedler & Co., New York; William C. Whitney, New York; The Milch Galleries, New York, 1964

EXHIBITIONS:
Lotos Club, New York, January 1902, *Paintings by Ralph Albert Blakelock*

REFERENCES:
Geske, Norman A. *Ralph A. Blakelock: A Re-evaluation and Catalogue of His Works*, Lincoln, University of Nebraska, forthcoming, cat. NU-603
Goodrich, Lloyd. "Letters to the Editor," *Magazine of Art*, 40, February 1947, p. 80
———. *Ralph Albert Blakelock*, New York, Whitney Museum of American Art, 1947, p. 17
Unsigned. "Auction Reports: Bloomingdale Sale," *Art News*, 27, December 15, 1928, p. 18
———. "Lost Blakelocks," *Art Digest*, 21, January 15, 1947, p. 10

The Three Trees. c. 1885.
 Oil on canvas, 22 × 30 inches

PROVENANCE:
The artist; Harry W. Watrous, New York; William T. Evans; American Art Association, New York, Sale, February 1, 1900, *Evans Collection*, no. 110; Catholina Lambert, Paterson, New Jersey; Mrs. H. R. Lambert, Paterson; American Art Association, Sale, January 28, 1916, *Andrews-Ives-Canfield Collection*, no. 120; G. T. Otto Bernet, New York; Walter Jennings, New York; Mrs. Henry C. Taylor, New York; Florence Lewison Gallery, New York, 1962

EXHIBITIONS:
Lotos Club, New York, December 1900, *Paintings by Ralph A. Blakelock*, no. 2
Whitney Museum of American Art, New York, April 22–May 29, 1947, *Ralph Albert Blakelock Centenary Exhibition*, no. 29, ill. p. 30
Florence Lewison Gallery, New York, April 10–May 5, 1962, *Paintings by Ralph Albert Blakelock and Some of His Contemporaries*, cat.

REFERENCES:
Faunce, Sara C. "Reviews and Previews: Blakelock," *Art News*, 61, Summer 1962, p. 49
Geske, Norman A. *Ralph A. Blakelock: A Re-evaluation and Catalogue of His Works*, Lincoln, University of Nebraska, forthcoming, cat. NU-601
Goodrich, Lloyd. *Ralph Albert Blakelock*, New York,

Whitney Museum of American Art, 1947, p. 53
Judd, Donald. "In the Galleries: Ralph Blakelock," *Arts*, 36, September 1962, p. 53
Unsigned. "Andrews-Ives-Canfield Sale," *American Art News*, 14, February 5, 1916, p. 3
———. "Art," *Time*, 49, May 12, 1947, ill. p. 61
Young, Vernon. " 'Out of Deepening Shadows,' The Art of Ralph Albert Blakelock," *Arts*, 32, October 1957, p. 25, ill. p. 24

IRVING BLOCK (b. 1910)

Irving Alexander Block, born New York, December 2, 1910. Studied, New York: New York University, B.S., 1933; National Academy of Design, 1932–34. WPA Federal Art Project, Mural Division, New York, 1934–39. Mural commissions: *The Men and the Means of Medicine*, Medicine and Public Health Building, New York World's Fair, Flushing Meadows (sponsored by the Federal Art Project, and American Medical Association), 1939; U.S. Post Office, Batesburg, South Carolina, 1940; U.S. Post Office, Wakefield Station, The Bronx, New York, 1941. Civilian employee, Geodetic Division, Office of the Chief of Engineers, Washington, D.C., 1942–44. Studied, Académie de la Grande Chaumière, Paris, 1947–48. Awarded prize, California Watercolor Society, Los Angeles, 1949. Co-produced, directed, and wrote films: *Rembrandt, Poet of Light*, 1953; *Goya*, 1956 (Venice Film Festival selection, 1956; award winner, Third International Art Film Festival, The Metropolitan Museum of Art, New York, 1957); *World of Rubens*, 1959. One-man shows, Ankrum Gallery, Los Angeles, from 1963. Received: Joseph H. Hirshhorn Foundation Grant, 1969; California State Colleges Distinguished Teaching Award, 1970. Has taught, California State University at Northridge, since 1963. Lives in Studio City, California.

Interior with Candle. 1963.
 Oil on canvas, 16½ × 20½ inches
 Signed l. l.: "Block/"

PROVENANCE:
Ankrum Gallery, Los Angeles, 1963

HYMAN BLOOM (b. 1913)

Born Brunoviski, Lithuania, April 11, 1913. Emigrated to Boston, 1920. First art lessons, West End Community Center, Roxbury, Massachusetts, with Harold Zimmerman, c. 1924–31; Jack Levine a fellow student. With Levine, worked under tutelage of Denman Ross, Department of Fine Arts, Harvard University, Cambridge, Massachusetts, c. 1929–32. WPA Federal Art Project, Easel Division, Boston, 1933–36. Included in: "Americans 1942," and "Romantic Painting in America," The Museum of Modern Art, New York, 1942, 1943; "Biennial Exhibition of Contemporary American Paintings," Virginia Museum of Fine Arts, Richmond, 1948; Pittsburgh International, 1955; "4 Boston Masters," Jewett Arts Center, Wellesley College, Massachusetts, and Museum of Fine Arts, Boston, 1959; "Francis Bacon–Hyman Bloom," The Art Galleries, University of California at Los Angeles, 1960. One-man shows: Stuart Gallery, Boston, 1945; Durlacher Brothers, New York, 1946–47, 1954; Boris Mirski Gallery, Boston, 1949; Swetzoff Gallery, Boston, 1958. Taught: Wellesley College, 1949–51; Harvard University, 1951–53. Retrospectives: Institute of Contemporary Art, Boston, and tour, 1954–55; Currier Gallery of Art, Manchester, New Hampshire, and tour (drawings), 1957–58; University of Connecticut, Storrs, and tour (drawings), 1968. One-man show, Terry Dintenfass Gallery, New York, (drawings), 1972. Member, The National Institute of Arts and Letters, 1974. Lives in Boston.

Apparition of Danger. 1951.
 Oil on canvas, 54½ × 43¼ inches

PROVENANCE:
Durlacher Brothers, New York, 1954

EXHIBITIONS:
Durlacher Brothers, New York, March 9–April 3, 1954, *Hyman Bloom*
Institute of Contemporary Art, Boston, April 8–May 16, 1954, *Hyman Bloom Retrospective*, no. 35, colorplate p. 15; toured to Art Galleries, Grover Cronin, Inc., Waltham, Massachusetts, June 11–July 15; M. H. de Young Memorial Museum, San Francisco, August 11–September 8; Albright Art Gallery, Buffalo, New York, October 16–November 8; The Joe and Emily Lowe Art Gallery, University of Miami, Coral Gables, Florida, December 15–January 10, 1955; Whitney Museum of American Art, New York, February 24–April 3
Carnegie Institute, Pittsburgh, October 14–December 18, 1955, *The 1955 Pittsburgh International Exhibition of Contemporary Painting*, no. 29
Brandeis University, Waltham, Massachusetts, June 1–17, 1955, *Three Collections*, no. 3
Greenwich Gallery, New York, May 1–June 30, 1957, *Fifty Contemporary American Artists*, no. 5, ill. p. 21

REFERENCES:
de Kooning, Elaine. "Hyman Bloom," *Art News*, 54, March 1955, p. 67
Hess, Thomas B. "Reviews and Previews: Hyman Bloom," *Art News*, 53, April 1954, pp. 5, 43, colorplate, cover

OSCAR BLUEMNER (1867–1938)

Oscar Julius Bluemner, born Preuzlau, Germany, 1867. Studied architecture and design, Königliche Akademie der Künste, Berlin. One-man show, Latin School, Berlin, 1885. Emigrated to Chicago, 1892. Moved to New York, 1901; worked as architect. Awarded commission, Bronx County Courthouse, New York, 1902; won lawsuit against partner for theft of Courthouse designs, 1912. Traveled to Europe, 1912–13; one-man show, Galerie Gurlitt, Berlin, 1912. Five works included in the Armory Show, 1913; wrote critical review for Alfred Stieglitz's *Camera Work*. One-man show, Stieglitz's Photo-Secession Gallery, "291," New York, 1915. Included in "The Forum Exhibition of Modern American Painters," The Anderson Galleries, New York, 1916. Moved to New

Jersey, 1916; settled in South Braintree, Massachusetts, 1926. One-man shows: Bourgeois Galleries, New York, 1917–23; J. B. Neumann's New Art Circle, New York, 1924–26; Stieglitz's Intimate Gallery, New York, 1928; Whitney Studio Galleries, New York, 1929; Marie Harriman Gallery, New York, 1935; The Arts Club of Chicago, 1935. Included in: Whitney Biennial, 1932–33; "Abstract Painting in American Art," Whitney Museum of American Art, New York, 1935. Adopted Florianus as middle name, 1933. Public Works of Art Project, Massachusetts, 1934–35. Died by suicide, South Braintree, January 12, 1938. Posthumous exhibitions: Cooperative Gallery, Newark, New Jersey, 1939; University Gallery, University of Minnesota, Minneapolis, 1939; Today's Art Gallery, Boston, 1945; James Graham and Sons, New York, 1956, 1957, 1959, 1960, 1967, 1972; Fogg Art Museum, Harvard University, Cambridge, Massachusetts, 1967. Retrospective, New York Cultural Center, 1969–70.

Old Canal, Red and Blue. 1915.
Oil on canvas, 14¼ × 20 inches
Signed l. r.: "O Bluemner"

PROVENANCE:
James Graham and Sons, New York; Gallery Gertrude Stein, New York; Robert Schoelkopf Gallery, New York, 1962

EXHIBITIONS:
James Graham and Sons, New York, November 15–December 10, 1956, *Oscar F. Bluemner*, no. 15
Zabriskie Gallery, New York, March 18–April 13, 1963, *The Forum–1916*

Morning Light (Dover Hills, October). c. 1916.
Oil on canvas, 20 × 30 inches
Signed l. l.: "O. Bluemner"

PROVENANCE:
The artist; Robert Bluemner; Hirschl & Adler Galleries, New York, 1968

EXHIBITIONS:
University Gallery, University of Minnesota, Minneapolis, March 1939, *Oscar Florianus Bluemner*, no. 33

REFERENCES:
Jacobs, Jay. "Collector: Joseph H. Hirshhorn," *Art in America*, 57, July–August 1969, p. 58, ill.
———. "Quality as Well as Quantity: Joseph H. Hirshhorn," in Lipman, Jean, ed. *The Collector in America*, New York, Viking, 1971, p. 84, ill.

FRANK BOGGS (1855–1926)

Frank Myers Boggs, born Springfield, Ohio, December 6, 1855. Youth spent in New York; worked in Niblo's Garden Theatre. Studied: with John Barnard Whittaker, New York, 1871; École des Beaux-Arts, Paris, with Jean-Léon Gérôme, 1876. Traveled to Dieppe, France, and London, 1877. Returned to the U.S., 1878; established New York studio. Exhibited: The Union League Club of New York, 1879; Pennsylvania Academy Annual, 1881; Annual Exhibition of Contemporary American Art, Museum of Fine Arts, Boston, 1881 (Bronze Medal). Exhibited, the Salon, Paris, from 1880; paintings purchased by French Government, 1882, 1884. Settled permanently in France, 1881. One-man show, American Art Association, New York, 1884. Associated with marine painter Johan Jongkind, c. 1884–91. Awarded Silver Medal, Exposition Universelle of 1889, Paris. One-man show, Galerie Haussmann, Paris, 1913. Lived in southern France (Midi), c. 1914–23; French citizen, 1923. Chevalier, Légion d'honneur, 1926. Died Meudon, outside of Paris, August 8, 1926. Posthumous exhibitions, Bernard Black Gallery, New York, 1962, 1964, 1965. Retrospective, Galerie Philippe Reichenbach, Paris, 1969.

New York: Entering the Harbor. 1887.
Oil on canvas, 20 × 26 inches
Signed l. l.: "Boggs New York"

PROVENANCE:
P. Trussy, France; Private collection, Aix-en-Provence, France; Harry Spiro, New York; Bernard Black Gallery, New York; Parke-Bernet Galleries, New York, Sale 3133, December 10, 1970, no. 17, p. 20

EXHIBITIONS:
Bernard Black Gallery, New York, January 13–February 8, 1964, *Frank Boggs—An Exhibition of Major Works*, no. 3, ill.
Parrish Art Museum, Southampton, New York, May 26–June 25, 1967, *The Sea Around Us*

REFERENCES:
Alexandre, Arsène. *Frank Boggs*, Paris, Le Goupy, 1929, p. 130, ill. 158

AARON BOHROD (b. 1907)

Born Chicago, November 21, 1907. Studied: School of The Art Institute of Chicago, 1927–29; The Art Students League of New York, with John Sloan, Kenneth Hayes Miller, and Boardman Robinson, 1930–32. Included in: Whitney Biennial, 1934–35; "New Horizons in American Art," and "Romantic Painting in America," The Museum of Modern Art, New York, 1936, 1943; Corcoran Biennial, 1937 (Corcoran Silver Medal, and Second Clark Prize); Whitney Annual, 1938, 1940, 1947; Pennsylvania Academy Annual, 1938–45; Pennsylvania Academy Water Color Annual, 1942 (Philadelphia Water Color Prize); "Portrait of America (Artists for Victory, Inc.)," The Metropolitan Museum of Art, New York, 1942 (fifth prize). WPA Federal Art Project, Easel Division, Illinois, 1935–36. Received Guggenheim Foundation Fellowship, 1936, 1937. Murals, Treasury Department, Section of Painting and Sculpture, U.S. Post Office, Illinois: Vandalia, 1936; Galesburg, 1938. One-man shows, New York: Frank Rehn Gallery, 1938; Associated American Artists Galleries, 1938–55. Artist-in-residence, Southern Illinois University, Carbondale, 1941. Served, U.S. Army Corps of Engineers, 1942–45; artist-war correspondent, *Life*, 1943–45. One-man shows, New York: The Milch Galleries, 1957–65; Hammer Gallery, 1969; Bernard Danenberg Galleries, 1971. Awarded: Saltus Gold Medal, National Academy of Design Annual, 1961; Hassam Purchase Prize, The American Academy

of Arts and Letters, 1962; Kirk Memorial Prize, National Academy of Design Annual, 1965. Retrospective, Milwaukee Art Center, Wisconsin, 1966. Has taught, University of Wisconsin, Madison, since 1948. Lives in Madison.

The Shepherd Boy. 1957.
Oil on panel, 12 × 9 inches
Signed l. l.: "A. Bohrod"

PROVENANCE:
The Milch Galleries, New York, 1957

EXHIBITIONS:
The Milch Galleries, New York, November 18–December 7, 1957, *Recent Still Life Painting by Aaron Bohrod*, no. 21

ILYA BOLOTOWSKY (b. 1907)

Born St. Petersburg, Russia, July 1, 1907. Studied, Collège St. Joseph, Constantinople, Turkey, 1921–23. Emigrated to the U.S., 1923; citizen, 1929. Studied, National Academy of Design, New York, with Ivan Olinsky, 1924–30. Awarded Hallgarten Prize, National Academy of Design Annual, 1929, 1930. Received: Louis Comfort Tiffany Foundation Fellowship, 1929, 1930; Yaddo Foundation Fellowship, 1933. First one-man show, G.R.D. Studio, New York, 1930. Public Works of Art Project, New York, 1934–35. Co-founded The Ten, New York, 1935, with Adolph Gottlieb, Mark Rothko, and Joseph Solman, among others; included in "The Ten: Whitney Dissenters," Mercury Gallery, New York, 1938. WPA Federal Art Project, New York: Teaching Division, 1935–36; Mural Division, 1935–41; mural commission, Hospital for Chronic Diseases, Welfare Island, New York. Founding member, American Abstract Artists, New York, 1936. Received Baroness Hilla Rebay Fellowship, Museum of Non-Objective Painting, New York, 1942. Served, U.S. Army Air Corps, Nome, Alaska, 1943–45. Taught: Black Mountain College, North Carolina, 1946–48; University of Wyoming, Laramie, 1948–57. One-man shows, New York: J. B. Neumann's New Art Circle, 1946, 1952; Rose Fried Gallery, 1947, 1949; Grace Borgenicht Gallery, New York, from 1954. Retrospective, University Art Museum, University of New Mexico, Albuquerque, and tour, 1970–71. Received: award, The National Institute of Arts and Letters, and The American Academy of Arts and Letters, 1971; Guggenheim Foundation Fellowship, 1973. Also a playwright and producer of experimental films. Has taught, Southampton College of Long Island University, New York, since 1965. Lives in New York.

Trylon: Blue, Yellow and Red. 1967.
Polychromed wood, 94¾ × 9 × 9 inches
Markings: l. r. "I.B./67"

PROVENANCE:
Grace Borgenicht Gallery, New York, 1968

EXHIBITIONS:
Grace Borgenicht Gallery, New York, March 16–April 5, 1968, *Bolotowsky*

"Neoplasticism is an architectural or, more properly, architectonic form of painting. The columns are an extension of painting into architecture, a natural development for the Neoplastic style. In my painted columns, each side is a self-contained unit. Any two adjacent sides when seen together also form self-contained, complete compositions. When seen by a viewer walking around a column, the resulting sequence of design in motion may be read somewhat like an Oriental scroll, a sort of modern kakemono, or like an abstract motion picture. *Trylon: Blue, Yellow and Red* may be viewed either like a rising and yet still modern obelisk, or like a design of many combinations of facets in motion."

Statement by the artist, 1972

White Diamond. 1968.
Oil on canvas, 48 × 48 inches
Signed and dated on stretcher: "White Diamond 1968 by Ilya Bolotowsky"

PROVENANCE:
Grace Borgenicht Gallery, New York, 1968

EXHIBITIONS:
Grace Borgenicht Gallery, New York, March 16–April 5, 1968, *Bolotowsky*

"I liked to paint on diamond formats as early as 1947. A diamond format is obviously a square standing on one corner. The feeling of space, however, is much greater in a diamond area than in a square area of the same size. This is so because the vertical and horizontal measurement of such a diamond are larger than those of a square of the same size. One may object that vertical-horizontal Neoplastic painting on a diamond format creates triangular shapes. I do not think that this objection is important. Is it because the rectilinear 'tensions' are more important than the resulting triangles? For whatever reason, the viewer's eye seems to extend the triangles beyond the painting, without undermining the diamond format. The effect is still that of a rectangular relationship. The feeling of a free, open space in the *White Diamond* would be hard to achieve on a rectangular or square canvas."

Statement by the artist, 1972

PIERRE BONNARD (1867–1947)

Born Fontenay-aux-Roses, near Paris, October 13, 1867. Studied, Paris: law, 1886–88; painting, École des Beaux-Arts, and Académie Julian, with William-Adolphe Bouguereau, and Tony Robert-Fleury, 1888–89. Military service, Bourgoin-Jallieu, France, 1889–90. Designed poster, "France-Champagne," 1890. Associated with Nabis, including Maurice Denis, Édouard Vuillard, and Félix Vallotton, Paris, 1891; exhibited with group, Paris: Le Barc de Boutteville, 1891, 1893, 1894; Galerie Ambroise Vollard, 1897; Galerie Durand-Ruel, 1899. Included in "L'Art Nouveau," Galerie Bing, Paris, 1896. Contributed to *La Revue Blanche*: lithographs, 1893, 1897; poster, 1894. Lithographic suite, "Quelques

Aspects de la vie de Paris," published (Paris, Vollard), 1895. With Vuillard, Henri de Toulouse-Lautrec, and Paul Sérusier, designed sets and decor for Alfred Jarry's *Ubu Roi*, Théâtre de l'Oeuvre, Paris, 1896. One-man shows: Galerie Durand-Ruel, 1896; Galerie Bernheim-Jeune, Paris, 1904, 1906, 1909, 1910, 1921, 1924, 1926, 1933. Traveled in Belgium, The Netherlands, England, Italy, Spain, Tunisia, 1907–11; visited England, with Vuillard, 1913. Moved to Vernonnet, France, 1912; neighbors included Claude Monet and Auguste Renoir. Designed sets, Ballet Suédois production of Claude Debussy's *Jeux*, Paris, 1920. Included in: Venice Biennale, 1922; Carnegie International, 1923, 1936 (second prize). Retrospective, Galerie Druet, Paris, 1924. Settled in Le Cannet, near Cannes, 1925. Visited the U.S., as member of Carnegie International jury, 1926. One-man shows, New York: De Hauke & Co., 1928; Wildenstein & Co., 1934. Included in: "Painting in Paris," The Museum of Modern Art, New York, 1930; "Les Maîtres de l'Art Indépendant, 1895–1937," Musée du Petit Palais, Paris, 1937. Exhibited with Vuillard: Kunsthaus, Zurich, 1932; The Art Institute of Chicago, 1938–39; Paul Rosenberg and Co., New York, 1943. Retrospectives: Svensk-Franska Konstgalleriet, Stockholm, 1939; Galerie Bernheim-Jeune, 1946; Bignou Gallery, New York, 1946. Died Le Cannet, January 23, 1947. Memorial exhibitions: Ny Carlsberg Glyptotek, Copenhagen, 1947; Stedelijk Museum, Amsterdam, 1947; Salles de l'Orangerie, Paris, 1947; The Museum of Modern Art, and Cleveland Museum of Art, 1948.

Girl Bathing (Jeune Fille à sa toilette). c. 1900–1906.
Bronze, 10¾ × 4 × 4⅛ inches

PROVENANCE:
Félix Fénéon, Paris; Peridot Gallery, New York, 1957

EXHIBITIONS:
The Detroit Institute of Arts, and tour, 1959–60, *Sculpture in Our Time*, no. 57
The Solomon R. Guggenheim Museum, New York, October 3, 1962–January 6, 1963, *Modern Sculpture from the Joseph H. Hirshhorn Collection*, no. 34, ill. p. 91

REFERENCES:
Marchiori, Giuseppe. "La scultura in Europa tra le due guerre," *L'Arte Moderna* (Milan), 10, no. 88, 1967, ill. p. 274
Read, Herbert. *A Concise History of Modern Sculpture*, New York, Praeger, 1964, no. 18, pp. 30, 289, ill. p. 28
Sontag, Raymond J. *A Broken World 1919–1939*, New York, Harper & Row, 1971, ill. 21

Bather (La Femme aux rochers). c. 1900–1906.
Bronze, 6½ × 5¼ × 3 inches
Markings: back l. l. "Ḃ"
 3.12

PROVENANCE:
Private collection, Sweden; O'Hana Gallery, London; Fernand Legros, Paris; Parke-Bernet Galleries, New York, Sale 2199, May 15, 1963, no. 29; Fernand Legros; New Arts Center, New York; Parke-Bernet Galleries, Sale 2355, May 12, 1965, no. 54, ill. p. 44; G. David Thompson, Pittsburgh; Parke-Bernet Galleries, Sale 2444, May 19, 1966, no. 3, ill.

EXHIBITIONS:
O'Hana Gallery, London, June–September 1962, *French Paintings and Sculpture of the 19th and 20th Centuries*

LEE BONTECOU (b. 1931)

Born Providence, Rhode Island, January 15, 1931. Studied: Bradford Junior College, Massachusetts; The Art Students League of New York, 1952–55. Received: Fulbright Grant, to Rome, 1957–58; Louis Comfort Tiffany Foundation Fellowship, 1959. One-man show, Gallery G, New York, 1959. Included in: "Sculture nella città," Festival dei Due Mondi, Spoleto, Italy, 1958; Whitney Annual, 1960, 1962, 1966, 1968; VI São Paulo Bienal, 1961; "The Art of Assemblage," The Museum of Modern Art, New York, and tour, 1961–62; Pittsburgh International, 1961, 1967, 1970; Documenta III, Kassel, 1964; ROSC '67, Dublin, 1967. One-man shows: Leo Castelli Gallery, New York, 1960, 1962, 1966, 1971; Galerie Ileana Sonnabend, Paris, 1965. Awarded Corcoran Silver Medal, and Second Clark Prize, Corcoran Biennial, 1963. Sculpture acquired for New York State Theater, Lincoln Center for the Performing Arts, New York, 1964. Received grant, The National Institute of Arts and Letters, and The American Academy of Arts and Letters, 1966. Retrospectives: Museum Boymans-van Beuningen, Rotterdam, The Netherlands, 1968; Museum of Contemporary Art, Chicago, 1972. Lives in New York.

Untitled. 1967.
Cloth and wood, 55½ × 22½ × 22⅜ inches

PROVENANCE:
Leo Castelli Gallery, New York; Carnegie Institute, Pittsburgh, 1967

EXHIBITIONS:
Carnegie Institute, Pittsburgh, October 27, 1967–January 7, 1968, *1967 Pittsburgh International Exhibition of Painting and Sculpture*, no. 246, ill.

REFERENCES:
Jena, Jeannette. "34 Countries in Carnegie International," *Pittsburgh Post-Gazette*, October 26, 1967
Kuh, Katherine. "Pittsburgh's Mini-International," *Saturday Review*, 50, December 2, 1967, p. 46, ill.
Unsigned. "Focus: Carnegie International," *Pittsburgh Press*, October 15, 1967, sec. 7, p. 1

DAVIDE BORIANI (b. 1936)

Born Milan, April 5, 1936. Studied, Accademia di Belle Arti di Brera, Milan, 1951–60. Founding member, Gruppo T, Milan, 1959; exhibited with group: "Miriorama," Galleria Danese, Milan, 1960; "studio f," Ulm, Germany, 1964; Venice Biennale, 1964. Included in: "Bewogen Beweging," Stedelijk Museum, Amsterdam, and tour, 1961; "Arte Programmata," international tour, sponsored by Olivetti & Co., Milan, 1962; "Licht und Bewegung," Kunsthalle, Bern, 1965; "Nove Tendencije

3," Galerije Grada Zagreba, Zagreb, Yugoslavia, 1965; "NUL," Stedelijk Museum, 1965; "Directions in Kinetic Sculpture," University Art Museum, University of California, Berkeley, and Santa Barbara Museum of Art, California, 1966; "Kinetics," Hayward Gallery, London, 1970; Venice Biennale, 1970; "Constructivist Tendencies," The Art Galleries, University of California, Santa Barbara, and tour, 1970–72. Lives in Milan.

Magnetic Surface (Superficie magnetica). 1962.
Magnetized metal and glass (motorized), 40 × 40 × 6¼ inches

PROVENANCE:
The artist, Venice, 1964

EXHIBITIONS:
XXXII Biennale Internazionale d'Arte, Venice, June–October 1964, *Central Pavilion*, Gruppo T, no. 3

REFERENCES:
Gendel, Milton. "Hugger-Mugger in the Giardini," *Art News*, 63, September 1964, p. 35
Unsigned. "Gallery," *Architectural Review*, 136, September 1964, ill. p. 216

FERNANDO BOTERO (b. 1932)

Born Medellín, Colombia, April 19, 1932. Moved to Bogotá, 1951. One-man shows, Galería Leo Matiz, Bogotá, 1951, 1952. Studied, Real Academia de Bellas Artes de San Fernando, Madrid, 1952. Studied art history and fresco technique, Italy, and traveled in Europe, 1953–55. Returned to Bogotá, 1955; lived in Mexico, 1956–57. Awarded: first prize, III Bienal Hispanoamericano, Barcelona, 1955; first prize, "Primer Salón Intercol de Artistas Jóvenes," Museo de Arte Moderno, Bogotá, 1964. One-man shows: Pan American Union, Washington, D.C., 1957; Gres Gallery, Washington, D.C., 1957, 1960; The Contemporaries, New York, 1962; Staatliche Kunsthalle, Baden-Baden, Germany, 1966; Galerie Buchholz, Munich, 1966, 1968; Milwaukee Art Center, 1967. Included in: Venice Biennale, 1958; Guggenheim International Award, 1958, 1960; Pittsburgh International, 1964, 1967; "The Emergent Decade," Andrew Dickson White Museum of Art, Cornell University, Ithaca, New York, and The Solomon R. Guggenheim Museum, New York, and tour, 1966; "Inflated Images," The Museum of Modern Art, New York, Circulating Exhibition, 1969–70. One-man shows: Center for Inter-American Relations, New York, 1969; Galerie Claude Bernard, Paris, 1969, 1972; The Hanover Gallery, London, 1970; Marlborough Gallery, New York, 1972; Pyramid Galleries, Washington, D.C., 1973; Marlborough Galleria d'Arte, Rome, 1973. Retrospective, Staatliche Kunsthalle, Baden-Baden, and tour, 1970. Has lived in New York, since 1960.

Camera degli Sposi II. 1961.
Oil on canvas, 7 feet 7¼ inches × 8 feet 6¼ inches
Signed and dated l. l.: "Botero '61"

PROVENANCE:
Gres Gallery, Washington, D.C., 1962

Paintings by the Old Masters are often the prototypes for Botero's inflated images. This is one of several works by Botero based on Andrea Mantegna's frescoes in the Camera degli Sposi of the Palazzo Ducale, Mantua, Italy; Botero's figures loosely derive from those in the fresco on the north wall of the room. Marchese Ludovico Gonzaga sits at the left, a favorite dog beneath his chair; the Marchesa Barbara of Brandenburg is the central figure.

ÉMILE-ANTOINE BOURDELLE (1861–1929)

Born Montauban, France, October 30, 1861. Studied: École des Beaux-Arts, Toulouse, France, 1876; atelier of Jean-Alexandre-Joseph Falguière, École des Beaux-Arts, Paris, 1884. Included in the Salon, Paris, 1884–87, 1889; awarded honorable mention for *The First Victory of Hannibal*, 1885. Exhibited: Salon de la Société Nationale des Beaux-Arts, 1891–1922; Exposition Universelle de 1900, Paris (Silver Medal); Munich Sezession, 1903; Salon d'Automne, 1905–29; Berliner Sezession, 1907. *War Memorial to the Defenders of 1870*: first studies, 1893; commissioned by city of Montauban, 1897; installed, 1902. Engaged as assistant to Auguste Rodin, Paris, 1893; head of Rodin's atelier, until 1908. One-man shows: Galerie Hébrard, Paris, 1905; Mánes Society, Prague, 1909. Légion d'honneur: chevalier, 1909; officier, 1919; commandeur, 1924. Taught, Académie de la Grande Chaumière, Paris, 1909–29. Facade of Théâtre des Champs-Élysées, Paris: commissioned, 1910; completed, 1913. Six works included in the Armory Show, 1913. Traveled to Italy, 1914; one-man show, Venice Biennale, Co-founded Salon des Tuileries, Paris, with Albert Besnard and others, 1923; exhibited there, 1923–29. One-man show, Albright Art Gallery, Buffalo, New York, and tour, 1925. Retrospective, Palais des Beaux-Arts, Brussels, 1928. Died Le Vésinet, France, October 1, 1929. Memorial exhibitions: Exposition des Artistes Méridionaux, Toulouse, 1930; Galerie Vignon, Paris, 1930; The Leicester Galleries, London, 1930; City of Manchester Art Galleries, England, 1930; Salles de l'Orangerie, Paris, 1931. Musée Bourdelle, Paris: opened, 1949; Great Hall inaugurated, 1961.

The Great Warrior of Montauban. 1898.
Bronze (edition of ten), 71½ × 63 × 20 inches
Markings: l. r. side artist's monogram "⚒"
back l. r. "Susse Fondeur Paris N° 3
© by Bourdelle"

PROVENANCE:
Estate of the artist; World House Galleries, New York, 1959

EXHIBITIONS:
World House Galleries, New York, May 19–June 29, 1957, *Bourdelle*, no. 18, cover ill.
University Gallery, University of Minnesota, Minneapolis, November 8–December 8, 1957, *Antoine Bourdelle*, no. 2; toured to Walker Art Center, Minneapolis, January 12–February 9, 1958
The Solomon R. Guggenheim Museum, New York, October 3, 1962–January 6, 1963, *Modern Sculpture from*

the Joseph H. Hirshhorn Collection, no. 37, ill. p. 33

REFERENCES:
Arnason, H. Harvard. *History of Modern Art*, New York, Abrams, 1968, p. 65, ill.
Goode, James M. "Outdoor Sculpture: Washington's Overlooked Monuments," *Historic Preservation*, 25, January–March 1973, ill. p. 6
Jianou, Ionel, and Dufet, Michel. *Bourdelle*, trans. Kathleen Muston and Bryan Richardson, Paris, Arted, 1965, pp. 22–25, 77, plate 7
Levick, L. E. "444 Hirshhorn Sculptures," *New York Journal-American*, October 6, 1962, ill. p. 7

Bust of Ingres. 1908.
Bronze (edition of ten), 22½ × 16½ × 12½ inches
Markings: r. side "Emile-Antoine Bourdelle"
back l. c. "© by Bourdelle"
l. l. side "Susse Fondeur Paris N° 2"

PROVENANCE:
Estate of the artist; Charles E. Slatkin Galleries, New York, 1961

EXHIBITIONS:
The National Gallery of Canada, Ottawa, October 5–29, 1961, *Antoine Bourdelle* (organized by Charles E. Slatkin Galleries, New York), plate 18; toured to Charles E. Slatkin Galleries, November 13–December 9; The Toledo Museum of Art, Ohio, January 5–February 8, 1962; City Art Museum of St. Louis, Missouri, February 20–April 1; Santa Barbara Museum of Art, California, April 20–May 27; Fine Arts Gallery of San Diego, California, June 8–July 15; California Palace of the Legion of Honor, San Francisco, August 1–September 8; Cincinnati Art Museum, Ohio, October 5–November 4

REFERENCES:
Jianou, Ionel, and Dufet, Michel. *Bourdelle*, trans. Kathleen Muston and Bryan Richardson, Paris, Arted, 1965, pp. 32, 89, plate 44

Like Bourdelle, Jean-Auguste-Dominique Ingres was born in Montauban, France. Ingres, the dominant Neoclassicist of the nineteenth century, was for many years professor at the École des Beaux-Arts in Paris, and director of the Académie de France à Rome. While the format of this bust recalls the portraiture style of the Roman Republic, the execution reflects a more personalized and even romantic feeling. A larger version of the work is in the Musée Ingres, Montauban.

Torso of the Figure Called Fruit. 1911.
Bronze (edition of ten), 39 × 24¼ × 14 inches
Markings: back l. r. artist's monogram "⚒ © by Bourdelle"
back l. l. "E Godard Fondr Paris 2"

PROVENANCE:
Estate of the artist; Charles E. Slatkin Galleries, New York, 1961

EXHIBITIONS:
The Solomon R. Guggenheim Museum, New York, October 3, 1962–January 6, 1963, *Modern Sculpture from the Joseph H. Hirshhorn Collection*, no. 38, ill. p. 32
The National Gallery of Canada, Ottawa, October 5–29, 1961, *Antoine Bourdelle* (organized by Charles E. Slatkin Galleries, New York), plate 18; toured to Charles E. Slatkin Galleries, November 13–December 9; The Toledo Museum of Art, Ohio, January 5–February 8, 1962; City Art Museum of St. Louis, Missouri, February 20–April 1; Santa Barbara Museum of Art, California, April 20–May 27; Fine Arts Gallery of San Diego, California, June 8–July 15; California Palace of the Legion of Honor, San Francisco, August 1–September 8; Cincinnati Art Museum, Ohio, October 5–November 4

REFERENCES:
Arnason, H. Harvard. *History of Modern Art*, New York, Abrams, 1968, p. 65, ill. p. 67

Head of Beethoven with Architecture. 1925.
Bronze (edition of ten), 16 × 9¼ × 12½ inches
Markings: r. side at base artist's monogram "⚒△ N° 2"
l. side at base "© by Bourdelle
Susse Fondeur Paris"

PROVENANCE:
Estate of the artist; Saint-Georges, Beaulieu-sur-Mer, France, 1966

REFERENCES:
Jianou, Ionel, and Dufet, Michel. *Bourdelle*, trans. Kathleen Muston and Bryan Richardson, Paris, Arted, 1965, p. 73

Study for Monument to Daumier. 1925.
Bronze (edition of ten), 45 × 23¼ × 14½ inches
Markings: r. side near base artist's monogram "⚒△ 1925
© by Bourdelle"
back l. l. "Susse Fondeur Paris N° 2"

PROVENANCE:
Estate of the artist; Charles E. Slatkin Galleries, New York, 1968

This bronze was cast from the first rough sketch of a monument to Honoré Daumier, one of several projects that remained unfinished at Bourdelle's death.

Portrait Bust of Vincent d'Indy. 1927.
Bronze (edition of ten), 25¼ × 11⅜ × 11⅜ inches
Markings: l. side c. artist's monogram "⚒△Bourdelle"
back u. r. "N° 3
Susse Fres Fondeurs Paris"

PROVENANCE:
Estate of the artist; Charles E. Slatkin Galleries, New York, 1968

REFERENCES:
Jianou, Ionel, and Dufet, Michel. *Bourdelle*, trans. Kathleen Muston and Bryan Richardson, Paris, Arted, 1965, p. 116

Vincent d'Indy (1851–1931), composer of operas, symphonies, and chamber music, was a student of César Franck and a devotee of Richard Wagner.

ÉMILE BRANCHARD (1881–1938)

Émile Pierre Branchard, born New York, December 4, 1881, of French parents. As a child, moved to Kips Mansion on Washington Square, his mother's boarding house, which was frequented by artists and writers; lived there for more than fifty years. Worked as stevedore, truck driver, and dock policeman. Began to paint c. 1912; self-taught. Included in: Society of Independent Artists Annual, 1919–23, 1936; Salons of America, New York, 1925–30, 1933–36; Cincinnati Art Museum Annual, 1930, 1931, 1936; Pennsylvania Academy Annual, 1930, 1932, 1934. One-man shows, Bourgeois Galleries, New York, 1919–25, 1932. Died New York, February 15, 1938. Memorial exhibition, Marie Harriman Gallery, New York, 1938. Included in: "Masters of Popular Painting," The Museum of Modern Art, New York, 1938; "Work of the Twenties," with Vincent Canadé, and Arnold Friedman, Zabriskie Gallery, New York, 1958. One-man show, Zabriskie Gallery, 1962.

Burlesk Queen. n.d.
Oil on canvas mounted on board, 13 × 8¼ inches

PROVENANCE:
Leonard L. Bean, Trenton, New Jersey; Sterling Strauser, Stroudsberg, Pennsylvania; Zabriskie Gallery, New York, 1962

EXHIBITIONS:
Zabriskie Gallery, New York, March 26–April 14, 1962, *Émile Branchard*, no. 12

CONSTANTIN BRANCUSI (1876–1957)

Constantin Brâncuşi, born Hobitza, Rumania, February 19, 1876; moved to Tirgu Jiu, Rumania, 1887. Studied, Rumania: Craiova School of Arts and Crafts, 1895–98; Bucharest School of Fine Arts, 1898–1901. Bust of General Dr. Davila (pioneer of Rumanian medicine) commissioned, 1903. Traveled on foot to Paris, 1903–4; settled there permanently, 1904; studied, École des Beaux-Arts, 1905–7. Exhibited, Bucharest: Palatul Ateneului, 1903; Tinerimea Artistica, 1907–10, 1913, 1914, 1928. Exhibited, Paris: Salon d'Automne, 1906, 1907, 1909; Salon de la Société Nationale des Beaux-Arts, 1906–8; Salon des Indépendants, 1910–13, 1920, 1926. Met: Auguste Rodin, 1906; Henri Rousseau, Henri Matisse, Fernand Léger, Marcel Duchamp, Amedeo Modigliani, 1908; Jacob Epstein, 1912. Included in: the Armory Show, 1913; Cubist exhibition, with Alexander Archipenko, Raymond Duchamp-Villon, and others, Mánes Society, Prague, 1914. First one-man show, Alfred Stieglitz's Photo-Secession Gallery, "291," New York, 1914; works acquired by Stieglitz, and New York collector John Quinn, who became Brancusi's patron. Exhibited, New York: Society of Independent Artists Annual, 1917; "Allies of Sculpture," The Ritz-Carlton Hotel, 1917; Société Anonyme, 1920, 1926; Salons of America, 1923. Supervised installation of one-man shows, Wildenstein & Co., and Brummer Gallery, New York, 1926. Included in: Salon des Tuileries, Paris, 1926–29, 1933; "Abstrakte und Surrealistische Malerei und Plastik," Kunsthaus, Zurich, 1929. *Bird in Space*, 1926, declared work of art (not object of manufacture) by U.S. Customs Court, New York, 1928. One-man show, Brummer Gallery, 1933. Included in: "A Century of Progress," The Art Institute of Chicago, 1933; "Cubism and Abstract Art," The Museum of Modern Art, New York, and tour, 1936; "The International Surrealist Exhibition," New Burlington Galleries, London, 1936; "Origines et Développement de l'Art International Indépendant," Musée du Jeu de Paume, Paris, 1937. The Maharajah Olcar of Indore, India, purchased three versions of *Bird in Space*, and commissioned Temple of Contemplation and Deliverance (never built) to house them; Brancusi visited Indore, 1937. Visited Rumania for inauguration of war memorial, *Endless Column*, and *Gate of the Kiss* and *Table of Silence*, Public Park, Tirgu Jiu, 1937. Retrospectives: The Solomon R. Guggenheim Museum, New York, and tour, 1955; Muzeul de Artă al Academiei R.S.R., Bucharest, 1956–57. Willed studio and its contents to Musée National d'Art Moderne, Paris, 1956. Died Paris, March 16, 1957. Retrospective, The Solomon R. Guggenheim Museum, and tour, 1969–70.

Sleeping Muse. 1909–11.
Marble, 7 × 11 × 8 inches
Markings: beneath r. side "C Brancusi"

PROVENANCE:
The artist, Paris; Arthur B. Davies, New York; American Art Association, New York, Sale, April 16–17, 1929, *Arthur B. Davies Art Collection*, no. 449; M. Knoedler & Co., New York, 1962

EXHIBITIONS:
The Ritz-Carlton Hotel, New York, December 5–25, 1917, *Allies of Sculpture*, no. 26
The Solomon R. Guggenheim Museum, New York, October 3, 1962–January 6, 1963, *Modern Sculpture from the Joseph H. Hirshhorn Collection*, no. 39, ill. p. 54
Munson-Williams-Proctor Institute, Utica, New York, February 17–March 31, 1963, *1913 Armory Show: 50th Anniversary Exhibition*, no. 617, ill. p. 41; toured to Sixty-Ninth Infantry Armory, New York, April 6–28

REFERENCES:
Arnason, H. Harvard. *History of Modern Art*, New York, Abrams, 1968, p. 138, ill. p. 136
Canaday, John. "The Rodin Revolution," *The New York Times Magazine*, June 9, 1963, ill. p. 37
Christie, Manson & Woods, London. Sale, "Impressionist and Modern Paintings, Drawings and Sculpture," June 27, 1972, p. 64
Geist, Sidney. *Brancusi*, New York, Abrams, forthcoming, ill.
———. *Brancusi, A Study of the Sculpture*, New York, Grossman, 1968, no. 56, pp. 34–35, 218, ill.
———. *Constantin Brancusi 1876–1957: A Retrospective Exhibition*, New York, The Solomon R. Guggenheim Museum, 1969, pp. 21, 44, ill. pp. 21, 45

Giedion-Welcker, Carola. *Constantin Brancusi, 1876–1957*, trans. Maria Jolas and Anne Leroy, New York, Braziller, 1959, ill. p. 59

——. *Contemporary Sculpture*, 3rd rev. ed., New York, Wittenborn, 1960, p. 125, ill.

Hunter, Sam. *American Art of the 20th Century*, New York, Abrams, 1972, ill. 143

Jacobs, Jay. "Collector: Joseph H. Hirshhorn," *Art in America*, 57, July–August 1969, ill. p. 71

——. "Quality as Well as Quantity: Joseph H. Hirshhorn," in Lipman, Jean, ed. *The Collector in America*, New York, Viking, 1971, ill. p. 81

Jianou, Ionel. *Brancusi*, New York, Tudor, 1963, p. 93

Michelson, Annette. "Private but Public: The Joseph H. Hirshhorn Collection," *Contemporary Sculpture* (Arts Yearbook 8), New York, 1965, ill. p. 184

Zervos, Christian. *Constantin Brancusi*, Paris, Cahiers d'Art, 1957, ill. p. 27

Sleeping Muse is the first in Brancusi's highly idealized series of recumbent heads.

This is the only marble carving of *Sleeping Muse*. Brancusi planned to include the sculpture in the Armory Show of 1913; unable to obtain insurance for it, he sent a plaster in its place. Five bronzes, slightly smaller than the marble version, were subsequently cast.

Prometheus. 1911.
Polished bronze, 5⅛ × 6¾ × 5⅛ inches
Markings: bottom "C Brâncusi"

PROVENANCE:
The artist, Paris; Tarsila de Amaral, São Paulo, 1926; Galerie Europe, Paris, 1961

EXHIBITIONS:
"Pro Arte," Sociedade de Artes, Letras e Ciencias, São Paulo, April–May 1933
Galerie Europe, Paris, February–March 1961, *Klee, Kandinsky, Brancusi*, no. 1
Svensk-Franska Konstgalleriet, Stockholm, September 1961, *Fautrier—Brancusi*, no. 28, ill.
The Solomon R. Guggenheim Museum, New York, October 3, 1962–January 6, 1963, *Modern Sculpture from the Joseph H. Hirshhorn Collection*, no. 40, ill. p. 54
The Solomon R. Guggenheim Museum, New York, November 21, 1969–February 15, 1970, *Constantin Brancusi 1876–1957: A Retrospective Exhibition*, p. 48, ill.
Hayward Gallery, London, July 20–September 23, 1973, *Pioneers of Modern Sculpture* (organized by The Arts Council of Great Britain)

REFERENCES:
Geist, Sidney. *Brancusi*, New York, Abrams, forthcoming, ill.

——. *Brancusi, A Study of the Sculpture*, New York, Grossman, 1968, no. 63a, pp. 38–39, 218, ill.

Jianou, Ionel. *Brancusi*, New York, Tudor, 1963, pp. 40–41, 96

In ancient Greek mythology, Prometheus stole fire from the gods and gave it to man. As punishment he was chained to a rock and each day an eagle consumed his liver, which would grow again during the night.

Many interpretations have been given of Brancusi's transformation of this terrifying theme into such a serene and enigmatic work. When questioned by James Johnson Sweeney, the artist explained that it was simply the head of Prometheus. "If it is properly set you see how it falls on his shoulder as the eagle devoured his liver." ("The Brancusi Touch," *Art News*, 54, November 1955, p. 24)

Reclining Head (The First Cry). 1915.
Gouache on paper, 15 × 21 inches
Signed l. r.: "C. Brancusi"

PROVENANCE:
Albert Roullier Art Galleries, Chicago; Mrs. Inez Cunningham Stark, Chicago; James Goodman Gallery, New York, 1968

EXHIBITIONS:
The Art Institute of Chicago, April 25–May 26, 1940, *19th International Exhibition of Watercolors*, no. 102
James Goodman Gallery, New York, Spring 1968, *Spring 1968 Exhibition*, no. 32, ill. p. 9
The Solomon R. Guggenheim Museum, New York, November 21, 1969–February 15, 1970, *Constantin Brancusi 1876–1957: A Retrospective Exhibition*, p. 139

Torso of a Young Man. 1924.
Polished bronze on original stone and wood base, 18 × 11 × 7 inches; height of base 40½ inches (stone 6¼ inches, wood 34¼ inches)
Markings: l. l. side "C. Brancusi
Paris-1924"

PROVENANCE:
The artist, Paris; Henri-Pierre Roché, Paris; Sidney Janis Gallery, New York; Staempfli Gallery, New York, 1961

EXHIBITIONS:
Sidney Janis Gallery, New York, April 22–May 11, 1957, *Selection: Modern Art from Brancusi to Giacometti*, cat., ill.
Palais des Beaux-Arts, Brussels, April 17–October 19, 1958, *50 Ans d'Art Moderne* (Exposition Universelle et Internationale de Bruxelles), no. 33, ill. p. 210
XXX Biennale Internazionale d'Arte, Venice, May–September 1960, *Central Pavilion*, no. 9, p. 33, ill.
Staempfli Gallery, New York, November 29–December 31, 1960, *Constantin Brancusi 1876–1957*, no. 9, ill.
The Solomon R. Guggenheim Museum, New York, October 3, 1962–January 6, 1963, *Modern Sculpture from the Joseph H. Hirshhorn Collection*, no. 41, ill. p. 55
Sidney Janis Gallery, New York, October 2–November 3, 1973, *25 Years of Janis Part I: From Picasso to Dubuffet; from Brancusi to Giacometti*, no. 14, ill.

REFERENCES:
Arnason, H. Harvard. *History of Modern Art*, New York, Abrams, 1968, p. 138, ill. p. 137
Collier, Graham. *Art and the Creative Unconsciousness*,

Englewood Cliffs, New Jersey, Prentice-Hall, 1972, p. 80, ill. p. 81

Feldman, Edmund Burke. *Varieties of Visual Experience*, New York, Abrams, 1972, ill. p.163

Geist, Sidney. *Brancusi, A Study of the Sculpture*, New York, Grossman, 1968, no. 101, pp. 59, 222, ill.

——. *Constantin Brancusi 1876–1957: A Retrospective Exhibition*, New York, The Solomon R. Guggenheim Museum, 1969, p. 83

Giedion-Welcker, Carola. *Constantin Brancusi 1876–1957*, trans. Maria Jolas and Anne Leroy, New York, Braziller, 1959, pp. 16, 37, ill. p. 95

Jianou, Ionel. *Brancusi*, New York, Tudor, 1963, p. 105

Kramer, Hilton. "Two Exhibitions Marking Janis Gallery's 25 Years," *The New York Times*, October 6, 1973, p. 19

Lerner, Abram. "The Hirshhorn Collection," *The Museum World* (Arts Yearbook 9), 1967, p. 63, ill.

Levine, Les. "A Portrait of Sidney Janis on the Occasion of his 25th Anniversary As an Art Dealer," *Arts*, 48, November 1973, p. 54

Lynton, Norbert. *The Modern World*, New York, McGraw-Hill, 1965, ill. p. 135

Read, Herbert. *A Concise History of Modern Sculpture*, New York, Praeger, 1964, no. 47, p. 289, ill. p. 51

Sidney Janis Gallery. *10th Anniversary Exhibition*, New York, 1958, cat., ill.

Spear, Athena Tacha. "Brancusi and Contemporary Sculpture," *Arts Magazine*, 46, November 1971, ill. p. 30.

Staempfli Gallery, New York, *Art International*, 4, June 1960, ill. p. 89 (adv.)

Unsigned. "Exhibitions Here and There," *Art International*, 4, December 1960, ill. p. 64

WARREN BRANDT (b. 1918)

Born Greensboro, North Carolina, February 26, 1918. Studied: Pratt Institute, Brooklyn, New York, 1935–37; The Art Students League of New York, with Yasuo Kuniyoshi, 1946; Washington University, St. Louis, Missouri, with Philip Guston, and Max Beckmann B.F.A., 1948; University of North Carolina at Chapel Hill, M.F.A., 1953. Taught: Salem College, Winston-Salem, North Carolina, 1949–50; Pratt Institute, 1950–52; Guilford College, Greensboro, 1952–56; University of Mississippi, University, 1957–59; Southern Illinois University, Carbondale, 1959–61; The School of Visual Arts, New York, 1962–65. One-man shows, A. M. Sachs Gallery, New York, 1966–68, 1970, 1973. Director, New York Studio School, 1967. Retrospective, Allentown Art Museum, Pennsylvania, 1969. One-man shows: Agra Gallery, Washington, D.C., 1969; 1970; Pratt Manhattan Center, New York, 1970; Hooks Epstein Gallery, Houston, 1971. Lives in New York.

The Morning Paper. 1966.
Oil on canvas, 60 × 70 inches
Signed l. r.: "Warren Brandt"

PROVENANCE:
A. M. Sachs Gallery, New York; Ethel Steuer Epstein, New York; Parke-Bernet Galleries, New York, Sale 2688, April 19, 1968, no. 219, ill. p. 59

EXHIBITIONS:
A. M. Sachs Gallery, New York, March 29–April 16, 1966, *Warren Brandt*

REFERENCES:
Sawyer, Kenneth. "Notes on the Painter Warren Brandt," *Art International*, 10, March 20, 1966, ill. p. 29

GEORGES BRAQUE (1882–1963)

Born Argenteuil-sur-Seine, France, May 13, 1882. Moved with family to Le Havre, France, 1890; studied, École des Beaux-Arts, 1893–1900. Moved to Paris, 1900; worked as apprentice painter-decorator. Studied, Paris: Cours Municipal, with Eugène Quignolot, evenings, 1900; Académie Humbert, 1903; École des Beaux-Arts, with Léon Bonnat, 1903. Included in Salon des Indépendants, Paris, 1906–9. Saw *Les Demoiselles d'Avignon* in Picasso's studio, 1907; developed principles of Cubism, with Picasso, 1908–9. First one-man show, Galerie Kahnweiler, Paris, 1908. Met Henri Laurens, who became lifelong friend, 1911. First *papiers collés*, 1912; drypoints published by Daniel-Henry Kahnweiler (Paris), 1912. Three works included in the Armory Show, 1913. Exhibited with Picasso, Alfred Stieglitz's Photo-Secession Gallery, "291," New York, 1914. Served, French Army, 1914–16; severely wounded, 1915; received Croix de Guerre, 1916. One-man shows, Paris: Galerie de l'Effort Moderne, 1919; Galerie Simon, 1920; Galerie Paul Rosenberg, 1924, 1926. Commissioned by Sergei Diaghilev to design decor and costumes for Ballets Russes de Monte Carlo: *Les Fâcheux*, 1924; *Zéphyre et Flore*, 1925. Commissioned by Ambroise Vollard, 1931, to illustrate Hesiod's *Theogony* (Paris, Maeght), 1954. First incised plaster reliefs, 1931. Moved to Varengeville, France, 1931. Retrospective, Kunsthalle, Basel, 1933. One-man show, Alex, Reid & Lefevre Gallery, London, 1934. Worked primarily on sculpture, 1939–45. Légion d'honneur: officier, 1945; commandeur, 1951. Awarded Grand Prize for Painting, Venice Biennale, 1948. Retrospectives: The Museum of Modern Art, New York, 1949; Venice Biennale, 1958; Musée du Louvre, Paris, 1961. Commissioned to execute ceiling decoration, Etruscan Gallery, Musée du Louvre, 1953. One-man shows, sculpture: M. Knoedler & Co., New York, 1956; Contemporary Arts Center, Cincinnati, Ohio, 1956–57. Designed stained-glass windows, church at Varengeville, 1957–58. Died Paris, August 31, 1963. Posthumous exhibitions: "Georges Braque, An American Tribute," four-gallery retrospective, New York, 1964; "Braque: The Great Years," The Art Institute of Chicago, 1972–73.

Hesperis. 1939, cast 1955.
Bronze, 16½ × 8¾ × 3⅜ inches
Markings: front l. r. "G Braque 1/6"
back l. l. "Susse Fondeur Paris"

PROVENANCE:
M. Knoedler & Co., New York, 1957

EXHIBITIONS:
M. Knoedler & Co., New York, May 8–June 29, 1956, *Braque Bronzes*, no. 5
Contemporary Arts Center, Cincinnati, Ohio, December 1956–January 1957, *The Sculpture of Georges Braque*, no. 4
The Detroit Institute of Arts, and tour, 1959–60, *Sculpture in Our Time*, no. 60
The Solomon R. Guggenheim Museum, New York, October 3, 1962–January 6, 1963, *Modern Sculpture from the Joseph H. Hirshhorn Collection*, no. 42, ill. p. 89

Little Horse. 1939, cast 1955.
Bronze, 8⅛ × 6⅜ × 2⅛ inches
Markings: back r. leg "GB"
back l. leg "2/6"

PROVENANCE:
Fine Arts Associates, New York, 1956

EXHIBITIONS:
Fine Arts Associates, New York, October 9–November 3, 1956, *Rodin to Lipchitz, Part II*, no. 7, ill.
The Museum of Modern Art, New York, January 29–March 2, 1958, *Three Painters as Printmakers: Braque, Miró, Morandi*
The Detroit Institute of Arts, and tour, 1959–60, *Sculpture in Our Time*, no. 58
The Solomon R. Guggenheim Museum, New York, October 3, 1962–January 6, 1963, *Modern Sculpture from the Joseph H. Hirshhorn Collection*, no. 43
M. Knoedler & Co., New York, April 7–May 2, 1964, *Georges Braque 1882–1963, An American Tribute* (sponsored by the Public Education Association), no. 23, ill.

Little Horse (Gelinotte). 1939, cast 1955.
Bronze, 7⅛ × 7⅛ × 2 inches
Markings: back r. leg "G Braque"
back l. leg "Susse Fondeur Paris 1/6"

PROVENANCE:
M. Knoedler & Co., New York, 1958

EXHIBITIONS:
The Detroit Institute of Arts, 1959, *Sculpture in Our Time*, no. 59, ill. p. 5
The Solomon R. Guggenheim Museum, New York, October 3, 1962–January 6, 1963, *Modern Sculpture from the Joseph H. Hirshhorn Collection*, no. 44
M. Knoedler & Co., New York, April 7–May 2, 1964, *Georges Braque 1882–1963, An American Tribute* (sponsored by the Public Education Association), no. 17

MORRIS BRODERSON (b. 1928)

Born Los Angeles, November 4, 1928. Studied: Pasadena Art Museum School, California, 1943; University of Southern California, Los Angeles, with Francis de Ederley, 1943–47; Jepson Art Institute, Los Angeles, 1948. One-man shows: Dixie Hall Studio, Laguna Beach, California, 1954; Stanford University Art Gallery and Museum, California, 1957; Santa Barbara Museum of Art, California, 1958; Bertha Lewinson Gallery, Los Angeles, 1959, 1960; M. H. de Young Memorial Museum, San Francisco, 1961. Included in: Pittsburgh International, 1961; "The Image Retained," Municipal Art Gallery, Los Angeles, and tour, 1961; "Young America," Whitney Museum of American Art, New York, 1961; Contemporary American Exhibition, University of Illinois, Champaign-Urbana, 1963, 1965, 1967, 1969. One-man shows: Ankrum Gallery, Los Angeles, from 1961; Container Corporation of America, Chicago, 1963; The Downtown Gallery, New York, 1965, 1966; Staempfli Gallery, New York, 1971. Retrospective, Fine Arts Gallery of San Diego, 1969. Lives in Los Angeles.

Angel and Holy Mary, after Leonardo da Vinci. 1960.
Oil on canvas, 50 × 72 inches
Signed and dated l. l.: "Broderson 60"

PROVENANCE:
Ankrum Gallery, Los Angeles, 1961

EXHIBITIONS:
M. H. de Young Memorial Museum, San Francisco, January 12–February 12, 1961, *Morris Broderson*, no. 15
Municipal Art Gallery, Los Angeles, May 30–June 25, 1961, *The Image Retained*, no. 13, ill.; toured to Fine Arts Gallery of San Diego, California, July 7–30; California Palace of the Legion of Honor, San Francisco, August 5–September 4
Servite Marian Center, Riverside, California, May 4–19, 1963, *Servite Arts Festival*, no. 15, colorplate, frontispiece
Container Corporation of America, Chicago, June 23–July 21, 1963, *Morris Broderson*
Fine Arts Gallery of San Diego, California, April 25–June 1, 1969, *Morris Broderson Retrospective*, no. 9

REFERENCES:
Ankrum Gallery, Los Angeles, *Art News*, 60, December 1961, colorplate p. 2 (adv.)
Frankenstein, Alfred. "Kollwitz and Broderson—Artists of Similar Conviction," *San Francisco Sunday Chronicle*, January 22, 1961, ill. p. 25
——. "Nobody Runs the Slightest Risk Showing These Angelenas," *San Francisco Sunday Chronicle*, August 20, 1961, p. 29
Fried, Alexander. "Art: Two New Dramatic Exhibits," *San Francisco Examiner*, January 22, 1961, p. 6

BYRON BROWNE (1907–1961)

George Byron Browne, born Yonkers, New York, June 26, 1907. Studied, National Academy of Design, New York, with Charles W. Hawthorne, and Ivan Olinsky, 1924–28. Awarded Third Hallgarten Prize, National Academy of Design Annual, 1928. One-man shows, New York: Eighth Street Gallery, 1933; Gallery Secession, 1934; New School for Social Research, 1934, 1935; The Artists' Gallery, 1938. Public Works of Art Project, New York, 1934. WPA Federal Art Project, Mural Division, New York, 1935–39; mural commissions, New

York: U.S. Passport Office, Rockefeller Center, 1936; radio station WNYC, 1937; New York World's Fair, Health and Science Building, Flushing Meadows, 1939. Included in "New Horizons in American Art," The Museum of Modern Art, New York, 1936. Founding member, American Abstract Artists, New York, 1936; exhibited with group, 1937–61. One-man shows: The Pinacotheca, New York, 1944, 1945; Kootz Gallery, New York, 1946–48; Galerie Maeght, Paris, 1947; Allen R. Hite Art Institute, University of Louisville, Kentucky, 1948; Grand Central Moderns, New York, 1949–62; Tirca Karlis Gallery, Provincetown, Massachusetts, 1960–63. Taught: The Art Students League of New York, 1948–61; New York University, 1959–61. Died New York, December 25, 1961. Memorial exhibition, The Art Students League of New York, 1962. Retrospectives: Gallery 63, New York, 1964; Harmon Gallery, Naples, Florida, 1971.

Icon. 1949.
Oil and collage on canvas, 25¼ × 19¼ inches
Signed and dated l. r.: "Byron Browne 1949"

PROVENANCE:
Tirca Karlis Gallery, New York, 1957

EXHIBITIONS:
Gallery 63, New York, March 24–April 11, 1964, *Byron Browne*

"Always concerned with the human condition, he devised an allegorical icon—part man, part crustacean—that he explored through many variations from a series based on a butterfly he was painting in 1946–47. The jagged projections protruding from the neck, the crescent form of the hat above the round head, are remnants of claws and claw teeth more explicitly defined in earlier examples."

Statement by Rosalind Bengelsdorf Browne, 1971

PATRICK HENRY BRUCE (1881–1936)

Born Long Island, Virginia, April 2, 1881. Studied: Richmond Art School, Virginia, with Edward Valentine, 1897; New York School of Art, with William Merritt Chase, and Robert Henri, 1902–3. Exhibited: National Academy of Design Annual, 1904; St. Louis International Exposition, Missouri, 1904; 18th and 19th American Exhibition, The Art Institute of Chicago, 1905, 1906. Moved to Paris, 1904; supported himself by selling antiques. Met: painter Arthur Burdett Frost, Jr., and Gertrude and Leo Stein, 1907; Robert Delaunay, 1912. Included in: Salon d'Automne, Paris, 1907–29; Erster Deutscher Herbstsalon, Galerie der Sturm, Berlin, 1913; Salon des Indépendants, Paris, 1913–30. Studied with Henri Matisse, 1908. Four works included in the Armory Show, 1913; withdrawn with those of Robert and Sonia Delaunay, at their request, prior to Boston and Chicago tour. First one-man show, Montross Gallery, New York, 1916. Included in Society of Independent Artists Annual, 1917. Exhibited with Société Anonyme: New York, 1920; Worcester Art Museum, Massachusetts, and tour, 1921; MacDowell Club, New York, 1922; Vassar College Art Gallery, Poughkeepsie, New York, 1923. Exhibited rarely thereafter. Moved to Versailles, France, 1932; returned to the U.S., 1936. Destroyed much of his work shortly before his death, by suicide, New York, November 12, 1936. Posthumous exhibitions: with Morgan Russell and Stanton Macdonald-Wright, Rose Fried Gallery, New York, 1950; "Synchromism and Color Principles in American Painting, 1910–1930," M. Knoedler & Co., New York, 1965; "Synchromism and Related American Color Painting, 1910–30," The Museum of Modern Art, New York, Circulating Exhibition, 1967.

Forms # 12. 1927.
Oil on canvas, 35 × 45¾ inches

PROVENANCE:
Henri-Pierre Roché, Paris; Mme Henri-Pierre Roché, Paris; Jon N. Streep, New York, 1968

EXHIBITIONS:
State University of New York, College at Oswego, February 4–26, 1967, *Synchromism and Related American Color Painting, 1910–1930* (The Museum of Modern Art, New York, Circulating Exhibition), cat.; toured to nine U.S. cities

Vertical Beams. c. 1932.
Oil on canvas, 31¼ × 51¼ inches

PROVENANCE:
Henri-Pierre Roché, Paris; Mme Henri-Pierre Roché, Paris; Jon N. Streep, New York, 1968

EXHIBITIONS:
M. Knoedler & Co., New York, October 12–November 6, 1965, *Synchromism and Color Principles in American Painting, 1910–1930,* no. 15, p. 36, ill. 4
State University of New York, College at Oswego, February 4–26, 1967, *Synchromism and Related American Color Painting, 1910–1930* (The Museum of Modern Art, New York, Circulating Exhibition), no. 9; toured to nine U.S. cities

REFERENCES:
Agee, William C. "Letters: Patrick Henry Bruce," *Art in America,* 57, November–December 1969, p. 38
Jacobs, Jay. "Collector: Joseph H. Hirshhorn," *Art in America,* 57, July–August 1969, p. 63
———. "Quality as Well as Quantity: Joseph H. Hirshhorn," in Lipman, Jean, ed. *The Collector in America,* New York, Viking, 1971, p. 85, ill.
Lerner, Abram. "Letters: Patrick Henry Bruce, Reply," *Art in America,* 57, November–December 1969, p. 38

CHARLES BURCHFIELD (1893–1967)

Charles Ephraim Burchfield, born Ashtabula Harbor, Ohio, April 9, 1893. Moved with family to Salem, Ohio, 1898. Studied, Cleveland School of Art, with Henry G. Keller, Frank N. Wilcox, and William J. Eastman, 1912–16. Received scholarship to National Academy of Design, New York, 1916. One-man shows: Cleveland School of Art, 1916; Sunwise Turn Bookshop, New York, 1916; Kevorkian Gallery, New York, 1920. Settled in Buffalo, New York, 1921; worked as wallpaper

designer, 1921–29. One-man shows: The Art Institute of Chicago, 1921; Grosvenor Gallery, London, 1923; Montross Gallery, New York, 1924, 1926, 1928; The Museum of Modern Art, New York, 1930; Frank Rehn Gallery, New York, 1930. Included in "Romantic Painting in America," The Museum of Modern Art, 1933. Retrospectives: Carnegie Institute, Pittsburgh, 1938; Albright Art Gallery, Buffalo, New York, and tour, 1944; Whitney Museum of American Art, New York, and tour, 1956–57; The University of Arizona Art Gallery, Tucson, 1966. Member, The National Institute of Arts and Letters, 1943. Awarded Gold Medal for Painting, The National Institute of Arts and Letters, and The American Academy of Arts and Letters, 1960. Died West Seneca, New York, January 10, 1967. Memorial exhibitions: The American Academy of Arts and Letters, New York, 1968; Munson-Williams-Proctor Institute, Utica, New York, 1970.

Midsummer Afternoon. 1952.
Watercolor on paper, 40 × 30 inches
Signed l. l. with monogram: "CB"

PROVENANCE:
Frank Rehn Gallery, New York, 1954

EXHIBITIONS:
Frank Rehn Gallery, New York, November 17–December 20, 1952, *Burchfield,* no. 8
Whitney Museum of American Art, New York, March 17–April 18, 1954, *Annual Exhibition of Contemporary American Sculpture, Watercolors and Drawings,* no. 77
The National Gallery of Canada, Ottawa, and tour, 1957, *Some American Paintings from the Collection of Joseph H. Hirshhorn,* no. 6
American Federation of Arts tour, 1959–60, *Ten Modern Masters of American Art,* no. 6

REFERENCES:
Trovato, Joseph. *Charles Burchfield, Catalogue of Paintings in Public and Private Collections,* Utica, New York, Munson-Williams-Proctor Institute, 1970, no. 1091

DAVID BURLIUK (1882–1967)

David Davidovich Burliuk, born Riabushki, Russia, July 22, 1882. Studied: Kazan School of Art, Odessa, Russia, 1899–1902; Bayerische Akademie der Schönen Künste, Munich, with Anton Azbé, 1903; École des Beaux-Arts, Paris, 1904–5. Settled in Moscow, 1907. Exhibited, Russia: First Wreath Exhibition, Moscow, 1907; Link Exhibition, Kiev, 1908; Third Wreath Exhibition, St. Petersburg, and tour, 1909; International Salon, Odessa, 1909, 1910; Jack of Diamonds Exhibition, Moscow, and St. Petersburg, 1910–18. Wrote manifesto *In Defense of New Art* (St. Petersburg), 1910. Studied, Moscow Institute of Painting, Sculpture and Architecture, 1911–13; left Moscow, with Futurist poet Vladimir Mayakowsky, for lecture tour of Russia, 1913. Included in: first exhibition of Der Blaue Reiter, Galerie Thannhauser, Munich, and tour, 1911–12; Erster Deutscher Herbstsalon, Galerie der Sturm, Berlin, 1913. Friendly with Wassily Kandinsky, Moscow, 1914. Edited *First Futurist Newspaper* (Vladivostok, Russia), 1915. Emigrated to New York, 1922; U.S. citizen, 1930. One-man shows: Société Anonyme, The Brooklyn Museum, New York, 1924; J. B. Neumann's New Art Circle, New York, 1927; California Palace of the Legion of Honor, San Francisco, 1931; Eighth Street Gallery, New York, 1934; Boyer Galleries, New York, 1936–40; The Phillips Memorial Gallery, Washington, D.C., 1937; ACA Gallery, New York, from 1941. Included in: The Sesquicentennial International Exposition, Philadelphia, 1926; Society of Independent Artists Annual, 1926–33; "Abstract and Surrealist American Art," The Art Institute of Chicago, 1947–48. Moved to Hampton Bays, New York, 1950. Visited: Soviet Union, as guest of Union of Writers, 1956; Czechoslovakia, 1957. One-man show, Grosvenor Gallery, London, 1966. Member, The National Institute of Arts and Letters, 1967. Died Southampton, New York, January 15, 1967.

Dreams About Travel. 1943.
Oil on canvas, 41 × 36 inches
Signed and dated l. r.: "Burliuk 1943"

PROVENANCE:
ACA Gallery, New York, 1944

EXHIBITIONS:
ACA Gallery, New York, December 20, 1943–January 8, 1944, *David Burliuk: Artist-Scholar, Father of Russian Futurism,* no. 2, ill. p. 13
ACA Gallery, New York, May 25–June 6, 1959, *31 American Contemporary Artists,* cat., ill.

REFERENCES:
Burliuk, Marussia, ed. *Color and Rhyme,* no. 61, Hampton Bays, New York, 1966, ill. p. 12
McCausland, Elizabeth. "Burliuk: A Fable," *David Burliuk, 55 Years of Painting,* Long Beach, New York, Lido Galleries, 1962, p. 9
Riley, Maude. "David Burliuk, Factual to Fantastic," *Art Digest,* 18, January 1, 1944, ill. p. 15

POL BURY (b. 1922)

Born Haine-St.-Pierre, Belgium, April 26, 1922. Studied, Académie Royale des Beaux-Arts, Mons, Belgium, 1938–39. Included in International Surrealist Exhibition, Brussels, 1945. Member: Belgian Jeune Peinture, 1947; CoBrA, 1949–51. Included in: "Mouvement I," Galerie Denise René, Paris, 1955; "Bewogen Beweging," Stedelijk Museum, Amsterdam, 1961. One-man shows: Galerie Saint-Laurent, Brussels, 1958; Galerie Iris Clert, Paris, 1962; Lefebre Gallery, New York, from 1964; Felix Landau Gallery, Los Angeles, 1965, 1966; Kasmin Gallery, London, 1967; Galerie Françoise Mayer, Brussels, 1967 (Prix de la Critique). Settled near Paris, 1961; lived in New York, 1966. Included in: Pittsburgh International, 1961, 1967, 1970; Venice Biennale, 1964; Documenta III, Kassel, 1964; Guggenheim International, 1967–68; "Kinetics," Hayward Gallery, London, 1970. Fountain commissioned, University of Iowa, Iowa City, 1969. Taught, University of California, Berkeley, 1970–71. One-man shows, Galerie Maeght, Paris, 1970, 1971.

Retrospective, University Art Museum, University of California, Berkeley, and tour, 1970–71. Lives in Paris.

1053 White Dots. 1964.
Motorized construction of nylon wires in wood panel, 54½ × 27½ × 7 inches

PROVENANCE:
Lefebre Gallery, New York, 1964

EXHIBITIONS:
The Solomon R. Guggenheim Museum, New York, April 15–June 6, 1971, *Pol Bury,* no. 38

REG BUTLER (b. 1913)

Reginald Cotterell Butler, born Buntingford, Hertfordshire, England, April 28, 1913. Trained as architect, 1933–36. Associate, Royal Institute of British Architects, 1937; taught, Architectural Association School of Architecture, London, 1937–39; technical editor, *Architects' Journal* (London), 1946–50. Worked as blacksmith, 1941–45. First one-man show, sculpture, The Hanover Gallery, London, 1949. Gregory Fellow in Sculpture, University of Leeds, England, 1950–53. Included in: Venice Biennale, 1952; 2nd, 5th, 6th Middelheim Biënnale, Antwerp, 1953, 1959, 1961; Documenta I and II, Kassel 1955, 1959; Pittsburgh International, 1955–70; "New Images of Man," The Museum of Modern Art, New York, and The Baltimore Museum of Art, 1959; "Painting and Sculpture of a Decade, 54–64," The Tate Gallery, 1964. Awarded grand prize, international competition for monument to "The Unknown Political Prisoner," Institute of Contemporary Arts, London, 1953; maquette shown, The Tate Gallery, London, 1953. One-man shows: Venice Biennale, 1954; The Hanover Gallery, 1954, 1957, 1960, 1963; Curt Valentin Gallery, New York, 1955; Pierre Matisse Gallery, New York, 1959, 1962, 1973. Retrospectives: Rotterdamsche Kunstkring, Rotterdam, The Netherlands, 1957; J. B. Speed Art Museum, Louisville, Kentucky, 1963. Has taught, Slade School of Fine Art, University College, London, since 1950. Lives in Berkhampstead, Hertfordshire.

Girl. 1954–56.
Bronze, 88½ × 30 × 25 inches
Markings: back of base at l. "R
Susse Fondeur Paris
5/8"

PROVENANCE:
The Hanover Gallery, London, 1957

EXHIBITIONS:
Art Gallery of Toronto, June 27, 1957–March 31, 1959, extended loan
The Detroit Institute of Arts, and tour, 1959–60, *Sculpture in Our Time,* no. 63
The Solomon R. Guggenheim Museum, New York, October 3, 1962–January 6, 1963, *Modern Sculpture from the Joseph H. Hirshhorn Collection,* no. 47, ill. p. 154

REFERENCES:
Driver, Morley. "Art Notes," *Detroit Free Press,* May 8, 1960, ill.

Manipulator. 1956.
Bronze, 66 × 23½ × 21 inches
Markings: inside l. foot "R
56
C8"

PROVENANCE:
Curt Valentin Gallery, New York, 1956

EXHIBITIONS:
Art Gallery of Toronto, June 27, 1957–March 31, 1959, extended loan
Dallas Museum for Contemporary Arts, May 8–July 3, 1958, *From Rodin to Lipchitz,* p. 7
The Detroit Institute of Arts, and tour, 1959–60, *Sculpture in Our Time,* no. 62
The Solomon R. Guggenheim Museum, New York, October 3, 1962–January 6, 1963, *Modern Sculpture from the Joseph H. Hirshhorn Collection,* no. 46, ill. p. 155

REFERENCES:
Mastai, Marie-Louise D'Otrange. "The Connoisseur in America," *Connoisseur,* 151, December 1962, p. 270
Saltmarche, Kenneth. "Hirshhorn Collection," *Windsor (Ontario) Daily Star,* March 23, 1959
Sweeney, James Johnson. "A Living Frame for Sculpture," *House & Garden,* 126, August 1964, ill. p. 110

Musée Imaginaire. 1963.
Thirty-nine bronze figures in wooden case, 30½ × 48½ × 5 inches
Markings: each piece "R 5/9" numbered 1–39

PROVENANCE:
Pierre Matisse Gallery, New York, 1967

EXHIBITIONS:
Pierre Matisse Gallery, New York, May–June 1967, *Selections 1967,* no. 1, ill. p. 3

ALEXANDER CALDER (b. 1898)

Born Philadelphia, July 22, 1898; son of sculptor Alexander Stirling Calder (1870–1945). Studied: mechanical engineering, Stevens Institute of Technology, Hoboken, New Jersey, 1915–19; The Art Students League of New York, with John Sloan, George Luks, Guy Pène du Bois, and Boardman Robinson, 1923–26. Line drawings published in *National Police Gazette,* 1923–26. Traveled to Paris, 1926–27, 1928, 1930; exhibited animated circus toys and wire sculpture, Salon des Humoristes, 1927; met Joan Miró, Fernand Léger, Piet Mondrian. One-man shows: Weyhe Gallery, New York, 1928; Galerie Billiet, Paris, 1929; Galerie Nierendorf, Berlin, 1929; Galerie Percier, Paris, 1931; Galerie Vignon, Paris, 1932 (first mechanized constructions were named "mobiles" by Marcel Duchamp). Member, Association Abstraction-Création, Paris, 1931. One-man shows, New York: Julien Levy Gallery, 1932; Pierre Matisse Gallery, 1934–43; Willard Gallery (jewelry), 1940; Buchholz Gallery (later Curt Valentin Gallery), 1944–55. Designed: mobile

ballet sets, Martha Graham Dance Company, 1935, 1936; mechanized mercury fountain, Spanish Pavilion, Exposition Universelle de 1937, Paris. Retrospectives: George Walter Vincent Smith Art Museum, Springfield, Massachusetts, 1938; The Museum of Modern Art, New York, 1943; Massachusetts Institute of Technology, Cambridge, 1950. Collaborated with Duchamp, Léger, and Hans Richter on film *Dreams that Money Can Buy*, 1944. One-man shows: Galerie Maeght, Paris, from 1950; Stedelijk Museum, Amsterdam, 1951; Museo de Bellas Artes, Caracas, 1955; Perls Galleries, New York, from 1956; Museu de Arte Moderna, Rio de Janeiro, 1959. Awarded First Prize for Sculpture: Venice Biennale, 1952; Carnegie International, 1958. Commissions: acoustic ceiling, auditorium, University of Caracas, 1952; General Motors Technological Center, Detroit, 1954; eleven works, Ahmedabad, India, 1954–55; International Arrivals Building, John F. Kennedy International Airport, New York, 1957; United States Pavilion, Exposition Universelle et Internationale de Bruxelles, 1958; Lincoln Center for the Performing Arts, New York, 1965; Expo '67, Montreal, 1967; Port of New York Authority World Trade Center, New York, 1970. Member: The National Institute of Arts and Letters, 1962; The American Academy of Arts and Letters, 1964. Retrospectives: The Tate Gallery, London, 1962; The Solomon R. Guggenheim Museum, New York, and tour, 1964–65; Musée National d'Art Moderne, Paris, 1965; Akademie der Künste, Berlin, 1967; Fondation Maeght, St.-Paul-de-Vence, France, and tour, 1969. Awarded Gold Medal for Sculpture, The National Institute of Arts and Letters, 1971. Lives in Roxbury, Connecticut, and in Saché, France.

Crank-Driven Mobile. 1931–32.
Wood, wire, and sheet metal, 23 × 24½ inches

PROVENANCE:
The artist; Private collection, Paris; William N. Copley, New York; Harold Diamond, New York, 1964

EXHIBITIONS:
Galerie Vignon, Paris, February 12–29, 1932, *Calder: Ses Mobiles*
The Solomon R. Guggenheim Museum, New York, November 5, 1964–January 31, 1965, *Alexander Calder, A Retrospective Exhibition*, no. 127
Musée National d'Art Moderne, Paris, July–October 1965, *Calder*, no. 35
M. Knoedler & Co., New York, December 5–29, 1967, *Space and Dream*, ill. p. 34
The Museum of Modern Art, New York, November 25, 1968–February 9, 1969, *The Machine as Seen at the End of the Mechanical Age*, p. 149, ill.

REFERENCES:
Arnason, H. Harvard. *Calder*, Princeton, New Jersey, Van Nostrand, 1966, p. 42
Brett, Guy. *Kinetic Art*, New York, Reinhold, 1968, ill. p. 20
Goldwater, Robert. *Space and Dream*, New York, Walker, 1967, ill. p. 34

Form Against Yellow. 1936.
Painted sheet metal and wood, 42 × 40 × 30 inches

PROVENANCE:
The artist; Herbert Matter, New York; Harold Diamond, New York, 1968

Fish Mobile. 1940.
Glass, metal, wire, and cord, 16¼ × 46 × 3 inches

PROVENANCE:
Buchholz Gallery, New York; Keith Warner, Vermont; G. David Thompson, Pittsburgh; Harold Diamond, New York, 1963

REFERENCES:
Jacobs, Jay. "Collector: Joseph H. Hirshhorn," *Art in America*, 57, July–August 1969, ill. p. 71

Constellation. 1943.
Painted and unpainted wood and wire, 21½ × 28 × 24 inches

PROVENANCE:
Pierre Matisse Gallery, New York; Mrs. Manuel Seff, New York; Herbert Matter, New York; Harold Diamond, New York, 1968

EXHIBITIONS:
Pierre Matisse Gallery, New York, May 18–June 12, 1943, *Calder*

REFERENCES:
Meredith, Burgess, producer and narrator, and Matter, Herbert, director. Film, *Works of Calder*, New York, 1950

Mobile–Stabile. 1950.
Painted sheet metal and metal rods, 12 × 16 feet
Markings: on one metal leaf "℟"

PROVENANCE:
Curt Valentin Gallery, New York; G. David Thompson, Pittsburgh; Harold Diamond, New York, 1965

REFERENCES:
Unsigned. "Sculpture: Fresh-Air Fun," *Time*, 90, September 8, 1967, colorplate p. 75

Zarabanda (Un Disco Blanco). 1955.
Mobile, painted sheet metal, metal rods, and wire, 33 × 89½ × 21½ inches

PROVENANCE:
The artist; Dr. Andrés Parra Pulido, Caracas; Parke-Bernet Galleries, New York, Sale 2679, April 4, 1968, no. 189, ill. p. 113

EXHIBITIONS:
Museo de Bellas Artes, Caracas, *Exposición Calder*, September 11–25, 1955, no. 27

Orange and Black Composition. 1956.
Gouache and ink on paper, 29 × 40 inches
Signed and dated l. r.: "Calder 56"

PROVENANCE:
Galerie Semiha Huber, Zurich, 1963

Mobile. 1958.
Painted sheet metal, metal rods, and wire, 3 feet 5 inches × 8 feet 4 inches × 4 feet 10 inches

PROVENANCE:
The artist; Marie Cuttoli, Paris; Jon N. Streep, New York, 1961

EXHIBITIONS:
The Solomon R. Guggenheim Museum, New York, October 3, 1962–January 6, 1963, *Modern Sculpture from the Joseph H. Hirshhorn Collection*, no. 48, ill. p. 177
Better Living Center, New York World's Fair, Flushing Meadows, May 1–October 18, 1964, *Four Centuries of American Masterpieces*, no. 2

The Red Mobile. 1958.
Painted sheet metal and wire, 27 × 78 inches

PROVENANCE:
Staempfli Gallery, New York; Philippe Dotremont, Brussels; Parke-Bernet Galleries, New York, Sale 2345, April 14, 1965, no. 10

Twenty-Nine Circles. 1958.
Painted sheet metal and wire, 47½ × 30 × 22 inches

PROVENANCE:
The artist; Marie Cuttoli, Paris; Harold Diamond, New York, 1968

Little Long Nose (Le Petit Nez). 1959.
Painted sheet metal, 66 × 66 × 47 inches

PROVENANCE:
Galerie Maeght, Paris; Galerie Claude Bernard, Paris, 1962

EXHIBITIONS:
Galerie Maeght, Paris, March 6–April 13, 1959, *Calder: Stabiles*, no. 4
Stedelijk Museum, Amsterdam, May 15–June 22, 1959, *Alexander Calder*, no. 4, ill.; toured to Kunsthalle, Hamburg, July 17–August 30; Museum Haus Lange, Krefeld, Germany, September 13–October 25; Städtische Kunsthalle, Mannheim, Germany, November 7–December 13; Städtisches Museum, Haus der Jugend, Wuppertal-Barmen, Germany, January 10–February 21, 1960; Kunst- und Museumsverein, Wuppertal, March 5–April 10; Kunstgewerbemuseum, Zurich, April 17–May 5
The Solomon R. Guggenheim Museum, New York, October 3, 1962–January 6, 1963, *Modern Sculpture from the Joseph H. Hirshhorn Collection*, no. 50, ill. p. 176

REFERENCES:
Davidson, Jean, and Salles, Georges. "Calder: Stabiles," *Derrière le Miroir*, no. 113, 1959, no. 4
Mates, Robert E. *Photographing Art*, New York, Amphoto, 1966, ill. p. 109
——. "Photographing Sculpture and Museum Exhibits," *Curator*, 10, June 1967, ill. pp. 106–7
Read, Herbert. *A Concise History of Modern Sculpture*, New York, Praeger, 1964, no. 290, p. 290, ill. p. 245
—— (ed.). *Encyclopedia of the Arts*, London, Thames and Hudson, 1966, ill. p. 148
Unsigned. "Art: Lone Wolf," *Newsweek*, 60, October 15, 1962, p. 110, ill.

Two Discs (Deux Disques). 1965.
Painted steel plate, 25 feet 6 inches × 27 feet 4 inches × 17 feet 4 inches
Markings: central vertical form, six feet above ground "℟65"

PROVENANCE:
Perls Galleries, New York, 1966

EXHIBITIONS:
Musée National d'Art Moderne, Paris, July–October 1965, *Calder*, no. 278

REFERENCES:
Calder, Alexander. *An Autobiography with Pictures*, New York, Pantheon, 1966, p. 273, ill. p. 272
Jacobs, Jay. "Collector: Joseph H. Hirshhorn," *Art in America*, 57, July–August 1969, colorplate p. 69
——. "Quality as Well as Quantity: Joseph H. Hirshhorn," in Lipman, Jean, ed. *The Collector in America*, New York, Viking, 1971, colorplate p. 82
Mulas, Ugo, and Arnason, H. Harvard. *Calder*, New York, Viking, 1971, p. 77
Raynor, Vivien. "1,000 Paintings and 4,500 Sculptures," *The New York Times Magazine*, November 27, 1966, ill. p. 52
Root, Waverley. "Artistic Sainthood for Calder," *The Washington [D.C.] Post*, August 29, 1965, ill.
Saarinen, Aline B. *The Proud Possessors*, rev. ed., New York, Vintage, 1968, p. IX

At the Calder retrospective at the Musée National d'Art Moderne, Paris, from July to October 1965, "The biggest object was *Deux Disques*—too big to put inside, so it was erected on the sidewalk by the entrance. Buses with visitors stopped and people got out to have their pictures taken in groups under the stabile; others took pictures of the object at various angles . . ."

The artist, in Mulas and Arnason, p. 77

Stainless Stealer. 1966.
Painted stainless steel and aluminum, 10 × 15 × 15 feet

PROVENANCE:
The artist, Saché, France, 1966

Effect of Red (Effet de Rouge). 1967.
Painted sheet metal, metal rods, and wire, 34½ × 65 inches
Markings: on one leaf "℟67"

PROVENANCE:
Galerie Maeght, Paris; Martha Jackson Gallery, New York, 1969; Parke-Bernet Galleries, New York, Sale 3104, October 29, 1970, no. 69

SERGIO DE CAMARGO (b. 1930)

Born Rio de Janeiro, April 8, 1930. In Paris, 1948: studied philosophy, Université de Paris à la Sorbonne;

met Constantin Brancusi, Jean Arp, Georges Vantongerloo. Traveled to China, 1954. Awarded: purchase prize, III Salão Nacional de Arte Moderna, Rio de Janeiro, 1954; purchase prize, Salão Paulista de Arte Moderna, São Paulo, 1954; International Sculpture Prize, 3ᵉ Biennale de Paris, 1963. Included in: III, IV, VIII São Paulo Bienal, 1955, 1957, 1965; Salon de la Jeune Sculpture, Paris, from 1963; "Mouvement II," Galerie Denise René, Paris, 1965; "White on White," De Cordova Museum, Lincoln, Massachusetts, 1965; "Art and Movement," Royal Scottish Academy, Edinburgh, 1965; "Lumière et Mouvement," Musée d'Art Moderne de la Ville de Paris, 1967; Salon des Réalités Nouvelles, Paris, 1967–69; Documenta 4, Kassel, 1968. One-man shows: Galeria GEA, Rio de Janeiro, 1958; Galería de Arte das Folhas, São Paulo, 1958; Museu de Arte Moderna, Rio de Janeiro, 1965; Venice Biennale, 1966; Gimpel & Hanover Galerie, Zurich, Gimpel Fils, London, and Gimpel and Weitzenhoffer Ltd., New York, from 1968; Galerie Buchholz, Munich, from 1968. Has lived in Paris, since 1961.

Column. 1967–68.
Marble, 55½ × 11 × 9 inches

PROVENANCE:
Gimpel Fils, London, 1968

EXHIBITIONS:
Gimpel & Hanover Galerie, Zurich, March 2–April 3, 1968, *Camargo*, no. 48; toured to Gimpel Fils, London, May 14–June 8

REFERENCES:
Spencer, Marshall. "How to See Sculpture," *Sculpture International*, 2, October 1968, ill. p. 37

VINCENT CANADÉ (1879–1961)

Born San Giorgio Albanese, Italy, 1879. Emigrated to the U.S., 1892. Lived in Brooklyn; worked as barber, jeweler, plasterer, and house painter. Self-taught Sunday painter until about 1918, when Joseph Stella encouraged him to paint full time. Included in: Salons of America, New York, 1922–30; "Painting and Sculpture by Living Americans," and "Masters of Popular Painting," The Museum of Modern Art, New York, 1930–31, 1938; Whitney Biennial, 1932–33; Venice Biennale, 1934; "Self-Portraits by Living American Artists," Whitney Museum of American Art, New York, 1934. One-man shows, New York: Weyhe Gallery, 1925, 1927, 1929; L'Elan Gallery, 1932. WPA Federal Art Project, Easel Division, New York, c. 1936–38. One-man show, Cooperative Gallery, Newark, New Jersey, 1938. Exhibited with Émile Branchard and Arnold Friedman, "Work of the Twenties," Zabriskie Gallery, New York, 1959. Died New York, September 2, 1961. Memorial exhibition, Zabriskie Gallery, 1964.

Self-Portrait #28. c. 1937.
Oil on canvas mounted on board, 13 × 8¼ inches
Signed l. r.: "V. Canade"

PROVENANCE:
Estate of the artist; Zabriskie Gallery, New York, 1965

EXHIBITIONS:
Zabriskie Gallery, New York, November 30–December 24, 1964, *Vincent Canadé (1879–1961)*

ARTHUR B. CARLES (1882–1952)

Arthur Beecher Carles, born Philadelphia, March 9, 1882. The Pennsylvania Academy of the Fine Arts, Philadelphia: studied, with Henry McCarter, and William Merritt Chase, 1901, 1903–7; received fellowship, 1905; received Toppan Prize, and Cresson Traveling Scholarship, 1907. Included in Pennsylvania Academy Annual, 1905. Commissioned, by St. Paul's Episcopal Church, Philadelphia, to copy Raphael's *Transfiguration* (The Vatican, Rome), 1907; finished version, completed in Paris, now in St. Paul's Reformed Episcopal Church, Oreland, Pennsylvania. Lived in Paris, 1907–10; associated with Alfred Maurer, and Edward Steichen; met Henri Matisse, and Gertrude and Leo Stein. Included in: "Younger American Painters," Alfred Stieglitz's Photo-Secession Gallery, "291," New York, 1910; the Armory Show, 1913; Cincinnati Art Museum Annual, 1913. First one-man show, "291," 1912. Worked on camouflage projects, with Franklin C. Watkins, Philadelphia Navy Yard, 1917–18. Taught, Pennsylvania Academy, 1917–25; conducted private classes, 1926–27. Awarded, Pennsylvania Academy: Lippincott Prize, 1917; Stotesbury Prize, 1919; Temple Gold Medal, 1930; Scheidt Memorial Prize, 1939. One-man shows: Montross Gallery, New York, 1922; Gimbel Gallery, Philadelphia, 1935; Marie Harriman Gallery, New York, 1936; Pennsylvania Academy, 1940–41; The Philadelphia Art Alliance, 1944; Nierendorf Gallery, New York, 1944. Awarded Logan Medal, 41st American Annual, The Art Institute of Chicago, 1928. Included in: "Painting and Sculpture by Living Americans," and "Painting and Sculpture from 16 American Cities," The Museum of Modern Art, New York, 1930–31, 1933; "Half a Century of American Art," The Art Institute of Chicago, 1939–40. Friendly with Hans Hofmann, from 1936. Stopped painting, after sustaining serious injuries, 1941. Exhibited with Watkins, Philadelphia Museum of Art, 1946. Died, Chestnut Hill, Pennsylvania, June 19, 1952. Memorial exhibition, Pennsylvania Academy, 1953. Included in "Two Friends, Marin and Carles," Allen Memorial Art Museum, Oberlin College, Ohio, 1955. Retrospectives: James Graham and Sons, New York, 1959; Pennsylvania Academy, 1966–67.

The Lake, Annecy. c. 1920.
Oil on canvas, 24¼ × 29¾ inches

PROVENANCE:
B. I. de Young, Philadelphia; Parke-Bernet Galleries, New York, Sale 1659, March 14, 1956, no. 70; James Graham and Sons, New York, 1959

EXHIBITIONS:
James Graham and Sons, New York, April 14–May 9, 1959, *Arthur B. Carles, 1882–1952: Retrospective Exhibition*, no. 32

Nude. 1922.
 Oil on canvas, 28¼ × 34¼ inches

PROVENANCE:
The artist, Philadelphia; Maurice J. Speiser, Philadelphia; Raymond A. Speiser, Philadelphia; Mrs. Wilton Jaffe, Philadelphia

EXHIBITIONS:
The Museum of Modern Art, New York, December 2, 1930–January 20, 1931, *Painting and Sculpture by Living Americans,* no. 11
The Pennsylvania Academy of the Fine Arts, Philadelphia, May 18–April 12, 1953, *Arthur B. Carles Memorial Exhibition,* no. 44

REFERENCES:
Formes, no. 20, December 1931, ill. f.p. 223
O'Connor, Elizabeth C. W. *Arthur B. Carles 1882–1952: Colorist and Experimenter,* M.A. thesis, New York, Columbia University, 1965

Composition (Seated Nude). c. 1933.
 Oil on canvas, 30½ × 27¼ inches

PROVENANCE:
The artist, Philadelphia; Mercedes Carles Matter, New York; Dr. Jack M. Greenbaum, New York, 1959

EXHIBITIONS:
James Graham and Sons, New York, April 14–May 9, 1959, *Arthur B. Carles, 1882–1952: Retrospective Exhibition,* no. 64

Abstraction (Last Painting). 1936–41.
 Oil on board, 41½ × 58½ inches

PROVENANCE:
The artist, Philadelphia; Mercedes Carles Matter, New York; Harold Diamond, New York, 1968

EXHIBITIONS:
The Pennsylvania Academy of the Fine Arts, Philadelphia, May 18–April 12, 1953, *Arthur B. Carles Memorial Exhibition,* no. 8
The Pennsylvania Academy of the Fine Arts, Philadelphia, January 15–March 13, 1955, *One Hundred and Fifth Anniversary Exhibition,* no. 166
James Graham and Sons, New York, April 14–May 9, 1959, *Arthur B. Carles, 1882–1952: Retrospective Exhibition,* no. 74

REFERENCES:
Clifford, Henry. "Prophet with Honor," *Art News,* 52, April 1953, p. 48
Hunter, Sam. *American Art of the 20th Century,* New York, Abrams, 1972, ill. 292
O'Connor, Elizabeth C. W. *Arthur B. Carles, 1882–1952: Colorist and Experimenter,* M.A. thesis, New York, Columbia University, 1965, p. 58, ill. 40
Rose, Barbara. *American Art Since 1900,* New York, Praeger, 1967, pp. 150–51, colorplate 5–43
Unsigned. "What Can Happen in Philadelphia," *Art News,* 53, February 1955, ill. p. 49

ANTHONY CARO (b. 1924)

Born London, March 8, 1924. Studied: engineering, Christ's College, Cambridge, England, 1942; sculpture, The Polytechnic, London, 1946; Royal Academy of Arts, London, 1947–52. Worked as assistant to Henry Moore, 1951–53. Included in: "New Sculptors and Painter-Sculptors," Institute of Contemporary Arts, London, 1955; Pittsburgh International, 1958; Venice Biennale, 1958, 1966 (Bright Foundation Prize); 5th Middelheim Biënnale, Antwerp, 1959; 1ᵉ Biennale de Paris (Sculpture Prize), 1959; "Sculpture in the Open Air," Battersea Park, London, from 1960. One-man shows: Galleria del Naviglio, Milan, 1956; Gimpel Fils, London, 1957; Whitechapel Art Gallery, London, 1963; André Emmerich Gallery, New York, from 1964; Washington [D.C.] Gallery of Modern Art, 1965; Kasmin Gallery, London, from 1965; The David Mirvish Gallery, Toronto, from 1966; Rijksmuseum Kröller-Müller, Otterlo, The Netherlands, 1967. Taught, Bennington College, Vermont, 1963–64, spring, 1965. Included in: "Painting and Sculpture of a Decade, 54–64," The Tate Gallery, London, 1964; "Primary Structures," The Jewish Museum, New York, 1966; "Between Object and Environment: Sculpture in an Extended Format," Institute of Contemporary Art, University of Pennsylvania, Philadelphia, 1969; "British Painting and Sculpture 1960–70," National Gallery of Art, Washington, D.C., 1970–71. Exhibited with Kenneth Noland and Morris Louis, The Metropolitan Museum of Art, New York, 1968. Retrospective, Hayward Gallery, London, 1969. Has taught, St. Martin's School of Art, London, since 1953. Lives in London.

Rainfall. 1964.
 Steel painted green, 48 × 99 × 52 inches

PROVENANCE:
Richard Rubin, Scarsdale, New York; Lawrence Rubin Gallery, New York, 1967

REFERENCES:
Forge, Andrew. "Anthony Caro Interviewed by Andrew Forge," *Studio International,* 171, January 1966, ill. p. 8
Russell, John. "Portrait: Anthony Caro," *Art in America,* 54, September–October 1966, p. 86, ill. p. 84

"In 1959 or '60, I wanted my sculpture to look straightforward: no art props, no nostalgia, no feelings of the preciousness associated with something because it's old or bronze, or it's rusty, encrusted, or patinated. So I just covered it with a coat of paint. I used brown or black paint and the sculptures looked more as if they were destined for a locomotive factory than an art gallery. Later, I found the browns and blacks rather drab, and so I experimented with other colors and I found that they often helped to emphasize the mood of the work."

The artist, in Tuchman, Phyllis, "An Interview with Anthony Caro," *Artforum,* 10, June 1972, p. 58

JEAN-BAPTISTE CARPEAUX (1827–1875)

Born Valenciennes, France, May 11, 1827. Moved with family to Paris, c. 1840. Worked in atelier of François Rude, 1844–50. Studied, Paris: École Royale et Spéciale de Dessin et de Mathématiques (Petite École); École des Beaux-Arts, with Francisque-Joseph Duret, 1850–55. Appointed assistant professor of sculpture, Petite École, 1850. First exhibited, Salon of 1852, Paris. Received Prix de Rome, 1855; lived in Rome, 1856–62. Awarded First Class Medal, Salon of 1863, for bronze version of *Ugolino and His Sons.* Official commissions, Paris: decorations, new Pavillon de Flore (now sculpture wing), Musée du Louvre, 1863; *The Dance,* facade of the Opéra, 1865–69; *The Four Cardinal Points,* fountain of the Observatoire, 1869–74. Légion d'honneur: chevalier, 1866; officier, 1875. Lived in London, 1871–72. Returned to France, 1872; re-established his atelier in Auteuil, outside of Paris, where assistants cast his works in bronze and terra-cotta. Died Courbevoie, France, October 12, 1875. Retrospectives: Musée des Beaux Arts, Valenciennes, 1927; Musée du Petit Palais, Paris, 1955–56; Mallett at Bourdon House, London, 1965; Wildenstein & Co., New York, 1965–66.

The Negress. 1868.
 Plaster, 24½ × 18½ × 14 inches
 Markings: l. r. side of base "Carpeaux"
 front of base "Pourquoi/naitre/esclave"

PROVENANCE:
L. Aubert, Paris; Mallett at Bourdon House, London; Wildenstein & Co., New York, 1965

EXHIBITIONS:
Mallett at Bourdon House, London, October 22–November 9, 1963, *Sculptures in Terra Cotta,* no. 99
Mallett at Bourdon House, London, May 24–June 12, 1965, *Sculptures and Sketches by Jean-Baptiste Carpeaux,* no. 10, frontispiece
Wildenstein & Co., New York, December 7, 1965–January 15, 1966, *Carpeaux,* no. 9

REFERENCES:
La Farge, Henry A. "Reviews and Previews: Jean-Baptiste Carpeaux," *Art News,* 64, January 1966, p. 11, ill. p. 10

Jean-Léon Gérôme. 1871.
 Plaster, 23½ × 10 × 10 inches
 Markings: r. side of base "Jean Gérôme
 JB Carpeaux"
 front of base "Gérôme"

PROVENANCE:
Unidentified collection, France; Mallett at Bourdon House, London; Wildenstein & Co., New York, 1965

EXHIBITIONS:
Mallett at Bourdon House, London, May 24–June 12, 1965, *Sculptures and Sketches by Jean-Baptiste Carpeaux,* no. 21
Wildenstein & Co., New York, December 7, 1965–January 15, 1966, *Carpeaux,* no. 20

REFERENCES:
La Farge, Henry A. "Reviews and Previews: Jean-Baptiste Carpeaux," *Art News,* 64, January 1966, p. 11
T. H. "Carpeaux A Master of the Second Empire," *Apollo,* 81, June 1965, p. 490, ill.

Carpeaux's bust of Jean-Léon Gérôme was modeled in London in 1871. A bronze version was exhibited at the Salon of 1872, Paris. There are several plaster, terracotta, and bronze casts of this work, and at least two marble versions.

Charles Gounod. 1872.
 Terra-cotta, 25½ × 17¾ × 15½ inches
 Markings: r. side of base "JB Carpeaux"
 c. back of base "Propriété Carpeaux"
 and stamp of the atelier

PROVENANCE:
Private collection, France; Wildenstein & Co., New York, 1965

EXHIBITIONS:
Wildenstein & Co., New York, December 7, 1965–January 15, 1966, *Carpeaux,* no. 23

REFERENCES:
La Farge, Henry A. "Reviews and Previews: Jean-Baptiste Carpeaux," *Art News,* 64, January 1966, p. 11

Charles Gounod (1818–93), French composer and church organist, was best known for his opera *Faust* (first produced in Paris in 1859). Gounod was in London from 1870 to 1875, and it was undoubtedly there that his friend Carpeaux modeled the plaster original of this bust.

Alexandre Dumas Fils. 1873.
 Bronze, 31½ × 22½ × 17½ inches
 Markings: r. side of base "All'Sommo Pensiéroso
 Alexandre Dumas Fils
 Sua Amico
 JB Carpeaux 1873"

PROVENANCE:
Unidentified collection, France; Mallett at Bourdon House, London; Wildenstein & Co., New York, 1965

EXHIBITIONS:
Mallett at Bourdon House, London, May 24–June 12, 1965, *Sculptures and Sketches by Jean-Baptiste Carpeaux,* no. 25
Wildenstein & Co., New York, December 7, 1965–January 15, 1966, *Carpeaux,* no. 28

REFERENCES:
La Farge, Henry A. "Reviews and Previews: Jean-Baptiste Carpeaux," *Art News,* 64, January 1966, p. 11
Mullaly, T. "Sensitive Show of Carpeaux's Art," *The [London] Daily Telegraph and Morning Post,* June 3, 1965, ill.
Roberts, Keith. "Current and Forthcoming Exhibitions: London," *Burlington Magazine,* 107², July 1965, p. 387
T. H. "Carpeaux A Master of the Second Empire," *Apollo,* 81, June 1965, p. 490, ill.

Alexandre Dumas Fils (1824–1895)—illegitimate son of Alexandre Dumas Père (1802–1870)—was, like his father, a celebrated novelist and dramatist. His first important theatrical success, *La Dame aux camélias* of 1852 (based on his novel of 1848), provided the libretto for Giuseppe Verdi's opera *La Traviata.*

A marble version of this bust, exhibited at the Salon of 1874, now belongs to the Comédie-Française, Paris.

ANDREA CASCELLA (b. 1920)

Born Pescara, Italy, January 16, 1920; son and pupil of painter Tommaso Cascella. Worked in Rome, with brother Pietro, primarily on ceramic decorations for architectural projects. One-man shows: Galleria dell'Obelisco, Rome, 1949; Galleria del Cavallino, Venice, 1951; Galleria Selecta, Rome, 1958; Grosvenor Gallery, London, 1960, 1962; Galleria dell'Ariete, Milan, 1961, 1963. Included in Venice Biennale, 1950. Received Copley Foundation Award, 1950. With Pietro, won international competition for Memorial, Auschwitz, Poland, 1958. Included in: Quadriennale Nazionale d'Arte, Rome, 1960; Venice Biennale, 1964 (Grand Prize for Sculpture); Pittsburgh International, 1964; Salon de Mai, Paris, 1965–68; Salon de la Jeune Sculpture, Paris, 1965–68; V Biennale Internazionale di Scultura, Carrara, Italy, 1967; Guggenheim International, 1967–68; "Recent Italian Painting and Sculpture," The Jewish Museum, New York, 1968. Sculpture reliefs commissioned: Olivetti factory, Düsseldorf, 1961; Olivetti Building, Buenos Aires, 1962. One-man shows: Betty Parsons Gallery, New York, 1965, 1968, 1972; Musée d'Ixelles, Brussels, 1968; Galatea Galleria d'Arte, Turin, 1971. Lives in Milan.

I Dreamed My Genesis 1964.
 Granite, 3 feet 10 inches × 9 feet 1 inch × 3 feet

PROVENANCE:
Galleria dell'Ariete, Milan, 1964

EXHIBITIONS:
XXXII Biennale Internazionale d'Arte, Venice, June 20–October 18, 1964, *Central Pavilion,* no. 5, p. 77

REFERENCES:
Del Renzio, Toni. *Andrea Cascella,* New York, Betty Parsons Gallery, 1968, cat., ill.

Geronimo. 1964.
 Black Belgian marble, 15⅝ × 33½ × 14½ inches

PROVENANCE:
Galleria dell'Ariete, Milan, 1965

EXHIBITIONS:
Betty Parsons Gallery, New York, April 20–May 15, 1965, *Andrea Cascella,* cat.

MARY CASSATT (1844–1926)

Mary Stevenson Cassatt, born Allegheny City (now part of Pittsburgh), Pennsylvania, May 22, 1844. Toured Europe with family, 1851–58. Studied, The Pennsylvania Academy of the Fine Arts, Philadelphia, 1861–65. Traveled extensively in Europe, 1866–70; returned to Philadelphia, during Franco-Prussian War, ½1870–71. Studied: Accademia Parmense di Belle Arti, Parma, Italy, with Carlo Raimondi, 1872; atelier of Charles Chaplin, Paris, briefly, 1875. Influenced by Édouard Manet and Edgar Degas. Included in: Salon of 1872–74, 1876, Paris; National Academy of Design Annual, 1874–76; Pennsylvania Academy Annual, 1876; Society of American Artists Exhibition, New York, 1879; Exposition des Impressionistes, Paris, 1879–81, 1886. Settled in Paris, 1874; established summer residence, Château de Beaufresne, Mesnil-Théribus, near Paris, 1890. First graphic works, 1879–80. One-man shows, Galerie Durand-Ruel: Paris, 1891, 1893, 1908, 1910; New York, from 1895. Mural *Modern Woman* commissioned, World's Columbian Exposition, Chicago, 1893. Visited the U.S., 1898–99. Traveled in Italy and Spain, as advisor to art collectors Mr. and Mrs. Henry O. Havemeyer, 1901. Awarded: Lippincott Prize, Pennsylvania Academy (declined acceptance), 1904; Gold Medal of Honor, Pennsylvania Academy, 1914. Chevalier, Légion d honneur, 1904. Associate, National Academy of Design, 1909. Traveled: to the U.S., 1908–9; Egypt, 1910–11. Onset of progressive blindness, 1911. Two works included in the Armory Show, 1913. One-man shows, graphics: The Metropolitan Museum of Art, New York, 1922; The Cleveland Museum of Art, 1923; The Minneapolis Institute of Arts, Minnesota, 1925. Died Château de Beaufresne, June 14, 1926. Memorial exhibitions: The Art Institute of Chicago, 1926–27; The Pennsylvania Museum of Art, Philadelphia, 1927.

Portrait of an Italian Lady. c. 1879.
 Oil on canvas, 32 × 23½ inches
 Signed l. l.: "M. S. Cassatt"

PROVENANCE:
Private collection, Mesnil-Théribus, France; Jacques Spiess, Paris; Parke-Bernet Galleries, New York, Sale 3170, March 10, 1971, no. 40, colorplate p. 77

EXHIBITIONS:
National Gallery of Art, Washington, D.C., September 27–November 8, 1970, *Mary Cassatt 1844–1926,* no. 17, ill.

REFERENCES:
Breeskin, Adelyn Dohme. *Mary Cassatt: A Catalogue Raisonné of the Oils, Pastels, Watercolors, and Drawings,* Washington, D.C., Smithsonian Institution, 1970, no. 938, ill. p. 305

"This may possibly be a portrait of Mme. Marie Del Sarte, who ran a fashionable boarding school for young ladies which was attended by Louisine Waldron Elder, later Mrs. H. O. Havemeyer, as well as Mary Ellison of Philadelphia."

Breeskin, p. 305

Baby Charles. 1900.
 Pastel on paper, 12½ × 9½ inches

PROVENANCE:
The artist; Payson Thompson; American Art Association, New York, Sale, January 12, 1928, no. 70; Dr. Harlow Brooks; John Levy Galleries, New York; Gilbert R. Gabriel, New York; M. Knoedler & Co., New York;

Lionel Rosenbaum, Albuquerque, New Mexico; Hirschl & Adler Galleries, New York, 1959

EXHIBITIONS:
Society of the Four Arts, Palm Beach, Florida, March 7–April 5, 1959, *John Singer Sargent and Mary Cassatt*, no. 48
Davis Galleries, New York, May 10–28, 1960, *Pastel*, cat.
The Gallery of Modern Art, New York, January 15–March 1, 1965, *Major 19th and 20th Century Drawings*

REFERENCES:
Breeskin, Adelyn Dohme. *Mary Cassatt: A Catalogue Raisonné of the Oils, Pastels, Watercolors, and Drawings*, Washington, D.C., Smithsonian Institution, 1970, no. 321, ill. p. 140
Pictures on Exhibit. October 1958, ill. p. 25
Unsigned. "Auction Reports: Thompson Paintings," *Art News*, 26, January 21, 1928, p. 9

Woman in Raspberry Costume Holding a Dog. c. 1901.
Pastel on paper mounted on canvas, 29 × 23½ inches
Signed 1. r.: "Mary Cassatt"

PROVENANCE:
Galerie de l'Art Moderne, Paris; C. Michael Paul, New York; Parke-Bernet Galleries, New York, Sale 2464, October 20, 1966, no. 91, colorplate p. 109

REFERENCES:
Breeskin, Adelyn Dohme. *Mary Cassatt: A Catalogue Raisonné of the Oils, Pastels, Watercolors, and Drawings*, Washinton, D.C., Smithsonian Institution, 1970, no. 462, ill. p. 178

ENRICO CASTELLANI (b. 1930)

Born Castelmassa (Rovigo), Italy, August 4, 1930. Intermediate studies, Novara and Milan, Italy. Studied: Brussels, 1952–56: painting and sculpture, Académie Royale des Beaux-Arts; architecture, École Nationale Supérieure d'Architecture et des Arts Visuels. Settled in Milan, 1956. Co-founded periodical *Azimut*, with Piero Manzoni, 1959. One-man shows: Galleria Azimut, Milan, 1960; New Vision Centre Gallery, London, 1961; Galleria La Tartaruga, Rome, 1961; Galerie Aujourd'hui, Brussels, 1962; Galleria dell'Ariete, Milan, from 1963; Galerie Lawrence, Paris, 1965; Betty Parsons Gallery, New York, 1966; Galleria La Bertesca, Genoa, 1968. Exhibited with Zero group (of kinetic artists): Galerie Dato, Frankfort, 1961; Stedelijk Museum, Amsterdam, 1962; Galerie Schindler, Bern, 1962; Galerie "diogenes im Cubus," Berlin, 1963; Institute of Contemporary Art, University of Pennsylvania, Philadelphia, 1964. Included in: Guggenheim International Award, 1964; Venice Biennale, 1964, 1966 (Gallin Prize); "The Responsive Eye," The Museum of Modern Art, New York, 1965; "Plus by Minus: Today's Half-Century," Albright-Knox Art Gallery, Buffalo, New York, 1968; Documenta 4, Kassel, 1968; "Young Italians," Institute of Contemporary Art, Boston, and The Jewish Museum, New York, 1968. Awarded Gold Medal, VI San Marino Biennale, 1967. Lives in Milan.

White Surface 2. 1962.
Oil on shaped canvas, 74 × 55½ inches

PROVENANCE:
Galleria dell'Ariete, Milan, 1964

EXHIBITIONS:
Galleria dell'Ariete, Milan, February–March 1963, *Castellani*, no. 11
The Solomon R. Guggenheim Museum, New York, January 16–March 9, 1964, *Guggenheim International Award 1964*, no. 40; toured to Honolulu Academy of Arts, Hawaii, May 14–July 5; Akademie der Künste, Berlin, August 19–September 15; The National Gallery of Canada, Ottawa, October 5–November 9; John and Mable Ringling Museum of Art, Sarasota, Florida, January 16–March 14, 1965; Museo Nacional de Bellas Artes, Buenos Aires, April 20–May 20

REFERENCES:
Unsigned. "The Guggenheim International Award No. 4," *Art International*, 7, January 16, 1964, p. 77, ill.

CÉSAR (b. 1921)

César Baldaccini, born Marseilles, France, January 1, 1921. Studied: École des Beaux-Arts, Marseilles, 1935–39; École des Beaux-Arts, Paris, 1943–46. One-man shows: Galerie Lucien Durand, Paris, 1954; Galerie Rive Droite, Paris, 1955; The Hanover Gallery, London, 1957, 1960; Galerie Creuzevault, Paris, 1957, 1970; Galerie Claude Bernard, Paris, 1959; Saidenberg Gallery, New York, 1961; Galleria Apollinaire, Milan, 1961; Galleria Schwarz, Milan, 1970. Included in: Salon de Mai, Paris, from 1955; Venice Biennale, 1956; 4th Middelheim Biennale, Antwerp, 1957; IV and IX São Paulo Bienal, 1957, 1967; Pittsburgh International, 1958, 1967; Documenta II, III, 4, Kassel, 1959, 1964, 1968; "New Images of Man," The Museum of Modern Art, New York, and The Baltimore Museum of Art, 1959–60; "The Art of Assemblage," The Museum of Modern Art, and tour, 1961–62; 8th Tokyo Biennale, 1966; Guggenheim International, 1967–68; ROSC '71, Dublin, 1971. Co-founded "Nouveaux Réalistes," with Arman, Martial Raysse, Jean Tinguely, and others, Paris, 1960. Exhibited with Raoul d'Haese and Tinguely, Musée des Arts Décoratifs, Paris, 1965. Retrospective, Musée Cantini, Marseilles, 1966. One-man shows: Stedelijk Museum, Amsterdam, and Wilhelm-Lehmbruck-Museum der Stadt, Duisberg, Germany, 1966; Centre National d'Art Contemporain, Paris, 1970; Palais des Beaux-Arts, Brussels, and tour, 1971. Has taught, École Nationale Supérieure des Beaux-Arts, Paris, since 1970. Lives in Paris.

Venus of Villetaneuse. 1960.
Bronze, 40¾ × 10¾ × 13¾ inches
Markings: rear 1. of base "Cesar cire perdue A Valsuani 2/6"
rear r. of base "2/6"

PROVENANCE:
Galerie Claude Bernard, Paris, 1964

EXHIBITIONS:
Hopkins Art Center, Dartmouth College, Hanover, New Hampshire, May 25–July 9, 1967, *Sculpture in Our Century: Selections from the Joseph H. Hirshhorn Collection*, no. 9

Marseille. 1960, cast 1963.
Bronze, 99 × 54 × 25½ inches
Markings: front 1. c. 'Cesar ½"
rear 1. 1. "Susse fondeur"

PROVENANCE:
The Hanover Gallery, London, 1963

César's Thumb (Le Pouce de César). 1967.
Bronze, 34½ × 20 × 14½ inches
Markings: 1. back "Cesar 67 4/6"

PROVENANCE:
Galerie Claude Bernard, Paris, 1968

JOHN CHAMBERLAIN (b. 1927)

Born Rochester, Indiana, April 16, 1927. Youth spent in Chicago. Served, U.S. Navy, 1941–44. Studied: School of The Art Institute of Chicago, 1950–52; Black Mountain College, North Carolina, 1955–56. Moved to New York, 1956. First one-man show, Wells Street Gallery, Chicago, 1957. Included in: "Recent Sculpture: USA," The Museum of Modern Art, New York, and tour, 1959–60; "Le Nouveau Réalisme," Galerie Rive Droite, Paris, 1960; Whitney Annual, 1960–71; VI São Paulo Bienal, 1961; "The Art of Assemblage," The Museum of Modern Art, and tour, 1961–62; Pittsburgh International, 1961, 1967; "Sculpture in the Open Air," Battersea Park, London, 1963; Venice Biennale, 1964; "États-Unis: Sculptures du XXᵉ Siècle," Musée Rodin, Paris, 1965; "New York Painting and Sculpture: 1940–1970," The Metropolitan Museum of Art, New York, 1969–70; "Art and Technology," Los Angeles County Museum of Art, 1971; Whitney Biennial, 1973. One-man shows: Martha Jackson Gallery, New York, 1960; Leo Castelli Gallery, New York, from 1962; Galerie Ileana Sonnabend, Paris, 1964; Dwan Gallery, Los Angeles, 1966–67; Galerie Rudolf Zwirner, Cologne, 1967; The Cleveland Museum of Art, 1967; LoGiudice Gallery, Chicago, 1970. Retrospective, The Solomon R. Guggenheim Museum, New York, 1971. Lives in New York.

Beezer. 1964.
Auto lacquer, metal flake, and chrome on Masonite, 48¼ × 48¼ × 3½ inches
Signed and dated on back: "Chamberlain 64"

PROVENANCE:
Jacques Kaplan, New York; Murray Hill Antiques, New York, 1967

WILLIAM MERRITT CHASE (1849–1916)

Born Williamsburg (now Ninevah), Indiana, November 1, 1849. Studied: with Benjamin F. Hayes, Indianapolis, 1867, 1869; National Academy of Design, New York, with L. E. Wilmarth, 1869–70; exhibited there, 1871. Traveled to Munich, 1872; shared studio with Frank Duveneck. Studied, Bayerische Akademie der Schönen Künste, Munich, with Alexander Wagner, and Karl Theodor von Piloty, 1872–77; awarded bronze medals there, 1873–76. Traveled with Duveneck and John Twachtman to Venice, 1877. Taught: The Art Students League of New York, 1878–85, 1886–96, 1907–12; The Brooklyn Art School, New York, 1891–95; The Pennsylvania Academy of the Fine Arts, Philadelphia, once a week, 1898–1908. Society of American Artists, New York: member, 1880; president, 1885–95. First of many trips to Europe, 1881. Visited London, 1885; met James McNeill Whistler, and painted his portrait (now in The Metropolitan Museum of Art, New York). One-man shows: Boston Art Club, 1886; The Art Institute of Chicago, 1897. National Academy of Design: associate, 1889; academician, 1890. Awarded: Silver Medal, Exposition Universelle de 1889, Paris; Gold Medal of Honor, Pennsylvania Academy Annual, 1895; Gold Medal, Exposition Universelle de 1900; Gold Medal, Pan-American Exposition, Buffalo, New York, 1901; Gold Medal, St. Louis International Exposition, Missouri, 1904; Gold Medal, International Fine Arts Exposition, Buenos Aires, 1910. Directed Shinnecock Summer School of Art, Southampton, New York, 1891–93, 1906; spent summers abroad, conducting classes, 1903–5, 1907–13. His distinguished students included Charles W. Hawthorne, Kenneth Hayes Miller, Charles Sheeler, Joseph Stella, Marsden Hartley, Patrick Henry Bruce, Georgia O'Keeffe, and Edwin Dickinson. Founded The Chase School (later New York School of Art), 1896; director, until 1908. Elected member of The Ten (group of American Impressionists), 1902. One-man shows: M. Knoedler & Co., New York, 1903; Albright Art Gallery, Buffalo, New York, 1909; Cincinnati Art Museum, Ohio, 1909; National Academy of Design, and National Arts Club, New York, 1910; The Detroit Institute of Arts, 1915; The Toledo Museum of Art, Ohio, 1916. Member: The National Institute of Arts and Letters, 1905; The American Academy of Arts and Letters, 1908. Died New York, October 25, 1916. Memorial exhibitions: The Metropolitan Museum of Art, 1917; John Herron Art Institute, Indianapolis, Indiana, 1923. Retrospectives: Ferargil Galleries, New York, 1922; Albright Art Gallery, 1923; Newhouse Galleries, Los Angeles, 1927; The American Academy of Arts and Letters, New York, 1928; The Arts Club of Chicago, 1929.

Interior: Young Woman Standing at Table. c. 1898.
Pastel on paper, 22 × 28 inches
Signed 1. 1.: "Wm. M. Chase"

PROVENANCE:
Edward M. Shepherd, Brooklyn, New York; Charles S. Shepherd, Brooklyn; Mrs. Rodney Bean, Washington, D.C.; M. Knoedler & Co., New York, 1958

EXHIBITIONS:
Davis Galleries, New York, November 17–December 5, 1959, *William Merritt Chase*, no. 8
The Art Galleries, University of California, Santa Barbara, October 6–November 8, 1964, *William Merritt*

Chase: First West Coast Retrospective, no. 24, ill.; toured to La Jolla Museum of Art, California, December 1–27; California Palace of the Legion of Honor, San Francisco, January 10–February 7, 1965; Seattle Art Museum, March 3–April 4; The Gallery of Modern Art, New York, April 27–May 30

REFERENCES:
Hoopes, Donelson F. *The American Impressionists*, New York, Watson-Guptil, 1972, p. 46, colorplate 14
Sawin, Martica. "In the Galleries: William Merritt Chase," *Arts*, 34, November 1959, p. 57

In this painting, the artist's wife, Alice Gerson Chase, is shown in the family home on Stuyvesant Square, New York. The works of art in the background were part of the artist's collection. A copy of Alexandre Regnault's *Automedon with the Horses of Archilles*, 1868 (Museum of Fine Arts, Boston), which enjoyed great popularity at the time, hangs of the wall behind the table. A section of the hallway appears in Chase's *A Friendly Call*, 1895 (National Gallery of Art, Washington, D.C., Chester Dale Collection).

Artist's Daughter in Mother's Dress (Young Girl in Black). c. 1899.
Oil on canvas, 60 × 36 inches

PROVENANCE:
The artist, New York; American Art Association, New York, May 14–17, 1917, *Chase Collection*, no. 190; Henry Rittenberg, New York; Robert Hosea, New York; American Art Association, Sale 4370, February 3, 1938, no. 69, ill. p. 37; Julius H. Weitzner, New York; Davis Galleries, New York, 1957

EXHIBITIONS:
The Art Galleries, University of California, Santa Barbara, October 6–November 8, 1964, *William Merritt Chase: First West Coast Retrospective*, no. 28, ill.; toured to La Jolla Museum of Art, California, December 1–27; California Palace of the Legion of Honor, San Francisco, January 10–February 7, 1965; Seattle Art Museum, March 3–April 4; The Gallery of Modern Art, New York, April 27–May 30

REFERENCES:
Flexner, James Thomas. "The Great Chase," *Art News*, 48, December 1949, p. 60
Peat, Wilbur D. "Checklist of Known Work by William Merritt Chase," *Chase Centennial Exhibition Catalogue*, John Herron Art Institute, Indianapolis, Indiana, 1949.
Unsigned. "A Chase Retrospective," *Arts Magazine*, 39, February 1965, ill. p. 33

Good Friends. c. 1909.
Oil on panel, 22½ × 30¼ inches
Signed 1. r.: "Wm. M. Chase"

PROVENANCE:
James Graham and Sons, New York, 1959

EXHIBITIONS:
The Corcoran Gallery of Art, Washington, D.C., December 13, 1910–January 22, 1911, *Third Exhibition of Oil Paintings by Contemporary American Artists*, no. 114
Davis Galleries, New York, November 17–December 5, 1959, *William Merritt Chase*, no. 6
The American Academy of Arts and Letters, New York, March 5–April 3, 1960, *A Change of Sky: Paintings by Americans Who Have Worked Abroad*, no. 48
Isaac Delgado Museum of Art, New Orleans, November 15–December 31, 1960, *The World of Art in 1910*, cat.
Grolier Club, New York, October 9–November 21, 1961, *Italian Influence on American Literature*
Greenwich Public Library, Connecticut, May–June 1967, *Joseph H. Hirshhorn Collects*

Still Life with Fish and Brown Vase (Venetian Fish). 1914.
Oil on canvas, 29 × 36 inches
Signed and dated 1. r.: "Wm M-Chase 1914"

PROVENANCE:
The artist; William Smith Stimmel, Pittsburgh; William Smith Stimmel, Jr., Pittsburgh; Hirschl & Adler Galleries, New York, 1968

JEAN CHAUVIN (b. 1889)

Born Rochefort-sur-Mer, France, March 30, 1889. Moved to Paris, 1908. Studied, Paris: École des Arts Décoratifs; École des Beaux-Arts, with Marius-Jean-Antonin Mercier. Pupil, and assistant to Joseph Bernard, until 1914. First exhibited, Salon des Indépandants, Paris, 1920. One-man shows, Paris: Galerie Au Sacre du Printemps, 1928; Galerie Jeanne Bucher, 1936, 1941, 1947, 1951. Included in Salon des Réalités Nouvelles, Paris, 1946, 1947. Retrospective, Galerie Maeght, Paris, 1949. Included in Venice Biennale, 1962. One-man shows, Paris: Galerie Suzanne de Coninck, 1957; Galerie de l'Élysée, 1960; Galerie Villand & Galanis, 1971. Lives in Paris.

An Island in the Night (Une Île de la nuit). 1932.
Wood, 19⅝ × 7⅞ × 7⅜ inches
Markings: 1. r. at base "Chauvin MCMXXXII"

PROVENANCE:
Galerie de l'Élysée, Paris, 1961

REFERENCES:
Zervos, Christian. *Chauvin*, Paris, Cahiers d'Art, 1960, p. 31, plate 15

EDUARDO CHILLIDA (b. 1924)

Born San Sebastián (Basque region of Spain), January 10, 1924. Studied architecture, University of Madrid, 1943–47. Lived in Paris, 1948–51. Exhibited, Paris: "Les Mains Éblouies," Galerie Maeght, 1949; Salon de Mai, 1949, 1950. Returned to Spain, 1951. Commissions: four iron doors, Franciscan basilica, Aranzazu, Spain, 1954; monument to Sir Alexander Fleming, San Sebastián, 1955. One-man shows: Sala Clan, Madrid, 1954; Galerie Maeght, 1955–59. Awarded: Diploma of Honor, Milan Triennale, 1954; International Prize for Foreign

Sculpture, Venice Biennale, 1958; Kandinsky Prize, Paris, 1960; Lehmbruck Prize, Duisburg, Germany, 1966. Included in: Pittsburgh International, 1958, 1961, 1964 (Sculpture Prize), 1967; Documenta II, III, 4, Kassel, 1959, 1964, 1968; "New Spanish Painting and Sculpture," The Museum of Modern Art, New York, 1960; "Three Spaniards: Picasso, Miró, Chillida," The Museum of Fine Arts, Houston, 1961; Venice Biennale, 1962. Received Graham Foundation Grant, 1958. One-man shows: Kunsthalle, Basel, 1962; The Museum of Fine Arts, Houston, 1966; Kunsthalle, Hamburg, 1968; Kunsthaus, Zurich, 1969. Lives in San Sebastián.

Ikaraundi (The Great Tremor). 1957.
Bronze, 23 × 58 × 26½ inches
Markings: l. r. "☐☐
SUSSE FOND^R PARIS
1/3''

PROVENANCE:
Galerie Claude Bernard, Paris, 1962

REFERENCES:
Sweeney, James Johnson. "A Living Frame for Sculpture," *House & Garden,* 126, August 1964, p. 110, ill.

DAN CHRISTENSEN (b. 1942)

Daniel Christensen, born Lexington, Nebraska, October 6, 1942. Studied, Kansas City Art Institute and School of Design, Missouri; B.F.A., 1964. Included in: "Contemporary Americans," Noah Goldowsky Gallery, New York, 1967; Whitney Annual, 1967–72; Corcoran Biennial, 1969; "Nine Young Artists: Theodoron Awards," The Solomon R. Guggenheim Museum, New York, 1969; "Lyrical Abstraction," The Aldrich Museum of Contemporary Art, Ridgefield, Connecticut, and tour, 1970–71; "Color and Field 1890–1970," Albright-Knox Art Gallery, Buffalo, New York, and tour, 1970–71; "Six Painters," Albright-Knox Art Gallery, and tour, 1971–72; Whitney Biennial, 1973. One-man shows, Galerie Rolf Ricke, Kassel, 1968; André Emmerich Gallery, New York, from 1969; Nicholas Wilder Gallery, Los Angeles, 1970, 1973. Lives in New York.

Grus. 1968.
Acrylic on canvas, 10 feet 10 inches × 8 feet 3 inches
Signed and dated on back: "D. Christensen May 1968"

PROVENANCE:
Richard Bellamy, New York, 1968

REFERENCES:
Heyer, Robert J., and Payne, Richard J. *Discovery Patterns, Supplement One,* Paramus, New Jersey, Paulist Press, 1971, ill. p. 18

CHRYSSA (b. 1933)

Chryssa Vardea Mavromichali, born Athens, Greece, December 31, 1933. Studied: Académie de la Grande Chaumière, Paris, 1953–54; California School of Fine Arts, San Francisco, 1954–55. Lived in Europe, 1955–58; settled in New York, 1958. Included in: "New Forms, New Media," Martha Jackson Gallery, New York, 1960; Whitney Annual, 1960–71; "Le Nouveau Réalisme," Galerie Rive Droite, Paris, 1961; Pittsburgh International, 1961, 1967. One-man shows, New York: Betty Parsons Gallery, 1961; The Solomon R. Guggenheim Museum, 1961; Cordier & Ekstrom, 1962. Included in: "Americans 1963," The Museum of Modern Art, New York, 1963; VII São Paulo Bienal, 1963; "Kunst Licht Kunst," Stedelijk van Abbemuseum, Eindhoven, The Netherlands, 1966; "Light-Motion-Space," Walker Art Center, Minneapolis, 1967; "American Sculpture of the Sixties," Los Angeles County Museum of Art, and Philadelphia Museum of Art, 1967; Documenta 4, Kassel, 1968. One-man shows: Institute of Contemporary Art, University of Pennsylvania, Philadelphia, 1965; The Pace Gallery, New York, 1966, 1968; Carpenter Center, Harvard University, Cambridge, Massachusetts, 1968; Walker Art Center, 1968; Galleria Diagramma, Milan, 1971; Whitney Museum of American Art, New York, 1972; Galerie Denise René, New York, 1973. Received Guggenheim Foundation Fellowship, 1973. Lives in New York.

Study for the Gates # 15 (Flock of Morning Birds from "Iphigenia in Aulis" by Euripides). 1967.
Black glass neon tubing with timer, 62 × 35½ × 29½ inches

PROVENANCE:
The Pace Gallery, New York, 1968

EXHIBITIONS:
The Pace Gallery, New York, February 10–March 14, 1968, *Chryssa: Selected Works 1955–1967,* no. 4, ill. p. 13

REFERENCES:
Brown, Gordon. "The Cool Mind: Notes on Neon from Chryssa," *Arts Magazine,* 42, March 1968, ill. p. 41
Calas, Nicolas, and Calas, Elena. *Icons and Images of the Sixties,* New York, Dutton, 1971, p. 307
Campbell, Vivian. *Chryssa,* New York, Galerie Denise René, 1973, cat., ill.
Glueck, Grace. "Chryssa's Neo-Neons Glowing at the Pace Gallery," *The New York Times,* February 24, 1968, p. 26

"I used a form which I had also used in the *Gates.* This particular form resembled a bird shape, and that is one reason why the piece is entitled *Flock of Morning Birds.* The sculpture lights up in five horizontal sections—the lower lighting first for six seconds followed progressively by the second section and so forth to the fifth and top section—which gives the impression of birdlike movement. This motion is also related to the way the chorus moves on stage in Euripides' play *Iphigenia in Aulis,* the opening lines of which refer to a 'flock of morning birds,' the title of the sculpture."

Statement by the artist, 1972

JOHN CLEM CLARKE (b. 1937)

Born Bend, Oregon, June 6, 1937. Studied: Oregon

State University, Corvallis, 1955–57; Universidad Nacional Autónoma de México, Mexico City, summer, 1957; Mexico City College, 1959; University of Oregon, Eugene, with Jack Wilkinson, B.F.A., 1960. Served, U.S. Coast Guard, 1960–61. Traveled to Paris, Greece, Spain, 1961–64. Moved to New York, 1964. Included in: Whitney Annual, 1967–72; "Aspects of a New Realism," Milwaukee Art Center, and tour, 1969; "22 Realists," Whitney Museum of American Art, New York, 1970; "Radical Realism," Museum of Contemporary Art, Chicago, 1971; Whitney Biennial, 1973. First prints, 1969. One-man shows: Kornblee Gallery, New York, 1968–71; Franklin Siden Gallery, Detroit, 1969; Michael Walls Gallery, San Francisco, 1970; Galerie M. E. Thelen, Essen, Germany, 1970; O. K. Harris, New York, from 1970; Jack Glenn Gallery, Corona del Mar, California, 1972. Lives in New York.

Copley—Governor and Mrs. Thomas Mifflin. 1969.
Oil on canvas, 8 feet 8 inches × 6 feet 10 inches

PROVENANCE:
Kornblee Gallery, New York, 1969

EXHIBITIONS:
Kornblee Gallery, New York, June 3–27, 1969, *John Clem Clarke*

REFERENCES:
Siegel, Jeanne. "An Art of Transmission: John Clem Clarke at Kornblee," *Arts Magazine,* 43, Summer 1969, p. 44
Wilson, William S. "John Clem Clarke Transmits a Picture," *Art News,* 68, Summer 1969, pp. 46–47

This is one of a series of fourteen paintings based on John Singleton Copley's *Portrait of Governor and Mrs. Thomas Mifflin,* 1773 (The Historical Society of Pennsylvania, Philadelphia).

CARROLL CLOAR (b. 1913)

Born Earle, Arkansas, January 18, 1913. Studied: Southwestern College, Memphis, B.A., 1934; Memphis Academy of Arts, 1934–36; The Art Students League of New York, with William C. McNulty, and Harry Sternberg, 1936–40. Lithographer and painter, from the late 1930s. Received: MacDowell Colony Fellowship, Peterborough, New Hampshire, 1940; Guggenheim Foundation Fellowship, 1946. Served, U.S. Army Air Corps, World War II. Traveled extensively in Central and South America, 1950–54. Included in: Whitney Annual, 1952, 1953, 1958, 1961; Pittsburgh International, 1955, 1958. One-man shows: Brooks Memorial Art Gallery, Memphis, 1955, 1957, 1966; Arkansas Arts Center, Little Rock, and Arts Center Gallery, University of Arkansas, Fayetteville, 1956–57; The Alan Gallery, New York, 1956–58; Arts Center Gallery, 1961; Fort Worth Art Center Museum, Texas, 1963. Retrospectives: Brooks Memorial Art Gallery, 1960; State University of New York at Albany, 1968; Kennedy Galleries, New York, 1973. Awarded grant, The National Institute of Arts and Letters, and The American Academy of Arts and Letters, 1966. Lives in Memphis.

Day Remembered. 1955.
Casein and tempera on Masonite, 28 × 40 inches

PROVENANCE:
The Alan Gallery, New York, 1956

EXHIBITIONS:
The Alan Gallery, New York, January 31–February 25, 1956, *Carroll Cloar,* no. 4
Arkansas Arts Center, Little Rock, December 1956, *Carroll Cloar;* toured to Arts Center Gallery, University of Arkansas, Fayetteville, January 1957
Brooks Memorial Art Gallery, Memphis, April 13–May 4, 1966, *Carroll Cloar: Painter of the Mid-South,* no. 3, ill.; toured to ten U.S. cities

REFERENCES:
Burrow Library. *Monograph No. 6: Catalogue of Paintings by Carroll Cloar,* Memphis, Southwestern State, 1963, p. 10, ill. p. 9
Campbell, Lawrence. "Reviews and Previews: Cloar," *Art News,* 54, February 1956, p. 55
Northrup, Guy, Jr. "New Carroll Cloar Exhibition Shown in Preview at Brooks," *The Commercial Appeal,* Memphis, November 20, 1955, ill.
Wyllie, John Cook. "Isolated in a Hostile World," *The New York Times Book Review,* October 15, 1961, ill. p. 44

"One never knows what occasion, what trivial incident or image, will stick in the memory. When I was a child, I took a great interest in the goings-on of the grown-ups— what they did, the clothes they wore, the songs they sang.

"*Day Remembered* tells no particular story; it is simply a memory of two couples who have just emerged from Sunday School at Lewis schoolhouse, four miles north of Earle, Arkansas."

Statement by the artist, 1972

CLAUDE MICHEL, called CLODION (1738–1814)

Claude Michel, born Nancy, France, December 20, 1738; son of Thomas Michel, First Sculptor to the King of Prussia. Studied, Paris: with uncle, Lambert-Sigisbert Adam, 1755–59; with Jean-Baptiste Pigalle, 1759; École Royale des Élèves Protégés, with Carle van Loo, 1759–62. Received Prix de Rome, 1761. Lived in Rome, 1762–71; Duc de La Rochefoucauld, and Catherine II of Russia, among his patrons. Returned to Paris, 1771; first exhibited, Salon of 1773. His brother Sigisbert-François, and Joseph-Charles Marin, assisted in his atelier, which produced decorations for private houses, and small-scale sculpture such as candelabra, vases, and sconces. Royal commissions: marble statue of Montesquieu, 1776/77–83 (exhibited, Salon of 1779, 1783); *Iris,* grounds of Palace of Versailles, 1780. Marble relief of Saint Cecilia commissioned, choir screen, Rouen Cathedral; installed, 1777. During French Revolution, lived in Nancy; made decorations for private houses, and models for porcelain figurines. Returned to Paris, 1798. Exhibited, Salon of 1801, 1806, 1810. Died Paris, March 28, 1814.

Atelier of CLAUDE MICHEL, called CLODION.
Female Satyr Group. c. 1780.
Terra-cotta, 17 × 12 × 9¾ inches
Markings: l. back "Clodion"

PROVENANCE:
Mrs. Richard Gambrill, New York, and Newport, Rhode Island; Mrs. Richard Gambrill, Jr., Peapack, New Jersey; Parke-Bernet Galleries, New York, Sale 2808, February 21, 1969, no. 210, ill. p. 56

Atelier of CLAUDE MICHEL, called CLODION.
Male Satyr Group. c. 1780.
Terra-cotta, 18½ × 12 × 11 inches
Markings: l. back "Clodion"

PROVENANCE:
Mrs. Richard Gambrill, New York, and Newport, Rhode Island; Mrs. Richard Gambrill, Jr., Peapack, New Jersey; Parke-Bernet Galleries, New York, Sale 2808, February 21, 1969, no. 210, ill. p. 57

The *Satyr Groups* are similar to Clodion's other terracottas and bronzes of the same subject, especially to a pair of sculptures, in the Musée Denon, Chalon-sur-Saône, France. Such fanciful variations on bacchanalian themes are characteristic of Clodion's work between the time he returned to Paris, from Rome, in 1771, and the outbreak of the French Revolution.

GLENN O. COLEMAN (1887–1932)

Born Springfield, Ohio, July 18, 1887. Moved with family to Indianapolis, Indiana, 1891. Studied, Manual Training High School, Indianapolis, with Otto Stark; worked as newspaper illustrator. Moved to New York, 1905. Studied: New York School of Art, with William Merritt Chase, and Robert Henri, c. 1906–9; transferred to Henri School of Art, 1909. Portfolio of drawings *Scenes from the Lives of People,* privately printed, 1908, illustrated Hutchins Hapgood's *Types from City Streets* (New York, Funk & Wagnalls), 1910. Organized The Original Independent Show, New York, with Arnold Friedman, and Julius Golz, Jr., 1908. Included in: Exhibition of Independent Artists Annual, New York, 1910; the Armory Show, 1913; Pennsylvania Academy Watercolor Annual, 1913; Society of Independent Artists Annual, 1917. Contributed illustrations to *The Masses,* 1912–16 (John Sloan, art editor); active Socialist. Exhibited with: William and Marguerite Zorach, The Daniel Gallery, New York, 1916; Henri Burkhard, Whitney Studio Club, New York, 1926; Stuart Davis, Valentine Gallery, New York, 1928. One-man shows: The Daniel Gallery, 1918; Whitney Studio Club, 1927; The Downtown Gallery, New York, 1929–32. *Minetta Lane* (second version) purchased by Musée du Luxembourg, Paris, 1920. Awarded: Medal of the Third Class, Carnegie International, 1928; Brewster Prize for Lithography, International Exhibition of Lithographs and Wood Engravings, The Art Institute of Chicago, 1930; honorable mention, International Competitive Print Exhibition, The Cleveland Print Club, 1931. Included in: 43rd American Exhibition, The Art Institute of Chicago, 1930; Corcoran Biennial, 1930; "Murals by American Painters and Photographers," and "American Painting and Sculpture 1862–1932," The Museum of Modern Art, New York, 1932, 1932–33. Died Long Beach, New York, May 8, 1932. Memorial exhibitions: Whitney Museum of American Art, New York, 1932; Cleveland Museum of Art (graphics), 1932.

Queensboro Bridge, East River. c. 1910.
Oil on canvas, 30 × 38 inches
Signed l. r.: "G. O. Coleman"

PROVENANCE:
Edith Gurenson; James Graham and Sons, New York, 1964

EXHIBITIONS:
New York State Pavilion, New York World's Fair, Flushing Meadows, April–October 1965, *The City: Places and People,* cat.

PIETRO CONSAGRA (b. 1920)

Born Mazara del Vallo, Sicily, October 4, 1920. Studied, Accademia di Belle Arti e Liceo Artistico, Palermo, Italy, 1938–44. Moved to Rome, 1944. Co-founded Forma (group of abstract artists); contributed to manifesto *Forma I* (Rome), 1947. One-man shows: Galleria Mola, Rome, 1947; Galleria Sandri, Venice, 1948; Galleria del Secolo, Rome, 1949; Galleria del Pincio, Rome, 1951; Galleria del Naviglio, Milan, 1953. Venice Biennale: exhibited, 1950, 1952, 1954, 1962, 1972; one-man shows, 1956 (Einaudi Prize), 1960 (Grand Prize for Sculpture). Author of: *La Necessità della scultura* (Rome), 1952, a polemic answer to Arturo Martini's *La Scultura, lingua morta* (Verona), 1948; *L'Agguato C'è* (Rome), 1961. Included in: III and V São Paulo Bienal, 1955 (Metallurgical Prize), 1959; Pittsburgh International, 1958; "50 Ans d'Art Moderne," Palais des Beaux-Arts, Brussels, 1958 (Belgian Critics' Prize); Documenta II and III, Kassel, 1959, 1964. One-man shows: Palais des Beaux-Arts, Brussels, 1958; Galerie de France, Paris, 1959; Galerie Charles Lienhard, Zurich, 1961; Galería Bonino, Buenos Aires, 1962; Staempfli Gallery, New York, 1962; Galleria dell'Ariete, Milan, 1965–69; Marlborough Galleria d'Arte, Rome, 1966; Marlborough-Gerson Gallery, New York, 1967; Museum Boymans-van Beuningen, Rotterdam, The Netherlands, 1967; Galleria d'Arte Peccolo, Livorno, Italy, 1972. Lives in Rome.

Little Colloquy (Piccolo Colloquio). 1955.
Bronze (unique), 29½ × 29¾ × 3 inches
Markings: l. r. front of base "Consagra 55"

PROVENANCE:
The artist, Rome, 1956; World House Galleries, New York, 1961

EXHIBITIONS:
World House Galleries, New York, April 1–May 2, 1959, *Sculpture Annual,* no. 13, ill.
The Solomon R. Guggenheim Museum, New York, October 3, 1962–January 6, 1963, *Modern Sculpture*

from the Joseph H. Hirshhorn Collection, no. 58
The Baltimore Museum of Art, October 25–November 27, 1966, Twentieth Century Italian Art, cat.
Hopkins Art Center, Dartmouth College, Hanover, New Hampshire, May 25–July 9, 1967, Sculpture in Our Century: Selections from the Joseph H. Hirshhorn Collection, no. 11

Transparent Turquoise Iron (Ferro trasparente turchese). 1966.
Painted iron, 99¼ × 65½ × 18 inches

PROVENANCE:
Marlborough-Gerson Gallery, New York, 1967

EXHIBITIONS:
Marlborough Galleria d'Arte, Rome, December 1966, Consagra: ferri trasparenti 1966, colorplate p.4
Marlborough-Gerson Gallery, New York, October 1967, Consagra, no. 5, colorplate
The Solomon R. Guggenheim Museum, New York, October 20, 1967–February 4, 1968, Guggenheim International Exhibition: Sculpture from Twenty Nations, ill. p. 79; toured to Art Gallery of Ontario, Toronto, February 24–March 27; The National Gallery of Canada, Ottawa, April 26–June 9; Montreal Museum of Fine Arts, June 20–August 18

REFERENCES:
Carandente, Giovanni. Pietro Consagra, Palermo, Italy, Edizioni "Nuovo Sud," 1973, ill. p. 40

JOSEPH CORNELL (1903–1972)

Born Nyack, New York, December 24, 1903. Attended Phillips Academy, Andover, Massachusetts. Self-taught as an artist. In 1929, moved with family to house on Utopia Parkway, Flushing, New York, where he lived all his life. Included in: "Surrealist Group Show," Julien Levy Gallery, New York, 1932; "Fantastic Art, Dada, Surrealism," The Museum of Modern Art, New York, 1936; "Exposition Internationale du Surréalisme," Galerie des Beaux-Arts, Paris, 1938; "Objects by Joseph Cornell, Box-Valise by Marcel Duchamp, Bottles by Lawrence Vail," Peggy Guggenheim's Art of This Century, New York, 1942; "Abstract and Surrealist Art in the United States," The Denver Art Museum, and tour, 1944. Published scenario Monsieur Phot, in Julien Levy's Surrealism (New York, Black Sun Press), 1936. One-man shows, Julien Levy Gallery, 1939–40. Associated with André Breton, Max Ernst, Salvador Dali, Piet Mondrian, New York, during World War II. Wrote and illustrated imaginary biographies of ballerinas; published, New York: Dance Index, 1942, 1944, 1946, 1947, and View, 1943. One-man shows: Hugo Gallery, New York, 1946; Copley Galleries, Beverly Hills, California, 1948; Egan Gallery, New York, 1949, 1950, 1953; Walker Art Center, Minneapolis, 1953; Stable Gallery, New York, 1955, 1957; Bennington College, Vermont, 1959; Robert Schoelkopf Gallery, New York, 1966; Rose Art Museum, Brandeis University, Waltham, Massachusetts, 1968; The Metropolitan Museum of Art, New York, 1970; The Cooper Union for the Advancement of Science and Art, New York, 1972. Included in: Whitney Annual from 1953; Pittsburgh International, 1958; "The Art that Broke the Looking Glass," Dallas Museum for Contemporary Arts, 1961; "The Art of Assemblage," The Museum of Modern Art, and tour, 1961–62; "Dada, Surrealism and Their Heritage," The Museum of Modern Art, and tour, 1968; I Triennale of Contemporary World Art, New Delhi, 1968; "New York Painting and Sculpture: 1940–1970," The Metropolitan Museum of Art, 1969–70; "Das Ding als Objekt," Kunsthalle, Nuremberg, Germany, 1970; Documenta 5, Kassel, 1972. Retrospectives: Pasadena Art Museum, California, 1967; The Solomon R. Guggenheim Museum, New York, 1967. Received: Award of Merit, The American Academy of Arts and Letters, 1968; Brandeis University Creative Arts Award Medal, 1968. Died Flushing, December 29, 1972. Memorial exhibition, Queens County Art and Cultural Center, New York, 1973.

Boötes. Mid-1950s.
Box construction, 8⅛ × 13 × 3¼ inches
Signed on back, partly obscured: "Joseph Cornell"

PROVENANCE:
Oscar Krasner Gallery, New York, 1964

A fragment of a star chart on the back of this box shows the bright star Arcturus, and the constellation Boötes (the Bear Keeper, or Herdsman).

Shadow Box. Mid-1950s.
Box construction, 5¾ × 8¾ × 3¼ inches
Signed on back, on label: "Joseph Cornell"

PROVENANCE:
The Hanover Gallery, London, 1964

REFERENCES:
Elgar, Frank. "The New Departures: The United States," Larousse Encyclopedia of Modern Art, New York, Prometheus, 1965, ill. 1112, p. 408
Read, Herbert. A Concise History of Modern Sculpture, New York, Praeger, 1964, no. 327, p. 291, ill. p. 264

T. Lucretii. Mid-1950s.
Box construction, 10 × 15½ × 3¼ inches
Signed on back, on label: "Joseph Cornell"

PROVENANCE:
Unidentified private collection; Neil J. Ranells, New York, 1964

The title of this work is taken from the pages of Lucretius's De rerum natura, which are pasted on the back of the box.

Hôtel goldene Sonne. c. 1955–57.
Box construction, 12¾ × 9½ × 4 inches
Signed on back: "Joseph Cornell"

PROVENANCE:
Stable Gallery, New York, 1958; Jane Wade, New York, 1964

Hotel Boule-D'Or. 1957.
Box construction, 17¼ × 10¼ × 4⅜ inches
Signed on back: "Joseph Cornell"

PROVENANCE:
Unidentified private collection; Neil J. Ranells, New York, 1964

EXHIBITIONS:
Hopkins Art Center, Dartmouth College, Hanover, New Hampshire, May 25–July 9, 1967, Sculpture in Our Century: Selections from the Joseph H. Hirshhorn Collection, no. 12

Suite de la longitude. c. 1957.
Box construction, 13½ × 19¼ × 4⅛ inches
Signed on back: "Joseph Cornell"

PROVENANCE:
Jon N. Streep, New York, 1961

EXHIBITIONS:
Whitney Museum of American Art, New York, November 20, 1957–January 12, 1958, Annual Exhibition: Sculpture, Watercolors and Drawings, no. 8
The Solomon R. Guggenheim Museum, New York, October 3, 1962–January 6, 1963, Modern Sculpture from the Joseph H. Hirshhorn Collection, no. 60, ill. p. 204
The Solomon R. Guggenheim Museum, New York, May 4–June 25, 1967, Joseph Cornell, p. 25, ill. p. 47

REFERENCES:
Ashbery, John. "Cornell: The Cube Root of Dreams," Art News, 64, Summer 1967, p. 63
Samaras, Lucas. "Cornell Size," Arts Magazine, 41, May 1967, ill. p. 47
Sandler, Irving. "In the Art Galleries," New York Post, October 14, 1962, p. 12

Sand Fountain. Late 1950s.
Box construction, 10¼ × 7⅛ × 3½ inches
Signed on back, on label: "Joseph Cornell"

PROVENANCE:
Jon N. Streep, New York, 1961

EXHIBITIONS:
The Solomon R. Guggenheim Museum, New York, October 3, 1962–January 6, 1963, Modern Sculpture from the Joseph H. Hirshhorn Collection, no. 3
The Solomon R. Guggenheim Museum, New York, May 4–June 25, 1967, Joseph Cornell, p. 25, ill. p. 45

REFERENCES:
Ashbery, John. "Cornell: The Cube Root of Dreams," Art News, 64, Summer 1967, p. 63
Cortesi, Alexandra. "Joseph Cornell," Artforum, 4, April 1966, p. 29

Rapport de Contreras (Circe). c. 1965.
Collage, 8⅛ × 11½ inches
Signed and titled on back: "Joseph Cornell
 Rapport de Contreras"

PROVENANCE:
Robert Schoelkopf Gallery, New York, 1967

EXHIBITIONS:
Robert Schoelkopf Gallery, New York, April 26–May 14, 1966, Joseph Cornell, cat.

The Circe fragment is a detail of a reproduction of Dosso Dossi's Circe, c. 1515 (National Gallery of Art, Washington, D.C.).

Sorrows of Young Werther. 1966.
Collage, 8¼ × 11¼ inches
Signed and titled on back: "Sorrows of Young Werther
 Joseph Cornell"

PROVENANCE:
Robert Schoelkopf Gallery, New York, 1967

The Uncertainty Principle. 1966.
Collage, 7⅛ × 9½ inches
Signed and titled on back: "Joseph Cornell
 The Uncertainty Principle"

PROVENANCE:
Robert Schoelkopf Gallery, New York, 1967

EXHIBITIONS:
Robert Schoelkopf Gallery, New York, April 26–May 14, 1966, Joseph Cornell, cat.

Cornell was often inspired by divas and ballerinas. He identified the subject of this collage as Henrietta Sontag, the nineteenth-century German operatic soprano who is mentioned in the memoirs of Robert Schumann and Frédéric Chopin.

According to the artist, he contrasted an original nineteenth-century lithograph with a pirated copy (which had been printed in reverse) to illustrate the nature of uncertainty.

Telephone interview with the artist, 1972

RALSTON CRAWFORD (b. 1906)

Born St. Catherines, Ontario, September 5, 1906. Moved with family to Buffalo, New York, 1910. Studied: Otis Art Institute, Los Angeles, 1926–27; The Pennsylvania Academy of the Fine Arts, Philadelphia, and Barnes Foundation, Merion, Pennsylvania, 1927–30; Académie Colarossi, and Académie Scandinave, Paris, 1932–33; Columbia University, New York, 1933. Received Louis Comfort Tiffany Foundation Fellowship, 1931. One-man shows: The Maryland Institute, Baltimore, 1934; Boyer Galleries, Philadelphia, 1937, and New York, 1939; Flint Institute of Arts, Michigan, 1942; The Downtown Gallery, New York, 1944, 1946, 1950; Caresse Crosby Gallery, Washington, D.C., 1945; Santa Barbara Museum of Art, and tour, 1946. Active as photographer, from 1938; lithographer, from 1942. Taught: Art Academy of Cincinnati, Ohio, 1940–41; Honolulu Academy of the Arts, Hawaii, 1947; The Brooklyn Museum Art School, New York, 1948–49; Louisiana State University, Baton Rouge, 1949; New School for Social Research, New York, 1952–57. Served, U.S. Army Air Corps, 1942–45. Illustrations of Test Able, the detonation of the atom bomb, Bikini Atoll, commissioned by Fortune, 1946. Included in: "Abstract Painting and Sculpture in America," The Museum of Modern Art, New York, 1951; "The Precisionist View in American Art," Walker Art Center,

Minneapolis, and tour, 1960. Retrospectives: Milwaukee Art Center, Wisconsin, 1958; Creighton University Fine Arts Gallery, Omaha, Nebraska, 1968; The Contemporary Arts Center, Cincinnati, 1971. One-man shows, New York: Century Association, 1969; Lee Nordness Galleries, 1969; Zabriskie Gallery, 1973; Whitney Museum of American Art, 1973. Lives in New York.

Electrification. 1936.
Oil on canvas, 32 × 40 inches
Signed l. l.: "Crawford"

PROVENANCE:
Boyer Galleries, Philadelphia; The Downtown Gallery, New York; Lee Nordness Galleries, New York, 1969

EXHIBITIONS:
Caresse Crosby Gallery, Washington, D.C., April 10–30, 1945, Ralston Crawford, no. 18
Santa Barbara Museum of Art, California April 2–May 2, 1946, Paintings: Ralston Crawford, no. 19

REFERENCES:
Freeman, Richard B. Ralston Crawford, University, Alabama, University of Alabama, 1953, no. 36.1, p. 44, ill. p. 12

Torn Signs #2. 1967–68.
Oil on canvas, 60 × 45 inches
Signed l. r.: "RC"

PROVENANCE:
Lee Nordness Galleries, New York, 1969

EXHIBITIONS:
Century Association, New York, February 5–April 27, 1969, An Exhibition of Recent Paintings, Drawings, and Lithographs by Ralston Crawford

LEONARDO CREMONINI (b. 1925)

Leonardo Rafaello Cremonini, born Bologna, November 26, 1925. Studied: Accademia di Belle Arti e Liceo Artistico di Bologna, 1939–43; Accademia di Belle Arti di Bologna, 1944–46; Accademia di Belle Arti di Brera, Milan, 1946–50. Received Bourse d'Étude du Gouvernement Français, 1950; settled in Paris, 1951. One-man shows: Centre d'Art Italien, Paris, 1951; Catherine Viviano Gallery, New York, 1952, 1954, 1957, 1962; The Hanover Gallery, London, 1955. Included in: Pittsburgh International, 1952, 1955, 1958, 1964; "Modern Italian Art," The Tate Gallery, London, 1956; Salon de Mai, Paris, 1958, 1965, 1968; "Twentieth Century Italian Art from American Collections," Palazzo Reale, Milan, and Galleria Nazionale d'Arte Moderna, Rome, 1960; Salon des Comparaisons, Paris, 1961, 1962, 1964; Venice Biennale, 1964, 1966; Salon de la Jeune Peinture, Paris, 1965, 1966; Quadriennale Nazionale d'Arte, Rome, 1966; "Visage humain dans l'art contemporain," Musée Rath, Geneva, 1967. One-man shows: Galerie du Dragon, Paris, from 1960; Galatea Galleria d'Arte, Turin, 1963; Palais des Beaux-Arts, Brussels, 1969; Kunsthalle, Basel, 1969. Retrospective, Museo Civico, Bologna, and tour, 1969–70. Lives in Paris.

Bathers Amongst the Rocks. 1955–56.
Oil on canvas, 35 × 57½ inches
Signed and dated l. l. of center: "Cremonini/1955–56"

PROVENANCE:
Catherine Viviano Gallery, New York, 1957

EXHIBITIONS:
Catherine Viviano Gallery, New York, February 11–March 9, 1957, Leonardo Cremonini, no. 5, cover ill.
Palazzo Reale, Milan, April 30–June 26, 1960, Twentieth Century Italian Art from American Collections (The Museum of Modern Art, New York, International Circulating Exhibition), no. 77, ill. p. 163; toured to Galleria Nazionale d'Arte Moderna, Rome, July 10–September 10
Museo Civico, Bologna, October 15–November 15, 1969, Leonardo Cremonini, no. 14, ill.

REFERENCES:
Rubin, William S. "Cremonini," Arts, 31, February 1957, p. 33, ill. p.

JOSÉ LUIS CUEVAS (b. 1933)

Born Mexico City, February 26, 1933. Studied, Mexico City: Escuela de Pintura y Escultura la Esmeralda, 1944; graphics, Mexico City College, with Lola Cueto, 1948. One-man shows: walls of vacated lot, Donceles Street, Mexico City, 1947; Galería Prisse, Mexico City, 1953; Pan American Union, Washington, D.C., 1954, 1963; Galerie Édouard Loeb, Paris, 1955; Palacio de Bellas Artes, Havana, 1956; De Aenlle Gallery, New York, 1957; Gres Gallery, Washington, D.C., 1957. Included in: III and V São Paulo Bienal, 1955, 1959 (First International Drawing Prize); Guggenheim International Award, 1960; VII Mostra Internazionale de Bianco e Nero, Lugano, Switzerland, 1962 (first prize); II Bienal, Santiago, Chile, 1965 (purchase prize); ROSC '67, Dublin, 1967; I Triennale of Contemporary World Art, New Delhi, 1968. Taught, Universidad Iberoamericana, Mexico City, 1956, 1959. Illustrator of: The Worlds of Kafka and Cuevas (Philadelphia, Falcon), 1959; The Ends of Legends String, poems by William MacLeod (Washington, D.C., Views Associates), 1960. One-man shows: Fort Worth Art Center Museum, Texas, 1960; David Herbert Gallery, New York, 1960, 1962; University Art Museum, University of Texas at Austin, 1960–61; Silvan Simone Gallery, Los Angeles, 1960–66; Grace Borgenicht Gallery, New York, from 1965; Galería Misrachi, Mexico City, 1966. Author of: Recollections of Childhood (Los Angeles, Kanthos), 1962; Cuevas por Cuevas (Mexico City, ERA), 1965. Lives in Mexico City.

Assaulted Woman VII. 1959.
Gouache on paper, 40 × 26 inches
Signed l. l.: "Cuevas"

PROVENANCE:
David Herbert Gallery, New York, 1960

EXHIBITIONS:
Fort Worth Art Center Museum, Texas, April 4–27, 1960, The Drawings of José Luis Cuevas, no. 67

University Art Museum, The University of Texas at Austin, December 8, 1960–January 8, 1961, *Drawings by José Luis Cuevas*

JOHN CUNNINGHAM, JR. (b. 1940)

Born Greenwich, Connecticut, August 18, 1940. Studied: Kenyon College, Gambier, Ohio, B.A., 1962; Yale University, New Haven, Connecticut, B.F.A., 1963, M.F.A., 1965; University of Pennsylvania, Philadelphia, 1965–66. Received commission for architectural screen, Grace New Haven Hospital, Connecticut, 1965. Assistant to George Rickey, summer, 1965, 1966–67. Exhibited with Jon Moscartolo, State University of New York at Albany, 1968. Guest lecturer and visiting critic: Williams College, Williamstown, Massachusetts, spring, 1968; Institute of Arts and Sciences, Williamstown, summer, 1968; Union College, Schenectady, New York, spring, 1971. Included in: "Structured Sculpture," Galerie Chalette, New York, 1968; "Work in Wood," Zabriskie Gallery, New York, 1970. One-man shows: Atelier Chapman Kelley, Dallas, 1971; Takumi Gallery, Saratoga Springs, New York, 1971; Greenwich Library, Connecticut, 1972. Has taught, Skidmore College, Saratoga Springs, since 1967. Lives in Schuylerville, New York.

Rock Candy Mountain. 1971.
Plexiglas, 25⅜ × 16 × 1⅞ inches
Markings l. r. front: "J. Cunningham 71"

PROVENANCE:
The artist, Schuylerville, New York, 1972

EXHIBITIONS:
Greenwich Library, Connecticut, *John Cunningham*, April 1972, cover ill.

SALVADOR DALI (b. 1904)

Salvador Domenech Felipe Jacinto Dali, born Figueras, Catalonia, Spain, May 11, 1904. Studied: academy, conducted by Brothers of the Marist Order, Figueras, 1914–18; Real Academia de Bellas Artes de San Fernando, Madrid, intermittently, 1921–26. Met Luis Buñuel, and Federico García Lorca, 1921–22. First one-man show, Galeria Dalmau, Barcelona, 1922. Contributed to journals *Gaceta de les Artes*, and *L'Amic des Arts* (*Gaceta de Sitges*), 1925–29. Met Pablo Picasso, Joan Miró, André Breton, Paul Éluard, Paris, 1927–29; joined official Surrealist group, 1929. Collaborated with Buñuel on films: *Un Chien Andalou*, Paris, 1929; *L'Âge d'or*, Paris, 1930–31. One-man shows: Galerie Goemans, Paris, 1929; Galerie Pierre Colle, Paris, 1931–33; Galeria d'Arte Catalonia, Barcelona, 1933, 1934; Julien Levy Gallery, New York, 1933–41; Zwemmer Gallery, London, 1934. Lived in Paris, 1929–40; traveled to the U.S., 1934; to Italy, 1937–39; remained in Paris, 1939–45. Wrote: *La Femme visible* (Paris, Éditions Surréalistes), 1930; *Babaou* (Paris, Cahiers Libres), 1932; *La Conquête de l'irrational* (Paris, Éditions Surréalistes), 1935; *The Secret Life of Salvador Dali* (New York, Dial), 1942. Created *Dream of Venus*, New York World's Fair, Flushing Meadows, 1939. Designed decor and costumes for Les Ballets Russes de Monte Carlo: *Bacchanale*, 1939; *Labyrinth*, 1941. Retrospective, The Museum of Modern Art, New York, 1941–42. One-man shows: M. Knoedler & Co., New York, from 1943; Bignou Gallery, New York, 1945–48; Carstairs Gallery, New York, 1950–60; Santa Barbara Museum of Art, 1953; Philadelphia Museum of Art (jewelry), 1955; Casino Communal, Knokke-le-Zoute, Belgium, 1956; Musée de l'Athénée, Geneva, 1970. Retrospectives: Palazzo Pallavicini-Rospigliosi, Rome, 1954; Prince Hotel Gallery, Tokyo, 1964; The Gallery of Modern Art, New York, 1965–66; Museum Boymans-van Beuningen, Rotterdam, The Netherlands, 1970–71. Salvador Dali Museum established, Figueras, 1970. Lives in New York, in Paris, and in Port Lligat, Spain.

Skull of Zurbarán (Crâne de Zurbarán). 1956.
Oil on canvas, 39⅜ × 39⅜ inches
Signed and dated l. c.: "Dali 1956"

PROVENANCE:
Carstairs Gallery, New York, 1957

EXHIBITIONS:
Carstairs Gallery, New York, December 4, 1956–January 5, 1957, *Salvador Dali*, no. 2
American Federation of Arts tour, 1962–65, *Paintings from the Joseph H. Hirshhorn Foundation Collection: A View of the Protean Century*, no. 18, ill.
The Gallery of Modern Art, New York, December 17, 1965–September 11, 1966, *Salvador Dali*, no. 146, ill. p. 127

REFERENCES:
Bulletin of the Allentown Art Museum, Allentown, Pennsylvania, 5, November 1964, cover ill.

Francisco de Zurbarán (1598–1664) was a Spanish Baroque painter of religious subjects.

AIMÉ-JULES DALOU (1838–1902)

Born Paris, December 31, 1838. Studied, Paris: privately, with Jean-Baptiste Carpeaux; École Royale et Spéciale de Dessin et de Mathématiques (Petit École), 1852–53; École des Beaux-Arts, 1854–57. First exhibited, Salon of 1861, Paris. Worked with Ernest Carrier-Belleuse, and Auguste Rodin, on sculptural decorations, Hôtel de Païva, Paris, 1864. Marble replicas of *Daphnis and Chloë* and *Woman Embroidering* shown, Salon of 1869 and 1870, respectively; subsequently acquired by French government. Joined Fédération des Artistes, in support of Paris Commune, 1871; appointed one of four revolutionary curators, Musée du Louvre; escaped to London after fall of Commune. Exhibited, Royal Academy of Arts, London, 1872–79. Assistant professor, National Art Training School (now Royal College of Art), London, 1877–80. Commissioned by Queen Victoria to design memorial to three of her grandchildren, private chapel, Windsor Castle, England, 1878. Returned to Paris, after general amnesty, 1879. Entered competition, sponsored by city, for statue of the *Republic*, 1879; model retained, though not selected; project evolved into *Triumph of the Republic*, inaugurated, Place de la Nation, Paris, 1899.

Légion d'honneur: chevalier, 1883; officier, 1889; commandeur, 1899. Awarded Grand Prix, Exposition Universelle de 1889, Paris. Monuments commissioned, Paris, 1890s: Eugène Delacroix; Jean Leclaire; Léon Gambetta; Charles Floquet. Died Paris, April 15, 1902. Unfinished sketches and models for larger works sold from studio to City of Paris, 1905 (now in Musée du Petit Palais).

Fall of Lucifer. n.d.
Bronze, 5⅜ × 3⅜ × 4¾ inches
Markings: l. r. "DALOU"
l. c. back "A. A. Hebrard Paris Cire Perdue"

PROVENANCE:
Dr. Barnett Fine, Stamford, Connecticut; Shepherd Gallery, New York, 1967

EXHIBITIONS:
The Drawing Shop, New York, March 5–April 19, 1964, *The Non-Dissenters: Second Exhibition, David through Meissonier*, checklist

The Revolutionary. n.d.
Bronze, 21 × 10½ × 7 inches
Markings: l. r. front of base "Dalou"
l. r. back of base "5 Cire Perdue A. A. Hebrard"

PROVENANCE:
René Dreyfus, Paris; James Goodman Gallery, Buffalo, New York, 1965

Wisdom Supporting Freedom. 1889.
Bronze on a base, 24 × 10½ × 10¼ inches
Markings: r. side of base "Dalou. 1889"
"4 Cire Perdue A. A. Hebrard"

PROVENANCE:
René Dreyfus, Paris; James Goodman Gallery, Buffalo, New York, 1965

Study of a Nude. c. 1896, cast 1902–5.
Bronze, 20½ × 7⅛ × 9 inches
Markings: r. side of base "Dalou"
l. r. side of base "Cire Perdue A. A. Hebrard 3"

PROVENANCE:
Mallett at Bourdon House, London, 1964; James Goodman Gallery, Buffalo, New York, 1966

EXHIBITIONS:
Mallett at Bourdon House, London, April 28–May 9, 1964, *Sculptures by Jules Dalou*, no. 73
Galerie Heim, Paris, March 20–April 15, 1965, *Jules Dalou*, no. 44

This bronze was cast from the plaster study for the allegorical figure of the Republic, part of Dalou's memorial to French republican politician Charles Floquet (1826–96). Floquet was active in the government of national defense in 1870, and later held office in the Third Republic.

The monument was commissioned in 1896, and was unveiled in the Cimetière du Père-Lachaise, Paris, in 1899.

DANTAN LE JEUNE (1800–1869)

Jean-Pierre-Édouard Dantan, born Paris, December 28, 1800; son of a wood-carver, and younger brother of sculptor Antoine-Laurent Dantan (1798–1878). Carved rifle stocks, for munitions manufacturer, 1819. Worked on: restoration of sculptural decorations, abbey church of St. Denis, outside of Paris; sculptural programs of the Bourse (new stock exchange), and the Chapelle Expiatoire (memorial to Louis XVI), Paris. With his brother, studied, École des Beaux-Arts, Paris, with François-Joseph Bosio, 1823. First exhibited Salon of 1827, Paris. Lived in Italy, 1827–31. Commissioned to make portraits, Musée de Versailles, France, 1831; awarded second-class medal, for fifteen portraits, Salon of 1831. Exhibited *portraits-charges* (caricatures), at the firm of Susse, Paris, from 1832. Lived in London, 1833–34, 1842; exhibited, Royal Academy of Arts, London, 1834. *Musée Dantanorama*, album of lithographs after his caricatures, first issued, Paris, 1834; *Les Dominotiers de Dantan jeune* issued, 1848. Statue of Queen Victoria commissioned, World Exposition of 1851, London. Died Baden-Baden, Germany, September 6, 1869. Complete collection of his caricature sculpture maintained, Musée Carnavalet, Paris.

Caricature of Auguste Vestris. 1834, cast 1961.
Bronze (edition of four), 11½ × 3¼ × 6½ inches
Markings: r. side of base "Dantan J 1834"

PROVENANCE:
Swetzoff Gallery, Boston; The Alan Gallery, New York, 1961

Like his father before him, Marie-Auguste-Allard Vestris (1760–1842) was the greatest male ballet dancer of his time—and also the most vain. Dantan's caricature shows Vestris (who was then about sixty) as Zephyr in the ballet *Psyche*.

ITZHAK DANZIGER (b. 1916)

Born Berlin, June 26, 1916. Emigrated with family to Palestine, 1923. Studied: Bezalel School of Arts and Crafts, Jerusalem, 1929–33; Slade School of Fine Art, University College, London, 1934–37. Settled in Tel Aviv, 1938. Awarded Dizengoff Prize for Art, Israel, 1945. Lived in London, 1949; studied landscape architecture, University of London; one-man show, Brook Street Gallery. Joined New Horizons (group of abstract artists), Tel Aviv, 1957–58. Included in: 1e Biennale de Paris, 1959; 5th Middelheim Biënnale, Antwerp, 1959; "Art Israel," The Museum of Modern Art, New York, and tour, 1964–65; annual exhibition of modern art, Tel Aviv Museum, 1964–66. Awarded Israel Prize, 1968. Sculpture commissions: mural and entrance, Hebrew University, Jerusalem, 1956–58; monument to martyred hero Ben-Joseph, Rosh Pina, Galilee, Israel, 1957; garden sculpture, Israel Museum, Jerusalem, 1965 (in collaboration with Shamai Haber); 1968 Olympic games, Mexico City. Member, Government Commission for

Higher Education, Israel, 1971. Landscape designs: rehabilitation project, Nesher Quarry, near Haifa, Israel, 1971–72; Tel Aviv municipality, 1972; Hilton Hotel, Teheran, Iran, 1972–73. Has taught three-dimensional design, The Technion, Haifa, since 1956. Lives in Tel Aviv.

"The Lord Is My Shepherd" (Negev Sheep). 1964.
Bronze (edition of six), 2 feet 10 inches × 8 feet 8½ inches × 6 feet 9½ inches

PROVENANCE:
Galerie Israel, Tel Aviv, 1964

EXHIBITIONS:
The Jewish Museum, New York, December 9, 1964–January 24, 1965, *Art Israel* (sponsored by The Museum of Modern Art, New York, International Council, and America-Israel Cultural Foundation), ill. p. 32; toured to eleven U.S. and three Canadian cities

ALLAN D'ARCANGELO (b. 1930)

Born Buffalo, New York, June 16, 1930. Studied: State University of New York at Buffalo, 1948–53; Mexico City College, 1957–59. One-man shows: Galería Genova, Mexico City, 1958; Thibault Gallery, New York, 1963. Taught: The School of Visual Arts, New York, 1963–68; Cornell University, Ithaca, New York, 1968. Designed facade mural, Transportation and Travel Pavilion, New York World's Fair, Flushing Meadows, 1964. One-man shows: Fischbach Gallery, New York, 1964–69; Galerie Ileana Sonnabend, Paris, 1965; Dwan Gallery, Los Angeles, 1966; Minami Gallery, Tokyo, 1967. Included in: "The New American Realism," Worcester Art Museum, Massachusetts, 1965; "Two Decades of American Painting," The Museum of Modern Art, New York, International Circulating Exhibition, 1966–67; "American Painting Now," Institute of Contemporary Art, Boston, 1967; Whitney Annual, 1967, 1969; "The Highway," Institute of Contemporary Art, University of Pennsylvania, Philadelphia, and tour, 1970; "Using Walls (Outdoors)," The Jewish Museum, New York, 1970. Created first outdoor wall painting, New York, 340 East Ninth Street, 1967. Received grant, The National Institute of Arts and Letters, and The American Academy of Arts and Letters, 1970. One-man shows: Institute of Contemporary Art, University of Pennsylvania, and Albright-Knox Art Gallery, Buffalo, 1971; Marlborough Gallery, New York, 1971. Lives in Kenoza Lake, New York.

Number One of Road Series 2. 1965.
Acrylic on canvas, 6 feet 9 inches × 8 feet 6 inches

PROVENANCE:
The artist, New York, 1967

EXHIBITIONS:
Dwan Gallery, Los Angeles, January 18–February 12, 1966, *Allan D'Arcangelo*
Fischbach Gallery, New York, February 14–March 4, 1967, *D'Arcangelo*
The Detroit Institute of Arts, April 11–May 21, 1967, *Color Image Form*, no. 10
The Aldrich Museum of Contemporary Art, Ridgefield, Connecticut, June 18–September 4, 1967, *Highlights of the 1966–67 Art Season*, no. 9
Institute of Contemporary Art, University of Pennsylvania, Philadelphia, March 10–April 16, 1971, *Allan D'Arcangelo: Paintings 1963–1970*, cat., ill.; toured to Albright-Knox Art Gallery, Buffalo, New York, May 18–June 27; Museum of Contemporary Art, Chicago, July 9–August 22

REFERENCES:
Antin, David. "Brev Fra New York: Painting Is Dead," *Billedkunst*, Copenhagen, 1, 1966, p. 45, ill.
Ashton, Dore. "New York Gallery Notes," *Art in America*, 55, January–February 1967, ill. p. 91
Atlantic Richfield Company. *Smithsonian*, 3, March 1973, colorplate p. 12 (adv.)
Dwan Gallery, Los Angeles, *Artforum*, 4, January 1966, ill. p. 7 (adv.)
Kultermann, Udo. *The New Painting*, New York, Praeger, 1969, no. 216, ill. p. 90
Nakahara, Yūsuke. "Road, Artificial Nature," *Geijutsu-sincho*, Tokyo, no. 8, August 1967, ill.

HONORÉ DAUMIER (1808–1879)

Honoré-Victorin Daumier, born Marseilles, France, February 26, 1808. Moved with family to Paris, 1816. Studied drawing, c. 1822, with Alexandre-Marie Lenoir, founder, Musée des Monuments Français. Frequented Musée du Louvre, and Académie Suisse, 1823. Apprenticed to lithographer Charles Ramelet; produced lithographs for Achille Ricourt, editor of *La Silhouette*, and Zéphyrin Béliard, 1829–30. Following Revolution of 1830, commissioned by Charles Philipon, radical Republican editor of *La Caricature* and *Le Charivari*, to make series of caricature busts of deputies, senators, and ministers of July Monarchy. Condemned to six months in prison and fined five hundred francs for lithographs attacking new regime, 1832; during imprisonment, painted series of watercolors *L'Imagination*. After *La Caricature* was suppressed, 1834, continued career as illustrator for *Le Charivari*, a daily specializing in social satire. Made about four thousand lithographs, including suites: *Robert Macaire*, 1836–38; *Physiologies*, 1840; *Les Canotiers*, 1843; *Les Gens de Justice*, 1845–48. Friend of Charles Baudelaire, from mid-1840s; associated with sculptors Adolphe-Victor Geoffroy-Dechaume, and Antoine-Louis Barye, from 1847. Met with fellow artists to protest official Salon policy, 1847–48. Oil sketch of *La République* exhibited, École des Beaux-Arts, Paris, 1848. After Revolution of 1848, delineated Bonapartist character of *Ratapoil*, in lithographs for *Le Charivari*. Temporarily abandoned lithography for painting and sculpture, 1848–49. Included in Salon of 1849, 1850–51, 1861. Worked almost exclusively on painting, 1860–64; returned to *Le Charivari*, 1864. Summered, Valmondois, France, from 1863; friendly with Barbizon painters Jean-Baptiste-Camille Corot, François Millet, Charles-François Daubigny. Made lithographs related to Franco-Prussian War, and Paris Commune, 1870–71. One-man show (paintings and drawings), Galerie

Durand-Ruel, Paris, 1878. Died Valmondois, February 11, 1879. Posthumous exhibition, Palais de l'École des Beaux-Arts, Paris, 1901. Retrospectives: with Corot, The Museum of Modern Art, New York, 1930; Philadelphia Museum of Art, 1937. Sculpture exhibitions: Akademie der Künste, Berlin, 1952; Museum of Fine Arts, Boston, 1958 (also graphics); Museo Poldi Pezzoli, Milan, 1961; Smith College Museum of Art, Northampton, Massachusetts, 1963; Fogg Art Museum, Harvard University, Cambridge, Massachusetts, 1969.

Podenas (The Malicious Man of Importance; L'Important malicieux). c. 1832–35, cast 1929–52.
Bronze, 8¼ × 7¼ × 5 inches
Markings: back l. r. "[MLG] Bronze"
inside "18/25"

Gobin, Maurice. *Daumier Sculpteur*, Geneva, Pierre Cailler, 1952, no. 1 (hereafter cited as Gobin)
Fogg Art Museum. *Daumier Sculpture, A Critical and Comparative Study*, Cambridge, Massachusetts, Harvard University, 1969, no. 27 (hereafter cited as Fogg)

PROVENANCE:
Private collection, France; Palais Galliera (Ader-Picard), Paris, Sale, November 30, 1970, no. 44, ill.

In 1832, at the suggestion of Charles Philipon, Daumier began his series of *portraits-charges* (literally, "weighted" or "jesting" portraits, or caricatures). His subjects were the deputies, peers, and ministers of Louis-Philippe and the July Monarchy, whom he observed from the press galleries of the Chamber of Deputies and the Chamber of Peers. The busts, originally modeled in clay, and then painted, probably served as models for Daumier's lithographs which were published in Philipon's *La Caricature* in 1832–33.

Originally, Daumier may have made as many as forty-five busts, but only thirty-six have survived. They were purchased from the Philipon family by Maurice Le Garrec in 1927, and cast in bronze at the Barbedienne foundry, Paris, between 1929 and 1952, in numbered editions of twenty-five and thirty. In 1953, Mme Le Garrec authorized the Valsuani foundry, Paris, to cast another series of the busts, in editions of three each.

Joseph, Baron de Podenas (1782–c. 1838), nicknamed "Pot-de-nez" (Pot-nose), was an obscure politician, a Leftist who conveniently converted to the Right.

Fulchiron (The Hypocrite; Le Tartufe). c. 1832–35, cast c. 1929–30.
Bronze, 6½ × 5 × 4½ inches
Markings: l. r. side [MLG]
bottom rim "B1 1/30"
inside "1/30"

Gobin, no. 3
Fogg, no. 13

PROVENANCE:
Weyhe Gallery, New York; Mrs. John D. Rockefeller, Jr., New York; The Museum of Modern Art, New York; M. Knoedler & Co., New York, 1968

EXHIBITIONS:
The Museum of Modern Art, New York, March 6–April 7, 1940, *New Acquisitions: A Gift of Modern Sculpture*, cat.

REFERENCES:
Barr, Alfred H., Jr., ed. *Painting and Sculpture in the Museum of Modern Art*, New York, The Museum of Modern Art, no. 126, p. 34
Unsigned. "A Gift of Modern Sculpture," *The Museum of Modern Art Bulletin*, 7, April 1940, p. 2

Jean-Claude Fulchiron (1774–1859) was a minor poet, and a deputy from Philipon's hometown of Lyons.

Comte de Kératry (The Obsequious; L'Obséquieux). c. 1832–35, cast 1929–30.
Bronze, 4¾ × 5¼ × 3⅝ inches
Markings: l. r. side "[MLG]"
at base "4/25 B 2"

Gobin, no. 4
Fogg, no. 19

PROVENANCE:
M. Knoedler & Co., New York, 1964

EXHIBITIONS:
Norman Mackenzie Art Gallery, University of Saskatchewan, Regina, Canada, February 24–March 24, 1968, *The French as Seen through Their Art 1600–1925*, p. 24

Auguste-Hilarion, Comte de Kératry (1769–1859), was an art critic and one-time liberal who became an obsequious courtier under the July Monarchy. Louis-Philippe made him a peer.

Royer-Collard (The Sly Old Man; Le Vieux finaud). c. 1832–35, cast 1929–52.
Bronze, 5¼ × 4 × 3¼ inches
Markings: back l. r. "[MLG] Bronze"
inside "21/25"

Gobin, no. 6
Fogg, no. 29

PROVENANCE:
Mme Berthe Le Garrec, Paris; Galerie Sagot-Le Garrec, Paris; M. Knoedler & Co., New York, 1958

EXHIBITIONS:
Galerie Sagot-Le Garrec, Paris, June 14–July 13, 1957, *Daumier: Sculpteur, Lithographe, et Dessinateur*, no. 6
The Detroit Institute of Arts, 1959, *Sculpture in Our Time*, no. 4
The Solomon R. Guggenheim Museum, New York, October 3, 1962–January 6, 1963, *Modern Sculpture from the Joseph H. Hirshhorn Collection*, no. 77, ill. p. 37

Pierre-Paul Royer-Collard (1763–1845) was a prominent political philosopher and Monarchist.

Dr. Prunelle (The Scornful; Le Dédaigneux). c. 1832–35, cast 1929–52.
Bronze, 5¼ × 5¼ × 4 inches
Markings: back l. l. "Bronze"
inside "30/30"

Gobin, no. 8
Fogg, no. 28

PROVENANCE:
M. Knoedler & Co., New York, 1961

EXHIBITIONS:
The Solomon R. Guggenheim Museum, New York, October 3, 1962–January 6, 1963, *Modern Sculpture from the Joseph H. Hirshhorn Collection*, no. 98

Dr. Clément-François-Victor-Gabriel Prunelle (1774–1853) was a professor, physician, mayor of Lyons, and member of the Chamber of Deputies.

Dupin (The Orator; L'Orateur). c. 1832–35, cast 1929–52.
Bronze, 5¾ × 5½ × 3¾ inches
Markings: back l. l. "[MLG] Bronze"
inside "11/25"

Gobin no. 10
Fogg, no. 9

PROVENANCE:
M. Knoedler & Co., New York, 1959

EXHIBITIONS:
The Solomon R. Guggenheim Museum, New York, October 3, 1962–January 6, 1963, *Modern Sculpture from the Joseph H. Hirshhorn Collection*, no. 79

REFERENCES:
Roy, Claude. *Daumier*, Geneva, Skira, 1971, colorplate, title page
André-Marie-Jean-Jacques Dupin (1783–1895), an influential lawyer, was attorney-general of the High Court of Appeals. Under the Second Empire he became a senator.

Unknown (Toothless Laughter; Le Rieur édenté). c. 1832–35, cast 1929–52.
Bronze, 6¼ × 4⅜ × 3⅜ inches
Markings: back l. l. " [MLG] Bronze"
inside "12/25"

Gobin, no. 12
Fogg, no. 35

PROVENANCE:
M. Knoedler & Co., New York, 1961

EXHIBITIONS:
The Solomon R. Guggenheim Museum, New York, October 3, 1962–January 6, 1963, *Modern Sculpture from the Joseph H. Hirshhorn Collection*, no. 97
Norman Mackenzie Art Gallery, University of Saskatchewan, Regina, Canada, February 24–March 24, 1968, *The French as Seen through Their Art 1600–1925*, p. 24

Pelet de la Lozère? (Man with a Flat Head; L'Homme à tête plate). c. 1832–35, cast 1929–52.
Bronze, 5¼ × 4¼ × 3½ inches
Markings: back l. r. " [MLG] Bronze"
inside "12/25"

Gobin, no. 13
Fogg, no. 34

PROVENANCE:
M. Knoedler & Co., New York, 1958

EXHIBITIONS:
The Detroit Institute of Arts, and tour, 1959–60, *Sculpture in Our Time*, no. 2
The Solomon R. Guggenheim Museum, New York, October 3, 1962–January 6, 1963, *Modern Sculpture from the Joseph H. Hirshhorn Collection*, no. 66, ill. p. 39

REFERENCES:
Hale, William Harlan. *The World of Rodin 1840–1917*, New York, Time-Life Books, 1969, ill. p. 18
Read, Herbert. *A Concise History of Modern Sculpture*, New York, Praeger, 1964, no. 1, p. 291, ill. p. 11

Girod de l'Ain or Admiral Verhuel? (The Simpleton; Le Niais). c. 1832–35, cast 1929–52.
Bronze, 5 × 4⅛ × 3⅞ inches
Markings: back l. c. " [MLG] Bronze"
inside, and bottom rim "6/30"

Gobin, no. 20
Fogg, no. 33

PROVENANCE:
Hugo Moser, New York; Parke-Bernet Galleries, New York, Sale 1730, February 6, 1957, no. 32

EXHIBITIONS:
The Detroit Institute of Arts, and tour, 1959–60, *Sculpture in Our Time*, no. 1
The Solomon R. Guggenheim Museum, New York, October 3, 1962–January 6, 1963, *Modern Sculpture from the Joseph H. Hirshhorn Collection*, no. 65

REFERENCES:
Roy, Claude. *Daumier*, Geneva, Skira, 1971, colorplate, title page

Comte de Falloux ((A Sly One; Un Malin). c. 1832–35, cast 1929–52.
Bronze, 9 × 5⅜ × 5¼ inches
Markings: "[MLG]"
"21/25"

Gobin, no. 23
Fogg, no. 11

PROVENANCE:
Mme Berthe Le Garrec, Paris; Galerie Sagot-Le Garrec, Paris; Robert Q. Lewis, Los Angeles; Parke-Bernet Galleries, New York, Sale 2679, April 4, 1968, no. 105

EXHIBITIONS:
Galerie Sagot-Le Garrec, Paris, June 14–July 13, 1957, *Daumier: Sculpteur, Lithographe, et Dessinateur*, no. 23

Lefebvre (The Fine, Trenchant Spirit; L'Esprit fin et tranchant). c. 1832–35, cast 1929–52.
Bronze, 7¾ × 4½ × 5 inches
Markings: back l. l. " [MLG] Bronze"
inside "11/25"

Gobin, no. 28
Fogg, no. 22

PROVENANCE:
Private collection, Sweden; M. Knoedler & Co., New York, 1963

REFERENCES:
Rey, Robert. *Daumier*, trans. Norbert Guterman, New York, Abrams, 1965, ill. p. 49

Jacques Lefebvre (1773–1856) was president of the Chamber of Commerce, and regent of the Bank of France. He became a deputy in 1827.

Comte d'Argout (Spiritual and Malignant; Spirituel et malin). c. 1832–35, cast 1929–52.
Bronze, 5 × 6¼ × 3¼ inches
Markings: back l. r. [MLG] Bronze"
inside "21/25"

Gobin, no. 31
Fogg, no. 1

PROVENANCE:
Mme Berthe Le Garrec, Paris; Galerie Sagot-Le Garrec, Paris; M. Knoedler & Co., New York, 1958

EXHIBITIONS:
Galerie Sagot-Le Garrec, Paris, June 14–July 13, 1957, *Daumier: Sculpteur, Lithographe, et Dessinateur*, no. 31
The Detroit Institute of Arts, 1959, *Sculpture in Our Time*, no. 12
The Solomon R. Guggenheim Museum, New York, October 3, 1962–January 6, 1963, *Modern Sculpture from the Joseph H. Hirshhorn Collection*, no. 75

Antoine-Maurice Apollinaire, Comte d'Argout (1782–1858), was censor for the July Monarchy. Under Louis-Philippe, he was Minister of Commerce, Public Works, Fine Arts, and the Interior.

Harlé Père (The Old Fool; Le Gâteux). c. 1832–35, cast 1929–52.
Bronze, 4⅛ × 5¼ × 4¼ inches
Markings: back l. l. " [MLG] Bronze"
inside "12/30"

Gobin, no. 32
Fogg, no. 18

PROVENANCE:
M. Knoedler & Co., New York, 1961

EXHIBITIONS:
The Solomon R. Guggenheim Museum, New York, October 3, 1962–January 6, 1963, *Modern Sculpture from the Joseph H. Hirshhorn Collection*, no. 88

REFERENCES:
Rey, Robert. *Daumier*, trans. Norbert Guterman, New York, Abrams, 1965, ill. p. 47

Jean-Marie Harlé, Père (1765–1838), a deputy from Calais, was "remarkable for interrupting sessions in the Chamber of Deputies by loudly blowing his nose."

Fogg, p. 99

Gaudry (Sorrowful unto Death; Triste jusqu'à la mort). c. 1832–35, cast 1929–52.
Bronze, 6¼ × 4¼ × 5 inches
Markings: back l. l. " [MLG]"
inside "14/25"

Gobin, no. 35
Fogg, no. 16

PROVENANCE:
M. Knoedler & Co., New York, 1961

EXHIBITIONS:
The Solomon R. Guggenheim Museum, New York, October 3, 1962–January 6, 1963, *Modern Sculpture from the Joseph H. Hirshhorn Collection*, no. 99

Joachim-Antoine-Joseph Gaudry (1790–1875) was the judge in the proceedings against the Republican newspaper *Le National*.

Ratapoil. c. 1850, cast 1925.
Bronze (edition of twenty), 17⅜ × 6¼ × 7¼ inches
Markings: u. r. top of base "Daumier"
u. l. rim of base "Alexis Rudier Fondeur Paris"

Gobin, no. 61
Fogg, no. 37

PROVENANCE:
Estate of Alexis Rudier, Paris; Curt Valentin Gallery, New York, 1955

EXHIBITIONS:
The Detroit Institute of Arts, and tour, 1959–60, *Sculpture in Our Time*, no. 14, ill. p. 15
The Solomon R. Guggenheim Museum, New York, October 3, 1962–January 6, 1963, *Modern Sculpture from the Joseph H. Hirshhorn Collection*, no. 82, ill. p. 38
Marlborough-Gerson Gallery, New York, November–December 1963, *Artist and Maecenas: A Tribute to Curt Valentin*, no. 10, ill.
Los Angeles County Museum of Art, April–July 1965, *Inaugural Loan Exhibition*
J. B. Speed Art Museum, Louisville, Kentucky, November 2–December 5, 1971, *Nineteenth Century French Sculpture: Monuments for the Middle Class*, no. 49, ill. p. 134

REFERENCES:
Arnason, H. Harvard. *History of Modern Art*, New York, Abrams, 1968, p. 66, ill. p. 68
Ashton, Dore. "New York Letter," *Das Kunstwerk*, 16, October 1962, p. 26
Hale, William Harlan. *The World of Rodin 1840–1917*, New York, Time-Life Books, 1969, p. 19, ill. p. 18
Saltmarche, Kenneth. "Notes on Special Exhibitions: 'Sculpture in Our Time,'" *Art Quarterly*, 22, Winter 1959, p. 351

After the February Revolution of 1848, Louis-Napoleon, nephew of Bonaparte, returned from exile in England and began to campaign for the presidency of the Second

Republic. To the alarm of Daumier and other Republicans, Louis-Napoleon won a staggering victory in the December elections, and then went on, with the aid of propagandists and hired rabble-rousers, to stage a coup d'état in December 1851. Sporting the moustache and goatee of Louis-Napoleon, Daumier's *Ratapoil* (literally, "ratskin") is the epitome of the *agent-provocateur* whose role was to assure the success of the coup d'état.

The Parisian Janitor (Le Portier parisien). c. 1840–62, cast after 1930.
Bronze, 6¼ × 2½ × 3¼ inches
Markings: back l. r. "h.D"
 back l. c. "Cire Perdue/Valsuani"
 at base "18/30"

Gobin, no. 44
Fogg, no. 58

PROVENANCE:
Galerie des Arts Anciens et Modernes, Schaan, Liechtenstein; Marlborough Fine Art, London, 1958

EXHIBITIONS:
Marlborough Fine Art, London, October–December 1957, *Nineteenth and Twentieth Century European Masters*, no. 98, ill. p. 35
The Detroit Institute of Arts, and tour, 1959–60, *Sculpture in Our Time*, no. 15
The Solomon R. Guggenheim Museum, New York, October 3, 1962–January 6, 1963, *Modern Sculpture from the Joseph H. Hirshhorn Collection*, no. 92

REFERENCES:
Aarons, Leroy. "Sound the Hirshhorn! The Collection," *The Washington [D.C.] Post Potomac*, March 19, 1967, colorplate p. 17

Daumier's figurines had no apparent political significance, but were gently satirical and humorous commentaries on various Parisian social types. Bronze casting of the figurines was begun at the Valsuani foundry in the 1930s, but the origin of the terra-cottas from which they were cast is still a mystery. Maurice Gobin discovered and published nineteen of the terra-cottas for the first time in his catalogue raisonné of 1952. Gobin divided the figurines into three chronological periods, relating them to Daumier's graphic work, for which he thought they had served as models. Three additional figurines, discovered since the publication of Gobin's book, were cast in 1965. All the bronzes have been cast in editions of thirty, in addition to three or four trial proofs. All are numbered and stamped with the Valsuani seal.

The Reader (Le Lecteur). c. 1840–62, cast after 1930.
Bronze, 6¾ × 2½ × 3¼ inches
Markings: l. l. side "h.D"
 back l. r. "Cire Perdue/C. Valsuani"
 at base "9/30"

Gobin, no. 45
Fogg, no. 54

PROVENANCE:
M. Knoedler & Co., Paris, 1963

The Representative Knotting His Tie (Le Représentant noue sa cravate). c. 1840–62, cast after 1930.
Bronze, 7 × 2¾ × 2¾ inches
Markings: back l. l. "h.D"
 back l. r. "Bronze Cire Perdue/C. Valsuani"
 at base "18/30"

Gobin, no. 48
Fogg, no. 59

PROVENANCE:
Galerie des Arts Anciens et Modernes, Schaan, Liechtenstein; Marlborough Fine Art, London, 1958

EXHIBITIONS:
Marlborough Fine Art, London, October–December 1957, *Nineteenth and Twentieth Century European Masters*, no. 91, ill. p. 34
The Solomon R. Guggenheim Museum, New York, October 3, 1962–January 6, 1963, *Modern Sculpture from the Joseph H. Hirshhorn Collection*, no. 95

The Confidant (Le Confident). c. 1840–62, cast after 1930.
Bronze, 7⅛ × 2⅜ × 2½ inches
Markings: back l. l. "h.D"
 back l. r. "Cire Perdue/C. Valsuani"
 at base "18/30"

Gobin, no. 49
Fogg, no. 51

PROVENANCE:
Galerie des Arts Anciens et Modernes, Schaan, Liechtenstein; Marlborough Fine Art, London, 1958

EXHIBITIONS:
Marlborough Fine Art, London, October–December 1957, *Nineteenth and Twentieth Century European Masters*, no. 92, ill. p. 34
The Solomon R. Guggenheim Museum, New York, October 3, 1962–January 6, 1963, *Modern Sculpture from the Joseph H. Hirshhorn Collection*, no. 93

The Lover (L'Amoureux). c. 1840–62, cast after 1930.
Bronze, 7⅛ × 2¾ × 2½ inches
Markings: back l. c. "h.D"
 back l. r. "Cire Perdue/C. Valsuani"
 at base "11/30"

Gobin, no. 50
Fogg, no. 45

PROVENANCE:
Hugo Moser, New York; Parke-Bernet Galleries, New York, Sale 1757, May 8, 1957, no. 75, ill.

EXHIBITIONS:
The Solomon R. Guggenheim Museum, New York, October 3, 1962–January 6, 1963, *Modern Sculpture from the Joseph H. Hirshhorn Collection*, no. 89

The Scavenger (Le Rôdeur). c. 1840–62, cast after 1930.
Bronze, 5¾ × 2⅜ × 2¼ inches
Markings: back l. r. "h.D"

back l. l. "Cire Perdue/Valsuani"
 at base "18/30"

Gobin, no. 53
Fogg, no. 60

PROVENANCE:
Galerie des Arts Anciens et Modernes, Schaan, Liechtenstein; Marlborough Fine Art, London, 1958

EXHIBITIONS:
Marlborough Fine Art, London, October–December 1957, *Nineteenth and Twentieth Century European Masters*, no. 97, ill. p. 35
The Solomon R. Guggenheim Museum, New York, October 3, 1962–January 6, 1963, *Modern Sculpture from the Joseph H. Hirshhorn Collection*, no. 94

The Listener (Le Bourgeois en attente). c. 1840–62, cast after 1930.
Bronze, 6¼ × 2⅜ × 2½ inches
Markings: back l. l. "h.D"
 back l. r. "Cire Perdue/C. Valsuani"
 at base "18/30"

Gobin, no. 55
Fogg, no. 48

PROVENANCE:
Galerie des Arts Anciens et Modernes, Schaan, Liechtenstein; Marlborough Fine Art, London, 1958

EXHIBITIONS:
Marlborough Fine Art, London, October–December 1957, *Nineteenth and Twentieth Century European Masters*, no. 94, ill. p. 34
The Detroit Institute of Arts, and tour, 1959–60, *Sculpture in Our Time*, no. 16
The Solomon R. Guggenheim Museum, New York October 3, 1962–January 6, 1963, *Modern Sculpture from the Joseph H. Hirshhorn Collection*, no. 83

Small-Fry Landlord (Le Petit propriétaire). c. 1840–62, cast after 1930.
Bronze, 6½ × 3⅛ × 2½ inches
Markings: l. l. side "h.D"
 back l. r. "Cire Perdue/C. Valsuani"
 at base "18/30"

Gobin, no. 56
Fogg, no. 56

PROVENANCE:
Galerie des Arts Anciens et Modernes, Schaan, Liechtenstein; Marlborough Fine Art, London, 1958

EXHIBITIONS:
Marlborough Fine Art, London, October–December 1957, *Nineteenth and Twentieth Century European Masters*, no. 95, ill. p. 35
The Solomon R. Guggenheim Museum, New York, October 3, 1962–January 6, 1963, *Modern Sculpture from the Joseph H. Hirshhorn Collection*, no. 91

REFERENCES:
Rey, Robert. *Daumier*, trans. Norbert Guterman, New York, Abrams, 1965, ill. p. 51

The Visitor (Le Visiteur). c. 1840–62, cast after 1930.
Bronze, 6⅛ × 2½ × 2½ inches
Markings: back l. l. "h.D"
 back l. r. "Cire Perdue/C. Valsuani"
 at base "18/30"

Gobin, no. 57
Fogg, no. 61

PROVENANCE:
Galerie des Arts Anciens et Modernes, Schaan, Liechtenstein; Marlborough Fine Art, London, 1958

EXHIBITIONS:
Marlborough Fine Art, London, October–December 1957, *Nineteenth and Twentieth Century European Masters*, no. 96, ill. p. 35
The Solomon R. Guggenheim Museum, New York, October 3, 1962–January 6, 1963, *Modern Sculpture from the Joseph H. Hirshhorn Collection*, no. 90

ARTHUR B. DAVIES (1862–1928)

Arthur Bowen Davies, born Utica, New York, September 26, 1862. Studied, privately with Dwight Williams, Utica, 1877. Moved with family to Chicago, 1878. Studied: Chicago Academy of Design, c. 1878; School of The Art Institute of Chicago, 1882–86; The Art Students League of New York, and Gotham Art School, New York, 1887. Worked as draftsman, civil engineering firm, Mexico, 1880–82; illustrator, *Century Magazine*, and *St. Nicholas*, New York, 1887–90. Traveled to Italy (sponsored by Benjamin Altman), 1893. One-man shows: Macbeth Gallery, New York, 1896, 1897, 1901, 1905, 1912, 1918; Doll & Richards Gallery, Boston, 1905; Worcester Art Museum, Massachusetts, 1909; The Art Institute of Chicago, 1911. Awarded Silver Medal for Painting, Pan-American Exposition, Buffalo, New York, 1901. Included in: "Exhibition of Eight American Painters," Macbeth Gallery, and tour, 1908; Exhibition of Independent Artists, New York, 1910. President, Association of American Painters and Sculptors, organizers of the Armory Show, 1912–14; in Europe, with Walt Kuhn and Walter Pach, assembled foreign section. Six of his own works included in the Armory Show, 1913. Awarded: honorable mention, Carnegie International, 1913; Corcoran Gold Medal, and First Clark Prize, Corcoran Biennial, 1916; first prize, Carnegie International, 1923. Exhibited, New York: with Walt Kuhn, and Jules Pascin, Macbeth Gallery, 1916; with Kuhn, Charles Sheeler, Max Weber, Montross Gallery, 1917. One-man shows: The Arts Club of Chicago, 1918, 1920; M. De Zayas Gallery, New York, 1920; Weyhe Gallery, New York, 1920, 1921, 1923; Ferargil Galleries, New York, 1921, 1922, 1925, 1929, 1933; Montross Gallery, 1923. Mural commissions, New York, 1924: music room, Lillie P. Bliss residence; International House. Supervised execution of his tapestry designs, Manufactures Françaises des Gobelins, Paris, 1924–26. Advised art collectors, including John Quinn, and Miss Bliss, Mrs. John D. Rockefeller, Jr., and Mrs. Cornelius J. Sullivan, co-founders of The Museum of

Modern Art, New York. Died Florence, October 24, 1928. Memorial exhibition, The Metropolitan Museum of Art, New York, 1930. Retrospective, Munson-Williams-Proctor Institute, Utica, New York, 1941.

Valley's Brim. Before 1910.
Oil on canvas, 18 × 30 inches
Signed l. l.: "A. B. Davies"

PROVENANCE:
Macbeth Gallery, New York; Henry Harper Benedict, New York; Mrs. Henry Harper Benedict, New York; Sotheby & Co., London, Sale, November 21, 1962, no. 35, ill.

EXHIBITIONS:
29–31 West Thirty-fifth Street, New York, April 1–27, 1910, *Exhibition of Independent Artists*, no. 10
Macbeth Gallery, New York, March 18–30, 1912, *Paintings by Arthur B. Davies*, no. 20
Quincy Art Center, Illinois, February 23–March 15, 1964, *The Eight*, no. 13 (The Museum of Modern Art, New York, Circulating Exhibition); toured to ten U.S. cities

REFERENCES:
St. John, Bruce. *The Fiftieth Anniversary of the Exhibition of Independent Artists in 1910*, Wilmington, Delaware Art Center, 1960, p. 5
Townsend, James B. "Davies at Macbeth," *American Art News*, 10, March 23, 1912, p. 8

Madonna of the Sun. c. 1910.
Oil on canvas, 28 × 23 inches
Signed l. r.: "A. B. Davies"

PROVENANCE:
Robert McIntyre, New York; Estate of the artist; James Graham and Sons, New York, 1961

EXHIBITIONS:
Ferargil Galleries, New York, November 4–25, 1929, *Arthur B. Davies Paintings*, no. 8
The Corcoran Gallery of Art, Washington, D.C., May 1–25, 1930, *Special Memorial Exhibition of Works by the Late Arthur B. Davies*, no. 5
The Detroit Institute of Arts, April 14–May 17, 1931, *17th Annual Exhibition of American Art*, no. 42
XVIII Biennale Internazionale d'Arte, Venice, June–September 1932, *United States Pavilion*, no. 12, p. 282
Ferargil Galleries, New York, February 6–25, 1933, *Arthur B. Davies Paintings*, no. 6
Munson-Williams-Proctor Institute, Utica, New York, May 1941, *Arthur Bowen Davies*, no. 2
James Graham and Sons, New York, February 2–March 5, 1960, *Arthur B. Davies*, no. 7
Munson-Williams-Proctor Institute, Utica, New York, July 8–August 23, 1962, *Arthur B. Davies (1862–1928), A Centennial Exhibition*, no. 47, ill.; toured to Whitney Museum of American Art, New York, September 18–October 17; Memorial Art Gallery, University of Rochester, New York, November 30–December 26; Virginia Museum of Fine Arts, Richmond, January 11–February 10, 1963; Cincinnati Art Museum, Ohio, February 25–March 25; City Art Museum of St. Louis, Missouri; April 3–May 5; Museum of Fine Arts, Boston, May 23–June 23

REFERENCES:
Art News, 30, May 28, 1932, ill. p. 12
Cortissoz, Royal. *Arthur B. Davies*, New York, Whitney Museum of American Art, 1931, p. 29
Shapley, John, ed. *Index of Twentieth Century Artists 1933–1937*, 1937, reprinted in one vol., New York, Arno, 1970, p. 690

Dust of Color. c. 1915–20.
Oil on canvas, 28¼ × 23¼ inches

PROVENANCE:
Estate of the artist; James Graham and Sons, New York, 1961

EXHIBITIONS:
The Pennsylvania Academy of the Fine Arts, Philadelphia, April 16–May 15, 1921, *Exhibition of Paintings and Drawings Showing the Later Tendencies in Art*, cat.
James Graham and Sons, New York, February 1–28, 1958, *Arthur B. Davies*, no. 19
James Graham and Sons, New York, February 2–March 5, 1960, *Arthur B. Davies*, no. 5

REFERENCES:
Cortissoz, Royal. *Arthur B. Davies*, New York, Whitney Museum of American Art, 1931, p. 23
Geist, Sidney. "Month in Review," *Arts*, 32, February 1958, p. 48

A Thousand Flowers. c. 1922.
Oil on canvas, 33½ × 64 inches

PROVENANCE:
Estate of the artist; Birnbaum Auction Galleries, New York, Sale, October 3, 1962

EXHIBITIONS:
Tucson Art Center, Arizona, March 4–April 1, 1967, *Arthur B. Davies: Paintings and Graphics*, no. 59; toured to La Jolla Museum of Art, California, April 5–May 7; Utah Museum of Fine Arts, University of Utah, Salt Lake City, May 21–June 18

A tapestry based on this painting is in The Museum of Modern Art, New York (gift of Abby Aldrich Rockefeller).

"*A Thousand Flowers* was woven by Monsieur G. G. Labouré of the Manufactures (Françaises) des Gobelins. . . . The design for this work was really his [Davies's] reaction to the Chinese Art treasures shown him by Mrs. Rockefeller. He came home from seeing them very much exalted in spirit and said: 'I shall make something fit to put beside them. . . .'"

Letter from the artist's widow, Dr. Virginia M. Davies, October 5, 1931. Courtesy The Museum of Modern Art, New York

Beauty and Good Fortune. Early 1920s.
Bronze relief, 5¼ × 5⅞ × ⅜ inches

PROVENANCE:
Estate of the artist; James Graham and Sons, New York, 1969

Head with Cape. Early 1920s.
Bronze relief, 7¼ × 4 × 2⅛ inches

PROVENANCE:
Estate of the artist; James Graham and Sons, New York, 1969

Maenad. Early 1920s.
Bronze relief, 15½ × 4⅜ × 2¾ inches

PROVENANCE:
Estate of the artist; James Graham and Sons, New York, 1969

Mirror of Venus. Early 1920s.
Bronze relief, 15¼ × 5⅞ × ⅞ inches

PROVENANCE:
Estate of the artist; Jon N. Streep, New York, 1962

Nude. Early 1920s.
Bronze relief, 6 × 2 × ⅜ inches

PROVENANCE:
Estate of the artist; Jon N. Streep, New York, 1962

Pillars of Ialysos. Early 1920s.
Bronze relief, 13½ × 11⅜ × 1¼ inches

PROVENANCE:
Estate of the artist; James Graham and Sons, New York, 1969

Standing Nude, Right Arm on Shoulder. Early 1920s.
Bronze relief, 7¼ × 3¼ × ½ inches

PROVENANCE:
Estate of the artist; James Graham and Sons, New York, 1969

STUART DAVIS (1894–1964)

Born Philadelphia, December 7, 1894; son of art editor of *The* [*Philadelphia*] *Press.* Moved with family to East Orange, New Jersey, 1901. Studied, Henri School of Art, New York, with Robert Henri, 1910–13; classmate and friend of Glenn O. Coleman. Included in: Exhibition of Independent Artists, New York, 1910; the Armory Show, 1913; Society of Independent Artists Annual, 1917. Cartoonist, *Harper's Weekly,* 1913; contributed to *The Masses* (John Sloan, art editor), 1913–16. One-man shows: Sheridan Square Gallery, New York, 1917; Ardsley Gallery, Brooklyn, New York, 1918; Whitney Studio Club, New York, 1920, 1926, 1929; Newark Museum, New Jersey, 1925; The Downtown Gallery, New York, from 1927. Cartographer, U.S. Army Intelligence, 1918. Lived in Paris, 1928–29. Included in: "Painting and Sculpture by Living Americans," and "American Painting and Sculpture," The Museum of Modern Art, New York, 1930–31, 1932–33; Whitney Annual, from 1934; "Abstract Painting in America," Whitney Museum of American Art, New York, 1935. Taught, The Art Students League of New York, 1931–32. Mural commissions: *Men without Women,* Radio City Music Hall, Rockefeller Center, New York, 1932; *Swing Landscape,* Williamsburg Federal Housing Project, Brooklyn, New York, 1938 (now at Indiana University, Bloomington). WPA Federal Art Project, New York, 1933–39. Joined Artists' Union, 1934; editor, *Art Front,* 1935. American Artists' Congress: national secretary, 1936; national chairman, 1938. Taught: New School for Social Research, New York, 1940–50; Yale University, New Haven, Connecticut, 1951; Famous Artists School, Westport, Connecticut, 1954–64. Retrospectives: with Marsden Hartley, Cincinnati Modern Art Society, Ohio, 1941; The Museum of Modern Art, 1945. Received Guggenheim Foundation Fellowship, 1952, 1953. One-man shows: Venice Biennale, 1952; Walker Art Center, Minneapolis, and tour, 1957. Member, The National Institute of Arts and Letters, 1956. Awarded: Brandeis University Creative Arts Award Medal, 1957; Fine Arts Gold Medal, American Institute of Architecture, 1962. Designed Fine Arts Commemorative Stamp, U.S. Post Office Department, 1964. Died New York, June 24, 1964. Memorial exhibition, National Collection of Fine Arts, Smithsonian Institution, Washington, D.C., and tour, 1965.

Rue des Rats No. 2. 1928.
Oil and sand on canvas, 19¾ × 28½ inches
Signed l. l.: "Stuart Davis"

PROVENANCE:
The Downtown Gallery, New York; Private collection, New York; Harold Diamond, New York, 1966

EXHIBITIONS:
The Downtown Gallery, New York, January 21–February 10, 1930, *Recent Paintings (from France) by Stuart Davis,* no. 9

REFERENCES:
Archives of American Art, Smithsonian Institution, Washington, D.C., *The Downtown Gallery Archives*
Goossen, Eugene C. *Stuart Davis,* New York, Braziller, 1959, p. 23, ill. 26
Lucas, John. "The Fine Art Jive of Stuart Davis," *Arts,* 31, September 1957, p. 34

The Terminal. 1937.
Oil on canvas, 30 × 40 inches
Signed and dated u. l.: "Stuart Davis 1937"

PROVENANCE:
The Downtown Gallery, New York; Pepsi-Cola Company, New York; Parke-Bernet Galleries, New York, Sale 1183, October 18, 1950, no. 107; The Downtown Gallery, 1953

EXHIBITIONS:
Cincinnati Modern Art Society, Ohio, October 24–November 24, 1941, *Marsden Hartley—Stuart Davis,* cat.
The Pennsylvania Academy of the Fine Arts, Philadelphia, January 23–February 27, 1944, *One Hundred and Thirty-Ninth Annual Exhibition of Painting and Sculpture,* no. 45

The Metropolitan Museum of Art, New York, October 4–December 3, 1944, *Portrait of America (Artists for Victory, Inc.),* no. 31; toured to Museum of Fine Arts, Springfield, Massachusetts, December 15–January 15, 1945; Carnegie Institute, Pittsburgh, February 1–March 4
Brandeis University, Waltham, Massachusetts, June 1–17, 1955, *Three Collections,* no. 5
Tweed Gallery, University of Minnesota, Duluth, April 1–30, 1956, *Collector's Choice*
Walker Art Center, Minneapolis, March 30–May 19, 1957, *Stuart Davis,* no. 10, p. 21, ill. p. 20; toured to Des Moines Art Center, Iowa, June 9–30; San Francisco Museum of Art, August 6–September 8; Whitney Museum of American Art, New York, September 25–November 17
American Federation of Arts tour, 1959–60, *Ten Modern Masters of American Art,* no. 7, ill.
National Collection of Fine Arts, Smithsonian Institution, Washington, D.C., May 25–July 5, 1965, *Stuart Davis Memorial Exhibition,* no. 68, ill. p. 75; toured to The Art Institute of Chicago, July 30–August 29; Whitney Museum of American Art, New York, September 14–October 17; The Art Galleries, University of California at Los Angeles, November 6–December 5
Greenwich Library, Connecticut, May 7–June 5, 1967, *Joseph H. Hirshhorn Collects*
Lawrence University, Appleton, Wisconsin, February 25–March 15, 1968, *Social Comment in America* (The Museum of Modern Art, New York, Circulating Exhibition), no. 8; toured to nine U.S. cities

REFERENCES:
Abell, Walter. "Industry and Painting," *Magazine of Art,* 39, March 1946, p. 83, ill.
Archives of American Art, Smithsonian Institution, Washington, D.C., *The Downtown Gallery Archives*
Boswell, Peyton, Jr. "Portrait of America," *Art Digest,* 18, August 1, 1944, p. 6
Davis, Stuart. *Stuart Davis,* New York, American Artists Group, 1945, ill. (p. 25)
Goossen, Eugene C. *Stuart Davis,* New York, Braziller, 1959, ill. 42
McCausland, Elizabeth. "Pepsi-Cola and Patronage," *American Contemporary Art,* 1, August–September 1944, p. 6
Riley, Maude K. "Portrait of America Starts Nation-Wide Tour at Metropolitan," *Art Digest,* 19, October 15, 1944, p. 10
Unsigned. "Artists for Victory: Portrait of America," *Art News,* 43, December 1–14, 1944, p. 24
———. "Pepsi-Cola Buys 14 More Paintings," *Art Digest,* 19, November 15, 1944, p. 8
———. "12 Americans Hit the Spot!" *Art News,* 43, August 1944, pp. 14, 26
Watson, Ernest W. "Portrait of America," *American Artist,* 8, October 1944, ill. p. 27
Watson, Forbes. *American Painting Today,* Washington, D.C., American Federation of Arts, 1939, ill. p. 136

The Terminal was a prizewinner in the "Portrait of America (Artists for Victory, Inc.)" exhibition of 1944–45, sponsored by the Pepsi-Cola Company. A colorplate of the painting appeared on the January page of the 600,000 Pepsi-Cola calendars distributed in 1945.

Rapt at Rappaport's. 1952.
Oil on canvas, 52⅜ × 40⅜ inches
Signed l. c.: "Stuart Davis"

PROVENANCE:
The Downtown Gallery, New York; Mr. and Mrs. Stanley Wolf, Great Neck, New York; The Downtown Gallery, 1957

EXHIBITIONS:
Whitney Museum of American Art, New York, November 6, 1952–January 4, 1953, *1952 Annual Exhibition of Contemporary American Painting,* no. 33
University of Illinois, Urbana, March 1–April 12, 1953, *Contemporary American Painting and Sculpture,* no. 30, plate 34
The Downtown Gallery, New York, March 2–27, 1954, *Stuart Davis,* no. 4, colorplate cover
Walker Art Center, Minneapolis, March 30–May 19, 1957, *Stuart Davis,* no. 29, pp. 27, 43, colorplate p. 50; toured to Des Moines Art Center, Iowa, June 9–30; San Francisco Museum of Art, August 6–September 8; Whitney Museum of American Art, New York, September 25–November 17
American Federation of Arts tour, 1959–60, *Ten Modern Masters of American Art,* no. 80, colorplate frontispiece
Galerie Würthle, Vienna, June 19–July 8, 1961, *Vanguard American Painting* (organized by The Solomon R. Guggenheim Museum, New York, for the U.S. Information Agency), no. 8, ill.; toured to nine European cities
American Federation of Arts tour, 1962–65, *Paintings from the Joseph H. Hirshhorn Foundation Collection: A View of the Protean Century,* no. 20, ill. p. 37
National Collection of Fine Arts, Smithsonian Institution, Washington, D.C., May 25–July 5, 1965, *Stuart Davis Memorial Exhibition,* no. 89, p. 35, colorplate p. 40; toured to The Art Institute of Chicago, July 30–August 29; Whitney Museum of American Art, New York, September 14–October 17; The Art Galleries, University of California at Los Angeles, November 6–December 5
Art & Home Center, Exposition Grounds, Syracuse, New York, August 30–September 5, 1966, *125 Years of New York State Painting and Sculpture,* no. 13

REFERENCES:
Archives of American Art, Smithsonian Institution, Washington, D.C., *The Downtown Gallery Archives*
Arnason, H. Harvard. *History of Modern Art,* New York, Abrams, 1968, colorplate 192
Blesh, Rudi. *Stuart Davis,* New York, Grove, 1960, p. 58
Davis, Stuart. "Owh! in San Paó," *Contemporary American Painting,* Urbana, University of Illinois, 1952, p. 184
Donson, Jerome A. "The American Vanguard Exhibitions in Europe," *The Art Journal,* 22, Spring 1963, ill. p. 244

Forgey, Benjamin. "A Hirshhorn Art Survey: Striking and Surprising," *Washington* [*D.C.*] *Evening Star,* February 23, 1971, pp. B–7, ill.
Goodrich, Lloyd. "Rebirth of a National Collection," *Art in America,* 53, June 1965, colorplate p. 86
Goossen, Eugene C. *Stuart Davis,* New York, Braziller, 1959, ill. 57
Hess, Thomas B. "The Art Comics of Ad Reinhardt," *Artforum,* 12, April 1974, pp. 49, 50
Hunter, Sam. *American Art of the 20th Century,* New York, Abrams, 1972, ill. 283
Kelder, Diane M., ed. *Stuart Davis,* New York, Praeger, 1971, p. 105, ill. 35
Lucas, John. "The Fine Art Jive of Stuart Davis," *Arts,* 31, September 1957, p. 37, ill. p. 36
O'Doherty, Brian. *American Masters: The Voice and the Myth,* New York, Random House, 1973, p. 73
Reinhardt, Ad. "Foundingfathersfollyday," *Art News,* 53, April 1954, p. 24
Seckler, Dorothy Gees. "Stuart Davis Paints a Picture," *Art News,* 52, Summer 1953, pp. 30–33, 73–74, colorplate p. 33
Unsigned. "A Selection from Some Current Exhibitions Organized and Circulated by the A.F.A.," *Art International,* 3, 1959–60, p. 61, no. 5
Wight, Frederick S. "Stuart Davis," *Art Digest,* 27, May 15, 1953, p. 23

Rappaport's, founded in 1892, is a toy bazaar on Third Avenue in New York.

"My painting *Owh! in San Paó,* like my *Amazene,* and *Rapt at Rappaport's,* are statements in a visual-proprioceptive idiom as simple as a Tabloid headline. Anyone with enough coordination to decipher a traffic beacon, granted they accept the premise of its function, can handle their communicative potential with ease."

The artist, in "Owh! in San Paó," p. 184

Tropes de Teens. 1956.
Oil on canvas, 45 × 60 inches
Signed r. c.: "Stuart Davis"

PROVENANCE:
The Downtown Gallery, New York, 1957

EXHIBITIONS:
The Downtown Gallery, New York, November 6–December 1, 1956, *Stuart Davis, Recent Paintings,* no. 2
University of Illinois, Urbana, March 3–April 7, 1957, *Contemporary American Painting and Sculpture,* no. 40, p. 194, ill. 56
Brandeis University, Waltham, Massachusetts, June 1–20, 1957, *Art on the Campus,* no. 24
American Federation of Arts tour, 1959–60, *Ten Modern Masters of American Art,* no. 9
The Downtown Gallery, New York, May 10–June 4, 1960, *Stuart Davis,* no. 8
Galerie Würthle, Vienna, June 19–July 8, 1961, *Vanguard American Painting* (organized by The Solomon R. Guggenheim Museum, New York, for the U.S. Information Agency), no. 8, ill.; toured to nine European cities
National Collection of Fine Arts, Smithsonian Institution, Washington, D.C., May 25–July 5, 1965, *Stuart Davis Memorial Exhibition,* no. 110, p. 36, ill. p. 43; toured to The Art Institute of Chicago, July 30–August 29; Whitney Museum of American Art, New York, September 14–October 17; The Art Galleries, University of California at Los Angeles, November 6–December 5

REFERENCES:
Archives of American Art, Smithsonian Institution, Washington, D.C., *The Downtown Gallery Archives*
Benedikt, Michael. "New York Letter: Stuart Davis: 1894–1964," *Art International,* 9, November 20, 1965, p. 44
Blesh, Rudi. *Stuart Davis,* New York, Grove, 1960, plate J
Kelder, Diane M., ed. *Stuart Davis,* New York, Praeger, 1971, ill. 44
Munro, Eleanor C. "Reviews and Previews: Stuart Davis," *Art News,* 59, Summer 1960, p. 14
O'Doherty, Brian. *American Masters: The Voice and the Myth,* New York, Random House, 1973, p. 56
Tillim, Sidney, "Month in Review," *Arts,* 34, June 1960, pp. 48–49, ill.

(A "trope," in both English and French, is a figurative use of a word or expression.)

"*Tropes de Teens* has already been 'Audience-Tested' in New York City. Many took it for granted that they had an obligation to be puzzled by the title—and by the presence of a few identifiable 'figures,' to detect a new 'trend' in my work. But everybody knows what 'Teens' are, and their prerogative to make a switch in viewpoint and behavior as the essence of their liveness. Fortunately, a capacity to turn is not exclusive to Teens; otherwise the elegant and concrete Sound-Figures of Art would not be so amply available to us. A title is just a Title as far as I am concerned, a convenient identification tag for a painting in casual conversation."

The artist, in "Tropes de Teens," p. 194

JOSÉ DE CREEFT (b. 1884)

Born Guadalajara, Spain, November 27, 1884. Moved with family to Barcelona, 1888; apprenticed to maker of religious artifacts, 1897; in bronze art foundry, 1898. Moved to Madrid, 1900; studied in atelier of sculptor Agustín Querol. Moved to Paris, 1905; studied, Académie Julian, 1905–9; worked at Maison Gréber, commercial firm that reproduced sculptors' models in stone, 1911–14. Included in: Salon of 1909, 1910–12, 1914; Salon de la Société Nationale des Beaux-Arts, 1916, 1918, 1920, 1927; Salon d'Automne, 1920–27, 1930; Salon des Indépendants, 1922–25, 1928; Salon des Tuileries, 1925–27, 1932. Sculpture commission, War Memorial, Saugues (Puy de Dôme), France, 1918. Emigrated to the U.S., 1929; citizen, 1940. One-man shows: Seattle Art Museum, 1929; Ferargil Galleries, New York, 1929; The Arts Club of Chicago, 1930; Philadelphia Art Alliance, 1933; Passedoit Gallery, New York, 1936–49. Taught:

New School for Social Research, New York, 1932–48, 1957–60; Black Mountain College, North Carolina, summer, 1944; The Art Students League of New York, 1944–48, and since 1957. Awarded: First Prize in Sculpture, "Portrait of America (Artists for Victory, Inc.)," The Metropolitan Museum of Art, New York, 1942; Widener Memorial Gold Medal, Pennsylvania Academy Annual, Philadelphia, 1945. National Sculpture Society, New York: fellow, 1946; awarded Richard Prize, 1969. Commissions: *Poet*, Fairmont Park, Philadelphia, 1951; *Alice in Wonderland*, Central Park, New York, 1957; *The Gift of Health to Mankind*, Bellevue Hospital, New York, 1966. Member, The National Institute of Arts and Letters, 1955. One-man shows: The Contemporaries, New York, 1956–66; touring retrospective, sponsored by The Ford Foundation, and American Federation of Arts, 1960–61. Academician, National Academy of Design, 1964; member, The American Academy of Arts and Letters, 1969. One-man shows, Kennedy Galleries, New York, 1970, 1971. Lives in Rye, New York.

Bird. 1927.
Found objects, 11⅞ × 13⅜ × 3⅛ inches
Markings: front of base "JOSÉ CREEFT 1927"

PROVENANCE:
The Contemporaries, New York, 1964

REFERENCES:
Campos, Jules. *The Sculpture of José de Creeft*, New York, Da Capo, 1972, ill. 280

Dancer. 1943–54.
Chestnut, 58 × 13¾ × 12¼ inches
Markings: l. r. side "JOSÉ de CREEFT"

PROVENANCE:
The Contemporaries, New York, 1956

EXHIBITIONS:
The Contemporaries, New York, October 27–November 17, 1956, *José de Creeft Sculptures: 1954–55–56*, no. 26, ill.
The Detroit Institute of Arts, and tour, 1959–60, *Sculpture in Our Time*, no. 67
The Solomon R. Guggenheim Museum, New York, October 3, 1962–January 6, 1963, *Modern Sculpture from the Joseph H. Hirshhorn Collection*, no. 101, ill. p. 172

REFERENCES:
Campos, Jules. *The Sculpture of José de Creeft*, New York, Da Capo, 1972, ill. 229

EDGAR DEGAS (1834–1917)

Hilaire-Germain-Edgar de Gas, born Paris, July 19, 1834. Studied, Paris: law, 1853–54; etching, with Gregorio Soutzo, 1853–54; in private atelier of Louis Lamothe, 1854; École des Beaux-Arts, 1855. Met Jean-Auguste-Dominique Ingres, 1855. Traveled to Italy, 1856–57, 1858, 1860. Earliest dated graphic work, 1857. Friendly with Édouard Manet, from 1862 (despite periodic quarrels). Included in the Salon, Paris, 1865–70. Associated with writers Émile Zola, Edmond Duranty, and Théodore Duret, and musicians Désiré Dilhau and Ludovic Halévy, 1867–70. First sculpture, c. 1868–70. Served, artillery unit near Paris, Franco-Prussian War, 1870. Stayed with childhood friend Paul de Valpinçon and family, Le Ménil-Hubert, France, during Paris Commune, 1871. Visited New Orleans, where brothers Achille and René were cotton merchants, 1872–73. Experimented with monotypes and lithographs, 1874–75; with pastels, 1880s. Exhibited with Impressionists, 1874, 1876, 1877, 1879–81, 1886. Met Mary Cassatt, 1877; invited her to exhibit with Impressionists, 1879. Suffered from failing eyesight, from late 1870s. Only sculpture shown in his lifetime, *Petite Danseuse de quatorze ans*, included in Impressionist exhibition, 1881. Group exhibitions: Dowdeswell Gallery, London (organized by Durand-Ruel), 1883; Hôtel du Grand Miroir, Brussels, 1885; "Works in Oil and Pastel by the Impressionists in Paris," Durand-Ruel Gallery, New York, 1886. Lived in increasing isolation, after 1890; turned exclusively to modeling in wax and clay. Only one-man show, Galerie Durand-Ruel, Paris, 1892. Visited Musée Ingres, Montauban, France, 1897. Died Paris, September 27, 1917. Approximately one hundred and fifty wax models found in his studio; about half cast in bronze, 1919–21, and exhibited, Galerie Hébrard, Paris, 1921. Other sculpture exhibitions: Galerie Bernheim-Jeune, Zurich, 1921; Salles de l'Orangerie, Paris, 1931, 1937; Kunstsmuseum, Bern, 1951–52; M. Knoedler & Co., New York, 1955 (original works in wax).

Picking Apples. c. 1865–81, cast 1919–21.
Bronze relief (5/22), 17⅞ × 18¾ × 2¼ inches
Markings: l. l. "Degas"
l. r. "Cire Perdue
AA Hebrard
$\frac{37}{E}$"

PROVENANCE:
E. Bachmann, New York; Harold Diamond, New York, 1958

EXHIBITIONS:
The Detroit Institute of Arts, 1959, *Sculpture in Our Time*, no. 28
The Solomon R. Guggenheim Museum, New York, October 3, 1962–January 6, 1963, *Modern Sculpture from the Joseph H. Hirshhorn Collection*, no. 103

REFERENCES:
Rewald, John. *Degas: Works in Sculpture, A Complete Catalogue*, New York, Pantheon, 1944, no. 1
———. *Complete Degas Sculpture*, New York, Abrams, 1956, no. 1, p. 141

Under the supervision of Degas's friend Paul-Albert Bartholomé, the founder Hébrard cast seventy-two of Degas's sculptures in editions of twenty-two. Twenty bronzes in each edition were given identifying letters, while the other two were reserved for the founder and heirs of the artist. The markings "$\frac{37}{E}$" thus indicate that *Picking Apples* was the thirty-seventh sculpture to be cast, and that this was the fifth cast in its edition.

Prancing Horse. c. 1865–81, cast 1919–21.
Bronze, 10⅝ × 10¾ × 5 inches
Markings: top of base "Degas"
"$\frac{65}{D}$
Cire Perdue
AA Hebrard"

PROVENANCE:
Buchholz Gallery, New York; Paul Rosenberg & Co., New York, 1958

EXHIBITIONS:
The Cleveland Museum of Art, February 5–March 9, 1947, *Works by Edgar Degas*, no. 76
The Detroit Institute of Arts, and tour, 1959–60, *Sculpture in Our Time*, no. 26
The Solomon R. Guggenheim Museum, New York, October 3, 1962–January 6, 1963, *Modern Sculpture from the Joseph H. Hirshhorn Collection*, no. 102

REFERENCES:
Arnason, H. Harvard. *History of Modern Art*, New York, Abrams, 1968, ill. p. 68
Rewald, John. *Degas: Works in Sculpture, A Complete Catalogue*, New York, Pantheon, 1944, no. 16, p. 54
———. *Complete Degas Sculpture*, New York, Abrams, 1956, no. 16, p. 143

Dancer at Rest, Hands Behind Her Back, Right Leg Forward. c. 1882–95, cast 1919–21.
Bronze (5/22), 17⅞ × 4¾ × 10 inches
Markings: base "Degas"
"$\frac{63}{E}$
Cire Perdue
AA Hebrard"

PROVENANCE:
Private collection, Copenhagen; M. Knoedler & Co., New York, 1959

EXHIBITIONS:
The Detroit Institute of Arts, 1959, *Sculpture in Our Time*, no. 20
The Solomon R. Guggenheim Museum, New York, October 3, 1962–January 6, 1963, *Modern Sculpture from the Joseph H. Hirshhorn Collection*, no. 108
Marlborough-Gerson Gallery, New York, November–December 1963, *Artist and Maecenas: A Tribute to Curt Valentin*, no. 17, ill. p. 30

REFERENCES:
Rewald, John. *Degas: Works in Sculpture, A Complete Catalogue*, New York, Pantheon, 1944, no. 22
———. *Complete Degas Sculpture*, New York, Abrams, 1956, no. 22

Dancer Moving Forward, Arms Raised. c. 1882–95, cast 1919–21.
Bronze (6/22), 13¾ × 6¼ × 6¾ inches
Markings: base "Degas"
"$\frac{19}{F}$
Cire Perdue
AA Hebrard"

PROVENANCE:
Peridot Gallery, New York, 1958

EXHIBITIONS:
The Detroit Institute of Arts, and tour, 1959–60, *Sculpture in Our Time*, no. 23
J. B. Speed Art Museum, Louisville, Kentucky, October 15–November 28, 1965, *The Figure in Sculpture, 1885–1965*, no. 2
The Solomon R. Guggenheim Museum, New York, October 3, 1962–January 6, 1963, *Modern Sculpture from the Joseph H. Hirshhorn Collection*, no. 109

REFERENCES:
Rewald, John. *Degas: Works in Sculpture, A Complete Catalogue*, New York, Pantheon, 1944, no. 24
———. *Complete Degas Sculpture*, New York, Abrams, 1956, no. 24, p. 146

Dancer Moving Forward, Arms Raised, Right Leg Forward. c. 1882–95, cast 1919–21.
Bronze (heirs' cast/22), 25¾ × 12¾ × 8¼ inches
Markings: r. foot "Degas"
"Cire Perdue
AA Hebrard"
lower r. leg "$\frac{72}{HERD}$"

PROVENANCE:
E. Bachmann, New York; Parke-Bernet Galleries, New York, Sale 1897, April 15, 1959, no. 25, ill. p. 16

EXHIBITIONS:
The Solomon R. Guggenheim Museum, New York, October 3, 1962–January 6, 1963, *Modern Sculpture from the Joseph H. Hirshhorn Collection*, no. 105

REFERENCES:
Rewald, John. *Degas: Works in Sculpture, A Complete Catalogue*, New York, Pantheon, 1944, no. 26
———. *Complete Degas Sculpture*, New York, Abrams, 1956, no. 26, p. 146

Dancer, Arabesque over Right Leg, Left Arm in Line. c. 1882–95, cast 1919–21.
Bronze (founder's cast/22), 11¼ × 17¼ × 3¾ inches
Markings base: "Degas"
"Cire Perdue
AA Hebrard 3/"

PROVENANCE:
Mme A. A. Hébrard, Paris; M. Knoedler & Co., New York, 1958

EXHIBITIONS:
The Detroit Institute of Arts, 1959, *Sculpture in Our Time*, no. 25, ill. p. 19
The Solomon R. Guggenheim Museum, New York, October 3, 1962–January 6, 1963, *Modern Sculpture from the Joseph H. Hirshhorn Collection*, no. 107
Marlborough-Gerson Gallery, New York, November–December 1963, *Artist and Maecenas: A Tribute to Curt Valentin*, no. 13

REFERENCES:
Rewald, John. *Degas: Works in Sculpture, A Complete Catalogue*, New York, Pantheon, 1944, no. 42

———. *Complete Degas Sculpture*, New York, Abrams, 1956, no. 42, p. 150

Woman Arranging Her Hair. c. 1896–1911, cast 1919–21.
Bronze (20/22), 18¼ × 10⅜ × 6⅝ inches
Markings: base "Degas"
"$\frac{50}{T}$ Cire Perdue
AA Hebrard"

PROVENANCE:
Michel Kellerman, Paris; Marlborough Fine Art, London; Robin Howard, London, 1952; Sotheby & Co., London, Sale, July 1, 1964, no. 113

REFERENCES:
Rewald, John. *Degas: Works in Sculpture, A Complete Catalogue*, New York, Pantheon, 1944, no. 50
———. *Complete Degas Sculpture*, New York, Abrams, 1956, no. 50, p. 152

Woman Rubbing Back with a Sponge, Torso. c. 1896–1911, cast 1919–21.
Bronze (4/22), 17 × 10¼ × 7 inches
Markings: l. l. side "Degas"
l. r. side "Cire Perdue
AA Hebrard 28
D"

PROVENANCE:
Mr. and Mrs. Otto E. Spaeth, New York; Marlborough-Gerson Gallery, New York, 1964

EXHIBITIONS:
Munson-Williams-Proctor Institute, Utica, New York, October 1952, *Spaeth Collection*, no. 5, ill.
Marlborough-Gerson Gallery, New York, November–December 1963, *Artist and Maecenas: A Tribute to Curt Valentin*, no. 14, ill. p. 29

REFERENCES:
Rewald, John. *Degas: Works in Sculpture, A Complete Catalogue*, New York, Pantheon, 1944, no. 51
———. *Complete Degas Sculpture*, New York, Abrams, 1956, no. 51, p. 153

Dancer Putting on Her Stockings. c. 1896–1911, cast 1919–21.
Bronze, 18¼ × 8¾ × 7½ inches
Markings: base "Degas"
bottom r. foot "Cire Perdue
AA Hebrard $\frac{52}{D}$"

PROVENANCE:
Walter Halvorsen, Paris; Justin K. Thannhauser, New York; Mrs. Norman K. Winston, New York; M. Knoedler & Co., New York, 1958

EXHIBITIONS:
Galerie Thannhauser, Munich [1931?], *Edgar Degas: rastelle, Zeichnungen, das plastische Werk*, no. 12
Stedelijk Museum, Amsterdam, July–September 1939, *Random Rodin, Tentoonstelling Honderd Jaar Fransche Sculptuur*, no. 90
Buchholz Gallery, New York, October 19–November 13, 1943, *Bronzes by Degas, Matisse, Renoir*, no. 16
The Detroit Institute of Arts, and tour, 1959–60, *Sculpture in Our Time*, no. 22
The Solomon R. Guggenheim Museum, New York, October 3, 1962–January 6, 1963, *Modern Sculpture from the Joseph H. Hirshhorn Collection*, no. 116

REFERENCES:
Rewald, John. *Degas: Works in Sculpture, A Complete Catalogue*, New York, Pantheon, 1944, no. 57
———. *Complete Degas Sculpture*, New York, Abrams, 1956, no. 57, p. 154

Woman Getting Out of the Bath. c. 1896–1911, cast 1919–21.
Bronze (14/22), 16⅜ × 5¼ × 5¼ inches
Markings: base "Degas"
"Cire Perdue
AA Hebrard 71
N"

PROVENANCE:
Estate of the artist; Peridot Gallery, New York, 1957

EXHIBITIONS:
The Detroit Institute of Arts, 1959, *Sculpture in Our Time*, no. 27
The Solomon R. Guggenheim Museum, New York, October 3, 1962–January 6, 1963, *Modern Sculpture from the Joseph H. Hirshhorn Collection*, no. 114

REFERENCES:
Rewald, John. *Degas: Works in Sculpture, A Complete Catalogue*, New York, Pantheon, 1944, no. 59
———. *Complete Degas Sculpture*, New York, Abrams, 1956, no. 59, p. 155

Dancer Holding Her Right Foot in Her Right Hand. c. 1896–1911, cast 1919–21.
Bronze (2/22), 20⅛ × 10¼ × 13¼ inches
Markings: base "Degas"
"Cire Perdue
AA Hebrard 68
B"

PROVENANCE:
Curt Valentin Gallery, New York, 1955

EXHIBITIONS:
The Detroit Institute of Arts, and tour, 1959–60, *Sculpture in Our Time*, no. 18
The Solomon R. Guggenheim Museum, New York, October 3, 1962–January 6, 1963, *Modern Sculpture from the Joseph H. Hirshhorn Collection*, no. 111, ill. p. 41

REFERENCES:
Rewald, John. *Degas: Works in Sculpture, A Complete Catalogue*, New York, Pantheon, 1944, no. 62
———. *Complete Degas Sculpture*, New York, Abrams, 1956, no. 62, p. 155

Woman Stretching. c. 1896–1911, cast 1919–21.
Bronze (5/22), 14¼ × 8 × 8 inches
Markings: base "Degas"
"Cire Perdue
AA Hebrard 53
E"

PROVENANCE:
Galerie Drouet, Paris; La Boetie, New York; Paula Mailman, New York, 1962

REFERENCES:
Rewald, John. *Degas: Works in Sculpture, A Complete Catalogue,* New York, Pantheon, 1944, no. 64
———. *Complete Degas Sculpture,* New York, Abrams, 1956, no. 64, p. 156

Seated Woman Wiping Her Left Side. c. 1896–1911, cast 1919–21.
Bronze (6/22), 14 × 13¼ × 9 inches
Markings: base "Degas"
"Cire Perdue
AA Hebrard 46
F"

PROVENANCE:
Michel Kellerman, Paris; Marlborough-Gerson Gallery, New York, 1964

EXHIBITIONS:
Marlborough-Gerson Gallery, New York, November–December 1963, *Artist and Maecenas: A Tribute to Curt Valentin,* no. 15, ill. p. 29

REFERENCES:
Rewald, John. *Degas: Works in Sculpture, A Complete Catalogue,* New York, Pantheon, 1944, no. 69
———. *Complete Degas Sculpture,* New York, Abrams, 1956, no. 69, p. 157

The Masseuse. c. 1896–1911, cast 1919–21.
Bronze (3/22), 16½ × 17 × 13¾ inches
Markings: back l. r. "Degas"
back l. l. "Cire Perdue
AA Hebrard 55
C"

PROVENANCE:
Mme A. A. Hébrard, Paris; M. Knoedler & Co., New York; Mr. and Mrs. Paul Sampliner, New York; Parke-Bernet Galleries, New York, Sale 2072, December 13, 1961, no. 34, ill. p. 23

EXHIBITIONS:
The Solomon R. Guggenheim Museum, New York, October 3, 1962–January 6, 1963, *Modern Sculpture from the Joseph H. Hirshhorn Collection,* no. 110, ill. p. 40

REFERENCES:
Arnason, H. Harvard. *History of Modern Art,* New York, Abrams, 1968, ill. p. 68
Geldzahler, Henry. "Taste for Modern Sculpture: The Hirshhorn Collection," *Art News,* 61, October 1962, ill. p. 29
Mates, Robert E. *Photographing Art,* New York, Amphoto, 1966, ill. p. 101
———. "Photographing Sculpture and Museum Exhibits," *Curator,* 10, June 1967, ill. p. 98
Rewald, John. *Degas: Works in Sculpture, A Complete Catalogue,* New York, Pantheon, 1944, no. 73, p. 28
———. *Complete Degas Sculpture,* New York, Abrams, 1956, no. 73, p. 157
Rubin, William S. "The Hirshhorn Collection at the Guggenheim Museum," *Art International,* 6, November 1962, ill. p. 35

WILLEM DE KOONING (b. 1904)

Born Rotterdam, The Netherlands, April 24, 1904. Apprentice, commercial art firm, 1916–20. Studied: Academie voor Beeldende Kunsten en Technische Wetenschappen, Rotterdam, evenings, 1916–24; in Brussels and Antwerp, 1924. Emigrated to the U.S., 1926; citizen, 1963. Worked: as house painter, Hoboken, New Jersey, 1926; free-lance commercial artist, stage designer, decorator, New York, 1927–35. Met Arshile Gorky, c. 1933. Assisted Fernand Léger, on mural for French Line Pier, New York, 1935. WPA Federal Art Project, Easel and Mural Divisions, New York, 1935–36; sketches for mural, Williamsburg Federal Housing Project, Brooklyn, New York. Included in "New Horizons in American Art," The Museum of Modern Art, New York, 1936. Exhibited with Jackson Pollock, Lee Krasner, Stuart Davis, and others, McMillen, Inc., New York, 1942. Included in Whitney Annual, from 1947. First one-man show, Egan Gallery, New York, 1948. Taught: Black Mountain College, North Carolina, 1948; Yale University, New Haven, Connecticut, 1950–51. Included in: Venice Biennale, 1950, 1954, 1956; "Abstract Painting and Sculpture in America," The Museum of Modern Art, 1951; I and II São Paulo Bienal, 1951, 1953; "The New Decade," Whitney Museum of American Art, New York, and tour, 1955–56; "New Images of Man," The Museum of Modern Art, and The Baltimore Museum of Art, 1959–60; "Painting and Sculpture of a Decade, 54–64," The Tate Gallery, London, 1964. Awarded: Logan Medal, 60th Annual American Exhibition, The Art Institute of Chicago, 1951; first prize, Carnegie International, 1951. One-man shows, New York: Egan Gallery, 1951; Sidney Janis Gallery, 1953, 1956, 1959, 1972; Martha Jackson Gallery, 1955; Allan Stone Gallery, 1962, 1964, 1965, 1966, 1971; M. Knoedler & Co., 1967; The Baltimore Museum of Art, 1972. Retrospectives: School of the Museum of Fine Arts, Boston, 1953; Venice Biennale, 1954; Smith College Museum of Art, Northampton, Massachusetts, and Hayden Gallery, Massachusetts Institute of Technology, Cambridge, 1965; The Museum of Modern Art, International Circulating Exhibition, 1968–69. Member, The National Institute of Arts and Letters, 1960. Received: Freedom Award Medal, presented by President Lyndon B. Johnson, 1963; Brandeis University Creative Arts Award Medal, 1973. Lives in Springs, New York.

Seated Man. c. 1939.
Oil on canvas, 38½ × 34½ inches

PROVENANCE:
Gift of the artist, Springs, New York, 1968

EXHIBITIONS:
Whitney Museum of American Art, New York, October 15–December 1, 1968, *The 1930's: Painting and Sculpture in America,* no. 60, ill.

REFERENCES:
Frasnay, Daniel. *The Artist's World,* New York, Viking, 1969, p. 233, ill. 7
Hess, Thomas B. *Willem de Kooning,* New York, Braziller, 1959, ill. 22
O'Doherty, Brian. *American Masters: The Voice and the Myth,* New York, Random House, 1973, colorplate p. 140
Rosenberg, Harold. *The De-definition of Art,* New York, Horizon, 1972, p. 186
Siegel, Jeanne. "The 1930's: Painting and Sculpture in America," *Arts Magazine,* 43, November 1968, p. 32

Queen of Hearts. 1943–46.
Oil and charcoal on composition board, 46 × 27½ inches
Signed l. r.: "de Kooning"

PROVENANCE:
Martha Jackson Gallery, New York, 1962

EXHIBITIONS:
Martha Jackson Gallery, New York, November 9–December 3, 1955, *Recent Oils by Willem de Kooning,* no. 9, ill.
Martha Jackson Gallery, New York, February 6–March 3, 1962, *Selections 1934–1961: American Artists from the Collection of Martha Jackson,* p. 10, ill. p. 11
Trabia-Morris Gallery, New York, October 16–November 10, 1962, *Art of the Americas,* cat., ill.
Whitney Museum of American Art, New York, May 8–June 16, 1964, *The Friends Collect,* no. 32
Smith College Museum of Art, Northampton, Massachusetts, April 8–May 2, 1965, *Willem de Kooning,* no. 5
Stedelijk Museum, Amsterdam, September 19–November 17, 1968, *Willem de Kooning* (The Museum of Modern Art, New York, International Circulating Exhibition), no. 14, ill.; toured to The Tate Gallery, London, December 8–January 26, 1969; The Museum of Modern Art, New York, March 3–April 27, no. 16, ill. p. 41; The Art Institute of Chicago, May 16–July 6; Los Angeles County Museum of Art, July 28–September 14
The Metropolitan Museum of Art, New York, October 18, 1969–February 8, 1970, *New York Painting and Sculpture: 1940–1970,* no. 56, ill. p. 134

REFERENCES:
Alloway, Lawrence. *Francis Bacon,* New York, The Solomon R. Guggenheim Museum, 1963, p. 17
Denby, Edwin. "My Friend de Kooning," *Art News Annual,* 29, 1964, ill. p. 89
Drudi, Gabriella. *Willem de Kooning,* Milan, Fratelli Fabbri, 1972, ill. 22
Forge, Andrew. "De Kooning in Retrospect," *Art News,* 68, March 1969, ill. p. 45
Kramer, Hilton. "De Kooning Survey Opens at the Modern," *The New York Times,* March 5, 1969, p. 38, ill.
———. "30 Years of the New York School," *The New York Times Magazine,* October 12, 1969, p. 28, colorplate
———. "The New York School," *Dialogue,* 3, 1970, p. 35, ill.
Larson, Philip, and Schjeldahl, Peter. *De Kooning Drawings/Sculptures,* Minneapolis, Walker Art Center, 1974, ill. 15
Lippard, Lucy R. "Three Generations: De Kooning's First Retrospective," *Art International,* 9, November 20, 1965, p. 30
Raynor, Vivien. "In the Galleries: Art of the Americas," *Arts Magazine,* 37, December 1962, p. 46
Rose, Barbara. *American Art Since 1900,* New York, Praeger, 1967, p. 182, ill. 6–32
Rosenberg, Harold. *Willem de Kooning,* New York, Abrams, forthcoming, colorplate
Sandler, Irving. *The Triumph of American Painting,* New York, Praeger, 1970, p. 123, ill. p. 124
Steinberg, Leo. "Month in Review," *Arts,* 30, November 1955, p. 46, ill. p. 47
———. *Other Criteria,* New York, Oxford, 1972, p. 260, ill. p. 261
Unsigned. "On Exhibitions: U.S. & Canada," *Studio International,* 178, September 1969, p. 29, ill.
Varian, Elayne H., intro. *The Private Collection of Martha Jackson,* College Park, University of Maryland, 1973, p. 7

Special Delivery. 1946.
Oil, enamel, and charcoal on paper mounted on cardboard, 23⅛ × 30 inches
Signed and dated l. r.: "de Kooning
46"

PROVENANCE:
Harold Diamond, New York, 1962

EXHIBITIONS:
Institute of Contemporary Art, University of Pennsylvania, Philadelphia, January 14–March 1, 1965, *1943–1953: The Decisive Years,* cat.
Stedelijk Museum, Amsterdam, September 19–November 17, 1968, *Willem de Kooning* (The Museum of Modern Art, New York, International Circulating Exhibition), no. 20, ill.; toured to The Tate Gallery, London, December 8–January 26, 1969; The Museum of Modern Art, New York, March, 3–April 27, no. 22; The Art Institute of Chicago, May 16–July 6; Los Angeles County Museum of Art, July 28–September 14

REFERENCES:
Drudi, Gabriella. *Willem de Kooning,* Milan, Fratelli Fabbri, 1972, ill. 27

Woman (recto). 1948.
Oil and enamel on composition board, 53½ × 44½ inches
Signed and dated l. r.: "de Kooning/48"

Untitled (verso). 1948.
Oil and enamel on composition board, 53½ × 44½ inches
Signed and dated u. l.: "de Kooning/48"

PROVENANCE:
Harold Diamond, New York, 1962

EXHIBITIONS:
Indiana University Art Museum, Bloomington, April 19–May 10, 1964, *American Painting 1910 to 1960,* no. 15, ill.
Marlborough-Gerson Gallery, New York, April–May 1968, *International Expressionism Part I,* no. 9, ill.
Stedelijk Museum, Amsterdam, September 19–November 17, 1968, *Willem de Kooning* (The Museum of Modern Art, New York, International Circulating Exhibition), no. 24, ill.; toured to The Tate Gallery, London, December 8–January 26, 1969; The Museum of Modern Art, New York, March 3–April 27, no. 50, ill. p. 81; The Art Institute of Chicago, May 16–July 6; Los Angeles County Museum of Art, July 28–September 14

REFERENCES:
Drudi, Gabriella. *Willem de Kooning,* Milan, Fratelli Fabbri, 1972, ill. 46
Larson, Philip, and Schjeldahl, Peter. *De Kooning Drawings/Sculptures,* Minneapolis, Walker Art Center, 1974, ill. 14
Rose, Barbara. *American Art Since 1900,* New York, Praeger, 1967, p. 184, ill. 6–33
Rosenberg, Harold. *Willem de Kooning,* New York, Abrams, forthcoming, ill.

Secretary. 1948.
Oil and charcoal on composition board, 24¼ × 36½ inches
Signed l. l.: "de Kooning"

PROVENANCE:
Harold Diamond, New York, 1962

EXHIBITIONS:
University Art Museum, The University of Texas at Austin, February 18–April 1, 1968, *Painting as Painting,* no. 20, ill. p. 31
Stedelijk Museum, Amsterdam, September 19–November 17, 1968, *Willem de Kooning* (The Museum of Modern Art, New York, International Circulating Exhibition), no. 26, ill.; toured to The Tate Gallery, London, December 8–January 26, 1969; The Museum of Modern Art, New York, March 3–April 27, no. 32; The Art Institute of Chicago, May 16–July 6; Los Angeles County Museum of Art, July 28–September 14

REFERENCES:
Drudi, Gabriella. *Willem de Kooning,* Milan, Fratelli Fabbri, 1972, ill. 38
Rosenberg, Harold. *Willem de Kooning,* New York, Abrams, forthcoming, ill.

Woman. 1953.
Oil and charcoal on paper mounted on canvas, 25½ × 19¾ inches
Signed l. r.: "de Kooning"

PROVENANCE:
Sidney Janis Gallery, New York; Albert L. Arenberg, Chicago, 1954; E. V. Thaw & Co., New York, 1964

EXHIBITIONS:
Stedelijk Museum, Amsterdam, September 19–November 17, 1968, *Willem de Kooning* (The Museum of Modern Art, New York, International Circulating Exhibition), no. 54, ill.; toured to The Tate Gallery, London, December 8–January 26, 1969; The Museum of Modern Art, New York, March 3–April 27, no. 62, ill. p. 88; The Art Institute of Chicago, May 16–July 6; Los Angeles County Museum of Art, July 28–September 14

REFERENCES:
Drudi, Gabriella. *Willem de Kooning,* Milan, Fratelli Fabbri, 1972, colorplate 79
Forge, Andrew. "De Kooning in Retrospect," *Art News,* 68, March 1969, p. 61, ill. p. 45
Rosenberg, Harold. "Sviluppi dell'arte di de Kooning," *L'Arte Moderna* (Milan), 13, no. 117, 1967, ill. p. 328

Two Women in the Country. 1954.
Oil, enamel, and charcoal on canvas, 46 × 41 inches
Signed l. r.: "de Kooning"

PROVENANCE:
Martha Jackson Gallery, New York; Felix Landau Gallery, Los Angeles; Paul Kantor Gallery, Beverly Hills, California, 1964

EXHIBITIONS:
Martha Jackson Gallery, New York, November 9–December 3, 1955, *Recent Oils by Willem de Kooning,* no. 4
The Minneapolis Institute of Arts, June 18–September 1, 1957, *American Paintings 1945–1957,* no. 30
Contemporary Arts Museum, Houston, April 23–May 31, 1959, *The Romantic Agony: from Goya to de Kooning,* ill. p. 18
Paul Kantor Gallery, Beverly Hills, California, April 3–29, 1961, *Willem de Kooning,* ill.
Los Angeles County Museum of Art, April–July 1965, *Inaugural Loan Exhibition*
Fondation Maeght, St.-Paul-de-Vence, France, April 9–May 31, 1966, *10 Ans d'Art Vivant 1945–1955,* no. 87, ill.
Stedelijk Museum, Amsterdam, September 19–November 17, 1968, *Willem de Kooning* (The Museum of Modern Art, New York, International Circulating Exhibition), no. 55, ill.; toured to The Tate Gallery, London, December 8–January 26, 1969; The Museum of Modern Art, New York, March 3–April 27, no. 64, ill. p. 98; The Art Institute of Chicago, May 16–July 6; Los Angeles County Museum of Art, July 28–September 14

REFERENCES:
Drudi, Gabriella. *Willem de Kooning,* Milan, Fratelli Fabbri, 1972, colorplate 91
Gerdts, William H. *The Great American Nude,* New York, Praeger, forthcoming, ill.
Hunter, Sam. "Action Painting: La generazione eroica," *L'Arte Moderna* (Milan), 13, no. 110, 1967, p. 47, colorplate

——. *La Pittura americana del dopoguerra*, Milan, Fratelli Fabbri, 1967, colorplate 11

Munro, Eleanor C. "Twentieth Century," *Golden Encyclopedia of Art*, New York, Golden, 1961, colorplate p. 258

Porter, Fairfield. "Reviews & Previews: Willem de Kooning," *Art News*, 54, November 1955, p. 48, colorplate

Rosenberg, Harold. "Tenth Street: A Geography of Modern Art," *Art News Annual*, 28, 1959, p. 139, colorplate

Untitled. 1963.
Oil on canvas, 80 × 70 inches
Signed l. c.: "de Kooning"

PROVENANCE:
Harold Diamond, New York, 1963

EXHIBITIONS:
The Solomon R. Guggenheim Museum, New York, January 16–March 29, 1964, *Guggenheim International Award 1964*, no. 77, ill. p. 61; toured to Honolulu Academy of Arts, May 14–July 5; Akademie der Künste, Berlin, August 21–September 15; The National Gallery of Canada, Ottawa, October 15–November 9; John and Mable Ringling Museum of Art, Sarasota, Florida, January 16–March 14, 1965; Museo Nacional de Bellas Artes, Buenos Aires, April 20– May 20 Stedelijk Museum, Amsterdam, September 19–November 17, 1968, *Willem de Kooning* (The Museum of Modern Art, New York, International Circulating Exhibition), no. 74, ill.; toured to The Tate Gallery, London, December 8–January 26, 1969; The Museum of Modern Art, New York, March 3–April 27, no. 84, ill. p. 120; The Art Institute of Chicago, May 16–July 6; Los Angeles County Museum of Art, July 28–September 14

REFERENCES:
Canaday, John. "'Olympics' for Painters," *The New York Times Magazine*, January 12, 1964, ill. p. 54
Denby, Edwin. "My Friend de Kooning," *Art News Annual*, 29, 1964, ill. p. 85
Drudi, Gabriella. *Willem de Kooning*, Milan, Fratelli Fabbri, 1972, p. 22, colorplate 117
Rosenberg, Harold. "Sviluppi dell'arte di de Kooning," *L'Arte Moderna* (Milan), 13, no. 117, 1967, ill. p. 329

Woman, Sag Harbor. 1964.
Oil on wooden door, 80 × 36 inches
Signed l. r.: "de Kooning"

PROVENANCE:
The artist, Springs, New York, 1964

EXHIBITIONS:
M. Knoedler & Co., New York, November 13–December 27, 1967, *De Kooning: Recent Paintings*
Stedelijk Museum, Amsterdam, September 19–November 17, 1968, *Willem de Kooning* (The Museum of Modern Art, New York, International Circulating Exhibition), no. 82, ill.; toured to The Tate Gallery, London, December 8–January 26, 1969; The Museum of Modern Art, New York, March 3–April 27, no. 94, ill. p. 130; The Art Institute of Chicago, May 16–July 6; Los Angeles County Museum of Art, July 28–September 14

REFERENCES:
Aarons, Leroy. "Sound the Hirshhorn! The Collection," *The Washington [D.C.] Post Potomac*, March 19, 1967, colorplate p. 19
Drudi, Gabriella. *Willem de Kooning*, Milan, Fratelli Fabbri, 1972, colorplate 126
Hess, Thomas B. "De Kooning's New Women," *Art News*, 64, March 1965, pp. 36, 64, ill. p. 36
——. *De Kooning: Recent Paintings*, New York, Walker, 1967, colorplate p. 11
Hunter, Sam. *American Art of the 20th Century*, New York, Abrams, 1972, colorplate 323
Jacobs, Jay. "Collector: Joseph H. Hirshhorn," *Art in America*, 57, July–August 1969, colorplate p. 68
——. "Quality as Well as Quantity: Joseph H. Hirshhorn," in Lipman, Jean, ed. *The Collector in America*, New York, Viking, 1971, colorplate p. 75
Marmer, Nancy. "Los Angeles Letter," *Art International*, 9, June 1965, p. 40
Sylvester, David. "De Kooning's Women," *The Sunday Times Magazine*, London, December 8, 1968, colorplate p. 45
Unsigned. "Prisoner of the Seraglio," *Time*, February 26, 1965, colorplate p. 75

TONY DELAP (b. 1927)

Born Oakland, California, November 4, 1927. Studied, California: Academy of Art, San Francisco, 1948–49; California College of Arts and Crafts, Oakland, and Claremont Graduate School, 1949–50. One-man show, Richmond Art Center, California, 1954. Awarded first prize, San Francisco Art Festival, 1957. Taught: Academy of Art, San Francisco, 1957–59; California College of Arts and Crafts, 1961–63; San Francisco Art Institute, 1964; University of California, Davis, 1964–65. One-man shows: Oakland Art Museum, 1960; Dilexi Gallery, San Francisco, 1963, 1967; San Francisco Art Institute, 1964 (Sullivan Award); Robert Elkon Gallery, New York, from 1965; Felix Landau Gallery, Los Angeles, 1966, 1969; University of California, Irvine, 1969. Included in: Whitney Annual, 1964, 1966, 1968; Pittsburgh International, 1964, 1967; "The Responsive Eye," The Museum of Modern Art, New York, and tour, 1965–66; "American Sculpture of the Sixties," Los Angeles County Museum of Art, and Philadelphia Museum of Art, 1967. Commissioner of Art, San Francisco, 1964–65. Received American Federation of Arts and Ford Foundation Grant, Artist-in-residence Program, Art Center, Haverford, Pennsylvania, 1966. Commissions: Carborundum Sculpture Award, 1970; The National Endowment for the Arts (for Englewood, California), 1973. Has taught, University of California, Irvine, since 1965. Lives in Corona del Mar, California.

Zingone. 1969.
Wood, Fiberglas, lacquer, and anodized aluminum, 22¼ × 22 × 4¼ inches

PROVENANCE:
Felix Landau Gallery, Los Angeles, 1969

ROBERT DELAUNAY (1885–1941)

Robert-Victor-Félix Delaunay, born Paris, April 12, 1885. Apprentice, Rosin Decorative Studio, Belleville, France, 1902–4. Began painting, 1904; read Michel-Eugène Chevreul's book on Neo-Impressionist color theory, *De la Loi du contraste simultané des couleurs*, 1905. Exhibited, Paris: Salon d'Automne, 1904, 1906; Salon des Indépendants, 1904, 1906, 1909, 1911, 1913, 1914. Met: Fernand Léger, c. 1909; Guillaume Apollinaire, and Albert Gleizes, 1911; Patrick Henry Bruce, and Arthur B. Frost, Jr., 1912–13. First series of Eiffel Tower paintings, 1909–10. Married artist Sonia Uhde-Terk, 1910. Included in: first exhibition of Der Blaue Reiter, Galerie Thannhauser, Munich, and tour, 1911–12; Erster Deutscher Herbstsalon, Galerie der Sturm, Berlin, 1913; the Armory Show, 1913. Apollinaire used term "Orphism" to describe Delaunay's style, in review of Salon des Indépendants (*Montjoie!*, March 18, 1913). One-man show, Galerie der Sturm, 1913. Lived in Spain and Portugal, 1915–17. Designed decor for *Cléopâtre*, Sergei Diaghilev's Ballets Russes de Monte Carlo, 1918 (costumes by Sonia Delaunay). Returned to Paris, 1921. One-man show, Galerie Paul Guillaume, Paris, 1922. Second Eiffel Tower series, 1922–24. Commissions: with Léger, murals, Palais de l'Ambassade de France, Exposition Internationale d'Art Décoratif, Paris, 1925; with Léger, murals and sculptural reliefs, Palais des Chemins de Fer and Palais de l'Air, Exposition Universelle of 1937, Paris; with Gleizes, André Lhote, and Jacques Villon, sculptural decorations, Salon des Tuileries, Paris, 1938. Organized first Salon des Réalités Nouvelles, Paris, with Nelly van Doesburg, and others, 1939. Died Montpellier, France, October 25, 1941. Posthumous exhibitions: Galerie Louis Carré, Paris, 1946; Musée des Beaux-Arts de la Ville de Liège, Belgium, 1955; Musée National d'Art Moderne, Paris, 1957; Fine Arts Associates, New York, 1959; Kunstverein, Hamburg, and tour, 1962. Collection of the Delaunays' works donated by Sonia Delaunay to Musée National d'Art Moderne, 1963; exhibited, Musée du Louvre, Paris, 1964.

Study for Portrait of Philippe Soupault. 1922.
Watercolor and black chalk on paper mounted on canvas, 76¼ × 51 inches

PROVENANCE:
Sonia Delaunay, Paris; Fine Arts Associates, New York; M. Knoedler & Co., New York, 1969

EXHIBITIONS:
Musée National d'Art Moderne, Paris, Summer 1954, *Le Dessin de Toulouse-Lautrec aux Cubistes*, no. 30, ill.
Musée des Beaux-Arts de la Ville de Liège, Belgium, April–May 1955, *Robert Delaunay*, no. 8
Palais des Beaux-Arts, Brussels, March 3–April 22, 1956, *De Toulouse-Lautrec à Chagall, Dessins-Aquarelles-Gouaches*
Musée National d'Art Moderne, Paris, May 25–September 30, 1957, *Robert Delaunay (1885–1941)*, no. 63, ill. 23
Fine Arts Associates, New York, January 13–31, 1959, *Robert Delaunay, Paintings*, no. 9, cover ill.
Marlborough Fine Art, London, November–December 1966, *Kandinsky and His Friends Centenary Exhibition*, no. 46, ill. p. 30

REFERENCES:
Courthion, Pierre. "Apollinaire Notre Patron," *XXᵉ Siècle*, new series no. 3, June 1952, p. 12, ill.
——. *L'Art indépendant: panorama international de 1900 à nos jours*, Paris, A. Michel, 1958, p. 105
Habasque, Guy. "Catalogue de l'oeuvre de R. Delaunay," in Francastel, Pierre, ed., *Robert Delaunay: Du Cubisme à l'Art abstrait*, Paris, Bibliothèque Générale de l'École Pratique des Hautes-Études, 1957, no. 195
Sawin, Martica. "New York Letter: Delaunay," *Art International*, 3, January–February 1959, p. 46

In 1919, the French poet Philippe Soupault (b. 1897), together with Louis Aragon and André Breton, founded and edited the Dada review *Littérature*. He participated in Dada exhibitions, and wrote and acted in many Dada plays. Soupault was a founder of the Surrealist movement, but was expelled from the official group by Breton in 1926.

This study and Delaunay's oil portrait of Soupault were completed in 1922.

Eiffel Tower (La Tour Eiffel). 1924–26.
Oil on canvas, 63¼ × 47¼ inches

PROVENANCE:
Sonia Delaunay, Paris; Leo Castelli Gallery, New York; Sidney Janis Gallery, New York; Mr. and Mrs. Leigh B. Block, Chicago; Marlborough-Gerson Gallery, New York; Saidenberg Gallery, New York, 1968

EXHIBITIONS:
Sidney Janis Gallery, New York, December 30, 1957–January 25, 1958, *New Acquisitions of Twentieth Century Painting and Sculpture*, ill.

REFERENCES:
Habasque, Guy. "Catalogue de l'oeuvre de R. Delaunay," in Francastel, Pierre, ed., *Robert Delaunay: Du Cubisme à l'Art abstrait*, Paris, Bibliothèque Générale de l'École Pratique des HautesÉtudes, 1957, no. 195
Oeri, Georgine. "Delaunay in Search of Himself," *Arts*, 33, March 1959, colorplate p. 36
Sidney Janis Gallery. *10th Anniversary Exhibition*, New York, 1958, ill. 114

Relief. 1936–37, cast 1962.
Bronze, 51¼ × 38 × 6 inches
Markings: r. bottom edge "R. DELAUNAY
2/5
Susse Fondeur Paris"

PROVENANCE:
Sonia Delaunay, Paris; Leonard Hutton Galleries, New York, 1963

EXHIBITIONS:
Leonard Hutton Galleries, New York, February 19–March 30, 1963, *Der Blaue Reiter*, checklist

DEBORAH DE MOULPIED (b. 1933)

Born Manchester, New Hampshire, November 22, 1933. Studied: School of the Museum of Fine Arts, Boston, 1952–56; Yale University, New Haven, Connecticut, B.F.A., 1960, M.F.A., 1962. Received Clarissa Bartlett Traveling Fellowship to Europe, School of the Museum of Fine Arts, 1961–62. Included in: "Recent Acquisitions," The Museum of Modern Art, New York, 1961; "Structured Sculpture," Galerie Chalette, New York, 1961, 1968; "Recent American Painting and Sculpture," The Museum of Modern Art, and tour, 1962; "Exhibition of Contemporary Painting and Sculpture," The American Academy of Arts and Letters, and The National Institute of Arts and Letters, New York, 1968; Whitney Annual, 1969. Taught, University of Bridgeport, Connecticut, 1965–68. Received MacDowell Colony Fellowship, Peterborough, New Hampshire, 1969, 1970. Has taught, Paterson State College, Wayne, New Jersey, since 1969. Lives in New Canaan, Connecticut.

Palamos. 1965–67.
Plexiglas, 32⅜ × 47¼ × 35¼ inches

PROVENANCE:
Galerie Chalette, New York, 1968

EXHIBITIONS:
Whitney Museum of American Art, New York, December 17, 1968–February 9, 1969, *1968 Annual Exhibition of Contemporary American Sculpture*, no. 28

REFERENCES:
Rickey, George. *Constructivism: Origins and Evolution*, New York, Braziller, 1967, ill. p. 152

CHARLES DEMUTH (1883–1935)

Charles Henry Demuth, born Lancaster, Pennsylvania, November 8, 1883. Studied, Philadelphia: Drexel Institute of Art, Science and Industry, 1901–5; Philadelphia Museum School of Industrial Art, summer, 1905. Visited Paris, 1904. Met William Carlos Williams, Philadelphia, 1904–5; formed life-long friendship. Studied, The Pennsylvania Academy of the Fine Arts, Philadelphia, with Thomas Anshutz, Henry McCarter, Hugh Breckenridge, William Merritt Chase, 1905–7, 1908–11. Lived in Paris, 1907–8. Studied, Paris, 1912–14: Académie Moderne; Académie Julian; Académie Colarossi. Met Gertrude and Leo Stein, and Marcel Duchamp. Included in: Pennsylvania Academy Watercolor Annual, 1912; Society of Independent Artists Annual, 1917. One-man shows, The Daniel Gallery, New York, 1914–23. Illustrated: Émile Zola's *Nana*, 1915–16, and *L'Assommoir*, 1916; Edgar Allan Poe's *The Masque of the Red Death*, c. 1918; Frank Wedekind's *Der Erdgeist*, and *Die Buchse der Pandora*, 1918; Henry James's *The Turn of the Screw*, 1918, and *The Beast in the Jungle*, 1919. In poor health, from 1920. Closely associated with Alfred Stieglitz, and his circle, New York, from 1925; one-man shows: Intimate Gallery, 1926, 1929; An American Place, 1931. Awarded: Silver Medal for Watercolor, Sesquicentennial Exposition, Philadelphia, 1926; Dana Watercolor Medal, Pennsylvania Academy Watercolor Annual, 1926. Included in: "Paintings by Nineteen Living Americans," and "American Painting and Sculpture," The Museum of Modern Art, New York, 1930, 1932–33; Whitney Biennial, 1932–33; Venice Biennale, 1934. Died Lancaster, October 23, 1935. Memorial exhibitions: Whitney Museum of American Art, New York, 1937–38; Franklin and Marshall College, Lancaster, 1941. Retrospectives: The Museum of Modern Art, 1950; William Penn Memorial Museum, Harrisburg, Pennsylvania, 1966; Akron Art Institute, Ohio, 1968; University of California, Santa Barbara, and tour, 1971–72.

Sailor, Soldier and Policeman. 1916.
Watercolor on paper, 10⅓ × 8 inches
Signed and dated l. l.: "C. Demuth 1916"

PROVENANCE:
The artist, Lancaster, Pennsylvania; Frank Everest Moffat, Lancaster; Edwin Hewitt Gallery, New York, 1957

REFERENCES:
Farnham, Emily. *Charles Demuth: His Life, Psychology and Works*, Ph.D. dissertation, Columbus, Ohio State University, 1959, no. 205, p. 489

Vaudeville: "Many Brave Hearts Are Asleep in the Deep." 1916.
Watercolor on paper, 13 × 8 inches
Signed and dated l. l.: "C. Demuth 1916"

PROVENANCE:
The artist, Lancaster, Pennsylvania; Mary Mullen, Merion, Pennsylvania; Kennedy Galleries, New York; Peter Gilbert, New York; Bernard Danenberg Galleries, New York, 1971

EXHIBITIONS:
The Museum of Modern Art, New York, March 21–June 11, 1950, *Charles Demuth*, no. 34, ill. p. 28
Kennedy Galleries, New York, March 15–April 6, 1968, *1900–1960: American Masters*, no. 7, ill.
Carnegie Institute, Pittsburgh, November 18, 1971–January 9, 1972, *Forerunners of American Abstraction*, no. 5

REFERENCES:
Farnham, Emily. *Charles Demuth, Behind a Laughing Mask*, Norman, University of Oklahoma, 1971, pp. 184, 200
——. *Charles Demuth: His Life, Psychology and Works*, Ph.D. dissertation, Columbus, Ohio State University, 1959, no. 195, p. 484
Unsigned. "Images: At the Kennedy," *Arts Magazine*, 42, March 1968, p. 24, ill.

Circus. 1917.
 Watercolor and pencil on paper, 8 × 17 inches
 Signed and dated l. c.: "C. Demuth 1917"

PROVENANCE:
The artist, Lancaster, Pennsylvania; Philip L. Goodwin, New York; Edwin Hewitt Gallery, New York, 1963

EXHIBITIONS:
William Penn Memorial Museum, Harrisburg, Pennsylvania, September 24–November 6, 1966, *Charles Demuth of Lancaster*, no. 45
Akron Art Institute, Ohio, April 16–May 12, 1968, *Paintings by Charles Demuth*, no. 42, ill. p. 1

REFERENCES:
Farnham, Emily. *Charles Demuth: His Life, Psychology and Works*, Ph.D. dissertation, Columbus, Ohio State University, 1959, no. 249, p. 506

Flour Mill (Factory). 1921.
 Tempera on composition board, 18¼ × 15¾ inches
 Signed and dated l. l.: "C Demuth—21"

PROVENANCE:
Ferargil Galleries, New York; Coleman Art Gallery, Philadelphia; Albert Duveen, New York; Robert Graham, New York; E. & A. Silberman Galleries, New York, 1963

EXHIBITIONS:
E. & A. Silberman Galleries, New York, March 1–April 1, 1961, *Exhibition 1961*, no. 5, ill.

REFERENCES:
Farnham, Emily. *Charles Demuth: His Life, Psychology and Works*, Ph.D. dissertation, Columbus, Ohio State University, 1959, no. 404, p. 570

ANDRÉ DERAIN (1880–1954)

Born Chatou, France, June 10, 1880. Studied: with local artist, Father Jacomin, Chatou, 1895; Académie Camillo, with Eugène Carrière, Paris, 1898–99. Met Henri Matisse, 1899. Shared studio with Maurice de Vlaminck, Paris, 1900. Worked with Matisse, Collioure, France, 1905; made first ceramics. Exhibited with Fauves, Paris: Salon d'Automne, 1905–7; Salon des Indépendants, 1905–7. Associated with art dealers: Ambroise Vollard, 1905; Daniel-Henry Kahnweiler, from 1907. Worked: with Georges Braque, Carrières-St.-Denis, France, 1909; with Picasso, Cagnes-sur-Mer, France, and Cadaqués, Spain, 1910. Illustrated: Guillaume Apollinaire's *L'Enchanteur Pourrissant* (Paris, Kahnweiler), 1909; Max Jacob's *Les Oeuvres burlesques et mystiques de Frère Matorel* (Paris, Kahnweiler), 1912. Included in: second exhibition of Der Blaue Reiter (graphics), Galerie Neue Kunst, Munich, 1912; Erster Deutscher Herbstsalon, Galerie der Sturm, Berlin, 1913; the Armory Show, 1913. First one-man show, Galerie Paul Guillaume, Paris, 1916. Designed sets and costumes, and wrote libretto, for *La Boutique Fantasque*, Sergei Diaghilev's Ballets Russes de Monte Carlo, 1919. One-man shows: Galerie Alfred Flechtheim, Berlin, 1922, 1929, and Düsseldorf, 1927, 1929; The Lefevre Gallery, London, 1928, 1929; Cincinnati Art Museum, Ohio, 1930; M. Knoedler & Co., New York, 1930; Marie Harriman Gallery, New York, 1931; Durand-Ruel Galleries, New York, 1933; Brummer Gallery, New York, 1936. Included in: Carnegie International, 1928 (Medal of the First Class), 1931, 1933, 1935; "Painting in Paris," and "Modern Works of Art," The Museum of Modern Art, New York, 1930, 1934–35; "Les Maîtres de l'art indépendant, 1895–1937," Musée du Petit Palais, Paris, 1937. Worked also as sculptor, from 1938. Died Garches, France, September 10, 1954. Memorial exhibitions: Musée National d'Art Moderne, Paris, 1954; III São Paulo Bienal, 1955. Exhibitions of sculpture: Galerie D. Mouradian et Vallotton, Paris, 1959; Charles E. Slatkin Galleries, New York, and Santa Barbara Museum of Art, California, 1959–60; Leonard Hutton Galleries, New York, 1962. Retrospective, arranged by The Arts Council of Great Britain, Edinburgh Festival Society, Scotland, 1967.

The Old Gaul (Le Vieux Gaulois, Tête d'expression). 1939–54.
 Bronze, 15½ × 4½ × 7¼ inches
 Markings: back at base of neck "Atelier André Derain 4/11"

PROVENANCE:
Pierre Cailler, Switzerland; Charles E. Slatkin Galleries, New York, 1959

EXHIBITIONS:
Charles E. Slatkin Galleries, New York, October 21–November 14, 1959, *Derain*, no. 13; toured to Santa Barbara Museum of Art, California, April 14–May 15, 1960
The Solomon R. Guggenheim Museum, New York, October 3, 1962–January 6, 1963, *Modern Sculpture from the Joseph H. Hirshhorn Collection*, no. 121

REFERENCES:
Cailler, Pierre. *Catalogue raisonné de l'oeuvre sculpté de André Derain*, I, Aigle, Switzerland, L'Imprimerie de la Plaine du Rhône, 1965, no. 13

JOSÉ DE RIVERA (b. 1904)

José A. Ruiz, born West Baton Rouge, Louisiana, September 18, 1904. Worked on family sugar plantation, then in tool and die and machine shops, 1922–30. Moved to Chicago, 1924. Studied drawing, Studio School of Art, Chicago, with John Norton, evenings, 1928–30. Included in: 35th and 36th American Exhibition, The Art Institute of Chicago, 1930, 1931; Whitney Annual, from 1934; "Twelve Americans," The Museum of Modern Art, New York, and tour, 1938. WPA Federal Art Project, Sculpture Division, New York, 1937–38. Served as armorer, U.S. Army Air Corps, 1942–43; designed training aids, U.S. Navy, 1943–46. One-man shows: Harvard University, Cambridge, Massachusetts, 1945; Mortimer Levitt Gallery, New York, 1946; Grace Borgenicht Gallery, New York, from 1952. Taught: Brooklyn College, New York, 1953; Yale University, New Haven, Connecticut, 1953–55; North Carolina

State University at Raleigh, 1957–60. Awarded: Blair Prize, 62nd American Exhibition, The Art Institute of Chicago, 1957; grant, The National Institute of Arts and Letters, 1959. Included in: Pittsburgh International, 1958, 1961; "Recent Sculpture U.S.A.," The Museum of Modern Art, and tour, 1959; "Sculpture in the Open Air," Battersea Park, London, 1963. Retrospectives: Whitney Museum of American Art, New York, and tour (organized by American Federation of Arts, with grant from Ford Foundation), 1961; La Jolla Museum of Contemporary Art, California, and Whitney Museum of American Art, 1972. Commissions: American Iron and Steel Institute Award, 1965; *Infinity*, Museum of History and Technology, Smithsonian Institution, Washington, D.C., 1967. Received Brandeis University Creative Arts Award Medal, 1969. Member, The National Institute of Arts and Letters, 1971. Lives in New York.

Construction # 76. 1961.
 Bronze forged rod, 6¼ × 9½ × 7¼ inches

PROVENANCE:
Grace Borgenicht Gallery, New York, 1961

REFERENCES:
Rickey, George. *Constructivism: Origins and Evolution*, New York, Braziller, 1967, p. 115, ill.
Tibbs, Thomas S., intro. *José de Rivera Retrospective Exhibition 1930–1971*, La Jolla Museum of Contemporary Art, California, 1972, catalogue raisonné no. 114

Construction # 107. 1969.
 Stainless steel forged rod, 21½ × 41 × 41 inches

PROVENANCE:
Gift of the artist, New York, 1969

EXHIBITIONS:
Grace Borgenicht Gallery, New York, October 8–30, 1969, *Recent Sculpture: José de Rivera*, ill. pp. 6–7
La Jolla Museum of Contemporary Art, California, February 20–April 16, 1972, *José de Rivera Retrospective Exhibition 1930–1971*, no. 43, ill.; toured to Whitney Museum of American Art, New York, May 8–June 8

REFERENCES:
Tibbs, Thomas S., intro. *José de Rivera Retrospective Exhibition 1930–1971*, La Jolla Museum of Contemporary Art, California, 1972, catalogue raisonné no. 153, ill.

CHARLES DESPIAU (1874–1946)

Born Mont-de-Marsan, France, November 4, 1874; father and grandfather stucco artisans. Studied, Paris: École des Arts Décoratifs, with Hector-Joseph Lemaire, 1891–93; École des Beaux-Arts, with Louis-Ernest Barrias, 1893–96. Hand-colored post cards, 1899–1903. Exhibited, Paris: Salon of 1898, 1899, 1900; Salon de la Société Nationale des Beaux-Arts, 1909–21. Met Auguste Rodin, 1903; worked in Rodin's atelier, on works in marble, 1907–14. Sculpture commissions: *Monument à Victor Duruy*, Mont-de-Marsan, 1907; *Monument aux Morts de Mont-de-Marsan*, 1920–22; figures for *Tomb of Émile Mayrisch*, City Park, Colpach, Grand Duché de Luxembourg, 1930. Included in: Salon d'Automne, Paris, 1923; Salon des Tuileries, Paris, 1923–25, 1927; Exposition Internationale d'Art Décoratif, Paris, 1925; "Summer Exhibition," and "Modern Works of Art," The Museum of Modern Art, New York, 1930, 1934–35; "Les Maîtres de l'art indépendant," Musée du Petit Palais, Paris, 1937. Portrait busts: *Mme André Derain*, 1923; *Mme Othon Friesz*, 1924; *Mrs. Chester Dale*, 1931; *Anne Morrow Lindbergh*, 1939. One-man shows: Brummer Gallery, New York, 1927, 1934; Fifty-sixth Street Galleries, New York, 1929; Memorial Art Gallery, The University of Rochester, New York, 1930; Musée du Petit Palais, 1937; Buchholz Gallery, New York, 1939, 1942. Exhibited with: Aristide Maillol, Pierre-Auguste Renoir, Émile-Antoine Bourdelle, Balzac Galleries, New York, 1931; Maillol, Institute of Modern Art, Boston, 1939. *Apollo* commissioned, Musée National d'Art Moderne, Paris, 1946. Died Paris, October 28, 1946.

Paulette (Tête de jeune fille). 1907.
 Plaster, 12¾ × 8½ × 7 inches
 Markings: l. l. back "Despiau Pour Joseph Brummer"

PROVENANCE:
Joseph Brummer, New York; Hôtel Drouot, Paris, Sale, February 17–18, 1944, no. 236; Mrs. Davis Dunbar; Parke-Bernet Galleries, New York, Sale 2679, April 4, 1968, no. 108, ill. p. 11

EXHIBITIONS:
Société Nationale des Beaux-Arts, Paris, 1907, *Salon de 1907*, no. 1885
Brummer Gallery, New York, November 5–December 29, 1934, *Despiau*, no. 9
Musée du Petit Palais, Paris, June–October 1937, *Les Maîtres de l'art indépendant, 1895–1937*, no. 48, p. 14

REFERENCES:
Alazard, Jean. "L'Art de Charles Despiau," *Gazette des Beaux-Arts*, 21, February 1939, p. 107, ill. p. 106
Champigneulle, Bernard. *Rodin*, New York, Abrams, 1967, p. 260
Deshairs, Léon. *C. Despiau*, Paris, Crès, 1930, p. 40, plate 2
George, Waldemar. *Despiau*, London, Zwemmer, 1958, plate 3
Pératé, André. "Les Salons de 1907," *Gazette des Beaux-Arts*, 49, July 1907, p. 56, ill. p. 57
Taft, Lorado. *Modern Tendencies in Sculpture*, Chicago, University of Chicago, 1921, p. 46, ill. f.p. 49
Unsigned. "Hommage à Charles Despiau," *La Renaissance*, 21, June 1938, ill. p. 4

Eve. c. 1925.
 Bronze, 31¼ × 10¼ × 6¼ inches
 Markings: c. top of base "C. Despiau"
 l. l. back of base "Alex Rudier Fondeur Paris"

PROVENANCE:
Fine Arts Associates, New York, 1957

EXHIBITIONS:
The Detroit Institute of Arts, 1959, *Sculpture in Our Time*, no. 69, ill. p. 36
The Solomon R. Guggenheim Museum, New York, October 3, 1962–January 6, 1963, *Modern Sculpture from the Joseph H. Hirshhorn Collection*, no. 127
Stephen Hahn Gallery, New York, April 26–May 21, 1966, *Seven Decades: 1895–1965. Crosscurrents in Modern Art* (sponsored by the Public Education Association), no. 174, ill. p. 98

Mme André Derain. 1926.
 Stone, 15¾ × 9 × 6½ inches
 Markings: c. back "C. Despiau"

PROVENANCE:
M. Knoedler & Co., Paris, 1961

EXHIBITIONS:
Musée du Petit Palais, Paris, June–October 1937, *Les Maîtres de l'art indépendant, 1895–1937*, no. 44
The Solomon R. Guggenheim Museum, New York, October 3, 1962–January 6, 1963, *Modern Sculpture from the Joseph H. Hirshhorn Collection*, no. 128, ill. p. 35

REFERENCES:
Alazard, Jean. "L'Art de Charles Despiau," *Gazette des Beaux-Arts*, 21, February 1939, p. 111, ill. p. 117
Baschet, Jacques. *Sculpteurs de ce temps*, Paris, Nouvelles Éditions Françaises, 1946, ill. p. 34
Gauthier, Maximilien. *Despiau*, Paris, Les Gemeaux, 1949, plate 6

Mme André Derain is a variation of a stone sculpture executed in 1923. A plaster version, dated 1932, is in The Phillips Collection, Washington, D.C.

EDWIN DICKINSON (b. 1891)

Edwin Walter Dickinson, born Seneca Falls, New York, October 11, 1891. Studied: Pratt Institute, Brooklyn, New York, 1910–11; The Art Students League of New York, with William Merritt Chase, and Frank Vincent Du Mond, 1911–13; Cape Cod School of Art, Provincetown, Massachusetts, with Charles W. Hawthorne, 1912–14. Taught, Buffalo Academy of Fine Arts, New York, 1916. Served, U.S. Navy, 1917–19. Studied, Académie de la Grande Chaumière, Paris, 1919–20. Included in: "American Painters," Musée du Luxembourg, Paris, 1919; Pennsylvania Academy Annual, 1922; Carnegie International, 1928. Taught: The Art Students League of New York, 1922–23, 1945–60, 1963–66; Provincetown Art Association, 1929–30. First one-man show, Albright Art Gallery, Buffalo, 1927. National Academy of Design, New York: Second Altman Prize, 104th Annual, 1929; associate, 1948; First Portrait Prize, 124th Annual, 1949; academician, 1950. One-man shows, Passedoit Gallery, New York, 1936, 1938–42. Taught: The Art Institute of Buffalo, 1939; The Association of Music and Art, Cape Cod, Massachusetts, 1941; The Cooper Union for the Advancement of Science and Art, New York, 1945–49. Included in "Fifteen Americans," The Museum of Modern Art, New York, 1952. The National Institute of Arts and Letters: grant, 1954; member, 1956; vice-president, 1958–60. Received Medal for Art, Century Association, New York, 1956; Brandeis University Creative Arts Award Medal, 1959; Ford Foundation Grant, 1959. One-man show, Andrew Dickson White Museum of Art, Cornell University, Ithaca, New York, 1957. Retrospectives: Cushman Gallery, Houston, 1958; Art Gallery, Boston University, School of Fine and Applied Arts, 1958; Whitney Museum of American Art, New York, 1965; Venice Biennale, 1968. Member, The American Academy of Arts and Letters, 1961. One-man shows: The Museum of Modern Art, Circulating Exhibition, 1961; James Graham and Sons, New York, 1961, 1965, 1968; Syracuse University, New York, 1965; Hawthorne Memorial Gallery, Provincetown, 1967; Institute of Contemporary Art, and Weeden Gallery, Boston, 1970. Lives in New York, and in Provincetown.

Antoinette. 1919.
 Oil on canvas, 32 × 26 inches
 Signed and dated u. l. of c.: "E. W. Dickinson 1919"

PROVENANCE:
James Graham and Sons, New York, 1965

EXHIBITIONS:
James Graham and Sons, New York, October 1965, *American Paintings*

REFERENCES:
James Graham and Sons, New York, *Art in America*, 53, October–November 1965, ill. p. 10 (adv.)

Nude (Helen). 1925.
 Oil on beaverboard, 36 × 30 inches

PROVENANCE:
James Graham and Sons, New York, 1959

EXHIBITIONS:
James Graham and Sons, New York, February 1–March 11, 1961, *Edwin Dickinson Retrospective*, no. 22
Fine Arts Center, Nashville, Tennessee, November 15–December 5, 1961, *Edwin Dickinson* (The Museum of Modern Art, New York, Circulating Exhibition); toured to twelve U.S. cities
Whitney Museum of American Art, New York, October 20–November 28, 1965, *Edwin Dickinson*, p. 49, ill. p. 25

Self-Portrait. 1954.
 Oil on canvas, 26¼ × 24½ inches
 Signed and dated u. l.: "E. W. Dickinson/New York 1954"

PROVENANCE:
The artist, New York, 1959

REFERENCES:
Aarons, Leroy. "Sound the Hirshhorn! The Collection," *The Washington [D.C.] Post Potomac*, March 19, 1967, colorplate p. 17
Jacobs, Jay. "Collector: Joseph H. Hirshhorn," *Art in America*, 57, July–August 1969, ill. p. 66

———. "Quality as Well as Quantity: Joseph H. Hirshhorn," in Lipman, Jean, ed. *The Collector in America,* New York, Viking, 1971, ill. p. 88

PRESTON DICKINSON (1891–1930)

Born New York, 1891. Studied, The Art Students League of New York, with Ernest Lawson, George Bellows, George B. Bridgman, 1910. Lived abroad, mainly in Paris, 1910–15. First exhibited, Salon of 1912, Paris. Returned to New York, 1915. Included in: Pennsylvania Academy Watercolor Annual, 1922; Pennsylvania Academy Annual, 1924; The Cleveland Museum of Art Annual, 1925, 1927. One-man shows, The Daniel Gallery, New York, 1924, 1927, 1930, 1932. Member, Whitney Studio Club, New York, 1925–26. Awarded Bronze Medal, Sesquicentennial Exposition, Philadelphia, 1926. Included in: Société Anonyme, The Brooklyn Museum, New York, 1926–27; Opening Exhibition, Museum of Living Art, New York University, 1927–28; Carnegie International, 1929, 1930; "Paintings by Nineteen Living Americans," The Museum of Modern Art, New York, 1929–30. Died Bilbao, Spain, 1930. Memorial exhibitions: Smith College Museum of Art, Northampton, Massachusetts, 1934; M. Knoedler & Co., New York, 1943. Included in: "Abstract Painting in America," and "Pioneers of Modern Art in America," Whitney Museum of American Art, New York, 1935, 1946; "The Precisionist View in American Art," Walker Art Center, Minneapolis, 1960.

Still Life with Navajo Blanket. 1929.
Oil on canvas, 20 × 20 inches
Signed l. r.: "P. Dickinson"

PROVENANCE:
The Daniel Gallery, New York; Ralph M. Chait, New York; M. Knoedler & Co., New York, 1961

EXHIBITIONS:
The Phillips Memorial Gallery, Washington, D.C., February–June 1931, *Second Exhibition,* no. 59
The Art Institute of Chicago, October 29–December 13, 1931, *The Forty-Fourth Annual Exhibition of American Paintings and Sculpture,* no. 51
M. Knoedler & Co., New York, February 8–27, 1943, *Preston Dickinson,* no. 27

REFERENCES:
Unsigned. "Information, Please," *Art Digest,* 13, July 1939, p. 11

RICHARD DIEBENKORN (b. 1922)

Born Portland, Oregon, April 22, 1922. Studied, Stanford University, California, 1940–43; B.A., 1949. War artist, U.S. Marine Corps, 1943–45. Studied: California School of Fine Arts, San Francisco, with David Park, 1946; University of New Mexico, Albuquerque, M.A., 1951. Taught: California School of Fine Arts, 1947–50; University of Illinois, Champaign, 1952–53; California College of Arts and Crafts, Oakland, 1955–57. Awarded Walter Purchase Prize, San Francisco Art Museum Annual, 1948. One-man shows: California Palace of the Legion of Honor, San Francisco, 1948; Paul Kantor Gallery, Los Angeles, 1952, 1954; San Francisco Museum of Art, 1954; The Oakland Museum, California, 1956; Poindexter Gallery, New York, 1956, 1958, 1963. Included in: "Younger American Painters," The Solomon R. Guggenheim Museum, New York, 1954; III São Paulo Bienal, 1955; Pittsburgh International, 1955–70; Whitney Annual, from 1955; "New Images of Man," The Museum of Modern Art, New York, and The Baltimore Museum of Art, 1959–60. Retrospectives: Pasadena Art Museum, California, and California Palace of the Legion of Honor, 1960; Washington [D.C.] Gallery of Modern Art, and tour, 1964–65. Received grant, The National Institute of Arts and Letters, and The American Academy of Arts and Letters, 1962; member, The National Institute of Arts and Letters, 1967. Artist-in-residence, Stanford University, 1963–64. One-man shows: The Waddington Galleries, London, 1963; Poindexter Gallery, 1966, 1968, 1969, 1971; Marlborough Gallery, New York, 1971; Martha Jackson Gallery, New York (drawings), 1973. Member, The National Council on the Arts, 1966–69. Included in: Venice Biennale, 1968; "L'Art Vivant aux États-Unis," Fondation Maeght, St.-Paul-de-Vence, France, 1970. Awarded Logan Medal, 70th American Exhibition, The Art Institute of Chicago, 1972. Has taught, University of California at Los Angeles, since 1966. Lives in Santa Monica, California.

Man and Woman in Large Room 1957.
Oil on canvas, 71 × 62½ inches
Signed and dated l. l.: "R. D. 57"

PROVENANCE:
Poindexter Gallery, New York, 1958

EXHIBITIONS:
Poindexter Gallery, New York, February 24–March 22, 1958, *Richard Diebenkorn*
Florida State University Art Gallery, Tallahassee, March 1959, *New Directions in Painting,* cat., ill.; toured to John and Mable Ringling Museum of Art, Sarasota, Florida, April; Norton Gallery and School of Art, West Palm Beach, Florida, May
The Museum of Modern Art, New York, September 29–November 29, 1959, *New Images of Man,* no. 35, ill. p. 58; toured to The Baltimore Museum of Art, January 9–February 7, 1960
Pasadena Art Museum, California, September 6–October 6, 1960, *Richard Diebenkorn,* no. 28; toured to California Palace of the Legion of Honor, San Francisco, October 22–November 27
Carnegie Institute, Pittsburgh, October 27, 1961–January 7, 1962, *1961 Pittsburgh International Exhibition of Contemporary Painting and Sculpture,* no. 490
The Tate Gallery, London, April 22–June 28, 1964, *Painting and Sculpture of a Decade, 54–64* (organized by the Calouste Gulbenkian Foundation), no. 244, colorplate p. 43
Washington [D.C.] Gallery of Modern Art, November 6–December 31, 1964, *Richard Diebenkorn,* no. 26, colorplate; toured to The Jewish Museum, New York, January 13–February 21, 1965

Providence Art Club, Rhode Island, March 31–April 24, 1965, *Critics' Choice: Art Since World War II,* no. 17, ill. p. 24

REFERENCES:
Arnason, H. Harvard. *History of Modern Art,* New York, Abrams, 1968, p. 537, ill. 952
———. "Richard Diebenkorn," *The Britannica Encyclopedia of American Art,* New York, Simon and Schuster, 1973, colorplate p. 144
Hunter, Sam. *American Art of the 20th Century,* New York, Abrams, 1972, ill. 337
Lippard, Lucy R. "New York Letter," *Art International,* 9, March–April 1965, p. 48
Unsigned. "Color Spectacle, the Human Figure Returns in Separate Ways and Places," *Life,* 52, June 8, 1962, colorplate p. 54
———. "Richard Diebenkorn—Master Poushih Krasok [The Singing Colors and Evocative Scenes of Richard Diebenkorn]," *Amerika* (America Illustrated, U.S.I.A., Russian ed.), no. 110, November 1965, colorplate p. 14
———. "Richard Diebenkorn—Symfonia koloru; nastrój zadumy [The Singing Colors and Evocative Scenes of Richard Diebenkorn]," *Ameryka* (America Illustrated, U.S.I.A., Polish ed.), no. 82, November 1965, colorplate p. 48

BURGOYNE DILLER (1906–1965)

Burgoyne Andrew Diller, born New York, January 13, 1906. Youth spent in Battle Creek, Michigan. Studied, Michigan State University, East Lansing, 1926–27. Returned to New York, 1928. Studied, The Art Students League of New York: with George B. Bridgman, and Boardman Robinson, 1928–29; with William Von Schlegell, and Kimon Nikolaides, summer, 1929; with Jan Matulka, 1929–31; with A. S. Baylinson, and Charles Locke, briefly, 1931–32; with George Grosz, summer, 1932; with Hans Hofmann, 1932–33. First one-man show, Contemporary Arts, New York, 1933. First painted wood constructions, 1934. WPA Federal Art Project, supervisor, Mural Division, New York, 1935–40; assistant technical director, 1940–41. Exhibited with American Abstract Artists, New York, 1936–39. Director, New York City War Service Art Section, 1941–43. Taught, Brooklyn, New York: Brooklyn College, and Pratt Institute, 1945–64. One-man shows, New York: The Pinacotheca, 1946, 1949; Rose Fried Gallery, 1951. Included in: "Abstract Painting and Sculpture in America," The Museum of Modern Art, New York, 1951; Whitney Annual, 1952–54, 1964; "Konkrete Kunst," Helmhaus, Zurich, 1960; "Geometric Abstraction in America," Whitney Museum of American Art, New York, 1962. Visiting critic, School of Art and Architecture, Yale University, New Haven, Connecticut, 1954. One-man shows, Galerie Chalette, New York, 1961–64. Included in: VII São Paulo Bienal, 1963; "The New Tradition: Modern Americans Before 1940," The Corcoran Gallery of Art, Washington, D.C., 1963. Died New York, January 30, 1965. Retrospectives: New Jersey State Museum, Trenton, 1966; Noah Goldowsky Gallery, New York, and Los Angeles County Museum of Art, 1968; Walker Art Center, Minneapolis, and tour, 1971–72.

Construction. 1934.
Painted wood and Masonite relief, 24 × 24 × 2 inches
Signed and dated on back: "Diller 1934"

PROVENANCE:
Galerie Chalette, New York, 1962

No. 2, First Theme. 1955–60.
Oil on canvas, 60 × 48 inches
Signed and dated on back: "Diller–1955/60"

PROVENANCE:
Galerie Chalette, New York; Estate of the artist; Noah Goldowsky Gallery, New York, 1968

EXHIBITIONS:
Galerie Chalette, New York, May 1961, *Burgoyne Diller,* no. 12
Noah Goldowsky Gallery, New York, May 7–25, 1968, *Burgoyne Diller;* toured to Los Angeles County Museum of Art, June 18–July 21, cat.

JIM DINE (b. 1935)

James Dine, born Cincinnati, Ohio, June 16, 1935. Studied: Art Academy of Cincinnati, with Paul Chidlaw, evenings, 1952–53; School of the Museum of Fine Arts, Boston; University of Cincinnati; Ohio University, Athens, B.F.A., 1958. Moved to New York, 1958: met Jasper Johns, and Robert Rauschenberg. Exhibited with Claes Oldenburg, Judson Gallery, New York, 1959. Participated in Happenings, New York: Judson Gallery, 1959; Reuben Gallery, 1960. One-man shows: Reuben Gallery, 1960; Martha Jackson Gallery, New York, 1962; Galleria dell'Ariete, Milan, 1962; Galerie Rudolf Zwirner, Cologne, 1963; Sidney Janis Gallery, New York, 1963–67; Galerie Ileana Sonnabend, Paris, 1963, 1969. Included in: "New Forms—New Media," Martha Jackson Gallery, 1960; "Black and White," The Jewish Museum, New York, 1963; "Six Painters and The Object," and "American Drawings," The Solomon R. Guggenheim Museum, New York, 1963, 1964; "American Pop Art," Stedelijk Museum, Amsterdam, 1964; Venice Biennale, 1964; 67th American Exhibition, The Art Institute of Chicago, 1964 (Harris Silver Medal); Pittsburgh International, 1964, 1967. Lived in London, 1965–66, 1967–71. One-man shows: Robert Fraser Gallery, London, 1965, 1966 (twenty-one works confiscated by Obscene Publications Branch, Scotland Yard); Andrew Dickson White Museum of Art, Cornell University, Ithaca, New York, 1967; The Museum of Modern Art, New York, 1967; Sonnabend Gallery, New York, from 1970. Taught, Cornell University, 1966–67. Included in: ROSC '67, Dublin, 1967; Documenta 4, Kassel, 1968; Whitney Biennial, 1973. Author of: *Welcome Home Lovebirds,* poems and drawings (London, Trigram), 1969; in collaboration with Ron Padgett, *The Adventures of Mister & Mrs. Jim & Ron* (New York, Grossman), 1970. Retrospectives: Whitney Museum of American Art, New York, 1970; Museum Boymans-van Beuningen, Rotterdam, The Netherlands, and tour, 1971. Lives in Putney,

Vermont.

Flesh Striped Tie. 1961.
Oil and collage on canvas, 60¼ × 50 inches

PROVENANCE:
Martha Jackson Gallery, New York, 1962

EXHIBITIONS:
Martha Jackson Gallery, New York, January 10–February 3, 1962, *Jim Dine*
Greenwich Library, Connecticut, March 1965, *Twentieth Century Art*
Whitney Museum of American Art, New York, February 27–April 19, 1970, *Jim Dine,* no. 17

REFERENCES:
Finch, Christopher. *Jim Dine,* New York, Abrams, forthcoming, ill.
Kozloff, Max. "Pop Culture, Metaphysical Disgust, and the New Vulgarians," *Art International,* 6, March 1962, ill. p. 36
Unsigned. "U.S.A.: Towards the End of 'Abstract Painting'?" *Metro,* 4/5, May 1962, p. 7, ill. no. 13

"My painting of the *Flesh Striped Tie,* of 1961, is one of my earliest experiments with the idea of FLESH paint. In 1961 I needed a vehicle like a tie to paint it on. Those were very different days.

"Today:
1. I might not do it at all.
2. I could be content with a ready-mixed tube of flesh paint in my back pocket.
3. I'd probably think about it, then paint the wound on an elm tree with creosote."

Statement by the artist, 1972

MARK DI SUVERO (b. 1933)

Marco Polo di Suvero, born Shanghai, China, September 18, 1933; son of Italian parents. Emigrated with family to the U.S., 1941. Studied, University of California, Berkeley, 1956–57; taught there, 1968. One-man show, The Green Gallery, New York, 1960. Received: Longview Foundation Grant, 1961, 1970; Logan Medal, 66th American Exhibition, The Art Institute of Chicago, 1963. One-man shows: Park Place Gallery, New York, 1964, 1966; Dwan Gallery, Los Angeles, 1965; Lo Giudice Gallery, Chicago, 1968; Noah Goldowsky Gallery, New York, from 1968. Included in: "Recent American Sculpture," The Jewish Museum, New York, 1964; Whitney Annual, 1966, 1968, 1970; "American Sculpture of the Sixties," Los Angeles County Museum of Art, and Philadelphia Museum of Art, 1967; Guggenheim International, 1967–68; "Plus by Minus: Today's Half-Century," Albright-Knox Art Gallery, Buffalo, New York, 1968; Documenta 4, Kassel, 1968; "New York Painting and Sculpture, 1949–70," The Metropolitan Museum of Art, New York, 1969–70; "Works for New Spaces," Walker Art Center, Minneapolis, 1971; 11th Middelheim Biënnale, Antwerp, 1971. Retrospectives: Stedelijk van Abbemuseum, Eindhoven, The Netherlands, and Wilhelm-Lehmbruck-Museum der Stadt, Duisberg, Germany, 1972; Institute of Contemporary Art, University of Pennsylvania, Philadelphia, 1974. Lives in Venice, Italy.

The "A" Train. 1965.
Wood and painted steel, 13 feet × 11 feet 11 inches × 9 feet 7 inches

PROVENANCE:
Park Place Gallery, New York, 1967

EXHIBITIONS:
Park Place Gallery, New York, January–February 1966, *Mark di Suvero and David Novros*

REFERENCES:
Ashbery, John. "Reviews and Previews: Mark di Suvero and David Novros (Park Place)," *Art News,* 65, March 1966, p. 13
Hoene, Anne. "In the Galleries: Mark di Suvero, David Novros," *Arts Magazine,* 40, May 1962, p. 62

EUGÈNE DODEIGNE (b. 1923)

Born Rouvreux, Liège, Belgium, July 27, 1923. Apprenticed to his father, a stonemason. Studied: École des Beaux-Arts, Tourcoing, France, 1943; École des Beaux-Arts, and Académie de la Grande Chaumière, Paris, 1943–46. One-man shows: Galerie Evrard, Lille, France, 1953; Galerie Émile Veranneman, Brussels, 1953; Palais des Beaux-Arts, Brussels, 1957; Galerie Claude Bernard, Paris, 1958. Included in Salon de Mai, Paris, from 1954. Included in: 3rd and 9th Middelheim Biënnale, Antwerp, 1955, 1969; Documenta II and III, Kassel, 1959, 1964; Pittsburgh International, 1964; Sonsbeek '66, Arnhem, The Netherlands, 1966; Expo '67, Montreal, 1967. Received Prize for Sculpture, Ie Biennale de Paris, 1959. One-man shows: Galerie Pierre, Paris, 1961; Galerie Springer, Berlin, 1962; Galerie Jeanne Bucher, Paris, 1964; Palais des Beaux-Arts, Charleroi, Belgium, 1966; Buckingham Gallery, London, 1971; Palais des Beaux-Arts, Brussels, 1971; Galerie Émile Veranneman, 1971, 1973 (drawings). Exhibited with Asger Jörn, Kunsthalle, Basel, 1964. Lives in Bondues, France.

Pregnant Woman (Femme enceinte). 1961.
Belgian limestone, 50 × 14 × 14 inches
Markings: back l. l. "←▷"

PROVENANCE:
The Hanover Gallery, London; Carnegie Institute, Pittsburgh, 1964

EXHIBITIONS:
Carnegie Institute, Pittsburgh, October 30, 1964–January 10, 1965, *The 1964 Pittsburgh International Exhibition of Contemporary Painting and Sculpture,* no. 60

CÉSAR DOMELA (b. 1900)

César Domela-Nieuwenhuis, born Amsterdam, January 15, 1900. Self-taught as an artist. Exhibited with Novembergruppe, Berlin, 1923. One-man show, d'Audretsch Gallery, The Hague, 1924. Met Piet Mondrian, Paris,

1924; associated with de Stijl group, 1924–25. Lived in Berlin, 1927–33; settled in Paris, 1933. Member of Cercle et Carré, Paris, 1930. One-man shows: Galerie Pierre, Paris, 1934, 1939; Museum of Living Art, New York University, 1936. Included in: "Cubism and Abstract Art," The Museum of Modern Art, New York, 1936; "Konstruktivisten," Kunsthalle, Basel, 1937; "Origines et Développement de l'Art International In-dépendant," Musée du Jeu de Paume, Paris, 1937. Co-founded review *Plastique* (Paris, and New York), with Jean Arp, and Sophie Taeuber-Arp, 1937. One-man shows: Galerie Denise René, Paris, 1947; Galerie Colette Allendy, Paris, 1949, 1951; Galerie Cahiers d'Art, Paris, 1953, 1964, 1967; Gemeentemuseum, The Hague, 1960; Galerie Chalette, New York, 1961. Retrospectives: Museu de Arte Moderna, Rio de Janeiro, 1954; Museu de Arte Moderna, São Paulo, 1955; Stedelijk Museum, Amsterdam, 1955. Included in: "The Sphere of Mon-drian," Contemporary Arts Museum, Houston, 1957; "Léger and Purist Paris," The Tate Gallery, London, 1970–71. Retrospective, Kunstverein für die Rheinlande und Westfalen, Düsseldorf, 1972. Lives in Paris.

Construction. 1929.
Glass and polychromed metal on board, 35¾ × 29¼ × 1¾ inches
Signed and dated on back: "Domela 1929 (Berlin)"

PROVENANCE:
The artist; Fritz Glarner; Rose Fried Gallery, New York; Mrs. Donald Peters, New York; Harold Diamond, New York, 1964

EXHIBITIONS:
Rose Fried Gallery, New York, December 1952, *Group Show*, no. 3
Contemporary Arts Museum, Houston, February 27–March 24, 1957, *The Sphere of Mondrian*, cat.

PIERO DORAZIO (b. 1927)

Born Rome, June 29, 1927. Studied, Scuola Superiore di Architettura, Rome, 1945. Co-founded Forma (group of abstract artists); contributed to manifesto *Forma I* (Rome), 1947. Received Bourse d'Étude du Gouverne-ment Français, 1947–48; studied, École des Beaux-Arts, Paris. Returned to Italy; participated in Arte Concreta movement, Milan; edited *Omaggio a W. Kandinsky* (Rome, Age d'Or), 1950. Designed mural, with M. Guerrini, and Achille Perilli, IX Milan Triennale, 1951. Founded and edited magazine *Arti visive*, Rome, 1952–53. Included in: Venice Biennale, 1952, 1956, 1958; Pittsburgh International, 1958, 1964, 1967; Documenta II, Kassel, 1959. One-man shows: Wittenborn One-Wall Gallery, New York, 1953; Rose Fried Gallery, New York, 1954; Galleria Apollinaire, Milan, 1955; Galleria del Cavallino, Venice, 1955. Published *La Fantasia dell'arte nella vita moderna* (Rome, Polveroni e Quinti), 1955. Awarded: Premio Internazionale di Pittura, Lis-sone, Italy, 1959, 1962, 1965; Kandinsky Prize, Paris, 1961. One-man shows: Venice Biennale, 1960 (Turzi Foundation Prize); Städtische Kunsthalle, Düsseldorf, 1961; Galleria dell'Ariete, Milan, 1962, 1965, 1967, 1968; VII São Paulo Bienal, 1963; Marlborough Galleria d'Arte, Rome, 1964, 1968, 1969; Marlborough-Gerson Gallery, New York, 1965, 1967; Palais des Beaux-Arts, Brussels, 1969; Bennington College, Vermont, 1969; Galleria d'Arte Peccolo, Livorno, Italy, 1971. Taught, Graduate School of Fine Arts, University of Pennsylva-nia, Philadelphia, 1960–67. Lives in Rome.

Eye Numerator. 1953.
Wood and plastic box construction, 28¼ × 15¼ × 3⅜ inches

PROVENANCE:
The artist, Rome, 1963

EXHIBITIONS:
Rose Fried Gallery, New York, April 27–May 22, 1954, *Cartographies by Piero Dorazio*, no. 12
Städtische Kunsthalle, Düsseldorf, October 18–Novem-ber 26, 1961, *Piero Dorazio*, no. 15
The Baltimore Museum of Art, October 25–November 27, 1966, *Twentieth Century Italian Art*, checklist

ARTHUR G. DOVE (1880–1946)

Arthur Garfield Dove, born Canandaigua, New York, August 2, 1880. Studied: Hobart College, Geneva, New York, 1898–1900; Cornell University, Ithaca, New York, with illustrator Charles W. Furlong, 1900–1903. Com-mercial artist and illustrator, *The Saturday Evening Post, Harper's, Scribner's,* and *Collier's,* New York, 1903–7. Traveled to Paris, 1907; met Alfred H. Maurer, and Arthur B. Carles. Lived in Cagnes-sur-Mer, France, 1907–9. Included in: Salon d'Automne, Paris, 1908, 1909; "Younger American Painters," Alfred Stieglitz's Photo-Secession Gallery, "291," New York, 1910. Worked as chicken farmer, then lobsterman, Westport, Connecticut, 1910–20. One-man shows, Stieglitz's galleries ("291"; Intimate Gallery; An American Place), New York, 1912–46. Included in: "The Forum Exhibition of Modern American Painters," The Anderson Galleries, New York, 1916; Society of Independent Artists Annual, 1917; Société Anonyme, The Brooklyn Museum, New York, 1926–27. Duncan Phillips his patron, from 1926. Group exhibitions: The Phillips Memorial Gallery, Washington, D.C., 1926, 1930–31, 1931; "Painting and Sculpture by Living Americans," The Museum of Modern Art, New York, 1930–31; Whitney Biennial, 1932–33. 1934–35; "Abstract Painting in America," Whitney Museum of American Art, New York, 1935. Moved to Geneva, New York, 1934; lived in abandoned post office, Centerport, New York, from 1938. Retrospective, The Phillips Memorial Gallery, 1937. Included in: Golden Gate International Exposition, San Francisco, 1940; "History of an American, Alfred Stieglitz: '291' and After," Philadelphia Museum of Art, 1944. Died Centerport, November 22, 1946. Memorial exhibition, Munson-Williams-Proctor Institute, Utica, New York, 1947.

Haystack. 1931.
Oil on canvas, 18½ × 29 inches
Signed l. c.: "Dove"

PROVENANCE:
Alfred Stieglitz, An American Place, New York; The Downtown Gallery, New York; G. David Thompson, Pittsburgh; Harold Diamond, New York, 1965

EXHIBITIONS:
An American Place, New York, March 14–April 9, 1932, *Arthur G. Dove: New Paintings (1931–1932)*, no. 6

REFERENCES:
Archives of American Art, Smithsonian Institution, Washington, D.C., *The Downtown Gallery Archives*
Unsigned. "An Artist's Coming of Age: Arthur G. Dove," *Springfield [Massachusetts] Sunday Union,* March 20, 1932

Sunrise IV. 1937.
Oil and wax emulsion on canvas, 10 × 14 inches
Signed l. c.: "Dove"

PROVENANCE:
Alfred Stieglitz, An American Place, New York; The Downtown Gallery, New York; Dr. and Mrs. Michael Watter, Philadelphia; Parke-Bernet Galleries, New York, Sale 2600, October 19, 1967, *American Paintings, Drawings, Sculpture, Folk Art: The Collection of Dr. and Mrs. Michael Watter*, no. 29, ill. p. 31

EXHIBITIONS:
An American Place, New York, March 23–April 15, 1937, *Arthur G. Dove: New Oils and Watercolors,* no. 4
Contemporary Arts Museum, Houston, January 7–23, 1951, *Sheeler–Dove,* no. 13
Philadelphia Museum of Art, June 13–October 5, 1958, *Sonia and Michael Watter Collection*
The Pennsylvania Academy of the Fine Arts, Phila-delphia, October 25–November 30, 1958, *Twentieth Century American Painting and Sculpture from Phil-adelphia Private Collections,* no. 261
Philadelphia Museum of Art, October 3–November 17, 1963, *Philadelphia Collects Twentieth Century,* p. 13
The Pennsylvania Academy of the Fine Arts, Phila-delphia, February 2–March 12, 1967, *Charles Demuth, Arthur Dove, John Marin, and Elie Nadelman,* no. 12

REFERENCES:
Archives of American Art, Smithsonian Institution, Washington, D.C., *The Downtown Gallery Archives*
Devree, Howard. "A Reviewer's Notebook: Comment on Some of the Newly Opened Shows: Arthur Dove and Others," *The New York Times,* March 28, 1937, sec. 11, p. 10

City Moon. 1938.
Oil and wax emulsion on canvas, 35 × 25 inches
Signed l. c.: "Dove"

PROVENANCE:
Alfred Stieglitz, An American Place, New York; The Downtown Gallery, New York; Mr. and Mrs. Joseph Shapiro, Oak Park, Illinois; Harold Diamond, New York, 1963

EXHIBITIONS:
An American Place, New York, March 29–May 10, 1938, *Arthur G. Dove: Exhibition of Recent Paintings,* 1938, no. 1
Munson-Williams-Proctor Institute, Utica, New York, December 1947, *Arthur G. Dove Retrospective*
Contemporary Arts Museum, Houston, January 7–23, 1951, *Sheeler–Dove,* no. 10
Whitney Museum of American Art, New York, October 1–November 16, 1958, *Arthur Dove Retrospective,* no. 61, ill. p. 62; toured to The Phillips Collection, Washington, D.C., December 1–January 5, 1959; Museum of Fine Arts, Boston, January 25–February 28; Marion Koogler McNay Art Institute, San Antonio, Texas, March 18–April 18; The Art Gal-leries, University of California at Los Angeles, May 1–June 15; Art Center in La Jolla, California, June 20–July 30; San Francisco Museum of Art, August 15–September 30

REFERENCES:
Archives of American Art, Smithsonian Institution, Washington, D.C., *The Downtown Gallery Archives*
Wight, Frederick S. *Arthur G. Dove.* Los Angeles, University of California, 1958, p. 70, ill. p. 62

GUY PÈNE DU BOIS (1884–1958)

Born Brooklyn, New York, January 4, 1884. Studied: New York School of Art, with William Merritt Chase, James Carroll Beckwith, Frank Vincent Du Mond, Robert Henri, Kenneth Hayes Miller, 1899–1905; privately, with Théophile-Alexandre Steinlen, Paris, 1905. First exhibited, Salon de la Société Nationale des Beaux-Arts, Paris, 1906. Reporter, and art and music critic, *New York American, New York Herald Tribune, New York Evening Post, Vogue,* and other publications, from 1906; editor, *Arts and Decoration,* 1913–20. In-cluded in: Pennsylvania Academy Annual, 1906, 1917, 1918; Original Independent Show, New York, 1908; the Armory Show, 1913; Corcoran Biennial, 1914, 1916–17, 1937 (Corcoran Silver Medal, and Second Clark Prize); Panama-Pacific International Exposition, San Francisco, 1915; Venice Biennale, 1920, 1934. Exhibited with Ernest Lawson, Whitney Studio, New York, 1918. Taught, The Art Students League of New York, 1920–24, 1930–32, 1935–36, 1939. One-man shows, Kraushaar Galleries, New York, 1922–46. Lived in France, 1924–30. Included in: 43rd American Exhibition, The Art Institute of Chicago, 1930 (Harris Silver Medal); "Painting and Sculpture by Living Americans," The Museum of Modern Art, New York, 1930–31; National Academy of Design Annual, 1936 (Second Altman Prize). Associate, National Academy of Design, 1937. U.S. Treasury Department, Section of Fine Arts, mural commissions: *Saratoga in the Racing Season,* U.S. Post Office, Saratoga Springs, New York, 1937; *Chief Justice John Jay Arrives Home,* Court House, Rye, New York, 1938. Retrospectives: Carnegie Institute, Pitts-burgh, 1939; Washington County Museum of Fine Arts, Hagerstown, Maryland, and tour, 1940. Published autobiography, *Artists Say the Silliest Things* (New York, American Artists Group), 1940. Member, The National Institute of Arts and Letters, 1942. Included in: "200 Years of American Art," The Tate Gallery, London, 1946; Pittsburgh International, 1950. Died Boston, July 18, 1958.

The Lawyers. 1919.
Oil on panel, 20 × 15 inches
Signed and dated l. l.: "Guy Pène du Bois 1919"

PROVENANCE:
C. W. Kraushaar Galleries, New York; Arthur F. Egner, South Orange, New Jersey; Parke-Bernet Gal-leries, New York, Sale 670, May 4, 1945, no. 33, ill. p. 9; Julius H. Weitzner, New York, 1959

EXHIBITIONS:
C. W. Kraushaar Galleries, New York, April 4–30, 1922, *Guy Pène du Bois,* no. 9
C. W. Kraushaar Galleries, New York, March 17–April 2, 1924, *Guy Pène du Bois,* no. 2
Kraushaar Galleries, New York, November 15–Decem-ber 10, 1938, *Guy Pène du Bois, Retrospective,* no. 8
Carnegie Institute, Pittsburgh, January 4–22, 1939, *Guy Pène du Bois 1908–1939,* no. 35
Newark YM-YWHA, New Jersey, September 25–October 2, 1960, *Art from New Jersey Collectors,* no. 7

REFERENCES:
du Bois, Guy Pène, *Artists Say the Silliest Things,* New York, American Artists Group, 1940, p. 195
Unsigned. "Current Shows in New York Galleries: The Social Satires of du Bois," *American Art News,* 20, April 8, 1922, p. 1

Night Club. 1933.
Oil on canvas, 29 × 36 inches
Signed and dated l. r.: "Guy Pène du Bois '33"

PROVENANCE:
C. W. Kraushaar Galleries, New York; The artist, New York; James Graham and Sons, New York, 1961

EXHIBITIONS:
The Cleveland Museum of Art, June 16–July 16, 1933, *The Thirteenth Exhibition of Contemporary American Oils,* cat.
Carnegie Institute, Pittsburgh, October 19–December 10, 1933, *Thirty-First International Exhibition of Paintings,* no. 42; toured to The John Herron Art Institute, Indianapolis, Indiana
William Rockhill Nelson Gallery of Art, Kansas City, Missouri, April 2–May 1, 1934, *Contemporary Ameri-can Painting*
National Academy of Design, New York, March 13–April 9, 1935, *One Hundred and Tenth Annual Exhibi-tion,* no. 107
Albright Art Gallery, Buffalo, New York, January 3–31, 1936, *Art of Today,* no. 36
The Brooklyn Museum, New York, October 31–Novem-ber 29, 1936, *Paintings by Six American Artists,* cat.
Wildenstein & Co., London, May 25–June 20, 1938, *Contemporary American Paintings,* no. 15
Whitney Museum of American Art, New York, March 11–April 13, 1941, *This Is Our City: Watercolors, Drawings and Prints for the Greater New York Fund,* no. 21
Public Library, Art Room, Dubuque, Iowa, November 6–29, 1942, *America at Rest and Play* (American Federation of Arts, Circulating Exhibition)
The Museum of the City of New York, December 1943–March 1944, *Fun and Folly,* cat.
James Graham and Sons, New York, March 17–April 15, 1961, *Guy Pène du Bois: 1884–1958,* no. 7, ill.

REFERENCES:
Mangravite, Peppino. "America at Rest and Play," *Magazine of Art,* 35, December 1942, p. 297
Unsigned. "Exhibitions and Exhibits," *The Bulletin of the Cleveland Museum of Art,* June 1933, p. 100

Forbes Watson (1880–1960), art critic, lecturer, and editor of *The Arts,* and du Bois, himself, who often wrote for the magazine, are portrayed standing at the far right of the scene.

JEAN DUBUFFET (b. 1901)

Born Le Havre, France, July 31, 1901. Studied: École des Beaux-Arts, Le Havre, 1916; Académie Julian, Paris, 1918. Met Suzanne Valadon, and Max Jacob, 1919. Served, French Army, meteorological service, Eiffel Tower, Paris, 1923. Traveled: to Italy, 1923; Switzerland, and Brazil, 1924. Returned to Le Havre, 1925. Conducted small wholesale wine business, Paris, 1930–34, 1937–42. Resumed painting briefly, 1933. Created theatrical masks, 1935–36. One-man shows: Galerie René Drouin, Paris, 1944, 1946, 1947; Galerie André, Paris, 1945; Pierre Matisse Gallery, New York, 1947–59; Galerie Kootz, New York, 1948; Galerie Geert van Bruaene, Brussels, 1949. Published *Prospectus aux amateurs de tout genre,* first of many writings, 1946. Traveled to the Sahara, 1947, 1949. First public exhibition of his collection of "Art brut," Galerie René Drouin, 1949. One-man show, The Arts Club of Chicago, 1949. Visited the U.S., 1951–52. Retrospective, Cercle Volney, Paris, 1954. One-man shows: Galerie Rive Gauche, Paris, 1954; Institute of Contemporary Arts, London, 1955; Galerie Rive Droite, Paris, 1957; Arthur Tooth & Sons, London, 1958, 1960; Galerie Daniel Cordier, Paris, 1960; Stedelijk van Abbemuseum, Eindhoven, The Netherlands, and tour, 1960; Palazzo Grassi, Venice, 1964; Philadelphia Museum of Art, 1964–65; The Solomon R. Guggenheim Museum, New York, 1966; The Pace Gallery, New York, 1968–73; The Art Institute of Chicago, 1971; The Museum of Modern Art, New York, 1972. Retrospectives: Musée des Arts Décoratifs, Paris, 1960; The Museum of Modern Art, and tour, 1962; The Tate Gallery, London, 1966; Dallas Museum of Fine Arts, Texas, and Walker Art Center, Minneapolis, 1966; Montreal Museum of Fine Arts, 1969; The Solomon R. Guggenheim Museum, and Grand Palais, Paris, 1973. Sculpture commission, *Group of Four Trees,* Chase Manhattan Plaza, New York, 1972. Lives in Paris.

Masks (Masques). 1935.
René Pontier.

Painted papier-mâché, 11¼ × 6¾ inches
Markings: inside "J. Dubuffet 1935
Rene Pontier"

André Claude.
Painted papier-mâché, 9¼ × 6 inches
Markings: inside "J. Dubuffet 1935
Andre Claude"

Robert Polgure.
Painted papier-mâché, 9¾ × 7¼ inches
Markings: inside "J. Dubuffet 1935
Robert Polguère"

PROVENANCE:
Henri-Pierre Roché, Paris; Mme Henri-Pierre Roché, Paris; Galerie Claude Bernard, Paris, 1962

EXHIBITIONS:
The Museum of Modern Art, New York, February 19–April 8, 1962, *The Work of Jean Dubuffet*, no. 2, ill. p. 11; toured to The Art Institute of Chicago, May 11–June 17; Los Angeles County Museum of Art, July 10–August 12
The Solomon R. Guggenheim Museum, New York, October 3, 1962–January 6, 1963, *Modern Sculpture from the Joseph H. Hirshhorn Collection*, no. 129
The Solomon R. Guggenheim Museum, New York, April 20–July 29, 1973, *Jean Dubuffet*, no. 1, ill. p. 41

REFERENCES:
Limbour, Georges. *Tableau bon levain à vous de cuire la pâte. L'Art brut de Jean Dubuffet*, New York, Pierre Matisse Gallery, 1953, p. 99, ill. p. 17
Loreau, Max. *Catalogue des travaux de Jean Dubuffet*, fascicule 1, Paris, Jean-Jacques Pauvert, 1966, ill. p. 21
———. *Jean Dubuffet: Délits, Déportements, Lieux de Haut Jeu*, Paris, Weber, 1971, ill. p. 17
Trucchi, Lorenza. *Jean Dubuffet*, Rome, de Luca, 1965, ill. facing p. 69

Limbour as a Crustacean (Limbour crustacé). 1946.
Oil on canvas, 45½ × 35 inches

PROVENANCE:
Pierre Matisse Gallery, New York, 1958

EXHIBITIONS:
Galerie René Drouin, Paris, October 7–31, 1947, *Portraits à ressemblance extraite, à ressemblance cuite et confite dans la mémoire, à ressemblance éclatée dans la mémoire de M. Jean Dubuffet, peintre*, no. 14

REFERENCES:
Loreau, Max. *Catalogue des travaux de Jean Dubuffet*, fascicule 3, Paris, Jean-Jacques Pauvert, 1966, no. 95, ill. p. 69

Georges Limbour, a boyhood friend of Dubuffet's in Le Havre, became a poet, writer, and critic. He was an original member of the Surrealist group, and author of the first important essays on Dubuffet. Limbour is the subject of twelve portraits which Dubuffet painted between 1945 and 1947.

Landscape with Three Trees (Paysage aux trois arbres). 1959.
White mullein, vine, wild sorrel, spinach, and beet on cardboard, 23½ × 22½ inches
Signed and dated u. r.: "J. Dubuffet 59"

PROVENANCE:
Galerie Daniel Cordier, Paris; Private collection, Paris; Redfern Gallery, London, 1968

EXHIBITIONS:
Arthur Tooth & Sons, London, May 31–June 18, 1960, *Jean Dubuffet: Éléments botaniques (Août–Décembre 1959)*, no. 7, ill.
Stedelijk Museum, Amsterdam, December 16, 1960–January 16, 1961, *van natuur tot Kunst*, no. 3, ill.; toured to Städtische Kunsthalle, Recklinghausen, Germany, February 4–March 5
Redfern Gallery, London, Summer 1968, *Dubuffet collage and McEwen sculpture*

REFERENCES:
Loreau, Max. *Catalogue des travaux de Jean Dubuffet*, fascicule 17, Paris, Weber, 1969, no. 2, ill. p. 8
Trucchi, Lorenza. *Jean Dubuffet*, Rome, de Luca, 1965, no. 221, ill. p. 24

The series "Éléments botaniques," made between August and December 1959, resulted from Dubuffet's botanical studies. The artist created these small, private forests from parts of plants and trees that he found near his residence in Vence, France.

Oberon. 1960.
Papier-mâché, 34 × 14½ × 12½ inches
Markings: l. r. front "J. Dubuffet 1960"

PROVENANCE:
Cordier & Ekstrom, New York, 1964

EXHIBITIONS:
The Museum of Modern Art, New York, February 19–April 8, 1962, *The Work of Jean Dubuffet*, no. 175, ill. p. 157; toured to The Art Institute of Chicago, May 11–June 17; Los Angeles County Museum of Art, July 10–August 12

REFERENCES:
Loreau, Max. *Catalogue des travaux de Jean Dubuffet*, fascicule 17, Paris, Weber, 1969, no. 120, ill. p. 102
———. *Jean Dubuffet: Délits, Déportements, Lieux de Haut Jeu*, Paris, Weber, 1971, ill. p. 339

Actor in a Ruff (Acteur à la collerette). 1961.
Oil on canvas, 45¼ × 35¼ inches
Signed and dated l. l.: "J. Dubuffet '61"

PROVENANCE:
Robert Fraser, London; Galerie Daniel Cordier, Paris; Private collection, Paris; Harold Diamond, New York, 1968

REFERENCES:
Loreau, Max. *Catalogue des travaux de Jean Dubuffet*, fascicule 19, Paris, Jean-Jacques Pauvert, 1965, no. 146, ill. p. 80

Glass of Water II (Le Verre d'eau II). 1966.
Cast polyester resin (unique), 94¼ × 42½ × 4 inches
Signed and dated l. l.: "JD 67"

PROVENANCE:
The Pace Gallery, New York, 1968

EXHIBITIONS:
The Pace Gallery, New York, April 13–May 18, 1968, *Dubuffet: New Sculpture and Drawings*, no. 8, colorplate p. 13
The Solomon R. Guggenheim Museum, New York, April 20–July 29, 1973, *Jean Dubuffet*, no. 260, ill. p. 254

REFERENCES:
Loreau, Max. *Catalogue des travaux de Jean Dubuffet*, fascicule 23, Paris, Weber, 1972, ill. p. 52
Ossorio, Alfonso. "The Hour of the Hourloupe," *Art News*, 67, May 1968, pp. 5, 65, colorplate, cover
Pincus-Witten, Robert. "New York: Jean Dubuffet, Pace Gallery," *Artforum*, 6, Summer 1968, ill. p. 53

RAYMOND DUCHAMP-VILLON (1876–1918)

Pierre-Maurice-Raymond Duchamp, born Damville, near Rouen, France, November 5, 1876. Brother of artists Marcel Duchamp, Suzanne Duchamp, and Jacques Villon. Studied medicine, Université de Paris, 1894–98. First sculptures, 1899–1900. Changed name to Duchamp-Villon, 1901. Exhibited, Paris: Salon de la Société Nationale des Beaux-Arts, 1902–4, 1906, 1908; Salon d'Automne, 1905–13; Salon des Indépendants, 1909, 1910. Exhibited with Villon, Galerie Legrip, Rouen, 1905. Moved to Puteaux, France, 1907. Included in: Salon de "La Section d'Or," Galerie La Boétie, Paris, 1912; the Armory Show, 1913; Cubist exhibition, with Alexander Archipenko, Constantin Brancusi, and others, Mánes Society, Prague, 1914. Exhibited with Villon, Gleizes, and Jean Metzinger, Galerie André Groult, Paris, and Galerie der Sturm, Berlin, 1914. Enlisted as medical officer, French Army, 1914. Contracted typhoid fever, while stationed in Champagne, France, 1916. Died, Cannes Military Hospital, France, October 7, 1918. Retrospectives: Salon d'Automne, 1919; Salon des Indépendants, 1926; Brummer Gallery, New York, 1929; Galerie Pierre, Paris, 1931. Retrospectives: Galerie Louis Carré, Paris, 1963; M. Knoedler & Co., New York, 1967.

Torso of a Young Man. 1910.
Plaster, 23¾ × 13½ × 13½ inches
Markings: l. l. side "R. Duchamp Villon"

PROVENANCE:
The artist, Puteaux, France; Walter Pach, New York; Peridot Gallery, New York, 1958

EXHIBITIONS:
Sixty-Ninth Infantry Armory, New York, February 17–March 15, 1913, *International Exhibition of Modern Art*, no. 610; toured to The Art Institute of Chicago, March 24–April 16, no. 109; Copley Hall, Boston, April 28–May 19, no. 41
The Solomon R. Guggenheim Museum, New York, October 3, 1962–January 6, 1963, *Modern Sculpture from the Joseph H. Hirshhorn Collection*, no. 131, ill. p. 62
M. Knoedler & Co., New York, October 10–November 7, 1967, *Raymond Duchamp-Villon*, no. 13, pp. 47–50, ill. p. 48

REFERENCES:
Brown, Milton W. *The Story of the Armory Show*, New York, Hirshhorn Foundation, 1963, no. 610, p. 240, ill.
Elsen, Albert E. "The Sculpture of Duchamp-Villon," *Artforum*, 6, October 1967, p. 22
Hamilton, George Heard. *Raymond Duchamp-Villon*, New York, Walker, 1967, p. 19

The art historian Walter Pach acquired this original plaster version of *Torso of a Young Man* from the Armory Show. One known terra-cotta and many bronze casts were made from another, probably later, version of the sculpture in which the square block supporting the figure's left leg was removed and the leg extended.

Head of Baudelaire. 1911.
Bronze, 15¾ × 8½ × 9¾ inches
Markings: l. l. side "Duchamp Villon 1911"

PROVENANCE:
Mme Rudier, Paris; Peridot Gallery, New York, 1959

EXHIBITIONS:
The Solomon R. Guggenheim Museum, New York, October 3, 1962–January 6, 1963, *Modern Sculpture from the Joseph H. Hirshhorn Collection*, no. 132, ill. p. 65
Leonard Hutton Galleries, New York, October 21–December 5, 1964, *Albert Gleizes and the Salon de la Section d'Or*, no. 21, ill. p. 12
Art Gallery of Toronto, April 4–May 5, 1963, *Baudelaire*
Washington [D.C.] Gallery of Modern Art, September 17–October 24, 1965, *20th Century Painting and Sculpture*, no. 18; toured to Wadsworth Atheneum, Hartford, Connecticut, October 28–December 5
M. Knoedler & Co., New York, October 10–November 7, 1967 *Raymond Duchamp-Villon*, no. 16, ill. p. 15
Smithsonian Institution, Washington, D.C., 1972–73, extended loan

REFERENCES:
Ashton, Dore. "New York Report," *Das Kunstwerk*, 4, October 1962, p. 26, ill. p. 31
Hamilton, George Heard. *Raymond Duchamp-Villon*, New York, Walker, 1967, p. 16, ill. p. 15
Kuh, Katherine. "Great Sculpture," *Saturday Review*, 45, June 23, 1962, p. 19
Read, Herbert. *A Concise History of Modern Sculpture*, New York, Praeger, 1964, no. 72, p. 291, ill. p. 74
Tomkins, Calvin. *The World of Marcel Duchamp*, New York, Time-Life Books, 1966, ill. p. 44

Different versions of Duchamp-Villon's *Baudelaire* were exhibited at the Salon d'Automne, Paris, 1911, and at the Armory Show, 1913. Like Auguste Rodin's *Head of Baudelaire*, this was a posthumous portrait, probably

based on photographs taken by Nadar (Gaspard Tournachon) and Étienne Carjat.

Decorative Basin (La Vasque décorative). 1911.
Bronze (4/8), 23½ × 7 × 8¼ inches
Markings: l. r. side "Duchamp Villon"
back l. "Georges Rudier Fondeur Paris"
back l. c. "Louis Carré Editeur"

PROVENANCE:
Galerie Louis Carré, Paris; Galerie Claude Bernard, Paris, 1962

EXHIBITIONS:
The Solomon R. Guggenheim Museum, New York, October 3, 1962–January 6, 1963, *Modern Sculpture from the Joseph H. Hirshhorn Collection*, no. 133, ill. p. 64

REFERENCES:
Hamilton, George Heard. *Raymond Duchamp-Villon*, New York, Walker, 1967, p. 16

Maggy. 1912.
Bronze (5/8), 28½ × 13½ × 15¾ inches
Markings: l. r. side "Duchamp Villon"
l. l. side "Georges Rudier Fondeur Paris Louis Carré Editeur"

PROVENANCE:
Galerie Louis Carré, Paris; Galerie Claude Bernard, Paris, 1962

EXHIBITIONS:
The Solomon R. Guggenheim Museum, New York, October 3, 1962–January 6, 1963, *Modern Sculpture from the Joseph H. Hirshhorn Collection*, no. 134, ill. p. 64

REFERENCES:
Hamilton, George Heard. *Raymond Duchamp-Villon*, New York, Walker, 1967, pp. 16–19
Michelson, Annette. "Private but Public: The Joseph H. Hirshhorn Collection," *Contemporary Sculpture* (Arts Yearbook 8), New York, 1965, ill. p. 186
Robbins, Daniel. "Modern Sculpture from the Joseph H. Hirshhorn Collection," *Apollo*, 76, November 1962, ill. p. 721

Head of a Horse (Tête de cheval). 1914.
Bronze, 18½ × 19¼ × 15¾ inches
Markings: l. r. side "Duchamp-Villon
Georges Rudier Fondeur Paris
Louis Carré Editeur Paris 7/8"

PROVENANCE:
Galerie Louis Carré, Paris; Galerie Claude Bernard, Paris, 1961

EXHIBITIONS:
The Solomon R. Guggenheim Museum, New York, October 3, 1962–January 6, 1963, *Modern Sculpture from the Joseph H. Hirshhorn Collection*, no. 136, ill. p. 66
The Baltimore Museum of Art, October 6–November 15, 1964, *1914: An Exhibition of Paintings, Drawings and Sculpture*, no. 57, ill. p. 54
M. Knoedler & Co., New York, October 10–November 7, 1967, *Raymond Duchamp-Villon*, no. 25.4, ill. p. 91

REFERENCES:
Hamilton, George Heard. *Raymond Duchamp-Villon*, New York, Walker, 1967, p. 22, ill. p. 91

Horse (Le Cheval). 1914.
Bronze (6/8), 18½ × 18½ × 8½ inches
Markings: l. l. "Duchamp-Villon"
back l. "Georges Rudier Fondeur Paris
Louis Carré Editeur"

PROVENANCE:
Galerie Louis Carré, Paris; E. V. Thaw & Co., New York, 1964

EXHIBITIONS:
Galerie Louis Carré, Paris, June 7–July 20, 1963, *Duchamp-Villon*, no. 12, ill. p. 35
Hopkins Art Center, Dartmouth College, Hanover, New Hampshire, May 25–July 9, 1967, *Sculpture in Our Century: Selections from the Joseph H. Hirshhorn Collection*, no. 15

REFERENCES:
Hamilton, George Heard. *Raymond Duchamp-Villon*, New York, Walker, 1967, p. 23

The final version of *Horse*—begun in 1913–14 as a "Horse and Rider"—was probably under way when war was declared in August 1914, and was finished in the fall when Duchamp-Villon returned to Puteaux on leave. The sculpture was posthumously enlarged in 1930–31, and again in 1965, under the supervision of the artist's brothers.

Head of a Horse exists as an independent sculpture, related to the final version of *Horse* but not incorporated in it.

Head of Professor Gosset (Tête du Professeur Gosset). 1917.
Bronze, large version (1/8), 12 × 9 × 8 inches
Markings: front l. c. "Duchamp-Villon
Louis Carré Editeur Paris"

PROVENANCE:
Galerie Louis Carré, Paris; Galerie Claude Bernard, Paris, 1962

REFERENCES:
Hamilton, George Heard. *Raymond Duchamp-Villon*, New York, Walker, 1967, p. 24

THOMAS EAKINS (1844–1916)

Thomas Cowperthwait Eakins, born Philadelphia, July 25, 1844. Studied, The Pennsylvania Academy of the Fine Arts, 1861–65, while taking courses in anatomy, Jefferson Medical College of Philadelphia. Studied École des Beaux-Arts, Paris, with Jean-Léon Gérôme, 1866–69, and with sculptor Augustin-Alexandre Dumont; worked briefly in atelier of Léon Bonnat, 1869. Traveled to: Italy,

and Germany, 1868; Spain, 1869–70. Returned to Philadelphia, 1870; resumed studies, Jefferson Medical College. Included in: American Society of Painters in Water Color Annual, 1874, 1877; Centennial Exhibition, Philadelphia, 1876; Pennsylvania Academy Annual, 1876–1917 (Temple Gold Medal, 1904); National Academy of Design Annual, 1877–1916 (Proctor Prize, 1905); Society of American Artists Annual, 1878–1906. Pennsylvania Academy: taught, 1876–86; director, 1882–86; forced to resign because of his emphasis on study from nude models. Member, Society of American Artists, 1880–92. Designed camera for experiments in photographing horses and nude athletes in motion, 1884; worked with Eadweard Muybridge, and conducted his own studies in motion photography, University of Pennsylvania, Philadelphia, 1884–85. Director, The Art Students' League of Philadelphia (founded by his former students), 1886–92. Lectured on anatomy: National Academy of Design, New York, 1888–95; The Cooper Union for the Advancement of Science and Art, New York, 1891–98; Drexel Institute of Art, Science and Industry, Philadelphia, 1895. Included in: 2nd–29th American Exhibition, The Art Institute of Chicago, 1889–1916; World's Columbian Exposition, Chicago, 1893 (Gold Medal); Carnegie International, 1896–1912 (Medal of the Second Class, 1907); Exposition Universelle de 1900, Paris (honorable mention); Pan-American Exposition, Buffalo, New York, 1901 (Gold Medal); St. Louis International Exposition, Missouri, 1904 (Gold Medal); International Society of Sculptors, Painters and Gravers, London, Annual Exhibition, 1906; Panama-Pacific International Exposition, San Francisco, 1915. Worked with William R. O'Donovan on sculptures of horses for equestrian reliefs of Abraham Lincoln and Ulysses S. Grant, Memorial Arch, Prospect Park, Brooklyn, New York, 1891–94. Bronze reliefs commissioned, Trenton Battle Monument, New Jersey, 1893. Only one-man show, Earle Galleries, Philadelphia, 1896. National Academy of Design, associate, and academician, 1902. Died Philadelphia, June 25, 1916. Memorial exhibitions: The Metropolitan Museum of Art, New York, 1917; Pennsylvania Academy, 1917. Centennial exhibitions: Philadelphia Museum of Art, 1944; M. Knoedler & Co., New York, and tour, 1944–45; Carnegie Institute, 1945. Retrospectives: National Gallery of Art, Washington, D.C., and tour, 1961; "The Sculpture of Thomas Eakins," The Corcoran Gallery of Art, Washington, D.C., 1969; Whitney Museum of American Art, New York, 1970; "Thomas Eakins: His Photographic Works," Pennsylvania Academy, and tour, 1970–72.

Margaret. 1871.
Oil on canvas, 18¼ × 15 inches

PROVENANCE:
Mrs. Thomas Eakins, Philadelphia; Mrs. Francis W. Sheafer, New Milford, Connecticut; Joseph Katz, Baltimore; M. Knoedler & Co., New York, 1961

EXHIBITIONS:
The Pennsylvania Academy of the Fine Arts, Philadelphia, December 23, 1917–January 13, 1918, *Memorial Exhibition of the Works of the Late Thomas Eakins*
Whitney Museum of American Art, New York, September 22–November 21, 1970, *Thomas Eakins Retrospective Exhibition*, no. 7

REFERENCES:
Burroughs, Alan. "Catalogue of Work by Thomas Eakins (1869–1916)," *The Arts*, 5, June 1924, p. 328
Goodrich, Lloyd. *Thomas Eakins, His Life and Work*, New York, Whitney Museum of American Art, 1933, no. 40, p. 163
Hendricks, Gordon. *Thomas Eakins*, New York, Viking, 1974, no. 40, p. 319
Marceau, Henri Gabriel. "Catalogue of the Works of Thomas Eakins," *Pennsylvania Museum Bulletin*, 25, March 1930, no. 10, p. 18
McHenry, Margaret. *Thomas Eakins Who Painted*, Oreland, Pennsylvania, privately printed, 1946, p. 21
Schendler, Sylvan. *Eakins*, Boston, Little, Brown, 1967, pp. 23, 284, plate 7

Of his three sisters, Margaret was closest to Eakins. "A favorite model of his, she appeared in many early works, and also helped him in practical affairs, appointing herself his business manager, keeping a record of his paintings, and seeing that they were sent out to exhibitions."

· Goodrich, pp. 38–39

Study for The Crucifixion. 1880.
Oil on canvas, 22 × 18 inches

PROVENANCE:
The artist, Philadelphia; Samuel Murray, Philadelphia; Mrs. Samuel Murray, Philadelphia; M. Knoedler & Co., New York, 1963

EXHIBITIONS:
The Pennsylvania Academy of the Fine Arts, Philadelphia, December 23, 1917–January 13, 1918, *Memorial Exhibition of the Works of the Late Thomas Eakins*, no. 99
Brummer Gallery, New York, March 17–April 14, 1923, *Exhibition of Paintings and Watercolors by Thomas Eakins*, no. 21
Philadelphia Museum of Art, April 8–May 14, 1944, *Thomas Eakins Centennial Exhibition, 1844–1944*, no. 42
M. Knoedler & Co., New York, June 5–July 31, 1944, *A Loan Exhibition of the Works of Thomas Eakins, 1844–1944*, no. 21, ill.; toured to Wilmington Society of the Fine Arts, Delaware Art Center, October 1–29; Doll & Richards Gallery, Boston, November 4–21; State Art Gallery, Raleigh, North Carolina, November 26–December 31
Carnegie Institute, Pittsburgh, April 26–June 1, 1945, *Thomas Eakins Centennial Exhibition, 1844–1944*, no. 24, ill.
Westmoreland County Museum of Art, Greensburg, Pennsylvania, 1959, *Two Hundred and Fifty Years of Art in Pennsylvania*, no. 38, plate 84
The Brooklyn Museum, New York, February 8–April 5, 1965, *Paintings from the Joseph H. Hirshhorn Foundation Collection: A View of the Protean Century*, no. 80

University Art Museum, University of California, Berkeley, June 28–August 27, 1972, *The Hand and the Spirit: Religious Art in America, 1770–1900*, no. 100, colorplates p. 157, cover; toured to National Collection of Fine Arts, Smithsonian Institution, Washington, D.C., September 28–November 5; Dallas Museum of Fine Arts, December 10–January 14, 1973; Indianapolis Museum of Art, Indiana, February 20–April 15

REFERENCES:
Burroughs, Alan. "Catalogue of Work by Thomas Eakins (1869–1916)," *The Arts*, 5, June 1924, p. 329
Goodrich, Lloyd. *Thomas Eakins, His Life and Work*, New York, Whitney Museum of American Art, 1933, no. 143, p. 174
———, and Marceau, Henri Gabriel. "Thomas Eakins Centennial Exhibition," *Philadelphia Museum Bulletin*, 39, May 1944, no. 42, p. 134
Hendricks, Gordon. *Thomas Eakins*, New York, Viking, 1974, no. 55, p. 320, ill.
Marceau, Henri Gabriel. "Catalogue of the Works of Thomas Eakins," *Pennsylvania Museum Bulletin*, 25, March 1930, no. 78, p. 21
McHenry, Margaret. *Thomas Eakins Who Painted*, Oreland, Pennsylvania, privately printed, 1946, p. 53

Knitting. 1882–83.
Bronze relief, 18½ × 14½ inches
Markings: bottom c. "Knitting/Thomas Eakins/1881"
 l. r. rim "Roman Bronze Works N.Y."

PROVENANCE:
The artist, Philadelphia; Samuel Murray, Philadelphia; Mrs. Samuel Murray, Philadelphia; Joseph Katz, Baltimore; M. Knoedler & Co., New York, 1961

EXHIBITIONS:
Philadelphia Museum of Art, April 8–May 14, 1944, *Thomas Eakins Centennial Exhibition, 1844–1944*
M. Knoedler & Co., New York, June 5–July 31, 1944, *A Loan Exhibition of the Works of Thomas Eakins, 1844–1944*, no. 85; toured to Wilmington Society of the Fine Arts, Delaware Art Center, October 1–29; Doll & Richards Gallery, Boston, November 4–21; State Art Gallery, Raleigh, North Carolina, November 26–December 31
The Solomon R. Guggenheim Museum, New York, October 3, 1962–January 6, 1963, *Modern Sculpture from the Joseph H. Hirshhorn Collection*, no. 140, ill. p. 163

REFERENCES:
Genauer, Emily. "Human Spirit and Hirshhorn," *New York Herald Tribune*, October 7, 1962, sec. 4, ill. p. 6
Goodrich, Lloyd. *Thomas Eakins, His Life and Work*, New York, Whitney Museum of American Art, 1933, no. 505, pp. 62, 209
———, and Marceau, Henri Gabriel. "Thomas Eakins Centennial Exhibition," *Philadelphia Museum Bulletin*, 39, May 1944, no. 119, p. 135
Hendricks, Gordon. *Thomas Eakins*, New York, Viking, 1974, no. 59, p. 321, ill.

Spinning. 1882–83.
Bronze relief, 18¼ × 14½ inches
Markings: bottom c. "Spinning/Thomas Eakins/1881"
 l. r. rim "Roman Bronze Works N.Y."

PROVENANCE:
The artist, Philadelphia; Samuel Murray, Philadelphia; Mrs. Samuel Murray, Philadelphia; Joseph Katz, Baltimore; M. Knoedler & Co., New York, 1961

EXHIBITIONS:
Philadelphia Museum of Art, April 8–May 14, 1944, *Thomas Eakins Centennial Exhibition, 1844–1944*
M. Knoedler & Co., New York, June 5–July 31, 1944, *A Loan Exhibition of the Works of Thomas Eakins, 1844–1944*, no. 83; toured to Wilmington Society of the Fine Arts, Delaware Art Center, October 1–29; Doll & Richards Gallery, Boston, November 4–21; State Art Gallery, Raleigh, North Carolina, November 26–December 31
The Solomon R. Guggenheim Museum, New York, October 3, 1962–January 6, 1963, *Modern Sculpture from the Joseph H. Hirshhorn Collection*, no. 141

REFERENCES:
Genauer, Emily. "Human Spirit and Hirshhorn," *New York Herald Tribune*, October 7, 1962, sec. 4, ill. p. 6
Goodrich, Lloyd. *Thomas Eakins, His Life and Work*, New York, Whitney Museum of American Art, 1933, no. 504, pp. 64, 209
———, and Marceau, Henri Gabriel. "Thomas Eakins Centennial Exhibition," *Philadelphia Museum Bulletin*, 39, May 1944, no. 118, p. 135
Hendricks, Gordon. *Thomas Eakins*, New York, Viking, 1974, no. 60, p. 321, ill.

Commissioned as chimney-piece decorations by a wealthy Philadelphia wool merchant, James P. Scott, *Spinning* and *Knitting* were Eakins's first sculptures. Because Eakins was determined to render the subjects accurately, he went so far as to have the model take spinning lessons. He later wrote to his client, "after I had worked some weeks, the girl in learning to spin well became so much more graceful than when she had learned to spin only passably, that I tore down all my work and recommenced."

The artist, in Goodrich, p. 64

Arcadia. 1883.
Plaster relief, 11½ × 24 inches
Markings: u. l. "Eakins"
 u. c. "1883"

PROVENANCE:
Mrs. Thomas Eakins, Philadelphia; Charles Bregler, Philadelphia; Joseph Katz, Baltimore; M. Knoedler & Co., New York, 1961

EXHIBITIONS:
The Pennsylvania Museum of Art, Philadelphia, March 5–April 17, 1930, *An Exhibition of Thomas Eakins' Work*
Philadelphia Museum of Art, April 8–May 14, 1944,

Thomas Eakins Centennial Exhibition, 1844–1944, no. 120
M. Knoedler & Co., New York, June 5–July 31, 1944, *A Loan Exhibition of the Works of Thomas Eakins, 1844–1944*, no. 87; toured.to Wilmington Society of the Fine Arts, Delaware Art Center, October 1–29; Doll & Richards Gallery, Boston, November 4–21; State Art Gallery, Raleigh, North Carolina, November 26–December 31
Carnegie Institute, Pittsburgh, April 26–June 1, 1945, *Thomas Eakins Centennial Exhibition 1844–1944*, no. 114
The Solomon R. Guggenheim Museum, New York, October 3, 1962–January 6, 1963, *Modern Sculpture from the Joseph H. Hirshhorn Collection*, no. 142, ill. p. 163
Jesup Gallery, Westport Public Library, Connecticut, March 25–April 13, 1963, *Music in Art* (sponsored by the Westport Community Art Association), cat.

REFERENCES:
Goodrich, Lloyd. *Thomas Eakins, His Life and Work*, New York, Whitney Museum of American Art, 1933, no. 506, p. 209
———, and Marceau, Henri Gabriel. "Thomas Eakins Centennial Exhibition," *Philadelphia Museum Bulletin*, 39, May 1944, no. 120, p. 135
Hendricks, Gordon. *Thomas Eakins*, New York, Viking, 1974, no. 64, p. 321
Marceau, Henri Gabriel. "Catalogue of the Works of Thomas Eakins," *Pennsylvania Museum Bulletin*, 25, March 1930, p. 32
Michelson, Annette. "Private but Public: The Joseph H. Hirshhorn Collection," *Contemporary Sculpture* (Arts Yearbook 8), New York, 1965, ill. p. 188

Shortly after he became director of The Pennsylvania Academy of the Fine Arts, in 1882, Eakins made a series of photographs, oil sketches, and plaster reliefs on the theme of Arcadia (see also *A Youth Playing the Pipes*).

At about the same time that he modeled the plaster *Arcadia*, Eakins delivered a lecture on the importance of relief sculpture. The Pennsylvania Academy owned plaster casts of reliefs from the Parthenon, and Eakins believed the work of Phidias to be the most perfect example of the art, midway between painting and fully three-dimensional sculpture.

Eakins's practice of posing nude male and female models in the classroom brought him into conflict with Victorian notions of propriety, and generated a controversy which resulted in his resignation from the Academy.

A Youth Playing the Pipes. 1883.
Bronze relief, 19¾ × 11 inches
Markings: l. r. "TE/Thomas Eakins/1888"
 "Roman Bronze Works N.Y."

PROVENANCE:
Leroy Ireland, Philadelphia; T. Edward Hanley, Bradford, Pennsylvania; Mrs. Elizabeth Molnar, Bradford; Parke-Bernet Galleries, New York, Sale 2401, January 22, 1966, no. 24

EXHIBITIONS:
National Gallery of Art, Washington, D.C., October 8–November 12, 1961, *Thomas Eakins: A Retrospective Exhibition*, no. 102; toured to The Art Institute of Chicago, December 1–January 7, 1962; Philadelphia Museum of Art, February 1–March 18
The Corcoran Gallery of Art, Washington, D.C., May 3–June 10, 1969, *The Sculpture of Thomas Eakins*, no. 17, ill.

REFERENCES:
Burroughs, Alan. "Catalogue of Work by Thomas Eakins (1869–1916)," *The Arts*, 5, June 1924, p. 330
Goodrich, Lloyd. *Thomas Eakins, His Life and Work*, New York, Whitney Museum of American Art, 1933, no. 508, p. 209
Hendricks, Gordon. *Thomas Eakins*, New York, Viking, 1974, no. 63, p. 321, ill.
McKinney, Roland. *Thomas Eakins*, New York, Crown, 1942, ill. p. 85

This bronze version of *A Youth Playing the Pipes* is closely related to a photographic study of the same subject, made in 1883 (The Hirshhorn Museum). According to Lloyd Goodrich, the original plaster also dates from 1883 although the bronze was inscribed 1888, probably in error.

Girl in a Big Hat. c. 1888.
Oil on canvas, 24 × 20 inches
Signed on back, l. r.: "Eakins"

PROVENANCE:
Mrs. Thomas Eakins, Philadelphia; Charles Bregler, Philadelphia; Joseph Katz, Baltimore; M. Knoedler & Co., New York, 1961

EXHIBITIONS:
The Pennsylvania Museum of Art, Philadelphia, March 5–April 17, 1930, *An Exhibition of Thomas Eakins' Work*, no. 120
Philadelphia Museum of Art, April 8–May 14, 1944, *Thomas Eakins Centennial Exhibition, 1844–1944*, no. 60
M. Knoedler & Co., New York, June 5–July 31, 1944, *A Loan Exhibition of the Works of Thomas Eakins, 1844–1944*, no. 43, ill.; toured to Wilmington Society of the Fine Arts, Delaware Art Center, October 1–29; Doll & Richards Gallery, Boston, November 4–21; State Art Gallery, Raleigh, North Carolina, November 26–December 31
Carnegie Institute, Pittsburgh, April 26–June 1, 1945, *Thomas Eakins Centennial Exhibition 1844–1944*, no. 23
Whitney Museum of American Art, New York, September 22–November 21, 1970, *Thomas Eakins Retrospective Exhibition*, no. 50

REFERENCES:
Burroughs, Alan. "Catalogue of Work by Thomas Eakins (1869–1916)," *The Arts*, 5, June 1924, p. 330
Goodrich, Lloyd. *Thomas Eakins, His Life and Work*,

New York, Whitney Museum of American Art, 1933, no. 234, p. 180

———, and Marceau, Henri Gabriel. "Thomas Eakins Centennial Exhibition," *Philadelphia Museum Bulletin*, 39, May 1944, no. 60, p. 134 .

Hendricks, Gordon. *Thomas Eakins*, New York, Viking, 1974, no. 69, p. 322, ill.

Marceau, Henri Gabriel. "Catalogue of the Works of Thomas Eakins," *Pennsylvania Museum Bulletin*, 25, March 1930, no. 120, p. 123

McHenry, Margaret. *Thomas Eakins Who Painted*, Oreland, Pennsylvania, privately printed, 1946, p. 99

Schendler, Sylvan. *Eakins*, Boston, Little, Brown, 1967, p. 130, plate 56

The Continental Army Crossing the Delaware (The American Army Crossing the Delaware). 1893, cast 1969.
Bronze relief, 55 × 94 inches
Markings: l. l. "Presented by the Commonwealth of Pennsylvania"
Pennsylvania State Seal

PROVENANCE:
Division of Parks, Forestry and Recreation, State of New Jersey Department of Conservation and Economic Development, Trenton, 1969

EXHIBITIONS:
Whitney Museum of American Art, New York, September 22–November 21, 1970, *Thomas Eakins Retrospective Exhibition*, no. 108, ill. p. 66

REFERENCES:
Buki, Zoltan, and Corlette, Suzanne, eds. *The Trenton Battle Monument: Eakins Bronzes*, Trenton New Jersey State Museum, Bulletin 14, 1973, pp. 43, 60

The Opening of The Fight (The Battle of Trenton). 1893, cast 1969.
Bronze relief, 55 × 94 inches
Markings: l. l. "Presented by the State of New York"
New York State Seal

PROVENANCE:
Division of Parks, Forestry and Recreation, State of New Jersey Department of Conservation and Economic Development, Trenton, 1969

EXHIBITIONS:
Whitney Museum of American Art, New York, September 22–November 21, 1970, *Thomas Eakins Retrospective Exhibition*, no. 109, ill. p. 67

REFERENCES:
Buki, Zoltan, and Corlette, Suzanne, eds. *The Trenton Battle Monument: Eakins Bronzes*, Trenton, New Jersey State Museum, Bulletin 14, 1973, pp. 43, 60

Miss Anna Lewis. c. 1898.
Oil on canvas, 33 × 28 inches
Signed l. r.: "T. E."

PROVENANCE:
Mrs. Thomas Eakins, Philadelphia; Lucy Lewis, Philadelphia; Mrs. Nolan Carter; Arthur J. Sussel, Philadelphia; M. Knoedler & Co., New York, 1957

EXHIBITIONS:
The Pennsylvania Museum of Art, Philadelphia, March 5–April 17, 1930, *An Exhibition of Thomas Eakins' Work*, no. 180
Fort Worth Art Center Museum, Texas, March 11–April 15, 1949, *Homer, Eakins, Ryder, Inness and Their French Contemporaries*, no. 24, plate 24
Whitney Museum of American Art, New York, September 22–November 21, 1970, *Thomas Eakins Retrospective Exhibition*, no. 65

REFERENCES:
Burroughs, Alan. "Catalogue of Work by Thomas Eakins (1869–1916)," *The Arts*, 5, June 1924, p. 330
Goodrich, Lloyd. *Thomas Eakins, His Life and Work*, New York, Whitney Museum of American Art, 1933, no. 300, p. 188
Hendricks, Gordon. *Thomas Eakins*, New York, Viking, 1974, no. 81, p. 323, ill.
Marceau, Henri Gabriel. "Catalogue of the Works of Thomas Eakins," *Pennsylvania Museum Bulletin*, 25, March 1930, no. 180, p. 26
Schendler, Sylvan. *Eakins*, Boston, Little, Brown, 1967, p. 145, plate 68

William Merritt Chase. c. 1899.
Oil on canvas, 24 × 20 inches
Inscribed on back: "To my friend William M. Chase, Thomas Eakins"

PROVENANCE:
The artist, Philadelphia; William Merritt Chase, New York; American Art Association, New York, May 15, 1917, Chase Collection, no. 190; Leroy Ireland, Philadelphia; John F. Braun, Merion, Pennsylvania; Macbeth Gallery, New York; Bartlett Arkell, Canajoharie, New York; Robert G. McIntyre, New York; Dr. C. J. Robertson; Hirschl & Adler Galleries, New York, 1959

EXHIBITIONS:
Carnegie Institute, Pittsburgh, November 2, 1899–January 1, 1900, *Fourth Annual Exhibition*, no. 77
The Pennsylvania Academy of the Fine Arts, Philadelphia, January 15–February 24, 1900, *The Sixty-Ninth Annual Exhibition*, no. 433
American Fine Arts Society, New York, March 28–May 3, 1903, *Twenty-Fifth Annual Exhibition of the Society of American Artists*, no. 140
The Metropolitan Museum of Art, New York, November 5–December 3, 1917, *Thomas Eakins Memorial Exhibition*, no. 55, ill.
The Pennsylvania Academy of the Fine Arts, Philadelphia, December 23, 1917–January 13, 1918, *Memorial Exhibition of the Works of the Late Thomas Eakins*, no. 75, ill. p. 47
The Pennsylvania Museum of Art, Philadelphia, May–September 1930, *Loan Exhibition of American Paintings from the Collection of John F. Braun*, no. 23
Grand Central Art Galleries, New York, April 1–15, 1932, *American Masterpieces of Painting Acquired by a Collector over a Period of 25 Years*
The Baltimore Museum of Art, December 1, 1936–

January 1, 1937, *Thomas Eakins Retrospective*, no. 29
Mount Holyoke College, South Hadley, Massachusetts, May–June 1938, *American Paintings from the Canajoharie Art Gallery*
Hirschl & Adler Galleries, New York, May 3–31, 1957, *18th–20th Century Americans*
Birmingham Museum of Art, Alabama, December 1–29, 1957, *The Philadelphia Tradition*, no. 14
Hirschl & Adler Galleries, New York, April 13–May 9, 1959, *The Portrait in American Art*, no. 33
National Gallery of Art, Washington, D.C., October 8–November 12, 1961, *Thomas Eakins: A Retrospective Exhibition*, no. 78, ill.; toured to The Art Institute of Chicago, December 1–January 7, 1962; Philadelphia Museum of Art, February 1–March 18
Greenwich Library, Connecticut, November 8–27, 1962, *American Painting from 1875 to 1925*
Forum Gallery, New York, January 8–30, 1965, *Artists by Artists*, no. 8
Milwaukee Art Center, September 15–October 23, 1966, *The Inner Circle*, no. 33, ill.
The Brooklyn Museum, New York, October 3–November 19, 1967, *The Triumph of Realism*, no. 84, ill. p. 165; toured to Virginia Museum of Fine Arts, Richmond, December 11–January 14, 1968; California Palace of the Legion of Honor, San Francisco, February 2–March 31
Whitney Museum of American Art, New York, September 22–November 21, 1970, *Thomas Eakins Retrospective Exhibition*, no. 75

REFERENCES:
Burroughs, Alan. "Catalogue of Work by Thomas Eakins (1869–1916)," *The Arts*, 5, June 1924, p. 332
———. "Thomas Eakins," *The Arts*, 3, March 1923, p. 186
du Bois, Guy Pène. "Current Exhibitions—American Masters Effectively Presented," *Arts Weekly*, 1, April 2, 1932, ill. p. 73
Goodrich, Lloyd. *Thomas Eakins, His Life and Work*, New York, Whitney Museum of American Art, 1933, no. 330, p. 190
Hendricks, Gordon. *Thomas Eakins*, New York, Viking, 1974, no. 84, p. 323
Hirschl & Adler Galleries, New York, *Antiques*, 7, November 1956, ill. p. 420 (adv.)
Marceau, Henri Gabriel. "Catalogue of the Works of Thomas Eakins," *Pennsylvania Museum Bulletin*, 25, March 1930, no. 197, p. 27
McHenry, Margaret. *Thomas Eakins Who Painted*, Oreland, Pennsylvania, privately printed, 1946, p. 109
Porter, Fairfield. "Reviews and Previews," *Art News*, 56, Summer 1957, p. 22, ill.
Schendler, Sylvan. *Eakins*, Boston, Little, Brown, 1967, pp. 174–75, plate 85
Unsigned. "The 'Golden Age' of Gentlemen Artists," *Art Digest*, 12, June 1, 1938, p. 7, ill.
Ziegler, Francis. "Eakins Memorial Exhibition in New York," *The Record*, Philadelphia, November 11, 1917

Mrs. Thomas Eakins. c. 1899.
Oil on canvas, 20 × 16 inches

PROVENANCE:
Mrs. Thomas Eakins, Philadelphia; Joseph Katz, Baltimore; M. Knoedler & Co., New York, 1961

EXHIBITIONS:
Philadelphia Museum of Art, April 8–May 14, 1944, *Thomas Eakins Centennial Exhibition, 1844–1944*, no. 89
M. Knoedler & Co., New York, June 5–July 31, 1944, *A Loan Exhibition of the Works of Thomas Eakins, 1844–1944*, no. 59, ill.; toured to Wilmington Society of the Fine Arts, Delaware Art Center, October 1–29; Doll & Richards Gallery, Boston, November 4–21; State Art Gallery, Raleigh, North Carolina, November 26–December 31
Carnegie Institute, Pittsburgh, April 26–June 1, 1945, *Thomas Eakins Centennial Exhibition 1844–1944*, no. 5
Fort Worth Art Center Museum, Texas, March 11–April 15, 1949, *Homer, Eakins, Ryder, Inness and Their French Contemporaries*, no. 25, plate 25
The Pennsylvania Academy of the Fine Arts, Philadelphia, January 15–March 13, 1955, *The One Hundred and Fiftieth Anniversary Exhibition*, no. 81, ill. p. 62
Carnegie Institute, Pittsburgh, October 18–December 1, 1957, *American Classics of the Nineteenth Century*, no. 64; toured to Munson-Williams-Proctor Institute, Utica, New York, January 5–26, 1958; Virginia Museum of Fine Arts, Richmond, February 14–March 16; The Baltimore Museum of Art, April 8–May 4; Currier Gallery of Art, Manchester, New Hampshire, May 22–June 25
Whitney Museum of American Art, New York, September 22–November 21, 1970, *Thomas Eakins Retrospective Exhibition*, no. 72, ill. p. 57
Smithsonian Institution, Washington, D.C., September 26, 1971–January 31, 1972, *One Hundred and Twenty-Fifth Anniversary of the Institution*

REFERENCES:
Baldinger, Wallace S. "The Art of Eakins, Homer and Ryder: A Social Revaluation," *The Art Quarterly*, Summer 1946, pp. 219, 225, ill.
Burroughs, Alan. "Catalogue of Work by Thomas Eakins (1869–1916)," *The Arts*, 5, June 1924, p. 330
Goodrich, Lloyd. *Thomas Eakins, His Life and Work*, New York, Whitney Museum of American Art, 1933, no. 325, p. 190
———. "Thomas Eakins Today," *Magazine of Art*, May 1944, p. 162, ill. 166
———, and Marceau, Henri Gabriel. "Thomas Eakins Centennial Exhibition," *Philadelphia Museum Bulletin*, 39, May 1944, no. 89, p. 135
Green, Samuel M. *American Art: A Historical Survey*, New York, Ronald, 1966, p. 410, ill. 5–57
Hamilton, George Heard. "Essays on Autumn Books: U.S. Art Begins to Get a Literature," *Art News*, 58, October 1959, p. 56
Hendricks, Gordon. *Thomas Eakins*, New York, Viking, 1974, no. 83, p. 323, colorplate
Kronenberger, Louis, ed. *Atlantic Brief Lives, a Biographic Companion to the Arts*, Boston, Little, Brown, 1971, p. 249

M. Knoedler & Co., New York, *Art News*, 43, June 1–30, 1944, ill. p. 3 (adv.)
Marceau, Henri Gabriel. "Catalogue of the Works of Thomas Eakins," *Pennsylvania Museum Bulletin*, 25, March 1930, no. 304, p. 31
McCaughey, Patrick. "Thomas Eakins and the Power of Seeing," *Artforum*, 9, December 1970, p. 61, ill. p. 59
McHenry, Margaret. *Thomas Eakins Who Painted*, Oreland, Pennsylvania, privately printed, 1946, pp. 59, 70
Moynihan, Rodrigo. "The Odd American," *Art News*, 69, January 1971, p. 51, ill. p. 52
Ormsbee, Thomas Hamilton. "Thomas Eakins, American Realist Painter," *American Collector*, 13, July 1944, ill. p. 7
Riley, Maude K. "Philadelphia Honors Thomas Eakins with Centennial Exhibition," *Art Digest*, 18, April 15, 1944, p. 20
Schendler, Sylvan. *Eakins*, Boston, Little, Brown, 1967, p. 172, plate 81
Unsigned. "The Camera Eye of Thomas Eakins," *Life*, 71, July 23, 1971, ill. p. 54

Mrs. Joseph H. Drexel. 1900.
Oil on canvas mounted on wood, 47 × 37 inches

PROVENANCE:
Mrs. Thomas Eakins, Philadelphia; Charles Bregler, Philadelphia; Joseph Katz, Baltimore; M. Knoedler & Co., New York, 1961

EXHIBITIONS:
Philadelphia Museum of Art, April 8–May 14, 1944, *Thomas Eakins Centennial Exhibition, 1844–1944*, no. 93
M. Knoedler & Co., New York, June 5–July 31, 1944, *A Loan Exhibition of the Works of Thomas Eakins, 1844–1944*, no. 60; toured to Wilmington Society of the Fine Arts, Delaware Art Center, October 1–29; Doll & Richards Gallery, Boston, November 4–21; State Art Gallery, Raleigh, North Carolina, November 26–December 31
Carnegie Institute, Pittsburgh, April 26–June 1, 1945, *Thomas Eakins Centennial Exhibition 1844–1944*, no. 62
Whitney Museum of American Art, New York, September 22–November 21, 1970, *Thomas Eakins Retrospective Exhibition*, no. 81

REFERENCES:
Goodrich, Lloyd. *Thomas Eakins, His Life and Work*, New York, Whitney Museum of American Art, 1933, no. 339, pp. 117–18, 191
———, and Marceau, Henri Gabriel. "Thomas Eakins Centennial Exhibition," *Philadelphia Museum Bulletin*, 39, May 1944, no. 93, p. 135
Hendricks, Gordon. *Thomas Eakins*, New York, Viking, 1974, no. 85, p. 323, colorplate

Robert C. Ogden. 1904.
Oil on canvas, 72 × 48 inches
Signed l. l.: "Eakins 1904"

PROVENANCE:
The artist, Philadelphia; Robert C. Ogden, New York; Mrs. Alexander Purves, Hampton, Virginia; The Milch Galleries, New York, 1959

EXHIBITIONS:
M. Knoedler & Co., New York, June 5–July 31, 1944, *A Loan Exhibition of the Works of Thomas Eakins, 1844–1944*, no. 69; toured to Wilmington Society of the Fine Arts, Delaware Art Center, October 1–29; Doll & Richards Gallery, Boston, November 4–21; State Art Gallery, Raleigh, North Carolina, November 26–December 31
Carnegie Institute, Pittsburgh, April 26–June 1, 1945, *Thomas Eakins Centennial Exhibition 1844–1944*, no. 71
The American Academy of Arts and Letters, New York, January 16–February 16, 1958, *Thomas Eakins, 1844–1916, Exhibition of Paintings and Sculpture*, no. 30
American Federation of Arts tour, 1962–65, *Paintings from the Joseph H. Hirshhorn Collection: A View of the Protean Century*, no. 23, ill. p. 9

REFERENCES:
Burroughs, Alan. "Catalogue of Work by Thomas Eakins (1869–1916)," *The Arts*, 5, June 1924, p. 332
Driscoll, Edgar J., Jr. "Contemporary Exhibition at Boston Museum," *The Boston Globe*, December 13, 1964
Genauer, Emily. "Impressive—75 Paintings Assembled by Hirshhorn," *New York Herald Tribune*, October 31, 1962, p. 15
Goodrich, Lloyd. *Thomas Eakins, His Life and Work*, New York, Whitney Museum of American Art, 1933, no. 394, p. 198
Hendricks, Gordon. *Thomas Eakins*, New York, Viking, 1974, no. 97, p. 324, ill.
Marceau, Henri Gabriel. "Catalogue of the Works of Thomas Eakins," *Pennsylvania Museum Bulletin*, 25, March 1930, no. 263, p. 30
Schendler, Sylvan. *Eakins*, Boston, Little, Brown, 1967, pp. 183, 188, plate 89

Robert Ogden (1836–1913), a member of the New York firm of John Wanamaker and Company, met Eakins through the artist's pupil Frank Wilbert Stokes. This portrait was painted in Stokes's New York studio beginning in January 1904. Ogden disliked the portrait, and attempted to return it to Eakins, who refused the offer.

A small preparatory oil sketch for the painting is also in The Hirshhorn Museum.

Frank B. A. Linton. 1904.
Oil on canvas, 24 × 20¼ inches
Signed u. l.: "Eakins/1904"
on back: To my pupil
Frank B. A. Linton
Thomas Eakins
1904

PROVENANCE:
The artist, Philadelphia; Frank B. A. Linton, Philadelphia; M. Knoedler & Co., New York; Joseph Katz, Baltimore; M. Knoedler & Co., 1961

EXHIBITIONS:
Babcock Galleries, New York, November 18–30, 1929, *Paintings by Thomas Eakins*, no. 10
M. Knoedler & Co., New York, June 5–July 31, 1944, *A Loan Exhibition of the Works of Thomas Eakins, 1844–1944*, no. 73, ill.; toured to Wilmington Society of the Fine Arts, Delaware Art Center, October 1–29; Doll & Richards Gallery, Boston, November 4–21; State Art Gallery, Raleigh, North Carolina, November 26–December 31
The American Academy of Arts and Letters, New York, January 16–February 16, 1958, *Thomas Eakins, 1844–1916, Exhibition of Paintings and Sculpture*, no. 43
Whitney Museum of American Art, New York, September 22–November 21, 1970, *Thomas Eakins Retrospective Exhibition*, no. 92

REFERENCES:
Burroughs, Alan. "Catalogue of Work by Thomas Eakins (1869–1916)," *The Arts*, 5, June 1924, p. 332
Goodrich, Lloyd. *Thomas Eakins, His Life and Work*, New York, Whitney Museum of American Art, 1933, no. 406, p. 199
———. "Thomas Eakins, Realist," *The Arts*, 16, October 1929, p. 78, ill.
Hendricks, Gordon. "The Belle with the Beautiful Bones," *Arts in Virginia*, Richmond, Virginia Museum of Fine Arts, 9, Fall 1968, ill. p. 36
———. *Thomas Eakins*, New York, Viking, 1974, no. 95, p. 324, ill.
Jacobs, Jay. "Collector: Joseph H. Hirshhorn," *Art in America*, 57, July–August 1969, colorplate p. 60
———. "Quality as Well as Quantity: Joseph H. Hirshhorn," in Lipman, Jean, ed. *The Collector in America*, New York, Viking, 1971, colorplate p. 87
Marceau, Henri Gabriel. "Catalogue of the Works of Thomas Eakins," *Pennsylvania Museum Bulletin*, 25, March 1930, no. 277, p. 30
McHenry, Margaret. *Thomas Eakins Who Painted*, Oreland, Pennsylvania, privately printed, 1946, p. 122
Schendler, Sylvan. *Eakins*, Boston, Little, Brown, 1967, p. 289, plate 149
Unsigned. "Exhibition in the New York Galleries: Thomas Eakins," *Art News*, 28, November 23, 1929, p. 12
Werrin, Nathaniel. "Letters: Frank B. A. Linton," *Art in America*, 58, March–April 1970, p. 21

Frank Benton Ashley Linton (1871–1943) studied with Eakins at The Art Students' League of Philadelphia, and later in Paris with Eakins's former teachers Jean-Léon Gérôme and Léon Bonnat, and with Benjamin Constant, Jean-Paul Laurens, and William-Adolphe Bouguereau at the Académie Julian. He became a successful portrait painter, exhibiting regularly at the Salon, and was appointed Officier de l'Académie after receiving a Bronze Medal in 1927.

This portrait was probably painted shortly after Linton returned from Paris

The Violinist. 1904.
Oil on canvas, 39¼ × 39½ inches

PROVENANCE:
Mrs. Thomas Eakins, Philadelphia, 1939; Babcock Galleries, New York, 1957

EXHIBITIONS:
The Pennsylvania Academy of the Fine Arts, Philadelphia, January 20–February 29, 1908, *One Hundred and Third Annual Exhibition*, no. 40
Brummer Gallery, New York, November 2–29, 1925, *Paintings and Drawings by Thomas Eakins*, no. 3
Albright Art Gallery, Buffalo, New York, April 16–May 9, 1926, *Paintings and Drawings by Thomas Eakins*, no. 3
Fifty-sixth Street Galleries, New York, January 17–February 1, 1931, *Paintings by Thomas Eakins, Sculpture by Samuel Murray*, no. 13
The Milch Galleries, New York, January 30–February 25, 1933, *Paintings by Thomas Eakins*, no. 10
Art Club Gallery, Philadelphia, October 17–November 15, 1936, *Paintings by Thomas Eakins, Charles Bregler, E. MacDowell, S. M. Eakins, Charles L. Fussell, David W. Jordan*, no. 39
The Baltimore Museum of Art, December 1, 1936–January 1, 1937, *Thomas Eakins Retrospective*, no. 38
Kleemann Galleries, New York, March 1–31, 1937, *Paintings by Thomas Eakins*, no. 12
Kleemann Galleries, New York, October 31–November 25, 1939, *Paintings by Thomas Eakins*, no. 9

REFERENCES:
Aarons, Leroy. "Sound the Hirshhorn! The Collection," *The Washington [D.C.] Post Potomac*, March 19, 1967, colorplate p. 17
Comstock, Helen. "Pictures by Eakins Seen at Brummer's," *Art News*, 24, November 7, 1925, p. 4
Flint, Ralph. "Milch Galleries Hold Interesting Eakins Exhibit," *Art News*, 31, February 4, 1933, p. 1
Goodrich, Lloyd. *Thomas Eakins, His Life and Work*, New York, Whitney Museum of American Art, 1933, no. 404, p. 199
Hendricks, Gordon. *Thomas Eakins*, New York, Viking, 1974, no. 93, p. 324, ill.
Marceau, Henri Gabriel. "Catalogue of the Works of Thomas Eakins," *Pennsylvania Museum Bulletin*, 25, March 1930, no. 269, p. 30
Porter, Fairfield. *Thomas Eakins*, New York, Braziller, 1959, ill. 71
Schendler, Sylvan. *Eakins*, Boston, Little, Brown, 1967, p. 296
Unsigned. "Eakins, American Realist, Revealed by Portraits of His Friends," *Art Digest*, 11, March 1, 1937, p. 11
———. "30 Canvases by Eakins in New York Show," *Art Digest*, 7, February 1, 1933, p. 9

In 1904, Hedda van der Beemt, a violinist with the Philadelphia Orchestra, and pianist Samuel Myers posed together for Eakins's *Music* (Albright-Knox Art Gallery, Buffalo, New York). Later that year Eakins began individual portraits of the two musicians. Since Mr. van der Beemt did not have enough time to pose for the

artist, his portrait—intended as a gift from Eakins—remained unfinished.

Dr. Edward Anthony Spitzka. c. 1913.
Oil on canvas, 30 × 25 inches

PROVENANCE:
Mrs. Thomas Eakins, Philadelphia; Joseph Katz, Baltimore; Babcock Galleries, New York, 1959

EXHIBITIONS:
The Baltimore Museum of Art, October 6–November 15, 1964, *1914*, no. 62, ill. p. 32
Whitney Museum of American Art, New York, September 22–November 21, 1970, *Thomas Eakins Retrospective Exhibition*, no. 103

REFERENCES:
Goodrich, Lloyd. *Thomas Eakins, His Life and Work*, New York, Whitney Museum of American Art, 1933, no. 474, p. 206
Hendricks, Gordon. *Thomas Eakins*, New York, Viking, 1974, no. 104, p. 324
Moynihan, Rodrigo. "The Odd American," *Art News*, 69, January 1971, p. 51, ill. p. 52
The Pennsylvania Academy of the Fine Arts. *Susan Macdowell Eakins*, Philadelphia, 1973, p. 24
Schendler, Sylvan. *Eakins*, Boston, Little, Brown, 1967, p. 238, plate 120

Dr. Edward Anthony Spitzka (1876–1922) was professor of anatomy and director of the Daniel Baugh Institute of Anatomy, Jefferson Medical College of Philadelphia. This portrait of Dr. Spitzka, begun about 1913, was Eakins's final painting. Mrs. Eakins, at her husband's request, may have completed portions of the canvas, which originally measured 84 × 43½ inches.

WILLIAM EDMONDSON (c. 1883–1951)

Born Nashville, Tennessee, c. 1883. Worked: Nashville, Chattanooga, and St. Louis Railroad, and shops, 1900–1907; as orderly, fireman, janitor, Women's Hospital, 1908–31. First limestone carvings, c. 1931–32; self-taught as a sculptor. One-man show, The Museum of Modern Art, New York, 1937. Included in "Trois Siècles d'Art aux États-Unis," Musée du Jeu de Paume, Paris, 1938. WPA, Sculpture Division, Nashville, 1939–41. One-man show, Nashville Museum of Art, Tennessee, 1941. Died Nashville, February 7, 1951. Retrospectives: Nashville Artists' Guild, 1951; Tennessee Fine Arts Center at Cheekwood, Nashville, 1964. Included in Stony Point Folk Art Gallery exhibition, Willard Gallery, New York, 1971.

Mary and Martha. 1930s.
Limestone, 13¾ × 16¾ × 5¼ inches

PROVENANCE:
Robert Schoelkopf, New York, and Galerie Osten-Kaschey, New York; Shepherd Gallery, New York, 1968

EXHIBITIONS:
Great Hall, City College, The City University of New York (in cooperation with the Harlem Cultural Council, and The New York Urban League), November 8, 1967, *The Evolution of Afro-American Artists: 1800–1950*, p. 66, ill. p. 40

REFERENCES:
Fuller, Edmund L. *Visions in Stone: The Sculpture of William Edmondson*, University of Pittsburgh, 1973, ill. 29

LOUIS EILSHEMIUS (1864–1941)

Louis Michel Eilshemius, born Arlington, near Newark, New Jersey, February 4, 1864. Studied: with Jacques Mattias Schenker, Dresden; Cornell University, Ithaca, New York, 1882–84; The Art Students League of New York, with Kenyon Cox, and privately, with Robert L. Minor, 1884–86; Académie Julian, Paris, with William-Adolphe Bouguereau, and privately, with Josef van Luppen, summers, 1886, 1887. Included in: National Academy of Design Annual, 1887, 1888; Pennsylvania Academy Annual, 1890, 1891. Traveled: Europe, and North Africa, 1892–94; Samoa, and the South Seas, 1901. Privately published his own essays, poems, and manifestos, including: *Songs of Spring and Blossoms*, 1895; *Mystery and Truth*, 1907; *Thoughts at Nighttime*, 1909; *My Brother Victor*, 1912; *Creation's End*, 1925. One-man shows, New York: framemaker's shop, 1897; his own studios, 1909, 1914–17. First published *The Art Reformer*, 1909. "Discovered" by Marcel Duchamp, at Society of Independent Artists Annual, 1917. Exhibited, with Independents, and at Salons of America, New York, 1917–21. One-man shows: Société Anonyme, New York, 1920, 1924; F. Valentine Dudensing, New York, 1926; Durand-Ruel & Cie. Paris, 1932; Morton Galleries, New York, 1932; Valentine Gallery, New York, 1932, 1943–46; Crillon Galleries, Philadelphia, 1933; Gallery 144, New York, 1933. Stopped painting, 1921. Exhibited with Société Anonyme: Worcester Art Museum, Massachusetts, 1921; MacDowell Club, New York, 1922; The Brooklyn Museum, New York, 1926. Included in: Whitney Biennial, 1934–35; "Modern Works of Art," and "Art in Our Time," The Museum of Modern Art, New York, 1934–35, 1939; "Trois Siècles d'Art aux États-Unis," Musée du Jeu de Paume, Paris, 1938. One-man shows: Boyer Galleries, New York, 1937, 1938; Kleemann Galleries, New York, 1937, 1939; Ferargil Galleries, New York, 1939; Willard Straight Hall, Cornell University, 1940; Newark State College, Union, New Jersey, 1940; Symphony Hall, Boston, 1940. Died New York, December 29, 1941. Memorial exhibitions: Durand-Ruel Galleries, New York, 1942; Lyman Allyn Museum, New London, Connecticut, 1943.

Figure Seated. 1890.
Oil on canvas, 16 × 12 inches
Signed and dated l. r.: "Eilshemius/1890"

PROVENANCE:
Kleemann Galleries, New York, 1940

EXHIBITIONS:
Kleemann Galleries, New York, October 1937, *All of*

Eilshemius, no. 7, cover ill.
Kleemann Galleries, New York, October 1939, *Eilshemius Paintings and Watercolors*, no. 18
The Artists' Gallery, New York, February 1959, *Masterpieces of Eilshemius*, no. 3, ill.
The Phillips Collection, Washington, D.C., May–June 1959, *Masterpieces of Eilshemius*

REFERENCES:
Devree, Howard. "All of Eilshemius," *Magazine of Art*, 30, October 1937, p. 610
Farber, Manny. "Eilshemius: Artist Behind Mahatma," *Art News*, 58, April 1959, p. 5
Karlstrom, Paul J. *Louis M. Eilshemius, 1864–1941*, Ph.D. dissertation, University of California at Los Angeles, 1973
Lane, James. "Eilshemius: The Late Recognition of a Pioneer of American Painting," *Art News*, 36, October 9, 1937, p. 17
Schack, William. *And He Sat Among the Ashes*, New York, American Artists Group, 1939, p. 66, ill. p. 60
Unsigned. "Dramaticism, Lyricism and Eilshemius," *Art Digest*, 12, October 1, 1937, p. 9

Mother Bereft. c. 1890.
Oil on canvas, 20½ × 14½ inches
Signed l. r.: "Elshemus"

PROVENANCE:
Kleemann Galleries, New York, 1958

EXHIBITIONS:
Kleemann Galleries, New York, October 1937, *All of Eilshemius*, no. 4
Kleemann Galleries, New York, February 6–28, 1950, *Louis M. Eilshemius*, no. 10
The Artists' Gallery, New York, February 1959, *Masterpieces of Eilshemius*, no. 2, ill.
American Federation of Arts tour, 1962–65, *Paintings from the Joseph H. Hirshhorn Foundation Collection: A View of the Protean Century*, no. 24

REFERENCES:
Coates, Robert M. "The Art Galleries: Eilshemius and Duchamp," *The New Yorker*, 35, April 18, 1959, p. 151
Devree, Howard. "All of Eilshemius," *Magazine of Art*, 30, October 1937, ill. p. 606
Farber, Manny. "Eilshemius: Artist Behind Mahatma," *Art News*, 58, April 1959, p. 5, colorplate cover
Karlstrom, Paul J. *Louis M. Eilshemius, 1864–1941*, Ph.D. dissertation, University of California at Los Angeles, 1973
Kleemann Galleries, New York, *Art Digest*, 12, October 1, 1937, ill. back cover (adv.)
Schack, William. *And He Sat Among the Ashes*, New York, American Artists Group, 1939, p. 66
Unsigned. "Dramaticism, Lyricism and Eilshemius," *Art Digest*, 12, October 1, 1937, p. 9
Watson, Forbes. *American Painting Today*, Washington, D.C., American Federation of Arts, 1939, ill. p. 63

Mountain Stream (Three Nudes at a Mountain Creek). 1900.
Oil on canvas, 27½ × 19¼ inches
Signed and dated l. r.: "Elshemus 1900"

PROVENANCE:
Kleemann Galleries, New York, 1958

EXHIBITIONS:
Kleemann Galleries, New York, October 1937, *All of Eilshemius*, no. 17
Kleemann Galleries, New York, October 1939, *Eilshemius Paintings and Watercolors*, no. 21
Kleemann Galleries, New York, February 6–28, 1950, *Louis M. Eilshemius*, no. 5

REFERENCES:
Breuning, Margaret. "Eilshemius Said It Better," *Art Digest*, 24, February 1, 1950, p. 12, ill.
Devree, Howard. "All of Eilshemius," *Magazine of Art*, 30, October 1937, ill. p. 609
Karlstrom, Paul J. *Louis M. Eilshemius, 1864–1941*, Ph.D. dissertation, University of California at Los Angeles, 1973
Schack, William. *And He Sat Among the Ashes*, New York, American Artists Group, 1939, ill. p. 80

Fairy Tale. 1901.
Oil on canvas, 14½ × 20½ inches
Signed and dated l. l.: "Elshemus/01"

PROVENANCE:
Ferargil Galleries, New York, c. 1940

EXHIBITIONS:
American Federation of Arts tour, 1962–65, *Paintings from the Joseph H. Hirshhorn Foundation Collection: A View of the Protean Century*, no. 25, ill.

REFERENCES:
Karlstrom, Paul J. *Louis M. Eilshemius, 1864–1941*, Ph.D. dissertation, University of California at Los Angeles, 1973

East Side, New York. c. 1908.
Oil on board, 15 × 13¼ inches
Signed l. l.: "Elshemus"

PROVENANCE:
Stanley N. Barbee, Los Angeles; Parke-Bernet Galleries, New York, Sale 1927, November 11, 1959, no. 62; Stanley N. Barbee; Parke-Bernet Galleries, Sale 2024, March 23, 1961, no. 75, ill. p. 23

EXHIBITIONS:
Balin-Traube Gallery, New York, March 5–30, 1963, *Louis M. Eilshemius*
The Jewish Museum, New York, September 21–November 6, 1966, and April 4–July 2, 1967, *The Lower East Side: Portal to American Life (1870–1924)*, no. 11; toured to Arts and Industries Building, Smithsonian Institution, Washington, D.C. (sponsored by the Jewish Social Service Agency), December 17–January 18, 1968

REFERENCES:
Jacobs, Jay. "Collector: Joseph H. Hirshhorn," *Art in America*, 57, July–August 1969, colorplate p. 61

——. "Quality as Well as Quantity: Joseph H. Hirshhorn," in Lipman, Jean, ed. *The Collector in America,* New York, Viking, 1971, colorplate p. 86
Karlstrom, Paul J. *Louis M. Eilshemius, 1864–1941,* Ph.D. dissertation, University of California at Los Angeles, 1973
Rose, Barbara. "New York Letter," *Art International,* 7, April 25, 1963, p. 60

Gas Tanks at End of 23rd Street, New York. 1909.
Oil on board, 16¾ × 24½ inches
Signed and dated l. l.: "Elshemus 1909"

PROVENANCE:
James Graham and Sons, New York, 1963

REFERENCES:
Karlstrom, Paul J. *Louis M. Eilshemius, 1864–1941,* Ph.D. dissertation, University of California at Los Angeles, 1973

Coney Island. c. 1909.
Oil on paper mounted on Masonite, 13½ × 21½ inches
Signed l. r.: "Elshemus"

PROVENANCE:
Ferargil Galleries, New York, 1939; Parke-Bernet Galleries, New York, Sale 835, February 6, 1947, no. 33, ill.

EXHIBITIONS:
Ferargil Galleries, New York, February 13–25, 1939, *Pre-War Paintings by Eilshemius*
Ferargil Galleries, New York, July 5–September 1, 1944, *Summer 1944*

REFERENCES:
Karlstrom, Paul J. *Louis M. Eilshemius, 1864–1941,* Ph.D. dissertation, University of California at Los Angeles, 1973
Lowe, Jeannette. "Eilshemius, Manning: Landscapes," *Art News,* 37, February 18, 1939, p. 15
Riley, Maude K. "American Group," *The Art Digest,* 18, August 1, 1944, p. 11

The Flood. c. 1910–11.
Oil on cardboard, 17¾ × 21⅞ inches
Signed l. r.: "Elshemus"

PROVENANCE:
Ferargil Galleries, New York, 1939

EXHIBITIONS:
Marlborough-Gerson Gallery, New York, September 27–October 14, 1967, *The New York Painter, A Century of Teaching: Morse to Hofmann,* p. 86, ill. p. 37
Sidney Janis Gallery, New York, March 11–April 4, 1970, *The High Kitsch of Eilshemius,* no. 12, ill.

Statue of Liberty. c. 1913.
Oil on Masonite, 13¾ × 10 inches
Signed l. l.: "Eilshemius"

PROVENANCE:
The artist, New York, c. 1940

ROBERT ENGMAN (b. 1927)

Born Belmont, Massachusetts, April 29, 1927. Studied: Rhode Island School of Design, Providence, 1948–52; Yale University, New Haven, Connecticut, 1952–54. Taught, Yale, 1954–63. Included in: Boston Arts Festival, 1957–61; "Recent Sculpture, USA," The Museum of Modern Art, New York, and tour, 1959–60; VI São Paulo Bienal, 1961; Whitney Annual, 1962–68; "Retinal Art," University of Texas at Austin, 1965. One-man shows, Stable Gallery, New York, 1960, 1962, 1965. Received Morse Fellowship, University of Pennsylvania, Philadelphia, 1963–64. One-man shows: Massachusetts Institute of Technology, Cambridge, 1966; Kanegis Gallery, Boston, 1967; Hathorn Gallery, Skidmore College, Saratoga Springs, New York, 1968; John Bernard Myers Gallery, New York, 1972. Member, Commission of Fine Arts, Philadelphia, 1968–72. Has taught, University of Pennsylvania, since 1963. Lives in Haverford, Pennsylvania.

Untitled. 1969.
Bronze, 59½ × 59½ × 59½ inches
Markings: front rim "Engman 1.10.69 For Joe Hirshhorn"

PROVENANCE:
The artist, Haverford, Pennsylvania, 1969

SIR JACOB EPSTEIN (1880–1959)

Jacob Epstein, born New York, November 10, 1880. Studied, The Art Students League of New York, with James Carroll Beckwith, and George Grey Barnard, intermittently, 1893–1902. Worked in bronze foundry, New York, c. 1899–1900. Illustrated Hutchins Hapgood's *The Spirit of the Ghetto* (New York, Funk & Wagnalls), 1902. Lived in Paris, 1902–5; studied: École des Beaux-Arts, 1903; Académie Julian, 1904. Moved to London, 1905; British citizen, 1907. Commissions: *The Strand Sculptures,* British Medical Association Building, London, 1907 (destroyed 1937); Oscar Wilde monument, Cimetière du Père-Lachaise, Paris, 1909, installed, 1912. Met Constantin Brancusi, Pablo Picasso, Amedeo Modigliani, Paris, 1912. Group exhibitions, London: "Post Impressionists and Futurists," Doré Gallery, 1913; "Twentieth Century Art," Whitechapel Art Gallery, 1914; "The London Group," Goupil Gallery, 1914, 1915. Published two drawings in Wyndham Lewis's Vorticist magazine, *Blast* (London), 1914. Served, British Armed Services, 1916–17. One-man shows: The Leicester Galleries, London, 1917–33, and from 1938; Ferargil Galleries, New York, 1927; Arthur Tooth & Sons, London, 1933–38. Visited New York, 1927; made portraits of Franz Boas, John Dewey, Paul Robeson. Commission, *Day* and *Night,* Underground Headquarters Building, London, 1928. Other portraits: Albert Einstein, 1933; George Bernard Shaw, 1934; Sir Winston Churchill, 1946; Pandit Jawaharlal Nehru, 1949; T. S. Eliot, 1951; Lord Bertrand Russell, 1953. Published autobiography, *Let There Be Sculpture* (New York, G. P. Putnam's Sons), 1940; reissued as *Epstein, An Autobiography* (New York, Dutton), 1955. Sculpture

commissions: *Madonna and Child,* Convent of the Holy Child Jesus, London, 1950; *Social Consciousness,* Fairmount Park Trust, Philadelphia (for Philadelphia Museum of Art), 1951; *Portrait of William Blake,* Westminster Abbey, London, 1956; *St. Michael and the Devil,* Coventry Cathedral, England, 1958. Retrospective, The Tate Gallery, London, 1952. Made Knight Commander of the Order of the British Empire, 1954. Died London, August 19, 1959. Memorial retrospectives: The Leicester Galleries, 1960; Edinburgh Festival Society, Scotland, 1961.

First Marble Doves (Second Group of Birds). 1914.
Marble, 13¾ × 19½ × 7¼ inches

PROVENANCE:
Mrs. Ethel Steyn, Little Common, England; Sir Robert Sainsbury, London; Sotheby & Co., London, Sale, April 15, 1964, no. 98, ill.

REFERENCES:
Black, Robert. *The Art of Jacob Epstein,* Cleveland, and New York, World, 1942, no. 33, p. 229
Buckle, Richard. *Jacob Epstein, Sculptor,* Cleveland, and New York, World, 1963, p. 78, ill.
Haskell, Arnold L., and Epstein, Jacob. *The Sculptor Speaks, A Series of Conversations on Art,* London, William Heinemann, 1931, p. 170

The Duchess of Hamilton. 1915.
Bronze, 25½ × 20½ × 10¾ inches

PROVENANCE:
The artist, London; John Quinn, New York, 1927; American Art Association, New York, Sale, February 12, 1927, *Quinn Collection,* no. 713, ill.; Stevenson Scott, New York, 1933; The Toledo Museum of Art, Ohio, 1937; Scott & Fowles Art Galleries, New York; Parke-Bernet Galleries, New York, Sale, March 28, 1946, no. 99A; Peter Tretyakov, New York, 1969

EXHIBITIONS:
The Toledo Museum of Art, Ohio, 1933–1937, *Museum Collection*

REFERENCES:
Black, Robert. *The Art of Jacob Epstein,* Cleveland, and New York, World, 1942, no. 36, p. 230, plate 66
Reid, B. L. *The Man from New York: John Quinn and His Friends,* New York, Oxford, 1968, pp. 303, 617
Unsigned. "Honor the Giver," *Art News,* 31, January 28, 1933, p. 8, ill.
——. *John Quinn 1870–1925, Collection of Paintings, Watercolors, Drawings and Sculpture,* Huntington, New York, Pidgeon Hill, 1926, p. 28
——. "New Accessions—Toledo," *American Magazine of Art,* 26, March 1933, p. 149, ill.

Nina Mary Benita (1878–1951), a friend and patron of the artist, was married in 1901 to Alfred Douglas, the thirteenth Duke of Hamilton. She became chairman of The Society for Anti-Vivisection in England, and Grace of the Order of St. John of Jerusalem.

Joseph Conrad. 1924.
Bronze, 16¼ × 11¾ × 10 inches
Markings: back l. l. "Epstein"

PROVENANCE:
The Leicester Galleries, London; M. Knoedler & Co., New York, 1958

EXHIBITIONS:
The Detroit Institute of Arts, and tour, 1959–60, *Sculpture in Our Time,* no. 71, ill. p. 37
The Solomon R. Guggenheim Museum, New York, October 3, 1962–January 6, 1963, *Modern Sculpture from the Joseph H. Hirshhorn Collection,* no. 146, ill. p. 142
American Federation of Arts Gallery, New York, April 29–May 18, 1963, *The Educational Alliance Art School Retrospective Art Exhibit,* ill.

REFERENCES:
Feldman, Edmund Burke. *Art as Image and Idea,* Englewood Cliffs, New Jersey, Prentice-Hall, 1967, ill. p. 158
——. *Varieties of Visual Experience,* New York, Abrams, 1972, p. 149, ill.
Hale, William Harlan. *The World of Rodin: 1840–1917,* New York, Time-Life Books, 1969, p. 176, ill. p. 177
Scott, Gail. "Jacob Epstein," *Encyclopedia Americana,* New York, 1972, 10, ill. p. 526

Epstein's portrait of Joseph Conrad (1857–1924) was completed in the last year of the novelist's life. Epstein wrote that his "admiration for Conrad was immense . . . and he had a head that appealed to a sculptor, massive and fine at the same time."

Epstein, Jacob. *Epstein, An Autobiography,* New York, Dutton, 1963, p. 73

The Visitation. 1926, cast 1955.
Bronze, 66 × 19 × 17½ inches
Markings: back l. c. "Epstein"

PROVENANCE:
The artist, London, 1955

EXHIBITIONS:
The Detroit Institute of Arts, and tour, 1959–60, *Sculpture in Our Time,* no. 72, ill. p. 38
The Solomon R. Guggenheim Museum, New York, October 3, 1962–January 6, 1963, *Modern Sculpture from the Joseph H. Hirshhorn Collection,* no. 147, ill. p. 143

REFERENCES:
Arnason, H. Harvard. *History of Modern Art,* New York, Abrams, 1968, p. 514, ill. p. 515
Getlein, Frank, and Getlein, Dorothy. *Christianity in Modern Art,* Milwaukee, Bruce, 1961, p. 139, ill. p. 138
Jacobs, Jay. "Collector: Joseph H. Hirshhorn," *Art in America,* 57, July–August 1969, ill. p. 56
——. "Quality as Well as Quantity: Joseph H. Hirshhorn," in Lipman, Jean, ed. *The Collector in America,* New York, Viking, 1971, colorplate p. 82

Mastai, Marie Louise D'Otrange. "The Connoisseur in America," *Connoisseur,* 151, December 1962, p. 271
Mates, Robert E. *Photographing Art,* New York, Amphoto, 1966, ill. p. 100
——. "Photographing Sculpture and Museum Exhibits," *Curator,* 10, June 1967, ill. p. 98
Sontag, Raymond J. *A Broken World 1919–1939,* New York, Harper & Row, 1971, no. 19, ill. following p. 138, and jacket
Sweeney, James Johnson. "A Living Frame for Sculpture," *House & Garden,* 126, August 1964, ill. p. 115
Unsigned. "Range of Hirshhorn Collection," *The Times,* London, July 3, 1964, ill.

JIMMY ERNST (b. 1920)

Born Cologne, June 24, 1920. Son of painter and sculptor Max Ernst. Emigrated to New York, 1938; U.S. citizen, 1951. Began painting, 1940. One-man shows, New York: Norlyst Gallery, 1943–46; Laurel Gallery, 1948–50; Grace Borgenicht Gallery, from 1951. Received Steves Memorial Award Purchase Prize, First Annual Pasadena National, 1946. Included in: Whitney Annual, 1949–51, 1953–59, 1961, 1963, 1965, 1969, 1972; "Young American Painters," The Solomon R. Guggenheim Museum, New York, 1954; "100 Years of American Painting," The Metropolitan Museum of Art, New York, 1954. Taught, Brooklyn, New York: Pratt Institute, 1950–51; Brooklyn College, from 1953. One-man show, Walker Art Center, Minneapolis, 1954. Received: Harris Prize, 57th Annual American Exhibition, The Art Institute of Chicago, 1954; Brandeis Creative Arts Award Citation, 1957. Included in: "Young American Painters," Whitney Museum of American Art, New York, 1955; Venice Biennale, 1956; "American Abstract Expressionists and Imagists," The Solomon R. Guggenheim Museum, 1961; Whitney Biennial, 1973. Received mural commission, The Continental National Bank, Lincoln, Nebraska, 1959. Awarded Guggenheim Foundation Fellowship, 1961; toured Soviet Union on American Specialists Abroad Grant, U.S. State Department, 1961. One-man shows: Kunstverein, Cologne, 1963; The Detroit Institute of Arts, 1963; The Arts Club of Chicago, 1968; Galerie Lucie Weill, Paris, 1972. Lives in East Hampton, New York.

Papageno. 1960.
Oil on canvas, 54 × 72 inches
Signed and dated: l. r. "Jimmy Ernst 60"
back "Jimmy Ernst 1960 Papageno"

PROVENANCE:
Grace Borgenicht Gallery, New York, 1962

EXHIBITIONS:
The Detroit Institute of Arts, December 10, 1963–January 5, 1964, *The Art of Jimmy Ernst,* no. 47, pp. 14, 15
The Aldrich Museum of Contemporary Art, Ridgefield, Connecticut, April 17–June 26, 1966, *Brandeis University Creative Arts Awards 1957–1966,* no. 5

MAX ERNST (b. 1891)

Born Brühl, near Cologne, April 2, 1891. Studied, Universität, Bonn, 1909–12. Self-taught as an artist. Included in: Das Junge Rheinland exhibition, Bonn, and Cologne, 1912–13; Erster Deutscher Herbstsalon, Galerie der Sturm, Berlin, 1913. Met Jean Arp, who became lifelong friend, Cologne, 1914. Served, German Army, 1914–18. One-man show, Galerie der Sturm, 1916. Co-founded Cologne Dada group, 1919–20; participated in "Dada-Vorfrühling," Brauhaus Winter, Cologne, 1920; co-edited review *Die Schammade,* 1920–21. One-man show, Galerie Sans Pareil, Paris, 1921. Moved to Paris, 1922. Included in "Exposition, La Peinture Surréaliste," Galerie Pierre, Paris, 1925. With Joan Miró, designed set for *Romeo et Juliette,* Sergei Diaghilev's Ballets Russes de Monte Carlo, Paris, 1926. One-man shows: Galerie Le Centaure, Brussels, 1926–27; Galerie Bernheim-Jeune, Paris, 1928; Galerie Alfred Flechtheim, Berlin, 1928; Julien Levy Gallery, New York, 1931; Galerie Pierre, 1932; Galerie Cahiers d'Art, Paris, 1934. Included in: "Newer Super-Realism," Wadsworth Atheneum, Hartford, Connecticut, 1931; "Fantastic Art, Dada, Surrealism," The Museum of Modern Art, New York, 1936–37. Interned as enemy alien, France, 1939–40. Emigrated to New York, 1941. Group exhibitions, New York, 1942: "Artists in Exile," Pierre Matisse Gallery; "First Papers of Surrealism," 451 Madison Avenue. One-man show, Galerie Denise René, Paris, 1945. Moved to Arizona, 1946. Included in: "Exposition Internationale du Surréalisme," Galerie Maeght, Paris, 1947; I São Paulo Bienal, 1951; Venice Biennale (Grand Prize for Painting), 1954; Documenta I–III, Kassel, 1955, 1959, 1964. Retrospectives: Palace of the Archbishop of Cologne, Brühl, 1951; Kunsthalle, Bern, 1956; Musée National d'Art Moderne, Paris, 1959. Returned to Paris, 1953; French citizen, 1958. Awarded: Grand Prix National des Arts, 1959; Stefan Lochner Medal, City of Cologne, 1961. Retrospectives: The Museum of Modern Art, and The Art Institute of Chicago, 1961; Le Point Cardinal (sculpture), Paris, 1961; The Tate Gallery, London, and Wallraf-Richartz-Museum, Cologne, 1962; Kunsthaus, Zurich, 1963; Kunsthalle, Hamburg, and tour (graphics), 1964; Moderna Museet, Stockholm, and tour, 1969–70; tour organized by Institute for the Arts, Rice University, Houston, 1970–73. Officier, Légion d'honneur, 1966. Lives in Seillans, France.

The Sun and the Sea (Le Soleil et la mer). c. 1926–29.
Oil paint on glass, 21½ × 17¼ inches
Signed l. r.: "Max Ernst"

PROVENANCE:
The artist, Paris; Mrs. Wagner, Paris; Dr. Wagner, Paris; Georges Martin du Nord, Paris; Sotheby & Co., London, Sale, April 26, 1967, no. 74, ill.

Moonmad. 1944.
Bronze (edition of six), 36½ × 11½ × 12 inches

PROVENANCE:
Constantin Xenakis, Athens; Alexandre Iolas Gallery, New York; Harold Diamond, New York, 1961

690

EXHIBITIONS:
Galerie Chalette, New York, October 16–November 29, 1958, *Sculpture by Painters*, cat.
The Solomon R. Guggenheim Museum, New York, October 3, 1962–January 6, 1963, *Modern Sculpture from the Joseph H. Hirshhorn Collection*, no. 150, ill. p. 118
Dallas Museum of Fine Arts, May 12–June 13, 1965, *Sculpture Twentieth Century*, no. 24

REFERENCES:
Read, Herbert. *A Concise History of Modern Sculpture*, New York, Praeger, 1964, no. 144, p. 292, ill. p. 146

Moonmad evolved from a series of chess pieces Ernst made for art dealer Julien Levy in the summer of 1944.

The Table is Set (Table mise). 1944.
Bronze (edition of nine), 12 × 23½ × 21¼ inches

PROVENANCE:
The artist; Jeanne Reynal, New York; Harold Diamond, New York, 1966

REFERENCES:
Read, Herbert. *A Concise History of Modern Sculpture*, New York, Praeger, 1964, no. 143, p. 292, ill. p. 145

The Parisian Woman (La Parisienne). 1950.
Bronze, 31½ × 7¼ × 5¼ inches
Markings: back l. r. "Max Ernst
Susse Fondeur Paris 9/9"

PROVENANCE:
David Talbot Rice, Edinburgh; Sotheby & Co., London, Sale, July 1, 1964, no. 116, ill.

Daughter and Mother (Fille et mère). 1959.
Bronze, 17⅛ × 10⅛ × 11⅛ inches
Markings: l. l. "Max Ernst
IV/VI A. Valsuani Cire Perdue"

PROVENANCE:
Galerie Chalette, New York, 1961

EXHIBITIONS:
The Museum of Modern Art, New York, March 1–May 7, 1961, *Max Ernst*, no. 168, ill. p. 23; toured to The Art Institute of Chicago, June 16–July 23
The Solomon R. Guggenheim Museum, New York, October 3, 1962–January 6, 1963, *Modern Sculpture from the Joseph H. Hirshhorn Collection*, no. 151, ill. p. 119

REFERENCES:
Marchiori, Giuseppe. "Il dopoguerra in Europa: la scultura," *L'Arte Moderna* (Milan), 12, no. 104, 1967, ill. p. 199
Spies, Werner. *Die Rückkehr der schönen Gärtner in: Max Ernst 1950–1970*, Cologne, DuMont Schauberg, 1971, ill. a, p. 129

Belle of the Night (Belle de nuit). 1954.
Oil on canvas, 51 × 35 inches
Signed and dated l. r.: "Max Ernst '54"

PROVENANCE:
The artist; Inocente Palacios, Caracas; Harold Diamond, New York, 1967

REFERENCES:
Diehl, Gaston. *El Arte Moderno Francés en Caracas*, Instituto Venezolano-Francés, 1959, ill. p. 13

Under the Bridges of Paris (Sous les Ponts de Paris). 1961.
Bronze, 58⅝ × 10⅞ × 10⅞ inches
Markings: l. r. side "Max Ernst
Susse Fondeur Paris III/III"

PROVENANCE:
Le Point Cardinal, Paris, 1964

EXHIBITIONS:
Musée Grimaldi, Antibes, France, August–September 1964, *Max Ernst: Sculptures et Masques*, no. 16, ill.

SOREL ETROG (b. 1933)

Born Jassy, Rumania, August 29, 1933. Emigrated to Israel, 1950. Served, Israeli Army, 1953. Studied, Institute of Painting and Sculpture, Tel Aviv, evenings, 1953–55. Joined artists' community, Ein Hod, near Haifa, 1955. One-man show, Z.O.A. House, Tel Aviv, 1958. Included in "Ten Years of Israel Art," Israel Museum, Jerusalem, and tour, 1958. Received scholarship to The Brooklyn Museum Art School, New York, 1958. Lived in New York, 1958–61; moved to Toronto, 1961. One-man shows: Gallery Moos, Toronto, 1959–67; Dominion Gallery, Montreal, 1963, 1967; Rose Fried Gallery, New York, 1963, 1969; Pierre Matisse Gallery, New York, 1965; Felix Landau Gallery, Los Angeles, 1965, 1969; Galleria Pagani, Milan, 1966; Galerie Springer, Berlin, 1967; Dartmouth College, Hanover, New Hampshire, 1967; Galerie Schneider, Rome, 1967. Sculpture commissions: Los Angeles County Museum of Art, 1964; Canadian Pavilion, and Corporation of Expo, Expo '67, Montreal, 1967. Included in: Pittsburgh International, 1964, 1967; Venice Biennale, 1966. Retrospectives: Palazzo Strozzi, Florence, 1968; Art Gallery of Ontario, Toronto, and tour, 1968–69. One-man shows: Staempfli Gallery, New York, 1969, 1972; The Hanover Gallery, London, 1970; Dunkelman Gallery, Toronto, 1970–72; Marion Koogler McNay Art Institute, San Antonio, Texas, 1971. Lives in Toronto.

Mother and Child. 1962–64.
Bronze, 9 feet 4 inches × 3 feet 4¼ inches × 3 feet 2 inches
Markings: back l. l. top of base "ETROG 2/5"

PROVENANCE:
Pierre Matisse Gallery, New York, 1965

EXHIBITIONS:
Pierre Matisse Gallery, New York, February 16–March 13, 1965, *Sculpture by Sorel Etrog*, no. 30, ill.

The Source. 1964.
Bronze, 35½ × 79 × 28½ inches
Markings: back l. r. top of base "ETROG 1/5"

PROVENANCE:
The artist, Toronto, 1964

EXHIBITIONS:
Pierre Matisse Gallery, New York, February 16–March 13, 1965, *Sculpture by Sorel Etrog*, no. 24, ill.

REFERENCES:
Judd, Donald. "New York Letter: Etrog," *Art International*, 9, April 1965, ill. p. 76

PHILIP EVERGOOD (1901–1973)

Philip Howard Francis Dixon Blashki, born New York, October 26, 1901; son of painter Meyer Evergood Blashki. Lived in England, 1909–23. Studied: University of Cambridge, England, 1918–20; Slade School of Fine Art, University College, London, 1920–23; The Art Students League of New York, with William Von Schlegell, and George Luks, and Educational Alliance Art School, New York, evenings, 1923; Académie Julian, Paris, with Jean-Paul Laurens, and André Lhote, 1924; S. W. Hayter's Atelier 17, Paris, 1930. Included in: National Academy of Design Annual, 1924, 1927; Salon d'Automne, Paris, 1925; "Murals by American Painters and Photographers," and "New Horizons in American Art," The Museum of Modern Art, New York, 1932, 1936; Whitney Annual, 1934–65; 46th American Exhibition, The Art Institute of Chicago, 1935 (Kohnstamm Prize). One-man shows, New York: Dudensing Galleries, 1927; Montross Gallery, 1929, 1933, 1935. Public Works of Art Project, New York, 1934. WPA Federal Art Project, New York, Mural Division, 1935–38; commission, *The Story of Richmond Hill*, New York Public Library, Richmond Hill Branch, 1937; managing supervisor, Easel Division, 1938–39. U.S. Treasury Department, Section of Fine Arts, mural commission, U.S. Post Office, Jackson, Georgia, 1938. One-man shows, ACA Gallery, New York, 1938–62. Included in: Carnegie International, 1938, 1939; "Portrait of America (Artists for Victory, Inc.)," The Metropolitan Museum of Art, New York, 1942, 1944 (Pepsi-Cola 2nd Prize); Carnegie Annual, 1943–50 (honorable mention, 1945; second prize, 1950); "Franco-American Competition," Institute of Contemporary Art, Boston, and tour, 1949–50 (Hallmark 4th Prize); Pennsylvania Academy Annual, 1949 (Beck Gold Medal), 1958 (Temple Gold Medal); Pittsburgh International, 1955. Artist-in-residence, Kalamazoo College, Michigan, 1940–42; painted mural there, 1941. Received Carnegie Corporation Grant, 1941. Retrospectives: ACA Gallery, 1946; Tweed Gallery, University of Minnesota, Duluth, 1955; Whitney Museum of American Art, New York, and tour, 1960–61; The Gallery of Modern Art, New York, 1969. Member, The National Institute of Arts and Letters, 1959. Received grant, The American Academy of Arts and Letters, 1961. One-man show, Kennedy Galleries, New York, 1972. Died Bridgewater, Connecticut, March 11, 1973.

Nude by the El. 1934.
Oil on canvas, 38 × 43 inches
Signed l. l. of c.: "Philip Evergood"

PROVENANCE:
Montross Gallery, New York; ACA Gallery, New York, c. 1945.

EXHIBITIONS:
Montross Gallery, New York, January 21–February 2, 1935, *Recent Paintings by Philip Evergood*, no. 34
ACA Gallery, New York, April 5–24, 1948, *Philip Evergood*, no. 11
Tweed Gallery, University of Minnesota, Duluth, May 1–29, 1955, *Philip Evergood Retrospective*, no. 18
The American Academy of Arts and Letters, New York, March 3–18, 1956, *National Institute of Arts and Letters Annual*
Whitney Museum of American Art, New York, April 5–May 22, 1960, *Philip Evergood*, no. 9, colorplate p. 17; toured to Walker Art Center, Minneapolis, June 8–July 17; Wadsworth Atheneum, Hartford, Connecticut, August 3–September 11, no. 33; Des Moines Art Center, Iowa, September 28–November 6; San Francisco Museum of Art, November 23–January 2, 1961; Colorado Springs Fine Arts Center, Colorado, January 18–February 26; Munson-Williams-Proctor Institute, Utica, New York, March 15–April 30
American Federation of Arts tour, 1962–65, *Paintings from the Joseph H. Hirshhorn Foundation Collection: A View of the Protean Century*, no. 27
The Gallery of Modern Art, New York, October 19–November 15, 1965, *About New York, Night and Day, 1915–1965*, p. 14

REFERENCES:
Arb, Renée. "Spotlight on: Evergood," *Art News*, 47, April 1948, p. 32, ill.
Baur, John I. H. *Philip Evergood*, New York, Whitney Museum of American Art, 1960, pp. 47, 50, 51, 113, colorplate 8
——. *Philip Evergood*, New York, Abrams, forthcoming, ill.
Brown, Gordon. "An Interview with Philip Evergood," *Art Voices*, 2, December 1963, colorplate cover, ill. p. 3
Reed, Judith Kaye. "Not So Evergood," *Art Digest*, 22, April 15, 1948, p. 11

In *Nude by the El*, Evergood is seen sketching a model in his apartment at Milligan Place, New York. About the painting he said, "I was really pleased with the nasty red in relation to other colors in the painting. It could only be nasty—any color can only be nasty or nice—in relation to something else, right? I felt really thrilled and pleased with the violent reds of the velvet couch the model is lying on in relation to the paleness of her skin and the rather crude house-paint green on the elevated structure outside and the pinks on the wall and the yellows in the mirror. It seemed to me that I had struck a note that I liked very much, one that got away from an everything-is-beautiful-beautiful harmony. It gave me a little shot in the arm to have painted that way once, and I found it going into other canvases where it seemed to develop as a kind of curious taste which very few people liked, and like, but it pleases me for some reason."

The artist, in Baur, *Philip Evergood*, New York, Whitney Museum of American Art, p. 51

Juju as a Wave. 1935–42.
Oil on canvas, 69 × 43¼ inches
Signed l. l.: "Philip Evergood"

PROVENANCE:
ACA Gallery, New York, 1953

EXHIBITIONS:
ACA Gallery, New York, October 11–31, 1942, *Evergood 1942*, no. 7, ill.
ACA Gallery, New York, April 21–May 11, 1946, *Evergood: 20 Years*, p. 15, ill. p. 58
The American Academy of Arts and Letters, New York, March 1954, *Works by Candidates for Grants in Art*
Tweed Gallery, University of Minnesota, Duluth, May 1–29, 1955, *Philip Evergood Retrospective*, no. 28
American Federation of Arts tour, 1959–60, *Ten Modern Masters of American Art*, no. 10
Whitney Museum of American Art, New York, April 5–May 22, 1960, *Philip Evergood*, no. 21, colorplate p. 35; toured to Walker Art Center, Minneapolis, June 8–July 17; Wadsworth Atheneum, Hartford, Connecticut, August 3–September 11, no. 42; Des Moines Art Center, Iowa, September 28–November 6; San Francisco Museum of Art, November 23–January 2, 1961; Colorado Springs Fine Arts Center, Colorado, January 18–February 26; Munson-Williams-Proctor Institute, Utica, New York, March 15–April 30

REFERENCES:
Baur, John I. H. *Philip Evergood*, New York, Whitney Museum of American Art, 1960, pp. 67, 113, colorplate 21
——. *Philip Evergood*, New York, Abrams, forthcoming, ill.
Dennison, George. "Month in Review," *Arts*, 34, May 1960, p. 53, ill. p. 52
Evergood, Philip. "Sure, I'm a Social Painter," *Magazine of Art*, 36, November 1943, p. 258, ill. p. 256
Genauer, Emily. "Philip Evergood's Works Hailed as Exhibit Opens," *New York Herald Tribune*, April 6, 1960
Gibbs, Jo. "Evergood Looks Across Twenty Years," *Art Digest*, 20, April 15, 1946, p. 9
Larkin, Oliver. "The Humanist Realism of Philip Evergood," *Evergood: 20 Years*, New York, ACA Gallery, 1946, p. 15
Unsigned. "The Passing Shows," *Art News*, 41, October 15–31, 1942, p. 27
——. "Art: Evergood," *Time*, 47, May 6, 1946, ill. p. 64

This painting of the artist's wife, Julia, originally dating from 1935, was repainted in 1942.

Turmoil. 1941.
Oil on canvas, 24¼ × 20¼ inches
Signed l. l.: "Philip Evergood"

PROVENANCE:
ACA Gallery, New York, c. 1943–44

EXHIBITIONS:
The Pennsylvania Academy of the Fine Arts, Philadelphia, January 24–February 28, 1943, *One Hundred and Thirty-Eighth Annual Exhibition of Painting and Sculpture*, no. 285
The Corcoran Gallery of Art, Washington, D.C., March 1943, *18th Biennial Exhibition of Contemporary American Oil Paintings*, no. 55
ACA Gallery, New York, April 21–May 11, 1946, *Evergood: 20 Years*, p. 31, colorplate p. 24
Tweed Gallery, University of Minnesota, Duluth, May 1–29, 1955, *Philip Evergood Retrospective*
Whitney Museum of American Art, New York, April 5–May 22, 1960, *Philip Evergood*, no. 23, ill. p. 39

REFERENCES:
Baur, John I. H. *Philip Evergood*, New York, Whitney Museum of American Art, 1960, p. 56, ill. 24
——. *Philip Evergood*, New York, Abrams, forthcoming, ill.
Frost, Rosamund. "Wartime Corcoran Biennial Is Hand-picked This Year," *Art News*, 42, April 1–14, 1943, p. 19, ill.
Larkin, Oliver. "The Humanist Realism of Philip Evergood," *Evergood: 20 Years*, New York, ACA Gallery, 1946, p. 20, colorplate p. 24
Unsigned. "Philip Evergood When He Is Good—and Bad," *Art Digest*, 17, November 1, 1942, p. 9, ill.

American Shrimp Girl. 1954.
Oil on canvas mounted on board, 46¼ × 32⅜ inches
Signed l. l.: "Philip Evergood"

PROVENANCE:
ACA Gallery, New York, 1955

EXHIBITIONS:
ACA Gallery, New York, April 11–30, 1955, *Philip Evergood*
The Baltimore Museum of Art, January 16–February 20, 1955, *The Seaport*, cat.
The American Academy of Arts and Letters, New York, March 3–18, 1956, *National Institute of Arts and Letters Annual*
Wildenstein & Co., New York, October 23–November 16, 1957, *The American Vision*, no. 52, ill. p. 17
American Federation of Arts tour, 1959–60, *Ten Modern Masters of American Art*, no. 12, ill.
Whitney Museum of American Art, New York, April 5–May 22, 1960, *Philip Evergood*, no. 47, ill. p. 87; toured to Walker Art Center, Minneapolis, June 8–July 17; Wadsworth Atheneum, Hartford, Connecticut, August 3–September 11, no. 59; Des Moines Art Center, Iowa, September 28–November 6; San Francisco Museum of Art, November 23–January 2, 1961; Colorado Springs Fine Arts Center, Colorado, January 18–February 26; Munson-Williams-Proctor Institute, Utica, New York, March 15–April 30
American Federation of Arts tour, 1962–65, *Paintings from the Joseph H. Hirshhorn Foundation Collection: A View of the Protean Century*, no. 26, ill.

REFERENCES:
Baur, John I. H. *Philip Evergood*, New York, Whitney

Museum of American Art, 1960, pp. 107, 113, ill. no. 65

——. *Philip Evergood,* New York, Abrams, forthcoming, ill.

Bryant, Edward. "Philip Evergood," *Doris Caesar—Philip Evergood,* Hartford, Connecticut, Wadsworth Atheneum, 1960, p. 22

Campbell, Lawrence. "Reviews and Previews: Philip Evergood," *Art News,* 54, May 1955, p. 46

Dennison, George. "Month in Review," *Arts,* 34, May 1960, p. 53, ill. p. 51

Eliot, Alexander. *Three Hundred Years of American Painting,* New York, Time, Inc., 1957, p. 239, colorplate p. 240

Genauer, Emily. "Private Collection Put to Public Use," *New York Herald Tribune,* August 2, 1959, sec. 4, p. 6–A

Lippard, Lucy. *The Graphic Work of Philip Evergood,* New York, Crown, 1966, pp. 28, 154

Oglesby, John C. "Evergood Retrospective Opens in S.F. Museum of Art," *Sacramento [California] Bee,* December 11, 1960, sec. L, p. 6

Schiff, Bennett. "In the Art Galleries," *New York Post,* August 2, 1959, sec. M, ill. p. 12

Unsigned. "Art: Big Spender," *Time,* 66, July 25, 1955, p. 72, colorplate p. 73

This painting won first prize at The Baltimore Museum of Art exhibition "The Seaport," in 1955. The title pays homage to William Hogarth's *Shrimp Girl* (The National Gallery, London).

ALEXANDRE FALGUIÈRE (1831–1900)

Jean-Alexandre-Joseph Falguière, born Toulouse, France, September 7, 1831. Studied, École des Beaux-Arts, Paris, with François Jouffroy, 1854. First exhibited, Salon of 1857, Paris. Received Prix de Rome, 1859; lived in Rome, 1859–65. Awarded: Gold Medal, Exposition Universelle of 1867, 1878, Paris; Medal of Honor, Salon of 1868. Served in National Guard, during siege of Paris, Franco-Prussian War, 1870. Légion d'honneur: chevalier, 1870; officier, 1878; commandeur, 1889. Commissions: *Pierre Corneille,* Théâtre-Français, Paris, 1872; decorations, Palais du Trocadéro, Paris, 1878; Fontaine Sainte-Marie, Rouen, France, 1879; statue of Marquis de Lafayette, Washington, D.C., completed 1890. Active as painter and sculptor, from 1873. Paintings included in Salon of 1875 (Medal of the Second Class), 1877, 1879. *Triomphe de la république* commissioned for Arc de Triomphe, Paris, 1881–86 (project abandoned). Appointed: professor, École des Beaux-Arts, 1882; member, Académie des Beaux-Arts de l'Institut de France, 1882. *Balzac* commissioned by Société des Gens de Lettres, Paris, 1899, to replace the statue by Auguste Rodin rejected in 1898. *Monument to Alphonse Daudet,* Nîmes, France, installed 1900. Died Paris, April 18, 1900. Memorial exhibition, École des Beaux-Arts, 1902.

Head of Diana. c. 1882.
Bronze, 17 × 15¾ × 10¼ inches
Markings: r. shoulder "A. Falguiere
Thiebaut Freres Fondeurs-
Paris"

PROVENANCE:
Shepherd Gallery, New York, 1967

JOHN FERREN (1905–1970)

Born Pendleton, Oregon, October 17, 1905. Youth spent in California; apprenticed to stonecutter, San Francisco, 1925–29. Studied: Université de Paris à la Sorbonne, 1929; Università degli Studi, Florence; Universidad de Salamanca, Spain. First one-man show, Art Center, San Francisco, 1930. Lived in Paris, 1931–38. Studied, Paris: Académie de la Grande Chaumière; Académie Ranson; Académie Colarossi; engraving, S. W. Hayter's Atelier 17, c. 1932–35. One-man shows: Galerie Zak, Paris, 1932; Galerie Pierre, Paris, 1936; Pierre Matisse Gallery, New York, 1936–38; The Minneapolis Institute of Arts, 1936; San Francisco Museum of Art, 1936, 1952; The Arts Club of Chicago, 1937. Member, American Abstract Artists; exhibited with group, 1934, 1935, 1937. Chief of Publications for France, Psychological Warfare Division, U.S. War Department, 1942–45. Taught, New York: The Brooklyn Museum Art School, 1946–50; The Cooper Union for the Advancement of Science and Art, 1947–54; Queens College, 1952–70. Included in: "Abstract Painting and Sculpture in America," The Museum of Modern Art, New York, 1951; Whitney Annual, 1951, 1955, 1956, 1959; Pittsburgh International, 1955; 8th Contemporary American Exhibition, University of Illinois, Urbana, 1957; "American Abstract Expressionists and Imagists," The Solomon R. Guggenheim Museum, New York, 1961. One-man shows, Stable Gallery, New York, 1955–58. Consultant to Alfred Hitchcock on films: *The Trouble with Harry,* 1955; *Vertigo,* 1958. Received: Longview Foundation Grant, 1960; American Specialists Abroad Grant, U.S. State Department, Beirut, Lebanon, 1963–64. Member, Advisory Council, Yale University School of Art and Architecture, New Haven, Connecticut, 1959–62. One-man shows, New York: Rose Fried Gallery, 1965–68; A. M. Sachs Gallery, 1969, 1972. Died Southampton, New York, July 24, 1970.

Construction in Wood: Daylight Experiment (Facade). 1968.
Painted wood, 72½ × 48 × 14 inches

PROVENANCE:
Gift of the artist, New York, 1968

EXHIBITIONS:
Rose Fried Gallery, New York, April 16–May 11, 1968, *John Ferren*

REFERENCES:
Brown, Gordon. "Reflective Art: The Light Constructions of John Ferren," *Arts Magazine,* 42, May 1968, colorplate p. 33

Pincus-Witten, Robert. "New York: John Ferren," *Artforum,* 10, Summer 1968, ill. p. 53

MAX FINKELSTEIN (b. 1915)

Born New York, June 15, 1915. Worked as machinist in tool and die shops, New York, and Los Angeles, 1942–65. Studied: California School of Art, Los Angeles, 1951–52; Los Angeles City College, 1952–53; University of California at Los Angeles, 1953. Included in: "Sculpture West," Municipal Art Gallery, Los Angeles, 1965; San Francisco Museum of Art Annual, 1965, 1966; 13th Contemporary American Exhibition, University of Illinois, Champaign-Urbana, 1967 (Purchase Award). One-man shows: Fresno Arts Center, California, 1964; Adele Bednarz Gallery, Los Angeles, 1965; Feigen-Palmer Gallery, Los Angeles, 1966; A. M. Sachs Gallery, New York, 1968; La Jolla Museum of Art, California, 1968; Santa Barbara Museum of Art, California, 1968; Esther-Robles Gallery, Los Angeles, 1970, 1973; California Institute of Technology, Pasadena, 1973. Has taught sculpture, University of Judaism, Los Angeles, since 1964. Lives in Los Angeles.

Square Plus 300. 1967.
Aluminum, 36 × 32 × 1 inches
Signed back u. l.: "M. Finkelstein '67"

PROVENANCE:
Herbert Palmer Gallery, Los Angeles, 1967

JOHN FLANNAGAN (1895–1942)

John Bernard Flannagan, born Fargo, North Dakota, April 7, 1895. Boarded, St. John's Orphanage, Little Falls, Minnesota, 1905–10. Studied: vocational course, St. John's University, Collegeville, Minnesota, 1910–13; Minneapolis School of Art, 1914–18. Served, U.S. Merchant Marine, 1918–20. Included in Society of Independent Artists Annual, 1919, 1921. Farmhand for Arthur B. Davies, Congers, New York, 1922–23. Exhibited, New York: with Davies, Maurice and Charles Prendergast, William Glackens, Charles Sheeler, Walt Kuhn, Montross Gallery, 1923; Whitney Studio Club, 1925; "46 Painters and Sculptors under 35 Years of Age," The Museum of Modern Art, 1930; Whitney Biennial, 1934–35. Lived in New York City, Rockland County, and Woodstock, New York, 1924–30; Clifden, on west coast of Ireland, 1930–31. One-man shows, New York: Weyhe Gallery, 1927, 1928, 1930, 1931; Whitney Studio Galleries, 1929. Received Guggenheim Foundation Fellowship, 1932–33. Hospitalized after attempted suicide, New York, 1934. One-man shows: The Arts Club of Chicago, 1934; Weyhe Gallery, 1934, 1936, 1938; Vassar College, Poughkeepsie, New York, 1936; Carnegie Institute, Pittsburgh, 1938. *The Gold Miner* commissioned, Ellen Phillips Samuel Memorial, Fairmount Park, Philadelphia, 1936. Included in: "Six American Artists," The Brooklyn Museum, New York, 1936; Whitney Annual, 1940. Received Alexander Shilling Award (Purchase Prize), The Metropolitan Museum of Art, New York, 1941. Died by suicide, New York, January 6, 1942. Memorial exhibitions: Buchholz Gallery, New York, 1942; The Museum of Modern Art, and tour, 1942–43.

Lady with Death Mask. 1926.
Mahogany, 12⅛ × 7¾ × 14¾ inches

PROVENANCE:
Mrs. Lewis Stoneman; Mrs. Edward L. McColgin, Detroit, 1959

REFERENCES:
Forsyth, Robert J. "John B. Flannagan: His Life and Works," Ph.D. dissertation, Minneapolis, University of Minnesota, 1965, no. 32, pp. 141, 236, 309

Triumph of the Egg I. 1937, cast 1941.
Cast stone (edition of seven), 12 × 15½ × 8¾ inches

PROVENANCE:
Curt Valentin Gallery, New York, 1955

EXHIBITIONS:
Curt Valentin Gallery, New York, June 1955, *Closing Exhibition: Sculpture, Paintings and Drawings,* no. 32

The Detroit Institute of Arts, and tour, 1959–60, *Sculpture in Our Time,* no. 78

The Solomon R. Guggenheim Museum, New York, October 3, 1962–January 6, 1963, *Modern Sculpture from the Joseph H. Hirshhorn Collection,* no. 146, ill. p. 171

Pierre Matisse Gallery, New York, April 26–May 21, 1966, *Seven Decades: Crosscurrents in Modern Art 1895–1965* (sponsored by the Public Education Association), no. 222, ill. p. 122

Hopkins Art Center, Dartmouth College, Hanover, New Hampshire, May 25–July 9, 1967, *Sculpture in Our Century: Selections from the Joseph H. Hirshhorn Collection,* no. 19, ill. p. 18

REFERENCES:
Bruner, Louise. "The Hirshhorn Sculpture Collection," *Toledo [Ohio] Sunday Blade Pictorial,* July 26, 1959, ill.

Hunter, Sam. *American Art of the 20th Century,* New York, Abrams, 1972, ill. 429

Kuh, Katherine. "Great Sculpture," *Saturday Review,* 45, June 1962, p. 19, ill.

The Lamb. 1939.
Carved limestone, 11 × 19½ × 8¼ inches
Markings: underneath "JBF 39"

PROVENANCE:
Chaim Gross, New York, 1955

EXHIBITIONS:
The Detroit Institute of Arts, 1959, *Sculpture in Our Time,* no. 80

REFERENCES:
Forsyth, Robert J. "John B. Flannagan: His Life and Works," Ph.D. dissertation, Minneapolis, University of Minnesota, 1965, pp. 250, 315

LUCIO FONTANA (1899–1968)

Born Rosario de Santa Fe, Argentina, February 19, 1899. Moved with family to Milan, 1905. Served, Italian Army, 1917–18. Studied, Accademia di Belle Arti di Brera,

Milan, 1927–29. Included in: Venice Biennale, 1930; "Prima Mostra collettiva di arte astratta italiana," studio of Felice Casorati and Enrico Paolucci, Turin, 1935; 2nd and 3rd Quadriennale Nazionale d'Arte, Rome, 1935, 1939; 4th Milan Triennale, 1936. One-man shows: Galleria del Milione, Milan, 1930–38; Galerie Jeanne Bucher, Paris, 1937; Galerie Zak, Paris, 1938. Joined Association Abstraction-Création, Milan; exhibited, Galerie Abstraction-Création, Paris, 1934. Traveled to Paris, 1937; returned to Argentina, 1939. Taught, Academia d'Altamira, Buenos Aires, 1940–47. Co-authored: *Manifesto Blanco* (Buenos Aires), 1946; *Spaziali 1* and *Spaziali 2* (Milan), 1948, 1948–49; *Manifesto del Movimento Spaziale per la Televisione* (Milan), 1952. Returned to Milan, 1947. Created "Spatial Environment with Spatial Forms and Black Light Illumination," Galleria del Naviglio, Milan, 1949. Included in: Venice Biennale, 1950, 1954, 1958 (retrospective), 1964, 1966 (Grand Prize for Painting); First International Congress on Proportion (9th Milan Triennale), 1951; I and V São Paulo Bienal, 1951, 1959; 7th Quadriennale Nazionale d'Arte, Rome, 1955; Documenta II and 4, Kassel, 1959, 1968; "Recent Italian Painting and Sculpture," The Jewish Museum, New York, 1968. One-man shows: Galleria del Milione, 1950–59; Galerie Alfred Schmela, Düsseldorf, 1960, 1968; Martha Jackson Gallery, New York, 1961, 1970; Tokyo Gallery, Japan, 1962; Städtisches Museum, Leverkusen, Germany, 1962; Marlborough Galleria d'Arte, Rome, 1964, 1967; Stedelijk Museum, Amsterdam, and tour, 1967; Walker Art Center, Minneapolis, and tour, 1968. Died Comabbio, near Varese, Italy, September 7, 1968. Retrospectives: Istituto Italo-Latino Americano, Rome, 1969; Museo Civico di Torino, 1970; Palazzo Reale, Milan, 1972.

Spatial Concept (Concetto spaziale). 1967.
Lacquered wood, four plaques, each 68¼ × 28¼ inches

PROVENANCE:
Marlborough Galleria d'Arte, Rome, 1967

EXHIBITIONS:
The Jewish Museum, New York, May 24–September 2, 1968, *Recent Italian Painting and Sculpture,* cat., ill.

PETER FORAKIS (b. 1927)

Born Hanna, Wyoming, October 2, 1927. Served, U.S. Army, Korea and Japan, 1951–54. Studied, San Francisco Art Institute, 1954–57; taught there, 1958. Included in: San Francisco Museum of Art Annual, 1956–59; "New Forms—New Media," Martha Jackson Gallery, New York, 1960; "Plastics," John Daniels Gallery, New York, 1965; "Colored Sculpture," American Federation of Arts, Circulating Exhibition, 1965–66; "American Sculpture of the Sixties," Los Angeles County Museum of Art, and The Philadelphia Museum of Art, 1967; 13th Contemporary American Exhibition, University of Illinois, Champaign-Urbana, 1967; "Cool Art—1967," The Aldrich Museum of Contemporary Art, Ridgefield, Connecticut, 1967; "Art for the City," Institute of Contemporary Art, University of Pennsylvania, Philadelphia, 1967. Taught: The Brooklyn Museum Art School, New York, 1961–63; Pennsylvania State University, University Park, 1965; Carnegie Institute of Technology, Pittsburgh, 1965; University of Rhode Island, Kingston, 1966. One-man shows: Tibor de Nagy Gallery, New York, 1962, 1963; Park Place Gallery, New York, 1966; Windham College, Putney, Vermont, 1967; Paula Cooper Gallery, New York, 1970. Published *Grope* magazine I and II, New York, 1964, 1966. Sculpture commission, University of Houston, Texas, 1971. Has taught, Windham College, since 1968. Lives in Putney.

Double Exeter III (Mirror Image Series). 1968.
Painted cold-rolled steel, 2 feet 10 inches × 10 feet 4 inches × 3 feet

PROVENANCE:
Paula Cooper Gallery, New York, 1968

EXHIBITIONS:
Paula Cooper Gallery, New York, November 1968, *Group Show*

SAM FRANCIS (b. 1923)

Samuel Lewis Francis, born San Mateo, California, June 25, 1923. Studied medicine and psychology, University of California, Berkeley, 1941–43. Served, U.S. Army Air Corps, 1943–45; became interested in painting while hospitalized for war injuries, 1945. Studied: California School of Fine Arts, San Francisco, with David Park, 1945–46; University of California, Berkeley, B.A., 1949, M.A., 1950. Lived in Paris, 1950–61; studied, Académie Fernand Léger, 1950. Exhibited, Salon de Mai, Paris, 1950. One-man shows, Galerie du Dragon, Paris, 1952; Martha Jackson Gallery, New York, 1956–59; Kornfeld & Klipstein, Bern, from 1957. Included in: Pittsburgh International, 1955; "12 Americans," The Museum of Modern Art, New York, 1956; "New American Painting," The Museum of Modern Art, International Circulating Exhibition, 1958–59; V São Paulo Bienal, 1959; Documenta II and III, Kassel, 1959, 1964; "American Abstract Expressionists and Imagists," The Solomon R. Guggenheim Museum, New York, 1961; "Vanguard American Painting," European tour, organized by the U.S. Information Agency, 1961–62. Mural commissions: Sogetsu-Ryu, Sofu Teshigahara, Tokyo, 1957; Kunsthalle, Basel, 1958; Chase Manhattan Bank, New York, 1959. Traveled extensively in Europe and the Far East, 1957, 1959. Returned to the U.S., 1961. Awarded first prize, III International Biennial Exhibition of Prints, Tokyo, 1962. Retrospectives: Kestner-Gesellschaft, Hanover, 1963; The Museum of Fine Arts, Houston, and University of California, Berkeley, 1967; Stedelijk Museum, Amsterdam, 1968. One-man shows: Pierre Matisse Gallery, New York, 1967; André Emmerich Gallery, New York, 1969; Felix Landau Gallery, Los Angeles, 1969–70; Albright-Knox Art Gallery, Buffalo, New York, and tour, 1972–73. Lives in Santa Monica, California.

Blue Out of White. 1958.
Oil on canvas, 78 × 90 inches

PROVENANCE:
Martha Jackson Gallery, New York, 1958

EXHIBITIONS:
Martha Jackson Gallery, New York, November 25–
December 20, 1958, *Sam Francis*
V Bienal de Arte Moderna, São Paulo, September 21–
December 31, 1959, *United States Representation*, no.
59, ill.

MARY FRANK (b. 1933)

Mary Lockspeiser, born London, February 4, 1933.
Studied, New York: with Max Beckmann, 1950; with
Hans Hofmann, 1951. One-man shows, New York:
Poindexter Gallery, 1958; Stephen Radich Gallery, 1961,
1963, 1966; Drawing Shop Gallery, 1964. Received:
Merrill Foundation Grant, 1961; Longview Foundation
Grant, 1962–64; National Council on the Arts Grant,
1968. Included in "Hans Hofmann and His Students,"
The Museum of Modern Art, New York, Circulating
Exhibition, 1963–65. One-man shows: Boris Mirski
Gallery, Boston, 1965, 1967; Donald Morris Gallery,
Detroit, 1968; Zabriskie Gallery, New York, 1968–
73; Richard Gray Gallery, Chicago, 1969. Taught, New
School for Social Research, New York, 1965–70. Included in: Whitney Annual, 1970; "10 Independents:
An Artist-Initiated Exhibition," The Solomon R. Guggenheim Museum, New York, 1972; "Women Choose
Women," The New York Cultural Center, 1973; Whitney Biennial, 1973. Received: grant, The National Institute of Arts and Letters, and The American Academy
of Arts and Letters, 1972; Guggenheim Foundation
Fellowship, 1973. Has taught, Queens College, City
University of New York, since 1970. Lives in New York.

Untitled. 1967.
Unglazed terra-cotta, 6¾ × 9¾ × 10 inches
Markings: r. side "MF"

PROVENANCE:
Zabriskie Gallery, New York, 1968

EXHIBITIONS:
Zabriskie Gallery, New York, February 6–March 2,
1968, *Mary Frank*, cat.

HELEN FRANKENTHALER (b. 1928)

Born New York, December 12, 1928. Studied: with
Rufino Tamayo, New York, 1945; Bennington College,
Vermont, with Paul Feeley, B.A., 1949; Columbia
University, New York, 1949; Hans Hofmann School of
Fine Art, Provincetown, Massachusetts, summer, 1950.
Exhibited, New York: "Bennington College Alumni
Paintings," Jacques Seligmann and Co., 1950; "Fifteen
Unknowns," Kootz Gallery, 1950. One-man shows,
Tibor de Nagy Gallery, New York, 1951–58. Included
in: "U.S. Painting: Some Recent Directions," Stable
Gallery, New York, 1955; Pittsburgh International,
1955–64; "Artists of the New York School: Second
Generation," The Jewish Museum, New York, 1957;
"Young America 1957: 30 American Painters and Sculptors Under 35," Whitney Museum of American Art,
New York, 1957; Documenta II, Kassel, 1959; V São
Paulo Bienal, 1959, Iᵉ Biennale de Paris, 1959 (first
prize). One-man shows: André Emmerich Gallery, New
York, from 1959; The Jewish Museum, 1960; Galerie
Lawrence, Paris, 1961, 1963; Bennington College, 1962.
Included in: "Post-Painterly Abstraction," Los Angeles
County Museum of Art, 1964; Venice Biennale, 1966;
Expo '67, Montreal, 1967; Pennsylvania Academy
Annual, 1968 (Temple Gold Medal); "New York Painting and Sculpture: 1940–70," The Metropolitan Museum
of Art, New York, 1969–70. Appointed Fellow, Calhoun
College, Yale University, New Haven, Connecticut,
1968. Retrospective, Whitney Museum of American Art,
and European tour (organized by the International
Council of The Museum of Modern Art, New York),
1969. One-man show, André Emmerich Downtown,
New York, 1972. Member, The National Institute of
Arts and Letters, 1974. Lives in New York.

Indian Summer. 1967.
Acrylic on canvas, 93½ × 93½ inches
Signed and dated l. r.: "Frankenthaler '67"

PROVENANCE:
Lawrence Rubin Gallery, New York, 1968

DONALD HAMILTON FRASER (b. 1929)

Born London, July 30, 1929. Studied, St. Martin's School
of Art, London, 1949–52. Included in: Contemporary
Art Society Exhibition, The Tate Gallery, London, 1952,
1953, 1956; "British Romantic Painting in the 20th
Century," The Arts Council of Great Britain, London,
1953; "Critics' Choice," Arthur Tooth & Sons, London,
1955; "Six Young British Painters," Ashmolean
Museum of Art and Archaeology, Oxford, England, and
tour, 1956–58. Received Bourse d'Étude du Gouvernement Français, to study in Paris, 1953–54. One-man
shows: Gimpel Fils, London, from 1953; Paul Rosenberg
& Co., New York, from 1957; Gimpel & Hanover
Galerie, Zurich, 1964. Included in: "British Art Today,"
San Francisco Museum of Art, 1962; "Contemporary
British Painting and Sculpture," Albright-Knox Art
Gallery, Buffalo, New York, 1964; Pittsburgh International, 1967; "Mostra Mercato d'Arte Contemporanea,"
Palazzo Strozzi, Florence, 1968. Author of articles
on ballet and painting. Has taught, St. Martin's School
of Art, and Royal College of Art, London, since
1957. Lives in London.

Landscape Sea and Wind. 1957.
Oil on canvas, 48 × 36 inches
Signed l. l.: "Fraser"

PROVENANCE:
Gimpel Fils, London, 1957

FREDERICK FRIESEKE (1874–1939)

Frederick Carl Frieseke, born Owosso, Michigan, April
7, 1874. Studied: School of The Art Institute of Chicago;
The Art Students League of New York. Settled in France,
1898. Studied, Paris: Académie Julian, with Benjamin
Constant, and Jean-Paul Laurens; briefly, with James

Abbott McNeill Whistler. First exhibited with American
Art Association, Paris, 1900. Société Nationale des Beaux-
Arts, Paris: associate, 1901; exhibited, 1901–39; member,
1907. Mural commissioned, John Wanamaker and
Company, New York, 1904. Awarded: Gold Medal, IX
Internationalen Kunstausstellung, Munich, 1904; Silver
Medal, St. Louis International Exposition, Missouri,
1904; Temple Gold Medal, Pennsylvania Academy
Annual, 1913; Grand Prize, Panama-Pacific International Exposition, San Francisco, 1915; Harris Prize,
29th American Exhibition, The Art Institute of Chicago,
1916; Corcoran Bronze Medal, and Third Clark Prize,
Corcoran Biennial, 1928; Corcoran Silver Medal, and
Second Clark Prize, Corcoran Biennial, 1935. National
Academy of Design: associate, 1912; academician, 1914.
One-man shows: Worcester Art Museum, Massachusetts,
1912; Macbeth Gallery, New York, 1912–35; The Art
Institute of Chicago, 1913; The Cleveland Museum of
Art, 1918; The Detroit Institute of Arts, 1918, 1921;
Cincinnati Art Museum, Ohio, 1921; The Corcoran
Gallery of Art, Washington, D.C., 1924; Addison
Gallery of American Art, Phillips Academy, Andover,
Massachusetts, 1931. Chevalier, Légion d'honneur,
1920. Retrospective, Grand Central Art Galleries, New
York, 1939. Died Mesnil-sur-Blangy, Normandy,
France, August 28, 1939. Posthumous exhibition,
Hirschl & Adler Galleries, New York, 1966.

La Chaise Longue. 1919.
Oil on canvas, 39⅛ × 60½ inches
Signed and dated l. r.: "F. C. Frieseke 1919"

PROVENANCE:
Grand Central Art Galleries, New York; Thomas B.
Watson; IBM Collection, New York; Hirschl & Adler
Galleries, New York, 1968

EXHIBITIONS:
Grand Central Art Galleries, New York, March 21–
April 5, 1939, *Retrospective Exhibition of Paintings
by Frederick C. Frieseke, N.A.*, no. 25
Hirschl & Adler Galleries, New York, April–May 1966,
Frederick Frieseke

ELISABETH FRINK (b. 1930)

Born Thurlow, Suffolk, England, November 14, 1930.
Studied: Guildford School of Art, England, 1947–49;
Chelsea School of Art, London, 1949–53. Exhibited with
London Group (Kenneth Armitage, Reg Butler, Anthony
Caro, Lynn Chadwick, Bernard Meadows, Eduardo
Paolozzi), The Beaux Arts Gallery, London, 1951.
Taught: Guildford School of Art, and Chelsea School
of Art, 1951–63; Royal College of Art, London, 1963–
65. Included in: "Open Air Exhibition," Holland Park,
London, 1954, 1957, and Battersea Park, London, 1960,
1963; 5th Middelheim Biënnale, Antwerp, 1959. One-
man shows: St. George's Gallery, London, 1955; The
Waddington Galleries, London, from 1959; Bertha
Schaefer Gallery, New York, 1959, 1961, 1965; Felix
Landau Gallery, Los Angeles, 1961. Included in: "British
Sculpture Since 1945," The Tate Gallery, London, 1965;
Royal Academy of Art, Summer Exhibition, London,
1971, 1972. Made Commander of the Order of the
British Empire, 1969. Lives in Anduze, Gard, France.

Fallen Bird Man. 1961.
Bronze (1/3), 20 × 63 × 34 inches

PROVENANCE:
Bertha Schaefer Gallery, New York, 1962

EXHIBITIONS:
Bertha Schaefer Gallery, New York, October 30–
November 18, 1961, *Elisabeth Frink*, no. 14
Philadelphia Art Alliance, February 26–March 27,
1962, *Today's European Sculpture*
The Solomon R. Guggenheim Museum, New York,
October 3, 1962–January 6, 1963, *Modern Sculpture
from the Joseph H. Hirshhorn Collection*, no. 160, ill.
p. 151

REFERENCES:
Byng, Tom. "Mods and Baroquers," *House & Garden*,
British ed., 20, February 1965, ill. p. 57
Jacobs, Jay. "Collector: Joseph H. Hirshhorn," *Art in
America*, 57, July–August 1969, colorplate p. 69
———. "Quality as Well as Quantity: Joseph H. Hirshhorn," in Lipman, Jean, ed. *The Collector in America*,
New York, Viking, 1971, colorplate p. 82
Sweeney, James Johnson. "A Living Frame for Sculpture," *House & Garden*, 126, August 1964, ill. p. 113
Unsigned. "Exhibition of Today's European Sculpture,"
Art Alliance Bulletin, Philadelphia, March 1962, p. 9

NAUM GABO (b. 1890)

Naum Neemia Pevsner, born Briansk, Russia, August
5, 1890; brother of sculptor Antoine Pevsner. Studied,
Munich: medicine and natural sciences, and attended
Heinrich Wölfflin's art history lectures, Universität,
1910–14; engineering, Technische Hochschule, 1912.
Lived in Oslo, 1914–17. Adopted the name Gabo, 1915.
Returned to Russia, 1917. In Moscow, 1920: wrote
Realist Manifesto (co-signed by Pevsner); organized
open-air exhibition, Tverskoi Boulevard. Lived in Berlin,
1922–32. Included in: "Erste Russische Kunstausstellung" (organized by government of the U.S.S.R.),
Galerie van Diemen, Berlin, 1922; "Constructivistes
Russes: Gabo et Pevsner," Galerie Percier, Paris, 1924.
Exhibited with Pevsner and Theo van Doesburg, Little
Review Gallery, New York, 1926. With Pevsner, designed
sets, properties, and costumes for *La Chatte*, Sergei Diaghilev's Ballets Russes de Monte Carlo, 1926. Lectured,
Bauhaus, Dessau, Germany, 1928. First one-man show,
Kestner-Gesellschaft, Hanover, 1930. Moved to Paris,
1932; member, Association Abstraction-Création, 1932–
35. Moved to London, 1936. Included in: "Abstract
and Concrete," The Lefevre Gallery, London, 1936;
"Cubism and Abstract Art," The Museum of Modern
Art, New York, 1936. Edited *Circle: International Survey of Constructive Art*, with Ben Nicholson, and James
Lee Martin (London, Faber & Faber), 1937. Visited the
U.S., 1938. One-man shows, 1938: London Gallery,
London; Wadsworth Atheneum, Hartford, Connecticut;
Julien Levy Gallery, New York; Vassar College, Pough-

keepsie, New York. Lived in St. Ives, Cornwall, England,
1939–45. Moved to the U.S., 1946; citizen, 1952. Exhibited with: Pevsner, The Museum of Modern Art,
1948; Josef Albers, The Arts Club of Chicago, 1952.
Taught, Graduate School of Architecture, Harvard
University, Cambridge, Massachusetts, 1953–54. Included in: 61st American Exhibition, The Art Institute
of Chicago, 1954 (Logan Medal); Documenta I, Kassel
1955; "50 Ans d'Art Moderne," Exposition Universelle
et Internationale de Bruxelles, 1958. Received: Guggenheim Foundation Fellowship, 1954; Brandeis University Creative Arts Award Medal, 1960. One-man
show, Museum Boymans-van Beuningen, Rotterdam,
The Netherlands, and Stedelijk Museum, Amsterdam,
1958. Visited Moscow and Leningrad, 1962. Retrospectives: Stedelijk Museum, and tour, 1965–66; The Tate
Gallery, London, 1966; Albright-Knox Art Gallery,
Buffalo, New York, 1968; with Pevsner, Musée National d'Art Moderne, Paris, 1971. Lives in Middlebury,
Connecticut.

"The public is prone to find in any abstract work some
kind of relationship to what they have seen, may it be in
Nature or in their own imagination. In the structure of
my work and in particular in the pieces in this collection,
the steel springs or nylon strings may provoke an association with the strings of a musical instrument.

"This would be, of course, totally wrong, and it is most
important to tell the public that in these linear structures
the strings by themselves have no life of their own. They
are important insofar as they are used to create a surface of a particular preconceived shape.

"I do that for the sake of creating a metallic surface which
is transparent, and all the sides of that surface are visible
to the observer, a quality which is absent in a solid
surface.

"Knowing that, the observer, I am sure, will conceive
the entire image with richer impressions of the work's
whole three-dimensional life in space."

Statement by the artist, 1972

Linear Construction No. 1 (smaller version). 1942–43.
Plastic construction with nylon thread, 12¼ × 12¼ × 2½
inches

PROVENANCE:
Ashley Havinden, England; Harold Diamond, New
York, 1958

EXHIBITIONS:
The Detroit Institute of Arts, 1959, *Sculpture in Our
Time*, no. 81, ill. p. 39
The Solomon R. Guggenheim Museum, New York,
October 3, 1962–January 6, 1963, *Modern Sculpture
from the Joseph H. Hirshhorn Collection*, no. 161, ill.
p. 93

REFERENCES:
Feldman, Edmund Burke. *Art as Image and Idea*, Englewood Cliffs, New Jersey, Prentice-Hall, 1967, ill. p. 363
———. *Varieties of Visual Experience*, New York,
Abrams, 1972, p. 344, ill.
Hale, William Harlan. *The World of Rodin: 1840–1917*,
New York, Time-Life Books, 1969, p. 184, ill.
Ramsden, E. H. *Sculpture: Theme and Variations*, London, Lund Humphries, 1953, p. 45, plate 101
Saltmarche, Kenneth. "Notes on Special Exhibitions:
'Sculpture in Our Time,'" *Art Quarterly*, 22, Winter
1959, p. 352

Linear Construction No. 2 (smaller version). 1949.
Plastic construction with nylon thread, 15 × 11 × 11
inches

PROVENANCE:
The artist, Middlebury, Connecticut, 1956; G. David
Thompson, Pittsburgh; Harold Diamond, New York,
1962

Linear Construction No. 4. 1959–61.
Aluminum construction with stainless steel spring
wire, 39 × 29 ×29 inches
Markings: back l. c. "Gabo"

PROVENANCE:
Otto Gerson Gallery, New York, 1962

EXHIBITIONS:
Otto Gerson Gallery, New York, June–July 1962,
Monumental Sculpture, no. 3, ill.
Wadsworth Atheneum, Hartford, Connecticut, July 18–
September 15, 1963, *11 New England Sculptors*, no. 7
The Cleveland Museum of Art, June 14–July 31, 1966,
Fifty Years of Modern Art 1916–1966, no. 139a, ill.

Vertical Construction No. 1. 1964–65.
Brass construction with stainless steel spring wire,
39½ × 9 ×7 inches

PROVENANCE:
The artist, Middlebury, Connecticut, 1967

EXHIBITIONS:
The Tate Gallery, London, March 15–April 15, 1966,
Naum Gabo, Constructions, Paintings, Drawings
(sponsored by The Arts Council of Great Britain), no.
31, plate 13

PABLO GARGALLO (1881–1934)

Born Maella, Aragon, Spain, December 5, 1881. Moved
with family to Barcelona, 1888. Studied: atelier of
sculptor Eusebio Arnau y Mascort, Barcelona, 1895;
Escuela de Bellas Artes de Barcelona: evenings, 1896–
99; with José Ruiz Blasco, father of Pablo Picasso, 1899–
1902. Frequented café Els Quatre Gats, Barcelona,
meeting place of Picasso and other Catalan artists and
intellectuals. Received fellowship to study six months in
Paris, 1903. One-man shows, Sala Parés, Barcelona, 1904,
1906. Worked: in Vallmitjana foundry, Barcelona, 1905;
in atelier of sculptor Agustín Querol, Madrid, 1906.
Visited Paris, 1907. First metal sculptures, 1911. Lived
in Paris, 1912–14; friendly with Manolo, and Picasso.
Returned to Barcelona, 1914. One-man show, Galería

Valenti, Barcelona (metalwork and jewelry), 1916. Taught, Escuela de Artes y Oficios, and Escuela de Bellas Artes de Barcelona, 1917–23. One-man show, Museo de Arte Moderno, Barcelona, 1921. Exhibited, Paris: Salon d'Automne, and Salon des Indépendants, 1921–23. Settled in Paris, 1923. Met Julio González, 1927. One-man shows: Venice Biennale, 1928; Galerie Bernheim-Jeune, Paris, 1929; Sala Parés, 1934; Brummer Gallery, New York, 1934; Salon d'Automne, 1934. Sculpture commission, Spanish Pavilion, and one-man show, Exposición Internacional de Barcelona, 1929. Died Reus, Tarragona, Spain, December 28, 1934. Retrospectives: Museo de Arte Moderno, Madrid, 1935; Salon d'Automne, 1935; Musée du Petit Palais, Paris, 1947; Wilhelm-Lehmbruck-Museum der Stadt, Duisburg, Germany, 1966; Musée Rodin, Paris, 1970.

Kiki of Montparnasse. 1928.
Polished bronze (edition of seven), 9 × 6⅛ × 5⅛ inches

PROVENANCE:
Mme Gargallo, Paris; Galerie Zak, Paris; M. Raykis, Paris; Theodore Schempp, Paris, 1963

Alice Prin, known as "Kiki of Montparnasse," was a popular artist's model and singer, and a favorite among the bohemians of Montparnasse; perhaps more than any other personality in Paris during the twenties she typified the gaiety of Parisian life and *la vie bohème*. Ernest Hemingway and Robert Desnos wrote about her; Man Ray (she was his mistress for six years) photographed her; many artists painted her. In 1929 she published her memoirs, *Souvenirs Kiki* (later reissued as *The Education of a French Model*). She worked for the French underground during the Occupation, and died in obscurity in 1953.

The Prophet (St. John the Baptist). 1933.
Bronze (5/7), 92¼ × 29¾ × 18⅛ inches

PROVENANCE:
Galerie Claude Bernard, Paris, 1969

LEE GATCH (1902–1968)

Born near Baltimore, September 11, 1902. Studied: The Maryland Institute for the Promotion of the Mechanic Arts, and The School of Fine and Practical Arts, Baltimore, with Leon Kroll 1920–24; The American School, Fontainebleau, France, with Jean Despujols; Académie Moderne, Paris, with André Lhote, and Moise Kisling, 1924. Returned to the U.S., 1925. Exhibited, J. B. Neumann's New Art Circle, New York: with Young American group, 1928; one-man shows, 1932, 1934, 1937, 1946, 1949. Moved to Lambertville, New Jersey, 1935. Included in: Whitney Annual, 1937; "The Ten: Whitney Dissenters," Mercury Gallery, New York, 1938; Pennsylvania Academy Annual, 1939, 1941, 1944–46, 1948; Golden Gate International Exposition, San Francisco, 1939–40; "Advance Trends in Contemporary American Art," The Detroit Institute of Arts, 1944. Federal Works Agency, Public Buildings Administration, Section of Fine Arts, mural commission, U.S. Post Office, Mullins, South Carolina, 1940. One-man shows: Willard Gallery, New York, 1943; Grace Borgenicht Gallery, New York, and The Phillips Collection, Washington, D.C., 1954; The Phillips Collection, 1956; World House Galleries, New York, 1958, 1960. Included in: Carnegie Annual, 1945, 1950; Whitney Annual, 1949–65; Venice Biennale, 1950, 1956; "Paintings by Lee Gatch, Karl Knaths, Ben Shahn," Santa Barbara Museum of Art, California, and tour, 1952; "Painters of Expressionistic Abstraction," The Phillips Collection, 1952; 61st–63rd American Exhibition, The Art Institute of Chicago, 1954, 1956–57 (Blair Prize), 1959–60; Pittsburgh International, 1955–64. Retrospective, Whitney Museum of American Art, New York, and tour, 1960–61. One-man shows, Staempfli Gallery, New York, 1963, 1965, 1967, 1972. Received grant, The National Institute of Arts and Letters, and The American Academy of Arts and Letters, 1965; member, The National Institute of Arts and Letters, 1966. Died Lambertville, November 10, 1968. Retrospective, National Collection of Fine Arts. Smithsonian Institution, Washington, D.C., and tour, 1971–72.

The Dancer. 1955.
Oil on canvas, 50 × 22 inches
Signed l. r.: "Gatch"

PROVENANCE:
Grace Borgenicht Gallery, New York, 1955

EXHIBITIONS:
World House Galleries, New York, May 13–June 14, 1958, *Gatch*, ill. 1
Whitney Museum of American Art, New York, February 2–March 13, 1960, *Lee Gatch* (American Federation of Arts, Circulating Exhibition), no. 31, ill.; toured to ten U.S. cities

REFERENCES:
Guest, Barbara. "Avery and Gatch," *Art News*, 59, March 1960, p. 44
Sawin, Martica. "The Paintings of Lee Gatch," *Arts*, 32, May 1958, pp. 31–32, ill.

HENRI GAUDIER-BRZESKA (1891–1915)

Henri Gaudier, born St.-Jean-de-Braye, France, October 4, 1891. Visited London, 1906. Traveled through Germany and France, 1909–10. In Paris, 1910, met Sophie Suzanne Brzeska, whose last name he later adopted; settled with her in London. Met Roger Fry, Ezra Pound, Jacob Epstein, 1913. Exhibited, London: Allied Artists' Association, 1913, 1914; with Grafton group, Alpine Club, 1914; with London group, Goupil Gallery, 1914, 1915; "First Vorticist Exhibition," Doré Gallery, 1915. Made portraits of Pound, and Frank Harris, 1914. Wrote reviews, London: *Egoist*, 1914; Wyndham Lewis's Vorticist magazine *Blast*, 1914, 1915. Enlisted, French Army, 1914; received two citations for bravery; killed in action, Neuville-St.-Vaast, France, June 5, 1915. Pound's *Gaudier-Brzeska: A Memoir* published (London, John Lane), 1916. Memorial exhibition, The Leicester Galleries, London, 1918. Retrospectives: Musée des Beaux-Arts d'Orléans, France, 1956; The Arts Council of Great Britain, London, 1956.

Wrestler. 1912.
Lead (2/2), 26 × 14½ × 14¼ inches
Markings: c. top of base "Gaudier-Brzeska 1912"

PROVENANCE:
Wyndham Lewis, London; W. Staite Murray, England; Fred L. S. Murray, England; Harold Diamond, New York, 1964

REFERENCES:
Ede, H. S. *A Life of Gaudier-Brzeska*, London, William Heinemann, 1930, p. 196

PAUL GAUGUIN (1848–1903)

Born Paris, June 7, 1848. Moved with family to Lima, Peru, 1851. Lived in Orléans, France, 1855–64. Served, French Merchant Marine and Navy, 1865–71. Worked in stock brokerage, bank, and insurance company, 1871–83. Met Camille Pissarro; started to collect Impressionist paintings; began to paint, 1874. Exhibited, Salon of 1876, Paris. First sculptures, with help of Jules-Ernest Bouillot, Paris, 1877. Exhibited, Salon des Impressionistes, Paris, 1880, 1881, 1886. Worked with Pissarro, Osny, France, 1883. Began to paint full-time, 1883. Lived in Copenhagen, 1884–85. Visited Pont-Aven, Brittany, 1886; met Émile Bernard, and Charles Laval. Met Vincent van Gogh, Paris, 1886. Traveled with Laval to Panama and Martinique, 1887. Worked with Bernard, Meyer de Haan, Laval, Pont-Aven, 1888. One-man show, Boussod and Valadon (gallery managed by Theo van Gogh), Paris, 1888. Worked briefly with Vincent van Gogh, Arles, France, 1888. Returned to Pont-Aven, then moved to Le Pouldu, Brittany, 1889. Exhibited with *Les XX*, Brussels, 1889, 1891. Associated with Daniel de Monfreid, and the Symbolists, 1890. Exhibited, Salon de la Société Nationale des Beaux-Arts, Paris, 1891. Sold his works at auction, Hôtel Drouot, Paris, 1891, to finance trip to Tahiti; arrived, Papeete, 1891. Returned to Paris, 1893; began writing *Noa Noa*, in collaboration with Charles Morice. One-man show, Galerie Durand-Ruel, Paris, 1893. Second auction of his paintings, Hôtel Drouot; traveled to Punaauia, Tahiti, 1895. Publication of *Noa Noa* begun in *La Revue Blanche* (Paris), 1897. Moved to Atuana, Marquesas Islands, 1901. Began journal, *Avant et Après*, 1902. Died Atuana, May 8, 1903. Memorial retrospective, Salon d'Automne, Paris, 1906. *Avant. et Après* published (Paris, Crès), 1923; *Noa Noa* published (Paris, Crès), 1924. Retrospectives: Musée du Luxembourg, Paris (sculpture), 1927; Salles de l'Orangerie, Paris, 1949; The Tate Gallery, London, 1955; Wildenstein & Co., New York, 1956; The Metropolitan Museum of Art, New York, and The Art Institute of Chicago, 1959.

Torso of a Tahitian Woman. c. 1893, cast c. 1955.
Bronze, 11½ × 5⅜ × 6 inches
Markings: l. r. side "4/10"
l. l. side "Valsuani"

PROVENANCE:
Curt Valentin Gallery, New York, 1955

EXHIBITIONS:
The New York School of Social Work, Columbia University, New York, March 27–May 1, 1957, *19th and 20th Century French Painting and Sculpture*
The Detroit Institute of Arts, 1959, *Sculpture in Our Time*, no. 29
The Solomon R. Guggenheim Museum, New York, October 3, 1962–January 6, 1963, *Modern Sculpture from the Joseph H. Hirshhorn Collection*, no. 163, ill. p. 40

REFERENCES:
Gray, Christopher. *Sculpture and Ceramics of Paul Gauguin*, Baltimore, Johns Hopkins, 1963, no. 116, p. 252, ill.
Saltmarche, Kenneth. "Notes on Special Exhibitions: 'Sculpture in Our Time,'" *Art Quarterly*, 22, Winter 1959, p. 352

Mask of a Woman. c. 1893–95.
Bronze, 14⅜ × 9⅜ × 4 inches

PROVENANCE:
Charles E. Slatkin Galleries, New York, 1959

EXHIBITIONS:
The Solomon R. Guggenheim Museum, New York, October 3, 1962–January 6, 1963, *Modern Sculpture from the Joseph H. Hirshhorn Collection*, no. 164

REFERENCES:
Gray, Christopher. *Sculpture and Ceramics of Paul Gauguin*, Baltimore, Johns Hopkins, 1963, no. 112, p. 244

YUN GEE (1906–1963)

Chu Yuan-chi, born Canton, China, February 22, 1906. Studied painting, with Chinese master Chu, 1918–19. Emigrated to San Francisco, 1921. Studied, California School of Fine Arts, San Francisco, 1921–23. Closely associated with John Ferren, from the 1920s. First one-man show, The Modern Gallery, San Francisco, 1926. Lived in Paris, 1927–30; met Synchromist Morgan Russell. One-man shows, Paris: Galerie Carmine, 1927; Galerie Bernheim-Jeune, 1928. Moved to New York, 1930. Seventeen-foot mural exhibited, Chinatown, New York, for benefit of Chinese flood victims, 1931. One-man shows: The Brooklyn Museum, New York, 1931; Balzac Galleries, New York, 1932; Art Center, San Francisco (watercolors), 1933. Included in "Murals by American Painters and Photographers," The Museum of Modern Art, New York, 1932. Mural, St. Peter's Lutheran Church, Bronx, New York, 1933. WPA Federal Art Project, Easel Division, New York, 1934–36. Lived in Paris, 1937–39. One-man shows, New York: Montross Gallery, 1940; The Milch Galleries, 1942, 1943; Lilienfeld Galleries, 1945. Included in "Art for China," Ritz Tower Hotel, New York, 1941; Pennsylvania Academy Annual, 1942. Stopped painting, due to illness, c. 1945. Died New York, 1963. Retrospectives, New York: Gudenzi Gallery, 1963; Robert Schoelkopf Gallery, 1968.

Chinese Musicians. 1926–27.
Oil on canvas, 19 × 14 inches
Signed l. r. with monogram in Chinese

PROVENANCE:
Mrs. Helen Gee, New York; Robert Schoelkopf Gallery, New York, 1968

EXHIBITIONS:
Galerie Bernheim-Jeune, Paris, June 17–28, 1928, *Yun Gee*
Robert Schoelkopf Gallery, New York, May 7–31, 1968, *Yun Gee*, no. 11, ill.

JUAN GENOVÉS (b. 1930)

Born Valencia, Spain, June 1, 1930. Studied, Escuela Superior de Bellas Artes de San Carlos, Valencia. One-man shows, Galería Alfil, Madrid, 1956, 1957. Co-founded, El Grupo Hondo, with Gaston Orellana, and others, 1961; group exhibitions, Madrid: Galería Nebli, 1961; Galería Juana Mordó, 1963. Included in: 2ᵉ Biennale de Paris, 1961; Venice Biennale, 1962, 1966 (honorable mention); Spanish Pavilion, New York World's Fair, Flushing Meadows, 1964; VIII São Paulo Bienal, 1965; "La Figuration Narrative dans l' Art Contemporain," Galerie Raymond Creuze, Paris, 1965; VI San Marino Biennale, 1967 (Gold Medal); II Internazionale della giovane pittura, Bologna, 1967; "L'Art Vivant 1965–68," Fondation Maeght, St.-Paul-de-Vence, France, 1968. Received Premio Internazionale di Pittura, Lissone, Italy, 1965. One-man shows: Marlborough Fine Art, London, Marlborough Gallery, New York, and Marlborough Galleria d'Arte, Rome, from 1967; Frankfurter Kunstverein, Frankfort, Germany, and tour, 1971–72. Lives in Madrid.

The Prisoner (El Detenido). 1968.
Acrylic and oil on canvas, 78½ × 59⅛ inches
Signed and dated l. r.: "Genovés '68"

PROVENANCE:
Marlborough Galleria d'Arte, Rome, 1969

EXHIBITIONS:
Marlborough Galleria d'Arte, Rome, April–May 1969, *Genovés*, no. 15, ill.

JEAN-LÉON GÉRÔME (1824–1904)

Born Vesoul, Haute-Saône, France, May 11, 1824. Moved to Paris, 1841. Studied, Paris: École des Beaux-Arts, with Paul Delaroche, 1842–44; with Marc-Gabriel-Charles Gleyre, briefly, 1845. Traveled to Italy, with Delaroche, 1844–45. Exhibited, the Salon, Paris, from 1847; Third Class Medal, 1847; Second Class Medal, 1848, 1855; Medal of Honor, 1874; First Class Medal, 1881. Légion d'honneur: chevalier, 1855; officier, 1867; commandeur, 1878; grand officier, 1900. First trip to Egypt, 1856; traveled extensively in the Middle East, 1860s, 1870s. Included in Pennsylvania Academy Annual, 1860–62. Appointed professor, École des Beaux-Arts, Paris, 1863. Distinguished teacher of: Frank Boggs, Thomas Eakins, Fernand Léger, Aristide Maillol, Édouard Vuillard, J. Alden Weir. Served on Salon jury, which rejected Édouard Manet's paintings, 1866, and reviled Impressionists Monet and Pissarro, 1890s. Elected member, Institut de France, 1865. Exposition Universelle de Paris: awarded Medal of Honor, 1867; awarded Medal of Honor, and first sculpture exhibited, 1878. Monument to Napoleon I, *L'Aigle expirant*, installed, battlefield of Waterloo, Belgium, 1904. Died Paris, January 10, 1904.

Horse. c. 1890.
Bronze, 26 × 6⅜ × 28⅝ inches
Markings: l. r. front of base "J L Gerome
Siot-Decauville Paris"

PROVENANCE:
Unidentified collection, Paris; Grant Barney Schley, New York, and Far Hills, New Jersey; Mrs. Max Howell Behr, New York, and Far Hills; Mr. and Mrs. Sanborn Griffin, Cannes, 1968

"Boules" Player (La Joueuse de boules). After 1901.
Bronze, 10⅜ × 5 × 3¼ inches
Markings: front of base "J. L. Gerome"
r. side of base "Siot-Decauville Fondeur Paris"

PROVENANCE:
Landau-Alan Gallery, New York, 1967

EXHIBITIONS:
The Alan Gallery, New York, December 4–30, 1961, *The Romantic Temperament*, no. 17, ill.

REFERENCES:
Ackerman, Gerald M. "Gérôme: The Academic Realist," *The Academy, Art News Annual XXXIII*, 1967, ill. p. 106

ALBERTO GIACOMETTI (1901–1966)

Born Stampa, Switzerland, October 10, 1901; son of Impressionist painter Giovanni Giacometti (1868–1933). Studied sculpture, École des Arts et Métiers, Geneva, 1919. Traveled through Italy, with his father, 1920–21. Studied, Académie de la Grande Chaumière, Paris, with Émile-Antoine Bourdelle, 1922–25. First exhibited, Salon des Tuileries, Paris, 1925. With brother Diego, designed chandeliers, lamps, and other furnishings, for interior decorator Jean-Michel Franck, Paris, early 1930s. Exhibited with Joan Miró and Jean Arp, Galerie Pierre, Paris, 1930. Joined the Surrealists, 1930; published articles in *Le Surréalisme au service de la révolution* (Paris), 1931, 1933; expelled from group, 1935. First one-man show, Galerie Pierre Colle, Paris, 1932. Included in "Exposition Surréaliste," Galerie Pierre Colle, 1933; "International Surrealist Exhibition," New Burlington Galleries, London, 1936; "Fantastic Art, Dada, Surrealism," The Museum of Modern Art, New York, 1936. One-man show, Julien Levy Gallery, New York, 1934. Lived in Switzerland, 1942–45; returned to Paris. One-man shows: Peggy Guggenheim's Art of This Century, New York, 1945; Pierre Matisse Gallery, New York, from 1948; Venice Biennale, 1950; Galerie Maeght,

Paris, from 1951. Medal of Henri Matisse commissioned by French Mint, 1954. Retrospectives: The Solomon R. Guggenheim Museum, New York, and The Arts Council of Great Britain, London, 1955; Kunsthalle, Bern, 1956. Awarded: First Prize for Sculpture, Pittsburgh International, 1961; Grand Prize for Sculpture, Venice Biennale, 1962; Guggenheim International Award for Painting, Guggenheim International, 1964. Retrospectives: Kunstmuseum, Zurich, 1962; Galerie Beyeler, Basel, 1963; The Museum of Modern Art, 1965; The Tate Gallery, London, 1965; Louisiana Museum, Humblebaek, Denmark, 1965. Received Grand Prix des Arts de la Ville de Paris, 1965. Died Coire, Switzerland, January 11, 1966. Fondation Alberto Giacometti, Zurich, inaugurated, 1966. Retrospectives: Salles de l'Orangerie, Paris, 1969–70; The Solomon R. Guggenheim Museum, and tour, 1974–75.

Woman. 1927–28, cast 1929.
Bronze, 16¼ × 14⅞ × 3¼ inches
Markings: back l. l. "A. Giacometti XXIX"
back l. r. "Cire Perdue Valsuani"

PROVENANCE:
Galerie Pierre, Paris; Louis Broder, Paris; Berggruen & Cie., Paris; Brook Street Gallery, London; Harold Diamond, New York, 1968

Man and Woman. 1928.
Bronze, 12⅛ × 7¼ × 5¼ inches
Markings: top of base "A. Giacometti"
side of base "Susse Fondeur Paris 1/6"

PROVENANCE:
Pierre Matisse Gallery, New York, 1957

EXHIBITIONS:
The Detroit Institute of Arts, 1959, *Sculpture in Our Time,* no. 82
The Solomon R. Guggenheim Museum, New York, October 3, 1962–January 6, 1963, *Modern Sculpture from the Joseph H. Hirshhorn Collection,* no. 165
M. Knoedler & Co., New York, December 5–29, 1967, *Space and Dream,* ill. p. 45

Man. 1929.
Bronze, 16 × 11¾ × 3⅛ inches
Markings: back l. l. "Alberto Giacometti 1929"
c. back "3/6"

PROVENANCE:
Pierre Matisse Gallery, New York, 1957

EXHIBITIONS:
The Detroit Institute of Arts, 1959, *Sculpture in Our Time,* no. 83, ill. p. 7
The Solomon R. Guggenheim Museum, New York, October 3, 1962–January 6, 1963, *Modern Sculpture from the Joseph H. Hirshhorn Collection,* no. 166, ill. p. 10

REFERENCES:
Read, Herbert. *A Concise History of Modern Sculpture,* New York, Praeger, 1964, no. 140, p. 293, ill. p. 143

Reclining Woman Who Dreams. 1929, cast c. 1959.
Bronze painted white, 9¼ × 16¼ × 5 inches
Markings: u. r. top of base "Alberto Giacometti 1/6"
u. l. top of base "Susse Fondeur Paris"

PROVENANCE:
Galerie Lawrence, Paris; Peridot Gallery, New York, 1961

EXHIBITIONS:
The Solomon R. Guggenheim Museum, New York, October 3, 1962–January 6, 1963, *Modern Sculpture from the Joseph H. Hirshhorn Collection,* no. 167, ill. p. 111
The Museum of Modern Art, New York, June 9–October 12, 1965, *Alberto Giacometti,* no. 6, ill. p. 35; toured to The Art Institute of Chicago, November 5–December 12; Los Angeles County Museum of Art, January 11–February 20, 1966; San Francisco Museum of Art, March 10–April 24
Hopkins Art Center, Dartmouth College, Hanover, New Hampshire, May 25–July 9, 1967, *Sculpture in Our Century: Selections from the Joseph H. Hirshhorn Collection,* no. 20, ill. p. 19
M. Knoedler & Co., New York, December 5–29, 1967, *Space and Dream,* p. 24, ill. p. 46
The Museum of Modern Art, New York, March 27–June 9, 1968, *Dada, Surrealism, and Their Heritage,* no. 123; toured to Los Angeles County Museum of Art, July 16–September 8; The Art Institute of Chicago, October 19–December 8
Smithsonian Institution, Washington, D.C., September 26, 1971–January 31, 1972, *One Hundred and Twenty-Fifth Anniversary of the Institution*

REFERENCES:
Adreane, Christopher. "Dada and the Surrealists," *Christian Science Monitor,* 60, April 27, 1968, ill. p. 9
Geldzahler, Henry. "Taste for Modern Sculpture: The Hirshhorn Collection," *Art News,* 61, October 1962, ill. p. 31
Read, Herbert. *A Concise History of Modern Sculpture,* New York, Praeger, 1964, no. 141, p. 293, ill. p. 144

Standing Man. 1930.
Polychromed plaster, 25⅜ × 19¼ × 7⅜ inches
Markings: l. l. side "Alberto Giacometti 1930"

PROVENANCE:
Private collection, Baltimore; The Baltimore Museum of Art; M. Knoedler & Co., New York, 1963

EXHIBITIONS:
The Baltimore Museum of Art, March 17–April 16, 1950, *The Saidie A. May Collection of Modern Paintings and Sculpture,* no. 119
The Phillips Collection, Washington, D.C., February 2–March 4, 1963, *Alberto Giacometti: A Loan Exhibition,* no. 3
The Museum of Modern Art, New York, June 9–October 12, 1965, *Alberto Giacometti,* no. 7; toured to The Art Institute of Chicago, November 5–December 12; Los Angeles County Museum of Art, January 11–February

20, 1966; San Francisco Museum of Art, March 10–April 24
M. Knoedler & Co., New York, December 5–29, 1965, *Space and Dream,* ill. p. 46

Cubist Head. 1934–35.
Painted plaster, 7 × 7¼ × 8¼ inches

PROVENANCE:
Man Ray, Paris; G. David Thompson, Pittsburgh; Galerie Beyeler, Basel; Harold Diamond, New York, 1963

EXHIBITIONS:
Galerie Pierre, Paris, May 2–14, 1936, *Oeuvres récents de Arp, Ferren, Giacometti, Hartung, Hélion, Kandinsky, Nelson, Paalen, Taeuber-Arp,* cat., ill.
The Solomon R. Guggenheim Museum, New York, June 7–July 17, 1955, *Alberto Giacometti,* cat.
Galerie Beyeler, Basel, Summer 1963, *Alberto Giacometti,* no. 22

The Nose. 1947.
Bronze, head 16⅜ × 3⅞ × 26 inches; cage 32 × 14¼ × 18¼ inches
Markings: bottom of neck "Alberto Giacometti ⅛ "Susse Fondeur Paris"

PROVENANCE:
Pierre Matisse Gallery, New York; Mr. and Mrs. Arthur J. Kobacker, Steubenville, Ohio; Parke-Bernet Galleries, New York, Sale 3104, October 29, 1970, no. 33, ill.

EXHIBITIONS:
The Museum of Modern Art, New York, June 9–October 12, 1965, *Alberto Giacometti,* no. 27; toured to The Art Institute of Chicago, November 5–December 12; Los Angeles County Museum of Art, January 11–February 20, 1966; San Francisco Museum of Art, March 10–April 24

REFERENCES:
Eagle, Joanna. "Washington: Upbeat Ending," *The Art Gallery,* 15, May 1972, ill. p. 64

Tall Figure. 1947.
Bronze, 80 × 6 × 5 inches
Markings: back of base "Alberto Giacometti 1/6" "Susse Fondeur Paris"

PROVENANCE:
Pierre Matisse Gallery, New York, 1957

EXHIBITIONS:
Dallas Museum for Contemporary Arts, May 8–July 3, 1958, *Sculpture from Rodin to Lipchitz,* cat.
The Museum of Fine Arts, Houston, October 10–November 23, 1958, *The Human Image,* cat.
The Detroit Institute of Arts, and tour, 1959–60, *Sculpture in Our Time,* no. 84
The Solomon R. Guggenheim Museum, New York, October 3, 1962–January 6, 1963, *Modern Sculpture from the Joseph H. Hirshhorn Collection,* no. 168
The Museum of Modern Art, New York, June 9–October 12, 1965, *Alberto Giacometti,* no. 28

Walking Man. 1947–48.
Bronze (1/6), 26½ × 11½ × 5 inches
Markings: top of base "A. Giacometti"

PROVENANCE:
Sidney Janis Gallery, New York, 1955

EXHIBITIONS:
The Solomon R. Guggenheim Museum, New York, October 3, 1962–January 6, 1963, *Modern Sculpture from the Joseph H. Hirshhorn Collection,* no. 179, ill. p. 113
Hopkins Art Center, Dartmouth College, Hanover, New Hampshire, May 25–July 9, 1967, *Sculpture in Our Century: Selections from the Joseph H. Hirshhorn Collection,* no. 22, ill. p. 34

Three Figures and a Head (La Place). 1950.
Bronze, 22 × 21½ × 16¼ inches
Markings: l. r. side "A. Giacometti ⅚"
back l. l. "Alexis Rudier Fondeur Paris"

PROVENANCE:
Galerie Maeght, Paris; The Hanover Gallery, London; Sidney Janis Gallery, New York; Mrs. Henry Epstein, New York, 1963

Dog. 1951, cast 1957.
Bronze, 17¼ × 36¼ × 6¼ inches
Markings: u. l. top of base "Alberto Giacometti 3/8"
r. side of base "Susse Fᵈ Paris"

PROVENANCE:
Pierre Matisse Gallery, New York, 1958

EXHIBITIONS:
The Detroit Institute of Arts, and tour, 1959–60, *Sculpture in Our Time,* no. 87, ill. p. 40
The Solomon R. Guggenheim Museum, New York, October 3, 1962–January 6, 1963, *Modern Sculpture from the Joseph H. Hirshhorn Collection,* no. 172, ill. p. 114
Greenwich Library, Connecticut, May 1–28, 1967, *Joseph H. Hirshhorn Collects*

REFERENCES:
Arnason, H. Harvard. *History of Modern Art,* New York, Abrams, 1968, ill. p. 396
Byng, Tom. "Mods and Baroquers," *House & Garden,* British ed., 20, February 1965, ill. p. 56
Canaday, John. "New Vistas Open for Sculpture," *The New York Times Magazine,* September 30, 1962, ill. p. 25
Jacobs, Jay. "Collector: Joseph H. Hirshhorn," *Art in America,* 57, July–August 1969, colorplate p. 69
———. "Quality as Well as Quantity: Joseph H. Hirshhorn," in Lipman, Jean, ed. *The Collector in America,* New York, Viking, 1971, colorplate p. 82
Johnson, Lady Bird. *A White House Diary,* New York, Holt, Rinehart and Winston, 1970, pp. 307–8
Kuh, Katherine. "Great Sculpture," *Saturday Review,* 45, June 23, 1962, p. 19
Mates, Robert E. *Photographing Art,* New York, Amphoto, 1966, ill. p. 118

———. "Photographing Sculpture and Museum Exhibits," *Curator,* 10, June 1967, ill. p. 117
Robbins, Daniel. "Modern Sculpture from the Joseph H. Hirshhorn Collection," *Apollo,* 76, November 1962, ill. p. 721
Sweeney, James Johnson. "A Living Frame for Sculpture," *House & Garden,* 126, August 1964, ill. p. 111
Unsigned. "Range of Hirshhorn Collection," *The Times,* London, July 3, 1964, ill.

In 1951, Giacometti executed a series of sculptures of animals—a horse (destroyed), a cat, and a dog. Of the dog, he said, "For a long time I'd had in my mind the memory of a Chinese dog I'd seen somewhere. And then one day I was walking along the rue de Vanves in the rain, close to the walls of the buildings, with my head down, feeling a little sad, perhaps, and I felt like a dog just then. So I made that sculpture. But it's not really a likeness at all. Only the sad muzzle is anything of a likeness."

The artist, in Lord, James. *A Giacometti Portrait,* New York, The Museum of Modern Art, 1965, p. 21

Bust of a Man (Diego). 1954.
Bronze, 11⅛ × 6¾ × 5¼ inches
Markings: l. r. "Alberto Giacometti 4/6"
back l. l. "Susse Fondeur Paris"

PROVENANCE:
Passedoit Gallery, New York, 1956

EXHIBITIONS:
The Solomon R. Guggenheim Museum, New York, October 3, 1962–January 6, 1963, *Modern Sculpture from the Joseph H. Hirshhorn Collection,* no. 178

Certain images recur throughout Giacometti's work, among them the faces of his wife, Annette, and of his brother, Diego.

"Diego's head is the one I know best. He's posed for me over a longer period of time and more often than anyone else. From 1935 to 1940 he posed for me every day, and again after the war for years. So when I draw or sculpt or paint a head from memory, it always turns out to be more or less Diego's head, because Diego's is the head I've done most often from life. And women's heads tend to become Annette's head for the same reason."

The artist, in Lord, James. *A Giacometti Portrait,* New York, The Museum of Modern Art, 1965, pp. 24–25

Bust of Diego. 1957.
Bronze, 24⅛ × 10⅛ × 5⅛ inches
Markings: l. l. side "Alberto Giacometti 1/6"
l. c. back "Susse Fondeur Paris"

PROVENANCE:
Pierre Matisse Gallery, New York, 1958

EXHIBITIONS:
The Solomon R. Guggenheim Museum, New York, October 3, 1962–January 6, 1963, *Modern Sculpture from the Joseph H. Hirshhorn Collection,* no. 175, ill. p. 112
The Museum of Modern Art, New York, June 9–October 12, 1965, *Alberto Giacometti,* no. 59, colorplate p. 53 (detail); toured to The Art Institute of Chicago, November 5–December 12; Los Angeles County Museum of Art, January 11–February 20, 1966; San Francisco Museum of Art, March 10–April 24

REFERENCES:
Dorra, Henri. *Art in Perspective: A Brief History,* New York, Harcourt, Brace, Jovanovich, 1972, p. 259, ill. ·p. 260
Unsigned. "Sculptor of Isolation," *MD,* 14, October 1970, ill. p. 158

Bust of Diego on a Stele (Stele II). 1958.
Bronze, 65 × 8½ × 3 inches
Markings: back l. l. "A. Giacometti"
top of stele "1/6"

PROVENANCE:
Pierre Matisse Gallery, New York, 1959

EXHIBITIONS:
The Solomon R. Guggenheim Museum, New York, October 3, 1962–January 6, 1963, *Modern Sculpture from the Joseph H. Hirshhorn Collection,* no. 176

Monumental Head. 1960.
Bronze, 37½ × 12 × 15 inches
Markings: l. l. side "Alberto Giacometti 1/6"
back l. l. "Susse Fondeur Paris"

PROVENANCE:
Pierre Matisse Gallery, New York, 1961

EXHIBITIONS:
Pierre Matisse Gallery, New York, December 12–30, 1961, *Giacometti,* no. 4
The Solomon R. Guggenheim Museum, New York, October 3, 1962–January 6, 1963, *Modern Sculpture from the Joseph H. Hirshhorn Collection,* no. 177, ill. p. 115
The Museum of Modern Art, New York, June 9–October 12, 1965, *Alberto Giacometti,* no. 64, ill. p. 74

REFERENCES:
Read, Herbert. *A Concise History of Modern Sculpture,* New York, Praeger, 1964, no. 148, p. 294, ill. p. 151
Sweeney, James Johnson. "A Living Frame for Sculpture," *House & Garden,* 126, August 1964, ill. p. 110

Annette. 1961.
Oil on canvas, 21½ × 18¼ inches
Signed and dated l. r.: "Alberto Giacometti 1961"

PROVENANCE:
Pierre Matisse Gallery, New York, 1962

EXHIBITIONS:
Pierre Matisse Gallery, New York, December 12–30, 1961, *Giacometti,* no. 19
The Museum of Modern Art, New York, June 9–October 12, 1965, *Alberto Giacometti,* no. 99, colorplate p. 103; toured to The Art Institute of Chicago, November 5–December 12; Los Angeles County Museum of Art,

January 11–February 20, 1966; San Francisco Museum of Art, March 10–April 24

REFERENCES:
Unsigned. "Searching for the Kernel of Life," *Newsweek*, 65, June 14, 1965, ill. p. 94A

Head of a Man. 1961.
Oil on canvas, 21⅛ × 15¼ inches
Signed and dated l. r.: "1961 Alberto Giacometti"

PROVENANCE:
Pierre Matisse Gallery, New York, 1962

EXHIBITIONS:
Pierre Matisse Gallery, New York, December 12–30, 1961, *Giacometti*, no. 25

The Studio (L'Atelier). 1961.
Oil on canvas, 36⅛ × 28¾ inches
Signed and dated l. r.: "Alberto Giacometti 1961"

PROVENANCE:
Galerie Maeght, Paris; Galerie Claude Bernard, Paris, 1962

ÉMILE GILIOLI (b. 1911)

Born Paris, June 10, 1911. Youth spent in Italy. Studied: École Nationale d'Art Décorative de Nice, 1928; École des Beaux-Arts, Paris, with Jean Boucher, 1931. Served, French Army, World War II; demobilized, 1940; settled in Grenoble, France. Returned to Paris, 1945. First one-man show, Galerie Breteau, Paris, 1945. Public monument commissioned, Voreppe, France, 1945. First tapestries, 1949. Included in Salon de la Jeune Sculpture, Paris, 1949–66. Sculpture commissions, France: *Monument to the Deported*, Grenoble, 1950; *Reclining Figure*, La Chapelle-en-Vercors, 1951–52. One-man shows: Galerie Arnaud, Paris, 1953–54; Galerie Louis Carré, Paris, 1958; Galerie Craven, Paris, 1960; World House Galleries, New York, 1964. Included in: IV São Paulo Bienal, 1957 (Prize for Tapestry); Pittsburgh International, 1958, 1967, 1970. Tapestry commissioned, Palais de Justice, Lille, France, 1968. Published *La Sculpture* (St.-Yrieix-la-Perche, Morel), 1968. Retrospective, Palais Galliera, Paris, 1968. Lives in Paris, and in St.-Martin-la-Cluze, France.

Bell Tower (Le Clocher). 1958.
Bronze (2/5), 23⅜ × 14 × 6 inches

PROVENANCE:
World House Galleries, New York, 1962

GREGORY GILLESPIE (b. 1936)

Born Roselle Park, New Jersey, November 29, 1936. Studied: The Cooper Union for the Advancement of Science and Art, New York, 1954–60; San Francisco Art Institute, B.F.A., M.F.A., 1962. Lived in Rome, 1962–70. Received: Fulbright Fellowship, 1962–64; Chester Dale Grant to the American Academy in Rome, 1964–66; Rosenthal Foundation Award, The National Institute of Arts and Letters, 1964. Included in: Whitney Annual, 1965, 1967, 1972; "Human Concern—Personal Torment," Whitney Museum of American Art, New York, 1969; National Academy of Design Annual, 1971 (Hallgarten Prize), 1972 (Saltus Medal); Whitney Biennial, 1973. One-man shows: Forum Gallery, New York, from 1966; Smith College Museum of Art, Northampton, Massachusetts, 1971; The Alpha Gallery, Boston, 1971. Received Louis Comfort Tiffany Foundation Fellowship, 1971. Taught, Smith College, 1972; visiting critic, Yale University, New Haven, Connecticut, 1972–73. Lives in Haydensville, Massachusetts.

Exterior Wall with Landscape. 1967.
Mixed media, 38⅛ × 23¾ × 4 inches

PROVENANCE:
Forum Gallery, New York, 1968

EXHIBITIONS:
Forum Gallery, New York, January 2–20, 1968, *Gillespie*
Whitney Museum of American Art, New York, October 14–November 30, 1969, *Human Concern—Personal Torment*, no. 42, colorplate

REFERENCES:
Psychiatry and Social Science Review, 4, July 14, 1970, cover ill.
Unsigned. "Art: Trends, Beyond Nightmare," *Time*, 93, June 13, 1969, p. 74, colorplate p. 75

CHARLES GINNEVER (b. 1931)

Born San Mateo, California, August 28, 1931. Studied, College of San Mateo, 1949–51. Served, U.S. Air Force, 1951–52. Studied: Académie de la Grande Chaumière, Paris, with Ossip Zadkine, 1953–55; Università degli Studi, Perugia, Italy, 1954; S. W. Hayter's Atelier 17, Paris, 1955; San Francisco Art Institute, 1955–57; Cornell University, Ithaca, New York, M.F.A., 1959. Included in: "Bay Area Sculpture," San Francisco Museum of Art, 1956; "New Forms, New Media," Martha Jackson Gallery, New York, 1960; "New York Artists," Andrew Dickson White Museum of Art, Cornell University, 1961; "Colored Sculpture," American Federation of Arts, Circulating Exhibition, 1965–66; "Painting and Sculpture Today," Indianapolis Museum of Art, Indiana, 1970. One-man shows: Allan Stone Gallery, New York, 1961; Bennington College, Vermont, 1965; Paula Cooper Gallery, New York, 1966, 1970, 1971. Taught: Pratt Institute, Brooklyn, New York, 1963; New School for Social Research, New York, 1964; The Brooklyn Museum Art School, New York, 1964–65; Newark School of Fine and Industrial Art, New Jersey, 1965; Dayton Art Institute, Ohio, 1966; Wyndham College, Putney, Vermont, 1967–70; Hobart College, Geneva, New York, from 1973. One-man show, Dag Hammarskjöld Plaza, New York, 1972–73. Lives in New York.

Untitled. 1968.
Cor-Ten steel, 8 feet 2 inches × 9 feet 1½ inches × 6 inches

PROVENANCE:
Paula Cooper Gallery, New York, 1968

EXHIBITIONS:
Paula Cooper Gallery, New York, November 1968, *Group Show*

FRITZ GLARNER (1899–1972)

Born Zurich, July 20, 1899. Moved with family to Italy, 1904. Studied, Accademia di Belle Arti e Liceo Artistico, Naples, 1914–20. Moved to Paris, 1923; studied, Académie Colarossi, 1924–26; met Jean Hélion, Theo van Doesburg, Piet Mondrian, Georges Vantongerloo, Alexander Calder, Jean Arp. One-man shows: Galerie Contemporaine, Paris, 1926; Galerie Povolotsky, Paris, 1928, 1930; Century Club, New York, 1931. Joined Association Abstraction-Création, Paris, 1932. Emigrated to the U.S., 1936. Joined and exhibited with American Abstract Artists, New York, 1938–44. One-man shows, New York: Kootz Gallery, 1945; Pinacotheca Gallery, 1949; Rose Fried Gallery, 1951, 1954. Included in: 58th, 61st, 67th American Exhibition, The Art Institute of Chicago, 1947, 1958, 1964; Whitney Annual, 1950–57, 1963, 1965; 1 São Paulo Bienal, 1951; "Abstract Painting and Sculpture in America," and "12 Americans," The Museum of Modern Art, New York, 1951, 1956; Documenta I, Kassel, 1955; Corcoran Biennial, 1957 (second prize); Venice Biennale, 1958; Pittsburgh International, 1958, 1961; American National Exhibition, Sokolniki Park, Moscow, 1959; "Art Since 1950," Seattle World's Fair, 1962; "Geometric Abstraction in America," Whitney Museum of American Art, New York, 1962; "Formalists," Washington [D.C.] Gallery of Modern Art, 1963; Dunn International, The Tate Gallery, London, 1964. Mural commissions, New York: lobby, Time-Life Building, 1960; Dag Hammarskjöld Library, United Nations, 1962. Retrospectives: Venice Biennale, 1968; San Francisco Museum of Art, and tour, 1970–71; Kunsthalle, Bern, 1972. One-man show, Gimpel & Hanover Galerie, Zurich (drawings), 1972. Died Locarno, Switzerland, September 18, 1972.

Relational Painting Tondo # 20. 1951–54.
Oil on Masonite, diameter 47 ¾ inches
Signed and dated on back: "Fritz Glarner
1951
1954"

PROVENANCE:
Duveen-Graham Gallery, New York; Harold Diamond, New York, 1968

EXHIBITIONS:
Portland Art Museum, Oregon, September 2–October 9, 1955, *Younger American Painters* (organized by The Solomon R. Guggenheim Museum, New York); toured to Henry Art Gallery, University of Washington, Seattle, October 16–November 13; San Francisco Museum of Art, November 15–January 22, 1956; Los Angeles County Museum of Art, February 1–29; University of Arkansas, Fayetteville, March 9–April 10; Isaac Delgado Museum of Art, New Orleans, April 15–May 20

REFERENCES:
Baur, John I. H., ed. *New Art in America*, Greenwich, Connecticut, New York Graphic Society, 1957, ill. p. 226

Relational Painting No. 83. 1957.
Oil on canvas, 45½ × 43½ inches
Signed, dated, and titled on back: "Fritz Glarner/ Relational Painting No. 83/ 1957"

PROVENANCE:
Mrs. Harriet Mnuchin Weiner; Harold Diamond, New York, 1968

PETER GOLFINOPOULOS (b. 1928)

Born New York, August 3, 1928. Served, U.S. Army Air Corps, 1945–48. Studied: The Art Students League of New York, with George Grosz, 1950, and Reginald Marsh, intermittently, 1951–57; Columbia University, New York, with Edwin Dickinson, B.F.A., 1957, M.F.A., 1958. First one-man show, Grand Central Moderns, New York, 1959. Taught, Columbia University, 1959–70. One-man shows, Egan Gallery, New York, 1964, 1966, 1967, 1969, 1971. Included in: Corcoran Biennial, 1967; "American Artists of the 1960's," Art Gallery, Boston University School of Fine and Applied Arts, 1970. Received Guggenheim Foundation Fellowship, 1971. Has taught, the Art Students League of New York, since 1966. Lives in New York.

Number 4. 1963.
Oil on canvas, 79½ × 84 inches

PROVENANCE:
Egan Gallery, New York, 1964

EXHIBITIONS:
Egan Gallery, New York, February 4–March 14, 1964, *Peter Golfinopoulos*

JULIO GONZÁLEZ (1876–1942)

Born Barcelona, September 21, 1876; family goldsmiths and metal craftsmen. With his older brother, Joan, learned metalwork in father's atelier. Studied painting, Escuela de Bellas Artes de Barcelona, evenings, c. 1892. Exhibited: Exposición Internacional de Barcelona, 1892, 1894, 1896, 1898; World's Columbian Exposition, Chicago, 1893. Moved with his brother to Paris, 1900; associated with Pablo Picasso, Juan Gris, Manolo. Worked primarily as a painter; stopped painting after death of his brother, 1908. Gradually returned to metalwork and sculpture. Assisted Picasso in technical aspects of welded constructions, c. 1929–31. One-man shows: Galerie de France, Paris, 1930; Galerie Le Centaure, Brussels, 1931. Exhibited, Salon des Surindépendants, Paris, from 1931. Joined: Cercle et Carré, Paris, 1932; Association Abstraction-Création, Paris, 1934. One-man shows, Paris: Galerie Cahiers d'Art, 1933; Galerie Percier, 1934; Galerie Pierre, 1937. Included in: "Cubism and Abstract Art," The Museum of Modern Art, New York, 1936; Spanish Pavilion, Exposition Universelle de 1937, Paris; "L'Art Espagnol Contemporain," Musée

du Jeu de Paume, Paris, 1938. Died Arcueil, outside of Paris, March 27, 1942. Retrospectives: Musée National d'Art Moderne, Paris, 1952; Stedelijk Museum, Amsterdam, and tour, 1955; The Museum of Modern Art, 1956; Galerie Chalette, New York, 1961; Ateneo de Madrid, and Palacio de la Virreina, Barcelona, 1968; Saidenberg Gallery, New York, and international tour, 1969–70; The Tate Gallery, London, 1970.

Woman with Bundle of Sticks (Femme au fagot). 1932.
Welded iron, 14⅜ × 5¾ × 4 inches
Markings: l. l. side "J. Gonzalez 1932"

PROVENANCE:
M. J. Ulmann, Paris; Galerie Claude Bernard, Paris, 1964

EXHIBITIONS:
Musée National d'Art Moderne, Paris, February 1–March 9, 1952, *Julio Gonzalez*, no. 53
Stedelijk Museum, Amsterdam, April 7–May 10, 1955, *Julio Gonzalez*, no. 75e, ill.; toured to Palais des Beaux-Arts, Brussels, May 20–June 19
Kestner-Gesellschaft, Hanover, November 1–December 1, 1957, *Julio Gonzalez*, no. 36

Although many of González's sculptures were cast in bronze after his death, under the supervision of his daughter, Roberta, *Woman with Bundle of Sticks* is his original welded iron, and a unique piece.

Head Called "Hooded" (Head Called "The Cagoulard"). c. 1934–35.
Bronze, 5⅛ × 8¼ × 7⅛ inches
Markings: back c. "© by Gonzalez
Susse Fond. Paris 1/9"

PROVENANCE:
Roberta González, Paris; Galerie Chalette, New York, 1961

EXHIBITIONS:
Galerie Chalette, New York, October–November 1961, *Julio Gonzalez*, no. 31, ill. p. 41

Mask of Montserrat Crying. 1936–37.
Bronze, 11 × 6 × 5 inches
Markings: back l. l. "J. Gonzalez Susse Fondeur 5/6 © by Roberta"

PROVENANCE:
Roberta González, Paris; Kleemann Galleries, New York, 1958

EXHIBITIONS:
Kleemann Galleries, New York, March 12–April 7, 1956, *Julio Gonzalez 1876–1942*, no. 8, ill.
The Detroit Institute of Arts, 1959, *Sculpture in Our Time*, no. 95
The Solomon R. Guggenheim Museum, New York, October 3, 1962–January 6, 1963, *Modern Sculpture from the Joseph H. Hirshhorn Collection*, no. 189, ill. p. 98

REFERENCES:
Ashton, Dore. "New York Letter," *Das Kunstwerk*, 16, October 1962, p. 26

Head of "The Montserrat II." 1941–42.
Bronze, 12⅜ × 6¼ × 10¼ inches
Markings: l. r. side "© by Gonzalez
Susse Fondeur Paris 5/6"

PROVENANCE:
Roberta González, Paris; Galerie Chalette, New York, 1961

EXHIBITIONS:
Galerie Chalette, New York, October–November 1961, *Julio Gonzalez*, no. 57, ill. p. 71
Washington [D.C.] Gallery of Modern Art, September 17–October 24, 1965, *20th Century Painting and Sculpture*, no. 23; toured to Wadsworth Atheneum, Hartford, Connecticut, October 28–December 5
The Solomon R. Guggenheim Museum, New York, October 3, 1962–January 6, 1963, *Modern Sculpture from the Joseph H. Hirshhorn Collection*, no. 191

REFERENCES:
Unsigned. "Homage to Gonzalez," *Time*, 77, November 17, 1961, ill. p. 68

On a mountain near Barcelona, in a shrine dedicated to Our Lady of Montserrat, there is a wooden statue of the Virgin which, according to legend, was carved by Saint Luke. Montserrat appeared as a theme in González's work as early as 1932.

Head of "The Montserrat II" was cast from an unfinished plaster figure of a screaming woman begun by González at the end of his life, during the early years of World War II.

ARSHILE GORKY (1904–1948)

Vosdanig Manoog Adoian, born Khorkom Vari, Haiyotz Dzor, Turkish Armenia, October 25, 1904. After massacre of the Armenians by the Turks, moved with family to Erevan, 1914. Emigrated to the U.S., with younger sister, Vartoosh, 1920. Settled in Watertown, Massachusetts; worked in Hood Rubber Factory. Studied: engineering, Brown University, Providence, Rhode Island, 1920–23; New School of Design, Boston, 1923, and taught there, 1924; Grand Central School of Art, New York, 1925, and taught there, 1925–31. Changed name to Arshile Gorky; moved to New York, 1925. Associated with: Stuart Davis, 1929–34; Willem de Kooning, from c. 1933. Included in: "An Exhibition of Work of 46 Painters and Sculptors under 35 Years of Age," and "New Horizons in American Art," The Museum of Modern Art, New York, 1930, 1936; Société Anonyme, New York, 1931; "Abstract Painting in America," Whitney Museum of American Art, New York, 1935. Joined Association Abstraction-Création, Paris, 1932. Public Works of Art Project, 1933–34; WPA, Federal Art Project, Mural Division, New York, 1935–41; mural commissions: *Aviation: Evolution of Forms under Aerodynamic Limitations*, Administration Building, Newark Airport, New Jersey, 1935; Aviation Building, New York World's Fair, Flushing Meadows, 1939. One-man shows: Mellon Galleries, Philadelphia,

1934; Guild Art Gallery, New York, 1936; Boyer Galleries, New York, 1938. Included in: Whitney Annual, 1937, 1940, 1941, 1945–47; "Trois Siècles d'Art aux États-Unis," Musée du Jeu de Paume, Paris, 1938; "Fourteen Americans," The Museum of Modern Art, 1946; 58th American Exhibition, The Art Institute of Chicago, 1947–48; Venice Biennale, 1950. Retrospective, San Francisco Museum of Art, 1941. Met André Breton, and other Surrealists, 1944. One-man shows, New York: Julien Levy Gallery, 1945–48; Sidney Janis Gallery, 1948. Studio and paintings destroyed by fire, Sherman, Connecticut, 1946. Died by suicide, Sherman, July 21, 1948. Memorial exhibitions: Kootz Gallery, New York, 1951; Whitney Museum of American Art, and tour, 1951; The Art Museum, Princeton University, New Jersey, 1952. Retrospectives: Venice Biennale, 1962; The Museum of Modern Art, New York, and Washington [D.C.] Gallery of Modern Art, 1962–63; The Tate Gallery, London, and tour, 1965.

Portrait of Myself and My Imaginary Wife. 1923.
Oil on cardboard, 8½ × 14½ inches
Signed and dated u. l.: "A. Gorky/23"

PROVENANCE:
The artist, New York, c. 1942.

EXHIBITIONS:
The Museum of Modern Art, New York, December 17, 1962–February 12, 1963, *Arshile Gorky, Paintings, Drawings, Studies*, no. 8, p. 53; toured to Washington [D.C.] Gallery of Modern Art, March 12–April 14
The Tate Gallery, London, April 2–May 2, 1965, *Arshile Gorky: Paintings and Drawings*, no. 14

REFERENCES:
Jordan, Jim M. *Catalogue Raisonné of the Oil Paintings of Arshile Gorky,* New York, Walker, forthcoming
Levy, Julien. *Arshile Gorky,* New York, Abrams, 1968, plate 16
Rosenberg, Harold. *Arshile Gorky,* New York, Horizon, 1962, p. 48
Schwabacher, Ethel K. *Arshile Gorky,* New York, Whitney Museum of American Art/Macmillan, 1957, p. 29, ill.

Portrait of a Young Man. 1924–42.
Oil on canvas, 20 × 16 inches
Signed and dated l. r.: "A. Gorky/1924–42"

PROVENANCE:
The artist, New York, c. 1942

EXHIBITIONS:
The National Gallery of Canada, Ottawa, and tour, 1957, *Some American Paintings from the Collection of Joseph H. Hirshhorn,* no. 18

REFERENCES:
Jordan, Jim M. *Catalogue Raisonné of the Oil Paintings of Arshile Gorky,* New York, Walker, forthcoming
Schwabacher, Ethel K. *Arshile Gorky,* New York, Whitney Museum of American Art/Macmillan, 1957, p. 28

Portrait of Vartoosh. c. 1932.
Oil on canvas, 20½ × 15½ inches
Signed and dated l. l.: "A. Gorky/XXII"

PROVENANCE:
The artist, New York, c. 1942

EXHIBITIONS:
Whitney Museum of American Art, New York, January 5–February 18, 1951, *Arshile Gorky Memorial Exhibition,* no. 1; toured to Walker Art Center, Minneapolis, March 2–April 22; San Francisco Museum of Art, May 9–June 9
The Art Museum, Princeton University, New Jersey, October 5–26, 1952, *Gorky Memorial Exhibition,* no. 1
Martha Jackson Gallery, New York, March 31–April 24, 1954, *Exhibition of Paintings by Arshile Gorky: the Middle Period,* no. 45
The Museum of Modern Art, New York, December 17, 1962–February 12, 1963, *Arshile Gorky: Paintings, Drawings, Studies,* no. 10, ill. p. 14; toured to Washington [D.C.] Gallery of Modern Art, March 12–April 14
The Tate Gallery, London, April 2–May 2, 1965, *Arshile Gorky: Paintings and Drawings,* no. 12, ill.; toured to Palais des Beaux-Arts, Brussels, May 22–June 27; Museum Boymans-van Beuningen, Rotterdam, The Netherlands, July 9–August 15, no. 13, ill.

REFERENCES:
Ashton, Dore. "Gli Inizi dell'Espressionismo Astratto in America," *L'Arte Moderna,* Milan, 13, 1967, colorplate p. 8
Jacobs, Jay. "Collector: Joseph H. Hirshhorn," *Art in America,* 57, July–August 1969, p. 68
Jordan, Jim M. *Catalogue Raisonné of the Oil Paintings of Arshile Gorky,* New York, Walker, forthcoming
Levy, Julien. *Arshile Gorky,* New York, Abrams, 1968, colorplate 26
Schwabacher, Ethel K. *Arshile Gorky,* New York, Whitney Museum of American Art/Macmillan, 1957, pp. 24, 29, ill. 1

Vartoosh Gorky (Mrs. Moorad Mooradian) was the youngest of Gorky's three sisters, and the closest to him throughout his life.

Woman's Head. 1933?
Oil on canvas, 12 × 9 inches
Signed and dated u. l.: "A. Gorky/1920"

PROVENANCE:
The artist, New York, c. 1942

REFERENCES:
Jordan, Jim M. *Catalogue Raisonné of the Oil Paintings of Arshile Gorky,* New York, Walker, forthcoming

Personage. 1936.
Oil on board, 10 × 8 inches
Signed and dated u. r.: "A Gorky/1936"

PROVENANCE:
The artist, New York, c. 1942

REFERENCES:
Jordan, Jim M. *Catalogue Raisonné of the Oil Paintings of Arshile Gorky,* New York, Walker, forthcoming
Rosenberg, Harold. *Arshile Gorky,* New York, Horizon, 1962, ill. p. 47
Schwabacher, Ethel K. *Arshile Gorky,* New York, Whitney Museum of American Art/Macmillan, 1957, p. 69

Composition. c. 1938–40.
Oil on canvas, 34 × 56 inches

PROVENANCE:
Harold Diamond, New York, 1967

REFERENCES:
Jordan, Jim M. *Catalogue Raisonné of the Oil Paintings of Arshile Gorky,* New York, Walker, forthcoming

Waterfall. c. 1943.
Oil on canvas, 38 × 25 inches
Signed on stretcher: "Arshile Gorky"

PROVENANCE:
Agnes Gorky Phillips; Sidney Janis Gallery, New York; Harold Diamond, New York, 1964

EXHIBITIONS:
Sidney Janis Gallery, New York, February 5–March 3, 1962, *Paintings by Arshile Gorky from 1929 to 1948,* no. 14, ill.
University Art Museum, The University of Texas at Austin, February 18–April 1, 1968, *Painting as Painting,* no. 26, ill. p. 17
National Collection of Fine Arts, Smithsonian Institution, Washington, D.C., May 3–September 1, 1968, *Contemporary American Art,* p. 6

REFERENCES:
Forgey, Benjamin. "A Hirshhorn Art Survey: Striking and Surprising," *Washington [D.C.] Evening Star,* February 23, 1971, sec. B, ill. p. 7
Jordan, Jim M. *Catalogue Raisonné of the Oil Paintings of Arshile Gorky,* New York, Walker, forthcoming
Levy, Julien. *Arshile Gorky,* New York, Abrams, 1968, ill. 89
Schwabacher, Ethel K. *Arshile Gorky,* New York, Whitney Museum of American Art/Macmillan, 1957, p. 94

Nude. 1946.
Oil on canvas, 50½ × 38 inches
Signed and dated l. r.: "A. Gorky/46"

PROVENANCE:
Julien Levy Gallery, New York; Mr. and Mrs. Frederick Varady, New York; Harold Diamond, New York, 1964

EXHIBITIONS:
Julien Levy Gallery, New York, April 9–27, 1946, *Arshile Gorky*
The Museum of Modern Art, New York, September 10–December 8, 1946, *Fourteen Americans,* no. 39
Whitney Museum of American Art, New York, December 10, 1946–January 16, 1947, *Annual Exhibition of Contemporary American Painting,* no. 56
California Palace of the Legion of Honor, San Francisco, November 19, 1947–January 4, 1948, *Second Annual Exhibition of Painting,* cat.
Whitney Museum of American Art, New York, January 5–February 18, 1951, *Arshile Gorky Memorial Exhibition,* no. 44; toured to Walker Art Center, Minneapolis, March 2–April 22; San Francisco Museum of Art, May 9–June 9
The Art Museum, Princeton University, New Jersey, October 5–26, 1952, *Gorky Memorial Exhibition,* No. 15
XXXI Biennale Internazionale d'Arte, Venice, June 16–October 7, 1962, *United States Pavilion,* no. 20, p. 116
The Museum of Modern Art, New York, December 17, 1962–February 12, 1963, *Arshile Gorky: Paintings, Drawings, Studies,* no. 86; toured to Washington [D.C.] Gallery of Modern Art, March 12–April 14
Providence Art Club, Rhode Island, March 31–April 24, 1965, *Critics' Choice: Art Since World War II,* no. 22, ill. p. 26
Fondation Maeght, St.-Paul-de-Vence, France, April 9–May 31, 1966, *Dix Ans d'Art Vivant: 1945–1955,* no. 69, ill.

REFERENCES:
Calas, Nicolas. *Bloodflames,* New York, Hugo Gallery, 1947, p. 8, ill.
Jordan, Jim M. *Catalogue Raisonné of the Oil Paintings of Arshile Gorky,* New York, Walker, forthcoming
Levy, Julien. *Arshile Gorky,* New York, Abrams, 1968, plate 136
Reiff, Robert. "The Late Work of Arshile Gorky," *Art Journal,* 22, Spring 1963, p. 151
Schwabacher, Ethel K. *Arshile Gorky,* New York, Whitney Museum of American Art/Macmillan, 1957, pp. 126, 132, plate 61

ADOLPH GOTTLIEB (1903–1974)

Born New York, March 14, 1903. Studied: The Art Students League of New York, with John Sloan, and Robert Henri, 1920; Académie de la Grande Chaumière, Paris, 1921–23; Parsons School of Design, New York, 1923. One-man shows, New York: Dudensing Galleries, 1930; Uptown Gallery, 1934; Theodore A. Kohn & Son, 1934. Co-founded The Ten, New York, with Ilya Bolotowsky, Mark Rothko, Joseph Solman, and others, 1935; included in "The Ten: Whitney Dissenters," Mercury Gallery, New York, 1938. WPA Federal Art Project, Easel Division, New York, 1936; U.S. Treasury Department, Section of Fine Arts, mural, U.S. Post Office, Yerington, Nevada, 1939. Lived in Arizona, 1937–39. One-man shows, New York: The Artists' Gallery, 1940, 1942–43; Wakefield Gallery, 1944; Gallery 67, 1945; Nierendorf Gallery, 1945; Kootz Gallery, 1947, 1950–54, and Provincetown, Massachusetts, 1954; Jacques Seligmann & Co., 1949. Included in: Whitney Annual, from 1940; Pittsburgh International, 1952–70 (third prize, 1961); Guggenheim International Award, 1954, 1961, 1964; "The New American Painting," The Museum of Modern Art, New York, International Circulating Exhibition, 1958–59; Documenta II, Kassel,

1959. President, Federation of Modern Painters and Sculptors, New York, 1944–45. Retrospectives: Bennington College, Vermont, 1954; The Jewish Museum, New York, 1957; Walker Art Center, Minneapolis, 1963. One-man shows: Martha Jackson Gallery, New York, 1957; André Emmerich Gallery, New York, 1959; French & Company, 1960; Sidney Janis Gallery, New York, 1960, 1962; Marlborough-Gerson Gallery, New York, 1964, 1966; The Arts Club of Chicago, 1967; Marlborough Galleria d'Arte, Rome, 1970; Marlborough Fine Art, London, and Marlborough Galerie AG, Zurich, 1971. Taught: Pratt Institute, Brooklyn, New York, 1958; University of California at Los Angeles, 1958. Retrospective, The Solomon R. Guggenheim Museum, and Whitney Museum of American Art, New York, and tour, 1967–68. Awarded Grand Prix, VII São Paulo Bienal, 1963. Member, Art Commission, City of New York, 1967–69. Member, The National Institute of Arts and Letters, 1972. Died New York, March 4, 1974.

Pictogenic Fragments. 1946.
Oil on canvas, 36 × 30 inches

PROVENANCE:
Kootz Gallery, New York; Mr. and Mrs. Albert List, New York; Harold Diamond, New York, 1963

EXHIBITIONS:
Kootz Gallery, New York, January 6–25, 1947, *Adolph Gottlieb,* cat.
The Solomon R. Guggenheim Museum, New York, February 14–March 31, 1968, *Adolph Gottlieb,* no. 14, ill. p. 32; toured to The Corcoran Gallery of Art, Washington, D.C., April 26–June 2; Rose Art Museum, Brandeis University, Waltham, Massachusetts, September 9–October 20

REFERENCES:
Jacobs, Jay. "Collector: Joseph H. Hirshhorn," *Art in America,* 57, July–August 1969, p. 68
———. "Quality as Well as Quantity: Joseph H. Hirshhorn," in Lipman, Jean, ed. *The Collector in America,* New York, Viking, 1971, p. 75

Two Discs. 1963.
Oil on canvas, 7 feet 6 inches × 9 feet
Signed and dated on back: "Adolph Gottlieb/1963"

PROVENANCE:
Marlborough-Gerson Gallery, New York, 1966

EXHIBITIONS:
Marlborough-Gerson Gallery, New York, February 12–March 15, 1966, *Adoph Gottlieb, 12 Paintings,* no. 5, ill.
Whitney Museum of American Art, New York, February 14–March 31, 1968, *Adolph Gottlieb,* no. 94, ill. p. 82

REFERENCES:
Hudson, Andrew. "Adolph Gottlieb's Paintings at the Whitney," *Art International,* 12, April 20, 1968, pp. 24, 26, ill. p. 24
Rosenstein, Harris. "Gottlieb at the Summit," *Art News,* 65, April 1966, p. 42
———. "Reviews and Previews: Adolph Gottlieb," *Art News,* 64, February 1966, p. 16

ROBERT GRAHAM (b. 1938)

Robert Charles Pena Graham, born Mexico City, August 19, 1938. Studied, California: San Jose State College, 1961–64; San Francisco Art Institute, M.F.A., 1966. One-man shows: Lanyon Gallery, Palo Alto, California, 1964; Nicholas Wilder Gallery, Los Angeles, 1966–69; Galerie Thelen, Essen, Germany, 1967. Included in: Whitney Annual, 1966, 1968, 1970; "Here and Now," Washington University Gallery of Art, St. Louis, Missouri, 1969; "Contemporary American Sculpture: Selection 2," Whitney Museum of American Art, New York, 1969. One-man shows: Kornblee Gallery, New York, 1968, 1969; Whitechapel Art Gallery, London, 1970; Galerie Neuendorf, Cologne, 1971; Sonnabend Gallery, New York, 1971; Kunstverein in Hamburg, Germany, 1972. Lives in Los Angeles.

Girl with Towel. 1968.
Wax, balsa wood, paper, and Plexiglas, 11 × 20 × 20 inches

PROVENANCE:
Kornblee Gallery, New York, 1968

EXHIBITIONS:
Kornblee Gallery, New York, April 6–25, 1968, *Robert Graham*

REFERENCES:
Unsigned. *Robert Graham Works 1963–1969,* Cologne, Walter König, 1970, no. 41, ill.

MORRIS GRAVES (b. 1910)

Born Fox Valley, Oregon, August 28, 1910. Moved with family to Washington, 1911. Largely self-taught as an artist. Traveled to the Orient, 1928, 1930. Seattle Museum: First Purchase Prize, Northwest Annual, 1933; one-man show, 1936; studied calligraphy, with Mark Tobey, 1939; part-time staff member, 1940–42. WPA, Federal Art Project, Easel Division, Washington, 1936–37. Served, U.S. Army, 1942–43. One-man shows, Willard Gallery, New York, from 1942. Included in: "Americans 1942," and "Romantic Painting in America," The Museum of Modern Art, New York, 1942, 1943; Whitney Annual, 1942–61. Received Guggenheim Foundation Fellowship, 1946. Awarded Harris Bronze Medal, 58th American Exhibition, and Blair Prize, Watercolor Annual, The Art Institute of Chicago, 1948. Retrospectives: California Palace of the Legion of Honor, San Francisco, 1948; Whitney Museum of American Art, New York, and tour (organized by the Art Galleries, University of California at Los Angeles), 1956. Traveled: to Europe, 1948–49; Mexico, 1950; Japan, 1954. Included in: I São Paulo Bienal, 1951; "Expressionism in American Painting," Albright Art Gallery, Buffalo, New York, 1952; "50 Ans d'Art Moderne," Palais des Beaux-Arts, Brussels, 1958; "Art Since 1950," Seattle World's Fair,

1962. Received grant, The National Institute of Arts and Letters, and The American Academy of Arts and Letters, 1956; member, The National Institute of Arts and Letters, 1957. First American recipient, Windsor Award, 1957. Lived in County Cork, Ireland, 1957–65. Retrospectives: Balboa Pavilion Gallery, California, 1963; University of Oregon, Eugene, 1966; Tacoma Art Museum, Washington, 1971. Lives in Loleta, California.

Colossal Owls and Eagles of the Inner Eye. 1941.
Oil and gouache on paper, 20¾ × 36¼ inches
Signed and dated l. r.: "M. Graves '41"

PROVENANCE:
Willard Gallery, New York; Mrs. Patrick J. Kelleher, Buffalo, New York; Willard Gallery, 1956

EXHIBITIONS:
Albright Art Gallery, Buffalo, New York, May 10–June 29, 1952, *Expressionism in American Painting*, no. 31, ill. p. 38

REFERENCES:
Jolson, Betty K. *Morris Graves*, M.A. thesis, New York University, 1969, pp. 24, 25, ill. p. 81
McBride, Henry. "It's called Expressionism," *Art News*, 51, May 1952, p. 63

"I paint to evolve a changing language of symbols, a language with which to remark upon the qualities of our mysterious capacities which direct us toward ultimate reality. I paint to rest from the phenomena of the external world—to pronounce it—and to make notations of its essences with which to verify the inner eye."

The artist, in Miller, Dorothy C., ed. *Americans 1942: 18 Artists from 9 States*, New York, The Museum of Modern Art, 1942, p. 51

RED GROOMS (b. 1937)

Charles Rogers Grooms, born Nashville, Tennessee, June 1, 1937. Studied: School of The Art Institute of Chicago, 1955; George Peabody College for Teachers, Nashville, 1956; New School for Social Research, New York, 1956; Hans Hofmann School of Fine Art, Provincetown, Massachusetts, 1958. One-man shows: Sun Gallery, Provincetown, 1958; City Gallery, New York, 1958–59; Reuben Gallery, New York, 1960. Films include: *The Unwelcome Guests*, 1961; *Fat Feet*, 1966; *Tappy Toes*, 1969–70; *Hippodrome Hardware*, 1972–73. One-man shows: Nashville Artists' Guild, 1962; Tibor de Nagy Gallery, New York, 1963–70; Allan Frumkin Gallery, Chicago, 1967. Included in: 67th and 68th American Exhibition, The Art Institute of Chicago, 1964, 1966; Venice Biennale, 1968; "Ten Independents: An Artist-Initiated Exhibition," The Solomon R. Guggenheim Museum, New York, 1971. Received grant: The National Institute of Arts and Letters, and The American Academy of Arts and Letters, 1969; Creative Artists Public Service Program, 1970–71. One-man shows: Walker Art Center, Minneapolis, and 924 Madison Avenue, New York, 1971; John Bernard Myers Gallery, New York, from 1971; Rutgers University Art Gallery, The State University of New Jersey, New Brunswick, and New York Cultural Center, 1973–74. Lives in New York.

Hollywood. 1965.
Painted wood, 27¾ × 37 × 15 inches

PROVENANCE:
Tibor de Nagy Gallery, New York, 1967

EXHIBITIONS:
Waddell Gallery, New York, 1967, *Artists for C.O:R.E.*

Loft on 26th Street. 1965–66.
Mixed media, 30¼ × 70 × 35½ inches
Signed and dated l. r.: "Red Grooms 65.66"

PROVENANCE:
Tibor de Nagy Gallery, New York, 1967

EXHIBITIONS:
Tibor de Nagy Gallery, New York, December 1966, *Red Grooms*
The Art Institute of Chicago, August 19–October 16, 1966, *68th American Exhibition*, no. 5, ill.
The American Academy of Arts and Letters, New York, March 1–April 21, 1968, *Exhibition of Works by Newly Elected Members and Recipients of Honors and Awards*, no. 23

REFERENCES:
Berrigan, Ted. "Red Power," *Art News*, 65, December 1966, p. 45, ill. p. 46
Glueck, Grace. "Red Grooms, the Ruckus Kid," *Art News*, 72, December 1973, p. 26
Kostelanetz, Richard, et al. *The Story of Great Music: The Music of Today*, New York, Time-Life Records, 1967, p. 6, colorplate pp. 6–7

"'I had such a strong feeling about it—as if the place were really me,' said painter and film-maker Red Grooms of his loft studio in New York. Because the building was scheduled for demolition, he devoted seven months, working ten hours a day, to constructing this absorbing, amusing, and sentimental scale model, complete with painted cardboard cutouts of his wife, Mimi . . . his friends and himself."

Kostelanetz, p. 6

The artist has identified the people in the loft as, from left to right: Esther Rabinowitz, Jay Milder, Sheila Milder, Gretchen Jessup Riley, Sam Riley, Katharine Kean, Mimi Gross Grooms, Elisse Suttman, Candice Brown, Thomas Stearns, Carol Summers, Gillian Walker, Paul Suttman, Red Grooms, and Spencer Grooms.

WILLIAM GROPPER (b. 1897)

Born New York, December 3, 1897. Studied, New York: Ferrer Center, with George Bellows, and Robert Henri, 1912–13; National Academy of Design, 1913–14; New York School of Fine and Applied Art, with Howard Giles, and Jay Humbridge, 1915–18. Staff member: *New York Tribune*, 1919–21; *New York World*, 1925–27; *Morning Freiheit*, 1925–32. Contributed illustrations and cartoons to *The Quill, Dial, Vanity Fair, The Nation, New Masses*, 1920–35. Received American Newspaper Guild

Awards: Collier Prize, 1920; Harmon Prize, 1930. Exhibited monotypes, Greenwich Village, New York, 1921. First paintings, 1921. Traveled to the U.S.S.R., with Theodore Dreiser, and Sinclair Lewis, 1927. Author of twelve books, 1929–68. Included in: "Murals by American Painters and Photographers," "Art in Our Time," and "Romantic Painting in America," The Museum of Modern Art, New York, 1932, 1939, 1943; Whitney Annual, 1933–55; "Trois Siècles d'Art aux États-Unis," Musée du Jeu de Paume, Paris, 1938; Carnegie International, 1938, 1939; "American Art Today," New York World's Fair, Flushing Meadows, 1939; Golden Gate International Exposition, San Francisco, 1939, 1940; Carnegie Annual, 1943–50 (third prize, 1946). One-man shows, ACA Gallery, New York, from 1936. U.S. Treasury Department, Section of Fine Arts, murals: U.S. Post Office, Freeport, New York, 1936; South Building, U.S. Department of Interior, Washington, D.C., 1938; U.S. Post Office, Northwestern Station, Detroit, 1939 (now at Wayne State University, Detroit). Received Guggenheim Foundation Fellowship, 1937. One-man shows, Associated American Artists Galleries, New York, 1945, 1951, 1952, 1965 (graphics); Silvan Simone Gallery, Los Angeles, 1959, 1960; Galerie de Tours, San Francisco, 1962, 1965. Taught, American Artists School, New York, 1946–48. Received American Federation of Arts, and Ford Foundation Grant, artists-in-residence program, Evansville Museum of Arts and Science, Indiana, 1965. Included in "The Lower East Side: Portal to American Life (1870–1924)," The Jewish Museum, New York, and Arts and Industries Building, Smithsonian Institution, Washington, D.C., 1966–68. Commission, stained-glass windows, Temple Har Zion, River Forest, Illinois, 1967. Member, The National Institute of Arts and Letters, 1968. Retrospectives: The Lowe Art Museum, University of Miami, Coral Gables, Florida, and tour, 1968; ACA Gallery, and tour, 1971–72. Lives in Great Neck, New York.

Tailor. 1940.
Oil on canvas, 20 × 26½ inches
Signed l. l.: "Gropper"

PROVENANCE:
ACA Gallery, New York, 1941

EXHIBITIONS:
ACA Gallery, New York, November 22–December 11, 1965, *Gropper*, cat.
The Lowe Art Museum, University of Miami, Coral Gables, Florida, February 15–March 10, 1968, *William Gropper: Retrospective*, no. 29, ill. p. 51

"*The Tailor* goes back as far as I can remember—it is very close to me. My father, grandfather and great grandfathers were the Tailors, with their legs folded, crouched on tables sewing clothes late into the night. Who can forget the huge bundles of clothes I carried as a child from the sweatshops, the homework for my parents—it was these bundles we used as bedding to sleep on."

Statement by the artist, 1972

CHAIM GROSS (b. 1904)

Born Galicia, Austria, March 17, 1904. Studied: National Academy of Fine Arts, Budapest, 1919; Kunstgewerbeschule, Vienna, 1920. Emigrated to New York, 1921. Studied, New York: Educational Alliance Art School, 1921–26; Beaux-Arts Institute of Design, 1922–26; The Art Students League of New York, with Robert Laurent, 1926–27. One-man shows: Gallery 144, New York, 1932; Boyer Galleries, Philadelphia, 1935, and New York, 1937. Received Louis Comfort Tiffany Foundation Fellowship, 1933. WPA, Federal Art Project, Sculpture Division, New York, 1933–35. Commissions: *Alaskan Mail Carrier*, U.S. Post Office Department Building, Washington, D.C., 1936; *Riveters*, Federal Trade Commission Building, Washington, D.C., 1938; *Puddlers*, U.S. Post Office, Irwin, Pennsylvania, 1940. Exhibited, Paris: Exposition Universelle de 1937 (Silver Medal); "Trois Siècles d'Art aux États-Unis," Musée du Jeu de Paume, 1938. Plaster reliefs installed, New York World's Fair, Flushing Meadows, 1939: *Harvest*, French Pavilion; *Communication*, Court of Peace. Awarded second prize, "Portrait of America (Artists for Victory, Inc.)," The Metropolitan Museum of Art, New York, 1942. One-man shows: Associated American Artists Galleries, New York, 1942, 1969; The Massillon Museum, Ohio, and tour, 1946; The Jewish Museum, New York, 1953; Duveen-Graham Gallery, New York, 1957. Included in: Boston Arts Festival, 1954 (Third Prize for Sculpture), 1963 (first prize); American National Exhibition, Sokolniki Park, Moscow, 1959; "Four American Expressionists: Doris Caesar, Chaim Gross, Karl Knaths, Abraham Rattner," Whitney Museum of American Art, New York, and tour, 1959–60. Received The National Institute of Arts and Letters Grant, 1956. Commissions: Reiss-Davis Child Guidance Clinic, Beverly Hills, California, 1961; Hadassah-Hebrew University Medical Center, Jerusalem, 1964; Temple Shaaray Tefila, New York, 1964. One-man shows, Forum Gallery, New York, from 1962. Received Award of Merit, The American Academy of Arts and Letters, 1963; member, The National Institute of Arts and Letters, 1964. With Peter Robinson, co-authored *Sculpture in Progress* (New York, Van Nostrand-Reinhold), 1972. Has taught: Educational Alliance Art School, New York, since 1927; New School for Social Research, New York, since 1950. Lives in New York.

Strong Woman (Acrobats). 1935.
Lignum vitae, 48¾ × 11⅜ × 8 inches
Markings: c. top of base "Ch. Gross"

PROVENANCE:
Gift of the artist, New York, 1968

EXHIBITIONS:
Boyer Galleries, New York, February 8–27, 1937, *Chaim Gross*, checklist

REFERENCES:
Lombardo, Josef Vincent. *Chaim Gross: Sculptor*, New York, Dalton House, 1949, p. 225

Playful Sisters (Family of Three). 1949.
Mexican tulipwood, 54 × 16¼ × 13¾ inches

PROVENANCE:
Duveen-Graham Gallery, New York, 1957

EXHIBITIONS:
Duveen-Graham Gallery, New York, April 14–May 4, 1957, *Chaim Gross*, no. 12
Whitney Museum of American Art, New York, January 14–March 1, 1959, *Four American Expressionists: Doris Caesar, Chaim Gross, Karl Knaths, Abraham Rattner*, no. 50, ill. p. 59
The Detroit Institute of Arts, and tour, 1959–60, *Sculpture in Our Time*, no. 97
The American Academy of Arts and Letters, New York, May 20–August 30, 1964, *Exhibition of Works by Newly Elected Members and Recipients of Honors and Awards*, no. 20

REFERENCES:
Getlein, Frank. *Chaim Gross*, New York, Abrams, forthcoming, ill.
Lombardo, Josef Vincent. *Chaim Gross: Sculptor*, New York, Dalton House, 1949, pp. 193, 195, 235, ill. p. 137
Shirkey, Howard. "A Tour of 'Sculpture in Our Time' at The Detroit Institute of Arts," *Detroit Times Pictorial Living*, July 19, 1959, ill. p. 5
Unsigned. "Chaim Gross," in *Phaidon Dictionary of Twentieth Century Art*, London, and New York, Phaidon, 1973, p. 147

ROBERT GROSVENOR (b. 1937)

Born New York, March 31, 1937. Studied: École des Beaux-Arts, Dijon, France, 1956; École Nationale Supérieure des Arts Décoratifs, Paris, 1957–59; Università degli Studi, Perugia, Italy, 1958. Exhibited, Park Place Gallery, New York, 1963–67. One-man show, Dwan Gallery, New York, 1966. Included in: "Primary Structures," The Jewish Museum, New York, 1966; Whitney Annual, 1968; "Plus by Minus: Today's Half-Century," Albright-Knox Art Gallery, Buffalo, New York, 1968. Received: National Council on the Arts Grant, 1969; Guggenheim Foundation Fellowship, 1970. One-man shows: Fischbach Gallery, New York, 1970; Galerie Rolf Ricke, Cologne, 1970; Paula Cooper Gallery, New York, 1970, 1971. Included in: Sonsbeek '71, Arnhem, The Netherlands, 1971; Whitney Biennial, 1973. Received award, The National Institute of Arts and Letters, and The American Academy of Arts and Letters, 1973. Lives in New York.

Niaruna. 1965.
Painted aluminum and cables, 3 feet 1 inch × 24 feet 7 inches × 6 feet 9 inches

PROVENANCE:
Park Place Gallery, New York, 1967

GEORGE GROSZ (1893–1959)

Born Berlin, July 26, 1893. Youth spent in Stolp, Pomerania, Germany. Studied: Königliche Kunstakademie, Dresden, with Richard Müller, Osmar Schindler, Robert Sterl, Raphael Wehle, 1909–11; Staatliche Kunstgewerbeschule, Berlin, with Emil Orlik, 1911; Académie Colarossi, Paris, 1913. Contributed drawings to magazines *Ulk*, and *Lustige Blätter*, 1909–13. Served, German Army, 1914–18. Joined Dada movement, Berlin, 1918. Exhibited: Galerie Neue Kunst, Munich, 1918–23; Galerie Alfred Flechtheim, Berlin, 1920–31. Published books of drawings: *Das Gesicht der herrschenden Klasse*, 1919; *Ecce Homo*, 1922; *Der Spiesser-Spiegel*, 1924; *Über alles die Liebe*, 1931. Collaborated in publishing *Die Pleite*, and other magazines, 1919–24. Active in theater, 1920–30. Arrested and fined for attacking military in his portfolio *Gott mit Uns*, 1920; thirty original plates confiscated and destroyed by police, 1923. Included in "Die Neue Sachlichkeit," Städtische Kunsthalle, Mannheim, Germany, with Max Beckmann, Otto Dix, and others, 1925. Denounced as "Cultural Bolshevik No. 1" by Nazis, 1930; included in "Entartete Kunst (Degenerate Art)," Munich, and tour, 1937. One-man shows: Weyhe Gallery, New York, 1931; Galerie de la N.R.F., Paris, 1931; Barbizon-Plaza Galleries (organized by J. B. Neumann), New York, 1933; The Arts Club of Chicago, 1933; Milwaukee Art Institute, 1933. Included in: International Watercolor Exhibition, The Art Institute of Chicago, 1931 (Blair Prize), 1937; "German Painting and Sculpture," and "Fantastic Art, Dada, Surrealism," The Museum of Modern Art, New York, 1931, 1936–37; Carnegie International, 1931, 1938, 1939; Venice Biennale, 1932. Emigrated to the U.S., 1932; citizen, 1938. Taught, The Art Students League of New York, intermittently, 1932–55; conducted own art school, with Maurice Sterne, New York, 1933–37; taught, Columbia University, New York, 1941–42. Received Guggenheim Foundation Fellowship, 1937, 1938. One-man shows: The Art Institute of Chicago, 1938–39; Maynard Walker Gallery, New York, 1939, 1941; The Museum of Modern Art, 1941–42; Associated American Artists Galleries, New York, 1943, 1946, 1948; The Baltimore Museum of Art, 1944; Busch-Reisinger Museum of Germanic Culture, Harvard University, Cambridge, Massachusetts, 1949. Included in: Pittsburgh International, 1950; I São Paulo Bienal, 1951. Retrospective, Whitney Museum of American Art, New York, and tour, 1954. Member, Akademie der Künste, Berlin, 1958. Returned to Berlin, 1959; died there, July 6. The American Academy of Arts and Letters: Gold Medal for Graphic Art, 1959; Award of Merit, 1963. Retrospective, Forum Gallery, and E. V. Thaw & Co., New York, 1963.

Café (Das Caféhaus). 1915.
Oil on canvas, 24 × 16 inches
Signed and dated on back: "Grosz 1915"

PROVENANCE:
Galerie van Diemen, Berlin; Curt Valentin Gallery, New York, 1954

EXHIBITIONS:
Forum Gallery, and E. V. Thaw & Co., New York, September 24–October 12, 1963, *George Grosz 1893–1959*, no. 6
Santa Barbara Museum of Art, California, February 26–March 27, 1966, *Harbingers of Surrealism*, no. 24

REFERENCES:
Friedlaender, Salomo (Myrona). *George Grosz*, Dresden, Rudolph Kaemmerer, 1922, ill. p. 88

Circe. c. 1925.
Watercolor on paper, 24¾ × 19¼ inches
Signed l. r.: "Grosz"

PROVENANCE:
Galerie Nierendorf, Berlin; Leonard Hutton Galleries, New York; Parke-Bernet Galleries, New York, Sale 2114, May 16, 1962, no. 28, p. 16

EXHIBITIONS:
Forum Gallery, and E. V. Thaw & Co., New York, September 24–October 12, 1963, *George Grosz 1893–1959*, no. 42

A Man of Opinion. 1928.
Watercolor on paper, 24½ × 18½ inches
Signed and dated l. l.: "Grosz 1928"

PROVENANCE:
Maynard Walker Gallery, New York; Estate of the artist; Forum Gallery, New York, 1963

EXHIBITIONS:
Maynard Walker Gallery, New York, March 20–April 15, 1939, *George Grosz: Paintings*
Forum Gallery, and E. V. Thaw & Co., New York, September 24–October 12, 1963, *George Grosz 1893–1959*, no. 53, ill.
Galerie Claude Bernard, Paris, February 1966, *George Grosz:Dessins et Aquarelles*, cat.

REFERENCES:
Craven, Thomas. *A Treasury of Art Masterpieces*, New York, Simon & Schuster, 1939, p. 566, colorplate p. 567
Genauer, Emily. "Grosz: A Lion in the Streets," *New York Herald Tribune*, September 29, 1963, ill. p. 51
Myers, Bernard. "How to Look at Art," *The Book of Art*, 10, London, Grolier, 1965, colorplate p. 52
Preston, Stuart. "Acidulous Satirist," *The New York Times*, September 29, 1963, sec. 2, ill. p. 17
Unsigned. "Art from Hell to Holocaust," *Time*, 82, October 4, 1963, p. 92, colorplate p. 91

George Grosz is best known as a political satirist whose biting commentaries were directed against the bourgeois villainy and sentimentality of the Weimar Republic. His drawings and paintings attacked the ruling class, the profiteers, militarists, and immoralists, whom he identified as the oppressors and enemies of the German people.

There is an uncanny prescience in *A Man of Opinion*—a stormtrooper carrying the swastika insignia. Four years after this painting was completed Grosz fled to the United States.

PHILIP GUSTON (b. 1913)

Born Montreal, June 27, 1913. Moved with family to Los Angeles, 1919. Studied, Otis Art Institute, Los Angeles, 1930. Influenced by David Alfaro Siqueiros; traveled in Mexico, 1934. Public Works of Art Project, Los Angeles, 1934–35. Moved to New York, 1936. WPA, Federal Art Project, Mural Division, 1936–40. WPA and U.S. Treasury Department, Section of Fine Arts, mural commissions: *Early Mail Service and the Construction of Railroads*, U.S. Post Office, Commerce, Georgia, 1938; facade, WPA Building, New York World's Fair, Flushing Meadows, 1939; Community Building, Queensbridge Housing Project, New York, 1940; *Pulp Wood Logging*, Forestry Building, Laconia, New Hampshire, 1941 (with wife, Musa McKim); auditorium, Social Security Building, Washington, D.C., 1942. Included in: Whitney Annual, 1938, 1940, 1942–43, 1944–48, 1950, 1953, 1954, 1956–58, 1961, 1963; Carnegie Annual, 1941–49 (first prize, 1945). Taught: University of Iowa, Iowa City, 1941–45; Washington University, St. Louis, Missouri, 1945–47; University of Minnesota, Minneapolis, 1950; New York University, 1950–59; Pratt Institute, Brooklyn, New York, 1953–57. One-man shows: University of Iowa, 1944; Midtown Galleries, New York, 1945; School of the Museum of Fine Arts, Boston, 1947; Munson-Williams-Proctor Institute, Utica, New York, 1947. Received: Guggenheim Foundation Fellowship, 1947, 1968; grant, The National Institute of Arts and Letters, and The American Academy of Arts and Letters, 1948; Prix de Rome, 1948. One-man shows: University Gallery, University of Minnesota, 1950; Peridot Gallery, New York, 1952; Egan Gallery, New York, 1953; Sidney Janis Gallery, New York, 1956–61; Venice Biennale, 1960. Participated in activities of The Club, New York, 1950–51. Included in: Pittsburgh International, 1950, 1955, 1958, 1964; "Twelve Americans," The Museum of Modern Art, New York, 1956; IV São Paulo Bienal, 1957; Documenta II, Kassel, 1959; "American Abstract Expressionists and Imagists," The Solomon R. Guggenheim Museum, New York, 1961; Guggenheim International Award, 1964. Received Ford Foundation Grant, 1959. Retrospectives: V São Paulo Bienal, 1959; The Solomon R. Guggenheim Museum, and tour, 1962–63; Rose Art Museum, Brandeis University, Waltham, Massachusetts, 1966. One-man shows: The Jewish Museum, New York, 1966; Marlborough Gallery, New York, 1970; Boston University, 1970. Member, The National Institute of Arts and Letters, 1972. Lives in Woodstock, New York.

Oasis. 1957.
Oil on canvas, 62 × 68 inches
Signed l. r. of c.: "Philip Guston"

PROVENANCE:
Sidney Janis Gallery, New York, 1958

EXHIBITIONS:
Sidney Janis Gallery, New York, February 24–March 22, 1958, *Philip Guston*, no. 21
Palazzo Reale, Naples, November 1959, *Twenty-Five Years of American Painting: 1932–1958* (organized by the City Art Museum of St. Louis for the U.S. Information Agency); toured to six European cities
The Solomon R. Guggenheim Museum, New York, May 3–July 1, 1962, *Philip Guston Retrospective*, no. 41, p. 29, ill. p. 78; toured to Stedelijk Museum, Amsterdam,

September 20–October 15, no. 39; Los Angeles County Museum of Art, May 22–June 23, 1963
University of Hartford, West Hartford, Connecticut, November 8–December 4, 1964, *The Arts in Society*, no. 24

REFERENCES:
Hunter, Sam. "Philip Guston," *Art International*, 6, May 1962, p. 67
O'Hara, Frank. "Growth and Guston," *Art News*, 61, May 1962, p. 52

"It has always been difficult for me to explain my own work, feeling of course that the meaning is always in the painting itself. During the time that I completed *Oasis*, my conscious desire, as I remember, was to paint and structure with color as directly as I could. I would hope to reach a prepared moment when this spontaneity could come through in a natural way."

Statement by the artist, 1972

ROBERT GWATHMEY (b. 1903)

Born Richmond, Virginia, January 24, 1903. Studied: North Carolina State College, Raleigh, 1924–25; The Maryland Institute for the Promotion of the Mechanic Arts, and the School of Fine and Practical Arts, Baltimore, 1925–26; The Pennsylvania Academy of the Fine Arts, Philadelphia (with George Harding, and Daniel Garber, 1926–30 (Cresson Traveling Scholarship, 1929, 1930). Taught: Beaver College, Philadelphia, 1931–37; Carnegie Institute of Technology, Pittsburgh, 1938–42. Public Buildings Administration, Federal Works Agency, Section of Fine Arts, mural commission, U.S. Post Office, Eutaw, Alabama, 1938. Included in: "American Art Today," New York World's Fair, Flushing Meadows, 1939; Golden Gate International Exposition, San Francisco, 1940; "*PM* Competition: The Artist as Reporter," The Museum of Modern Art, New York, 1940 (award); Whitney Annual, 1940–67; Carnegie Annual, 1941, 1943 (second prize), 1944–50; Pennsylvania Academy Annual, 1942–45, 1947, 1950, 1952, 1953, 1958 (Fellowship Prize), 1961–64, 1966; "Portrait of America (Artists for Victory, Inc.)," The Metropolitan Museum of Art, New York, 1944, and National Academy of Design, New York, 1946 (Pepsi-Cola 3rd Prize). One-man shows, ACA Gallery, New York, 1940, 1946, 1949, 1957. Taught, The Cooper Union for the Advancement of Science and Art, New York, 1942–68. Received: Rosenwald Fund Fellowship, 1944; The National Institute of Arts and Letters Grant, 1946. Founding member, Artists Equity, 1947. Included in: "Advancing American Art," U.S. Department of State South American tour, 1947; "Reality and Fantasy, 1900–1954," Walker Art Center, Minneapolis, 1954; Corcoran Biennial (Corcoran Copper Medal, and Fourth Clark Prize), 1957; "New Vistas in American Art," Howard University, Washington, D.C., 1961; "The Portrayal of the Negro in American Painting," The Bowdoin College Museum of Art, Brunswick, Maine, 1964. One-man shows, Terry Dintenfass Gallery, New York, from 1962. Retrospectives: Randolph-Macon Woman's College, Lynchburg, Virginia, 1967; Boston University, 1968. Taught: Boston University, 1968–69; Syracuse University, New York, 1972. Member, The National Institute of Arts and Letters, 1971. Lives in Amagansett, New York.

Portrait of a Farmer's Wife. 1951.
Oil on canvas, 44¼ × 33¼ inches
Signed u. r.: "Gwathmey"

PROVENANCE:
ACA Gallery, New York, 1951

EXHIBITIONS:
Artists Equity, New York, 1952, *Artists Equity Founding Members Exhibition*, no. 24
University of Illinois, Urbana, March 1–April 2, 1953, *Contemporary American Painting and Sculpture*, no. 51, plate 4
Walker Art Center, Minneapolis, May 23–July 2, 1954, *Reality and Fantasy, 1900–1954*, no. 74
The National Gallery of Canada, Ottawa, and tour, 1957, *Some American Paintings from the Collection of Joseph H. Hirshhorn*, no. 27, ill. no. 14
ACA Gallery, New York, September 30–October 19, 1957, *Robert Gwathmey*, no. 4, ill.
Carnegie Institute, Pittsburgh, March 11–April 21, 1960, *Golden Anniversary Exhibition, Associated Artists of Pittsburgh*, no. 468
Howard University, Washington, D.C., March 31–April 30, 1961, *New Vistas in American Art*
Randolph-Macon Woman's College, Lynchburg, Virginia, March 5–21, 1967, *56th Annual Exhibition of American Art*, no. 5

REFERENCES:
Hughes, Emmet John. "Joe Hirshhorn, the Brooklyn Uranium King," *Fortune*, 54, November 1956, colorplate p. 156

"Art is the conceptual solution of complicated forms, the perceptual fusion of personality, not humble ornamentation or surface pyrotechnics. Beauty never comes from decorative effects but from structural coherence. Art never grows out of polished eclecticism or the inviting momentum of the bandwagon. It is, in part, a desire to separate truth from the complex of lies and evasions in which one lives.

"Within the context of the preceding paragraph *Portrait of a Farmer's Wife* is my response to a lady of character who has borne the scars of outrageous circumstance and has refused to be destroyed."

Statement by the artist, 1972

DIMITRI HADZI (b. 1921)

Born New York, March 21, 1921. Served, U.S. Army Air Corps, 1943–46. Studied: The Cooper Union for the Advancement of Science and Art, New York, 1946; The Brooklyn Museum Art School, 1948–50; Polytechneion, Athens, 1950–51 (Fulbright Grant); Museo Artistico Industriale, Rome, 1951. Received: Louis Comfort Tiffany Foundation Fellowship, 1955; Guggenheim Foundation Fellowship, 1957. Included in: "New Talent

IX," The Museum of Modern Art, New York, 1956; Venice Biennale, 1956, 1962; 4th, 5th, 11th Middelheim Biënnale, Antwerp, 1957, 1959, 1971; Pittsburgh International, 1958, 1961; Whitney Annual, 1960, 1962; "Sculpture in the Open Air," Battersea Park, London, 1963. One-man shows: Galleria Schneider, Rome, 1958, 1960; Seiferheld and Co., New York, 1959; Stephen Radich Gallery, New York, 1961; Galerie Van de Loo, Munich, 1961; Gallery Hella Nebelung, Düsseldorf, 1962. Received The National Institute of Arts and Letters Grant, 1962. Commissions: Massachusetts Institute of Technology, Cambridge, 1963; Philharmonic Hall, Lincoln Center for the Performing Arts, New York, 1964; John Fitzgerald Kennedy Federal Building, Boston, 1969. One-man shows: Tyler School of Art, Temple Abroad, Rome, 1968; Felix Landau Gallery, Los Angeles, 1969; The Alpha Gallery, Boston, 1971; Richard Gray Gallery, Chicago, 1972. Lives in Rome.

Helmet V (Elmo). 1959–61.
Bronze (1/4), 76½ × 42½ × 29½ inches

PROVENANCE:
Stephen Radich Gallery, New York, 1962

EXHIBITIONS:
The Solomon R. Guggenheim Museum, New York, January 9–February 25, 1962, *Sculpture from the Museum Collection* (on loan pending completion of casting for The Solomon R. Guggenheim Museum)
The Solomon R. Guggenheim Museum, New York, October 3, 1962–January 6, 1963, *Modern Sculpture from the Joseph H. Hirshhorn Collection*, no. 195, ill. p. 194
Battersea Park, London, May 29–September 28, 1963, *Sculpture in the Open Air* (sponsored by the London County Council), no. 20, ill.

REFERENCES:
Jacobs, Jay. "Collector: Joseph H. Hirshhorn," *Art in America*, 57, July–August 1969, colorplate p. 69
———. "Quality as Well as Quantity: Joseph H. Hirshhorn," in Lipman, Jean, ed. *The Collector in America*, New York, Viking, 1971, colorplate p. 82
Unsigned. "Sculpture," *The Arts Review*, London, 15, June 1–15, 1963, ill. p. 8

RAOUL HAGUE (b. 1904)

Raoul Heukelekian, born Constantinople, March 28, 1904, of Armenian parents. Emigrated to the U.S., 1921; citizen, 1930. Studied: Iowa State College, Ames, 1921; School of The Art Institute of Chicago, 1922–25; Beaux-Arts Institute of Design, New York, 1926–27; The Art Students League of New York, with William Zorach, 1927–28. Worked informally with John Flannagan, New York, 1927–28. Included in: "American Sources of Modern Art," The Museum of Modern Art, New York, 1933; "American Art Today," New York World's Fair, Flushing Meadows, 1939. WPA Federal Art Project, Sculpture Division, New York, 1935–39. Served, U.S. Army, 1941–43. Settled in Woodstock, New York, 1943. Included in: "Recent American Art," Buchholz Gallery, New York, 1945; Whitney Annual, 1947–66; "Twelve Americans," The Museum of Modern Art, 1956; 66th American Exhibition, The Art Institute of Chicago, 1963; "Sculpture in the Open Air," Battersea Park, London, 1963; "États-Unis: Sculptures du XXᵉ Siècle," Musée Rodin, Paris, 1965; The White House Festival of the Arts, Washington, D.C., 1965. Received: Ford Foundation Grant, 1959; Guggenheim Foundation Fellowship, 1967; award, the National Institute of Arts and Letters, and The American Academy of Arts and Letters, 1973. One-man shows, Egan Gallery, New York, 1962, 1965. Retrospective, Washington [D.C.] Gallery of Modern Art, 1964. Lives in Woodstock.

Sculpture in Walnut. 1962.
Walnut, 33½ × 58 × 33 inches

PROVENANCE:
Egan Gallery, New York, 1962

EXHIBITIONS:
Egan Gallery, New York, October 2–November 30, 1962, *Raoul Hague*
The Art Institute of Chicago, January 11–February 10, 1963, *66th Annual American Exhibition*, no. 30
Washington [D.C.] Gallery of Modern Art, September 18–October 17, 1964, *Raoul Hague*, no. 24
The White House, Washington, D.C., June 14, 1965, *The White House Festival of the Arts*, sculpture no. 9

ÉTIENNE HAJDU (b. 1907)

Born Turda, Transylvania, Rumania, August 12, 1907. Moved to Paris, 1927; French citizen, 1930. Studied: École Nationale Supérieure des Arts Décoratifs, Paris, with Paul-François Niclausse; Académie de la Grande Chaumière, with Émile-Antoine Bourdelle. Traveled through France, studying Romanesque art; visited Greece, Crete, The Netherlands, 1931–38. Exhibited with Maria Elena Vieira da Silva, and Arpad Szenes, Galerie Jeanne Bucher, Paris, 1939. Served, French Army, 1939; demobilized, 1940. Worked as stonemason in Pyrenees, during Occupation. One-man shows, Galerie Jeanne Bucher, 1946, 1948, 1952, 1957. Included in: Salon de Mai, Paris, 1947, 1950, 1953–62; 1st–4th Middelheim Biënnale, Antwerp, 1950–57; "The New Decade," The Museum of Modern Art, New York, 1955; III São Paulo Bienal, 1955; Pittsburgh International, 1964. One-man shows: M. Knoedler & Co., New York, 1958, 1962, 1969; Kestner-Gesellschaft, Hanover, and tour, 1961; The Contemporary Arts Center, Cincinnati, Ohio, 1962; The Phillips Collection, Washington, D.C., 1964; M. Knoedler et Cie., Paris, 1965, 1968. Commissions, France: fountain, Grenoble, 1967; monument to Louis Pasteur, Lille, 1969. Lives in Bagneux, near Paris.

Adolescence. 1957.
Marble, 35½ × 11½ × 2½ inches
Markings: l. r. top of base "Hajdu 1957"

PROVENANCE:
M. Knoedler & Co., New York, 1958

EXHIBITIONS:
M. Knoedler & Co., New York, April 29–May 19, 1958, *Hajdu*, no. 26, ill.

The Detroit Institute of Arts, 1959, *Sculpture in Our Time*, no. 100, ill. p. 46, and extended loan
The Solomon R. Guggenheim Museum, New York, October 3, 1962–January 6, 1963, *Modern Sculpture from the Joseph H. Hirshhorn Collection*, no. 198

The Bird, Uranus II. 1957.
Bronze, 39 × 75 × 10 inches
Markings: 1. top of base "Hajdu
1957"
r. side of base "Cire Perdue A. Valsuani"
r. top of base "1–3"

PROVENANCE:
M. Knoedler et Cie., Paris, 1961

EXHIBITIONS:
The Solomon R. Guggenheim Museum, New York, October 3, 1962–January 6, 1963, *Modern Sculpture from the Joseph H. Hirshhorn Collection*, no. 199, ill. p. 106

REFERENCES:
Mastai, Marie-Louise D'Otrange. "The Connoisseur in America," *Connoisseur*, 151, December 1962, p. 270, ill.

"POP" HART (1868–1933)

George Overbury Hart, born Cairo, Illinois, May 10, 1868. Worked in father's glue factory, Cairo. Traveled to New York, and London. Worked as newspaper illustrator, Chicago; studied briefly, School of The Art Institute of Chicago. Visited Central and South America, the Near East, the South Seas, Europe, and traveled throughout the U.S., 1900–1907. Supported himself by painting signs and portraits. Studied, Académie Julian, Paris, briefly, 1907. Returned to the U.S., 1907. Painted: signs for amusement parks, 1907–12; stage sets for movie studio, Fort Lee, New Jersey, summers, 1912–30. Wintered in southern U.S., Caribbean, Mexico, South America. First one-man show, M. Knoedler & Co., New York, 1918. First prints, 1921. One-man shows, New York: Keppel Galleries, 1922, 1928, 1937, 1938; Marie Sterner Gallery, 1923; J. B. Neumann's Print Room, 1924, 1925; The Downtown Gallery, 1927, 1930, 1933. Included in: Brooklyn Society of Etchers Annual, The Brooklyn Museum, New York, 1922–32; Society of Independent Artists Annual, 1925, 1929. Traveled in Mexico, 1925–29. One-man shows: The Art Institute of Chicago, 1926; Skidmore College, Saratoga Springs, New York, 1929. Died Coytesville, New Jersey, September 9, 1933. Memorial exhibitions: The Brooklyn Museum, 1933; Newark Museum, New Jersey, 1935. One-man shows, Smithsonian Institution, Washington, D.C.: prints, 1942; watercolors, 1964. Retrospective, Howard University, Washington, D.C., 1956.

Centaurs and Nymphs. 1921.
Watercolor and pencil on paper, 26 × 19 inches
Signed and dated 1. r.: "Hart 1921"

PROVENANCE:
Arthur F. Egner, South Orange, New Jersey; Parke-Bernet Galleries, New York, Sale 670, May 4, 1945, no. 42, ill. p. 13; Mr. and Mrs. Albert Segat, New York; M. Knoedler & Co., New York; Parke-Bernet Galleries, Sale 3133, December 10, 1970, no. 45

EXHIBITIONS:
The Gallery of Modern Art, New York, June 28–September 6, 1965, *The Twenties Revisited*, cat.

MARSDEN HARTLEY (1877–1943)

Edmund Hartley, born Lewiston, Maine, January 4, 1877. Youth spent in Cleveland. Studied: privately, with John Semon, Cleveland; Cleveland School of Art, 1892; New York School of Art, with William Merritt Chase, Frank Vincent Du Mond, F. Luis Mora, 1898–99; National Academy of Design, New York, 1900. One-man shows, Alfred Stieglitz's Photo-Secession Gallery, "291," New York, 1909, 1912, 1914, 1916, 1917. Sponsored by Stieglitz, and Arthur B. Davies; traveled to Paris, Munich, Berlin, 1912–13. Included in: second exhibition of Der Blaue Reiter, Galerie Neue Kunst, Munich, 1912; Erster Deutscher Herbstsalon, Galerie der Sturm, Berlin, 1913; the Armory Show, 1913. Returned to Berlin, 1914–15. One-man shows: Max Lieberman's house, Berlin, 1915; The Daniel Gallery, New York, 1915; Montross Gallery, New York, 1920. Exhibited, New York: "The Forum Exhibition of Modern American Painters," The Anderson Galleries, 1916; Society of Independent Artists Annual, 1917, 1921. Traveled in the Southwest, 1918–20. Major auction of his work, The Anderson Galleries, 1921; proceeds enabled him to live in Europe, 1921–30. Published first book of poetry, *Twenty-Five Poems*, Paris, 1923; associated with Hart Crane. One-man shows: Stieglitz's Intimate Gallery, New York, 1926, 1929; The Arts Club of Chicago, 1928; Stieglitz's An American Place, New York, 1930, 1936, 1937. Received Guggenheim Foundation Fellowship, 1931; traveled in Mexico, Germany, Bermuda, Nova Scotia, 1932–35. One-man shows, New York: The Downtown Gallery, 1932; Hudson D. Walker Gallery, 1938–40. WPA Federal Art Project, Easel Division, New York, 1936. Retrospective, with Stuart Davis, Cincinnati Modern Art Society, Ohio, 1941. One-man shows, New York: Macbeth Gallery, 1942, 1945; Paul Rosenberg & Co., 1943, 1948, 1950, 1951, 1955. Died Ellsworth, Maine, September 2, 1943. Retrospectives: The Philips Memorial Gallery, Washington, D.C., 1943; The Columbus Gallery of Fine Arts, Ohio, 1944; with Lyonel Feininger, The Museum of Modern Art, New York, 1944; Stedelijk Museum, Amsterdam, and tour, 1960–62; University Galleries, University of Southern California, Los Angeles, and tour, 1968–69.

Painting No. 47, Berlin. 1914–15.
Oil on canvas, 39¼ × 31½ inches

PROVENANCE:
Estate of the artist; Martha Jackson Gallery, New York, 1968

EXHIBITIONS:
The Baltimore Museum of Art, October 4–November 6, 1955, *If Wishes Could Buy*, no. 73
Stedelijk Museum, Amsterdam, February 3–March 6, 1961, *Marsden Hartley* (American Federation of Arts, Circulating Exhibition), no. 14, ill.; toured to four European and five U.S. cities
The Baltimore Museum of Art, October 6–November 15, 1964, *1914*, no. 83, colorplate frontispiece
National Collection of Fine Arts, Smithsonian Institution, Washington, D.C., December 2, 1965–January 6, 1966, *Roots of Abstract Art in America, 1910–1930*, no. 85, colorplate p. 4
Perls Galleries, New York, May–June 1966, *Seven Decades of Modern Art; 1895–1965* (sponsored by the Public Education Association), no. 123, ill.

REFERENCES:
Jacobs, Jay. "Collector: Joseph H. Hirshhorn," *Art in America*, 57, July–August 1969, ill. p. 58
———. "Quality as Well as Quantity: Joseph H. Hirshhorn," in Lipman, Jean, ed. *The Collector in America*, New York, Viking, 1971, ill. p. 84
Kramer, Hilton. "Abstract Interlude," *Arts Digest*, 29, January 1, 1955, p. 9, ill.

Military symbols and emblems, spurs, epaulettes, regimental ribbons, badges, and numerals are recurring motifs in Hartley's second series of "German paintings." The German Imperial colors—black, white, and red—provide a strong decorative band across *Painting No. 47, Berlin*. The cursive script "E" denotes the Bavarian Eisenbahn Regiment. The initials "K.v.F." next to the iron cross commemorate Hartley's friend, Karl von Freyburg, who was killed on the Western Front in September 1914.

Christ Held by Half-Naked Men. 1940–41.
Oil on Masonite, 39¾ × 29¾ inches

PROVENANCE:
Paul Rosenberg & Co., New York, 1959

EXHIBITIONS:
La Jolla Museum of Art, California, February 12–March 27, 1966, *Marsden Hartley—John Marin*, no. 31, p. 5, ill.
Marlborough-Gerson Gallery, New York, April–May 1968, *International Expressionism, Part I*, no. 15, ill.

Mt. Katahdin. 1941.
Oil on Masonite, 22 × 28 inches
Signed and dated 1. r.: "M.H/41"

PROVENANCE:
Macbeth Gallery, New York; Paul Rosenberg & Co., New York, 1942

EXHIBITIONS:
Paul Rosenberg & Co., New York, November 3–28, 1942, *Hartley, Weber, Rattner*
Paul Rosenberg & Co., New York, February 2–27, 1943, *Recent Works by Marsden Hartley*
Brandeis University, Waltham, Massachusetts, June 1–17, 1955, *Three Collections*, no. 16
The National Gallery of Canada, Ottawa, and tour, 1957, *Some American Paintings from the Collection of Joseph H. Hirshhorn*, no. 32, ill. 6

REFERENCES:
Ayre, Robert. "Art Notes: The Hirshhorn Collection," *Montreal Star*, March 23, 1957, p. 27
Unsigned. "The Passing Shows," *Art News*, 41, November 15, 1942, p. 27

The first rays of the sun to reach the United States fall upon the mile-high Mt. Katahdin in Maine. This was a scene that Hartley painted many times. Other versions of this work are in the Newark Museum, New Jersey; City Art Museum of St. Louis, Missouri; William Rockhill Nelson Gallery of Art and Mary Atkins Museum of Fine Arts, Kansas City, Missouri; and the University of Nebraska Art Galleries, Lincoln.

Crow with Ribbons. 1941–42.
Oil on Masonite, 28 × 22 inches

PROVENANCE:
Paul Rosenberg & Co., New York, 1952

EXHIBITIONS:
Paul Rosenberg & Co., New York, April 16–May 12, 1951, *Paintings by Marsden Hartley*, no. 20
Des Moines Art Center, Iowa, February 27–March 23, 1952, *The Artists' Vision*, no. 32
American Federation of Arts tour, 1962–65, *Paintings from the Joseph H. Hirshhorn Foundation Collection: A View of the Protean Century*, no. 34'
La Jolla Museum of Art, California, February 12–March 27, 1966, *Marsden Hartley—John Marin*, no. 29, p. 5, ill.

REFERENCES:
Campbell, Larry. "Reviews and Previews: Marsden Hartley," *Art News*, 50, May 1951, p. 42
Cole, Mary. "Marsden Hartley's Poetry of Paint," *Art Digest*, 25, May 1, 1951, p. 17, ill.
Raynor, Vivien. "New York Exhibitions: Paintings from the Hirshhorn Collection," *Arts Magazine*, 37, December 1962, ill. p. 45

HANS HARTUNG (b. 1904)

Born Leipzig, September 21, 1904. Studied: Universität, Leipzig, 1924; Akademie der Bildenden Künste, Leipzig, 1924; Kunstakademie, Dresden, 1925; Akademie der Bildenden Künste, Munich, 1928. Lived in Paris, 1927–32; Minorca, Spain, 1932–34. One-man shows: Galerie Heinrich Kühl, Dresden, 1931; Bloqvist Kunsthandel, Oslo, 1932. Kept under Nazi surveillance during brief visit to Germany, 1935. Moved to Paris, 1935; French citizen, 1946. Exhibited, Paris: Salon des Surindépendants, 1935–38, 1945; Salon des Réalités Nouvelles, 1939, 1946, 1948. Associated with Julio González, 1937–38; married his daughter, Roberta, 1939. Fought, along with French Foreign Legion and Free French, 1939–45; severely wounded. One-man shows: Galerie Lydia Conti, Paris, 1947–48; Galerie de France, Paris, from 1956; Lefebre Gallery, New York, 1961, 1971. Retrospectives: Kunsthalle, Basel, 1952; Palais des Beaux-Arts, Brussels, 1954; Kestner-Gesellschaft,

Hanover, and tour, 1957; Kunsthaus, Zurich, and tour, 1963–64; Museo Civico di Torino, 1966; Musée National d'Art Moderne, Paris, 1969. Included in: Guggenheim International, Paris, 1963 (Guggenheim Continental Section Award); Venice Biennale, 1960 (Grand Prize for Painting); ROSC '67, Dublin, 1967. Awarded Grand Prix des Beaux-Arts de la Ville de Paris, 1970. One-man shows: Fondation Maeght, St.-Paul-de-Vence, France, 1971; Gimpel Fils, London, 1972. Lives in Paris, and near St.-Paul-de-Vence.

Composition. 1936.
Water color and colored chalk on paper, 37½ × 30¼ inches

PROVENANCE:
The artist, Paris; Winifred Nicholson, London; Harold Diamond, New York, 1958

EXHIBITIONS:
Galerie de France, Paris, May 24–September 9, 1961, *Hans Hartung: Early Works*

CHILDE HASSAM (1859–1935)

Frederick Childe Hassam, born Dorchester, Massachusetts, October 17, 1859. Worked for Little, Brown and Company, publishers, and in wood engraver's office, Boston; contributed prints and illustrations to *Harper's*, *Century*, *Scribner's*, and other newspapers and magazines, late 1870s. Studied, Boston: Boston Art Club; Lowell Institute; privately, with Ignaz Gaugengigl. Visited England, The Netherlands, Spain, Italy, 1883. One-man show (watercolors), Williams & Everett Gallery, Boston, 1883. Returned to Europe, 1886. Studied, Académie Julian, Paris, with Gustave-Clarence-Rudolphe Boulanger, and Jules-Joseph Lefebvre, 1886–89. Awarded: Bronze Medal, Exposition Universelle de 1889, Paris; Gold Medal, VI Internationalen Kunstausstellung, Munich, 1892; Temple Gold Medal, Pennsylvania Academy Annual, 1899; Gold Medal, Pan-American Exposition, Buffalo, New York, 1901; Gold Medal, St. Louis International Exposition, Missouri, 1904. Co-founded The Ten (American Impressionists), with J. Alden Weir, and John Twachtman, New York, 1898. One-man shows, New York: Macbeth Gallery, 1900, 1923, 1925, 1929; Durand-Ruel Galleries, 1903, 1904, 1918, 1926; Montross Gallery, 1905–17; The Milch Galleries, from 1919. Twelve works included in the Armory Show, 1913. Included in Society of Independent Artists Annual, 1917. Established summer studio, East Hampton, New York, 1920. National Academy of Design, New York: associate, 1902; Clarke Prize, 1905; academician, 1906; Second Altman Prize, 1918; First Altman Prize, 1926; Saltus Medal, 1935. Member, The American Academy of Arts and Letters, 1920. Retrospectives: The American Academy of Arts and Letters, New York, 1927; Albright Art Gallery, Buffalo, New York, 1929. Received American Art Dealers Association Medal, 1934. Died East Hampton, August 27, 1935. Artistic estate bequeathed to The American Academy of Arts and Letters; sold to create the Childe Hassam Purchase Fund for acquisition of works by contemporary American and Canadian artists for donation to American and Canadian museums. Retrospectives: The Corcoran Gallery of Art, Washington, D.C., and tour, 1965; The University of Arizona Art Gallery, Tucson, and tour, 1972.

Vesuvius. 1897.
Oil on canvas, 25½ × 30¼ inches
Signed and dated 1. 1.: "Childe Hassam 1897"

PROVENANCE:
Estate of the artist; The American Academy of Arts and Letters, New York; The Milch Galleries, New York; Sidney A. Levyne, Baltimore; Hirschl & Adler Galleries, New York, 1959

EXHIBITIONS:
Armory of the Sixty-Ninth Regiment, New York, February 17–March 15, 1913, *International Exhibition of Modern Art*, no. 74
Durand-Ruel Galleries, New York, January 25–February 15, 1926, *Exhibition of Paintings by Childe Hassam*, no. 11
The American Academy of Arts and Letters, New York, April 21–October 21, 1927, *Exhibition of the Works of Childe Hassam*, no. 39
Munson-Williams-Proctor Institute, Utica, New York, February 17–March 31, 1963, *1913 Armory Show: 50th Anniversary*, no. 74, ill. p. 133; toured to Armory of the Sixty-Ninth Regiment, New York, April 6–28
Hirschl & Adler Galleries, New York, February 18–March 7, 1964, *Childe Hassam*, no. 2

REFERENCES:
Brown, Milton W. *The Story of the Armory Show*, New York, Hirshhorn Foundation, 1963, pp. 70, 249
Perlman, Bennard B. *The Immortal Eight*, New York, Exposition, 1962, p. 11, ill.
Unsigned. "Exhibitions in New York: Childe Hassam," *Art News*, 24, January 30, 1926, p. 9

Vesuvius was painted by Hassam while he was in Italy in 1897. It was one of fifty-seven works selected for reproduction on postcards sold at the historic Armory Show.

The East Window. 1913.
Oil on canvas, 55 × 45 inches
Signed and dated 1. c.: "Childe Hassam/1913"

PROVENANCE:
Macbeth Gallery, New York; City Art Museum of St. Louis, Missouri; Kende Galleries of Gimbel Brothers, New York, Sale, May 4, 1945, no. 161, ill. p. 112; The Milch Galleries, New York; Parke-Bernet Galleries, New York, Sale 2169, February 20, 1963

EXHIBITIONS:
Carnegie Institute, Pittsburgh, April 24–June 30, 1913, *Seventeenth Annual Exhibition*, no. 121, ill.
The Art Institute of Chicago, November 14–December 25, 1913, *26th Annual Exhibition of American Paintings and Sculpture*, no. 166

Museum of Fine Arts, Boston, July 21–November 30, 1915, *Summer Loan*
The Pennsylvania Academy of the Fine Arts, Philadelphia, February 6–March 26, 1916, *One Hundred and Eleventh Annual Exhibition*, no. 256, ill.
City Art Museum of St. Louis, Missouri, September–October 1916, *The Eleventh Annual Exhibition of Paintings by American Artists*, ill.
Albright Art Gallery, Buffalo, New York, March 9–April 18, 1929, *Retrospective Exhibition of Group of Paintings Representative of the Life Work of Childe Hassam*, no. 125, ill. p. 21
The Milch Galleries, New York, February 23–March 15, 1947, *Childe Hassam*
Lotos Club, New York, March 15–April 15, 1955, *85th Anniversary Exhibition: Works of Childe Hassam*, no. 23
The Milch Galleries, New York, June–July 1959, *American Paintings*

REFERENCES:
Burrows, Carlyle. "Art of the Week: A Good Round of New One-Man Exhibitions," *New York Herald Tribune*, March 2, 1947, sec. 5, p. 8
Bye, A. E. *Pots and Pans, or Studies in Still Life Paintings*, Princeton, New Jersey, Princeton University, 1921, ill. p. 226
D'Unger, Giselle. "Annual Art Institute Show," *American Art News*, 12, November 15, 1913, p. 7
The Milch Galleries, New York, *Art Quarterly*, 22, Summer 1959, ill. p. 201 (adv.)
Pousette-Dart, Nathaniel. *Childe Hassam*, New York, Stokes, 1922
Riley, Maude K. "Childe Hassam Revived," *Art Outlook*, 1, March 3, 1947, p. 2
Unsigned. "Annual Carnegie Display," *American Art News*, 11, May 3, 1913, p. 3
———. "A Painting by Childe Hassam," *City Art Museum of St. Louis Bulletin*, Missouri, 2, December 1916, p. 11, ill. p. 10
———. "Reviews and Previews: Childe Hassam," *Art News*, 46, March 1947, p. 24
———. "St. Louis," *American Art News*, 14, September 16, 1916, p. 5

The Union Jack, New York, April Morn. 1918.
Oil on canvas, 37 × 20 inches
Signed and dated l. r.: "Childe Hassam 1918"

PROVENANCE:
Estate of the artist; The American Academy of Arts and Letters, New York; The Milch Galleries, New York; John Fox, Boston; Parke-Bernet Galleries, New York, Sale 1782, November 13, 1957, no. 30, ill. p. 22

EXHIBITIONS:
Durand-Ruel Galleries, New York, November 15–December 7, 1918, *Paintings of the "Avenue of the Allies" by Childe Hassam*
The Corcoran Gallery of Art, Washington, D.C., April 30–August 1, 1965, *Childe Hassam: A Retrospective Exhibition*, no 53, ill. p. 32; toured to Museum of Fine Arts, Boston, August 17–September 19; Currier Gallery of Art, Manchester, New Hampshire, September 28–October 31; The Gallery of Modern Art, New York, November 16–December 19

REFERENCES:
Aarons, Leroy. "Sound the Hirshhorn! The Collection," *The Washington [D.C.] Post Potomac*, March 19, 1967, colorplate p. 17
Hoopes, Donelson F. *The American Impressionists*, New York, Watson-Guptil, 1972, p. 76, colorplate 29
Lowe, David G. "The Banner Years," *American Heritage*, 20, June 1969, colorplate p. 58
Unsigned. "Childe Hassam, America's Own Impressionist," *Time*, 86, September 3, 1965, colorplate p. 61

During World War I, Fifth Avenue was temporarily renamed "Avenue of the Allies." Hassam painted a series of canvases which depict this flag-festooned New York scene.

CHARLES HAWTHORNE (1872–1930)

Charles Webster Hawthorne, born Lodi, Illinois, January 8, 1872. Youth spent in Richmond, Maine. Moved to New York, 1890; worked as dockhand, and in stained glass factory. Studied: with Frank Vincent Du Mond, New York, evenings, 1893; The Art Students League of New York, with George de Forest Brush, and Henry Siddons Mowbray, evenings, 1894–95; Shinnecock Summer School of Art, Southampton, New York, 1896. Assistant, Shinnecock Summer School, and Chase School, New York, 1896–97. Exhibited, Society of American Artists Annual, 1897–1906. Traveled to The Netherlands, 1898; one-man show of his "Dutch" paintings at his studio, New York, 1898. Founded Cape Cod School of Art, Provincetown, Massachusetts, 1899; director, until his death in 1930. One-man shows, New York: Clausen Galleries, 1902; Schaus Gallery, 1908; Grand Central Art Galleries, and Macbeth Gallery, from 1909. Taught, The Art Students League, 1905. National Academy of Design: associate, 1908; academician, 1911; Isador Gold Medal, 89th Annual, 1914; Altman Prize, 90th Annual, 1915; taught, 1923–26; Carnegie Prize, 99th Annual, 1924. Included in the Salon, Paris, 1912–14. Awarded Silver Medal, Panama-Pacific International Exposition, San Francisco, 1915. Retrospective, Macbeth Gallery, 1917. Member: The National Institute of Arts and Letters, 1920; The American Academy of Arts and Letters, 1927. One-man shows: Milwaukee Art Institute, 1921; City Art Museum of St. Louis, Missouri, 1921. Awarded: Corcoran Gold Medal, and First Clark Prize, Corcoran Biennial, 1926; Gold Medal, Sesquicentennial Exposition, Philadelphia, 1926. One-man show, Babcock Galleries, New York, 1930. Died Baltimore, November 29, 1930. Hawthorne Memorial Gallery, Provincetown, dedicated, 1940. Retrospectives: Grand Central Art Galleries, 1947; Provincetown Art Association Gallery, 1952; Chrysler Art Museum, Provincetown, 1961; The University of Connecticut Museum of Art, Storrs, and Hirschl & Adler Galleries, New York, 1968.

The Story (Two Men at Table; The Diners; Pleasures of the Table). c. 1898.

Oil on canvas, 48 × 30 inches
Signed u. l.: "C W Hawthorne"

PROVENANCE:
Holland Galleries, New York; Floyd Williams, New York; Margaret Cottier Williams, New York; American Art Association, New York, Sale, March 13, 1919, *Ball and White Collections*, no. 80; Schultheis Galleries, New York; John F. Braun, Merion, Pennsylvania; Kende Galleries of Gimbel Brothers, New York, Sale, January 16, 1942, *Braun Collection*, no. 56, ill.; Allen Galleries, Houston; Vose Galleries of Boston, Inc.; Richard L. Mills, Exeter, New Hampshire; Zabriskie Gallery, New York, 1961

EXHIBITIONS:
The University of Connecticut Museum of Art, Storrs, October 12–November 17, 1968, *The Paintings of Charles Hawthorne*, no. 2, ill; toured to Hirschl & Adler Galleries, New York, December 5–31

REFERENCES:
Benjamin, Frederick. "C. W. Hawthorne, Painter," *Brush and Pencil*, 4, August 1899, ill. p. 257
Hartmann, Sadakichi. "Studio-Talk," *International Studio*, 26, July 1905, p. 261
Kramer, Hilton. "Charles Hawthorne, Gifted but Minor," *The New York Times*, December 7, 1968, p. 56
Ruge, Clara. "Charles W. Hawthorne," *The Art Interchange*, 52, June 1904, p. 138, ill. p. 143
Unsigned. "Ball-White Picture Sale," *American Art News*, 17, March 22, 1919, p. 6

Evening (recto). c. 1920.
Oil on canvas, 40 × 38½ inches
Signed u. l.: "C W Hawthorne"

Woman with Raised Arms (verso). c. 1920.
Oil on canvas, 38½ × 40 inches

PROVENANCE:
Estate of the artist; Babcock Galleries, New York, 1962

EXHIBITIONS:
Milwaukee Art Institute, June 1921, *Paintings by Charles W. Hawthorne*
City Art Museum of St. Louis, Missouri, August 14–September 12, 1921, *The Paintings of Charles W. Hawthorne*, no. 25
Thomas Whipple Dunbar Galleries, Chicago, January 1926, *Charles W. Hawthorne*
Babcock Galleries, New York, February 3–15, 1930, *Charles W. Hawthorne*, no. 3
The Toledo Museum of Art, Ohio, December 1–29, 1957, *Chase and Hawthorne: Two American Teachers*

REFERENCES:
J. K. "Hawthorne Rediscovers Methods of Old Masters," *The Milwaukee Journal*, June 26, 1921, p. V, ill.
McCaul, Lena M. "Hawthorne Portraits at Dunbar Gallery," *Chicago Evening Post Magazine of the Art World*, January 12, 1926, p. 2, ill.
Unsigned. "On View During Current Week," *Brooklyn [N.Y.] Daily Eagle*, February 9, 1930, p. 7, ill.

ROBERT HENRI (1865–1929)

Robert Henry Cozad, born Cincinnati, Ohio, June 24, 1865. Studied: The Pennsylvania Academy of the Fine Arts, Philadelphia, with Thomas Anshutz, Thomas Hovenden, James P. Kelly, 1886–88, 1891–92; Académie Julian, Paris, with William-Adolphe Bouguereau, and Tony Robert-Fleury, 1888–91; École des Beaux-Arts, Paris, 1891. Met John Sloan, Philadelphia, 1892. Taught, Philadelphia School of Design for Women, 1892–95. With Sloan, organized Charcoal Club, Philadelphia, as alternative to Pennsylvania Academy, 1893; after Charcoal Club's demise, held weekly meetings in his studio, attended regularly by Sloan, William Glackens, and later Everett Shinn and George Luks. Lived in Paris, 1895–97, 1898–1900; included in Salon of 1896, 1897, 1899. One-man show, Pennsylvania Academy, 1897. Moved to New York, 1900. One-man shows: Pennsylvania Academy, and Pratt Institute, Brooklyn, New York, 1902–3; Macbeth Gallery, New York, 1902, 1911, 1914, 1924, 1925. Member, Society of American Artists, 1903. Taught, New York School of Art, 1903–9. National Academy of Design: associate, 1905; academician, 1906. Organized, with Sloan, and participated in "Exhibition of Eight American Painters," Macbeth Gallery, and tour, 1908. Established and directed Henri School of Art, New York, 1909–12 (renamed Independent Art School, under Homer Boss, 1912). Included in: Exhibition of Independent Artists, New York, 1910; the Armory Show, 1913. Taught, New York: Ferrer Center, 1911–18; The Art Students League of New York, 1915–28. Member, Board of Directors, Society of Independent Artists, New York, 1917. One-man shows, New York: Montross Gallery, 1918; The Milch Galleries, 1918, 1921. *The Art Spirit*, compilation of his notes, articles, and talks to students, published (Philadelphia, Lippincott), 1923. Students included George Bellows, Glenn O. Coleman, Stuart Davis, Guy Pène du Bois, Arnold Friedman, Edward Hopper, Bernard Karfiol, Rockwell Kent, Morgan Russell, Eugene Speicher. Died New York, July 12, 1929. Memorial exhibition, The Metropolitan Museum of Art, New York, 1931. Retrospectives: Sheldon Memorial Art Gallery, University of Nebraska, Lincoln, 1965; New York Cultural Center, 1969.

Woman in White (Morelle in White). 1904.
Oil on canvas, 77 × 38 inches
Signed l. l.: "Robert Henri"

PROVENANCE:
Estate of Mrs. Robert Henri; Violet Organ, New York; Private collection, Illinois; Parke-Bernet Galleries, New York, Sale 2251, January 29, 1964, no. 63, ill.

EXHIBITIONS:
The Metropolitan Museum of Art, New York, March 9–April 19, 1931, *The Work of Robert Henri*, no. 24, ill.
Hirschl & Adler Galleries, New York, January 5–30, 1960, *Full-Length Portraits and Paintings of Children by Robert Henri*, no. 5

Whitney Museum of American Art, New York, May 8–June 16, 1964, *The Friends Collect*, no. 69

REFERENCES:
Read, Helen Appleton. *Robert Henri*, New York, Whitney Museum of American Art, 1931, p. 48, ill. p. 49
Shapley, John, ed. "Robert Henri," *Index of Twentieth Century Artists*, 1934–37, reprint ed. in one vol., New York, Arno, 1970, p. 321
Unsigned. "American Art Is Auctioned at Parke-Bernet Galleries," *The New York Times*, January 30, 1964, p. 59

John Butler Yeats. 1909.
Oil on canvas, 32 × 26 inches

PROVENANCE:
Estate of the artist; Hirschl & Adler Galleries, New York, 1959

EXHIBITIONS:
Hirschl & Adler Galleries, New York, February 3–28, 1958, *Robert Henri, 50 Paintings*, no. 23
Hirschl & Adler Galleries, New York, April 13–May 9, 1959, *The Portrait in American Art*, no. 36

REFERENCES:
Homer, William Innes. *Robert Henri and His Circle*, Ithaca, New York, Cornell University, 1969, p. 205
Porter, Fairfield. "Reviews and Previews: Robert Henri," *Art News*, 56, February 1958, p. 12

John Butler Yeats (1839–1922), a portrait painter and noted conversationalist, is perhaps best known as the father of poet William Butler Yeats and artist Jack Butler Yeats. In 1908 the elder Yeats made his first visit from Ireland to the United States. He remained in New York for the last fourteen years of his life. Henri and John Sloan, who painted *Yeats at Petipas*, 1910 (The Corcoran Gallery of Art, Washington, D.C.), were among his friends in Greenwich Village.

Blind Singers. 1913.
Oil on canvas, 33 × 41 inches

PROVENANCE:
Estate of the artist; Violet Organ, New York; Hirschl & Adler Galleries, New York, 1959

EXHIBITIONS:
Jesup Gallery, Westport Public Library, Connecticut, March 25–April 13, 1963, *Music in Art* (sponsored by the Westport Community Art Association), cat.

REFERENCES:
Forgey, Benjamin. "A Hirshhorn Art Survey: Striking and Surprising," *Washington [D.C.] Evening Star*, February 23, 1971, sec. B, ill. p. 7
Jacobs, Jay. "Collector: Joseph H. Hirshhorn," *Art in America*, 57, July–August 1969, ill. p. 59
———. "Quality as Well as Quantity: Joseph H. Hirshhorn," in Lipman, Jean, ed. *The Collector in America*, New York, Viking, 1971, ill. p. 89

DAME BARBARA HEPWORTH (b. 1903)

Barbara Hepworth, born Wakefield, Yorkshire, England, January 10, 1903. Studied: Leeds School of Art, England, 1920; Royal College of Art, London, 1921–24. Lived in Italy, 1924–26. Returned to London, 1926; exhibited with husband, sculptor John Skeaping, in their studio, 1927. Exhibited, London: with Skeaping, and William E. C. Morgan, The Beaux-Arts Gallery, 1928; with Skeaping, Arthur Tooth & Sons, 1930; with Ben Nicholson, Arthur Tooth & Sons, 1932; with Nicholson, Alex, Reid & Lefevre, Ltd., 1933; with L. S. Lowry, The Lefevre Gallery, 1948. Member: 7 & 5 Society, London, with Henry Moore, Nicholson, John Piper, and others, 1931–36; Association Abstraction-Création, Paris, 1933–35; Unit One (group of architects, painters, sculptors, decorators), London, 1934–35. Married Nicholson, 1937 (divorced, 1951). One-man shows, The Lefevre Gallery, 1937, 1946, 1950, 1952. Moved to St. Ives, Cornwall, England, 1939. Retrospectives: with Paul Nash, Temple Newsam House, Leeds, 1943; City Art Gallery and Museum, Wakefield, 1944, 1951; Venice Biennale, 1950; Whitechapel Art Gallery, London, 1954, 1962; Walker Art Center, Minneapolis, and tour, 1955–56; V São Paulo Bienal, 1959 (Grand Prize). One-man shows: Durlacher Gallery, New York, 1949; Gimpel Fils, London, 1956, 1958, 1961, 1964, 1966; Galerie Chalette, New York, 1959. Commissions: *Contrapuntal Forms*, Harlow New Town, England, 1951; *Meridian*, State House, London, 1960; *Single Form*, memorial to Dag Hammarskjöld, United Nations Plaza, New York, inaugurated, 1964. Included in: international competition for monument to "The Unknown Political Prisoner," Institute of Contemporary Arts, London, 1953 (second prize); Documenta I and II, Kassel, 1955, 1959; Pittsburgh International, 1958–67; 7th Biennale, Tokyo, 1963 (Foreign Minister's Award). Commander of the Order of the British Empire, 1958; promoted to Dame Commander, 1965. Retrospectives: Rijksmuseum Kröller-Müner, Otterlo, The Netherlands, 1965; The Tate Gallery, London, 1968. One-man shows: Gimpel & Weitzenhoffer, Ltd., New York, 1969, 1971; Marlborough Fine Art, London, 1970, 1972. Trustee, The Tate Gallery, since 1965. Lives in St. Ives.

Pendour. 1947.
Painted wood, 10⅜ × 27½ × 9 inches

PROVENANCE:
Galerie Chalette, New York, 1959

EXHIBITIONS:
The Lefevre Gallery, London, April 1948, *Paintings by Barbara Hepworth and L. S. Lowry*, no. 63
XXV Biennale Internazionale d'Arte, Venice, June–September 1950, *British Pavilion*, no. 75, p. 335
Riverside Museum, New York, March–April 1951, *Abstract Artists of Three Nations*
Whitechapel Art Gallery, London, April 8–June 6, 1954, *Barbara Hepworth, A Retrospective Exhibition of Carvings and Drawings from 1927 to 1954*, no. 82, plate J
Walker Art Center, Minneapolis, April 15–May 29, 1955,

Barbara Hepworth Carvings and Drawings 1937–1954 (organized by the Martha Jackson Gallery, New York), no. 11, ill.; toured to University of Nebraska Art Galleries, Lincoln, June 15–August 15; San Francisco Museum of Art, September 1–October 16; Albright Art Gallery, Buffalo, New York, November 9–December 15; Art Gallery of Toronto, January 1–February 15, 1956; Montreal Museum of Fine Arts, March 1–31; The Baltimore Museum of Art, April 15–June 30
Galerie Chalette, New York, October–November 1959, *Hepworth*, no. 7
The Solomon R. Guggenheim Museum, New York, October 3, 1962–January 6, 1963, *Modern Sculpture from the Joseph H. Hirshhorn Collection*, no. 205, ill. p. 153
IBM Gallery, New York, March 15–April 9, 1965, *5 British Sculptors (Work and Talk)*, no. 15
The Tate Gallery, London, April 3–May 19, 1968, *Barbara Hepworth*, no. 49, ill. p. 19

REFERENCES:
Hammacher, A. M. *The Sculpture of Barbara Hepworth*, trans. James Brockway, New York, Abrams, 1968, no. 70
Hodin, J. P. *Barbara Hepworth*, New York, McKay, 1961, no. 145, ill.
Read, Herbert. "Barbara Hepworth," *La Biennale di Venezia*, 3, June 1951, ill. p. 14
———. intro. *Barbara Hepworth: Carvings and Drawings*, London, Lund Humphries, 1952, plates 95–97b

Head (Elegy). 1952.
Mahogany and string, 16¾ × 11 × 7½ inches

PROVENANCE:
Martha Jackson Gallery, New York, 1957

EXHIBITIONS:
The Lefevre Gallery, London, October 1952, *Sculpture and Drawings by Barbara Hepworth*, no. 15
Whitechapel Art Gallery, London, April 8–June 6, 1954, *Barbara Hepworth, A Retrospective Exhibition of Carvings and Drawings from 1927 to 1954*, no. 148, plate O
Walker Art Center, Minneapolis, April 15–May 29, 1955, *Barbara Hepworth Carvings and Drawings 1937–1954* (organized by the Martha Jackson Gallery, New York), no. 15; toured to University of Nebraska Art Galleries, Lincoln, June 15–August 15; San Francisco Museum of Art, September 1–October 16; Albright Art Gallery, Buffalo, New York, November 9–December 15; Art Gallery of Toronto, January 1–February 15, 1956; Montreal Museum of Fine Arts, March 1–31; The Baltimore Museum of Art, April 15–June 30
The Detroit Institute of Arts, and tour, 1959–60, *Sculpture in Our Time*, no. 105
The Solomon R. Guggenheim Museum, New York, October 3, 1962–January 6, 1963, *Modern Sculpture from the Joseph H. Hirshhorn Collection*, no. 206, ill. p. 152
The Tate Gallery, London, April 3–May 19, 1968, *Barbara Hepworth*, no. 64, ill. p. 25

REFERENCES:
Fish, Margaret. "Moderns' Diversity Dominates Great Sculpture Show," *Milwaukee Sentinel*, September 27, 1959, sec. D, ill. p. 6
Goldwater, Robert. *What Is Modern Sculpture?*, New York, The Museum of Modern Art, 1969, p. 61, ill.
Hammacher, A. M. *The Evolution of Modern Sculpture, Tradition and Innovation*, New York, Abrams, 1969, ill. p. 252
———. *The Sculpture of Barbara Hepworth*, trans. James Brockway, New York, Abrams, 1968, ill. p. 122
Hodin, J. P. *Barbara Hepworth*, New York, McKay, 1961, no. 184, ill.
Kaufman, Betty. "Hirshhorn: The Collector's Art," *Commonweal*, 77, November 9, 1962, p. 182

Figure for Landscape. 1960.
Bronze, 8 feet 10 inches × 4 feet 2½ inches × 2 feet 2½ inches
Markings: l. l. top of base "Barbara Hepworth 1960 2/7"
l. l. front of base "Morris Singer Founders London"

PROVENANCE:
Gimpel Fils, London, 1965

EXHIBITIONS:
Rijksmuseum Kröller-Müller, Otterlo, The Netherlands, May 8–July 18, 1965, *Barbara Hepworth*, no. 26, ill.

REFERENCES:
Alley, Ronald, intro. *Barbara Hepworth*, London, The Tate Gallery, 1968, no. 108, p. 58
Jacobs, Jay. "Collector: Joseph H. Hirshhorn," *Art in America*, 57, July–August 1969, ill. p. 68
———. "Quality as Well as Quantity: Joseph H. Hirshhorn," in Lipman, Jean, ed. *The Collector in America*, New York, Viking, 1971, colorplate p. 82

PHILIPPE HIQUILY (b. 1925)

Born Paris, March 27, 1925. Lived in Orléans, France, 1937–44; studied, École Régionale Supérieure des Beaux-Arts. Served, French Army, France, and Indochina, 1944–47. Studied, École des Beaux-Arts, Paris, with Alfred-Auguste Janniot, 1947–51; influenced by Germaine Richier, and Robert Müller. First one-man show, Galerie Palmes, Paris, 1954. Exhibited, Paris: Salon de Mai, 1956, 1957, 1959, 1960, 1964; Salon de la Jeune Sculpture, 1957–60; "Sculpteurs français," Musée Rodin, 1958. Included in Pittsburgh International, 1958. One-man shows: Galerie du Dragon, Paris, 1958; The Contemporaries, New York, 1959, 1961. Awarded Critics Prize, 1ᵉ Biennale de Paris, 1959. One-man shows: Institute of Contemporary Arts, London, 1963; Galerie Claude Bernard, Paris, 1964. Lives in Paris.

Buccaneer (Le Boucanier). 1963.
Sheet metal in five movable parts, 68½ × 38 × 30 inches

PROVENANCE:
Galerie Claude Bernard, Paris, 1963

DAVID HOCKNEY (b. 1937)

Born Bradford, England, July 9, 1937. Attended, Bradford College of Art, 1953–57. Conscientious objector; worked in hospital instead of military service, 1957–59. Studied, Royal College of Art, London, 1959–62; awarded Gold Medal, 1962. Exhibited, R.B.A. Galleries, London: "Young Contemporaries," 1960; "The Graven Image," 1961 (Guinness Award, and First Prize for Etching). Visited New York, Egypt, Berlin; toured the U.S., 1961–65. Taught: Maidstone College of Art, England, 1962; University of Iowa, Iowa City, 1964; University of Colorado, Boulder, 1965; University of California at Los Angeles, 1966–67; University of California, Berkeley, 1967. One-man shows: Kasmin Gallery, London, from 1963; The Alan Gallery, New York, 1964; The Museum of Modern Art, New York, 1964 (prints), 1968; Stedelijk Museum, Amsterdam, 1966; Palais des Beaux-Arts, Brussels, 1966; Landau-Alan Gallery, New York, 1967; André Emmerich Gallery, New York, 1969, 1970, 1972. Included in: "Nieuwe Realisten," Gemeentemuseum, The Hague, and tour, 1964; "The Harry N. Abrams Family Collection," The Jewish Museum, New York, 1966; Pittsburgh International, 1967; IX São Paulo Bienal, 1967; Documenta 4, Kassel, 1968; "British Painting and Sculpture, 1960–1970," National Gallery of Art, Washington, D.C., 1970–71. Lives in London.

Cubist (American) Boy with Colourful Tree. 1964.
Acrylic on canvas, 65¾ × 65¾ inches
Signed and dated on back: "David Hockney, June 1964"

PROVENANCE:
The Alan Gallery, New York, 1964

EXHIBITIONS:
The Alan Gallery, New York, September 27–October 17, 1964, *David Hockney*, no. 9

REFERENCES:
Glazebrook, Mark. "Catalogue of Paintings," *David Hockney: Paintings, Prints and Drawings 1960–1970*, London, Whitechapel Art Gallery, 1970, no. 64.16, ill. p. 47
Hodin, J. P. "David Hockney," *Quadrum*, 18, 1965, p. 144, ill.
Raynor, Vivien. "In the Galleries: Hockney," *Arts Magazine*, 39, November 1964, p. 61
Russell, John. "London/NYC: The Two-Way Traffic," *Art in America*, 53, April 1965, ill. p. 136

"*Cubist (American) Boy with Colourful Tree* was painted in Los Angeles, California, in 1964. The imagery is based on a number of earlier pictures using ideas of style in different ways. There are paintings, for example, of trees done in a decorative Cubist style, and as I thought that American athletes usually have nice clear, rounded, and well-defined forms in their bodies, I thought it was an appropriate subject to do in the Cubist style. Therefore a certain amount of humour was intended."

Statement by the artist, 1972

HANS HOFMANN (1880–1966)

Born Weissenburg, Bavaria, Germany, March 21, 1880. Moved to Munich, 1886; studied art, 1898–1904. Lived in Paris, 1904–14; studied, Académie de la Grande Chaumière, 1904. Exhibited, Berlin: Neue Sezession, 1910; one-man show, Galerie Paul Cassirer, 1910. Founded the Hans Hofmann School of Fine Art, Munich, 1915; director, until 1932. Taught: University of California, Berkeley, summers, 1930, 1931; Chouinard School of Art, Los Angeles, 1931. One-man show (drawings), California Palace of the Legion of Honor, San Francisco, 1931. Settled in the U.S., 1932; citizen, 1941. Taught, The Art Students League of New York, 1932. Founded and directed the Hans Hofmann School of Fine Art: New York, 1933–58, and Provincetown, Massachusetts, 1934–58; students included Robert Beauchamp, Burgoyne Diller, Mary Frank, Helen Frankenthaler, Red Grooms, Jan Müller, Louise Nevelson, Larry Rivers, Richard Stankiewicz, Wilfred Zogbaum. Author of *Essays, Search for the Real and Other* (Cambridge, Massachusetts Institute of Technology), 1948. One-man shows: Isaac Delgado Museum of Art, New Orleans, 1941; Peggy Guggenheim's Art of This Century, New York, 1944; The Arts Club of Chicago, 1944; Mortimer Brandt Gallery, New York, 1946; Betty Parsons Gallery, New York, 1947; Kootz Gallery, New York, 1947–66; The Baltimore Museum of Art, 1954; University Art Gallery, Rutgers University, The State University of New Jersey, New Brunswick, 1956; Santa Barbara Museum of Art, California, 1963. Retrospectives: Addison Gallery of American Art, Phillips Academy, Andover, Massachusetts, 1948; Bennington College, Vermont, 1955; Philadelphia Art Alliance, 1956; Whitney Museum of American Art, New York, and tour, 1957–60; Fränkische Galerie am Marientor, Nuremberg, Germany, and tour, 1962; The Museum of Modern Art, New York, 1963. Included in: Documenta II, Kassel, 1959; Venice Biennale, 1960. Died New York, February 17, 1966. Hans Hofmann Wing dedicated, University Art Museum, University of California, Berkeley, 1970.

Composition No. III. 1953.
Oil on canvas, 36 × 48 inches
Signed and dated l. r.: "Hans Hofmann/53"

PROVENANCE:
The artist, New York, 1958

EXHIBITIONS:
American Federation of Arts tour, 1959–60, *Ten Modern Masters of American Art*, no. 13
American Federation of Arts tour, 1962–65, *Paintings from the Joseph H. Hirshhorn Foundation Collection: A View of the Protean Century*, no. 36, ill.

Flowering Swamp. 1957.
Oil on wood panel, 48 × 36 inches
Signed and dated l. r.: "Hans Hofmann/57"

PROVENANCE:
Kootz Gallery, New York, 1958

EXHIBITIONS:
Kootz Gallery, New York, January 7–25, 1958, *Hans Hofmann*, no. 24, ill.
American Federation of Arts tour, 1959–60, *Ten Modern Masters of American Art*, no. 15
Fränkische Galerie am Marientor, Nuremberg, Germany, April–May 1962, *Hans Hofmann Retrospective*, no. 42; toured to Kunstverein, Cologne, June–July; Kongresshalle, Berlin, October–November; Städtische Galerie im Lenbachhaus, Munich, December–January 1963
Joseloff Gallery, University of Hartford, West Hartford, Connecticut, November 8–December 4, 1964, *The Arts in Society*, no. 26, ill.

REFERENCES:
Hunter, Sam. *Hans Hofmann*, New York, Abrams, 1963, ill. 69

Oceanic. 1958.
Oil on canvas, 60½ × 48¼ inches
Signed and dated l. r.: "Hans Hofmann 58"

PROVENANCE:
Kootz Gallery, New York, 1959

EXHIBITIONS:
Kootz Gallery, New York, January 6–31, 1959, *Hans Hofmann: Paintings of 1958*, cat., ill.
Contemporary Arts Museum, Houston, April 23–May 31, 1959, *The Romantic Agony: From Goya to De Kooning*, ill. p. 21
Fränkische Galerie am Marientor, Nuremberg, Germany, April–May 1962, *Hans Hofmann Retrospective*, no. 59; toured to Kunstverein, Cologne, June–July; Kongresshalle, Berlin, October–November; Städtische Galerie im Lenbachhaus, Munich, December–January 1963

REFERENCES:
Hunter, Sam. *Hans Hofmann*, New York, Abrams, 1963, colorplate 86
Sawin, Martica. "In the Galleries: Hofmann," *Arts*, 33, February 1959, p. 56

WINSLOW HOMER (1836–1910)

Born Boston, February 24, 1836. Youth spent in Cambridge, Massachusetts. Apprenticed to lithographer John H. Bufford, Boston, c. 1855. Began career as freelance illustrator, 1857; contributed to *Harper's Weekly*, 1857–75. Moved to New York, 1859. Studied, New York: drawing school, Brooklyn, c. 1859–61; National Academy of Design, evenings, c. 1861; with Frédéric Rondel, briefly, 1861. First paintings, 1862. Sent by *Harper's Weekly* to cover Civil War, on Virginia Front, 1863–65. National Academy of Design, New York: exhibited, Annual, 1863–88, 1906–10; associate, 1864; academician, 1865. Spent ten months in Paris, 1866–67; two paintings included, Exposition Universelle de 1867. Visited: White Mountains, New Hampshire, summer, 1868, 1869; Adirondacks, New York, 1870. Summered, Gloucester, Massachusetts, 1873; first watercolors, 1873. Abandoned illustration, 1875. Visited: Petersburg, Virginia, 1875; Houghton Farm, Mountainville, New York, summer, 1878. Member, American Society of Painters of Watercolors, New York, 1877. Traveled to Tynemouth, England, 1881–82; included in Royal Academy of Arts Annual, London, 1882. Settled in Prout's Neck, Maine, 1883. One-man shows: Doll & Richards Gallery, Boston, 1883–94; Reichard and Company, New York, 1890–97; M. Knoedler & Co., New York, 1897–1910. First etchings, 1884. Traveled to Nassau, The Bahamas, 1885, 1898, 1900–1901. Awarded Gold Medal, World's Columbian Exposition, Chicago, 1893. Died Prout's Neck, September 29, 1910. Memorial exhibition, The Metropolitan Museum of Art, New York, 1911. Centenary exhibition, Whitney Museum of American Art, New York, 1936. Retrospectives: National Gallery of Art, Washington, D.C., and The Metropolitan Museum of Art, 1958–59; Whitney Museum of American Art, and tour, 1973–74.

Army Boots. 1865.
Oil on canvas, 14 × 18 inches
Signed and dated l. r.: "Homer N.Y. 65"

PROVENANCE:
William Heineman; M. Knoedler & Co., New York; Joseph Katz, Baltimore; William J. Poplack, Detroit; James Graham and Sons, New York; Victor Spark, New York; James Graham and Sons, 1964

EXHIBITIONS:
The Detroit Institute of Arts, May 1940, *The Age of Impressionism and Objective Realism*, no. 61
Babcock Galleries, New York, December 8–31, 1941, *Paintings, Winslow Homer*, no. 18
James Graham and Sons, New York, November 22–December 24, 1958, *American Group*
The University of Arizona Art Gallery, Tucson, October 11–December 1, 1963, *Yankee Painter: A Retrospective Exhibition of Winslow Homer*, no. 125, ill. p. 18
The Bowdoin College Museum of Art, Brunswick, Maine, April 17–September 6, 1964, *The Portrayal of the Negro in American Painting*, no. 42
Whitney Museum of American Art, New York, April 3–June 3, 1973, *Winslow Homer*, no. 4

REFERENCES:
Goodrich, Lloyd. *Winslow Homer*, New York, Whitney Museum of American Art/Macmillan, 1944, pp. 20, 50
James Graham and Sons, New York, *Art Quarterly*, 24, Summer 1961, ill. p. 215 (adv.)
———, *Arts*, 33, February 1959, ill. p. 4 (adv.)

During the Civil War years Homer began to experiment with watercolors and oils. His first paintings, based on his experiences at the Front as artist-correspondent for *Harper's Weekly*, portrayed soldiers on bivouac, and camp diversions rather than battle scenes. *Army Boots* was painted a year earlier than the renowned *Prisoners from the Front* (The Metropolitan Museum of Art, New York).

The Country Store. 1872.
Oil on board, 11½ × 18 inches
Signed and dated l. l.: "Homer 1872"
u. r.: "Homer 1872"

PROVENANCE:
Samuel P. Avery, New York; R. Somerville Gallery, New York, Sale, May 13–14, 1873, *Samuel P. Avery's Collection of Paintings*, no. 93; Noah Brooks, Castline, Maine; Private collection, New York; William D. Swaney, New York; Parke-Bernet Galleries, New York, Sale 2276, April 23, 1964, no. 43, ill. p. 17

EXHIBITIONS:
National Academy of Design, New York, 1872, *Forty-Seventh Annual Exhibition*, no. 349
Whitney Museum of American Art, New York, April 3–June 3, 1973, *Winslow Homer*

REFERENCES:
Downes, William Howe. *The Life and Works of Winslow Homer*, Boston, Houghton Mifflin, 1911, p. 70
Gardner, Albert Ten Eyck. *Winslow Homer*, New York, Potter, 1961, p. 204
Hendricks, Gordon. "The Flood Tide in the Winslow Homer Market," *Art News*, 72, May 1973, p. 69
Unsigned. "Auctions in Review, 1963–64," *Art News*, 63, September 1964, p. 47, ill.
Walton, William. "A Slice From Another Mellon," *The Washingtonian*, 3, August 1968, colorplate p. 51

Scene at Houghton Farm. c. 1878.
Watercolor on paper, 7¼ × 11¼ inches
Signed l. r.: "Homer"

PROVENANCE:
Joseph Montezinos, New York; Jon N. Streep, New York, 1959

EXHIBITIONS:
Storm King Art Center, Mountainville, New York, June 29–August 22, 1963, *Winslow Homer in New York State*, no. 31, ill. p. 20
The University of Arizona Art Gallery, Tucson, October 11–December 1, 1963, *Yankee Painter: A Retrospective Exhibition of Winslow Homer*, no. 61, ill. p. 54

Homer painted this watercolor during the summer of 1878, when he was the house guest of Lawson Valentine at Houghton Farm, Mountainville, New York.

The Houses of Parliament. 1881.
Watercolor on paper, 12½ × 19½ inches
Signed and dated l. l.: "Homer 1881"

PROVENANCE:
Charles Savage Homer, Jr., New York; Mrs. Charles S. Homer, Jr., New York; Charles Lowell Homer, Prout's Neck, Maine; Babcock Galleries, New York, 1957

EXHIBITIONS:
M. Knoedler & Co., New York, March 22–April 16, 1954, *Americans Abroad*, no. 20
National Gallery of Art, Washington, D.C., November 22, 1958–January 4, 1959, *Winslow Homer*, no. 105, ill. p. 57; toured to The Metropolitan Museum of Art, New York, January 27–March 8
Museum of Fine Arts, Boston, March 25–May 3, 1959, *Winslow Homer, A Retrospective Exhibition*, no. 96, ill. p. 55

REFERENCES:
Beam, Philip C. *Winslow Homer at Prout's Neck*, Boston, Little, Brown, 1966, p. 17
Gardner, Albert Ten Eyck. *Winslow Homer*, New York, Potter, 1961, ill. p. 123
Grosser, Maurice. "Art," *The Nation*, 188, February 14, 1959, p. 148
Vaughan, Malcolm. "The Connoisseur in America: Winslow Homer, American Master," *Connoisseur*, 143, April 1959, ill. p. 130

"In the spring of 1881 . . . he sailed for England. He was forty-five years old."

"In London, Homer soon created a striking memento of his stay, the watercolor study of the *Parliament Buildings*. . . . The deep, almost monochromatic tones have the richness of oil; technically the picture seems to sum up all the years of Impressionist practices."

Beam, p. 17

GOTTFRIED HONEGGER (b. 1917)

Born Zurich, June 12, 1917. Youth spent in Engadine, Switzerland. Studied, Kunstgewerbeschule, Zurich, 1931–32. Decorator's apprentice, Zurich, 1932–35. With his wife, opened commercial design studio, 1938. First one-man show, Galerie Haller, Zurich, 1950. Lived in New York, 1958–60. One-man shows: Martha Jackson Gallery, New York, 1960, 1964; Galerie Jeanne Fillon, Paris, 1961; Galerie Lawrence, Paris, 1963; Gimpel & Hanover Galerie, Zurich, 1963, 1965, 1966, 1971; Gimpel Fils, London, 1964; Galerie M. E. Thelen, Essen, Germany, 1965; Kunsthaus, Zurich, 1967; Museum am Ostwall, Dortmund, Germany, 1968. Included in: Pittsburgh International, 1961–70; Guggenheim International Award, 1964. Artist-in-residence, University of Dallas, 1969. One-man shows: Galerie M. E. Thelen, Cologne, 1970; Gimpel & Weitzenhoffer, Ltd., New York, 1970. Also a printmaker. Has lived in Zurich, and in Paris, since 1961.

Tableau-Relief. Z–470. 1963–67.
Collage and acrylic on canvas, 78½ × 59 inches
Signed and dated on back: "Honegger/1963–67"

PROVENANCE:
Gimpel & Hanover Galerie, Zurich, 1969

EXHIBITIONS:
Kunsthaus, Zurich, February 1968, *Honegger*, no. 26

REFERENCES:
Forster, Kurt W. *Honegger*, Teufen, Switzerland, Arthur Niggli, 1972, ill. 50

EDWARD HOPPER (1882–1967)

Born Nyack, New York, July 22, 1882. Studied: illus-
tration, commercial art school, New York, 1899–1900; New York School of Art, with Robert Henri, George Luks, Kenneth Hayes Miller, 1900–1906. Traveled in Europe, 1906–7, 1909, 1910. Settled in New York, 1908; worked as commercial illustrator, 1908–24. Exhibited, New York: Original Independent Show, 1908; Exhibition of Independent Artists, 1910; the Armory Show, 1913. First etchings, 1915; active as printmaker, 1915–23. Awarded U.S. Shipping Board Poster Prize, 1918. One-man shows. New York: Whitney Studio Club, 1920, 1922; Frank Rehn Gallery, 1924, 1927, 1929, 1941, 1943, 1948. Included in "Paintings by Nineteen Living Americans," The Museum of Modern Art, New York, 1929–30. Declined membership, National Academy of Design, 1932 (because of Academy's history of rejecting his work). Retrospectives: The Museum of Modern Art, 1933; The Arts Club of Chicago, 1934; Carnegie Institute, Pittsburgh, 1937. Awarded: Corcoran Gold Medal, and First Clark Prize, Corcoran Biennial, 1937; Garrett Prize, and Logan Medal, 52nd and 55th American Exhibition, The Art Institute of Chicago, 1942, 1945; Gold Medal for Painting, The National Institute of Arts and Letters, and The American Academy of Arts and Letters, 1955. Member: The National Institute of Arts and Letters, 1945; The American Academy of Arts and Letters, 1955. Retrospectives: Whitney Museum of American Art, New York, and tour, 1950, 1964–65; Philadelphia Museum of Art, and Worcester Art Museum, Massachusetts (graphics), 1962–63; The University of Arizona Art Gallery, Tucson, 1963; IX São Paulo Bienal, 1967. Died New York, May 15, 1967. After Mrs. Hopper's death in 1968, entire artistic estate bequeathed to Whitney Museum of American Art; selections from bequest exhibited, 1971, 1972.

Tramp Steamer. 1908.
Oil on canvas, 20 × 29 inches
Signed l. r.: "E. Hopper"

PROVENANCE:
Frank Rehn Gallery, New York; Park Gallery, Detroit; Lawrence Fleischman, Detroit; Donald Morris Gallery, Detroit; James Goodman Gallery, Buffalo, New York, 1962

EXHIBITIONS:
Frank Rehn Gallery, New York, January 6–February 1, 1941, *Early Paintings by Edward Hopper*
Wilmington Society of the Fine Arts, Delaware Art Center, January 9–February 21, 1960, *The Fiftieth Anniversary of Independent Artists in 1910*, no. 40, ill.
James Goodman Gallery, Buffalo, New York, Fall 1962, *G Contemporary Paintings*, no. 27, ill. p. 7
The Rotunda, Asbury Park, New Jersey, May 2–31, 1965, *The Spell of the Sea* (sponsored by the Monmouth Museum, New Jersey), no. 59
Flint Institute of Arts, Michigan, April 2–May 29, 1966, *Realism Revisited*, no. 21, p. 14
The Baltimore Museum of Art, October 22–December 8, 1968, *From El Greco to Pollock: Early and Late Works by European and American Artists*, no. 111, p. 134

REFERENCES:
Goodrich, Lloyd. *Edward Hopper*, New York, Whitney Museum of American Art, 1964, p. 8
——. *Edward Hopper*, New York, Abrams, 1971, p. 27
Hopper, Edward. *Notebook 2*, The Hopper Bequest, New York, Whitney Museum of American Art, pp. 68, 74
Lane, James W. "Early Hopper Paintings Before 1915," *Art News*, 39, February 1, 1941, p. 13
Unsigned. "The Early Roots of Edward Hopper's Art," *Art Digest*, 15, January 15, 1941, p. 13

"As early as 1908, when he was only twenty-six, his subjects and viewpoint were in essence the same as later, though less developed. While sharing the general realistic outlook of the Henri group, his realism was more objective, less romantic. And he was interested in different things. *Tramp Steamer*, *Tugboat*, *The El Station*, and *Railroad Train*, all painted in 1908, were naively honest portrayals of essential features of modern life that few artists had pictured."

Goodrich, Abrams, p. 27

Very early, 20″ × 29″
Dull blue water, big waves
heavy paint. Black hull.
Sky pale, whitish.
Smoke horizontal. On way
into England—Norwegian flag?

Mrs. Josephine Hopper, in Hopper,
Edward. *Notebook 2*, p. 74

First Row Orchestra. 1951.
Oil on canvas, 31 × 40 inches
Signed l. l.: "Edward Hopper"

PROVENANCE:
Frank Rehn Gallery, New York, 1954

EXHIBITIONS:
Whitney Museum of American Art, New York, November 8, 1951–January 6, 1952, *1951 Annual Exhibition of Contemporary Painting*, no. 68, ill.
The National Gallery of Canada, Ottawa, and tour, 1957, *Some American Paintings from the Collection of Joseph H. Hirshhorn*, no. 35, ill. 11
American Federation of Arts tour, 1962–65, *Paintings from the Joseph H. Hirshhorn Foundation Collection: A View of the Protean Century*, no. 39
IX Bienal de Arte Moderna, São Paulo, September 22, 1967–January 8, 1968, *United States Representation*, no. 31, ill. p. 12; toured to Rose Art Museum, Brandeis University, Waltham, Massachusetts, February 24–March 31
The Metropolitan Museum of Art, New York, October 18, 1969–February 8, 1970, *New York Painting and Sculpture, 1940–1970*, no. 127, ill. p. 183

REFERENCES:
Goodrich, Lloyd. *Edward Hopper*, New York, Abrams, 1971, p. 280, ill.
Hopper, Edward. *Notebook 3*, The Hopper Bequest, New York, Whitney Museum of American Art, p. 39

Loercher, Diana. "Edward Hopper," *The Christian Science Monitor*, April 26, 1971, ill. p. 10
Nordness, Lee, ed. *Art U.S.A. Now*, New York, Viking, 1963, p. 230, ill. p. 24

Hotel by a Railroad. 1952.
Oil on canvas, 31¼ × 40 inches
Signed l. r.: "Edward Hopper"

PROVENANCE:
Frank Rehn Gallery, New York, 1954

EXHIBITIONS:
Whitney Museum of American Art, New York, October 15–December 6, 1953, *1953 Annual Exhibition of Contemporary American Painting*, no. 68
Hotel Carlyle, New York, May 9, 1957, *American Federation of Arts: Art Collectors' Club Exhibition*
American Federation of Arts tour, 1960, *Ten Modern Masters of American Art*, no. 18, ill. p. 21
Whitney Museum of American Art, New York, September 29–November 29, 1964, *Edward Hopper*, no. 57, ill. p. 55; toured to The Art Institute of Chicago, December 18–January 31, 1965; The Detroit Institute of Arts, February 18–March 21; City Art Museum of St. Louis, Missouri, April 7–May 9
United States Embassy, Paris, June 1968–June 1969, extended loan (Art and Embassies Program, The Museum of Modern Art, New York)

REFERENCES:
Finley, Barry. "Light of Genius," *The New York Herald Tribune*, November 21, 1971, p. 29
Garvin, Adelaide. "Art and Artists," *The Critic*, Chicago, 18, October–November 1959, p. 67
Goodrich, Lloyd. *Edward Hopper*, New York, Whitney Museum of American Art, 1964, p. 56
——. *Edward Hopper*, New York, Abrams, 1971, p. 149, colorplate p. 150
Hopper, Edward. *Notebook 3*, The Hopper Bequest, New York, Whitney Museum of American Art, p. 45
Mellow, James R. "The World of Edward Hopper," *The New York Times Magazine*, September 5, 1971, p. 19

"Man, pale, graying dark hair, dark blue trousers and vest, white shirt sleeves. Woman (wife): gray straight hair, pink slip, in blue chair. Greeny gray walls, green carpet, green window shade. Pale yellow curtains. Light mahogany stain bureau and mirror frame. Outdoors: yellow stone wall, green shade at window and white curtain; gray warehouse, bit of blue sky and below burnt sienna RR tracks. Emphasis on mood. Wife better watch husband and tracks below window."

Mrs. Josephine Hopper, in Hopper,
Edward. *Notebook 3*, p. 45

City Sunlight. 1954.
Oil on canvas, 28 × 40 inches
Signed l. r.: "E. Hopper"

PROVENANCE:
Frank Rehn Gallery, New York, 1955

EXHIBITIONS:
Carnegie Institute, Pittsburgh, October 13–December 18, 1955, *The 1955 Pittsburgh International Exhibition of Contemporary Painting*, no. 136, plate 46
The Arts Club of Chicago, May 3–June 15, 1956, *Marsden Hartley, Edward Hopper, Walt Kuhn, John Sloan*, no. 18
Whitney Museum of American Art, New York, March 5–April 12, 1959, *The Museum and Its Friends*, p. 47
Whitney Museum of American Art, New York, September 29–November 29, 1964, *Edward Hopper*, no. 61, ill. p. 51; toured to The Art Institute of Chicago, December 18–January 31, 1965; The Detroit Institute of Arts, February 18–March 21; City Art Museum of St. Louis, Missouri, April 7–May 9
IX Bienal de Arte Moderna, São Paulo, September 22, 1967–January 8, 1968, *United States Representation*, no. 33; toured to Rose Art Museum, Brandeis University, Waltham, Massachusetts, February 24–March 31
The Baltimore Museum of Art, October 22–December 8, 1968, *From El Greco to Pollock: Early and Late Works by European and American Artists*, no. 112, ill. p. 135

REFERENCES:
Goodrich, Lloyd. *Edward Hopper*, New York, Whitney Museum of American Art, 1964, p. 56
——. *Edward Hopper*, New York, Abrams, 1971, p. 151, colorplate p. 282
Hopper, Edward. *Notebook 3*, The Hopper Bequest, New York, Whitney Museum of American Art, p. 51
Rose, Barbara. "New York Letter: The Hopper Retrospective," *Art International*, 8, November 1964, ill. p. 53
Tyler, Parker. "Hopper/Pollock," *Art News Annual XXVI*, 1957, p. 95, ill. p. 86
The Villager, New York, 27, April 23, 1959, p. 11, ill.

JEAN-ANTOINE HOUDON (1741–1828)

Born Versailles, France, March 20, 1741. Moved to Paris, 1749, when his father became concierge at École Royale des Élèves Protégés (preparatory school for Académie de France à Rome). Frequented ateliers of Jean-Baptiste Lemoyne II, and Jean-Baptiste Slodtz, Académie Royale de Peinture et de Sculpture; received Third Prize for Sculpture, 1756; formally enrolled as student of Michel-Ange Slodtz, 1758. Received Prix de Rome, 1761. Studied: École Royale des Élèves Protégés, 1761–64; Académie de France à Rome, 1764–68. Returned to Paris, 1768. Académie Royale de Peinture et de Sculpture: agréé, 1769; academician, 1777; assistant professor, 1792. Included in the Salon, Paris, 1769–1814. Portrait commissions: Denis Diderot, c. 1771; Catherine II of Russia, 1773; Arouet de Voltaire, 1778, 1781; Jean-Jacques Rousseau, and Benjamin Franklin, c. 1779; George Washington, c. 1785; Marquis de Lafayette, and Louis XVI, c. 1786; Thomas Jefferson, c. 1789; Napoleon I, and Empress Josephine, 1806. Member, newly founded Institut de France, 1796. Chevalier, Légion d'honneur, 1804. Professor, École des Beaux-Arts, Paris, 1805. Died Paris, July 15, 1828. Retrospectives: Bibliothèque Municipale, Versailles, 1928; Galeries Buvelot, Paris, 1928; Galerie Jean de Ruaz, Paris, 1941; Akademie der Künste,

Berlin, 1955; Worcester Art Museum, Massachusetts, 1964.

Jean Louis Leclerc, Comte de Buffon. 1782.
Tinted plaster, 23¾ × 11¼ × 10¼ inches
Markings: l. side "Houdon f
1782"
back c. wax seal of the atelier

Réau, Louis. *Houdon: sa vie et son oeuvre*, 3/4, Paris, F. de Nobele, 1964, no. 94, p. 27

PROVENANCE:
Comte de Buffon, Château de Montbard, France; Dr. Xavier Gillot, Autun, France; Private collection, United States; Bernard Black Gallery, New York, 1966

EXHIBITIONS:
Bernard Black Gallery, New York, Spring 1966, *Sculpture for a Small Museum*, no. 14, ill.

Comte de Buffon was director of the Jardin du Roi (later the Jardin des Plantes) in Paris, and author of a monumental encyclopedia of plant and animal life. His forty-four-volume *Histoire naturelle*, published between 1749 and 1804, contains the results of the research he directed at the Jardin, as well as speculations of his own that often anticipated the theories of Darwin.

In 1781, Catherine II of Russia commissioned Houdon to portray Buffon; a marble version of the portrait is now in The Hermitage, Leningrad.

Sabine Houdon. c. 1791.
Marble, 17 × 13½ × 8 inches

Réau, Louis. *Houdon: sa vie et son oeuvre*, 3/4, Paris, F. de Nobele, 1964, no. 230, p. 50

PROVENANCE:
Mr. and Mrs. B. M. Frank, New York; Parke-Bernet Galleries, New York, Sale 2808, February 21, 1969, no. 211, ill. p. 59 and frontispiece

REFERENCES:
Parke-Bernet Galleries, New York, *Arts Magazine*, 43, February 1969, ill. p. 8 (adv.)
Unsigned. "Coming Auctions," *Art News*, 67, February 1969, ill. p. 25
———. "Coming Up," *Auction*, 2, February 1969, ill p. 28

Houdon made four portraits of his oldest daughter, Sabine (1787–1836). This marble, the third in the series, shows her at the age of four. It was probably executed as part of a family group, since there are similar busts of Sabine's younger sisters from the same year. There is another version, without drapery, in terra-cotta, and several in marble.

RICHARD HUNT (b. 1935)

Richard Howard Hunt, born Chicago, September 12, 1935. Studied, School of The Art Institute of Chicago (junior school), 1948–53; B.Ed., 1957. Exhibited, The Art Institute of Chicago: "Annual Exhibition of Artists of Chicago and Vicinity," 1955, 1956, 1961, 1962; Annual American Exhibition, 1957, 1959, 1961, 1962. Received James Nelson Raymond Foreign Travel Scholarship, The Art Institute of Chicago, 1957; toured Europe, 1957–58. Included in: "Irons in the Fire," Contemporary Arts Museum, Houston, 1957; "New Talent U.S.A," American Federation of Arts, Circulating Exhibition, 1958–59; Pittsburgh International, 1958, 1961; Whitney Annual, 1958, 1962–70. Served, U.S. Army, 1958–60. One-man shows: The Alan Gallery, New York, 1958, 1960, 1963; Stewart Rickard Gallery, San Antonio, Texas, 1960, 1965. Taught: School of The Art Institute of Chicago, and University of Illinois, Chicago, 1960–62; Chouinard School of Art, Los Angeles, 1964; Yale University, New Haven, Connecticut, 1964; Purdue University, Lafayette, Indiana, 1965. Received Guggenheim Foundation Fellowship, 1962. One-man shows: B. C. Holland Gallery, Chicago, 1963, 1966, 1968, 1970; Felix Landau Gallery, Los Angeles, 1965; Cleveland Museum of Art, 1967; Milwaukee Art Center, Wisconsin, 1967; Dorsky Gallery, New York, 1968, 1969, 1971. Taught, Illinois: Northwestern University, Evanston, 1968–69; Southern Illinois University, Carbondale, 1969. Member, National Council on the Arts, 1968–74. Retrospective, The Museum of Modern Art, New York, and The Art Institute of Chicago, 1971. Commission, Kraftco Corporation, Glenville, Illinois, 1971. Lives in Chicago.

Construction. 1958.
Bronze and steel, 20½ × 18 × 12 inches

PROVENANCE:
The Alan Gallery, New York, 1958

EXHIBITIONS:
The Alan Gallery, New York, September 29–October 18, 1958, *Sculpture: Richard Hunt*, no. 10

ROBERT INDIANA (b. 1928)

Robert Clark, born New Castle, Indiana, September 13, 1928. Studied: John Herron Art Institute, Indianapolis, Indiana, 1945–46; Munson-Williams-Proctor Institute, Utica, New York, 1947–48; School of The Art Institute of Chicago, 1949–53; Skowhegan School of Painting and Sculpture, Maine, summer, 1953; University of Edinburgh, Scotland, 1953–54. First exhibited, Stable Gallery, New York, 1962. Included in: "Formalists," Washington [D.C.] Gallery of Modern Art, 1963; "Americans 1963," The Museum of Modern Art, New York, and tour, 1963–64; "White House Festival of the Arts," Washington, D.C., 1965; Whitney Annual, 1965–67. Exhibited with Richard Stankiewicz, Walker Art Center, Minneapolis, and Institute of Contemporary Art, Boston, 1963–64. Mural, New York State Pavilion, New York World's Fair, Flushing Meadows, 1964–65. One-man shows: Stable Gallery, 1964, 1966; Galerie Alfred Schmela, Düsseldorf, 1966; Stedelijk Museum, Amsterdam, 1966. Included in: Pittsburgh International, 1967; ROSC '67, Dublin, 1967; IX São Paulo Bienal, 1967; Documenta 4, Kassel, 1968. One-man shows: Herron Museum of Art, Indianapolis, 1968; Multiples, Inc., New York, 1971; Galerie Denise René, New York, 1972; New

York Cultural Center, 1973. Designed *Love* stamp, issued by U.S. Post Office Department, Valentine's Day, 1973. Also a theatrical designer. Lives in New York.

The Beware-Danger American Dream #4. 1963.
Oil on canvas, 8 feet 6 inches × 8 feet 6 inches
Signed and dated on back: "Robert Indiana 1963"

PROVENANCE:
Stable Gallery, New York, 1963

EXHIBITIONS:
Washington [D.C.] Gallery of Modern Art, June 6–July 6, 1963, *Formalists*, no. 23, ill. back cover
Walker Art Center, Minneapolis, October 22–November 24, 1963, *Stankiewicz & Indiana*, no. 12, ill.; toured to Institute of Contemporary Art, Boston, December 14–January 26, 1964
Whitney Museum of American Art, New York, May 8–June 16, 1964, *The Friends Collect*, no. 75, ill. p. 49

REFERENCES:
Feldman, Edmund Burke. *Art as Image and Idea*, Englewood Cliffs, New Jersey, Prentice-Hall, 1967, ill. p. 338
———. *Varieties of Visual Experience*, New York, Abrams, 1972, ill. p. 310
Unsigned. "Art: State of the Market," *Time*, 81, June 21, 1963, ill. p. 62

Love. 1966–67.
Aluminum, 12 × 12 × 6 inches
Markings: beneath "V" "INDIANA '67 4/6 HF"

PROVENANCE:
Multiples, Inc., New York, 1966

EXHIBITIONS:
Smithsonian Institution, Washington, D.C., 1972–73, extended loan

GEORGE INNESS (1825–1894)

Born near Newburgh, New York, May 1, 1825. Moved with family to New York, then to Newark, New Jersey, 1830. Studied drawing, with John Jesse Barker, Newark, c. 1841. Worked for map engravers Sherman and Smith, New York, 1841–42. Exhibited: National Academy of Design Annual, 1844–94; American Art Union, New York, 1845–51. Studied, with Régis-François Gignoux, New York, briefly, c. 1845. Lived in Florence and Rome, 1850–52; Paris, 1853/54. Included in: Pennsylvania Academy Annual, 1852, 1855, 1888, 1892–94; Royal Academy of Arts, London, 1859, 1863, 1872; Exposition Universelle de 1867, 1889, 1891, 1900 (Bronze Medal), Paris; Society of American Artists, 1878, 1881, 1882; World's Columbian Exposition, Chicago, 1893. National Academy of Design: associate, 1853; academician, 1868. Moved from New York, and lived in Medfield, Massachusetts, 1860–64; in Eaglewood, New Jersey, 1865–67; settled in Montclair, New Jersey, 1878. Represented in Boston by: Williams & Everett Gallery, 1860–64; Doll & Richards Gallery, 1873–94. Traveled to Italy and France, 1870–75. One-man show, American Art Association, New York, 1884. Died on trip to Europe, Bridge-of-Allan, Scotland, August 3, 1894. Memorial exhibition, Fine Arts Building, New York, 1894. Centennial exhibitions, 1925: Albright Art Gallery, Buffalo, New York; National Academy of Design, New York; Macbeth Gallery, New York. Retrospectives: Montclair Art Museum, 1935; The George Walter Vincent Smith Art Museum, Springfield, Massachusetts, and tour, 1946; M. Knoedler & Co., New York, 1953; Paine Art Center, Oshkosh, Wisconsin, 1962; University Art Museum, The University of Texas at Austin, 1966.

Niagara. 1893.
Oil on canvas, 45 × 70 inches
Signed and dated twice l. l.: "G. Inness, 1893"

PROVENANCE:
The artist; George Inness, Jr.; Mrs. George Inness, Jr.; Elizabeth Inness Greenley; Parke-Bernet Galleries, New York, Sale, May 31, 1945, no. 76, ill. p. 35; J. N. Bartfield, New York; Jon N. Streep, New York, 1961

EXHIBITIONS:
Montclair Art Museum, New Jersey, May 1935, *Paintings by George Inness: 110th Anniversary Exhibition*, no. 34
Albright-Knox Art Gallery, Buffalo, New York, May 12–September 7, 1964, *Three Centuries of Niagara Falls*, no. 38, ill. p. 28
The Corcoran Gallery of Art, Washington, D.C., October 9–November 14, 1971, *Wilderness* (sponsored by The National Endowment for the Arts), no. 115

REFERENCES:
Getlein, Frank. "Corcoran's 'Wilderness,' a Show of Vast Importance," *Washington [D.C.] Sunday Star*, October 10, 1971, sec. J, p. 1
Ireland, Leroy. *The Works of George Inness, Catalogue Raisonné*, Austin, The University of Texas, 1965, no. 1476, ill. p. 386

JEAN IPOUSTÉGUY (b. 1920)

Jean-Robert Ipoustéguy, born Dun-sur-Meuse, France, January 6, 1920. Studied, atelier of Robert Lesbounit, Paris, evenings, 1938. Exhibited, Paris: Librairie-Galerie La Hune, 1943; Galerie Visconti, 1945; Galerie André Maurice, 1950; Salon de Mai, 1956–67; Galerie Claude Bernard, 1958, 1959. Frescoes and stained glass commissioned, church of St.-Jacques-de-Montrouge, Paris, 1947–49. Included in: "Sculpture in the Open Air," Battersea Park, London, 1960; Pittsburgh International, 1961, 1964, 1967; "Three Sculptors; Berrocal, Ipoustéguy, Müller," Albert Loeb Gallery, New York, 1962; Documenta III, Kassel, 1964; Venice Biennale, 1964 (Bright Foundation Sculpture Prize). One-man shows: Galerie Claude Bernard, from 1962; Albert Loeb Gallery, 1964; The Hanover Gallery, London, 1964. Included in: VIII São Paulo Bienal, 1965; "Five Sculptors," The Museum of Fine Arts, Houston, 1966; Guggenheim International, 1967; "A Generation of Innovation," The Art Institute of Chicago, 1967; "The Obsessive Image," Institute of Contemporary Arts, London, 1968. One-man shows: Pierre Matisse Gallery, New York, 1968; Galleria Odyssia, Rome, 1968; Kunsthalle, Darmstadt, Germany, 1969; Nationalgalerie, Berlin, 1970. Lives in Paris.

The Crab and the Bird (Le Crabe et l'oiseau). 1958.
Bronze, 25½ × 61½ × 20 inches
Markings: back l. r. "Ipousteguy 1/6"
back l. l. "Susse Fondeur, Paris"

PROVENANCE:
Galerie Claude Bernard, Paris, 1963

David. 1959.
Bronze, 47 × 24½ × 24 inches
Markings: l. r. side "Ipousteguy 2/6"
l. l. side "Susse Fondeur, Paris"

PROVENANCE:
Galerie Claude Bernard, Paris, 1962

EXHIBITIONS:
Albert Loeb Gallery, New York, October 15–November 10, 1962, *Three Sculptors: Berrocal, Ipoustéguy, Müller*, cat., ill.
The Museum of Fine Arts, Houston, October 3–28, 1966, *Five Sculptors*, no. 2

REFERENCES:
Arnason, H. Harvard. *History of Modern Art*, New York, Abrams, 1968, p. 527, ill.
Raynor, Vivien. "In the Galleries: Berrocal, Ipoustéguy, Müller," *Arts Magazine*, 37, December 1962, p. 48
Sweeney, James Johnson. "A Living Frame for Sculpture," *House & Garden*, 126, August 1964, ill. p. 112

Goliath. 1959.
Bronze, 30½ × 56 × 35 inches
Markings: back l. r. "Ipousteguy 1959 2/6"

PROVENANCE:
Galerie Claude Bernard, Paris, 1962

EXHIBITIONS:
Albert Loeb Gallery, New York, October 15–November 10, 1962, *Three Sculptors: Berrocal, Ipoustéguy, Müller*, hors cat.
The Museum of Fine Arts, Houston, October 3–28, 1966, *Five Sculptors*, no. 2

REFERENCES:
Raynor, Vivien. "In the Galleries: Berrocal, Ipoustéguy, Müller," *Arts Magazine*, 37, December 1962, p. 48
Sweeney, James Johnson. "A Living Frame for Sculpture," *House & Garden*, 126, August 1964, ill. p. 112

The Earth (La Terre). 1962.
Bronze, 69½ × 25½ × 20½ inches
Markings: l. r. back of base "Ipousteguy 1962 1/6"

PROVENANCE:
Galerie Claude Bernard, Paris, 1963

REFERENCES:
Jacobs, Jay. "Collector: Joseph H. Hirshhorn," *Art in America*, 57, July–August 1969, ill. p. 69
Sweeney, James Johnson. "A Living Frame for Sculpture," *House & Garden*, 126, August 1964, ill. p. 113

Man Pushing the Door (L'Homme poussant la porte). 1966.
Bronze, 77½ × 51 × 46 inches
Markings: l. top of base "Ipousteguy Paris 1966"
r. top of base "E Godard Fonde Paris 4/9"

PROVENANCE:
Galerie Claude Bernard, Paris, 1967

SARAH JACKSON (b. 1924)

Born Detroit, November 13, 1924. Studied, Wayne State University, Detroit, M.A., 1948. Exhibited: Salon des Réalités Nouvelles, and Salon de la Jeune Sculpture, Paris, 1949–50. One-man shows, London: Apollinaire Gallery, 1951; New Vision Centre Gallery, 1956; Grosvenor Gallery, 1963. Settled in Canada, 1956. One-man shows, Canada: Montreal Museum of Fine Arts, 1957; Robertson Galleries, Ottawa, 1959; Here and Now Gallery, Toronto, 1960; Roberts Gallery, Toronto, 1961; Carmen Lamanna Gallery, Toronto, 1961, 1966; Galerie Libre, Montreal, 1963, 1968; Jerrold Morris Gallery, Toronto, 1963; Dalhousie University, Halifax, Nova Scotia, 1965; Mount St. Vincent University, Halifax, 1968; Zwicker's Gallery, Halifax, 1971; St. Mary's University, Halifax, 1973. Commissions: Ontario Association of Architects Building, Toronto, 1958; Student Union Building and Lounge, Dalhousie University, 1969. Lives in Halifax.

Dancer. 1961–62.
Bronze, 94½ × 62 × 27 inches
Markings: l. top of base "Sarah Jackson 61
Modern Art Foundry
New York USA"

PROVENANCE:
The artist, Toronto, 1962

EXHIBITIONS:
Trabia-Morris Gallery, New York, October 16–November 10, 1962, *Art of the Americas*, cat.

PAUL JENKINS (b. 1923)

William Paul Jenkins, born Kansas City, Missouri, July 12, 1923. Studied: Kansas City Art Institute and School of Design, 1938–41 (while apprentice in ceramics factory); Drama Department, Carnegie Institute of Technology, Pittsburgh, 1946–48; The Art Students League of New York, with Yasuo Kuniyoshi, and Morris Kantor, 1948–51. Served, U.S. Navy Air Corps, 1944–46. Traveled in Europe; settled in Paris, 1953. One-man shows: Zimmergalerie, Frankfort, 1954; Galerie Paul Facchetti, Paris, 1954; Dusanne Gallery, Seattle, 1955; Martha Jackson Gallery, New York, from 1956; Arthur Tooth & Sons, London, 1960, 1963; Galerie Karl Flinker, Paris, 1961, 1963, 1965, 1973; Gimpel Fils, London, 1972. Retrospective, The Museum of Fine Arts, Houston, and San Francisco Museum of Art, 1971–72. Lives in New York, and in Paris. With Esther E. Jenkins, edited *Observations of Michel Tapié* (New York, Wittenborn), 1956. Included in: Pittsburgh International, 1958, 1961, 1967; 9th, 10th, 12th, 13th Contemporary American Exhibition, University of Illinois, Champaign-Urbana, 1959–61, 1965–67; Documenta III, Kassel, 1964; Corcoran Biennial, 1967 (Corcoran Silver Medal, and Second Clark Prize).

Phenomena Reverse Spell. 1963.
Acrylic on canvas, 6 feet 5 inches × 9 feet 7¾ inches
Signed l. r.: "Paul Jenkins"

PROVENANCE:
Martha Jackson Gallery, New York, 1964

EXHIBITIONS:
Martha Jackson Gallery, New York, March 3–28, 1964, *Paintings by Paul Jenkins*, no. 12

REFERENCES:
Edgar, Natalie. "Reviews and Previews: Paul Jenkins," *Art News*, 63, March 1964, p. 8
Elsen, Albert E. *Paul Jenkins*, New York, Abrams, 1973, p. 72, colorplate 103
Fried, Michael. "New York Letter," *Art International*, 8, May 1964, p. 43
Martha Jackson Gallery, New York, "Paul Jenkins," *Art International*, 8, March 1964, ill. p. 10 (adv.)

JASPER JOHNS (b. 1930)

Born Augusta, Georgia, May 15, 1930. Studied, University of South Carolina, Columbia, 1947–48. Moved to New York, 1949. Worked closely with Robert Rauschenberg, mid-1950s; designed window displays for Tiffany & Co., and other New York stores. Exhibited, New York: "Artists of the New York School: The Second Generation," The Jewish Museum, 1957; "Sixteen Americans," The Museum of Modern Art, 1959. Included in: Pittsburgh International, 1958 (Frew Memorial Purchase Prize), 1961, 1964, 1967; Venice Biennale, 1958, 1964; Whitney Annual, 1960–72; Salon de Mai, Paris, 1962. One-man shows: Leo Castelli Gallery, New York, from 1958; Galerie Rive Droite, Paris, 1959, 1962; Galerie Ileana Sonnabend, Paris, 1962; The Jewish Museum, 1964; Whitechapel Art Gallery, London, 1964; Ashmolean Museum of Art and Archaeology, Oxford, England, 1965; National Collection of Fine Arts, Smithsonian Institution, Washington, D.C. (drawings), 1966. First graphics, 1960. Included in: "Painting and Sculpture of a Decade, 54–64," The Tate Gallery, London, 1964; Documenta III and 4, Kassel, 1964, 1968; IX São Paulo Bienal, 1967 (Prize for Painting); "New York Painting and Sculpture: 1940–1970," The Metropolitan Museum of Art, New York, 1969–70; ROSC '71, Dublin, 1971; Whitney Biennial, 1973. Awarded first prize, VII International Exhibition of Prints, Moderna Galerija, Ljubljana, Yugoslavia, 1967. One-man shows (graphics): The Museum of Modern Art, and tour, 1968; Philadelphia Museum of Art, 1970; The Museum of Modern Art, 1971; Kunsthalle, Bern, 1971; Stedelijk Museum, Amsterdam, 1972. Member, The National Institute of Arts and Letters, 1973. Lives in New York.

Flag. 1960.
Bronze relief (1/4), 12⅞ × 18¾ × ¼ inches

PROVENANCE:
Leo Castelli Gallery, New York, 1961

EXHIBITIONS:
Leo Castelli Gallery, New York, January 31–February 25, 1961, *Jasper Johns*
The Solomon R. Guggenheim Museum, New York, October 3, 1962–January 6, 1963, *Modern Sculpture from the Joseph H. Hirshhorn Collection*, no. 214, ill. p. 205

REFERENCES:
Rubin, William S. "The Hirshhorn Collection at the Guggenheim Museum," *Art International*, 6, November 1962, p. 35
Steinberg, Leo. "Jasper Johns," *Metro*, 4/5, May 1962, p. 109
———. *Jasper Johns*, New York, Wittenborn, 1963, p. 42

Numbers O to 9. 1961.
Oil on canvas, 54 × 41½ inches
Signed and dated on back: "J. Johns '61"

PROVENANCE:
Galerie Rive Droite, Paris; Harriet Peters, New York; Harold Diamond, New York, 1963

EXHIBITIONS:
Galerie Rive Droite, Paris, June 13–July 14, 1962, *Jasper Johns*
Greenwich Library, Connecticut, May 7–June 5, 1967, *Joseph H. Hirshhorn Collects*

REFERENCES:
Restany, Pierre. "Jasper Johns and the Metaphysic of the Commonplace," *Cimaise*, 8, September–October 1961, colorplate p. 93
Rosenblum, Robert. "Les Oeuvres récentes de Jasper Johns," *XXe Siècle*, 24, February 1962, supplement

EASTMAN JOHNSON (1824–1906)

Jonathan Eastman Johnson, born Lovell, Maine, July 29, 1824. Apprentice in lithography shop, Boston, c. 1840–42. Worked as portrait draftsman: Augusta, Maine, 1842; Washington, D.C., 1844–45; Cambridge, Massachusetts, 1846–49. Studied, Königlich Preussische Kunstakademie der Rheinprovinzen, Düsseldorf, 1849–51; studio of Emanuel Leutze, Düsseldorf, 1851, when Leutze was painting *Washington Crossing the Delaware* (The Metropolitan Museum of Art, New York). Lived in The Hague, 1851–55. Studied, atelier of Thomas Couture, Paris; then returned to Washington, D.C., 1855. National Academy of Design, New York: exhibited, 1856–1900; associate, 1859; academician, 1860; taught, 1868–69. Settled in New York, 1858. Member, Century Association, New York, 1862. Followed Union Army on several campaigns during Civil War; sketched scenes of home front and battlefield. Member, Union League Club, New York, 1868. Summered, Nantucket, Massachusetts, or occasionally Maine, 1870–1880s. Primarily a portraitist, from 1880. Traveled abroad, 1885, 1891, 1897. Awarded: Bronze Medal, Exposition Universelle de 1889, Paris; Silver Medal, Exposition Universelle de 1900. Died New York, April 5, 1906. Memorial exhibition, Century Association, 1907. Retrospectives: The Brooklyn Museum, New York, 1940; M. Knoedler & Co., New York, 1946; California Palace of the Legion of Honor, San

Francisco, 1946; Whitney Museum of American Art, New York, and tour, 1972.

Mrs. Eastman Johnson. 1887.
Oil on canvas, 55⅛ × 42 inches
Signed and dated l. l.: "E. Johnson, 1887"

PROVENANCE:
The Old Print Shop, New York; M. Knoedler & Co., New York, 1958

EXHIBITIONS:
The Pennsylvania Academy of the Fine Arts, Philadelphia, December 17, 1894–February 23, 1895, *Sixty-fourth Annual Exhibition*, no. 178
Portraits, Inc., New York, December 5–29, 1945, *Portraits of American Women*, no. 26
M. Knoedler & Co., New York, January 7–26, 1946, *Paintings and Drawings by Eastman Johnson*, no. 6
California Palace of the Legion of Honor, San Francisco, March 1946, *The Art of Eastman Johnson*
Montclair Art Museum, New Jersey, March 27–April 17, 1949, *Portraits of Eminent People*, no. 14

REFERENCES:
MacAgy, Jermayne. "The Art of Eastman Johnson," *Bulletin of the California Palace of the Legion of Honor*, San Francisco, March 1946, p. 95

Self-Portrait. 1891.
Oil on canvas, 72 × 36 inches
Signed and dated l. r.: "E. Johnson Mich. 1891"

PROVENANCE:
The Old Print Shop, New York; M. Knoedler & Co., New York, 1958

EXHIBITIONS:
M. Knoedler & Co., New York, January 7–26, 1946, *Paintings and Drawings by Eastman Johnson*, no. 4
California Palace of the Legion of Honor, San Francisco, March 1946, *The Art of Eastman Johnson*
New York State Pavilion, New York World's Fair, Flushing Meadows, April–October 1964, *Art in New York State, The River; Places and People*, no. 45, ill.

REFERENCES:
Ames, Kenneth. "Eastman Johnson: The Failure of a Successful Artist," *The Art Journal*, 29, Winter 1969–70, ill. p. 175
Breuning, Margaret. "Tracing the Career of Eastman Johnson," *Art Digest*, 20, January 1, 1946, p. 8, ill.
Hartman, Sadakichi. "Eastman Johnson: American Genre Painter," *International Studio*, 34, April 1908, p. 108
Lansdale, Nelson. "Huge Sculpture Secretly Commissioned for New York World's Fair," *Art Voices*, 3, March 1964, ill. p. 7
MacAgy, Jermayne. "The Art of Eastman Johnson," *Bulletin of the California Palace of the Legion of Honor*, San Francisco, March 1946, ill. p. 94
Selby, Mark. "An American Painter: Eastman Johnson," *Putnam's Monthly*, 2, July 1907, p. 540, ill. p. 535

DONALD JUDD (b. 1928)

Donald Clarence Judd, born Excelsior Springs, Missouri, June 3, 1928. Served, U.S. Army, Korea, 1946–47. Studied: The Art Students League of New York, 1948, 1949–53; College of William and Mary, Williamsburg, Virginia, 1948–49; Columbia University, New York, B.S., 1953, M.A., 1962. One-man show, Panoras Gallery, New York, 1957. Contributing editor, *Arts Magazine*, and reviewer, *Art News* and *Art International*, 1959–65. One-man show, The Green Gallery, New York, 1963–64. Received travel grant, Svenska Institutet för Kulturellt Utbyte med Utlandet, Stockholm, 1965. Included in: VIII São Paulo Bienal, 1965; "Primary Structures," The Jewish Museum, New York, 1966; "American Sculpture of the Sixties," Los Angeles County Museum of Art, and Philadelphia Museum of Art, 1967; Guggenheim International, 1967–68, 1971; "Plus by Minus: Today's Half-Century," Albright-Knox Art Gallery, Buffalo, New York, 1968; Whitney Annual, 1968, 1970; Sonsbeek '71, Arnhem, The Netherlands, 1971; ROSC '71, Dublin, 1971; Whitney Biennial, 1973. One-man shows: Leo Castelli Gallery, New York, 1966, 1969, 1970, 1972–73; Ferus Gallery, Los Angeles, 1967. Taught, Yale University, New Haven, Connecticut, 1967. Received: National Council on the Arts Grant, 1967; Guggenheim Foundation Fellowship, 1968. One-man shows: Whitney Museum of American Art, New York, 1968; Irving Blum Gallery, Los Angeles, 1968, 1969; Stedelijk van Abbemuseum, Eindhoven, The Netherlands, and tour, 1970; Pasadena Art Museum, California, 1971. Lives in New York.

Untitled. 1969.
Brass and red Plexiglas, ten units, each 6 × 27 × 24 inches

PROVENANCE:
Leo Castelli Gallery, New York; Peter Brant, New York; Parke-Bernet Galleries, New York, Sale 3268, November 17, 1971, no. 50, ill.

REFERENCES:
Finch, Christopher. "Sale Report: Recent Prices for Recent Art," *Auction*, 5, January 1972, p. 8
Unsigned. "Devaluation: Bargains for Foreigners," *International Art Market*, 11, November 1971, p. 196

MENASHE KADISHMAN (b. 1932)

Born Tel Aviv, Palestine, August 21, 1932. Studied: with sculptor Sternshus, Tel Aviv, 1949; with Rudi Lehmann, Jerusalem, 1953. One-man show, Chemerinsky Gallery, Tel Aviv, 1955. Studied, London: St. Martin's School of Art, 1959; Slade School of Fine Art, University College, 1960. Included in "Young Contemporaries Exhibition," Institute of Contemporary Arts, London, 1960–61. Received Sainsbury Scholarship, 1961. One-man shows: Grosvenor Gallery, London, 1965; Harlow Arts Festival, Harlow New Town, England, 1965; Dunkelman Gallery, Toronto, 1967; Edinburgh Festival Society, Scotland, 1968. Awarded First Prize for Sculpture, 5e Biennale de Paris, 1967. Included in: Documenta 4, Kassel, 1968; International Sculpture Symposium, Montevideo, Uru-

guay, 1969. One-man shows: The Jewish Museum, New York, 1970; Museum Haus Lange, Krefeld, Germany, 1972. Lives in London.

Open Suspense. 1968.
Cor-Ten steel (edition of five), 9 feet 8¼ inches × 7 feet 3 inches × 1 foot 3 inches

PROVENANCE:
The artist, London, 1968

Segments. 1968.
Painted metal and glass (edition of three), 5 feet × 14 feet 6 inches × 1 foot

PROVENANCE:
The artist, London, 1969

Wave. 1969.
Stainless steel and glass (edition of four), 5 feet 1 inch × 10 feet 10½ inches × 2 feet 11½ inches

PROVENANCE:
The artist, London, 1969

EXHIBITIONS:
The Jewish Museum, New York, May 12–June 21, 1970, *Menashe Kadishman*, no. 11, ill.

REFERENCES:
Spector, Stephan. "In the Museums: Menashe Kadishman," *Arts Magazine*, 44, Summer 1970, ill. p. 56

JOHN KANE (1860–1934)

John Cain, born West Calder, Scotland, August 19, 1860. Coal miner, Scotland, 1869–78. Emigrated to Braddock, Pennsylvania, to join family, 1879. Worked as: laborer, Alabama, Tennessee, Kentucky, Pennsylvania, 1879–90; street paver, Pittsburgh, and surrounding towns; crossing guard, Baltimore and Ohio Railroad; freight car painter; enlarged and colored photographs; itinerant house painter; carpenter's apprentice, Youngstown, Ohio; carpenter, Akron, Ohio, 1910; house painter, and on construction gang, Pittsburgh, 1922. Self-taught as an artist. Carnegie International: submitted painting for first time, and rejected, 1925; second attempt also rejected, 1926; painting accepted, 1927, establishing reputation as artist; exhibited, 1928–34. Associated Artists of Pittsburgh: member, 1928; second prize, Annual Exhibition, 1928; Carnegie Institute Prize, Annual Exhibition, 1929. Included in: "Paintings by Nine Americans," Harvard Society for Contemporary Art, Cambridge, Massachusetts, 1929; "Painting and Sculpture by Living Americans," "Painting and Sculpture from 16 American Cities," "Modern Works of Art," "Masters of Popular Painting," The Museum of Modern Art, New York, 1930–31, 1933, 1934–35, 1938; Pennsylvania Academy Annual, 1932, 1933; 45th American Exhibition, The Art Institute of Chicago, 1932–33; Whitney Biennial, 1932–33, 1934–35. First one-man show, Junior League Headquarters, Clark Building, Pittsburgh, 1931. One-man shows, New York: Contemporary Arts, 1931; Gallery 144, 1932, 1934. Autobiography, *Sky Hooks*, begun, 1932; published (New York, Lippincott), 1938. Died Pittsburgh, August 10, 1934. Memorial exhibitions: Valentine Gallery, New York, 1935; U.S. Department of Labor Building, Washington, D.C., 1935; Carnegie Institute, Pittsburgh, 1936; M. Knoedler & Co., London, 1936.

My Daughter and Grandchild. c. 1931–32.
Oil on canvas, 23½ × 27¼ inches

PROVENANCE:
M. Martin Janis, Buffalo, New York; Richard Feigen Gallery, Chicago; Parke-Bernet Galleries, New York, Sale 2072, December 13, 1961, no. 58, ill. p. 41

EXHIBITIONS:
Greenwich Library, Connecticut, November 8–27, 1962, *American Painting from 1875 to 1925*
Charles and Emma Frye Art Museum, Seattle, March 4–27, 1966, *Seventeen Naive Painters* (The Museum of Modern Art, New York, Circulating Exhibition); toured to six U.S. cities

REFERENCES:
Arkus, Leon Anthony. *John Kane Painter, Catalogue Raisonné*, University of Pittsburgh, 1971, no. 10, ill. p. 197
Farber, Ann. "Naive Painters at Frye," *Seattle Post Intelligencer*, March 25, 1966, p. 46
Unsigned. "People in Art: Cheekwood Opens '17 Naive Painters,'" *Nashville [Tennessee] Banner*, May 11, 1966

BERNARD KARFIOL (1886–1952)

Born Budapest, May 6, 1886, of American parents. Youth spent on Long Island, New York. Studied: Pratt Institute, Brooklyn, New York, 1899; National Academy of Design, New York, 1900–1901; Académie Julian, Paris, 1901–2. Lived in Paris, 1901–6; met Gertrude and Leo Stein, Pablo Picasso, Henri Matisse. Exhibited, Paris: Salon of 1903; Salon d'Automne, 1904. Included in the Armory Show, 1913. Summered, Ogunquit, Maine, from 1914. Exhibited with John Marin, home of Hamilton Easter Field, Columbia Heights, Brooklyn, 1917. One-man shows, Brummer Gallery, New York, 1923, 1925, 1927. Included in: Carnegie International, 1927, 1930–31, 1933, 1935, 1938–39; "Paintings by Nineteen Living Americans," and "American Painting and Sculpture," The Museum of Modern Art, New York, 1929–30, 1932–33; "American Art Today," New York World's Fair, Flushing Meadows, 1939; Carnegie Annual, 1943–49. Received Corcoran Gold Medal, and First Clark Prize, Corcoran Biennial, 1928. One-man shows, The Downtown Gallery, New York, 1933, 1935 (drawings and watercolors), 1941, 1946, 1950. Retrospective, Carnegie Institute, Pittsburgh, 1939. Died Irvington-on-Hudson, New York, August 16, 1952. One-man shows, New York: The Downtown Gallery, 1956; Forum Gallery, 1967.

The Models. 1932.
Oil on canvas, 24 × 30 inches
Signed l. l.: "B. Karfiol"

PROVENANCE:
The Downtown Gallery, New York; Dr. and Mrs.

Michael Watter, Philadelphia; Parke-Bernet Galleries, New York, Sale 2600, October 19, 1967, *American Paintings, Drawings, Sculpture, Folk Art: The Collection of Dr. and Mrs. Michael Watter*

EXHIBITIONS:
The Downtown Gallery, New York, January 17–February 4, 1933, *Bernard Karfiol*
Philadelphia Museum of Art, June 13–October 5, 1958, *Sonia and Michael Watter Collection*, cat.
The Pennsylvania Academy of the Fine Arts, Philadelphia, October 25–November 30, 1958, *Twentieth Century American Paintings and Sculpture from Philadelphia Private Collections*, no. 269

DONALD KAUFMAN (b. 1935)

Donald Guy Kaufman, born New Orleans, December 11, 1935. Studied, University of Wisconsin, Madison, B.S., 1958; M.S., 1961. One-man shows, Richard Feigen Gallery: New York, 1966, 1967, 1970, 1972 (drawings); Chicago, 1966, 1969. Included in: Whitney Annual, 1967, 1969; "Lyrical Abstraction," The Aldrich Museum of Contemporary Art, Ridgefield, Connecticut, and tour, 1970–71. One-man show, Michael Walls Gallery, San Francisco, 1970. Lives in Berkeley, California.

Plink II. 1968.
Acrylic on canvas, 5 feet 8¼ inches × 8 feet 9 inches

PROVENANCE:
Richard Feigen Gallery, New York, 1968

ELLSWORTH KELLY (b. 1923)

Born Newburgh, New York, May 31, 1923. Studied: Pratt Institute, Brooklyn, New York, 1941–42; School of the Museum of Fine Arts, Boston, 1946–48. Served, U.S. Army, Europe, 1943–45. Lived in France, 1948–54. One-man shows: Galerie Arnaud, Paris, 1951; Betty Parsons Gallery, New York, 1956–63; Galerie Maeght, Paris, 1958, 1964; Arthur Tooth & Sons, London, 1962; Washington [D.C.] Gallery of Modern Art, and Institute of Contemporary Art, Boston, 1963–64. Included in: Pittsburgh International, 1958, 1961, 1964 (Award for Painting), 1967; "Sixteen Americans," The Museum of Modern Art, New York, 1959; Whitney Annual, 1959–63, 1965–69; "American Abstract Expressionists and Imagists," The Solomon R. Guggenheim Museum, New York, 1961; VI São Paulo Bienal, 1961; "Geometric Abstraction in America," Whitney Museum of American Art, New York, 1962; Documenta III and 4, Kassel, 1964, 1968; "Primary Structures," The Jewish Museum, New York, 1966; "Serial Imagery," Pasadena Art Museum, California, 1968; "Plus by Minus: Today's Half-Century," Albright-Knox Art Gallery, Buffalo, New York, 1968; "The Art of the Real," The Museum of Modern Art, and tour, 1968–69; "New York Painting and Sculpture: 1940–1970," The Metropolitan Museum of Art, New York, 1969–70; Whitney Biennial, 1973. Received Brandeis University Creative Arts Award Citation, 1963. One-man shows: Sidney Janis Gallery, New York, 1965, 1967, 1968, 1971; Irving Blum Gallery, Los Angeles, 1967, 1968; Albright-Knox Art Gallery (prints), 1972. Retrospective, The Museum of Modern Art, and tour, 1973–74. Member, The National Institute of Arts and Letters, 1974. Lives in New York.

Red White. 1961.
Oil on canvas, 62¾ × 85½ inches
Signed and dated on back: "EK'61"

PROVENANCE:
Betty Parsons Gallery, New York; Robert Fraser Gallery, London; Parke-Bernet Galleries, New York, Sale 2653, February 15, 1968, no. 105, ill. pp. 92–93

EXHIBITIONS:
Betty Parsons Gallery, New York, October 16–November 4, 1961, *Ellsworth Kelly*

REFERENCES:
Alloway, Lawrence. "Heraldry and Sculpture," *Art International*, 6, April 1962, p. 53, ill. 2
Coplans, John. *Ellsworth Kelly*, New York, Abrams, 1973, ill. 146
Parke-Bernet Galleries, New York, *Burlington Magazine*, 110, February 1968, ill. p. 11 (adv.)

ZOLTAN KEMENY (1907–1965)

Born Banica, Transylvania, Hungary, March 21, 1907. Apprenticed to cabinetmaker, 1921–23. Studied, Budapest: architecture, Hungarian College of Arts and Crafts, 1924–27; painting, National Academy of Fine Arts, 1927–30. Lived in Paris, 1930–40; designed wrought iron objects and lamps. Moved to Marseilles, France, 1940. Settled in Zurich, 1942; worked as fashion designer and editor. One-man show (paintings), Galerie des Eaux-Vives, Zurich, 1945. First relief collages, 1946. One-man shows: Galerie Kléber, Paris, 1946; Galerie des Eaux-Vives, 1947; Galerie Mai, Paris, 1950; Baldwin Kingrey Gallery, Chicago, 1953; Galerie Paul Facchetti, Paris, 1955, 1957, 1959, 1961; Gallery One, London, 1958; Sidney Janis Gallery, New York, 1960; Kestner-Gesellschaft, Hanover, 1963. First metal reliefs, 1954. Swiss citizen, 1957. Included in: Pittsburgh International, 1958, 1961, 1964; Documenta II and III, Kassel, 1959, 1964. Retrospective, Kunsthaus, Zurich, 1959. Commissions: Business School, Hochschule St. Gallen, Switzerland, 1963; municipal theater, Frankfort, 1963; Exposition Nationale Suisse, Lausanne, 1964. Awarded Grand Prize for Sculpture, Venice Biennale, 1964. Died Zurich, June 14, 1965. Retrospective, Musée National d'Art Moderne, Paris, and tour, 1966–67.

Visualization of the Invisible. 1960.
Brass (unique), 6 feet ½ inch × 8 feet 10 inches × 11½ inches
Markings: back u. c. "Kemeny"

PROVENANCE:
Private collection, Paris; Galerie Daniel Cordier, Paris, 1964

EXHIBITIONS:
XXXII Biennale Internazionale d'Arte, Venice, June 20–October 18, 1964, *Swiss Pavilion*, no. 10, p. 286

The Solomon R. Guggenheim Museum, New York, October 20, 1967–February 4, 1968, *Guggenheim International Exhibition 1967: Sculpture from Twenty Nations*, ill. p. 42; toured to Art Gallery of Ontario, Toronto, February 24–March 27; The National Gallery of Canada, Ottawa, April 26–June 9; Montreal Museum of Fine Arts, June 20–August 18

REFERENCES:
Giedion-Welcker, Carola. *Zoltan Kemeny*, St. Gallen, Switzerland, Erker-Verlag, 1968, pp. 27, 47, plate 8
Marchiori, Giuseppe. "Zoltan Kemeny: Visualization of the Invisible,'" *Studio International*, 168, November 1964, ill. p. 187

The importance of Kemeny's early exploration of the ambiguities of contemporary art, and the breaking down of formal categorization, has to this day not been fully appreciated. According to Michel Ragon, Kemeny always referred to his reliefs as "Canvases." Ragon says of Kemeny's work, as early as 1950, "Zoltan Kemeny at that time was indeed not a sculptor at all. But was he a painter? He already then paraded his fundamental originality which was to make him an artist who is neither a sculptor nor a painter, but beholden to both disciplines. He was already a painter of reliefs (or, if one prefers, a sculptor of paintings with projections)."

Ragon, Michel. *Zoltan Kemeny*, trans. Haakon Chevalier, Neuchâtel, Switzerland, Griffon, 1960, p. 11

ROCKWELL KENT (1882–1971)

Born Tarrytown, New York, June 21, 1882. Studied: architecture, Columbia University, New York, 1900–1903; painting, Shinnecock Summer School of Art, Southampton, New York, with William Merritt Chase, summers, 1900–1903; New York School of Art, with Robert Henri, and Kenneth Hayes Miller, 1903–4. Studio assistant to Abbott H. Thayer, Dublin, New Hampshire, 1904. Architectural draftsman, intermittently, 1904–13. Included in National Academy of Design Annual, 1904, 1905. One-man show, Clausen Galleries, New York, 1908. Exhibited, New York: Original Independent Show, 1908; Exhibition of Independent Artists, 1910. Organized "An Independent Exhibition of the Paintings and Drawings of Twelve Men," Society of Beaux-Arts Architects, New York, 1911. Chairman, Installation Committee, Society of Independent Artists Annual, 1917. One-man shows, New York: M. Knoedler & Co., 1920; Wildenstein & Co., 1925, 1942; Macbeth Gallery, 1934. Moved to farm near Ausable Forks, New York, 1928. Painted mural, *The Power of Electricity*, General Electric Company Building, New York World's Fair, Flushing Meadows, 1939. Published autobiography, *It's Me O Lord* (New York, Dodd, Mead), 1955. Illustrated books, including journals of his own extensive travels. One-man shows, Larcada Gallery, New York, 1966, 1969, 1972. Received Lenin Peace Prize, 1967; donated portion of award to North Vietnam. Died Plattsburgh, New York, March 13, 1971. His personal collection of sketches, drawings, and designs donated to Columbia University Libraries; one hundred works from the collection exhibited there, 1972.

The Seiners. 1910–13.
Oil on canvas, 34 × 43 inches
Signed and dated l. r.: "Rockwell Kent 1910–1913"
on back: "To Carl Ruggles–1913
—Rockwell Kent—"

PROVENANCE:
The artist; Carl Ruggles; Henry Clay Frick, New York; Helen Clay Frick, Pittsburgh; M. Knoedler & Co., New York

EXHIBITIONS:
Society of Beaux-Arts Architects, New York, March 24–April 21, 1911, *An Independent Exhibition of the Paintings and Drawings of Twelve Men*
Department of Fine Arts, University of Pittsburgh, January 10–February 28, 1938, *Oil Paintings from the Collection of Helen Clay Frick*, no. 9
Larcada Gallery, New York, November 1–19, 1966, *Rockwell Kent*, no. 7

REFERENCES:
Archives of American Art, Smithsonian Institution, Washington, D.C., "Letter from Carl Ruggles to Rockwell Kent, March 24, 1914," *Rockwell Kent Papers*, Box B
Harvey, George. *Henry Clay Frick, the Man*, New York, Scribner's, 1928, p. 342
Kent, Rockwell. *It's Me O Lord*, New York, Dodd, Mead, 1955, p. 233
Unsigned. "Rockwell Kent, Artist, Is Dead, Championed Left-Wing Causes," *The New York Times*, March 14, 1971, p. 74

GYÖRGY KEPES (b. 1906)

Born Selyp, Hungary, October 4, 1906. Studied, National Academy of Fine Arts, Budapest, 1924–28. Worked in Berlin, and London, on film, stage, and exhibition design, 1930–36. Emigrated to the U.S., 1937. Taught: (at László Moholy-Nagy's invitation) The New Bauhaus (later, School of Design), Chicago, 1937–43; North Texas State University, Denton, 1943–44; Brooklyn College, New York, 1944–45. Graphic designer, *Fortune* magazine, Container Corporation of America, and Abbott Laboratories, 1938–50. One-man shows: Katherine Kuh Gallery, Chicago, 1939; The Art Institute of Chicago, 1944, 1954; Margaret Brown Gallery, Boston, 1951, 1953, 1955. Author of *Language of Vision* (Chicago, Theobald), 1944. Mural commissions: Graduate Center, Harvard University, Cambridge, Massachusetts, 1950–51; KLM Royal Dutch Airlines, New York, 1959. Co-directed Rockefeller Foundation Research Project, Perceptual Form of Cities, 1954. One-man shows: Swetzoff Gallery, Boston, 1959–66; Saidenberg Gallery, New York, 1960, 1963, 1966, 1968, 1970, 1972. Received Guggenheim Foundation Fellowship, 1960. Professor of visual design, Massachusetts Institute of Technology, Cambridge, since 1946. Lives in Cambridge.

Amethyst Stain. 1970.
Oil and sand on canvas, 48 × 48 inches

Signed and dated on back: "G. Kepes, 1970"

PROVENANCE:
Saidenberg Gallery, New York, 1970

EXHIBITIONS:
Saidenberg Gallery, New York, April 25–May 30, 1970, *Gyorgy Kepes: Recent Paintings*, no. 6

EARL KERKAM (1891–1965)

Earl Cavis Kerkam, born Washington, D.C., October 7, 1891. Attended primary school, Bowling Green, Virginia. Awarded Gold Medal for Drawing, *Richmond [Virginia] Times Dispatch*, 1899. Studied, 1908–10: Rand School, New York; The Art Students League of New York; Henri School of Art, New York; The Pennsylvania Academy of the Fine Arts, Philadelphia. Created signs and displays for movie lobbies and exteriors for Stanley Theaters and Warner Brothers, Philadelphia, 1911–17. Art editor: *Progress* magazine, 1913–17; U.S. Army Tank Corps magazine *Treat 'em Rough*, 1917–18. Cartoons published in *New York World* under title "Barracks Sports," 1917–18. Twice, in mid-1920s, abandoned commercial art career to study at Académie de la Grande Chaumière, Paris. Operated poster shop, and managed several theaters, Philadelphia, and Atlantic City, New Jersey, 1929–31. Spent nine months in Paris, 1932–33; exhibited there, 1932: Salon d'Automne; Salon des Tuileries; Galerie Bernheim-Jeune; Galerie Van Leer. Moved to New York, 1933; first one-man show, Contemporary Arts, 1934. WPA Federal Art Project, Easel Division, 1935. One-man shows, New York: Babcock Galleries, 1937; Bonestell Gallery, 1942–45; Egan Gallery, 1946, 1948, 1952, 1953, 1955; The Chinese Gallery, 1947–49. Lived in Paris, 1951–53. One-man shows: Poindexter Gallery, New York, 1955–56; World House Galleries, New York, 1960, 1961, 1963; B. C. Holland Gallery, Chicago, 1964. Died New York, January 20, 1965. Memorial exhibition, Washington [D.C.] Gallery of Modern Art, 1966. Retrospective, Kresge Art Gallery, Michigan State University, East Lansing, 1973.

Self-Portrait. 1953.
Oil on canvas mounted on cardboard, 23¼ × 19 inches
Signed l. r.: "Kerkam"

PROVENANCE:
David Herbert Gallery, New York, 1960

EXHIBITIONS:
David Herbert Gallery, New York, October 3–31, 1960, *Appearance and Reality*, no. 18
Washington [D.C.] Gallery of Modern Art, May 13–June 26, 1966, *Earl Kerkam Memorial Exhibition*, p. 30

WILLIAM KING (b. 1925)

William Dickey King, born Jacksonville, Florida, February 25, 1925. Studied: University of Florida, Gainesville, 1942–44; The Cooper Union for the Advancement of Science and Art, New York, 1945–48; The Brooklyn Museum Art School, New York, 1948; Accademia di Belle Arti e Liceo Artistico, Rome, 1949–50 (received Fulbright Grant, 1949); Central School of Arts and Crafts, London, 1952. Included in: Whitney Annual, 1950–68; 6th–8th, 11th, 12th Contemporary American Exhibition, University of Illinois, Urbana, 1953–57, 1963–65; Pittsburgh International, 1958. Lived in London, 1952–53; Rome, 1955–56. Taught: The Brooklyn Museum Art School, 1953–60; University of California, Berkeley, 1965–66; The Art Students League of New York, Metal Sculpture School, Long Island City, 1968–70. One-man shows: The Alan Gallery, New York, 1954–61; Terry Dintenfass Gallery, New York, from 1962; San Francisco Museum of Art, and tour, 1970; Dag Hammarskjöld Plaza, New York, 1971; Wadsworth Atheneum, Hartford, Connecticut, 1972. Lives in New York.

Venus. 1956.
Bronze (1/3), 63 × 18¼ × 13¼ inches

PROVENANCE:
The Alan Gallery, New York, 1957

EXHIBITIONS:
University of Illinois, Urbana, March 3–April 7, 1957, *Contemporary American Painting and Sculpture*, no. 73, pp. 214–15, plate 40
The Alan Gallery, New York, April 15–May 4, 1957, *New Work: Andrews, Brice, Cloar, King, Knipschild, Oscar, Pribble, Squier*, no. 9
The Detroit Institute of Arts, 1959, *Sculpture in Our Time*, no. 108, ill. p. 49, and extended loan
The Solomon R. Guggenheim Museum, New York, October 3, 1962–January 6, 1963, *Modern Sculpture from the Joseph H. Hirshhorn Collection*, no. 216, ill. p. 198

REFERENCES:
Pierson, William, and Davidson, Martha, eds. *Art of the United States: A Pictorial Survey*, New York, McGraw-Hill, 1960, no. 3762, ill. p. 388

"Venus is a portrait of my wife, Shirley. It was modelled in clay (not plasticine) and cast in the usual way. It was really about the first time I'd tried this method—all the others (about thirty-five pieces) I'd made directly in wax. There must be literally hundreds of Venuses in this more or less traditional pose—mostly sculpture but a few depicted in painting. Anyway, it was the one in the Uffizi as far as the pose is concerned that set me on to the idea. You could say the head is sort of fourth century B.C. As you may gather, I was really quite taken with Greek and even Roman sculpture."

The artist, in *Contemporary American Painting and Sculpture*, pp. 214–15

FRANZ KLINE (1910–1962)

Franz Joseph Kline, born Wilkes-Barre, Pennsylvania, May 23, 1910. Studied: Boston University, 1931–35; Heatherley School of Fine Art, London, 1937–38. Moved to New York, 1938. Included in Washington Square Outdoor Exhibition, New York, 1939. Received Truman Prize, National Academy of Design Annual, 1943, 1944.

Charter member, The Club, New York, 1949. One-man shows: Egan Gallery, New York, 1950, 1951, 1954; Margaret Brown Gallery, Boston, 1952; Institute of Design, Chicago, 1954. Taught: Black Mountain College, North Carolina, 1952; Pratt Institute, Brooklyn, New York, 1953; Philadelphia Museum School of Art, 1954. Included in: Whitney Annual, from 1952; "Younger American Painters," The Solomon R. Guggenheim Museum, New York, 1954; Venice Biennale, 1956, 1960 (Ministry of Public Education Prize); IV São Paulo Bienal, 1957; "The New American Painting," The Museum of Modern Art, New York, and European tour, 1958–59; Documenta II, Kassel, 1959; Guggenheim International Award, 1960 (honorable mention); "American Abstract Expressionists and Imagists," The Solomon R. Guggenheim Museum, 1961. One-man shows: Sidney Janis Gallery, New York, 1956, 1958, 1960, 1961; Galleria La Tartaruga, Rome, 1958; The Arts Club of Chicago, 1961. Died New York, May 13, 1962. Memorial exhibitions: Washington [D.C.] Gallery of Modern Art, and tour, 1962–63; Sidney Janis Gallery, 1963. Retrospectives: Whitechapel Art Gallery, London, 1964; Marlborough-Gerson Gallery, New York, 1967; Whitney Museum of American Art, and tour, 1968–69.

Painting (Untitled). 1948.
Oil and collage on panel, 28 × 22¼ inches
Signed l. l.: "Kline"

PROVENANCE:
The New Gallery, New York; Mrs. Donald Peters, New York; Paul Kantor Gallery, Beverly Hills, California; Harold Diamond, New York, 1963

Delaware Gap. 1958.
Oil on canvas, 6 feet 6 inches × 8 feet 10 inches

PROVENANCE:
Sidney Janis Gallery, New York, 1959

EXHIBITIONS:
Sidney Janis Gallery, New York, January 5–31, 1959, *8 American Painters*, no. 5, ill.
The New York Coliseum, April 3–19, 1959, *Art: USA, 59*, no. 118b
Documenta II, Kassel, July 11–October 11, 1959, *Art Since 1945*, no. 3, ill. p. 218
Louisiana Museum, Humblebaek, Denmark, October 20–November 3, 1959, *Selections from Documenta II*, cat.
XXX Biennale Internazionale d'Arte, Venice, June 15–September 15, 1960, *United States Pavilion*, no. 32
Sidney Janis Gallery, New York, December 3–28, 1963, *Kline Memorial Exhibition*, no. 15, ill.

REFERENCES:
Ashton, Dore. "Art," *Arts and Architecture*, 76, March 1959, ill. p. 8
Gordon, John. *Franz Kline*, New York, Whitney Museum of American Art, 1968, pp. 9, 11
Sidney Janis Gallery, New York, *9 American Painters*, 1960, cat., ill.
Tillim, Sidney. "The New Avant-Garde," *Arts Magazine*, 38, February 1964, p. 20, ill. p. 19

Palladio. 1961.
Oil on canvas, 8 feet 8¾ inches × 6 feet 4¼ inches
Signed and dated on back: "Franz Kline '61"

PROVENANCE:
Sidney Janis Gallery, New York; Philippe Dotremont, Brussels, 1964

EXHIBITIONS:
Sidney Janis Gallery, New York, December 4–20, 1961, *New Paintings by Franz Kline*, no. 1, ill. p. 3
The Baltimore Museum of Art, October 22–December 8, 1968, *From El Greco to Pollock: Early and Late Works by European and American Artists*, no. 120, ill. p. 143

REFERENCES:
Ahlander, Leslie Judd. "Gallery of Modern Art, Washington, Opens with Kline Retrospective," *Art International*, 6, October 25, 1962, ill. p. 49
Feldman, Morton. "The Anxiety of Art," *Art in America*, 61, September–October 1973, ill. p. 93
Jacobs, Jay. "Collector: Joseph H. Hirshhorn," *Art in America*, 57, July–August 1969, no. 4, ill. p. 63
Kuh, Katharine. *The Artist's Voice*, New York, Harper & Row, 1962, p. 153, ill. pp. 148–49

"Often titles refer to places I've been at about the time a picture was painted, like the composition called *Palladio*. It was done after I visited the Villa Malcontenta near Venice, but it didn't have a thing to do with Palladian architecture. I always name my paintings after I've painted them."

The artist in Kuh, pp. 148–49

KARL KNATHS (1891–1971)
Otto G. Knaths, born Eau Claire, Wisconsin, October 21, 1891. Studied, The Art Institute of Chicago, 1912–16. Worked for Chicago, Milwaukee, and St. Paul Railroad, 1917–19. Settled in Provincetown, Massachusetts, 1919; associated with Ambrose Webster. Supported himself by working as carpenter. Awarded Harris Prize, 41st American Exhibition, The Art Institute of Chicago, 1928; Gold Medal, Boston Tercentenary Art Exhibition, 1932. One-man show, The Phillips Memorial Gallery, Washington, D.C., and The Daniel Gallery, New York, 1930. WPA Federal Art Project, Mural Division, 1934–35; mural commissions, science hall and music room, Falmouth High School, Massachusetts. One-man shows, Paul Rosenberg & Co., New York, from 1945. Awarded: first prize, Carnegie Annual, 1946; first prize, "American Painting Today," The Metropolitan Museum of Art, New York, 1950; Brandeis Creative Arts Award Medal, 1961; Carnegie Prize, National Academy of Design Annual, 1962; Altman Prize, National Academy of Design Annual, 1963, 1965. Included in "Four American Expressionists: Doris Caesar, Chaim Gross, Karl Knaths, Abraham Rattner," Whitney Museum of American Art, New York, and tour, 1959. Retrospective, Wisconsin State University, Eau Claire, 1966. Died Hyannis, Massachusetts, March 9, 1971. Memorial exhibitions: The Phillips

Collection, Washington, D.C., 1971; Paul Rosenberg & Co., 1972. Touring retrospective, International Exhibitions Foundation, Washington, D.C., 1973–74.

Pineapple. 1951.
Oil on canvas, 36 × 27 inches
Signed l. r.: "Karl Knaths"

PROVENANCE:
Paul Rosenberg & Co., New York, 1952

EXHIBITIONS:
Paul Rosenberg & Co., New York, November 5–24, 1951, *Recent Paintings by Karl Knaths*, no. 10
Brandeis University, Waltham, Massachusetts, June 1–17, 1955, *Three Collections*, no. 21
Tweed Gallery, University of Minnesota, Duluth, April 1–30, 1956, *Collector's Choice*
The National Gallery of Canada, Ottawa, and tour, 1957, *Some American Paintings from the Collection of Joseph H. Hirshhorn*, no. 38
Paul Rosenberg & Co., New York, January 17–February 19, 1972, *Karl Knaths Memorial Exhibition*, no. 19

GABRIEL KOHN (b. 1910)
Born Philadelphia, June 12, 1910; son of an engraver. Studied, New York: The Cooper Union for the Advancement of Science and Art, 1929; Beaux-Arts Institute of Design, 1930–34. Designer for theater and films, Hollywood, California, 1934–42. Served as camouflage engineer, U.S. Army, 1942–46. Studied, Académie de la Grande Chaumière, Paris, with Ossip Zadkine, 1946. Lived in Rome, 1948–49; France, 1949–52. One-man shows: Atelier Mannucci, Rome, 1948; Galleria Zodiaco, Rome, 1950; Tanager Gallery, New York, 1958; Leo Castelli Gallery, New York, 1959. Included in: Salon de la Jeune Sculpture, Paris, 1950; 2nd Middelheim Biënnale, Antwerp, 1953; Whitney Annual, New York, 1953–54, 1958–70; "Recent Sculpture USA," The Museum of Modern Art, New York, and tour, 1959; "Six Sculptors," Boston University Art Gallery, 1963. Studied, Cranbrook Academy of Art, Bloomfield Hills, Michigan, 1952. Returned to France, 1952–54. Received Ford Foundation Grant, 1960. One-man shows: Otto Gerson Gallery, New York, 1963; David Stuart Galleries, Los Angeles, 1963–72; John and Mable Ringling Museum of Art, Sarasota, Florida, 1964; Newport Harbor Art Museum, Balboa, California, and tour, 1971–72; Zabriskie Gallery, New York, 1972. Received: Guggenheim Foundation Fellowship, 1967; Mark Rothko Foundation Grant, 1971. Lives in Los Angeles.

Nantucket (Equatorial Trap). 1960.
Wood, 26 × 35 × 23¼ inches

PROVENANCE:
Leo Castelli Gallery, New York, 1961

EXHIBITIONS:
Whitney Museum of American Art, New York, December 7, 1960–January 22, 1961, *Annual Exhibition 1960: Sculpture and Drawings*, no. 46, cover ill.
Boston University Art Gallery, March 30–April 25, 1963, *Six Sculptors*, no. 6

REFERENCES:
Craig, Martin. "Notes on Sculpture in a Mad Society," *Art News*, 59, January 1961, p. 28, ill. p. 29
Feldman, Edmund Burke. *Art as Image and Idea*, Englewood Cliffs, New Jersey, Prentice-Hall, 1967, ill. p. 355
———. *Varieties of Visual Experience*, New York, Abrams, 1972, ill. p. 461
Hunter, Sam. *American Art of the 20th Century*, New York, Abrams, 1972, ill. 693

OSKAR KOKOSCHKA (b. 1886)
Born Pöchlarn, Austria, March 1, 1886. Studied, Kunstgewerbeschule, Vienna, 1905–9; associated with the Wiener Werkstätte. Wrote and illustrated poem *Die Träumenden Knaben*, privately printed, 1908. Included in Kunstschau, Vienna, 1908, 1909. Moved to Berlin, 1910. Contributed to periodical *Der Sturm*, Berlin, 1910. One-man shows, Germany: Galerie Paul Cassirer, Berlin, 1910; Museum Folkwang, Essen, 1910; Galerie der Sturm, Berlin, 1912. Returned to Austria to volunteer for Imperial and Royal 15th Dragoons, 1915; severely wounded, 1916. Moved to Dresden, 1917. Taught, Kunstakademie, Dresden, 1919–24. One-man shows: Kunstsalon Wolfsberg, Zurich, 1923; Kunsthaus, Zurich, 1927; Städtische Kunsthalle, Mannheim, Germany, 1931. Traveled extensively in Europe, 1924–34. Lived in Prague, 1934–38. One-man show, Österreichisches Museum für Kunst und Industrie, Vienna, 1937. Included in Nazi exhibition, "Entartete Kunst (Degenerate Art)," Munich, 1937. Moved to London, 1938; British citizen, 1947. One-man shows: Buchholz Gallery, New York, 1938, 1941; Galerie St. Etienne, New York, 1940, 1943, 1949, 1954, 1958, 1961; The Arts Club of Chicago, 1941, 1956. Retrospectives: Kunsthalle, Basel, and tour, 1947; Venice Biennale, 1948; Institute of Contemporary Art, Boston, and tour, 1948–49. Awarded: Stephan Lochner Medal, Cologne, 1951; Lichtwork Prize, Hamburg, 1952. Founded Schule des Sehens (later, Internationale Sommerakademie für Bildende Kunst), Salzburg, Austria, 1953; taught there, until 1962. Moved to Villeneuve, Switzerland, 1953. Appointed to Der Orden Pour le Mérite für Wissenschaften und Künste, 1955. One-man shows: Haus der Kunst, Munich, 1958; Marlborough Fine Art, London, 1960. Shared Erasmus Prize, with Marc Chagall, 1960. Retrospectives, London: The Tate Gallery, 1962; The British Museum (graphics), 1967. Eightieth birthday exhibitions, 1966: Marlborough Fine Art; Staatsgalerie, Stuttgart (drawings and watercolors); Kunstsalon Wolfsberg (graphics); Baukunst Galerie, Cologne; Marlborough-Gerson Gallery, New York; Kunsthaus, Zurich. Published autobiography, *Mein Leben* (Munich, Bruckmann), 1969. Retrospectives: Österreichische Galerie, Vienna, 1971; Nationalgalerie, Prague, 1971. Lives in Villeneuve.

Egon Wellesz. 1911.
Oil on canvas, 29¼ × 27¼ inches
Signed u. l.: "O K"

PROVENANCE:
The artist, Vienna; Egon Wellesz, Vienna; Staatliche Gemäldegalerie, Dresden; Buchholz Gallery, New York, 1947

EXHIBITIONS:
Städtische Kunsthalle, Mannheim, Germany, January 18–March 1, 1931, *Oskar Kokoschka: Das Gesammelte Werk*, no. 13
Städelsches Kunstinstitut, Frankfort, June 3–July 3, 1931, *Vom Abbild zum Sinnbild*, no. 126
Buchholz Gallery, New York, October 27–November 15, 1941, *Kokoschka*, no. 8
The Museum of Modern Art, New York, December 9, 1942–January 24, 1943, *Twentieth Century Portraits*, ill. p. 63
Buchholz Gallery, New York, January 2–28, 1947, *Painting and Sculpture from Europe*, no. 10, ill. p. 10
Institute of Contemporary Art, Boston, October 6–November 14, 1948, *Oskar Kokoschka: A Retrospective Exhibition*, no. 16, ill.; toured to The Phillips Memorial Gallery, Washington, D.C., December 5–January 15, 1949; City Art Museum of St. Louis, Missouri, February 21–March 21; M. H. de Young Memorial Museum, San Francisco, April 10–May 15; Wilmington Society of the Fine Arts, Delaware Art Center, June 5–July 3; The Museum of Modern Art, New York, July 19–October 4
The Arts Club of Chicago, October 1–31, 1956, *Soutine-Kokoschka*, no. 5
The Tate Gallery, London, September 14–November 11, 1962, *Oskar Kokoschka*, no. 32
Kunstverein in Hamburg, December 8, 1962–January 27, 1963, *Oskar Kokoschka*, plate 16
The Art Galleries, University of California at Los Angeles, January 24–March 7, 1965, *Years of Ferment: The Birth of Twentieth Century Art, 1886–1914*, no. 105, plate 77; toured to San Francisco Museum of Art, March 28–May 16; The Cleveland Museum of Art, July 13–August 22
Marlborough-Gerson Gallery, New York, October–November 1966, *Oskar Kokoschka*, no. 11, ill. p. 31

REFERENCES:
Hodin, J. P. *Oskar Kokoschka: The Artist and His Time*, London, Cory, Adams & Mackay, 1966, p. 108
Hoffmann, Edith. *Kokoschka, Life and Work*, London, Faber & Faber, 1947, no. 53
Hughes, Emmet John. "Joe Hirshhorn, The Brooklyn Uranium King," *Fortune*, 54, November 1956, colorplate p. 156
Plaut, James S. *Oskar Kokoschka*, New York, Chanticleer, 1945, p. 83, ill.
Reti, Rudolph. "Egon Wellesz, Musician and Scholar," *The Musical Quarterly*, 42, January 1956, frontispiece ill.
Unsigned. *Katalog der Modernen Galerie*, Dresden, Staatliche Gemäldegalerie, 1930, no. 2594c, p. 40
Westheim, Paul. *Oskar Kokoschka*, Potsdam-Berlin, Kiepenhauer, 1918, p. 53
Wingler, Hans Maria. *Oskar Kokoschka: The Work of the Painter, Catalogue Raisonné*, London, Faber & Faber, 1958, no. 64

Musicologist and composer Egon Wellesz was born in Vienna in 1885. He was a member of the group of Viennese intellectuals which included Sigmund Freud, Kokoschka, and Arnold Schoenberg (with whom Wellesz studied, 1906–8). Wellesz taught music history at the University of Vienna from 1913 until 1938, when he was invited to continue his research in Byzantine music at Oxford University. In addition to his scholarly writings, Wellesz has composed music for opera, ballet, piano, and voice.

Frau K. (Portrait of Frau Dr. K.) 1912.
Oil on canvas, 39½ × 29¼ inches
Signed l. l.: "O K"

PROVENANCE:
The artist, Vienna; Dr. and Mrs. Karpeles, Vienna; Dr. Oskar Reichel, Vienna; Buchholz Gallery, New York; Curt Valentin Gallery, New York, 1954

EXHIBITIONS:
Buchholz Gallery, New York, October 27–November 15, 1941, *Kokoschka*, no. 9, ill.
Institute of Contemporary Art, Boston, October 6–November 14, 1948, *Oscar Kokoschka: A Retrospective Exhibition*, no. 17, ill.; toured to The Phillips Memorial Gallery, Washington, D.C., December 5–January 15, 1949; City Art Museum of St. Louis, Missouri, February 21–March 21; M. H. de Young Memorial Museum, San Francisco, April 10–May 15; Wilmington Society of the Fine Arts, Delaware Art Center, June 5–July 3; The Museum of Modern Art, New York, July 19–October 4
Curt Valentin Gallery, New York, September 24–October 13, 1951, *Lehmbruck and His Contemporaries*, no. 27
Curt Valentin Gallery, New York, September 1954, *Contemporary Paintings and Sculpture*, no. 14
Brandeis University, Waltham, Massachusetts, June 1–17, 1955, *Three Collections*, no. 22
Tweed Gallery, University of Minnesota, Duluth, April 1–30, 1956, *Collector's Choice*
Pasadena Art Museum, California, April 23–June 4, 1961, *German Expressionism*, no. 58
The Tate Gallery, London, September 14–November 11, 1962, *Oskar Kokoschka*, no. 33
Kunstverein in Hamburg, December 8, 1962–January 27, 1963, *Oskar Kokoschka*, plate 17
Marlborough-Gerson Gallery, New York, November–December 1963, *Artist and Maecenas: A Tribute to Curt Valentin*, no. 243, ill. p. 127
The Solomon R. Guggenheim Museum, New York, July 1–September 13, 1964, *Van Gogh and Expressionism*, cat.
The Brooklyn Museum, New York, February 8–April 5, 1965, *Paintings from the Joseph H. Hirshhorn Foundation Collection: A View of the Protean Century*, no. 82
Marlborough-Gerson Gallery, New York, October–November 1966, *Oskar Kokoschka*, no. 12, ill. p. 32

REFERENCES:
Hodin, J. P. *Oskar Kokoschka: The Artist and His Time*,

London, Cory, Adams & Mackay, 1966, pp. 55, 114
Hoffmann, Edith. *Kokoschka, Life and Work*, London, Faber & Faber, 1947, no. 43
Hughes, Emmet John. "Joe Hirshhorn, The Brooklyn Uranium King," *Fortune*, 54, November 1956, ill. p. 156
Plaut, James S. *Oskar Kokoschka*, New York, Chanticleer, 1945, p. 83, ill.
Westheim, Paul. *Oskar Kokoschka*, Potsdam, and Berlin, Kiepenheuer, 1918, pp. 32, 53, plate 17
———. *Oskar Kokoschka*, Berlin, Cassirer, 1925, plate 66
Wingler, Hans Maria. *Oskar Kokoschka: The Work of the Painter, Catalogue Raisonné*, London, Faber & Faber, 1958, no. 65

Santa Margherita (The Port of Santa Margherita). c. 1930.
Oil on canvas, 29¼ × 36¼ inches
Signed l. l.: "O K"

PROVENANCE:
Paul Cassirer, Berlin; Neue Galerie, Vienna; Galerie St. Etienne, New York; Kende Galleries of Gimbel Brothers, New York, Sale 343, February 4, 1949, no. 47, ill. p. 33; Leonard Hutton Galleries, New York, 1959

EXHIBITIONS:
Galerie St. Etienne, New York, January 9–February 2, 1940, *Oskar Kokoschka*, no. 2
The Arts Club of Chicago, January 1941, *Oskar Kokoschka*, no. 19; toured to Kalamazoo Institute of Arts, Michigan, February; Flint Institute of Arts, Michigan, March; Grand Rapids Art Gallery, Michigan, April; Michigan State University, East Lansing, May
City Art Museum of St. Louis, Missouri, October 1–31, 1942, *Oskar Kokoschka*, cat.
Isaac Delgado Museum of Art, New Orleans, October 2–24, 1943, *Oskar Kokoschka;* toured to eighteen U.S. cities
The Brooklyn Museum, New York, February 8–April 5, 1965, *Paintings from the Joseph H. Hirshhorn Foundation Collection: A View of the Protean Century*, no. 83
The Rotunda, Asbury Park, New Jersey, May 2–31, 1965, *The Spell of the Sea* (sponsored by the Monmouth Museum, New Jersey), no. 47, ill.
Marlborough-Gerson Gallery, New York, April–May 1968, *International Expressionism, Part I*, no. 29, ill.

REFERENCES:
Bier, Justus. "Art: Exhibit of Czech Artist's Work Opens Tomorrow," *Louisville [Kentucky] Courier-Journal*, September 30, 1945, sec. 2, p. 9, ill.
Hoffmann, Edith. *Kokoschka, Life and Work*, London, Faber & Faber, 1947, no. 241
Wingler, Hans Maria. *Oskar Kokoschka: The Work of the Painter, Catalogue Raisonné*, London, Faber & Faber, 1958, ill. 268

KÄTHE KOLLWITZ (1867–1945)
Käthe Schmidt, born Königsberg, East Prussia, July 8, 1867. Studied: with Rudolf Mauer, Königsberg, c. 1884; Malerinnenschule von Karl Stauffer-Bern, Berlin, 1885–86; with Emil Neide, Königsberg; with Ludwig Herterich, Munich, 1888–89. Married Dr. Karl Kollwitz, 1891 (d. 1940); settled in Berlin. Included in Freie Kunstausstellung, Berlin, 1893. Series of etchings, *The Weavers*, 1894–98 (based on theme of peasants' revolt, 1844): exhibited, Grosse Berliner Kunstausstellung, 1898, but denied Gold Medal by Kaiser Wilhelm II; series purchased by Kupferstichkabinett, and her reputation established, Dresden, 1899. Second major series of etchings, *Peasant Wars*, 1902–8. Studied sculpture, Académie Julian, Paris, 1904. Received Villa Romana Prize, to work in Florence, 1907. Contributed drawings to progressive Munich periodical, *Simplicissimus*, 1908. First lithographs, 1913. Included in Freie Sezession, Berlin (sculpture), 1916. One-man show, arranged by Berliner Sezession, Galerie Paul Cassirer, Berlin, 1917. Elected to Preussische Akademie der Künste, Berlin, 1919. Increasingly involved in workers' movements, after 1920. Woodcut series: *War*, 1922–23; *Proletariat*, 1925. Visited Moscow, at invitation of Soviet government, 1927. Dedicated *Mother and Father*, memorial to son Peter (killed in World War I), Soldiers' Cemetery, Roggevelde, Belgium, 1932. Appointed to Der Orden Pour le Mérite für Wissenschaften und Künste, 1929. One-man shows, Moscow, and Leningrad, 1932. Forced to resign from Preussische Akademie, 1933; forbidden to exhibit in Germany by Nazi regime. One-man shows, New York: Hudson D. Walker Gallery, 1937, 1938; Buchholz Gallery, and Arista Gallery, 1938; Kleemann Galleries, 1939, 1941; Galerie St. Etienne, 1943, 1944. Moved to Nordhausen, Germany, 1943; Moritzburg, Germany, 1944. Died Moritzburg, April 22, 1945. Memorial exhibition, Galerie St. Etienne, 1945. One-man shows: Akademie der Künste, Berlin, 1951; Staatliche Graphische Sammlung, Munich, 1952–53. Centennial exhibitions, 1967: Galerie St. Etienne; Staatsgalerie, Stuttgart; Bethnal Green Museum, London.

Mother and Child. c. 1917, cast after 1954.
Bronze (6/6), 28¼ × 18 × 19 inches
Markings: back l. l. "Kollwitz"
 "Modern Art Fdry N.Y."

PROVENANCE:
Swetzoff Gallery, Boston, 1961

EXHIBITIONS:
The Solomon R. Guggenheim Museum, New York, October 3, 1962–January 6, 1963, *Modern Sculpture from the Joseph H. Hirshhorn Collection*, no. 221, ill. p. 50

REFERENCES:
Arnason, H. Harvard. *History of Modern Art*, New York, Abrams, 1968, ill. p. 135
Eichenberg, Fritz. "Käthe Kollwitz," *New Catholic Encyclopedia*, 8, New York, McGraw-Hill, 1967, ill. p. 247
Unsigned. "The Hirshhorn Approach," *Time*, 80, October 5, 1962, colorplate p. 75

Self-Portrait. 1936.
Bronze, 15¼ × 8¼ × 11¼ inches

Markings: back l. l. "Kollwitz"
 "H. Noack Berlin"

PROVENANCE:
Fine Arts Associates, New York, 1958

EXHIBITIONS:
Fine Arts Associates, New York, Summer–Fall 1958, *Paintings Watercolors Sculpture*, no. 16
The Detroit Institute of Arts, and tour, 1959–60, *Sculpture in Our Time*, no. 109, ill. p. 50
The Solomon R. Guggenheim Museum, New York, October 3, 1962–January 6, 1963, *Modern Sculpture from the Joseph H. Hirshhorn Collection*, no. 219, ill. p. 51

REFERENCES:
Arnason, H. Harvard. *History of Modern Art*, New York, Abrams, 1968, ill. p. 135
Frankenstein, Alfred. "Monumental Serenity—And A Critic's Choice," *San Francisco Sunday Chronicle: This World*, June 19, 1960, p. 18, ill.
Marchiori, Giuseppe. "La Scultura in Europa tra le due guerre," *L'Arte Moderna*, Milan, 10, 1967, no. 88, ill. p. 275
Saltmarche, Kenneth. "Notes on Special Exhibitions: 'Sculpture in Our Time,'" *Art Quarterly*, 22, Winter 1959, p. 351
———. "'Sculpture in Our Time,'" *Art Gallery of Toronto News and Notes*, 4, October 1960, p. 2

NORBERT KRICKE (b. 1922)
Born Düsseldorf, November 30, 1922. Moved to Berlin, 1935. Served in Luftwaffe, World War II. Studied, Staatliche Hochschule für Bildende Künste, Berlin, 1945–47. Returned to Düsseldorf, 1947. One-man shows: Galerie Ophir, Munich, 1953; Galerie Samlaren, Stockholm, 1956; Kunstverein, Freiburg, Germany, 1957; Galerie Iris Clert, Paris, 1957, 1958; Kunsthalle, Bern, 1960; The Museum of Modern Art, New York, 1961; Galerie Karl Flinker, Paris, 1961; Lefebre Gallery, New York, 1961, 1968; Venice Biennale, 1964. Received Graham Foundation Grant, 1958. Included in Documenta II and III, Kassel, 1959, 1964. Retrospective, Museum Haus Lange, Krefeld, Germany, and tour, 1962–63. Commissions: opera house, Münster, Germany, 1955–56; with Walter Gropius, water display, University of Baghdad, 1962; water relief, Dortmund, Germany, 1967; German Pavilion, Expo '67, Montreal, 1967. Has taught, Staatliche Kunstakademie, Düsseldorf, since 1964. Lives in Düsseldorf.

Space Sculpture. 1963.
Stainless steel, 58 × 83 × 89 inches

PROVENANCE:
Lefebre Gallery, New York, 1968

EXHIBITIONS:
Lefebre Gallery, New York, February 27–March 23, 1968, *Norbert Kricke*, cat., ill.

LEON KROLL (b. 1884)
Born New York, December 6, 1884. Studied: The Art Students League of New York, with John Twachtman; National Academy of Design, New York; Académie Julian, Paris, with Jean-Paul Laurens. One-man shows, New York: National Academy of Design, 1910; The Daniel Gallery, 1914. Included in the Armory Show, 1913. Taught: The Maryland Institute for the Promotion of the Mechanic Arts and The School of Fine and Practical Arts, Baltimore, 1919–21; School of The Art Institute of Chicago, 1924–25; The Pennsylvania Academy of the Fine Arts, Philadelphia, 1929–30. One-man shows: Kingore Gallery, New York, 1920; The Maryland Institute, 1922; The Art Institute of Chicago, 1924; Frank Rehn Gallery, New York, 1925, 1927, 1929; Albright Art Gallery, Buffalo, New York, 1929; Carnegie Institute, Pittsburgh, 1935. Awarded: Altman Prize, National Academy of Design Annual, 1922, 1932; first prize, Pan American Exposition, Baltimore, 1931; first prize, Carnegie International, 1936. Member: The National Institute of Arts and Letters, 1930; The American Academy of Arts and Letters, 1948. President, American Society of Painters, Sculptors, and Gravers, 1931–35. Mural commissions: U.S. Treasury Department, Section of Painting and Sculpture, *Triumph of Justice*, and *Defeat of Justice*, U.S. Department of Justice, Washington, D.C., 1935–37; War Memorial Building, Worcester, Massachusetts, 1938–41; mosaic dome, chapel of U.S. Military Cemetery, Omaha Beach, France, 1952–53; Johns Hopkins University, Baltimore, 1954–56. One-man shows, New York: The Milch Galleries, 1935, 1947, 1959; French & Company, 1947; ACA Gallery, 1966; Bernard Danenberg Galleries, 1971. Retrospective, Worcester Art Museum, Massachusetts, 1937. Lives in New York.

Mary at Breakfast. 1924.
Oil on canvas, 30 × 25¼ inches
Signed l. r.: "Leon Kroll"

PROVENANCE:
Carl Hamilton; Julius H. Weitzner, New York; The Minneapolis Institute of Arts; M. Knoedler & Co., New York, 1962

EXHIBITIONS:
Carnegie Institute, Pittsburgh, October 13–December 4, 1927, *Twenty-Sixth International Exhibition of Paintings*, no. 49
Carnegie Institute, Pittsburgh, April 25–June 2, 1935, *An Exhibition of Paintings by Leon Kroll*, no. 31, frontispiece ill.
M. H. de Young Memorial Museum, San Francisco, June 7–July 7, 1935, *Exhibition of American Painting from the Beginning to the Present Day*, no. 366, ill.
Worcester Art Museum, Massachusetts, December 1937, *Leon Kroll Retrospective*
The American Academy of Arts and Letters, New York, May 27–July 3, 1949, *Work by Newly Elected Members and Recipients of Grants*, no. 55
The Gallery of Modern Art, New York, June 29–September 5, 1965, *The Twenties Revisited*, cat.

REFERENCES:
Kroll, Leon. *Leon Kroll*, New York, American Artists Group, 1946, ill.
Shapley, John, ed. "Leon Kroll," *Index of Twentieth Century Artists 1933–1937*, 1934–37, reprint ed. in one vol., New York, Arno, 1970, p. 91
Unsigned. "Minneapolis Obtains Important Leon Kroll," *Art Digest*, 12, May 15, 1938, p. 13, ill.
———. "Purchase of Painting by Leon Kroll: *Mary at Breakfast*," *The Bulletin of the Minneapolis Institute of Arts*, 27, May 7, 1938, pp. 94–96, cover ill.

Mary Trenkla Johnson was the wife of Theodore Johnson, Kroll's close friend and fellow artist.

"*Mary at Breakfast* was painted at Neuilly, France, in 1926. The composition is partly influenced by thought on the golden proportion of 618 in line and area. The model is a gracious American girl."

Statement by the artist, 1972

JACK KRUEGER (b. 1941)
Jack Allen Krueger, born Appleton, Wisconsin, August 3, 1941. Self-taught as an artist. Exhibited: Bank of Minneapolis, 1960; Allan Stone Gallery, New York, 1964; Park Place Gallery, New York, 1967; "Three Young Americans," Allen Memorial Art Museum, Oberlin College, Ohio, 1968; 14th Contemporary American Biennial, University of Illinois, Urbana-Champaign, 1969. Taught: Rhode Island School of Design, Providence, 1967; Oberlin College, 1968; Tyler School of Art of Temple University, Philadelphia, 1968; The Art Students League of New York, Metal Sculpture School, Long Island City, 1969–70. One-man shows, New York: Leo Castelli Gallery, 1968; Castelli Warehouse, 1969. Published *Working Alone and Other Confusion 1*, and *Working Alone and Other Confusion 2*, New York, 1972. Received grant, Creative Artists Public Service Program, New York, 1973. Lives in New York.

Chuck Around. 1967.
Acrylic and lacquer on steel tubing, 7 feet 10 inches × 15 feet × 2 feet 5 inches

PROVENANCE:
Leo Castelli Gallery, New York, 1968

EXHIBITIONS:
Leo Castelli Gallery, New York, April 20–May 11, 1968, *Jack Krueger*

NICHOLAS KRUSHENICK (b. 1929)
Born New York, May 31, 1929. Studied: The Art Students League of New York, 1948–50; Hans Hofmann School of Fine Art, New York, 1950–51. Worked at The Museum of Modern Art, and designed store display windows, New York, 1951–57. With his brother John Krushenick: exhibited, Camino Gallery, New York, 1956; managed Brata Gallery, New York, 1958–62. One-man shows, New York: Camino Gallery, 1957; Brata Gallery, 1958, 1960; James Graham and Sons, 1962, 1964; Fischbach Gallery, 1965. Included in: Whitney Annual, 1963, 1965; "Post Painterly Abstraction," Los Angeles County Museum of Art, and tour, 1964; "New Forms and Shapes of Color," Stedelijk Museum, Amsterdam, 1966; Documenta 4, Kassel, 1968. Received Guggenheim Foundation Fellowship, 1967. Taught: The Cooper Union for the Advancement of Science and Art, New York, 1967–68; Dartmouth College, Hanover, New Hampshire, 1969; Cornell University, Ithaca, New York, 1970. One-man shows: The Pace Gallery, New York, from 1967; Walker Art Center, Minneapolis, 1968; Galerie Beyeler, Basel, 1971. Lives in Ridgefield, Connecticut.

Measure of Red. 1971.
Acrylic on canvas, 90 × 70 inches
Signed and dated on back: "Nicholas Krushenick July 1971"

PROVENANCE:
The Pace Gallery, New York, 1972

EXHIBITIONS:
The Pace Gallery, New York, January 8–February 2, 1972, *Nicholas Krushenick: New Paintings and Collages*, no. 10

WALT KUHN (1877–1949)
Walter Francis Kuhn, born Brooklyn, New York, October 27, 1877. Studied: Polytechnic Institute of Brooklyn, evenings, 1893; Académie Colarossi, Paris, 1901; Bayerische Akademie der Schönen Künste, Munich, with Heinrich von Zügel, 1901–3. Cartoonist: for *Wasp* (San Francisco), 1899–1900; for *Life, Puck, Judge, New York Sunday Sun, New York World*, 1905–14. Taught, New York School of Art, 1908. First one-man show, Madison Gallery, New York, 1910–11. Armory Show: executive secretary, Association of American Painters and Sculptors (organizers of the show), 1912; in Europe, with Arthur B. Davies, and Walter Pach, assembled foreign section; five of his own works included, 1913. Exhibited, New York: with Davies, and Jules Pascin, Macbeth Gallery, 1916; with Davies, Pascin, Charles Sheeler, Max Weber, Montross Gallery, 1917. Organized Penguin Club, New York, 1917; staged musical revues, 1922–23, 1925–26. One-man shows: M. de Zayas Gallery, New York, 1920; Montross Gallery, 1922, 1924, 1925; The Arts Club of Chicago, 1923, 1927; Grand Central Art Galleries, New York, 1927; The Downtown Gallery, New York, 1927–29; Milwaukee Art Institute (drawings), 1933; City Art Museum of St. Louis, Missouri, 1935. Taught, The Art Students League of New York, 1927–28. Included in "Paintings by Nineteen Living Americans," and "American Painting and Sculpture," The Museum of Modern Art, New York, 1929–30, 1932–33. Advisor to art collectors John Quinn, Lillie P. Bliss, Marie Harriman. One-man shows: Marie Harriman Gallery, New York, 1930–32, 1934, 1936–37, 1941; The Columbus Gallery of Fine Arts, Ohio, 1935, 1942; Durand-Ruel Galleries, New York, 1943–46; Colorado Springs Fine Arts Center, 1947. Consulting architect, Union Pacific Railroad, 1936–41. Retrospective, Durand-Ruel Galleries, 1948. Died White Plains, New York, July 13, 1949.

Retrospectives: Cincinnati Art Museum, Ohio, 1960; Maynard Walker Gallery, New York, 1962; The University of Arizona Art Gallery, Tucson, 1966; Kennedy Galleries, New York, 1967–68, 1972.

The Tragic Comedians. c. 1916.
Oil on canvas, 95¼ × 45 inches
Signed l. r.: "Walt Kuhn"

PROVENANCE:
Montross Gallery, New York; John Quinn, New York; American Art Association, New York, Sale, February 9–12, 1927, *Quinn Collection*, no. 516, p. 204; Mrs. Meredith Hare; Paul Rabout, Westport, Connecticut; Herbert Benevy Gallery, New York; Mrs. Solomon Ethe, New York, 1958

EXHIBITIONS:
Montross Gallery, New York, February 13–March 3, 1917, *Special Exhibition: Arthur B. Davies, Walt Kuhn, Jules Pascin, Charles Sheeler, Max Weber*, no. 13
Montross Gallery, New York, January 3–28, 1922, *Paintings by Walt Kuhn*
Cincinnati Art Museum, Ohio, October 5–November 9, 1960, *Walt Kuhn Memorial Exhibition*, no. 6

REFERENCES:
Gregg, Frederick James. "The Newest Works of Six Painters," *Vanity Fair*, 8, April 1917, p. 57, ill.
Reid, B. L. *The Man from New York, John Quinn and His Friends*, New York, Oxford University, 1968, p. 294
Townsend, James B. "Modernists at Montross Gallery," *American Art News*, 15, February 17, 1917, p. 3
Unsigned. *John Quinn 1870–1925: Collection of Paintings, Watercolors, Drawings and Sculpture*, Huntington, New York, Pidgeon Hill Press, 1926, p. 23
———. "Sale of the Quinn Collection Is Completed," *Art News*, 25, February 19, 1927, p. 11

According to Brenda Kuhn, the artist's daughter, this work was painted in the backyard studio of the family's house on Hudson Terrace, Fort Lee, New Jersey. Wilson, a well-known professional model, posed for the male figure. The model for the female figure was a girl called Casey.

Still Life with Apples. 1939.
Oil on canvas, 24⅛ × 29⅛ inches
Signed and dated l. r.: "Walt Kuhn 1939"

PROVENANCE:
Mrs. John W. Ames; Maynard Walker Gallery, New York; The Milch Galleries, New York, 1962

Acrobat in White and Blue. 1947.
Oil on canvas, 30 × 25 inches
Signed and dated l. r.: "Walt Kuhn 1947"

PROVENANCE:
Maynard Walker Gallery, New York, 1954

EXHIBITIONS:
Colorado Springs Fine Arts Center, Colorado, February 1–28, 1947, *Walt Kuhn: An Exhibition of Twenty-Four Paintings*; toured to San Francisco Museum of Art, March 15–April 6
Durand-Ruel Galleries, New York, November 8–December 4, 1948, *Walt Kuhn: Fifty Years a Painter*
The National Gallery of Canada, Ottawa, and tour, 1957, *Some American Paintings from the Collection of Joseph H. Hirshhorn*, no. 40, ill. p. 13
Cincinnati Art Museum, Ohio, October 5–November 9, 1960, *Walt Kuhn Memorial Exhibition*, no. 107, ill.
American Federation of Arts tour, 1962–65, *Paintings from the Joseph H. Hirshhorn Foundation Collection: A View of the Protean Century*, no. 41, ill. p. 11
The University of Arizona Art Gallery, Tucson, February 6–March 31, 1966, *Walt Kuhn: Painter of Vision*, no. 109, ill. p. 82

REFERENCES:
Genauer, Emily. "75 Choice Hirshhorn Paintings," *The New York Herald Tribune*, November 4, 1962, sec. 4, p. 7
Hughes, Emmet John. "Joe Hirshhorn, The Brooklyn Uranium King," *Fortune*, 54, November 1956, colorplate p. 157
Lansford, Alonzo. "State of the Union Interview," *Art Digest*, 23, November 1, 1948, p. 15
Pictures on Exhibit, November 1962, cover ill.
Unsigned. "A Cultural View Of The Protean Century At The Boston Museum Of Fine Arts," *Boston Herald*, December 13, 1964, ill.
———. "Art: Major Exhibition in the Midwest," *The New York Times*, October 9, 1960, sec. 10, p. 13, ill.

YASUO KUNIYOSHI (1893–1953)

Born Okayama, Japan, September 1, 1893. Emigrated to the U.S., 1906. Attended Los Angeles School of Art and Design, evenings, 1907–10. Moved to New York, 1910. Studied, New York: National Academy of Design, 1910; Henri School of Art; Independent School of Art, 1914–16; The Art Students League of New York, with Kenneth Hayes Miller, 1916–20. Exhibited: Society of Independent Artists Annual, 1917; "Paintings and Sculptures by 'Modernists'," Penguin Club, New York, 1917. Hamilton Easter Field gave him studio, Ogunquit, Maine, summers, 1918, 1919, and apartment, Brooklyn, New York. Summered: Ogunquit, 1920–24, 1926; Woodstock, New York, from 1929. Photographer of works of art, 1920–25. One-man shows, The Daniel Gallery, New York, 1922–28, 1930. Salons of America, New York: director, 1922–38; corresponding secretary, 1929–38. Visited Europe, 1925, 1928. Co-founded Hamilton Easter Field Foundation, Ogunquit, with Robert Laurent and others, 1929; corresponding secretary, from 1929. Included in "Paintings by Nineteen Living Americans," The Museum of Modern Art, New York, 1929–30. Visited Japan, 1931; one-man show, Tokyo, and Osaka, sponsored by *Osaka Mai Nichi* newspaper. Awarded: honorable mention, Carnegie International, 1931; Temple Gold Medal, Pennsylvania Academy Annual, 1934; first prize, American Section, Golden Gate International Exposition, San Francisco, 1939. Taught, New York: The Art Students League, 1933–53; New School for Social Research, 1936–47. One-man shows, The Downtown Gallery, New York, 1933–55. Received Guggenheim Foundation Fellowship,

1935. WPA Federal Art Project, Graphics Division, New York, 1936–38. President: An American Group, New York, 1939–44; Artists Equity, 1947–50. Awarded: first prize, Carnegie Annual, 1944; Scheidt Memorial Prize, Pennsylvania Academy Annual, 1944; Harris Bronze Medal, and Prize, 56th American Exhibition, The Art Institute of Chicago, 1945; fifth award, La Tausca Art Competition, Riverside Museum, New York, 1947. Retrospective, Whitney Museum of American Art, New York, 1948. One-man show, Venice Biennale, 1952. Died New York, May 14, 1953. Retrospectives: National Museum of Modern Art, Tokyo, and tour, 1954; Boston University Art Gallery, 1961; University Gallery, University of Florida, Gainesville, and National Collection of Fine Arts, Smithsonian Institution, Washington, D.C., 1969; University Art Museum, The University of Texas at Austin, and tour, 1975.

Child Frightened by Water. 1924.
Oil on canvas, 30⅛ × 24 inches
Signed l. r.: "Y. Kuniyoshi"

PROVENANCE:
The Daniel Gallery, New York; The Downtown Gallery, New York, 1953

EXHIBITIONS:
The Daniel Gallery, New York, January 1925, *Recent Paintings and Drawings by Yasuo Kuniyoshi*, no. 5
Albright Art Gallery, Buffalo, New York, February 18–March 8, 1931, *International Exhibition Illustrating the Most Recent Developments in Modern Art*
Whitney Museum of American Art, New York, March 27–May 9, 1948, *Yasuo Kuniyoshi Retrospective Exhibition*, no. 17
The National Gallery of Canada, Ottawa, and tour, 1957, *Some American Paintings from the Collection of Joseph H. Hirshhorn*, no. 41

REFERENCES:
Kuniyoshi, Yasuo. *Artist's Record Book*, courtesy Mrs. Yasuo Kuniyoshi, New York
McCarthy, Pearl. "Art and Artists: Hirshhorn Collection at Gallery," *Toronto Globe and Mail*, April 13, 1957, ill.

Nude. 1929.
Oil on canvas, 30 × 40 inches
Signed and dated u. r.: "Yasuo Kuniyoshi 1929"

PROVENANCE:
The Daniel Gallery, New York; Robert Laurent, Ogunquit, Maine; Parke-Bernet Galleries, New York, Sale 3133, December 10, 1970, no. 67

EXHIBITIONS:
The Daniel Gallery, New York, March–April 1930, *Paintings and Drawings by Kuniyoshi*, no. 16

REFERENCES:
Kuniyoshi, Yasuo. *Artist's Record Book*, courtesy Mrs. Yasuo Kuniyoshi, New York

Look, It Flies! 1946.
Oil on canvas, 39⅛ × 30⅛ inches
Signed u. l.: "Kuniyoshi"

PROVENANCE:
The Downtown Gallery, New York, 1947

EXHIBITIONS:
Riverside Museum, New York, January–February 1947, *The Second Exhibition of the La Tausca Art Competition*, cat., ill.
The Downtown Gallery, New York, January 20–February 7, 1948, *Five Americans*
Whitney Museum of American Art, New York, March 27–May 9, 1948, *Yasuo Kuniyoshi Retrospective Exhibition*, no. 67, ill. p. 45
Carnegie Institute, Pittsburgh, October 14–December 12, 1948, *Painting in the United States*, 1948, no. 11, plate 10
Art Gallery of Toronto, Ontario, November 1949–April 1950, *50th Anniversary Exhibition*
XXVI Biennale Internazionale d'Arte, Venice, Summer 1952, *United States Pavilion*, no. 46
The Downtown Gallery, New York, December 9–27, 1952, *Stuart Davis—Yasuo Kuniyoshi*
National Museum of Modern Art, Tokyo, March 20–April 25, 1954, *Kuniyoshi Memorial Exhibition* (The Museum of Modern Art, New York, International Circulating Exhibition), no. 29, colorplate; toured to Municipal Gallery, Osaka, Japan, May 1–23; Tenmondo Gallery, Nagoya, Japan, May 28–June 6
Brandeis University, Waltham, Massachusetts, July 1–17, 1955, *Three Collections*, no. 24
The Metropolitan Museum of Art, New York, February 24–April 29, 1956, *Five American Artists: Kuhn, Marin, Nordfeldt, Feininger and Kuniyoshi*
The National Gallery of Canada, Ottawa, and tour, 1957, *Some American Paintings from the Collection of Joseph H. Hirshhorn*, no. 43, ill. p. 20
Cincinnati Art Museum, Ohio, October 12–November 17, 1957, *An American Viewpoint: Realism in 20th Century American Painting*, cat., ill.; toured to The Dayton Art Institute, Ohio, November 27–December 29
Tweed Gallery, University of Minnesota, Duluth, October 19–November 23, 1958, *9 American Artists*, no. 35, ill.
Boston University Art Gallery, February 24–March 18, 1961, *Yasuo Kuniyoshi Retrospective*, no. 48
American Federation of Arts tour, 1962–65, *Paintings from the Joseph H. Hirshhorn Foundation Collection: A View of the Protean Century*, no. 42, ill. p. 30

REFERENCES:
Archives of American Art, Smithsonian Institution, Washington, D.C., *The Downtown Gallery Archives*
Bruening, Margaret. "Margaret Bruening Writes," *Arts*, 30, April 1956, p. 46
Coates, Robert M. "The Art Galleries: A Kuniyoshi Retrospective," *The New Yorker*, 24, April 3, 1948, p. 73
Devree, Howard. "Into the Eighteenth Century," *The New York Times*, January 25, 1948, sec. 2, ill. p. 8
Frost, Rosamund. "Pictures Before Pearls," *Art News*, 45, February 1947, p. 32, ill.
Gibbs, Jo. "La Tausca Unpearls Its Artists," *Art Digest*, 21, February 1, 1947, p. 12

Goodrich, Lloyd. *Yasuo Kuniyoshi*, New York, Watkins, 1948, p. 44
Kay, Jane H. "Sharing the Collection," *The Christian Science Monitor*, January 2, 1965
McCarthy, Pearl. "Art and Artists: Hirshhorn Collection at Gallery," *Toronto Globe and Mail*, April 13, 1957
Pierson, William Henry, and Davidson, Martha, eds. *Arts of the United States, A Pictorial Survey*, New York, McGraw-Hill, 1960, no. 3218, ill. p. 348
Preston, Stuart. "Art Survey by Nations," *The New York Times*, July 20, 1952, sec. 2, ill. p. 2
Price, Vincent, ed. *The Vincent Price Treasury of American Art*, Waukesha, Wisconsin, Country Beautiful, 1972, colorplate p. 265
Reed, Judith Kaye. "Whitney Museum Honors Kuniyoshi with Handsome Retrospective," *Art Digest*, 22, April 1, 1948, p. 12
Snow, Walter. "A Layman Speaks," *Arts Digest*, 21, March 1, 1947, p. 25
Unsigned. "Art News of America: Rattner Wins La Tausca First Prize," *Art News*, 45, January 1947, p. 8
———. "La Tausca Exhibition," *The New York Times*, January 5, 1948, ill. p. 5

"In explanation of [*Look, It Flies!* Kuniyoshi wrote in 1947: 'I would say that the war for the past few years has been the backdrop for a great number of my works. Not necessarily the battlefield, but war's implications: destruction, lifelessness, hovering between life and death, loneliness.' Of his recent work in general he says that it has 'implications of very sad things.'"

Goodrich, p. 44

GASTON LACHAISE (1882–1935)

Born Paris, March 19, 1882. Studied, Paris: École Bernard Palissy, 1895; École des Beaux-Arts, with Gabriel-Jules Thomas, 1898–1905. Exhibited, the Salon, Paris, 1899–1903. Worked for jewelry and glass designer René Lalique, Paris, 1905. Emigrated to Boston, 1906; U.S. citizen, 1917. Worked for sculptor Henry Hudson Kitson, Boston, 1906–12. Moved to New York, 1912. Included in the Armory Show, 1913. Chief assistant to sculptor Paul Manship, New York, 1913–c. 1921. Member, Board of Directors, Society of Independent Artists, New York, 1917–22. One-man shows, Bourgeois Galleries, New York, 1918, 1920. Works frequently reproduced in *The Dial*, 1919–25. Commissions: frieze, American Telephone and Telegraph Building, New York, 1921; National Coast Guard Memorial, Washington, D.C., 1928; RCA Building, New York, 1931; Century of Progress Exhibition, Chicago World's Fair, 1932; International Building, Rockefeller Center, New York, 1934. One-man shows, New York: Alfred Stieglitz's Intimate Gallery, 1927; Brummer Gallery, 1928. The Museum of Modern Art, New York: included in "Paintings and Sculpture by Living Americans," 1930–31; retrospective, 1935. Died New York, October 17, 1935. Posthumous exhibitions: Whitney Museum of American Art, New York, 1937; The Brooklyn Museum, New York, 1938; M. Knoedler & Co., New York, 1947; Weyhe Gallery, New York, 1955–56; Margaret Brown Gallery, Boston, 1957; Los Angeles County Museum of Art, and Whitney Museum of American Art, 1963–64; touring retrospective, organized by Lachaise Foundation, Boston, 1967–74.

Eternal Force (La Force éternelle). 1917.
Bronze, 13 × 6⅛ × 3⅛ inches
Markings: back l. r. "G. Lachaise 1917"
back l. l. "A. Kunst Foundry, N.Y."

PROVENANCE:
Bourgeois Galleries, New York; Mr. and Mrs. Charles J. Liebman, New York; Parke-Bernet Galleries, New York, Sale 1633, December 7, 1955, *Paintings, Drawings, and Sculptures from the Collection Formed by Mr. and Mrs. Charles J. Liebman*, no. 36, ill.

EXHIBITIONS:
Bourgeois Galleries, New York, February 13–March 9, 1918, *Lachaise*, no. 7
Whitney Museum of American Art, New York, April 9–May 19, 1946, *Pioneers of Modern Art in America*, no. 69
The Detroit Institute of Arts, and tour, 1959–60, *Sculpture in Our Time*, no. 115, ill. p. 52
The Solomon R. Guggenheim Museum, New York, October 3, 1962–January 6, 1963, *Modern Sculpture from the Joseph H. Hirshhorn Collection*, no. 223
Los Angeles County Museum of Art, December 3, 1963–January 19, 1964, *Gaston Lachaise: Sculpture and Drawings*, no. 17, ill.; toured to Whitney Museum of American Art, New York, February 18–April 5
Hopkins Art Center, Dartmouth College, Hanover, New Hampshire, May 25–July 9, 1967, *Sculpture in Our Century: Selections from the Joseph H. Hirshhorn Collection*, no. 113, ill. p. 52

REFERENCES:
Nordland, Gerald. "Gaston Lachaise," *Artforum*, 2, December 1963, p. 29

Woman on a Couch. 1918–23, cast 1928.
Bronze, 9⅛ × 16 × 10⅛ inches
Markings: back l. r. "G. Lachaise © 1928"
back l. l. "R.B.W."

PROVENANCE:
Weyhe Gallery, New York, 1956

EXHIBITIONS:
The Museum of Modern Art, New York, January 30–March 7, 1935, *Gaston Lachaise Retrospective Exhibition*, no. 13
Weyhe Gallery, New York, December 27, 1955–January 28, 1956, *Gaston Lachaise*
Leonid Kipnis Gallery, Westport, Connecticut, November 18–30, 1956, *Modern Sculpture* (sponsored by the Westport Community Art Association), no. 17
The Detroit Institute of Arts, and tour, 1959–60, *Sculpture in Our Time*, no. 117
The Solomon R. Guggenheim Museum, New York, October 3, 1962–January 6, 1963, *Modern Sculpture from the Joseph H. Hirshhorn Collection*, no. 227, ill. p. 167

Los Angeles County Museum of Art, December 3, 1963–January 19, 1964, *Gaston Lachaise: Sculpture and Drawings*, no. 69, ill.; toured to Whitney Museum of American Art, New York, February 18–April 5

REFERENCES:
B. G. "A Season for Sculpture," *Arts*, 30, January 1956, p. 22
Goodall, Donald. "Gaston Lachaise," *Art in America*, 51, October 1963, ill. p. 42
Seldis, Henry. "Lachaise—Study in Voluptuousness," *Los Angeles Times*, December 8, 1963, ill. p. 9

Walking Woman. 1919.
Bronze, 17 × 10¾ × 7¼ inches
Markings: u. l. top of base "G. Lachaise © 22"

PROVENANCE:
Weyhe Gallery, New York, 1957

EXHIBITIONS:
Weyhe Gallery, New York, December 27, 1955–January 28, 1956, *Gaston Lachaise*
Whitney Museum of American Art, New York, April 30–June 15, 1958, *The Museum and Its Friends*, no. 93
The Detroit Institute of Arts, and tour, 1959–60, *Sculpture in Our Time*, no. 114
The Solomon R. Guggenheim Museum, New York, October 3, 1962–January 6, 1963, *Modern Sculpture from the Joseph H. Hirshhorn Collection*, no. 224, ill. p. 166
Whitney Museum of American Art, New York, February 27–April 14, 1963, *The Decade of the Armory Show*, no. 52, ill. p. 67; toured to City Art Museum of St. Louis, Missouri, June 1–July 14; The Cleveland Museum of Art, August 6–September 15; The Pennsylvania Academy of the Fine Arts, Philadelphia, September 30–October 30; The Art Institute of Chicago, November 15–December 29; Albright-Knox Art Gallery, Buffalo, New York, January 20–February 23, 1964
Hopkins Art Center, Dartmouth College, Hanover, New Hampshire, May 25–July 9, 1967, *Sculpture in Our Century: Selections from the Joseph H. Hirshhorn Collection*, no. 28, ill. pp. 1, 23
Smithsonian Institution, Washington, D.C., September 26, 1971–January 31, 1972, *One Hundred and Twenty-Fifth Anniversary of the Institution*

REFERENCES:
Geldzahler, Henry. "Taste For Modern Sculpture: The Hirshhorn Collection," *Art News*, 61, October 1962, ill. p. 29
Kuh, Katherine. "Great Sculpture," *Saturday Review*, 45, June 23, 1962, ill. p. 21
Saarinen, Aline B. *The Proud Possessors*, New York, Random House, 1958, ill. following p. 200

Egyptian Head. 1923.
Bronze, 13¼ × 8¼ × 9 inches
Markings: l. r. side "Lachaise © 1923"
l. l. back "R.B.W."

PROVENANCE:
C. W. Kraushaar Galleries, New York, 1928; Mr. and Mrs. Charles J. Liebman, New York; Parke-Bernet Galleries, New York, Sale 1633, December 7, 1955, *Paintings, Drawings, and Sculptures from the Collection Formed by Mr. and Mrs. Charles J. Liebman*, no. 39, ill.

EXHIBITIONS:
The Museum of Modern Art, New York, December 2, 1930–January 20, 1931, *Paintings and Sculpture by Living Americans*, no. 105, ill.
M. Knoedler & Co., New York, January 20–February 15, 1947, *Gaston Lachaise*, no. 42
Westchester County Center, White Plains, New York, April 20–22, 1956, *Westchester Creative Arts Festival* (sponsored by Westchester Chapter, National Women's Committee, Brandeis University)
The Detroit Institute of Arts, and tour, 1959–60, *Sculpture in Our Time*, no. 115
The Solomon R. Guggenheim Museum, New York, October 3, 1962–January 6, 1963, *Modern Sculpture from the Joseph H. Hirshhorn Collection*, no. 225, ill. p. 167

Reclining Woman with Arm Upraised (Woman in a Chair). 1924.
Bronze, 13¼ × 9¼ × 14¼ inches
Markings: l. r. side "G. Lachaise ©"
l. l. side "Roman Bronze Works, N.Y."

PROVENANCE:
Weyhe Gallery, New York, 1956

EXHIBITIONS:
The Museum of Modern Art, New York, January 30–March 7, 1935, *Gaston Lachaise Retrospective Exhibition*, no. 26, ill.
Weyhe Gallery, New York, December 27, 1955–January 28, 1956, *Gaston Lachaise*
The Detroit Institute of Arts, 1959, *Sculpture in Our Time*, no. 116
The Solomon R. Guggenheim Museum, New York, October 3, 1962–January 6, 1963, *Modern Sculpture from the Joseph H. Hirshhorn Collection*, no. 226
Los Angeles County Museum of Art, December 3, 1963–January 19, 1964, *Gaston Lachaise: Sculpture and Drawings*, no. 49, ill.; toured to Whitney Museum of American Art, New York, February 18–April 5

The King's Bride (Garden Figure). c. 1927.
Cast cement (edition of five), 79½ × 27½ × 17 inches

PROVENANCE:
Arthur F. Egner, South Orange, New Jersey; M. Knoedler & Co., New York, 1968

REFERENCES:
Jacobs, Jay. "Collector: Joseph H. Hirshhorn," *Art in America*, 57, July-August 1969, colorplate p. 69
———. "Quality as Well as Quantity: Joseph H. Hirshhorn," in Lipman, Jean, ed. *The Collector in America*, New York, Viking, 1971, colorplate p. 82

Torso ("Ogunquit" Torso; "Classic" Torso). 1928, cast 1946.
Polished bronze, 10¾ × 6¾ × 4¼ inches

PROVENANCE:
Robert Schoelkopf Gallery, New York, 1962

EXHIBITIONS:
The Solomon R. Guggenheim Museum, New York, October 3, 1962–January 6, 1963, *Modern Sculpture from the Joseph H. Hirshhorn Collection*, no. 228

ROGER DE LA FRESNAYE (1885–1925)

Roger-Noël-François-André de La Fresnaye, born Le Mans, France, July 11, 1885. Studied, Paris: Académie Julian, 1903; École des Beaux-Arts, 1904, 1906–8; Académie Ranson, with Maurice Denis, and Paul Sérusier, 1908; Académie de la Grande Chaumière, 1910. Met Raymond Duchamp-Villon, 1910. Included in: Salon des Indépendants, and Salon d'Automne, Paris, 1910–14; second exhibition of Der Blaue Reiter, Galerie Neue Kunst, Munich, 1912; Salon de "La Section d'Or," with Alexander Archipenko, Marcel Duchamp, Duchamp-Villon, Albert Gleizes, Juan Gris, Fernand Léger, Jacques Villon, and others, Galerie La Boëtie, Paris, 1912; the Armory Show, 1913. One-man show, Galerie Levesque, Paris, 1914. Served, French Infantry, 1914–18. Settled in Grasse, France, 1919. Associated with poets Jean Cocteau and Raymond Radiguet, and avant-garde musicians Darius Milhaud, Arthur Honneger, and Francis Poulenc. Exhibited, Salon des Tuileries, Paris, 1923. Died Grasse, November 27, 1925. Memorial exhibition, Galerie Barbazanges, Paris, 1926. Posthumous one-man shows: The Lefevre Gallery, London, 1931; Galerie Jacques Bonjean, Paris, 1931–34; Marie Harriman Gallery, New York, 1932; Wildenstein & Co., London, 1937; Galerie Druet, Paris, 1938; The Art Institute of Chicago, 1943; The Phillips Collection, Washington, D.C., 1944; Buchholz Gallery, New York, 1945; Jacques Seligmann & Co., New York, 1947; Maison de la Pensée Française, Paris, 1949. Retrospectives: Musée National d'Art Moderne, Paris, 1950; Musée de Tessé, Le Mans, 1950–51; Musée des Beaux-Arts, Lyons, France, 1951. One-man shows: M. Knoedler & Co., New York, 1951; Galerie de l'Institut, Paris, 1962; Albert Loeb & Krugier Gallery, New York, 1967.

The Italian Girl. 1912.
Bronze, 24 × 12¾ × 6¼ inches
Markings: l. r. "R DELAFRESNAYE 2/6"
back l. r. "Alexis Rudier Fondeur Paris"

PROVENANCE:
M. Knoedler & Co., New York, 1958

EXHIBITIONS:
M. Knoedler & Co., New York, February 5–24, 1951, *Roger de La Fresnaye*, no. 4
The Detroit Institute of Arts, 1959, *Sculpture in Our Time*, no. 112, ill. p. 51
Otto Gerson Gallery, New York, September 12–30, 1961, *Cubist Sculpture* (American Federation of Arts, Circulating Exhibition), no. 3; toured to Rose Art Museum, Brandeis University, Waltham, Massachusetts, October 10–30; Allentown Art Museum, Pennsylvania, November 15–December 14; Hackley Art Gallery, Muskegon, Michigan, January 1–22, 1962; William Hayes Ackland Memorial Art Center, University of North Carolina at Chapel Hill, February 5–26; Kalamazoo Institute of Arts, Michigan, April 13–May 4
The Solomon R. Guggenheim Museum, New York, October 3, 1962–January 6, 1963, *Modern Sculpture from the Joseph H. Hirshhorn Collection*, no. 159, ill. p. 88
Leonard Hutton Galleries, New York, October 28–December 5, 1964, *Albert Gleizes and the Section d'Or*, no. 25
Los Angeles County Museum of Art, December 15, 1970–February 21, 1971, *The Cubist Epoch*, no. 155, pp. 134, 236, ill. p. 237; toured to The Metropolitan Museum of Art, New York, April 7–June 7

REFERENCES:
Geldzahler, Henry. "Taste for Modern Sculpture: The Hirshhorn Collection," *Art News*, 61, October 1962, ill. p. 30
Read, Herbert. *A Concise History of Modern Sculpture*, New York, Praeger, 1964, no. 69, p. 292, ill. p. 72
Selz, Jean. *Modern Sculpture: Origins and Evolution*, trans. Annette Michelson, New York, Braziller, 1963, p. 193, ill. p. 186

WIFREDO LAM (b. 1902)

Wifredo Oscar de la Concepción Lam y Castillo, born Sagua la Grande, Cuba, December 8, 1902. Studied: Academia de San Alejandro, Havana, 1921–23; Academia Libre del Alhambra, and privately with Fernández Álvarez de Sotomayor, Madrid, 1924–28. Fought in Republican Army, Spanish Civil War, 1938. Moved to Paris, 1938; associated with André Breton, Max Ernst, André Masson, Yves Tanguy, and other Surrealists from 1939. First one-man show, Galerie Pierre, Paris, 1939. Left Occupied France for the Antilles, 1941. Included in "First Papers of Surrealism," 451 Madison Avenue, New York, 1942; "Twentieth-Century Young Masters," Sidney Janis Gallery, New York, 1950; "Art Cubain Contemporain," Musée National d'Art Moderne, Paris, 1951; Documenta II and III, Kassel, 1959, 1964; Pittsburgh International, 1964; ROSC '67, Dublin, 1967. One-man shows, Pierre Matisse Gallery, New York, 1942, 1944, 1945, 1948, 1950; Parque Central, Havana, 1950; Galerie Maeght, Paris, 1953; Museo de Bellas Artes, Caracas, 1955. Settled in Paris, 1952; visited the U.S., 1958. Received: Premio Internazionale di Pittura, Lissone, Italy, 1953; Graham Foundation Fellowship, Chicago, 1958. Retrospectives: Kunsthalle, Basel, and tour, 1966–67; Musée d'Art Moderne de la Ville de Paris, 1968. One-man show, Gimpel & Weitzenhoffer, Ltd., New York, 1970–71. Lives in Paris.

The Siren of the Niger (La Sirena del Niger). 1950.
Oil and charcoal on canvas, 51 × 38 inches
Signed and dated l. r.: "Wifredo Lam 1950"

PROVENANCE:
Pierre Matisse Gallery, New York; Edwin Bergmann, Chicago; Galerie Albert Loeb, Paris, 1967

EXHIBITIONS:
Pierre Matisse Gallery, New York, May 2–20, 1950, *Wifredo Lam*
Parque Central, Havana, October 2–15, 1950, *Wifredo Lam*, no. 12, ill.
Museo de Bellas Artes, Caracas, May 8–22, 1955, *Exposición Lam*, no. 29
Kunsthalle, Basel, September 10–October 9, 1966, *Wifredo Lam*, no. 42; toured to Kestner-Gesellschaft, Hanover, December 16–January 15, 1967, no. 42; Stedelijk Museum, Amsterdam, January 26–March 12, no. 40; Moderna Museet, Stockholm, April 8–May 7, no. 44; Palais des Beaux-Arts, Brussels, May 18–June 18, no. 46

REFERENCES:
Leiris, Michel. *Wifredo Lam*, Milan, Fratelli Fabbri, 1970, p. 35, ill. 98
Ortiz, Fernando. "Wifredo Lam y su obra vista a través de significados críticos," *Publicaciones del Ministerio de Educación*, Havana, 1950, ill.
Tarnaud, Claude. "Wifredo Lam et le 'Bestiare Ambigu,'" *XXᵉ Siècle*, 25, May 1963, p. 38, ill.

RONNIE LANDFIELD (b. 1947)

Ronald Landfield, born Bronx, New York, January 9, 1947. Studied: The Art Students League of New York, Woodstock, New York, summer, 1962; New York City, summer, 1965; Kansas City Art Institute and School of Design, Missouri, 1963; San Francisco Art Institute, 1964–65. Included in: Whitney Annual, 1967, 1969; "Two Generations of Color Painting," Institute of Contemporary Art, University of Pennsylvania, Philadelphia, 1970; "Highlights of the 1969–70 Art Season," and "Lyrical Abstraction," The Aldrich Museum of Contemporary Art, Ridgefield, Connecticut, 1970, 1970–71, and tour; "Color and Field," The Museum of Fine Arts, Houston, 1971; Whitney Biennial, 1973. One-man shows: David Whitney Gallery, New York, 1969, 1971; Joseph Helman Gallery, St. Louis, Missouri, 1970; Jack Glenn Gallery, Corona del Mar, California, 1970; Corcoran and Corcoran Gallery, Miami, Florida, 1971; André Emmerich Downtown, New York, 1973. Lives in New York.

Rain Dance III. 1969–70.
Acrylic on canvas, 9 feet × 7 feet 8¼ inches

PROVENANCE:
David Whitney Gallery, New York, 1970

HENRI LAURENS (1885–1954)

Born Paris, February 18, 1885. In Paris: apprenticed to an ornamental sculptor; worked as stone carver of decorative architectural motifs; studied, with academic sculptor Jacques Perrin, evenings, 1899–1906. Met Georges Braque (who became lifelong friend), 1911. Included in Salon des Indépendants, Paris, 1913, 1914, 1924, 1927. One-man shows, Galerie de l'Effort Moderne, Paris, 1916, 1918, 1920. Daniel-Henry Kahnweiler became his dealer, 1921. Designed decor for *Le Train bleu*, Sergei Diaghilev's Ballets Russes de Monte Carlo, 1925. Sculpture exhibited, Le Corbusier's Pavillon de l'Esprit Nouveau, Exposition des Arts Décoratifs, Paris, 1925. Included in: "Cubism and Abstract Art," The Museum of Modern Art, New York, 1936; "Les Maîtres de l'Art Indépendant," Musée du Petit Palais, Paris, 1937. Fountain and four reliefs commissioned, Le Corbusier's Pavillon des Temps Nouveau, Exposition Universelle de 1937, Paris. One-man shows: Brummer Gallery, New York, 1938; Galerie Pierre, Paris, 1939; Galerie Jeanne Bucher, Paris, 1942; Buchholz Gallery, New York, 1947; Curt Valentin Gallery, New York, 1952. Included in: Venice Biennale, 1948, 1950; II São Paulo Bienal, 1953 (Grand Prize for Sculpture). Retrospectives: Palais des Beaux-Arts, Brussels, 1949; Musée National d'Art Moderne, Paris, 1951. Died Paris, May 5, 1954. Retrospectives: Galerie Louise Leiris, Paris, 1958; Stedelijk Museum, Amsterdam, 1962; Grand Palais, Paris, 1967; Hayward Gallery, London, and Ulster Museum, Belfast, Northern Ireland, 1971; with Braque, New York Cultural Center, 1971.

Man with Clarinet. 1919.
Stone, 23⅜ × 8¾ × 6⅜ inches
Markings: back l. c. "H.L. 1919"

PROVENANCE:
Daniel-Henry Kahnweiler, Paris; Peggy Guggenheim, New York; Buchholz Gallery, New York; G. David Thompson, Pittsburgh; Harold Diamond, New York, 1962

EXHIBITIONS:
Buchholz Gallery, New York, November 10–December 5, 1942, *Homage to Rodin: European Sculpture of Our Time*, no. 40
Buchholz Gallery, New York, September 29–October 18, 1947, *Henri Laurens: Stone, Bronze, Terracotta*, no. 3, ill.
Buchholz Gallery, New York, April 5–30, 1949, *Cubism*, no. 15
Curt Valentin Gallery, New York, May 12–June 7, 1952, *Henri Laurens*, no. 1, ill.
Museum of Fine Arts, Boston, October 10–November 17, 1957, *European Masters of Our Time*, no. 65, ill.

REFERENCES:
Gertz, Ulrich. *Plastik der Gegenwart*, Berlin, Rembrandt, 1953, p. 218, ill. p. 188
Goldscheider, Cécile. *Laurens*, New York, Universe, 1959, plate 5
Goldwater, Robert. "Truth to What?" *Arts Yearbook 8*, 1965, ill. p. 68
Guggenheim, Peggy, ed. *Art of this Century*, New York, Arno reprint, 1968, p. 76, ill.
Hofmann, Werner. *Henri Laurens: das plastische Werk*, Stuttgart, Gerd Hatje, 1970, plate 80
Laurens, Marthe. *Henri Laurens, sculpteur*, Paris, Pierre Bérès, 1955, ill. p. 78
Seuphor, Michel. *Sculpture of this Century*, trans. Haakon Chevalier, New York, Braziller, 1960, ill. p. 37
Stadler, Wolfgang. *Führer durch die europäische Kunst*, Freiburg, Germany, Herder, 1958, plate 42

Unsigned. "European Masters of Our Time," *Arts*, 32, October 1957, ill. p. 39

Guitar and Clarinet. 1920.
 Polychromed stone, 12¾ × 14½ × 3½ inches
 Markings: r. side "H.L."

PROVENANCE:
Galerie Louise Leiris, Paris; Saidenberg Gallery, New York, 1961

EXHIBITIONS:
Galerie Louise Leiris, Paris, October 29–November 29, 1958, *Henri Laurens sculptures en pierre 1919–1943*, no. 6, colorplate 6
The Solomon R. Guggenheim Museum, New York, October 3, 1962–January 6, 1963, *Modern Sculpture from the Joseph H. Hirshhorn Collection*, no. 229, ill. p. 71

REFERENCES:
Arnason, H. Harvard. *History of Modern Art*, New York, Abrams, 1968, p. 191, colorplate 67
Bruguière, P.-G. "Pierres sculptées d'Henri Laurens," *Cahiers d'Art*, 33–35, 1960, ill. p. 129
Goldscheider, Cécile. *Laurens*, New York, Universe, 1959, plate 7
Kahnweiler, Daniel-Henry, with Crémieux, Francis. *My Galleries and Painters*, trans. Helen Weaver, New York, Viking, 1971, ill. p. 16
Laurens, Marthe. *Henri Laurens, sculpteur*, Paris, Pierre Bérès, 1955, ill. p. 64
Limbour, Georges. "Paris Chronique," *Art International*, 2, December 1958–January 1959, p. 29
Zanini, Walter. *Tendências da escultura moderna*, São Paulo, Cultrix, 1971, ill. p. 115

Head of a Woman. 1925.
 Bronze, 16¼ × 7½ × 6¼ inches
 Markings: l. top of base "HL 2/6"
 r. top of base "Cire Perdue C. Valsuani"
 back l. l. "HL"

PROVENANCE:
Galerie Louise Leiris, Paris; Marlborough Fine Art, London, 1961

Reclining Woman. 1927.
 Alabaster, 6¼ × 12½ × 3½ inches
 Markings: l. r. side "HL"

PROVENANCE:
Curt Valentin Gallery, New York, 1954

EXHIBITIONS:
Buchholz Gallery, New York, September 29–October 18, 1947, *Henri Laurens: Stone, Bronze, Terracotta*, no. 19
Curt Valentin Gallery, New York, May 12–June 7, 1952, *Henri Laurens*, no. 6, ill.
The Detroit Institute of Arts, and tour, 1959–60, *Sculpture in Our Time*, no. 118, ill. p. 53

REFERENCES:
Limbour, Georges. "Laurens et les sphinx," *Le Point*, 33, Souillac, France, 1946, ill. p. 19
Martinelli, Valentino. "Modigliani e Laurens," *Scritti di Storia dell'Arte in Onore di Lionello Venturi*, Rome, De Luca, 1956, 2, pp. 211–12, ill. p. 209

Maternity (La Grande Maternité). 1932.
 Bronze, 21 × 55 × 23 inches
 Markings: l. back of base "HL 1/6"
 r. back of base "Cire Perdue C. Valsuani"

PROVENANCE:
Galerie Louise Leiris, Paris; Otto Gerson Gallery, New York, 1961

EXHIBITIONS:
The Solomon R. Guggenheim Museum, New York, October 3, 1962–January 6, 1963, *Modern Sculpture from the Joseph H. Hirshhorn Collection*, no. 231, ill. p. 71

REFERENCES:
Sweeney, James Johnson. "A Living Frame for Sculpture," *House & Garden*, 126, August 1964, ill. p. 113

ROBERT LAURENT (1890–1970)

Born Concarneau, Brittany, France, June 29, 1890. Emigrated with parents to the U.S., at the invitation of Hamilton Easter Field, 1901. Returned to Brittany to finish schooling, 1904. Assistant to print dealer Ernest Le Veel, Paris, 1905–7. Accompanied Field to Rome, 1907. Lived in Rome, 1907–10; studied drawing, British School at Rome, and with Maurice Sterne; also studied wood carving. Returned to New York, 1910; established reputation as frame maker. Exhibited, New York: with Field, The Daniel Gallery, 1915, 1917; Whitney Studio Club, 1917. U.S. citizen, 1917. Served, U.S. Navy, Brittany, 1918. Taught: The Art Students League of New York, intermittently, 1919–34; The Ogunquit School of Painting and Sculpture, Maine, summers, 1919–61. One-man shows, New York: Bourgeois Galleries, 1922; F. Valentine Dudensing, 1926, 1928; Valentine Gallery, 1931, 1941. At Field's death became sole heir of estate, 1922; co-founded Hamilton Easter Field Foundation, with Yasuo Kuniyoshi, and others, Ogunquit, 1929. Commissions: *The Goose Girl*, Radio City Music Hall, New York, 1932; *Spanning the Continent*, Fairmount Park, Philadelphia, 1936; *Shipping*, Federal Trade Building, Washington, D.C., 1938. Taught: Vassar College, Poughkeepsie, New York, 1939–40; Goucher College, Baltimore, 1940–41; Corcoran School of Art, Washington, D.C., 1940–42; Indiana University, Bloomington, 1942–63. One-man shows, Kraushaar Galleries, New York, 1947, 1952, 1956, 1962. Lived in Paris, 1949–50. Artist-in-residence, American Academy in Rome, 1954–55. One-man show, Galleria Schneider, Rome, 1955. Retrospective, Indiana University Art Museum, 1960. Member, The National Institute of Arts and Letters, 1970. Died Cape Neddick, Maine, April 20, 1970. Memorial exhibitions: Kraushaar Galleries, 1972; University of New Hampshire, Durham, and tour, 1972–73.

Bust of a Woman. 1920–21.
 Caen stone, 10¾ × 8½ × 8½ inches

Markings: back l. r. "LAURENT"

PROVENANCE:
The artist, 1949; Dr. Myron Bogdonoff, New York, 1969; Zabriskie Gallery, New York, 1970

JACOB LAWRENCE (b. 1917)

Born Atlantic City, New Jersey, September 7, 1917. Moved to New York, 1930. Studied, New York: Harlem Art Workshop, 1932; WPA classes, 141st Street Studio, 1934–37; American Artists School, 1937–39. One-man shows: Harlem YMCA, 1938; The Baltimore Museum of Art, 1939. WPA Federal Art Project, Easel Division, New York, 1938–39. Awarded second prize, American Negro Exposition, Chicago, 1939. Received: Rosenwald Fund Fellowship, 1940–42; Guggenheim Foundation Fellowship, 1946; Chapelbrook Foundation Fellowship, 1954. One-man shows, The Downtown Gallery, New York, 1941, 1943, 1945, 1947, 1950, 1953. Taught, Black Mountain College, North Carolina, summer, 1946. The National Institute of Arts and Letters: grant, 1953, member, 1965. Included in: Whitney Annual, from 1954; Pittsburgh International, 1967. Artists Equity: national secretary, 1954–56; president, New York Chapter, 1957. Taught: Pratt Institute, Brooklyn, New York, 1956–71; Brandeis University, Waltham, Massachusetts, 1965; New School for Social Research, New York, 1966; The Art Students League of New York, 1967; University of Washington, Seattle, from 1972. One-man shows, New York: The Alan Gallery, 1957, 1959; Terry Dintenfass Gallery, from 1963. Retrospective, American Federation of Arts, Circulating Exhibition, 1960–61; Whitney Museum of American Art, New York, and tour, 1974–75. Mural commission, State Capitol, Olympia, Washington, 1972. Lives in Seattle.

Cabinet Makers. 1946.
 Gouache on paper, 22 × 30 inches
 Signed and dated l. r.: "Jacob Lawrence/1946"

PROVENANCE:
The Downtown Gallery, New York, 1946

EXHIBITIONS:
The Brooklyn Museum, New York, November 22, 1960–January 2, 1961, *Jacob Lawrence Retrospective* (American Federation of Arts, Circulating Exhibition), no. 21, ill.; toured to sixteen U.S. cities

REFERENCES:
Archives of American Art, Smithsonian Institution, Washington, D.C., *The Downtown Gallery Archives*
Unsigned. " 'Narrative Painter' Lawrence's Works to be Exhibited at Allegheny College," *Meadville* [*Pennsylvania*] *Tribune*, February 17, 1961

"The painting *Cabinet Makers*, 1946, is one of a theme that I have been developing over a period of years. The general theme is *The Builders*. The tools that MAN has developed over the centuries are, to me, most beautiful and exciting in their forms and shapes. In developing their forms in a painting, I try to arrange them in a *dynamic and plastic composition*."

Statement by the artist, 1972

ERNEST LAWSON (1873–1939)

Born Halifax, Nova Scotia, Canada, March 22, 1873. Moved to Kansas City, Missouri, 1888. Worked as draftsman, Mexico City, 1889. Studied: The Art Students League of New York, 1891–92; with John Twachtman, and J. Alden Weir, Cos Cob, Connecticut, 1892; Académie Julian, Paris, 1893–94. Included in the Salon of 1893, Paris. Taught, University of Georgia, Columbus, 1897–98. Awarded: Silver Medal, St. Louis International Exposition, Missouri, 1904; Sesnan Gold Medal, Pennsylvania Academy Annual, 1907. One-man show, The Pennsylvania Academy of the Fine Arts, Philadelphia, 1907. Participated in "Exhibition of Eight American Painters," Macbeth Gallery, New York, and tour, 1908. National Academy of Design, New York: associate, 1908; academician, 1917. National Academy of Design Annual: First Hallgarten Prize, 1908; Inness Gold Medal, 1917; Saltus Gold Medal, 1930. Included in: the Armory Show, 1913; Society of Independent Artists Annual, 1917. Awarded: Gold Medal, Panama-Pacific International Exposition, San Francisco, 1915; Corcoran Silver Medal, and Second Clark Prize, Corcoran Biennial, 1916; Temple Gold Medal, Pennsylvania Academy Annual, 1920; Medal of the First Class, Carnegie International, 1921. One-man show, Nova Scotia Museum of Fine Arts, Halifax, 1919. Taught: Kansas City Art Institute and School of Design, 1926; Broadmoor Academy, Colorado Springs, Colorado, 1927. Included in "Paintings by Nineteen Living Americans," The Museum of Modern Art, New York, 1929–30. One-man shows, Ferargil Galleries, New York, 1930, 1932, 1936, 1938, 1945. Mural commission, Federal Works Agency, Public Buildings Administration, Section of Fine Arts, *Short Hills Landscape*, U.S. Post Office, Short Hills, New Jersey, 1939. Died Coral Gables, Florida, December 18, 1939. Posthumous one-man shows, New York: Babcock Galleries, 1943; Florence Lewison Gallery, 1962; Berry-Hill Gallery, 1968, 1969. Retrospective, The National Gallery of Canada, Ottawa, 1967.

Wet Night, Gramercy Park (After Rain; Nocturne). 1907.
 Oil on canvas, 26 × 29 inches
 Signed l. l. c.: "E. Lawson."

PROVENANCE:
Alexander Morten, New York; American Art Association, New York, Sale, January 29, 1919, no. 67; C. W. Kraushaar Galleries, New York; The Phillips Memorial Gallery, Washington, D.C.; Babcock Galleries, New York; Joseph Katz, Baltimore; Hirschl & Adler Galleries, New York, 1959

EXHIBITIONS:
Babcock Galleries, New York, April 10–May 1, 1943, *Ernest Lawson*, no. 4
The Brooklyn Museum, New York, November 24, 1943–January 16, 1944, *The Eight*, no. 37
The Cleveland Museum of Art, February 8–March 8, 1944, *The Eight* (The Museum of Modern Art, New

York, Circulating Exhibition), no. 37; toured to The Columbus Gallery of Fine Arts, Ohio, March 15–April 12; Worcester Art Museum, Massachusetts, April 26–May 24; Carnegie Institute, Pittsburgh, June 7–July 5; The Baltimore Museum of Art, July 19–September 19; The Toledo Museum of Art, Ohio, October 1–29; Memorial Art Gallery, The University of Rochester, New York, November 10–December 18
The Stamford Jewish Center, Connecticut, March 24–31, 1963, *Art in Homes in Stamford and Neighboring Communities*
New York State Pavilion, New York World's Fair, Flushing Meadows, 1964, *The City: Places and People*, cat.
The National Gallery of Canada, Ottawa, January 12–February 5, 1967, *Ernest Lawson*, no. 16, ill. p. 19

REFERENCES:
Berry-Hill, Henry, and Berry-Hill, Sidney. *Ernest Lawson*, Leigh-on-Sea, England, F. Lewis, 1968, plate 26
Boswell, Helen. "Noted American Impressionists," *Art Digest*, 17, April 15, 1943, p. 6
Phillips, Duncan. *A Collection in the Making*, Washington, D.C., The Phillips Memorial Gallery, 1926, p. 101
Unsigned. "Morten-Lawrence-Inglis Picture Sale," *American Art News*, 17, February 1, 1919, p. 9
——. "The Passing Shows," *Art News*, 42, April 15–30, 1943, p. 20

High Bridge. 1928.
 Oil on canvas, 30 × 36 inches
 Signed l. l.: "E. Lawson"

PROVENANCE:
G. David Thompson, Pittsburgh; Harold Diamond, New York, 1958

EXHIBITIONS:
Florence Lewison Gallery, New York, March 6–31, 1962, *Paintings by Ernest Lawson*, no. 12
Temple B'nai Sholom, Rockville Center, New York, March 31–April 3, 1963, *Fourth Annual Art Exhibit and Sale*

REFERENCES:
Tillim, Sidney. "In the Galleries: Lawson," *Arts Magazine*, 36, May–June 1962, p. 87

High Bridge, completed in 1884 as an aqueduct, spans the Harlem River, linking Manhattan to the Bronx. It was designated a New York City landmark in 1970.

Lawson painted views of High Bridge and its environs for over thirty years. Two other Lawson paintings of this scene are *Spring Night, Harlem River*, 1913 (The Phillips Collection, Washington, D.C.), and *High Bridge*, 1934 (Whitney Museum of American Art, New York).

Wild Bird's Roost. 1939.
 Oil on canvas, 25½ × 30 inches
 Signed l. l.: "E. Lawson"

PROVENANCE:
Ferargil Galleries, New York; Frederick Newlin Price, New York; Zabriskie Gallery, New York, 1959

EXHIBITIONS:
The Brooklyn Museum, New York, November 24, 1943–January 16, 1944, *The Eight*, no. 12
The Cleveland Museum of Art, February 8–March 8, 1944, *The Eight* (The Museum of Modern Art, New York, Circulating Exhibition), no. 42; toured to The Columbus Gallery of Fine Arts, Ohio, March 15–April 12; Worcester Art Museum, Massachusetts, April 26–May 24; Carnegie Institute, Pittsburgh, June 7–July 5; The Baltimore Museum of Art, July 19–September 19; The Toledo Museum of Art, Ohio, October 1–29; Memorial Art Gallery, The University of Rochester, New York, November 10–December 18
Zabriskie Gallery, New York, February 3–March 1, 1958, *The Eight*
Temple Emanuel, Great Neck, New York, October 12–19, 1961, *Great Neck Arts Festival*
Westport Public Library, Connecticut, February 13–March 6, 1962, *Collector's Choice*
The Corcoran Gallery of Art, Washington, D.C., October 9–November 14, 1971, *Wilderness* (sponsored by The National Endowment for the Arts), no. 122

JAN LEBENSTEIN (b. 1930)

Born Brest Litowsk, Poland, January 5, 1930. Studied, Academy of Fine Arts, Warsaw, until 1954. Included in: "Arsenal Exhibition of Young Painters," Warsaw, 1955; "2nd Exhibition of Modern Art," Warsaw, 1957; Guggenheim International, 1958; V São Paulo Bienal, 1959; Documenta II, Kassel, 1959; "15 Polish Painters," The Museum of Modern Art, New York, 1961. One-man shows, Society of Artists Gallery, Warsaw, 1956, 1958. Settled in Paris, 1959. Received Grand Prix de la Ville de Paris, I° Biennale de Paris, 1959. One-man shows: Galerie Lacloche, Paris, 1959, 1964; Galerie Lambert, Paris, 1960; Galerie Chalette, New York, 1961, 1962. Included in: Salon de Mai, Paris, 1960, 1961, 1965; Salon des Comparaisons, Paris, 1960, 1961, 1969; Pittsburgh International, 1961, 1964, 1967. Retrospective, Musée National d'Art Moderne, Paris, 1961. One-man shows: Palais des Beaux-Arts, Brussels, 1964; Bodley Gallery, New York, 1972; Galerie du Triangle, Paris, 1972; Michael Wyman Gallery, Chicago, 1973. Lives in Paris.

Axial Figure No. 90. 1960.
 Oil on canvas, 57½ × 35¼ inches
 Signed and dated l. r.: "Lebenstein 1960"

PROVENANCE:
Galerie Chalette, New York; Richard Feigen Gallery, Chicago; Mr. and Mrs. Harold E. Strauss, Chicago; Parke-Bernet Galleries, New York, Sale 2544, April 12, 1967, no. 36

LOUIS LE BROCQUY (b. 1916)

Born Dublin, November 10, 1916. Studied chemistry, Trinity College, Dublin, 1934–38. Visited museums in England and on the Continent, 1938–39. Returned to

Ireland, 1940. Designed sets and costumes, Gate Theatre, and Olympia Theatre, Dublin, 1940–41. Exhibited, Royal Hibernian Academy of Arts Annual, Dublin, 1941. One-man show at his studio, Dublin, 1942. Lived in London, 1946–58. Taught, London: Central School of Arts and Crafts, 1947–53; Textile School, Royal College of Art, 1954–57. One-man shows, London: Gimpel Fils, from 1947; The Leicester Galleries, 1948. Included in: "40 Years of Modern Art," Institute of Contemporary Arts, London, 1948; Salon de Mai, Paris, 1949; "Irish Painting," Institute of Contemporary Art, Boston, 1950; Venice Biennale, 1956; Guggenheim International Award, 1958; "50 Ans d'Art Moderne," Exposition Universelle et Internationale de Bruxelles, 1958. Mosaic commissions: College of Further Education, Merthyr Tydfil, Wales, 1953; St. Ignatius Church, Galway, Ireland, 1957. Worked in Var, France, 1958; near Lausanne, 1959. Elected: Fellow of Society of Industrial Artists, Dublin, 1960; member, Irish Council of Design, 1963; member of board, Kilkenny Design Workshops, 1964. Included in: Pittsburgh International, 1961, 1964; "British Painting in the Sixties," Contemporary Art Society, The Tate Gallery, London, 1963; "The Irish Imagination 1959–71," Municipal Gallery of Modern Art, Dublin (in association with ROSC '71), and tour, 1971–72. One-man shows: Dawson Gallery, Dublin, 1962, 1966, 1969, 1971; Gimpel & Hanover Galerie, Zurich, 1969; Gimpel & Weitzenhoffer Ltd., New York, 1971. Retrospective: Municipal Gallery of Modern Art, 1966, and Ulster Museum, Belfast, Northern Ireland, 1967. Lives in Carros, Alpes-Maritimes, France.

Willendorf Venus. 1964.
Oil on canvas, 25⅜ × 19⅜ inches
Signed and dated on back: "Louis Le Brocquy '64"

PROVENANCE:
Gimpel Fils, London, 1965

FERNAND LÉGER (1881–1955)

Born Argentan, Normandy, France, February 4, 1881. Worked as architect's apprentice, Caen, France, 1897–99. Moved to Paris, 1900; architectural draftsman, 1900–1902. Studied, Paris: École Nationale Supérieure des Arts Décoratifs, 1903; privately, with Jean-Léon Gérôme, and Gabriel Ferrier, 1903. Met Robert Delaunay, Paris, c. 1909. Exhibited, Salon des Indépendants, 1911, 1912; Salon de "La Section d'Or," with Alexander Archipenko, Marcel Duchamp, Raymond Duchamp-Villon, Albert Gleizes, Juan Gris, Roger de La Fresnaye, Jacques Villon, and others, Galerie La Boétie, 1912. One-man show, Galerie Kahnweiler, Paris, 1912. Served, French Army, 1914; wounded at Verdun, and discharged, 1917. One-man show, Galerie de l'Effort Moderne, Paris, 1919. Made film *Ballet Mécanique*, with Man Ray and Dudley Murphy, 1924. Murals, Exposition des Arts Décoratifs, Paris, 1925: Le Corbusier's Pavillon de l'Esprit Nouveau; with Delaunay, Palais de l'Ambassade de France. One-man shows: The Anderson Galleries, New York, 1925; Galerie Alfred Flechtheim, Berlin, 1928; Galerie Paul Rosenberg, Paris, 1930, 1937; Durand-Ruel Galleries, New York, 1931; Kunsthaus, Zurich, 1933; The Museum of Modern Art, New York, 1935; Palais des Beaux-Arts, Brussels, 1938. Co-directed Académie Moderne, Paris, with Amédée Ozenfant, 1929. Taught, Académie de la Grande Chaumière, Paris, 1932. Visited the U.S., 1940–45. Taught: Yale University, New Haven, Connecticut, 1940; Mills College, Oakland, California, 1941. Collaborated on film *Dreams that Money Can Buy*, with Marcel Duchamp, Alexander Calder, Hans Richter, 1944. Designed: mosaic for facade, Church at Assy, France, 1944–49; windows and tapestries, Church at Audincourt, France, 1951; murals, General Assembly, United Nations, New York, 1952. Retrospectives: Musée National d'Art Moderne, Paris, 1949; The Tate Gallery, London, 1950; The Art Institute of Chicago, and tour, 1953. Awarded Grand Prize, III São Paulo Bienal, 1955. Died Gif-sur-Yvette, France, August 17, 1955. Memorial exhibitions: The Museum of Modern Art, 1955; Musée des Arts Décoratifs, Paris, 1956; Palais des Beaux-Arts, Brussels, 1956. Musée Fernand Léger (now Musée National Fernand Léger) founded, Biot, France, 1960. Posthumous exhibitions: "Léger and Purist Paris," The Tate Gallery, 1970–71; retrospective, Grand Palais, Paris, 1971–72.

Nude on a Red Background (Nu sur fond rouge). 1927.
Oil on canvas, 51 × 32 inches
Signed and dated l. r.: "F. Leger/27"

PROVENANCE:
The artist, Paris; Marie Cuttoli, Paris; Harold Diamond, New York, 1968

EXHIBITIONS:
Musée National d'Art Moderne, Paris, October 6–November 13, 1949, *Fernand Léger: Exposition rétrospective 1905–1949*, no. 35
Musée des Arts Décoratifs, Paris, June–October 1956, *Léger rétrospective*, no. 63, ill. p. 197
Musée National d'Art Moderne, Paris, March 23–May 5, 1957, *Depuis Bonnard*, no. 111
Pavillon de Vendôme, Aix-en-Provence, France, July 15–September 28, 1958, *Collection d'un amateur parisien*, no. 21, ill.
Château de Rohan, Strasbourg, France, June–July 1960, *Picasso et ses amis*, no. 16
Galerie Charpentier, Paris, May 1960, *Cent Tableaux des collections privées, de Bonnard à de Staël*, no. 61, ill.
Documenta III, Kassel, June 27–October 5, 1964, part I, no. 14, p. 66

REFERENCES:
Forgey, Benjamin. "A Bonanza for Smithsonian," *Washington [D.C.] Star*, March 10, 1972, sec. E, ill. p. 12
George, Waldemar. *Fernand Léger*, Paris, Librairie Gallimard, 1929, ill. p. 37
Golding, John, and Green, Christopher. *Léger and Purist Paris*, London, The Tate Gallery, 1970, pp. 67, 101, ill. p. 65
Secrest, Meryle. "Hirshhorn: Gift to the Nation," *The Washington [D.C.] Post*, March 10, 1972, sec. C, ill. p. 1*
Unsigned. *Collection Marie Cuttoli Henri Langier Paris*, Basel, Beyeler, 1970, ill.
———. "The Story of a Great Patroness: The Cuttoli Tapestry," *Réalités*, 107, October 1959, p. 64, ill.

Still Life King of Diamonds (Nature morte, le roi de carreau). 1927.
Oil on canvas, 36 × 26 inches
Signed and dated l. r.: "F. Leger/27"

PROVENANCE:
J. B. Urvater, Brussels; Galerie Simon, Paris; Galerie Louise Leiris, Paris; Harold Diamond, New York, 1964

EXHIBITIONS:
Kunsthaus, Zurich, April 30–May 25, 1933, *Fernand Léger*, no. 130, ill.
Cercle Royal Artistique et Littéraire, XXXᵉ Salon, Brussels, 1956, *Hommage à Léger*
Palais des Beaux-Arts, Brussels, October–November 1956, *Fernand Léger*
Rijksmuseum Kröller-Müller, Otterlo, The Netherlands, 1957, *Les Grandes Collections belges: Collection Urvater*, no. 70; toured to Musée des Beaux-Arts de la Ville de Liège, Belgium
The Tate Gallery, London, December 1958–January 1959, *Urvater Collection*
Musée National d'Art Moderne, Paris, July 9–October 31, 1959, *L'École de Paris dans les collections belges*, no. 91
Galerie Beyeler, Basel, May–June 1964, *Fernand Léger*, no. 25, ill.

REFERENCES:
Unsigned. "Fernand Léger," *Cahiers d'Art*, 8, Paris, 1933, ill. p. 42

Sunflower (Le Tournesol). c. 1954.
Glazed ceramic and stone mosaic, 56¼ × 46¾ × 3¼ inches
Signed l. r.: "FL"

PROVENANCE:
Gift of Mme Nadia Léger, Antibes, France, 1968

WILHELM LEHMBRUCK (1881–1919)

Heinrich Wilhelm Lehmbruck, born Meiderich, Germany, January 4, 1881. Studied, Kunstgewerbeschule, Düsseldorf, 1895–99. Worked as sculptor's assistant, and illustrator of anatomy and botany textbooks, 1899–1901. Studied, Königlich Preussische Kunstakademie der Rheinprovinzen, Düsseldorf, with Karl Janssen, 1901–6. First trip to Italy, 1905. Traveled to Paris, 1907, 1908; lived in Paris, 1910–14. Included in: Salon de la Société Nationale des Beaux-Arts, Paris, 1907–11; Salon d'Automne, Paris, 1910, 1911, 1914; Salon des Indépendants, Paris, 1911, 1912; Sonderbund-Ausstellung, Cologne, 1912; the Armory Show, 1913; Neue Sezession, Munich, 1914; Freie Sezession, Berlin, 1914, 1916, 1917. One-man shows: Galerie Levesque, Paris, 1914; Städtische Kunsthalle, Mannheim, Germany, 1916; Kunsthaus, Zurich, 1917. Lived in Berlin, 1914–17. Moved to Switzerland, to avoid active military service, 1917; lived in Zurich, 1917–18. Returned to Berlin, 1919. Admitted to Preussische Akademie der Künste, Berlin, 1919. Died by suicide, Berlin, March 25, 1919. Memorial exhibitions: Kunstsalon Neupert, Zurich, 1919; Freie Sezession, Berlin, 1919; Galerie Paul Cassirer, Berlin, 1920; Neue Sezession, Munich, 1921. Posthumous exhibition, "Lehmbruck-Maillol," The Museum of Modern Art, New York, 1930. Wilhelm-Lehmbruck-Museum der Stadt founded, Duisburg, 1964. Retrospectives: Stedelijk Museum, Amsterdam, 1956; Kunsthaus, Zurich, 1956; The Tate Gallery, London, 1957; National Gallery of Art, Washington, D.C., and tour, 1972–73.

Torso. 1910–11.
Bronze, 26¼ × 9 × 8 inches
Markings: back l. c. "W. Lehmbruck"
back l.l. "H. Noack, Berlin"

PROVENANCE:
Fine Arts Associates, New York, 1957

EXHIBITIONS:
Mead Art Building, Amherst College, Massachusetts, February 17–March 17, 1958, *The 1913 Armory Show in Retrospect*, no. 30
The Detroit Institute of Arts, and tour, 1959–60, *Sculpture in Our Time*, no. 119, ill. p. 56
The Solomon R. Guggenheim Museum, New York, October 3, 1962–January 6, 1963, *Modern Sculpture from the Joseph H. Hirshhorn Collection*, no. 233, ill. p. 47
Hopkins Art Center, Dartmouth College, Hanover, New Hampshire, May 25–July 9, 1967, *Sculpture in Our Century: Selections from the Joseph H. Hirshhorn Collection*, no. 29, ill. p. 24

Bowing Female Torso. 1913.
Cast stone, 36 × 11¼ × 18 inches
Markings: l. top of base "Lehmbruck"

PROVENANCE:
Dr. Friedrich Bergius, Heidelberg, Germany; Janos Peter Kramer; Parke-Bernet Galleries, New York, Sale 1730, February 6, 1957, no. 38, ill.

EXHIBITIONS:
Museo Nacional de Bellas Artes, Buenos Aires, *Esculturas Argentinas y Extranjeras*, June 1956, cat., ill.
The Solomon R. Guggenheim Museum, New York, October 3, 1962–January 6, 1963, *Modern Sculpture from the Joseph H. Hirshhorn Collection*, no. 235, ill. p. 46

REFERENCES:
Unsigned. "Coming Auctions," *Art News*, 55, February 1957, ill. p. 14
———. "'Esculturas Argentinas y Extranjeras,'" *Boletín del Museo*, Museo Nacional de Bellas Artes, Buenos Aires, 1, June 1956, ill.

JEAN-BAPTISTE LEMOYNE (1704–1778)

Jean-Baptiste Lemoyne II, born Paris, February 15, 1704; son of sculptor Jean-Louis Lemoyne (1665–1755), and nephew of sculptor Jean-Baptiste Lemoyne I (1679/81–1731). Studied with father and Robert Le Lorrain. Received Prix de Rome, 1725. Académie Royale de Peinture et de Sculpture: agrée, 1728; academician, 1738; professor, 1744; director, 1768. Pupils included Jean-Baptiste Pigalle, Étienne-Maurice Falconet, Jean-Jacques Caffiéri, Jean-Antoine Houdon. Exhibited at the Salon, Paris, 1737–71. Principal portrait sculptor at the court of Louis XV. Commissions with painter Noël-Nicolas Coypel, decorations for Chapel of the Virgin, Church of Saint-Sauveur, Paris (completed), 1732; equestrian statue of Louis XV, Bordeaux, France, 1734 (destroyed during French Revolution). Died Paris, May 25, 1778. Busts of Voltaire, 1744, and Jean-Jacques Rousseau, 1766, exhibited posthumously, Salon of 1791.

Noël-Nicolas Coypel. c. 1730.
Terra-cotta, 24½ × 15¾ × 14¼ inches
Markings: r. side "J. B. Lemoyne fecit"
back l. "Coypel Peintre du Roy"

PROVENANCE:
Bernard Black Gallery, New York, 1969

EXHIBITIONS:
Bernard Black Gallery, New York, April 1969, *Recent Acquisitions*, no. 5

REFERENCES:
Bernard Black Gallery, New York, *Apollo*, 89, April 1969, ill. p. lxxx (adv.)
———, *Connoisseur*, 170, April 1969, ill. p. xc (adv.)

Like his friend Lemoyne, the painter Noël-Nicolas Coypel (1690–1734) came from a family of artists long associated with the French court and the Académie de France à Rome.

This is one of Lemoyne's earliest and most spontaneous portraits. It was perhaps made while the artists were working together on the decorations for the Chapel of the Virgin in the Church of Saint-Sauveur, Paris. Coypel's altarpiece *The Assumption of the Virgin*, made for the church at that time, was destroyed in 1776.

JULIO LE PARC (b. 1928)

Born Mendoza, Argentina, September 23, 1928. Studied, Escuela de Bellas Artes, Buenos Aires, c. 1943. Included in IV São Paulo Bienal, 1957. Settled in Paris, 1958. Co-founded Groupe de Recherche d'Art Visuel, Paris, with François Morellet, Francisco Sobrino, Joël Stein, Yvaral, 1960; exhibited with group, Paris: in their studio, 1960, 1961; Galerie Denise René, 1961. Included in: "Art Abstrait Constructif International," Galerie Denise René, 1961; "Nove Tendencije 1 and 2," Galerije Grada Zagreba, Zagreb, Yugoslavia, 1961, 1963; Pittsburgh International, 1961, 1967, 1970; "L'Instabilité: Groupe de Recherche d'Art Visuel—Paris," The Contemporaries, New York, 1962. Exhibited with Sobrino, and Yvaral, Galerie Aujourd'hui, Brussels, 1963. Included in: Documenta III, Kassel, 1964; Venice Biennale, 1964, 1966 (Grand Prize), 1970; "Mouvement II," Galerie Denise René, 1964; "Kinetic and Optic Art Today," and "Plus by Minus: Today's Half-Century," Albright-Knox Art Gallery, Buffalo, New York, 1965, 1968; "The Responsive Eye," The Museum of Modern Art, New York, and tour, 1965–66; IX São Paulo Bienal, 1967; "Kinetik und Bewegte Kunst," Museum des 20. Jahrhunderts, Vienna, 1967; "Lumière et Mouvement, Art Cinétique à Paris," Musée d'Art Moderne de la Ville de Paris, 1967. One-man shows: Galerie Denise René, 1966; Howard Wise Gallery, New York, 1966–67; Ulmer Museum, Ulm, Germany, 1970–71; Städtische Kunsthalle, Düsseldorf, 1972. Lives in Paris.

Instability. 1963.
Wood, plastic, and aluminum mobile (1/6), 31⅜ × 31⅜ × 3¼ inches
Signed and dated on back: "Le Parc 1963"

PROVENANCE:
The Contemporaries, New York, 1963

DAVID LEVINE (b. 1926)

Born Brooklyn, New York, December 20, 1926. Studied: Tyler School of Art of Temple University, Philadelphia, 1943–45, 1947–49; Hans Hofmann School of Fine Art, New York, and Provincetown, Massachusetts, 1950–51. Served, U.S. Army, 1945–47. Editorial artist, *Esquire, The New York Review of Books, The Washington [D.C.] Post, Newsweek, Time*. One-man shows: Davis Galleries, New York, 1953–57, 1959, 1961–63; California Palace of the Legion of Honor, San Francisco, 1959–60, 1968. Received Louis Comfort Tiffany Foundation Fellowship, 1955. Included in: Whitney Annual, 1960, 1962; National Academy Annual, 1962 (Clarke Prize); Pennsylvania Academy Annual, 1966, 1969. Taught: The School of Visual Arts, New York, 1961–62; The Brooklyn Museum Art School, 1963–66. One-man shows: Forum Gallery, New York, 1965–68, 1970, 1971, 1973; Lunn Gallery, Washington, D.C., 1971. Received Guggenheim Foundation Fellowship, 1966. Books of drawings include: *The Man from M.A.L.I.C.E.* (New York, Dutton), 1966; *Pens and Needles*, selected by John Updike (Boston, Gambit), 1969; *No Known Survivors*, selected by John Kenneth Galbraith (Boston, Gambit), 1970. Exhibited with Aaron Shikler, The Brooklyn Museum, 1971. Lives in Brooklyn.

Coney Island Bathing. 1965.
Watercolor on paper, 19 × 25 inches
Signed and dated l. l.: "D. Levine 65"

PROVENANCE:
Forum Gallery, New York, 1965

EXHIBITIONS:
Forum Gallery, New York, December 7–20, 1965, *David Levine: Coney Island*, no. 33
The Pennsylvania Academy of the Fine Arts, Philadelphia, January 17–March 2, 1969, *The One Hundred and Sixty-Fourth Annual Exhibition: Watercolors, Prints, Drawings*, no. 114

"The exotic tangle of color, ethnic variety, eternals of human relationships, drama and comedy, all of this

served up with traditional and contemporary awareness, is the subject of my 'Coney Island'. I have drawn and painted several hundred works on this theme. As Coney Island is left to decay, its structures become my 'Tinturn Abbey' and its people my 'Orientals.'"

<div style="text-align:right">Statement by the artist, 1972</div>

JACK LEVINE (b. 1915)

Born Boston, January 3, 1915. First art lessons, with Harold Zimmerman, West End Community Center, Roxbury, Massachusetts, 1924–31; Hyman Bloom, a fellow student. Studied drawing, Museum of Fine Arts, Boston, 1929. With Bloom, worked under tutelage of Denman Ross, Department of Fine Arts, Harvard University, Cambridge, Massachusetts, c. 1929–32. WPA Federal Art Project, Easel Division, intermittently, 1935–40. Included in: "New Horizons in American Art," and "Americans 1942," The Museum of Modern Art, New York, 1936, 1942; Whitney Annual, 1938–67; "Portrait of America (Artists for Victory, Inc.)," The Metropolitan Museum of Art (second prize), 1942. One-man shows, The Downtown Gallery, New York, 1939, 1948, 1952. Served, U.S. Army Corps of Engineers, 1942–45. Received: Guggenheim Foundation Fellowship, 1945, 1947; grant, The American Academy of Arts and Sciences, 1946; Sesnan Gold Medal, Pennsylvania Academy Annual, 1948; Fulbright Grant, Rome, 1950–51. Included in: I São Paulo Bienal, 1951; Pittsburgh International, 1955; Venice Biennale, 1956; I Bienal Interamericana, Mexico City, 1958. Skowhegan School of Painting and Sculpture, Maine: taught, summers, 1952, 1953; member, Board of Governors, 1962. Retrospective, Institute of Contemporary Art, Boston, and tour, 1952–55. One-man shows: The Alan Gallery, New York, 1953, 1957, 1959–60, 1963, 1964, 1966; Berkshire Museum, Pittsfield, Massachusetts, 1963; Museum of Art of Ogunquit, Maine, 1964. Member, The National Institute of Arts and Letters, 1956. Retrospectives: II Bienal Interamericana, Mexico City, 1960; De Cordova and Dana Museum, Lincoln, Massachusetts, 1968. Taught, The Pennsylvania Academy of the Fine Arts, Philadelphia, 1966–69. One-man shows, Kennedy Galleries, New York, 1972, 1973 (graphics). Member, The American Academy of Arts and Letters, 1973. Lives in New York.

Reception in Miami. 1948.
Oil on canvas, 50 × 56 inches
Signed l. l.: "J Levine"

PROVENANCE:
The Downtown Gallery, New York; Whitney Museum of American Art, New York; The Alan Gallery, New York, 1954

EXHIBITIONS:
The Downtown Gallery, New York, October 1–23, 1948, *23rd Annual Exhibition*
Whitney Museum of American Art, New York, November 13, 1948–January 2, 1949, *Annual Exhibition of Contemporary American Painting*, no. 84
University of Illinois, Urbana, February 26–April 3, 1949, *Contemporary American Painting*, plate 18
The Art Institute of Chicago, October 25–December 16, 1951, *60th Annual Exhibition: Paintings and Sculpture*, no. 98
Institute of Contemporary Art, Boston, September 17–October 19, 1952, *Jack Levine Retrospective*, no. 7, ill. p. 14; toured to Currier Gallery of Art, Manchester, New Hampshire, November 5–30; C olorado Springs Fine Arts Center, Colorado, February 3–28, 1953; Akron Art Institute, Ohio, March 18–April 19; The Phillips Collection, Washington, D.C., May 3–June 1; Whitney Museum of American Art, New York, February 9–April 3, 1955, no. 25, ill. p. 14
Hackley Art Gallery, Muskegon, Michigan, October 1–23, 1955, *A Collector's Choice* (American Federation of Arts, Circulating Exhibition); toured to nine U.S. cities

REFERENCES:
Archives of American Art, Smithsonian Institution, Washington, D.C., *The Downtown Gallery Archives*
Coates, Robert M. "The Art Galleries: Nineteenth Century French and Two Bostonians," *The New Yorker*, 139, March 12, 1955, p. 20
Devree, Howard. "Museum Purchases," *The New York Times*, January 2, 1949, sec. 2, p. 14, ill. 33
Frankfurter, Alfred M. "Spotlight on: Levine," *Art News*, 47, May 1948, p. 54
Getlein, Frank. "Jack Levine: The Degrees of Corruption," *The New Republic*, 139, October 6, 1958, p. 20
———. *Jack Levine*, New York, Abrams, 1966, p. 19, colorplates 36, 45
Kramer, Hilton. "Fortnight in Review: Hyman Bloom and Jack Levine," *Arts Digest*, 29, March 15, 1955, p. 22, ill.
Louchheim, Aline. "Boston Sees Levine in Retrospect," *The New York Times*, September 21, 1952, sec. 2, p. 9
Morgan, Patrick. "Coast to Coast: Boston," *Art Digest*, 27, October 1, 1952, p. 12
Robb, Marilyn. "Chicago Angle on the Country," *Art News*, 50, November 1951, part 1, p. 35
Wight, Frederick S. "A Jack Levine Profile," *Art Digest*, 26, September 15, 1952, p. 11

"I read one day in Earl Wilson's column that the Duke and Duchess of Windsor had come to Miami and that on their appearance in the lobby there was much bowing and curtseying on the part of our fellow Americans. I thought this disgusting. I also thought it amusing to base a large canvas on an item in Wilson's column."

<div style="text-align:right">Statement by the artist, 1972</div>

35 Minutes from Times Square. 1956.
Oil on canvas, 48 × 49 inches
Signed l. l.: "J. Levine"

PROVENANCE:
The Alan Gallery, New York, 1956

EXHIBITIONS:
The Alan Gallery, New York, May 7–25, 1957, *Jack Levine*, no. 2

Utah Museum of Fine Arts, University of Utah, Salt Lake City, March 1–23, 1958, *Fourth Annual Invitational Exhibition: Nine American Painters*, ill.
Whitney Museum of American Art, New York, April 30–June 15, 1958, *The Museum and Its Friends*, no. 101
Whitney Museum of American Art, New York, September 16–October 5, 1958, *Fulbright Painters* (Smithsonian Institution, Traveling Exhibition Service); toured to ten U.S. cities
Instituto Nacional de Bellas Artes, Mexico City, September 5–November 5, 1960, *II Bienal Interamericana*
Berkshire Museum, Pittsfield, Massachusetts, July 2–31, 1963, *Paintings by Jack Levine*, no. 8
Museum of Art of Ogunquit, Maine, July 4–September 10, 1964, *Paintings by Jack Levine*, no. 18

REFERENCES:
Coates, Robert M. "The Art Galleries: Male and Female," *The New Yorker*, 33, May 18, 1957, pp. 129–30
Gerdts, William H. *The Great American Nude*, New York, Praeger, forthcoming, ill.
Getlein, Frank. *Jack Levine*, New York, Abrams, 1966, plate 90
Sawin, Martica. "In the Galleries: Jack Levine," *Arts*, 31, June 1957, p. 53, ill.

"Now that midtown New York City has become the raunchiest place in the world it seems necessary to explain that in 1956 burlesque theaters were illegal in the city. Burlesque houses in Newark, in Jersey City, and elsewhere would advertise their distance from Times Square as a central point. Thirty-five minutes is I suppose a wrong estimate."

<div style="text-align:right">Statement by the artist, 1972</div>

The Last Waltz. 1962.
Oil on canvas, 78 × 48 inches
Signed l. r.: "J. Levine"

PROVENANCE:
The Alan Gallery, New York, 1962

EXHIBITIONS:
The Alan Gallery, New York, September 25–October 13, 1962, *Tenth Anniversary Season*, no. 15, ill.
The Alan Gallery, New York, April 8–27, 1963, *Jack Levine*, no. 10
Whitney Museum of American Art, New York, July 16–September 1, 1963, *26 Artists from the Collections of the Whitney Museum and Its Friends*
The Pennsylvania Academy of the Fine Arts, Philadelphia, January 15–March 1, 1964, *One Hundred and Fifty-Ninth Annual Exhibition of American Painting and Sculpture*, no. 100, ill.
De Cordova and Dana Museum, Lincoln, Massachusetts, February 4–March 24, 1968, *Jack Levine*, no. 18, ill. p. 11

REFERENCES:
Canaday, John. "Art: Debutante and a Grand Old Man," *The New York Times*, January 16, 1964, p. 22
Getlein, Frank. *Jack Levine*, New York, Abrams, 1966, colorplate 142

MON LEVINSON (b. 1926)

Born New York, January 6, 1926. Served, U.S. Army, 1945–46. Studied, University of Pennsylvania, Philadelphia; B.S., 1948. Self-taught as an artist. First exhibited, "New Forms, New Media," Martha Jackson Gallery, New York, 1960. One-man shows: Kornblee Gallery, New York, 1961, 1963–66, 1968–69, 1971–72; Franklin Siden Gallery, Detroit, 1965–67, 1969; Obelisk Gallery, Boston, 1968. Commissions, New York: banner, Betsy Ross Flag and Banner Co., 1963; sculpture, Public School 166, 1967; murals, for architect M. Paul Friedberg, vest-pocket parks, 1967–69. Included in: "The Classic Spirit in 20th Century Art," Sidney Janis Gallery, New York, 1964; "The Responsive Eye," The Museum of Modern Art, New York, and tour, 1965–66; "Plus by Minus: Today's Half-Century," Albright-Knox Art Gallery, Buffalo, New York, 1968; "A Plastic Presence," Milwaukee Art Center, 1969; Whitney Annual, 1970; Whitney Biennial, 1973. Taught, School of the Museum of Fine Arts, Boston, 1969. Lives in New York.

The Edge I. 1965.
Front panel: acetate ink on Plexiglas; back panel: moiré paper, 30 × 30 inches
Dated on back: "1965"

PROVENANCE:
Kornblee Gallery, New York, 1965

EXHIBITIONS:
Kornblee Gallery, New York, March 1965, *Mon Levinson*

ROY LICHTENSTEIN (b. 1923)

Born New York, October 27, 1923. Studied: The Art Students League of New York, with Reginald Marsh, 1939; Ohio State University, Columbus, 1940–43, B.F.A., 1946, M.F.A., 1949. Served as cartographic draftsman, U.S. Army, Europe, 1943–46. Taught: Ohio State University, 1949–51; College of Education, State University College at Oswego, New York, 1957–60; Douglass College, Rutgers University, New Brunswick, New Jersey, 1960–63. One-man shows, New York: Carlebach Gallery, 1951; John Heller Gallery, 1952–54, 1957. Lived in Cleveland, 1951–57. Included in: "New Paintings of Common Objects," Pasadena Art Museum, California, 1962; "Pop Goes the Easel," Contemporary Arts Museum, Houston, 1963; "Word and Image," The Solomon R. Guggenheim Museum, New York, 1965; Whitney Annual, 1965–72. One-man shows: Leo Castelli Gallery, New York, from 1962; Galerie Ileana Sonnabend, Paris, 1965; Pasadena Art Museum, 1967; Walker Art Center, Minneapolis, 1967; The Contemporary Arts Center, Cincinnati, Ohio, 1967; Stedelijk Museum, Amsterdam, and tour, 1967–68; The Solomon R. Guggenheim Museum, 1969; University of California, Irvine, and Gemini G.E.L., Los Angeles (graphics), 1970. Mural, New York State Pavilion, New York World's Fair, Flushing Meadows, 1964–65. Included in: Venice Biennale, 1966, 1970; ROSC '67, Dublin, 1967; Pittsburgh International,

1967; Documenta 4, Kassel, 1968; "New York Painting and Sculpture: 1940–1970," The Metropolitan Museum of Art, New York, 1969–70; Whitney Biennial, 1973. Lives in New York.

Modern Sculpture with Black Shaft. 1967.
Aluminum and glass (1/3), 81 × 53½ × 18 inches

PROVENANCE:
Leo Castelli Gallery, New York, 1967

EXHIBITIONS:
Leo Castelli Gallery, New York, October 28–November 18, 1967, *Roy Lichtenstein*
The Contemporary Arts Center, Cincinnati, Ohio, December 7–31, 1967, *Roy Lichtenstein: Exhibition of Paintings and Sculpture*, cat., ill.

REFERENCES:
Alfieri, Bruno. "Come andare avanti," *Metro*, 14, June 1968, ill. p. 83
Waldman, Diane. *Roy Lichtenstein*, New York, Abrams, 1971, p. 247, plate 157

Modern Painting with Clef. 1967.
Oil and acrylic on canvas, 8 feet 4 inches × 15 feet
Signed and dated on back: "Roy Lichtenstein '67"

PROVENANCE:
Leo Castelli Gallery, New York, 1967

EXHIBITIONS:
Leo Castelli Gallery, New York, October 28–November 18, 1967, *Roy Lichtenstein*
The Contemporary Arts Center, Cincinnati, Ohio, December 7–31, 1967, *Roy Lichtenstein: Exhibition of Paintings and Sculpture*, ill. pp. 6, 7
Documenta 4, Kassel, June 27–October 6, 1968, no. 4, p. 172, ill. p. 175
The Solomon R. Guggenheim Museum, New York, September 19–November 16, 1969, *Roy Lichtenstein*, no. 49, ill. p. 64

REFERENCES:
Alfieri, Bruno. "Come andare avanti," *Metro*, 14, June 1968, ill. p. 83
Compton, Michael. *Pop Art*, London, Hamlyn, 1970, colorplate 121
Jacobs, Jay. "Collector: Joseph H. Hirshhorn," *Art in America*, 57, July–August 1969, p. 64, colorplate
———. "Quality as Well as Quantity: Joseph H. Hirshhorn," in Lipman, Jean, ed. *The Collector in America*, New York, Viking, 1971, colorplate p. 79
Waldman, Diane. *Roy Lichtenstein*, New York, Abrams, 1971, pp. 22, 247, colorplate 146

RICHARD LINDNER (b. 1901)

Born Hamburg, November 11, 1901. Studied: music, Nuremberg Conservatory, Germany, with brief career as concert pianist; Kunstgewerbeschule, Nuremberg, 1922–24; Kunstgewerbeschule, Munich, 1924–25; Akademie der Bildenden Künste, Munich, 1925–27. Art director, Knorr & Hirth, publishers, Munich, 1929. Fled to Paris, 1933. Emigrated to the U.S., 1941; citizen, 1948. Illustrator, *Vogue*, *Fortune*, *Harper's Bazaar*, 1941–50. Taught, Pratt Institute, Brooklyn, New York, 1952–65. One-man shows: Betty Parsons Gallery, New York, 1954, 1956, 1959; Cordier & Ekstrom, New York, 1963–67; Städtisches Museum, Leverkusen, Germany, and tour, 1968–69; Spencer Samuels Gallery, New York, 1971; Musée National d'Art Moderne, Paris, 1972. Received Copley Foundation Award, 1957. Guest lecturer: Yale University, New Haven, Connecticut, 1957; Staatliche Hochschule für Bildende Künste, Hamburg, 1965. Included in: Whitney Annual, 1962, 1965, 1967; "Painting and Sculpture of a Decade, 54–64," The Tate Gallery, London, 1964; Documenta 4, Kassel, 1968; ROSC '71, Dublin, 1971. Member, The National Institute of Arts and Letters, 1972. Lives in New York, and in Paris.

New York City IV. 1964.
Oil on canvas, 69¼ × 60 inches
Signed and dated l. r.: "R. Lindner 1964"

PROVENANCE:
Galerie Claude Bernard, Paris, 1965

EXHIBITIONS:
Galerie Claude Bernard, Paris, May 1965, *Richard Lindner*, cat., ill.
University Art Museum, University of California, Berkeley, June 17–July 27, 1969, *Lindner*, no. 63; and Walker Art Center, Minneapolis, August 11–30

REFERENCES:
Ashton, Dore. *Richard Lindner*, New York, Abrams, 1970, no. 139, colorplate
Städtisches Museum, Leverkusen, Germany, *Richard Lindner*, 1968, no. 109

JACQUES LIPCHITZ (1891–1973)

Chaim Jacob Lipchitz, born Druskieniki, Lithuania, August 22, 1891. Moved to Paris; 1909; French citizen, 1924. Studied, École des Beaux-Arts, and Académie Julian, Paris, 1909–10. Introduced to Picasso, and other Cubists, by Diego Rivera, 1913. First one-man show, Galerie de l'Effort Moderne, Paris, 1920. Commissions: five reliefs, for Albert C. Barnes, Barnes Foundation, Merion, Pennsylvania, 1922; *La Joie de Vivre*, for garden of Vicomte de Noailles, Hyères, France, 1927; *Prometheus*, Exposition Universelle de 1937, Paris (Gold Medal). Retrospective, Galerie de la Renaissance, Paris, 1930. One-man show, Brummer Gallery, New York, 1935. Fled from Paris, to Toulouse, France, 1940; to New York, 1941. One-man shows, Buchholz Gallery, New York, 1942, 1943, 1946, 1948, 1951. Commission, *Prometheus Strangling the Vulture*, Ministry of Education and Health Building, Rio de Janeiro, 1943–44. Returned to France, 1946: chevalier, Légion d'honneur; one-man show, Galerie Maeght, Paris; baptismal font and sculpture of the Virgin commissioned, Church of Notre-Dame-de-Toute-Grâce, Assy. Settled in Hastings-on-Hudson, New York, 1947. One-man shows: Portland Art Museum, Oregon, and tour, 1950; Venice Biennale, 1952; The Museum of Modern Art, New York, Circulating Exhibition, 1954; The New Gallery, New York, 1955; Fine Arts Associates, New York, 1957–63;

Stedelijk Museum, Amsterdam, and tour, 1958–59; Otto Gerson Gallery, and Andrew Dickson White Museum of Art, Cornell University, Ithaca, New York, 1961–62; Marlborough Gallery, New York, from 1964. Member: The National Institute of Arts and Letters, 1961; The American Academy of Arts and Letters, 1962. Began working summers in Pietrasanta, Italy, 1963. Retrospective, The Art Galleries, University of California at Los Angeles, and tour, 1963–64. Awarded Gold Medal, The American Academy of Arts and Letters, 1966. *Peace on Earth* dedicated, Los Angeles County Music Center, 1969. Retrospectives: Tel Aviv Museum, Israel, and Nationalgalerie, Berlin, 1970–72; The Metropolitan Museum of Art, New York, 1972. Died Capri, May 26, 1973.

Bather. 1915.
Bronze, 31¼ × 7⅛ × 4⅛ inches
Markings back l.: "2/7 JLipchitz"
thumbprint

PROVENANCE:
Otto Gerson Gallery, New York, 1961

EXHIBITIONS:
The Solomon R. Guggenheim Museum, New York, October 3, 1962–January 6, 1963, *Modern Sculpture from the Joseph H. Hirshhorn Collection*, no. 238, ill. p. 69

REFERENCES:
Hamilton, George Heard. *Painting and Sculpture in Europe: 1880 to 1940*, Baltimore, Penguin, 1967, plate 103

Head. 1915.
Bronze, 24 × 7⅛ × 7⅜ inches
Markings: l. r. side "JLipchitz 2/7"
thumbprint

PROVENANCE:
Curt Valentin Gallery, New York; Fine Arts Associates, New York, 1956

EXHIBITIONS:
XXVI Biennale Internazionale d'Arte, Venice, June 14–October 19, 1952, *French Pavilion*, no. 118
The Detroit Institute of Arts, and tour, 1959–60, *Sculpture in Our Time*, no. 121
The Solomon R. Guggenheim Museum, New York, October 3, 1962–January 6, 1963, *Modern Sculpture from the Joseph H. Hirshhorn Collection*, no. 237, ill. p. 69

REFERENCES:
Arnason, H. Harvard. *History of Modern Art*, New York, Abrams, 1968, p. 188, ill. p. 189
———. *Jacques Lipchitz: Sketches in Bronze*, New York, Praeger, 1969, ill. p. 9
Hammacher, A. M. *Jacques Lipchitz: His Sculpture*, New York, Abrams, 1960, pp. 170, 172, ills. p. 37 and plate 21
Read, Herbert. *A Concise History of Modern Sculpture*, New York, Praeger, 1964, no. 75, p. 296, ill. p. 75
Zanini, Walter. *Tendências da escultura moderna*, São Paulo, Cultrix, 1971, ill. p. 109

"In my cubist sculpture I always wanted to retain the sense of organic life, of humanity. It was as a result of this encounter that I made the *Head*, about 1915, which was my most nonrealistic work to that time but was still strongly rooted in nature. I should say it is a sculpture parallel to nature maintaining its sense of humanity within the abstract forms. From this point I was able to create cubist sculpture with a confidence and understanding of what I was doing."

The artist, with Arnason, H. Harvard. *My Life in Sculpture*, New York, Viking, 1972, pp. 20–23

Still Life. 1919.
Gouache and sand on cardboard, 18 × 23 inches
Signed u. l.: "J Lipchitz"

PROVENANCE:
Curt Valentin Gallery, New York; G. David Thompson, Pittsburgh; The New Gallery, New York; Oscar Krasner Gallery, New York, 1965

EXHIBITIONS:
The New Gallery, New York, September 26–October 8, 1955, *Jacques Lipchitz: Studies for Polychromed Bas-reliefs, Cubist Drawings and Gouaches 1912–1919*, no. 17

REFERENCES:
The Museum of Modern Art, New York, *Curt Valentin Gallery Photo Archives*, vol. 1, ill. p. 11

Girl Reading (Liseuse). 1919.
Bronze, 30 × 11¼ × 9⅜ inches
Markings: back l. c. "JLipchitz 5/7"
thumbprint

PROVENANCE:
Fine Arts Associates, New York, 1956

EXHIBITIONS:
The Detroit Institute of Arts, and tour, 1959–60, *Sculpture in Our Time*, no. 122, ill. p. 57
The Solomon R. Guggenheim Museum, New York, October 3, 1962–January 6, 1963, *Modern Sculpture from the Joseph H. Hirshhorn Collection*, no. 239, ill. p. 69
The Art Galleries, University of California at Los Angeles, March 3–April 10, 1963, *Jacques Lipchitz: A Retrospective Selected by the Artist*, no. 28, ill.; toured to San Francisco Museum of Art, April 23–June 1; The Denver Art Museum, June 20–July 31; Fort Worth Art Center Museum, Texas, October; Walker Art Center, Minneapolis, November 18–January 18, 1964; Des Moines Art Center, Iowa, February 1–March 7; Philadelphia Museum of Art, April 1–May 31
J. B. Speed Art Museum, Louisville, Kentucky, October 15–November 28, 1965, *The Figure in Sculpture: 1865–1965*, no. 13, ill.
Hopkins Art Center, Dartmouth College, Hanover, New

Hampshire, May 25–July 9, 1967, *Sculpture in Our Century: Selections from the Joseph H. Hirshhorn Collection*, no. 33, ill. p. 25
Smithsonian Institution, Washington, D.C., 1972–73, extended loan

REFERENCES:
Crawford, Lenore. "'Sculpture in Our Time' at Detroit Shows Development of Past 75 Years," *London [Ontario] Free Press*, June 20, 1959

Figure. 1926–30.
Bronze, 87¼ × 38⅛ × 28⅛ inches
Markings: back l. c. "JLipchitz 1926–30"

PROVENANCE:
Otto Gerson Gallery, New York, 1961

EXHIBITIONS:
The Solomon R. Guggenheim Museum, New York, October 3, 1962–January 6, 1963, *Modern Sculpture from the Joseph H. Hirshhorn Collection*, no. 241, ill. p. 101
Los Angeles County Museum of Art, April–July 1965, *Inaugural Loan Exhibition*
Expo '67, Montreal, April 28–October 27, 1967, *International Exhibition of Contemporary Sculpture*, p. 119, ill. p. 92

REFERENCES:
Hamilton, George Heard. *Painting and Sculpture in Europe: 1880 to 1940*, Baltimore, Penguin, 1967, plate 104
Read, Herbert. *A Concise History of Modern Sculpture*, New York, Praeger, 1964, no. 79, p. 296, ill. p. 77
Rudikoff, Sonya. "New York Letter," *Art International*, 6, November 1962, p. 62
Sweeney, James Johnson. "A Living Frame for Sculpture," *House & Garden*, 126, August 1964, ill. p. 113
Unsigned. "Art: Lone Wolf," *Newsweek*, 60, October 15, 1962, ill. p. 110
———. "The Hirshhorn Approach," *Time*, 80, October 5, 1962, ill. p. 75

". . . the great *Figure*, 1926–1930, a work that summarized many of my ideas dating back to 1915. Specifically, it pulled together those different directions of massive, material frontality and of aerial openness in which I had been working during the 1920s. It is also very clearly a subject sculpture, an image with a specific and rather frightening personality. Although the *Figure* has been associated with African sculpture and the resemblance is apparent, it is now evident to me that it emerged, step by step, from findings I made in my cubist and postcubist sculpture over the previous fifteen years."

The artist, with Arnason, H. Harvard. *My Life in Sculpture*, New York, Viking, 1972, p. 90

Reclining Nude with Guitar. 1928.
Bronze, 16 × 29¾ × 13 inches
Markings: back l. l. "JLipchitz"
back l. r. "Cire Perdue C. Valsuani"

PROVENANCE:
Paul Kantor Gallery, Beverly Hills, California, 1961

EXHIBITIONS:
The Solomon R. Guggenheim Museum, New York, October 3, 1962–January 6, 1963, *Modern Sculpture from the Joseph H. Hirshhorn Collection*, no. 242, ill. p. 68

REFERENCES:
Arnason, H. Harvard. *History of Modern Art*, New York, Abrams, 1968, p. 190, ill. p. 189
———. *Jacques Lipchitz: Sketches in Bronze*, New York, Praeger, 1969, ill. p. 12
Byng, Tom. "Mods and Baroquers," *House & Garden*, British ed., 20, February 1965, ill. p. 56
Hale, William Harlan. *The World of Rodin: 1840–1917*, New York, Time-Life Books, 1969, p. 181, ill.
Read, Herbert. *A Concise History of Modern Sculpture*, New York, Praeger, 1964, no. 166, p. 296, ill. p. 170
Rogers, L. R. "Western Sculpture," *Encyclopedia Americana*, rev. ed., forthcoming, ill.
Sweeney, James Johnson. "A Living Frame for Sculpture," *House & Garden*, 126, August 1964, ill. p. 112

Rape of Europa, II. 1938.
Bronze, 16 × 24 ×12¾ inches
Markings: l. r. side "JLipchitz 7/7"
thumbprint

PROVENANCE:
Fine Arts Associates, New York, 1957

EXHIBITIONS:
Fine Arts Associates, New York, December 18, 1956–January 1, 1957, *Paintings Watercolors Sculpture*, no. 16, ill.
Whitney Museum of American Art, New York, April 30–June 15, 1958, *The Museum and Its Friends*, no. 103
The Detroit Institute of Arts, and tour, 1959–60, *Sculpture in Our Time*, no. 123
The Solomon R. Guggenheim Museum, New York, October 3, 1962–January 6, 1963, *Modern Sculpture from the Joseph H. Hirshhorn Collection*, no. 244, ill. p. 100

REFERENCES:
Fish, Margaret. "Moderns' Diversity Dominates Great Sculpture Show," *Milwaukee Sentinel*, September 27, 1959
Genauer, Emily. "Top Art Loans at the Whitney," *New York Herald Tribune*, May 4, 1958, ill. p. 9

PAT LIPSKY (b. 1941)
Patricia Sutton, born New York, September 21, 1941. Studied: The Brooklyn Museum Art School, New York, summers, 1960, 1961; Cornell University, Ithaca, New York, B.F.A., 1963; The Art Students League of New York, with Charles Alston, 1963–64; Hunter College, New York, M.F.A., 1968. Taught: Fairleigh Dickinson University, Rutherford, New Jersey, 1968–69; Hunter College, 1972. One-man shows: André Emmerich Gallery, New York, from 1970; Everson Museum of Art, Syracuse, New York, 1970; London Arts Inc.,

Detroit, 1971. Included in: "Lyrical Abstraction," The Aldrich Museum of Contemporary Art, Ridgefield, Connecticut, and tour, 1970–71; "Projected Art: Artists at Work," Finch College Museum of Art, New York, 1971; "Movement in Painting," Stamford Museum and Nature Center, Connecticut, 1973. Lives in New York.

Yaqui. 1969.
Acrylic on canvas, 6 feet 8¼ inches × 9 feet 9¼ inches
Signed and dated on back: "Pat Lipsky 1969"

PROVENANCE:
André Emmerich Gallery, New York, 1969

SEYMOUR LIPTON (b. 1903)
Born New York, November 6, 1903. Studied, New York: Polytechnic Institute of Brooklyn, 1921–23; Columbia University, D.D.S., 1927. Self-taught as a sculptor. Exhibited, John Reed Club, New York, 1933–34, 1935. First one-man show, ACA Gallery, New York, 1938. Taught: New School for Social Research, New York, 1940–65; The Cooper Union for the Advancement of Science and Art, New York, 1943; New Jersey State Teachers College, Newark, 1944–46. Included in: Sculptors' Guild Annual, New York, 1941–44; Whitney Annual, 1946–70. One-man shows: Galerie St. Etienne, New York, 1943; Betty Parsons Gallery, New York, 1948, 1950, 1952, 1954, 1958, 1961; American University, Washington, D.C., 1951. Included in: 58th and 62nd American Exhibition, The Art Institute of Chicago, 1947, 1957 (Logan Medal); 6th, 7th, 9th, 11th Contemporary American Exhibition, University of Illinois, Urbana, 1953, 1955, 1959, 1963; IV São Paulo Bienal, 1957. Commissions: Temple Israel, Tulsa, Oklahoma, 1953; Temple Beth El, Gary, Indiana, 1955; Inland Steel Company Building, Chicago, 1957. One-man show, while visiting artist, Munson-Williams-Proctor Institute, Utica, New York, 1956. Visiting critic, Yale University, New Haven, Connecticut, 1957–59. One-man show, Venice Biennale, 1958. Received: Guggenheim Foundation Fellowship, 1960; Ford Foundation Grant, 1961. Commissions: IBM Watson Research Center, Yorktown Heights, New York, 1961–62; Philharmonic Hall, Lincoln Center for the Performing Arts, New York, 1963–64. One-man shows: The Phillips Collection, Washington, D.C., 1964; Marlborough-Gerson Gallery, New York, 1965; Milwaukee Art Center, 1969; Marlborough Gallery, and Massachusetts Institute of Technology, Cambridge, 1971. Lives in New York.

Mandrake. 1958.
Nickel Silver on Monel Metal, 36 × 34 × 16¼ inches

PROVENANCE:
Betty Parsons Gallery, New York, 1961

EXHIBITIONS:
Whitney Museum of American Art, New York, December 7, 1960–January 22, 1961, *1960 Annual Exhibition: Contemporary Sculpture and Drawing*, no. 54, ill. p. 28
The Solomon R. Guggenheim Museum, New York, October 3, 1962–January 6, 1963, *Modern Sculpture from the Joseph H. Hirshhorn Collection*, no. 247, ill. p. 186

REFERENCES:
Canaday, John. "New Vistas Open for Sculpture," *The New York Times Magazine*, September 30, 1962, ill. p. 25
Elsen, Albert E. *Seymour Lipton*, New York, Abrams, 1970, p. 41, plate 152
Read, Herbert. *A Concise History of Modern Sculpture*, New York, Praeger, 1964, no. 214, p. 279, ill. p. 199

"*Mandrake* deals with forms and imagery to illuminate the ogres of man's inner and outer existence. The total abstract character must be adequate to specific reference in the world of changing reality. This is something I must feel. The title *Mandrake* resulted from the suggestion for me of a plant-woman-birth straining presence. There is always a reaching out for a wide and deep humanism through formal invention. Esthetic redemption of man's mortal conditions is what I hope for."

Statement by the artist, 1972

MORRIS LOUIS (1912–1962)
Morris Bernstein, born Baltimore, November 28, 1912. Studied, The Maryland Institute for the Promotion of the Mechanic Arts and The School of Fine and Practical Arts, Baltimore, 1929–33. Mural commission, Baltimore High School Library, 1934. Elected president, Baltimore Artists' Association, 1935. Participated in David Alfaro Siqueiros's experimental workshop, New York, 1936. WPA Federal Art Project, Easel Division, New York, 1937–40. Included in "American Art Today," New York World's Fair, Flushing Meadows, 1939. Moved to Washington, D.C., 1947; met and worked with Kenneth Noland. Included in: Maryland Artists Annual, The Baltimore Museum of Art, 1948–52 (received prize for best modern work, 1949, 1950); "Emerging Talent," Kootz Gallery, New York, 1954. Taught, Washington [D.C.] Workshop Center, 1952–62. One-man shows: Washington Workshop Center, 1953, 1955; Martha Jackson Gallery, New York, 1957; French & Company, New York, 1959, 1960; Institute of Contemporary Arts, London, 1960; Bennington College, Vermont, 1960; Galleria dell'Ariete, Milan, 1960; Galerie Neufville, Paris, 1961; Galerie Lawrence, Paris, 1961, 1962; André Emmerich Gallery, New York, 1961, 1962, 1964–69. Included in: "American Abstract Expressionists and Imagists," The Solomon R. Guggenheim Museum, New York, 1961–62; "Art Since 1950," Seattle World's Fair, 1962. Died Washington, D.C., September 7, 1962. Memorial exhibitions, The Solomon R. Guggenheim Museum, 1963; Venice Biennale, 1964. Retrospectives: Stedelijk Museum, Amsterdam, and tour, 1965; Whitechapel Art Gallery, London, 1965; Los Angeles County Museum of Art, and tour, 1967. Posthumous one-man shows: Washington [D.C.] Gallery of Modern Art, 1967; Museum of Fine Arts, Boston, 1973.

Point of Tranquility. 1958.
Acrylic on canvas, 8 feet 5⅜ inches × 11 feet 3 inches

PROVENANCE:
French & Company, New York; Galerie Lawrence, Paris, 1963

EXHIBITIONS:
French & Company, New York, March 23–April 16, 1960, *New Paintings by Morris Louis*, no. 7
The Tate Gallery, London, April 22–June 28, 1964, *Painting and Sculpture of a Decade, 54–64* (organized by the Calouste Gulbenkian Foundation), no. 163, ill. p. 145

REFERENCES:
Alfieri, Bruno. "Morris Louis: Romantic Optic Symbols," *Metro*, 4/5, 1962, p. 31, colorplate
Bowness, Alan. "54/64 Painting and Sculpture of a Decade: the Gulbenkian Foundation," *Studio International*, 167, May 1964, ill. p. 194
Fried, Michael. *Morris Louis*, New York, Abrams, 1970, plate 77
Greenberg, Clement. "Louis and Noland," *Art International*, 4, May 25, 1960, ill. p. 27
Kozloff, Max. "A Letter to the Editor," *Art International*, 7, June 25, 1963, p. 91
Sylvester, David. "Modern Art," *The Book of Art*, London, Grolier, 1965, ill. b, p. 286

Where. 1960.
Acrylic on canvas, 7 feet 10 inches × 11 feet 11¼ inches
Signed and dated upside down u. r.: "Louis '60"

PROVENANCE:
French & Company, New York; Galerie Lawrence, Paris, 1964

EXHIBITIONS:
French & Company, New York, March 23–April 16, 1960, *New Paintings by Morris Louis*, no. 8

LOUIS LOZOWICK (1892–1973)

Born Kiev, Russia, December 10, 1892. Emigrated to the U.S., 1906. Studied: National Academy of Design, New York, with Leon Kroll, 1912–15; Ohio State University, Columbus, B.A., 1918. Served, U.S. Army, 1918. Traveled to Paris, and Berlin, 1919–24. Member, November-gruppe, Berlin, 1920; associated with El Lissitzky, and other Russian artists, in Germany. Traveled to Russia, 1922; met Kasimir Malevitch. One-man shows, Berlin: Galerie Twardy, 1922; Galerie Albert Heller, 1923. Returned to New York, 1924. Collection of lectures, *Modern Russian Art*, published (Paris, Société Anonyme), 1925. Member of executive board, illustrator, and writer, *New Masses*, New York, 1926. Designed stage sets, Georg Kaiser's *Gas*, Goodman Theater, Chicago, 1926. Exhibited with Charles Sheeler, J. B. Neumann's New Art Circle, New York, 1926. One-man shows: Museum of Western Art, Moscow, 1928; Weyhe Gallery, New York, 1929 (prints), 1931, 1933–36. Co-authored *Voices of October* (New York, Vanguard), 1930. Received first prize, International Print Competition, Cleveland Print Club, 1931. WPA Federal Art Project, Graphics Division, New York, 1934. Included in: "American Realists and Magic Realists," The Museum of Modern Art, New York, 1943; "The Precisionist View in American Art," Walker Art Center, Minneapolis, 1960. Author of *100 Contemporary American Jewish Painters and Sculptors* (New York, Yiddisher Kultur Farband, Art Section), 1947. One-man shows: Zabriskie Gallery, New York, 1961, 1972; Newark Public Library, New Jersey, 1969; Robert Hull Fleming Museum, University of Vermont, Burlington, 1971; Dain Gallery, New York, 1973. Retrospective, Whitney Museum of American Art, New York (lithographs), 1972–73. Died, South Orange, New Jersey, September 9, 1973.

Minneapolis. 1926–27.
Oil on canvas, 30 × 22¼ inches
Signed l. r.: "Louis Lozowick"

PROVENANCE:
Zabriskie Gallery, New York, 1961

EXHIBITIONS:
Zabriskie Gallery, New York, January 3–21, 1961, *Louis Lozowick: Paintings and Drawings 1923–29*, no. 3

GEORGE LUKS (1866–1933)

George Benjamin Luks, born Williamsport, Pennsylvania, August 13, 1866. Studied: The Pennsylvania Academy of the Fine Arts, Philadelphia, c. 1884; Königlich Preussische Kunstakademie der Rheinprovinzen, Düsseldorf. Traveled to Munich, Paris, London. Artist reporter, *Philadelphia Press*, 1895. Sent to Cuba, by *Philadelphia Evening Bulletin*, to cover Spanish-American War, 1896. In Philadelphia: shared living quarters with Everett Shinn; associated with William Glackens, and John Sloan; attended weekly sessions, Robert Henri's studio. Joined staff of Joseph Pulitzer's *New York World*, 1896–97; moved to New York, 1897. Exhibited: Pennsylvania Academy Annual, 1900; with Henri, Sloan, Glackens, National Arts Club, New York, 1904; Society of American Artists Annual, 1905. Participated in "Exhibition of Eight American Painters," Macbeth Gallery, New York, and tour, 1908. One-man shows: Macbeth Gallery, 1910; C. W. Kraushaar Galleries, New York, 1913–24; Newark Museum, New Jersey, 1917. Six works included in the Armory Show, 1913. Awarded: Temple Gold Medal, Pennsylvania Academy Annual, 1918; Logan Medal, 33rd and 39th American Exhibition, The Art Institute of Chicago, 1920, 1926; Corcoran Gold Medal, and First Clark Prize, Corcoran Biennial, 1932. Taught, The Art Students League of New York, 1920–24; Philip Evergood, and Reginald Marsh among his pupils. One-man shows, Frank Rehn Gallery, New York, 1925–34. Included in: "Painting and Sculpture by Living Americans," The Museum of Modern Art, New York, 1930–31; Whitney Biennial, 1932. Died New York, October 29, 1933. Memorial exhibition, Newark Museum, 1934. Included in: "New York Realists," Whitney Museum of American Art, New York, 1937; "The Eight," The Brooklyn Museum, New York, and The Museum of Modern Art, New York, and tour, 1944. Retrospectives: ACA Gallery, New York, 1967; Munson-Williams-Proctor Institute, Utica, New York, 1973.

Girl in Green. Late 1920s.
Oil on canvas, 42 × 34 inches
Signed l. l.: "George Luks"

PROVENANCE:
Mrs. William Keighley, Paris; M. Knoedler & Co., New York, 1958

REFERENCES:
Katz, Leslie. "The World of the Eight," *Arts Yearbook*, I, 1957, p. 71, ill.

Girl in Orange Gown. Late 1920s.
Oil on canvas, 30 × 36 inches
Signed l. c.: "George Luks"

PROVENANCE:
Elizabeth Amis Cameron Blanchard, New York; M. Knoedler & Co., New York, 1957

EXHIBITIONS:
M. Knoedler & Co., New York, January 28–March 1, 1957, *Twentieth Century American Painters*, no. 7

Portrait of a Child. n.d.
Oil on canvas, 24 × 20 inches
Signed l. l.: "George Luks"

PROVENANCE:
Washington Irving Gallery, New York, 1958

STANTON MACDONALD-WRIGHT (1890–1973)

Born Charlottesville, Virginia, July 8, 1890. Studied art with private tutors, 1895–1900. Moved with family to Santa Monica, California, 1900. Studied, Art Students' League, Los Angeles, with Warren T. Hedges, 1905–6. Lived in Paris, 1907–13. Studied, Paris, 1907–9: Université de Paris à la Sorbonne; Académie Colarossi; Académie Julian; École des Beaux-Arts. Exhibited, Paris: Salon d'Automne, 1910; Salon des Indépendants, 1912. Developed principles of Synchromism, with Morgan Russell, 1912. Visited New York, 1913. Exhibited with Russell: Neue Kunstsalon, Munich, 1913; Galerie Bernheim-Jeune, Paris, 1913; The Carroll Art Galleries, New York, 1914. With brother, Willard Huntington Wright: returned to Paris, briefly, 1914; lived in London, 1914–16; collaborated on *Modern Art, Its Tendency and Meaning* (New York, John Lane), 1915, *The Creative Will* (New York, John Lane), 1916, *The Future of Painting* (New York, Huebsch), 1923. Returned to New York, 1916. Included in "The Forum Exhibition of Modern American Painters," The Anderson Galleries, New York, 1916. One-man show, Alfred Stieglitz's Photo-Secession Gallery, "291," New York, 1917. Moved to Santa Monica, 1919. Made first full-length color film, 1919; experimented with and patented color film processes. Director, Art Students' League, Los Angeles, 1922–30. Wrote *A Treatise on Color*, 1924. Exhibited with Russell: Los Angeles County Museum of History, Science and Art, 1927, 1932; Stendahl Galleries, Los Angeles, 1932. One-man show, Stieglitz's An American Place, New York, 1932. Public Works of Art Project, mural commission, Santa Monica Library, 1934–35. WPA Federal Art Project: director for Southern California, 1935–37; technical advisor, 1938–42. Taught: University of California at Los Angeles, 1942–52, 1953–54; Tokyo University of Education (Fulbright Exchange Professor), 1952–53. Included in: "Abstract Painting and Sculpture in America," The Museum of Modern Art, New York, 1951; "Synchromism and Color Principles in American Painting, 1910–1930," M. Knoedler & Co., New York, 1965; "The Cubist Epoch," Los Angeles County Museum of Art, and The Metropolitan Museum of Art, New York, 1970. Retrospectives: Los Angeles County Museum of Art, 1956; National Collection of Fine Arts, Smithsonian Institution, Washington, D.C., 1967; University of California at Los Angeles, 1970. Died Pacific Palisades, California, August 22, 1973.

Conception Synchromy. 1914.
Oil on canvas, 36⅛ × 30¼ inches
Signed and dated l. r.: "S. Macdonald-Wright/14"

PROVENANCE:
The artist, Pacific Palisades, California, 1962

EXHIBITIONS:
National Collection of Fine Arts, Smithsonian Institution, Washington, D.C., May 3–June 18, 1967, *The Art of Stanton Macdonald-Wright*, no. 6

REFERENCES:
Seuphor, Michel. *Abstract Painting*, New York, Abrams, 1961, p. 309, colorplate p. 51

HENRY LEE MCFEE (1886–1953)

Born St. Louis, Missouri, April 14, 1886. Studied: School of Fine Arts, Washington University, St. Louis; Stevenson Art School, Pittsburgh, 1907; The Art Students League of New York, Woodstock, New York, summer session, 1908. Moved to Woodstock, 1910. Included in: "The Forum Exhibition of Modern American Painters," The Anderson Galleries, New York, 1916; Venice Biennale, 1920, 1934; Carnegie International, 1923–1927, 1930–35; Corcoran Biennial, 1928 (Corcoran Copper Medal, and Fourth Clark Prize). One-man shows, Frank Rehn Gallery, New York, 1927, 1929, 1933, 1936, 1950. Included in: "Painting and Sculpture by Living Americans," and "Modern Works of Art," The Museum of Modern Art, New York, 1930–31, 1934–35; Pennsylvania Academy Annual, 1937 (Temple Gold Medal); "American Art Today," New York World's Fair, Flushing Meadows, 1939. Taught: Chouinard School of Art, Los Angeles, 1940–41; Scripps College, Claremont, California, 1942–50. Received Guggenheim Foundation Fellowship, 1941. Member, The National Institute of Arts and Letters, 1943. One-man show, Pasadena Art Museum, California, 1950. Died Pasadena, March 20, 1953.

Still Life with Yellow Flowers (Bouquet of Yellow Flowers). c. 1925–28.
Oil on canvas, 30¼ × 24¼ inches
Signed l. r.: "McFee"

PROVENANCE:
Frank Rehn Gallery, New York; Ralph Pulitzer, New York; Bernard Black Gallery, New York, 1966

EXHIBITIONS:
Frank Rehn Gallery, New York, March 25–April 13, 1929, *Henry Lee McFee*, no. 8

REFERENCES:
Hard, Frederick, foreword. *Henry Lee McFee*, Claremont, California, Scripps College, 1950, ill.
Shapley, John. "Art Activities in New York," *Parnassus*, 1, April 1929, p. 4

JAMES MCGARRELL (b. 1930)

Born Indianapolis, Indiana, February 22, 1930. Studied: Indiana University, Bloomington, B.A., 1953; Skowhegan School of Painting and Sculpture, Maine, summer, 1953; University of California at Los Angeles, M.A., 1955; Staatliche Akademie der Bildenden Künste, Stuttgart, 1955–56 (Fulbright Grant). Included in: Whitney Annual, 1955, 1956, 1959, 1963, 1967, 1969; Pittsburgh International, 1958, 1964; "New Images of Man," The Museum of Modern Art, New York, and The Baltimore Museum of Art, 1959; 9th–11th Contemporary American Exhibition, University of Illinois, Urbana, 1959, 1961, 1963; "Recent Painting U.S.A.: The Figure," The Museum of Modern Art, and tour, 1962–63; Documenta III, Kassel, 1964. One-man shows: Frank Perls Gallery, Beverly Hills, California, 1955, 1957, 1958, 1962, 1964; Portland Art Museum, Oregon, 1958; Allan Frumkin Gallery, Chicago, and New York, from 1961; Galerie Claude Bernard, Paris, 1968, 1970. Received: Ford Foundation Grant, 1962, 1963; The National Institute of Arts and Letters Award, 1963; Guggenheim Foundation Fellowship, 1964, 1965 (lived in Paris, 1964–65). Member, Board of Directors, College Art Association of America, 1970–73. Has taught, University of Illinois, since 1960. Lives in Bloomington, and in Perugia, Italy.

Veracity. 1969.
Oil on canvas, 61⅛ × 71 inches

PROVENANCE:
Allan Frumkin Gallery, New York; Galerie Claude Bernard, Paris, 1970

EXHIBITIONS:
Galerie Claude Bernard, Paris, September 1970, *McGarrell*, cat., ill.

REFERENCES:
Applegate, Judith. "Paris," *Art International*, 14, November 1970, p. 88
Langui, Émile. "Expressionism Since 1945 and the Cobra Movement," in *Figurative Art Since 1945*, London, Thames and Hudson, 1971, p. 84, plate 89

Veracity is a self-portrait of the artist in his studio. On the wall at the left is a detail of Jan Vermeer's *A Painter in His Studio*, c. 1666, in which the model is posed as Clio, muse of history. McGarrell's costume and the architectonic composition are based on Vermeer's masterpiece.

LOREN MACIVER (b. 1909)

Loren MacIver, born New York, February 2, 1909. Studied, The Art Students League of New York, 1919. WPA, Federal Art Project, Easel Division, New York, 1936–39. One-man shows: East River Gallery, New York, 1938; Pierre Matisse Gallery, New York, 1940, 1944, 1949, 1956, 1961, 1966, 1970; The Museum of Modern Art, New York, Circulating Exhibition, 1941–42; Vassar College Art Gallery, Poughkeepsie, New York, 1950. Designed lighting and interior decorations for four "Coffee Concerts," The Museum of Modern Art, 1941. Included in: Whitney Annual, 1944–69; "Fourteen Americans," The Museum of Modern Art, 1946. Murals commissioned: S.S. *Argentina*, 1947; S.S. *Excalibur*, S.S. *Exeter*, S.S. *Exochorda*, S.S. *Excambion*, 1948. Exhibited with I. Rice Pereira: Santa Barbara Museum of Art, California, and tour, 1950; Whitney Museum of American Art, New York, and tour, 1953. Included in: I São Paulo Bienal, 1951; Pittsburgh International, 1955, 1958; Corcoran Biennial, 1957 (Corcoran Gold Medal, and First Clark Prize); Venice Biennale, 1962. Member, The National Institute of Arts and Letters, 1959. Received Ford Foundation Grant, 1960. One-man show, The Phillips Collection, Washington, D.C., and tour, 1965–66. Lived in Paris, 1966–70. Retrospective, Musée National d'Art Moderne, Paris, and tour, 1968. Lives in New York.

Skylight Moon. 1958.
Oil on canvas, 50 × 39¾ inches
Signed l. l.: "MacIver"

PROVENANCE:
Pierre Matisse Gallery, New York, 1958

EXHIBITIONS:
Carnegie Institute, Pittsburgh, December 5, 1958–February 8, 1959, *The 1958 Pittsburgh Bicentennial International Exhibition of Painting and Sculpture*, no. 272
American Federation of Arts tour, September 21–November 11, 1959, *International Exhibition of Contemporary Painting and Sculpture* (organized by the Ford Foundation)
Galerie Würthle, Vienna, June 19–July 8, 1961, *Vanguard American Painting* (organized by The Solomon R. Guggenheim Museum, New York, for the U.S. Information Agency), no. 46, ill.; toured to nine European cities

REFERENCES:
Breeskin, Adelyn Dohme. *Loren MacIver*, New York, Abrams, forthcoming, ill.

HEINZ MACK (b. 1931)

Born Lollar, Germany, March 8, 1931. Studied, Staatliche Kunstakademie, Düsseldorf, 1950–53; Universität zu Köln (Cologne), degree in philosophy, 1956. Co-founded Zero group, Düsseldorf, with Otto Piene, 1957; published three issues of review *Zero*, 1958. One-man shows: Galerie Alfred Schmela, Düsseldorf, 1957, 1958, 1960; Galerie Iris Clert, Paris, 1959; New Vision Centre Gallery, London, 1960; Palais des Beaux-Arts, Brussels, 1962. Exhibited with Zero group: Galerie A, Arnhem, The Netherlands, 1961; Stedelijk Museum, Amsterdam,

1962; Institute of Contemporary Art, University of Pennsylvania, Philadelphia, and tour, 1964. Included in: Pittsburgh International, 1961, 1964, 1967; Documenta III, Kassel, 1964; Guggenheim International Award, 1964; 8th Middelheim Biënnale, Antwerp, 1965; "The Responsive Eye," The Museum of Modern Art, New York, and tour, 1965–66; Venice Biennale, 1968; "Plus by Minus: Today's Half-Century" Albright-Knox Art Gallery, Buffalo, New York, 1968; "Constructivist Tendencies," University of California, Santa Barbara, 1970–72. One-man shows: Howard Wise Gallery, New York, 1965, 1966; Galerie Denise René, Paris, 1967, 1968; Galleria dell'Ariete, Milan, 1968; Galerie Heseler, Munich, 1969; Galerie Denise René, New York, 1972; Akademie der Künste, Berlin, 1972. Lives in Düsseldorf.

Relief Stele: Lumen et Luxuria. 1967.
Aluminum on wood, 9 feet 10 inches × 1 foot 1½ inches × 1½ inches

PROVENANCE:
Galleria dell'Ariete, Milan, 1968

EXHIBITIONS:
Galleria dell'Ariete, Milan, March 20–April 18, 1968, *Heinz Mack*, no. 2

REFERENCES:
Staber, Margit. "Heinz Mack–einige Feststellunges zu seinem Werk," *Art International*, 8, Summer 1969, ill. p. 20

RENÉ MAGRITTE (1898–1967)

René-François-Ghislain Magritte, born Lessines, Belgium, November 21, 1898. Studied, Académie Royale des Beaux-Arts, Brussels, intermittently, 1916–18. Settled in Brussels, 1918. Exhibited with Pierre Flouquet, Galerie Le Centre d'Art, Brussels, 1920. Contributed to Dada review *391*, Paris, 1924. First one-man show, Galerie Le Centaure, Brussels, 1927. Lived in Paris, 1927–30; associated with André Breton, Paul Éluard, and other Surrealists. Returned to Brussels, 1930. Included in: "L'Art Vivant en Europe," and "Trois Peintres Surréalistes," Palais des Beaux-Arts, Brussels, 1931, 1937; "Fantastic Art, Dada, Surrealism," and "Art in Our Time," The Museum of Modern Art, New York, 1936–37, 1939; "Exposition Internationale du Surréalisme," Galerie des Beaux-Arts, Paris, 1938; "First Papers of Surrealism," 451 Madison Avenue, New York, 1942. One-man shows: Palais des Beaux-Arts, Brussels, 1933, 1939; Julien Levy Gallery, New York, 1936–38; Galerie Dietrich, Brussels, 1941, 1944, 1946, 1948, 1951; Galerie du Faubourg, Paris, 1948; Alexandre Iolas Gallery, New York, 1953, 1957–59, 1962, 1965; Venice Biennale, 1954. Included in: Carnegie International, 1938, 1950; Pittsburgh International, 1958, 1964, 1967; Documenta II, Kassel, 1959. Retrospectives: Palais des Beaux-Arts, Brussels, 1954; Dallas Museum for Contemporary Arts, and The Museum of Fine Arts, Houston, 1960–61; Walker Art Center, Minneapolis, 1962; The Museum of Modern Art, and tour, 1965–66. Died Brussels, August 15, 1967. Retrospective, The Tate Gallery, London (organized by The Arts Council of Great Britain), 1969.

Delusions of Grandeur (La Folie des grandeurs). 1948.
Oil on canvas, 39 × 32 inches
Signed l. r.: "Magritte"

PROVENANCE:
Hugo Gallery, New York; William S. Rubin, New York, 1963

EXHIBITIONS:
Hugo Gallery, New York, May 3–29, 1948, *Recent Paintings by René Magritte*
The Art Galleries, University of California, Santa Barbara, February 26–March 27, 1966, *Surrealism: A State of Mind*, no. 17, ill.
The Museum of Modern Art, New York, March 27–June 9, 1968, *Dada, Surrealism and Their Heritage*, no. 179; toured to Los Angeles County Museum of Art, July 16–September 8; The Art Institute of Chicago, October 19–December 8

REFERENCES:
Rubin, William S. *Dada and Surrealist Art*, New York, Abrams, 1968, p. 209, ill. p. 204

Delusions of Grandeur (La Folie des grandeurs). 1967.
Bronze (artist's cast), 61½ × 48 × 32½ inches
Markings l. r. side: "Magritte E. A. 1967"

PROVENANCE:
Mme René Magritte, Brussels, 1968

EXHIBITIONS:
Casino Communal, Knokke-le-Zoute, Belgium, June 30–September 9, 1968, *Trésors du Surréalisme*, no. 84, ill. p. 54

The Therapeutist (Le Thérapeute). 1967.
Bronze (edition of five), 59 × 51¾ × 35 inches

PROVENANCE:
Mme René Magritte, Brussels, 1968

In the last year of his life Magritte supervised the construction of eight sculptures based on images from his paintings. *Delusions of Grandeur* was the first to be cast. The tripartite female torso appears in our painting of 1948, and in a larger painting of 1961.

The Therapeutist is an image that is seen in many variations throughout Magritte's work, but the sculpture is based most closely on a painting of 1937. The lower half of the sculpture was cast from a man's legs and feet; the torso from a specially constructed birdcage.

ARISTIDE MAILLOL (1861–1944)

Aristide-Joseph-Bonaventure Maillol, born Banyuls-sur-Mer, France, near Spanish Catalonia, December 8, 1861. Studied, Paris: École des Arts Décoratifs, 1883; École des Beaux-Arts, with Alexandre Cabanel, and Jean-Léon Gérôme, 1887–92. Met Émile-Antoine Bourdelle, 1889. Encouraged by Paul Gauguin, set up tapestry studio, Banyuls-sur-Mer, 1893. Exhibited, Salon de la Société Nationale des Beaux-Arts, Paris, 1893, 1895–97, 1899, 1903. Returned to Paris, 1895; first sculptures. Moved to

Villeneuve-St.-Georges, outside of Paris, 1899; studio became meeting place for the Nabis, sometimes joined by Henri Matisse. Primarily a sculptor, from 1900. One-man show, Galerie Ambroise Vollard, Paris (tapestries and sculpture), 1902. After 1900, lived in Banyuls-sur-Mer, and in Marly-le-Roy, near Paris. Included in Salon d'Automne, Paris, 1904–6, 1909, 1910, 1921, 1922, 1924, 1938. Met his life-time patron, Count Harry Graf Kessler, 1905. Made portrait bust of Pierre-Auguste Renoir, 1907. Traveled to Greece with Kessler, 1908. One-man show, Galerie Bernheim-Jeune, Paris (tapestries), 1911. Perfected process for making rag paper; established factory, Montval, France, 1913. War memorials dedicated, France: Céret, 1922; Port-Vendres, 1923; Banyuls-sur-Mer, 1933. Woodcuts for Virgil's *Eclogues* published (Weimar, Germany, Chranchpresse), 1925. One-man shows: Albright Art Gallery, Buffalo, New York, 1925; Galerie Alfred Flechtheim, Berlin, 1931–32; Brummer Gallery, New York, 1933; Buchholz Gallery, New York, 1940. Exhibited: "Lehmbruck-Maillol," The Museum of Modern Art, New York, 1930; with Charles Despiau, Renoir, Bourdelle, Balzac Gallery, New York, 1931; "Les Maîtres de l'Art Indépendant, 1895–1937," Musée du Petit Palais, Paris, 1937 (separate room); with Despiau, Institute of Modern Art, Boston, 1939. Retrospectives: Kunsthalle, Basel, 1933; Musée du Petit Palais, 1937. Illustrated: Ovid's *L'Art d'aimer* (Paris, Gonin), 1935; Longus's *Daphnis et Chloë* (Paris, Gonin), 1937; Paul Verlaine's *Chansons pour Elle* (Paris, Pelletan), 1939. Began woodcuts for Virgil's *Georgics*, 1939; published (Lausanne, Gonin), 1950. Died Banyuls-sur-Mer, September 27, 1944. Retrospectives: Albright Art Gallery, 1945; Paul Rosenberg & Co., New York, and tour, 1958–60; Musée National d'Art Moderne, Paris, and tour, 1961; Kunstverein, Frankfort, 1962; National Museum of Western Art, Tokyo, 1963. Collection of his sculpture permanently installed, Jardin du Carrousel, Les Tuileries, Paris, 1964.

Bather with Raised Arms. 1898.
Bronze, 10½ × 4½ × 4½ inches
Markings: l. r. side "⟨M⟩"

PROVENANCE:
Ganter Collection, Karlsruhe, Germany; Marlborough Fine Art, London, 1961

EXHIBITIONS:
The Solomon R. Guggenheim Museum, New York, October 3, 1962–January 6, 1963, *Modern Sculpture from the Joseph H. Hirshhorn Collection*, no. 248

Kneeling Nude. c. 1900.
Bronze, 33 × 16½ × 21¾ inches
Markings: l. r. side "A. Maillol 2/6"
 back of base "Georges Rudier Fondeur, Paris"

PROVENANCE:
Juliette Cramer, Paris; Kleemann Galleries, New York, 1958

EXHIBITIONS:
The Detroit Institute of Arts, 1959, *Sculpture in Our Time*, no. 129
The Solomon R. Guggenheim Museum, New York, October 3, 1962–January 6, 1963, *Modern Sculpture from the Joseph H. Hirshhorn Collection*, no. 250, ill. p. 29
Hopkins Art Center, Dartmouth College, Hanover, New Hampshire, May 25–July 9, 1967, *Sculpture in Our Century: Selections from the Joseph H. Hirshhorn Collection*, no. 33

REFERENCES:
Kaufman, Betty. "Hirshhorn: The Collector's Art," *Commonweal*, 77, November 9, 1962, p. 183

Standing Nude. 1910.
Terra-cotta, 10½ × 3½ × 2½ inches
Markings: l. r. side "⟨M⟩"

PROVENANCE:
Lucien Maillol, Banyuls-sur-Mer, France; Buchholz Gallery, New York; Richard S. Davis, Wayzata, Minnesota; Julius H. Weitzner, New York, 1958

EXHIBITIONS:
Buchholz Gallery, New York, February 1951, *Aristide Maillol*, no. 15, ill.
The Minneapolis Institute of Arts, February 27–April 1, 1951, *Masterpieces by Maillol*

Youth (La Jeunesse). 1910, cast c. 1925.
Bronze (3/6), 39½ × 16½ × 13 inches
Markings: l. r. side "⟨M⟩"
 "Alexis Rudier Fondeur Paris No. 3"

PROVENANCE:
Peridot Gallery, New York, 1958

EXHIBITIONS:
The Detroit Institute of Arts, and tour, 1959–60, *Sculpture in Our Time*, no. 128, ill. p. 60
The Solomon R. Guggenheim Museum, New York, October 3, 1962–January 6, 1963, *Modern Sculpture from the Joseph H. Hirshhorn Collection*, no. 249, ill. p. 29

REFERENCES:
Kaufman, Betty. "Hirshhorn: The Collector's Art," *Commonweal*, 77, November 9, 1962, p. 183

Nymph. 1936–38.
Bronze, 60½ × 24½ × 18 inches
Markings: u. r. top of base "⟨M⟩"
 back of base "Rudier"

PROVENANCE:
Curt Valentin Gallery, New York, 1955

EXHIBITIONS:
Curt Valentin Gallery, New York, June 8–30, 1955, *Closing Exhibition, Sculpture, Paintings and Drawings*, no. 99, ill.
The Detroit Institute of Arts, and tour, 1959–60, *Sculpture in Our Time*, no. 130, ill. p. 61

The Solomon R. Guggenheim Museum, New York, October 3, 1962–January 6, 1963, *Modern Sculpture from the Joseph H. Hirshhorn Collection*, no. 251, ill. p. 28

REFERENCES:
Kaufman, Betty. "Hirshhorn: The Collector's Art," *Commonweal*, 77, November 9, 1962, p. 183
Mates, Robert E. *Photographing Art*, New York, Amphoto, 1966, ill. pp. 122–23
——. "Photographing Sculpture and Museum Exhibits," *Curator*, 10, June 1967, ill. pp. 124–25
Unsigned. "Art: Lone Wolf," *Newsweek*, 60, October 15, 1962, ill. p. 110
——. "'round the World with Art Collectors: Joe Hirshhorn," *Art Voices*, 2, November 1962, ill. p. 20

MANOLO (1872–1945)

Manuel Martínez Hugué, born Barcelona, May 1, 1872. Moved to Paris, 1900; associated with Pablo Picasso, Pablo Gargallo, Julio González. Moved to Céret, France, near border of Spanish Catalonia, 1910. Exhibited with Elie Nadelman, Galería Dalmau, Barcelona, 1911. Associated with dealer Daniel-Henry Kahnweiler, Paris, from 1912. One-man show, Alfred Stieglitz's Photo Secession Gallery, "291," New York, 1912. Joined in Céret by Picasso, Georges Braque, Juan Gris, 1913. Returned to Spain; lived in Barcelona, and Arenys de Munt, 1916–19. One-man show, Galerías Layetanas, Barcelona, 1917. Included in Exposición de Bellas Artes de Barcelona, 1919. Returned to Céret, 1919. One-man shows: Galerie Simon, Paris, 1923, 1929; Weyhe Gallery, New York, 1926. Returned to Spain, 1927; settled in Caldas de Montbuy, near Barcelona, 1928. One-man shows: Kunstsalon Wolfsberg, Zurich, 1928; Sala Parés, Barcelona, 1928, 1931, 1934; Galerie Albert Flechtheim, Frankfort, Berlin, Düsseldorf, 1929, 1931. Included in: Venice Biennale, 1928; Exposición Internacional de Barcelona, 1929; Exposition Universelle de 1937, Paris; Exposición Nacional de Bellas Artes de Madrid, 1941. Died Caldas de Montbuy, November 17, 1945. Posthumous one-man shows: Galerie Louise Leiris, Paris, 1951, 1961; Musée d'Art Moderne, Céret, 1957.

Seated Nude (Femme assise). 1913.
Stone relief, 14 × 17½ × 4½ inches

PROVENANCE:
Galerie Kahnweiler, Paris; Galerie Simon, Paris; Galerie Louise Leiris, Paris; James Goodman Gallery, Buffalo, New York, 1964

EXHIBITIONS:
Galerie Louise Leiris, Paris, May 17–June 17, 1961, *Manuel Martinez Hugué dit Manolo: sculptures, gouaches, dessins*, no. 27, ill.
James Goodman Gallery, Buffalo, New York, October 11–November 14, 1964, *Manolo*, no. 6, ill.
Robert Schoelkopf Gallery, New York, December 1964, *Manolo*, no. 6, ill.

REFERENCES:
Barnitz, Jacqueline. "In the Galleries: Manolo," *Arts Magazine*, 39, January 1965, p. 54
Blanch, Montserrat. *Manolo*, Barcelona, Ediciones Polígrafa, 1972, pp. 37, 297, ill. p. 37

MAN RAY (b. 1890)

Emmanuel Radenski, born Philadelphia, August 27, 1890. Moved with family to New York, 1897. Studied, Ferrer Center, New York, 1912. Lived in Ridgefield, New Jersey, 1913–15. Returned to New York, 1915; met Marcel Duchamp. First photographs, 1915; first Rayographs, 1917. One-man shows, The Daniel Gallery, New York, 1915, 1916, 1919, 1927. Founding member: Society of Independent Artists, New York, 1916; Société Anonyme, New York, 1920. Group exhibitions, New York: "The Forum Exhibition of Modern American Painters," The Anderson Galleries, 1916; Society of Independent Artists Annual, 1917. Published only issue of *New York Dada*, with Duchamp, 1921. Moved to Paris, 1921. One-man shows, Paris: Librairie 6, 1921; Galerie Surréaliste, 1926, 1928. Included in: "Salon Dada," Galerie Montaigne, 1922; "Exposition, La Peinture Surréaliste," Galerie Pierre, 1925. Made films: *Ballet Mécanique*, with Fernand Léger, 1924; *Emak Bakia*, 1926; *L'Étoile de mer*, 1928. One-man show, Julien Levy Gallery, New York (photographs), 1932. Included in: "Exposition Retrospective Dada, 1916–32," Galerie de l'Institut, Paris, 1932; "Surrealist Exhibition," Julien Levy Gallery, 1932; "Fantastic Art, Dada, Surrealism," The Museum of Modern Art, New York, 1936–37; "Trois Peintres surréalistes," Palais des Beaux-Arts, Brussels, 1937; "Exposition Internationale du Surréalisme," Galerie des Beaux-Arts, Paris, 1938. Left Paris, 1940; moved to Hollywood, California. One-man shows, California: M. H. de Young Memorial Museum, San Francisco, 1941; Santa Barbara Museum of Art, 1943; Pasadena Art Institute, 1944; Los Angeles County Museum of History, Science and Art, 1945; Copley Galleries, Beverly Hills, 1948–49. Settled in Paris, 1951. One-man shows: Galerie Furstenberg, Paris, 1954; Institute of Contemporary Arts, London, 1959; Bibliothèque Nationale, Paris (photographs), 1962; The Art Museum, Princeton University, New Jersey, 1963. Included in "The Art of Assemblage," and "Dada, Surrealism and Their Heritage," The Museum of Modern Art, and tour, 1961–62, 1968. Published autobiography, *Self Portrait* (London, Deutsch), 1963. Retrospectives: Los Angeles County Museum of Art, 1966; Museum Boymans-van Beuningen, Rotterdam, The Netherlands, and tour, 1971–72. Lives in Paris.

The Hill. 1913.
Oil on canvas, 20 × 24 inches
Signed and dated l. r.: "Man Ray 1913"

PROVENANCE:
Charles L. Daniel, New York; Parke-Bernet Galleries, New York, Sale 750, March 14, 1946, no. 93; M. Knoedler & Co., New York, 1961

Column 1

EXHIBITIONS:
M. Knoedler & Co., New York, March 22–April 10, 1943, *Paintings of Our Native Shores*, no. 30
The Dayton Art Institute, Ohio, Circulating Gallery, 1949–1951

REFERENCES:
Waldberg, Patrick. *Man Ray*, New York, Abrams, forthcoming, ill.

Composition (Marchand de couleurs). 1929.
Oil on canvas, 21¼ × 28¾ inches
Signed and dated l. r.: "Man Ray 1929"

PROVENANCE:
G. David Thompson, Pittsburgh; Galerie Semiha Huber, Zurich, 1963

EXHIBITIONS:
Galerie Van Leer, Paris, November 16–30, 1929, *Man Ray*, no. 3
Kunstmuseum der Stadt, Düsseldorf, December 14, 1960–January 29, 1961, *Sammlung G. David Thompson*, no. 190; toured to Gemeentemuseum, The Hague, February 17–April 9, no. 183; The Solomon R. Guggenheim Museum, New York, May–August, cat.; Museo Civico di Torino, October–November
M. Knoedler & Co., New York, December 5–29, 1967, *Space and Dream*, cat., ill. p. 65

Shakespearean Equation: "Twelfth Night". 1948.
Oil on canvas, 34 × 30 inches
Signed and dated l. l.: "Man Ray 1948"

PROVENANCE:
The artist, Paris, 1968

EXHIBITIONS:
Copley Galleries, Beverly Hills, California, December 14, 1948–January 9, 1949, *Man Ray*, no. 6
Galerie Furstenberg, Paris, June 1–15, 1954, *Man Ray*
Tel Aviv Museum, Israel, January 1955, *Abstract and Surrealist Paintings*, no. 65
Los Angeles County Museum of Art, October 27, 1966–January 1, 1967, *Man Ray Retrospective*, no. 88

REFERENCES:
Man Ray. *To Be Continued Unnoticed: Some Papers by Man Ray*, Beverly Hills, California, Copley Galleries, 1948, ill. p. 6
Millier, Arthur. "Los Angeles Events," *Art Digest*, 23, January 1, 1949, p. 17
Waldberg, Patrick. "Bonjour Man Ray," *Quadrum*, 7, 1959, p. 100, ill. p. 101
———. *Man Ray*, New York, Abrams, forthcoming, ill.
———. *Surrealism*, New York, McGraw-Hill, 1965, ill.
80

About 1936, Max Ernst first called Man Ray's attention to the mathematical objects languishing in the dusty showcases of the Institut Poincaré, Paris. Later, Man Ray incorporated these mathematical objects into a series of still lifes entitled "Shakespearean Equations." Each painting bears the title of one of Shakespeare's plays.

Blue Bred (Pain peint). 1960.
Blue plastic, 3 × 29 inches, on Lucite base, 10½ × 36 inches
Markings: back "MAN RAY 6/9"

PROVENANCE:
Galerie Europe, Paris, 1967

REFERENCES:
Zerbib, Marcel, ed. *Man Ray*, Paris, Galerie Europe, 1968, p. 20

Chess Set. 1962.
Thirty-two pieces: bronze, from 1⅛ to 3⅛ inches high; enameled brass on wood board, 3⅛ × 39 × 22⅛ inches
Markings: white king "MAN RAY"
Chess board "6/50"
inlaid in gold letters around border "Faites de toutes pièces—Man Ray 1962 le Roi est à moi/la Reine est la tienne/la Tour fait un four/ le Fou est comme vous/ le Cavalier déraille/ le Pion fait l'espion/ comme tout canaille"

PROVENANCE:
Galerie Europe, Paris, 1967

REFERENCES:
Zerbib, Marcel, ed. *Man Ray*, Paris, Galerie Europe, 1968, p. 18

Puericulture II: Dream, January 1920 (Puériculture II: Rêve, janvier 1920). 1964.
Bronze, 11 × 4⅓ × 4 inches
Markings: l. c. "MAN RAY 64 8/12 Puericulture II"

PROVENANCE:
Galerie Europe, Paris, 1967

REFERENCES:
Zerbib, Marcel, ed. *Man Ray*, Paris, Galerie Europe, 1968, p. 14

Red Hot Iron (Le Fer rouge). 1965.
Painted steel, 4⅓ × 3⅞ × 6 inches, in illuminated box, 20 × 15⅞ × 7 inches
Signed on handle: "MAN RAY 8/10 FER ROUGE"

PROVENANCE:
Galerie Europe, Paris, 1967

REFERENCES:
Zerbib, Marcel, ed. *Man Ray*, Paris, Galerie Europe, 1968, p. 16

New York 17. 1966.
Bronze replica of 1917 mixed-media object, 17⅛ × 9⅜ × 9⅜ inches
Markings: base "MAN RAY 1917 4/9"

PROVENANCE:
Galerie Europe, Paris, 1967

Column 2

REFERENCES:
Zerbib, Marcel, ed. *Man Ray*, Paris, Galerie Europe, 1968, p. 10

GIACOMO MANZÙ (b. 1908)

Giacomo Manzoni, born Bergamo, Italy, December 22, 1908. Worked as apprentice: woodcarving, 1919–20; gilding and stucco work, 1921. Studied: intermittently, A. Fantoni di Bergamo, evenings, 1921; Accademia Cicognini, Verona, briefly, 1927. Visited Paris, then moved to Milan, 1930. First commission, chapel decoration, Università Cattolica del Sacro Cuore, Milan, 1930. Exhibited, Galleria del Milione, Milan, 1932. Returned to Bergamo, 1933; visited Rome, 1934. Included in Venice Biennale, 1936, 1938. One-man show, Galleria della Cometa, Rome, 1937. Taught, Accademia Albertina di Belle Arti e Liceo Artistico, Turin, 1940–42; professor of sculpture, Accademia di Belle Arti di Brera, Milan, 1940–54. Awarded Grand Prize, Quadriennale Nazionale d'Arte, Rome, 1942. One-man shows: Palazzo Reale, Milan, 1947; Venice Biennale, 1948 (Grand Prize for Italian Sculpture); The Hanover Gallery, London, 1952, 1953, 1955, 1956, 1965, 1969; Galerie Welz, Salzburg, Austria, 1954, 1955 (and tour), 1958, 1966; World House Galleries, New York, 1957, 1960; Paul Rosenberg & Co., New York, 1965–66, 1968, 1969, 1972. Set of bronze doors commissioned, St. Peter's, The Vatican, Rome, 1952; *Door of Death* installed, 1964. Member, 1954: Accademia Nazionale di San Luca, Rome; Académie Royale de Belgique. Made lithographs for Salvatore Quasimodo's *Il falso e vero verde* (Milan, Schwarz), 1954. Taught, Oskar Kokoschka's Internationale Sommerakademie für Bildende Kunst, Salzburg, 1954–60. Commissions: portals, Salzburg Cathedral, 1955; portrait of Pope John XXIII, 1960–62; relief, *Mother and Child*, Rockefeller Center, New York, 1965; bronze doors, Church of St. Lawrence, Rotterdam, The Netherlands, 1968. Included in: Venice Biennale, 1956; Pittsburgh International, 1958–70; Expo '67, Montreal, 1967; Guggenheim International, 1967–68. Moved to Rome, 1958; to Campo del Fico, outside of Rome, 1964. One-man shows: Haus der Kunst, Munich, and European tour, 1959–60; Museum Boymans-van Beuningen, Rotterdam, 1968; The Museum of Modern Art, New York, 1969. Awarded Lenin Peace Prize, 1966. "Raccolta amici di Manzù," museum to house collection of his works, established in Ardea, outside of Rome, 1969. Lives in Ardea.

Self-Portrait with Model at Bergamo. 1942.
Bronze high relief (unique), 50 × 37 × 10 inches
Markings: front l. r. "Fonderia MAF Milano/ Manzu"

PROVENANCE:
The artist, Rome, 1960; Herbert Mayer, Greenwich, Connecticut; World House Galleries, New York, 1962

EXHIBITIONS:
World House Galleries, New York, April 5–May 7, 1960, *Giacomo Manzù*, cover ill.
World House Galleries, New York, February 20–March 17, 1962, *Sculpture: Daumier to Picasso*, no. 40
The Solomon R. Guggenheim Museum, New York, October 3, 1962–January 6, 1963, *Modern Sculpture from the Joseph H. Hirshhorn Collection*, no. 253, ill. p. 133

REFERENCES:
Goode, James M. "Outdoor Sculpture—Washington's Overlooked Monuments," *Historic Preservation*, 25, January–March 1973, ill. p. 6
Lonngren, Lillian. "Reviews and Previews: Giacomo Manzù," *Art News*, 59, May 1960, p. 13
Mellow, James R. "In the Galleries: Giacomo Manzù," *Arts*, 34, May 1960, p. 57, ill.
Rewald, John. *Giacomo Manzù*, Greenwich, Connecticut, New York Graphic Society, 1966, plate 75

"This bronze was made in 1942. The first version was done in 1937, and of course there were drawings and paintings on this theme before 1942.

"The bronze is a unique piece I did that year while on vacation, made with the fervor that always accompanies my work.

"It is difficult for me to speak about my work; therefore I will not involve myself with criticism and will limit myself to the descriptions.

"This bronze first took shape in my thoughts toward 1939 (I mean this specific piece and not those preceeding it), and was executed without models, which is true of almost all my works. The creation of the image sometimes stops with the idea, which must then pass from my hands to the form itself. It is difficult to arrive at this point, especially when one finds his possibilities limited as I do. However, my work continues despite the difficulties—at times painful—that accompany us in life.

"What is most important is the drive to create, which at times also gives us the hope of perceiving the infinite. This is always the thought that accompanies our work, but it is a rare thing when the form preserves it."

Statement by the artist, 1972

The Deposition. c. 1953.
Charcoal and gouache on wood, 86 × 58⅓ inches
Signed l. l.: "Manzu"

PROVENANCE:
The artist, Rome, 1963

Large Standing Cardinal. 1954.
Bronze (unique), 66⅛ × 23 × 15⅞ inches
Markings: back l. l. "Fonderia MAF Milano/ Manzu"

PROVENANCE:
The artist; Jon N. Streep, New York, 1957

EXHIBITIONS:
The Detroit Institute of Arts, and tour, 1959–60, *Sculpture in Our Time*, no. 135, ill. p. 63
The Solomon R. Guggenheim Museum, New York, October 3, 1962–January 6, 1963, *Modern Sculpture*

Column 3

from the Joseph H. Hirshhorn Collection, no. 256, ill. p. 131

REFERENCES:
Arnason, H. Harvard. *History of Modern Art*, New York, Abrams, 1968, p. 531, ill. p. 530
Broner, Robert. "Keen, Perceptive Show of Sculpture," *Detroit Sunday Times*, May 3, 1959, sec. B, p. 4, ill.
Mates, Robert E. *Photographing Art*, New York, Amphoto, 1966, ill. p. 119
———. "Photographing Sculpture and Museum Exhibits," *Curator*, 10, June 1967, ill. p. 120
Saltmarche, Kenneth. "Notes on Special Exhibitions: 'Sculpture in Our Time,'" *Art Quarterly*, 22, Winter 1959, p. 352

Praying Cardinal. 1955.
Gouache on paper mounted on Masonite, 40½ × 26½ inches
Signed l. l.: "Manzu"

PROVENANCE:
World House Galleries, New York, 1959

EXHIBITIONS:
World House Galleries, New York, April 24–May 18, 1957, *Manzù*, no. 40, ill. 38
Pasadena Art Museum, California, October 7–November 16, 1958, *The New Renaissance in Italy*, no. 58
Forum Gallery, New York, October 1–20, 1962, *Sculptors' Drawings from the Joseph H. Hirshhorn Collection*, no. 23; toured to Jewish Community Center, Washington, D.C., May 15–June 15, 1963
Duke University, Durham, North Carolina, October 6–27, 1963, *Sculptors' Drawings from the Joseph H. Hirshhorn Collection* (American Federation of Arts, Circulating Exhibition); toured to New Britain Museum of American Art, Connecticut, November 10–December 1; Krannert Art Museum, University of Illinois, Urbana, January 19–February 9, 1964; Laguna Gloria Art Museum, Austin, Texas, February 23–March 15; Lytton Center of the Visual Arts, Hollywood, California, March 29–July 15; Des Moines Art Center, Iowa, October 2–23
The Gallery of Modern Art, New York, January 19–February 21, 1965, *Major 19th and 20th Century Drawings*

REFERENCES:
Johnson, Una E. *Twentieth Century Drawings Part II: 1940 to the Present*, New York, Shorewood, 1964, plate 77, p. 109

Young Girl on a Chair. 1955.
Bronze (unique), 44 × 23⅛ × 43⅛ inches
Markings: c. back of chair "Fonderia MAF Milano/ Manzu"

PROVENANCE:
The Hanover Gallery, London, 1957

EXHIBITIONS:
XXVIII Biennale Internazionale d'Arte, Venice, June–September 1956, *Central Pavilion*, no. 12, p. 82
The Hanover Gallery, London, November 7–December 7, 1956, *Giacomo Manzù*, no. 2, cover ill.
Art Gallery of Toronto, April 9, 1957–March 31, 1959, extended loan
The Detroit Institute of Arts, and tour, 1959–60, *Sculpture in Our Time*, no. 137, ill. p. 64
Art Gallery of Toronto, November 1, 1960–February 28, 1961, extended loan
The Solomon R. Guggenheim Museum, New York, October 3, 1962–January 6, 1963, *Modern Sculpture from the Joseph H. Hirshhorn Collection*, no. 259, ill. p. 129

REFERENCES:
Alloway, Lawrence. "Art News from London," *Art News*, 55, December 1956, p. 55
Arnason, H. Harvard. *History of Modern Art*, New York, Abrams, 1968, p. 528, ill. p. 530
De Micheli, Mario. *Giacomo Manzù*, New York, Abrams, forthcoming, colorplates 39, 40
Feldman, Edmund Burke. *Art as Image and Idea*, Englewood Cliffs, New Jersey, Prentice-Hall, 1967, p. 140, ill. p. 139
———. *Varieties of Visual Experience*, New York, Abrams, 1972, p. 184, ill.
Melville, Robert. "Giacomo Manzù," *Studio*, 153, March 1957, p. 81, ill. p. 83
Read, Herbert. *A Concise History of Modern Sculpture*, New York, Praeger, 1964, no. 249, p. 297, ill. p. 219
Saltmarche, Kenneth. "Notes on Special Exhibitions: 'Sculpture in Our Time,'" *Art Quarterly*, 22, Winter 1959, p. 352
Sweeney, James Johnson. "A Living Frame for Sculpture," *House & Garden*, 126, August 1964, ill. p. 110

"*Young Girl on a Chair* is a bronze from 1955; I made a few variations of it, but never any copies. One might say that this piece was the first to develop in my mind; in fact, the drawing is from 1931 and the first sculpture on this theme is a copper piece, without the chair, from 1933.

"Certainly from 1931 to 1955 twenty-four years passed, but time cannot be considered a measure—it only serves to improve, and this is the only reason for which distance is justified. The chair was my first model; I then continued by putting the child on it and, later on, a still life. Not that it is finished: I think that there are other projects and variations in my mind.

"I am convinced that the chair motif, along with the portraits of Inge and the Cardinals, are among the better things I have done. You will forgive my self-assurance, but given the time that has passed, I may be granted this, even if I do not consider myself a critic."

Statement by the artist, 1972

Bust of Inge, No. 2. 1956.
Bronze (unique), 23⅞ × 15⅞ × 12⅛ inches
Markings: back l. c. "Fonderia MAF Milano/ Manzu"

PROVENANCE:
The Hanover Gallery, London, 1957

The Detroit Institute of Arts, 1959, *Sculpture in Our Time*, no. 138
The Solomon R. Guggenheim Museum, New York, October 3, 1962–January 6, 1963, *Modern Sculpture from the Joseph H. Hirshhorn Collection*, no. 262
University House, New York, May 2–10, 1964, *Art Is Forever* (sponsored by the American Friends of the Hebrew University), cat.

REFERENCES:
Raynor, Vivien. "In the Galleries: The Hirshhorn Collection," *Arts Magazine*, 37, November 1962, p. 41
Saltmarche, Kenneth. "Notes on Special Exhibitions: 'Sculpture in Our Time,'" *Art Quarterly*, 22, Winter 1959, p. 352

Dancer with Skirt. 1956.
Bronze (unique), 79 × 18¼ × 15 inches
Markings: l. r. side of base "Fonderia MAF Milano/Manzu"

PROVENANCE:
The Hanover Gallery, London, 1957

EXHIBITIONS:
The Hanover Gallery, London, November 7–December 7, 1956, *Giacomo Manzù*, no. 2, ill.
The Detroit Institute of Arts, 1959, *Sculpture in Our Time*, no. 139
The Solomon R. Guggenheim Museum, New York, October 3, 1962–January 6, 1963, *Modern Sculpture from the Joseph H. Hirshhorn Collection*, no. 261, ill. p. 130

REFERENCES:
Faison, S. Lane, Jr. *Art Tours & Detours in New York State*, New York, Random House, 1964, p. 222
Saltmarche, Kenneth. "Notes on Special Exhibitions: 'Sculpture in Our Time,'" *Art Quarterly*, 22, Winter 1959, p. 352
Unsigned. "The Hirshhorn Approach," *Time*, 80, October 5, 1962, colorplate p. 75

The Deposition. 1956.
Bronze relief (unique), 13¼ × 9¼ × 1¼ inches
Markings: back "Fonderia MAF Milano/MANZU"

PROVENANCE:
The Hanover Gallery, London, 1957

EXHIBITIONS:
Art Gallery of Toronto, June 27, 1957–March 31, 1959, extended loan
The Detroit Institute of Arts, and tour, 1959–60, *Sculpture in Our Time*, no. 132
The Solomon R. Guggenheim Museum, New York, October 3, 1962–January 6, 1963, *Modern Sculpture from the Joseph H. Hirshhorn Collection*, no. 254
The Baltimore Museum of Art, October 25–November 27, 1966, *Twentieth Century Italian Art*, cat.

The Execution. 1956.
Bronze relief (unique), 13¼ × 8¼ × ⅜ inches
Markings: back "Fonderia MAF Milano/MANZU"

PROVENANCE:
The Hanover Gallery, London, 1957

EXHIBITIONS:
Art Gallery of Toronto, June 27, 1957–March 31, 1959, extended loan
The Detroit Institute of Arts, and tour, 1959–60, *Sculpture in Our Time*, no. 140, ill. p. 65
The Solomon R. Guggenheim Museum, New York, October 3, 1962–January 6, 1963, *Modern Sculpture from the Joseph H. Hirshhorn Collection*, no. 255
The Baltimore Museum of Art, October 25–November 27, 1966, *Twentieth Century Italian Art*, cat.

REFERENCES:
Ragghianti, Carlo Ludovico. *Giacomo Manzù: Scultore*, 2nd ed., enl., Milan, Milione, 1957, p. 72, plate 118
Saltmarche, Kenneth. "Notes on Special Exhibitions: 'Sculpture in Our Time,'" *Art Quarterly*, 22, Winter 1959, p. 352, ill. p. 353

The Deposition or *Descent from the Cross* is related to the theme "Cristo nella nostra umanità" (literally, "Christ in our humanity") with which Manzù was preoccupied, first in 1938–39, and again between 1947 and 1957.

The Execution is similar to *The Death of the Partisan*, 1955/56, from Manzù's second series of reliefs on the same theme, in which the sufferings of Christian martyrs are explicitly associated with those of the anti-Fascists. A related composition is found in *Death by Violence* on Manzù's *Door of Death* at St. Peter's, The Vatican, Rome.

Three Studies of Saint Séverin. 1958.
Bronze relief (unique), 21¼ × 28¼ inches
Markings: back l. l. "Fonderia MAF Milano/Manzu"

PROVENANCE:
The Hanover Gallery, London, 1959

EXHIBITIONS:
Galerie Welz, Salzburg, Austria, 1958, *Manzùs Entwürfe zum Salzburger Domtor*, no. 24, ill.
The Detroit Institute of Arts, 1959, *Sculpture in Our Time* (hors cat.)
Art Gallery of Toronto, December 1959–February 1961, extended loan
The Solomon R. Guggenheim Museum, New York, October 3, 1962–January 6, 1963, *Modern Sculpture from the Joseph H. Hirshhorn Collection*, no. 273, ill. p. 132
University House, New York, May 2–10, 1964, *Art Is Forever* (sponsored by the American Friends of the Hebrew University), cat.

REFERENCES:
Fuhrmann, Franz. *Giacomo Manzù, Entwürfe zum Salzburger Domtor 1955/58*, Salzburg, Austria, Galerie Welz, 1958, nos. 24–27, ill.
Rewald, John. *Giacomo Manzù*, Greenwich, Connecticut, New York Graphic Society, 1966, pp. 70, 77, plate 73 (detail)
Saltmarche, Kenneth. "Notes on Special Exhibitions: 'Sculpture in Our Time,'" *Art Quarterly*, 22, Winter 1959, p. 352

In 1955, Manzù was commissioned to make a set of bronze doors illustrating the theme of *caritas*, or Christian Love, for Salzburg Cathedral, in Austria. Among the many studies he made for the doors are the three combined on this relief showing scenes of the loving-kindness of Saint Séverin of Noricum (d. 482). (Noricum was the old Roman province, south of the Danube River, that is roughly analagous to modern Austria.) Saint Séverin came to the aid of wandering tribes and farmers in the area under his protection, but Manzù has chosen to emphasize his particular role as protector of women in grief.

Monumental Standing Cardinal. 1958.
Bronze (unique), 12 feet 6¼ inches × 3 feet × 1 foot 10¼ inches
Markings: back l. c. "Fonderia MAF Milano/Manzu"

PROVENANCE:
The artist, Rome, 1963

REFERENCES:
De Micheli, Mario. *Giacomo Manzù*, New York, Abrams, forthcoming, ill. 52

"*Monumental Standing Cardinal* is a bronze from 1958. The idea to enlarge the Cardinal did not originate with the desire to produce 'monumental works'; I was convinced that by enlarging the piece the sides of the folds would offer me more possibilities for adventure with form than exist in the smaller work.

"Now, however, apart from a few small Cardinals that I did in the last few years, I think that this theme has been exhausted.

"In fact, I cannot persist with a theme knowing what I am to do in advance. It is no longer an adventure of love, of form, nor of poetry, but becomes instead simply a job that interferes with my possibilities, possibilities that I develop in other directions, always with the intention of producing something new.

"What will interest the observer is this relationship between the empty forms and the nudity of the full ones that sometimes gives me ideas that I would like—or at least that I would want—to make one think of the poetry of forms, because in my youthful ignorance I was already inclined in this direction."

Statement by the artist, 1972

Study for **The Opening of the Ecumenical Council (Pope John XXIII and Cardinal Rugambwa).** 1962.
Bronze relief (unique), 27¼ × 25¼ × ¾ inches
Markings: front l. r. "NFMA/Manzu"

PROVENANCE:
Paul Rosenberg & Co., New York, 1966

EXHIBITIONS:
Paul Rosenberg & Co., New York, December 6, 1965–January 29, 1966, *The Bronze Reliefs for the Door of Saint Peter's and Sculpture, Paintings, Drawings by Giacomo Manzù*, no. 25

REFERENCES:
Brandi, Cesare. *Studi per la porta di San Pietro di Giacomo Manzù*, Milan, Milione, 1964, p. 10

At the request of Pope John XXIII, Manzù commemorated the convening of the Second Vatican Council, 1962, in a frieze on the reverse of his doors for St. Peter's. In this study for a detail of the frieze, the pope, whom Manzù had portrayed many times before, is shown with Cardinal Laurian Rugambwa, later Archbishop of Dar es Salaam in Tanzania.

CONRAD MARCA-RELLI (b. 1913)

Corrado di Marca-Relli, born Boston, June 5, 1913. Youth spent in Boston, with frequent trips to Europe. Moved with family to New York, 1926. Studied, The Cooper Union for the Advancement of Science and Art, New York, 1930. WPA Federal Art Project, Mural and Easel Divisions, New York, 1935–38. Traveled in Mexico, 1940. Served, U.S. Army, 1941–45. One-man shows: Niveau Gallery, New York, 1947, 1949; Galleria del Cortile, Rome, 1949; The New Gallery, New York, 1951. Lived in Rome, and Paris, 1948–49. Charter member, The Club, New York, 1949. Returned to Rome, 1951. One-man shows: Stable Gallery, New York, 1953, 1955, 1956, 1958; Galleria del Naviglio, Milan, 1957; Kootz Gallery, New York, 1959–64; Galerie de France, Paris, 1962; Galerie Charles Lienhard, Zurich, 1963; Galeria Bonino, Buenos Aires, 1965. Included in: Whitney Annual, 1953–67; 63rd American Exhibition, The Art Institute of Chicago, 1954 (Logan Medal); Venice Biennale, 1955; Pittsburgh International, 1955–67; V São Paulo Bienal, 1959; Documenta II, Kassel, 1959; "The Art of Assemblage," The Museum of Modern Art, New York, and tour, 1961–62. Visiting critic, Yale University, New Haven, Connecticut, 1954–55, 1959–60. Taught, University of California, Berkeley, 1958. Received Ford Foundation Grant, 1959. Artist-in-residence, New College, Sarasota, Florida, 1965–67. Retrospective, Whitney Museum of American Art, New York, and tour, 1967–68. One-man show, Marlborough Gallery, New York, 1970. Lives in East Hampton, New York.

The Picador. 1956.
Oil and canvas collage, 47¼ × 53 inches
Signed l. r.: "Marca-Relli"

PROVENANCE:
Kootz Gallery, New York; Mr. and Mrs. Lee Ault, New York; Parke-Bernet Galleries, New York, Sale 2240, December 11, 1963, no. 106, ill. p. 133

REFERENCES:
Arnason, H. Harvard. *Marca-Relli*, New York, Abrams, 1963, ill. p. 37

"This collage represents for me the challenge of using a 'theme subject matter' and pushing its plastic solution as far as possible without losing its descriptive character. This is a constant in my work, as in the *Battle* and other figurative works."

Statement by the artist, 1972

GERHARD MARCKS (b. 1889)

Born Berlin, February 18, 1889. Worked in studio of sculptor Richard Scheibe, Berlin, 1907–12. Exhibited, Neue Sezession, Berlin, 1912. At invitation of Walter Gropius, contributed to Deutscher Werkbund exhibition, Cologne, 1914. Visited Paris, 1914. Served, German Army, 1914–18. Taught, Staatliche Kunstgewerbeschule, Berlin, 1918. Exhibited, Galerie Ferdinand Müller, Berlin, 1919, 1923. Directed ceramic workshop, Bauhaus, Weimar, Germany, 1919–24. Visited Italy, 1925, 1926; Greece, 1928. Taught, Kunstgewerbeschule Burg Giebichenstein, near Halle, Germany, 1925–33. Received: Villa Romana Prize, to work in Florence, 1928; scholarship, Villa Massimo, Rome, 1934. Forbidden by Nazis to work and exhibit, 1937; included in Nazi "Entartete Kunst (Degenerate Art)" exhibition, Munich, and tour, 1937. One-man shows, Curt Valentin Gallery, New York, 1938–51. Completed figure series begun by Ernst Barlach, facade, Church of St. Catherine, Lübeck, Germany, 1946–48. Taught, Staatliche Landeskunstschule, Hamburg, 1946–50. War memorials commissioned: Cologne, 1949; Hamburg, 1951. One-man shows: Kestner-Gesellschaft, Hanover, 1949; Galerie Rudolf Hoffmann, Hamburg, from 1951; Städtische Kunsthalle, Mannheim, Germany, 1953; Nationalgalerie, East Berlin, 1958; Fine Arts Associates, New York, 1958; Otto Gerson Gallery, New York, 1961; Wallraf-Richartz-Museum, Cologne, 1964. Appointed to Der Orden Pour le Mérite für Wissenschaften und Künste, 1952. Received Stefan Lochner Medal, City of Cologne, 1952. Included in: Venice Biennale, 1952; Documenta I and II, Kassel, 1955, 1959; "German Art of the Twentieth Century," The Museum of Modern Art, New York, and City Art Museum of St. Louis, Missouri, 1957; Pittsburgh International, 1958, 1964, 1967. Commissions: *Empedocles*, University of Frankfort, 1954; *Albertus Magnus*, University of Cologne, 1955. Retrospectives: The Arts Council of Great Britain, London, 1954; Leonard Hutton Galleries, New York, 1967; University of California at Los Angeles, and tour, 1969–70; Musée Rodin, Paris, 1971–72. Has lived in Cologne, since 1950.

Girl with Braids. 1950.
Bronze, 45¼ × 14¼ × 8¼ inches
Markings: l. top of base "72"

PROVENANCE:
Galerie Rudolf Hoffmann, Hamburg; Fine Arts Associates, New York, 1957

EXHIBITIONS:
XXVI Biennale Internazionale d'Arte, Venice, June 14–October 19, 1952, *German Pavilion*, no. 126
Kunsthalle, Basel, October 27–November 25, 1956, *Hermann Blumenthal, Gerhard Marcks, Alexander Zschokke*, cat.
The Detroit Institute of Arts, and tour, 1959–60, *Sculpture in Our Time*, no. 142, ill. p. 66
The Solomon R. Guggenheim Museum, New York, October 3, 1962–January 6, 1963, *Modern Sculpture from the Joseph H. Hirshhorn Collection*, no. 275, ill. p. 52
Marlborough-Gerson Gallery, New York, November–December 1963, *Artist and Maecenas: A Tribute to Curt Valentin*, no. 61, ill. p. 46

REFERENCES:
Dorne, Albert. "In the Office: Joseph Hirshhorn," *Art in America*, 46, Summer 1958, ill. p. 40
Fish, Margaret. "Show to Highlight Sculpture Revival," *Milwaukee Sentinel*, August 30, 1959, ill.
Netter, Maria. "Ausstellungen: Basel," *Werk-Chronik*, 43, December 1956, p. 242
Unsigned. "Dreams Frozen in Stone and Metal—Art that Never Dies," *Detroit Free Press*, July 31, 1959, ill.

JOHN MARIN (1870–1953)

Born Rutherford, New Jersey, December 23, 1870. Youth spent in Weehawken, New Jersey. Studied engineering, Stevens Institute of Technology, Hoboken, New Jersey, 1888. Worked as free-lance architect, New Jersey, early 1890s. Studied: The Pennsylvania Academy of the Fine Arts, Philadelphia, with Thomas Anshutz, and Hugh Breckenridge, 1899–1901 (classmate and friend of Arthur B. Carles); The Art Students League of New York, with Frank Vincent Du Mond, 1901–3. Lived in Europe, 1905–11. Included in: Salon d'Automne, Paris, 1907, 1908, 1910; Carnegie Annual, 1908; Salon des Indépendants, Paris, 1909. One-man shows, Alfred Stieglitz's Photo-Secession Gallery, "291," New York, 1910–17. Included in: the Armory Show, 1913; "The Forum Exhibition of Modern American Painters," The Anderson Galleries, New York, 1916; Society of Independent Artists Annual, 1917. Summered in Maine, from 1914; settled in Cliffside, New Jersey, 1916. One-man shows, New York: Ardsley Studios, Brooklyn, 1917; The Daniel Gallery, 1920, 1921; Montross Gallery, 1922–24; Stieglitz's Intimate Gallery, 1925–29; Stieglitz's An American Place, 1930–50; The Downtown Gallery, 1948–54. Included in: Société Anonyme, The Brooklyn Museum, New York, 1926; "Paintings by Living Americans," "American Painting and Sculpture," and "Art in Our Time," The Museum of Modern Art, New York, 1929–30, 1932–33, 1939; "A Century of Progress," The Art Institute of Chicago, 1933; Venice Biennale, 1934. Retrospectives: The Museum of Modern Art, 1936; Institute of Modern Art, Boston, and tour, 1947; M. H. de Young Memorial Museum, San Francisco, and tour, 1949. Member: The National Institute of Arts and Letters, 1942; The American Academy of Arts and Letters, 1943. *The Selected Writings of John Marin*, edited by Dorothy Norman, published (New York, Pellegrini & Cudahy), 1949. Retrospectives: New Jersey State Museum, Trenton, 1950; Venice Biennale, 1950; Munson-Williams-Proctor Institute, Utica, New York, 1951; The Museum of Fine Arts, Houston, 1953. Died Cape Split, Maine, October 2, 1953. Memorial exhibitions: The Museum of Modern Art, 1953; The American Academy of Arts and Letters, 1954; Museum of Fine Arts, Boston, and tour (organized by The Art Galleries, University of California at Los Angeles), 1955–56. Posthumously awarded Temple Gold Medal, Pennsylvania Academy, 1954. Retrospectives: The Corcoran Gallery of Art, Washington, D.C., and tour, 1962; Montclair Art Museum, New

Jersey, 1964; Los Angeles County Museum of Art, and tour, 1970–71.

Green Head, Deer Isle, Maine. 1921.
Watercolor on paper, 16½ × 19½ inches
Signed and dated l. r.: "Marin/21"

PROVENANCE:
Montross Gallery, New York; The Downtown Gallery, New York, 1953

EXHIBITIONS:
Montross Gallery, New York, January 24–February 11, 1922, *Oils, Watercolors and Etchings by John Marin*
M. H. de Young Memorial Museum, San Francisco, February 15–March 22, 1949, *John Marin Retrospective,* no. 8; toured to Santa Barbara Museum of Art, California, April 1–30; Los Angeles County Museum of Art, May 12–June 12
The American Academy of Arts and Letters, New York, January 15–February 14, 1954, *John Marin,* no. 24
The National Gallery of Canada, Ottawa, and tour, 1957, *Some American Paintings from the Collection of Joseph H. Hirshhorn,* no. 52, ill. no. 5
The Katonah Gallery, Katonah, New York, January 5–30, 1958, *John Marin*
American Federation of Arts tour, 1962–65, *Paintings from the Joseph H. Hirshhorn Foundation Collection: A View of the Protean Century,* no. 47, ill.
The Gallery of Modern Art, New York, June 29–September 5, 1965, *The Twenties Revisited,* cat.

REFERENCES:
Archives of American Art, Smithsonian Institution, Washington, D.C., *The Downtown Gallery Archives*
Reich, Sheldon. *John Marin: A Stylistic Analysis and Catalogue Raisonné,* 2 vols., Tucson, University of Arizona, 1970, no. 21.21, p. 484, ill.

A Composing, Cape Split. No. 2. 1943.
Watercolor on paper, 15 × 20⅞ inches
Signed and dated l. r.: "Marin 43"

PROVENANCE:
Alfred Stieglitz, An American Place, New York; The Downtown Gallery, New York, 1953

EXHIBITIONS:
An American Place, New York, December 1943–January 1944, *Recent Paintings by John Marin*
Wadsworth Atheneum, Hartford, Connecticut, October 27–November 28, 1948, *Seven by Six,* no. 3
Farnsworth Museum of Art, Wellesley College, Massachusetts, October 15–November 20, 1949, *Masters of American Watercolor*
Munson-Williams-Proctor Institute, Utica, New York, December 2–30, 1951, *John Marin, Oils, Prints and Drawings,* no. 25
University of Nebraska Art Galleries, Lincoln, January–February 1952, *John Marin and Contemporary Watercolor*
The American Academy of Arts and Letters, New York, January 15–February 14, 1954, *John Marin,* no. 40
The National Gallery of Canada, Ottawa, and tour, 1957, *Some American Paintings from the Collection of Joseph H. Hirshhorn,* no. 51
The Katonah Art Gallery, Katonah, New York, January 5–30, 1958, *John Marin*
The Fieldston School Arts Center, Riverdale, New York, April 24–May 5, 1958, *Second Annual Exhibition*
Palazzo Reale, Naples, November 1959, *Twenty-Five Years of American Painting: 1932–1958* (organized by the City Art Museum of St. Louis, Missouri, for the U.S. Information Agency), cat., ill.; toured to six European cities
The Corcoran Gallery of Art, Washington, D.C., March 2–April 15, 1962, *John Marin in Retrospect,* no. 80; toured to Currier Gallery of Art, Manchester, New Hampshire, May 9–June 24
Amerika Haus, Berlin, *John Marin* (organized by the U.S. Information Agency), September 15–October 13, 1962, no. 58; toured to Amerika Haus, Hamburg, October 26–November 21
The Brooklyn Museum, New York, February 8–April 5, 1965, *Paintings from the Joseph H. Hirshhorn Foundation Collection: A View of the Protean Century,* no. 84

REFERENCES:
Archives of American Art, Smithsonian Institution, Washington, D.C., *The Downtown Gallery Archives*
Reich, Sheldon. *John Marin: A Stylistic Analysis and Catalogue Raisonné,* 2 vols., Tucson, University of Arizona, 1970, no. 43.1, p. 727, ill.
Rosenblum, Robert. "Marin's Dynamism," *Art Digest,* 28, February 1, 1954, p. 13, ill.

Movement: Boat and Sea in Greys. 1952.
Oil on canvas, 22 × 28 inches
Signed and dated l. r.: "Marin '52"

PROVENANCE:
The Downtown Gallery, New York, 1953

EXHIBITIONS:
The Downtown Gallery, New York, December 30, 1952–January 24, 1953, *John Marin: Paintings of Land, Sea and Circus,* cat.
Musée National d'Art Moderne, Paris, April 24–June 8, 1953, *12 Modern American Painters and Sculptors* (The Museum of Modern Art, New York, International Circulating Exhibition); toured to Kunsthaus, Zurich, July 25–August 30; Kunstmuseum der Stadt, Düsseldorf, September 20–October 25; Liljevalchs Konsthall, Stockholm, November 25–December 20; Taidehalli Konsthallen, Helsinki, January 8–24, 1954; Kunstnerns Hus, Oslo, February 18–March 7
Museum of Fine Arts, Boston, March 1–April 17, 1955, *John Marin Memorial Exhibition* (organized by The Art Galleries, University of California at Los Angeles), no. 35, ill.; toured to The Phillips Collection, Washington, D.C., May 11–June 29; San Francisco Museum of Art, July 31–September 11; The Art Galleries, University of California at Los Angeles, September 28–November 9; The Cleveland Museum of Art, December 10–January 17, 1956; The Minneapolis Institute of Arts, February 3–March 20; The Society

of The Four Arts, Palm Beach, Florida, April; University of Georgia, Athens, May; Whitney Museum of American Art, New York, June 13–July 29
The Arts Council of Great Britain, London, September 14–October 13, 1956, *John Marin Memorial* (organized by the U.S. Information Agency)
Palazzo Reale, Naples, November 1959, *Twenty-Five Years of American Painting: 1932–1958* (organized by the City Art Museum of St. Louis, Missouri, for the U.S. Information Agency); toured to six European cities
American Federation of Arts tour, 1962–65, *Paintings from the Joseph H. Hirshhorn Foundation Collection: A View of the Protean Century,* no. 48
La Jolla Museum of Art, California, February 12–March 27, 1966, *Marsden Hartley—John Marin,* no. 42

REFERENCES:
Archives of American Art, Smithsonian Institution, Washington, D.C., *The Downtown Gallery Archives*
Porter, Fairfield. "The Nature of John Marin," *Art News,* 54, March 1955, p. 63
Reich, Sheldon. *John Marin: A Stylistic Analysis and Catalogue Raisonné,* 2 vols., Tucson, University of Arizona, 1970, no. 52.34, p. 805, ill.

MARINO MARINI (b. 1901)

Born Pistoia, Italy, February 27, 1901. Graduated, Accademia di Belle Arti e Liceo Artistico, Florence, 1923. Included in: II Biennale Romana, Rome, 1923; Venice Biennale, 1930, 1932, 1934, 1948, 1962, 1964. Taught, Istituto Superiore delle Industrie Artistiche di Villa Reale, Monza, Italy, 1929–40. One-man shows: Galleria Milano, Milan, 1932; Galleria Sabatello, Rome, 1933. Awarded: Grand Prize, Quadriennale Nazionale d'Arte, Rome, 1936; Sculpture Prize, Exposition Universelle de 1937, Paris. Lived in Ticino, Switzerland, 1942–49; first visited the U.S., 1950. One-man shows: Buchholz Gallery, New York, 1950; The Hanover Gallery, London, 1951, 1956; Kestner-Gesellschaft, Hanover, and tour, 1951–53; Curt Valentin Gallery, New York, 1953; Cincinnati Art Museum, Ohio, 1953. Awarded: Grand Prize for Sculpture, Venice Biennale, 1952; Feltrinelli Prize, Accademia Nazionale dei Lincei, Rome, 1954. Included in: Documenta I–III, Kassel, 1955, 1959, 1964; Pittsburgh International, 1955–67. One-man shows: Museum Boymans-van Beuningen, Rotterdam, The Netherlands, and tour, 1955; Pierre Matisse Gallery, New York, from 1955. Member, Accademia Nazionale di San Luca, Rome, 1957. Retrospectives: Kunsthaus, Zurich, 1962; Museo di Palazzo Venezia, Rome, 1966; Galleria Toninelli Arte Moderna, Rome, 1970. Honorary member, The National Institute of Arts and Letters, and The American Academy of Arts and Letters, 1968. Professor of sculpture, Accademia di Belle Arti di Brera e Liceo Artistico, Milan, since 1940. Lives in Milan.

Susanna. 1943.
Bronze, 28¼ × 21 × 9⅜ inches
Markings: top of base [Fonderia Milano MM]

PROVENANCE:
Curt Valentin Gallery, New York, 1954

EXHIBITIONS:
Brandeis University, Waltham, Massachusetts, June 1–17, 1955, *Three Collections,* no. 30
Leonid Kipnis Gallery, Westport, Connecticut, November 18–30, 1956, *Modern Sculpture* (sponsored by the Westport Community Art Association), no. 26
The Detroit Institute of Arts, 1959, *Sculpture in Our Time,* no. 146
The Solomon R. Guggenheim Museum, New York, October 3, 1962–January 6, 1963, *Modern Sculpture from the Joseph H. Hirshhorn Collection,* no. 278, ill. p. 134
Marlborough-Gerson Gallery, New York, November–December 1963, *Artist and Maecenas: A Tribute to Curt Valentin,* no. 84, ill. p. 51

REFERENCES:
Genauer, Emily. "Boston Holds Outdoor Art Festival—Why Not New York?" *New York Herald Tribune Book Review,* June 19, 1955, ill. p. 10
Read, Herbert, Di San Lazzaro, Gualtieri, and Waldberg, Patrick. *Marino Marini: Complete Works,* New York, Tudor, 1970, no. 145, p. 342

Little Horse and Rider. 1949.
Polychromed bronze (edition of six), 17⅛ × 16¼ × 8¼ inches
Markings: top of base "MM"

PROVENANCE:
Buchholz Gallery, New York, 1951

EXHIBITIONS:
Hopkins Art Center, Dartmouth College, Hanover, New Hampshire, May 25–July 9, 1967, *Sculpture in Our Century: Selections from the Joseph H. Hirshhorn Collection,* no. 36, ill. p. 36

REFERENCES:
Apollonio, Umbro. *Marino Marini, Sculptor,* 3rd enlarged ed., trans. Anna Bossi Molina, Milan, Milione, 1958, p. 39
Busignani, Alberto. *Marino Marini,* Florence, Sadea Sansoni, 1968, p. 85, colorplate 25
Hammacher, A. M. *Marino Marini,* New York, Abrams, 1969, plate 132
Read, Herbert, Di San Lazzaro, Gualtieri, and Waldberg, Patrick. *Marino Marini: Complete Works,* New York, Tudor, 1970, no. 254, p. 361

Horse and Rider. 1952–53.
Bronze, 82 × 81 × 46¼ inches
Markings: back top of base "MM"

PROVENANCE:
The artist, Milan, 1955

EXHIBITIONS:
The Detroit Institute of Arts, and tour, 1959–60, *Sculpture in Our Time,* no. 148, ill. p. 68
The Solomon R. Guggenheim Museum, New York,

October 3, 1962–January 6, 1963, *Modern Sculpture from the Joseph H. Hirshhorn Collection,* no. 279, ill. p. 137

REFERENCES:
Apollonio, Umbro. *Marino Marini, Sculptor,* 3rd enlarged ed., trans. Anna Bossi Molina, Milan, Milione, 1958, p. 40
Arnason, H. Harvard. *History of Modern Art,* New York, Abrams, 1968, ill. p. 529
Fish, Margaret. "Moderns' Diversity Dominates Great Sculpture Show," *Milwaukee Sentinel,* September 27, 1959, ill.
Hammacher, A. M. *Marino Marini,* New York, Abrams, 1969, plate 195
Kilbourn, Elizabeth. "Coast to Coast in Art," *Canadian Art,* 17, January–February 1961, p. 66, ill.
Read, Herbert, Di San Lazzaro, Gualtieri, and Waldberg, Patrick. *Marino Marini: Complete Works,* New York, Tudor, 1970, no. 301a, p. 368
Saltmarche, Kenneth. "Hirshhorn Collection," *Windsor [Ontario] Daily Star,* May 23, 1959
Unsigned. "Sculpture: Fresh-Air Fun," *Time,* 90, September 8, 1967, colorplate p. 75

Red Horse. 1952.
Oil on canvas, 39½ × 29¼ inches
Signed and dated l. r.: "Marino 1952"

PROVENANCE:
The artist, Milan, 1955

Bull. 1953.
Bronze, 32 × 26½ × 15 inches
Markings: top of base "MM"

PROVENANCE:
Pierre Matisse Gallery, New York, 1956

EXHIBITIONS:
The Solomon R. Guggenheim Museum, New York, October 3, 1962–January 6, 1963, *Modern Sculpture from the Joseph H. Hirshhorn Collection,* no. 280, ill. p. 135

Juggler (Dancer; Acrobat). 1954.
Bronze, 65 × 23 × 16 inches
Markings: back top of base "MM"

PROVENANCE:
The artist, Milan, 1955

EXHIBITIONS:
The Detroit Institute of Arts, and tour, 1959–60, *Sculpture in Our Time,* no. 151
The Solomon R. Guggenheim Museum, New York, October 3, 1962–January 6, 1963, *Modern Sculpture from the Joseph H. Hirshhorn Collection,* no. 282, ill. p. 136

REFERENCES:
Arnason, H. Harvard. *History of Modern Art,* New York, Abrams, 1968, ill. p. 528
Byng, Tom. "Mods and Baroquers," *House & Garden,* British ed., 20, February 1965, ill. p. 56
Dorne, Albert. "In the Office: Joseph Hirshhorn," *Art in America,* 46, Summer 1958, ill. p. 39
Hammacher, A. M. *Marino Marini,* New York, Abrams, 1969, colorplate 209, plates 210, 212 (details)
Read, Herbert. *A Concise History of Modern Sculpture,* New York, Praeger, 1964, no. 247, p. 297, ill. p. 218
———, Di San Lazzaro, Gualtieri, and Waldberg, Patrick. *Marino Marini: Complete Works,* New York, Tudor, 1970, no. 318, p. 370
Sweeney, James Johnson. "A Living Frame for Sculpture," *House & Garden,* 126, August 1964, ill. p. 110
Trier, Edward. *The Sculpture of Marino Marini,* New York, Praeger, 1961, p. 140, plates 84–86

Portrait of Henry Miller. 1961.
Bronze, 11½ × 6½ × 8½ inches
Markings: back "MM 1/6"

PROVENANCE:
Galerie Springer, Berlin, 1964

EXHIBITIONS:
The Baltimore Museum of Art, October 25–November 27, 1966, *Twentieth Century Italian Art,* cat.

REFERENCES:
Read, Herbert, Di San Lazzaro, Gualtieri, and Waldberg, Patrick. *Marino Marini: Complete Works,* New York, Tudor, 1970, no. 366, p. 375

REGINALD MARSH (1898–1954)

Born Paris, March 14, 1898, of American parents. Youth spent in Nutley, New Jersey. Moved to New Rochelle, New York, 1914. Studied: Yale University, New Haven, Connecticut, A.B., 1920; The Art Students League of New York, summer, 1919, with John Sloan, 1920–21, with Kenneth Hayes Miller, George Luks, George B. Bridgman, 1922, with Miller, 1927–28. Illustrator, *New York Evening Post, New York Herald, Vanity Fair, Harper's Bazaar,* 1920–25; New York *Daily News,* 1922–25; *The New Yorker,* 1925–31. Member, Whitney Studio Club, New York, 1923. One-man shows, New York: Whitney Studio Club, 1924, 1928; F. Valentine Dudensing, 1927; Weyhe Gallery, 1928; Marie Sterner Gallery, 1929; Frank Rehn Gallery, 1930–53. Began working in egg tempera, 1929. Included in: 44th, 45th, 48th, 50th, 51st, 53rd American Exhibition, The Art Institute of Chicago, 1931 (Kohnstamm Prize), 1932, 1935, 1937, 1938, 1940 (Blair Prize); Carnegie International, 1931, 1933, 1935, 1937; "American Painting and Sculpture," and "Art in Our Time," The Museum of Modern Art, New York, 1932–33, 1939; Whitney Annual, 1932–54; "A Century of Progress," The Art Institute of Chicago, 1933; National Academy of Design Annual, 1937 (Clarke Prize); "American Art Today," New York World's Fair, Flushing Meadows, 1939; Pennsylvania Academy Watercolor Annual, 1941 (Dana Medal); Corcoran Biennial, 1945 (Corcoran Gold Medal, and First Clark Prize). Studied dissection: College of Physicians and Surgeons, Columbia University, New York, 1931; Cornell University Medical College, New York, 1934. Public Works of Art Project, Mural Division, New York, 1933–34. The Art Students League: vice-president, 1933–34; taught,

1935–54. Studied: fresco technique, with Olle Nordmark, c. 1934; sculpture, with Mahonri Young, The Art Students League, 1935. Mural commissions, U.S. Treasury Department, Section of Fine Arts, and Treasury Relief Art Project: U.S. Post Office Department, Washington, D.C., 1936; sixteen panels, rotunda, U.S. Customs House, New York, 1937. National Academy of Design: associate, 1937; academician, 1943. Studied: copper engraving, S. W. Hayter's Atelier 17, New York, 1940; emulsion technique ("Maroger medium"), with Jacques Maroger, New York, 1940–46. Wartime artist/correspondent, *Life*, 1943. Retrospectives, Berkshire Museum, Pittsfield, Massachusetts, 1944, 1953. Wrote *Anatomy for Artists* (New York, American Artists Group), 1945. Member, The National Institute of Arts and Letters, 1946. Taught, Moore Institute of Art, Science and Industry, Philadelphia, 1949–54. Art editor, *Encyclopaedia Britannica*, 1954. Awarded Gold Medal for Graphic Arts, The National Institute of Arts and Letters, and The American Academy of Arts and Letters, 1954. Died Dorset, Vermont, July 3, 1954. Memorial exhibition, Whitney Museum of American Art, New York, and tour, 1955–56. Retrospective, The University of Arizona Art Gallery, Tucson, 1969.

George C. Tilyou's Steeplechase Park. 1936.
Egg tempera on wood panel, 36 × 48 inches
Signed and dated l. r.: "Reginald Marsh '36"

PROVENANCE:
Frank Rehn Gallery, New York, 1955

EXHIBITIONS:
Frank Rehn Gallery, New York, October 26–November 4, 1936, *Paintings and Watercolors by Reginald Marsh*
Addison Gallery of American Art, Phillips Academy, Andover, Massachusetts, March 13–April 21, 1937, *Reginald Marsh—Waldo Peirce*
American Fine Arts Society, New York, June 16–July 31, 1937, *Second National Exhibition of American Art*, no. 455
Carnegie Institute, Pittsburgh, October 14–December 5, 1937, *The 1937 International Exhibition of Paintings*, no. 71, plate 70
The Pennsylvania Academy of the Fine Arts, Philadelphia, January 30–March 6, 1938, *The One Hundred and Thirty-Third Annual Exhibition*, no. 68, ill.
Frank Rehn Gallery, New York, July 1938, *Group Show*
Whitney Museum of American Art, New York, September 21–November 6, 1955, *Reginald Marsh Memorial Exhibition*, no. 24, ill.; toured to seven U.S. cities
Whitney Museum of American Art, New York, April 30–June 15, 1958, *The Museum and Its Friends*, no. 112, ill. p. 25
Sokolniki Park, Moscow, July 25–September 5, 1959, *American National Exhibition* (sponsored by the U.S. Information Agency), no. 13, ill.
Whitney Museum of American Art, New York, October 28–November 15, 1959, *Paintings and Sculpture from the American National Exhibition in Moscow*, cat.
American Federation of Arts tour, 1962–65, *Paintings from the Joseph H. Hirshhorn Foundation Collection: A View of the Protean Century*, no. 49

REFERENCES:
Bird, Paul. "The Fortnight in New York," *Art Digest*, 11, November 15, 1936, p. 19, ill.
Davidson, Martha. "Marsh's View of Tawdry and Seamy New York," *Art News*, 35, November 7, 1936, p. 15
———. "Selected Paintings by Native Artists in a Group Showing," *Art News*, 36, July 16, 1938, p. 15
Genauer, Emily. "Impressive—75 Paintings Assembled by Hirshhorn," *New York Herald Tribune*, October 31, 1962, p. 15
———. "Top Art Loans at the Whitney," *New York Herald Tribune Book Review*, May 4, 1958, p. 9
———. "75 Choice Hirshhorn Paintings," *New York Herald Tribune*, November 4, 1962, sec. 4, p. 7
Goodrich, Lloyd. *Reginald Marsh*, New York, Abrams, 1972, pp. 42, 44, colorplate p. 118, ill. p. 119 (detail)
Jewell, Edward Alden. "The Home-Made Product," *The New York Times*, November 1, 1936, sec. 10, p. 9

Hudson Burlesk Chorus. 1948.
Egg tempera on Masonite, recto and verso, 27 × 48 inches
Signed and dated l. r. recto: "Reginald Marsh 48"

PROVENANCE:
Frank Rehn Gallery, New York, 1955

EXHIBITIONS:
California Palace of the Legion of Honor, San Francisco, December 1, 1948–January 16, 1949, *Third Annual Exhibition of Painting*, p. 20
National Academy of Design, New York, February 24–March 20, 1955, *130th Annual Exhibition*, no. 59, ill. p. 32
Whitney Museum of American Art, New York, September 21–November 6, 1955, *Reginald Marsh Memorial Exhibition*, no. 35; toured to seven U.S. cities
The National Gallery of Canada, Ottawa, and tour, 1957, *Some American Paintings from the Collection of Joseph H. Hirshhorn*, no. 55

REFERENCES:
Goodrich, Lloyd. *Reginald Marsh*, New York, Abrams, 1972, colorplate p. 234, ill. p. 235 (detail)
Sargeant, Winthrop. "The Art Galleries: Exhibition at Whitney Museum," *The New Yorker*, 31, October 8, 1955, p. 102
Thomson, Hugh. "Art Review: Uranium King Shows Fabulous U.S. Art," *Toronto Daily Star*, April 11, 1957, p. 20

The subject of this painting is the Hudson Burlesque house in Union City, New Jersey. Although Marsh was interested in the seamy aspects of urban life, and frequently painted destitute alcoholics, bums, and prostitutes, he was also attracted by the theaters, beaches, and amusement parks of our cities.

AGNES MARTIN (b. 1912)

Born Maklin, Canada, March 22, 1912. Youth spent in Vancouver, British Columbia, Canada. Emigrated to the U.S., 1932; citizen, 1940. Studied: Western Washington State College, Bellingham, 1935–38; Teachers College, Columbia University, New York, B.S., 1942, M.A., 1952; University of New Mexico, Albuquerque, 1946–47. Taught, public schools: Orchard, Washington, 1937–38; Burley, Washington, 1939–41; Delmar, Delaware, 1942–43; Tacoma, Washington, 1943–44; Bremerton, Washington, 1944–46; Albuquerque, 1948–50. Also taught: University of New Mexico, Albuquerque, 1947–48; Eastern Oregon College, La Grande, 1952–53. Lived in Taos, New Mexico, 1956–57; met Betty Parsons. Moved to New York, 1957. One-man shows: Betty Parsons Gallery, New York, 1958, 1959, 1961; Robert Elkon Gallery, New York, 1961, 1963–66, 1970, 1972; Nicholas Wilder Gallery, Los Angeles, 1966, 1967, 1970; The School of Visual Arts, New York, 1971. Included in: "Geometric Abstraction in America," Whitney Museum of American Art, New York, 1962; "Formalists," Washington [D.C.] Gallery of Modern Art, 1963; "American Drawings," The Solomon R. Guggenheim Museum, New York, 1964; "The Responsive Eye," The Museum of Modern Art, New York, and tour, 1965–66; "Color, Image and Form," The Detroit Institute of Arts, 1967; "The Art of the Real," The Museum of Modern Art, International Circulating Exhibition, 1968–69. Received National Council on the Arts Grant, 1967. Included in: "White on White," Museum of Contemporary Art, Chicago, 1971–72; Documenta 5, Kassel, 1972. Retrospective, Institute of Contemporary Art, University of Pennsylvania, Philadelphia, and Pasadena Art Museum, California, 1973. Lives in Cuba, New Mexico.

Play. 1966.
Acrylic on canvas, 72 × 72 inches
Signed on back: "A. Martin 1966"

PROVENANCE:
J. L. Hudson Gallery, Detroit; Robert Elkon Gallery, New York, 1968

EXHIBITIONS:
Robert Elkon Gallery, New York, October 22–November 18, 1966, *Agnes Martin*
The Detroit Institute of Arts, April 11–May 21, 1967, *Color, Image and Form*, no. 51

REFERENCES:
Lippard, Lucy R. "Diversity in Unity: Recent Geometricizing Styles in America," in *Abstract Art since 1945*, London, Thames and Hudson, 1971, p. 232, ill. 238
Wilson, Ann. "Linear Webs," *Art and Artists*, 1, October 1966, p. 48, ill. p. 47

RAYMOND MASON (b. 1922)

Born Birmingham, England, March 2, 1922. Studied: Birmingham College of Art and Design, 1937–42; Royal College of Art, London, 1942–43; Ruskin School of Drawing and Fine Art, Oxford, England, 1943; Slade School of Fine Art, University College, London, 1943–46. Moved to Paris, 1946; studied, École des Beaux-Arts. Included in: "Les Mains Éblouies," Galerie Maeght, Paris, 1947; Salon de Mai, 1948, 1961. One-man shows, The Beaux-Arts Gallery, London, 1954, 1956. Designed sets and costumes for *Phèdre*, Théâtre du Gymnase, Paris, 1959. One-man show, Galerie Janine Hao, Paris, 1960. Received Copley Foundation Award, 1961. One-man shows: Galerie Claude Bernard, Paris, from 1965; Pierre Matisse Gallery, New York, from 1968. Included in: "The Obsessive Image," Institute of Contemporary Arts, London, 1968; "Trois Sculptures," Centre National d'Art Contemporain, Paris, 1968. Lives in Paris.

Big Midi Landscape. 1961.
Bronze relief, 41⅛ × 78¾ × 4 inches
Markings: l. r. "Raymond Mason 1961 1/8"
l. l. "A. Bruni. Fuse. Roma"

PROVENANCE:
Pierre Matisse Gallery, New York, 1968

EXHIBITIONS:
Pierre Matisse Gallery, New York, October 15–November 9, 1968, *Raymond Mason*, no. 11, ill.

ANDRÉ MASSON (b. 1896)

Born Balagny, Oise, France, January 4, 1896. Moved with family to Brussels, c. 1905. Worked for embroidery designer; attended evening classes, Académie Royale des Beaux-Arts, Brussels. Studied, École Nationale Supérieure des Beaux-Arts, Paris, with Paul-Albert Baudouin, 1912–14. Received Bourse d'Étude du Gouvernement Français, to study painting in Tuscany, Italy, 1914. Served, French Army, World War I; wounded and hospitalized, 1917. Moved to Paris, 1922; associated with Joan Miró; met André Breton, and Daniel-Henry Kahnweiler, 1923. First one-man show, Galerie Simon, Paris, 1924. Joined Surrealists; contributed to review *La Révolution Surréaliste*, 1924. Exhibited, Paris: "Exposition, La Peinture Surréaliste," Galerie Pierre, 1925; "Exposition Surréaliste," Au Sacre du Printemps, 1927. Severed connections with official Surrealist movement, 1929. Lived in Tossa de Mar, Spain, 1934–36; returned to Paris. Included in: "Fantastic Art, Dada, Surrealism," The Museum of Modern Art, New York, 1936–37; "Exposition Internationale du Surréalisme," Galerie des Beaux-Arts, Paris, 1938. Emigrated to the U.S., 1941; lived in Connecticut, 1941–45. Retrospective, The Baltimore Museum of Art, 1941. Exhibited, New York: "Artists in Exile," Pierre Matisse Gallery, 1942; "First Papers of Surrealism," 451 Madison Avenue, 1942. One-man shows: Willard Gallery, New York, 1942; Buchholz Gallery, New York, 1942, 1947, 1949; Galerie Louise Leiris, Paris, 1945, 1970. Returned to Paris, 1945. Volume of lithographs and drawings, *Bestiaire*, with introduction by Georges Duthuit, published (Paris, Galerie Louise Leiris), 1947. Retrospective, with Alberto Giacometti, Kunsthalle, Basel, 1950. Received Grand Prix National des Arts, 1954. Included in: Venice Biennale, 1954, 1958; Documenta I–III, Kassel, 1955, 1959, 1964; Pittsburgh International, 1964; "Dada, Surrealism and Their Heritage," The Museum of Modern Art, 1968. One-man shows: Saidenberg Gallery, New York, 1958, 1961, 1966; Venice Biennale, 1964; Galerie de Seine, Paris, 1972. Retrospectives: Graphische Sammlung Albertina, Vienna, and international tour, 1958; Akademie der Künste, Berlin, and Stedelijk Museum, Amsterdam, 1964; Musée National d'Art Moderne, Paris, 1965; Musée des Beaux-Arts, Lyons, 1967; Musée Cantini, Marseilles, France, 1968; Galleria Schwarz, Milan, 1970. Lives in Paris.

Elk Attacked by Dogs. 1945.
Oil on canvas, 20 × 25 inches
Signed l. l.: "André Masson"

PROVENANCE:
Galerie Louise Leiris, Paris; Buchholz Gallery, New York; Saidenberg Gallery, New York; William S. Rubin, New York; Galerie Lawrence, Paris, 1962

EXHIBITIONS:
Galerie Louise Leiris, Paris, December 11–29, 1945, *André Masson: Oeuvres rapportées d'Amérique 1941–1945*, no. 15
Buchholz Gallery, New York, February 4–March 1, 1947, *André Masson, Examples of His Work from 1922 to 1945*, no. 25
Kunsthalle, Basel, May 6–June 11, 1950, *Masson–Giacometti*
Saidenberg Gallery, New York, April 7–May 17, 1958, *André Masson: Recent Work and Earlier Paintings*, no. 32

REFERENCES:
Hahn, Otto. *Masson*, New York, Abrams, 1965, p. 20, plate 56
Rubin, William S. *Dada and Surrealist Art*, New York, Abrams, 1968, p. 370, colorplate 54
———. "Notes on Masson and Pollock," *Arts*, 34, November 1959, p. 43, ill.

Légende. 1945.
Tempera on canvas, 26 × 20 inches
Signed l. r.: "André Masson"

PROVENANCE:
Buchholz Gallery, New York; Saidenberg Gallery, New York, 1968

EXHIBITIONS:
Edgardo Acosta Gallery, Beverly Hills, California, November 3–29, 1958, *André Masson*, no. 9; toured to Pasadena Art Museum, California, December; San Francisco Museum of Art, January 6–February 15, 1959; Santa Barbara Museum of Art, California, February 18–March 15
Saidenberg Gallery, New York, February 14–March 25, 1961, *André Masson Retrospective Exhibition*, no. 21
Saidenberg Gallery, New York, September 27–October 22, 1966, *André Masson: Major Directions*, no. 23

HENRI MATISSE (1869–1954)

Henri-Émile-Benoît Matisse, born Le Cateau-Cambrésis, France, December 31, 1869. Studied law, Paris, 1887; practiced law, 1889–91. Studied painting, Paris: with William-Adolphe Bouguereau, Académie Julian, 1891–92; with Gustave Moreau, École des Beaux-Arts, 1892–97. First sculptures, portrait medallions, 1894. Paintings included in Salon de la Société Nationale des Beaux-Arts, 1896–99. Studied sculpture, Paris: Académie Camillo, with Eugène Carrière, 1899; École Communale de la Ville de Paris, evenings, 1899; Académie de la Grande Chaumière, with Émile-Antoine Bourdelle, 1900. Worked on painted decorations for Grand Palais, built for Exposition Universelle de 1900, Paris. Included in: Salon des Indépendants, from 1901; Salon d'Automne, from 1903 (with André Derain, and other Fauves, 1905, 1907). One-man shows, Paris: Galerie Ambroise Vollard, 1904; Galerie Druet, 1906. Works collected: by Leo, Gertrude, and Michael Stein, 1905; by Sergei I. Shchukin, 1908. With aid of the Steins, founded Académie Matisse, Paris, 1907 (Max Weber, and Patrick Henry Bruce among his first students); Académie closed, 1911. One-man shows: Alfred Stieglitz's Photo-Secession Gallery, "291," New York, 1908; Galerie Bernheim-Jeune, Paris (paintings and sculpture), 1910; "291," and European tour (sculpture), 1912. Included in the Armory Show, 1913. One-man shows: Galerie Bernheim-Jeune, 1913, 1919, 1920; The Leicester Galleries, London, 1919. Designed sets and costumes for *Le Chant du Rossignol*, Sergei Diaghilev's Ballets Russes de Monte Carlo, 1920. Lived in Paris, and Nice, 1922–38. One-man shows: Galerie Bernheim-Jeune, 1922–24, 1927, 1929; Brummer Gallery, New York, 1924, 1931; Venice Biennale, 1928; The Leicester Galleries, 1928, 1936. Retrospectives: Ny Carlsberg Glyptotek, Copenhagen, 1924; Galerie Thannhauser, Berlin, 1930; The Museum of Modern Art, New York, 1931; Galerie Georges Petit, Paris, 1931. Légion d'honneur: chevalier, 1925; commandeur, 1947. Awarded first prize, Carnegie International, 1927. Murals commissioned by Dr. Albert C. Barnes, Barnes Foundation, Merion, Pennsylvania, 1931; installed, 1933. Illustrated *Poésies de Stéphane Mallarmé* (Paris, Skira), 1932. Moved: to Cimiez, outside of Nice, 1938; to Vence, 1943. Retrospectives: Salon d'Automne, 1945; Philadelphia Museum of Art, and tour, 1951; The Museum of Modern Art, 1951; Ny Carlsberg Glyptotek, and tour, 1953. Designed and decorated Chapel of the Rosary, Vence, 1948–51. One-man show, Musée National d'Art Moderne, Paris, 1949. Awarded Grand Prize for Painting, Venice Biennale, 1950. Designed rose window, Union Church of Pocantico Hills, New York, 1954. Died, Nice, November 3, 1954. Retrospectives: Kunsthaus, Zurich (sculpture), 1959; The Art Galleries, University of California at Los Angeles, and tour, 1966; Hayward Gallery, London, 1968; Grand Palais, Paris, 1970; Statens Museum for Kunst, Copenhagen, 1970; The Museum of Modern Art, and tour (sculpture), 1972.

The Serf (Le Serf). 1900–1903.
Bronze, 36 × 13⅞ × 12¼ inches
Markings: r. back of base "HM 7/10"
c. front of base "Le Serf"
l. back of base "Bronze Cire Perdue C. Valsuani"

PROVENANCE:
Pierre Matisse Gallery, New York, 1957

EXHIBITIONS:
Fine Arts Associates, New York, November 25–December 20, 1958, *Henri Matisse, Sculpture, Drawings*, no. 1, ill.

The Detroit Institute of Arts, and tour, 1959–60, *Sculpture in Our Time*, no. 153
The Solomon R. Guggenheim Museum, New York, October 3, 1962–January 6, 1963, *Modern Sculpture from the Joseph H. Hirshhorn Collection*, no. 290, ill. pp. 76–77
The Art Galleries, University of California at Los Angeles, January 5–February 27, 1966, *Henri Matisse*, no. 96, ill. p. 124; toured to The Art Institute of Chicago, March 11–April 24; Museum of Fine Arts, Boston, May 11–June 26
Expo '67, Montreal, April 28–October 27, 1967, *International Exhibition of Contemporary Sculpture*, p. 119, ill. p. 97

REFERENCES:
Arnason, H. Harvard. *History of Modern Art*, New York, Abrams, 1968, p. 114, ill. p. 115
Elsen, Albert E. *The Sculpture of Henri Matisse*, New York, Abrams, 1972, pp. 25–30, ill. p. 24
Geldzahler, Henry. "Taste for Modern Sculpture: The Hirshhorn Collection," *Art News*, 61, October 1962, p. 31
Hale, William Harlan. *The World of Rodin: 1840–1917*, New York, Time-Life Books, 1969, p. 176, ill.
Kramer, Hilton. "Matisse as a Sculptor," *Boston Museum Bulletin*, 64, 1966, p. 51, ill. p. 50
Rubin, William S. "The Hirshhorn Collection at the Guggenheim Museum," *Art International*, 6, November 1962, ill. p. 36
Seldis, Henry J. "Matisse Sculpture Carves Niche in Fame," *Los Angeles Times Calendar*, February 6 1966, p. 2

Reclining Nude I. c. 1907.
Terra-cotta, 12¾ × 19 × 10⅜ inches
Markings: 1. back of base "Henri Matisse 1/5"

PROVENANCE:
The artist; Mr. and Mrs. Otto L. Spaeth, New York; Lee A. Ault, New York; Theodore Schempp, New York, 1959

REFERENCES:
Kuh, Katherine. "Great Sculpture," *Saturday Review*, 45, June 23, 1962, p. 14, ill.
Unsigned. "The Sculpture of Matisse," *Life*, 69, September 11, 1970, colorplate p. 42

Decorative Figure. 1908.
Bronze (4/10), 28¼ × 20 × 12 inches
Markings: c. left side "HM Aout 1908"
1. back of base "Cire Perdue No. 4 Valsuani"

PROVENANCE:
Curt Valentin Gallery, New York, 1955

EXHIBITIONS:
Curt Valentin Gallery, New York, November 20–December 15, 1951, *Sculpture by Painters*, no. 49, ill.
Curt Valentin Gallery, New York, February 1–28, 1953, *The Sculpture of Henri Matisse*, no. 17
Curt Valentin Gallery, New York, December 22, 1953–January 24, 1954, *Sculpture and Sculptors' Drawings*, no. 41, ill.
Silvermine Guild of Artists, New Canaan, Connecticut, July 8–26, 1956, *Sculpture of the 20th Century*, no. 56
The Detroit Institute of Arts, and tour, 1959–60, *Sculpture in Our Time*, no. 154, ill. p. 73
The Solomon R. Guggenheim Museum, New York, October 3, 1962–January 6, 1963, *Modern Sculpture from the Joseph H. Hirshhorn Collection*, no. 291, ill. pp. 78–79
Marlborough-Gerson Gallery, New York, November–December 1963, *Artist and Maecenas: A Tribute to Curt Valentin*, no. 31, ill. p. 36
Los Angeles County Museum of Art, April–July 1965, *Inaugural Loan Exhibition*
The Art Galleries, University of California at Los Angeles, January 5–February 27, 1966, *Henri Matisse*, no. 110, ill. p. 129; toured to The Art Institute of Chicago, March 11–April 24; Museum of Fine Arts, Boston, May 11–June 26
Smithsonian Institution, Washington, D.C., September 26, 1971–January 31, 1972, *One Hundred and Twenty-Fifth Anniversary of the Institution*
The Museum of Modern Art, New York, February 22–May 29, 1972, *The Sculpture of Matisse*, no. 34, ill. p. 22; toured to Walker Art Center, Minneapolis, June 20–August 6; University Art Museum, University of California, Berkeley, September 26–November 5

REFERENCES:
Arnason, H. Harvard. *History of Modern Art*, New York, Abrams, 1968, p. 115, ill. p. 116
Donadio, Emmie. "Matisse Sculpture at the Museum of Modern Art," *Arts Magazine*, 46, April 1972, p. 63
Elsen, Albert E. *The Sculpture of Henri Matisse*, New York, Abrams, 1972, pp. 87–90, ill. p. 88
Kramer, Hilton. "Matisse as a Sculptor," *Boston Museum Bulletin*, 64, 1966, p. 54, ill.
Read, Herbert. *A Concise History of Modern Sculpture*, New York, Praeger, 1964, no. 27, p. 8, ill. p. 35
Selz, Jean. *Modern Sculpture*, New York, Braziller, 1963, colorplate 8

Two Negresses (Deux Négresses). 1908.
Bronze, 18¼ × 9⅛ × 7⅛ inches
Markings: 1. r. back of base "Henri Matisse 1/10"
1. 1. back of base "A. Bingen Costenoble Fondeur Paris"

PROVENANCE:
The Hanover Gallery, London, 1958

EXHIBITIONS:
XVI Biennale Internazionale d'Arte, Venice, June–October 1928, *French Pavilion*, no. 58, p. 200
The Hanover Gallery, London, June 24–September 13, 1958, *Giacometti, Marini, Matisse, Moore*, no. 28, ill.
Art Gallery of Toronto, October 1–November 14, 1958, on loan
Fine Arts Associates, New York, November 25–December 20, 1958, *Henri Matisse, Sculpture, Drawings*, no. 14, ill.
The Detroit Institute of Arts, and tour, 1959–60, *Sculpture in Our Time*, no. 160

The Solomon R. Guggenheim Museum, New York, October 3, 1962–January 6, 1963, *Modern Sculpture from the Joseph H. Hirshhorn Collection*, no. 297, ill. p. 80
The Art Galleries, University of California at Los Angeles, January 5–February 27, 1966, *Henri Matisse*, no. 111, ill. p. 129; toured to The Art Institute of Chicago, March 11–April 24; Museum of Fine Arts, Boston, May 11–June 26

REFERENCES:
Arnason, H. Harvard. *History of Modern Art*, New York, Abrams, 1968, p. 115, ill.
Devree, Howard. "Matisse: Sculptor," *The New York Times*, November 30, 1958, sec. 2, p. 9
Elsen, Albert E. *The Sculpture of Henri Matisse*, New York, Abrams, 1972, pp. 83–86, ill. p. 82
Kramer, Hilton. "Matisse as a Sculptor," *Boston Museum Bulletin*, 64, 1966, p. 55, ill.
Rubin, William S. "The Hirshhorn Collection at the Guggenheim Museum," *Art International*, 6, November 1962, ill. p. 36
Sylvester, David, ed. *Modern Art*, New York, Grolier, 1965, ill. p. 225

Back I. 1909.
Bronze relief, 74¾ × 46 × 7 inches
Markings: front, 1. r. "HM 0/10"
front, 1. 1. "Henri Matisse Georges Rudier Fondeur Paris"

PROVENANCE:
Mme Henri Matisse; Private collection, Paris; Pierre Matisse Gallery, New York, 1963

REFERENCES:
Hughes, Robert. "Matisse: A Strange, Healing Calm," *Time*, 99, March 6, 1972, colorplate p. 54
Seldis, Henry J. "Matisse Sculpture Carves Niche in Fame," *Los Angeles Times Calendar*, February 6, 1966, p. 37
Sweeney, James Johnson. "A Living Frame for Sculpture," *House & Garden*, 126, August 1964, ill. p. 112
Unsigned. "The Sculpture of Matisse," *Life*, 69, September 11, 1970, colorplate p. 46

La Serpentine. 1909.
Bronze (6/10), 22 × 11¼ × 7½ inches
Markings: 1. r. side "Henri Matisse"
back 1. 1. "Bronze Cire Perdue C. Valsuani"
back 1. r. "No. 6"

PROVENANCE:
Dr. Philip Sandblom, Lund, Sweden; M. Knoedler & Co., New York, 1970

REFERENCES:
Berger, John. "Henri Matisse," *The New York Times Book Review*, December 3, 1972, sec. 7, ill. p. 3
Feldman, Edmund Burke. *Varieties of Visual Experience*, New York, Abrams, 1972, ill. p. 341

Seated Nude, Olga (Nu assis, Olga; Grand Nu accroupi). 1910.
Bronze, 17 × 9½ × 12½ inches
Markings: c. back of base "HM 10/10"
1. r. back of base "Cire Perdue Valsuani"

PROVENANCE:
Berggruen & Cie., Paris; Contemporary Art Establishment, Vaduz, Liechtenstein; The Hanover Gallery, London, 1958

EXHIBITIONS:
The Hanover Gallery, London, June 24–September 13, 1958, *Giacometti, Marini, Matisse, Moore*, no. 32, ill.
Art Gallery of Toronto, October 1–November 14, 1958, on loan
Fine Arts Associates, New York, November 25–December 20, 1958, *Henri Matisse, Sculpture, Drawings*, no. 13, ill.
The Detroit Institute of Arts, and tour, 1959–60, *Sculpture in Our Time*, no. 159, ill. p. 74
The Solomon R. Guggenheim Museum, New York, October 3, 1962–January 6, 1963, *Modern Sculpture from the Joseph H. Hirshhorn Collection*, no. 296, ill. p. 81
Hopkins Art Center, Dartmouth College, Hanover, New Hampshire, May 25–July 9, 1967, *Sculpture in Our Century: Selections from the Joseph H. Hirshhorn Collection*, no. 37, ill. p. 29

REFERENCES:
Elsen, Albert E. *The Sculpture of Henri Matisse*, New York, Abrams, 1972, pp. 96–103, ill. p. 98
Read, Herbert. *A Concise History of Modern Sculpture*, New York, Praeger, 1964, no. 29, p. 298, ill. p. 36

Head of Jeannette I. 1910–13.
Bronze (7/10), 12¼ × 7½ × 10 inches
Markings: back 1. c. "HM 7"
back 1. r. "Cire Perdue Valsuani"

PROVENANCE:
The artist; Mr. and Mrs. Theodor Ahrenberg, Stockholm; Sotheby & Co., London, Sale, July 7, 1960, no. 31, ill.; Gimpel & Hanover Galerie, Zurich, 1963

EXHIBITIONS:
Nationalmuseum, Stockholm, September 4–23, 1957, *Henri Matisse, Apollon*, no. 2; toured to Taidehalli, Helsinki, December 10, 1957–January 6, 1958, no. 157
Kunsthaus, Zurich, July 14–August 12, 1959, *Henri Matisse, das plastische Werk*, no. 43, ill.
Könsthallen, Gothenburg, Sweden, March 16–April 10, 1960, *Henri Matisse ur Theodor Ahrenbergs Samling*, no. 192
The Art Galleries, University of California at Los Angeles, January 5–February 27, 1966, *Henri Matisse*, no. 116, ill. p. 132; toured to The Art Institute of Chicago, March 11–April 24; Museum of Fine Arts, Boston, May 11–June 26

REFERENCES:
T. K. "Matisse scultore al Kunsthaus," *Emporium*, Zurich, 130, October 1959, p. 176

Head of Jeannette II. 1910–13.
Bronze (7/10), 10⅜ × 8¼ × 9 inches
Markings: back c. "HM 7"
back 1. c. "Cire Perdue C. Valsuani"

PROVENANCE:
The artist; Mr. and Mrs. Theodor Ahrenberg, Stockholm; Mayewski Collection, New York; Staempfli Gallery, New York, 1964

EXHIBITIONS:
Staempfli Gallery, New York, September 18–October 13, 1962, *Recent Acquisitions*, cover ill.
Staempfli Gallery, New York, February 25–March 21, 1964, *Stone Wood Metal*, cat., ill.
The Art Galleries, University of California at Los Angeles, January 5–February 27, 1966, *Henri Matisse*, no. 117, ill. p. 132; toured to The Art Institute of Chicago, March 11–April 24; Museum of Fine Arts, Boston, May 11–June 26

REFERENCES:
Seldis, Henry J. "Matisse Sculpture Carves Niche in Fame," *Los Angeles Times Calendar*, February 6, 1966, p. 2

Head of Jeannette III. 1910–13.
Bronze, 23½ × 8¼ × 9½ inches
Markings: 1. 1. side "HM 9/10 Cire Perdue C. Valsuani"

PROVENANCE:
Jean Matisse, Pontoise, France; Frank Perls Gallery, Beverly Hills, California, 1969

Head of Jeannette IV. 1910–13.
Bronze (3/10), 24 × 9¼ × 10¾ inches
Markings: back 1. c. "HM 3 Cire Perdue C. Valsuani"

PROVENANCE:
The artist; Mr. and Mrs. Theodor Ahrenberg, Stockholm; Sotheby & Co., London, Sale, July 7, 1960, no. 32, ill.; Marlborough-Gerson Gallery, New York, 1964

EXHIBITIONS:
Nationalmuseum, Stockholm, September 4–23, 1957, *Henri Matisse, Apollon*, no. 5; toured to Taidehalli, Helsinki, December 10, 1957–January 6, 1958, no. 159
Kunsthaus, Zurich, July 14–August 12, 1959, *Henri Matisse, das plastische Werk*, no. 46, ill.
Könsthallen, Gothenburg, Sweden, March 16–April 10, 1960, *Henri Matisse ur Theodor Ahrenbergs Samling*, no. 194
The Art Galleries, University of California at Los Angeles, January 5–February 27, 1966, *Henri Matisse*, no. 119, ill. p. 132; toured to The Art Institute of Chicago, March 11–April 24; Museum of Fine Arts, Boston, May 11–June 26
Greenwich Library, Connecticut, May 1–28, 1967, *Joseph H. Hirshhorn Collects*

REFERENCES:
Seldis, Henry J. "Matisse Sculpture Carves Niche in Fame," *Los Angeles Times Calendar*, February 6, 1966, p. 2
T. K. "Matisse scultore al Kunsthaus," *Emporium*, Zurich, 130, October 1959, p. 176

Head of Jeannette V. 1910–13.
Bronze, 23 × 8 × 11¼ inches
Markings: 1. 1. side "HM 2/10"
back 1. c. "Cire Perdue C. Valsuani"

PROVENANCE:
Estate of the artist, 1968

EXHIBITIONS:
Maison de la Pensée Française, Paris, July 5–September 24, 1950, *Henri Matisse*, no. 68

Back II. 1913.
Bronze relief, 74¾ × 47 × 8 inches
Markings: front, 1. r. "HM 0/10"
front, 1. 1. "Henri Matisse Georges Rudier Fondeur Paris"

PROVENANCE:
Mme Henri Matisse; Private collection, Paris; Pierre Matisse Gallery, New York, 1963

REFERENCES:
Hughes, Robert. "Matisse: A Strange, Healing Calm," *Time*, 99, March 6, 1972, colorplate p. 54
Seldis, Henry J. "Matisse Sculpture Carves Niche in Fame," *Los Angeles Times Calendar*, February 6, 1966, p. 37
Sweeney, James Johnson. "A Living Frame for Sculpture," *House & Garden*, 126, August 1964, ill. p. 112
Unsigned. "The Sculpture of Matisse," *Life*, 69, September 11, 1970, colorplate p. 46

Back III. 1916–17.
Bronze relief, 74 × 45 × 6 inches
Markings: front, 1. r. "HM 0/10"
front, 1. 1. "Henri Matisse Georges Rudier Fondeur Paris"

PROVENANCE:
Mme Henri Matisse; Private collection, Paris; Pierre Matisse Gallery, New York, 1963

REFERENCES:
Hughes, Robert. "Matisse: A Strange, Healing Calm," *Time*, 99, March 6, 1972, colorplate p. 54
Seldis, Henry J. "Matisse Sculpture Carves Niche in Fame," *Los Angeles Times Calendar*, February 6, 1966, p. 37
Sweeney, James Johnson. "A Living Frame for Sculpture," *House & Garden*, 126, August 1964, ill. p. 112
Unsigned. "The Sculpture of Matisse," *Life*, 69, September 11, 1970, colorplate p. 47

Reclining Nude III. 1929.
Bronze, 7¼ × 18½ × 5½ inches
Markings: back 1. 1. "HM 7/10"

PROVENANCE:
The Hanover Gallery, London, 1958

EXHIBITIONS:
The Hanover Gallery, London, June 24–September 13, 1958, *Giacometti, Marini, Matisse, Moore,* no. 30, ill.
Art Gallery of Toronto, October 1–November 14, 1958, on loan
Fine Arts Associates, New York, November 25–December 20, 1958, *Henri Matisse, Sculpture, Drawings,* no. 18, ill.
The Detroit Institute of Arts, and tour, 1959–60, *Sculpture in Our Time,* no. 161
The Solomon R. Guggenheim Museum, New York, October 3, 1962–January 6, 1963, *Modern Sculpture from the Joseph H. Hirshhorn Collection,* no. 299, ill. p. 82
The Museum of Modern Art, New York, February 22–May 29, 1972, *The Sculpture of Matisse,* no. 59, ill. p. 39; toured to Walker Art Center, Minneapolis, June 20–August 6; University Art Museum, University of California, Berkeley, September 26–November 5

REFERENCES:
Devree, Howard. "Matisse: Sculptor," *The New York Times,* November 30, 1958, sec. 2, p. 9, ill.
Elsen, Albert E. *The Sculpture of Henri Matisse,* New York, Abrams, 1972, pp. 155–59, ill. p. 158
Hughes, Robert. "Matisse: A Strange, Healing Calm," *Time,* 99, March 6, 1972, colorplate p. 54
Sontag, Raymond J. *A Broken World 1919–1939,* New York, Harper & Row, 1971, ill. following p. 138
Unsigned. "Great Sculpture at the Guggenheim," *Art in America,* 50, Fall 1962, ill. p. 19
———. "The Sculpture of Matisse," *Life,* 69, September 11, 1970, colorplate p. 43

Back IV. 1930.
Bronze relief, 74½ × 45 × 7 inches
Markings: front, l. r. "HM 0/10"
front, l. l. "Georges Rudier Fondeur Paris"

PROVENANCE:
Mme Henri Matisse; Private collection, Paris; Pierre Matisse Gallery, New York, 1963

REFERENCES:
Hughes, Robert. "Matisse: A Strange, Healing Calm," *Time,* 99, March 6, 1972, colorplate p. 54
Seldis, Henry J. "Matisse Sculpture Carves Niche in Fame," *Los Angeles Times Calendar,* February 6, 1966, p. 37
Sweeney, James Johnson. "A Living Frame for Sculpture," *House & Garden,* 126, August 1964, ill. p. 112
Unsigned. "The Sculpture of Matisse," *Life,* 69, September 11, 1970, colorplate p. 47

MATTA (b. 1912)

Roberto Sebastián Antonio Matta Echaurren, born Santiago, Chile, November 11, 1912. Studied, Escuela de Arquitectura, Universidad de Chile, Santiago, 1931–33. Moved to Paris, 1933. Worked as architectural draftsman, Le Corbusier's studio, Paris, 1935–37. In Madrid, 1936, met Spanish poet Federico García Lorca, who introduced him to Salvador Dalí, through whom he met André Breton. Joined Surrealist group, 1937; published "Mathématique sensible—Architecture du Temps," in Surrealist magazine *Minotaure* (Paris), 1938. Moved to New York, 1939. One-man shows, New York: Julien Levy Gallery, 1940, 1943; Pierre Matisse Gallery, 1942–47. Traveled to Mexico, with Robert Motherwell, 1941. Included in: "Artists in Exile," Pierre Matisse Gallery, 1942; "First Papers of Surrealism," 451 Madison Avenue, New York, 1942; "Exposition Internationale du Surréalisme," Galerie Maeght, Paris, 1947. Returned to Europe, 1948. One-man shows: Sidney Janis Gallery, New York, 1949, 1951, 1955; Institute of Contemporary Arts, London, 1951; Allan Frumkin Gallery, Chicago, 1952–63; Alexandre Iolas Gallery, New York, 1953, 1957, 1958, 1964, 1966, 1968, 1972; Pan American Union, Washington, D.C., 1955. Included in: Pittsburgh International, 1955 (4th prize), 1958, 1967, 1970; Documenta II and III, Kassel, 1959, 1964; ROSC '67, Dublin, 1967; "Dada, Surrealism and Their Heritage," The Museum of Modern Art, New York, and tour, 1968. Mural commission, UNESCO Building, Paris, 1956. Retrospectives: The Museum of Modern Art, and tour, 1957–58; Moderna Museet, Stockholm, 1959; Museo Civico, Bologna, Italy, 1963. One-man shows: Allan Frumkin Gallery, New York, 1960–65; Gimpel & Hanover Galerie, Zurich, 1964; Galerie Alexandre Iolas, Paris, from 1966; Akademie der Künste, Berlin, 1970. Lives in Rome, and in Paris.

Untitled. c. 1949.
Chalk and pastel on paper mounted on canvas, 39½ × 59½ inches

PROVENANCE:
Hugo Gallery, New York; Alexandre Iolas Gallery, New York; Bodley Gallery, New York; Solomon Ethe, New York; Parke-Bernet Galleries, New York, Sale 2072, December 13, 1961, no. 98, ill. p. 105

EXHIBITIONS:
Alexandre Iolas Gallery, New York, March 1–15, 1957, *Matta*
Bodley Gallery, New York, November 21–December 3, 1960, *Matta from 1942–1957,* cat.

The Three. 1951.
Oil on canvas, 34 × 48½ inches

PROVENANCE:
Alexandre Iolas Gallery, New York; William S. Rubin, New York, 1963

EXHIBITIONS:
Carnegie Institute, Pittsburgh, October 16–December 14, 1952, *The Pittsburgh International Exhibition of Contemporary Painting,* no. 170
California Palace of the Legion of Honor, San Francisco, February 1–March 1, 1953, *The 39th Carnegie International*

The Clan. 1958.
Bronze and iron, 28½ × 29 × 22½ inches
Markings: l. top of base "Matta 6/6"
r. top of base "Susse Fondeur Paris"

PROVENANCE:
Cordier & Warren, New York, 1962

EXHIBITIONS:
The Solomon R. Guggenheim Museum, New York, October 3, 1962–January 6, 1963, *Modern Sculpture from the Joseph H. Hirshhorn Collection,* no. 301, ill. p. 119
Allan Frumkin Gallery, New York, December 1, 1964–January 9, 1965, *Matta,* ill. p. 3

REFERENCES:
Rubin, William S. *Dada and Surrealist Art,* New York, Abrams, 1969, pp. 361, 441, plate D–210

CHARLES MATTOX (b. 1910)

Born Bronson, Kansas, July 21, 1910. Studied: Bethany College, Lindsborg, Kansas, 1926–27; McPherson College, Kansas, 1929–30; Kansas City Art Institute, Missouri, 1930–31; School of The Art Institute of Chicago, 1932. Moved to New York, 1933. Studied privately with Arshile Gorky, New York, 1934–35. WPA Federal Art Project, Mural Division, New York, 1935–36. Moved to Hollywood, California, 1937: worked as molder and tool designer, 1937–42; as special effects man, 1942–50. Taught, Kann Institute, Los Angeles, 1946–50. Moved to San Francisco, 1950. Taught: Academy of Advertising Art, San Francisco, 1958; San Francisco Art Institute, 1959–63, summer, 1966; University of California, Berkeley, 1960–63. One-man shows: University Art Museum, University of California, Berkeley, 1960, 1961; Lanyon Gallery, Palo Alto, California, 1962, 1964; San Francisco Museum of Art, 1963; University of California, Irvine, and tour, 1967–68. Included in: "Directions in Kinetic Sculpture," University Art Museum, University of California, Berkeley, 1966; "American Sculpture of the Sixties," Los Angeles County Museum of Art, and Philadelphia Museum of Art, 1967. One-man shows: University of New Mexico, Albuquerque, 1968; Hill's Gallery, Santa Fe, New Mexico, 1971. Member, Board of Directors, College Art Association of America, 1972–76. Has taught, University of New Mexico, since 1968. Lives in Albuquerque.

Opposing V's. 1966.
Wood and Fiberglas construction, electrically wired, 60½ × 73 × 16½ inches

PROVENANCE:
Nicholas Wilder Gallery, Los Angeles, 1967

EXHIBITIONS:
Los Angeles County Museum of Art, April 28–June 25, 1967, *American Sculpture of the Sixties,* no. 88, ill. p. 151; toured to Philadelphia Museum of Art, September 15–October 29

ALFRED H. MAURER (1868–1932)

Alfred Henry Maurer, born New York, April 21, 1868; son of Louis Maurer (1832–1932), an artist for Currier & Ives. Left school, 1884; worked in family lithography business, and for firm of A. Lenhard, 1884–97. Studied with Edward Ward, New York, National Academy of Design, and private Sunday classes. Lived in Europe, mainly Paris, 1897–1914, with occasional trips home; closely associated with Leo Stein, and Mahonri Young; frequent visitor to Stein household. Awarded: first prize, Carnegie International, 1901; Bronze Medal, Pan-American Exposition, Buffalo, New York, 1901; Silver Medal, St. Louis International Exposition, Missouri, 1904; Gold Medal, International Kunstausstellung, Munich, 1905; Bronze Medal, Exposition Internationale des Beaux-Arts, Liège, Belgium, 1905. Met Arthur G. Dove, Paris, 1907; helped organize American "Secession," Paris, 1908. One-man shows, New York: Alfred Stieglitz's Photo-Secession Gallery, "291," 1909; The Folsom Galleries, 1913. Included in the Armory Show, 1913. Returned to the U.S., 1914. Included in: Venice Biennale, 1914; Panama-Pacific International Exposition, San Francisco, 1915; "The Forum Exhibition of Modern American Painters," The Anderson Galleries, New York, 1916; Society of Independent Artists Annual, 1917–32 (member, Board of Directors, 1919); Pennsylvania Academy Annual, 1918, 1920; Carnegie International, 1921, 1922; "Exhibition of Paintings by Eleven Americans," The Phillips Memorial Gallery, Washington, D.C., 1925. Entire contents of studio, a decade's production, purchased by E. Weyhe, New York, January 1924; one-man shows, Weyhe Gallery, New York, 1924–31. Died by suicide, New York, August 4, 1932. Memorial exhibition, Uptown Gallery, New York, 1934. Posthumous one-man shows, New York: Hudson D. Walker Gallery, 1937; Buchholz Gallery, 1943; Bertha Schaefer Gallery, 1946–56. Retrospectives: Walker Art Center, Minneapolis, and Whitney Museum of American Art, New York, and tour, 1949–51; National Collection of Fine Arts, Smithsonian Institution, Washington, D.C., 1973.

The Model. c. 1902.
Oil on canvas, 36 × 29 inches
Signed l. l.: "Alfred H. Maurer"

PROVENANCE:
Estate of the artist; Hudson D. Walker Gallery, New York; Babcock Galleries, New York, 1959

Two Sisters. c. 1924.
Oil on board, 30 × 19½ inches
Signed u. l.: "A. Maurer"

PROVENANCE:
Estate of the artist; Hudson D. Walker Gallery, New York, 1941; Babcock Galleries, New York, 1959

EXHIBITIONS:
Hudson D. Walker Gallery, New York, November 22–December 11, 1937, *Oil and Gouaches by Alfred Maurer*
National Collection of Fine Arts, Smithsonian Institution, Washington, D.C., February 23–May 13, 1973, *Alfred H. Maurer,* no. 38, ill. 118

ERNEST MEISSONIER (1815–1891)

Jean-Louis-Ernest Meissonier, born Lyons, France,

February 21, 1815. Moved with family to Paris, 1818. Studied: atelier of Léon Cogniet, Paris, briefly, 1833; in Rome, 1834–35. Paintings included in the Salon, Paris, from 1834: Third Class Medal, 1840; Second Class Medal, 1841; First Class Medal, 1843, 1848; Grande Médaille d'Honneur, 1855. Légion d'honneur: chevalier, 1846; officier, 1855; commandeur, 1867; grand officier, 1880; Grand Croix, 1889. Established second residence, Poissy, France, 1848. Served: as Captain of Artillery, National Guard, 1848; as Lieutenant-Colonel, Infantry, during siege of Paris, Franco-Prussian War, 1870–71. Institut de France: elected member, 1861; president, 1876, 1891. Member: Académie Royale des Beaux-Arts, Brussels, 1869; Royal Academy of Arts, London, 1869; Real Academia de Bellas Artes de San Fernando, Madrid, 1872; Accademia Nazionale di San Luca, Rome, 1875; Accademia di Belle Arti e Liceo Artistico, Venice, 1879; Accademia Albertina di Belle Arti e Liceo Artistico, Turin, 1888. As Salon jury member, rejected Gustave Courbet's paintings, for political reasons, 1872. French representative, and president, Jury International des Beaux-Arts, Exposition Universelle de 1889, Paris. Co-founded Salon de la Société Nationale des Beaux-Arts, Paris, with Puvis de Chavannes, Auguste Rodin, Eugène Carrière, 1890. Died Paris, January 31, 1891.

A Horseman in a Storm. c. 1880–85.
Bronze, 18½ × 23 × 8½ inches
Markings: back of base "Meissonier"
l. side of base "E. Siot-Decauville Fondeur Paris 15"

PROVENANCE:
Edward T. Pawlin, New York, 1966

The wax sculptures that were left in Meissonier's studio at his death are related to the figures in his paintings and graphic works. *A Horseman in a Storm* is typical of the subject matter of Meissonier's *oeuvre* of the late 1880s.

WILLARD METCALF (1858–1925)

Willard Leroy Metcalf, born Lowell, Massachusetts, July 1, 1858. Apprenticed, Boston: to wood engraver, 1875; to landscape painter George L. Brown, 1876–77. Studied, Boston: Lowell Institute; Boston Normal Art School; School of the Museum of Fine Arts. Commissioned by *Century* magazine to travel to the Southwest with Howard Cushing of the Smithsonian Institution, 1881–82. Moved to Paris, 1883; studied, Académie Julian, with Gustave-Clarence-Rodolphe Boulanger, and Jules-Joseph Lefevre. Awarded honorable mention, Salon of 1888, Paris. Returned to Boston, 1889. Settled in New York, 1890; established summer studio, Chester, Vermont, c. 1900. Taught: The Cooper Union for the Advancement of Science and Art, New York, 1890–1903; The Art Students League of New York, 1891–92. Awarded: medal, World's Columbian Exposition, Chicago, 1893; Webb Prize, Society of American Artists Annual, 1896; honorable mention, Exposition Universelle de 1900, Paris; Silver Medal, Pan-American Exposition, Buffalo, New York, 1901; Silver Medal, St. Louis International Exposition, Missouri, 1904. Joined group of American Impressionists known as The Ten, New York, 1898. Pennsylvania Academy Annual: Temple Gold Medal, 1907; Medal of Honor, 1911; Sesnan Medal, 1912. Member, The National Institute of Arts and Letters, 1908. One-man shows: Montross Gallery, New York, 1909; Cincinnati Art Museum, Ohio, 1911; John Herron Art Institute, Indianapolis, Indiana, 1911; The Art Institute of Chicago, 1912. Awarded Medal of Honor, Panama-Pacific International Exposition, San Francisco, 1915. Member, The American Academy of Arts and Letters, 1924. One-man show, The Corcoran Gallery of Art, Washington, D.C., 1925. Died New York, March 9, 1925. Memorial exhibition, The Milch Galleries, New York, 1926. Retrospectives: Carnegie Institute, Pittsburgh, 1926; Century Association, New York, 1928.

Sunset at Grez. 1885.
Oil on canvas, 33¾ × 43½ inches
Signed and dated l. r.: "W. L. Metcalf/Paris 1885"

PROVENANCE:
The Home for Aged Women, Boston; Vose Galleries of Boston; Robert Schoelkopf Gallery, New York, 1967

CONSTANTIN MEUNIER (1831–1905)

Constantin Émile Meunier, born Etterbeek, near Brussels, April 12, 1831. Brother of engraver Jean-Baptiste Meunier (1821–1900). Studied, Académie Royale des Beaux-Arts, Brussels, with sculptor Charles-Auguste Fraikin, 1848–51; with painter François-Joseph Navez, 1854. Included in the Salon, Brussels, 1851. Visited Spain, 1882–83. Awarded: Bronze Medal, for his first major sculpture, *The Hammerman,* Salon of 1886, Paris; Grand Prize for Sculpture, Exposition Universelle de 1889, 1900, Paris. Taught painting: Académie des Beaux-Arts de Louvain, Belgium, 1887–95; Académie Royale des Beaux-Arts, Brussels, from 1895. Chevalier, Légion d'honneur, 1889. One-man shows: Salon de l'Art Nouveau, Galerie Bing, Paris, and tour, 1896–98. Died Brussels, April 4, 1905. Retrospectives: Académie des Beaux-Arts de Louvain, 1909; Carnegie Institute, Pittsburgh, 1913–14. *Monument to Labor* (begun 1903) dedicated, Place de Trooz, Brussels, 1930. Musée Constantin Meunier, Brussels, dedicated, 1939.

The Coal Miner. c. 1903.
Bronze, 21½ × 7½ × 5½ inches
Markings: top of base "C. Meunier"
back of base "Atelier C. Meunier
59 Rue L'Abbaye"

PROVENANCE:
Edward T. Pawlin, New York, 1966

MANOLO MILLARES (1926–1972)

Manuel Millares Sall, born Las Palmas, Grand Canary Island, February 17, 1926. Self-taught as artist. One-man shows: El Museo Canario, Las Palmas, 1945, 1947, 1948; Galería el Jardín, Barcelona, 1951; Sala Clan, Madrid, 1951; Galería Buchholz, Madrid, 1954. Moved

to Madrid, 1955. Co-founded magazine *Planas de Poesía;* contributed to *Arte Vivo, Problemas de Arte Contemporáneo, Plus.* Included in: Venice Biennale, 1956, 1958; IV São Paulo Bienal, 1957; "New Spanish Painting and Sculpture," The Museum of Modern Art, New York, 1960; Pittsburgh International, 1961, 1964, 1967; ROSC '67, Dublin, 1967. Co-founded El Paso group, Madrid, with Rafael Canoger, Luis Feito, Antonio Saura, 1957–60; exhibited with group, Galería Buchholz, 1957. One-man shows: Pierre Matisse Gallery, New York, 1960, 1965, 1971; Museo de Arte Moderno de la Ciudad Buenos Aires, 1964; Museu de Arte Moderna do Rio de Janeiro, 1965. Died in Madrid, August 14, 1972.

Painting (Cuadro). 1965.
Oil and collage on canvas, 63¾ × 63¾ inches
Signed l. l.: "Millares"

PROVENANCE:
Pierre Matisse Gallery, New York, 1965

EXHIBITIONS:
Pierre Matisse Gallery, New York, March 23–April 17, 1965, "los mutilados de paz," paintings on canvas and paper 1963–65, no. 1, cover ill.
Royal Dublin Society, Ireland, November 13–December 30, 1967, *ROSC '67: The Poetry of Vision*, no. 73, ill. p. 71

KENNETH HAYES MILLER (1876–1952)

Born Oneida, New York, March 11, 1876. Studied: The Art Students League of New York, with Henry Siddons Mowbray, Kenyon Cox, Frank Vincent Du Mond, F. Luis Mora, early 1890s; The Chase School, New York, with William Merritt Chase. Included in 13th Architectural League of New York Annual, 1898. Taught, New York School of Art, 1899–1911. Traveled to Europe, 1900. Included in: Society of American Artists Annual, 1904–6; "Pictures of 5 American Artists," Macbeth Gallery, New York, 1909. Taught, The Art Students League, 1911–31, 1932–35, 1941–51; among his students were Edward Hopper, Rockwell Kent, Yasuo Kuniyoshi, Reginald Marsh, Niles Spencer. Four works included in the Armory Show, 1913. Associated with Albert Pinkham Ryder, c. 1916–17. One-man shows, New York: Macbeth Gallery, 1916; Montross Gallery, 1922–28; Frank Rehn Gallery, 1929, 1935. Included in: "Paintings by Nineteen Living Americans," and "Modern Works of Art," The Museum of Modern Art, New York, 1929–30, 1934–35; "American Art Today," New York World's Fair, Flushing Meadows, 1939. Awarded: Gold Medal, National Academy Annual, 1943; Garrett Prize, 56th American Exhibition, The Art Institute of Chicago, 1945. Academician, National Academy of Design, 1944. Member, The National Institute of Arts and Letters, 1947. Retrospective, The Art Students League, 1949. Died New York, January 1, 1952. Memorial exhibitions, 1953: The Art Students League; Munson-Williams-Proctor Institute, Utica, New York. Posthumous one-man show, Zabriskie Gallery, New York, 1970.

Looking and Pricing. 1938.
Oil on canvas, 28 × 23 inches
Signed and dated u. r.: "Hayes Miller '38"

PROVENANCE:
Frank Rehn Gallery, New York; Estate of the artist; Zabriskie Gallery, New York, 1970

EXHIBITIONS:
The Pennsylvania Academy of the Fine Arts, Philadelphia, January 26–March 2, 1941, *The One Hundred and Thirty-Sixth Annual Exhibition of Painting and Sculpture*, no. 114
The Art Students League of New York, November 1949, *Kenneth Hayes Miller Retrospective*
Zabriskie Gallery, New York, October 6–31, 1970, *Kenneth Hayes Miller*, no. 16, ill.

REFERENCES:
Rothschild, Lincoln. *To Keep Art Alive: The Effort of Kenneth Hayes Miller, American Painter (1876–1952)*, Philadelphia, Art Alliance, 1974, no. 86, ill.

JOAN MIRÓ (b. 1893)

Joan Miró Ferra, born Montroig, near Barcelona, April 20, 1893. Studied, Barcelona: Escuela de Bellas Artes de Barcelona, with Modesto Urgell Inglada, and José Pascó, 1907–10; Francisco Galí's "Escuela d'Art," 1912–15. Met Francis Picabia, Barcelona, 1917. One-man show, Galería Dalmau, Barcelona, 1918. Traveled to Paris, 1919; met Pablo Picasso; associated with Tristan Tzara, and Paris Dadaists. Lived in Paris, and Montroig, 1920–40. One-man show, Galerie La Licorne, Paris, 1921. Associated with André Masson, 1922. Exhibited, Paris: Salon d'Automne, 1923; "Exposition, La Peinture Surréaliste," Galerie Pierre, 1925. Joined André Breton, Louis Aragon, Paul Éluard, in Surrealist group, 1924. One-man shows, Paris: Galerie Pierre, 1925; Galerie Bernheim-Jeune, 1928. For Sergei Diaghilev's Ballets Russes de Monte Carlo, designed: sets, with Max Ernst, *Roméo et Juliette*, 1926; costumes and scenery, *Les Jeux d'Enfants*, 1931. First relief constructions, 1928–29; experimented in assemblage, 1931–36. One-man shows, New York: Valentine Gallery, 1930; Pierre Matisse Gallery, from 1932. Included in: "Newer Super-Realism," Wadsworth Atheneum, Hartford, Connecticut, and Julien Levy Gallery, New York, 1931–32; Salon des Surindépendants, Paris, 1933; "Modern Works of Art," "Cubism and Abstract Art," "Fantastic Art, Dada, Surrealism," The Museum of Modern Art, New York, 1934–35, 1936, 1936–37; Carnegie International, 1938, 1939. Designed mural, *The Reaper*, Spanish Pavilion, Exposition Universelle de 1937, Paris. Returned to Spain, 1940; moved to Barcelona, 1942. Retrospectives: The Museum of Modern Art, and tour, 1941; Kunsthalle, Bern, 1949; Palais des Beaux-Arts, Brussels, and tour, 1956. First ceramics, with assistance of Joseph Llorens Artigas, 1944. Traveled to the U.S., 1947. Mural commissions: Terrace Hilton Hotel, Cincinnati, Ohio, 1947; Harvard University, Cambridge, Massachusetts, 1950. One-man shows, Galerie Maeght, Paris, from 1948. Included in Pittsburgh International, 1950, 1952, 1955, 1967, 1970. Awarded Grand Prize for Graphics, Venice Biennale, 1954. Received Guggenheim International

Award, for ceramic walls, UNESCO Building, Paris, 1958. Retrospectives: The Museum of Modern Art, New York, and Los Angeles County Museum of Art, 1959; Musée National d'Art Moderne, Paris, 1962; The Tate Gallery, London, 1964; National Museum of Modern Art, Tokyo, and National Museum of Modern Art, Kyoto, Japan, 1966. Honorary member, The National Institute of Arts and Letters, and The American Academy of Arts and Letters, 1960. Designed ceramic mural, with Artigas, The Solomon R. Guggenheim Museum, New York, 1967. Retrospectives: Fondation Maeght, St.-Paul-de-Vence, France, 1968; The Solomon R. Guggenheim Museum, 1972–73. Has lived in Palma de Majorca, Spain, since 1956.

Circus Horse (Cheval du cirque). 1927.
Oil on canvas, 6 feet 4⅞ inches × 9 feet 2¼ inches
Signed and dated l. r.: "Miró/1927"

PROVENANCE:
Galerie Rosengart, Lucerne, Switzerland; Philippe Dotremont, Brussels; Parke-Bernet Galleries, New York, Sale 2345, April 14, 1965, no. 18; Pierre Matisse Gallery, New York, 1968

EXHIBITIONS:
Städtische Kunsthalle, Düsseldorf, March 3–April 9, 1961, *Aktuelle Kunst: Bilder und Plastiken aus der Sammlung Dotremont*, no. 51, colorplate; toured to Kunsthalle, Basel, April 22–May 28, no. 45
Musée National d'Art Moderne, Paris, June–November 1962, *Joan Miró*, no. 45
The Tate Gallery, London, August 27–October 11, 1964, *Joan Miró*, no. 67, plate 14a; toured to Kunsthaus, Zurich, October 31–December 6
Los Angeles County Museum of Art, July 16–September 8, 1968, *Dada, Surrealism and Their Heritage* (The Museum of Modern Art, New York, Circulating Exhibition), no. 232; toured to The Art Institute of Chicago, October 19–December 8
The Solomon R. Guggenheim Museum, New York, October 26, 1972–January 14, 1973, *Joan Miró: Magnetic Fields*, no. 34, pp. 37, 124, ill.

REFERENCES:
Baro, Gene. "Miró: A Leap in the Air," *Arts Magazine*, 39, October 1964, p. 41
Dupin, Jacques. *Joan Miró: Life and Work*, New York, Abrams, 1962, no. 206, ill. p. 517
Parke-Bernet Galleries, New York, *Art International*, 9, March 1965, back cover (adv.)
———, *Art News*, 64, March 1965, p. 26 (adv.)
Unsigned. "Miró," *Cahiers de Belgique*, 2, Brussels, 1929, ill. p. 204

"In 1927 a miniature-scale circus became the fascination of the Montparnasse art world. It was the invention of Alexander Calder who performed it in his studio from 1927 to 1930. Whether or not the large number of circus pictures which Miró did in 1927 were painted under this new impetus, Calder's circus is certainly symptomatic of the intense delight the Surrealists took in the circus. In this painting by Miró the absorption of the figure and the linear element next to it—both of them white—into the space of the field is characteristic of Miró's treatment of images within landscape in 1927. This treatment allowed Miró to expand the field to an unprecedented size."

Krauss, Rosalind, and Rowell, Margit, in *Joan Miró: Magnetic Fields*, New York, The Solomon R. Guggenheim Museum, p. 124

Woman and Little Girl in Front of the Sun (Femme et fillette devant le soleil). 1946.
Oil on canvas, 56½ × 44⅞ inches
Signed and dated on back: "Miro 30–11–46
19–12–46"

PROVENANCE:
Pierre Matisse Gallery, New York; Mr. and Mrs. John David Eaton, Toronto; Pierre Matisse Gallery, 1968

EXHIBITIONS:
Pierre Matisse Gallery, New York, March 6–31, 1951, *Paintings and Sculpture from Nineteen Forty-Six to Nineteen Fifty by Joan Miró*, no. 1, ill.
Pierre Matisse Gallery, New York, November 4–29, 1958, *Miró: Peintures sauvages*, no. 15, ill.
The Museum of Modern Art, New York, March 8–May 10, 1959, *Joan Miró*, no. 89; toured to Los Angeles County Museum of Art, June 10–July 21, no. 93
The Tate Gallery, London, August 27–October 11, 1964, *Joan Miró*, no. 183, plate 35b; toured to Kunsthaus, Zurich, October 31–December 6
National Museum of Modern Art, Tokyo, August 26–October 9, 1966, *Joan Miró*, no. 70; toured to National Museum of Modern Art, Kyoto, Japan, October 20–November 30

REFERENCES:
Chilo, Michel. *Miró*, Paris, Maeght, forthcoming, ill.
Dupin, Jacques. *Joan Miró: Life and Work*, New York, Abrams, 1962, no. 702, ill. p. 553
———, *Miró*, Paris, Éditions Rencontre, by agreement with UNESCO, 1969, p. 18, color slide no. 17
Kramer, Hilton. "Month in Review: Miró Retrospective at MOMA," *Arts*, 33, May 1959, p. 49, ill.
Soby, James Thrall. *Joan Miró*, New York, The Museum of Modern Art, 1959, pp. 120–21, colorplate p. 119

Woman (Personnage). 1953.
Black marble, 38¼ × 27¾ × 28 inches

PROVENANCE:
Pierre Matisse Gallery, New York, 1957

EXHIBITIONS:
The Detroit Institute of Arts, and tour, 1959–60, *Sculpture in Our Time*, no. 165, ill. p. 76
The Solomon R. Guggenheim Museum, New York, October 3, 1962–January 6, 1963, *Modern Sculpture from the Joseph H. Hirshhorn Collection*, no. 305, ill. p. 120

REFERENCES:
Geldzahler, Henry. "Taste for Modern Sculpture," *Art News*, 61, October 1962, ill. p. 30

Taubes, Frederic. *Abracadabra and Modern Art*, New York, Dodd, Mead, 1963, ill. p. 31

Lunar Bird (Oiseau lunaire). 1966.
Bronze (1/5), 90¼ × 81¼ × 59¼ inches
Markings: back l. r. "MIRÓ"
 back l. l. "Susse Fondeur Paris"

PROVENANCE:
Pierre Matisse Gallery, New York, 1967

EXHIBITIONS:
Pierre Matisse Gallery, New York, November 1967, *Miró: Oiseau Solaire, Oiseau Lunaire, Étincelles*, pp. 5–15, 36, ill. p. 7

REFERENCES:
Kuh, Katherine. "Year-end Notes from a Critic's Diary," 50, *Saturday Review*, December 30, 1967, p. 35
Mellow, James R. "New York Letter," *Art International*, 12, January 1968, p. 65, ill.
Pictures on Exhibit, 3, December 1967, cover ill.

JOAN MITCHELL (b. 1926)

Born Chicago, February 12, 1926. Studied: Smith College, Northampton, Massachusetts, 1942–44; School of The Art Institute of Chicago, B.F.A., 1947 (received traveling fellowship). Lived in France, 1948–49. Studied, New York: Columbia University; New York University, M.F.A., 1950. Included in: Whitney Annual, 1950, 1955–67; "Vanguard 1955," Walker Art Center, Minneapolis, 1955; Pittsburgh International, 1955, 1958, 1970; Documenta II, Kassel, 1959; V São Paulo Bienal, 1959; "American Abstract Expressionists and Imagists," The Solomon R. Guggenheim Museum, New York, 1961. One-man shows: New Gallery, New York, 1951; Stable Gallery, New York, 1953–65; Galerie Neufville, Paris, 1960; Galerie Jacques Dubourg, Paris, 1962; Galerie Lawrence, Paris, 1962; Galerie Jean Fournier, Paris, from 1967; Martha Jackson Gallery, New York, from 1968; Everson Museum of Art, Syracuse, New York, and tour, 1972. Included in: "Younger Abstract Expressionists of the Fifties," The Museum of Modern Art, New York, 1971; Whitney Biennial, 1973; "Women Choose Women," The New York Cultural Center, 1973. Received Brandeis University Creative Arts Award Citation, 1973. Lives in Vétheuil, outside of Paris.

Lucky Seven. 1962.
Oil on canvas, 79 × 74⅞ inches

PROVENANCE:
Galerie Lawrence, Paris, 1962

AMEDEO MODIGLIANI (1884–1920)

Amedeo Clemente Modigliani, born Livorno, Italy, July 12, 1884. Contracted pleurisy and tuberculosis in childhood. Studied: with Guglielmo Micheli, Livorno, 1898–1900; Accademia di Belle Arti e Liceo Artistico, Florence, 1902; Regio Istituto di Belle Arti, Venice, 1903. Moved to Paris, 1906; enrolled in Académie Colarossi; met Gino Severini. Included in Salon des Indépendants, Paris, 1908, 1910. Friendly with Constantin Brancusi, from 1909. Active as a sculptor, 1909–15; exhibited seven sculptures, Salon d'Automne, Paris, 1912. Met: Chaim Soutine, and Jules Pascin, 1911; Jacques Lipchitz, 1913; Jean Cocteau, 1916; also friendly with writers Max Jacob, André Salmon, Guillaume Apollinaire. Rejected for military service by French Army, 1914. Only one-man show in lifetime, Galerie Berthe Weill, Paris, 1917. Traveled to French Riviera, with Soutine, Foujita, and poet Leopold Zborowski, 1918. Died Paris, January 25, 1920. Included in Venice Biennale, 1922. Retrospectives: Galerie Bernheim-Jeune, Paris, 1922; Venice Biennale, 1930; Palais des Beaux-Arts, Brussels, 1933; Kunsthalle, Basel, 1934; The Cleveland Museum of Art, and The Museum of Modern Art, New York, 1951; Palazzo Reale, Milan, 1958; Cincinnati Art Museum, Ohio, 1959; Museum of Fine Arts, Boston, and tour, 1961. Posthumous one-man shows: Galerie Bing, Paris, 1925; De Hauke & Co., New York, 1929; Demotte Galleries, New York, 1931; Valentine Gallery, New York, 1940; Galerie de France, Paris, 1945.

Head. 1911–12.
Stone, 19¾ × 7⅞ × 8¼ inches

PROVENANCE:
G. Hyordey, Paris; Curt Valentin Gallery, New York, 1955

EXHIBITIONS:
Curt Valentin Gallery, New York, December 22, 1953–January 24, 1954, *Sculpture and Sculptors Drawings*, no. 45
The Detroit Institute of Arts, and tour, 1959–60, *Sculpture in Our Time*, no. 166, ill. p. 77
Marlborough-Gerson Gallery, New York, November–December 1963, *Artist and Maecenas: A Tribute to Curt Valentin*, no. 53, ill. p. 43

REFERENCES:
Ceroni, Ambrogio. *Amedeo Modigliani*, Milan, Milione, 1965, no. 7, pp. 23–24, plate 43
Descargues, Pierre. *Amedeo Modigliani*, Paris, Braun, 1951, plate 13
Di San Lazzaro, Gualtieri. *Modigliani*, Paris, Chêne, 1953, ill. p. 4
Werner, Alfred. *Modigliani the Sculptor*, New York, Arts, 1962, plate 41

PIET MONDRIAN (1872–1944)

Pieter Cornelis Mondriaan, Jr., born Amersfoort, Utrecht, The Netherlands, March 7, 1872. Studied: drawing, with father; painting, with uncle, Fritz Mondriaan, a landscape painter, 1886; with Johannes Braet van Uberfeldt, Doetinchem, The Netherlands, briefly, 1892; Rijksakademie van Beeldende Kunsten, Amsterdam, with August Allebé, intermittently, 1892–97. Joined artists' society, Arti et Amicitiae, Amsterdam, 1897; exhibited with group, 1897–1909. Exhibited with C. R. H. Spoor, and Jan Sluyters, Stedelijk Museum, Amsterdam, 1909. Joined Dutch Theosophical Society, 1909. Included in Salon des Indépendants, Paris, 1911–14; lived in Paris, 1912–14. One-man show, Galerie Walrecht, The Hague,

1914. Visited father in The Netherlands, 1914; prevented from leaving by outbreak of World War I. Co-founded de Stijl group, with Theo van Doesburg, 1916–17; member, until 1925; contributed to periodical *De Stijl*. Returned to Paris, 1919. Author of *Le Néo-plasticisme* (Paris, L'Effort Moderne), 1920. Retrospective, Stedelijk Museum, 1922. Joined: Cercle et Carré, Paris, 1930; Association Abstraction-Création, Paris, 1931. Exhibited, New York: Société Anonyme, The Brooklyn Museum, 1926, and New School for Social Research, 1931; "Cubism and Abstract Art," The Museum of Modern Art, 1936. Essay "Plastic Art and Pure Art," published in *Circle* (London), 1937. Lived in Hampstead, London, near Naum Gabo, and Ben Nicholson, 1938–40. Emigrated to New York, 1940. Joined American Abstract Artists, New York, 1940; closely associated with Fritz Glarner, and Harry Holtzman. One-man shows, Valentine Dudensing Gallery, New York, 1942, 1943, 1946. Died New York, February 1, 1944. Memorial exhibition, The Museum of Modern Art, 1945. Retrospectives: Gemeentemuseum, The Hague, 1955; Kunsthaus, Zurich, 1955; Whitechapel Art Gallery, London, 1955; Santa Barbara Museum of Art, California, and tour, 1965; The Art Gallery of Toronto, and tour, 1966; Nationalgalerie, Berlin, 1968; Salles de l'Orangerie, Paris, 1969. Centennial exhibition, The Solomon R. Guggenheim Museum, New York, and European tour, 1971–72.

Composition with Blue and Yellow. 1935.
Oil on canvas, 28¼ × 27¼ inches
Signed and dated l. r.: "PM '35"

PROVENANCE:
The artist; Mrs. Nan Roberts, London; G. David Thompson, Pittsburgh; Galerie Beyeler, Basel; Harold Diamond, New York; Mr. and Mrs. Frederick R. Weisman, Los Angeles; Harold Diamond, 1968

EXHIBITIONS:
Kunstmuseum der Stadt, Düsseldorf, December 14, 1960–January 29, 1961, *Sammlung G. David Thompson*, no. 149, colorplate; toured to Gemeentemuseum, The Hague, February 17–April 9, no. 143, colorplate; The Solomon R. Guggenheim Museum, New York, May–August, cat., colorplate; Museo Civico di Torino, October–November
Pasadena Art Museum, California, November 24–December 19, 1964, *A View of This Century*, no. 44, ill.
Galerie Beyeler, Basel, January 1965, *Mondrian*, cat., colorplate
The Solomon R. Ggugenheim Museum, New York, October 7–December 12, 1971, *Piet Mondrian Centennial Exhibition*, no. 116, colorplate

REFERENCES:
Marmer, Nancy. "Los Angeles Letter," *Art International*, 9, February 1965, p. 32
Seuphor, Michel. *Piet Mondrian: Life and Work*, New York, Abrams, 1956, no. 531, p. 429

HENRY MOORE (b. 1898)

Henry Spencer Moore, born Castleford, Yorkshire, England, July 20, 1898. Served, British Army, 1917–19. Studied: Leeds College of Art, England, 1919–21; Royal College of Art, London, 1921–24. Awarded traveling scholarship, to France and Italy, 1925. Taught: Royal College of Art, 1925–32; Chelsea School of Art, London, 1932–39. Exhibited, London: St. George's Gallery, 1926; The Beaux-Arts Gallery, 1927. One-man show, Warren Gallery, London, 1928. Commission, relief *North Wind*, Underground Building, St. James's Park, London, 1928. Joined artists' groups, London: 7 & 5 Society, 1930; Unit One, 1933. One-man shows, The Leicester Galleries, London, 1931–60. Included in "International Surrealist Exhibition," New Burlington Galleries, London, 1936. Appointed trustee, The Tate Gallery, London, 1941; re-appointed, 1949. Commission, *Madonna and Child*, St. Matthew's Church, Northampton, England, 1943. One-man shows, New York: Buchholz Gallery, 1943, 1951; Curt Valentin Gallery, 1954. Retrospective, The Museum of Modern Art, New York, and tour, 1946–47. Appointed member, Royal Fine Art Commission, 1948; re-appointed, 1953, 1960; elected honorary associate, Royal Institute of British Architects, 1948. One-man show, Venice Biennale (International Prize for Sculpture), 1948. Retrospective, City Art Gallery and Museum, Wakefield, England, and European tour, 1949–50. *Reclining Figure*, commissioned by The Arts Council of Great Britain, for 1951 Festival of Britain (sculpture now at Temple Newsam House, Leeds), 1950. Retrospectives: The Tate Gallery, 1951; Kunsthalle, Basel, 1955; Musée Rodin, Paris, 1961. Commissions: *Draped Reclining Figure*, and stone screen, facade of Time-Life Building, London, 1952; brick wall relief, Bouwcentrum, Rotterdam, The Netherlands, 1954; *Reclining Figure*, UNESCO Building, Paris, 1956. Awarded: International Sculpture Prize, II São Paulo Bienal, 1953; International Prize for Sculpture, Tokyo Biennale, 1959. Appointed trustee, The National Gallery, London, 1955. One-man shows: Whitechapel Art Gallery, London, 1960; Kunstverein in Hamburg, and tour, 1960–62; Marlborough Fine Art, London, 1961–71; M. Knoedler & Co., New York, 1962; Smithsonian Institution, Traveling Exhibition Service, 1966–68; Marlborough Gallery, and M. Knoedler & Co., New York, 1970. Honorary member: The National Institute of Arts and Letters, and The American Academy of Arts and Letters, New York, 1961; Akademie der Künste, Berlin, 1961. Commission, *Reclining Figure*, reflecting pool, north plaza, Lincoln Center for the Performing Arts, New York, 1962. Retrospectives: Art Center in La Jolla, California, and tour, 1963; The Tate Gallery, 1968; Forte di Belvedere, Florence, 1972; "Henry Moore in Southern California," Los Angeles County Museum of Art, 1973. Appointed: member, The Arts Council of Great Britain, 1964; to Der Orden Pour le Mérite für Wissenschaften und Künste, 1972. Lives in Much Hadham, England, and in Forte de Marmi, Italy.

Mother and Child. 1931.
Cumberland alabaster, 17½ × 8½ × 6½ inches

PROVENANCE:
The Leicester Galleries, London; Sir Jacob Epstein,

London; C. Kearley, London; Marlborough Fine Art, London, 1961

EXHIBITIONS:
The Leicester Galleries, London, April 1931, *Henry Moore*, no. 1
The Museum of Modern Art, New York, December 17, 1946–March 6, 1947, *Henry Moore*, no. 15, ill. p. 21; toured to The Art Institute of Chicago, April 17–May 14; San Francisco Museum of Art, June 15–September 7
Musée National d'Art Moderne, Paris, 1949, *Henry Moore*, no. 10, ill.
Marlborough Fine Art, London, June–July 1961, *Henry Moore: Stone and Wood Carvings*, no. 24, ill.
The Solomon R. Guggenheim Museum, New York, October 3, 1962–January 6, 1963, *Modern Sculpture from the Joseph H. Hirshhorn Collection*, no. 309, ill. p. 144
The Tate Gallery, London, July 17–September 22, 1968, *Henry Moore*, no. 22, plate 20

REFERENCES:
Hall, Donald. *Henry Moore: The Life and Work of a Great Sculptor*, New York, Harper & Row, 1966, p. 74, ill. p. 73
Jianou, Ionel. *Henry Moore*, trans. Geoffrey Skelding, New York, Tudor, 1968, no. 92, p. 68
Marchiori, Giuseppe, ed. "Quattro scultori tra le due guerre," *L'Arte Moderna*, Milan, 10, no. 90, 1967, ill. p. 379
Read, Herbert. *Henry Moore: Mother and Child*, New York, Mentor, 1966, colorplate 5
——. *Henry Moore: Sculptor*, London, Zwemmer, 1934, plate 21
——, intro. *Henry Moore: Sculpture and Drawings*, New York, Curt Valentin, 1944, p. ix, plate 21
Seldis, Henry J. *Henry Moore in America*, New York, Praeger, 1973, p. 272
Sontag, Raymond J. *A Broken World 1919–1939*, New York, Harper & Row, 1971, ill. 22
Sylvester, David. *Henry Moore*, New York, Praeger, 1968, p. 21, plate 20
——, ed. *Henry Moore, Volume 1: Sculpture and Drawings 1921–1948*, 4th rev. ed., London, Lund Humphries, 1957, no. 105, ill. p. 59
——, ed. *Modern Art*, New York, Grolier, 1965, p. 99, ill. p. 98
Walter, Siegfried. *Henry Moore*, Cologne, Walter, 1955, pp. 11, 71, plate 7

Mother and Child was included in Moore's first exhibition at The Leicester Galleries, London, 1931, for which Sir Jacob Epstein wrote the catalogue introduction. Moore wrote, "Epstein was remarkably generous and helpful to me as a young man from this time on. By 1931 he had already bought one or two sculptures of mine and he went on buying sculptures and drawings until 1937."

The artist, in Hedgecoe, John, and Moore, Henry. *Henry Moore*, New York, Simon & Schuster, 1968, p. 81

Composition. 1934, cast 1961.
Bronze, 8 × 17 × 8 inches
Markings: inside bottom of base "Moore 1/9"

PROVENANCE:
M. Knoedler & Co., New York, 1962

EXHIBITIONS:
The Solomon R. Guggenheim Museum, New York, October 3, 1962–January 6, 1963, *Modern Sculpture from the Joseph H. Hirshhorn Collection*, no. 310

REFERENCES:
Hedgecoe, John, and Moore, Henry. *Henry Moore*, New York, Simon & Schuster, 1968, p. 526
Melville, Robert. *Henry Moore: Sculpture and Drawings 1921–1969*, New York, Abrams, 1971, p. 343
Michelson, Annette. "Private but Public: The Joseph H. Hirshhorn Collection," *Contemporary Sculpture*, Arts Yearbook, 8, New York, 1965, p. 187, ill.
Raynor, Vivien. "4,000 Paintings and 1,500 Sculptures," *The New York Times Magazine*, November 27, 1966, ill. p. 55
Sylvester, David, ed. *Henry Moore, Volume 1: Sculpture and Drawings 1921–1948*, 4th rev. ed., London, Lund Humphries, 1957, no. 140, p. 9

"Although this sculpture looks abstract, it has organic elements. These are two separate forms—a head and a torso—but related with their base."

The concrete cast of this early work was rediscovered in Moore's studio in the early 1960s and, to preserve it, was cast in bronze.

The artist, in Hedgecoe and Moore, p. 76

Carving. 1935.
Cumberland alabaster, 13½ × 11¼ × 7 inches

PROVENANCE:
The Leicester Galleries, London; Miss Benecke, Eastbourne, Sussex, England; Buchholz Gallery, New York; Martha Jackson Gallery, New York, 1956

EXHIBITIONS:
The Leicester Galleries, London, November 1936, *Henry Moore*, no. 12
Buchholz Gallery, New York, September 26–October 14, 1949, *Sculpture*, no. 37, ill.
Buchholz Gallery, New York, December 6, 1950–January 6, 1951, *The Heritage of Auguste Rodin*, no. 54, ill.
Buchholz Gallery, New York, March 6–31, 1951, *Henry Moore*, no. 1, ill.
The Detroit Institute of Arts, 1959, *Sculpture in Our Time*, no. 168, ill. p. 78
The Solomon R. Guggenheim Museum, New York, October 3, 1962–January 6, 1963, *Modern Sculpture from the Joseph H. Hirshhorn Collection*, no. 311

REFERENCES:
Grohmann, Will. *The Art of Henry Moore*, New York, Abrams, 1960, p. 29, plate 11
Jianou, Ionel. *Henry Moore*, trans. Geoffrey Skelding, New York, Tudor, 1968, no. 143, p. 70
Melville, Robert. *Henry Moore: Sculpture and Drawings 1921–1969*, New York, Abrams, 1971, p. 343, plate 126

Reed, Judith Kaye. "Diverse Trends in Twentieth Century Sculpture," *Art Digest*, 24, October 1, 1949, ill. p. 12
Schaeffer-Simmern, Henry. *Sculpture in Europe Today*, Berkeley, University of California, 1955, p. 14, plate 83
Sylvester, David, ed. *Henry Moore, Volume 1: Sculpture and Drawings 1921–1948*, 4th rev. ed., London, Lund Humphries, 1957, no. 156, p. 10, ill. p. 14

Miners. 1942.
Ink, black crayon, and white chalk on paper, 12¼ × 21¼ inches
Signed and dated l. l.: "Moore 42"

PROVENANCE:
Curt Valentin Gallery, New York, 1955

EXHIBITIONS:
Forum Gallery, New York, October 1–20, 1962, *Sculptors' Drawings from the Joseph H. Hirshhorn Collection*, no. 33; toured to Jewish Community Center, Washington, D.C., May 15–June 15, 1963
Duke University, Durham, North Carolina, October 6–27, 1963, *Sculptors' Drawings from the Joseph H. Hirshhorn Collection* (American Federation of Arts, Circulating Exhibition), no. 39; toured to New Britain Museum of American Art, Connecticut, November 10–December 1; Krannert Art Museum, University of Illinois, Urbana, January 19–February 9, 1964; Laguna Gloria Art Museum, Austin, Texas, February 23–March 15; Lytton Center of the Visual Arts, Hollywood, California, March 29–July 15; Des Moines Art Center, Iowa, October 2–23

Moore's series of drawings, made in 1940–41, of life in London's Underground air-raid shelters, commissioned by the War Artists Advisory Committee, was followed by a smaller series of drawings of coal miners. Moore returned to his hometown of Castleford, and, for the first time, spent two or three weeks in the mines, making studies for this series. Moore's father, a miner who had advanced to the post of mining engineer, had never permitted his son into the mines.

Family Group. 1946.
Bronze (edition of four), 17½ × 13¼ × 8⅜ inches

PROVENANCE:
Christoph Czwiklitzer, Cologne, 1954

EXHIBITIONS:
Yale University Art Gallery, New Haven, Connecticut, January 14–February 13, 1949, *Sculpture Since Rodin*, no. 23
Vassar College Art Gallery, Poughkeepsie, New York, October 22–November 12, 1952, *From Sketch to Sculpture* (The Museum of Modern Art, New York, Circulating Exhibition), checklist; toured to ten U.S. cities
The Detroit Institute of Arts, 1959, *Sculpture in Our Time*, no. 169
The Solomon R. Guggenheim Museum, New York, October 3, 1962–January 6, 1963, *Modern Sculpture from the Joseph H. Hirshhorn Collection*, no. 313, ill. p. 145
The Brooklyn Museum, New York, March 6–April 2, 1967, *Sculpture and Drawings by Henry Moore* (Smithsonian Institution, Traveling Exhibition Service)

REFERENCES:
Grohmann, Will. *The Art of Henry Moore*, New York, Abrams, 1960, p. 8
Jianou, Ionel. *Henry Moore*, trans. Geoffrey Skelding, New York, Tudor, 1968, no. 249, p. 75
Melville, Robert. *Henry Moore: Sculpture and Drawings 1921–1969*, New York, Abrams, 1971, p. 353
Sylvester, David, ed. *Henry Moore, Volume 1: Sculpture and Drawings 1921–1948*, 4th rev. ed., London, Lund Humphries, 1957, no. 265, p. 16

Reclining Figures (recto). 1948.
Watercolor, gouache, and wax crayon on paper, 11¼ × 9¼ inches
Signed and dated l. r.: "Moore 48"

Mother and Child on Rocking Chair (verso). 1948.
Watercolor, gouache, and wax crayon on paper, 11¼ × 9¼ inches
Signed and dated l. r.: "Moore 48"
Inscribed u. margin "Rocking Chair for terracotta"

PROVENANCE:
Buchholz Gallery, New York, 1951

EXHIBITIONS:
Buchholz Gallery, New York, March 6–31, 1951, *Henry Moore*, no. 47, ill. (verso)
Forum Gallery, New York, October 1–20, 1962, *Sculptors' Drawings from the Joseph H. Hirshhorn Collection*, no. 30; toured to Jewish Community Center, Washington, D.C., May 15–June 15, 1963
Duke University, Durham, North Carolina, October 6–27, 1963, *Sculptors' Drawings from the Joseph H. Hirshhorn Collection* (American Federation of Arts, Circulating Exhibition), no. 36; toured to New Britain Museum of American Art, Connecticut, November 10–December 1; Krannert Art Museum, University of Illinois, Urbana, January 19–February 9, 1964; Laguna Gloria Art Museum, Austin, Texas, February 23–March 15; Lytton Center of the Visual Arts, Hollywood, California, March 29–July 15; Des Moines Art Center, Iowa, October 2–23

Rocking Chair No. 2. 1950.
Bronze (edition of six), 11 × 12 × 3½ inches
Markings: underside of rocker "Bronze
Cire Perdue C. Valsuani"

PROVENANCE:
Buchholz Gallery, New York, 1951

EXHIBITIONS:
Buchholz Gallery, New York, March 6–31, 1951, *Henry Moore*, no. 30, ill.
The Detroit Institute of Arts, 1959, *Sculpture in Our Time*, no. 170
The Solomon R. Guggenheim Museum New York, October 3, 1962–January 6, 1963, *Modern Sculpture from the Joseph H. Hirshhorn Collection*, no. 314

REFERENCES:
Bowness, Alan. *Henry Moore, Volume 2: Sculpture and Drawings 1949–1954*, 2nd rev. ed., London, Lund Humphries, 1965, no. 275, p. xxiv
Breuning, Margaret. "Moore's Apertures," *Art Digest*, 25, May 15, 1951, p. 15, ill.
Grohmann, Will. *The Art of Henry Moore*, New York, Abrams, 1960, p. 7
Jianou, Ionel. *Henry Moore*, trans. Geoffrey Skelding, New York, Tudor, 1968, no. 259, p. 76
Melville, Robert. *Henry Moore: Sculpture and Drawings 1921–1969*, New York, Abrams, 1971, p. 354
Read, Herbert. *Henry Moore: Sculpture and Drawings*, vol. 2, catalogue by Alan Bowness, London, Lund Humphries, 1968, no. 275, p. xxiv

Moore's small *Rocking Chair* sculptures of 1950 were conceived as toys for his four-year-old daughter Mary. Each sculpture in the series rocks at a different speed, depending on the shape of the rocker curves and the balance of its weights.

Interior-Exterior Reclining Figure (Working Model for Reclining Figure: Internal and External Forms). 1951.
Bronze (edition of nine), 14 × 21½ × 7½ inches
Markings: back l. r. "Moore"

PROVENANCE:
Curt Valentin Gallery, New York, 1954

EXHIBITIONS:
Society of the Four Arts, Palm Beach, Florida, February 2–24, 1954, *Graham Sutherland—Henry Moore*, no. 58
Leonid Kipnis Gallery, Westport, Connecticut, November 18–30, 1956, *Modern Sculpture* (sponsored by the Westport Community Art Association), no. 27
The Detroit Institute of Arts, 1959, *Sculpture in Our Time*, no. 171, ill. p. 79; and extended loan
The Solomon R. Guggenheim Museum, New York, October 3, 1962–January 6, 1963, *Modern Sculpture from the Joseph H. Hirshhorn Collection*, no. 315, ill. p. 144
Art Center in La Jolla, California, August 4–September 8, 1963, *Henry Moore*, no. 28; toured to Santa Barbara Museum of Art, California, September 24–October 27; Los Angeles Municipal Art Gallery, November 7–December 1
Hopkins Art Center, Dartmouth College, Hanover, New Hampshire, May 25–July 9, 1967, *Sculpture in Our Century: Selections from the Joseph H. Hirshhorn Collection*, no. 38, ill. p. 44

REFERENCES:
Arnason, H. Harvard. *History of Modern Art*, New York, Abrams, 1968, p. 517, ill. p. 516
Bowness, Alan. *Henry Moore, Volume 2: Sculpture and Drawings 1949–1954*, 2nd rev. ed., London, Lund Humphries, 1965, no. 298, p. xxvi
Broner, Robert. "Keen, Perceptive Show of Sculpture," *Detroit Sunday Times*, May 3, 1959, sec. B, p. 4, ill.
Grohmann, Will. *The Art of Henry Moore*, New York, Abrams, 1960, p. 6
Hedgecoe, John, and Moore, Henry. *Henry Moore*, New York, Simon & Schuster, 1968, p. 528
Jianou, Ionel. *Henry Moore*, trans. Geoffrey Skelding, New York, Tudor, 1968, no. 281, p. 77
Kaufman, Betty. "Hirshhorn: The Collector's Art," *Commonweal*, 77, November 9, 1962, p. 182
Melville, Robert. *Henry Moore: Sculpture and Drawings 1921–1969*, New York, Abrams, 1971, p. 355
Read, Herbert. *Henry Moore*, New York, Praeger, 1966, p. 276

This sculpture was conceived as a working model for a larger reclining figure. The internal and external forms are separate pieces. After both pieces were enlarged in plaster, in 1953–54, Moore destroyed the plaster of the internal form. Only the external form was cast, with "the interesting result . . . that the interior form remains by implication."

The artist, in Hedgecoe and Moore, p. 200

Draped Reclining Figure. 1952–53, cast 1956.
Bronze (edition of three), 41¼ × 66½ × 34 inches
Markings: top of base "Susse Fondeur Paris"

PROVENANCE:
The artist, Much Hadham, England, 1956

EXHIBITIONS:
Musée Rodin, Paris, Summer 1956, *Exposition Internationale de Sculpture Contemporaine*, no. 82, ill.
Art Gallery of Toronto, February 1957–March 1959, extended loan
The Detroit Institute of Arts, and tour, 1959–60, *Sculpture in Our Time*, no. 176
The Solomon R. Guggenheim Museum, New York, October 3, 1962–January 6, 1963, *Modern Sculpture from the Joseph H. Hirshhorn Collection*, no. 319, ill. p. 148

REFERENCES:
Bowness, Alan. *Henry Moore, Volume 2: Sculpture and Drawings 1949–1954*, 2nd rev. ed., London, Lund Humphries, 1965, no. 336, p. xxvii
Hedgecoe, John, and Moore, Henry. *Henry Moore*, New York, Simon & Schuster, 1968, p. 528
Mates, Robert E. *Photographing Art*, New York, Amphoto, 1966, ill. p. 121
———. "Photographing Sculpture and Museum Exhibits," *Curator*, 10, 1967, ill. p. 122
Melville, Robert. *Henry Moore: Sculpture and Drawings 1921–1969*, New York, Abrams, 1971, p. 357
Read, Herbert. *Henry Moore*, New York, Praeger, 1966, p. 277
Seldis, Henry J. *Henry Moore in America*, New York, Praeger, 1973, p. 273
Unsigned. "Collections: A Jewel for the Mall," *Time*, 87, May 20, 1966, ill. p. 88
———. "Reclining Woman," *The Washington* [D.C.] *Post*, October 20, 1973, ill. p. C7

The *Draped Reclining Figure* was commissioned for the terrace of the Time-Life Building, London, for which the artist also carved a screen. Of the sculpture, Moore said, "Originally it wasn't for this purpose. Like all my

sculptures it would have been done anyway. I had the idea for it and, in my opinion, it turned out about the right size and the right proportion for the Time-Life terrace. It is one of the earliest of my draped figures and must have been done just after my first visit to Greece [1951] which led to my doing the draped sculptures. Firstly there were the shelter drawings, which caused me to look at drapery and use drapery. Secondly the visit to Greece made me realize how the Greeks used drapery to emphasise the tension of the inside form."

The artist, in Hedgecoe and Moore, p. 204

King and Queen. 1952–53.
Bronze (edition of five), 63¼ × 59 × 37½ inches

PROVENANCE:
Curt Valentin Gallery, New York; Percy and Harold Uris, New York; Curt Valentin Gallery, 1954

EXHIBITIONS:
Curt Valentin Gallery, New York, November 2–December 4, 1954, *Henry Moore*, no. 27, cover ill.
Art Gallery of Toronto, April 1957–March 1959, extended loan
The Detroit Institute of Arts, and tour, 1959–60, *Sculpture in Our Time*, no. 178, frontispiece
The Solomon R. Guggenheim Museum, New York, October 3, 1962–January 6, 1963, *Modern Sculpture from the Joseph H. Hirshhorn Collection*, no. 320

REFERENCES:
Arnason, H. Harvard. *History of Modern Art*, New York, Abrams, 1968, ill. p. 517
Bowness, Alan. *Henry Moore, Volume 2: Sculpture and Drawings 1949–1954*, 2nd rev. ed., London, Lund Humphries, 1965, no. 350, p. xxviii
Feldman, Edmund Burke. *Varieties of Visual Experience*, New York, Abrams, 1972, colorplate p. 348
George, Laverne. "Fortnight in Review," *ArtsDigest*, 29, November 15, 1954, p. 22
Grohmann, Will. *The Art of Henry Moore*, New York, Abrams, 1960, p. 8
Hall, Donald. *Henry Moore: The Life and Work of a Great Sculptor*, New York, Harper & Row, 1966, pp. 133–34
Hedgecoe, John, and Moore, Henry. *Henry Moore*, New York, Simon & Schuster, 1968, p. 528
Jianou, Ionel. *Henry Moore*, trans. Geoffrey Skelding, New York, Tudor, 1968, no. 328, p. 78
Johnson, Ladybird. *A White House Diary*, New York, Holt, Rinehart and Winston, 1970, p. 307
Kaufman, Betty. "Hirshhorn: The Collector's Art," *Commonweal*, 77, November 9, 1962, pp. 182–83
Kuh, Katherine. "Great Sculpture," *Saturday Review*, 45, June 23, 1962, pp. 16, 20, ill.
Melville, Robert. *Henry Moore: Sculpture and Drawings 1921–1969*, New York, Abrams, 1971, p. 357
Neumann, Erich. *The Archetypal World of Henry Moore*, trans. R. F. C. Hull, New York, Pantheon, 1959, pp. xiv, 112
Read, Herbert. *Henry Moore*, New York, Praeger, 1966, p. 276
Seldis, Henry J. *Henry Moore in America*, New York, Praeger, 1973, pp. 89, 110, 112–13, 273, colorplate p. 89
Sweeney, James Johnson. "A Living Frame for Sculpture," *House & Garden*, 126, August 1964, p. 110, ill. p. 112
Unsigned. "For Your Information: Deposed Royalty," *Interiors*, 114, November 1954, pp. 165–66
———. "Great Sculpture at the Guggenheim," *Art in America*, 50, October 1962, ill. p. 18
Walton, William. "A Slice from Another Mellon," *The Washingtonian*, 3, August 11, 1968, p. 49

King and Queen was acquired from the Curt Valentin Gallery in 1954 by Percy and Harold Uris for installation in the lobby of their new building at 380 Madison Avenue, New York. When several tenants objected, the sculpture was returned to the gallery and shortly thereafter was acquired by Mr. Hirshhorn. The work was orginally cast in an edition of four, with a fifth bronze made later for The Tate Gallery, London.

Reclining Figure No. 4. 1954–55.
Bronze (2/7), 14 × 23½ × 12½ inches

PROVENANCE:
The artist, Much Hadham, England, 1956

EXHIBITIONS:
Art Gallery of Toronto, 1957–60, extended loan
Art Center in La Jolla, California, August 4–September 8, 1963, *Henry Moore*, no. 30; toured to Santa Barbara Museum of Art, California, September 24–October 27; Los Angeles Municipal Art Gallery, November 7–December 1
IBM Gallery, New York, March 15–April 19, 1965, *Five British Sculptors*, no. 24
Virginia Museum of Fine Arts, Richmond, September 27–October 31, 1965, *Henry Moore*, no. 98
The Brooklyn Museum, New York, March 6–April 2, 1967, *Sculpture and Drawings by Henry Moore* (Smithsonian Institution, Traveling Exhibition Service)
Smithsonian Institution, Washington, D.C., September 26, 1971–January 31, 1972, *One Hundred and Twenty-Fifth Anniversary of the Institution*

REFERENCES:
Bowness, Alan. *Henry Moore, Volume 2: Sculpture and Drawings 1949–1954*, 2nd rev. ed., London, Lund Humphries, 1965, no. 332, p. xxvii
Jianou, Ionel. *Henry Moore*, trans. Geoffrey Skelding, New York, Tudor, 1968, no. 345, p. 79
Melville, Robert. *Henry Moore: Sculpture and Drawings 1921–1969*, New York, Abrams, 1971, p. 358
Seldis, Henry J. *Henry Moore in America*, New York, Praeger, 1973, p. 273

Upright Motive No. 1: Glenkiln Cross. 1955–56.
Bronze (edition of six), 11 feet × 3 feet × 3 feet 2 inches

PROVENANCE:
Gimpel Fils, London, 1957

EXHIBITIONS:
Art Gallery of Toronto, March 1958, on loan
The Solomon R. Guggenheim Museum, New York, October 3, 1962–January 6, 1963, *Modern Sculpture from the Joseph H. Hirshhorn Collection*, no. 329, ill. p. 149

REFERENCES:
Arnason, H. Harvard. *History of Modern Art*, New York, Abrams, 1968, p. 518, ill.
Bowness, Alan, ed. *Henry Moore, Volume 3: Sculpture 1955–64*, London, Lund Humphries, New York, no. 377, p. 21
Canaday, John. "New Vistas Open for Sculpture," *The New York Times Magazine*, September 30, 1962, ill. p. 24
Doty, Robert C. "Pope Now Faces Major Decisions," *The New York Times*, November 23, 1964, ill. p. 20
Grohmann, Will. *The Art of Henry Moore*, New York, Abrams, 1960, p. 8
Hedgecoe, John, and Moore, Henry. *Henry Moore*, New York, Simon & Schuster, 1968, p. 528
Jianou, Ionel. *Henry Moore*, trans. Geoffrey Skelding, New York, Tudor, 1968, no. 381, p. 81
Kuh, Katherine. "Great Sculpture," *Saturday Review*, 45, June 23, 1962, p. 17
Melville, Robert. *Henry Moore: Sculpture and Drawings 1921–1969*, New York, Abrams, 1971, p. 358
Read, Herbert. *Henry Moore*, New York, Praeger, 1966, p. 206
Rubin, William S. "The Hirshhorn Collection at the Guggenheim Museum," *Art International*, 6, November 1962, p. 35
Seldis, Henry J. *Henry Moore in America*, New York, Praeger, 1973, p. 273
Sweeney, James Johnson. "A Living Frame for Sculpture," *House & Garden*, 126, August 1964, ill. p. 112

"The maquettes for this upright motif theme were triggered off for me by being asked by the architect to do a sculpture for the courtyard of the new Olivetti building in Milan. It is a very low horizontal one-storey building. My immediate thought was that any sculpture that I should do must be in contrast to this horizontal rhythm. It needed some vertical form in front of it. At the time I also wanted to have a change from the Reclining Figure theme that I had returned to so often. So I did all these small maquettes. They were never used for the Milan building in the end because, at a later stage, when I found that the sculpture would virtually be in a car park, I lost interest. I had no desire to have a sculpture where half of it would be obscured most of the day by cars. I do not think that cars and sculptures really go well together. One of the upright motifs, without my knowing why, turned into a cross-form and is now in Scotland. We call it *The Glenkiln Cross*, because the Glenkiln Farm Estate is where the first cast of it is placed. From a distance it looks rather like one of the old Celtic crosses."

The artist, in Hedgecoe and Moore, p. 245

Falling Warrior. 1956–57.
Bronze (edition of ten), 23¼ × 57¼ × 30 inches

PROVENANCE:
Gimpel Fils, London, 1957

EXHIBITIONS:
Art Gallery of Toronto, March 1958–March 1959, extended loan
The Detroit Institute of Arts, and tour, 1959–60, *Sculpture in Our Time*, no. 182, ill. p. 80
The Solomon R. Guggenheim Museum, New York, October 3, 1962–January 6, 1963, *Modern Sculpture from the Joseph H. Hirshhorn Collection*, no. 330, ill. p. 147

REFERENCES:
Arnason, H. Harvard. *History of Modern Art*, New York, Abrams, 1968, p. 518, ill. p. 517
Bowness, Alan, ed. *Henry Moore, Volume 3: Sculpture 1955–64*, London, Lund Humphries, 1965, no. 405, p. 23
Duitz, Murray. "Museum," *Infinity*, 12, December 1963, ill. p. 17
Feldman, Edmund Burke. *Art as Image and Idea*, Englewood Cliffs, New Jersey, Prentice-Hall, 1967, pp. 185–86, ill.
———. *Varieties of Visual Experience*, New York, Abrams, 1972, p. 175, ill. p. 176
Grohmann, Will. *The Art of Henry Moore*, New York, Abrams, 1960, p. 8
Hedgecoe, John, and Moore, Henry. *Henry Moore*, New York, Simon & Schuster, 1968, p. 529
Jianou, Ionel. *Henry Moore*, trans. Geoffrey Skelding, New York, Tudor, 1968, no. 405, p. 82
Kaufman, Betty. "Hirshhorn: The Collector's Art," *Commonweal*, 77, November 9, 1962, p. 182
Read, Herbert. *Henry Moore*, New York, Praeger, 1966, p. 277
Rubin, William S. "The Hirshhorn Collection at the Guggenheim Museum," *Art International*, 6, November 1962, ill. p. 34
Unsigned. "Sculpture: Fresh-Air Fun," *Time*, 90, September 8, 1967, colorplate p. 75

Seated Woman. 1956–57.
Bronze (edition of six), 57 × 56 × 41 inches

PROVENANCE:
M. Knoedler & Co., Paris, 1961

EXHIBITIONS:
Kunstverein in Hamburg, May 28–July 3, 1960, *Henry Moore* (organized by the British Council), no. 42, ill.; toured to Kunsthaus, Zurich, September 11–October 16, no. 45, ill.; Musée Rodin, Paris, March 24–April 30, 1961, no. 38, plate 29; Stedelijk Museum, Amsterdam, June 9–July 10, no. 36; Akademie der Künste, Berlin, July 25–September 3, no. 37
The Solomon R. Guggenheim Museum, New York, October 3, 1962–January 6, 1963, *Modern Sculpture from the Joseph H. Hirshhorn Collection*, no. 331, ill. p. 150

REFERENCES:
Argan, Giulio Carlo. *Henry Moore*, Milan, Fratelli Fabbri, 1971, colorplate 145
Bowness, Alan, ed. *Henry Moore, Volume 3: Sculpture 1955–64*, London, Lund Humphries, 1965, no. 435, p. 26
Grohmann, Will. *The Art of Henry Moore*, New York, Abrams, 1960, pp. 9, 230
Hedgecoe, John, and Moore, Henry. *Henry Moore*, New York, Simon & Schuster, 1968, p. 529
Jianou, Ionel. *Henry Moore*, trans. Geoffrey Skelding, New York, Tudor, 1968, no. 414, p. 82
Melville, Robert. *Henry Moore: Sculpture and Drawings 1921–1969*, New York, Abrams, 1971, p. 360
Read, Herbert. *Henry Moore*, New York, Praeger, 1966, p. 279
Seldis, Henry J. *Henry Moore in America*, New York, Praeger, 1973, p. 273
Unsigned. " 'round the World with Art Collectors: Joe Hirshhorn," *Art Voices*, 2, November 1962, ill. p. 20

Three Motives Against Wall, No. 2. 1959.
Bronze (edition of ten), $18\frac{1}{4} \times 43\frac{1}{4} \times 16$ inches

PROVENANCE:
Galerie Claude Bernard, Paris, 1961

EXHIBITIONS:
The Solomon R. Guggenheim Museum, New York, October 3, 1962–January 6, 1963, *Modern Sculpture from the Joseph H. Hirshhorn Collection*, no. 334

REFERENCES:
Bowness, Alan, ed. *Henry Moore, Volume 3: Sculpture 1955–64*, London, Lund Humphries, 1965, no. 442, p. 27
Jianou, Ionel. *Henry Moore*, trans. Geoffrey Skelding, New York, Tudor, 1968, no. 427, p. 83
Melville, Robert. *Henry Moore: Sculpture and Drawings 1921–1969*, New York, Abrams, 1971, p. 361

Working Model for Standing Figure: Knife Edge (Bone Figure: Knife Edge). 1961.
Bronze, $64 \times 25 \times 13\frac{1}{2}$ inches
Markings: l. l. side "Moore $\frac{6}{9}$"

PROVENANCE:
M. Knoedler & Co., New York, 1962

EXHIBITIONS:
Art Center in La Jolla, California, August 4–September 8, 1963, *Henry Moore*, no. 31, ill.; toured to Santa Barbara Museum of Art, California, September 24–October 27; Los Angeles Municipal Art Gallery, November 7–December 1

REFERENCES:
Bowness, Alan, ed. *Henry Moore, Volume 3: Sculpture 1955–64*, London, Lund Humphries, 1965, no. 481, p. 30
Jianou, Ionel. *Henry Moore*, trans. Geoffrey Skelding, New York, Tudor, 1968, no. 465, p. 85
Seldis, Henry J. "Henry Moore," *Art in America*, 51, October 1963, p. 58, ill.
Sweeney, James Johnson. "A Living Frame for Sculpture," *House & Garden*, 126, August 1964, ill. p. 114
Unsigned. "Art: Lone Wolf," *Newsweek*, 60, October 15, 1962, p. 111

A fragment of a bone was included in the original maquette for this sculpture which, Moore has said, is "based on the principle wherein the thinness of one view contrasts sharply with the width of another."

The artist, in Hedgecoe and Moore, p. 363

Three-Piece Reclining Figure No. 2: Bridge Prop. 1963.
Bronze, $41\frac{1}{2} \times 99 \times 44\frac{1}{2}$ inches
Markings: l. l. top of base "Moore $\frac{6}{9}$"

PROVENANCE:
The artist, Much Hadham, England, 1965

EXHIBITIONS:
Marlborough Gallery, New York, April–May 1970, *Henry Moore: Carvings, Bronzes 1961–1970*, no. 7, ill. p. 44, colorplate p. 45

REFERENCES:
Bowness, Alan, ed. *Henry Moore, Volume 3: Sculpture 1955–64*, London, Lund Humphries, 1965, no. 513, plates 163–66
Hall, Donald, and Finn, David. *As the Eye Moves . . . a Sculpture by Henry Moore*, New York, Abrams, 1971, p. 13
Jianou, Ionel. *Henry Moore*, trans. Geoffrey Skelding, New York, Tudor, 1968, no. 499, p. 86
Marlborough Gallery, New York, *Artforum*, 8, April 1970, ill. back cover (adv.)
Melville, Robert. *Henry Moore: Sculpture and Drawings 1921–1969*, New York, Abrams, 1971, p. 364

"With the *Reclining Figure: Bridge Prop*, the prop is an arm supporting the figure. In making it, I was reminded of the view under Waterloo Bridge which I had passed on numerous occasions. The arches, seen from the Embankment, are strong."

The artists, in Hedgecoe and Moore, p. 404

Working Model for Three-Way Piece No. 2: Archer. 1964.
Bronze (edition of seven), $31 \times 31\frac{1}{2} \times 21$ inches
Markings: l. l. c. near base "H. Noack Berlin"

PROVENANCE:
The artist, Much Hadham, England, 1966

EXHIBITIONS:
The Brooklyn Museum, New York, March 6–April 2, 1967, *Sculpture and Drawings by Henry Moore* (Smithsonian Institution, Traveling Exhibition Service), no. 30, ill.
Marlborough Gallery, New York, April–May 1970, *Henry Moore: Carvings, Bronzes 1961–1970*, no. 17, colorplate p. 55

REFERENCES:
Baro, Gene. "Henry Moore Bronzes at Marlborough, Carvings at Knoedler," *Arts Magazine*, 44, May 1970, p. 28, ill. p. 27

Jianou, Ionel. *Henry Moore*, trans. Geoffrey Skelding, New York, Tudor, 1968, no. 509, p. 87
Melville, Robert. *Henry Moore: Sculpture and Drawings 1921–1969*, New York, Abrams, 1971, p. 365
Read, Herbert. *Henry Moore*, New York, Praeger, 1966, p. 280

MALCOLM MORLEY (b. 1931)

Born London, June 7, 1931. Studied, London: Camberwell School of Arts and Crafts, N.D.D., 1953; Royal College of Art, A.R.C.A., 1957. Included in "Young Contemporaries," F.B.A. Gallery, London, 1956–57. Moved to New York, 1959. Taught: Adult Education Program, Board of Education, Hewlett, New York, 1963–65; Ohio State University, Columbus, 1965–67; The School of Visual Arts, New York, 1967–69. One-man shows, Kornblee Gallery, New York, 1964, 1967, 1969. Included in: "The Photographic Image," The Solomon R. Guggenheim Museum, New York, 1966; IX São Paulo Bienal, 1967; "Aspects of a New Realism," Milwaukee Art Center, and tour, 1969; 14th Contemporary American Annual, University of Illinois, Champaign-Urbana, 1969. One-man show, Riverside Museum, New York, 1970. Included in: "Radical Realism," Museum of Contemporary Art, Chicago, 1971; Whitney Annual, 1972; "Sharp Focus Realism," and "Colossal Scale," Sidney Janis Gallery, New York, 1972; Documenta 5, Kassel, 1972. Has taught, State University of New York at Stony Brook, since 1972. Lives in New York.

Beach Scene. 1968.
Acrylic on canvas, 9 feet 2 inches \times 7 feet 6 inches

PROVENANCE:
Kornblee Gallery, New York, 1969

EXHIBITIONS:
Kornblee Gallery, New York, February 15–March 6, 1969, *Malcolm Morley*
Milwaukee Art Center, June 21–August 10, 1969, *Aspects of a New Realism*, no. 34, ill.; toured to Contemporary Arts Museum, Houston, September 17–October 19; Akron Art Institute, Ohio, November 9–December 14

REFERENCES:
Calas, Nicolas, and Calas, Elena. *Icons and Images of the Sixties*, New York, Dutton, 1971, p. 158
Constable, Rosalind. "Style of the Year: The Inhumanists," *New York*, December 16, 1968, p. 44, colorplate p. 45

"Morley divides and cuts into small squares the image to be painted. Each square is turned upside down, and the gridded canvas is turned upside down. Now any idea of a whole view is obliterated. Instead, the little squares become qualities which provide a stimulus for the placing of paint. . . .

"The grid itself has become a kind of Universal Receiver able to accommodate a complexity of multi-layered impulses. Thus, Morley sees painterly possibilities everywhere—a thing lying in the gutter, a bit of texture, a calendar, a phone book cover, a post card—and these can be transformed into works. 'I am painting the world bit by bit,' says Morley, 'by recycling garbage into art. Everything is useful, everything is a fit subject for art.' "

Morley, Frances. "Malcolm Morley," *Documenta 5*, Kassel, 1972, p. 37

ROBERT MOTHERWELL (b. 1915)

Robert Burns Motherwell, born Aberdeen, Washington, January 24, 1915. Moved with family to San Francisco, 1918. Studied: California School of Fine Arts, San Francisco, briefly, 1932; Stamford University, California, A.B., 1936; Harvard University, Cambridge, Massachusetts, 1937–38. Traveled in Europe, 1935, 1938–39. Taught, University of Oregon, Eugene, 1939–40. Studied, New York: Columbia University, with Meyer Schapiro, 1940–41; engraving, with Kurt Seligmann, 1940–41. Met Surrealist painters, New York, 1941; traveled to Mexico, with Matta. Included in "First Papers of Surrealism," 451 Madison Avenue, New York, 1942. One-man show, Peggy Guggenheim's Art of This Century, New York, 1944. Directed *The Documents of Modern Art* series (New York, Wittenborn), 1944. Studied engraving, S. W. Hayter's Atelier 17, New York, 1945. Taught, Black Mountain College, North Carolina, summers, 1945, 1951. One-man shows: San Francisco Museum of Art, 1946; The Arts Club of Chicago, 1946; Kootz Gallery, New York, 1946–50, 1952, 1953. Co-founded Subjects of the Artist: A New Art School, New York, with William Baziotes, Barnett Newman, Mark Rothko, David Hare, 1948. Directed Robert Motherwell School of Fine Art, New York, 1949–50. Included in: II São Paulo Bienal, 1953; Pittsburgh International, 1955–67; Documenta II and III, Kassel, 1959, 1964; Venice Biennale, 1970. Taught, Hunter College, City University of New York, 1951–60, 1971–72. One-man shows, Sidney Janis Gallery, New York, 1957, 1959, 1961, 1962. Retrospectives: Bennington College, Vermont, 1959; VI São Paulo Bienal, 1961; The Phillips Collection, Washington, D.C., 1965; The Museum of Modern Art, New York, and tour, 1965–66. Mural commission, John Fitzgerald Kennedy Federal Building, Boston, 1966. One-man shows: Whitney Museum of American Art, New York, 1968; Marlborough Gallery, New York, 1969; The David Mirvish Gallery, Toronto, 1970; "The Genesis of a Book," The Metropolitan Museum of Art, New York, 1972; Walker Art Center, Minneapolis, 1972; Lawrence Rubin Gallery, New York, 1972. Member: The National Institute of Arts and Letters, 1970; The Smithsonian Council, Washington, D.C., 1970–72; National Collection of Fine Arts Commission, Smithsonian Institution, 1971–72. Retrospective, The Museum of Fine Arts, Houston, and tour (collages), 1972–73. Lives in Greenwich, Connecticut.

Blue Air. 1946.
Oil on cardboard, $41\frac{1}{2} \times 27\frac{1}{4}$ inches
Signed and dated u. l.: "Motherwell '46"

PROVENANCE:
Kootz Gallery, New York; Private collection, Connecticut; Parke-Bernet Galleries, New York, Sale 1730, February 6, 1957, no. 61

EXHIBITIONS:
Kootz Gallery, New York, April 28–May 17, 1947, *Robert Motherwell*
Trabia-Morris Gallery, New York, October 16–November 10, 1962, *Art of the Americas*, cat.

Black and White Plus Passion. 1958.
Oil on canvas, 50×80 inches
Signed and dated on back: "R. Motherwell 1958"

PROVENANCE:
Sidney Janis Gallery, New York, 1959

EXHIBITIONS:
The Coliseum, New York, August 11–21, 1958, *National Home Furnishings Show* (organized by the United States Rubber Co.)

JAN MÜLLER (1922–1958)

Born Hamburg, December 27, 1922. Fled with family to Czechoslovakia, 1933; then to Switzerland, The Netherlands, France. Emigrated to the U.S., 1941. Studied: The Art Students League of New York, with Vaclav Vytlacil, 1945; Hans Hofmann School of Fine Art, New York, and Provincetown, Massachusetts, 1945–51. Co-founded Hansa Gallery, New York, with Felix Pasilis, 1952. One-man shows, Hansa Gallery, 1953–58. Included in: Whitney Annual, 1957; "Young America 1957," Whitney Museum of American Art, New York, 1957. Died New York, January 29, 1958. Memorial exhibition, Hansa Gallery, 1959. One-man shows: University Gallery, University of Minnesota, Minneapolis, 1960; Zabriskie Gallery, New York, 1961, 1963; Venice Biennale, 1962; Staempfli Gallery, New York, 1963, 1965; Noah Goldowsky Gallery, New York, 1971. Retrospective, The Solomon R. Guggenheim Museum, New York, and Institute of Contemporary Art, Boston, 1962.

St. George and Walpurgis Night. 1956.
Oil on wood, reversible triptych, $9\frac{3}{4} \times 23\frac{1}{4}$ inches
Left and right volets, each $9\frac{3}{4} \times 5\frac{1}{4}$ inches
Center panel, $9\frac{3}{4} \times 12$ inches

PROVENANCE:
Jon N. Streep, New York, 1960

EXHIBITIONS:
Hansa Gallery, New York, December 16, 1958–January 9, 1959, *Jan Müller Memorial Exhibition*

REFERENCES:
Sawin, Martica. "Jan Müller: 1922–1958," *Arts*, 33, February 1959, pp. 40–41

ROBERT MÜLLER (b. 1920)

Born Zurich, June 17, 1920. Studied, ateliers of Germaine Richier, and Charles-Otto Bänninger, Zurich, 1939–44. Lived in Lonay, Switzerland, 1945–46. Traveled in Italy, 1947–49; moved to Paris, 1950. Included in Salon de Mai, Paris, from 1953. One-man show, Galerie Craven, Paris, 1954. Received commission, iron fountain, École Kügeliloo, Zurich, 1954. Included in: Venice Biennale, 1956, 1960; Iᵉ Biennale de la Jeune Peinture et de la Jeune Sculpture, Paris, 1957; IV São Paulo Bienal, 1957; Pittsburgh International, 1958, 1964, 1970; Documenta II, Kassel, 1959; "European Art Today: 35 Painters and Sculptors," The Minneapolis Institute of Arts, and tour, 1959–60; "Bewogen-Beweging," Stedelijk Museum, Amsterdam, and tour, 1961. Retrospective, Kunsthalle, Basel, and Helmhaus, Zurich, 1959. One-man shows: Galerie de France, Paris, 1960, 1964, 1967, 1971; Albert Loeb Gallery, New York, 1963; Stedelijk Museum, and tour, 1964–65; Galerie Renée Ziegler, Zurich, 1964, 1972; Kunsthalle, Basel, 1971. Has lived in Villiers-le-Bel, near Paris, since 1961.

Larkspur (Rittersporn). 1958.
Iron, $47 \times 29\frac{1}{4} \times 25$ inches
Markings: front l. r. "\cancel{R}"

PROVENANCE:
Galerie de France, Paris; French & Company, New York, 1960

EXHIBITIONS:
The Minneapolis Institute of Arts, September 23–October 25, 1959, *European Art Today: 35 Painters and Sculptors*, no. 81, ill. p. 33; toured to Los Angeles County Museum of Art, November 11–December 20; San Francisco Museum of Art, January 6–February 9, 1960; North Carolina Museum of Art, Raleigh, February 26–April 3; The National Gallery of Canada, Ottawa, April 20–May 24; French & Company, New York, June 7–August 13; The Baltimore Museum of Art, September 18–October 16
The Solomon R. Guggenheim Museum, New York, October 3, 1962–January 6, 1963, *Modern Sculpture from the Joseph H. Hirshhorn Collection*, no. 336, ill. p. 122
Albert Loeb Gallery, New York, October 15–November 15, 1963, *Robert Müller: Sculpture and Drawings*, cat., ill.
Albert Loeb Gallery, New York, November 23–December 19, 1964, *Five Sculptors: Berrocal, César, Ipoustéguy, Metcalf, Müller*, cat.

REFERENCES:
De Mandiargues, André Pieyre. "Robert Müller," *Art International*, 4, nos. 2–3, 1960, ill. p. 39
Descargues, Pierre, and Prevot, Myriam. *Robert Müller*, Brussels, La Connaissance, 1971, no. 111, pp. 27, 130, ill. p. 76
De Solier, René, intro. *Robert Müller: Sculptures*, Paris, Galerie de France, 1960, plate 13
Galerie de France, Paris, *Art International*, 4, no. 1, 1960, ill. (adv.)
Netter, Maria. "Der Eisenschmied Robert Müller," *Quadrum*, 7, 1959, ill. p. 128
Preston, Stuart. "Contemporary Galaxy," *The New York Times*, October 20, 1963, sec. 2, p. 17, ill.

EDVARD MUNCH (1863–1944)

Born Løten, Hedmark, Norway, December 12, 1863. Moved with family to Christiania (now Oslo), 1864. Studied: Royal School of Design, with sculptor Julius

Middelthun, Oslo, 1881; studio work, under supervision of Christian Krohg, Oslo, 1882; Frits Thaulow's open-air academy, Modum, Norway, 1883. Visited Paris, briefly, 1885. First one-man show, Students' Association, Oslo; received state scholarship for study abroad, 1889. Studied, with Léon Bonnat, Paris, 1889–90; returned to Paris, 1891–92. One-man show, Verein Berliner Künstler, 1892, closed after one week (in protest, artists formed Berliner Sezession, and circulated show). Lived mainly in Berlin, until 1908, with visits to Paris; summered in Norway. Began association with writers, including August Strindberg, Julius Meier-Graefe, and Polish poet Stanislaw Przybyszewski, 1892. First etchings and lithographs, 1894; first woodcuts, 1896. Included in Salon de l'Art Nouveau, Galerie Bing, Paris, 1896, 1897. Commissions by Max Reinhardt: sketches, for Henrik Ibsen's *Ghosts* and *Hedda Gabler;* paintings for room in Kammerspielhaus, Berlin, 1906. Returned permanently to Norway, 1909. One-man shows, Blomqvist's Lokale, Oslo, 1909, 1918, 1929. Painted murals, Aula (Assembly Hall), University of Oslo, 1911–14. Honored exhibitor, Sonderbund-Ausstellung, Cologne, 1912; included in the Armory Show, 1913. Awarded Gold Medal for Graphics, Panama-Pacific International Exposition, San Francisco, 1915. Settled in Skøyen, outside of Oslo, 1916. Painted twelve murals, workers' dining room, Freia Chocolate factory, Oslo, 1922. Retrospectives: Kunsthaus, Zurich, 1922; Nationalgalerie, Berlin, and Nasjonalgalleriet, Oslo, 1927; Nationalmuseum, Stockholm (graphics), 1929. One-man show, The Detroit Institute of Arts (graphics), 1931. Included in Nazi exhibition "Entartete Kunst (Degenerate Art)," Munich, and tour, 1937; eighty-two works in Germany confiscated, 1937, and later sold in Norway. Died Skøyen, January 23, 1944. Memorial exhibition, Buchholz Gallery, New York (graphics), 1944. Left paintings, prints, drawings, sculptures to city of Oslo; Munch-museet built to house them, 1963. Retrospective, The Solomon R. Guggenheim Museum, New York, 1965.

Kneeling Nude (Knelende Akte). c. 1913.
Oil on canvas, 32½ × 31 inches
Signed l. r.: "E. Munch"

PROVENANCE:
Harold Holst Halvorsen, Oslo; Ragnar Moltzau, Oslo; Marlborough Fine Art, London, 1958

EXHIBITIONS:
Kunstnernes Hus, Oslo, November 10–December 16, 1951, *Edvard Munch, Utstilling malerier, akvareller, tegninger, grafikk,* ill. p. 33
Nationalmuseum, Stockholm, April–June 1956, *Modern konst ur Ragnar Moltzau Samling,* no. 83; toured to Kunsthaus, Zurich, 1957; Gemeentemuseum, The Hague, April 19–June 11, 1957
Marlborough Fine Art, London, Summer 1958, *XIX and XX Century Masters,* no. 46, ill. p. 71
American Federation of Arts, tour, 1962–65, *Paintings from the Joseph H. Hirshhorn Foundation Collection: A View of the Protean Century,* no. 51, ill. p. 8
Marlborough-Gerson Gallery, New York, April–May 1968, *International Expressionism,* part I, no. 42, ill.

REFERENCES:
Genauer, Emily. "75 Choice Hirshhorn Paintings," *New York Herald Tribune,* November 4, 1962, sec. 4, p. 7, ill.
Preston, Stuart. "A Collector's Eye-view," *The New York Times,* February 28, 1965, sec. 2, p. 19

ROBERT MURRAY (b. 1936)
Born Vancouver, British Columbia, Canada, March 2, 1936. Studied: School of Art, University of Saskatchewan, Regina, 1956–58; Artists' Workshops, Emma Lake, Saskatchewan, summers, 1957–62. Received Canada Council Bursary Grant, 1960. Moved to New York, 1960; studied, The Art Students League of New York. Included in: "Canadian Outdoor Sculpture Exhibition," The National Gallery of Canada, Ottawa, 1962; Whitney Annual, 1964–70; "Young America 1965," Whitney Museum of American Art, New York, 1965; "American Sculpture of the Sixties," Los Angeles County Museum of Art, and Philadelphia Museum of Art, 1967; Expo '67, Montreal, 1967; Guggenheim International, 1967–68. One-man shows: Betty Parsons Gallery, New York, 1965, 1966, 1968; The Jewish Museum, New York, 1967; The David Mirvish Gallery, Toronto, 1967, 1968, 1972. Taught, Hunter College, City University of New York, 1966–69. Received National Council on the Arts Grant, 1968. Included in X São Paulo Bienal, 1969; 11th Middelheim Biënnale, Antwerp, 1971; Whitney Biennial, 1973. One-man show, Dag Hammarskjöld Plaza, New York, 1971–72. Lives in New York.

Marker. 1964–65.
Steel painted white, 84 × 34½ × 21 inches
Markings: back top of base "Murray 64–65"

PROVENANCE:
Betty Parsons Gallery, New York, 1965

EXHIBITIONS:
Betty Parsons Gallery, New York, March 30–April 17, 1965, *Robert Murray: Painted Sculpture,* no. 5
Whitney Museum of American Art, New York, June 23–August 29, 1965, *Young America 1965,* no. 59
Institute of Contemporary Art, Boston, May 18–June 21, 1967, *Nine Canadians,* no. 26, ill.

REFERENCES:
Grossberg, Jacob. "In the Galleries: Robert Murray," *Arts Magazine,* 39, May–June 1965, p. 59
Meilach, Dona, and Seiden, Don. *Direct Metal Sculpture,* New York, Crown, 1966, ill. p. 25

SAMUEL MURRAY (1870–1941)
Samuel Aloysius Murray, born Philadelphia, June 12, 1870. Studied, The Art Students League of Philadelphia, with Thomas Eakins, c. 1886–87; later Eakins's assistant and close friend. Taught, Moore Institute of Art, Science and Technology, Philadelphia, 1891–1941. Included in Pennsylvania Academy Annual, 1892, 1894–95, 1900–1910, 1913–17, 1920, 1921, 1929, 1933. Awarded: honorable mention, World's Columbian Exposition,

Chicago, 1893, and Pan-American Exposition, Buffalo, New York, 1901; Silver Medal, St. Louis International Exposition, Missouri, 1904. Public monuments commissioned, Pennsylvania: *Commodore Barry,* Independence Hall Square, Philadelphia, 1907; *Liberty Statue,* Gettysburg Monument, 1910; *Bishop Shanahan Memorial,* St. Patrick's Cathedral, Harrisburg, 1919; *Admiral Melville,* Philadelphia Navy Yard, 1923; *Progress,* Philadelphia Sesqui-Centennial Exposition, 1926. Included in "Paintings by Thomas Eakins, Sculpture by Samuel Murray," Fifty-Sixth Street Galleries, New York, 1931. Died Philadelphia, November 3, 1941.

Full-Length Figure of Mrs. Thomas Eakins. 1894.
Plaster, 24¾ × 8⅛ × 9¾ inches
Markings: back l. r. "Murray 94"

PROVENANCE:
Mrs. Samuel Murray, Philadelphia; M. Knoedler & Co., New York, 1965

Susan Hannah MacDowell (1852–1938) became Mrs. Thomas Eakins in 1884. A talented painter in her own right, she was so impressed by Eakins's painting *The Gross Clinic* when it was exhibited in 1875 that she went on to study with him at The Pennsylvania Academy of the Fine Arts.

"Although after their marriage she was unable to paint as much, he [Eakins] considered her the best woman painter in the country. . . . Musical, and gifted with a lively sense of humor, she furnished a foil to his temperament."

Goodrich, Lloyd. *Thomas Eakins, His Life and Work,* New York, Whitney Museum of American Art, 1933, p. 96

Portrait Bust of Benjamin Eakins. 1894.
Plaster, 24 × 13 × 9⅞ inches
Markings: back l. "S. Murray 94"
 front l. c. "EAKINS"

PROVENANCE:
Mrs. Samuel Murray, Philadelphia; M. Knoedler & Co., New York, 1963

EXHIBITIONS:
Arts Club of Philadelphia, November 19–December 16, 1894, *6th Annual Exhibition: Oil Paintings and Sculpture,* no. 240
M. Knoedler & Co., New York, June 5–July 31, 1944, *A Loan Exhibition of the Works of Thomas Eakins 1844–1944,* no. 189; toured to Wilmington Society of the Fine Arts, Delaware Art Center, October 1–29; Doll & Richards Gallery, Boston, November 4–21; State Art Gallery, Raleigh, North Carolina, November 26–December 31
Carnegie Institute, Pittsburgh, April 26–June 1, 1945, *Thomas Eakins Centennial Exhibition 1844–1944,* no. 121

REFERENCES:
Hartmann, Sadakichi, ed. *Modern American Sculpture,* New York, Paul Wenzel, 1918, plate 56

Until his death, Benjamin Eakins (1818–1899) lived with his son Thomas. The elder Eakins was a master—and teacher—of the art of Spencerian penmanship, and his script, meticulously executed on copperplates, ornamented countless deeds, diplomas and birth certificates that documented the lives of his fellow Philadelphians.

Portrait Bust of Thomas Eakins. 1894.
Painted plaster, 21½ × 8 × 9¾ inches
Markings: back l. c. "Murray 1894"
 front c. "Eakins"

PROVENANCE:
Mrs. Samuel Murray, Philadelphia; M. Knoedler & Co., New York, 1961

EXHIBITIONS:
The Pennsylvania Academy of the Fine Arts, Philadelphia, January 23–March 4, 1905, *100th Anniversary Exhibition,* no. 973
M. Knoedler & Co., New York, June 5–July 31, 1944, *A Loan Exhibition of the Works of Thomas Eakins 1844–1944,* no. 90; toured to Wilmington Society of the Fine Arts, Delaware Art Center, October 1–29; Doll & Richards Gallery, Boston, November 4–21; State Art Gallery, Raleigh, North Carolina, November 26–December 31

JEROME MYERS (1867–1940)
Born Petersburg, Virginia, March 20, 1867. Youth spent in Petersburg, Philadelphia, Baltimore. Settled in New York, 1886; worked as scene painter for New York theaters. Studied, New York: The Cooper Union for the Advancement of Science and Art, 1887–89; The Art Students League of New York, with George de Forest Brush, 1888–89. Staff artist, *New York Tribune,* 1895–96. Visited Europe, 1896, 1914. First exhibited, Macbeth Gallery, New York, 1903. Awarded Bronze Medal, St. Louis International Exposition, Missouri, 1904. First one-man show, Macbeth Gallery, 1908. Exhibited, New York: Exhibition of Independent Artists, 1910; with Walt Kuhn, and Elmer MacRae, "The Pastellists," Madison Gallery, 1911. Member, executive committee, Association of American Painters and Sculptors (organizers of the Armory Show), 1912–13. Three paintings included in the Armory Show, 1913. Taught, Finch College, New York, 1913. First etchings, 1915. One-man shows, New York: The Ehrich Galleries, 1915; The Milch Galleries, 1919; C. W. Kraushaar Galleries, 1920. Included in Society of Independent Artists Annual, 1917. National Academy of Design, New York: Clarke Prize, 94th Annual, 1919; associate, 1919; academician, 1929. Awarded Carnegie Prize, Carnegie International, 1936. One-man shows, New York: New School for Social Research, 1939; Macbeth Gallery, 1940. Wrote autobiography, *The Artist in Manhattan,* 1940; published (New York, American Artists Group), 1941. Died New York, June 29, 1940. Memorial exhibitions: Whitney Museum of American Art, New York, and tour, 1941–42; Virginia Museum of Fine Arts, Richmond, 1942; The Arts Club of Chicago, 1943. Included in "The

Lower East Side: Portal to American Life (1870–1924)," The Jewish Museum, New York, and Arts and Industries Building, Smithsonian Institution, Washington, D.C., 1966–68.

Children Dancing. 1903.
Oil on canvas, 16¼ × 22½ inches
Signed and dated l. l.: "Jerome Myers/1903-N.Y."

PROVENANCE:
Jon N. Streep, New York, 1961

Street Scene. 1904.
Oil on canvas, 22⅝ × 28¼ inches
Signed and dated l. r.: "Jerome Myers/1904 N.Y."

PROVENANCE:
Robert Schoelkopf Gallery, New York, 1962

ELIE NADELMAN (1882–1946)
Born Warsaw, February 20, 1882. Studied: Academy of Fine Arts, Warsaw, late 1890s, interrupted by one year's service, Imperial Russian Army, and returned to Academy, 1901; privately, with Konstantin Laszczka, Krakow, 1902. Received annual prize, Polish-language art journal *Sztuka* (Paris), 1902. Traveled to Munich, 1903. Lived in Paris, 1903–14: studied, Académie Colarossi, 1904; exhibited, Salon des Artistes Indépendants, and Salon d'Automne, 1905–8; met Gertrude and Leo Stein, 1908. First one-man show, Galerie Druet, Paris, 1909. Exhibited with Manolo, Galería Dalmau, Barcelona, 1941. One-man shows: Paterson Gallery, London, 1911 (entire show purchased by Helena Rubinstein); Galerie Druet, 1913. One sculpture and twelve drawings included in the Armory Show, 1913. Issued *Vers l'unité plastique,* folio of fifty-one drawings, Paris, 1914. Emigrated to the U.S., 1914. One-man shows: Alfred Stieglitz's Photo-Secession Gallery, "291," New York, 1915; Scott & Fowles Co., New York, 1917, 1925; M. Knoedler & Co., New York, 1919, 1927; The Arts Club of Chicago, 1925; International Gallery, New York, 1932. Settled in Riverdale, New York, 1919. Began collection of folk art, 1919–20. Withdrew almost entirely from exhibitions, c. 1930. Facade reliefs commissioned, Fuller Building, 41 East 57th Street, and Bank of Manhattan, 40 Wall Street, New York, 1931. Died New York, December 28, 1946. Retrospectives: The Museum of Modern Art, New York, 1948; Edwin Hewitt Gallery, New York, 1951, 1957; Zabriskie Gallery, New York, 1967; Whitney Museum of American Art, New York, and The Hirshhorn Museum and Sculpture Garden, Washington, D.C., 1974–75.

Standing Female Nude. c. 1909.
Pen and ink, and pencil on paper, 21¾ × 8¾ inches
Signed l. r.: "Elie Nadelman"

PROVENANCE:
Mrs. Elie Nadelman, New York; Edwin Hewitt Gallery, New York, 1957

EXHIBITIONS:
Edwin Hewitt Gallery, New York, April 16–May 18, 1957, *Elie Nadelman 1882–1946*
Forum Gallery, New York, October 1–20, 1962, *Sculptors' Drawings from the Joseph H. Hirshhorn Collection,* no. 36; toured to Jewish Community Center, Washington, D.C., May 15–June 15, 1963
Duke University, Durham, North Carolina, October 6–27, 1963, *Sculptors' Drawings from the Joseph H. Hirshhorn Collection* (American Federation of Arts, Circulating Exhibition), no. 42; toured to New Britain Museum of American Art, Connecticut, November 10–December 1; Krannert Art Museum, University of Illinois, Urbana, January 19–February 9, 1964; Laguna Gloria Art Museum, Austin, Texas, February 23–March 15; Lytton Center of the Visual Arts, Hollywood, California, March 29–July 15; Des Moines Art Center, Iowa, October 2–23

REFERENCES:
Getlein, Frank. "Art and Artists: Jewish Center," *Washington [D.C.] Evening Star,* May 19, 1963
Kirstein, Lincoln. *Elie Nadelman,* New York, Eakins, 1973, no. 46
———. *Elie Nadelman Drawings,* New York, Bittner, 1949; reprint, New York, Hacker, 1970, no. 20, plate 20
Nadelman, Elie. *Vers l'unité plastique,* Paris, 1914, ill.; republished as *Vers la beauté plastique,* New York, E. Weyhe, 1921, plate 17
Spear, Athena Tacha. "The Multiple Styles of Elie Nadelman: Drawings and Figure Sculptures, ca. 1905–12," *Allen Memorial Art Museum Bulletin,* Oberlin, Ohio, 31, 1973–74, p. 54, ill. 26, p. 55

Standing Male Nude. c. 1909.
Pen and ink, and pencil on paper, 21 × 9½ inches
Signed l. r.: "Elie Nadelman"

PROVENANCE:
Mrs. Elie Nadelman, New York; Edwin Hewitt Gallery, New York, 1957

EXHIBITIONS:
The Brooklyn Museum, New York, January 22–March 17, 1957, *Golden Years of American Drawings 1905–1956,* p. 31, ill.
Edwin Hewitt Gallery, New York, April 16–May 18, 1957, *Elie Nadelman 1882–1946*
Forum Gallery, New York, October 1–20, 1962, *Sculptors' Drawings from the Joseph H. Hirshhorn Collection,* no. 35, ill.; toured to Jewish Community Center, Washington, D.C., May 15–June 15, 1963
Duke University, Durham, North Carolina, October 6–27, 1963, *Sculptors' Drawings from the Joseph H. Hirshhorn Collection* (American Federation of Arts, Circulating Exhibition), no. 41; toured to New Britain Museum of American Art, Connecticut, November 10–December 1; Krannert Art Museum, University of Illinois, Urbana, January 19–February 9, 1964; Laguna Gloria Art Museum, Austin, Texas, February 23–March 15; Lytton Center of the Visual Arts, Hollywood, California, March 29–July 15; Des Moines Art Center, Iowa, October 2–23

REFERENCES:
Getlein, Frank. "Art and Artists: Jewish Center," *Washington [D.C.] Evening Star,* May 19, 1963

Kirstein, Lincoln. *Elie Nadelman,* New York, Eakins, 1973, no. 91, plate 35, p. 168

——. *Elie Nadelman Drawings,* New York, Bittner, 1949; reprint, New York, Hacker, 1970, no. 21, plate 21

Spear, Athena Tacha. "The Multiple Styles of Elie Nadelman: Drawings and Figure Sculptures, ca. 1905–12," *Allen Memorial Art Museum Bulletin,* Oberlin, Ohio, 31, 1973–74, p. 54, ill. 27

Standing Female Nude. c. 1909.
Bronze, 26 × 7¼ × 7¼ inches
Markings: back "Eli Nadelman"

PROVENANCE:
The artist, Paris; Helena Rubinstein, New York; Unknown collection; David Drey Ltd., London; Parke-Bernet Galleries, New York, Sale 3104, October 29, 1970, no. 7, ill.

EXHIBITIONS:
International Gallery, New York, April 16–May 6, 1932, *Sculpture by Elie Nadelman from the Private Collection of Helena Rubinstein,* cat., ill.
Smithsonian Institution, Washington, D.C., 1972–73, extended loan

REFERENCES:
Reich, Sheldon. "The Halpert Sale, A Personal View," *American Art Review,* 1, September–October 1973, p. 81
Spear, Athena Tacha. "The Multiple Styles of Elie Nadelman: Drawings and Figure Sculptures ca. 1905–12," *Allen Memorial Art Museum Bulletin,* Oberlin, Ohio, 1973–74, p. 48

Classical Head. c. 1909–11.
Marble, 12⅜ × 9 × 11½ inches
Markings: l. r. side "Eli Nadelman"

PROVENANCE:
The artist, Paris; Helena Rubinstein, New York; Parke-Bernet Galleries, New York, Sale 2428, April 20, 1966, *Modern Paintings and Sculpture from the Helena Rubinstein Collection,* no. 18, ill.

EXHIBITIONS:
Paterson Gallery, London, April 1911, *Nadelman*
International Gallery, New York, April 16–May 6, 1932, *Sculpture by Elie Nadelman from the Private Collection of Helena Rubinstein*

REFERENCES:
Kirstein, Lincoln. *Elie Nadelman,* New York, Eakins, 1973, no. 23, plate 27
Spear, Athena Tacha. "Elie Nadelman's Early Heads (1905–1911)," *Allen Memorial Art Museum Bulletin,* Oberlin, Ohio, 28, Spring 1971, p. 212

Classical Figure. c. 1909–11.
Marble, 34½ × 15⅜ × 13⅜ inches
Markings: l. l. side "Eli Nadelman"

PROVENANCE:
The artist, Paris, 1911; Helena Rubinstein, New York; Parke-Bernet Galleries, New York, Sale 2428, April 20, 1966, *Modern Paintings and Sculpture from the Helena Rubinstein Collection,* no. 23, ill.

EXHIBITIONS:
Paterson Gallery, London, April 1911, *Nadelman*
International Gallery, New York, April 16–May 6, 1932, *Sculpture by Elie Nadelman from the Private Collection of Helena Rubinstein*

REFERENCES:
Kirstein, Lincoln. *Elie Nadelman,* New York, Eakins, 1973, plate 177
——. *Elie Nadelman Drawings,* New York, Bittner, 1949; reprint, New York, Hacker, 1970, ill. p. 22
Nirdlinger, Virginia. "Elie Nadelman," *Parnassus,* 4, April 1932, p. 13, ill. p. 22
Spear, Athena Tacha. "Elie Nadelman's Early Heads (1905–1911)," *Allen Memorial Art Museum Bulletin,* Oberlin, Ohio, 28, Spring 1971, pp. 202, 214, notes 5, 19
Unsigned. "A New Sculptor: Two Examples of the Work of Elie Nadelman," *Black and White,* April 1, 1911, ill.
Weichsel, John. "Elie Nadelman's Sculpture," *East and West,* 1, August 1915, ill. p. 144

Head of a Man. c. 1913.
Bronze, 15½ × 8 × 11 inches
Markings: l. r. side "Eli Nadelman"
 back l. l. "Alexis Rudier
 Fondeur Paris"

PROVENANCE:
Private collection, Paris; Greer Gallery, New York; Zabriskie Gallery, New York, 1967

EXHIBITIONS:
Zabriskie Gallery, New York, February 7–March 11, 1967, *Elie Nadelman,* no. 3, ill.

REFERENCES:
Geist, Sidney. *Brancusi, A Study of the Sculpture,* New York, Grossman, 1968, p. 35, ill. p. 189
Kirstein, Lincoln. *Elie Nadelman,* New York, Eakins, 1973, no. 65, plate 16
——. *The Sculpture of Elie Nadelman,* New York, The Museum of Modern Art, 1948, ill. p. 18

Horse. c. 1914.
Bronze, 12½ × 11¾ × 3½ inches

PROVENANCE:
Paul Magriel, New York; Harold Diamond, New York, 1958

EXHIBITIONS:
The Detroit Institute of Arts, and tour, 1959–60, *Sculpture in Our Time,* no. 183
The Solomon R. Guggenheim Museum, New York, October 3, 1962–January 6, 1963, *Modern Sculpture from the Joseph H. Hirshhorn Collection,* no. 338, ill. p. 165
Zabriskie Gallery, New York, February 7–March 11, 1967, *Elie Nadelman,* no. 11

REFERENCES:
Hunter, Sam. *American Art of the 20th Century,* New York, Abrams, 1972, ill. 414
Kirstein, Lincoln. *Elie Nadelman,* New York, Eakins, 1973, no. 181, plate 55, p. 200
Saltmarche, Kenneth. "Notes on Special Exhibitions: 'Sculpture in Our Time'," *The Art Quarterly,* 22, Winter 1959, p. 351
——. "Sculpture in Our Time," *Art Gallery of Toronto News and Notes,* 4, October 1960, p. 2

Hostess. c. 1918–20.
Painted cherry wood, 32½ × 9¼ × 13½ inches

PROVENANCE:
Estate of the artist; Edwin Hewitt Gallery, New York, 1956

EXHIBITIONS:
Edwin Hewitt Gallery, New York, November 28–December 22, 1951, *Wood Sculpture by Elie Nadelman,* no. 3
The Detroit Institute of Arts, 1959, *Sculpture in Our Time,* no. 185, ill. p. 83
Robert Isaacson Gallery, New York, October 18–November 19, 1960, *Elie Nadelman,* no. 17
The Solomon R. Guggenheim Museum, New York, October 3, 1962–January 6, 1963, *Modern Sculpture from the Joseph H. Hirshhorn Collection,* no. 340, ill. p. 165
Whitney Museum of American Art, New York, February 27–April 14, 1963, *The Decade of the Armory Show,* no. 67

REFERENCES:
Hunter, Sam. *American Art of the 20th Century,* New York, Abrams, 1972, ill. 159
Kirstein, Lincoln. *Elie Nadelman,* New York, Eakins, 1973, no. 122
——. "Elie Nadelman: 1882–1946," *Harper's Bazaar,* 82, August 1948, ill. p. 134
Murrell, William. *Elie Nadelman,* Woodstock, New York, Fisher, 1923, colorplate
Rudikoff, Sonya. "New York Letter," *Art International,* 6, November 1962, p. 62

Host. c. 1920–23.
Painted cherry wood and iron, 28¾ × 15½ × 14½ inches

PROVENANCE:
Estate of the artist; Edwin Hewitt Gallery, New York, 1957

EXHIBITIONS:
Edwin Hewitt Gallery, New York, November 28–December 22, 1951, *Wood Sculpture by Elie Nadelman,* no. 2
Edwin Hewitt Gallery, New York, April 16–May 18, 1957, *Elie Nadelman 1882–1946*
The Detroit Institute of Arts, and tour, 1959–60, *Sculpture in Our Time,* no. 184
The Solomon R. Guggenheim Museum, New York, October 3, 1962–January 6, 1963, *Modern Sculpture from the Joseph H. Hirshhorn Collection,* no. 339

REFERENCES:
Burkhardt, Edith. "Reviews and Previews: Elie Nadelman," *Art News,* 56, April 1957, p. 10
Kirstein, Lincoln. *Elie Nadelman,* New York, Eakins, 1973, pp. 26, 300
——. "Elie Nadelman: 1882–1946," *Harper's Bazaar,* 82, August 1948, ill. p. 134
Michelson, Annette. "Private but Public: The Joseph H. Hirshhorn Collection," *Contemporary Sculpture,* Arts Yearbook 8, 1965, ill. p. 185
Rudikoff, Sonya. "New York Letter," *Art International,* 6, November 1962, p. 62

Two Acrobats. 1934.
Polychrome-glazed ceramic, 10½ × 9¼ × 6½ inches

PROVENANCE:
Estate of the artist; Robert Isaacson Gallery, New York; Robert Schoelkopf Gallery, New York, 1962

Head of Baudelaire. c. 1940–45.
Marble, 17½ × 8½ × 12½ inches

PROVENANCE:
Estate of the artist; Robert Isaacson Gallery, New York, 1960

EXHIBITIONS:
Robert Isaacson Gallery, New York, October 18–November 19, 1960, *Elie Nadelman,* no. 6, cover ill.
The Solomon R. Guggenheim Museum, New York, October 3, 1962–January 6, 1963, *Modern Sculpture from the Joseph H. Hirshhorn Collection,* no. 343, ill. p. 164
Art Gallery of Toronto, April 4–May 2, 1963, *Baudelaire*

REFERENCES:
Hunter, Sam. *American Art of the 20th Century,* New York, Abrams, 1972, ill. 413
Kirstein, Lincoln. *Elie Nadelman,* New York, Eakins, 1973, no. 177, plate 159, pp. 20, 26
——. *Elie Nadelman Drawings,* New York, Bittner, 1949; reprint, New York, Hacker, 1970, p. 34, note 12
Kuh, Katherine. "Great Sculpture," *Saturday Review,* 45, June 23, 1962, p. 19
Sawin, Martica. "In the Galleries: Elie Nadelman," *Arts,* 35, December 1960, p. 53
Unsigned. "The Hirshhorn Approach," *Time,* 80, October, 5, 1962, p. 84

Like Raymond Duchamp-Villon's portrait of Baudelaire, Nadelman's sculpture is based on a photograph taken by Étienne Carjat. Nadelman was an avid reader of Baudelaire, and must have been impressed by the poet's plea for modernism.

MASAYUKI NAGARE (b. 1923)

Born Nagasaki, Japan, 1923. Studied, Kyoto: at Zen temple, 1935–40; Ritsumeikan University, 1941–42. First one-man show, Tokyo, 1955. Commissions, gardens and fountains, Japan: Palace Hotel, Tokyo, 1961; Festival Hall, Ueno, 1962; Prefecture, Oita, 1962. One-man shows, Staempfli Gallery, New York, from 1963. Received Japanese Architectural Award, 1964. Commissions: sculptured walls, Japanese Pavilion, New York World's Fair, Flushing Meadows, 1964; Northwestern National Life Insurance Building, Minneapolis, 1965; Bank of America Headquarters Building, San Francisco, 1967; government buildings, Kagawa Prefecture, Takamatsu City, Island of Shikoku, Japan, 1967; Juilliard School of Music, Lincoln Center for the Performing Arts, New York, 1970; World Trade Center, New York, 1970. One-man shows: San Francisco Museum of Art, and tour, 1967–68; Japan House, New York, 1972. Lives near Aji, Island of Shikoku.

Wind Form. 1965.
Polished Italian travertine marble, 31½ × 10½ × 9 inches

PROVENANCE:
Staempfli Gallery, New York, 1965

EXHIBITIONS:
Staempfli Gallery, New York, November 9–December 4, 1965, *Recent Sculpture of Masayuki Nagare,* ill. p. 6
The Aldrich Museum of Contemporary Art, Ridgefield, Connecticut, July 10–September 11, 1966, *Highlights from the 1965–1966 Art Season,* no. 59

REUBEN NAKIAN (b. 1897)

Born College Point, New York, August 10, 1897. Studied, New York: The Art Students League of New York, 1912; Independent Art School, and Beaux-Arts Institute of Design, 1915. Worked with Paul Manship, and Gaston Lachaise, 1916–23. Received: Louis Comfort Tiffany Foundation Fellowship, summer, 1919; Gertrude Vanderbilt Whitney Grant, 1920–28; Guggenheim Foundation Fellowship, 1931. Exhibited, New York: Salons of America, 1920–23; with John Dos Passos, and Adelaide Lawson, Whitney Studio Club, 1923. One-man shows: Whitney Studio Club, 1926; The Downtown Gallery, New York, 1930–35. Included in "46 Painters and Sculptors under 35 Years of Age," The Museum of Modern Art, New York, 1930. One-man show, portrait busts of President Franklin D. Roosevelt and his Cabinet, The Corcoran Gallery of Art, Washington, D.C., 1935. WPA Federal Art Project, Sculpture Division, New York, 1936–39. Included in "Trois Siècles d'Art aux États-Unis," Musée du Jeu de Paume, Paris, 1938. Taught: Newark School of Fine and Industrial Art, New Jersey, 1946–51; Pratt Institute, Brooklyn, New York, 1952–54. One-man shows: Egan Gallery, New York, 1949–55; 1959–70; Stewart-Marean Gallery, New York, 1958; VI São Paulo Bienal, 1961; Los Angeles County Museum of Art, 1962; Washington [D.C.] Gallery of Modern Art, 1963; Venice Biennale, 1968; University of Bridgeport, Connecticut, 1972. Received: Ford Foundation and Longview Foundation grants, 1958; Award of Merit for Sculpture, The American Academy of Arts and Letters, and The National Institute of Arts and Letters, 1973. Retrospective, The Museum of Modern Art, New York, and tour, 1966–67. Member, The National Institute of Arts and Letters, 1974. Lives in Stamford, Connecticut.

Head of Marcel Duchamp. 1943, cast 1961.
Bronze, 22 × 6 × 10½ inches
Markings: r. side "NAKIAN
 1/7
 Roman Bronze Works Inc NY"

PROVENANCE:
Egan Gallery, New York, 1962

EXHIBITIONS:
Great Jones Gallery, New York, September 12–October 12, 1961, *Heads in Sculpture*
VI Bienal de Arte Moderna, São Paulo, September 10–December 31, 1961, *United States Representation,* no. 35
Los Angeles County Museum of Art, May 16–June 26, 1962, *Reuben Nakian, Sculpture and Drawings,* no. 1
Washington [D.C.] Gallery of Modern Art, January 8–February 18, 1963, *Nakian,* no. 1
New School for Social Research, New York, February 2–27, 1965, *Portraits from the American Art World,* no. 61, ill.
The Museum of Modern Art, New York, June 20–September 5, 1966, *Nakian,* no. 1, ill. pp. 12, 45
Museum of Art, University of Iowa, Iowa City, January 4–25, 1967, *Reuben Nakian: Small Bronzes, Terra-Cottas, and Drawings* (The Museum of Modern Art, New York, Circulating Exhibition); toured to ten U.S. cities

REFERENCES:
Arnason, H. Harvard. "Nakian," *Art International,* 7, April 25, 1963, ill. p. 37
D'Harnoncourt, Anne, and McShine, Kynaston. *Marcel Duchamp,* New York, The Museum of Modern Art, 1973, ill. p. 211
Edgar, Natalie. "Heads," *Art News,* 60, September 1961, p. 14, ill. p. 15
Hess, Thomas B. "Private Faces in Public Places," *Art News,* 63, February 1965, ill. p. 36
Jaffee, Cynthia J. *Nakian,* Master's thesis, New York, Columbia University, 1967, ills. 51, 67
Nordland, Gerald. "Art: An Important Los Angeles Showing," *Frontier,* 13, June 1962, p. 21, ill.
Schjeldahl, Peter. "A New Domain," *The Village Voice,* New York, June 30, 1966, p. 11
Schwartz, Fred. *Structure and Potential in Art Education,* Waltham, Massachusetts, Ginn-Blaisdell, 1970, ill. p. 3
Unsigned. "Two Great American Artists," *Vogue,* 138, October 15, 1961, ill. p. 91

The younger brother of Raymond Duchamp-Villon and Jacques Villon, Marcel Duchamp (1887–1968) was a leading Dadaist and the inventor of the "Ready-made." His painting *Nude Descending a Staircase* was the *cause célèbre* of the 1913 Armory Show.

Nakian's portrait was made during World War II, when Duchamp was again living in New York.

Europa and the Bull. 1949–50.
Terra-cotta (unique), 26½ × 24½ × 21 inches
Markings: back c. "Nakian"

PROVENANCE:
Egan Gallery, New York; Noah Goldowsky Gallery, New York, 1963

EXHIBITIONS:
Egan Gallery, New York, May 1952, *Nakian*
Stewart-Marean Gallery, New York, November–December 1958, *Nakian*
The Museum of Modern Art, New York, June 20–September 5, 1966, *Nakian*, no. 10, ill. p. 13

REFERENCES:
Porter, Fairfield. "Reviews and Previews: Nakian," *Art News*, 51, May 1952, ill. p. 43

Europa. 1959–60.
Terra-cotta (unique), $10\frac{1}{2} \times 13\frac{1}{4} \times 3\frac{1}{4}$ inches
Markings: back "Nakian"

PROVENANCE:
Egan Gallery, New York; Felix Landau Gallery, Los Angeles, 1962

EXHIBITIONS:
Los Angeles County Museum of Art, May 16–June 26, 1962, *Reuben Nakian, Sculpture and Drawings*, no. 24
The Solomon R. Guggenheim Museum, New York, October 3, 1962–January 6, 1963, *Modern Sculpture from the Joseph H. Hirshhorn Collection*, no. 347, ill. p. 174

Olympia. 1960–62.
Bronze, $71\frac{1}{4} \times 67 \times 25$ inches
Markings: back c. "Nakian 1960–62 2/4"

PROVENANCE:
Egan Gallery, New York, 1962

REFERENCES:
Arnason, H. Harvard. "Nakian," *Art International*, 7, April 25, 1963, ill. p. 43

FRANK A. NANKIVELL (1869–1959)

Frank Arthur Nankivell, born Maldon, Australia, November 16, 1869. Studied architecture and engineering, Wesley College, Melbourne. Engineer, Australian railroads, until 1891. Lived in Japan, 1891–95; illustrated English-language newspaper *Yokohama*. Published and illustrated *Chic*, San Francisco, 1895–96. Moved to New York, 1896; cartoonist and caricaturist, *Puck*, and other periodicals. Worked as printmaker for Arthur B. Davies; also portraitist, journalist, etcher. Included in: Exhibition of Independent Artists, New York, 1910; Pennsylvania Academy Annual, 1912; the Armory Show, 1913. One-man shows, New York: Ferargil Galleries, 1929 (etchings), 1930; Leonard Clayton Gallery (prints and drawings), July 4, 1959. Died Morristown, New Jersey, July 4, 1959.

Children on Rocks by Sea. n.d.
Oil on canvas, $17\frac{1}{2} \times 25\frac{1}{2}$ inches

PROVENANCE:
Mitchell Work, New Jersey; Ira Spanierman, New York, 1967

ERNST WILHELM NAY (1902–1968)

Born Berlin, June 11, 1902. Studied, Kunstakademie, Berlin, with Karl Hofer, 1925–28. One-man shows, Berlin: Galerie Nierendorf, 1925–28; Galerie Alfred Flechtheim, 1932. Received Prix de Rome, 1932. Included in Nazi "Entartete Kunst (Degenerate Art)" exhibition, Munich, and tour, 1937. Invited to Oslo, by Edvard Munch; traveled in Norway, 1937–38. Served as cartographer, German Army, 1939–45. One-man shows: Galerie Günther Franke, Munich, 1946–67; Kestner-Gesellschaft, Hanover, 1950; Kunstverein, Frankfort, 1952; Kunstverein für die Rheinlande und Westfalen, Düsseldorf, 1953, 1959; Kleemann Galleries, New York, 1955, 1958, 1959; Galerie der Spiegel, Cologne, 1957–67. Settled in Cologne, 1951. Awarded Lichtwark Prize, Hamburg, 1955. Included in: Documenta I and II, Kassel, 1955, 1959; "German Art of the Twentieth Century," The Museum of Modern Art, New York, and City Art Museum of St. Louis, Missouri, 1957; Guggenheim International Award, 1960. One-man shows: M. Knoedler & Co., New York, 1961–68; Akademie der Künste, Berlin, 1967; Museum des 20.Jahrhunderts, Vienna, 1967. Died Cologne, April 8, 1968. Retrospective, Nationalgalerie, Berlin, 1969.

Untitled. 1954.
Oil on canvas, $22\frac{1}{2} \times 31$ inches
Signed and dated l. r.: "Nay 54"

PROVENANCE:
Kleemann Galleries, New York, 1954

LOUISE NEVELSON (b. 1899)

Louise Beliawsky, born Kiev, Russia, September 23, 1899. Moved with family to Rockland, Maine, 1905. Studied: painting and drawing, with Theresa Bernstein, and William Meyerowitz, New York, 1920; The Art Students League of New York, with Kenneth Hayes Miller, and Kimon Nicolaides, 1929–30; with Hans Hofmann, Munich, briefly, 1931. Assisted Diego Rivera, mural, New Workers' School, New York, 1932. Included in: "Young Sculptors," The Brooklyn Museum, New York, 1935; Pennsylvania Academy Annual, 1944; Whitney Annual, from 1946. One-man shows: Nierendorf Gallery, New York, 1941–46. Traveled: to Europe, 1948; to Mexico, 1949–50. One-man shows: Lotte Jacobi Gallery, New York, 1950, 1954; Grand Central Moderns, New York, 1955–58; Martha Jackson Gallery, New York, 1959–69; Galerie Daniel Cordier, Paris, 1960, 1961; Staatliche Kunsthalle, Baden-Baden, Germany, 1961; Sidney Janis Gallery, New York, 1963; The Hanover Gallery, London, 1963; Gimpel & Hanover Galerie, Zurich, 1964; The Pace Gallery, New York, and Boston, from 1964. Studied printmaking, S. W. Hayter's Atelier 17, New York, with Peter Grippi, and Leo Katz, 1953–55. President, Artists Equity Association: New York chapter, 1962; national chapter, 1963. Included in: Venice Biennale, 1962; Documenta III and 4, Kassel, 1964, 1968. Retrospectives: Whitney Museum of American Art, New York, 1966, 1970–71; Rose Art

Museum, Brandeis University, Waltham, Massachusetts, 1967; The Arts Club of Chicago, 1968; Rijksmuseum Kröller-Müller, Otterlo, The Netherlands, 1969; Museo Civico di Torino, 1969; The Museum of Fine Arts, Houston, and University of Texas at Austin, 1969–70. Member, The National Institute of Arts and Letters, 1968. Lives in New York.

Standing Figure. 1955–57.
Wood construction painted black, $68\frac{1}{4} \times 8\frac{1}{4} \times 4\frac{1}{8}$ inches on base $1\frac{1}{8} \times 14\frac{1}{4} \times 12$ inches

PROVENANCE:
The artist, New York; Private collection, Pennsylvania; Robert Schoelkopf Gallery, New York, 1962

EXHIBITIONS:
Whitney Museum of American Art, New York, March 8–April 30, 1967, *Louise Nevelson*, no. 33, ill. p. 22
Rose Art Museum, Brandeis University, Waltham, Massachusetts, May 22–July 2, 1967, *Louise Nevelson*

Black Wall. 1964.
Wood construction painted black, $64\frac{3}{4} \times 39\frac{1}{4} \times 10\frac{1}{4}$ inches
Markings: each of twelve boxes signed and dated "Nevelson 1964"

PROVENANCE:
The artist, New York; Jacques Kaplan, New York; Harold Diamond, New York, 1964

EXHIBITIONS:
Whitney Museum of American Art, New York, March 8–April 30, 1967, *Louise Nevelson*, no. 71, ill. p. 41

Silent Music IX. 1964.
Wood construction, with mirrors, Formica, and Plexiglas, $33\frac{1}{2} \times 30 \times 14$ inches

PROVENANCE:
The Pace Gallery, New York, 1964

EXHIBITIONS:
Whitney Museum of American Art, New York, March 8–April 30, 1967, *Louise Nevelson*, no. 81
Rose Art Museum, Brandeis University, Waltham, Massachusetts, May 22–July 2, 1967, *Louise Nevelson*

BARNETT NEWMAN (1905–1970)

Born New York, January 29, 1905. Studied, City College of New York, B.A., 1927; The Art Students League of New York, with Duncan Smith, William Von Schlegell, John Sloan, 1922–24, 1929–30. Substitute art teacher, New York high schools, 1931–39. Organized Writers-Artists ticket, New York, 1933; mayoralty candidate against Fiorello La Guardia. Stopped painting for five years, c. 1939–44. Studied ornithology, Cornell University, Ithaca, New York, summer, 1941. Exhibited, Betty Parsons Gallery, New York, 1946–49. Contributed to periodical *Tiger's Eye*, 1947–49. Co-founded Subjects of the Artist: A New Art School, New York, with William Baziotes, Robert Motherwell, Mark Rothko, David Hare, 1948. One-man shows: Betty Parsons Gallery, 1950, 1951 (including first sculpture); French & Company, New York, 1959. Retrospective: Bennington College, Vermont, 1958. Directed Artists' Workshop, Emma Lake, Saskatchewan, Canada, summer, 1959; taught, University of Pennsylvania, Philadelphia, 1962–63. Exhibited with Willem de Kooning, Allan Stone Gallery, New York, 1962. Included in VIII São Paulo Bienal, 1965. One-man shows: Nicholas Wilder Gallery, Los Angeles, 1965; The Solomon R. Guggenheim Museum, New York, 1966; M. Knoedler & Co., New York, 1969. Died New York, July 3, 1970. Retrospectives: Pasadena Art Museum, California, 1970; Kammerkunsthalle, Bern (lithographs), 1970; The Museum of Modern Art, New York, and European tour, 1971–72. Rothko Chapel, and Newman's sculpture *Broken Obelisk*, dedicated as memorial to the Reverend Martin Luther King, Jr., Institute of Religion and Human Development, Houston, 1971.

Covenant. 1949.
Oil on canvas, 48×60 inches

PROVENANCE:
French & Company, New York; Galerie Lawrence, Paris; Mr. and Mrs. Joseph Slifka, New York; Harold Diamond, New York, 1968

EXHIBITIONS:
Betty Parsons Gallery, New York, January 23–February 11, 1950, *Barnett Newman*
Bennington College, Vermont, May 4–24, 1958, *Barnett Newman: First Retrospective Exhibition*, no. 10
French & Company, New York, March 11–April 5, 1959, *Barnett Newman: A Selection 1946–1952*, cat.
Institute of Contemporary Art, University of Pennsylvania, Philadelphia, January 14–March 1, 1965, *1943–1953: The Decisive Years*, cat.
The Metropolitan Museum of Art, New York, October 18, 1969–February 8, 1970, *New York Painting and Sculpture: 1940–1970*, no. 266, p. 31, ill. p. 239
The Museum of Modern Art, New York, October 21, 1971–January 10, 1972, *Barnett Newman*, no. 13, pp. 63–64, note p. 109, ill.; toured to Stedelijk Museum, Amsterdam, March 31–May 22, no. 12, ill. p. 52; The Tate Gallery, London, June 21–July 30, no. 12; Grand Palais, Paris, October 4–November 27, no. 12, ill. p. 53

REFERENCES:
Alloway, Lawrence. "Notes on Barnett Newman," *Art International*, 13, Summer 1969, p. 35
Hess, Thomas B. *Barnett Newman*, New York, Walker, 1969, p. 54
Lanes, Jerrold. "Reflections on Post-Cubist Painting," *Arts*, 33, May 1959, p. 26
Rose, Barbara, ed. *Readings in American Art Since 1900: A Documentary Survey*, New York, Praeger, 1968, ill. 52
Sandler, Irving. *The Triumph of American Painting*, New York, Praeger, 1970, p. 190, ill. p. 189

"Newman is not interested in straight lines, right angles, or empty spaces as such, or in bareness or purity. He pursues his vision. The vertical stripes enter as a result,

not as part of a layout. The color comes first and does the controlling. The stained surface spreads, ascends and descends, and in certain places it pauses. The line that marks the pause does not demarcate or limit; it simply inflects a continuity, and all it needs in order to do this is to proceed as directly as possible from one point to another."

Clement Greenberg. "Barnett Newman," *Barnett Newman: First Retrospective Exhibition*, cat.

BEN NICHOLSON (b. 1894)

Benjamin Nicholson, born Denham, Bucks, England, April 10, 1894. Studied, Slade School of Fine Art, London, 1910–11. Lived in London, and Cumberland, England, 1920–31; wintered in Switzerland, 1920–24. One-man show, Adelphi Gallery, London, 1922; exhibited with wife, Winifred Nicholson, Paterson Gallery, London, 1923. Member, 7 & 5 Society, 1925–36. One-man shows, The Lefevre Gallery, London, 1930–54. Exhibited with second wife, Barbara Hepworth, Arthur Tooth & Sons, London, 1932; The Lefevre Gallery, 1933. Joined Association Abstraction-Création, Paris, 1932–33. Edited *Circle: International Survey of Constructive Art*, with Naum Gabo, and James Lee Martin (London, Faber & Faber), 1937. Associated with Piet Mondrian, England, 1938–40. Retrospective, Temple Newsam House, Leeds, England, 1944. One-man shows: Durlacher Brothers, New York, 1949, 1951, 1952; The Phillips Memorial Gallery, Washington, D.C., 1951. Awarded: First Prize for Painting, Pittsburgh International, 1952; First Guggenheim International Painting Prize, 1956; International Prize for Painting, IV São Paulo Bienal, 1957. Retrospectives: Venice Biennale (Ulissi Prize), 1954; The Tate Gallery, London, 1955; Stedelijk Museum, Amsterdam, and tour, 1955; Laing Art Gallery and Museum, Newcastle-on-Tyne, England, 1959. One-man shows: Marlborough Fine Art, London, 1963, 1967; André Emmerich Gallery, and Marlborough-Gerson Gallery, New York, 1965; Gimpel & Hanover Galerie, Zurich, 1966; Galerie Beyeler, Basel, 1968. Order of Merit conferred by Queen Elizabeth II, 1968. Retrospectives: Dallas Museum of Fine Arts, 1964; The Tate Gallery, 1969. Has lived in Ticino, Switzerland, since 1958.

Painting. 1937.
Oil on canvas, $16\frac{1}{4} \times 22$ inches
Signed and dated on back: "Ben Nicholson/1937"

PROVENANCE:
E. C. Barnes; Sotheby & Co., London, Sale, June 20, 1962, no. 226, ill.; André Emmerich Gallery, New York; Mr. and Mrs. James H. Clark, Dallas; Sotheby & Co., Sale, April 12, 1967, no. 201, ill.

EXHIBITIONS:
Palais de Chaillot, Paris, November 11–December 18, 1938, *Société du Salon d'Automne*, no. 1913
Dallas Museum of Fine Arts, April 15–May 17, 1964, *Ben Nicholson*, no. 13, ill.

REFERENCES:
Unsigned. *Artist in Witness Box*, December 1939, London, British Broadcasting Company, colorplate

White Relief (version I). 1938.
Painted wood relief, $47\frac{1}{4} \times 72 \times 3$ inches
Signed and dated on back: "Ben Nicholson 1938"

PROVENANCE:
Gimpel Fils, London; Mr. and Mrs. Arnold Maremont, Winnetka, Illinois; Harold Diamond, New York, 1969

EXHIBITIONS:
Documenta I, Kassel, July 15–September 18, 1955, *Twentieth Century Art*, no. 490
Palais des Beaux-Arts, Brussels, April 17–October 19, 1958, *50 Ans d'Art Moderne* (Exposition Universelle et Internationale de Bruxelles), no. 244, ill: 153
Crown Hall, Illinois Institute of Technology, Chicago, April 5–30, 1961, *The Maremont Collection at the Institute of Design*, no. 89
Washington [D.C.] Gallery of Modern Art, April 1–May 3, 1962, *Treasures of 20th Century Art from The Maremont Collection*, no. 217

REFERENCES:
Hunter, Sam. "The Maremont Collection," *Art International*, 5, July–August 1961, p. 38
Langui, Emile. *50 Years of Modern Art*, New York, Praeger, 1959, no. 238, ill. p. 211
Nicholson, Ben. *Album of Photographs of Paintings and Reliefs*, 2 vols., The Museum of Modern Art, New York, 1940(?)
Read, Herbert. *Ben Nicholson*, vol. I, London, Lund Humphries, 1948, no. 130, ill.
Reid, Norman. *Ben Nicholson*, London, The Tate Gallery, 1969, p. 69

Still Life June 4, 1949 (Diagonal). 1949.
Oil on board, $23\frac{3}{4} \times 18\frac{1}{4}$ inches
Signed and dated on back: "Ben Nicholson June 4, '49"

PROVENANCE:
G. David Thompson, Pittsburgh; Gimpel Fils, London, 1955

REFERENCES:
Read, Herbert. *Ben Nicholson*, vol. II, London, Lund Humphries, 1956, no. 59, ill.
Russell, John. *Ben Nicholson*, New York, Abrams, 1969, p. 308, plate 53

COSTANTINO NIVOLA (b. 1911)

Born Orani, Sardinia, July 5, 1911. One-man show (paintings), Galleria Perella, Sassari, Sardinia, 1927. Studied, Istituto Superiore d'Arte, Monza, Italy, 1930–36. Art director, Olivetti Corporation, Milan, 1936–38. Emigrated to the U.S., 1939. Art director, *Interiors* magazine, 1941–45. Exhibited with Saul Steinberg, Wakefield Gallery, New York, 1943. One-man shows, New York: Tibor de Nagy Gallery, 1950; Peridot Gallery, 1954, 1957. Taught, Graduate School of Design, Harvard University, Cambridge, Massachusetts, 1954–57. Commissions: mural, Olivetti showroom, New York,

1954; Four Chaplains Memorial Fountain, Falls Church, Virginia, 1955; facade relief, Mutual Insurance Company of Hartford, Connecticut, 1957. One-man shows: Galleria del Milione, Milan, 1959; The Arts Club of Chicago, 1959; American Federation of Arts, Circulating Exhibition, 1960; Galleria dell'Ariete, Milan, 1962. Taught, Columbia University, New York, 1961–63. Commissions: Carborundum Award, 1962; Morse and Stiles Colleges, Yale University, New Haven, Connecticut, 1962; 1968 Olympics, Mexico City. One-man shows: Andrew-Morris Gallery, New York, 1963; Byron Gallery, New York, 1965–67; Marlborough Galleria d'Arte, Rome, 1972; Willard Gallery, New York, 1973. Member, The National Institute of Arts and Letters, 1972. Lives in Springs, New York.

Seascape Plaque. 1963.
White terra-cotta relief, $12\frac{1}{2} \times 9\frac{3}{4} \times 3\frac{1}{8}$ inches
Signed and dated l. r.: "Nivola 63"

PROVENANCE:
Byron Gallery, New York, 1965

EXHIBITIONS:
Byron Gallery, New York, January 5–30, 1965, *Nivola*, cat.

"The work is one of a series of terra-cotta plaques of beach scenes and beds I had been doing, inspired by the beaches of East Hampton and by that significant part of our lives in bed. I like to call these works 'finger prints in clay,' also my vacation from the determined monumental sculptures I do for architectural purposes. They are also meant to fulfill a more intimate and sympathetic feeling for nature and its pathetic human inhabitants.

"When I started doodling with clay ten years ago I naturally approached the new medium charged with pretentious ideas. I discovered that this material, like any other used in sculpture, was perfectly comfortable in its inertial condition. However, the material listened with curiosity to my flattering proposition and eventually agreed to be partially shaped so long as its properties and identity were preserved and respected. On my part, it required a renunciation of a great many of my original intentions. As a result of this dialogue between personal emotion and the limitation of the material, I came to the habit in my work of trying over and over again to reach that only desirable relation between matter and idea."

Statement by the artist, 1972

ISAMU NOGUCHI (b. 1904)
Born Los Angeles, November 17, 1904, son of American mother and Japanese father. Moved with family to Tokyo, 1906. Attended French Jesuit elementary school, St. Joseph's College, Yokohama, Japan, 1912–17. Returned to the U.S., 1918. Apprenticed to Gutzon Borglum, Stamford, Connecticut, 1922. Studied, New York: Columbia University, 1922–24; Leonardo da Vinci Art School, with Onorio Ruotolo, 1924. First one-man show, Leonardo da Vinci Art School, 1924. Received Guggenheim Foundation Fellowship, 1927–29; studied, Académie Colarossi, and Académie de la Grande Chaumière, Paris; worked in Brancusi's atelier. One-man shows: Eugene Schoen Gallery, New York, 1929; Marie Sterner Gallery, New York, 1930; The Arts Club of Chicago, 1930; Albright Art Gallery, Buffalo, New York, 1930; Memorial Art Gallery, The University of Rochester, New York, 1931; Mellon Galleries, Philadelphia, 1933; Honolulu Academy of Arts, 1934, 1939; Marie Harriman Gallery, New York, 1935. Studied brush drawing and ceramics, Peking, Tokyo, Kyoto, 1930–32. Designed set for ballet *Frontier* (first of many collaborations with Martha Graham), 1935. Awarded first prize, national competition to design stainless-steel facade relief, Associated Press Building, Rockefeller Center, New York, 1938. One-man show, Egan Gallery, New York, 1948. Received Bollingen Foundation Fellowship, 1949–50; traveled to Europe, and Asia. Designed gardens: Keiyo University, Japan, 1951–52; UNESCO Building, Paris, 1956–58; Beinecke Rare Book and Manuscript Library, Yale University, New Haven, Connecticut, 1960–64; Billy Rose Sculpture Garden, Israel Museum, Jerusalem, 1960–65; Chase Manhattan Plaza, New York, 1960–65. One-man shows: Museum of Modern Art, Kamakura, Japan, 1952; Stable Gallery, New York, 1954, 1959; Fort Worth Art Center Museum, Texas, 1961; Cordier & Ekstrom, New York, from 1963; Gimpel Fils, London, from 1968. Member: The National Institute of Arts and Letters, 1962; The American Academy of Arts and Letters, 1971. Received Brandeis University Creative Arts Award Medal, 1966. Retrospective, Whitney Museum of American Art, New York, 1968. Lives in Long Island City, New York, in Mure, Japan, and in Lucca, Italy.

Lunar Landscape. c. 1944.
Magnesite cement, cork, fishing line, and electric lights, $33\frac{1}{4} \times 24 \times 7$ inches

PROVENANCE:
Jeanne Reynal, New York; Harold Diamond, New York, 1964

EXHIBITIONS:
Whitney Museum of American Art, New York, March 17–May 6, 1951, *1951 Annual Exhibition of Contemporary American Sculpture, Watercolors and Drawings*, no. 49
Whitney Museum of American Art, New York, April 16–June 16, 1968, *Isamu Noguchi*, no. 11, ill. p. 21

REFERENCES:
Noguchi, Isamu. *A Sculptor's World*, New York, Harper & Row, 1968, colorplate I

"About [*Lunar Landscape*] I may say that I came out of the War Relocation Camp for citizens of Japanese ancestry in 1942. Coming to New York from the wide open spaces of Arizona was quite a contrast. The artificiality, the enclosure of New York. The memory of Arizona was like that of the moon, a moonscape of the mind. The handicaps of a situation often make for invention. Not given the actual space of freedom one makes its equivalent—an illusion within the confines

of a room or a box—where the imagination may roam to the further limits of possibilities, to the moon and beyond (which themselves turn out to be equivalents of other depths and needs of the psyche). Every landscape I make is that sort of a thing. I made a whole series I called 'Lunars' of which *Lunar Landscape* is one. I used electricity and the controlled interior lighting this makes possible. After all, everything is reflected light, indoors or out, excepting for luminosities which came later. What I was interested in was the reflected light of which man was not a part. He does not participate within the illumination but is an observer from outside. It might be said that *Lunar Landscape* and other Lunars stem from my work with the theater where similar means are employed. All the things I do have links to each other."

Statement by the artist, 1972

Endless Coupling (Accouplement sans fin). 1957.
Cast iron in three parts (1/6), $58\frac{1}{2} \times 13 \times 9\frac{3}{4}$ inches

PROVENANCE:
Galerie Claude Bernard, Paris, 1963

"*Endless Coupling* was made in Japan in the country place I had in Kamakura. It followed a period in which I made things in clay (ceramic sculptures). I might say it was an effort to go beyond the limitations of size imposed by ceramics, and the taking advantage of multiple reproduction which casting in iron permitted. It could go on to any length. The coupling itself, implying pulling as well as pushing, came I think from railroad couplings. No doubt Brancusi's *Endless Column* was also in mind."

Statement by the artist, 1972

KENNETH NOLAND (b. 1924)
Born Asheville, North Carolina, April 10, 1924. Studied: Black Mountain College, North Carolina, with Josef Albers, and Ilya Bolotowsky, 1946; Académie de la Grande Chaumière, Paris, with Ossip Zadkine, 1948–49. One-man show, Galerie Raymond Creuze, Paris, 1949. Moved to Washington, D.C.: taught, The Catholic University of America, and the Institute of Contemporary Arts, 1950–52. Included in "Emerging Talent," Kootz Gallery, New York, 1954. One-man shows: Tibor de Nagy Gallery, New York, 1957–58; Jefferson Place Gallery, Washington, D.C., 1958, 1960; French & Company, New York, 1959; André Emmerich Gallery, New York, from 1960; Galerie Lawrence, Paris, 1961, 1963. Moved to New York, 1961. Included in: "American Abstract Expressionists and Imagists," The Solomon R. Guggenheim Museum, New York, 1961; "Geometric Abstraction in America," Whitney Museum of American Art, New York, 1962; "Art Since 1950," Seattle World's Fair, 1962; "Toward a New Abstraction," The Jewish Museum, New York, 1963; Venice Biennale, 1964; "Three American Painters," Fogg Art Museum, Harvard University, Cambridge, Massachusetts, 1965; Documenta 4, Kassel, 1968; "The Art of the Real," The Museum of Modern Art, New York, International Circulating Exhibition, 1968–69; "New York Painting and Sculpture: 1940–1970," The Metropolitan Museum of Art, New York, 1969–70. Retrospective, The Jewish Museum, 1965. One-man shows: Kasmin Gallery, London, 1965, 1968, 1970; Lawrence Rubin Gallery, New York, 1969. Taught, Bennington College, autumn, 1967. Lives in New York.

Beginning. 1958.
Acrylic on canvas, 90×96 inches

PROVENANCE:
French & Company, New York, 1959

EXHIBITIONS:
French & Company, New York, October 14–November 7, 1959, *Kenneth Noland*, no. 17
Whitney Museum of American Art, New York, March 20–May 13, 1962, *Geometric Abstraction in America*, no. 67
The Jewish Museum, New York, February 4–March 7, 1965, *Kenneth Noland*, no. 2

REFERENCES:
Aarons, Leroy. "Sound the Hirshhorn! The Collection," *The Washington [D.C.] Post-Potomac*, March 19, 1967, colorplate p. 19
Harrison, Jane. "On Color in Kenneth Noland's Painting," *Art International*, 9, June 1965, pp. 36, 37
Jacobs, Jay. "Collector: Joseph H. Hirshhorn," *Art in America*, 57, July–August 1969, colorplate p. 65
———. "Quality as Well as Quantity: Joseph H. Hirshhorn," in Lipman, Jean, ed. *The Collector in America*, New York, Viking, 1971, p. 77, ill.
Judd, Don. "New York Letter," *Art International*, 9, April 1965, p. 74

Bend Sinister. 1964.
Acrylic on canvas, 7 feet $8\frac{3}{4}$ inches \times 13 feet $5\frac{3}{4}$ inches

PROVENANCE:
Galerie Lawrence, Paris, 1964

EXHIBITIONS:
XXXII Biennale Internazionale d'Arte, Venice, June 20–October 18, 1964, *United States Pavilion*, no. 25, p. 277
The Jewish Museum, New York, February 4–March 7, 1965, *Kenneth Noland*, no. 32, ill.
The Metropolitan Museum of Art, New York, October 18, 1969–February 8, 1970, *New York Painting and Sculpture: 1940–1970*, no. 283, ill. p. 252

REFERENCES:
Baro, Gene. "The Venice Biennale," *Arts Magazine*, 38, September 1964, colorplate p. 35
Di San Lazzaro, Gualtieri. "La XXXIIᵉ Biennale de Venise," *XXᵉ Siècle*, 24, December 1964, ill. p. 115
Goossen, Eugene C. "Kenneth Noland," *The Britannica Encyclopedia of American Art*, New York, Simon and Schuster, 1973, colorplate p. 398
Harrison, Jane. "On Color in Kenneth Noland's Painting," *Art International*, 9, June 1965, p. 38
Hess, Thomas B. "Barnett Newman e la pittura americana," *L'Arte Moderna*, Milan, 13, no. 117, 1967, ill. p. 338

Judd, Donald. "In the Galleries: Kenneth Noland," *Arts Magazine*, 39, March 1965, p. 55
Kramer, Hilton. "30 Years of the New York School," *The New York Times Magazine*, October 12, 1969, colorplate p. 31
Moffet, Kenworth. *Kenneth Noland*, New York, Abrams, forthcoming, colorplate
Rose, Barbara. "Kenneth Noland," *Art International*, 8, Summer 1964, ill. p. 61
Solomon, Alan R. *XXXII International Biennial Exhibition of Art Venice 1964: United-States of America, Four Germinal Painters, Four Younger Artists*, New York, The Jewish Museum, 1964, colorplate

"In *Bend Sinister*, a magnificent asymmetrical chevron painting from 1964, the V-forms sweep several feet across from the central axis and come to a point within a few inches from the lower framing edge, so that the right hand bands are almost double the length of the left. The effect of this double span of color is to increase the momentum of the implied downward sweep of color, a sweep which is abruptly checked and held in balance by the sharper downward thrust of the shorter bands of color. The laterally oriented thrust of the configuration of V-forms across the surface in turn has the effect of firing the entire canvas into an active whole."

Harrison, p. 37

GEORGIA O'KEEFFE (b. 1887)
Born near Sun Prairie, Wisconsin, November 15, 1887. Studied: The Art Institute of Chicago, with John Vanderpoel, 1905–6; The Art Students League of New York, 1907–8; Teachers College, Columbia University, New York, with Arthur Dow, 1914–15, spring, 1916. Commercial artist, Chicago, 1908–12. Supervisor of art, Amarillo, Texas, public schools, 1912–13. Taught: University of Virginia, summers, 1913–16; Columbia College, South Carolina, autumn, 1915. Exhibited, New York: Alfred Stieglitz's Photo-Secession Gallery, "291," 1916; Society of Independent Artists Annual, 1917. First one-man show, Photo-Secession Gallery, 1917. Moved to New York, 1918. One-man shows, arranged by Stieglitz, The Anderson Galleries, New York, 1923, 1924. Married Stieglitz, 1924. One-man shows: Stieglitz's Intimate Gallery, New York, 1926–29; An American Place, New York, 1930–46, 1950. Retrospective, The Brooklyn Museum, New York, 1927. Traveled: to Canada, 1932; to Bermuda, 1934; to Hawaii, 1939. Retrospectives: The Art Institute of Chicago, 1943; The Museum of Modern Art, New York, 1946. Settled in Abiquiu, New Mexico, 1949. Member, The National Institute of Arts and Letters, 1949. One-man shows, The Downtown Gallery, New York, 1952–61. Retrospective, Worcester Art Museum, Massachusetts, 1960. Received Brandeis University Creative Arts Award Medal, 1963. Member: The American Academy of Arts and Letters, 1963; The American Academy of Arts and Sciences, 1966. Retrospectives: Amon Carter Museum of Western Art, Fort Worth, Texas, and tour, 1966; Whitney Museum of American Art, New York, and tour, 1970–71. Awarded: Gold Medal for Painting, The National Institute of Arts and Letters, 1970; Edward MacDowell Medal, 1972. Lives in Abiquiu.

Soft Gray, Alcalde Hill (Near Alcalde, New Mexico). 1929–30.
Oil on canvas, 10×24 inches
Signed on back: "Georgia O'Keeffe"

PROVENANCE:
Alfred Stieglitz, An American Place, New York; The Downtown Gallery, New York; Dr. and Mrs. Michael Watter, Philadelphia; Parke-Bernet Galleries, New York, Sale 2600, October 19, 1967, *American Paintings, Drawings, Sculpture, Folk Art: The Collection of Dr. and Mrs. Michael Watter*, no. 23, ill. p. 22

EXHIBITIONS:
An American Place, New York, February 7–March 17, 1930, *New Paintings by Georgia O'Keeffe*
Philadelphia Museum of Art, May 20–September 15, 1950, *Masterpieces from Philadelphia Private Collections—Part II*, no. 64
Philadelphia Museum of Art, June 13–October 5, 1958, *Sonia and Michael Watter Collection*, cat.
The Pennsylvania Academy of the Fine Arts, Philadelphia, October 25–November 30, 1958, *Twentieth Century American Painting and Sculpture from Philadelphia Private Collections*, no. 283
The Corcoran Gallery of Art, Washington, D.C., October 1–November 14, 1971, *Wilderness* (sponsored by the National Endowment for the Arts), no. 144

REFERENCES:
Archives of American Art, Smithsonian Institution, Washington, D.C., *The Downtown Gallery Archives*
Unsigned. "Exhibitions in the New York Galleries," *Art News*, 28, February 22, 1930, p. 10
———. "59 U.S. Art Works Sold for $253,875," *The New York Times*, October 21, 1967, p. 14
———. "Masterpieces from Philadelphia Private Collections—Part II," *Philadelphia Museum Bulletin*, 45, Spring 1950, p. 97

Goat's Horn with Red. 1945.
Pastel on paper, $31\frac{3}{4} \times 27\frac{3}{4}$ inches

PROVENANCE:
Alfred Stieglitz, An American Place, New York; The Downtown Gallery, New York; Dr. and Mrs. Michael Watter, Philadelphia; Parke-Bernet Galleries, New York, Sale 2600, October 19, 1967, *American Paintings, Drawings, Sculpture, Folk Art: The Collection of Dr. and Mrs. Michael Watter*, no. 42, ill. p. 43

EXHIBITIONS:
An American Place, New York, February 4–March 27, 1946, *Georgia O'Keeffe*, no. 12
The Downtown Gallery, New York, February 19–March 9, 1952, *Georgia O'Keeffe, Paintings in Pastel, 1914–1945*, no. 23
Dallas Museum of Fine Arts, February 1–22, 1953, *Georgia O'Keeffe Retrospective*; toured to The Mayo Hill Galleries, Delray Beach, Florida, March 16–April 11

Philadelphia Museum of Art, June 13–October 5, 1958, *Sonia and Michael Watter Collection*, cat.
The Pennsylvania Academy of the Fine Arts, Philadelphia, October 25–November 30, 1958, *Twentieth Century American Painting and Sculpture from Philadelphia Private Collections*, no. 281
Philadelphia Museum of Art, October 3–November 17, 1963, *Philadelphia Collects Twentieth Century*, p. 28, ill.

REFERENCES:
Archives of American Art, Smithsonian Institution, Washington, D.C., *The Downtown Gallery Archives*
McBride, Henry. "Georgia O'Keeffe in pastel," *Art News*, 51, March 1952, p. 49
Unsigned. "59 U.S. Art Works Sold for $253,875," *The New York Times*, October 21, 1967, p. 14

JULES OLITSKI (b. 1922)

Born Gomel, Russia, March 27, 1922. Emigrated with family to the U.S., 1924. Studied: National Academy of Design, New York, 1939–42; Beaux-Arts Institute of Design, New York, 1940–42; Académie de la Grande Chaumière, Paris, with Ossip Zadkine, 1949–50; New York University, B.A., 1952, M.A., 1954. One-man shows: Galerie Huit, Paris, 1950; Alexandre Iolas Gallery, New York, 1958; French & Company, New York, 1959, 1960. Taught, C. W. Post College, Greenvale, New York, 1956–63. Included in: Pittsburgh International, 1961 (third prize), 1967; Whitney Annual, 1963, 1967, 1969, 1972; "Three American Painters," Fogg Art Museum, Harvard University, Cambridge, Massachusetts, and Pasadena Art Museum, California, 1965; Venice Biennale, 1966; Corcoran Biennial, 1967 (Corcoran Gold Medal, and First Clark Prize); Documenta 4, Kassel, 1968. One-man shows: Poindexter Gallery, New York, 1961–65; Galerie Lawrence, Paris, 1964; Kasmin Gallery, London, 1964–66; The David Mirvish Gallery, Toronto, from 1964; André Emmerich Gallery, New York, 1966–68; The Corcoran Gallery of Art, Washington, D.C., and tour, 1967; The Metropolitan Museum of Art, New York (sculpture), 1969; Lawrence Rubin Gallery, New York, 1972; Museum of Fine Arts, Boston, 1973; Knoedler Contemporary Art, New York (sculpture), 1973. Has taught, Bennington College, Vermont, since 1963. Lives in New York, and in Meredith, New Hampshire.

Bad Bugaloo. 1968.
Acrylic on canvas, 3 feet 7¼ inches × 9 feet 9¼ inches
Signed and dated on stretcher: "Jules Olitski 1968"

PROVENANCE:
Lawrence Rubin Gallery, New York, 1968

NATHAN OLIVEIRA (b. 1928)

Born Oakland, California, December 19, 1928. Studied, Oakland: Mills College, with Max Beckmann, summer, 1950; California College of Arts and Crafts, M.F.A., 1952. Served as cartographer, U.S. Army, 1953–55. Taught: California College of Arts and Crafts, 1955; California School of Fine Arts, San Francisco, 1956; University of Illinois, Urbana, 1961–62; University of California at Los Angeles, 1963–64. Received: Louis Comfort Tiffany Foundation Fellowship, 1956; Guggenheim Foundation Fellowship, 1958. One-man shows: Eric Locke Gallery, San Francisco (prints), 1957; The Alan Gallery, New York, 1958, 1960, 1963; Paul Kantor Gallery, Beverly Hills, California, 1959, 1961, 1963; Krannert Art Museum, University of Illinois, 1961–62. Included in: "New Images of Man," The Museum of Modern Art, New York, and The Baltimore Museum of Art, 1959–60; Pittsburgh International, 1964. One-man shows: The Art Galleries, University of California at Los Angeles, and tour, 1963–64; Felix Landau Gallery, Los Angeles, 1965; Landau-Alan Gallery, New York, 1967; San Francisco Museum of Art, 1969; Terry Dintenfass Gallery, New York, 1972. Teaches at Stanford University, California. Lives in Stanford.

Man Walking. 1958.
Oil on canvas, 60¼ × 48 inches
Signed and dated l. r.: "Oliveira 58"

PROVENANCE:
The Alan Gallery, New York, 1958

EXHIBITIONS:
The Alan Gallery, New York, October 20–November 8, 1958, *Nathan Oliveira*, no. 12
The Museum of Modern Art, New York, September 29–November 29, 1959, *New Images of Man*, no. 78, p. 114, ill. p. 115; toured to The Baltimore Museum of Art, January 9–February 7, 1960
Sheldon Swope Art Gallery, Terre Haute, Indiana, November 1–22, 1960, *The Figure in Contemporary American Painting* (American Federation of Arts, Circulating Exhibition); toured to eight U.S. cities
The Art Galleries, University of California at Los Angeles, September 15–October 20, 1963; *Nathan Oliveira*, no. 5, colorplate cover; toured to San Francisco Museum of Art, November 8–December 8; Fort Worth Art Center Museum, Texas, January 1964; Colorado Springs Fine Arts Center, Colorado, March

REFERENCES:
Eager, Gerald. "The Missing and the Mutilated Eye in Contemporary Art," *Journal of Aesthetics and Art Criticism*, 20, September 1961, p. 56, ill. p. 57
Langsner, Jules. "Los Angeles Letter," *Art International*, 7, October 25, 1963, p. 80
Tillim, Sidney. "In the Galleries: Nathan Oliveira," *Arts*, 33, December 1958, p. 58
Unsigned. "Art Display Will Open," *World-News*, Roanoke, Virginia, January 12, 1961, ill.
———. "Contemporary Figure Paintings on Exhibit at State Arts Museum," *Sun-News*, Las Cruces, New Mexico, June 18, 1961
———. "Figure Painting Art on View at Museum in State's Capital," *News-Journal*, Clovis, New Mexico, June 15, 1961
———. "New Talent in the U.S.A. 1959," *Art in America*, 47, Spring 1959, p. 53, colorplate

GASTÓN ORELLANA (b. 1933)

Born Valparaíso, Chile, July 18, 1933. Studied archaeology, Peru, Bolivia, Argentina. Met Pablo Neruda, Miguel Ángel Asturias, Rafael Alberti, Buenos Aires. Moved to Spain, 1957; lived in Majorca, and Madrid. Co-founded El Grupo Hondo, with Juan Genovés, and others, 1961; group exhibitions, Madrid: Galería Nebli, 1961; Galería Juana Mordó, 1964. One-man shows: Galería Mayer, Madrid, 1961; Museo de Arte Moderno Barcelona, 1963; Galería Dia Rio de Noticias, Lisbon, 1963; Ateneo de Madrid, 1964; Galerie L'Entracte, Lausanne, 1964; Galería Carmen Waugh, Santiago, Chile, 1966; Sala de Exposiciones de la Dirección General de Bellas Artes, Madrid, 1968. Lived in New York, 1968–70. One-man shows: Bienville Gallery, New Orleans, 1969; Galería Seiquer, Madrid, 1969; Galleria Schubert, Milan, 1971. Included in Venice Biennale, 1970. Lives in Savona, Italy, and in Madrid.

Train in Flames (Il Treno in Fiamme). 1970.
Oil on canvas, three panels, each 98 × 88 inches

PROVENANCE:
The artist, New York, 1970

EXHIBITIONS:
XXXV Biennale Internazionale d'Arte, Venice, June 24–October 25, 1970, *Spanish Pavilion*, no. 87, p. 100

REFERENCES:
De Micheli, Mario. *Gastón Orellana*, Milan, Alberto Schubert, 1971, p. 3

EDUARDO PAOLOZZI (b. 1924)

Born Leith, Scotland, March 7, 1924, of Italian parents. Studied: Edinburgh College of Art, 1943; Slade School of Fine Art, University College, London, 1944–47. One-man shows, The Mayor Gallery, London, 1947–49. Lived in Paris, 1947–49; included in "Les Mains Éblouies," Galerie Maeght, 1950. Taught: textile design, Central School of Arts and Crafts, London, 1949–55; sculpture, St. Martin's School of Art, London, 1955–58. Designed fountain, Festival of Britain, South Bank, London, 1951. Received: First British Critics' Prize, 1952; Copley Foundation Award, 1956. Included in: Venice Biennale, 1952, 1960 (Bright Award); IV and VII São Paulo Bienal, 1957, 1963; Documenta II, III, 4, Kassel, 1959, 1964, 1968; Guggenheim International, 1967; Pittsburgh International, 1967. One-man shows: The Hanover Gallery, London, 1958; Betty Parsons Gallery, New York, 1960, 1962; The Waddington Galleries, London, 1963. Visiting professor, Staatliche Hochschule für Bildende Künste, Hamburg, 1960–62. Published first series of prints, *As Is When*, 1964–65. One-man shows: The Museum of Modern Art, New York, 1964; Robert Fraser Gallery, London, 1964, 1966; The Pace Gallery, New York, 1965–67; Rijksmuseum Kröller-Müller, Otterlo, The Netherlands, 1967. Taught, University of California, Berkeley, 1968. Retrospective, The Tate Gallery, London, 1971. Lives in London, and in Essex, England.

Basla. 1967.
Stainless steel, 8 feet 4 inches × 5 feet 2 inches × 1 foot ½ inch

PROVENANCE:
The Hanover Gallery, London, 1968

JULES PASCIN (1885–1930)

Julius Mordecai Pincas, born Vidin, Bulgaria, March 31, 1885. Studied with Moritz Heymann, Munich, 1903–4. Illustrator and cartoonist, German periodicals *Simplicissimus* and *Jugend*, 1904–9. Moved to Paris, 1905. First one-man show, Galerie Paul Cassirer, Berlin, 1907. Illustrated Heinrich Heine's *Die Memoiren des Herrn von Schnabelewopski* (Berlin, Cassirer), 1910. Included in: Berlin Sezession, 1911; Sonderbund-Ausstellung, Cologne, 1912; the Armory Show, 1913. Emigrated to the U.S., 1914; citizen, 1920. Traveled to Texas, Louisiana, South Carolina, Florida, Cuba, 1914–19. One-man show, Berlin Photographic Company, New York, 1915. Exhibited, New York: with Arthur B. Davies, and Walt Kuhn, Macbeth Gallery, 1916; with Davies, Kuhn, Charles Sheeler, Max Weber, Montross Gallery, 1917. Collector John Quinn his patron, 1917–19. Sketchbook, *Ein Sommer*, published (Berlin, Cassirer), 1920. Returned to Paris, 1920; illustrated works by Pierre MacOrlan, André Warnod, André Salmon, Charles Perrault. Traveled to Algeria, and Tunisia, 1921, 1924; returned to the U.S., 1927–28. One-man shows: Brummer Gallery, New York, 1923; Galerie Pierre, Paris, 1924; Galerie Bernheim-Jeune, Paris, 1929; Galeries Georges Petit, Paris, 1930; M. Knoedler & Co., New York, 1930. Died by suicide, Paris, June 2, 1930. Memorial exhibitions: The Downtown Gallery, New York, 1931; Galerie Lucy Krohg, Paris, 1931. Posthumous one-man shows, New York: Pierre Matisse Gallery, 1932; Rains Galleries, 1935; Passedoit Gallery, 1939. Retrospectives: Bezalel National Art Museum, Israel Museum, Jerusalem, 1958; University Art Museum, University of California, Berkeley, and tour, 1966–67.

The Brunette (La Brune). 1921.
Oil on canvas, 31¾ × 25½ inches

PROVENANCE:
Lucy Krohg, Paris; The Jewish Museum, New York; Parke-Bernet Galleries, New York, Sale 2240, December 11, 1962, no. 83, ill. p. 107

Embarkation for the Islands [Homage to MacOrlan] (L'Embarquement pour les îles [Hommage à MacOrlan]). c. 1924.
Oil, gouache, charcoal, and pastel on paper mounted on canvas, 67¼ × 62 inches
Inscribed l. r.: "à Mac-Orlan Pascin"

PROVENANCE:
Galerie Pierre, Paris; Pierre Matisse Gallery, New York; Galerie Albert Loeb, Paris, 1970

EXHIBITIONS:
Pierre Matisse Gallery, New York, March 26–April 16, 1932, *Jules Pascin: Important Decorations*, no. 9

REFERENCES:
Gutman, Walter. "News and Gossip," *Creative Art*, 10, April 1932, p. 314, ill. p. 315
Shelley, Melvin Geer. "Around the Galleries: Pierre Matisse Gallery," *Creative Art*, 10, May 1932, p. 395
Unsigned. "Exhibitions in New York: Jules Pascin," *Art News*, 30, April 2, 1932, p. 9
———. "Pascin Shown in Role of Pleasing Himself," *Art Digest*, 6, April 1, 1932, p. 10
Warnod, André. *Pascin*, Monte Carlo, André Sauret, 1954, p. 76

The ancient idea of a pilgrimage to an enchanted isle is ironically interpreted in this work, one of the artist's rare large-scale decorations. The subject is a parody of Antoine Watteau's *Embarkation for Cythera (L'Embarquement pour Cythère)* of 1717 (Musée du Louvre, Paris). Cythera is a Greek island, long associated with Aphrodite and love. The painting is dedicated to Pierre MacOrlan (the central male figure), author and member of the Académie Goncourt, who was a close friend of Pascin. Pascin illustrated three of MacOrlan's works, and in 1944 MacOrlan published a tender memoir, *Le Tombeau de Pascin*.

"Salon" at Marseilles. c. 1929.
Watercolor and pen and ink on paper, 17¼ × 22½ inches
Signed l. r.: "Pascin"

PROVENANCE:
Buchholz Gallery, New York; Frank Crowninshield, New York; Parke-Bernet Galleries, New York, Sale 489, October 20, 1943, no. 59; Kleemann Galleries, New York; Clifford Odets, Los Angeles; Paul Kantor Gallery, Beverly Hills, California, 1964; Parke-Bernet Galleries, Sale 2862, May 15, 1969, no. 66, ill. p. 59

EXHIBITIONS:
The Museum of Modern Art, New York, February 16–May 10, 1944, *Modern Drawings*, p. 95, ill. p. 53
Kleemann Galleries, New York, November 6–30, 1944, *Exhibition of Paintings and Drawings by Modigliani and Pascin*, no. 25
Pasadena Art Museum, California, November 24–December 19, 1964, *A View of the Century*, no. 25

PAUL PAULIN (1852–1937)

Born Chamalières, near Clermont-Ferrand, France, July 13, 1852. Dentist by profession. Self-taught as an artist; encouraged by painter/sculptor Albert Bartholomé (1848–1928). Specialized in portrait busts of artists, including Edgar Degas, Auguste Renoir, Claude Monet. Exhibited, the Salon, Paris, 1882–1922. Member, Société Nationale des Beaux-Arts, 1890. Commission, *Monument to Auguste Comte*, Panthéon, Paris. Chevalier, Légion d'honneur. Included in "Les Paysages de Jean-Paul Paulin; Les Sculptures de Paul Paulin," Galerie Hector Brame, Paris, 1926. Died 1937.

Auguste Rodin. 1917.
Bronze, 14¼ × 11 × 13¼ inches
Markings: l. r. side "RODIN
 [Paulin 1917"
back l. c. "Pour M. Rosenthal"
l. l. side "Cire Perdue C. Valsuani"

PROVENANCE:
De Koenigsberg Collection; Parke-Bernet Galleries, New York, Sale 2539, April 5, 1967, no. 16

PHILLIP PAVIA (b. 1913)

Born Stratford, Connecticut, March 15, 1913, son of master stonecutter Louis Pavia. Apprenticed as stone carver, New York, 1930. Studied: Beaux-Arts Institute of Design, New York, 1930; The Art Students League of New York, with William Von Schlegell, and Arthur Lee, 1930–33; Accademia di Belle Arti, Florence, 1934; atelier of Paul Boanet, Paris, 1934–36. Returned to the U.S., 1937. WPA Federal Art Project, Sculpture Division, New York. Founding member, and treasurer, The Club, New York, 1949–55. Founded, edited, and published *IT IS* magazine, New York, 1959–60. First one-man show, Kootz Gallery, New York, 1961. Commission, sculpture group, The New York Hilton, 1962. One-man shows: Washington [D.C.] Gallery of Modern Art, 1966; Martha Jackson Gallery, New York, 1966, 1969; San Francisco Museum of Art, 1967. Included in "International Sculpture Symposium," Cooper-Hewitt Museum of Decorative Arts and Design, Smithsonian Institution, New York, summers, 1971, 1972. Bust of President John F. Kennedy exhibited, The Metropolitan Museum of Art, New York, 1973. Lives in New York.

Horsetail. 1961.
Bronze, 73 × 12 × 13 inches
Markings: front c. "Pavia 1/6"

PROVENANCE:
The artist, New York, 1962

EXHIBITIONS:
The Solomon R. Guggenheim Museum, New York, October 3, 1962–January 6, 1963, *Modern Sculpture from the Joseph H. Hirshhorn Collection*, no. 360, ill. p. 190
Providence Art Club, Rhode Island, March 31–April 24, 1965, *Critics' Choice: Art Since World War II*, no. 57, ill. p. 39

REFERENCES:
Geldzahler, Henry. "Taste for Modern Sculpture: The Hirshhorn Collection," *Art News*, 61, October 1962, ill. p. 31

PHILIP PEARLSTEIN (b. 1924)

Philip M. Pearlstein, born Pittsburgh, May 24, 1924. Studied, Carnegie Institute of Technology, Pittsburgh, B.F.A., 1949. Moved to New York, 1949. Worked sporadically on industrial trade catalogues, with Ladislav Sutner, 1949–57. Exhibited, Tanager Gallery, New York, 1952–62; "Emerging Talent," Kootz Gallery, New York, 1954; Whitney Annual, 1955–72. One-man shows: Tanager Gallery, 1955, 1959; Peridot Gallery, New York, 1956, 1957, 1959. Studied, Institute of Fine Arts, New York University, M.A., 1955. Received Fulbright

Grant, Rome, 1958. Taught: Pratt Institute, Brooklyn, New York, 1959–63; visiting critic, Yale University, New Haven, Connecticut, 1962; New York Studio School of Drawing, Painting and Sculpture, spring, 1968. One-man shows, Allan Frumkin Gallery: Chicago, 1960, 1965, 1969; New York, from 1961. Member, Board of Directors, Skowhegan School of Painting and Sculpture, Maine, from 1968. Received: National Council on the Arts Grant, 1969; The American Academy of Arts and Letters, and The National Institute of Arts and Letters Award, 1973. One-man shows: Georgia Museum of Art, University of Georgia, Athens, and tour, 1970–71; Hansen-Fuller Gallery, San Francisco, 1972; Galerie M. E. Thelen, Cologne, 1972. Has taught, Brooklyn College, City University of New York, since 1963. Lives in New York.

Male and Female Nudes with Red and Purple Drape. 1968.
 Oil on canvas, 75¼ × 75½ inches
 Signed and dated l. l.: "Pearlstein 68"

PROVENANCE:
Allan Frumkin Gallery, New York, 1969

EXHIBITIONS:
San Francisco Museum of Art, November 9–December 29, 1968, *Untitled, 1968*, no. 57, ill.
Allan Frumkin Gallery, New York, March 29–April 26, 1969, *Philip Pearlstein*

"During the year 1960 I began my personal odyssey as a painter to carry as far forward as I possibly could certain ideas about painting, the consequences of which I could only dimly foresee then. I had based my work of the previous decade on my tendency toward expressionism, and my understanding of abstraction. My painting style then was indebted equally to a study of ancient Southern Sung landscape painting of a very calligraphic character, and certain of the New York Abstract Expressionists. But my manner in drawing had always, from student days on, been tensely controlled, linear and precise, never sketchy or impressionistic. My drawings in the '50s of rock formations and tree roots, Roman ruins and Amalfi coast cliffs, and, finally, of models in the studio, were persistently precise; the paintings I developed from them were loose and expressive. I determined to abandon the expressionistic element as being less essential to my basic drives, and chose to concentrate on painting in a manner as true to my subjects as my drawings were.

"Painting models in the studio gave me the most convenient complex subject. I began by taking the same attitude toward the models as I had toward landscape, concentrating on the spatial relationships that result from the models' positions and the visual overlapping of forms, seeing the forms themselves as being unique in each posture and from each vantage point—as abstract as rocks. I thought of the subject of models posing in the studio as an artistic tradition, devoid of narrative though not devoid of humanity. I tried to paint them 'as is.' By taking models in the studio as my subject, and painting them with clarity, I found myself embattled with the art world as it then was, oriented toward either varied aspects of abstraction, or social comment. As my aims and technical command developed, the work became increasingly sharp focused, finally reaching the point where many persons assumed I was painting from photographs. Of course I never have."

Statement by the artist, 1972

ALICIA PENALBA (b. 1918)

Born San Pedro, Argentina, August 9, 1918. Studied, Escuela de Bellas Artes de Buenos Aires, Argentina, from 1934. Received Bourse d'Étude du Gouvernement Français; moved to Paris, 1948. Studied, Académie de la Grande Chaumière, with Ossip Zadkine, 1948–51. Included in: Salon de Mai, Paris, 1952; Salon de la Jeune Sculpture, 1952, 1957; 2nd, 3rd, 6th, 10th Middelheim Biënnale, Antwerp, 1953, 1955, 1961, 1969; Salon des Réalités Nouvelles, Paris, 1955–58; "Sculpture and Drawings of Seven Sculptors," The Solomon R. Guggenheim Museum, New York, 1958; Pittsburgh International, 1958, 1964, 1967, 1970; Documenta II and III, Kassel, 1959, 1964. One-man shows, Galerie du Dragon, Paris, 1957; Galerie Claude Bernard, Paris, 1960; Otto Gerson Gallery, New York, 1960. Commissions: fountain, Paris office, Electricité de France, 1957; garden, Business School, University of St. Gallen, Switzerland, 1963; relief wall, Rijksmuseum Kröller-Müller, Otterlo, The Netherlands, 1965. Awarded International Sculpture Prize, VI São Paulo Bienal, 1961. Retrospective, Rijksmuseum Kröller-Müller, and tour, 1964. One-man shows: Galerie Creuzevault, Paris, 1965; Galeria Bonino, New York, 1966; The Phillips Collection, Washington, D.C., 1966; Galleria Toninelli, Milan, 1969; Galerie d'Art Moderne, Basel, 1967, 1971. Lives in Paris.

The Sparkler (L'Étincelle). 1957.
 Bronze on carved stone base, 47 × 27¾ × 25 inches; height of base 20 inches
 Markings: l. l. side "Penalba 1/4";
 l. r. side "Susse Fondeur Paris"

PROVENANCE:
Otto Gerson Gallery, New York, 1961

EXHIBITIONS:
Otto Gerson Gallery, New York, October 11–November 4, 1960, *Alicia Penalba Sculpture*, no. 4, ill.
The Solomon R. Guggenheim Museum, New York, October 3, 1962–January 6, 1963, *Modern Sculpture from the Joseph H. Hirshhorn Collection*, no. 361, ill. p. 73

BEVERLY PEPPER (b. 1924)

Born Brooklyn, New York, December 20, 1924. Studied painting: Pratt Institute, Brooklyn; The Art Students League of New York; with Fernand Léger, and André Lhote, Paris, 1949. Included in Salon d'Automne, Paris, 1952. One-man shows: Galleria Zodiaco, Rome, 1952; Barone Gallery, New York, 1954, 1956, 1958; Obelisk Gallery, Washington, D.C., 1955; Galleria Schneider, Rome,

1956; Galleria dell'Obelisco, Rome, 1959; Galleria Pogliani, Rome, 1961; Thibault Gallery, New York, 1962. Included in: "Sculture nella città," Festival dei Due Mondi, Spoleto, Italy, 1962; INCO Architectural Symposium, Washington, D.C., 1964. Commissions: Italsider, Piombino, Italy, 1962; U.S. Plywood Building, New York, 1963; monument to President John F. Kennedy, Weizmann Institute, Rehovoth, Israel, 1964; *Strands of Mirror*, Southland Mall, Memphis, Tennessee, 1966; *Flags Over Georgia*, Atlanta, 1968; Hotel Sonesta, Milan, 1969; *Land Canal*, North Park, Dallas, 1971. One-man shows: Marlborough Gallery, New York, and Marlborough Galleria d'Arte, Rome, from 1965; Galleria La Bussola, Turin, 1968; Studio Marconi, Milan, 1970; Galleria Hella Nebelung, Düsseldorf, 1971; Qui Arte Contemporanea, Rome, 1972. Has lived in Rome, since 1951.

Fallen Sky. 1968.
 Stainless steel, 4 feet 10 inches × 15 feet 1 inch × 8 feet 9¾ inches

PROVENANCE:
Marlborough-Gerson Gallery, New York, 1969

EXHIBITIONS:
Marlborough-Gerson Gallery, New York, February 1–22, 1969, *Beverly Pepper: Recent Sculpture*, no. 25, cover ill.; toured to Museum of Contemporary Art, Chicago, March 8–April 13; Hayden Court and Hayden Plaza, Massachusetts Institute of Technology, Cambridge, May 21–September 1; Albright-Knox Art Gallery, Buffalo, New York, September 29–November 2; Everson Museum of Art, Syracuse, New York, January 18–April 19, 1970

REFERENCES:
Davis, Alexander. *Literature on Modern Art 1970*, London, Lund Humphries, 1971, ill. p. 83

"*Fallen Sky* was part of a series of polished open box forms which, through the precarious balance of their elements and their use of color, were mostly concerned with optical illusion.

"*Fallen Sky* is especially important in this series because not only does it contain the elements of my first floor pieces—that extended, stretched, and crawled—but it also suspends elements against one another to emphasize the many different views the work presents. No two views are the same.

"The basic idea behind this particular sculpture involved the relationship between it, the environment, and time. It was to absorb the sky (fallen sky) and landscape at continually changing times of day and through the ever new combinations of color, light, and even the very content of the reflections that express time, in the most physical way possible.

"The mirror finish, essential to the captured illusions, does not seek to multiply reflections as in earlier works, but rather to enhance the environmental quality. Thus, as the mirror reflects the environment, its effect cancels out the sculpture. But change of light or positioning can reverse this process, and the sculpture may again appear to stand out from its environment.

"Though the work is extremely heavy (about one ton of counterweights are needed to control the suspension of the two middle elements), the paradoxical effect desired was one of weightlessness and self-effacement. The purpose of the use of white within the sculpture was, again, to complement the mirrored illusions without, however, creating still another solid element.

"I think of these as optimistic sculptures."

Statement by the artist, 1972

I. RICE PEREIRA (1907–1971)

Irene Rice Pereira, born Chelsea, Massachusetts, August 5, 1907. Studied: The Art Students League of New York, with Richard Lahey, and Jan Matulka, 1927–31, 1933; Académie Moderne, Paris, 1932. One-man shows, ACA Gallery, New York, 1933–35, 1946, 1949. WPA Federal Art Project, instructor in Design Laboratory, later Easel Division, 1935–39. Member, American Abstract Artists, 1938. One-man shows: East River Gallery, New York, 1938; Howard University, Washington, D.C., 1938; Julien Levy Gallery, New York, 1939; Peggy Guggenheim's Art of This Century, New York, 1944; The Arts Club of Chicago, 1945; San Francisco Museum of Art, 1947. Taught, Pratt Institute, Brooklyn, New York, 1942–43. Included in: "Fourteen Americans," and "Abstract Painting and Sculpture in America," The Museum of Modern Art, New York, 1946, 1951; Whitney Annual, from 1947; Venice Biennale, 1948. Exhibited with Loren MacIver: Santa Barbara Museum of Art, California, and tour, 1950; Whitney Museum of American Art, New York, 1953. One-man shows: The Baltimore Museum of Art, 1951; The Phillips Collection, Washington, D.C., 1952; The Corcoran Gallery of Art, Washington, D.C., 1956; Lee Nordness Galleries, New York, 1958, 1959, 1961; William Hayes Ackland Memorial Art Center, University of North Carolina at Chapel Hill, 1968. Books include *The Nature of Space*, 1956 (reprint, Washington, D.C., Corcoran, 1968). Died Marbella, Spain, January 11, 1971.

Two Becomes One. 1951.
 Front plane: mixed media on glass; back plane: casein on gesso panel, 22⅝ × 18⅝ inches
 Signed on back plane l. r.: "I. Rice Pereira"

PROVENANCE:
Harold Diamond, New York, 1957

EXHIBITIONS:
Durlacher Brothers, New York, October 2–27, 1951, *I. Rice Pereira*
Whitney Museum of American Art, New York, January 8–March 1, 1953, *Loren MacIver—I. Rice Pereira*, no. 44

JOHN FREDERICK PETO (1854–1907)

Born Philadelphia, May 21, 1854. The Pennsylvania Academy of the Fine Arts, Philadelphia: studied, 1878;

exhibited, 1879–81, 1885–87. Associated with, and influenced by, William Michael Harnett, before 1880. Three paintings included, St. Louis Exposition, Missouri, 1881; one painting exhibited, Uter's, New Orleans, 1886. Moved to Island Heights, New Jersey, 1889; supported himself playing cornet for revival meetings. Painting commissioned, Stag Saloon, Cincinnati, Ohio, 1894. Many paintings re-signed and sold as the work of Harnett. Died Island Heights, November 23, 1907. Virtually unknown, until 1940s. Retrospective, The Brooklyn Museum, New York, and tour, 1950. Included in "The Reality of Appearance: the Trompe-l'Oeil Tradition in American Painting," University Art Museum, University of California, Berkeley, and tour, 1970.

Mug, Pipe and Match. c. 1887.
 Oil on board, 6 × 9 inches

PROVENANCE:
Joseph Katz, Baltimore; Victor D. Spark, New York; Jon N. Streep, New York, 1968

Mug, Book, Pipe, Matchstick and Biscuit on a Brown Ledge. c. 1887.
 Oil on board, 5¾ × 8¾ inches
 Signed l. r.: "J. F. Peto"

PROVENANCE:
Joseph Katz, Baltimore; Victor D. Spark, New York; Jon N. Streep, New York, 1968

EXHIBITIONS:
The Pennsylvania Academy of the Fine Arts, Philadelphia, January 16–March 13, 1955, *The One Hundred and Fiftieth Anniversary Exhibition*, no. 179

WILLIAM PETTET (b. 1942)

Born Whittier, California, October 10, 1942. Studied, Chouinard School of Art, Los Angeles, B.F.A., 1965. One-man shows: Nicholas Wilder Gallery, Los Angeles, 1966, 1968, 1970; Robert Elkon Gallery, New York, 1968, 1969. Included in: Whitney Annual, 1967, 1969; Corcoran Biennial, 1969; "Two Generations of Color Painting," Institute of Contemporary Art, University of Pennsylvania, Philadelphia, 1970; "Lyrical Abstraction," The Aldrich Museum of Contemporary Art, Ridgefield, Connecticut, and tour, 1970–71; Whitney Biennial, 1973. Moved to New York, 1969. One-man shows: David Whitney Gallery, New York, 1970, 1971; Dunkelman Gallery, Toronto, 1971; Willard Gallery, New York, 1973. Taught, Skowhegan School of Painting and Sculpture, Maine, summer, 1972. Lives in New York.

Slip Rent. 1969.
 Acrylic on canvas, 7 feet 4 inches × 16 feet 11 inches
 Signed and dated on back: "William Pettet 1969"

PROVENANCE:
David Whitney Gallery, New York, 1970

ANTOINE PEVSNER (1886–1962)

Anton Pevsner, born Orel, Russia, January 18, 1886; brother of sculptor Naum Gabo. Studied: School of Fine Arts, Kiev, 1902–9; Petersburg Academy of Fine Arts, St. Petersburg, 1910. Lived in: Paris, 1911–14; Oslo, 1915–17; Moscow, 1917–23. Taught, Higher Technical-Artistic Studios (Vkhutemas, the reorganized Moscow School of Painting, Sculpture, and Architecture), 1917–22. In Moscow, 1920: co-signed Gabo's *Realist Manifesto;* included, with his students, in openair exhibition, organized by Gabo, Tverskoi Boulevard. Included in "Erste Russische Kunstausstellung" (organized by government of the U.S.S.R.), Galerie van Diemen, Berlin, 1922. Settled in Paris, 1923; French citizen, 1930. Included in "Constructivistes Russes: Gabo et Pevsner," Galerie Percier, Paris, 1924; exhibited with Gabo, and Theo van Doesburg, Little Review Gallery, New York, 1926. With Gabo, designed sets, properties, costumes for *La Chatte*, Sergei Diaghilev's Ballets Russes de Monte Carlo, 1926. Member, Association Abstraction-Création, Paris, 1932. Included in: "Cubism and Abstract Art," and "Art of Our Time," The Museum of Modern Art, New York, 1936, 1939; "Réalités Nouvelles," Galerie Charpentier, Paris, 1939; "Art Concret," Galerie René Drouin, Paris, 1947. Co-founded, Salon des Réalités Nouvelles, Paris, 1946; honorary president, 1956. One-man show, Galerie René Drouin, 1947. Exhibited with Gabo, The Museum of Modern Art, 1948; with Max Bill, and Georges Vantongerloo, Kunsthaus, Zurich, 1949. Awarded Second Grand Prize, international competition, monument to "The Unknown Political Prisoner," Institute of Contemporary Arts London, 1953. Retrospective, Musée National d'Art Moderne, Paris, 1956–57. Chevalier, Légion d'honneur, 1961. Died Paris, April 13, 1962.

Head of a Woman (Tête de Femme). 1923.
 Plastic construction on wood panel, 14½ × 9¾ × 3¼ inches
 Markings: back "Antoine Pevsner 1923" front l. l. "Pevsner 1923"

PROVENANCE:
Galerie Louise Leiris, Paris; André Lefèvre, Paris; Hôtel Drouot, Paris, Sale, November 24, 1967, no. 73, ill.

EXHIBITIONS:
Musée National d'Art Moderne, Paris, December 21, 1956–March 10, 1957, *Antoine Pevsner*, no. 17

REFERENCES:
Massat, René. *Antoine Pevsner et le Constructivisme*, Paris, Caractères, 1956, plate 4
Peissi, Pierre, and Giedion-Welcker, Carola, *Antoine Pevsner*, trans. Haakon Chevalier, Neuchâtel, Switzerland, Griffon, 1961, no. 38, p. 148, plate 38
Pevsner, Alexei. *A Biographical Sketch of My Brothers Naum Gabo and Antoine Pevsner*, trans. Michael Scammell and William Burke, Amsterdam, Augustin & Schoonman, 1964, p. 53, ill. p. 48
Read, Herbert. *A Concise History of Modern Sculpture*, New York, Praeger, 1964, no. 100, p. 301, ill. p. 98
Zanini, Walter. *Tendências da escultura moderna*, São Paulo, Cultrix, 1971, ill. p. 225

The Black Lily (Spiral Construction). 1943.
Bronze, 20½ × 16½ × 14¾ inches
Markings: l. r. "Pevsner 1943 No. 1"
 back l. "Susse Fondeur Paris"

PROVENANCE:
The artist, Paris; Harold Diamond, New York, 1959

EXHIBITIONS:
The Detroit Institute of Arts, and tour, 1959–60, *Sculpture in Our Time*, no. 186
The Solomon R. Guggenheim Museum, New York, October 3, 1962–January 6, 1963, *Modern Sculpture from the Joseph H. Hirshhorn Collection*, no. 362, ill. p. 95
Hopkins Art Center, Dartmouth College, Hanover, New Hampshire, May 25–July 9, 1967, *Sculpture in Our Century: Selections from the Joseph H. Hirshhorn Collection*, no. 42

Column of Peace. 1954.
Bronze, 52 × 33 × 17½ inches
Markings: l. top of base "Pevsner 3/3"
 r. top of base "Susse Fondeur Paris"

PROVENANCE:
Galerie Claude Bernard, Paris, 1962

REFERENCES:
Peissi, Pierre, and Giedion-Welcker, Carola. *Antoine Pevsner*, trans. Haakon Chevalier, Neuchâtel, Switzerland, Griffon, 1961, no. 112 (addenda)

PABLO PICASSO (1881–1973)

Pablo Diego José Francisco de Paula Juan Nepomuceno María de los Remedios Cipriano de la Santísima Trinidad Ruiz Picasso, born Málaga, Andalusia, Spain, October 25, 1881; son of painter José Ruiz Blasco. Studied: Escuela de Bellas Artes de Barcelona, 1895–97; Real Academia de Bellas Artes de San Fernando, Madrid, 1897. Awarded honorable mention, Exposición Nacional de Bellas Artes de Madrid, 1897, 1899. Returned to Barcelona, 1898; one-man show, café Els Quatre Gats, meeting place of painters and writers. First visit to Paris, 1900. Beginning of Blue period; one-man show, Galerie Ambroise Vollard; started signing paintings "Picasso" (mother's surname), 1901. Settled in Paris, 1904. Beginning of Rose period; works acquired by Leo and Gertrude Stein and Sergei Shchukine, 1905. Interest in Iberian and African sculpture, 1906–7. Completed *Les Demoiselles d'Avignon*, milestone in history of Cubism, 1907; began close association with Georges Braque, 1908–9. Applied Cubist techniques to three-dimensional constructions, 1912–14. Eight works included in the Armory Show, 1913. Designed decor for *Parade*, Sergei Diaghilev's Ballets Russes de Monte Carlo, 1917. Included in "Exposition, La Peinture Surréaliste," Galerie Pierre, Paris, 1925. First welded metal sculpture, in collaboration with Julio González, 1928. Established studio at Boisgeloup, northwest of Paris, 1932. Retrospectives: Wadsworth Atheneum, Hartford, Connecticut, 1934; The Museum of Modern Art, New York, and tour, 1939–40. Returned to Paris, 1935. *Guernica* commissioned, Spanish Pavilion, Exposition Universelle of 1937, Paris (on extended loan to The Museum of Modern Art, from 1939). Lived in and near Antibes, France, 1946–55; produced ceramics, which were fired at Madoura pottery, Vallauris. Retrospectives: Galleria Nazionale d'Arte Moderna, Rome, 1953; Palazzo Reale, Milan, 1953; Museu de Arte Moderna, São Paulo, 1954; Haus der Kunst, Munich, and tour, 1955; The Museum of Modern Art, and tour, 1957; The Tate Gallery, London, 1960. First large-scale sheet metal sculpture, 1960. Settled in Mougins, near Cannes, 1961. Retrospectives: "Picasso: An American Tribute," Public Education Association, New York, 1962; "Hommage à Picasso," Grand Palais, Musée du Petit Palais, and Bibliothèque Nationale, Paris, 1966; The Tate Gallery, 1967; The Museum of Modern Art (sculpture), 1967–68; Musée du Louvre, Paris, 1971. Monumental sculpture dedicated, Chicago Civic Center, 1967. Over nine hundred works donated by the artist to Museo Pablo Picasso, Barcelona, 1970. Died Mougins, April 8, 1973.

Mask of a Picador with a Broken Nose. 1903.
Bronze, 7½ × 5½ × 4½ inches
Markings: back "Cire Perdue C. Valsuani 5/6"

PROVENANCE:
Galerie Louise Leiris, Paris; Galerie Claude Bernard, Paris, 1963

EXHIBITIONS:
Art Gallery of Toronto, January 11–February 16, 1964, *Picasso and Man*, no. 16, ill. p. 37; toured to Montreal Museum of Fine Arts, February 28–March 31

Head of a Jester (Tête de Fou). 1905.
Bronze, 16½ × 14½ × 9 inches
Markings: back l. c. "Picasso"

Zervos, Christian. *Pablo Picasso: Oeuvres de . . .*, 1, Paris, Cahiers d'Art, 1932, no. 322¹ (hereafter cited as Zervos)

PROVENANCE:
Curt Valentin Gallery, New York, 1955

EXHIBITIONS:
Curt Valentin Gallery, New York, February 19–March 15, 1952, *Pablo Picasso Paintings, Sculpture, Drawings*, no. 41, ill.
Leonid Kipnis Gallery, Westport, Connecticut, November 18–30, 1956, *Modern Sculpture* (sponsored by the Westport Community Art Association), no. 31
Fine Arts Associates, New York, January 15–February 9, 1957, *Picasso Sculpture*, no. 2, ill.
New York School of Social Work, Columbia University, March 27–May 1, 1957, *19th and 20th Century French Painting and Sculpture*
The Detroit Institute of Arts, and tour, 1959–60, *Sculpture in Our Time*, no. 187, ill.
The Solomon R. Guggenheim Museum, New York, October 3, 1962–January 6, 1963, *Modern Sculpture from the Joseph H. Hirshhorn Collection*, no. 363, ill. p. 84

Art Gallery of Toronto, January 11–February 16, 1964, *Picasso and Man*, no. 26, ill.; toured to Montreal Museum of Fine Arts, February 28–March 31
Dallas Museum of Fine Arts, February 8–March 26, 1967, *Picasso*, no. 87
Hopkins Art Center, Dartmouth College, Hanover, New Hampshire, May 25–July 9, 1967, *Sculpture in Our Century: Selections from the Joseph H. Hirshhorn Collection*, no. 43, ill. p. 32

REFERENCES:
Fitzsimmons, James. "Picasso: Half-Century Survey," *Art Digest*, 26, March 1, 1952, p. 16
Key, Donald. "Sculpture Show at Art Center Reflects Trends," *The Milwaukee Journal*, September 13, 1959, sec. 5, p. 6
Mellow, James R. "In the Galleries: Picasso Sculpture," *Arts*, 31, February 1957, p. 54
Tyler, Parker. "Reviews and Previews: Picasso's," *Art News*, 55, February 1957, p. 8

Head of a Jester is closely related to Picasso's paintings of the Rose period, in which circus themes predominate. In *Picasso: His Life and Work* (New York, Harper), 1959, Roland Penrose relates that the *Jester* was begun one evening after Picasso and his friend, the poet Max Jacob (1876–1944), returned from a visit to the circus. Although the sculpture was at first a likeness of Jacob, only the lower portion of the face retains a trace of the original resemblance.

Head of Fernande. 1905.
Bronze, 14½ × 9½ × 9 inches
Markings: back l. r. "Picasso 5/9"
 back l. c. "Cire Perdue C. Valsuani"

Zervos, 1, no. 323

PROVENANCE:
Galerie de l'Élysée, Paris, 1961

EXHIBITIONS:
Art Gallery of Toronto, January 11–February 16, 1964, *Picasso and Man*, no. 34, ill. p. 50; toured to Montreal Museum of Fine Arts, February 28–March 31

Head of a Man. c. 1905.
Bronze, 6½ × 8½ × 4½ inches
Markings: back r. "Picasso"

Zervos, 1, no. 380

PROVENANCE:
Sidney Janis Gallery, New York, 1957

EXHIBITIONS:
The Detroit Institute of Arts, 1959, *Sculpture in Our Time*, no. 188
The Solomon R. Guggenheim Museum, New York, October 3, 1962–January 6, 1963, *Modern Sculpture from the Joseph H. Hirshhorn Collection*, no. 364
Art Gallery of Toronto, January 11–February 16, 1964, *Picasso and Man*, no. 37, ill. p. 52; toured to Montreal Museum of Fine Arts, February 28–March 31
Dallas Museum of Fine Arts, February 8–March 26, 1967, *Picasso*, no. 88

Kneeling Woman Combing Her Hair. 1905–6.
Bronze, 16½ × 11½ × 13½ inches
Markings: l. l. side "Picasso"

Zervos, 1, no. 329

PROVENANCE:
The artist; Ambroise Vollard, Paris; Buchholz Gallery, New York; Walter P. Chrysler, Jr., New York; Jeffrey H. Loria, New York, 1970

EXHIBITIONS:
The Museum of Modern Art, New York, November 15, 1939–January 7, 1940, *Picasso: Forty Years of His Art*, no. 60; toured to The Art Institute of Chicago, February 1–March 3; City Art Museum of St. Louis, Missouri, March 16–April 14; Institute of Modern Art, Boston, April 26–May 25
Buchholz Gallery, New York, March 5–30, 1940, *Pablo Picasso Watercolors*, no. 63
Virginia Museum of Fine Arts, Richmond, January 16–March 4, 1941, *The Collection of Walter P. Chrysler, Jr.*, no. 154; toured to Philadelpia Museum of Art, March 29–May 11

Head of a Woman. 1906.
Bronze, 4½ × 3½ × 3½ inches
Markings: back l. c. "Picasso"

PROVENANCE:
Estate of Ambroise Vollard, Paris; Peridot Gallery, New York, 1958

EXHIBITIONS:
The Detroit Institute of Arts, 1959, *Sculpture in Our Time*, no. 190
The Solomon R. Guggenheim Museum, New York, October 3, 1962–January 6, 1963, *Modern Sculpture from the Joseph H. Hirshhorn Collection*, no. 366

Head of a Woman. 1906.
Bronze relief, 4¼ × 2½ inches

PROVENANCE:
Brook Street Gallery, London; Harold Diamond, New York, 1957

EXHIBITIONS:
The Detroit Institute of Arts, 1959, *Sculpture in Our Time*, no. 189, ill.
Otto Gerson Gallery, New York, April 25–May 12, 1962, *Picasso: An American Tribute* (sponsored by the Public Education Association), no. 9, ill.
The Museum of Modern Art, New York, October 16, 1967–January 7, 1968, *The Sculpture of Picasso*, no. 8, ill. p. 54

Mask of a Woman. 1908.
Bronze, 7½ × 6½ × 4½ inches
Markings: back "Picasso 1908 Cire Perdue C. Valsuani 5/6"

PROVENANCE:
Galerie Louise Leiris, Paris; Marlborough Fine Art, London, 1961

EXHIBITIONS:
Marlborough Fine Art, London, Summer 1958, *Nineteenth and Twentieth Century European Masters*, no. 86, ill. p. 111
Marlborough Fine Art, London, February–March 1961, *Nineteenth and Twentieth Century Drawings, Watercolors, Sculpture*, no. 79, ill.
Art Gallery of Toronto, January 11–February 16, 1964, *Picasso and Man*, no. 45, ill. p. 58; toured to Montreal Museum of Fine Arts, February 28–March 31

Head of a Woman (Cubist Head; Fernande Olivier). 1909, cast 1960.
Bronze, 16½ × 10 × 10½ inches
Markings: back l. r. "Picasso"
 back c. "Cire Perdue C. Valsuani"
 back l. l. "1/9"

Zervos, 2², no. 573

PROVENANCE:
M. Knoedler & Co., New York, 1961

EXHIBITIONS:
Otto Gerson Gallery, New York, April 25–May 12, 1962, *Picasso: An American Tribute* (sponsored by the Public Education Association), no. 12, ill.
The Solomon R. Guggenheim Museum, New York, October 3, 1962–January 6, 1963, *Modern Sculpture from the Joseph H. Hirshhorn Collection*, no. 368, ills. pp. 57, 85
University Art Museum, The University of New Mexico, Albuquerque, October 20–November 15, 1964, *Art Since 1889*, no. 85, ill. p. 21

REFERENCES:
Hale, William Harlan. *The World of Rodin 1840–1917*, New York, Time-Life Books, 1969, ill. p. 176
Michelson, Annette. "Private but Public: The Joseph H. Hirshhorn Collection," *Contemporary Sculpture, Arts Yearbook* 8, 1965, p. 188
Read, Herbert. *A Concise History of Modern Sculpture*, New York, Praeger, 1964, no. 54, pp. 66–67, 301, ill. p. 60

Fernande Olivier, "La Belle Fernande," was Picasso's mistress from 1905 to 1911, and the subject of many of his early works. This portrait of Fernande represents Picasso's major attempt to apply the faceted planes of Analytical Cubism to three-dimensional form.

The bronze in our collection is from a second authorized edition, approved by the artist, cast from the original plaster in the collection of H. Ulmann, Paris. The first edition was made by the dealer Ambroise Vollard shortly after the piece was executed. The Vollard edition is unmarked.

Pregnant Woman. 1950.
Bronze, first version, 41½ × 11½ × 10 inches
Markings: back l. l. "Cire Perdue C. Valsuani 1/6"

PROVENANCE:
Galerie Louise Leiris, Paris; M. Knoedler & Co., Paris, 1966

A scrap heap near his studio in Vallauris provided Picasso with discarded fragments of pottery and metal which he began incorporating into his sculpture in 1950. *Pregnant Woman* was made from three ceramic water pitchers embedded in plaster. Françoise Gilot described the figure as having "almost no feet, it swayed perilously, and the arms were too long" (Gilot, Françoise, and Lake, Carlton. *Life with Picasso*, London, Nelson, 1965, p. 296). After it was cast Picasso modified *Pregnant Woman*, giving it greater stability and adding some naturalistic detail. The second version was cast in bronze in 1959.

Woman with Baby Carriage. 1950.
Bronze, after found objects, 80 × 57 × 23½ inches
Markings: r. top of base "2/2"

PROVENANCE:
Galerie Louise Leiris, Paris, 1969

REFERENCES:
Eagle, Joanna. "Washington: Upbeat Ending," *The Art Gallery*, 15, May 1972, p. 64
Robertson, Nan. "Hirshhorn Gives Museum 326 Works," *The New York Times*, March 10, 1972, p. 46
Secrest, Meryle. "Hirshhorn: Gift to the Nation," *The Washington [D.C.] Post*, March 10, 1972, sec. C, p. 1, ill.

From 1943, Picasso used elements of machine manufacture, industrial scrap and commonplace objects, incorporating them in his sculpture as he had previously incorporated collage in his Cubist paintings. In *Woman with Baby Carriage* one can recognize, among other objects, a stove plate, cake tins, and a baby carriage.

The only other bronze cast of this sculpture belongs to the artist's estate.

Head of a Woman. 1951.
Bronze (3/6), 21½ × 7½ × 13½ inches

PROVENANCE:
Galerie Louise Leiris, Paris; Galerie Chalette, New York, 1958

EXHIBITIONS:
Galerie Chalette, New York, October 16–November 29, 1958, *Sculpture by Painters*, cat.
The Detroit Institute of Arts, 1959, *Sculpture in Our Time*, no. 191, ill. p. 86
The Solomon R. Guggenheim Museum, New York, October 3, 1962–January 6, 1963, *Modern Sculpture from the Joseph H. Hirshhorn Collection*, no. 369, p. 86
Art Gallery of Toronto, January 11–February 16, 1964, *Picasso and Man*, no. 250, ill. p. 140; toured to Montreal Museum of Fine Arts, February 28–March 31
University Art Museum, The University of New Mexico, Albuquerque, March 25–May 1, 1966, *Twentieth Century Sculpture*, no. 44, ill. p. 38
Dallas Museum of Fine Arts, February 8–March 26, 1967, *Picasso*, no. 91
Hopkins Art Center, Dartmouth College, Hanover, New Hampshire, May 25–July 9, 1967, *Sculpture in Our*

Century: Selections from the Joseph H. Hirshhorn Collection, no. 44, ill. p. 33

REFERENCES:
Lucie-Smith, Edward. *Late Modern: The Visual Arts Since 1945,* New York, Praeger, 1969, no. 178, p. 283, ill. p. 210
Read, Herbert. *A Concise History of Modern Art,* New York, Praeger, 1964, no. 42, p. 302, ill. p. 46
Rubin, William S. "The Hirshhorn Collection at the Guggenheim Museum," *Art International,* 6, November 25, 1962, ill. p. 36
Sones, Derek. "108 Works on Show: Sculpture Exhibit Feast of Excellence," *Toronto Daily Star,* October 1, 1960, p. 29

Little Owl. 1953.
Painted bronze, 10¼ × 7 × 5¼ inches
Markings: back l. r. "C. Valsuani Cire Perdue bronze"

PROVENANCE:
Galerie Louise Leiris, Paris; Curt Valentin Gallery, New York, 1954

EXHIBITIONS:
Curt Valentin Gallery, New York, November 24–December 19, 1953, *Pablo Picasso 1950–1953,* no. 35, ill.
Fine Arts Associates, New York, January 15–February 9, 1957, *Picasso Sculpture,* no. 20, ill. no. 19
The Museum of Modern Art, New York, May 20–September 8, 1957, *Picasso: 75th Anniversary Exhibition,* ill. p. 101; toured to The Art Institute of Chicago, October 19–December 1; Philadelphia Museum of Art, January 8–February 23, 1958
The Detroit Institute of Arts, 1959, *Sculpture in Our Time,* no. 192
Otto Gerson Gallery, New York, April 25–May 12, 1962, *Picasso: An American Tribute* (sponsored by the Public Education Association), no. 19, ill.
The Solomon R. Guggenheim Museum, New York, October 3, 1962–January 6, 1963, *Modern Sculpture from the Joseph H. Hirshhorn Collection,* no. 320, ill. p. 87

REFERENCES:
Aaron, Louise. "Picasso's Art Works on Display in Gotham," *Oregon Journal,* August 11, 1957, ill. p. 4C
Preston, Stuart. "Lessons of the Master: Sixty Years of Picasso's Art in an Eightieth Birthday Celebration," *The New York Times,* April 29, 1962, sec. 2, p. 21, ill.
Saltmarche, Kenneth. "Notes on Special Exhibitions: 'Sculpture in Our Time'," *The Art Quarterly,* 22, Winter 1959, p. 352

The Arm. 1959.
Bronze, 22¼ × 6¼ × 6¼ inches
Markings: front wrist "15.3.59"
back r. "Cire Perdue C. Valsuani"
back l. "4/6"

PROVENANCE:
The artist; Daniel-Henry Kahnweiler, Paris; Saidenberg Gallery, New York, 1963

EXHIBITIONS:
Otto Gerson Gallery, New York, April 25–May 12, 1962, *Picasso: An American Tribute* (sponsored by the Public Education Association), no. 35, ill.
Art Gallery of Toronto, January 11–February 16, 1964, *Picasso and Man,* no. 269, ill. p. 152; toured to Montreal Museum of Fine Arts, February 28–March 31
Dallas Museum of Fine Arts, February 8–March 26, 1967, *Picasso,* no. 93
The Museum of Modern Art, New York, October 16, 1967–January 7, 1968, *The Sculpture of Picasso,* no. 146, ill. p. 159
The Baltimore Museum of Art, December 2, 1969–February 1, 1970, *The Partial Figure in Modern Sculpture from Rodin to 1969,* no. 56, ill. p. 63

REFERENCES:
Elsen, Albert E. "Notes on the Partial Figure," *Artforum,* 3, November 1969, p. 63, ill. p. 58

HORACE PIPPIN (1888–1946)

Born West Chester, Pennsylvania, February 22, 1888. Childhood spent in Goshen, New York. Worked at odd jobs, New York and New Jersey, 1903–17. Served, U.S. Army, 1917–19; wounded in right shoulder, partially paralyzing arm. Returned to West Chester, 1920. Self-taught as an artist. First oil painting, based on memory of war experiences, 1931. Work discovered by Dr. Christian Brinton, and N. C. Wyeth; first one-man show, West Chester Community Center, 1937. Included in "Masters of Popular Painting," The Museum of Modern Art, New York, 1938; American Negro Exposition, Tanner Art Galleries, Chicago, 1940. Dr. Albert C. Barnes became his patron; attended lectures, Barnes Foundation, Merion, Pennsylvania, 1940. One-man shows: Bignou Gallery, New York, 1940; Robert Carlen Galleries, Philadelphia, 1940, 1941; The Arts Club of Chicago, 1941; San Francisco Museum of Art, 1942; The Downtown Gallery, New York, 1944. Died West Chester, July 6, 1946. Memorial exhibition, M. Knoedler & Co., New York, 1947. Included in: "American Primitive Paintings," Smithsonian Institution, Washington, D.C., Traveling Exhibition Service, 1958; "Three Self-Taught Pennsylvania Artists: Hicks, Kane, Pippin," Carnegie Institute, Pittsburgh, and The Corcoran Gallery of Art, Washington, D.C., 1966–67.

Birmingham Meeting House in Late Summer. 1940.
Oil on canvas, 16 × 20 inches
Signed and dated l. r.: "H. Pippin/1940"

PROVENANCE:
Robert Carlen Galleries, Philadelphia, before 1947

EXHIBITIONS:
M. Knoedler & Co., New York, September 29–October 11, 1947, *Horace Pippin Memorial Exhibition,* no. 7
The National Gallery of Canada, Ottawa, and tour, 1957, *Some American Paintings from the Collection of Joseph H. Hirshhorn,* no. 60
Newark Museum, New Jersey, May 12–June 27, 1971, *Black Artists: Two Generations,* no. 24, ill.

REFERENCES:
Ayre, Robert. "Art Notes: The Hirshhorn Collection," *Montreal Star,* March 23, 1957, p. 27
Unsigned. "Negro Primitive Finds Peace After War," *Art Digest,* 15, October 1, 1940, p. 7

Holy Mountain III. 1945.
Oil on canvas, 25 × 30 inches
Signed and dated l. r.: "H. Pippin, Aug. 9/1945"

PROVENANCE:
Robert Carlen Galleries, Philadelphia, before 1947

EXHIBITIONS:
Philadelphia Art Alliance, April 8–May 4, 1947, *Horace Pippin Memorial Exhibition,* no. 45
The National Gallery of Canada, Ottawa, and tour, 1957, *Some American Paintings from the Collection of Joseph H. Hirshhorn,* no. 61, ill. 18
Smithsonian Institution, Washington, D.C., Traveling Exhibition Service, June 1958–November 1959, *American Primitive Paintings,* no. 57; toured to eight U.S. cities
The Bowdoin College Museum of Art, Brunswick, Maine, May 15–September 6, 1964, *The Portrayal of the Negro in American Painting,* no. 74, ill.
Carnegie Institute, Pittsburgh, October 21–December 4, 1966, *Three Self-Taught Pennsylvania Artists: Hicks, Kane, Pippin,* no. 116, ill.; toured to The Corcoran Gallery of Art, Washington, D.C., January 6–February 19, 1967
The Corcoran Gallery of Art, Washington, D.C., October 9–November 14, 1971, *Wilderness* (sponsored by the National Endowment for the Arts), no. 150

REFERENCES:
Fine, Elsa Honig. *The Afro-American Artist: A Search for Identity,* New York, Holt, Rinehart & Winston, 1973, p. 119, ill. 160
Jacobs, Jay. "Collector: Joseph H. Hirshhorn," *Art in America,* 57, July–August 1969, p. 61, colorplate
——. "Quality as Well as Quantity: Joseph H. Hirshhorn," in Lipman, Jean, ed. *The Collector in America,* New York, Viking, 1971, p. 79, colorplate
Rodman, Selden. *Horace Pippin, A Negro Painter in America,* New York, Quadrangle, 1947, no. 84
——and Cleaver, Carole. *Horace Pippin: The Artist as a Black American,* New York, Doubleday, 1971, p. 84, colorplate 7, and back endpaper
Sadik, Marvin S. "The Negro in American Art," *Art in America,* 52, June 1964, p. 82, ill.
Walton, William. "A Slice from Another Mellon," *The Washingtonian,* 3, August 1968, colorplate p. 71

Horace Pippin's series of four *Holy Mountain* paintings is the counterpart of Edward Hicks's *The Peaceable Kingdom,* over forty versions of which were painted by the eighteenth-century Quaker preacher, all interpreting the Biblical prophecy of Isaiah 11:6–9: "The wolf shall dwell with the lamb, and the leopard shall lie down with the kid; and the calf and the young lion and the fatling together; and a little child shall lead them . . ." Adam, here, is a black shepherd who is taming the beasts.

Dwarfed in the background of the dense forest is an almost imperceptible leitmotif: a lynching, a graveyard of tiny crosses, two soldiers, and a tank. The background theme is the artist's allegorical reminder of happenings in the South, the horrors of World War I—in which he had been severely wounded in action—and World War II, which ended the year this painting was completed.

Pippin himself said: "If a man knows nothing but hard times, he will paint them, for he must be true to himself, but even that man may have a dream, an ideal—and 'Holy Mountain' is my answer to such dreaming."

ULI POHL (b. 1935)

Born Munich, 1935. Studied, Akademie der Bildenden Künste, Munich, with Ernst Geitlinger, 1956–60. Included in: "Neue Generation," Kunstverein, Hanover, 1959; "Exposition Dato 61," Dato Galerie, Frankfort, 1961; "Structures," Galerie Denise René, Paris, 1961–62. Exhibited with Zero group: Galerie A, Arnhem, The Netherlands, 1961; Stedelijk Museum, Amsterdam, 1962; Institute of Contemporary Art, University of Pennsylvania, Philadelphia, and tour, 1964. Included in: "Movement," Gimpel & Hanover Galerie, Zurich, 1964; "Mouvement II," Galerie Denise René, 1965; "Art Today," Albright-Knox Art Gallery, Buffalo, New York, 1965; "The Responsive Eye," The Museum of Modern Art, New York, and tour, 1965–66. One-man shows, Galerie Appel und Fertsch, Frankfort, 1964, 1971. Lives in Munich.

PX 11/30/10. 1959–64.
Plexiglas on steel base, 27¼ × 16¼ × 12 inches

PROVENANCE:
Gimpel & Hanover Galerie, Zurich, 1964

EXHIBITIONS:
Gimpel & Hanover Galerie, Zurich, July 3–August 22, 1964, *Movement,* no. 19, ill.
The Museum of Modern Art, New York, February 23–April 25, 1965, *The Responsive Eye,* no. 87, ill. p. 4; toured to City Art Museum of St. Louis, Missouri, May 20–June 20; Seattle Art Museum, July 15–August 23; Pasadena Art Museum, California, September 25–November 7; The Baltimore Museum of Art, December 14–January 23, 1966

SERGE POLIAKOFF (1906–1969)

Born Moscow, January 8, 1906. Left Russia, 1918; settled in Paris, 1923. Studied: Académie Frochot, and Académie de la Grande Chaumière, Paris, 1930–34; Chelsea School of Art, and Slade School of Fine Art, University College, London, 1935–36. Associated with Vassily Kandinsky, and Robert and Sonia Delaunay, Paris, 1937. One-man show, Galerie L'Esquisse, Paris, 1945. Exhibited, Salle du Centre des Recherches, Paris, from 1946. Awarded: Kandinsky Prize, Paris, 1947; Premio Internazionale di Pittura, Lissone, Italy, 1955. One-man shows: Gallery Tokanten, Copenhagen, 1948, 1949; Galerie Denise René, Paris, 1950; Galerie Dina Vierny, Paris, 1951; Palais des Beaux-Arts, Brussels,

1953; M. Knoedler & Co., New York, 1955, 1959; Palais des Beaux-Arts, Paris, 1958. Retrospective, Kestner-Gesellschaft, Hanover, and tour, 1963. One-man show: Venice Biennale, 1962; Württembergischer Kunstverein, Stuttgart, 1968; Théâtre Maison de la Culture, Caen, France, 1968. Died Paris, October 12, 1969. Memorial exhibition, Musée National d'Art Moderne, Paris, 1970.

Untitled. 1958.
Oil on canvas, 28¾ × 36¼ inches
Signed l. l.: "Serge Poliakoff"

PROVENANCE:
Theodore Schempp, New York, 1959

EXHIBITIONS:
American Federation of Arts tour, 1962–65, *Paintings from the Joseph H. Hirshhorn Foundation Collection: A View of the Protean Century,* no. 54, ill. p. 40

JACKSON POLLOCK (1912–1956)

Paul Jackson Pollock, born Cody, Wyoming, January 28, 1912. Moved with family to Arizona and California, then settled in Los Angeles, 1925. Attended Manual Arts High School, Los Angeles, intermittently, 1928, 1929–30. Joined older brothers in New York, 1930. Studied: The Art Students League of New York, with Thomas Hart Benton, 1930–33; briefly with John Sloan, and Robert Laurent. Continued association with Benton, through 1937. One painting shown, The Brooklyn Museum Annual, New York, 1935. WPA Federal Art Project, Easel Division, intermittently, 1935–43. Participated in David Alfaro Siqueiros's "experimental workshop," New York, 1936. Included in "American and French Paintings," organized by John Graham, McMillen Gallery, New York, 1942. Custodian, Museum of Non-Objective Painting, New York, for several months, 1943. Mural commissioned, Peggy Guggenheim's New York home, 1943. One-man shows: Peggy Guggenheim's Art of This Century, New York, 1943–47; San Francisco Museum of Art, 1945; The Arts Club of Chicago, 1945. Studied printmaking, S. W. Hayter's Atelier 17, New York, 1944–45. Married Lee Krasner, and moved to Springs, New York, 1945. Included in: Whitney Annual, 1946–54; "Large Scale Paintings," and "Fifteen Americans," The Museum of Modern Art, New York, 1947, 1952; Venice Biennale, 1950; I São Paulo Bienal, 1951; Pittsburgh International, 1952, 1955; "Younger American Painters," The Solomon R. Guggenheim Museum, New York, 1954; "The New American Painting," The Museum of Modern Art, and European tour, 1958–59. One-man shows: Betty Parsons Gallery, New York, 1948–51; Galleria del Naviglio, Milan, 1950; Bennington College, Vermont, 1952; Sidney Janis Gallery, New York, 1952, 1953, 1955; Kunsthaus, Zurich, 1953; The Museum of Modern Art, 1956–57. Died Springs, August 11, 1956. Retrospectives: IV São Paulo Bienal, and tour, 1957–59; Kunsthaus, Zurich, 1961; Marlborough-Gerson Gallery, New York, 1964; The Museum of Modern Art, 1967.

Water Figure. 1945.
Oil on canvas, 71½ × 29 inches
Signed l. l.: "Jackson Pollock"
on stretcher: "11–45
Jackson Pollock"

PROVENANCE:
Peggy Guggenheim, Art of This Century, New York; Betty Parsons Gallery, New York; Mrs. Graydon Walker, Ridgefield, Connecticut; Mrs. Anne Bakewell Davis; Sotheby & Co., London, Sale, June 12, 1963, no. 100, ill. facing p. 43; Marlborough-Gerson Gallery, New York, 1964

EXHIBITIONS:
Art of This Century, New York, April 2–20, 1946, *Jackson Pollock*
Smith College Museum of Art, Northampton, Massachusetts, October 14–November 18, 1959, "Paintings from Smith Alumnae Collections," no. 45, ill. p. 103
Marlborough-Gerson Gallery, New York, January–February 1964, *Jackson Pollock,* no. 76, ill.

REFERENCES:
O'Connor, Francis V. *Jackson Pollock,* New York, The Museum of Modern Art, 1967, p. 38
Wolf, Ben. "By the Shores of Virtuosity," *The Art Digest,* 20, April, 15, 1946, p. 16

Number 3, 1949. 1949.
Oil and aluminum paint on canvas mounted on Masonite, 62 × 37¼ inches
Signed and dated: l. l. "Jackson Pollock"
l. r. "49"

PROVENANCE:
Betty Parsons Gallery, New York; Richard Romney, New York; Sotheby & Co., London, Sale, December 6, 1961, no. 42, ill. facing p. 27; Mr. and Mrs. David E. Bright, Beverly Hills, California; Frank Perls Gallery, Beverly Hills, 1967

EXHIBITIONS:
Betty Parsons Gallery, New York, November 21–December 10, 1949, *Jackson Pollock*
Frank Perls Gallery, Beverly Hills, California, January 11–February 7, 1951, *Seventeen Modern American Painters, The School of New York*
The Art Institute of Chicago, October 25–December 16, 1951, *60th Annual American Exhibition of Painting and Sculpture,* no. 133, ill.
Los Angeles County Museum of Art, April 24–May 19, 1963, *Contemporary American Art*
Marlborough-Gerson Gallery, New York, January–February 1964, *Jackson Pollock,* no. 92, ill.
M. Knoedler & Co., Paris, October 18–November 25, 1967, *Six Peintres américains,* cat., ill.

REFERENCES:
O'Connor, Francis V. *Jackson Pollock,* New York, The Museum of Modern Art, 1967, p. 48
Robinson, Amy. "Reviews and Previews: Jackson Pollock," *Art News,* 48, December 1949, p. 43

Number 25, 1950. 1950.
Encaustic on canvas, 10 × 37⅞ inches
Signed and dated l. r.: "J. Pollock '50"

PROVENANCE:
Betty Parsons Gallery, New York; Private collection, New York; Harold Diamond, New York, 1963

EXHIBITIONS:
Betty Parsons Gallery, New York, November 28–December 16, 1950, *Jackson Pollock*
Smithsonian Institution, Washington, D.C., September 26, 1971–January 31, 1972, *One Hundred and Twenty-Fifth Anniversary of the Institution*

REFERENCES:
O'Connor, Francis V. *Jackson Pollock*, New York, The Museum of Modern Art, 1967, p. 56

Collage and Oil. 1951.
Collage, oil, and string on board, 41 × 31 inches
Signed and dated l. r.: "Jackson Pollock/51"

PROVENANCE:
Lee Krasner Pollock, New York; Sidney Janis Gallery, New York, 1961

EXHIBITIONS:
Sidney Janis Gallery, New York, November 3–29, 1958, *Jackson Pollock*, no. 29, ill.
The Brooklyn Museum, New York, February 8–April 5, 1965, *Paintings from the Joseph H. Hirshhorn Foundation Collection: A View of the Protean Century*, no. 87
Sidney Janis Gallery, New York, January 7–31, 1970, *String and Rope*, no. 9, ill.

REFERENCES:
Janis, Harriet, and Blesh, Rudi. *Collage: Personalities, Concepts, Techniques*, Philadelphia, Chilton, 1967, ill. p. 161
Rasmussen, Henry, and Grant, Art. *Sculpture from Junk*, New York, Reinhold, 1967, p. 89, ill.

ARNALDO POMODORO (b. 1926)

Born Morciano di Romagna, Italy, June 23, 1926. Studied architecture, stage design, jewelry making. One-man shows: Galleria Numero, Florence, 1954; Galleria Montenapoleone, Milan, 1954; Galleria del Cavallino, Venice, 1955, 1956; Galleria dell'Obelisco, Rome, 1957; Galleria del Naviglio, Milan, 1955, 1958; Galleria Bonino, Buenos Aires, 1957; Galleria Il Prisma, Turin, 1957; Galerie Helios Art, Brussels, 1958; Galerie 22, Düsseldorf, 1958; Kunstverein, Cologne, 1958, 1965, 1969; Galerie Internationale d'Art Contemporain, Paris and Brussels, 1959, Paris, 1962. Included in: Venice Biennale, 1956; Pittsburgh International, 1958, 1961, 1964, 1967 (Sculpture Award), 1970; Documenta II, Kassel, 1959. Awarded: first prize, "Scultura nella città," Festival dei Due Mondi, Spoleto, Italy, 1960; International Sculpture Prize, VII São Paulo Bienal, 1963; Italian Sculpture Prize, Venice Biennale, 1964. Organized "New York from Italy," Bolles Gallery, San Francisco, and tour, 1961. Exhibited with brother, Giò: Musée de l'Athénée, Geneva, 1962; Palais des Beaux-Arts, Brussels, 1963. One-man shows: Felix Landau Gallery, Los Angeles, 1962; Marlborough Galleria d'Arte, Rome, Marlborough Gallery, New York, Marlborough Fine Art, London, from 1965; Museum Boymans-van Beuningen, Rotterdam, The Netherlands, 1969; University of California, Berkeley, and tour, 1970–71; Galerie Otto Stangl, Munich, 1972. Taught: Stanford University, California, 1966–67; University of California, Berkeley, 1968, 1970. Has lived in Milan, since 1954.

Homage to a Cosmonaut (Omaggio al cosmonauta). 1962.
Bronze, 62½ × 62½ × 18 inches
Markings: back l. l. "A.P. 62"

PROVENANCE:
Marlborough Galleria d'Arte, Rome, 1963

REFERENCES:
Dorfles, Gillo. "Arnaldo Pomodoro: Sculptor of the Cosmos," *Studio International*, 167, April 1964, ill. pp. 144, 145
Unsigned. *Arnaldo Pomodoro*, Rome, Marlborough Galleria d'Arte, 1965, ill. p. 18

The Traveler's Column (La Colonna del viaggiatore). 1962.
Bronze, 99½ × 15 × 15 inches

PROVENANCE:
Marlborough Galleria d'Arte, Rome, 1964

EXHIBITIONS:
XXXII Biennale Internazionale d'Arte, Venice, June 20–October 18, 1964, *Central Pavilion*, no. 1, p. 73
Marlborough-Gerson Gallery, New York, October 14–November 13, 1965, *Arnaldo Pomodoro*, no. 10, ill.

REFERENCES:
Museum Boymans-van Beuningen. *Arnaldo Pomodoro: An Over-all View of His Work 1959–1969*, Rotterdam, The Netherlands, 1969, nos. 9, 10, ill.
Unsigned. "Sculpture: Dissatisfied Aristotle," *Time*, 86, December 3, 1965, colorplate p. 75

Sphere Number 6 (Sfero numero 6). 1963–65.
Bronze (edition of two), diameter 47½ inches

PROVENANCE:
Marlborough-Gerson Gallery, New York, 1965

EXHIBITIONS:
Marlborough-Gerson Gallery, New York, October 14–November 13, 1965, *Arnaldo Pomodoro*, no. 14, ill.

REFERENCES:
Del Renzio, Toni. "Arnaldo Pomodoro: Invention of a Sculptural Style," *Art International*, 12, Summer 1968, ill. p. 98

GIÒ POMODORO (b. 1930)

Born Orciano di Pesaro, Italy, November 17, 1930; younger brother of Arnaldo. Studied, Technical Institute, Pesaro. First small silver reliefs and jewelry, 1950. One-man shows: Galleria Numero, Florence, 1954; Galleria

dell'Obelisco, Rome, 1955; Galleria del Cavallino, Venice, 1955, 1956; Galleria del Naviglio, Milan, 1955, 1965; Galleria Bonino, Buenos Aires, 1957; Galerie Helios Art, Brussels, 1958; Galerie 22, Düsseldorf, 1958; Kunstverein, Cologne, 1958; Galerie Rothe, Heidelberg, 1958; Galerie Internationale d'Art Contemporain, Paris and Brussels, 1959, Paris, 1961. Included in: Venice Biennale, 1956; Documenta II and III, Kassel, 1959, 1964. Awarded: Sculpture Prize, Iᵉ Biennale de Paris, 1959; Bright Award, Venice Biennale, 1962. Exhibited with Arnaldo: Musée de l'Athénée, Geneva, 1962; Palais des Beaux-Arts, Brussels, 1963. One-man shows: Galleria Blu, Milan, 1962, 1970; Marlborough-Gerson Gallery, New York, and Marlborough Galleria d'Arte, Rome, 1964, 1967; Dom-Galerie, Cologne, 1965; Von der Heydt-Museum, Wuppertal, Germany, 1966; Galleria d'Arte Rampa, Naples, 1968; Galerie de France, Paris, 1968; Galleria dell'Ariete, Milan, 1968, 1971; Galerie Pierre, Stockholm, 1969; Felix Landau Gallery, Los Angeles, 1969; Martha Jackson Gallery, New York, from 1969; Galerie Françoise Mayer, Brussels, 1971. Has lived in Milan, since 1954.

Matrix I (Matrice I). 1962.
Bronze (edition of three), 62½ × 36 × 28 inches

PROVENANCE:
Marlborough Galleria d'Arte, Rome, 1963

Opposition (Opposizione). 1968.
Fiberglas with metallic paint, 6 feet 6⅛ inches × 12 feet 5½ inches × 1 foot 5 inches

PROVENANCE:
Galleria dell'Ariete, Milan, 1968

EXHIBITIONS:
Galleria dell'Ariete, Milan, June 1968, *Giò Pomodoro*

FRANÇOIS POMPON (1855–1933)

Born Saulieu, France, May 9, 1855. Studied, École Nationale des Beaux-Arts, Dijon, France, 1870. Moved to Paris, 1875: carved marble decorations for buildings and funerary monuments; studied evenings, École Nationale Supérieure des Arts Décoratifs. Assistant in ateliers of Antonin Mercié, Charles René de Saint-Marceaux, Jean-Alexandre-Joseph Falguière. Portraits exhibited, Paris: Salon of 1879, 1881–83, 1885, 1886, 1888 (medal of the Third Class); Exposition Universelle de 1889 (honorable mention), 1900 (Bronze Medal). Foreman and carver, Auguste Rodin's atelier, c. 1891–1906; worked on small figures for *The Gates of Hell*. Primarily a sculptor of animals, from 1906. *White Bear* acclaimed, Salon d'Automne, Paris, 1922. Chevalier, Légion d'honneur, 1926. Died Paris, May 6, 1933. Contents of his studio willed to France; over three hundred works placed in Musée Pompon, Jardin des Plantes, Paris. Posthumous exhibitions: Brummer Gallery, New York, 1937; Galerie Bernard Lorenceau, Paris, 1962; Acquavella Galleries, New York, 1970–71. Retrospective, Musée des Beaux-Arts, Dijon, 1964.

Sleeping Rooster (Le Coq dormant). 1923.
Bronze (edition of six), 9 × 12½ × 4¾ inches
Markings: top of base "Pompon"
 l. side of base "Cire Perdue C. Valsuani"

PROVENANCE:
Parke-Bernet Galleries, New York, Sale 2034, April 26, 1961, no. 29, ill.

Carrier Pigeon (Pigeon Voyageur). 1926.
Bronze (edition of six), 12 × 10½ × 4½ inches
Markings: top of base "Pompon"
 l. side of base "Cire Perdue C. Valsuani"

PROVENANCE:
Parke-Bernet Galleries, New York, Sale 2240, December 11, 1963, no. 27, ill.

ANTOINE PONCET (b. 1928)

Born Paris, May 5, 1928, son of painter Marcel Poncet (1894–1953). Studied, École Cantonale des Beaux-Arts, Lausanne, 1942–45; assisted father with stained glass and mosaic work. Encouraged to become sculptor by Germaine Richier; studied, Académie de la Grande Chaumière, Paris, with Ossip Zadkine, 1946. Met Henri Laurens, and Constantin Brancusi, 1951; settled in studio of maternal grandfather, Maurice Denis, St.-Germain-en-Laye, near Paris. Assistant to Jean Arp, 1952–55. Included in: Salon de la Jeune Sculpture, Salon des Réalités Nouvelles, Salon de Mai, Paris, regularly, 1950s to early 1960s; Venice Biennale, 1956. Sculpture and stained glass commissioned, church, Baccarat, France, 1955. One-man shows: Kunstmuseum, Winterthur, Switzerland, 1954; Galerie Iris Clert, Paris, 1959; Galerie Roque, Paris, 1960, 1962; Brook Street Gallery, London, 1962; Galerie Marbach, Bern, 1965, and Paris, 1966. Lives in St.-Germain-en-Laye.

Cororeol. 1966.
Aluminum, 80½ × 41 × 13 inches
Markings: front l. c. "Poncet 1966 1/4"

PROVENANCE:
Galerie Europe, Paris, 1966

LARRY POONS (b. 1937)

Lawrence Poons, born Tokyo, October 1, 1937, of American parents. Moved with family to the U.S., 1938. Studied, Boston: New England Conservatory of Music, 1955–57; School of the Museum of Fine Arts, 1958. One-man shows, The Green Gallery, New York, 1963–65. Included in: "Formalists," Washington [D.C.] Gallery of Modern Art, 1963; Pittsburgh International, 1964, 1967; "Young America 1965," Whitney Museum of American Art, New York, 1965; VIII São Paulo Bienal, 1965; Whitney Annual, from 1965; "The Responsive Eye," The Museum of Modern Art, New York, and tour, 1965–66; "Plus by Minus: Today's Half-Century," Albright-Knox Art Gallery, Buffalo, New York, 1968; Documenta 4, Kassel, 1968; "The Art of the Real," The Museum of Modern Art, International Circulating Exhibition, 1968–69; Whitney Biennial, 1973. Taught: The Art Students League of New York,

1966–70; visiting lecturer, New York Studio School, 1967–72. One-man shows: Leo Castelli Gallery, New York, 1967, 1968; Kasmin Gallery, London, 1968, 1971; The David Mirvish Gallery, Toronto, 1969, 1972; Lawrence Rubin Gallery, New York, 1970–72. Lives in New York.

Sicilian Chance. 1964.
Acrylic on canvas, 6 feet × 12 feet ¼ inch

PROVENANCE:
The Green Gallery, New York, 1964

EXHIBITIONS:
The Green Gallery, New York, February 10–March 6, 1965, *Larry Poons*
VII Bienal de Arte Moderna, São Paulo, September 4–November 28, 1965, *United States Representation*, no. 37, ill.; toured to National Collection of Fine Arts, Smithsonian Institution Washington, D.C., January 27–March 6, 1966
The Art Institute of Chicago, August 19–October 16, 1966, *68th American Exhibition*, no. 15
Grand Palais, Paris, November 14–December 23, 1968, *L'Art du Réel USA 1948–1968* (The Museum of Modern Art, New York, International Circulating Exhibition), no. 38, ill. p. 55; toured to Kunsthaus, Zurich, January 18–February 16, 1969, no. 37, ill. p. 79; The Tate Gallery, London, April 24–June 1, no. 38, ill. p. 40

REFERENCES:
Bowling, Frank. "Problems of Criticism I-II-III-IV-V-VI," *Arts Magazine*, 46, May 1972, ill. p. 34
Goodrich, Lloyd, intro. *The Artist in America*, New York, Norton, 1967, p. 239, ill.
Hopps, Walter. "United States Exhibit, São Paulo Bienal," *Art in America*, 53, October–November 1965, ill. p. 82
Judd, Don. "New York Letter," *Art International*, 9, April 1965, pp. 74–75
Kozloff, Max. "Larry Poons," *Artforum*, 3, April 1965, ill. p. 28
Tillim, Sidney. "Larry Poons: The Dotted Line," *Arts Magazine*, 39, February 1965, ill. p. 20
Tuchman, Phyllis. "An Interview with Larry Poons," *Artforum*, 9, December 1970, p. 47, ill.

Via Regia. 1964.
Acrylic on canvas, 6 feet ⅛ inch × 12 feet

PROVENANCE:
The Green Gallery, New York, 1964

EXHIBITIONS:
The Green Gallery, New York, February 10–March 6, 1965, *Larry Poons*
Leo Castelli Gallery, New York, October 2–November 15, 1965, *Americans*
Whitney Museum of American Art, New York, December 8, 1965–January 30, 1966, *1965 Annual Exhibition of Contemporary American Painting*, no. 105, ill.
The Art Institute of Chicago, August 19–October 16, 1966, *68th American Exhibition*, no. 15, ill.
The Corcoran Gallery of Art, Washington, D.C., February 24–April 9, 1967, *30th Biennial Exhibition of Contemporary American Painting*, no. 68

REFERENCES:
Goldin, Amy. "Requiem for a Gallery," *Arts Magazine*, 40, January 1966, p. 29, ill.
Jacobs, Jay. "Collector: Joseph H. Hirshhorn," *Art in America*, 57, July–August 1969, p. 64, colorplate
——. "Quality as Well as Quantity: Joseph H. Hirshhorn," in Lipman, Jean, ed. *The Collector in America*, New York, Viking, 1971, p. 86, colorplate
Judd, Don. "New York Letter," *Art International*, 9, April 1965, ill.
Lippard, Lucy R. "Larry Poons: The Illusion of Disorder," *Art International*, 11, April 1967, p. 25

FAIRFIELD PORTER (b. 1907)

Born Winnetka, Illinois, June 10, 1907. Studied: Harvard University, Cambridge, Massachusetts, B.S., 1928; The Art Students League of New York, with Thomas Hart Benton, and Boardman Robinson, 1928–30. First one-man show, Community House, Winnetka, 1939. Editorial associate, *Art News*, 1950s, 1960s; author of *Thomas Eakins* (New York, Braziller), 1959, and of articles in *The Nation*, *Art in America*, *Evergreen Review*. Member, International Association of Art Critics. One-man shows: Tibor de Nagy Gallery, New York, 1952–70; Museum of Art, Rhode Island School of Design, Providence, 1959; University of Southern California, School of Design, Los Angeles, 1963; University Galleries, Southern Illinois University, Carbondale, 1964; Reed College, Portland, Oregon, 1965; The Cleveland Museum of Art, 1966; Kent State University, Ohio, 1967; Swarthmore College, Pennsylvania, 1967; Parrish Art Museum, Southampton, New York, 1972; Hirschl & Adler Galleries, New York, 1972. Included in Venice Biennale, 1968. Lives in Southampton.

Katie and Anne. 1955.
Oil on canvas, 80½ × 62½ inches
Signed and dated l. r.: "Fairfield Porter '55"

PROVENANCE:
Tibor de Nagy Gallery, New York, 1962

EXHIBITIONS:
Tibor de Nagy Gallery, New York, March 27–April 21, 1956, *Fairfield Porter*
Guild Hall, East Hampton, New York, August 23–September 12, 1959, *Painters, Sculptors, and Architects of the Region*, no. 1
University Galleries, Southern Illinois University, Carbondale, November 1–27, 1964, *Fairfield Porter*, p. 3
The Cleveland Museum of Art, August 9–September 11, 1966, *The Genre Art of Fairfield Porter*

REFERENCES:
Mellow, James R. "In the Galleries: Fairfield Porter," *Arts*, 30, April 1956, p. 58, ill.
The New York Times Book Review, October 20, 1963, ill. p. 46
Unsigned. "Color Spectacle, the Human Figure Returns in Separate Ways and Places," *Life*, 52, June 8, 1962, colorplate p. 55

———. "Chelovek v zhivopisi nashih dney (Painting Today: The Human Figure)," *Amerika* (America Illustrated, U.S.I.A., Russian ed.), no. 84, September 1963, colorplate p. 39
———. "Nawrót do malarstwa figuralnego (Painting Today: The Human Figure)," *Ameryka* (America Illustrated, U.S.I.A., Polish ed.), no. 56, August 1963, colorplate p. 17

"Though I painted *Katie and Anne* seventeen years ago, I can identify with and recall the process of painting it. I think that learning to paint—which, having started, one continues all one's life—is very much a matter of having the energy to put aside almost all that one has been told, especially all that one thought important, in favor of trusting the process by watching it closely. I try to get rid of irrelevant conscientiousness which expresses what is outside of and unrelated to the painting in question. This one went easily, and it seemed 'finished' almost from the beginning, in a way I think Whistler meant. This eliminates a tiresome process of continual correcting, and it is easier to achieve an organic whole. But when I last saw it, a few years ago, I found it perhaps too thin, that is to say, unsubstantial: I hadn't trusted the materiality of the paint enough, out of a cautious desire to keep an easiness. So I must also put aside what Whistler told me."

Statement by the artist, 1972

EDWARD POTTHAST (1857–1927)

Edward Henry Potthast, born Cincinnati, Ohio, June 10, 1857. Lithographer's apprentice, Cincinnati, 1874–79. Studied: Art Academy of Cincinnati, 1879–87; Antwerp, Munich, Paris, 1887–90. Returned to Cincinnati. Worked as illustrator: Cincinnati, 1891; *Harper's*, New York, 1892. Included in Pennsylvania Academy Annual, 1896–1927. National Academy of Design, New York: Clarke Prize, 1899; associate, 1899; academician, 1906. Awarded: Evans Prize, American Watercolor Society, 1901; Silver Medal, St. Louis International Exposition, Missouri, 1904; Inness Prize, Salmagundi Club, New York, 1905. Member, Society of American Artists, 1902. Included in "Contemporary American Painters," Macbeth Gallery, New York, 1915. Awarded Silver Medal, Panama-Pacific International Exposition, San Francisco, 1915. Member, New York: American Watercolor Society, Water Color Club, Lotos Club. Died New York, March 9, 1927. Memorial exhibition, Grand Central Art Galleries, New York, 1928.

Enchanted. n.d.
Watercolor on paper, 21¾ × 25⅞ inches
Signed l. r.: "E. Potthast"

PROVENANCE:
Louise Weidman, Columbus, Ohio; Ira Spanierman, New York, 1966

Beach Scene. c. 1916–20.
Oil on canvas, 24 × 30 inches
Signed l. l.: "E. Potthast"

PROVENANCE:
Washington Irving Gallery, New York, 1960

RICHARD POUSETTE-DART (b. 1916)

Born St. Paul, Minnesota, June 8, 1916; son of artist/writer Nathaniel Pousette-Dart. Moved to Valhalla, New York, 1918. Studied, Bard College, Annandale-on-Hudson, New York, 1936. Lived in New York, 1938–50. One-man shows, New York: The Artists' Gallery, 1941; Willard Gallery, 1943, 1945, 1946; Peggy Guggenheim's Art of This Century, 1947; Betty Parsons Gallery, 1948–61, 1964, 1967. Included in: Whitney Annual, 1949–72; "Abstract Painting and Sculpture in America," The Museum of Modern Art, New York, 1951; "The New Decade," Whitney Museum of American Art, New York, and tour, 1955; "American Abstract Expressionists and Imagists," The Solomon R. Guggenheim Museum, New York, 1961. Received: Guggenheim Foundation Fellowship, 1951; Ford Foundation Grant, 1959. Moved to Suffern, New York, 1958. Taught: New School for Social Research, New York, 1959–61; The School of Visual Arts, New York, 1965. Retrospective, Whitney Museum of American Art, 1963. Included in: "New York School: The First Generation: Paintings of the 1940s and 1950s," Los Angeles County Museum of Art, 1965; "The New American Painting and Sculpture: The First Generation," The Museum of Modern Art, 1969. One-man shows: Washington University, St. Louis, Missouri, 1969; The Museum of Modern Art, Circulating Exhibition, 1969; Obelisk Gallery, Boston, 1970. Lives in Suffern.

Cavernous Earth with 27 Folds of Opaqueness. 1961–64.
Oil on canvas, 6 feet 7½ inches × 9 feet 7 inches
Signed and dated on back: "Richard Pousette-Dart '61–'64"

PROVENANCE:
Betty Parsons Gallery, New York, 1967

EXHIBITIONS:
Betty Parsons Gallery, New York, November 14–December 2, 1967, *Richard Pousette-Dart*
Whitney Museum of American Art, New York, December 13, 1967–February 4, 1968, *1967 Annual Exhibition of Contemporary American Painting*, no. 117

REFERENCES:
Lippard, Lucy R. "New York Letter," *Art International*, 9, February 1965, p. 32

HIRAM POWERS (1805–1873)

Born on farm near Woodstock, Vermont, July 29, 1805. Moved with family to Cincinnati, Ohio, 1819. In Cincinnati: worked as mechanic, Watson's clock and organ factory, 1822–28; learned techniques of clay modeling, from German sculptor Frederick Eckstein, 1823; became supervisor, mechanical department, Dorfeuille's Western Museum (of waxworks and other curiosities), 1828. Encouraged in career by English author Frances Trollope, and Cincinnati ˙patron Nicholas Longworth. Visited New York, 1829. Moved to Washington, D.C.,

1834; made portrait busts of President Andrew Jackson, and Chief Justice John Marshall, 1835. Traveled to Europe; settled in Florence, 1837. Assisted by Italian craftsmen, produced portrait busts and idealized statues in the style of classical Greek and Roman sculpture. Honorary member, National Academy of Design, 1838. Exhibited: Royal Academy of Arts, London, 1841–67; National Academy Annual, 1843, 1853. Famed *Greek Slave* completed, 1843; replica toured the U.S., late 1840s, 1850s; another included in "The Great Exhibition," Crystal Palace, London, 1851. Statues of Benjamin Franklin and Thomas Jefferson purchased by Congress for U.S. Capitol, Washington, D.C., 1859. Died Florence, June 27, 1873.

Proserpine. c. 1849–50.
White marble (second version), 25 × 18½ × 10 inches
Markings: back l. c. "H. Powers Sculp."

PROVENANCE:
Private collection, London; Bernard Black Gallery, New York, 1966

EXHIBITIONS:
Bernard Black Gallery, New York, Spring 1966, *Sculpture for a Small Museum*, no. 17, ill.

In mythology, Proserpine was queen of the lower world and of the shades of the dead.

Powers's bust of Proserpine was so popular among American and English collectors that his workshop was besieged by orders for replicas of the statue. This marble differs only slightly from the original: a border of acanthus leaves, a reference to Proserpine's annual emergence from the underworld, has been replaced by a more simple bead-and-leaf motif.

Powers also made a series of smaller versions, two-thirds the size of the original.

MAURICE PRENDERGAST (1859–1924)

Maurice Brazil Prendergast, born St. John's, Newfoundland, Canada, October 10, 1859. Moved with family to Boston, 1861. Traveled abroad, with brother Charles, 1886. Studied, Académie Julian, with Jean-Paul Laurens, and Joseph-Paul Blanc, and Académie Colarossi, Paris, 1891–94. Returned to Boston, 1894; managed frame shop, with Charles, 1894–97. One-man shows, Chase Gallery, Boston, 1897, 1899. Traveled to Italy, and France, 1898–99. Exhibited with Herman Dudley Murphy, The Art Institute of Chicago, 1900. Awarded Bronze Medal for Watercolor, Pan-American Exposition, Buffalo, New York, 1901. One-man shows: Cincinnati Art Museum, Ohio, 1901; Macbeth Gallery, New York, 1905. Included in "Exhibition of Eight American Painters," Macbeth Gallery, 1908. Lived in France, 1909–10. Exhibited, New York: Union League Club, 1912; Cosmopolitan Club, 1912; the Armory Show, 1913. Moved to New York, 1914; summered in New England, 1914–22. Exhibited, New York: with William Glackens, and John Marin, Bourgeois Galleries, 1917; with Charles Prendergast, Brummer Gallery, 1922. Awarded Corcoran Bronze Medal, and Third Clark Prize, Corcoran Biennial, 1923. Died New York, February 1, 1924. Memorial exhibition, The Cleveland Museum of Art, 1926. Retrospectives: Whitney Museum of American Art, New York, 1934; Museum of Fine Arts, Boston, and tour, 1960–61; M. Knoedler & Co., New York, 1966.

Beach at Saint-Malo. 1909.
Watercolor on paper, 13½ × 19⅞ inches
Signed l. c.: "Prendergast"

PROVENANCE:
Charles Prendergast, Westport, Connecticut; Mrs. Eugénie Prendergast, Westport; Kraushaar Galleries, New York, 1954

EXHIBITIONS:
Norton Gallery and School of Art, West Palm Beach, Florida, February 3–26, 1950, *Masters of Watercolor: Marin, Demuth, Prendergast*
The National Gallery of Canada, Ottawa, and tour, 1957, *Some American Paintings from the Collection of Joseph H. Hirshhorn*, no. 63
Greenwich Library, Connecticut, November 8–27, 1962, *American Painting from 1875–1925*

REFERENCES:
Unsigned. "Loan Collection at Arts Museum," *Montreal Gazette*, March 23, 1957

A Dark Day. c. 1910.
Oil on canvas, 21 × 27 inches
Signed l. l.: "Prendergast"

PROVENANCE:
Charles Prendergast, Westport, Connecticut; Mrs. Eugénie Prendergast, Westport; Kraushaar Galleries, New York, 1954

EXHIBITIONS:
The Brooklyn Museum, New York, November 24, 1943–January 16, 1944, *The Eight*, no. 49
The Cleveland Museum of Art, February 8–March 8, 1944, *The Eight* (The Museum of Modern Art, New York, Circulating Exhibition), no. 49; toured to The Columbus Gallery of Fine Arts, Ohio, March 15–April 12; Worcester Art Museum, Massachusetts, April 26–May 24; Carnegie Institute, Pittsburgh, June 7–July 5; The Baltimore Museum of Art, July 19–September 19; The Toledo Museum of Art, Ohio, October 1–29; Memorial Art Gallery, The University of Rochester, New York, November 10–December 18
The National Gallery of Canada, Ottawa, and tour, 1957, *Some American Paintings from the Collection of Joseph H. Hirshhorn*, no. 62
Davis Galleries, New York, March 10–April 4, 1959, *American Paintings*
American Federation of Arts tour, 1962–65, *Paintings from the Joseph H. Hirshhorn Foundation Collection: A View of the Protean Century*, no. 56

Beach at Gloucester. c. 1912–14.
Oil on canvas, 30½ × 43 inches
Signed l. l.: "Prendergast"

PROVENANCE:
Charles Prendergast, Westport, Connecticut; Mrs. Eugénie Prendergast, Westport; Kraushaar Galleries, New York, 1954

EXHIBITIONS:
The Harvard Society for Contemporary Art, Cambridge, Massachusetts, April–May 1929, *Maurice Prendergast*, no. 8
Whitney Museum of American Art, New York, February 20–March 22, 1934, *Maurice B. Prendergast Memorial Exhibition*, no. 123
The Art Institute of Chicago, June 1–November 11, 1934, *A Century of Progress Exhibition*, no. 459
Philadelphia Art Alliance, December 1936–January 1937, *Maurice Prendergast*
Addison Gallery of American Art, Phillips Academy, Andover, Massachusetts, September 24–November 6, 1938, *The Prendergasts*, no. 80
The Baltimore Museum of Art, January 12–February 11, 1940, *Modern Painting Isms and How They Grew*, cat.
Art Gallery of Toronto, November–December 1940, *Benefit Survey of Four Centuries*
The Renaissance Society at The University of Chicago, January 29–February 28, 1946, *Paintings by Maurice Prendergast with Watercolors by Charles Demuth and Carl Kahler*, no. 2
The Brooklyn Museum, New York, November 19, 1948–January 16, 1949, *The Coast and the Sea*, no. 93
Des Moines Art Center, Iowa, September–November 1949, *The Turn of the Century*, p. 6
Brandeis University, Waltham, Massachusetts, June 1–17, 1955, *Three Collections*, no. 34
Tweed Gallery, University of Minnesota, Duluth, April 1–30, 1956, *Collector's Choice*, cat.
Museum of Fine Arts, Boston, October 26–December 4, 1960, *Maurice Prendergast, 1859–1924*, no. 24, ill. p. 137; toured to Wadsworth Atheneum, Hartford, Connecticut, December 29–February 5, 1961; Whitney Museum of American Art, New York, February 21–April 2; California Palace of the Legion of Honor, San Francisco, April 22–June 3; The Cleveland Museum of Art, June 20–July 30
American Federation of Arts tour, 1962–65, *Paintings from the Joseph H. Hirshhorn Foundation Collection: A View of the Protean Century*, no. 57, ill. p. 26

REFERENCES:
Unsigned. "Art of America is Feature of Chicago's Great 1934 Exhibition," *Art Digest*, 8, June 1, 1934, p. 20
———. "The Brothers Prendergast in Review," *Art News*, 37, October 8, 1938, p. 19

Seated Girl. c. 1912–14.
Oil on canvas, 24 × 18½ inches

PROVENANCE:
Charles Prendergast, Westport, Connecticut; Mrs. Eugénie Prendergast, Westport; Kraushaar Galleries, New York, 1957

EXHIBITIONS:
The Brooklyn Museum, New York, November 24, 1943–January 16, 1944, *The Eight*, no. 47
The Renaissance Society at The University of Chicago, October 13–November 8, 1955, *Paintings by 11 American Pioneers of the 20th Century*, no. 24

REFERENCES:
Brown, Milton W. *American Painting from the Armory Show to the Depression*, New Jersey, Princeton, 1955, p. 60, ill.
Rhys, Hedley Howell. *Maurice Prendergast 1859–1924*, Cambridge, Massachusetts, Harvard, 1960, p. 70

GREGORIO PRESTOPINO (b. 1907)

Born New York, June 21, 1907. Studied, National Academy of Design, New York, with Charles Hawthorne, Ivan Olinsky, George Laurence Nelson, 1922–27. WPA Federal Art Project, Easel Division, New York, 1936. One-man shows, ACA Gallery, New York, 1943–57. Awarded: Pepsi-Cola Third Prize, "Portrait of America (Artists for Victory, Inc.)," 1945; Temple Gold Medal, Pennsylvania Academy Annual, 1946. Taught, New York: Veterans' Art Center, The Museum of Modern Art, 1946–48; The Brooklyn Museum Art School, 1946–49; New School for Social Research, 1949–66. Included in Whitney Annual, 1948, 1950, 1953, 1955. One-man shows, New York: Lee Nordness Galleries, 1959–64; Terry Dintenfass Gallery, 1966; Lerner-Misrachi Gallery, 1971. Received: The National Institute of Arts and Letters Grant, 1961; Altman Award, National Academy Annual, 1972. Painter-in-residence, American Academy in Rome, 1969. Lives in Roosevelt, New Jersey.

Supper in Bethlehem. 1945.
Oil on canvas, 32⅜ × 43¼ inches
Signed l. r.: "Prestopino"

PROVENANCE:
ACA Gallery, New York, 1946

EXHIBITIONS:
Whitney Museum of American Art, New York, December 10, 1946–January 16, 1947, *1946 Annual Exhibition of Contemporary American Painting*, no. 122

"*Supper in Bethlehem* relates to Bethlehem, Pennsylvania, the Bethlehem Steel plant there. The steelworker's home and family—the plant in the background and the steelworker going out on his night shift.

"In 1945, when this painting was done, my visual, aesthetic needs were satisfied by the opportunity to use the bold shapes and subtle color derived from this locale."

Statement by the artist, 1972

C. S. PRICE (1874–1950)

Clayton S. Price, born Bedford, Iowa, May 11, 1874. Moved to Wyoming, 1886. Worked as rancher, 1895–1905. Studied: The School of Fine Arts, Washington University, St. Louis, Missouri, 1905–6; painting, with Armin Hansen, Monterey, California, c. 1918–20. Traveled to Alberta, Canada, 1908. Illustrated western stories,

Pacific Monthly, Portland, Oregon, 1909–10. Lived in California, 1910–28; settled in Portland, 1928. WPA Federal Art Project, Mural Division, Portland, 1935–40. One-man shows: Beaux Arts Gallery, San Francisco, 1925; League of Fine Art, Berkeley, California, 1927; Oregon Society of Artists, Portland, 1929; Valentine Gallery, New York, 1945; Reed College, Portland, 1948; Willard Gallery, New York, 1949. Retrospective, Portland Art Museum, 1942. Included in: "The Monterey Group," Beaux Arts Gallery, 1927; "Fourteen Americans," The Museum of Modern Art, New York, 1946; "Ten Painters of the Pacific Northwest," Munson-Williams-Proctor Institute, Utica, New York, and tour, 1947–48. Died Portland, May 1, 1950. Memorial exhibitions: Oregon Journal Auditorium, Portland, 1950; Portland Art Museum, and tour, 1951.

Coastline. c. 1924.
Oil on canvas, 40 × 50½ inches
Signed l. l.: "C S PRICE"

PROVENANCE:
Mrs. August F. Gay, Carmel, California; Paul Kantor Gallery, Beverly Hills, California, 1964

EXHIBITIONS:
Portland Art Museum, Oregon, March 9–April 18, 1951, *C. S. Price 1894–1950, a Memorial Exhibition*, no. 11, ill. p. 27; toured to eight U.S. cities
Fine Arts Patrons of Newport Harbor, Balboa, California, February 8–March 19, 1967, *C. S. Price: The Man and His Works*, p. 14

KENNETH PRICE (b. 1935)

Born Los Angeles, February 16, 1935. Studied: Chouinard School of Art, Los Angeles, 1953–54; University of California at Los Angeles, 1955; University of Southern California, Los Angeles, B.F.A., 1957; Otis Art Institute, Los Angeles, 1957–58; State University of New York, College of Ceramics at Alfred University, Alfred, New York, M.F.A., 1959. One-man shows: The Art Galleries, University of California at Los Angeles, 1956; Ferus Gallery, Los Angeles, 1960, 1962, 1964; Kasmin Gallery, London, 1968, 1970; Whitney Museum of American Art, New York, 1969; Mizuno Gallery, Los Angeles, from 1969; Gemini G.E.L., Los Angeles, 1970; David Whitney Gallery, New York, 1971. Included in: "Fifty California Artists," Whitney Museum of American Art, 1962; "American Sculpture of the Sixties," Los Angeles County Museum of Art, and Philadelphia Museum of Art, 1967; "Abstract Expressionist Ceramics," University of California, Irvine, 1967; Whitney Annual, 1966, 1968, 1970. Lives in Los Angeles.

Orange. 1961.
Glazed ceramic on wooden base, 7½ × 5¼ × 5¼ inches

PROVENANCE:
Ferus Gallery, Los Angeles, 1961

REFERENCES:
Unsigned. "New Talent USA: Newly Nominated," *Art in America*, 52, August 1964, ill. p. 98

D. Black. 1961.
Glazed ceramic on wooden base, 9¼ × 5¼ × 5¼ inches

PROVENANCE:
Ferus Gallery, Los Angeles, 1961

MEL RAMOS (b. 1935)

Born Sacramento, California, July 25, 1935. Studied, California: San Jose State College, 1954–55; Sacramento State College, 1955–58, B.A., M.A. Included in Winter Invitational, California Palace of the Legion of Honor, San Francisco, 1959–61. One-man shows: Bianchini Gallery, New York, 1964, 1965; David Stuart Galleries, Los Angeles, 1965, 1967–69; Galerie Rolf Ricke, Kassel, 1966; California State College at Hayward, 1966–67; Galerie Tobiès & Silex, Cologne, 1967; San Francisco Museum of Art, 1967; Mills College Art Gallery, Oakland, California, 1968; French & Company, New York, 1971. Taught, California State College at Hayward, 1966–67. Lives in Oakland.

Kar Kween. 1964.
Oil on canvas, 60 × 48 inches
Signed and dated on back: "Mel Ramos 1964"

PROVENANCE:
Bianchini Gallery, New York, 1965

EXHIBITIONS:
Bianchini Gallery, New York, November 6–22, 1964, *Mel Ramos*
La Jolla Museum of Art, California, February 28–April 11, 1965, *Some Aspects of California Painting and Sculpture*, no. 58

ABRAHAM RATTNER (b. 1895)

Born Poughkeepsie, New York, July 8, 1895. Studied: George Washington University, and The Corcoran School of Art, Washington, D.C., 1913–14; The Pennsylvania Academy of the Fine Arts, Philadelphia, 1916–17. Served, U.S. Army, France, World War I. Returned to Pennsylvania Academy, 1919; received Cresson Traveling Fellowship. Toured Europe, 1920. Studied, Paris: École des Beaux-Arts, Académie de la Grande Chaumière, Académie Julian, Académie Ranson, 1921. Lived in Giverny, France, 1922. Established studio, Paris, 1923. Exhibited, Paris: Salon d'Automne, and Salon des Indépendants, 1924; Salon des Printemps, 1925. One-man shows: Galerie Jacques Bonjean, Paris, 1935; Julien Levy Gallery, New York, 1935, 1939, 1941. When Nazis invaded Paris, 1940, returned to the U.S.; toured the country, with Henry Miller. Settled in New York, 1941. One-man shows: Stendahl Galleries, Los Angeles, 1941; Paul Rosenberg & Co., New York, 1943–56; Philadelphia Art Alliance, 1945; The Baltimore Museum of Art, 1946; Santa Barbara Museum of Art, California, 1947; Vassar College, Poughkeepsie, 1948, 1952; University of Illinois, Urbana, 1952, 1955. Awarded: Temple Gold Medal, Pennsylvania Academy Annual, 1945; honorable mention, Carnegie Annual, 1949; Corcoran Gold Medal, and First Clark Prize, Corcoran Biennial,

1953. Taught: New School for Social Research, New York, 1948; Yale University, New Haven, Connecticut, and The Brooklyn Museum Art School, New York, 1949; Columbia University, New York, 1955–56. Artist-in-residence: American Academy in Rome, 1951; University of Illinois, Urbana, 1952. One-man shows: The Downtown Gallery, New York, 1957–66; The Corcoran Gallery of Art, Washington, D.C., 1958; American Federation of Arts, Traveling Exhibition, 1959–60; Pennsylvania Academy, 1966; Kennedy Galleries, New York, 1969, 1972; New School for Social Research, 1970. Member, The American Academy of Arts and Letters, 1958. Lives in New York, and in Paris.

The Bride. 1944.
Oil on canvas, 36½ × 32 inches
Signed l. l.: "Rattner"

PROVENANCE:
Paul Rosenberg & Co., New York, 1952

EXHIBITIONS:
Paul Rosenberg & Co., New York, September–October 1944, *Paintings by Abraham Rattner*
Society of The Four Arts, Palm Beach, Florida, January–February 1946, *Abstract and Expressionist Paintings*
Hamline University Galleries, St. Paul, Minnesota, September 1946, *Abraham Rattner*
California Palace of the Legion of Honor, San Francisco, October 1946, *Abraham Rattner*
The National Gallery of Canada, Ottawa, and tour, 1957, *Some American Paintings from the Collection of Joseph H. Hirshhorn*, no. 66, ill. 7
American Federation of Arts tour, 1959–60, *Ten Modern Masters of American Art*, no. 20

REFERENCES:
Leepa, Allen. *Abraham Rattner*, New York, Abrams, forthcoming, ill.
Riley, Maude. "Abraham Rattner Continues His Story," *Art Digest*, 19, October 1, 1944, p. 11
Unsigned. "The Passing Shows," *Art News*, 43, October 1–14, 1944, p. 23

ROBERT RAUSCHENBERG (b. 1925)

Born Port Arthur, Texas, October 22, 1925. Served as neuro-psychiatric technician, U.S. Navy, 1944–46. Studied: Kansas City Art Institute and School of Design, Missouri, 1946–47; Académie Julian, Paris, 1947; Black Mountain College, North Carolina, with Josef Albers, 1948–49; The Art Students League of New York, 1949–51. First one-man show, Betty Parsons Gallery, New York, 1951. Traveled to Europe, and North Africa, 1951–52. Artist-in-residence, Black Mountain College, 1952. Returned to New York, 1953. One-man shows: Stable Gallery, New York, 1953; Galleria d'Arte Contemporanea, Florence, 1953; Galleria dell' Obelisco, Rome, 1953; Egan Gallery, New York, 1955; Leo Castelli Gallery, New York, from 1958. Designed lighting, stage sets, and costumes, and performed: Merce Cunningham Dance Company, 1955–64; Yvonne Rainer's Surplus and Exchange Dance Theater, 1964; Judson Dance Theater, throughout mid-1960s. Included in: "Artists of the New York School: Second Generation," The Jewish Museum, New York, 1957; Festival dei Due Mondi, Spoleto, Italy, 1958; Pittsburgh International, 1958–67; "Sixteen Americans," The Museum of Modern Art, New York, 1959; V São Paulo Bienal, 1959; Documenta II–4, Kassel, 1959, 1964, 1968. One-man shows: Galerie Daniel Cordier, Paris, 1961; Galleria dell'Ariete, Milan, 1961; Galerie Ileana Sonnabend, Paris, 1963–64. Began extensive printmaking, 1962. Awarded: first prize, V International Print Exhibition, Ljubljana, Yugoslavia, 1963; First Prize for Painting, Venice Biennale, 1964. Retrospectives: The Jewish Museum, 1963; Whitechapel Art Gallery, London, 1964. One-man shows: The Museum of Modern Art, and European tour, 1964–65; Walker Art Center, Minneapolis, 1965; Stedelijk Museum, Amsterdam, 1968; Musée National d'Art Moderne, Paris, 1968; Fort Worth Art Center Museum, Texas, 1969; Newport Harbor Art Museum, Balboa, California, and tour, 1969–70; The Minneapolis Institute of Arts, and tour, 1970; Kunsthalle, Basel, 1971. Participated in "Nine Evenings: Theater and Engineering," 69th Regiment Armory, New York, 1966. Lives in New York, and in Captiva, Florida.

Dam. 1959.
Combine painting on canvas, 75½ × 61½ inches
Signed and dated on back: "Rauschenberg 1959"

PROVENANCE:
Leo Castelli Gallery, New York; G. David Thompson, Pittsburgh; Galerie Beyeler, Basel; Harold Diamond, New York, 1963

REFERENCES:
Forge, Andrew. *Rauschenberg*, New York, Abrams, 1969, p. 90, ill. p. 19

Rauschenberg's combine paintings of the mid- and late fifties incorporated actual objects such as stuffed birds, automobile tires, Coca-Cola bottles, and clothing. The introduction of such "inartistic" ingredients, and the use of art techniques previously employed only by mass-media artists, challenged the basic imperatives of Abstract Expressionism and anticipated the Pop Art movement of the sixties.

In the combine paintings, street and traffic signs, photographs, and newspaper and magazine clippings are silk-screened or mounted on canvas and wood. Although in many ways reminiscent of the collages and montages of an earlier generation, Rauschenberg's use of these techniques created a fresh and dynamic formal synthesis of object and idea.

Fossil for Bob Morris, N.Y. 1965.
Combine painting on canvas, 84½ × 60½ × 10 inches
Signed and dated on back: "Rauschenberg 1965"

PROVENANCE:
Leo Castelli Gallery, New York; Dwan Gallery, Los Angeles, 1967

EXHIBITIONS:
Whitney Museum of American Art, New York, December 8, 1965–January 30, 1966, *1965 Annual Exhibition of Contemporary American Painting*, no. 111, ill.

REFERENCES:
Forge, Andrew. *Rauschenberg*, New York, Abrams, 1969, p. 228
Forgey, Benjamin. "A Washington Art Survey: Striking and Surprising," *Washington [D.C.] Evening Star*, February 23, 1971, sec. B, p. 7, ill.
Rauschenberg, Robert. *Autobiography*, second panel of three-part color-offset lithograph, New York, Broadside Art, 1967
Seckler, Dorothy Gees. "The Artist Speaks: Robert Rauschenberg," *Art in America*, 54, May–June 1966, p. 77, ill.

The artist Robert Morris (b. 1931) works in diverse media including felt, cotton waste, Sculptmetal, earthworks, and designs in steam.

MARTIAL RAYSSE (b. 1936)

Born Golfe-Juan, France, February 12, 1936. One-man shows: Galerie Longchamp, Nice, 1957; Galerie Egmont, Brussels, 1959; Galleria Schwarz, Milan, 1961; Alexandre Iolas Gallery, Paris, and New York, from 1962; Dwan Gallery, Los Angeles, 1963, 1967; M. H. de Young Memorial Museum, San Francisco, 1963. Included in: Salon des Réalités Nouvelles, Paris, 1960; Salon de la Jeune Sculpture, Paris, 1960, 1963; "The Art of Assemblage," The Museum of Modern Art, New York, and tour, 1961–62; "The New Realists," Sidney Janis Gallery, New York, 1962; Biennale de San Marino, 1963; "Nieuwe Realisten," Gemeentemuseum, The Hague, 1964; "Pop, etc., etc.," Museum des 20. Jahrhunderts, Vienna, 1964; "Light/Motion/Space," Walker Art Center, Minneapolis, 1967. Designed costumes and sets, Roland Petit's ballets: *Eulogy of Folly*, 1965; *Paradise Lost*, 1967. One-man shows: Stedelijk Museum, Amsterdam, 1965; Palais des Beaux-Arts, Brussels, 1967; Museum of Contemporary Art, Chicago, 1968; Galerie Mathias Fels, Paris, 1970. Awarded Bright Foundation Prize, Venice Biennale, 1966. Included in Documenta 4, Kassel, 1968. Lives in Nice, in New York, and in Los Angeles.

Made in Japan. 1964.
Mixed media on canvas, 4 feet 3 inches × 8 feet 9 inches

PROVENANCE:
Dwan Gallery, Los Angeles, 1967

EXHIBITIONS:
Dwan Gallery, Los Angeles, May 31–June 24, 1967, *Martial Raysse*, p. 19, ill. p. 11, and colorplate cover
Museum of Contemporary Art, Chicago, March 2–April 7, 1968, *Martial Raysse*, no. 14

REFERENCES:
Hahn, Otto. "Martial Raysse ou la Beauté comme invention et délire," *Art International*, 10, Summer 1966, p. 83, ill.
Kultermann, Udo. *The New Painting*, New York, Praeger, 1969, p. 15, ill.
Sharp, Willoughby. "Martial Raysse," *Quadrum*, 17, 1964, p. 151, ill.

Like many neo-Dada and Pop artists of his generation, Raysse uses venerated masterpieces as a point of departure. In this painting his subject is Jean-Auguste-Dominique Ingres's *La Grande Odalisque* of 1814 (Musée du Louvre).

AD REINHARDT (1913–1967)

Adolph Frederick Reinhardt, born Buffalo, New York, December 24, 1913. Moved with family to New York, 1915. Studied, New York: Columbia University, with Meyer Schapiro, 1931–35; American Artists' School, with Carl Holty; National Academy of Design, with Karl Anderson, 1936. WPA Federal Art Project, Easel Division, New York, 1936–41. Member: Artists' Union, 1937–40; American Abstract Artists, 1937–47; founding member, The Club, 1948. One-man shows: The Artists' Gallery, New York, 1944; Betty Parsons Gallery, New York, from 1946; Galerie Iris Clert, Paris, 1960, 1964; Institute of Contemporary Art, London, 1964. Cartoonist and critic: *PM*, 1944–46; *Art News*, 1947–67. Specialized in Oriental studies, Institute of Fine Arts, New York University, 1946–50; traveled to: Greece, 1952; Japan, India, Iran, Egypt, 1958; Turkey, Syria, Jordan, 1961. Taught: Brooklyn College, New York, 1947–67; California School of Fine Arts, San Francisco, 1950; University of Wyoming, Laramie, 1951; Yale University, New Haven, Connecticut, 1952–53; New York University, 1955; Syracuse University, New York, 1957; Hunter College, New York, 1959–67. Included in: Whitney Annual, from 1947; "Abstract Painting and Sculpture in America," The Museum of Modern Art, New York, 1951; Pittsburgh International, 1955; "Abstract Expressionists and Imagists," The Solomon R. Guggenheim Museum, New York, 1961; "New York School: The First Generation: Paintings of the 1940s and 1950s," Los Angeles County Museum of Art, 1965; "Plus by Minus: Today's Half-Century," Albright-Knox Art Gallery, Buffalo, New York, 1968; Documenta 4, Kassel, 1968. Retrospectives, New York: Betty Parsons Gallery, 1960; James Graham and Sons, Stable Gallery, and Betty Parsons Gallery, 1965; The Jewish Museum, 1966–67. Died New York, August 30, 1967. Retrospective, Städtische Kunsthalle, Düsseldorf, and tour, 1972–73.

Number 88, 1950 (blue). 1950.
Oil on canvas, 6 feet 3 inches × 12 feet

PROVENANCE:
Marlborough-Gerson Gallery, New York, 1969

EXHIBITIONS:
Los Angeles County Museum of Art, June 16–August 1, 1965, *New York School: The First Generation: Paintings of the 1940s and 1950s*, no. 95, ill. p. 174
The Jewish Museum, New York, November 23, 1966–January 15, 1967, *Ad Reinhardt Paintings*, no. 46, ill.

REFERENCES:
Newman, Barnett. "The New York School Question," *Art News*, 64, September 1965, ill. p. 41
Tuchman, Maurice. *New York School: The First Generation*, Greenwich, Connecticut, New York Graphic Society, 1971, no. 103, ill. p. 135

"Fine art can only be defined as exclusive, negative, absolute and timeless. It is not practical, useful, related, applicable or subservient to anything else. Fine art has its own thought, its own history and tradition, its own reason, its own discipline. . . .

"Fine art is not 'a means of making a living' or 'a way of living a life.' Art that is a matter of life and death cannot be fine or free art. An artist who dedicates his life to art burdens his art with his life and his life with his art. 'Art is Art, and Life is Life.' . . ."

Excerpted from the artist's "Twelve rules for a new academy," *Art News*, 56, May 1957, p. 38

Number 90, 1952 (red). 1952.
Oil on canvas, 11 × 20 feet

PROVENANCE:
Marlborough-Gerson Gallery, New York, 1969

EXHIBITIONS:
Los Angeles County Museum of Art, June 16–August 1, 1965, *New York School: The First Generation: Paintings of the 1940s and 1950s*, no. 96, ill. p. 176
The Jewish Museum, New York, November 23, 1966–January 15, 1967, *Ad Reinhardt Paintings*, no. 61

REFERENCES:
Tuchman, Maurice. *New York School: The First Generation*, Greenwich, Connecticut, New York Graphic Society, 1971, ill. p. 135

Number 119, 1958 (black). 1958–62.
Oil on canvas, 84 × 75 inches
Signed and dated on back: "Ad Reinhardt 1958–1962"

PROVENANCE:
Betty Parsons Gallery, New York; Marlborough-Gerson Gallery, New York, 1969

EXHIBITIONS:
The Art Institute of Chicago, January 11–February 10, 1963, *66th Annual American Exhibition: Directions in Contemporary Painting and Sculpture*, no. 72, ill.
The Jewish Museum, New York, November 23, 1966–January 15, 1967, *Ad Reinhardt Paintings*, no. 113

REINHOUD (b. 1928)

Reinhoud d'Haese, born Grammont, Belgium, October 21, 1928; younger brother of sculptor Roël d'Haese. Studied: Collège des Jésuites, Aalst, Belgium; Institut National Supérieur d'Architecture et des Arts Visuels, Brussels, 1947–51. Included in second CoBrA exhibition, Musée des Beaux-Arts de la Ville de Liège, Belgium, 1951. One-man show, Galerie Taptoe, Brussels, 1956. Awarded Young Belgian Sculptor Prize, 1957. Moved to St.-Rémy-de-Provence, France, 1959. One-man shows: Galerie Smith, Brussels, 1959, 1964; Galerie de France, Paris, from 1959; Stedelijk Museum, Amsterdam, 1961; Rotterdamsche Kunstkring, Rotterdam, The Netherlands, 1961; Galerie Birch, Copenhagen, 1961, 1965, 1969; Lefebre Gallery, New York, from 1963; Museo Instituto Torcuato Di Tella, Buenos Aires, 1963; Galerie La Balance, Brussels, 1966, 1968. Included in: Salon de Mai, Paris, from 1960; VII São Paulo Bienal, 1963; Venice Biennale, 1966; Pittsburgh International, 1967, 1970. Has lived in La Bosse, France, since 1961.

Hopscotch (À cloche-pied). 1965.
Hammered and brazed brass sheets, 57¼ × 28 × 37 inches

PROVENANCE:
Lefebre Gallery, New York, 1967

EXHIBITIONS:
Lefebre Gallery, New York, October 10–November 4, 1967, *Reinhoud, Recent Sculptures*, cat.

REFERENCES:
De Heusch, Luc. *Reinhoud*, Turin, Pozzo, 1970, no. 72, colorplate

PIERRE-AUGUSTE RENOIR (1841–1919)

Born Limoges, France, February 25, 1841. Moved with family to Paris, 1845. Apprenticed to porcelain painter, 1854–58. Studied painting, École des Beaux-Arts, Paris, with Marc-Gabriel-Charles Gleyre, 1862–63. Painted in forest of Fontainebleau, with Claude Monet, Alfred Sisley, Frédéric Bazille, and others, from 1863. Paintings accepted, Salon of 1864, 1865, 1868, Paris; showed at Salon, intermittently, until 1890. Drafted, 1870; served in cavalry, Bordeaux, and the Pyrenees. Settled in Paris, 1872. Met Paul Durand-Ruel, who purchased several paintings, 1873; rented studio in Montmartre. Included in Salon des Refusés, 1873. Helped organize first Impressionist exhibition, 1874; exhibited with Impressionists, 1876, 1877. Modeled plaster and ceramic reliefs, 1875. One-man shows: Galerie Durand-Ruel, Paris, 1883, 1892, 1896, 1899; Durand-Ruel Galleries, New York, 1886. Légion d'honneur: chevalier, 1900; officier, 1912. Moved to Le Cannet, 1902. Retrospective, Salon d'Automne, Paris, 1904. Settled at Cagnes-sur-Mer, 1905. Interest in sculpture renewed by visit from Aristide Maillol, 1907; encouraged to continue sculpture by Ambroise Vollard. Retrospective, Galerie Bernheim-Jeune, Paris, 1913. Produced some twenty sculptures, with assistance of Richard Guino, student of Maillol, 1913–18. Died Cagnes-sur-Mer, December 3, 1919. Retrospectives: Salles de l'Orangerie, Paris, 1933; The Metropolitan Museum of Art, New York, 1937; "Renoir Centennial Exhibition," Duveen Brothers, New York, 1941; The Tate Gallery, London, 1953. Exhibited New York (sculpture): Buchholz Gallery, 1943; Charles E. Slatkin Galleries, 1962.

Small Venus Victorious, with base showing **The Judgment of Paris** 1913, base 1915.
Bronze, figure 23¾ × 12¼ × 7⅜ inches; base 9½ × 9 × 9½ inches

Markings: 1. back of foot "Renoir"
r. back near drapery "E"

PROVENANCE:
Ambroise Vollard, Paris; Galerie Renou & Poyet, Paris; Harold Diamond, New York, 1958

EXHIBITIONS:
The Detroit Institute of Arts, and tour, 1959–60, *Sculpture in Our Time*, no. 30, ill. p. 20
The Solomon R. Guggenheim Museum, New York, October 3, 1962–January 6, 1963, *Modern Sculpture from the Joseph H. Hirshhorn Collection*, no. 375, ill. p. 44

REFERENCES:
Hamilton, George Heard. *19th and 20th Century Art*, New York, Abrams, 1970, p. 99, ill. p. 101

Renoir's *Venus* holds an apple in one hand, symbolic of her triumph over Hera and Athena. The figure was completed in 1913; the relief for the base was begun two years later, after a drawing of 1908. Like most of Renoir's sculptures, the enlarged editions of *Venus* and the base were executed with the assistance of a young artist, Richard Guino.

Mme Renoir. 1916.
Bronze, 23½ × 19⅞ × 13½ inches
Markings: back l. l. "Renoir 8/20"
back l. r. "Cire Perdue C. Valsuani"

PROVENANCE:
Galerie Bignou, Paris; Curt Valentin Gallery, New York, 1955; World House Galleries, New York, 1959

EXHIBITIONS:
Curt Valentin Gallery, New York, June 8–30, 1955, *Closing Exhibition, Sculpture, Painting and Drawings*, no. 164
World House Galleries, New York, April 1–May 2, 1959, *Sculpture Annual*, no. 61
The Solomon R. Guggenheim Museum, New York, October 3, 1962–January 6, 1963, *Modern Sculpture from the Joseph H. Hirshhorn Collection*, no. 376, ill. p. 44

Boy with a Flute (Pipe Player). 1918.
Bronze relief, 24 × 17¼ × 2 inches
Markings: 1. r. "Renoir
Cire Perdue Valsuani Bronze 3/20"

PROVENANCE:
E. Bachmann, New York; Harold Diamond, New York, 1958

EXHIBITIONS:
The Detroit Institute of Arts, and tour, 1959–60, *Sculpture in Our Time*, no. 32
The Solomon R. Guggenheim Museum, New York, October 3, 1962–January 6, 1963, *Modern Sculpture from the Joseph H. Hirshhorn Collection*, no. 378

Dancer with a Tambourine I. 1918.
Bronze relief, 23¾ × 16⅜ × 1½ inches
Markings: 1. 1. "Renoir ⁸⁄₁₀"
1. r. side "Cire Perdue Valsuani"

PROVENANCE:
E. Bachmann, New York; Harold Diamond, New York, 1958

EXHIBITIONS:
The Detroit Institute of Arts, and tour, 1959–60, *Sculpture in Our Time*, no. 33
The Solomon R. Guggenheim Museum, New York, October 3, 1962–January 6, 1963, *Modern Sculpture from the Joseph H. Hirshhorn Collection*, no. 379

Head of a Woman. c. 1918.
Bronze, 12½ × 8½ × 13½ inches
Markings: back of neck "Renoir"
rear l. l. "Alexis Rudier Fondeur Paris"

PROVENANCE:
Curt Valentin Gallery, New York, 1955

EXHIBITIONS:
New York School of Social Work, Columbia University, March 27–May 1, 1957, *19th and 20th Century French Painting and Sculpture*
The Detroit Institute of Arts, 1959, *Sculpture in Our Time*, no. 31, ill. p. 21
The Solomon R. Guggenheim Museum, New York, October 3, 1962–January 6, 1963, *Modern Sculpture from the Joseph H. Hirshhorn Collection*, no. 377, ill. p. 44
Marlborough-Gerson Gallery, New York, November–December 1963, *Artist and Maecenas: A Tribute to Curt Valentin*, no. 22, ill. p. 32

GERMAINE RICHIER (1904–1959)

Born Grans, near Arles, France, September 16, 1904. Studied, École Régionale des Beaux-Arts, Montpellier, France, 1922–25. Moved to Paris, 1925; studied privately, with Émile-Antoine Bourdelle, 1925–29. One-man show, Galerie Max Kaganovitch, Paris, 1934. Awarded Sculpture Prize, Blumenthal Foundation, 1936. Lived in Switzerland, and southern France, 1939–45; settled in Paris, 1945. Exhibited with Marino Marini, and Fritz Wotruba, Kunsthalle, Basel, 1944–45. One-man shows: Anglo-French Art Centre, London, 1947; Galerie Maeght, Paris, 1948. Included in: Venice Biennale, 1948, 1952, 1954, 1958, 1960, 1964; I and II São Paulo Bienal, 1951 (Sculpture Prize), 1953; 2nd and 3rd Middelheim Biennale, Antwerp, 1953, 1955; Pittsburgh International, 1958; "New Images of Man," The Museum of Modern Art, New York, and The Baltimore Museum of Art, 1959–60. One-man shows: Allan Frumkin Gallery, Chicago, 1954; The Hanover Gallery, London, 1955, 1961. Exhibited with Maria Elena Vieira da Silva, Stedelijk Museum, Amsterdam, 1955. Moved to Provence, 1956. Retrospective, Musée National d'Art Moderne, Paris, 1956. One-man shows: Martha Jackson Gallery, New York, 1957, 1958; Walker Art Center, Minneapolis, 1958; School of Fine and Applied Arts, Boston University, 1959; Stedelijk Museum, 1959. Died Montpellier, July 31, 1959. Retrospective, Kunsthaus, Zurich, 1963.

Grain (Le Grain). 1955.
Bronze, 57 × 13½ × 12 inches
Markings: back l. r. "G. Richier"
back l. l. "C. Valsuani
Cire Perdue"

PROVENANCE:
Martha Jackson Gallery, New York, 1958

EXHIBITIONS:
Martha Jackson Gallery, New York, November 27–December 28, 1957, *Germaine Richier*
Walker Art Center, Minneapolis, September 28–November 9, 1958, *Sculpture by Germaine Richier*, no. 25
Martha Jackson Gallery, New York, November 27–December 27, 1958, *The Sculptures of Germaine Richier*, no. 17
School of Fine and Applied Arts, Boston University, January 10–February 7, 1959, *Sculpture by Germaine Richier*, no. 14
The Detroit Institute of Arts, and tour, 1959–60, *Sculpture in Our Time*, no. 196, ill. p. 87
The Solomon R. Guggenheim Museum, New York, October 3, 1962–January 6, 1963, *Modern Sculpture from the Joseph H. Hirshhorn Collection*, no. 384

REFERENCES:
Geist, Sidney. "Month in Review," *Arts*, 32, December 1957, p. 47, ill. p. 46

VJENCESLAV RICHTER (b. 1917)

Born Zagreb, Yugoslavia, April 18, 1917. Graduated from architecture school, Zagreb, 1949. Architect, Yugoslav Pavilion, Exposition Universelle et Internationale de Bruxelles, 1959. Included in: "Nouvelles Tendances," Musée des Arts Décoratifs, Paris, 1964; VIII São Paulo Bienal, 1965; Guggenheim International, 1967–68. One-man shows, 1968: Staempfli Gallery, New York; Museum of Art and Industry, Zagreb. Included in: "Plus by Minus: Today's Half-Century," Albright-Knox Art Gallery, Buffalo, New York, 1968; Venice Biennale, 1972. Lives in Zagreb.

Rasver III. 1968.
Aluminum, 59¼ × 14⅜ × 15⅛ inches

PROVENANCE:
Staempfli Gallery, New York, 1968

EXHIBITIONS:
Staempfli Gallery, New York, November 19–December 7, 1968, *Vjenceslav Richter*, no. 4

GEORGE RICKEY (b. 1907)

George Warren Rickey, born South Bend, Indiana, June 6, 1907. Moved with family to Scotland, 1913. Studied: Trinity College, Glenalmond, Scotland, 1921–26; Balliol College, Oxford, England, B.A., 1929, M.A., 1931; Ruskin School of Drawing and Fine Art, Oxford, 1928–29; Académie André Lhote, and Académie Moderne, Paris, 1929–30. Taught history, Groton School, Groton, Massachusetts, 1930–33. First one-man show, Caz-Delbo Gallery, New York, 1933. Lived in: Paris, 1933–34; New York, 1934–37. Carnegie artist-in-residence: Olivet College, Olivet, Michigan, 1937–39; Knox College, Galesburg, Illinois, 1940–41. Director, Kalamazoo Institute of Arts, Michigan, 1939–40. Served, U.S. Army Air Corps, 1942–45. Studied, Institute of Fine Arts, New York University, 1945–46. Taught: Indiana University, Bloomington, 1949–55; Newcomb College, Tulane University, New Orleans, 1955–61; Rensselaer Polytechnic Institute, Troy, New York, 1961–66. One-man shows (sculpture): John Herron Art Institute, Indianapolis, Indiana, 1953; Kraushaar Galleries, New York, 1955, 1959, 1961; Amerika Haus, Hamburg, 1957; Santa Barbara Museum of Art, California, 1960; Kunstverein für die Rheinlande und Westfalen, Düsseldorf, 1962; Institute of Contemporary Art, Boston, 1964; Staempfli Gallery, New York, from 1964; The Corcoran Gallery of Art, Washington, D.C., 1966; Museum Boymans-van Beuningen, Rotterdam, The Netherlands, 1969. Included in: "Bewogen-Beweging," Stedelijk Museum, Amsterdam, 1961; "Art Today: Kinetic and Optic," and "Plus by Minus: Today's Half-Century," Albright-Knox Art Gallery, Buffalo, New York, 1965,1968; "New Directions in Kinetic Art," University Art Museum, University of California, Berkeley, 1966; "Kinetic Art," Hayward Gallery, London, 1970. Publications include *Constructivism: Origins and Evolution* (New York, Braziller), 1967. Retrospective, University of California at Los Angeles, and tour, 1971–72. Member, The National Institute of Arts and Letters, 1974. Has lived in East Chatham, New York, since 1960.

Summer III. 1962–63.
Stainless steel kinetic construction, height 13 feet

PROVENANCE:
Kraushaar Galleries, New York, 1963

EXHIBITIONS:
Battersea Park, London, May–September 1963, *Sculpture in the Open Air* (The Museum of Modern Art, New York, International Circulating Exhibition), no. 34, plate 34

REFERENCES:
Gosling, Nigel. "Odd Shapes in the Park," *The Observer Weekend Review*, London, June 9, 1963
Levey, Michael. "The World of Art: Battersea Pleasures," *The Sunday Times*, London, June 9, 1963
Lucie-Smith, Edward. *Late Modern: The Visual Arts Since 1945*, New York, Praeger, 1969, ill. p. 178
Piene, Nan R. *George Rickey*, New York, Abrams, forthcoming, ill.
Read, Herbert. *A Concise History of Modern Sculpture*, New York, Praeger, 1964, no. 283, p. 302, ill. p. 241
Rickey, George. "The Morphology of Movement," *The Art Journal*, 22, Summer 1963, cover ill.
Selz, Peter. *George Rickey: Sixteen Years of Kinetic Sculpture*, Washington, D.C., The Corcoran Gallery of Art, 1966
Unsigned. "American and British Sculpture," *The Times*, London, May 30, 1963, p. 15
———. "Open Air Sculpture: LCC Display in Battersea Park," *The Builder*, June 7, 1963, p. 1134, ill.

Wallis, Nevile. "Lakeside Sculpture," *The Spectator*, London, June 7, 1963
Whittet, G. S. "Battersea Power Sculpture," *Studio*, 166, August 1963, ill. p. 52

Joe's Silver Vine. 1964.
Steel and sterling silver kinetic construction, 28½ × 11 × 10 inches

PROVENANCE:
The artist, East Chatham, New York, 1964

Three Red Lines. 1966.
Lacquered stainless steel kinetic construction, height 37 feet

PROVENANCE:
Partial gift of the artist, East Chatham, New York, 1967

EXHIBITIONS:
The Corcoran Gallery of Art, Washington, D.C., September 30–November 20, 1966, *George Rickey: Sixteen Years of Kinetic Sculpture*, no. 49
National Museum of History and Technology, Smithsonian Institution, Washington, D.C., 1967–73, extended loan

REFERENCES:
Aarons, Leroy. "Gallery Lawn Gets a Whatsit," *The Washington [D.C.] Post*, September 1966, ill.
Piene, Nan R. *George Rickey*, New York, Abrams, forthcoming, ill.
Unsigned. "Engineer of Movement," *Time*, 88, November 4, 1966, colorplate p. 77
——. "Motion on the Mall," *Washington [D.C.] Evening Star*, May 4, 1967

"I have been working with the movement of lines since 1961. The 'line' in my sculptures consisted of a hollow spar of thin sheet metal folded into a triangular section and tapering to a point at the top. The counterweight was of lead cast directly into the spar, below the bearing. The bearing was an arm of steel projecting at right angles to the spar at the point of balance. It was sharpened to a knife-edge to reduce friction. The motion was through an arc in the vertical plane, or, if the bearing was mounted on gimbals (universal joint), the motion was random through a wide cone of space whose apex was at the bearing.

"These rigid lines, sometimes curved, more often straight, tapered to give some of the change of density of a pen stroke, offered a great variety of possibilities—straight lines, curved lines, vertical lines, horizontals and diagonals and combinations, few lines, many lines, parallel lines, radiating or converging lines, distribution on diverse grids, equal or disparate lengths, and any scale from six inches high to the thirty-two-foot limit I have reached thus far.

"In relation to movement, change of scale is more than change of size. Time is always a factor of movement. Movement slows as dimension grows. A three-second oscillation might seem lethargic on a six-foot scale; at thirty feet, twenty seconds might seem faster. Ventures into large scale are also ventures into retarded time.

"In 1963, I made a pair of blades, thirty feet high, swinging vertically in parallel planes on bearings eight feet above the ground, of mild steel, painted red, standing against a curtain of trees in my garden. This seemed at the time an awesome project, and it took several months to plan it, cut and fold the steel, weld the seams, and design a bearing which would carry the weight and wind load. The first counterweights were several hundred pounds of sash weights. Later, I cut down the weight and increased the efficiency by casting triangular lead sections which would fit neatly inside the blades and could be stacked up till the balance was achieved. Because of the greater efficiency, less than half the weight of lead was needed.

"Then I made *Three Red Lines* for the Hirshhorn Collection. I mounted these on ball bearing assemblies housed inside the blade. Because the arc of swing had to be limited (so that the blades would not hit the ground), I designed a system of shock absorbers to engage at the limit of swing in either direction. They convert the energy into heat.

"The blades, made of sheet stainless steel, are spotwelded. The sheet metal is 1/16 inch thick at the bottom, 1/40 inch thick at the top. The triangular section with welded flanges is very strong for its weight. The heavier members, bearings, etc., are welded with heliarc. The bolts, screws, etc., are stainless steel.

"Adjustment of the speed of swing is made by adding or subtracting weight. Unlike an ordinary pendulum, a decrease in the counterweight slows the movement.

"The color is arbitrary and for visibility rather than for sensual satisfaction. It is the movement which is declaratory."

Statement by the artist, 1972

JEAN-PAUL RIOPELLE (b. 1923)

Born Montreal, October 7, 1923. Studied, Académie des Beaux-Arts, Montreal, 1943–44. Moved to Paris, 1948. One-man shows: Galerie Nina Dausset, Paris, 1949; Galerie Raymond Creuze, Paris, 1950; Galerie Paul Facchetti, Paris, 1952; Galerie Pierre, Paris, 1952, 1953; Pierre Matisse Gallery, New York, from 1954; Gimpel Fils, London, 1956; Arthur Tooth & Sons, London, 1959; Kunsthalle, Basel, 1959. Included in: Venice Biennale, 1954; "Younger European Painters," The Solomon R. Guggenheim Museum, New York, 1954; III and VI São Paulo Bienal, 1955, 1961; Guggenheim International, 1958, 1960, 1964; Pittsburgh International, from 1958; "School of Paris 1959: The Internationals," Walker Art Center, Minneapolis, 1959; "Eight Artists from Canada," Tel Aviv Museum, 1970. Awarded UNESCO Prize, Venice Biennale, 1962. Retrospective, The National Gallery of Canada, Ottawa, and tour, 1963. One-man shows: Galerie Maeght, Paris, 1970; Palais des Beaux-Arts, Charleroi, Belgium, 1971; Galerie Maeght, Zurich, 1972. Lives in Paris.

Don Quixote. 1961.
Bronze, 30 × 22 × 10 inches
Markings: back l. r. "RIOPELLE 6"
front l. r. "Cire Perdue Berjar Paris"
side l. r. "Cire Perdue Berjar Paris"

PROVENANCE:
Pierre Matisse Gallery, New York, 1963

EXHIBITIONS:
Pierre Matisse Gallery, New York, April 23–May 18, 1963, *Riopelle: Paintings, Sculpture*, no. 42, ill. title page

REFERENCES:
Schneider, Pierre. *Riopelle: Signes mêlés*, Bern, Maeght, 1972, ill. no. 101

Large Triptych. 1964.
Oil on canvas, 9 × 21 feet

PROVENANCE:
Pierre Matisse Gallery, New York, 1965

EXHIBITIONS:
Pierre Matisse Gallery, New York, November 30–December 24, 1965, *Riopelle: Sculpture, Paintings, Aquarelle*, no. 1, ill.

LARRY RIVERS (b. 1923)

Lawrence Rivers, born Bronx, New York, August 17, 1923. Jazz saxophonist, 1940–45. Studied, New York: Juilliard School of Music, 1944; Hans Hofmann School of Fine Art (also at Provincetown, Massachusetts), 1947–48; New York University, B.S., 1951. One-man shows, New York: Jane Street Gallery, 1949; Tibor de Nagy Gallery, 1951–62. First sculpture, 1951. Designed sets, Frank O'Hara's play *Try! Try!*, 1952. Included in: "Twelve Americans," The Museum of Modern Art, New York, 1955; Pittsburgh International, 1955–67; IV São Paulo Bienal, 1957. Collaborated on "painting poems": with O'Hara, 1957; with Kenneth Koch, 1960. One-man shows: Stable Gallery, New York (sculpture), 1954; Martha Jackson Gallery, New York (sculpture), 1960; Dwan Gallery, Los Angeles, 1961, 1963; Galerie Rive Droite, Paris, 1962; Gimpel Fils, London, 1962, 1964. Included in Documenta III and 4, Kassel, 1964, 1968. Artist-in-residence, Slade School of Fine Art, University College, London, 1964. Designed sets, LeRoi Jones's plays *The Toilet* and *The Slave*, 1964. Retrospective, Rose Art Museum, Brandeis University, Waltham, Massachusetts, and tour, 1965–66. Designed sets and costumes, Igor Stravinsky's *Oedipus Rex*, Lincoln Center for the Performing Arts, New York, 1966. Extended travel in Africa, film project, 1967–68. Two murals commissioned, New England Merchants National Bank of Boston, 1968. One-man shows: The Art Institute of Chicago (drawings), 1970; Marlborough Gallery, New York, 1970–71, 1973. Lives in New York City, and in Southampton, New York.

Molly and Breakfast. 1956.
Oil on Masonite, 47¾ × 71¾ inches
Signed r. c.: "Rivers"

PROVENANCE:
Tibor de Nagy Gallery, New York, 1957

EXHIBITIONS:
Tibor de Nagy Gallery, New York, November 27–December 29, 1956, *Larry Rivers*
The Tate Gallery, London, April 22–June 28, 1964, *Painting and Sculpture of a Decade, 54–64*, no. 267, ill.
Rose Art Museum, Brandeis University, Waltham, Massachusetts, April 10–May 9, 1965, *Larry Rivers*, no. 19; toured to The Jewish Museum, New York, September 23–October 31

REFERENCES:
Hunter, Sam. *Larry Rivers*, New York, Abrams, 1970, p. 29, plate 59
——. "Larry Rivers," *Quadrum*, 18, 1965, p. 105

"With the increasing distance of *Molly and Breakfast* the temptation to make use of 'in retrospect' becomes unmanageable. How can I improve or transform a basically tableside plein-air quality into a hip-er and more contemporary concern? A concern that points to the rendition of the box of Hudson napkins on the table as the beginnings of my interest in everyday packaging and packages, to the initial use of gossip, autobiographical touches (a girl at breakfast suggests she slept over), and the opening salvos on singular objects in singular positions. I won't try."

Statement by the artist, 1972

Billboard for the First New York Film Festival. 1963.
Oil on canvas, 9 feet 6 inches × 15 feet
Signed l. r.: "Rivers '63"

PROVENANCE:
The artist, New York, 1963

EXHIBITIONS:
Lincoln Center for the Performing Arts, New York, August 20–September 19, 1963, *First New York Film Festival*
The Museum of Modern Art, New York, September 24–November 4, 1963, on loan
Rose Art Museum, Brandeis University, Waltham, Massachusetts, April 10–May 9, 1965, *Larry Rivers*, no. 71, ill. p. 39; toured to The Jewish Museum, New York, September 23–October 31

REFERENCES:
Benedikt, Michael. "New York Letter: Larry Rivers in Retrospect," *Art International*, 9–10, December 1965, p. 36
Canaday, John. "Art: Larry Rivers Juxtaposing the High and Low," *The New York Times*, August 26, 1963, p. 21, ill.
Gruen, John. "Art on a Billboard and in the Galleries," *New York Herald Tribune*, August 25, 1962, p. 5
——. "What an Appealing En-Plein-Air Studio," *New York Herald Tribune*, August 22, 1963, p. 17, ill.
Hunter, Sam. *Larry Rivers*, New York, Abrams, 1970, pp. 35–36, colorplate 152
——. "Larry Rivers," *Quadrum*, 18, 1965, pp. 109–10

——. "The Recent Work of Larry Rivers," *Arts Magazine*, 39, April 1965, ill. p. 46
Robbins, Daniel. *An American Collection*, Providence, Museum of Art, Rhode Island School of Design, 1968, p. 403
Rosenberg, Harold. "Rivers' commedia dell'arte," *Art News*, 64, April 1965, ill. p. 35
Unsigned. "Rivers Is Painting Canvas Outdoors," *The New York Times*, August 21, 1963, p. 38

"*Billboard for the First New York Film Festival* among other mind-blowing possibilities proved that the much-vaunted power of the great outdoors was no match for a pre-paid artist, his determination, and the time-tested durability of the combo of Oil on Canv. For neither rain, nor bleaching sun, nor destructive wind over a two month period did a thing to my painting, except perhaps to give it a grand laundering. 'In retrospect,' i.e., that irresistible convention of artists for improving on what has already been abandoned, *Billboard* . . . and many other works of mine are really 'home histories,' managed by my illustration of some known objects on a given subject, confined to a visually accessible space and understood instantly. The now dead René d'Harnoncourt who I liked a lot watched unbeknownst to this artist the progress of this billboard. Not long after I finished it we met somewhere. With what I thought were moist eyes and halting rhetoric and an adorable inconsistency considering that he was the head of that institution of walls, The Museum of Modern Art, René told me that my working hours on end high up on the scaffolding overlooking busy Broadway in full view of the 'people' was his early and continuing dream for art. I used large brushes, spray paint, charcoal, tape, lots of photo books on Hollywood, and my stepson."

Statement by the artist, 1972

The Greatest Homosexual. 1964.
Oil and collage on canvas, 80½ × 61 inches
Signed and dated on back: "Rivers, April '64"

PROVENANCE:
Gimpel Fils, London, 1964

EXHIBITIONS:
Gimpel Fils, London, April 28–May 30, 1964, *Larry Rivers*, no. 16, ill.
Rose Art Museum, Brandeis University, Waltham, Massachusetts, April 10–May 9, 1965, *Larry Rivers*, no. 75, ill. frontispiece. p. 41; toured to Pasadena Art Museum, California, August 10–September 5; The Jewish Museum, New York, September 23–October 31; The Detroit Institute of Arts, November 17–December 26; The Minneapolis Institute of Arts, January 20–February 20, 1966
Gimpel & Weitzenhoffer Ltd., New York, March 1969, *Collectors Choice*, no. 79, ill.

REFERENCES:
Benedikt, Michael. "New York Letter: Larry Rivers in Retrospect," *Art International*, 9–10, December 1965, p. 36
Brookner, Anita. "Current & Forthcoming Exhibitions: London," *Burlington Magazine*, 106, June 1964, p. 298, ill. p. 299
Calas, Nicolas, and Calas, Elena. *Icons and Images of the Sixties*, New York, Dutton, 1971, p. 61, ill. p. 63
Hunter, Sam. *Larry Rivers*, New York, Abrams, 1970, pp. 38–39, ill. 18, colorplate 174
——. "Larry Rivers," *Quadrum*, 18, 1965, pp. 112–13, ill. p. 113
——. "The Recent Work of Larry Rivers," *Arts Magazine*, 39, April 1965, p. 48, ill. p. 50
Lynton, Norbert. "London Letter: Rivers," *Art International*, 8, Summer 1964, p. 73, ill. p. 74
Selle, Carol. *Larry Rivers: Drawings 1949–1969*, The Art Institute of Chicago, 1970, p. 35

"*The Greatest Homosexual* is a work in the tradition of a contemporary artist 'paying homage' to some brilliant ancestor. I didn't 'set up' at the National Gallery as did Matisse when he copied at The Louvre. (I just bought a large color repro.) *The Greatest Homosexual* nevertheless was clearly guided by what happens in *Napoleon in His Study*, David's (if I may) MASTERPIECE. After many days of drawing, brushing, cutting, gluing, stenciling, etc., on canvas—which necessitated repeated and detailed observations of the repro—I couldn't avoid some obvious nontechnical conclusions. Given a right hand nestling in the split of the cream vest, a gesture which by itself has come to represent Napoleon, the plump torso settled comfortably on the left hip, the careful curls and coif, the cliché of pursed lips and what self-satisfaction I read into the rest of the face, I decided Napoleon was Gay. Now if *he* wasn't history's 'Greatest Homosexual,' who was—Michelangelo?"

Statement by the artist, 1972

HUGO ROBUS (1885–1964)

Born Cleveland, May 10, 1885. Studied: Cleveland School of Art, 1904–8; National Academy of Design, New York, 1910–11; Académie de la Grande Chaumière, Paris, with Émile-Antoine Bourdelle. Settled in New York, 1915; taught, Myra Carr Art School, 1915–17. Included in: Whitney Annual, from 1933; "New Horizons in American Art," and "Art in Progress," The Museum of Modern Art, New York, 1936, 1944; "American Art Today," New York World's Fair, Flushing Meadows, 1939. WPA Federal Art Project, Sculpture Division, New York, 1937–39. Public Buildings Administration, Federal Works Agency, Section of Fine Arts, sculpture commission, *Chippewa Legend*, U.S. Post Office, Munising, Michigan, 1939. Taught, New York: Columbia University, intermittently, summers, 1942–56; Hunter College, 1950–58; The Brooklyn Museum Art School, 1955–56. One-man shows: Grand Central Art Galleries, New York, 1946, 1949; Munson-Williams-Proctor Institute, Utica, New York, 1948; The Corcoran Gallery of Art, Washington, D.C., 1958; Forum Gallery, New York, 1963, 1966, 1968. Received grant, The National Institute of Arts and Letters, 1957. Retrospective, American Federation of Arts tour, 1960. Died New York, January 14, 1964.

Column 1

The General. 1922.
Bronze, 18¼ × 19¼ × 9 inches
Markings: back l. r. "Hugo Robus"
front l. r. "Battaglia + C Milano"

PROVENANCE:
Forum Gallery, New York, 1963

EXHIBITIONS:
Forum Gallery, New York, January 3–26, 1963, *Hugo Robus*
Forum Gallery, New York, January 18–February 12, 1966, *Hugo Robus Memorial Exhibition*, no. 18, ill.

REFERENCES:
Tillim, Sidney. "Month in Review: Robus," *Arts Magazine*, 37, February 1963, p. 43

AUGUSTE RODIN (1840–1917)

François-Auguste-René Rodin, born Paris, November 12, 1840. Attended Catholic school, until 1849; uncle's boarding school, Beauvais, France, 1851–54. Studied, Paris: École Royale et Spéciale de Dessin et de Mathématiques (Petit École), 1854–57; literature and history, Collège de France. Rejected as sculpture student, École des Beaux-Arts; worked for various commercial artists and decorators, 1858–64. Completed earliest surviving sculpture, portrait of his father, 1860. Entered monastic order, briefly, 1862. Plaster version of *Mask of the Man with the Broken Nose* rejected, Salon of 1864, Paris. Worked in Sèvres porcelain factory, with sculptor Ernest Carrier-Belleuse, intermittently, 1864–82. Served, National Guard, Paris, 1870–71. Lived in Brussels, 1871–77; visited Italy, to study works of Michelangelo, 1875. Marble version of *Man with the Broken Nose* accepted: Salon of 1872, Brussels; Salon of 1875, Paris. Eight Rodin works among Belgian entries, U.S. Centennial Exhibition, Philadelphia, 1876. *The Vanquished* (now *The Age of Bronze*): exhibited, Exposition du Cercle Artistique, Brussels, 1877; accepted, Salon of 1880, Paris; acquired by French government for Luxembourg Gardens, Paris. Sculpture relief (later to become *The Gates of Hell*, left unfinished at his death) commissioned, for bronze doors of proposed Musée des Arts Décoratifs, Paris, 1880. Visited London, 1882; on return to Paris, given studio in Dépôt des Marbres by government. *The Burghers of Calais* commissioned, city of Calais, France, 1884; dedicated, 1895. Légion d'honneur: chevalier, 1888; officier, 1903; grand officier, 1910. Illustrated Charles Baudelaire's *Fleurs du Mal* (Paris, Gallimard), 1889. Exhibited portrait engravings, Société des Peintres et Graveurs, Paris, 1889–90. *Monument to Balzac* commissioned by Société des Gens de Lettres, Paris, 1891; rejected by Société following exhibition of final plaster model, Salon de la Société Nationale des Beaux-Arts, Paris, 1898. President, sculpture section, Société Nationale des Beaux-Arts, 1893. Moved to Meudon, outside of Paris, 1897. Built pavilion for his own retrospective, Exposition Universelle of 1900, Paris. Thereafter, besieged with orders, greatly enlarged his workshop staff; many assistants included Émile-Antoine Bourdelle, Jules Desbois, François Pompon, Charles Despiau, Malvina Hoffman. Established Académie Rodin, Paris, 1901. Began casting works, Alexis Rudier Foundry, Paris, 1902. Upon James Abbott McNeill Whistler's death, 1903, elected president, International Society of Sculptors, Painters and Gravers, London. *The Thinker* (part of *The Gates of Hell*), enlarged and cast, and installed in front of Panthéon, Paris, 1905. Large collection of his works acquired by The Metropolitan Museum of Art, New York; exhibited there, 1912. President, Society of Sculptors, and International Society of Painters and Sculptors, London, 1912; vice-president, Société des Artistes Français, Paris, 1912. Included in the Armory Show, 1913. Donated all works in his possession to French government, for Musée Rodin; museum established, Hôtel Biron, Paris, 1916. Nominated to Institut de France, 1916. Died Meudon, November 17, 1917. California Palace of the Legion of Honor, San Francisco, established by Loie Fuller, and Alma de Bretteville Spreckels, 1924, to house their Rodin collections; Rodin Museum, Philadelphia, established by Jules E. Mastbaum, 1929. Retrospectives: The Museum of Modern Art, New York, 1963; Hayward Gallery, London, 1970.

Mask of the Man with the Broken Nose. 1864.
Bronze, 12¼ × 7¼ × 6¼ inches
Markings: l. r. "A. Rodin"
l. l. side "Alexis Rudier Fondeur Paris"

PROVENANCE:
Hammer Galleries, New York; James Graham and Sons, New York, 1961

EXHIBITIONS:
The Solomon R. Guggenheim Museum, New York, October 3, 1962–January 6, 1963, *Modern Sculpture from the Joseph H. Hirshhorn Collection*, no. 387, ill. p. 17

REFERENCES:
Arnason, H. Harvard. *History of Modern Art*, New York, Abrams, 1968, pp. 56–57, ill. p. 56
Ashton, Dore. "New York Report," *Das Kunstwerk*, 16, October 1962, p. 26
Mates, Robert. *Photographing Art*, New York, Amphoto, 1966, ill. p. 120
———. "Photographing Sculpture and Museum Exhibits," *Curator*, 10, June 1967, p. 123, ill. p. 121

Third architectural model for The Gates of Hell. 1880.
Plaster, 39½ × 25 × 7¼ inches
Markings: l. r. "Rodin"
"A M. Edmund Davis
en hommage
du Musée Rodin"

PROVENANCE:
Musée Rodin, Paris; Sir Edmund Davis, Chilham Castle, Kent, England; Lady Davis, Chilham Castle; Christie, Manson & Woods, London, Sale, March 27, 1942, no. 134; Arcade Gallery, London; H. J. Laufer, London; Philip Granville, London; Peridot Gallery, New York, 1966

Column 2

EXHIBITIONS:
Peridot Gallery, New York, December 23, 1957–January 11, 1958, *European Drawings and Sculpture*
Peridot Gallery, New York, June 1960, *Painting and Sculpture*
The Museum of Modern Art, New York, April 29–September 10, 1963, *Rodin*, no. 28, pp. 37, 217, ill. p. 39; toured to California Palace of the Legion of Honor, San Francisco, October 19–December 8, no. 34

REFERENCES:
Burrows, Carlyle. "Art: Events on Hand for Holiday Season," *New York Herald Tribune*, December 29, 1957, sec. 6, p. 9
Jianou, Ionel, and Goldscheider, Cécile. *Rodin*, Paris, Arted, 1967, p. 88
Munsterberg, Hugo. "In the Galleries: European Drawings and Sculpture," *Arts*, 32, December 1957, p. 52, ill.
Preston, Stuart. "The State Department Builds Abroad," *The New York Times*, December 29, 1957, sec. 2, p. 9
———. "1960—The Aftermath of a Revolution in Art," *The New York Times*, June 5, 1960, sec. 2, p. 16

In 1880, Rodin was commissioned by the French government to design the doors for a proposed new Musée des Arts Décoratifs, in Paris. The subject, based on Dante's *Inferno*, was apparently of Rodin's own choosing.

In this early model, one of several preparatory studies for *The Gates of Hell, The Thinker* is already in place in the central focal point above the door, just as he appears in the final version. Although Rodin worked on *The Gates* until the year of his death, he never considered it finished.

Our terra-cotta was cast from the plaster original in the Musée Rodin, Paris, for Sir Edmund Davis (1863–1939), a prominent British financier and art collector, to whom it is inscribed. Related terra-cotta casts are in the Rodin Museum, Philadelphia, and National Museum of Western Art, Tokyo.

The Crouching Woman. 1882, cast 1962.
Bronze (3/12), 37½ × 26 × 21½ inches
Markings: l. r. side "A. Rodin © by Musée Rodin 1962"
back l. c. "Georges Rudier Fondeur Paris"

PROVENANCE:
Musée Rodin, Paris; Galerie Claude Bernard, Paris, 1963

EXHIBITIONS:
Galerie Claude Bernard, Paris, January 1963, *Auguste Rodin*, no. 14, ill.

REFERENCES:
Arnason, H. Harvard. *History of Modern Art*, New York, Abrams, 1968, p. 60, ill. p. 61
Jianou, Ionel, and Goldscheider, Cécile. *Rodin*, Paris, Arted, 1967, p. 91
Unsigned. "Sculpture: Fresh-Air Fun," *Time*, 90, September 8, 1967, p. 77, colorplate p. 75

She Who Was Once the Helmet-Maker's Beautiful Wife, (Celle qui fut la belle heaulmière; The Old Courtesan). 1885.
Bronze, 19¼ × 9¼ × 12 inches
Markings: l. r. side "A. Rodin
Alexis Rudier Fondeur Paris"
inside cast "A. Rodin"

PROVENANCE:
Stephen C. Clark, New York; M. Knoedler & Co., New York; James Goodman Gallery, New York, 1968

EXHIBITIONS:
Smithsonian Institution, Washington, D.C., 1972–73, extended loan

The title of this sculpture was taken from a ballad by the fifteenth-century French poet François Villon.

Rodin's model may have been an old Italian woman who came to his studio looking for her long lost son. A more plausible explanation is that she was a professional model who had posed for one of Rodin's assistants.

The same figure appears on the left pilaster of *The Gates of Hell*, grouped with a young woman and child.

The Burghers of Calais. 1886.
Bronze, 82½ × 95 × 78 inches
Markings: c. top of base "A. Rodin"
l. l. back of base "Alexis Rudier"

PROVENANCE:
The artist; Alexis Rudier, Le Vésinet, France; Musée Rodin, Meudon, France; Otto Gerson Gallery, New York, 1962

EXHIBITIONS:
Palais de la Méditerranée, Nice, December 1961–January 1962, *Sculptures de Rodin*, no. 1, plate I
The Solomon R. Guggenheim Museum, New York, October 3, 1962–January 6, 1963, *Modern Sculpture from the Joseph H. Hirshhorn Collection*, no. 391, ill. pp. 19–21

REFERENCES:
Arnason, H. Harvard. *History of Modern Art*, New York, Abrams, 1968, p. 60, 132, ill. p. 63
Elsen, Albert E. *Rodin*, New York, The Museum of Modern Art, 1963, pp. 67, 218, ill. p. 71
Fogg Art Museum, Harvard University. *Rodin—The Burghers of Calais*, written and filmed by Robin Jones, and Robert Kuretsky, © 1969 Robert Kuretsky
Geldzahler, Henry. "Taste for Modern Sculpture: The Hirshhorn Collection," *Art News*, 61, October 9, 1962, p. 31, ill. p. 28
Hale, William Harlan. *The World of Rodin: 1840–1917*, New York, Time-Life Books, 1969, pp. 130–131, colorplates pp. 126, 128–33
Hamilton, George Heard. *19th and 20th Century Art*, New York, Abrams, 1970, p. 146, ill. pp. 129, 147
Handlin, Oscar. *The Statue of Liberty*, New York, Newsweek Books, 1972, colorplate p. 34
Jacobs, Jay. "Collector: Joseph H. Hirshhorn," *Art in*

Column 3

America, 57, July–August 1969, colorplate p. 57 (detail)
———. "Quality as Well as Quantity: Joseph H. Hirshhorn," in Lipman, Jean, ed. *The Collector in America*, New York, Viking, 1971, colorplate p. 83
Jianou, Ionel, and Goldscheider, Cécile. *Rodin*, Paris, Arted, 1967, p. 99
Johnson, Lady Bird. *A White House Diary*, New York, Holt, Rinehart and Winston, 1970, p. 307
Raynor, Vivien. "4,000 Paintings and 1,500 Sculptures: Joseph Hirshhorn's Mine of Modern Art," *The New York Times Magazine*, November 6, 1966, ill. p. 55
Seldis, Henry J. *Henry Moore in America*, New York, Praeger, 1973, p. 55
Spear, Athena Tacha. *Rodin Sculpture in the Cleveland Museum of Art*, Cleveland Museum of Art, 1967, no. VIII–8, pp. 46, 95, ill. p. 41, plate 58
Sweeney, James Johnson. "A Living Frame for Sculpture," *House & Garden*, 126, August 1964, ill. p. 111
Tancock, John L. *Rodin Museum Handbook*, Philadelphia Museum of Art, 1969, p. 59
Unsigned. "The Hirshhorn Approach," *Time*, 80, October 5, 1962, colorplate p. 76
———. "Un Musée de Sculpture en plein air au Vésinet: Chez M. et Mme. Eugène Rudier," *Art et Industrie*, 15, May 1949, p. 38, ill. p. 39
———. "The Ways of Rodin," *The New York Times Magazine*, September 16, 1962, ill. p. 45

The Burghers of Calais was commissioned by the city of Calais to honor Eustache de Saint-Pierre, one of the heroes of the city during the Hundred Years War. The medieval *Chroniques* of Jean Froissart record the following events: On September 4, 1346, Edward III of England laid siege to Calais. Eleven months later, on August 3, 1347, he offered to lift the siege if six leading citizens, barefooted and with ropes around their necks, and carrying the keys to the city, would be brought to him. Eustache de Saint-Pierre was the first to volunteer to sacrifice himself in order to save the city. The others who followed him were Jean d'Aire, Jacques de Wiessant, Pierre de Wiessant, Jean de Fiennes, and Andrieu d'Andres. However, through the entreaties of Queen Philippa, the lives of the burghers were eventually spared.

Rodin's monument was erected on the Place de Richelieu, Calais, and dedicated, June 3, 1895. In 1924 it was moved to the Place d'Armes, in front of the Town Hall, where Rodin had originally wished it to stand.

The second cast of the work was purchased by the British government, and placed near the Houses of Parliament, London, in 1913. Our cast was originally in the collection of Rodin's founder Alexis Rudier.

Head of St John the Baptist. 1887.
Bronze relief, 10½ × 8½ × 5¼ inches
Markings: l. r. "A. Rodin"
l. l. "Alexis Rudier Fondeur Paris"

PROVENANCE:
Harold Maker, New York; Hammer Galleries, New York, 1960; Parke-Bernet Galleries, New York, Sale 2096, March 21, 1962, no. 35

EXHIBITIONS:
The Solomon R. Guggenheim Museum, New York, October 3, 1962–January 6, 1963, *Modern Sculpture from the Joseph H. Hirshhorn Collection*, no. 388

REFERENCES:
Jianou, Ionel, and Goldscheider, Cécile. *Rodin*, Paris, Arted, 1967, p. 102

Iris, Messenger of the Gods. 1890–91.
Bronze, 32 × 36 × 24 inches
Markings: l. l. "A. Rodin"

PROVENANCE:
Curt Valentin Gallery, New York, 1955

EXHIBITIONS:
Curt Valentin Gallery, New York, May 4–29, 1954, *Auguste Rodin*, no. 23, ill.
The Detroit Institute of Arts, and tour, 1959–60, *Sculpture in Our Time*, no. 37, ill. p. 22
The Solomon R. Guggenheim Museum, New York, October 3, 1962–January 6, 1963, *Modern Sculpture from the Joseph H. Hirshhorn Collection*, no. 392, ill. p. 23
Marlborough-Gerson Gallery, New York, November–December 1963, *Artist and Maecenas: A Tribute to Curt Valentin*, no. 9

REFERENCES:
Arnason, H. Harvard. *History of Modern Art*, New York, Abrams, 1968, p. 60, ill. p. 61
Ashton, Dore. "New York Report," *Das Kunstwerk*, 16, October 1962, p. 26
Duitz, Murray. "Museum," *Infinity*, 12, December 1963, ill. p. 18
Jianou, Ionel, and Goldscheider, Cécile. *Rodin*, Paris, Arted, 1967, p. 105
Licht, Fred. *Sculpture: 19th and 20th Centuries*, Greenwich, Connecticut, New York Graphic Society, 1967, no. 124, p. 321, ill.
Raynor, Vivien. "In the Galleries: The Hirshhorn Collection," *Arts Magazine*, 37, November 1962, p. 41
Read, Herbert. *A Concise History of Modern Sculpture*, New York, Praeger, 1964, no. 22, p. 302, ill. p. 31
Saltmarche, Kenneth. "Sculpture in Our Time," *Toronto Art Gallery News and Notes*, 4, October 1960, p. 2
———. "Notes on Special Exhibitions: 'Sculpture in Our Time,'" *Art Quarterly*, 22, Winter 1959, p. 351
Unsigned. "Range of Hirshhorn Collection," *The Times*, London, July 3, 1964, ill.

Half-Length Portrait of Balzac. 1892.
Bronze, 18½ × 14¼ × 12½ inches
Markings: l. r. "A. Rodin"
inside cast "A. Rodin"
back l. l. "Alexis Rudier Fondeur Paris"

PROVENANCE:
Jules E. Mastbaum, Philadelphia; Etta Wedell Mast-

baum, Philadelphia; Elizabeth Mastbaum; James Graham and Sons, New York, 1961

EXHIBITIONS:
The Solomon R. Guggenheim Museum, New York, October 3, 1962–January 6, 1963, *Modern Sculpture from the Joseph H. Hirshhorn Collection*, no. 393, ill p. 25
The Museum of Modern Art, New York, April 29–September 10, 1963, *Rodin*, no. 14, p. 219, ill. p. 94; toured to California Palace of the Legion of Honor, San Francisco, October 19–December 8

REFERENCES:
Arnason, H. Harvard. *History of Modern Art*, New York, Abrams, 1968, p. 60, ill. p. 62
Spear, Athena Tacha. *Rodin Sculpture in the Cleveland Museum of Art*, Cleveland Museum of Art, 1967, no. IV-M, p. 91

Monument to Balzac. 1898.
Bronze, 8 feet 10 inches × 3 feet 6½ inches × 4 feet 2 inches
Markings: r. top of base "A Rodin"
l. l. back of base "Georges Rudier Fondeur Paris"

PROVENANCE:
Musée Rodin, Paris, 1966

REFERENCES:
Jianou, Ionel, and Goldscheider, Cécile. *Rodin*, Paris, Arted, 1967, p. 106
Spear, Athena Tacha. *Rodin Sculpture in the Cleveland Museum of Art*, Cleveland Museum of Art, 1967, p. 93

In 1891, Rodin received a commission from the Société des Gens de Lettres for a sculpture honoring the nineteenth-century French novelist Honoré de Balzac (1799–1850), author of an enormous opus which is encompassed in *La Comédie humaine*. In the course of the next seven years Rodin read all of Balzac's novels, as well as biographies and descriptions of him. He completed more than twenty studies of Balzac's head and an equal number of models of the whole figure, alternately clothed and nude. He finally decided to portray the author wrapped in the Dominican robe in which it had been his custom to work.

When the final full-size plaster was exhibited at the Salon de la Société Nationale des Beaux-Arts, in May 1898, it caused a scandal. The Société des Gens de Lettres rejected the sculpture on the grounds that it was too crude and incomplete, and failed to capture Balzac's likeness. Rodin withdrew the work from the Salon and, although there were several offers to purchase it, the sculptor kept the plaster himself. It was never cast in bronze during his lifetime. In 1939, twenty-two years after Rodin's death, the monument was erected in Paris at the crossing of the Boulevards Raspail and Montparnasse.

Head of Baudelaire. 1898.
Bronze, 9 × 7½ × 8 inches
Markings: l. side "A. Rodin
 Georges Rudier Fondeur
 Paris"
 inside cast "A. Rodin"

PROVENANCE:
Otto Gerson Gallery, New York, 1962

EXHIBITIONS:
The Solomon R. Guggenheim Museum, New York, October 3, 1962–January 6, 1963, *Modern Sculpture from the Joseph H. Hirshhorn Collection*, no. 396, ill. p. 24
Art Gallery of Toronto, April 4–May 2, 1963, *Baudelaire*

REFERENCES:
Ashton, Dore. "New York Report," *Das Kunstwerk*, 16, October 1962, ill. p. 31
Elsen, Albert E. *Pioneers of Modern Sculpture*, London, Hayward Gallery, 1973, ill. p. 32
Jianou, Ionel, and Goldscheider, Cécile. *Rodin*, Paris, Arted, 1967, p. 109
Kuh, Katherine. "Great Sculpture," *Saturday Review*, 45, June 23, 1962, ill. p. 19
Raynor, Vivien. "The Hirshhorn Collection," *Arts*, 37, November 1962, p. 41
Unsigned. "The Hirshhorn Approach," *Time*, 80, October 5, 1962, p. 84

Walking Man. 1905, cast 1962.
Bronze (5/12), 83 × 61 × 28 inches
Markings: front top of base "A. Rodin"
l. l. back of base "Georges Rudier, Fondeur Paris"
l. l. side of base "© by Musée Rodin 1962"

PROVENANCE:
Musée Rodin, Paris; Galerie Claude Bernard, Paris, 1963

EXHIBITIONS:
Galerie Claude Bernard, Paris, January 1963, *Auguste Rodin*, no. 1, ill.

REFERENCES:
Arnason, H. Harvard. *History of Modern Art*, New York Abrams, 1968, pp. 57, 114, ill. p. 58
Jacobs, Jay. "Collector: Joseph H. Hirshhorn," *Art in America*, 57, July–August 1969, colorplate p. 69
———. "Quality as Well as Quantity: Joseph H. Hirshhorn," in Lipman, Jean, ed. *The Collector in America*, New York, Viking, 1971, colorplate p. 83
Jianou, Ionel, and Goldscheider, Cécile. *Rodin*, Paris, Arted, 1967, p. 87
Zanini, Walter. *Tendências da escultura moderna*, São Paulo, Cultrix, 1971, ill. p. 27

Head of Sorrow. 1905.
Bronze, 9½ × 8½ × 10½ inches
Markings: l. r. side "A. Rodin"
back l. l. "Georges Rudier Fondeur Paris"

PROVENANCE:
Curt Valentin Gallery, New York, 1954

EXHIBITIONS:
Curt Valentin Gallery, New York, May 4–29, 1954, *Auguste Rodin*, no. 7, ill.
Brandeis University, Waltham, Massachusetts, June 1–17, 1955, *Three Collections*, no. 37
The Detroit Institute of Arts, 1959, *Sculpture in Our Time*, no. 35
The Solomon R. Guggenheim Museum, New York, October 3, 1962–January 6, 1963, *Modern Sculpture from the Joseph H. Hirshhorn Collection*, no. 389

REFERENCES:
Saltmarche, Kenneth. "Notes on Special Exhibitions: 'Sculpture in Our Time,'" *Art Quarterly*, 22, Winter 1959, p. 351
Spear, Athena Tacha. "A Note on Rodin's 'Prodigal Son' and on the Relationship of Rodin's Marbles and Bronzes," *Allen Memorial Art Museum Bulletin*, Oberlin College, Ohio, 27, Fall 1969, no. L–2, p. 36

Étienne Clémentel. 1916.
Bronze, 21½ × 15½ × 11½ inches
Markings: r. side "Rodin"
back l. l. "Alexis Rudier Fondeur Paris"

PROVENANCE:
Galerie Jacques Dubourg, Paris; Albert Loeb & Krugier Gallery, New York; James Goodman Gallery, Buffalo, New York, 1967

Étienne Clémentel (1864–1936) was Minister of Commerce, an amateur painter, and an intimate of Rodin's toward the end of the artist's life. He arranged for Rodin's medical care and helped to draw up the artist's will, which assured that his estate would be established as a museum.

The portrait of Clémentel was left unfinished at Rodin's death.

JAMES ROSATI (b. 1912)

Born Washington, Pennsylvania, June 9, 1912. Violinist, Pittsburgh String Symphony Orchestra, 1928–29. Studied sculpture, with Frank Vittor, Pittsburgh, 1934–37. WPA Federal Art Project, Sculpture Division, Pittsburgh, 1937–41. Moved to New York, 1943. Taught: Newark School of Fine and Industrial Art, New Jersey, 1947; Pratt Institute, Brooklyn, New York, 1954; The Cooper Union for the Advancement of Science and Art, New York, 1955. Founding member, The Club, New York, 1949. Received Ford Foundation Grant, 1951. Included in: Whitney Annual, from 1952; Pittsburgh International, 1958, 1961, 1964, 1970. One-man shows, New York: Peridot Gallery, 1954; Fine Arts Associates, 1959; Otto Gerson Gallery, 1962. Received: Brandeis University Creative Arts Award Citation, 1960; Logan Medal, 65th American Exhibition, The Art Institute of Chicago, 1962. Received commission, Carborundum Sculpture Awards, 1962. Visiting critic in sculpture, Dartmouth College, Hanover, New Hampshire, 1963; one-man show, Hopkins Art Center, Dartmouth College, 1963. Received: Guggenheim Foundation Fellowship, 1964; National Council on the Arts Grant, 1968. Included in "Four American Sculptors," The Museum of Modern Art, New York, Circulating Exhibition, 1964–65; 11th Middelheim Biënnale, Antwerp, 1971. One-man shows: Colgate University, Hamilton, New York, 1968; Rose Art Museum, Brandeis University, Waltham, Massachusetts, and tour, 1969–70; Marlborough Gallery, New York, 1971. Has taught, Yale University, New Haven, Connecticut, intermittently, since 1960. Lives in New York.

Hamadryad. 1957–58.
Marble, 35½ × 8½ × 7 inches

PROVENANCE:
Fine Arts Associates, New York, 1959

EXHIBITIONS:
Fine Arts Associates, New York, April 7–25, 1959, *James Rosati: Sculpture Collages*, no. 10, ill.
The Detroit Institute of Arts, 1959, *Sculpture in Our Time*, no. 198, ill. endpapers
The Solomon R. Guggenheim Museum, New York, October 3, 1962–January 6, 1963, *Modern Sculpture from the Joseph H. Hirshhorn Collection*, no. 401, ill. p. 181

REFERENCES:
Ashton, Dore. "Art," *Arts and Architecture*, 76, June 1959, p. 10
Kramer, Hilton. "The Sculpture of James Rosati," *Arts*, 33, March 1959, p. 27, ill. p. 30
Rudikoff, Sonya. "New York Letter," *Art International*, 6, November 1962
Seitz, William C. "James Rosati Sculpture 1963–1969," *Art International*, 14, January 1970, ill. p. 61
———. *James Rosati Sculpture 1963–1969*, Waltham, Massachusetts, Brandeis University, 1970, no. 1, ill. p. 9

HERMAN ROSE (b. 1909)

Herman Rappaport, born Brooklyn, New York, November 6, 1909. Studied, National Academy of Design, New York, 1926–28. WPA Federal Art Project, Mural and Easel Divisions, New York, 1934–39. One-man shows, New York: Egan Gallery, 1946–48; ACA Gallery, 1952, 1955, 1956. Included in "15 Americans," The Museum of Modern Art, New York, 1952. Taught: New School for Social Research, New York, 1954–55, 1963–72; University of New Mexico, Albuquerque, 1970–71. Received: Yaddo Foundation Grant, 1955; Longview Foundation Grant, 1959, 1960, 1961. One-man shows, New York: Forum Gallery, 1962; Zabriskie Gallery, 1967, 1969, 1972. Received The American Academy of Arts and Letters, and The National Institute of Arts and Letters Award, 1972. Traveled to Israel, 1972–73. Lives in New York.

Skyline, New York. 1949.
Oil on canvas, 24 × 12 inches
Signed l. r.: "HR"

PROVENANCE:
Egan Gallery, New York, 1950

EXHIBITIONS:
Whitney Museum of American Art, New York, December 16, 1949–February 5, 1950, *1949 Annual Exhibition of Contemporary American Painters*, no. 116
Brandeis University, Waltham, Massachusetts, June 1–17, 1955, *Three Collections*, no. 38
Tweed Gallery, University of Minnesota, Duluth, April 1–30, 1956, *Collector's Choice*, cat.

"I was stunned by this scene when I saw it from the roof of the tenement I lived in at 19th Street and Third Avenue. Although I had painted many rooftops, and loved their weathered bricks, ledges, chimneys—even the cement and ugly gray tar paper begrimed with dirt and soot—this was the first time I saw the city in all its breadth, overwhelming in its dramatic impact. Rooftops and skyscrapers shooting haphazardly into the sky in fantastic strength and beauty. I was awed, and proud of man's achievement—his spirit was everywhere—and it was with this feeling that I painted the picture. It was done in the late afternoon. I set about chimney by chimney, brick by brick—plastering even the sky."

Statement by the artist, 1972

JAMES ROSENQUIST (b. 1933)

James Albert Rosenquist, born Grand Forks, North Dakota, November 29, 1933. Worked as outdoor sign painter, 1952–54. Studied painting and drawing, University of Minnesota, Minneapolis, with Cameron Booth, 1953. Moved to New York, 1955. Studied: The Art Students League of New York, 1955; drawing classes, with Jack Youngerman, and Robert Indiana, 1957–58. Sign painter, 1957–60; designed window displays, Bonwit Teller, and Tiffany & Co., New York, 1959. First one-man show, The Green Gallery, New York, 1962. Included in: "Pop Art USA," The Oakland Museum, California, 1963; "Six Painters and the Object," The Solomon R. Guggenheim Museum, New York, 1963; "Americans 1963," The Museum of Modern Art, New York, and tour, 1963–64; Documenta 4, Kassel, 1968; "New York Painting and Sculpture: 1940–1970," The Metropolitan Museum of Art, New York, 1969–70. One-man shows: The Green Gallery, 1963, 1964; Galleria Sperone, Turin, 1964; Galerie Ileana Sonnabend, Paris, 1964, 1968; Dwan Gallery, Los Angeles, 1964; Leo Castelli Gallery, New York, from 1965; Stedelijk Museum, Amsterdam, 1966; The National Gallery of Canada, Ottawa, 1968. Mural, New York State Pavilion, New York World's Fair, 1965. Painting *F-111* (Collection Mr. and Mrs. Robert Scull, New York) toured Europe, 1965; exhibited, The Metropolitan Museum of Art, 1968. Retrospectives: Wallraf-Richartz-Museum, Cologne, 1972; Whitney Museum of American Art, New York, 1972. Lives in Southampton, New York.

The Light That Won't Fail, I. 1961.
Oil on canvas, 72 × 96 inches

PROVENANCE:
The Green Gallery, New York, 1962

EXHIBITIONS:
The Green Gallery, New York, January 30–February 17, 1962, *James Rosenquist*
The Museum of Modern Art, New York, June 20–August 18, 1963, *Americans 1963*, no. 111, ill. p. 88; toured to twelve U.S. and Canadian cities
Milwaukee Art Center, April 9–May 9, 1965, *Pop Art and the American Tradition*, no. 54
The National Gallery of Canada, Ottawa, January 24–February 25, 1968, *James Rosenquist*, no. 3, ill. p. 23
Whitney Museum of American Art, New York, April 12–May 29, 1972, *James Rosenquist*, ill. p. 42

REFERENCES:
Jacobs, Jay. "Collector: Joseph H. Hirshhorn," *Art in America*, 57, July–August 1969, ill. p. 67
———. "Quality as Well as Quantity: Joseph H. Hirshhorn," in Lipman, Jean, ed. *The Collector in America*, New York, Viking, 1971, ill. p. 88
Rose, Barbara. "Americans 1963," *Art International*, 7, September 1963, p. 78, ill.
Unsigned. "In A New Year, New Art," *St. Louis [Missouri] Post-Dispatch*, December 31, 1961, ill.

MEDARDO ROSSO (1858–1928)

Born Turin, June 21, 1858. Moved with family to Milan, 1870. Served, Italian Army, 1879–82. Studied sculpture and anatomy, Accademia di Belle Arti di Brera, Milan, 1882–83. Four works included, Esposizione Belle Arti, Rome, 1883. First trip to Paris, 1884; assistant to Aimé-Jules Dalou; met Auguste Rodin. Worked in Milan, 1884–89. Included in: Salon des Artistes Français, and Salon des Indépendants, Paris, 1886–89; II Esposizione Internazionale Artistica, Venice, 1887; Exposition Universelle de 1889, Paris. Hospitalized on return to Paris, 1889. Sought out by art collector Henri Rouart, who gave him a studio and equipment for bronze casting. Exhibited, foyer, Théâtre d'Application Bodinier, Paris, meeting place of intelligentsia, 1893. His studio visited by Rodin, 1894. Included in Pre-Raphaelite exhibition, Boussod and Valadon Gallery, London, 1896. Returned to Milan, 1897. Rodin's *Monument to Balzac* exhibited, Paris, 1898; Rosso's feeling that it was based on his own works put a bitter end to their friendship. Included in Exposition Universelle de 1900, Paris (hors catalogue), where he met patroness Etha Fles. Helped found Salon d'Automne, Paris, 1903; one-man show there, 1904. Included in: Vienna Secession, 1903; International Society of Painters, Sculptors, and Gravers exhibition, London, 1906; "Prima Mostra dell'Impressionismo e di Medardo Rosso," Lyceum, Florence, 1910. One-man shows: Kunsthaus Artaria, Vienna, 1905; Cremetti Gallery, London, 1906. Two works purchased by French government, for Musée du Luxembourg, Paris, 1907. Included in: Esposizione Internazionale di Belle Arti, Rome, 1911; Venice Biennale, 1914. Rosso room inaugurated, Galleria Internazionale d'Arte Moderna di Ca' Pesaro, Venice, 1915. One-man show, Bottega di Poesia, Milan, 1923. Died Milan, March 31, 1928. Memorial exhibition, Salon d'Automne, 1929. Rosso museum established, Barzio, near Como, Italy, 1934. One-man show, Venice Biennale, 1950. Retrospective, The Museum of Modern Art, New York, 1963.

The Golden Age (L'Età d'oro). 1886.
Wax over plaster, 16⅝ × 20½ × 11 inches

PROVENANCE:
Sra Tilde Rosso, Milan; Peridot Gallery, New York, 1961

EXHIBITIONS:
Peridot Gallery, New York, December 15, 1959–January 16, 1960, *Medardo Rosso*, no. 3
The Solomon R. Guggenheim Museum, New York, October 3, 1962–January 6, 1963, *Modern Sculpture from the Joseph H. Hirshhorn Collection*, no. 406
The Museum of Modern Art, New York, October 2–November 23, 1963, *Medardo Rosso*, checklist no. 8

REFERENCES:
Kramer, Hilton. "Medardo Rosso," *Arts*, 34, December 1959, ill. p. 32
Tillim, Sidney. "Month in Review: Rosso," *Arts Magazine*, 38, November 1963, ill. p. 29
Unsigned. "Italy's Sculptor of Impressionism," *Time*, 82, October 11, 1963, colorplate p. 81

"Rosso never made preparatory drawings but invented directly in clay. From the clay he made a *modello* or working model in plaster, then he made a negative mold from which he cast either in bronze or again in plaster, thereby obtaining a duplicate of his original *modello*; this he coated with wax, varying many details in each of his new versions."

Margaret Scolari Barr, *Medardo Rosso*, New York, The Museum of Modern Art, 1963, p. 21

The artist's wife, Giuditta, and his year-old son, Francesco, served as the models for this sculpture.

Child in the Poorhouse (Bimbo all'asilo dei poveri; Baby Chewing Bread). 1893.
Wax over plaster, 17½ × 19 × 6 inches
Markings: l. r. "MR"

PROVENANCE:
Francesco Rosso, Milan, 1946; E. Pastorio, Milan; Grossetti Collection, Milan; Peridot Gallery, New York, 1962

EXHIBITIONS:
The Solomon R. Guggenheim Museum, New York, October 3, 1962–January 6, 1963, *Modern Sculpture from the Joseph H. Hirshhorn Collection*, no. 409
The Museum of Modern Art, New York, October 2–November 23, 1963, *Medardo Rosso*, checklist no. 17

REFERENCES:
Barr, Margaret Scolari. *Medardo Rosso*, New York, The Museum of Modern Art, 1963, p. 38, ill. p. 39
Borghi, Mino. *Medardo Rosso*, Milan, Milione, 1950, p. 67
Rubin, William S. "The Hirshhorn Collection at the Guggenheim," *Art International*, 6, November 1962, p. 35
Unsigned. "The Current Scene: Medardo Rosso at the Modern," *Arts Magazine*, 38, October 1963, ill. p. 44

The Bookmaker (L'Uomo alle Corse.) 1894.
Bronze, 18 × 13¼ × 13¼ inches
Markings: l. l. side "M. Rosso"

PROVENANCE:
Henri Rouart, Paris; Francesco Rosso, Milan; Giovanni de Rossi, Milan; Peridot Gallery, New York, 1960

EXHIBITIONS:
The Solomon R. Guggenheim Museum, New York, October 3, 1962–January 6, 1963, *Modern Sculpture from the Joseph H. Hirshhorn Collection*, no. 407, ill. p. 31
The Baltimore Museum of Art, October 25–November 27, 1966, *Twentieth Century Italian Art*, cat.
Hayward Gallery, London, July 20–September 23, 1973, *Pioneers of Modern Sculpture* (organized by The Arts Council of Great Britain), no. 186, ill. p. 44

REFERENCES:
Borghi, Mino. *Medardo Rosso*, Milan, Milione, 1950, p. 67
Geldzahler, Henry. "Taste for Modern Sculpture: The Hirshhorn Collection," *Art News*, 61, October 1962, ill. p. 29
Kuh, Katherine. "Great Sculpture," *Saturday Review*, 45, June 23, 1962, p. 18

According to Margaret Scolari Barr, the model for this sculpture was Eugène Marin, son-in-law of Henri Rouart, Rosso's patron.

Man in Hospital (Il Malato all'ospedale). 1889.
Plaster, 9 × 10¾ × 11¾ inches

PROVENANCE:
The artist; Guido Berizzi, Milan; Peridot Gallery, New York, 1961

EXHIBITIONS:
The Solomon R. Guggenheim Museum, New York, October 3, 1962–January 6, 1963, *Modern Sculpture from the Joseph H. Hirshhorn Collection*, no. 407, ill. p. 31
The Museum of Modern Art, New York, October 2–November 23, 1963, *Medardo Rosso*, checklist no. 10
Wildenstein & Co., New York, March 4–April 3, 1971, *From Realism to Symbolism: Whistler and His World*, no. 125, plate 70; toured to Philadelphia Museum of Art, April 15–May 23

REFERENCES:
Barr, Margaret Scolari. *Medardo Rosso*, New York, The Museum of Modern Art, 1963, p. 30, ill. p. 31
Borghi, Mino. *Medardo Rosso*, Milan, Milione, 1950, p. 65, plates 18, 19
Rudikoff, Sonya. "New York Letter," *Art International*, 6, November 1962
Tillim, Sidney. "Month in Review: Rosso," *Arts Magazine*, 38, November 1963, ill. p. 30

Soon after his return to Paris, in 1889, Rosso became ill and, out of poverty, was forced to go to a public hospital. It is there that *Man in Hospital* was conceived.

Behold the Boy (Ecce Puer). 1906–7.
Wax over plaster, 17½ × 13½ × 9 inches

PROVENANCE:
Sra Tilde Rosso, Milan; Sra Danila Rosso Paravicini, Barzio, Italy; Peridot Gallery, New York, 1963

EXHIBITIONS:
The Museum of Modern Art, New York, October 2–November 23, 1963, *Medardo Rosso*, checklist no. 27, cover ill.

REFERENCES:
Barr, Margaret Scolari. *Medardo Rosso*, New York, The Museum of Modern Art, 1963, colorplate frontispiece
Borghi, Mino. *Medardo Rosso*, Milan, Milione, 1950, p. 69
Kozloff, Max. "The Equivocation of Medardo Rosso," *Art International*, 7, December 5, 1963, p. 47, ill.
———. *Renderings: Critical Essays on a Century of Modern Art*, New York, Clarion, 1969, p. 175, ill. 9
Tillim, Sidney. "Month in Review: Rosso," *Arts Magazine*, 38, November 1963, ill. p. 30
Unsigned. "Art: The Moment Caught," *Newsweek*, 62, October 7, 1963, ill. p. 106
———. "From Exhibitions Here and There," *Art International*, 4, nos. 2–3, 1960, ill. p. 72

This portrait of Alfred William Mond was one of Rosso's rare commissions. A bronze cast of *Behold the Boy* marks the artist's grave in the Cimitero Monumentale di Milano.

THEODORE J. ROSZAK (b. 1907)

Born Poznan, Poland, May 1, 1907. Emigrated with family to Chicago, 1909; U.S. citizen, 1921. Studied: School of The Art Institute of Chicago, 1922–25, 1927–29; National Academy of Design, New York, with Charles Hawthorne, and George Luks, 1926; Columbia University, New York, 1926. First one-man show (lithographs), Allerton Galleries, Chicago, 1928. Received: American Traveling Fellowship, 1928; Anna Louis Raymond Fellowship for European Study, 1929–30; Louis Comfort Tiffany Foundation Fellowship, 1931. Settled in New York, 1931. Included in: Whitney Annual, from 1932; "A Century of Progress," The Art Institute of Chicago, 1933. One-man shows: Nicholas Roerich Museum of Art, New York, 1935; Albany Institute of History and Art, Albany, New York, 1936. WPA Federal Art Project, Easel Division, New York, 1937–39; instructor, Design Laboratory, 1938–40. One-man shows, New York: Julien Levy Gallery, and The Artists' Gallery, 1940; Pierre Matisse Gallery, from 1951. Taught, Sarah Lawrence College, Bronxville, New York, 1941–56. Awarded Purchase Prize for Sculpture, I São Paulo Bienal, 1951. Designed bell tower and chapel, Massachusetts Institute of Technology, Cambridge, 1953. Retrospective, Walker Art Center, Minneapolis, and Whitney Museum of American Art, New York, and tour, 1956–57. Included in: Exposition Universelle et Internationale de Bruxelles, 1958; Venice Biennale, 1960. Eagle commissioned, U.S. Embassy, London, 1960; exhibited, Court of New Horizons, New York World's Fair, Flushing Meadows, 1964–65. Member: Commission of Fine Arts, Washington, D.C., 1963–67; The National Institute of Arts and Letters, 1964; Art Commission of the City of New York, from 1968. One-man show, Riverside Museum, New York, 1968. Lives in New York.

Invocation I. 1947.
Steel, 30½ × 21½ × 14 inches
Markings: underside of base "T. J. Roszak"
r. side "Theodore Roszak"

PROVENANCE:
Pierre Matisse Gallery, New York, 1961

EXHIBITIONS:
Pierre Matisse Gallery, New York, April 1951, *Theodore Roszak*, no. 6
Whitney Museum of American Art, New York, September 18–November 11, 1956, *Theodore Roszak*, no. 3, ill. p. 35; toured to Walker Art Center, Minneapolis, December 16–January 29, 1957; Los Angeles County Museum of Art, February 13–March 17; San Francisco Museum of Art, April 4–May 26; Seattle Art Museum, June 12–August 11
The Solomon R. Guggenheim Museum, New York, October 3, 1962–January 6, 1963, *Modern Sculpture from the Joseph H. Hirshhorn Collection*, no. 410, ill. p. 184
Whitney Museum of American Art, New York, May 8–June 16, 1964, *The Friends Collect*, no. 130

REFERENCES:
Krasne, Belle. "A Theodore Roszak Profile," *Art Digest*, 27, October 15, 1952, ill. p. 9
Lucie-Smith, Edward. *Late Modern: The Visual Arts Since 1945*, New York, Praeger, 1969, p. 284, ill. p. 215
Roszak, Theodore J. "Some Problems of Modern Sculpture," *Magazine of Art*, 42, February 1949, ill. p. 54
Rubin, William S. "The Hirshhorn Collection at the Guggenheim Museum," *Art International*, 6, November 1962, ill. p. 37

MARK ROTHKO (1903–1970)

Marcus Rothkowitz, born Dvinsk, Russia, September 25, 1903. Emigrated with family to Portland, Oregon, 1913. Studied: Yale University, New Haven, Connecticut, 1921–23; The Art Students League of New York, with Max Weber, 1925. Exhibited, Opportunity Gallery, New York, 1929. Taught: Center Academy, Brooklyn Jewish Center, New York, 1929–52; California School of Fine Arts, San Francisco, summers, 1947, 1949. One-man shows: Contemporary Arts, New York, 1933; J. B. Neumann's New Art Circle, New York, 1940; Peggy Guggenheim's Art of This Century, New York, 1945; San Francisco Museum of Art, and Santa Barbara Museum of Art, California, 1946; Betty Parsons Gallery, New York, 1946–51. Co-founded The Ten, New York, with Ilya Bolotowsky, Adolph Gottlieb, and Joseph Solman, among others, 1935; group exhibitions, 1935–38, included "The Ten: Whitney Dissenters," Mercury Gallery, New York, 1938. WPA Federal Art Project,

Easel Division, New York, 1936–37. Included in: Whitney Annual, 1947–50; Venice Biennale, 1948; "Abstract Painting and Sculpture in America," and "15 Americans," The Museum of Modern Art, New York, 1951, 1952. Co-founded Subjects of the Artist: A New Art School, New York, with William Baziotes, Robert Motherwell, Barnett Newman, David Hare, 1948. Taught: Brooklyn College, New York, 1951–54; University of Colorado, Boulder, 1955. One-man shows: Sidney Janis Gallery, New York, 1955, 1958; Venice Biennale, 1958; The Phillips Collection, Washington, D.C., 1960; The Museum of Modern Art, New York, International Circulating Exhibition, 1961–63; Marlborough Fine Art, London, 1964. Included in: Guggenheim International Award, 1958; Pittsburgh International, 1958, 1961; Documenta II, Kassel, 1959. Member, The National Institute of Arts and Letters, 1968. Died by suicide, New York, February 25, 1970. Memorial exhibition, Galleria Internazionale d'Arte Moderna di Ca' Pesaro, Venice, and Marlborough Gallery, New York, 1970. Rothko room installed, The Tate Gallery, London, 1970; Rothko Chapel dedicated, Institute of Religion and Human Development, Houston, 1971. Retrospective, Kunsthaus, Zurich, and tour, 1971–72.

Number 24. 1949.
Oil on canvas, 88 × 57½ inches

PROVENANCE:
Betty Parsons Gallery, New York; G. David Thompson, Pittsburgh; Jeanne Reynal, New York, 1961; Harold Diamond, New York, 1964

EXHIBITIONS:
The Museum of Modern Art, New York, January 18–March 12, 1961, *Mark Rothko*, p. 43; toured to Whitechapel Art Gallery, London, October 10–November 12; Stedelijk Museum, Amsterdam, November 24–December 27; Palais des Beaux-Arts, Brussels, January 6–29, 1962; Kunsthalle, Basel, March 3–April 8; Galleria Nazionale d'Arte Moderna, Rome, April 27–May 20; Musée d'Art Moderne de la Ville de Paris, December 5–January 13, 1963
Institute of Contemporary Art, University of Pennsylvania, Philadelphia, January 14–March 1, 1965, *1943–1953: The Decisive Years*, cat.
Los Angeles County Museum of Art, June 16–August 1, 1965, *New York School: The First Generation: Paintings of the 1940s and 1950s*, no. 103, ill. p. 184

REFERENCES:
Kozloff, Max. "The Problem of Color-Light in Rothko," *Artforum*, 4, September 1965, p. 43, ill.
Newman, Barnett. "The New York School Question," *Art News*, 64, September 1965, ill. p. 39
Rose, Barbara. *American Art since 1900*, New York, Praeger, 1967, p. 196, ill. nos. 7–8, p. 197
Sandler, Irving. *The Triumph of American Painting*, New York, Praeger, 1970, p. 179, ill. p. 180
Tuchman, Maurice. *New York School: The First Generation*, Greenwich, Connecticut, New York Graphic Society, 1971, p. 143, ill. 112

Blue, Orange, Red. 1961.
Oil on canvas, 90½ × 81 inches
Signed and dated on back: "Mark Rothko 1961"

PROVENANCE:
Marlborough Fine Art, London, 1963

EXHIBITIONS:
Marlborough Fine Art, London, February–March 1964, *Mark Rothko*, no. 5, colorplate
School of Fine and Applied Arts, Boston University, February 6–March 14, 1970, *American Artists of the 1960's*, no. 50, ill.

REFERENCES:
Cogniat, Raymond. "Return to Zero: a time for questioning," *Studio International*, 168, September 1964, colorplate p. 123
Mellow, James R., ed. "New York: The Art World," *Arts Yearbook 7*, 1964, colorplate p. 75

FRANÇOIS RUDE (1784–1855)

Born Dijon, France, January 4, 1784. Apprenticed to father, a metalworker. Studied with François Devosge, founder and director, École des Beaux-Arts, Dijon. Arrived in Paris, 1807; worked in atelier of Edmé Gaulle, on sculptural reliefs for column to be erected in Place Vendôme. Entered atelier of Pierre Cartellier, École des Beaux-Arts, Paris. Received: Second Prize for Sculpture, Prix de Rome, 1809; Prix de Rome, 1812 (although funding never provided for trip to Italy). After Napoleon's abdication in 1815, exiled in Brussels (then part of The Netherlands); appointed official court sculptor, and commissioned to make portrait bust of King William I. Sculptural decorations, Brussels: Hôtel des Monnaies; Théâtre Royale; palace of William I. Returned to Paris, 1827. Chevalier, Légion d'honneur, 1833. Two reliefs, *The Return of the Army from Egypt*, and *The Departure of the Volunteers of 1792*, commissioned, Arc de Triomphe, Paris; dedicated, 1836. Traveled in Italy, 1842. On return to Paris, established atelier, independent of Académie des Beaux-Arts (to which he was never admitted). Worked on decorations, Musée du Louvre, with Jean-Baptiste Carpeaux, Antoine-Louis Barye, and others. Died Paris, November 3, 1855. Posthumously awarded Médaille d'honneur, Exposition Universelle de 1855, Paris. Musée Rude established, Dijon, 1947. Centennial exhibition, Musée des Beaux-Arts, Dijon, 1955.

Head of an Old Warrior. c. 1833–36.
Terra-cotta, 25¼ × 15 × 13¼ inches
Markings: l. r. side "Fcois Rude"

PROVENANCE:
Galerie Claude Bernard, Paris; Bernard Black Gallery, New York, 1968

EXHIBITIONS:
Galerie Claude Bernard, Paris, January 1967, *Portraits in Sculpture*
Bernard Black Gallery, New York, December 12, 1967–January 13, 1968, *Sculpture for a Small Museum—2*, no. 25, ill. and cover (detail)

Head of an Old Warrior is a study for the central figure in the final version of Rude's allegory of French patriotism, *The Departure of the Volunteers of 1792,* on the Arc de Triomphe, Paris.

EDWARD RUSCHA (b. 1937)

Born Omaha, Nebraska, December 16, 1937. Moved to Oklahoma City, Oklahoma, 1942. Studied advertising design, Chouinard School of Art, Los Angeles, 1956–60. Included in "Four Oklahoma Artists," Oklahoma City Art Center, 1960. Traveled to Europe, 1961. Published first book, *Twenty-six Gasoline Stations* (Hollywood, California, Heavy Industry Press), 1962. Included in: "New Paintings of Common Objects," Pasadena Art Museum, California, 1962; "American Drawings," "Words and Images," The Solomon R. Guggenheim Museum, New York, 1964, 1965; IX São Paulo Bienal, 1967; Whitney Annual, 1967, 1969. One-man shows: Ferus Gallery, Los Angeles, 1963–65; Alexandre Iolas Gallery, New York, 1967, 1970; Galerie Rudolf Zwirner, Cologne, 1968; Irving Blum Gallery, Los Angeles, 1968, 1969. Received National Council on the Arts Grant, 1967. Included in: "Ed Ruscha—Joe Goode," Newport Harbor Art Museum, Balboa, California, 1968; Venice Biennale, 1970; Sonsbeek '71, Arnhem, The Netherlands, 1971; Documenta 5, Kassel, 1972. One-man shows: DM Gallery, London, 1972; Museum Boymans-van Beuningen, Rotterdam, The Netherlands, 1972; The Minneapolis Institute of Arts, 1972; Leo Castelli Gallery, New York, 1973; Root Art Center, Hamilton College, Clinton, New York, 1974. Lives in Hollywood.

The Los Angeles County Museum on Fire. 1968.
Oil on canvas, 4 feet 6 inches × 11 feet

PROVENANCE:
Irving Blum Gallery, Los Angeles, 1968

EXHIBITIONS:
Irving Blum Gallery, Los Angeles, February 1968, *Ed Ruscha*
Newport Harbor Art Museum, Balboa, California, March 24–April 21, 1968, *Ed Ruscha—Joe Goode,* cat., colorplate

REFERENCES:
Bourdon, David. "Ruscha as Publisher (Or All Booked Up)," *Art News,* 71, April 1972, pp. 36, 68, 69, ill. p. 33
Hoag, Jane. "Los Angeles," *Art News,* 67, April 1968, p. 23
Mussman, Toby. "L.A. on Fire," *Arts Magazine,* 42, March 1968, p. 15
Terbell, Melinda. "Realignments in the Galleries," *Art News,* 72, October 1973, p. 60

MORGAN RUSSELL (1886–1953)

Born New York, January 25, 1886; son of an architect. Studied, New York: architecture, 1904–5; The Art Students League of New York, with Robert Henri, and James Earle Fraser, 1906–8. Traveled to Paris, and Italy, spring and summer, 1906–8. Gertrude Vanderbilt Whitney his patron, 1908–13. Settled in Paris, 1909. Exhibited, Paris: Salon d'Automne, 1910; Salon des Indépendants, 1913. Developed principles of Synchromism, with Stanton Macdonald-Wright, 1912. Exhibited with Macdonald-Wright: Neue Kunstsalon, Munich, and Galerie Bernheim-Jeune, Paris, 1913; The Carroll Art Galleries, New York, 1914. Included in: the Armory Show, 1913; "The Forum Exhibition of Modern American Painters," The Anderson Galleries, New York, 1916. One-man show, Galerie La Licorne, Paris, 1923. Exhibited with Macdonald-Wright: Los Angeles County Museum of History, Science and Art, 1927, 1932; Stendahl Galleries, Los Angeles, 1932. Returned to the U.S., 1946. Exhibited, New York: "Pioneers of Modern Art in America," Whitney Museum of American Art, 1946; "Abstract Painting and Sculpture in America," The Museum of Modern Art, 1951; "Synchromism and Color Principles in American Painting, 1910–1930," M. Knoedler & Co., 1965. Died Broomall, Pennsylvania, May 29, 1953. Memorial exhibitions: Rose Fried Gallery, New York, 1953; Portland Art Museum, Oregon, 1954.

Synchromy. 1914–15.
Oil on canvas, 32 × 10 inches
Signed l. l.: "Morgan Russell"

PROVENANCE:
The artist; Stanton Macdonald-Wright, Pacific Palisades, California, 1962

EXHIBITIONS:
ACA Gallery, New York, March 14–April 9, 1966, *The Forum Exhibition of Modern American Painters: March 1916*

Synchromy. 1915–17.
Oil on canvas mounted on board, 12¾ × 10½ inches
Signed u. r.: "Morgan Russell"

PROVENANCE:
Rose Fried Gallery, New York, 1962

ANNE RYAN (1889–1954)

Born Hoboken, New Jersey, July 20, 1889. Studied, College of Saint Elizabeth, Convent Station, New Jersey, 1908–11. Lived in Newark, New Jersey, 1911–30. Published book of poetry, *Lost Hills,* 1925. Moved to Majorca, Spain, 1930. Returned to the U.S., 1934; settled in New York. First paintings, 1937–38. Studied printmaking, S.W. Hayter's Atelier 17, New York. One-man shows, New York: The Pinacotheca, 1941; Marquié Gallery, 1943, 1944, 1946; Willard Gallery, 1945. Included in: Brooklyn Museum Annual National Print Exhibition, New York, 1947–52; "Abstract Painting and Sculpture in America," The Museum of Modern Art, New York, 1951. First collages 1948, after seeing Kurt Schwitters exhibition at The Pinacotheca. One-man shows, New York: Betty Parsons Gallery, 1950, 1951, 1954; Kraushaar Galleries, 1951. Died Morristown, New Jersey, April 17, 1954. Memorial exhibition, Betty Parsons Gallery, 1955. Posthumous one-man shows: Kraushaar Galleries, 1957; Museum of Fine Arts, Boston, and tour, 1962; Stable Gallery, New York, 1963; Fischbach Gallery, New York, 1968; Betty Parsons

Gallery, 1970. Retrospective, The Brooklyn Museum, and National Collection of Fine Arts, Smithsonian Institution, Washington, D.C., 1974.

Collage #534. 1953.
Collage on cardboard, 12½ × 9⅜ inches
Signed l. r.: "Anne Ryan"

PROVENANCE:
Stable Gallery, New York; Fischbach Gallery, New York, 1968

EXHIBITIONS:
Stable Gallery, New York, April 23–May 11, 1963, *Anne Ryan,* cat.
Fischbach Gallery, New York, January 27–February 22, 1968, *Anne Ryan,* cat.

Collage #538. 1953.
Collage on cardboard, 12½ × 9⅜ inches
Signed l. r.: "A. Ryan"

PROVENANCE:
Stable Gallery, New York; Fischbach Gallery, New York, 1968

EXHIBITIONS:
Stable Gallery, New York, April 23–May 11, 1963, *Anne Ryan,* cat.
Fischbach Gallery, New York, January 27–February 22, 1968, *Anne Ryan,* cat.

ALBERT PINKHAM RYDER (1847–1917)

Born New Bedford, Massachusetts, March 19, 1847. Moved with family to New York, c. 1870. Studied, New York: informally, with portrait painter and engraver William Edgar Marshall, c. 1870; National Academy of Design, 1870–72, 1874–75. Included in: National Academy of Design Spring Exhibition, 1873; exhibition of works rejected by the Academy, Cottier & Co., New York, 1875. Traveled in Europe, 1877, 1882. One of twenty-two founders, Society of American Artists, 1877; exhibited there, 1878–87. Small circle of admirers included J. Alden Weir, art dealer Daniel Cottier, critic Charles de Kay, collector Thomas B. Clarke, and in later years Kenneth Hayes Miller, and Marsden Hartley. Made sea voyages with friend Captain John Robinson, 1887, 1896. Rarely exhibited after 1887; from late 1890s, chiefly reworked canvases painted earlier. Ten paintings included in the Armory Show, 1913. Died Elmhurst, New York, March 28, 1917. Memorial exhibition, The Metropolitan Museum of Art, New York, 1918. Retrospectives: "Homer, Ryder, Eakins," The Museum of Modern Art, New York, 1930; Kleemann Galleries, New York, 1935; Whitney Museum of American Art, New York, 1947; The Corcoran Gallery of Art, Washington, D.C., 1961.

Mending the Harness. n.d.
Oil on panel, 7⅞ × 8 inches
Signed l. r.: "A. P. Ryder"

PROVENANCE:
The artist, Elmhurst, New York; Mr. and Mrs. Charles Fitzpatrick, Elmhurst; Philip Evergood, New York; Passedoit Gallery, New York, 1952

"Among [Ryder's] closest later friends were a couple who lived in the same house—Charles Fitzpatrick, a carpenter and ex-sailor, and his wife Louise, an amateur painter. This kind couple took care of him, as best they could, and in his old age, in 1915, took him into their house in Elmhurst, Long Island. Here he died on March 28, 1917, a few days after his seventieth birthday."

Goodrich, Lloyd. *Albert Pinkham Ryder,* Washington, D.C., The Corcoran Gallery of Art, 1961, p. 16

Pegasus. n.d.
Oil on wood, 7 × 9 inches

PROVENANCE:
The artist, Elmhurst, New York; Mr. and Mrs. Charles Fitzpatrick, Elmhurst; Philip Evergood, New York; Passedoit Gallery, New York, 1952

EXHIBITIONS:
Brandeis University, Waltham, Massachusetts, June 1–17, 1955, *Three Collections,* no. 39
Tweed Gallery, University of Minnesota, Duluth, April 1–30, 1956, *Collector's Choice,* cat.

LUCAS SAMARAS (b. 1936)

Born Kastoria, Macedonia, Greece, September 14, 1936. Emigrated with family to the U.S.; 1948; citizen, 1955. Studied: Rutgers University, New Brunswick, New Jersey, with Allan Kaprow, 1955–59; Columbia University, New York, 1959–62. One-man shows: Rutgers University, 1955, 1958; Reuben Gallery, New York, 1959; The Green Gallery, New York, 1961, 1964; Dwan Gallery, Los Angeles, 1964; The Pace Gallery, New York, from 1966. Included in: "New Media–New Forms II," Martha Jackson Gallery, New York, 1961; "The Art of Assemblage," The Museum of Modern Art, New York, and tour, 1961–62; Whitney Annual, 1964–70; "The Obsessive Image," Institute of Contemporary Arts, London, 1968; "Dada, Surrealism and Their Heritage," The Museum of Modern Art, and tour, 1968; Documenta 4 and 5, Kassel, 1968, 1972; ROSC '71, Dublin, 1971. One-man shows: Museum of Contemporary Art, Chicago, 1971; Whitney Museum of American Art, New York, 1972–73. Lives in New York.

Untitled. 1962.
Wood, cloth, plastic, metal pins, and woolen glove, 13½ × 15 × 10½ inches

PROVENANCE:
Jacques Kaplan, New York; Oscar Krasner Gallery, New York, 1967

EXHIBITIONS:
Whitney Museum of American Art, New York, November 18, 1972–January 7, 1973, *Lucas Samaras,* no. 156

JOHN SINGER SARGENT (1856–1925)

Born Florence, January 12, 1856, of American parents. Studied: Accademia di Belle Arti e Liceo Artistico,

Florence, 1870; briefly, École des Beaux-Arts, Paris; atelier of portrait painter Émile-Auguste Carolus-Duran, Paris, c. 1874–78. Traveled extensively, throughout his life. First exhibited, Salon of 1877, Paris; awarded honorable mention, Salon of 1878. Exhibited with James Abbott McNeill Whistler, National Academy of Design, New York, 1878. Visited Venice, 1880, 1882; stayed with cousins, the Daniel Curtises, Palazzo Barbaro. His portrait of *Madame X* (The Metropolitan Museum of Art, New York) the scandal of Salon of 1884, Paris. Moved to London, 1885. Exhibited, Royal Academy of Arts, London, from 1887. One-man show, St. Botolph Club, Boston, 1887–88. Worked on portrait commissions, New York, and Boston, 1887–89. Served on jury, Salon of 1889, Paris. Légion d'honneur: chevalier, 1889; officier, 1897. Awarded Medal of Honor, Exposition Universelle de 1889, and 1900, Paris. Mural, Boston Public Library: commissioned, 1890; installed, 1916. Founding member, Société Nationale des Beaux-Arts, Paris, 1890. National Academy of Design: associate, 1891; academician, 1897. Royal Academy of Arts: associate, 1894; academician, 1897. One-man show, Copley Galleries, Boston, 1899. Awarded: Gold Medal, Venice Biennale, 1907; Gold Medal in Painting, The National Institute of Arts and Letters, and The American Academy of Arts and Letters, New York, 1914. Mural commissions: Museum of Fine Arts, Boston, rotunda, 1916, main staircase, 1921; Widener Memorial Library, Harvard University, Cambridge, Massachusetts, 1922. Exhibited: with Winslow Homer, Carnegie Institute, Pittsburgh (watercolors), 1917; with Abbott H. Thayer, M. Knoedler & Co., New York, 1918. Retrospective, Grand Central Art Galleries, New York, 1924. Died, London, April 15, 1925. Memorial exhibitions: Museum of Fine Arts, Boston, 1925; The Metropolitan Museum of Art, 1926; Royal Academy of Arts, 1926. Included in "Sargent, Whistler and Mary Cassatt," The Art Institute of Chicago, and The Metropolitan Museum of Art, 1954. Retrospectives: Museum of Fine Arts, 1956; The Corcoran Gallery of Art, Washington, D.C., and tour, 1964–65.

Mrs. Kate A. Moore. 1884.
Oil on canvas, 70 × 44 inches
Signed and dated l. l.: "John S. Sargent 1884"

PROVENANCE:
The artist, Paris; Mrs. Kate A. Moore, Pittsburgh, and Paris; Sir Hugh Lane, London; Mrs. Carroll Carstairs, New York; Charles Stewart J. Carstairs, London; M. Knoedler & Co., New York and London; Huntington Hartford, New York; The Gallery of Modern Art, New York; Parke-Bernet Galleries, Sale 3185, April 7–8, 1971, no. 24, ill. p. 81; James Graham and Sons, New York, 1971

EXHIBITIONS:
M. Knoedler & Co., New York, December 1918, *Sargent —Thayer*
M. Knoedler & Co., New York, Summer 1919, *Twelfth Annual Summer Exhibition of Paintings by American Artists,* no. 21
City Art Museum of St. Louis, Missouri, September 14–October 28, 1919, *Fourteenth Annual Exhibition of Paintings by American Artists,* no. 134, ill.
Albright Art Gallery, Buffalo, New York, January 10–February 15, 1920, *Important Works by a Number of America's Leading Painters,* ill. p. 2
The Pennsylvania Academy of the Fine Arts, Philadelphia, February 6–March 27, 1921, *The One Hundred and Sixteenth Annual Exhibition,* no. 83, ill.
Cincinnati Art Museum, Ohio, May 28–July 31, 1921, *Twenty-Eighth Annual Exhibition of American Art,* cat., ill.
Royal Academy of Arts, London, January 14–March 13, 1926, *Winter Exhibition of Works by the Late John S. Sargent, R.A.,* no. 589, ill.
Albright Art Gallery, Buffalo, New York, April 26–June 22, 1931, *25th Annual Exhibition of Selected Paintings by American Artists,* no. 24, ill.
XIX Biennale Internazionale d'Arte, Venice, May–October 1934, *Central Pavilion,* no. 25, p. 94
Society of the Four Arts, Palm Beach, Florida, March 7–April 5, 1959, *John Singer Sargent and Mary Cassatt,* no. 5, ill. p. 15
The Gallery of Modern Art, New York, March–June 1964, *The Huntington Hartford Collection*

REFERENCES:
Charteris, Evan. *John Sargent,* New York, Scribner's, 1927, pp. 157, 258
Downes, William Howe. *John S. Sargent: His Life and Work,* Boston, Little, Brown, 1925, p. 134
Field, Hamilton Easter. "The Pennsylvania Academy," *The Arts,* 1, February–March 1921, p. 22
Frankfurter, Alfred M. "Caviare?—New York's Newest Museum," *Art News,* 63, March 1964, p. 34, ill.
McKibbin, David. *Sargent's Boston,* Boston, Museum of Fine Arts, 1956, p. 111
Mount, Charles Merrill. *John Singer Sargent, A Biography,* reprint ed., New York, Kraus, 1969, pp. 82, 446
Ormand, Richard. *John Singer Sargent,* New York, Harper & Row, 1970, pp. 32, 40, 242, plate 43
Pousette-Dart, Nathaniel. *John Singer Sargent,* New York, Stokes, 1924, ill.
Unsigned. "La Diciannovesina Biennale: Il Ritratto Ottocentesco," *Emporium,* 79, June 1934, ill. p. 344
———. *Illustrations of the Sargent Exhibition,* London, Walter Judd, 1926, ill. p. 26
———. "Sargent Portraits," *American Magazine of Art,* 10, February 1919, pp. 141, 143, ill. p. 142
———. "Summer Exhibition of Americans," *American Art News,* 17, July 12, 1912, p. 2
———. "Works by Sargent and Thayer," *American Art News,* 17, December 21, 1918, p. 2
Watson, Forbes. "John Singer Sargent," *The Arts,* 7, May 1925, ill. p. 244

"[Sargent] was at the same time engaged on a presentation portrait of the wife of a Chilean painter named Errazuriz and a full-length of an American woman named Moore. The latter had a remarkable reputation for her malapropisms in French, and she frightened him

half to death while he worked at her home for fear that when she asked the butler to remove a vase of flowers she would be misunderstood, and he would be ejected instead."

Mount, p. 82

Catherine Vlasto. 1897.
Oil on canvas, 58¼ × 33¾ inches
Signed and dated u. r.: "John S. Sargent 1897"

PROVENANCE:
Alexander A. Vlasto; Anthony Alexander Vlasto; Mrs. Erato Vlasto, Ascot, Berkshire, England; R. A. Vlasto; Christie's, London, Sale, March 10, 1967, no. 51, ill.; Gimpel Fils, London, 1967

The Redemption. 1900.
Bronze, 28½ × 20 × 2¼ inches

PROVENANCE:
The artist; Mr. and Mrs. Daniel Sargent Curtis, Palazzo Barbaro, Venice; Ralph Wormeley Curtis, Palazzo Barbaro; Ralph D. Curtis, Paris; Parke-Bernet Galleries, New York, Sale 2531, March 16, 1967, no. 59, ill.; Ralph D. Curtis, 1967

EXHIBITIONS:
University Art Museum, University of California, Berkeley, June 28–August 27, 1972, *The Hand and the Spirit: Religious Art in America 1770–1900*, no. 122, ill.; toured to National Collection of Fine Arts, Smithsonian Institution, Washington, D.C., September 28–November 5; Dallas Museum of Fine Arts, December 10–January 14, 1973; Indianapolis Museum of Art, Indiana, February 20–April 15

REFERENCES:
Sargent, John Singer. Letter to Mrs. Daniel Sargent Curtis, October 1, 1900. Private collection

Betty Wertheimer Salaman (Mrs. Arthur Ricketts). Before 1906.
Watercolor on paper, 13¼ × 9¾ inches
Inscribed l. l.: "To Mrs. Salaman John S. Sargent"

PROVENANCE:
The artist, London; Mrs. Arthur Ricketts, London; Miss Thumen, Millwater, Surrey, England; Sotheby & Co., London, Sale, November 21, 1962, no. 60

REFERENCES:
McKibbin, David. *Sargent's Boston*, Boston, Museum of Fine Arts, 1956, p. 130
Unsigned. "In the Sale Rooms: Whistler Works Fetch £10,870," *The Times*, London, November 22, 1962

Sargent sketched and painted many portraits of his friend Asher Wertheimer, a wealthy London art dealer, and his large family. Upon his death, in 1918, Mr. Wertheimer left nine of the paintings to The National Gallery, London. In 1926, they were placed in a special room in The Tate Gallery, London.

Sargent made several formal portraits of Mr. Wertheimer's daughter Betty (1877–1953), who married Eustace A. Salaman and, after his death in 1915, Arthur Ricketts, M.D. One of these portraits, dated c. 1898, is in the Gellatly Collection, National Collection of Fine Arts, Smithsonian Institution, Washington, D.C.

Boats on Lake Garda (Lago di Garda). 1913.
Watercolor on paper, 15⅛ × 21 inches
Signed l. l.: "John S. Sargent"

PROVENANCE:
Clement Parsons, London; Sir Alan Parsons, London; Sotheby & Co., London, Sale, November 21, 1962, no. 58

EXHIBITIONS:
Royal Academy of Arts, London, January 14–March 13, 1926, *Winter Exhibition of Works by the Late John S. Sargent, R.A.*, no. 127

REFERENCES:
Downes, William Howe. *John S. Sargent: His Life and Work*, Boston, Little, Brown, 1925, p. 282
Unsigned. "In the Sale Rooms: Whistler Works Fetch £10,870," *The Times*, London, November 22, 1962

Study for The Conflict Between Victory and Death. 1921–22.
Bronze, 12 × 6⅜ × 9¼ inches
Markings: l. r. side "JSS"

PROVENANCE:
B. Weinreb, London; R. E. Lewis, San Francisco; Robert Schoelkopf Gallery, New York, 1962

EXHIBITIONS:
The Corcoran Gallery of Art, Washington, D.C., April 18–June 14, 1964, *The Private World of John Singer Sargent*, no. 167, ill.; toured to The Cleveland Museum of Art, July 17–August 18; Worcester Art Museum, Massachusetts, September 17–November 1; Munson-Williams-Proctor Institute, Utica, New York, November 15–January 3, 1965

REFERENCES:
Sutton, Denys. "A Bouquet for Sargent," *Apollo*, 79, May 1964, ill. p. 399

ANTONIO SAURA (b. 1930)

Born Huesca, Spain, September 22, 1930. Self-taught as an artist. One-man shows, Galeria Buchholz, Madrid, 1951, 1952, 1956. Lived in Paris, 1953–55. Included in: Venice Biennale, 1956, 1958; Pittsburgh International, 1958, 1961, 1964, 1967; Documenta II, Kassel, 1959. One-man shows, Galerie Stadler, Paris, 1957, 1959, 1960, 1963, 1965, 1967. Co-founded El Paso group, Madrid, with Rafael Canoger, Luis Feito, and Manolo Millares, 1957–60; exhibited with group, Galeria Buchholz, 1957. Exhibited with Antonio Tapies, Galerie Van de Loo, Munich, 1959. Included in: "European Art Today," The Minneapolis Institute of Arts, 1959; "New Spanish Painting and Sculpture," The Museum of Modern Art, New York, 1960; Guggenheim International, 1960, 1964; Seattle World's Fair, 1962; ROSC '67, Dublin, 1967. One-man shows: Galerie Blanche, Stockholm, 1959, 1960; Pierre Matisse Gallery, New York, from

1961; Galerie Aujourd'hui, Brussels, 1963; Stedelijk Museum, Amsterdam, 1964; Galerie M. Peppiatt, Paris, 1970–71. Lives in Paris.

Crucifixion (Triptych). 1959–60.
Oil on canvas, 6 feet 5 inches × 10 feet 7 inches
Signed and dated, center panel: "Saura 59–60"

PROVENANCE:
Pierre Matisse Gallery, New York, 1961

EXHIBITIONS:
Pierre Matisse Gallery, New York, March 6–April 1, 1961, *Antonio Saura*, no. 11, ill.
Seattle World's Fair, April 21–October 21, 1962, *Art Since 1950*, no. 83, ill. p. 121

REFERENCES:
Ashton, Dore, and Pease, Roland F., Jr. "New York Notes," *Art International*, 5, May 1961, ill. p. 71
Ayllon, José. *Antonio Saura*, Barcelona, Gustavo Gili, 1969, p. 64, ill. p. 43a
Canaday, John. "Art: Brutal World of Antonio Saura's Paintings," *The New York Times*, March 7, 1961, ill. p. 71
Langsner, Jules. "Clues to the Art of Our Time: The Exhibition at the Seattle World's Fair," *Art International*, 6, May 1962, ill. p. 36
Unsigned. *Saura*, Rome, Galleria Odyssia, 1962, no. 23, ill.

NICOLAS SCHÖFFER (b. 1912)

Born Kalocsa, Hungary, September 6, 1912. Studied, National Academy of Fine Arts, Budapest. Moved to Paris, 1936; studied, École des Beaux-Arts. First one-man show (paintings), Galerie Breteau, Paris, 1948. Became interested in kinetics, 1948; developed first spatiodynamic theories. One-man show (kinetic sculpture), Galerie des Deux-Îles, Paris, 1950. Built "cybernetic towers," multimedia, motorized structures: Parc de St.-Cloud, Paris, 1954; city of Liège, Belgium, 1961. Published *Le Spatiodynamisme* (Boulogne-sur-Seine, France, Éditions AA), 1955. One-man shows: Galerie Denise René, Paris, from 1958; Institute of Contemporary Arts, London, 1960; Palais des Beaux-Arts, Brussels, 1961; Musée des Arts Décoratifs, Paris, 1963; Stedelijk Museum, Amsterdam, 1964. Exhibited: Documenta III, Kassel, 1964; "Kinetic and Optic Art Today," Albright-Knox Art Gallery, Buffalo, New York, 1965; with Jean Tinguely, "Two Kinetic Sculptors," The Jewish Museum, New York, and tour, 1965–66; Venice Biennale, 1968 (Grand Prize). One-man shows: Waddell Gallery, New York, 1968; Städtische Kunsthalle, Düsseldorf, 1968; Galerie Denise René, New York, 1972. Published *La Ville cybernétique* (Paris, Tchou), 1969. Lives in Paris.

Spatiodynamique 17. 1968.
Chromed metal with motor, 17 feet 6 inches × 7 feet 11¼ inches × 7 feet 9¼ inches

PROVENANCE:
Galerie Denise René, Paris, 1968

"In the present phase of the evolution of artistic investigations, I consider that the work must be absolutely separated from the problem of form.

"The formal aspect of works must be reduced to a minimum of signs that can create a visual (or audiovisual) language in the service of programmings of all kinds, diversified to their extreme limits, in order to realize temporal and microtemporal structures, organized with a view to obtaining amplitudes varied by the combined progress of the events (complex or simple), and their retroactions.

"The visual or audiovisual complex thus created can have deeper repercussions in the psychophenomenological field of the spectator, can take charge of him, so to speak, stimulate him or relax him, through aesthetic products that are all the more effective as they are non-formalist, and immaterial in their essence, in which durations replace volumes, and temporal rhythms the configurations of surfaces.

"The programmed climates have an immediate power of communication.

"Cybernetics gives the work a flexibility of adaptation hardly known until now; the work becomes organic, rising to a level never yet reached.

"The work lives and adapts itself as much to the one who perceives it as the latter lives and adapts himself to the climates created by the works, which are finally merely his own prolongations transcended with a view to his own improvement.

"These considerations likewise relate to the art of building on the scale of architecture, city planning, and the organization of a territory.

"Here, too, diversified but simple and effective languages will create structures using elements such as time, light, sound, climate, and space.

"The complex programming of these elements leads us toward structured ensembles in which cybernetics maintains the optimum balance in a fluctuating permanence."

Statement by the artist, 1972

TIM SCOTT (b. 1937)

Timothy Scott, born London, April 18, 1937. Studied: Lycée Jaccard, Lausanne, 1950–54; Architectural Association, London, 1954–59; St. Martin's School of Art, London, with Anthony Caro, 1955–59. Included in "Young Contemporaries," R.B.A. Galleries, London, 1958, 1959. Worked in Le Corbusier's studio, Paris, 1959–61. Returned to London; began teaching, St. Martin's, 1961. Included in: "26 Young Sculptors," Institute of Contemporary Arts, London, 1961; "The New Generation," Whitechapel Art Gallery, London, 1965; "Primary Structures," The Jewish Museum, New York, 1966; "Sculpture in the Open Air," Battersea Park, London, 1966. One-man shows: The Waddington Galleries, London, 1966, 1969, 1971; White-

chapel Art Gallery, 1967; Museum of Modern Art, Oxford, England, 1969; Lawrence Rubin Gallery, New York, 1969, 1971; Museum of Fine Arts, Boston, and The Corcoran Gallery of Art, Washington, D.C., 1972–73. Lives in Peckham, England.

Quali I. 1967.
Painted steel tube and acrylic sheet, 4 feet 10 inches × 15 feet 1 inch × 9 feet 1 inch

PROVENANCE:
Lawrence Rubin Gallery, New York, 1969

EXHIBITIONS:
Lawrence Rubin Gallery, New York, May 3–June 1, 1969, *Tim Scott*, checklist, no. 2

REFERENCES:
Mellow, James R. "A Briton and an American in a 'Transatlantic Dialogue,'" *The New York Times*, May 18, 1969, sec. 2, p. 27, ill.

HARRY SEAGER (b. 1931)

Born Birmingham, England, May 9, 1931. Studied, Birmingham College of Art and Design. Military service, Far East, 1956–57. One-man shows, Gimpel Fils, London, from 1965. Included in: "Six Young Artists," Institute of Contemporary Arts, London, 1968; "Collectors Choice," Gimpel & Weitzenhoffer, New York, 1969. Has taught, Stourbridge College of Art, England, since 1964. Lives in Stourbridge.

Opus 29. 1965.
Glass and iron, 23¼ × 25 × 25¼ inches

PROVENANCE:
Gimpel Fils, London, 1966

JOHN SEERY (b. 1941)

Born Cincinnati, Ohio, October 29, 1941. Studied: Miami University, Oxford, Ohio, 1959–63; Art Academy of Cincinnati, summer, 1963; Ohio State University, Columbus, 1963–64. Included in: "Ohio Painters," Dayton Art Show, Ohio, 1963; "Language #3," Dwan Gallery, New York, 1968; "Creative Uses of Television," Howard Wise Gallery, New York, 1968; "Two Generations of Color Painting," Institute of Contemporary Art, University of Pennsylvania, Philadelphia, 1970; "Young American Artists," The Contemporary Arts Center, Cincinnati, 1970. Moved to New York, 1964. One-man shows: André Emmerich Gallery, New York, from 1970; The New Gallery, Cleveland, 1971; Richard Gray Gallery, Chicago, 1971, 1973. Included in: Whitney Biennial, 1973; "Six Painters of the Seventies, Abstract Painting in New York," William Hayes Ackland Memorial Art Center, University of North Carolina at Chapel Hill, 1973. Lives in New York.

Wind and Bone Eclipse. 1970.
Acrylic on canvas, 8 feet 10¼ inches × 6 feet 10¼ inches
Signed and dated on back: "John Seery 2–1970"

PROVENANCE:
André Emmerich Gallery, New York, 1970

GEORGE SEGAL (b. 1924)

Born New York, November 26, 1924. Moved with family to North Brunswick, New Jersey, 1940. Studied: The Cooper Union for the Advancement of Science and Art, New York, 1941; Rutgers University, New Brunswick, New Jersey, part-time, 1941–46; Pratt Institute, Brooklyn, New York, 1947; New York University, B.S., 1949; Rutgers University, M.F.A., 1963. One-man shows: Hansa Gallery, New York, 1956–59; Rutgers University, 1958; The Green Gallery, New York, 1960–64. Included in "The New York School: The Second Generation," The Jewish Museum, New York, 1957. Taught, Rutgers University, 1958–59. Received Gutman Foundation Award, 1962. Included in: VII and IX São Paulo Bienal, 1963, 1967; Pittsburgh International, 1964, 1967, 1970; Documenta 4, Kassel, 1968. One-man shows: Galerie Ileana Sonnabend, Paris, 1963; Galerie Alfred Schmela, Düsseldorf, 1963; Sidney Janis Gallery, New York, from 1965; Museum of Contemporary Art, Chicago, 1968; Galerie Darthea Speyer, Paris, 1969; Kunsthaus, Zurich, 1971; Art History Galleries, University of Wisconsin, Milwaukee, and Indianapolis Museum of Art, Indiana, 1973. Exhibited and lectured, Princeton University, New Jersey, 1968. Has taught, City University of New York, since 1972. Lives in North Brunswick.

Bus Riders. 1964.
Plaster, metal, and vinyl, 69 × 40 × 76 inches

PROVENANCE:
The Green Gallery, New York, 1964

EXHIBITIONS:
The Green Gallery, New York, March 10–April 4, 1964, *George Segal*
Carnegie Institute, Pittsburgh, October 30, 1964–January 10, 1965, *The 1964 Pittsburgh International Exhibition of Contemporary Painting and Sculpture*, no. 370, ill.

REFERENCES:
Aarons, Leroy. "Sound the Hirshhorn! The Collection," *The Washington [D.C.] Post Potomac*, March 19, 1967, colorplate p. 19
Canaday, John. "Pop Art Sells On and On. Why?" *The New York Times Magazine*, May 31, 1964, ill. p. 52
Geldzahler, Henry. "An Interview with George Segal," *Artforum*, 3, November 1964, ill. p. 28
Grossman, Emery. *Art and Tradition*, New York, Yoseloff, 1967, ill. p. 147
Hunter, Sam. *American Art of the 20th Century*, New York, Abrams, 1972, ill. 543
Levin, Kim. "Anything Goes at the Carnegie," *Art News*, 63, December 1964, p. 35, ill. p. 36
Seitz, William C. *Segal*, New York, Abrams, 1972, ill. 27
Swenson, Gene. "Reviews and Previews: George Segal," *Art News*, 63, May 1964, pp. 10–11
Unsigned. "Modern Plaster Master," *Life*, 56, June 19, 1964, ill. p. 106

van der Marck, Jan. *George Segal*, New York, Abrams, forthcoming, ill.

"I worked on *Bus Riders* at the same time I was doing *Bus Driver* and spent a lot of time in a junk yard in Newark that scrapped only buses. My hunt was for real objects whose shape and plastic presence excited me, pieces I could stack and build into a place I could enter, with a strong memory of their past life in the world.

"The bus seats struck me as perfect repetitions, endless rows of identical empty seats. What would happen if I gave no instructions to my models? I just asked them to sit down on a bus seat. Each did it in his or her own way, quite true to his own nature. My pleasure in the piece is much the same as I get in reading Proust: a delight in examining minute differences in the large bulks before me."

Statement by the artist, 1972

ANTONIO SEGUÍ (b. 1934)

Born Córdoba, Argentina, January 11, 1934. Studied painting and sculpture, Argentina, Spain, France, 1950–53. One-man show Galería Paideia, Córdoba, 1957. Lived in Mexico City, 1957–61. One-man shows: Galería Genova, Mexico City, 1958–59; Museo Nacional de Historia y Bellas Artes, Guatemala City, 1959; Bolles Gallery, San Francisco, 1959; Galería Witcomb, Buenos Aires, 1960–62. Included in: "Arte Argentino Contemporáneo," Museu de Arte Moderna do Rio de Janeiro, 1961; "L'Art Argentin Actuel," Musée National d'Art Moderne, Paris, 1963; Venice Biennale, 1964; Pittsburgh International, 1964; "New Art in Argentina," Walker Art Center, Minneapolis, 1964–65; "The Emergent Decade," The Andrew Dickson White Museum of Art, Cornell University, Ithaca, New York, and The Solomon R. Guggenheim Museum, New York, 1965–66. Two-gallery show, Galerie Jeanne Bucher, and Galerie Claude Bernard, Paris, 1964. One-man shows: Galerie Claude Bernard, 1968, 1969; Kunsthalle, Darmstadt, Germany, 1969; Galerie-T, Haarlem, The Netherlands, 1970; Galerie du Dragon, Paris, 1971; Lefebre Gallery, New York, 1972. Has lived in Paris, since 1963.

Fat Luisa in the Bordello (La Gorda Luisa). 1963.
Oil and collage on board, 69 × 39 inches
Signed and dated r. r.: "Segui 63"

PROVENANCE:
Galerie Claude Bernard, Paris, 1964

EXHIBITIONS:
XXXII Biennale Internazionale d'Arte, Venice, June–September 1964, *Argentine Pavilion*, no. 9

PABLO SERRANO (b. 1910)

Born Crivillén, Spain, March 10, 1910. Studied, Escuela de Bellas Artes de Barcelona, 1922. Lived in Montevideo, Uruguay, 1930–55; associated with Joaquín Torres-García, 1946. Awarded Grand Prize: II Bienal, Montevideo, 1955; III Bienal Hispanoamericano, Barcelona, 1955. Returned to Spain, 1955. One-man show, Sala de Santa Catalina, Ateneo de Madrid, 1956. Member, El Paso group, 1957–58; exhibited with group, Galería Buchholz, Madrid, 1957. One-man shows: Galerie Édouard Loeb, Paris, 1958; Galería Nebli, Madrid, 1959. Included in: "New Spanish Painting and Sculpture," The Museum of Modern Art, New York, and tour, 1960–62; "Ten Sculptors," Marlborough Fine Art, London, 1961; Pittsburgh International, 1961, 1964, 1967; Guggenheim International, 1967–68. Awarded Julio González Prize, Salon de Mayo, Barcelona, 1961. One-man shows: Venice Biennale, 1962; Galleria L'Annunciata, Milan, 1963; Galería Biosca, Madrid, 1963. Exhibited, Spanish Pavilion, New York World's Fair, Flushing Meadows, 1964. Commissioned to make portrait of Spanish poet Antonio Machado, 1965. One-man show, Galería Juana Mordó, Madrid, 1967. Lives in Madrid.

A Contradictory Duality in Man between His Inner Ambit and His Outer Configuration (Contradictoria dualidad en el hombre entre su ambito interior y su configuración exterior). 1964.
Bronze (unique), 52 × 41½ × 43 inches
Markings: l. l. side of base "Serrano 1964"
l. r. side of base "Condina Fundidor Madrid"

PROVENANCE:
Galería Juana Mordó, Madrid; Carnegie Institute, Pittsburgh, 1964

EXHIBITIONS:
Carnegie Institute, Pittsburgh, October 30, 1964–January 10, 1965, *The 1964 Pittsburgh International Exhibition of Contemporary Painting and Sculpture*, no. 217

REFERENCES:
Cannon, Calvin. *Serrano en la Decada del 60*, Madrid, Galería Juana Mordó, 1969, plate 27

"Always absorbed in the conflict of Man with himself, such as he was created, the distinction between his two spaces, the inner and outer ones, has guided my thoughts and hands with the aim of giving expressiveness to the matter, making the outer part dramatic with textures and rugose touches, while the interior stays lit due to the passage of light through the matter."

Statement by the artist, 1972

Portrait of Joseph H. Hirshhorn. 1967.
Plaster, 12½ × 10½ × 12¼ inches
Markings: l. l. side "Serrano 1967"

PROVENANCE:
The artist, Madrid, 1968

REFERENCES:
Serrano, Pablo. *Mr. Joseph H. Hirshhorn (genesis of his expression in the portrait)*, Madrid, Luis Perez, 1967, 9 pp., ill.

BEN SHAHN (1898–1969)

Born Kovno, Lithuania, September 12, 1898; father a woodcarver. Emigrated with family to Brooklyn, New York, 1906. Worked as lithographer's apprentice, New York, 1911–17; intermittently, as lithographer, until 1930. Studied, New York: Educational Alliance, evenings, 1911; New York University, and City College of New York, 1917–21; National Academy of Design; The Art Students League of New York. Traveled to Europe, and North Africa, 1925, 1927–29. Studied, Académie de la Grande Chaumière, Paris, 1925. Returned to New York, 1929; shared studio with Walker Evans. One-man shows, The Downtown Gallery, New York, 1930–61. Painted: Sacco-Vanzetti series of gouaches, 1931–32; Mooney series, 1933. Mural assistant to Diego Rivera, RCA Building, Rockefeller Center, New York, and New Workers' School, New York, 1933. Member, editorial staff, *Art Front*, 1934. Photographer, Farm Security Administration, 1935–38. Murals: community center and school building, Resettlement Administration housing project, Jersey Homesteads (now Roosevelt), New Jersey, 1938; Bronx Central Annex Post Office, New York, 1938–39. Settled in Jersey Homesteads, 1939. One-man shows: Julien Levy Gallery, New York, 1940; The Phillips Memorial Gallery, Washington, D.C., 1950–51. Served as senior liaison officer, Graphics Division, Office of War Information, Washington, D.C., 1942–43. Director, Graphic Arts Division, CIO, 1945–46. Retrospectives: The Mayor Gallery, London, 1947; The Museum of Modern Art, New York, and tour, 1947–48; Venice Biennale, 1954; The Downtown Gallery, 1955; Institute of Contemporary Art, Boston, 1957. Taught: School of the Museum of Fine Arts, Boston, Pittsfield, Massachusetts, summer, 1947; University of Colorado, Boulder, summer, 1950; The Brooklyn Museum Art School, New York, 1951; Black Mountain College, North Carolina, summer, 1951. Included in: II São Paulo Bienal, 1953 (Purchase Prize); Venice Biennale, 1954; Pennsylvania Academy Annual, 1956 (Temple Gold Medal). Illustrated: *The Alphabet of Creation* (New York, Pantheon), 1954; *The Shape of Content* (Cambridge, Harvard), 1957; *Love and Joy About Letters* (New York, Grossman), 1963; *Ecclesiastes, or The Preacher* (New York, Spiral), 1965. Member: The National Institute of Arts and Letters, 1956; The American Academy of Arts and Letters, 1959. Appointed Norton Professor of Poetry, Harvard University, Cambridge, Massachusetts, 1956–57; one-man show, Fogg Art Museum, Harvard University. Designed sets for Jerome Robbins's ballets: *New York Export–Opus Jazz*, 1958; *Events*, 1961. Awarded: American Institute of Graphic Arts Medal, 1958; Gold Medal for Graphic Art, The National Institute of Arts and Letters, and The American Academy of Arts and Letters, 1964. Retrospectives, The Museum of Modern Art, International Circulating Exhibitions, 1961–62, 1962–63. One-man shows, Kennedy Galleries, New York, 1968, 1969. Died New York, March 4, 1969. Retrospectives: New Jersey State Museum, Trenton, 1969; Ishibashi Memorial Hall, Kurume, Japan, and tour, 1970.

Supreme Court of California: Mooney Series. 1932.
Gouache on paper mounted on Masonite, 16 × 24 inches
Signed and dated l. r.: "Ben Shahn 32"

PROVENANCE:
The Downtown Gallery, New York; Thomas Dabney Mabry, New York; The Alan Gallery, New York, 1957

EXHIBITIONS:
The Downtown Gallery, New York, May 2–20, 1933, *The Mooney Case by Ben Shahn*, no. 8
The Museum of Modern Art, New York, September 30, 1947–January 4, 1948, *Ben Shahn Retrospective Exhibition*, cat.

REFERENCES:
Archives of American Art, Smithsonian Institution, Washington D.C., *The Downtown Gallery Archives*
Soby, James Thrall. "Ben Shahn," *The Museum of Modern Art Bulletin*, New York, 14, Summer 1947, p. 42, ill. p. 12
Unsigned. "Mooney Theme," *Art Digest*, 7, May 1, 1933, p. 14
Wheelwright, John. "Ben Shahn," *Hound and Horn*, 6, July–September 1933, ill.

Although not as dramatic as the famed Sacco-Vanzetti case, the Mooney case was nonetheless a *cause célèbre*. Thomas J. Zechariah Mooney (1883–1942), a California labor leader, was convicted of participating in the bombing of the 1916 San Francisco Preparedness Day Parade, and was sentenced to death. The case aroused international interest; confessions of perjured testimony at Mooney's trial reinforced the widely held belief in his innocence. In 1918 his sentence was commuted to life imprisonment. Years of agitation on his behalf culminated in January 1939 in an unconditional pardon by California's Governor Culbert L. Olson.

In Shahn's painting, one in a series of sixteen gouaches, the members of the Supreme Court of California are, from left to right, William H. Langdon, J. W. Curtis, J. W. Shank, Emmett Seawell, William Waste, and John E. Richards.

Brothers. 1946.
Tempera on Masonite, 39 × 26 inches

PROVENANCE:
The Downtown Gallery, New York, 1946

EXHIBITIONS:
Whitney Museum of American Art, New York, December 10, 1946–January 16, 1947, *1946 Annual Exhibition of Contemporary American Painting*, no. 140
Tokyo Metropolitan Museum of Art. *Thirty U.S. Contemporaries, International Fine Arts Exhibition* (American Federation of Arts, Circulating Exhibition), colorplate; toured in Japan to Osaka, Fukuoka, Nagoya, Sapporo, 1951–52
San Francisco Museum of Art, October 21–November 30, 1952, *Thirty U.S. Contemporaries*, colorplate; toured to Pomona College Art Gallery, Claremont, California, January 4–25, 1953; Stanford University Museum, California, February 8–March 1; Museum of the

University of Manitoba, Winnipeg, Canada, March 22–April 12
Westchester County Center, White Plains, New York, April 20–22, 1956, *Contemporary Art Festival*
The National Gallery of Canada, Ottawa, and tour, 1957, *Some American Paintings from the Collection of Joseph H. Hirshhorn*, no. 69, ill. 23
American Federation of Arts tour, 1959–60, *Ten Modern Masters of American Art*, no. 23, ill. p. 25
American Federation of Arts tour, 1962–65, *Paintings from the Joseph H. Hirshhorn Foundation Collection: A View of the Protean Century*, no. 62, ill. p. 23

REFERENCES:
Archives of American Art, Smithsonian Institution, Washington, D.C., *The Downtown Gallery Archives*
Bentivoglio, Mirella. *Ben Shahn*, Rome, De Luca, 1963, colorplate 5
Chicoine, René. "Formes et Couleurs," *Le Devoir*, Montreal, March 30, 1957
Flexner, James Thomas. "Behind The Picture Is The Man," *The New York Times Book Review*, October 21, 1951, ill. p. 1
Garvin, Adelaide. "Art and Artists," *The Critic*, 18, Chicago, October–November 1959, p. 67
McCarthy, Pearl. "Art and Artists: Hirshhorn Collection at Gallery," *Toronto Globe and Mail*, April 13, 1957
Rodman, Selden. *Portrait of the Artist as an American: Ben Shahn, A Biography with Pictures*, New York, Harper & Row, 1951, p. 49, ill. p. 50
Shahn, Ben. *The Biography of a Painting*, Cambridge, Massachusetts, Fogg Art Museum, 1956, ill. p. 32
Shahn, Bernarda Bryson. *Ben Shahn*, New York, Abrams, 1972, pp. 85, 348, colorplate p. 80
Soby, James Thrall. *Ben Shahn: Paintings*, New York, Braziller, 1963, no. 39, ill.
Unsigned. "Gallery Previews in New York," *Pictures on Exhibit*, November 1962, ill.
———. "Outstanding Show to Open," *Quincy [Illinois] Herald Whig*, February 1, 1959, ill p. 9

Song. 1950.
Tempera on canvas mounted on board, 31 × 52 inches
Signed l. r.: "Ben Shahn"

PROVENANCE:
The Downtown Gallery, New York, 1952

EXHIBITIONS:
Virginia Museum of Fine Arts, Richmond, April 22–June 4, 1950, *American Painting, 1950*
Carnegie Institute, Pittsburgh, October 19–December 21, 1950, *The Pittsburgh International Exhibition of Paintings*, no. 72
The Corcoran Gallery of Art, Washington, D.C., April 1–May 13, 1951, *22nd Biennial Exhibition of Contemporary American Oil Paintings*, no. 221, ill. p. 38
Los Angeles County Museum of Art, June 2–July 2, 1951, *Contemporary Painting in the United States*, cat., ill.
The Downtown Gallery, New York, March 11–29, 1952, *Ben Shahn: Paintings*, no. 2
Santa Barbara Museum of Art, California, June–August 1952, *Paintings by Lee Gatch, Karl Knaths, Ben Shahn*, cat.; toured to California Palace of the Legion of Honor, San Francisco; Los Angeles County Museum of Art
Worcester Art Museum, Massachusetts, February 17–April 3, 1955, *Five Painters of America*
The National Gallery of Canada, Ottawa, and tour, 1957, *Some American Paintings from the Collection of Joseph H. Hirshhorn*, no. 71, cover ill.
American Federation of Arts tour, 1959–60, *Ten Modern Masters of American Art*, no. 24
American Federation of Arts tour, 1962–65, *Paintings from the Joseph H. Hirshhorn Foundation Collection: A View of the Protean Century*, no. 63

REFERENCES:
Archives of American Art, Smithsonian Institution, Washington, D.C., *The Downtown Gallery Archives*
Burrows, Carlyle. "Art in Review: Expression in the Van," *New York Herald Tribune*, March 16, 1952, sec. 4, p. 5, ill.
McCarthy, Pearl. "Art and Artists: Hirshhorn Collection at Gallery," *Toronto Globe and Mail*, April 13, 1957
Sweeney, James Johnson. "Sweeney setting his American scene," *Art News*, 49, May 1950, p. 19, ill.
Unsigned. "American Painting, 1950," *Virginia Museum of Fine Arts Bulletin*, Richmond, 10, April 1950, ill. p. 1

CHARLES SHEELER (1883–1965)

Charles R. Sheeler, Jr., born Philadelphia, July 16, 1883. Studied: Philadelphia Museum School of Industrial Art, 1900–1903; The Pennsylvania Academy of the Fine Arts, Philadelphia, with William Merritt Chase, 1903–6. Traveled to Europe, with Chase's class, summers, 1904, 1905. First exhibited, National Academy of Design, New York, 1906. One-man show, McClees Galleries, Philadelphia, 1908. Visited Italy, London, Paris, 1908. Photography a major interest and means of support, from 1912. Six paintings included in the Armory Show, 1913. Exhibited, New York: "The Forum Exhibition of Modern American Painters," The Anderson Galleries, 1916; Society of Independent Artists Annual, 1917; with Arthur B. Davies, Walt Kuhn, Max Weber, Montross Gallery, 1917. One-man shows, New York: Modern Gallery (photographs), 1917 (paintings and photographs), 1920; The Daniel Gallery (paintings, drawings, photographs), 1922; Whitney Studio Club (paintings and photographs), 1924. Moved to New York, 1919. Collaborated with Paul Strand on *Manhatta*, film study of New York skyscrapers, 1920. Included in: "Sheeler–Lozowick," J. B. Neumann's New Art Circle, New York, 1926; "American Painting and Sculpture," The Museum of Modern Art, New York, 1932–33; Venice Biennale, 1934; "American Art Today," New York World's Fair, Flushing Meadows, 1939; "A New Realism: Crawford, Demuth, Sheeler, Spencer," Cincinnati Modern Art Society, 1941. Photographic assignment, Ford Motor plant, River Rouge, Michigan, 1927. Lived in: South Salem, New York, 1927–32; Ridgefield, Connecticut, 1933–43. One-man shows, The Downtown

Gallery, New York, 1931, 1946, 1951, 1958, 1965. Retrospective, The Museum of Modern Art, 1939. Lived in Irvington-on-Hudson, New York, from 1944. Artist-in-residence: Phillips Academy, Andover, Massachusetts, 1946; Currier Gallery of Art, Manchester, New Hampshire, 1948. Retrospectives: The Art Galleries, University of California at Los Angeles, and tour, 1954; Allentown Art Museum, Pennsylvania, 1961. Received Award of Merit, The American Academy of Arts and Letters, New York, 1962. Member, The National Institute of Arts and Letters, New York, May 7, 1965. Retrospectives: The Downtown Gallery, 1966; National Collection of Fine Arts, Smithsonian Institution, Washington, D.C., and tour, 1968–69.

Staircase, Doylestown. 1925.
Oil on canvas, 24 × 20 inches
Signed and dated l. r.: "Sheeler 1925"

PROVENANCE:
J. B. Neumann's New Art Circle, New York; Matthew Josephson, Gaylordsville, Connecticut, 1930; Robert Schoelkopf Gallery, New York, 1967

EXHIBITIONS:
New Art Circle, New York, January 14–February 4, 1926, *Sheeler—Lozowick*
The Museum of Modern Art, New York, October 2–November 1, 1939, *Charles Sheeler*, no. 15, ill.
The Art Galleries, University of California at Los Angeles, October 1954, *Charles Sheeler Retrospective*, Colorplate p. 16
The American Academy of Arts and Letters, New York, May 25–June 17, 1962, *Works by Newly Elected Members and Recipients of Academy Honors*, no. 22
National Collection of Fine Arts, Smithsonian Institution, Washington, D.C., October 9–November 24, 1968, *Charles Sheeler*, no. 43, ill. p. 38; toured to Philadelphia Museum of Art, January 9–February 16, 1969; Whitney Museum of American Art, New York, March 10–April 27

REFERENCES:
Brace, Ernest. "Charles Sheeler," *Creative Art*, 11, October 1932, p. 100
Dochterman, Lillian. *The Stylistic Development of the Work of Charles Sheeler*, Ph.D. dissertation, Iowa City, The University of Iowa, 1963, pp. 24, 32, 280, ill.
Friedman, Martin. *Charles Sheeler*, New York, Abrams, forthcoming, colorplate
Goodrich, Lloyd. "New York Exhibitions: Sheeler and Lozowick," *The Arts*, 9, February 1926, ill. p. 96
Kootz, Samuel. *Modern American Painters*, New York, Brewer & Warren, 1930, plate 50
Kramer, Hilton. *The Age of the Avant-Garde*, New York, Farrar, Straus and Giroux, 1973, p. 294
Lane, James W. "Charles Demuth," *Parnassus*, 8, March 1936, p. 9
McCurdy, Charles, ed. *Modern Art: A Pictorial Anthology*, New York, Macmillan, 1958, ill. B33, p. 158
Rourke, Constance. *Charles Sheeler*, New York, Harcourt, Brace, 1938, pp. 107–8, ill. p. 74
Wight, Frederick S. "Charles Sheeler," *Art in America*, 42, October 1954, colorplate p. 185

In 1911, Sheeler and the artist Morton Shamberg (1882–1918) rented a house near Doylestown, in Bucks County, Pennsylvania, for weekend sketching. The interior and architectural details of the Doylestown house appear in several of Sheeler's paintings and photographs.

About *Staircase, Doylestown*, Sheeler said, "Two things are going on at the same time in the picture, irrelevant to each other but relevant to the whole, one in the room downstairs, one leading to the room upstairs. I meant it to be a study in movement and balances."

The artist, in Rourke, p. 108

EVERETT SHINN (1876–1953)

Born Woodstown, New Jersey, November 6, 1876. Studied, Philadelphia: mechanical drawing, Spring Garden Institute, 1891–93; The Pennsylvania Academy of the Fine Arts, 1894–95. Artist/reporter, *Philadelphia Inquirer*, and *Philadelphia Press*, 1893–96. Roommate and colleague of George Luks; attended weekly open house, Robert Henri's studio. Moved to New York, 1897. Illustrator: *New York World*, and *New York Herald*, 1897–99; *Harper's Weekly*, and *The Critic*, 1898–1900. Traveled: to Paris, 1900; to Paris, and London, 1903. One-man shows, New York: Boussod & Valadon, 1901; M. Knoedler & Co., 1903. Exhibited, Society of American Artists, New York, from 1904. Taught, The Art Students League of New York, 1906–7. Participated in: "Exhibition of Eight American Painters," Macbeth Gallery, New York, and tour, 1908; Exhibition of Independent Artists, New York, 1910. Commissions: mural, David Belasco's Stuyvesant Theatre, New York, 1908; mural, City Hall, Trenton, New Jersey, 1912; murals and decorations, homes of Stanford White, Clyde Fitch, William Randolph Hearst, among others. Wrote and produced melodramas, such as *Lucy Moore or The Prune Hater's Daughter*, Waverly Players, New York. One-man show, Fifty-Sixth Street Galleries, New York, 1930. Awarded Blair Prize, 50th American Exhibition, The Art Institute of Chicago, 1939. Academician, National Academy of Design, 1943. Retrospective, Ferargil Galleries, New York, 1943. One-man shows: American British Art Center, New York, 1945, 1946, 1949; James Vigeveno Galleries, Los Angeles, 1945, 1947, 1948. Member, The National Institute of Arts and Letters, 1951. One-man shows, James Graham and Sons, New York, 1952, 1958, 1965. Died, New York, January 2, 1953. Retrospective, Henry Clay Frick Fine Arts Building, University of Pittsburgh, 1959.

The Door, Paris. 1900.
Watercolor and charcoal on paper, 10 × 13¾ inches
Signed and dated l. r.: "Everett Shinn/1900"

PROVENANCE:
Marshall Kerrochan, New York; Maynard Walker Gallery, New York, 1957

EXHIBITIONS:
Henry Clay Frick Fine Arts Building, University of Pittsburgh, February 23–March 28, 1959, *Everett Shinn: 1876–1953*, no. 7

Nude Bathers. 1910.
Oil on canvas, 25 × 30 inches

PROVENANCE:
Davis Galleries, New York, 1958

EXHIBITIONS:
Quincy Art Center, Illinois, February 23–March 15, 1964, *The Eight* (The Museum of Modern Art, New York, Circulating Exhibition); toured to ten U.S. cities

Acrobat Falling. 1930.
Oil on canvas, 36 × 26½ inches
Signed and dated l. r.: "Everett Shinn 1930"

PROVENANCE:
Washington Irving Gallery, New York, 1960

RENÉE SINTENIS (1888–1965)

Born Glatz, Silesia, Poland, March 20, 1888. Studied, Staatliche Kunstgewerbeschule, Berlin, with painter Wilhelm Haverkamp, and sculptor Leo von König, 1908–11. Settled in Berlin; began working independently, c. 1914. Exhibited, Berliner Sezession, 1915; met Rainer Maria Rilke. Married painter Emil Rudolph Weiss (1875–1942). First etchings, 1919. Portfolios published by Galerie Gurlitt, Berlin: *Badende Mädchen*, 1919; *Tiere*, 1922; *Zoo*, 1924. Illustrated books: *Sappho* (Berlin, Marées-Gesellschaft), 1921; *Tigerschiff* by Hans Siemsen (Berlin, Galerie Alfred Flechtheim), 1923; *Dialogue* by Franz Hessel (Berlin, Rowohlt), 1924. One-man show, Weyhe Gallery, New York, 1928. Exhibited with Marie Laurencin, Martel Schwichtenberg, Alexandra Exter, Galerie Alfred Flechtheim, 1930. Remained in Berlin throughout World War II, although not permitted to exhibit there. Exhibited, New York: "German Painting and Sculpture," and "Art in Our Time," The Museum of Modern Art, New York, 1931, 1939; with Aristide Maillol, Buchholz Gallery, 1937. One-man shows, Buchholz Gallery, 1939, 1940. Professor, Staatliche Hochschule für Bildende Künste, Berlin, 1947–48. Awarded Kunstpreis der Stadt, Berlin, 1948. Appointed to Der Orden Pour le Mérite für Wissenschaften und Künste, 1952. One-man shows, Galerie Alex Vömel, Düsseldorf, 1952, 1956. Included in "German Art of the Twentieth Century," The Museum of Modern Art, and City Art Museum of St. Louis, Missouri, 1957. Died, Berlin, April 22, 1965. Memorial exhibition, Galerie Alex Vömel, 1965.

Donkey of Selow. 1927.
Bronze, 30¼ × 27 × 8½ inches
Markings: r. top of base "R. S."
 l. r. side of base "H. Noack Berlin"

PROVENANCE:
Otto Gerson Gallery, New York, 1961

EXHIBITIONS:
Fine Arts Associates, New York, December 10, 1957–January 11, 1958, *Sculpture: 1880–1957*, no. 64, ill.
Fine Arts Associates, New York, September 21–October 10, 1959, *Sculpture and Sculptors' Drawings*, no. 46

REFERENCES:
Raynor, Vivien. "4,000 Paintings and 1,500 Sculptures," *The New York Times Magazine*, November 27, 1966, ill. pp. 53–54

DAVID ALFARO SIQUEIROS (1896–1974)

José David Alfaro Siqueiros, born Chihuahua, Mexico, December 29, 1896. Studied, Academia de San Carlos, Mexico City, 1911–13. Served, revolutionary army supporting Constitutional forces of Venustiano Carranza, 1914–18; military attaché, Paris Consulate. Associated with Diego Rivera and Cubists, 1919–22. Wrote "Manifesto de los pintores de América"; included in only issue of *Vida Americana*, Barcelona, published, 1921. Returned to Mexico City, 1922; mural project, Escuela Nacional Preparatoria. Founding member, Syndicate of Revolutionary Painters, Sculptors, and Engravers of Mexico; editor of their periodical, *El Machete*, 1924. Organized labor unions, Guadalajara, 1924–26; imprisoned, Mexico City, 1930; exiled, 1932. One-man show, Casino Español, Mexico City, 1932. In Los Angeles, 1932: taught mural painting, Chouinard School of Art; painted fresco, Plaza Art Center; one-man show, Stendahl Galleries. Deported from U.S., 1933; traveled to South America. One-man shows, New York: Delphic Studios, 1934; Pierre Matisse Gallery, New York, 1940. Delegate, with José Clemente Orozco, and Rufino Tamayo, First American Artists' Congress, New York. Conducted Experimental Workshop, New York, 1936–37. Served as officer, Republican Army, Spanish Civil War, 1937–39. Mural commissions: Sindicato de Electricistas, Mexico City, 1939; Escuela México, Chillán, Chile, 1941–42. Included in "20 Centuries of Mexican Art," The Museum of Modern Art, New York, 1940. Exiled from Mexico, after death of Trotsky, 1940. Returned to Mexico, 1944. Mural commissions, Mexico City: Palacio de Bellas Artes, 1945; Instituto Politécnico, Universidad Nacional Autónoma de México, and Centro Médico Nacional, 1952–58. One-man show, Palacio de Bellas Artes, 1947. Awarded second prize, Venice Biennale, 1950. Imprisoned for political activities, 1960–64. One-man shows: ACA Gallery, New York, 1962; Galería Misrachi, Mexico City, 1964, 1968; Marion Koogler McNay Art Institute, San Antonio, Texas, 1968. Awarded: National Prize for Art, Mexico, 1966; Lenin Peace Prize, 1967 (donated award money to North Vietnam). President, Academia de las Artes de México, 1968. Retrospective, Center for Inter-American Relations, New York, 1971. Three-dimensional mural permanently installed, Siqueiros Center, Mexico City, 1971. Died Cuernavaca, January 6, 1974.

Zapata. 1931.
Oil on canvas, 53¼ × 41½ inches

PROVENANCE:
Charles Laughton, Hollywood, California; Tyrone

Power, New York; Paul Kantor Gallery, Beverly Hills, California, 1964

EXHIBITIONS:
Delphic Studios, New York, March 12–25, 1934, *Paintings and Photographs of Frescoes by Siqueiros*, no. 2
Pasadena Art Museum, California, August 5–October 1, 1951, *Modern Mexican Artists*
Pasadena Art Museum, California, March 15–April 16, 1953, *Contemporary Mexican Painting*, no. 30
Marion Koogler McNay Art Institute, San Antonio, Texas, January 12–February 16, 1958, *Mexican Painting of the Twentieth Century*, no. 47

REFERENCES:
De Micheli, Mario. *Siqueiros*, New York, Abrams, 1970, p. 8
Siqueiros, J. D. A. *Siqueiros: Through the Road of a Neo-Realism, or Social Realistic Painting in Mexico*, Mexico, D.F., Instituto Nacional de Bellas Artes, 1951, ill. 28
Tibol, Raquel. *Siqueiros*, Mexico, D.F., Universidad Nacional Autónoma de México, 1961, ill. 18

Emiliano Zapata (1877?–1919) was a Mexican revolutionary leader and champion of agrarian reform, who was murdered in 1919. He subsequently became a national hero, and has been memorialized in folk song and legend. Zapata was a favorite subject for José Orozco and Diego Rivera, as well as for Siqueiros.

JOHN SLOAN (1871–1951)

John French Sloan, born Lock Haven, Pennsylvania, August 2, 1871. Moved to Philadelphia, 1876. Worked for Porter and Coates, booksellers and print dealers, Philadelphia, 1888–89; as commercial artist, 1890–91. First etchings, 1888. Studied, Philadelphia: Spring Garden Institute, evenings, 1890; The Pennsylvania Academy of the Fine Arts, with Thomas Anshutz, 1892–93/94. Met Robert Henri, 1892; together, organized Charcoal Club, Philadelphia, as alternative to Pennsylvania Academy, 1893. Illustrator: *Philadelphia Inquirer*, 1892–95; *Philadelphia Press*, 1895–1903. Exhibited, 1900: 13th American Exhibition, The Art Institute of Chicago; Carnegie International. Moved to New York, 1904. Awarded honorable mention, Carnegie International, 1905. Organized, with Henri, and participated in "Exhibition of Eight American Painters," Macbeth Gallery, New York, and tour, 1908. Included in: Exhibition of Independent Artists, New York, 1910; the Armory Show, 1913. Socialist Party candidate, New York State Assembly, 1910, 1915. Art editor, *The Masses*, 1912–15. One-man shows, New York, 1916: Whitney Studio; Hudson Guild. The Art Students League of New York: taught, 1916–38 (Adolph Gottlieb, Reginald Marsh, Barnett Newman among his students); president, 1931–32. One-man shows, C. W. Kraushaar Galleries, New York, from 1917. Society of Independent Artists, New York: helped install first Annual, 1917; president, 1918–44. Summered in Santa Fe, New Mexico, from 1919. Member, The National Institute of Arts and Letters, 1929. Included in: Pennsylvania Academy Annual, 1931 (Beck Gold Medal); Venice Biennale, 1932. WPA Federal Art Project, Easel Division, New York, 1934–39; U.S. Treasury Department mural, U.S. Post Office, Bronxville, New York, 1939. One-man shows: Montross Gallery, New York, 1934; Whitney Museum of American Art, New York (graphics), 1936; The Renaissance Society, The University of Chicago, 1945. Retrospectives: Addison Gallery of American Art, Phillips Academy, Andover, Massachusetts, 1938; Dartmouth College, Hanover, New Hampshire, 1946; Kraushaar Galleries, 1948. Member, The American Academy of Arts and Letters, 1942. Awarded Gold Medal for Painting, The National Institute of Arts and Letters, and The American Academy of Arts and Letters, 1950. Died, Hanover, September 7, 1951. Retrospectives: Whitney Museum of American Art, 1952; Wilmington Society of the Fine Arts, Delaware Art Center, and Pennsylvania Academy, 1961; Smithsonian Institution, Traveling Exhibition Service, 1963–65; National Gallery of Art, Washington, D.C., and tour, 1971–72.

Carmine Theater. 1912.
Oil on canvas, 25 × 31 inches
Signed and dated l. r.: "John Sloan 1912"

PROVENANCE:
C. W. Kraushaar Galleries, New York; Lawrence A. Fleischman, Detroit; Mr. and Mrs. Albert Hackett, New York; Kraushaar Galleries, 1954

EXHIBITIONS:
The Pennsylvania Academy of the Fine Arts, Philadelphia, February 9–March 30, 1913, *One Hundred and Eighth Annual Exhibition*, no. 325
Whitney Studio, New York, January 25–February 6, 1916, *The Work of John Sloan*, no. 21
C. W. Kraushaar Galleries, New York, February 15–March 5, 1927, *Paintings, Drawings, Lithographs and Etchings by John Sloan*, no. 12
Montross Gallery, New York, January 1934, *Paintings and Etchings by John Sloan*, no. 28
Whitney Museum of American Art, New York, January 10–March 2, 1952, *John Sloan Retrospective*, no. 28; toured to The Corcoran Gallery of Art, Washington, D.C., March 15–April 20; The Toledo Museum of Art, Ohio, May 4–June 8
Museum of Art, University of Michigan, Ann Arbor, November 15–December 6, 1953, *Mr. and Mrs. Lawrence A. Fleischman Collection of American Paintings*, no. 33
The National Gallery of Canada, Ottawa, and tour, 1957, *Some American Paintings from the Collection of Joseph H. Hirshhorn*, no. 72, ill.
Whitney Museum of American Art, New York, April 30–June 15, 1958, *The Museum and Its Friends: A Loan Exhibition*, no. 154
Wilmington Society of the Fine Arts, Delaware Art Center, September 22–October 29, 1961, *The Life and Times of John Sloan*, no. 15; toured to The Pennsylvania Academy of the Fine Arts, Philadelphia, November 17–December 23
American Federation of Arts tour, 1962–65, *Paintings*

from the Joseph H. Hirshhorn Foundation Collection: A View of the Protean Century, no. 65
National Gallery of Art, Washington, D.C., September 18–October 31, 1971, *John Sloan Centennial Exhibition*, no. 73, ill. p. 117; toured to Georgia Museum of Art, University of Georgia, Athens, November 20–January 16, 1972; M. H. de Young Memorial Museum, San Francisco, February 15–April 2; City Art Museum of St. Louis, Missouri, May 4–June 18

REFERENCES:
Holcomb, Grant, III. *A Checklist for John Sloan's Paintings*, Lock Haven, Pennsylvania, Annie Halenbake Ross Library, 1970, p. 5
St. John, Bruce, ed. *John Sloan's New York Scene*, New York, Harper & Row, 1965, pp. 597, 598, 635
Sloan, John. *Gist of Art*, New York, American Artists Group, 1939, ill. 230

"Wistful little customers hanging around a small movie show. In those days it was called 'ash can art'—today it's the 'American Scene.'"

Sloan, John. *Gist of Art*, p. 230

This is Sloan's only painting actually depicting an ashcan. The location of the old movie house is Carmine Street, Greenwich Village, New York.

Rain, Rooftops, West 4th Street. 1913.
Oil on canvas, 20 × 24 inches
Signed l. l.: "John Sloan"

PROVENANCE:
Estate of the artist; Kraushaar Galleries, New York, 1954

EXHIBITIONS:
People's Art Guild, New York, 1916, *26th Exhibition*, no. 124
C. W. Kraushaar Galleries, New York, June–July 1928, *American Artists*
Cedar Rapids Art Center, Iowa, September 1–22, 1953, *The City*, (The Museum of Modern Art, New York, Circulating Exhibition); toured to seven U.S. cities
Smithsonian Institution, Washington, D.C., Traveling Exhibition Service, 1963–65, *John Sloan Paintings*
The Brooklyn Museum, New York, February 8–April 5, 1965, *Paintings from the Joseph H. Hirshhorn Foundation Collection: A View of the Protean Century*, no. 88

REFERENCES:
Holcomb, Grant, III. *A Checklist for John Sloan's Paintings*, Lock Haven, Pennsylvania, Annie Halenbake Ross Library, 1970, p. 24
Preston, Stuart. "A Collector's Eye-View," *The New York Times*, February 28, 1965, sec. 2, p. 19

Efzenka the Czech. 1918.
Oil on canvas, 32¼ × 19¾ inches
Signed u. r.: "John Sloan"

PROVENANCE:
The artist, New York; Mrs. Cyrus McCormick; C. W. Kraushaar Galleries, New York, 1928; ACA Gallery, New York, 1956

EXHIBITIONS:
Whitney Studio Club, New York, December 1918, *Paintings and Sculpture by Members of the Whitney Studio Club*, no. 10
Waldorf Astoria Hotel, New York, March 28–April 14, 1919, *Third Annual Exhibition of the Society of Independent Artists*, no. 535, ill.
Carnegie Institute, Pittsburgh, April 29–June 30, 1920, *Nineteenth Annual International Exhibition of Paintings*, no. 312
The Pennsylvania Academy of the Fine Arts, Philadelphia, February 5–March 26, 1922, *One Hundred and Seventeenth Annual Exhibition*, no. 246
C. W. Kraushaar Galleries, New York, April 16–May 5, 1923, *Paintings by John Sloan*, no. 13

REFERENCES:
Holcomb, Grant, III. *A Checklist for John Sloan's Paintings*, Lock Haven, Pennsylvania, Annie Halenbake Ross Library, 1970, p. 9
Sloan, John. *Gist of Art*, New York, American Artists Group, 1939, p. 257, ill.
Unsigned. "John Sloan at Kraushaar's," *Art News*, 21, April 21, 1923, p. 1
———. "Unnamed Collector Buys 32 Sloans," *Art News*, 26, March 31, 1928, p. 2

"This queer looking name is Eugenia to us. One of the Steins, well liked models for twenty years. Robert Henri painted [Eugenia] Stein many times, some of the most important canvasses result. She had strong opinions on politics and society and her English was odd but understandable. Good model and friend. Where now?"

Sloan, John. *Gist of Art*, p. 257

McSorley's Saturday Night. 1929.
Oil on canvas, 30 × 36 inches
Signed l. r. "John Sloan"
Titled, signed and dated on back: "McSorley's Saturday Night, John Sloan—'29"

PROVENANCE:
Estate of the artist; Kraushaar Galleries, New York, 1954

EXHIBITIONS:
Kraushaar Galleries, New York, April 3–26, 1930, *Exhibition of Paintings by John Sloan*, no. 19
The Detroit Institute of Arts, April 14–May 17, 1931, *Seventeenth Annual Exhibition of American Art*, no. 147
Carnegie Institute, Pittsburgh, October 15–December 6, 1931, *Thirtieth Annual International Exhibition of Paintings*, no. 42
XVIII Biennale Internazionale d'Arte, Venice, June–September 1932, *United States Pavilion*, no. 42, p. 284
Hotel St. Moritz, New York, April 1934, *Repeal Art Show*
Addison Gallery of American Art, Phillips Academy, Andover, Massachusetts, April 2–May 18, 1938, *John Sloan Retrospective*, no. 26, ill.
Colorado Springs Fine Arts Center, May 1938, *Exhibition of Nineteenth Century French and American Painting*

American Fine Arts Society, New York, February 7–28, 1943, *Fifty Years on 57th St.*, no. 194, ill. p. 10
Kraushaar Galleries, New York, February 2–28, 1948, *John Sloan Retrospective Exhibition*, no. 28
The Dayton Art Institute, Ohio, April 1948, *John Sloan Paintings*
Des Moines Art Center, Iowa, February 27–March 23, 1952, *The Artists' Vision*, no. 68
Kraushaar Galleries, New York, September 28–October 17, 1953, *Paintings by Glackens, Lawson, Prendergast, and Sloan*, no. 21
Brandeis University, Waltham, Massachusetts, June 1–17, 1955, *Three Collections*, no. 43
Tweed Gallery, University of Minnesota, Duluth, April 1956, *Collector's Choice*
The National Gallery of Canada, Ottawa, and tour, 1957, *Some American Paintings from the Collection of Joseph H. Hirshhorn*, no. 73
American Federation of Arts tour, 1962–65, *Paintings from the Joseph H. Hirshhorn Foundation Collection: A View of the Protean Century*, no. 64
Marlborough-Gerson Gallery, New York, September 27–October 14, 1967, *The New York Painter, A Century of Teaching: Morse to Hofmann*, p. 97, ill. p. 60
National Gallery of Art, Washington, D.C., September 18–October 31, 1971, *John Sloan Centennial Exhibition*, no. 148, ill. p. 181; toured to Georgia Museum of Art, University of Georgia, Athens, November 20–January 16, 1972; M. H. de Young Memorial Museum, San Francisco, February 15–April 2; City Art Museum of St. Louis, Missouri, May 4–June 18

REFERENCES:
Brace, Ernest. "John Sloan," *Magazine of Art*, 31, March 1938, p. 136, ill. p. 134
Breuning, Margaret. "Retrospective for John Sloan, Famed Realist," *Art Digest*, 22, February 15, 1948, p. 13
Brooks, Van Wyck. *John Sloan: A Painter's Life*, New York, Dutton, 1955, p. 60
Holcomb, Grant, III. *A Checklist for John Sloan's Paintings*, Lock Haven, Pennsylvania, Annie Halenbake Ross Library, 1970, p. 19
Jena, Jeanette. "Hirshhorn Art Exhibit at Carnegie Institute," *Pittsburgh Post-Gazette*, February 4, 1963
St. John, Bruce, ed. *John Sloan's New York Scene*, New York, Harper & Row, 1965, p. 614
Sloan, John. *Gist of Art*, New York, American Artists Group, 1939, p. 305, ill.
Unsigned. "Have a Picture on Me!" *Art Digest*, 8, April 1, 1934, p. 12
———. *John Sloan*, New York, American Artists Group, 1945, ill.

"Here we have McSorley's during the dark days of prohibition. Had all the saloons been conducted with the dignity and decorum of McSorley's, prohibition could never have been brought about. Saloons would not have been closed. McSorley's never was closed. An example of the triumph of right over might. The mugs became smaller, the juices higher, the crowd greater. Painted from blessed memory."

Sloan, John. *Gist of Art*, p. 305

DAVID SMITH (1906–1965)

David Roland Smith, born Decatur, Indiana, March 9, 1906. Studied, Cleveland School of Art (correspondence course), 1923; Ohio University, Athens, 1924–25. Worked in steel frame assembly department, Studebaker plant, South Bend, Indiana, summer, 1925. Attended art and literature evening classes, George Washington University, Washington, D.C., 1926. Moved to New York, fall, 1926; studied painting, The Art Students League of New York, with Richard Lahey, John Sloan, Jan Matulka, 1926–32; privately, with Matulka, 1928–29. First welded steel sculptures, 1932. Two sculptures included in Winter Exhibition, Academy of Allied Arts, New York, 1934. U.S. Treasury Department Relief Art Project, Fine Arts Section, New York, 1934–37; WPA Federal Art Project, New York, 1937. Occupied studio, Brooklyn Terminal Iron Works, New York, 1934–40. Included in: Second Annual Membership Exhibition, American Artists' Congress, New York, 1938; "American Art Today," New York World's Fair, Flushing Meadows, 1939; American Abstract Artists Exhibition, Riverside Museum, New York, 1939. One-man show, Marian Willard's East River Gallery, New York, 1938; exhibited, Willard Gallery, until 1956. Settled in Bolton Landing, New York, 1940. One-man show, St. Paul Gallery and School of Art, Minnesota, and tour, 1940–41; Willard Gallery, and Buchholz Gallery, New York, 1946. Included in: Whitney Annual, from 1941; "Fifteen American Sculptors," The Museum of Modern Art, New York, 1941–43. Assembled locomotives and tanks, American Locomotive Company, Schenectady, New York, 1942. Participated in first Woodstock Art Conference, New York, 1947. Taught: Sarah Lawrence College, Bronxville, New York, 1948–50; Indiana University, Bloomington, 1954; University of Mississippi, Oxford, 1955. Received Guggenheim Foundation Fellowship, 1950; renewed, 1951. One-man shows: Willard Gallery, and Kleemann Galleries, New York, 1952; Walker Art Center, Minneapolis, 1952; Cincinnati Art Museum, Ohio, and tour, 1954; The Museum of Modern Art, 1957; Fine Arts Associates, New York, 1957; New Gallery, Bennington College, Vermont, 1959; French & Company, New York, 1959, 1960; Otto Gerson Gallery, New York, 1961; Institute of Contemporary Art, University of Pennsylvania, Philadelphia, 1964; Marlborough-Gerson Gallery, New York, from 1964. Included in: Venice Biennale, 1954, 1958; V São Paulo Bienal, 1959; Documenta II and III, Kassel, 1959, 1964; Pittsburgh International, 1961; "Sculture nella città," Festival dei Due Mondi, Spoleto, Italy, 1962. Received Brandeis University Creative Arts Award Medal, 1964. Appointed to National Council on the Arts, Washington, D.C., 1965. Died near Bennington, May 23, 1965. Memorial exhibition, Los Angeles County Museum of Art, 1965. Retrospectives: The Museum of Modern Art, International Circulating Exhibition, 1966–67; Fogg Art Museum, Harvard University, Cambridge, Massachusetts, 1966; The Solomon R. Guggenheim Museum, New York, and tour, 1969.

Aerial Construction. 1936.
Painted iron, 10 × 30½ × 9¼ inches
Markings u. l.: "▷∑3Ƨ"

PROVENANCE:
Estate of the artist; Marlborough-Gerson Gallery, New York, 1967

EXHIBITIONS:
East River Gallery, New York, January 19–February 5, 1938, *David Smith Steel Sculpture*, no. 6
Marlborough-Gerson Gallery, New York, April 1967, *David Smith: Eight Early Works 1935–38*, no. 4, ill.
The Solomon R. Guggenheim Museum, New York, March 29–May 11, 1969, *David Smith*, no. 9, ill. p. 29

REFERENCES:
Archives of American Art, Smithsonian Institution, Washington, D.C., *David Smith Archives*
Cone, Jane Harrison, and Paul, Margaret. *David Smith 1906–1965: A Retrospective Exhibition*, Cambridge, Massachusetts, Fogg Art Museum, Harvard University, 1966, handlist no. 25
Davidson, Martha. "Sculptural Essays in Forged Metal by David Smith," *Art News*, 36, January 29, 1938, p. 15
Krauss, Rosalind E. *Terminal Iron Works: The Sculpture of David Smith*, Cambridge, Massachusetts Institute of Technology, 1971, pp. 16–19, 36, 67, ill. p. 16

These three medallions are part of a series of fifteen *Medals for Dishonor* which Smith began c. 1936–37, when the world was horrified by the rise of Fascism and the impending threat of war. The iconography of the medals is derived from a complex mixture of historical sources, including Sumerian seals, Greek coins, and German World War I propaganda medallions. According to David McKee of the Marlborough Gallery, the Greek inscriptions on *Propaganda for War* and *Death by Gas* are the titles; in the lower left is the punning signature "Blacksmith." The inscription on *War Exempt Sons of the Rich* reads "Softies."

Medal for Dishonor: Propaganda for War. 1939–40.
Bronze relief (edition of three), 9½ × 11¾ × ⅞ inches
Markings: l. l. "1939–40"

PROVENANCE:
Willard Gallery, New York, 1946

EXHIBITIONS:
Willard Gallery, New York, November 5–23, 1940, *Medals for Dishonor by David Smith*, no. 1, ill.
Willard Gallery, and Buchholz Gallery, New York, January 2–26, 1946, *The Sculpture of David Smith*, no. 20
The Detroit Institute of Arts, 1959, *Sculpture in Our Time*, no. 202, ill. p. 90

REFERENCES:
Archives of American Art, Smithsonian Institution, Washington, D.C., *David Smith Archives*
Brown, Milton W. "Exhibitions—New York: Three American Sculptors," *Parnassus*, 12, December 1940, p. 36, ill.
Cone, Jane Harrison, and Paul, Margaret. *David Smith 1906–1965: A Retrospective Exhibition*, Cambridge, Massachusetts, Fogg Art Museum, Harvard University, 1966, handlist no. 71
Gray, Cleve, ed. *David Smith by David Smith*, New York, Holt, Rinehart & Winston, 1968, p. 31
Hunter, Sam. *American Art of the 20th Century*, New York, Abrams, 1972, p. 216, ill. 323
Krauss, Rosalind E. *Terminal Iron Works: The Sculpture of David Smith*, Cambridge, Massachusetts Institute of Technology, 1971, p. 72, ill. p. 70
McCoy, Garnett, ed. *David Smith*, New York, Praeger, 1973, p. 48
Unsigned. "Mr. Smith Shows His Medals," *Time*, 36, November 18, 1940, p. 57

Medal for Dishonor: War Exempt Sons of the Rich. 1939–40.
Bronze relief (edition of three), 10 × 8¾ × ⅞ inches
Markings: l. l. " "

PROVENANCE:
Willard Gallery, New York, 1946

EXHIBITIONS:
Willard Gallery, New York, November 5–23, 1940, *Medals for Dishonor by David Smith*, no. 6, ill.
Willard Gallery, and Buchholz Gallery, New York, January 2–26, 1946, *The Sculpture of David Smith*, no. 20
The Detroit Institute of Arts, 1959, *Sculpture in Our Time*, no. 201

REFERENCES:
Archives of American Art, Smithsonian Institution, Washington, D.C., *David Smith Archives*
Cone, Jane Harrison, and Paul, Margaret. *David Smith 1906–1965: A Retrospective Exhibition*, Cambridge, Massachusetts, Fogg Art Museum, Harvard University, 1966, handlist no. 68
Gray, Cleve, ed. *David Smith by David Smith*, New York, Holt, Rinehart & Winston, 1968, p. 31
McCoy, Garnett, ed. *David Smith*, New York, Praeger, 1973, p. 50

Medal for Dishonor: Death by Gas. 1939–40.
Bronze relief (edition of three), 10½ × 11½ × 1¼ inches
Markings: metal plate, bottom r. "David Smith"
l. l. "1939–1940"

PROVENANCE:
Willard Gallery, New York, 1946

EXHIBITIONS:
Willard Gallery, New York, November 5–23, 1940, *Medals for Dishonor by David Smith*, no. 8
Willard Gallery, and Buchholz Gallery, New York, January 2–26, 1946, *The Sculpture of David Smith*, no. 20
The Detroit Institute of Arts, 1959, *Sculpture in Our Time*, no. 200
The Solomon R. Guggenheim Museum, New York, October 3, 1962–January 6, 1963, *Modern Sculpture from the Joseph H. Hirshhorn Collection*, no. 416

REFERENCES:

Archives of American Art, Smithsonian Institution, Washington, D.C., *David Smith Archives*

Cone, Jane Harrison, and Paul, Margaret. *David Smith 1906–1965: A Retrospective Exhibition*, Cambridge, Massachusetts, Fogg Art Museum, Harvard University, 1966, handlist no. 69

Gray, Cleve, ed. *David Smith by David Smith*, New York, Holt, Rinehart & Winston, 1968, p. 31

McCausland, Elizabeth. "David Smith's New Sculptural Idiom," *The Springfield [Massachusetts] Sunday Union and Republican*, November 10, 1940

McCoy, Garnett, ed. *David Smith*, New York, Praeger, 1973, p. 50

Big Rooster. 1945.
Steel, 16½ × 23½ × 14½ inches
Markings: back and u. l. on plaque "David Smith 1945"

PROVENANCE:
Willard Gallery, New York, 1956

EXHIBITIONS:
Willard Gallery, and Buchholz Gallery, New York, January 2–26, 1946, *The Sculpture of David Smith*, no. 27
Des Moines Art Center, Iowa, February 27–March 23, 1952, *The Artists' Vision*, no. 122
Walker Art Center, Minneapolis, April 12–May 11, 1952, *Sculpture and Drawings—David Smith*
Cincinnati Art Museum, Ohio, May 19–June 13, 1954, *David Smith: Sculpture, Drawings, Graphics*, no. 3; toured to Wisconsin Union, University of Wisconsin, Madison, July 11–August 20
Leonid Kipnis Gallery, Westport, Connecticut, November 18–30, 1956, *Modern Sculpture* (sponsored by the Westport Community Art Association), no. 37
The Detroit Institute of Arts, and tour, 1959–60, *Sculpture in Our Time*, no. 205
The Phillips Collection, Washington, D.C., February 12–March 31, 1966, *Birds in Contemporary Art*, no. 29

REFERENCES:
Cone, Jane Harrison, and Paul, Margaret. *David Smith 1906–1965: A Retrospective Exhibition*, Cambridge, Massachusetts, Fogg Art Museum, Harvard University, 1966, handlist no. 113
Pineda, Marianna. "David Smith," *Notes and Comments from the Walker Art Center*, 6, May 1952, ill.

Steel Drawing I. 1945.
Steel, 22½ × 26 × 6 inches
Markings: l. l. side of base "David Smith 1945"
l. r. side of base "David Smith 1945"

PROVENANCE:
Otto Gerson Gallery, New York, 1961

EXHIBITIONS:
Willard Gallery, and Buchholz Gallery, New York, January 2–26, 1946, *The Sculpture of David Smith*, no. 40
City Art Museum of St. Louis, Missouri, March 30–May 1, 1946, *Origins of Modern Sculpture*
Morrill Hall, University of Nebraska, Lincoln, March 2–April 30, 1947, *57th Annual Exhibition of Contemporary Art*, no. 210
Walker Art Center, Minneapolis, April 12–May 11, 1952, *Sculpture and Drawings—David Smith*
The Solomon R. Guggenheim Museum, New York, October 3, 1962–January 6, 1963, *Modern Sculpture from the Joseph H. Hirshhorn Collection*, no. 417, ill. p. 183
Greenwich Library, Connecticut, May 1–28, 1967, *Joseph H. Hirshhorn Collects*
The Solomon R. Guggenheim Museum, New York, March 29–May 11, 1969, *David Smith*, no. 25, ill. p. 47

REFERENCES:
Cone, Jane Harrison, and Paul, Margaret. *David Smith 1906–1965: A Retrospective Exhibition*, Cambridge, Massachusetts, Fogg Art Museum, Harvard University, 1966, handlist no. 138

Agricola I. 1951–52.
Painted steel, 73¾ × 54½ × 23½ inches
Markings: front l. c. "David Smith 1951–2 G-2"

PROVENANCE:
Park International, New York, 1962

EXHIBITIONS:
Willard Gallery, and Kleemann Galleries, New York, April 1–26, 1952, *David Smith Sculpture & Drawings*, no. 22
The Solomon R. Guggenheim Museum, New York, March 29–May 11, 1969, *David Smith*, no. 44, ill. p. 81

REFERENCES:
Cone, Jane Harrison, and Paul, Margaret. *David Smith 1906–1965: A Retrospective Exhibition*, Cambridge, Massachusetts, Fogg Art Museum, Harvard University, 1966, handlist no. 209, ill. p. 46

Auburn Queen. 1951–52.
Bronze, 87½ × 37 × 18 inches
Markings: front "David Smith 1951–52 G2"

PROVENANCE:
Otto Gerson Gallery, New York, 1961

EXHIBITIONS:
French & Company, New York, February 1960, *David Smith, Sculpture*, no. 1, ill.
The Solomon R. Guggenheim Museum, New York, October 3, 1962–January 6, 1963, *Modern Sculpture from the Joseph H. Hirshhorn Collection*, no. 422

REFERENCES:
Cone, Jane Harrison, and Paul, Margaret. *David Smith 1906–1965: A Retrospective Exhibition*, Cambridge, Massachusetts, Fogg Art Museum, Harvard University, 1966, handlist no. 369
Sandler, Irving H. "9 shows for spring: David Smith," *Art News*, 59, March 1960, p. 55

Pittsburgh Landscape. 1954.
Stainless steel and bronze, 2 feet 6 inches × 9 feet 8 inches × 5 inches
Markings: u. r. "David Smith 9/15/1954 For G.D.T."

PROVENANCE:
The artist, Bolton Landing, New York; G. David Thompson, Pittsburgh; Harold Diamond, New York, 1967

Sentinel II. 1956–57.
Stainless steel, 70½ × 10½ × 7½ inches
Markings: top of base "David Smith Sen II 56.57"

PROVENANCE:
Otto Gerson Gallery, New York, 1961

EXHIBITIONS:
Fine Arts Associates, New York, September 17–October 12, 1957, *Sculpture by David Smith*, no. 19, ill.
French & Company, New York, February 1960, *David Smith, Sculpture*, no. 13, ill.
The Solomon R. Guggenheim Museum, New York, October 3, 1962–January 6, 1963, *Modern Sculpture from the Joseph H. Hirshhorn Collection*, no. 420, ill. p. 182

REFERENCES:
Cone, Jane Harrison, and Paul, Margaret. *David Smith 1906–1965: A Retrospective Exhibition*, Cambridge, Massachusetts, Fogg Art Museum, Harvard University, 1966, handlist no. 338, ill. p. 47
Sweeney, James Johnson. "A Living Frame for Sculpture," *House & Garden*, 126, August 1964, ill. p. 111
Unsigned. "Great Sculpture at the Guggenheim," *Art in America*, 50, Fall 1962, ill. p. 19

Animal Weights. 1957.
Steel, 21 × 46 × 7½ inches
Markings: bottom "David Smith 1957"

PROVENANCE:
Fine Arts Associates, New York, 1959

EXHIBITIONS:
Fine Arts Associates, New York, September 17–October 12, 1957, *Sculpture by David Smith*, no. 20, ill.
The Cleveland Museum of Art, June 1958, *Some Contemporary Works of Art*, no. 74, ill.
V Bienal de Arte Moderna, São Paulo, September 21–December 31, 1959, *United States Representation*, no. 46
The Solomon R. Guggenheim Museum, New York, October 3, 1962–January 6, 1963, *Modern Sculpture from the Joseph H. Hirshhorn Collection*, no. 421
Joseloff Gallery, University of Hartford, West Hartford, Connecticut, November 8–December 4, 1964, *Arts in Society*, no. 65
University Art Museum, University of New Mexico, Albuquerque, March 25–May 1, 1966, *Twentieth Century Sculpture*, no. 50, ill.
Hopkins Art Center, Dartmouth College, Hanover, New Hampshire, May 25–July 9, 1967, *Sculpture in Our Century: Selections from the Joseph H. Hirshhorn Collection*, no. 49, ill. p. 38

REFERENCES:
Cone, Jane Harrison, and Paul, Margaret. *David Smith 1906–1965: A Retrospective Exhibition*, Cambridge, Massachusetts, Fogg Art Museum, Harvard University, 1966, handlist no. 319
Kramer, Hilton. "The Sculpture of David Smith," *Arts*, 34, February 1960, ill. p. 41
Weismann, Donald. *The Visual Arts as Human Experience*, Englewood Cliffs, New Jersey, Prentice-Hall, 1970, ill. p. 147

Raven IV. 1957.
Steel, 29 × 33 × 13½ inches
Markings: underside of base "David Smith 3–14–57"

PROVENANCE:
The artist, Bolton Landing, New York; Mr. and Mrs. Robert Staub, New York; Parke-Bernet Galleries, New York, Sale 2311, November 18, 1964, no. 50, ill.

EXHIBITIONS:
French & Company, New York, February 1960, *David Smith Sculpture*, no. 39, ill.
Rijksmuseum Kröller-Müller, Otterlo, The Netherlands, May 15–July 17, 1966, *David Smith 1906–1965* (The Museum of Modern Art, New York, Circulating Exhibition), no. 18; toured to The Tate Gallery, London, August 18–September 24, no. 19, ill. p. 6; Kunsthalle, Basel, October 25–November 23, no. 18
The Solomon R. Guggenheim Museum, New York, March 29–May 11, 1969, *David Smith*, no. 58, ill. p. 9

REFERENCES:
Cone, Jane Harrison, and Paul, Margaret. *David Smith 1906–1965: A Retrospective Exhibition*, Cambridge, Massachusetts, Fogg Art Museum, Harvard University, 1966, handlist no. 336

Voltri I. 1962.
Steel, 93 × 21½ × 18½ inches
Markings: l. l. top of base "David Smith"
c. top of base "5/25/62"
back top of base l. r. "Voltri I"

PROVENANCE:
Marlborough Galleria d'Arte, Rome, 1965

EXHIBITIONS:
Festival dei Due Mondi, Spoleto, Italy, Summer 1962, "Sculture nella città"

REFERENCES:
Carandente, Giovanni. *Voltron: Sculptures by David Smith*, Philadelphia, Institute of Contemporary Art, University of Pennsylvania, 1964, pp. 5, 74, ill. p. 39
Cone, Jane Harrison, and Paul, Margaret. *David Smith 1906–1965: A Retrospective Exhibition*, Cambridge, Massachusetts, Fogg Art Museum, Harvard University, 1966, handlist no. 576
Jacobs, Jay. "David Smith Sculpts for Spoleto," *Art News Annual XXIX*, 1964, p. 158
Rickey, George. *Constructivism: Origins and Evolution*, New York, Braziller, 1967, p. 67

In the summer of 1962, Smith was invited to submit two works to the Festival dei Due Mondi (Festival of Two Worlds) held in Spoleto, Italy. Although the Italian government offered him a studio, it was not until Gian Carlo Menotti, director of the Festival, promised to

dedicate an opera to Smith's two daughters that the sculptor finally set off for Italy. Working in the town of Voltri, near Genoa, in five condemned factories provided by Italsider, the national steel company (which also supplied a crew of electricians, welders, general factory hands, and an interpreter), Smith produced twenty-six monumental sculptures in one month. Wherever he looked, in the abandoned factories, he found objects that he wanted to incorporate in his works—obsolete iron tools, steel plates, cast-off forgings, and even an old flatcar (ultimately left behind only because it was too large to be transported through the railroad tunnel from Voltri to Spoleto). But he had to work fast. "A salvage crew was in several days a week," he later told an interviewer, "with their gondolas and switch engine, [to pick up] heavy scrap. Had I failed to take it first, I could have gone to the mill and got it back—but only as newly rolled plate."

The artist, in Jacobs, p. 49f

Voltri V. 1962.
Steel, 85½ × 36 × 25 inches
Markings: front l. l. "David Smith 6/62"
front l. of c. "Voltri V"

PROVENANCE:
Marlborough Galleria d'Arte, Rome, 1965

EXHIBITIONS:
Festival dei Due Mondi, Spoleto, Italy, Summer 1962, "Sculture nella città"

REFERENCES:
Archives of American Art, Smithsonian Institution, Washington, D.C., *David Smith Archives*
Carandente, Giovanni. *Voltron: Sculptures by David Smith*, Philadelphia, Institute of Contemporary Art, University of Pennsylvania, 1964, p. 74, ill. p. 34
Cone, Jane Harrison, and Paul, Margaret. *David Smith 1906–1965: A Retrospective Exhibition*, Cambridge, Massachusetts, Fogg Art Museum, Harvard University, 1966, handlist no. 463
Jacobs, Jay. "David Smith Sculpts for Spoleto," *Art News Annual XXIX*, 1964, p. 157, ill. pp. 43, 46
McCoy, Garnett, ed. *David Smith*, New York, Praeger, 1973, ill. 55

Voltri IX. 1962.
Steel, 78½ × 32 × 12 inches
Markings: l. r. top of base "David Smith 6/62"
back top of base l. l. "Voltri IX"

PROVENANCE:
Marlborough Galleria d'Arte, Rome, 1965

EXHIBITIONS:
Festival dei Due Mondi, Spoleto, Italy, Summer 1962, "Sculture nella città"

REFERENCES:
Carandente, Giovanni. *Voltron: Sculptures by David Smith*, Philadelphia, Institute of Contemporary Art, University of Pennsylvania, 1964, p. 74, ill. p. 34
Cone, Jane Harrison, and Paul, Margaret. *David Smith 1906–1965: A Retrospective Exhibition*, Cambridge, Massachusetts, Fogg Art Museum, Harvard University, 1966, handlist no. 445
Jacobs, Jay. "David Smith Sculpts for Spoleto," *Art News Annual XXIX*, 1964, p. 157, ill. pp. 43, 46

Voltri XV. 1962.
Steel, 90 × 77 × 2½ inches
Markings: l. c. top of base "David Smith"
l. r. top of base "Voltri XV"

PROVENANCE:
Marlborough Galleria d'Arte, Rome, 1965

EXHIBITIONS:
Festival dei Due Mondi, Spoleto, Italy, Summer 1962, "Sculture nella città"

REFERENCES:
Carandente, Giovanni. *Voltron: Sculptures by David Smith*, Philadelphia, Institute of Contemporary Art, University of Pennsylvania, 1964, pp. 9, 74, ill. p. 44
Cone, Jane Harrison, and Paul, Margaret. *David Smith 1906–1965: A Retrospective Exhibition*, Cambridge, Massachusetts, Fogg Art Museum, Harvard University, 1966, handlist no. 451
Gray, Cleve, ed. *David Smith by David Smith*, New York, Holt, Rinehart & Winston, 1968, ill. p. 44
Jacobs, Jay. "David Smith Sculpts for Spoleto," *Art News Annual XXIX*, 1964, p. 157

Voltri XXI. 1962.
Steel, 51 × 28 × 24 inches
Markings: front u. r. "David Smith 6/62"
front u. l. "Voltri XXI"

PROVENANCE:
Marlborough Galleria d'Arte, Rome, 1965

EXHIBITIONS:
Festival dei Due Mondi, Spoleto, Italy, Summer 1962, "Sculture nella città"

REFERENCES:
Archives of American Art, Smithsonian Institution, Washington, D.C., *David Smith Archives*
Carandente, Giovanni. *Voltron: Sculptures by David Smith*, Philadelphia, Institute of Contemporary Art, University of Pennsylvania, 1964, p. 75, ill. p. 48
Cone, Jane Harrison, and Paul, Margaret. *David Smith 1906–1965: A Retrospective Exhibition*, Cambridge, Massachusetts, Fogg Art Museum, Harvard University, 1966, handlist no. 457
Jacobs, Jay. "David Smith Sculpts for Spoleto," *Art News Annual XXIX*, 1964, p. 157, ill. p. 49
McCoy, Garnett, ed. *David Smith*, New York, Praeger, 1973, ill. 56

Cubi XII. 1963.
Stainless steel, 9 feet 1½ inches × 4 feet 1 inch × 2 feet 2 inches
Markings: front of base, c. "David Smith"
back top of base, c. "April 7, 1963 Cubi XII"

PROVENANCE:
Estate of the artist; Marlborough-Gerson Gallery, New York, 1968

EXHIBITIONS:
Marlborough-Gerson Gallery, New York, October 1964, *David Smith*, no. 5, ill.

REFERENCES:
Cone, Jane Harrison, and Paul, Margaret. *David Smith 1906–1965: A Retrospective Exhibition*, Cambridge, Massachusetts, Fogg Art Museum, Harvard University, 1966, handlist no. 499
Jacobs, Jay. "Collector: Joseph H. Hirshhorn," *Art in America*, 57, July–August 1969, ill. p. 69
Krauss, Rosalind E. *Terminal Iron Works: The Sculpture of David Smith*, Cambridge, Massachusetts Institute of Technology, 1971, p. 178, ill. p. 80

RICHARD SMITH (b. 1931)

Born Letchworth, England, October, 1931. Studied: Luton College of Technology and Art, Bedfordshire, England, 1948–50; St. Alban's School of Art, London, 1952–54; Royal College of Art, London, 1954–57. Received Royal College of Art Scholarship, for travel in Italy, 1957. Included in: "Six Young Contemporaries," Gimpel Fils, London, 1957; "Abstract Impressionism," Arts Council Gallery, London, 1958. Taught mural decoration, Hammersmith College of Art and Building, London, 1957–58. Lived in New York, 1959–61, 1963–65, 1967. One-man shows, The Green Gallery, New York, 1961, 1963, 1964. Taught: St. Martin's School of Art, London, 1961–63; University of Virginia, Charlottesville, 1967. Included in: Pittsburgh International, 1961; "Painting and Sculpture of a Decade, 54–64," The Tate Gallery, London, 1964; "The Shaped Canvas," The Solomon R. Guggenheim Museum, New York, 1964; "New Shapes of Color," Stedelijk Museum, Amsterdam, 1966–67; "Color Image and Form," The Detroit Institute of Arts, 1967; Documenta 4, Kassel, 1968; "British Painting and Sculpture 1960–1970," National Gallery of Art, Washington, D.C., 1970–71. One-man shows, London: Institute of Contemporary Arts, 1962; Kasmin Gallery, 1963, 1967, 1970; Whitechapel Art Gallery, 1966. Received: Scull Award, Venice Biennale, 1966; Grand Prize, IX São Paulo Bienal, 1967. One-man shows, New York: Richard Feigen Gallery, from 1966; The Jewish Museum, 1968. Lives in London.

Soft Pack. 1963.
Oil on canvas, 8 feet 6 inches × 5 feet 8 inches

PROVENANCE:
The Green Gallery, New York, 1963

EXHIBITIONS:
The Green Gallery, New York, February 19–March 16, 1963, *Richard Smith*
The Jewish Museum, New York, March 20–May 19, 1968, *Richard Smith*, no. 2, ill.

REFERENCES:
Andrae, Christopher. "Richard Smith," *The Christian Science Monitor*, May 27, 1968, ill.
Lippard, Lucy R. "Richard Smith: Conversations with the Artist," *Art International*, 8, November 1964, p. 32
Lucie-Smith, Edward. *Richard Smith*, London, Thames and Hudson, forthcoming, ill.
Mellow, James R. "New York Letter," *Art International*, 12, May 1968, p. 69
Rose, Barbara. "New York Letter," *Art International*, 7, March 25, 1963, p. 65
Sandler, Irving. "Reviews and Previews: Richard Smith, *Art News*, 62, April 1963, p. 14
Smith, Richard. "Trailer: Notes additional to a film," *Living Arts*, 1, 1963, ill. p. 34

Revolval 2 & 3. 1966.
Acrylic on shaped canvas, two panels, each 73 × 37 × 11 inches

PROVENANCE:
Richard Feigen Gallery, New York, 1968

EXHIBITIONS:
Macy's, New York, September 1968, *British Painting Here and Now . . . An Exhibition*, no. 12

REFERENCES:
Amaya, Mario. "British Art at Macy's," *Art and Artists*, 3, September 1968, colorplate p. 27

ROBERT SMITHSON (1938–1973)

Born Passaic, New Jersey, January 2, 1938. Studied, New York: The Art Students League of New York, 1954–56; The Brooklyn Museum Art School, fall, 1955. One-man shows (paintings): The Artists' Gallery, New York, 1959; Galleria George Lester, Rome, 1961. Included in: "Primary Structures," The Jewish Museum, New York, 1966; Whitney Annual, 1966–70; "Cool Art," The Aldrich Museum of Contemporary Art, Ridgefield, Connecticut, 1967; "American Sculpture of the Sixties," Los Angeles County Museum of Art, and Philadelphia Museum of Art, 1967; "Plus by Minus: Today's Half-Century," Albright-Knox Art Gallery, Buffalo, New York, 1968; "Art of the Real," The Museum of Modern Art, New York, International Circulating Exhibition, 1968–69; "Earthworks," Dwan Gallery, New York, 1969; "Information," The Museum of Modern Art, 1969; Sonsbeek '71, Arnhem, The Netherlands, 1971; Whitney Biennial, 1973. One-man shows: Dwan Gallery, New York, and Los Angeles, 1966–70; Galerie Konrad Fischer, Düsseldorf, 1968–69; John Weber Gallery, New York, from 1971. Statement, "Cultural Confinement," included in Documenta 5, Kassel, 1972. Received Kohnstamm Award, 70th American Exhibition, The Art Institute of Chicago, 1972. Critic, *Artforum*, *Arts Magazine*, *Studio International*. Died Amarillo, Texas, July 20, 1973.

Gyrostasis. 1968.
Painted steel, 73 × 57 × 40 inches

PROVENANCE:
Dwan Gallery, New York, 1968

EXHIBITIONS:
Dwan Gallery, New York, March 2–27, 1968, *Robert Smithson*

REFERENCES:
Andersen, Wayne. "La Scultura americana," *L'Arte Moderna*, Milan, 13, ill. p. 279
Coplans, John. "Robert Smithson, the 'Amarillo Ramp,'" *Artforum*, 12, April 1974, ill. p. 36
Nemser, Cindy. "In the Galleries: Robert Smithson," *Arts Magazine*, 42, April 1968, p. 59
Perreault, John. "Art," *The Village Voice*, New York, March 14, 1968, p. 17, ill.

"The title *Gyrostasis* refers to a branch of physics that deals with rotating bodies, and their tendency to maintain their equilibrium. The work is a standing triangulated spiral. When I made the sculpture I was thinking of mapping procedures that refer to the planet Earth. One could consider it as a crystallized fragment of a gyroscopic rotation, or as an abstract three-dimensional map that points to the *Spiral Jetty*, 1970, in the Great Salt Lake, Utah. *Gyrostasis* is relational, and should not be considered as an isolated object."

Statement by the artist, 1972

KENNETH SNELSON (b. 1927)

Born Pendleton, Oregon, June 29, 1927. Studied: University of Oregon, Eugene, 1946–48; Black Mountain College, North Carolina, with Josef Albers, and Buckminster Fuller, summers, 1948, 1949; engineering, Oregon State University, Corvallis, 1949; Institute of Design, Chicago, 1949; Atelier Fernand Léger, Paris, 1951. Experimented with kinetic sculpture, 1948. Free-lance film work, 1952–67. Included in: "Fuller Structures," and "Twentieth Century Engineering," The Museum of Modern Art, New York, 1959, 1962; Whitney Annual, 1966–70; "Plus by Minus: Today's Half-Century," Albright-Knox Art Gallery, Buffalo, New York, 1968; Expo'70, Osaka, Japan, 1970; Sonsbeek '71, Arnhem, The Netherlands, 1971; Whitney Biennial, 1973. One-man shows: Pratt Institute, Brooklyn, New York, 1963; Tower of Light Pavilion, New York World's Fair, Flushing Meadows, 1964; Dwan Gallery, New York, and Los Angeles, 1966–70; Fort Worth Art Center Museum, Texas, 1968; Bryant Park, New York, 1968; Rijksmuseum Kröller-Müller, Otterlo, The Netherlands, 1969; Städtische Kunsthalle, Düsseldorf, 1970; Kunstverein, Hanover, 1971; John Weber Gallery, New York, 1972. Designed model of the atom; published, *Industrial Design*, 1963; patented, 1966. Lives in New York.

Lorraine (Crane Booms). 1968.
Painted steel and stainless steel cable, 11 feet 9 inches × 16 feet 10 inches × 17 feet 2 inches

PROVENANCE:
Dwan Gallery, New York, 1969

EXHIBITIONS:
Whitney Museum of American Art, New York, December 17, 1968–February 9, 1969, *1968 Annual Exhibition of Contemporary Sculpture*, no. 115

REFERENCES:
Unsigned. *Kenneth Snelson*, Hanover, Kunstverein, 1971, ill. p. 61

"I am interested in form that results from structure. Most of my sculptures contain a dialogue between tension and compression; they are material elements under internal stress, as in a bicycle wheel, the frame of a kite, or an archer's bow.

"I am especially excited by working in a giant scale because, there, form has to find an elegant structural solution. It was with this in mind that I began looking jealously at the giant construction cranes standing about in the streets of New York. I thought how beautiful, if only to 'borrow' a few of these lacelike steel booms which seem never to get used on Sundays. I proposed to intersuspend a number of them with steel cable to make a colossal sculpture that would soar like a cathedral vault of fine pencil lines high over the city. (All cranes would return to their sites by Monday morning.) This immodest proposal prompted me to construct the modest prototype now in the Hirshhorn Museum—*Lorraine (Crane Booms)*, 1968. I still imagine one day I'll see *Lorraine* several hundred feet across, silhouetted against the sky. I'm waiting for the right weekend."

Statement by the artist, 1972

FRANCISCO SOBRINO (b. 1932)

Born Guadalajara, Spain, 1932. Studied: Escuela de Artes Aplicadas y Oficios Artísticos, Madrid, 1946; Escuela de Bellas Artes, Buenos Aires, 1950–57. Settled in Paris, 1959. Co-founded Groupe de Recherche d'Art Visuel, with Julio Le Parc, François Morellet, Yvaral, Joël Stein, 1960; exhibited with group, Paris: at their studio, 1960, 1961, and Galerie Denise René, 1961. Included in: "Art Abstrait Constructif International," Galerie Denise René, 1961; "L'Instabilité: Groupe de Recherche d'Art Visuel—Paris," The Contemporaries, New York, 1962; "Trente Argentins de la Nouvelle Génération," Galerie Raymond Creuze, Paris, 1962. Exhibited with Le Parc, and Yvaral, Galerie Aujourd'hui, Brussels, 1963. Included in: "Nove Tendencije 2," Galerije Grada Zagreba, Zagreb, Yugoslavia, 1963; 3e–5e Biennale de Paris, 1963, 1965, 1967; "Mouvement II," Galerie Denise René, 1964; Documenta III, Kassel, 1964; "The Responsive Eye," The Museum of Modern Art, New York, and tour, 1965–66; Salon Grands et Jeunes d'Aujourd'hui, Paris, 1966, 1969–71; "Kinetik und Bewegte Kunst," Museum des 20.Jahrhunderts, Vienna, 1967; "Lumière et Mouvement, Art Cinétique à Paris," Musée d'Art Moderne de la Ville de Paris, 1967; "Art Cinétique et Espace," Maison de la Culture, Le Havre, et Louviers, France, 1967. One-man shows: Galerie Denise René, Paris, 1968, and New York, 1971; Galerie Suzanne Bollag, Zurich, 1968; Galería Skira, Madrid, 1971. Lives in Paris.

Unstable Displacement (Déplacement instable). 1968.
Plexiglas, 37¼ × 15¼ × 2¼ inches

PROVENANCE:
Galerie Denise René, Paris, 1969

JOSEPH SOLMAN (b. 1909)

Born Vitebsk, Russia, January 25, 1909. Emigrated with family to New York, 1912. Studied, National Academy of Design, New York, with Ivan Olinsky, briefly, 1926. Exhibited, Washington Square Outdoor Art Show, New York, 1931. First one-man show, Contemporary Arts, New York, 1934. Co-founded The Ten, New York, with Ilya Bolotowsky, Adolph Gottlieb, Mark Rothko, among others, 1935; included in "The Ten: Whitney Dissenters," Mercury Gallery, 1938. Editor-in-chief, *Art Front*, 1936–37. WPA Federal Art Project, Easel Division, New York, 1936–41. One-man shows, New York: Another Place, 1937; Bonestell Gallery, 1942, 1945; ACA Gallery, New York, from 1950. Included in: "Five New American Painters," J. B. Neumann's New Art Circle, New York, 1938; "American Art Today," New York World's Fair, Flushing Meadows, 1939. Retrospective, The Phillips Memorial Gallery, Washington, D.C., 1949. Taught, The Museum of Modern Art, New York, 1952–54. Traveled to France, The Netherlands, Italy, 1956. One-man show, Bernhardt Crystal Gallery, New York, 1961. Received: The National Institute of Arts and Letters Award, 1961; Portrait Prize, National Academy of Design, 1969. President, Federation of Modern Painters and Sculptors, 1965–67. Has taught, City College, City University of New York, since 1967. Lives in New York.

Studio Interior with Statue. 1950.
Oil on canvas, 15¾ × 23⅜ inches
Signed l. r.: "JS"
Signed and dated on back: "J. Solman 1950"

PROVENANCE:
ACA Gallery, New York, 1951

EXHIBITIONS:
ACA Gallery, New York, November 20–December 9, 1950, *Joseph Solman*
The Pennsylvania Academy of the Fine Arts, Philadelphia, January 21–February 25, 1951, *The One Hundred and Forty-Sixth Annual Exhibition of Painting and Sculpture*, no. 88

REFERENCES:
Chanin, A. L. *Joseph Solman*, New York, Crown, 1966, p. 12, plate 60
Seckler, Dorothy Gees. "Reviews and Previews: Joseph Solman," *Art News*, 69, November 1950, ill. p. 48

FRANCESCO SOMAINI (b. 1926)

Born Lomazzo, near Como, Italy, August 6, 1926. Studied intermittently, Accademia di Belle Arti di Brera e Liceo Artistico, Milan. Included in: Quadriennale Nazionale d'Arte, Rome, 1948, 1952, 1959; Venice Biennale, 1950, 1954–58; X Milan Triennale, 1954; "Premier Salon de la Sculpture Abstraite," Galerie Denise René, Paris, 1955; 5th Middelheim Biënnale, Antwerp, 1959; "Sculture nella città," Festival dei Due Mondi, Spoleto, Italy, 1962. Awarded First Olivetti Prize, competition for monument to unknown political prisoner, Palazzo Strozzi, Florence, 1952. Sculpture commission, city park, Milan, 1954. One-man shows: Galleria La Strozzina, Florence, 1956; Galleria La Salita, Rome 1957; Galleria Saletta, Modena, Italy, 1958; Galleria Blu, Milan, 1959, 1962; Galleria Odyssia, Rome, 1959, 1962, 1964; Istituto Italiano di Cultura, New York, 1960; Venice Biennale, 1960; Museo de Arte Moderno de la Ciudad Buenos Aires, 1960; Galleria Odyssia, New York, 1964. Awarded: Best Foreign Sculptor Prize, V São Paulo Bienal, 1959; French Critics' Prize, 2e Biennale de Paris, 1961. Included in Pittsburgh International, 1961, 1964, 1970. Lives in Lomazzo.

Large Bleeding Martyrdom (Grande Martirio Sanguinate). 1960.
Lead, 51½ × 26 × 22¼ inches
Markings: l. l. side "SOMAINI
 60.55
 ESEGUITO-INLOMAZZO-
 COMO-ITALIA"

PROVENANCE:
Galleria Odyssia, Rome, 1963

JESUS RAFAEL SOTO (b. 1923)

Born Ciudad Bolívar, Venezuela, June 5, 1923. Studied, Escuela de Artes Plásticas y Artes Aplicadas, Caracas, 1942–47. Director, Escuela de Bellas Artes de Maracaibo, Venezuela, 1947–50. One-man show, Atelier Libre de Arte, Caracas, 1949. Moved to Paris, 1950. Included in: Salon des Réalités Nouvelles, Paris, 1951–68; "Mouvement I," and "Mouvement II," Galerie Denise René, Paris, 1955, 1964; Exposition Universelle et Internationale de Bruxelles, 1958; Venice Biennale, 1958–66, 1970; V and VII São Paulo Bienal, 1959, 1963; Documenta III, Kassel, 1964; "Kinetic and Optic Art Today," and "Plus by Minus: Today's Half-Century," Albright-Knox Art Gallery, Buffalo, New York, 1965, 1968; Expo '67, Montreal, 1967; "Painting in France, 1900–1967," National Gallery of Art, Washington, D.C., and tour, 1968. One-man shows: Galerie Denise René, 1956, 1967, 1970; Museo de Bellas Artes de Caracas, 1957, 1961; Palais des Beaux-Arts, Brussels, 1957, 1969; Kunsthalle, Bern, 1968; Stedelijk Museum, Amsterdam, 1968; Marlborough Galleria d'Arte, Rome, 1968; Marlborough-Gerson Gallery, New York, 1969; Musée d'Art Moderne de la Ville de Paris, 1969; Martha Jackson Gallery, New York, 1971; Galerie Beyeler, Basel, 1972. Retrospective, The Solomon R. Guggenheim Museum, New York, and tour, 1975. Lives in Paris.

Two Volumes in the Virtual (Due Volumi nel virtuale). 1968.
Painted metal, Masonite, and wood, 9 feet 10¼ inches × 6 feet 6¼ inches × 6 feet 6¼ inches

PROVENANCE:
Marlborough Galleria d'Arte, Rome, 1968

EXHIBITIONS:
Marlborough Galleria d'Arte, Rome, May 21–June 30, 1968, *Soto*

MOSES SOYER (b. 1899)

Born Borisoglebsk, Russia, December 25, 1899. Emigrated with family to Philadelphia, then settled in New York, 1913; U.S. citizen, 1925. Studied, New York: The Cooper Union for the Advancement of Science and Art, 1914–17; National Academy of Design, with Charles C. Curran, c. 1918–19; Ferrer Center, with Robert Henri, and George Bellows. Educational Alliance Art School, New York: studied, c. 1919–24; instructor, 1924–26; received Traveling Scholarship to Europe, 1926–28. One-man show, J. B. Neumann's New Art Circle, New York, 1929. Taught, New York, c. 1929–34: Contemporary Art School; New Art School; New School for Social Research. One-man shows: Kleemann Galleries, New York, 1936; Boyer Galleries, Philadelphia, 1936–37; Little Gallery, Washington, D.C., 1939–40; Macbeth Gallery, New York, 1940–43; ACA Gallery, New York, from 1944. WPA Federal Art Project, Mural Division, New York; with brother Raphael, painted two murals, U.S. Post Office, Kingsessing, Pennsylvania, 1939. Included in: Carnegie Annual, 1943–50; Whitney Annual, 1947, 1952, 1955–56, 1963. Academician, National Academy of Design, 1963. Member, The National Institute of Arts and Letters, New York, 1966. One-man shows: Reading Public Museum and Art Gallery, Pennsylvania, 1968; Albrecht Gallery of Art, St. Joseph, Missouri, 1970. Retrospective, Syracuse University, New York, and tour, 1972–73. Lives in New York.

Phyllis. 1954.
Oil on canvas, 30 × 25 inches
Signed and dated u. r.: "M. Soyer/1954"

PROVENANCE:
ACA Gallery, New York, 1954

EXHIBITIONS:
The National Gallery of Canada, Ottawa, and tour, 1957, *Some American Paintings from the Collection of Joseph H. Hirshhorn*, no. 74

REFERENCES:
Willard, Charlotte. *Moses Soyer*, Cleveland, and New York, World, 1962, plate 73

RAPHAEL SOYER (b. 1899)

Born Borisoglebsk, Russia, December 25, 1899; twin brother of Moses. Emigrated with family to Philadelphia, then settled in New York, 1913; U.S. citizen, 1925. Studied, New York: The Cooper Union for the Advancement of Science and Art, 1914–17; National Academy of Design, with George W. Maynard, and Charles C. Curran, 1918–22; The Art Students League of New York, with Guy Pène du Bois, briefly, 1920–21, 1923; with Boardman Robinson, one month, 1926. First exhibited, Salons of America, New York, 1926. Member, New York: Whitney Studio Club, 1927–28; John Reed Club, 1929, and taught there, c. 1930. One-man shows, New York: The Daniel Gallery, 1929; L'Elan Gallery, 1932; Valentine Gallery, 1933, 1935, 1938; Macbeth Gallery (lithographs and drawings), 1935. Awarded Kohnstamm Prize, 45th American Exhibition, The Art Institute of Chicago, 1932. Taught, The Art Students League, 1933–34, 1935–42. Included in: Whitney Annual, 1934–72; Carnegie Annual, 1935–50; "American Art Today," New York World's Fair, Flushing Meadows, 1939. Founding member, American Artists' Congress, 1936. WPA Federal Art Project, Easel and Graphic Arts Divisions, c. 1936; with Moses, painted two murals, U.S. Post Office, Kingsessing, Pennsylvania, 1939. One-man shows, New York: Associated American Artists Galleries, 1941, 1948, 1953; ACA Gallery, 1960; Forum Gallery, from 1966. Awarded Temple Gold Medal, Pennsylvania Academy Annual, 1943. The National Institute of Arts and Letters: received grant, 1945; member, 1958. National Academy of Design: associate, 1949; academician, 1951; taught, 1965–67. Awarded: Corcoran Gold Medal, and First Clark Prize, Corcoran Biennial, 1951; First Prize for Painting, "Art USA: '59," The Coliseum, New York, 1959. Co-founded *Reality* magazine, published annually, 1953–55. Taught, New School for Social Research, New York, 1957–62. The American Academy of Arts and Letters: Award of Merit, 1958; member, 1969. Author of: *Homage to Thomas Eakins, Etc.* (New Brunswick, New Jersey, Yoseloff), 1961; *A Painter's Pilgrimage* (New York, Crown), 1962; *Self-Revealment: A Memoir* (New York, Random House), 1967. Retrospective, Whitney Museum of American Art, New York, and tour, 1967–68. Lives in New York.

Farewell to Lincoln Square (Pedestrians). 1959.
Oil on canvas, 60¼ × 55 inches
Signed l. r.: "Raphael Soyer"

PROVENANCE:
The artist, New York, 1959

EXHIBITIONS:
The Coliseum, New York, April 1–11, 1959, *Art USA: '59*, no. 1966
ACA Gallery, New York, November 28–December 17, 1960, *Raphael Soyer*, no. 1, cover ill.
American Federation of Arts tour, 1962–65, *Paintings from the Joseph H. Hirshhorn Foundation Collection: A View of the Protean Century*, no. 66, ill. p. 13
Whitney Museum of American Art, New York, September 28–November 27, 1966, *Art of the United States 1670–1966*, no. 260, ill. p. 107
Whitney Museum of American Art, New York, October 25–December 3, 1967, *Raphael Soyer*, no. 80, pp. 22, 28, colorplate p. 59; toured to six U.S. cities

REFERENCES:
Frankenstein, Alfred. "Raphael Soyer," *The Britannica Encyclopedia of American Art*, New York, Simon and Schuster, 1973, ill. p. 532
Goodrich, Lloyd. *Raphael Soyer*, New York, Abrams, 1972, pp. 207–8, 337, colorplates, cover, pp. 217, 218–20 (detail)

——. *Three Centuries of American Art*, New York Praeger, 1966, ill. p. 107
Gutman, Walter K. *Raphael Soyer: Paintings and Drawings*, New York, Shorewood, 1960, ill. pp. 175–77
Taylor, Robert. "Events in Art," *Boston Sunday Herald*, December 13, 1964, p. 6
Tillim, Sidney. "Month in Review: Raphael Soyer," *Arts*, 35, January 1961, pp. 47–48
Unsigned. "Art: Oblivious People," *Time*, 76, December 12, 1960, p. 78, ill. (detail)
——. "2500 at Art Show," *The New York Times*, April 4, 1959
Weller, Allen S., and Nordness, Lee, eds. *Art USA Now*, 1, New York, Viking, 1962, p. 87, ill. p. 88
White, Claire Nicolas. "Reviews and Previews: Raphael Soyer," *Art News*, 66, November 1967, p. 64

"My subject matter has always been derived from the locale where I happen to be at a particular time. The earlier pictures were painted on the Lower East Side. In the 1930s I lived in the Union Square area where I painted the people I saw there. Much later I did *Village East* when my studio was downtown on Second Avenue.

"*Farewell to Lincoln Square* was painted in the Lincoln Arcade Building located in Lincoln Square, on the eve of its being demolished to make way for Lincoln Center. I loved that building. Many American painters from way back lived and worked there. The painting depicts the exodus of its denizens from that famous building, with myself in the group, waving farewell."

Statement by the artist, 1972

NILES SPENCER (1893–1952)

Born Pawtucket, Rhode Island, May 16, 1893. Studied: Rhode Island School of Design, Providence, 1913–15; with Charles Woodbury, Ogunquit, Maine, summers, 1913–15; The Art Students League of New York, with Kenneth Hayes Miller; Ferrer Center, New York, with Robert Henri, and George Bellows, 1915–16. Taught, Rhode Island School of Design, 1915. Lived in Ogunquit, under patronage of Hamilton Easter Field, 1917–21. Traveled: to Italy, and France, 1921–22; to Bermuda, 1927–28; to France, 1928–29. Settled in New York, 1923. Member, Whitney Studio Club, New York, 1923–30. One-man shows, The Daniel Gallery, New York, 1925, 1928. Awarded honorable mention, 29th Carnegie International, 1930. Included in: "Painting and Sculpture by Living Americans," The Museum of Modern Art, New York, 1930–31; "Abstract Painting in America," Whitney Museum of American Art, New York, 1935. U.S. Treasury Department Relief Art Project, mural, U.S. Post Office, Aliquippa, Pennsylvania, 1937. Included in: "American Art Today," New York World's Fair, Flushing Meadows, 1939; "A New Realism: Crawford, Demuth, Sheeler, Spencer," Cincinnati Modern Art Society, Ohio, 1941; "Abstract Painting and Sculpture in America," The Museum of Modern Art, 1951. One-man shows, The Downtown Gallery, New York, 1947, 1952. Died Dingman's Ferry, Pennsylvania, May 15, 1952. Retrospectives: The Museum of Modern Art, and tour, 1954; University of Kentucky Art Gallery, Lexington, and tour, 1965–66. One-man shows: Newark Museum, New Jersey, 1972; Washburn Gallery, New York (drawings), 1972.

Edge of the City. 1943.
Oil on canvas, 25 × 29 inches
Signed l. r.: "Niles Spencer"

PROVENANCE:
The Downtown Gallery, New York; Wright Ludington, Santa Barbara, California; The Downtown Gallery, 1953

EXHIBITIONS
Carnegie Institute, Pittsburgh, October 12–December 10, 1944, *Painting in the United States, 1944*, no. 302
The Downtown Gallery, New York, November 11–29, 1947, *Niles Spencer*, no. 8
San Francisco Museum of Art, May 13–June 20, 1948, *The Wright Ludington Collection*
The Downtown Gallery, New York, June 3–27, 1952, *Art for the 67%*
Akron Art Institute, Ohio, February 1–21, 1954, *Niles Spencer Memorial Exhibition* (The Museum of Modern Art, New York, Circulating Exhibition); toured to Cincinnati Art Museum, Ohio, March 1–29; Currier Gallery of Art, Manchester, New Hampshire, May 11–June 2; The Museum of Modern Art, New York, June 22–August 15; Walker Art Center, Minneapolis, September 1–October 1
Brandeis University, Waltham, Massachusetts, June 1955, *Three Collections*, no. 48
Tweed Gallery, University of Minnesota, Duluth, April 1–30, 1956, *Collector's Choice*, cat.
Walker Art Center, Minneapolis, November 13–December 25, 1960, *The Precisionist View in American Art*, no. 23, p. 58; toured to Whitney Museum of American Art, New York, January 24–February 28, 1961; The Detroit Institute of Arts, March 21–April 23; Los Angeles County Museum of Art, May 17–June 18; San Francisco Museum of Art, July 2–August 6
University of Kentucky Art Gallery, Lexington, October 10–November 6, 1965, *Niles Spencer*, no. 41, ill. p. 45; toured to six U.S. cities

REFERENCES:
Archives of American Art, Smithsonian Institution, Washington, D.C., *The Downtown Gallery Archives*
Freeman, Richard B. *Niles Spencer*, Lexington, University of Kentucky, 1965, preliminary checklist, no. 88

NICOLAS DE STAËL (1914–1955)

Born Petrograd, Russia, January 5, 1914. Exiled with family to Poland, 1919. Lived in Brussels, 1922–33, 1935–36. Studied, Brussels: Académie Royal des Beaux-Arts, and Académie des Beaux-Arts de Saint-Gilles, 1932–33. Traveled to Spain, North Africa, Italy, 1935–38. Studied, Atelier Fernand Léger, Paris, briefly, 1938. Served, French Foreign Legion, Tunisia, 1939. Lived in Nice, 1940; settled in Paris, 1943. Exhibited, Paris: with César Domela, Wassily Kandinsky, Alberto Magnelli,

Galerie L'Esquisse, 1944; Salon d'Automne, and Salon de Mai, 1944–52. One-man shows: Galerie L'Esquisse, 1944; Galerie Jeanne Bucher, Paris, 1945, 1958; Galerie Jacques Dubourg, Paris, 1950–51, 1954, 1957, 1958; M. Knoedler & Co., New York, 1953; The Phillips Collection, Washington, D.C., 1953, 1956; Paul Rosenberg & Co., New York, 1954, 1958, 1963. Included in: II São Paulo Bienal, 1953; "The Classic Tradition in Contemporary Art," Walker Art Center, Minneapolis, 1953; Venice Biennale, 1954, 1964; Documenta II and III, Kassel, 1959, 1964. Died by suicide, Antibes, France, March 16, 1955. Retrospectives: Paul Rosenberg & Co., 1955; Musée National d'Art Moderne, Paris, 1956; Museum of Fine Arts, Boston, and tour, 1965–66.

La Seine. 1954.
Oil on canvas, 35 × 51⅜ inches
Signed l. r.: "Staël"

PROVENANCE:
Paul Rosenberg & Co., New York, 1955

EXHIBITIONS:
Brandeis University, Waltham, Massachusetts, June 1–17, 1955, *Three Collections*, no. 6
Paul Rosenberg & Co., New York, October 31–November 26, 1955, *Loan Exhibition of Paintings by Nicolas de Staël*, no. 20
American Federation of Arts tour, 1962–65, *Paintings from the Joseph H. Hirshhorn Foundation Collection: A View of the Protean Century*, no. 21

REFERENCES:
Chastel, André. *Nicolas de Staël*, Paris, le temps, 1968, no. 850, ill. p. 338
Cooper, Douglas. "Paris 1964," *Art in America*, 52, December 1964, p. 111, ill.
Genauer, Emily. "75 Choice Hirshhorn Paintings," *New York Herald Tribune*, November 4, 1962, sec. 4, p. 7
Raynor, Vivien. "New York Exhibitions: In the Galleries: Paintings from the Hirshhorn Collection," *Arts Magazine*, 37, December 1962, p. 45

THEODOROS STAMOS (b. 1922)

Born New York, December 22, 1922. Studied, American Artists School, New York, 1936–39. One-man shows, New York: Wakefield Gallery, 1943; Mortimer Brandt Gallery, 1945, 1946; Betty Parsons Gallery, 1947–53, 1956. Taught: Black Mountain College, North Carolina, 1950; Cummington School of Art, Massachusetts, 1952–53; The Art Students League of New York, from 1953. One-man shows, The Phillips Collection, Washington, D.C., 1950, 1954. Received: Louis Comfort Tiffany Foundation Fellowship, 1951; The National Institute of Arts and Letters, and The American Academy of Arts and Letters Grant, 1956. Included in: "Nature in Abstraction," Whitney Museum of American Art, New York, 1958; "The New American Painting," The Museum of Modern Art, New York, International Circulating Exhibition, 1958–59; "American Abstract Expressionists and Imagists," The Solomon R. Guggenheim Museum, New York, 1961; "Dada, Surrealism and Their Heritage," The Museum of Modern Art, and tour, 1968. Retrospectives: The Corcoran Gallery of Art, Washington, D.C., 1958–59; Spingold Theater Arts Center Gallery, Brandeis University, Waltham, Massachusetts, 1967. One-man shows, André Emmerich Gallery, New York, 1958–63, 1966, 1968, 1970; Waddington Fine Arts, Montreal, 1968; Marlborough Gallery, New York, 1972. Received Brandeis University Creative Arts Award Citation, 1959. Lives in New York.

Byzantium II. 1958.
Oil on canvas, 69 × 68 inches
Signed l. l.: "Stamos"

PROVENANCE:
André Emmerich Gallery, New York, 1958

EXHIBITIONS:
The Corcoran Gallery of Art, Washington, D.C., December 31, 1958–March 1, 1959, *Theodoros Stamos*, no. 29

REFERENCES:
Sawyer, Kenneth B. *Stamos*, Paris, Georges Fall, 1960, p. 40

"*Byzantium II* . . . was painted ten years after a visit to the many Byzantine churches scattered throughout Greece, and in Torcello, Italy, followed by much reading on the Empire. A series of paintings started to appear from all this. They are not, in any sense, influenced by the architecture, mosaics, etc., but rather, I believe, a reaction to what Byzantium was, is, and means today to our own culture and life-style in a more intriguing society than the Empire ever dreamed of."

Statement by the artist, 1972

RICHARD STANKIEWICZ (b. 1922)

Born Philadelphia, October 18, 1922. Moved with family to Detroit, 1929. Served, U.S. Navy, 1941–47. Studied, painting: Hans Hofmann School of Fine Art, New York, and Provincetown, Massachusetts, 1948–49; with Fernand Léger, Paris, 1950; sculpture, Académie de la Grande Chaumière, Paris, with Ossip Zadkine, 1950–51. Settled in New York, 1951. Co-founded Hansa Gallery, New York, 1952; one-man shows there, 1953–58. Included in: Whitney Annual, 1956, 1960, 1962, 1964, 1966; Venice Biennale, 1958; Pittsburgh International, 1958, 1961; "Recent Sculpture U.S.A.," The Museum of Modern Art, New York, and tour, 1959–60; "Movement in Art," Moderna Museet, Stockholm, and Stedelijk Museum, Amsterdam, 1961; VI São Paulo Bienal, 1961; "The Art of Assemblage," The Museum of Modern Art, and tour, 1961–62; "Sculpture in the Open Air," Battersea Park, London, 1963. One-man shows: Stable Gallery, New York, 1959–65; Galerie Neufville, Paris, 1960. Exhibited with Robert Indiana, Walker Art Center, Minneapolis, and Institute of Contemporary Art, Boston, 1963–64. Received Brandeis University Creative Arts Award Citation, 1966. Taught, State University of New York at Albany, 1967–68, and since 1971; Amherst College, Massachusetts, 1970–71. Worked and lectured

in Australia, 1969. One-man shows, Zabriskie Gallery, New York, 1972, 1973. Has lived in Huntington, Massachusetts, since 1962.

Figure. 1955.
Iron, 80 × 20½ × 19¼ inches

PROVENANCE:
The artist, New York, 1959

EXHIBITIONS:
The Solomon R. Guggenheim Museum, New York, October 3, 1962–January 6, 1963, *Modern Sculpture from the Joseph H. Hirshhorn Collection*, no. 425, ill. p. 192
Dallas Museum of Fine Arts, May 12–June 13, 1965, *Sculpture: Twentieth Century*, no. 76
J. B. Speed Art Museum, Louisville, Kentucky, October 15–November 28, 1965, *The Figure in Sculpture 1865–1965*, no. 23

REFERENCES:
Ashton, Dore. "New York Report," *Das Kunstwerk*, 16, October 1962, p. 27
Rubin, William S. "The Hirshhorn Collection at the Guggenheim Museum," *Art International*, 6, November 1962, ill. p. 37

SAUL STEINBERG (b. 1914)

Born Râmnicu-Sărat, Rumania, June 15, 1914. Studied sociology and psychology, University of Bucharest, 1932. Lived in Milan, 1933–41; cartoons published in *Bertaldo*, Milan, 1936–39. Received degree in architecture, Politecnico di Milano, Facoltà di Architettura, 1940. Cartoons first appeared in the U.S. in *Harper's Bazaar*, and *Life*, 1940. Visited New York briefly, then traveled to Ciudad Trujillo (Santo Domingo), Dominican Republic, 1941. First contributed to *The New Yorker*, 1941. Emigrated to the U.S., 1942; citizen, 1943. Served, U.S. Navy, China, India, North Africa, Italy, 1943–46. Exhibited with Costantino Nivola, Wakefield Gallery, New York, 1943; one-man show there, 1945. Included in "Fourteen Americans," The Museum of Modern Art, New York, 1946. Mural commissioned, Terrace Plaza Hotel, Cincinnati, Ohio, 1947. One-man shows: Museu de Arte Moderna de São Paulo, 1952; Frank Perls Gallery, Beverly Hills, California, 1952; Institute of Contemporary Arts, London, 1952; Galerie Maeght, Paris, and European tour, 1953–54, 1967; American Federation of Arts, Circulating Exhibition, 1953–55. Two-gallery exhibitions, Betty Parsons Gallery, and Sidney Janis Gallery, New York, 1952, 1966, 1969, 1973. Mural, U.S. Pavilion, Exposition Universelle et Internationale de Bruxelles, 1958. Awarded American Institute of Graphic Arts Medal, 1963. Artist-in-residence, Smithsonian Institution, Washington, D.C., 1967. Lives in New York.

Still Life with Golem. 1965.
Pen, ink, pencil, and collage on paper, 20 × 30 inches
Signed and dated l. r.: "Steinberg 65"

PROVENANCE:
Parke-Bernet Galleries, New York, *United Jewish Appeal Benefit Auction*, June 11, 1968, no. 21 (donated by the artist)

FRANK STELLA (b. 1936)

Frank Phillip Stella, born Malden, Massachusetts, May 12, 1936. Studied, Princeton University, New Jersey, A.B., 1958. Moved to New York, 1958. Included in: "Selections," Tibor de Nagy Gallery, New York, 1959; "Three Young Americans," Allen Memorial Art Museum, Oberlin College, Ohio, 1959; "Sixteen Americans," The Museum of Modern Art, New York, 1959–60; "Abstract Expressionists and Imagists," The Solomon R. Guggenheim Museum, New York, 1961. One-man shows: Leo Castelli Gallery, New York, from 1960; Galerie Lawrence, Paris, 1961, 1964; Kasmin Gallery, London, 1964, 1966, 1968. Artist-in-residence, Dartmouth College, Hanover, New Hampshire, summer, 1963; lectured, Yale University, New Haven, Connecticut, fall, 1965. Included in: Whitney Annual, 1963–72; Venice Biennale, 1964; "Three American Painters," Fogg Art Museum, Harvard University, Cambridge, Massachusetts, and Pasadena Art Museum, California, 1965; VIII São Paulo Bienal, 1965. One-man shows: Pasadena Art Museum, and Seattle Art Museum, 1966–67; Washington [D.C.] Gallery of Modern Art, 1968; Rose Art Museum, Brandeis University, Waltham, Massachusetts, 1969; Irving Blum Gallery, Los Angeles, 1969–71; Lawrence Rubin Gallery, New York, 1969–72; The Museum of Modern Art, and European tour, 1970; Stedelijk Museum, Amsterdam, 1971; The Phillips Collection, Washington, D.C., 1973; M. Knoedler & Co., New York, 1973. Received Brandeis University Creative Arts Award Citation, 1968. Included in: Documenta 4, Kassel, 1968; "Plus by Minus: Today's Half-Century," Albright-Knox Art Gallery, Buffalo, New York, 1968; "The Art of the Real," The Museum of Modern Art, and tour, 1968–69; ROSC '71, Dublin, 1971; Whitney Biennial, 1973. Lives in New York.

Arundel Castle. 1959.
Oil on canvas, 10 feet 1 inch × 6 feet 1 inch
Signed and dated on back: "F. P. Stella/1959"

PROVENANCE:
Leo Castelli Gallery, New York; The artist, New York, 1966

EXHIBITIONS:
The Museum of Modern Art, New York, December 16, 1959–February 14, 1960, *Sixteen Americans*, ill. p. 79
Leo Castelli Gallery, New York, September 27–October 5, 1960, *Frank Stella*
Pasadena Art Museum, California, July 6–August 3, 1965, *Three American Painters*

REFERENCES:
Hamilton, George Heard. "Painting in Contemporary America," *Burlington Magazine*, 102, May 1960, p. 197, ill. p. 195
Rubin, William S. *Frank Stella*, New York, The Museum of Modern Art, 1970, pp. 45, 156

Pagosa Springs. 1960.
Copper paint on shaped canvas, 99¼ × 99¼ inches

PROVENANCE:
The artist, New York, 1966

EXHIBITIONS:
Leo Castelli Gallery, New York, April 28–May 19, 1962, *Frank Stella*
The Jewish Museum, New York, April 28–May 19, 1962 *A New Abstraction*, no. 44
XXXII Biennale Internazionale d'Arte, Venice, June–September 1964, *United States Pavilion*, no. 83, p. 279
Pasadena Art Museum, California, July 6–August 3, 1965, *Three American Painters*

REFERENCES:
Coplans, John. *Serial Imagery*, Greenwich, Connecticut, New York Graphic Society, 1968, ill. p. 105
Judd, Donald. "New York Reports: In the Galleries," *Arts Magazine*, 36, September 1962, ill. p. 51
Kozloff, Max. "The Inert and The Frenetic," *Artforum*, 4, March 1966, ill. p. 44
Unsigned. "Venice: The Biennale XXXII," *Arts Magazine*, 38, May–June 1964, ill. p. 77

Darabjerd III. 1967.
Fluorescent acrylic on canvas, 10 × 15 feet

PROVENANCE:
Lawrence Rubin Gallery, New York, 1967

EXHIBITIONS:
Whitney Museum of American Art, New York, December 13, 1967–February 4, 1968, *1967 Annual Exhibition of Contemporary American Painting*, no. 155
Art Museum of South Texas, Corpus Christi, October 4–November 26, 1972, *Johns, Stella, Warhol: Works in Series*, p. 18, ill. p. 25

REFERENCES:
Cone, Jane Harrison. "Frank Stella's New York Paintings," *Artforum*, 7, December 1967, ill. p. 37
Kramer, Hilton. *The Art of the Avant-Garde*, New York, Farrar, Straus and Giroux, 1973, ill. following p. 400
Rubin, William S. *Frank Stella*, New York, The Museum of Modern Art, 1970, ill. p. 133

JOSEPH STELLA (1877–1946)

Born Muro Lucano, near Naples, June 13, 1877. Emigrated to New York, 1896; U.S. citizen, 1923. Pre-medical training, 1896–97. Studied: The Art Students League of New York, 1897; New York School of Art, with William Merritt Chase, 1898–1900. "Americans in the Rough," series of drawings of immigrants at Ellis Island, commissioned by *Outlook*, 1905. Illustrated Ernest Poole's novel *The Voice in the Street* (New York, Barnes), 1906. Illustrator, *Survey*, 1907–9, 1918–19, 1923, 1929. Traveled in Europe, 1909–12. One-man show (drawings), Carnegie Institute, Pittsburgh, and tour, 1910. Present at Futurist exhibition, Galerie Bernheim-Jeune, Paris, 1912; associated with Italian Futurists and other avant-garde artists in Paris. Returned to New York, 1912. Included in the Armory Show, 1913. One-man shows, New York: Italian National Club, 1913; Bourgeois Galleries, 1920. Member, Board of Directors, Society of Independent Artists, New York, 1917. Joined Société Anonyme, New York, 1920. Fall 1922 issue of *The Little Review* devoted to his work. Traveled extensively, France, Italy, North Africa, Barbados, 1922–38; lived in Paris, 1930–34. One-man shows: Société Anonyme, 1923; Dudensing Galleries, New York, 1924; F. Valentine Dudensing, New York, 1926; The New Gallery, New York, 1926; Valentine Gallery, New York, 1928, 1931, 1935; Galleria Angiporto, Naples, 1929; Cooperative Gallery, Newark, New Jersey, 1937. Included in: "American Painting and Sculpture," The Museum of Modern Art, New York, 1932–33; "Abstract Painting in America," Whitney Museum of American Art, New York, 1935. WPA Federal Art Project, Easel Division, New York, 1937. Included in "American Art Today," New York World's Fair, Flushing Meadows, 1939. Retrospective, Newark Museum, 1939. One-man shows, New York: Associated American Artists Galleries, 1941; M. Knoedler & Co., 1942; ACA Gallery, 1943. Died, Astoria, New York, November 5, 1946. Retrospective, Whitney Museum of American Art, 1963.

La Fontaine. c. 1925.
Oil on canvas, 43 × 37 inches
Signed l. r.: "Joseph Stella"

PROVENANCE:
ACA Gallery, New York; Rabin & Krueger Gallery, Newark, New Jersey, 1962

EXHIBITIONS:
ACA Gallery, New York, November 8–27, 1943, *Joseph Stella*, no. 19, ill.
Drew University, Madison, New Jersey, February 24–March 25, 1963, *Joseph Stella*

Cypress Tree. c. 1927.
Gouache on paper, 41 × 27 inches
Signed l. r.: "Joseph Stella"

PROVENANCE:
Estate of the artist; Rabin & Krueger Gallery, Newark, New Jersey; Robert Schoelkopf Gallery, New York, 1962

EXHIBITIONS:
Galleria Angiporto, Naples, May 1929, *Mostra di Arte del Pittore Giuseppe Stella*
Whitney Museum of American Art, New York, October 23–December 4, 1963, *Joseph Stella*, no. 58

REFERENCES:
Baur, John I. H. *Joseph Stella*, New York, Praeger, 1971, pp. 21, 51, plate 79
Jacobs, Jay. "Collector: Joseph H. Hirshhorn," *Art in America*, 57, July–August 1969, ill. p. 62
———. "Quality as Well as Quantity: Joseph H. Hirshhorn," in Lipman, Jean, ed. *The Collector in America*, New York, Viking, 1971, ill. p. 88
Jaffe, Irma B. *Joseph Stella*, Cambridge, Massachusetts, Harvard University, 1970, p. 189, plate 85

The Palm. c. 1928.
Pastel on paper, 44 × 32½ inches
Signed l. r.: "Joseph Stella"

PROVENANCE:
Estate of the artist; Rabin & Krueger Gallery, Newark, New Jersey, 1962

EXHIBITIONS:
Drew University, Madison, New Jersey, February 24–March 25, 1963, *Joseph Stella*

MAURICE STERNE (1878–1957)

Born Libau, Latvia, August 8, 1878. Emigrated with family to New York, 1889. Studied, New York: The Cooper Union for the Advancement of Science and Art, 1892; National Academy of Design, 1894–99, and received Mooney Traveling Scholarship, 1904. Lived in Paris, 1904–7; met Leo Stein. One-man show, Galerie Paul Cassirer, Berlin, 1910. Toured Mediterranean, and Far East; returned to New York, 1915. Member, Board of Directors, Society of Independent Artists, New York, 1917. Lived in Taos, New Mexico, 1917; annual trips to Anticoli Corrado, Italy, 1918–33. One-man shows: The Art Institute of Chicago, 1917; Boston Art Club, 1919; Bourgeois Galleries, New York, 1922; Scott & Fowles Co., New York, 1926; Reinhardt Galleries, New York, 1928. Sculpture commission, *Monument to Early Settlers*, Rogers-Kennedy Memorial, Worcester, Massachusetts, 1926–29. Awarded: Logan Medal, 41st American Exhibition, The Art Institute of Chicago, 1928; Corcoran Gold Medal, and First Clark Prize, Corcoran Biennial, 1930. Included in: Whitney Biennial, 1932–33; "American Painting and Sculpture, 1862–1932," The Museum of Modern Art, New York, 1932–33. Retrospective, The Museum of Modern Art, 1933. Lived in San Francisco, 1934–36. One-man shows: The Milch Galleries, New York, 1934, 1936; San Francisco Museum of Art, 1936, 1938. Taught, California School of Fine Arts, San Francisco, 1935–36. Public Buildings Administration, Federal Works Agency, Section of Fine Arts, mural commission, twenty panels, library, U.S. Department of Justice, Washington, D.C., 1935–41. Member: The National Institute of Arts and Letters, 1938; Commission of Fine Arts, Washington, D.C., 1945–50. One-man show, Wildenstein & Co., New York, 1944. Awarded: Sesnan Gold Medal, Pennsylvania Academy Annual, 1949; Carnegie Prize, National Academy Annual, 1957. Retrospective, The Phillips Collection, Washington, D.C., 1952. Died New York, July 24, 1957. Retrospective, Hirschl & Adler Galleries, and The Milch Galleries, New York, 1962.

Giovanina. 1925.
Oil on canvas, 33¾ × 27¼ inches
Signed and dated l. r.: "Sterne 1925"

PROVENANCE:
Scott & Fowles Co., New York; Hamilton Collection; The Milch Galleries, New York; The Toledo Museum of Art, Ohio; Parke-Bernet Galleries, New York, Sale 2822, March 20, 1969, no. 201A

EXHIBITIONS:
Scott & Fowles Co., New York, February 1926, *Recent Works of Maurice Sterne*
The Corcoran Gallery of Art, Washington, D.C., April 4–May 6, 1926, *Tenth Biennial Exhibition of Contemporary American Painting*, no. 155, ill. p. 72
The Art Institute of Chicago, October 28–December 12, 1926, *39th Annual Exhibition of American Paintings and Sculpture*, ill. p. 7
The Museum of Modern Art, New York, February 13–March 25, 1933, *Maurice Sterne: Retrospective Exhibition 1902–1932*, no. 66, ill. p. 29
M. H. de Young Memorial Museum, San Francisco, June 7–July 7, 1935, *Exhibition of American Painting: Beginning to Present Day*, no. 442, ill.
The Toledo Museum of Art, Ohio, June–July 1936, *23rd Annual Exhibition of Selected Paintings by Contemporary American Artists*, no. 61, ill.
The Toledo Museum of Art, Ohio, October 1949, *Flower Paintings in Your Home*, no. 34
The Toledo Museum of Art, Ohio, October 1–31, 1951, *Fiftieth Anniversary Exhibition of Contemporary American Oil Paintings Acquired by the Toledo Museum, 1901–1951*
Society of the Four Arts, Palm Beach, Florida, March 7–31, 1952, *Two Centuries of Flower Painting*, no. 51, ill.

REFERENCES:
Unsigned. "Accessions: Our Museum Collections Continue to Expand," *American Magazine of Art*, 29, October 1936, pp. 661, 680–81, ill. p. 661
———. "Art Throughout America: Toledo," *Art News*, 35, October 10, 1936, p. 19
———. "Contemporary American Painting, The Corcoran Gallery of Art's Tenth Biennial Exhibition," *American Magazine of Art*, 17, May 1926, p. 219, ill. p. 223
———. "Recent Accessions," *The Toledo [Ohio] Museum of Art News*, September 1936, pp. 7–8, ill. p. 7

CLYFFORD STILL (b. 1904)

Born Grandin, North Dakota, November 30, 1904. Lived in Spokane, Washington, and Bow Island, Alberta, Canada, 1904–20. Visited New York, 1924. Studied: Spokane University, B.A., 1933; Washington State University, Pullman, M.A., 1935. Received fellowship, The Trask Foundation (now Yaddo), Saratoga Springs, New York, summers, 1934, 1935. Taught, Washington State University, 1935–41. Worked in aircraft and shipbuilding industries, Oakland, and San Francisco, California, 1941–43. One-man show, San Francisco Museum of Art, 1943. Taught, Richmond Professional Institute, College of William and Mary, Virginia, 1943–45. Lived in New York, summer, 1945. One-man shows: Peggy Guggenheim's Art of This Century, New York, 1946; California Palace of the Legion of Honor, San Francisco, 1947; Betty Parsons Gallery, New York, 1947, 1950, 1951; Metart Galleries, San Francisco, 1950. Taught, California School of Fine Arts, San Francisco, 1946–50. Lived in New York, 1950–61; made occasional trips to

San Francisco. Included in: "Fifteen Americans," The Museum of Modern Art, New York, International Circulating Exhibition, 1958–59; Documenta II, Kassel, 1959; Guggenheim International Award, 1960; "American Abstract Expressionists and Imagists," The Solomon R. Guggenheim Museum, New York, 1961. One-man shows: Albright-Knox Art Gallery, Buffalo, New York, 1959, 1966, 1972; Institute of Contemporary Art, University of Pennsylvania, Philadelphia, and tour, 1963. Thirty-one paintings donated by the artist to Albright-Knox Art Gallery, 1964. One-man show, Marlborough-Gerson Gallery, New York, 1969. Received Award of Merit, The American Academy of Arts and Letters, 1972. Lives in New Windsor, Maryland.

1950–A No. 2. 1950.
Oil on canvas, 9 feet 1 inch × 7 feet 9 inches
Signed and dated l. r.: "Clyfford '50"

PROVENANCE:
Marlborough-Gerson Gallery, New York, 1969

EXHIBITIONS:
Clyfford Still Studio, New York, 1950, private showing
Institute of Contemporary Art, University of Pennsylvania, Philadelphia, October 18–December 15, 1963, *Clyfford Still*, no. 13, ill.
Los Angeles County Museum of Art, June 16–August 1, 1965, *New York School: The First Generation: Paintings of the 1940s and 1950s*, no. 111, ill. p. 194
Marlborough-Gerson Gallery, New York, October–November 1969, *Clyfford Still*, no. 21, colorplate p. 41

REFERENCES:
Tuchman, Maurice. *New York School: The First Generation*, Greenwich, Connecticut, New York Graphic Society, 1971, p. 149, ill. 119

"I choose that my art be engaged in that which exalts the spirit of man. To memorialize in the instruments of art the banal attritions of daily experience that are common to nearly every individual, appears to me to be of small virtue. It may give morbid pleasure to the viewer or reader, and profit to the artist, but it remains an exercise in degradation. Who seeks such satisfactions in my work will find little to reward his attention.

"But I hold to be self-evident that the most contemptible enemies of man are those who simulate the act of liberty with instruments of art exploited for intimidation, deception, or assault. The prisons of artifice are much more insidious and efficient than the prisons of concrete and steel—it is not merely coincidence that they so often reveal a paralleling likeness.

"*1950–A No. 2* was painted within a month of the first version for my personal record. Making additional versions is an act I consider necessary when I believe the importance of the idea or breakthrough merits survival on more than one stretch of canvas, especially when it is entrusted to the precarious world of exhibitions or collecting. Although the few replicas I make are usually close to or extensions of the original, each has its special and particular life and is not intended to be just a copy. The present work clarified certain factors and, paradoxically in this instance, was closer to my original concept than the first painting, which bore the ambivalences of struggle. Incidentally, my immediate artist friends at that time realized the originality and significance of both works with the most generous approbation—several of them by letter."

Statement by the artist, 1972

Untitled Painting. 1953.
Oil on canvas, 9 feet 2 inches × 7 feet 8 inches

PROVENANCE:
Sidney Janis Gallery, New York; Lawrence Rubin Gallery, New York, 1969

EXHIBITIONS:
Sidney Janis Gallery, New York, October 7–November 2, 1963, *11 Abstract Expressionist Painters*, no. 21, ill.
Sidney Janis Gallery, New York, March 3–April 4, 1964, *2 Generations: Picasso to Pollock*, cat.
The Tate Gallery, London, April 22–June 28, 1964, *Painting and Sculpture of a Decade, 54–64* (organized by the Calouste Gulbenkian Foundation), no. 107, ill. p. 115
Sidney Janis Gallery, New York, January 3–27, 1967, *2 Generations: Picasso to Pollock*, no. 48, ill.

"The panel was conceived as an implosion of infinities in all categories and dimensions.
Of neither field nor form nor paint.
But that which I would clarify with spiritual intensity,
Transcending intellectual co-ordinates.
Not illustration, but a state of being
Without struggle or labor.
A moment of transfiguration."

Statement by the artist, 1972

1960–R. 1960.
Oil on canvas, 9 feet × 7 feet 8 inches
Signed and dated on back: "Clyfford/1960"

PROVENANCE:
Gift of the artist, New Windsor, Maryland, 1969

EXHIBITIONS:
Clyfford Still Studio, New York, 1960, private showing
Marlborough-Gerson Gallery, New York, October–November 1969, *Clyfford Still*, no. 36, colorplate p. 71

REFERENCES:
Sandler, Irving. *The Triumph of American Painting*, New York, Praeger, 1970, p. 170, ill.

"When I was a young man I painted many landscapes—especially of the prairie and of men and the machines with which they ripped a meager living from the thin top soil. But mostly the paintings were records of air and light. Yet always and inevitably with the rising forms of the vertical necessity of life dominating the horizon.

"For in such a land a man must stand upright, if he would live.

"Even if he is the only upright form in the world about him.

"And so was born and became intrinsic this elemental characteristic of my life and my work. In later years the human spirit and its imaging fully engaged me. Not symbolically or as synthetic illustration, but as a total Act. The organic rigor of the inherent discipline made the ascending verticality of my canvases a categorical imperative. The aspirational thrust continues to preside over the dark encompassing forms in the *1960–R*.

Statement by the artist, 1972

SERGIO STOREL (b. 1926)

Sergio Pravato Storel, born Domegge di Cadore, Italy, June 14, 1926. Studied: Accademia di Belle Arti e Liceo Artistico, Venice, 1954; with Antonio Benetton, Treviso, Italy, 1954–58. Settled in Paris, 1958; studied, École des Beaux-Arts, with Henri-Georges Adam, 1960–62. Group exhibitions, Paris: Salon de la Jeune Sculpture, from 1960; Salon des Réalités Nouvelles, from 1961; "Exposition Internationale du Petit Bronze," Musée National d'Art Moderne, 1962; Salon Grands et Jeunes d'Aujourd'hui, from 1963; "Sept Propositions pour le métal," Centre Culturel Américain, 1965; Salon de Mai, 1972. Lives in Paris.

Caryatid (Cariatide). 1964.
Hammered copper, 40½ × 14 × 6¼ inches
Markings: back l. r. "Storel"

PROVENANCE:
M. Knoedler & Co., Paris, 1964

"Work conceived as a vertical development following a harmonious volume rhythm, at the utmost relation of the Abstract-Figurative concepts.

"This rhythm is discernible in the variation of a relief, conceived to convey the minimal impression of surface relief, hardly perceptible so as to impress this purity and nearly mythical simplicity which *Cariatide* suggests to me, which I mean to achieve in forms, to retrace a former language, going up to the source of a primitive archaic thought, still genuine, in its artistic vision."

Statement by the artist, 1972

JOHN STORRS (1885–1956)

John Henry Bradley Storrs, born Chicago, June 29, 1885. Studied: Académie Julian, Paris, 1908; School of The Art Institute of Chicago, with Lorado Taft, 1908–10; The Pennsylvania Academy of the Fine Arts, Philadelphia, with Charles Grafly, 1910–12; Académie Rodin, Paris, 1912–14. Closely associated with Rodin until his death in 1917. Included in Salon d'Automne, Paris, 1913, 1920. Wilbur Wright Monument commissioned, Le Mans, France, 1914. Acquired château near Orléans, France, 1920. One-man shows: The Folsom Galleries, New York, 1920; The Arts Club of Chicago, 1921, 1923, 1927; Société Anonyme, New York, 1923, 1925; Brummer Gallery, New York, 1928; M. Knoedler & Co., New York, 1928; Albert Roullier Galleries, Chicago, 1929–39; Galerie Bucher-Myrbor, Paris, 1937. Exhibited: Société Anonyme, The Brooklyn Museum, New York, 1926; "Contemporary American Sculpture," National Sculpture Society, California Palace of the Legion of Honor, San Francisco, 1929. Returned to Chicago, 1927. Visited France annually; settled there permanently, late 1930s. Awarded: Spalding Prize, 40th American Exhibition, The Art Institute of Chicago, 1927; Logan Medal, 42nd and 44th American Exhibitions, The Art Institute of Chicago, 1929, 1931. Sculpture reliefs commissioned, Hall of Science Court, A Century of Progress Exposition, Chicago, 1933. Included in: "Origines et développement de l'art international indépandant," Galerie du Jeu de Paume, Paris, 1937; "Contemporary American Sculpture," Carnegie Institute, Pittsburgh, 1938. Captured by Nazi occupation forces at outbreak of World War II; held in detention camp near Campeigne, France, 1942; did little work thereafter. One-man show, Bibliothèque Municipale d'Orléans, 1949. Died, Mer, France, April 22, 1956. Retrospective, The Corcoran Gallery of Art, Washington, D.C., 1969.

The Abbot (L'Abbé; Gendarme Seated). 1920.
Bronze, 17¼ × 7¼ × 12¼ inches
Markings: back c. "John Storrs 1.1.20"
 l. r. "Cire Perdue Valsuani"

PROVENANCE:
The artist; Mrs. M. Storrs Booz, Winnetka, Illinois; The Downtown Gallery, New York; Zabriskie Gallery, New York, 1966

EXHIBITIONS:
Albert Roullier Galleries, Chicago, January 1936, *John Storrs*
The Downtown Gallery, New York, March 23–April 17, 1965, *John Storrs*, no. 19
Zabriskie Gallery, New York, April 5–30, 1966, *The American Sculptor 1900–1930*
The Corcoran Gallery of Art, Washington, D.C., May 3–June 8, 1969, *John Storrs: A Retrospective Exhibition*

REFERENCES:
Davidson, Marshall B. *The Artists' America*, New York, American Heritage, 1973, ill. p. 329
Lerner, Abram. "The Hirshhorn Collection," *The Museum World*, Arts Yearbook 9, 1967, p. 66, ill.
Pilgrim, James. "The Work of John Storrs," unpublished manuscript, New York, based on notes, notebooks, and documents from the artist's estate
Rose, Barbara. *American Art Since 1900*, New York, Praeger, 1967, pp. 241, 314, ill. 9–4

Study in Form (Forms in Space). 1924.
Bronze (unique), 19¾ × 12 × 2¼ inches
Markings: back l. l. "STORRS 1.9.2.4."

PROVENANCE:
The artist; Mrs. M. Storrs Booz, Winnetka, Illinois; The Downtown Gallery, New York; Zabriskie Gallery, New York, 1966

EXHIBITIONS:
The Downtown Gallery, New York, March 23–April 17, 1965, *John Storrs*
Zabriskie Gallery, New York, April 5–30, 1966, *The American Sculptor 1900–1930*

Study in Pure Form (Forms in Space, No. 4). c. 1924.
Stainless steel, copper, and brass, 12¼ × 3 × 1½ inches

PROVENANCE:
The artist, Blois, France, 1926; Edward B. Garrison, London; Christie, Manson & Woods, Sale, March 18, 1969, no. 4

GRAHAM SUTHERLAND (b. 1903)

Born London, August 24, 1903. Studied, Epsom College, England, 1914–18. Apprentice, Midland Railway, Derby, England, 1919–20. Studied: Goldsmiths' College School of Art, University of London, 1921–26; engraving, with Stanley Anderson, and Malcolm Osborne. Associate, Royal Society of Painters, Etchers and Engravers, London, 1925–33. Taught, Chelsea School of Art, London: engraving, 1928–32; composition and book illustration, 1932–39. Designed advertising posters, 1932–39. One-man shows: Rosenberg and Helft Galleries, London, 1938; The Leicester Galleries, London, 1940; Buchholz Gallery, New York, 1946. Official war artist, 1940–45. Included in "La Jeune Peinture en Grande Bretagne," Galerie René Drouin, Paris, and Musée d'Art Moderne, Brussels, 1948. Portrait of W. Somerset Maugham commissioned, 1949. Appointed trustee, The Tate Gallery, London, 1949; resigned, 1954. Retrospectives: Institute of Contemporary Arts, London, 1951; Stedelijk Museum, Amsterdam, and Kunsthaus, Zurich, 1953; The Tate Gallery, 1953. First sculptures, 1952. Tapestry commission, New Coventry Cathedral, England, 1952. Included in: Venice Biennale, 1952, 1954; "Masters of British Painting," The Museum of Modern Art, New York, 1956. One-man shows: Curt Valentin Gallery, New York, 1953; Paul Rosenberg & Co., New York, 1959, 1964; Marlborough Fine Art, London, from 1964. Honorary member, The National Institute of Arts and Letters, and The American Academy of Arts and Letters, 1972. Lives in Trottiscliffe, Kent, England.

Cynocéphale. 1952.
Oil on canvas, 52½ × 23½ inches
Signed and dated l. l.: "Sutherland 1952"

PROVENANCE:
Curt Valentin Gallery, New York; Arthur Jeffress Gallery, London, 1957

EXHIBITIONS:
XXVI Biennale Internazionale d'Arte, Venice, June–September 1952, *British Pavilion*, no. 62
Curt Valentin Gallery, New York, March 10–28, 1953, *Graham Sutherland*, no. 6, ill.
Arthur Jeffress Gallery, London, July 9–August 2, 1957, *Five English Painters*, no. 19
Joseloff Gallery, University of Hartford, West Hartford, Connecticut, November 8–December 4, 1964, *The Arts in Society*, no. 67

REFERENCES:
Cooper, Douglas. *The Work of Graham Sutherland*, New York, David McKay, 1961, p. 81, ill. 124a
Seckler, Dorothy Gees. "Reviews and Previews: Graham Sutherland," *Art News*, 52, March 1953, p. 37, ill.

PAUL SUTTMAN (b. 1933)

Born Enid, Oklahoma, July 16, 1933; youth spent in New Mexico. Studied: University of New Mexico, Albuquerque, B.F.A., 1956; Cranbrook Academy of Art, Bloomfield Hills, Michigan, M.F.A., 1958. Taught, The University of Michigan, Ann Arbor, 1958, 1961–62. One-man shows: Park Gallery, Detroit, 1959, 1962; Donald Morris Gallery, Detroit, 1960–69; Museum of Art, The University of Michigan, 1962; Terry Dintenfass Gallery, New York, from 1962. Received Rackham Foundation Grant; studied with Giacomo Manzù, Rome, 1960–61. Received: Fulbright Grant, Paris, 1963; Rome Prize Fellowship, American Academy in Rome, 1965–67. One-man shows: Felix Landau Gallery, Los Angeles, 1970; Richard Gray Gallery, Chicago, 1971; Galerie Ann, Houston, 1971. Received Merrill Foundation Grant, 1971. Artist-in-residence, Dartmouth College, Hanover, New Hampshire, 1973. Lives in Rome, and Pergine, Italy.

Resting. 1965.
Bronze (unique), 65 × 27¼ × 23⅜ inches
Markings: l. l. base "Suttman 65"

PROVENANCE:
Terry Dintenfass Gallery, New York, 1967

Big Table No. 2. 1968.
Bronze (unique), 32 × 17 × 18 inches
Markings: l. l. side "Suttman 68"

PROVENANCE:
Terry Dintenfass Gallery, New York, 1969

EXHIBITIONS:
Terry Dintenfass Gallery, New York, April 1–19, 1969, *Paul Suttman*

ALBERT SWINDEN (1901–1961)

Born Birmingham, England, August 27, 1901. Emigrated to the U.S., c. 1919. Studied, New York: National Academy of Design, 1921–25; The Art Students League of New York, with William Von Schlegell, 1921, 1928–33; Hans Hofmann School of Fine Art, c. 1934. WPA Federal Art Project, Mural Division, New York, 1935–42; mural commission, *Abstraction*, Williamsburg Federal Housing Project, Brooklyn, New York, c. 1939 (now lost). Included in "New Horizons in American Art," The Museum of Modern Art, New York, 1936. American Abstract Artists, New York: founding member, 1936; secretary, 1938–39. Fire in New York studio, 1937; most early works destroyed. Included in "Loan Exhibition," The Solomon R. Guggenheim Museum, New York, 1951. Died New York, June 20, 1961. Memorial exhibition, James Graham and Sons, New York, 1962. Included in: "Geometric Abstraction in America," Whitney Museum of American Art, New York, 1962;

"Post-Mondrian Abstraction in America," Museum of Contemporary Art, Chicago, 1973.

Triangular Movement. 1946.
Oil on canvas, 40 × 30 inches
Signed and dated l. l.: "A. Swinden—46"

PROVENANCE:
James Graham and Sons, New York, 1962

EXHIBITIONS:
Museum of Contemporary Art, Chicago, March 31–May 13, 1973, *Post-Mondrian Abstraction in America*, cat., ill.

REFERENCES:
Moholy-Nagy, László. "Space-Time Problems in Art," *American Abstract, Artists* New York, Ram, 1946, ill.

YVES TANGUY (1900–1955)

Raymond-Georges-Yves Tanguy, born Paris, January 5, 1900. Traveled to South America and Africa, as merchant seaman, 1918–19. Served, French Army, 1920–22. Settled in Paris, 1922; began painting, 1923. Met André Breton; joined Surrealist group; exhibited three drawings, Salon de l'Araignée, Paris, 1925. First one-man show, Galerie Surréaliste, Paris, 1927. Included in "Exposition Surréaliste," Galerie Au Sacre du Printemps, Paris, 1928. Traveled to Africa, 1930. One-man shows: Galerie Cahiers d'Art, Paris, 1935, 1947; Stanley Rose Gallery, Hollywood, California, 1935; Julien Levy Gallery, New York, 1936; Guggenheim Jeune Gallery, London, 1938. Included in: "Cubism and Abstract Art," and "Fantastic Art, Dada, Surrealism," The Museum of Modern Art, New York, 1936, 1936–37. Emigrated to the U.S., 1939; citizen, 1948. One-man shows, Pierre Matisse Gallery, New York, 1939–50. Settled in Woodbury, Connecticut, 1941. Included in "Exposition Internationale Surréaliste," Galerie Maeght, Paris, 1947. One-man shows: Galleria dell'Obelisco, Rome, 1953; Galleria del Naviglio, Milan, 1953; Galerie Renou & Poyet, Paris, 1953. Exhibited with wife, Kay Sage, Wadsworth Atheneum, Hartford, Connecticut, 1954. Died Woodbury, January 15, 1955. Retrospectives: The Museum of Modern Art, 1955; Pierre Matisse Gallery, 1963.

The Doubter (Le Questionnant). 1937.
Oil on canvas, 23¾ × 32 inches
Signed and dated l. r.: "Yves Tanguy/37"

PROVENANCE:
Paul Éluard, Paris; Sir Roland Penrose, London, 1968

EXHIBITIONS:
The Museum of Modern Art, New York, September 6–October 30, 1955, *Yves Tanguy*, p. 39, ill.
Galleria d'Arte Moderna, Museo Civico di Torino, November 1967–January 1968, *Le Muse inquietanti: Maestri del Surrealismo*, no. 242, ill. p. 180

REFERENCES:
Breton, André. *Yves Tanguy*, New York, Pierre Matisse, 1946, ill. p. 40
Minotaure, 4, Winter 1937, ill. p. 29
Unsigned. *Yves Tanguy*, New York, Pierre Matisse, 1963, no. 202, ill. p. 104

Naked Water (L'Eau Nue.) 1942.
Oil on canvas, 36½ × 28 inches
Signed and dated l. r.: "Yves Tanguy/42"

PROVENANCE:
Pierre Matisse Gallery, New York; B. C. Holland Gallery, Chicago; Mrs. Harold Weinstein, Chicago; Harold Diamond, New York, 1967

EXHIBITIONS:
Pierre Matisse Gallery, New York, May 18–June 5, 1943, *Yves Tanguy: Recent Paintings*, no. 4
Pierre Matisse Gallery, New York, November 5–30, 1946, *Yves Tanguy*, no. 14, ill. p. 80

REFERENCES:
Unsigned. *Yves Tanguy*, New York, Pierre Matisse, 1963, no. 290, ill. p. 131

HENRY FITCH TAYLOR (1853–1925)

Born Cincinnati, Ohio, September 15, 1853. Learned painting from Joe Jefferson, while member of Jefferson's touring theatrical troupe. Entered Académie Julian, Paris, 1881; returned to New York, 1888. Exhibited, New York: National Academy of Design, 1889; Society of American Artists, 1889–95. Managed Madison Gallery, New York, with future wife, Clara Davidge, 1898. Founding member and later secretary, Association of American Painters and Sculptors, 1911. Helped organize the Armory Show, 1913; three of his paintings included. Designed "color organ," which demonstrated his theory of color, 1914; *The Taylor System of Organized Color* privately published, 1916. Exhibited, Montross Gallery, New York, 1914–21. Co-founded: Modern Artists of America, 1922; Salons of America, 1923. Died Cornish, New Hampshire, September 10, 1925. Retrospective, Noah Goldowsky Gallery, New York, 1966.

Head of a Woman (Cressida?). 1912–15.
Marble, 14¾ × 7½ × 10⅝ inches
Markings: back of base "HT4"

PROVENANCE:
Estate of the artist; Noah Goldowsky Gallery, New York, 1966

EXHIBITIONS:
Noah Goldowsky Gallery, New York, November–December 1966, *Henry Fitch Taylor (1853–1925)*, no. 12, ill.

Figure with Guitar I. 1914.
Oil on canvas, 36 × 26¼ inches

PROVENANCE:
Estate of the artist; Noah Goldowsky Gallery, New York, 1969

EXHIBITIONS:
Noah Goldowsky Gallery, New York, November–December 1966, *Henry Fitch Taylor (1853–1925)*, no. 3

PAVEL TCHELITCHEW (1898–1957)

Pavel Fyodorovitch Tchelitchew, born Kaluga, near Moscow, September 21, 1898. Moved to Kiev, 1918; attended drawing classes, Kiev Academy; apprenticed to local painters. Lived in Berlin, 1921–23; costume and set designer for ballet and opera. Moved to Paris, 1923. Exhibited (drawings): Galerie Henri, Paris, 1924; Redfern Gallery, London, 1924. Included in Salon d'Automne, Paris, 1925. Championed by: Gertrude Stein, 1925; Dame Edith Sitwell, England, from 1928. Exhibited: first "Neo-Romantic" exhibition, Galerie Druet, Paris, with Eugene Berman, Leonid, Christian Bérard, and others, 1926; with "Neo-Romantics," Balzac Galleries, New York, 1930. One-man shows: Claridge Gallery, London, 1928; Galerie Pierre, Paris, 1929; The Museum of Modern Art, New York (drawings), 1930; Galerie Vignon, Paris, 1931; Galerie Esher Surrey, The Hague, 1932; Arthur Tooth & Sons, London, 1933, 1935, 1938. Emigrated to New York, 1934; U.S. citizen, 1943. One-man shows, New York: Julien Levy Gallery, 1934–38; Durlacher Brothers, 1942–51. Retrospectives: The Museum of Modern Art, 1942; Instituto de Arte Moderno, Buenos Aires, 1949. Traveled to Italy, 1952; settled in Frascati, 1954. One-man shows: Galleria dell'Obelisco, Rome, 1954; Galerie Rive Gauche, Paris, 1954, 1956; Galleria del Naviglio, Milan, 1955. Died Rome, July 31, 1957. Retrospective, The Gallery of Modern Art, New York, 1964.

Untitled Portrait. c. 1926.
Oil on canvas, 39¾ × 31¾ inches
Signed l. r.: "P. Tchelitchew"

PROVENANCE:
Peridot Gallery, New York, 1961

EXHIBITIONS:
The Gallery of Modern Art, New York, March 20–April 19, 1964, *Pavel Tchelitchew*, no. 16

Maude Stettiner. 1931.
Oil on canvas, 51¼ × 35 inches
Signed and dated l. r.: "P. Tchelitchew 31"

PROVENANCE:
François Reichenbach, Paris, and Geneva; M. Knoedler & Co., New York, 1957

EXHIBITIONS:
American Federation of Arts tour, 1962–65, *Paintings from the Joseph H. Hirshhorn Foundation Collection: A View of the Protean Century*, no. 67, ill. p. 15

"My sister . . . worked in an art gallery for some years, and after [ward] she had a book-shop [which] specialized in art-books and in illustrated books. In fact, she always had been very interested in beautiful books and made . . . a collection of them. She married Mr. Jacques Maestracci, who died ten years ago. My sister died in December 1970, after a long illness.

"Our father, Oscar Stettiner, a British citizen, was an antique dealer in Paris, [who] specialized in rare French eighteen century furnitures [sic] and paintings; he died twenty years ago.

"I was an intimate friend of Pavel Tchelitcheff, who made my portrait too. Indeed [I am] a painter myself. . . ."

Letter from Jacques Stettiner, 1973

Interior Landscape. c. 1949.
Watercolor and gouache on paper, 20 × 18¼ inches

PROVENANCE:
Stewart Chaney, New York; Jon N. Streep, New York; Shepherd Gallery, New York, 1968

ABBOTT H. THAYER (1849–1921)

Abbott Handerson Thayer, born Boston, August 12, 1849. Studied: privately, with jeweler and animal painter Henry D. Morse, Boston, 1865–67; Brooklyn Academy of Design, New York (received Gold Palette, for drawing from the antique), 1868; National Academy of Design, New York, with L. E. Wilmarth, 1870–72; École des Beaux-Arts, Paris, with Henri Lehmann, 1875, and Jean-Léon Gérôme, 1875–79. Returned to New York, 1879. Society of American Artists: member, 1879; vice-president, 1883; president, 1884. Established summer studio, Dublin, New Hampshire, 1888. Awarded: Bronze Medal, Exposition Universelle de 1889, Paris; Gold Medal, and Elkins Prize, Pennsylvania Academy Annual, 1891, 1895; Temple Gold Medal, Exposition Universelle de 1900, Paris. Mural, Bowdoin College, Brunswick, Maine: commissioned, 1893; installed, 1894. Increasingly active as naturalist, from 1896. Delivered first paper on protective coloration in birds and animals, American Ornithologists' Union, Cambridge, Massachusetts, 1896; published influential articles which contributed to development of camouflage in World War I. Member: The National Institute of Arts and Letters, 1898; The American Academy of Arts and Letters, 1909. Academician, National Academy of Design, 1901. Awarded: Saltus Medal for Merit, National Academy Annual, 1915; Medal of the First Class, Carnegie International, 1920. Camouflage pictures exhibited, M. Knoedler & Co., and Whitney Studio Club, New York, 1918. One-man show, Carnegie Institute, Pittsburgh, 1919. Died Monadnock, New Hampshire, May 29, 1921. Thayer memorial issue of *The Arts* published, June–July 1921. Memorial exhibitions: Carnegie Institute, 1921; The Milch Galleries, New York, 1921; The Corcoran Gallery of Art, Washington, D.C., 1922; The Metropolitan Museum of Art, New York, 1922. Retrospective, Macbeth Gallery, New York, 1931.

Study for Seated Angel. 1899–1900.
Oil on canvas, 37½ × 29¼ inches
Signed u. r.: "Abbott H. Thayer"

PROVENANCE:
Estate of the artist; Macbeth Gallery, New York; Grand Central Art Galleries, New York; IBM Collection, New York; Parke-Bernet Galleries, New York, Sale 1951, February 18, 1960, no. 202; The Milch Galleries, New York, 1964

EXHIBITIONS:
Macbeth Gallery, New York, April 13–May 2, 1931, *Abbott H. Thayer: Paintings, Drawings*, cat., ill.
The Milch Galleries, New York, June 1963, *Nineteenth and Twentieth Century American Painting*

REFERENCES:
Macbeth Gallery, New York, *Parnassus*, 3, April 1931, ill. p. 20 (adv.)
Preston, Stuart. "The Last Roundup," *The New York Times*, June 23, 1963, sec. 2, p. 15

Self-Portrait. 1919.
Oil on wood panel, 35½ × 24½ inches
Signed and dated u. r. center: "Abbott H. Thayer/ 1919"

PROVENANCE:
Estate of the artist; Frederick R. Sisson, Providence, Rhode Island; Mrs. Frederick R. Sisson, Falmouth, Massachusetts; Hirschl & Adler Galleries, New York, 1968

EXHIBITIONS:
Macbeth Gallery, New York, April 13–May 2, 1931, *Abbott H. Thayer: Paintings, Drawings*, cover ill.

REFERENCES:
Unsigned. "Exhibitions in New York: Abbott H. Thayer," *Art News*, 29, April 18, 1931, p. 12
———. "The Art Market," *Parnassus*, 3, April 1931, ill. p. 26

WAYNE THIEBAUD (b. 1920)

Born Mesa, Arizona, November 15, 1920. Cartoonist, designer, advertising art director, New York, and Hollywood, California, 1938–49. Served, U.S. Army Air Corps, 1942–46. Studied, Sacramento State College, California, B.A., 1949, M.A., 1951. Design and art consultant, California State Fair and Exposition, Sacramento, 1950, 1952, 1955. Taught: Sacramento City College, 1951–59; San Francisco Art Institute, 1958. Produced educational films, 1954–57. One-man shows: Cooperative Gallery, Sacramento, 1961; Allan Stone Gallery, New York, from 1962; Galleria Schwarz, Milan, 1963; Stanford University Museum, California, 1965. Included in: "New Painting of Common Objects," Pasadena Art Museum, California, 1962; "Pop Art, U.S.A.," The Oakland Museum, California, 1963; "Nieuwe Realisten," Gemeentemuseum, The Hague, 1964; Whitney Annual, 1965, 1967, 1969. Visiting critic, Cornell University, Ithaca, New York, 1967. Included in: IX São Paulo Bienal, 1967; ROSC '71, Dublin, 1971; Documenta 5, Kassel, 1972. One-man shows: Pasadena Art Museum, and tour, 1968; graphics tour, organized by Parasol Press, New York, 1971–72. Has taught, University of California, Davis, since 1960. Lives in Hood, California.

French Pastries. 1963.
Oil on canvas, 16 × 24 inches
Signed and dated l. l.: "Thiebaud 1963"

PROVENANCE:
Allan Stone Gallery, New York, 1964

EXHIBITIONS:
Allan Stone Gallery, New York, March 24–April 11, 1964, *Wayne Thiebaud*, cat.
State University of New York, Oneonta, October 6–27, 1966, *Modern Realism and Surrealism* (American Federation of Arts, Circulating Exhibition)

"In my opinion the painting of *French Pastries* is actually the American notion of French pastries. Almost all of my paintings from that period were done from memory: I try to make a summation of a number of variable visual experiences to try and make them seem like a singular event."

Statement by the artist, 1972

BOB THOMPSON (1937–1966)

Robert Louis Thompson, born Louisville, Kentucky, June 26, 1937. Studied: School of the Museum of Fine Arts, Boston, 1955; University of Louisville, 1955–58. Visited Provincetown, Massachusetts, and met Jan Müller, summer, 1958; exhibited, Provincetown Art Festival. One-man shows: Arts in Louisville, 1958; Delancey Street Museum, New York, 1960; Superior Street Gallery, Chicago, 1961. Moved to New York, 1959. Exhibited with Jay Milder, Zabriskie Gallery, New York, 1960. Received Walter Gutman Foundation Grant, 1961, and John Hay Whitney Fellowship, 1962–63; traveled in England, France, Spain, 1961–63. Returned to New York, 1963. One-man shows: Martha Jackson Gallery, New York, 1963, 1965, 1968; Richard Gray Gallery, Chicago, 1964, 1965. Included in "Portraits from the American Art World," New School for Social Research, New York, 1965. Moved to Rome, 1965; died there, May 30, 1966. Retrospective, New School for Social Research, 1969.

LeRoi Jones and His Family. 1964.
Oil and pastel on canvas, 36 × 48 inches
Signed and dated l. l.: "Bob Thompson '64"

PROVENANCE:
The artist, New York, 1964

EXHIBITIONS:
New School Art Center, New School for Social Research, New York, February 2–27, 1965, *Portraits from the American Art World*, no. 85
Martha Jackson Gallery, New York, March 5–30, 1968, *Bob Thompson: Works in N.Y. Collections 1958–66*, no. 8, ill. p. 4

REFERENCES:
Martha Jackson Gallery, New York, *Art News*, 67, March 1968, ill. (detail) p. 64 (adv.)

LOUIS COMFORT TIFFANY (1848–1933)

Born New York, February 18, 1848; son of Charles L. Tiffany, goldsmith and jeweler, and founder of Tiffany & Co., New York. Studied: with George Inness, and Samuel Coleman, New York, 1866–68; with Léon Bailly,

Paris, 1868–69; glassmaking, with John La Farge, Heidt Glassworks, Brooklyn, New York, 1870s. National Academy of Design, New York: exhibited, 1867; associate, 1871; academician, 1880. First experiments with glass-coloring techniques, 1875; patented Favrile Process, 1880. Co-founded Society of American Artists, New York, 1877. Active as painter, until 1878. Founded: Louis C. Tiffany Company and Associated Artists, interior decorators, 1879; Tiffany Glass Company, 1885; Tiffany Glass and Decorating Company, 1892; Tiffany Studios, 1900. Designed and built chapel, World's Columbian Exposition, Chicago, 1893. Tiffany windows, designed by Pierre Bonnard, Édouard Vuillard, Henri de Toulouse-Lautrec, among others, exhibited, "Salon de l'Art Nouveau," Galerie Bing, Paris, 1895. Chevalier, Légion d'honneur, 1900. Awarded Gold Medal for Applied Arts, Exposition Universelle de 1900, Paris. Designed and built residence, Laurelton Hall, Oyster Bay, New York, 1902–4 (destroyed by fire, 1957). Established Louis Comfort Tiffany Foundation, 1918. Member: American Watercolor Society, New York; Société Nationale des Beaux-Arts, Paris. Died New York, January 17, 1933. Retrospective, "The Genius of Louis C. Tiffany," Heckscher Museum, Huntington, New York, 1967.

Italian Landscape. c. 1878.
Oil on canvas mounted on board, 21⅜ × 16¼ inches
Signed l. l.: "Louis C. Tiffany"

PROVENANCE:
Sloan & Roman Gallery, New York; Parke-Bernet Galleries, New York, Sale 2822, March 20, 1969, no. 71

SIDNEY TILLIM (b. 1925)

Born Brooklyn, New York, June 16, 1925. Studied, Syracuse University, New York, B.F.A., 1950. One-man shows: New Group Gallery, Monterey, California, 1952; Cober Gallery, New York, 1960. Staff member, *Arts*, 1959–65; contributed to *Artforum*, 1965–69. Received Yaddo Foundation Fellowship, 1961. Included in: "The Painter and the Photograph," University of New Mexico, Albuquerque, and tour, 1964; "Contemporary Realism in Figure and Landscape," Wadsworth Atheneum, Hartford, Connecticut, 1964; "Modern Realism and Surrealism," American Federation of Arts, Circulating Exhibition, 1965; "Recent Still Life," Museum of Art, Rhode Island School of Design, Providence, 1966; "Recent Figurative Art," Bennington College, Vermont, and tour, 1967; "Realism Now," Vassar College Art Gallery, Poughkeepsie, New York, 1968; "Aspects of a New Realism," Milwaukee Art Center, and tour, 1969; "22 Realists," Whitney Museum of American Art, New York, 1970; Whitney Annual, 1972. One-man shows, New York: Robert Schoelkopf Gallery, 1965–67; Noah Goldowsky Gallery, 1969–70.

Furniture War. 1966.
Oil on canvas, 36 × 50½ inches
Signed and dated l. r.: "Tillim 66"

PROVENANCE:
Robert Schoelkopf Gallery, New York; Richard Bellamy, New York, 1969

EXHIBITIONS:
Robert Schoelkopf Gallery, New York, May 2–20, 1967, *Sidney Tillim*
Whitney Museum of American Art, New York, February 10–March 29, 1970, *22 Realists*, p. 54, ill. p. 55

REFERENCES:
Mellow, James R. "New York," *Art International*, 11, October 20, 1967, ill. p. 65

MARK TOBEY (b. 1890)

Born Centerville, Wisconsin, December 11, 1890. Moved with family: vicinity of Jacksonville, Tennessee, 1893; Trempealeau, Wisconsin, 1894–1906; Hammond, Indiana, 1906–8; Chicago, 1909. Studied, School of The Art Institute of Chicago, Saturday classes, 1908. Moved to New York, 1911. Fashion illustrator and interior designer, New York, and Chicago. First one-man show, M. Knoedler & Co., New York, 1917. Moved to Seattle, 1922; taught, Cornish School of Allied Arts, intermittently, 1923–29. Traveled, Europe, and the Near East, 1925–26. Taught, Dartington Hall School, Devonshire, England, 1931–38. Studied calligraphy and Zen Buddhism, China and Japan, 1934. One-man shows, Seattle Art Museum, 1935, 1942. Returned to Seattle, 1938; WPA Federal Art Project, Easel Division. One-man shows: Willard Gallery, New York, from 1944; Portland Art Museum, Oregon, and tour, 1945–46. Included in: Whitney Annual, from 1945; "Fourteen Americans," The Museum of Modern Art, New York, 1946; Venice Biennale, 1948, 1956; Pittsburgh International, from 1952; III São Paulo Bienal, 1955; Guggenheim International Award, 1956; Documenta II, Kassel, 1959. Retrospectives: California Palace of the Legion of Honor, San Francisco, and tour, 1951; Seattle Art Museum, and tour, 1959–60. One-man shows: Institute of Contemporary Arts, London, 1955; Galerie Jeanne Bucher, Paris, 1955, 1959, 1965, 1968; Galerie Beyeler, Basel, 1961, 1966; Seattle Art Museum, 1963. Member, The National Institute of Arts and Letters, 1956. Awarded: first prize, Venice Biennale, 1958; first prize, Pittsburgh International 1961. Retrospectives: Musée des Arts Décoratifs, Paris, and tour, 1961–63; The Museum of Modern Art, and tour, 1962–63; Stedelijk Museum, Amsterdam, and tour, 1966; Dallas Museum of Fine Arts, 1970–71; National Collection of Fine Arts, Smithsonian Institution, Washington, D.C., 1974. Lives in Basel.

Saints and Serpents. 1953.
Gouache on paper, 22⅜ × 25⅜ inches
Signed and dated l. r.: "Tobey 53"

PROVENANCE:
Willard Gallery, New York, 1956

EXHIBITIONS:
Willard Gallery, New York, November 3–27, 1954, *Mark Tobey*, cat.

Galerie Würthle, Vienna, June 19–July 8, 1961, *Vanguard American Painting* (organized by The Solomon R. Guggenheim Museum, New York, for the U.S. Information Agency), no. 78, ill.; toured to nine European cities

Plains Ceremonial. 1956.
Gouache on paper, 23⅛ × 35½ inches
Signed and dated l. l.: "Tobey 56"

PROVENANCE:
Willard Gallery, New York, 1956

EXHIBITIONS:
XXIX Biennale Internazionale d'Arte, Venice, June–October 1958, *United States Pavilion*, no. 62
American Federation of Arts tour, 1959–60, *Ten Modern Masters of American Art*, no. 25, p. 27
Musée des Arts Décoratifs, Paris, October–December 1961, *Mark Tobey Retrospective*, no. 143; toured to Whitechapel Art Gallery, London, February 1962
The Museum of Modern Art, New York, September 10–November 4, 1962, *Mark Tobey*, no. 95, p. 109; toured to The Cleveland Museum of Art, December 11–January 13, 1963; The Art Institute of Chicago, February 22–March 24

White World. 1969.
Oil on canvas, 60 × 36¼ inches
Signed and dated l. r.: "Tobey 69"

PROVENANCE:
Harold Diamond, New York, 1969

BRADLEY WALKER TOMLIN (1899–1953)

Born Syracuse, New York, August 19, 1899. Studied, Syracuse: with Hugo Gari Wagner, 1913; Syracuse University, B.F.A., 1921. First book illustrations published, 1920; designed covers, *House & Garden, Vogue*, 1922–29. Moved to New York, 1921. Received Louis Comfort Tiffany Foundation Fellowship, summer, 1922. Studied, Académie Colarossi, and Académie de la Grande Chaumière, Paris, 1923. Exhibited, New York: The Anderson Galleries, 1923; Whitney Studio Club, 1925–28. Summered in Woodstock, New York, from 1925. Traveled to Europe, 1926, 1928. One-man shows, New York: Montross Gallery, 1926, 1927; Frank Rehn Gallery, 1931, 1944. Taught, New York: Buckley School, 1932–33; Dalton School, part-time, 1933–34; Sarah Lawrence College, Bronxville, 1933–41. U.S. Treasury Department Relief Art Project, c. 1937–38. Received: first honorable mention, Carnegie Annual, 1946; Purchase Award, Contemporary American Annual, University of Illinois, Urbana, 1949. One-man shows, Betty Parsons Gallery, New York, 1950, 1953. Included in: "Abstract Painting and Sculpture in America," and "15 Americans," The Museum of Modern Art, New York, 1951, 1952. Died New York, May 11, 1953. Retrospectives: The Phillips Collection, Washington, D.C., 1955; The Art Galleries, University of California at Los Angeles, and Whitney Museum of American Art, New York, and tour, 1957–58.

Number 2. 1952–53.
Oil on canvas, 23 × 32½ inches
Signed u. l.: "W Tomlin"

PROVENANCE:
Betty Parsons Gallery, New York; Paul Kantor Gallery, Beverly Hills, California; Harold Diamond, New York, 1963

EXHIBITIONS:
Betty Parsons Gallery, New York, April 1–18, 1953, *Bradley Walker Tomlin*
Pasadena Art Museum, California, September 25–October 19, 1962, *U.S. Abstract Expressionism*

JOAQUÍN TORRES-GARCÍA (1874–1949)

Born Montevideo, Uruguay, July 28, 1874. Moved with family to Mataró, Spain, near Barcelona, 1891. Studied, Academia de Bellas Artes, and Academia Baixas, Barcelona, 1892–95. With Picasso, and other Catalán artists, frequented cabaret El Quatre Gats, Barcelona. Began friendship with Julio González. One-man shows, Barcelona: Salon La Vanguardia, 1900; Galería Dalmau, 1901–29. Worked with Antoni Gaudí, on Church of the Sagrada Familia, Barcelona, and on stained-glass windows, Cathedral of Palma, Majorca, 1905–7. Mural commissions, Uruguayan Pavilion, Exposition Universelle et Internationale de Bruxelles, 1909–10. *Notes Sobre Art*, first of many theoretical books on art, published, 1913. Began designing wooden toys, 1915. Lived in New York, 1920–22. Exhibited with Stuart Davis, Whitney Studio Club, New York, 1921. Moved: to Italy, 1922–23; to Villefranche-sur-Mer, France, 1924–25. Included in Salon d'Automne, Paris, 1924. Moved to Paris, 1926; one-man show, Galerie Fabre. Co-founded artists' group and magazine *Cercle et Carré*, with Michel Seuphor, 1930. One-man show, Museo de Arte Moderno, Madrid, 1933. Returned to Montevideo, 1934. Founded Asociación de Arte Constructivo, 1935; began publishing magazine *Círculo y Cuadrado*, 1936. In Uruguay, 1944; awarded Grand National Prize for Painting, and founded Taller (workshop) Torres-García. *Universalismo Constructivo* (Buenos Aires), published, 1944. Died Montevideo, August 8, 1949. Retrospectives: Musée National d'Art Moderne, Paris, 1955; Stedelijk Museum, Amsterdam, and tour, 1962; tour organized by Museum of Art, Rhode Island School of Design, Providence, 1970–71.

New York Street Scene. 1920.
Oil on paper mounted on panel, 18½ × 26¼ inches
Signed and dated u. r.: "J. Torres-Garcia/1920"

PROVENANCE:
Joseph Jossua; Parke-Bernet Galleries, New York, Sale 2653, February 15, 1968, no. 79, ill. p. 75

EXHIBITIONS:
The National Gallery of Canada, Ottawa, September 1970, *Joaquín Torres-García 1874–1949*, no. 7, p. 19, ill. p. 40; toured to The Solomon R. Guggenheim Museum, New York, December 12–January 31, 1971; Museum of Art, Rhode Island School of Design, Providence, February 16–March 31

Untitled. 1931.
Wood relief, 30⅛ × 7⅞ × 2¼ inches
Signed and dated on back: "J·Torres·Garcia 31"

PROVENANCE:
Jean Craven, Paris; Robert Elkon Gallery, New York, 1963

EXHIBITIONS:
The Museum of Modern Art, New York, October 2–November 12, 1961, *The Art of Assemblage*, no. 239; toured to Dallas Museum for Contemporary Arts, January 9–February 11, 1962; San Francisco Museum of Art, March 5–April 15

Untitled. 1931.
Wood relief, 21 × 8½ × 3½ inches
Signed and dated on back: "J·Torres-Garcia 31 · T N⁰ 4"

PROVENANCE:
André Lefèvre, Paris; Galerie Percier, Paris; Galerie Rive Gauche, Paris; Albert Loeb & Krugier Gallery, New York, 1969

Composition. 1932.
Oil on canvas, 28½ × 23¼ inches
Signed l. r.: "J Torres-Garcia"
Dated l. r.: "32"

PROVENANCE:
Galerie Pierre, Paris; Gift of Jon N. Streep, New York, 1968

HAROLD TOVISH (b. 1921)

Born New York, July 31, 1921. Studied, New York: WPA Art Project, Teaching Program, 1938–40; Columbia University, 1940–43. Taught: State University of New York, College of Ceramics at Alfred University, Alfred, New York, 1947–49; University of Minnesota, Minneapolis, 1950–54. Studied, Paris: Atelier Ossip Zadkine, 1949–50; Académie de la Grande Chaumière, 1950–51. One-man shows: Walker Art Center, Minneapolis, 1953; Swetzoff Gallery, Boston, 1957, 1960, 1965; Fairweather-Hardin Gallery, Chicago, 1960. Included in: Whitney Annual, 1954, 1957, 1960, 1964, 1966; Venice Biennale, 1956; Guggenheim International, 1967–68. Taught: School of the Museum of Fine Arts, Boston, 1957–65; Massachusetts Institute of Technology, Cambridge, 1967–68; Boston University, from 1972. The National Institute of Arts and Letters, and The American Academy of Arts and Letters: Grant, 1960; Award, 1971. Sculptor-in-residence, American Academy in Rome, 1965. One-man shows: Terry Dintenfass Gallery, New York, 1965, 1972; Watson Gallery, Wheaton College, Norton, Massachusetts, 1967; The Solomon R. Guggenheim Museum, New York, and tour, 1968; Weyhe Gallery, New York (prints), 1972. Received Guggenheim Foundation Fellowship, 1967. Lives in Brookline, Massachusetts.

Mechanical Gypsy. 1955.
Bronze (edition of two), 22 × 9¾ × 9¾ inches
Markings: l. r. side "H. Tovish '55"

PROVENANCE:
Swetzoff Gallery, Boston, 1963

EXHIBITIONS:
The Art Institute of Chicago, December 2, 1959–January 31, 1960, *63rd American Exhibition*, no. 120, ill.
Terry Dintenfass Gallery, New York, March 2–27, 1965, *Harold Tovish*, no. 7

"In the Penny Arcades of my youth the Gypsy Fortune-Teller sat in a glass cage. For a quarter she'd tell you your fortune discreetly printed on a piece of cardboard. Her dippy image stuck in my mind and finally surfaced in 1955. I like to think Franz Kafka would have enjoyed *Mechanical Gypsy*. It was Kafka who taught me that the comical and the sinister can be identical."

Statement by the artist, 1972

Interior I. 1962.
Bronze and wood (1/3), 30½ × 35¾ × 7 inches

PROVENANCE:
Swetzoff Gallery, Boston, 1963

EXHIBITIONS:
American Federation of Arts Gallery, New York, July 15–29, 1964, *A Decade of New Talent* (American Federation of Arts, Circulating Exhibition), checklist no. 30; toured to nineteen U.S. cities, and Winnipeg, Manitoba, Canada

REFERENCES:
Unsigned. "Fifty-six Painters and Sculptors," *Art in America*, 52, August 1964, p. 72, ill.

"A friend remarked that *Interior I* would make a superb tombstone. At the time, he did not know that the face in the relief is my own. The luxury of being an artist!"

Statement by the artist, 1972

TOMONORI TOYOFUKU (b. 1925)

Born Kurume, Japan, February 18, 1925. Studied, ancient Japanese literature, Kokugakuin University, Tokyo, Ph.D., 1943; wood sculpture, with Tominaga Chodo, Japan, 1946. Commission, *Peace*, Tokyo Railroad Station, 1958. Received Takamura Prize, to study sculpture abroad, Tokyo Geijetsu University, 1959. First one-man show, Tokyo Gallery, 1960. Settled in Milan, 1960. Included in: Venice Biennale, 1960, 1964; Pittsburgh International, 1964 (Frew Memorial Purchase Prize), 1967, 1970; VIII São Paulo Bienal, 1965; "The New Japanese Painting and Sculpture," The Museum of Modern Art, New York, 1965–67. One-man shows: Galleria Grattacielo, Milan, 1962; Galleria del Cavallino, Venice, 1962; Galleria del Naviglio, Milan, 1963–71; Galerie Smith, Brussels, 1965; Galerie Alice Pauli, Lausanne, 1966. Commission, *The Column*, Rotterdam, The Netherlands, 1966. Lives in Milan.

Water (Sui). 1964.
Wood, 80¼ × 16 × 8⅛ inches
Markings front l. c.: " 木□TOYO 1964"

PROVENANCE:
The artist, Milan, 1964

PRINCE PAUL TROUBETZKOY (1866–1938)

Pavel Petrovich Troubetzkoy, born Itra, Italy, February 16, 1866; son of Russian father, Prince Pierre Troubetzkoy, and American mother. Studied, Accademia di Belle Arti di Brera, Milan, with Ernesto Bazzaro, briefly, mid-1880s. Exhibited: Palazzo di Brera, Milan, 1886; World's Columbian Exposition, Chicago, 1893; Venice Biennale, 1895. Moved to Moscow, 1897; appointed professor of sculpture, Imperial Academy of the Fine Arts. Associated with Count Leo Tolstoy; equestrian statue of Tolstoy acquired by Musée du Luxembourg, Paris, 1900. Awarded Grand Prize, Exposition Universelle de 1900, Paris. Chevalier, Légion d'honneur, 1900. Commission, equestrian monument of Czar Alexander III, 1901; installed, Snamenskaja Plaza, St. Petersburg, Russia, 1909. Over sixty-five works included, Salon d'Automne, Paris, 1904. Visited the U.S., 1911, 1912, at invitation of Archer Milton Huntington, president, Hispanic Society, New York. Portrait commissions: Baron Henri de Rothschild, Auguste Rodin, Anatole France, George Bernard Shaw, Enrico Caruso, William K. Vanderbilt, Harry Payne Whitney, Gabriele d'Annunzio, Giacomo Puccini. One-man shows: Hispanic Society, 1911; Albright Gallery, Buffalo, New York, 1911; The Art Institute of Chicago, and tour, 1912; Galleria d'Arte Moderna, Rome, 1912; M. Knoedler & Co., New York, 1914; Panama-Pacific International Exposition, San Francisco, 1915; Detroit Museum of Art, 1916; Los Angeles County Museum of History, Science and Art, 1917; Galerie Georges Petit, Paris, 1920–21; Société Nationale des Beaux-Arts, Paris, 1921. Lived in New York, and in Hollywood, California, 1914–21; worked in Paris, 1921–32. Died Pallanza, Italy, February 12, 1938.

Seated Woman. 1926.
Bronze, 15 × 8½ × 12 inches
Markings: front r. "Paul Troubetskoy 1926"
"Cire Perdue A. Valsuani Paris"
back r. "L C Tiffany"

PROVENANCE:
Prince Tchitchinay, Cannes; Gabriel Garcin, Cannes, 1966

ERNEST TROVA (b. 1927)

Ernest Tino Trova, born St. Louis, Missouri, February 19, 1927. Self-taught as an artist. Included in St. Louis Annual, 1947–61. Moved to New York, 1953; met Willem de Kooning. One-man shows: Image Gallery, St. Louis, 1959, 1961; H. Balban Carp Gallery, St. Louis, 1963; The Pace Gallery, Boston, 1963, New York, 1963, 1965–67, 1969–71, 1973, and Columbus, Ohio, 1965, 1970; Famous-Barr Company, St. Louis, 1964; The Hanover Gallery, London, 1964, 1966, 1970; Hayden Gallery, Massachusetts Institute of Technology, Cambridge, 1967. Included in: "Pop Art, U.S.A.," The Oakland Museum, California, 1963; 67th American Exhibition, The Art Institute of Chicago, 1964; "Art in the United States 1670–1966," Whitney Museum of American Art, New York, 1966; "Eight Sculptors: The Ambiguous Image," Walker Art Center, Minneapolis, 1966; Whitney Annual, 1966, 1968; Guggenheim International, 1967–68; "Dada, Surrealism and Their Heritage," The Museum of Modern Art, New York, and tour, 1967–68; Documenta 4, Kassel, 1968. One-man shows: Gimpel & Hanover Galerie, Zurich, 1970; Israel Museum, Jerusalem, 1971; Galerie Charles Kriwin, Brussels, 1972. Lives in St. Louis.

Study: Falling Man (Carman). 1965.
Polished silicone bronze and enamel (edition of three), 20¼ × 78 × 30¼ inches
Markings: on left ankle ⊕

PROVENANCE:
The Pace Gallery, New York; Mr. and Mrs. Frederick Weisman, Los Angeles; Harold Diamond, New York, 1969

REFERENCES:
Alloway, Lawrence. Trova: Selected Works 1953–1966, New York, The Pace Gallery, 1966, no. 29, ill. pp. 46–47

"The Study: Falling Man (Carman), 1965, is one of a series of works that I have been working on since the early 1960s. My concern is with the human figure . . . man as I see him . . . in his environment."

Statement by the artist, 1972

WILLIAM TURNBULL (b. 1922)

Born Dundee, Scotland, 1922. Studied, Slade School of Fine Art, University College, London, 1947–48. Lived in Paris, 1948–50. Settled in London, 1950; began teaching, Central School of Arts and Crafts, 1951. One-man shows, London: The Hanover Gallery, 1950–52; Institute of Contemporary Arts, 1957; Molton Gallery, 1960–61. Included in: Venice Biennale, 1952; "British Art Today," San Francisco Museum of Art, and tour, 1962–63; "Painting and Sculpture of a Decade, 54–64," The Tate Gallery, London, 1964; Guggenheim International, 1964, 1967–68; "British Sculpture in the Sixties," The Tate Gallery, 1965; "Signale," Kunsthalle, Basel, 1965; Documenta 4, Kassel, 1968. One-man shows: Marlborough-Gerson Gallery, New York, 1963; The Detroit Institute of Arts, 1963; Galerie H. J. Müller, Stuttgart, 1965; Bennington College, Vermont, 1965; Pavilion Gallery, Balboa, California, 1966; The Waddington Galleries, London, 1967, 1970; Museo Nacional de Bellas Artes, Buenos Aires, 1968; Hayward Gallery, London, 1968; The Tate Gallery, 1973. Lives in London.

Head. 1957.
Bronze on stone base (unique), 40 × 29 × 14 inches

PROVENANCE:
Molton Gallery, London, 1961

EXHIBITIONS:
The Solomon R. Guggenheim Museum, New York, October 3, 1962–January 6, 1963, Modern Sculpture

DOMENIĆK TURTURRO (b. 1936)

Born New York, May 13, 1936. Studied, New York: New School for Social Research, 1954–55; Pratt Institute, Brooklyn, 1958–59; The Cooper Union for the Advancement of Science and Art, 1960–61. Included in: "Group Show," Aspects Gallery, New York, 1960; "Collectors', Critics' and Curators' Choice," A. M. Sachs Gallery, New York, 1967; New England Exhibition, Silvermine Guild of Artists, New Canaan, Connecticut, 1970. One-man shows, Allan Stone Gallery, New York, 1968, 1971. Lives in New York.

Water. 1967.
Oil on canvas, 62½ × 72½ inches
Signed and dated l. r.: "Turturro 67"

PROVENANCE:
The artist, New York, 1968

JOHN TWACHTMAN (1853–1902)

John Henry Twachtman, born Cincinnati, Ohio, August 4, 1853. Studied, Cincinnati: Ohio Mechanics Institute, evening drawing classes, 1868–71; McMicken School of Design, 1871–73, with Frank Duveneck, 1874; privately, with Duveneck, 1875. Traveled to Munich, with Duveneck; studied, Akademie der Bildenden Künste, Munich, with Ludwig von Löffts, 1875–79. Traveled to Venice, with Duveneck and William Merritt Chase, 1877. Returned to the U.S., 1878. Included in first exhibition, Society of American Artists, New York, 1878; member, 1879. Taught, Duveneck's art school, Florence, 1880. Traveled to The Netherlands, with J. Alden Weir, 1881. Returned briefly to the U.S., 1881, 1882. Lived in Paris, 1883–85; studied, Académie Julian, with Gustave-Clarence-Rodolphe Boulanger, and Jules-Joseph Lefèbvre. Returned to the U.S., 1885; lived in Chicago, 1886–87; settled in Greenwich, Connecticut, 1888. Exhibited with Claude Monet, Weir, Paul-Albert Besnard, American Art Galleries, New York, 1893. Taught, New York: The Art Students League, from 1893; The Cooper Union for the Advancement of Science and Art, from 1894. Awarded: Silver Medal, World's Columbian Exposition, Chicago, 1893; Temple Gold Medal, Pennsylvania Academy Annual, 1894. Co-founded The Ten (American Impressionists), with Childe Hassam, and Weir, New York, 1898. Exhibited with son, J. Alden Twachtman, Cincinnati Art Museum, 1900. One-man show, Durand-Ruel Galleries, New York, and Cincinnati Art Museum, 1901. Died Gloucester, Massachusetts, August 8, 1902. Posthumous one-man shows: The Lotos Club, New York, 1907; Albright Art Gallery, Buffalo, New York, 1913; Century Association, New York, 1919. Retrospective, Cincinnati Art Museum, 1966.

Hemlock Pool (A Waterfall). c. 1895.
Oil on canvas, 30⅛ × 25⅛ inches
Signed l. r.: "J. H. Twachtman"

PROVENANCE:
Samuel T. Shaw, New York; American Art Association, New York, Sale, January 22, 1926, no. 177, ill.; Frank Rehn Gallery, New York; Arthur Altschul, New York; James Graham and Sons, New York; Chapellier Gallery, New York, 1959

REFERENCES:
Hale, John Douglas. The Life and Creative Development of John H. Twachtman, Ph.D. thesis, Columbus, Ohio State University, 1957, no. 778, pp. 254, 576, ill. 52
Unsigned. "New York Auctions: Samuel T. Shaw Paintings," Art News, 24, January 30, 1926, p. 12
————. "Paintings Sold at Auction," American Art Annual, 23, 1927, p. 364

The Waterfall. 1890s.
Oil on canvas, 22 × 30 inches
Stamped l. r.: "Twachtman Sale"

PROVENANCE:
Estate of the artist; American Art Association, New York, Sale, March 24, 1903, no. 85; M. Mott; Ferargil Galleries, New York; Mr. and Mrs. Niles Davies, Congers, New York; Parke-Bernet Galleries, New York, Sale 842, February 26, 1947, no. 94; Ferargil Galleries; James Graham and Sons, New York, 1962

EXHIBITIONS:
Ferargil Galleries, New York, February 11–March 1, 1929, 19th and 20th Century American Paintings
San Francisco Museum of Art, October–November 1936, American Forerunners of Contemporary Painting

REFERENCES:
Hale, John Douglas. The Life and Creative Development of John H. Twachtman, Ph.D. thesis, Columbus, Ohio State University, 1957, no. 679, p. 581
Unsigned. "Paintings by American Artists: Ferargil Galleries," Art News, 27, March 2, 1929, p. 10
————. "Twachtman Pictures, $16,610," The New York Sun, March 25, 1903

CY TWOMBLY (b. 1928)

Edwin Parker Twombly, Jr., born Lexington, Virginia, April 25, 1928. Studied: School of the Museum of Fine Arts, Boston, 1947–49; Washington and Lee University, Lexington, 1949–50; The Art Students League of New York, 1950–51; Black Mountain College, North Carolina, with Robert Motherwell, and Franz Kline, 1951. One-man shows: Kootz Gallery, New York, 1951; Stable Gallery, New York, 1953–57; Galleria del Cavallino, Venice, 1958; Galleria del Naviglio, Milan, 1958, 1960; Galleria La Tartaruga, Rome, 1958, 1960, 1963; Leo Castelli Gallery, New York, from 1960; Galerie Aujourd'hui, Brussels, 1962; Galleria del Leone, Venice, 1962; Galerie Rudolf Zwirner, Cologne, 1969. Included in: "Two Decades of American Painting," The Museum of Modern Art, New York, International Circulating Exhibition, 1966–67; Whitney Annual, 1967, 1969; ROSC '71, Dublin, 1971. Has lived in Rome, since 1957.

August Notes from Rome. 1961.
Oil and pencil on canvas, 65 × 79 inches
Signed and dated c. l.: "Cy Twombly Aug. 1961"

PROVENANCE:
Galleria La Tartaruga, Rome; Philippe Dotremont, Brussels; Parke-Bernet Galleries, New York, Sale 2345, April 14, 1965, no. 43

RAOUL UBAC (b. 1910)

Born Malmédy, Belgium, August 31, 1910. Studied, Paris: Université de Paris à la Sorbonne, and Académie de la Grande Chaumière, 1929. One-man shows (photographic collages): Galerie Louis Cattiaux, Paris, 1934; Galerie Gravitations, Paris, 1935. Photographs and photomontages published in Minotaure, 1936; photographic experiments published in L'Exercice de la pureté, 1942. Studied engraving, S. W. Hayter's Atelier 17, Paris, 1937. First painting, c. 1944; first slate sculpture, 1946. One-man shows: Galerie Lou Cosyn, Brussels, 1946; The Hanover Gallery, London, 1949; Galerie Maeght, Paris, 1951, 1955, 1958, 1961; Kunsthalle, Basel, 1954; Lefebre Gallery, New York, from 1966. Included in: Pittsburgh International, 1952 (fourth prize), 1955, 1958, 1964, 1967; IV São Paulo Bienal, 1957; Documenta II, Kassel, 1959; "Double Exposure," Lefebre Gallery, 1968. Retrospectives: Palais des Beaux-Arts, Charleroi, Belgium, 1968; Palais des Beaux-Arts, Brussels, 1968; Musée National d'Art Moderne, Paris, 1968. Has designed windows, mosaics, tapestries, since 1955. Lives in Paris, and in Dieudonne, France.

The Tree: Stele (L'Arbre: stele). 1961.
Carved slate on wooden pedestal, 65 × 38½ × 2½ inches
Markings: back of slate l. c. "Ụ̈"

PROVENANCE:
Galerie Maeght, Paris, 1967

EXHIBITIONS:
Galerie Maeght, Paris, November 1961, Ubac, no. 5, ill.

REFERENCES:
Bazaine, Jean, Bonnefoy, Yves, Éluard, Paul, et al. Ubac, Paris, Maeght, 1970, no. 152, p. 175, ill.
Ponge, Francis, and Volboudt, Pierre. "Ubac," Derrière le Miroir, no. 130, November 1961, no. 5, ill.

FÉLIX VALLOTTON (1865–1925)

Félix-Édouard Vallotton, born Lausanne, December 28, 1865. Moved to Paris, 1882; French citizen, 1900. Studied, Paris: École des Beaux-Arts; Académie Julian, with Jules-Joseph Lefebvre, and Gustave-Clarence-Rodolphe Boulanger, 1882–85. Exhibited, Paris: Salon des Artistes Français, 1885, 1886; Salon des Indépendants, 1891, 1893, 1902; Salon de la Rose-Croix, Galerie Durand-Ruel, Paris (woodcuts), 1892. Included in Nabi exhibitions, Paris: Galerie Le Barc de Boutteville, 1892; Galerie Ambroise Vollard, 1898; Galerie Durand-Ruel, 1899; Galerie Bernheim-Jeune, 1900. Exhibited with Édouard Vuillard, Galerie Bernheim-Jeune, 1903. One-man show, Galerie Druet, Paris, 1910. Published art criticism and illustrations, La Revue Blanche; illustrated The Chap Book, Scribners, Le Rire, L'Assiette au Beurre. Died Paris, December 29, 1925. Retrospectives: Kunsthalle, Bern, 1927; Musée de l'Athénée, Geneva, 1928, 1944; Kunsthalle, Zürich, 1938, 1969; Musée Cantonal des Beaux-Arts, Lausanne, 1953; Museum Boymans-van Beuningen, Rotterdam, The Netherlands, 1954; Palais des Beaux-Arts, Brussels, 1954; Kunsthalle, Basel, 1957; Musée National d'Art Moderne, Paris, 1966; Hirschl & Adler Galleries, New York, 1970.

The Bather (La Femme tenant sa chemise). 1904.
Bronze, 13 × 3 × 3¼ inches
Markings: l. r. "R"
l. l. "Cire Perdue A. Hebrard"

PROVENANCE:
Jacques Dubourg, Paris; Galerie Beyeler, Basel, 1959

GREGORIO VARDÁNEGA (b. 1923)

Born Possagno, Italy, March 21, 1923. Moved with family to Argentina, 1926. Graduated from Escuela Superior de Bellas Artes, Buenos Aires, 1946. Member of Arte Concreto, Buenos Aires, 1947; exhibited with group, Galería Artistas Plasticos, Galería Peuser, and Galería Kraft, Buenos Aires. Included in: Salon des Réalités Nouvelles, Paris, 1948; "Atelier, Sculpture and Theory," J. B. Justo, Buenos Aires, 1948. Visited Europe, 1948–50; met Max Bill. Exhibited with Madi group of Argentine artists, Paris, 1950. Returned to Argentina, 1950. First one-man show, Galería Galatea, Buenos Aires, 1955. Co-founded: Arte Nuevo group, 1955; Artistes Non Figuratifs Argentins (A.N.F.A.), 1956. Included in IV São Paulo Bienal, 1957. Awarded Gold Medal, Exposition Universelle et Internationale de Bruxelles, 1958. Settled in Paris, 1959. Included in: Salon des Réalités Nouvelles, 1961; "Structures," and "Mouvement II," Galerie Denise René, Paris, 1961, 1964; "Trente Argentins de la Nouvelle Génération," Galerie Raymond Creuze, Paris, 1962; "Movement," Gimpel & Hanover Galerie, Zurich, 1964; "Art Cinétique et Espace," Nouveau Musée des Beaux-Arts, Le Havre, France, 1968. Exhibited with wife, Martha Boto, Maison des Beaux-Arts, Paris, 1968. One-man show, Galerie Denise René, 1969. Lives in Paris.

Chromatic Variations. 1964.
Wood and plastic box construction with light and motor, 31⅛ × 35½ × 7¾ inches

PROVENANCE:
Gimpel & Hanover Galerie, Zurich, 1964

EXHIBITIONS:
Gimpel & Hanover Galerie, Zurich, July 3–August 22, 1964, Movement, no. 37, ill.

VICTOR VASARELY (b. 1908)

Born Pecs, Hungary, April 9, 1908. Studied medicine, University of Budapest, 1925–26; abandoned medicine for art, 1927. Studied, Budapest: Akadémia Podolini-

755

Volkmann, 1927; graphics, Akadémia Muhely (so-called Budapest Bauhaus), with Sandor Bortnyik, 1928–29. Exhibited graphics, Budapest, 1929–33. Moved to Paris, 1930; chief graphics designer, Agence Havas, 1931–35; commercial artist and designer, 1936–44. One-man shows, Galerie Denise René, Paris, from 1944. Included in: Salon des Réalités Nouvelles, Paris, 1947–63; "Younger European Painters," The Solomon R. Guggenheim Museum, New York, 1953; Documenta I–4, Kassel, 1955, 1959, 1964, 1968; Pittsburgh International, 1955, 1961, 1964, 1967, 1970; Guggenheim International Award, 1964. One-man shows, Palais des Beaux-Arts, Brussels, 1954, 1960. Published *Manifeste Jaune,* on occasion of "Mouvement" exhibition, Galerie Denise René, 1955. Awarded: Critics' Prize, Exposition Universelle et Internationale de Bruxelles, 1955; Gold Medal, XIV Milan Triennale, 1955. One-man shows: Rose Fried Gallery, New York, 1958; Brook Street Gallery, London, 1964, 1966. Retrospective, Kunsthalle, Bern, and tour, 1964. Received Grand Prize, VIII São Paulo Bienal, 1965. Commissions: Padogogische Hochschule, Essen, Germany, 1966; Faculté des Lettres et Sciences Humains, Montpellier, France, 1966; Israel Museum, Jerusalem, 1967; French Pavilion, Expo '67, Montreal, 1967; Olympic Speed Ring, Grenoble, France, 1968. One-man shows: Sidney Janis Gallery, New York, 1966, 1968, 1969; Musée des Arts Décoratifs, Paris (tapestries), 1967; Sidney Janis Gallery, and Galerie Denise René, New York, 1972. Retrospective, Palace of Fine Arts, Budapest, 1969. With son Yvaral, designed sets, Roland Petit's ballet *Kraanerg,* Ottawa, 1969. Vasarely Foundation, and Musée Didactique, Château de Gordes, Gordes, France, inaugurated, 1970. Lives in Annet-sur-Marne, France.

Mizzar. 1956–60.
Oil on canvas, 76¾ × 44¼ inches
Signed and dated on back: "Vasarely 1956–60"

PROVENANCE:
G. David Thompson, Pittsburgh; Richard Feigen Gallery, Chicago; Harold Diamond, New York, 1967

EXHIBITIONS:
Isaac Delgado Museum of Art, New Orleans, January 18–February 6, 1966, *Victor Vasarely*
Richard Feigen Gallery, Chicago, February 22–March 26, 1966, *Vasarely,* no. 2, ill.

"One of the last works of synthesis of the 'Black-White' period. The 'formal' element, the lozenge, and the 'undulatory' part which gives the idea of the birth of the lozenge, complete each other. Although a 'chapter ending,' *Mizzar* retains its importance in my work."

Statement by the artist, 1972

Orion. 1956–62.
Collage maquette on wood, 82½ × 78¾ inches
Signed and dated on back: "Vasarely 1962"

PROVENANCE:
Gimpel & Hanover Galerie, Zurich, 1964

EXHIBITIONS:
Gimpel & Hanover Galerie, Zurich, July 3–August 22, 1964, *Movement,* no. 43

"A typically changeable work demonstrating the force of the plastic bivalent units and showing the way to the humanitarian idea which I have called *Planetary Folklore.*"

Statement by the artist, 1972

Arcturus II. 1966.
Oil on canvas, 63 × 63 inches
Signed and dated on back: "Vasarely 1966"

PROVENANCE:
Galerie Denise René, Paris, 1968

REFERENCES:
Spies, Werner. *Vasarely,* New York, Abrams, 1969, p. 13, colorplate 61

"It is a composition of prime importance because it introduces two fundamental principles in my research: a) establishment of my shaded tones: theoretical contribution b) the introduction, as a result, of shade and light in abstract painting: perceptible contribution opening up a new metaphysical interpretation according to the subjectivity of the viewer."

Statement by the artist, 1972

MARIA ELENA VIEIRA DA SILVA (b. 1908)

Born Lisbon, Portugal, June 13, 1908. Studied, Paris: Académie de la Grande Chaumière, with Émile-Antoine Bourdelle, 1928–29; Académie Scandinave, with Charles-Georges Dufresne, Othon Friesz, Charles Despiau, 1928–29; Atelier Fernand Léger, 1928–29; graphics, S. W. Hayter's Atelier 17, 1928–29. One-man shows: Galerie Jeanne Bucher, Paris, 1933, 1937, 1939, 1947, 1951, 1967; Galerie U.P., Lisbon, 1935; Museu Nacional des Bellas Artes, Rio de Janeiro, 1942; Galeria Eskenazi, Rio de Janiero, 1944; Willard Gallery, New York, 1946; Galerie Pierre, Paris, 1949–55; Librairie-Galerie La Hune, Paris, 1950; Museo Civico di Torino, 1951, 1952, 1959; Kunsthalle, Bern, 1953; Saidenberg Gallery, New York, 1956; The Hanover Gallery, London, 1957; Kestner-Gesellschaft, Hanover, and tour, 1958; The Phillips Collection, Washington, D.C., 1961, 1963; M. Knoedler & Co., New York, 1961, 1963, 1966, 1971. Lived in Brazil, 1940–47. Returned to Paris, 1947; French citizen, 1956. Included in: Venice Biennale, 1950, 1954; Pittsburgh International, 1952, 1955, 1958 (fourth prize), 1961, 1964, 1967, 1970; II São Paulo Bienal, 1953–54; Guggenheim International Award, 1958; Documenta II and III, Kassel, 1959, 1964. Exhibited with Germaine Richier, Stedelijk Museum, Amsterdam, 1955. Awarded: Grand Prize, VI São Paulo Bienal, 1961; Grand Prix National des Arts, French government, 1966. Retrospectives: Musée de Peinture et de Sculpture, Grenoble, France, and Museo Civico di Torino, 1964; Musée National d'Art Moderne, Paris, and tour, 1969–70. Lives in Paris.

Labyrinth. 1956.
Oil on canvas, 31½ × 31½ inches
Signed and dated l. r.: "Vieira da Silva 56"

PROVENANCE:
Saidenberg Gallery, New York, 1961

EXHIBITIONS:
Walker Art Center, Minneapolis, April 5–May 17, 1959, *School of Paris 1959: The Internationals,* no. 73, ill.
The Phillips Collection, Washington, D.C., March 12–April 12, 1961, *Vieira da Silva,* no. 16
American Federation of Arts tour, 1962–65, *Paintings from the Joseph H. Hirshhorn Foundation Collection: A View of the Protean Century,* no. 71, ill. p. 39

DAVID VON SCHLEGELL (b. 1920)

Born St. Louis, Missouri, May 25, 1920. Studied engineering, University of Michigan, Ann Arbor, 1940–42. Worked for an architect, 1944–45. Studied painting, The Art Students League of New York, with his father, William Von Schlegell, and Yasuo Kuniyoshi, 1945–48. Taught privately, 1950–55. One-man shows (painting): Swetzoff Gallery, Boston, 1955, 1961; Poindexter Gallery, New York, 1960. One-man shows (sculpture): Stanhope Gallery, Boston, 1964; University of New Hampshire, Durham, 1964; Ward-Nasse Gallery, Boston, 1965; Royal Marks Gallery, New York, 1966, 1967; Rose Art Museum, Brandeis University, Waltham, Massachusetts, 1968; Obelisk Gallery, and Ward-Nasse Gallery, Boston, 1968; Paula Cooper Gallery, New York, 1969–70; Reese Palley Gallery, New York, 1971. Included in: Whitney Annual, 1964–69; "Primary Structures," The Jewish Museum, New York, 1966; "American Sculpture of the Sixties," Los Angeles County Museum of Art, and Philadelphia Museum of Art, 1967; "Sculpture: A Generation of Innovation," The Art Institute of Chicago, 1967; Pittsburgh International, 1967, 1970. Received National Council on the Arts Grant, 1968. Taught: University of California, Santa Barbara, 1968; School of Visual Arts, New York, 1969–70. Received Guggenheim Foundation Fellowship, 1974. Lives in Guilford, Connecticut.

Leda. 1963.
Cedar, oak, aluminum, and steel, 78 × 38½ × 18 inches

PROVENANCE:
Paula Cooper Gallery, New York, 1968

EXHIBITIONS:
Obelisk Gallery, and Ward-Nasse Gallery, Boston, May 1968, *David von Schlegell*

Untitled. 1969.
Stainless steel, 8 feet × 18 feet 2 inches × 8 feet 3½ inches

PROVENANCE:
Paula Cooper Gallery, New York, 1969

EXHIBITIONS:
Paula Cooper Gallery, New York, December 6, 1969–January 7, 1970, *David Von Schlegell*

"From *Leda,* of 1963 (a very early work—I started making sculpture that year), to the *Untitled* piece, of 1969, there is evident the process of change, which continues, of making the work lean, quiet, more geometric—the pure creation of the mind. Its intention now is to affect man's perceptual relationship with place—as in ancient religious structures."

Statement by the artist, 1972

PAUL WALDMAN (b. 1936)

Born Erie, Pennsylvania, August 1, 1936. Studied, Brooklyn, New York: The Brooklyn Museum Art School, 1953, 1955–56; Pratt Institute, 1955–57. Exhibited: Allan Stone Gallery, New York, 1961; "Recent American Drawings," Washington [D.C.] Gallery of Modern Art, 1963; "Survey of American Figure Painting," Wadsworth Atheneum, Hartford, Connecticut, 1964. One-man shows: Allan Stone Gallery, 1963, 1965; Albrecht Gallery of Art, St. Joseph, Missouri, 1966. Taught, Brooklyn: New York City Community College, 1963–64; The Brooklyn Museum Art School, 1963–67. Received Ford Foundation Grant, 1965. Included in: Whitney Annual, 1967; "Prints and Collages: De Kooning, Porter, Waldman," M. Knoedler & Co., New York, 1971. One-man show, Leo Castelli Gallery, New York, 1973. Has taught, The School of Visual Arts, New York, since 1966. Lives in New York.

Untitled. 1967.
Oil on Masonite, 48½ × 36 inches
Signed and dated on back: "Paul Waldman 1967"

PROVENANCE:
The artist, New York, 1967

JOHN WALKER (b. 1939)

Born Birmingham, England, November 12, 1939. Studied: Birmingham College of Art and Design, 1955–60; Académie de la Grande Chaumière, Paris, 1960–61. Included in "Young Contemporaries," The Arts Council of Great Britain, London, 1960. Received Abbey Minor Travelling Scholarship, 1962. Awarded: first prize, National Young Artists Drawing Competition, 1962; Arts Council Drawing Prize, 1966. Taught, England: Stourbridge College of Art, 1962–63; Birmingham College of Art and Design, 1963–68. Gregory Fellow in Painting, University of Leeds, England, 1967. One-man shows, London: Axiom Gallery, 1967, 1968; Hayward Gallery, 1968. Included in: "Four Axiom Artists," Betty Parsons Gallery, New York, 1967; "New British Painting and Sculpture," The Art Galleries, University of California at Los Angeles, and tour, 1968–69; "Nine Young Artists: Theodoron Awards," The Solomon R. Guggenheim Museum, New York, 1969. Received Harkness Fellowship to the U.S., 1969. Exhibited with William Tucker, Leeds City Art Gallery, 1969. One-man shows: National Museum of Modern Art, Tokyo, 1970; Reese Palley Gallery, New York, 1971; Ikon Gallery, London, 1972. Included in: "British Painting and Sculpture: 1960–1970," National Gallery of Art, Washington, D.C., 1970–71; ROSC '71, Dublin, 1971; Venice Biennale, 1972. Lives in Leeds, and in London.

Blackwell. 1967.
Acrylic on canvas, 8 feet 9 inches × 17 feet

PROVENANCE:
Betty Parsons Gallery, New York; Axiom Gallery, London, 1968

EXHIBITIONS:
The Art Galleries, University of California at Los Angeles, January 7–February 11, 1968, *New British Painting and Sculpture* (organized by the Whitechapel Art Gallery, London), cat; toured to University Art Museum, University of California, Berkeley, March 4–April 7; Portland Art Museum, Oregon, April 25–June 9; Vancouver Art Gallery, British Columbia, Canada, June 26–September 1

REFERENCES:
Read, Herbert, and Robertson, Bryan. "New British Painting and Sculpture at the University of California," *Art International,* 12, February 1968, ill. p. 28

ABRAHAM WALKOWITZ (1878–1965)

Born Tyumen, Russia, March 28, 1878. Emigrated with family to New York, c. 1886. Studied, New York: The Cooper Union for the Advancement of Science and Art, 1892; National Academy of Design, late 1890s. Taught, Educational Alliance Art School, New York, 1900–1906. Lived in Paris, 1906–8; studied, Académie Julian, with Jean-Paul Laurens; met Max Weber; first saw dancer Isadora Duncan. First one-man show, Julius Haas Frame Shop, New York, 1908. Shared New York studio with Weber, 1909. Organized exhibition of children's drawings, Alfred Stieglitz's Photo-Secession Gallery, "291," New York, 1912; one-man shows there, 1912, 1913, 1915, 1917. Included in: the Armory Show, 1913; "The Forum Exhibition of Modern American Painters," The Anderson Galleries, New York, 1916. Society of Independent Artists, New York: included in First Annual, 1917; member, Board of Directors, 1918–20. Société Anonyme, New York: first exhibited, 1920; director, 1934. One-man show, The Downtown Gallery, New York, 1930. Retrospective, The Brooklyn Museum, New York, 1939. "One Hundred Artists and Walkowitz," exhibition of portraits of Walkowitz by Ben Benn, Philip Evergood, Arnold Friedman, Yasuo Kuniyoshi, among others, The Brooklyn Museum, 1944. Drawings published in *Isadora Duncan in Her Dances,* and *Improvisations of New York: A Symphony in Lines* (Girard, Kansas, Haldeman-Julius), 1945, 1948. One-man shows, New York: Egan Gallery, 1947; The Jewish Museum, 1949; ACA Gallery, 1952, 1955, 1959; Zabriskie Gallery, from 1959. Received Waite Award, The American Academy of Arts and Letters, 1962. Died New York, January 26, 1965. Included in "The Lower East Side: Portal to American Life (1870–1924)," The Jewish Museum, and Arts and Industries Building, Smithsonian Institution, Washington, D.C., 1966–68.

The Road, Paris. 1906.
Watercolor and graphite on paper, 10¾ × 16 inches
Signed and dated l. r.: "A. Walkowitz Paris 1906"

PROVENANCE:
ACA Gallery, New York, c. 1951

In the Street. 1909.
Oil on board, 13½ × 10½ inches
Signed and dated across lower edge: "A Walkowitz 1909"

PROVENANCE:
ACA Gallery, New York, c. 1951

EXHIBITIONS:
The Jewish Museum, New York, September 21–November 6, 1966, and April 4–July 2, 1967, *The Lower East Side: Portal to American Life (1870–1924),* no. 47, ill. p. 40; toured to Arts and Industries Building, Smithsonian Institution, Washington, D.C. (sponsored by the Jewish Social Service Agency), December 17–January 18, 1968

REFERENCES:
Hunter, Sam. *American Art of the 20th Century,* New York, Abrams, 1972, colorplate 83
Walkowitz, Abraham. *A Demonstration of Objective, Abstract, and Nonobjective Art,* Girard, Kansas, Haldeman-Julius, 1945, ill. p. 9

Italian Improvisation. 1914.
Watercolor on paper, 14 × 21 inches
Signed and dated l. r.: "A Walkowitz 1914"

PROVENANCE:
ACA Gallery, New York, 1955

EXHIBITIONS:
ACA Gallery, New York, March 1–26, 1955, *Abraham Walkowitz Retrospective*
Zabriskie Gallery, New York, January 5–31, 1959, *Abraham Walkowitz Retrospective,* no. 19
The American Academy of Arts and Letters, New York, May 24–June 17, 1962, *Works by Newly Elected Members and Recipients of Academy Honors,* no. 71

REFERENCES:
Campbell, Lawrence. "Reviews and Previews: Walkowitz," *Art News,* 54, March 1955, p. 49
Feinstein, Sam. "Fortnight in Review: Walkowitz," *Arts Digest,* 29, March 15, 1955, p. 23

New York Improvisation. 1915.
Watercolor and charcoal on paper, 23 × 16½ inches
Signed and dated l. r.: "Walkowitz 1915"

PROVENANCE:
Estate of the artist; Zabriskie Gallery, New York, 1966

EXHIBITIONS:
Zabriskie Gallery, New York, May 3–28, 1966, *Abraham Walkowitz: Watercolors 1900–1920,* cat.

REFERENCES:
Walkowitz, Abraham. *Improvisations of New York: A Symphony in Lines,* Girard, Kansas, Haldeman-Julius, 1948, ill.

Metropolis—No. 2. 1923.
Watercolor on paper, 30 × 22 inches
Signed and dated l. r.: "A. Walkowitz 1923"

PROVENANCE:
ACA Gallery, New York, 1957

EXHIBITIONS:
Zabriskie Gallery, New York, October 5–31, 1964, *Improvisations of New York*, no. 11

REFERENCES:
Walkowitz, Abraham. *Improvisations of New York: A Symphony in Lines*, Girard, Kansas, Haldeman-Julius, 1948, ill.

Isadora Duncan: Seven Studies. n.d.
Pen and ink and watercolor on paper, each 6¾ × 2⅛ inches
Each drawing signed lower edge: "A. Walkowitz"

PROVENANCE:
ACA Gallery, New York, c. 1951

ANDY WARHOL (b. 1928)

Andrew Warhola, born Pittsburgh, August 6, 1928. Studied, Carnegie Institute of Technology, Pittsburgh, 1945–49. Settled in New York, 1949. Commercial artist, 1950–60. Received Art Directors Club Award, 1957; exhibited advertising drawings, Bodley Gallery, New York, 1959. One-man shows: Stable Gallery, New York, 1962, 1964; Ferus Gallery, Los Angeles, 1962–68; Galerie Ileana Sonnabend, Paris, 1964–67; Leo Castelli Gallery, New York, from 1964; Galerie Rudolf Zwirner, Cologne, 1967; Rowan Gallery, London, 1968; Gotham Book Mart, New York, 1971. Filmmaker, since 1963; *Kiss, Haircut, Eat, Sleep*, shown, New York Film Maker's Co-operative, 1964. Other films: *Empire*, 1964; *Henry Geldzahler*, 1964; *Chelsea Girls*, 1966; *Lonesome Cowboys*, 1967–68; *Blue Movie*, 1969. Retrospectives: Institute of Contemporary Art, University of Pennsylvania, Philadelphia, 1965; Institute of Contemporary Art, Boston, 1966; Moderna Museet, Stockholm, 1968; Museum of Art, Rhode Island School of Design, Providence, 1969–70; Pasadena Art Museum, California, and international tour, 1970–71. Included in: "The Arena of Love," Dwan Gallery, Los Angeles, 1965; Documenta 4, Kassel, 1968; "New York Painting and Sculpture: 1940–1970," The Metropolitan Museum of Art, New York, 1969–70. Novel *A* published (New York, Grove), 1968. Lives in New York.

Marilyn Monroe's Lips. 1964.
Acrylic and silkscreen enamel on canvas, diptych
Left panel, 82¾ × 80⅝ inches
Right, panel, 82¼ × 82⅝ inches

PROVENANCE:
Dwan Gallery, Los Angeles, 1967

EXHIBITIONS:
Dwan Gallery, Los Angeles, January 5–February 6, 1965, *The Arena of Love*

REFERENCES:
Coplans, John. *Andy Warhol*, Greenwich, Connecticut, New York Graphic Society, 1970, ill. p. 74
Crone, Rainer. *Andy Warhol*, New York, Praeger, 1970, nos. 73–74, p. 289, ill. pp. 120–121
Gidal, Peter. *Andy Warhol*, London, Studio Vista, 1971, ill. p. 60
Leider, Philip. "Saint Andy: Some notes on an artist who, for a large section of a younger generation, can do no wrong," *Artforum*, 3, February 1965, ill. pp. 26–27
Morphet, Richard. *Andy Warhol*, London, The Tate Gallery, 1971, pp. 17–18, ill. 4

"To depict Marilyn's lips 168 times in 49 square feet is a more remarkable innovation than may first appear. Requiring selection, masking, processing, enlargement, transposition and application, in conjunction with decisions on canvas size, colour and handling, it means that the finished painting is a complex and calculated artefact, which is not only unique, but strikingly different from any that another individual might have produced."

Morphet, pp. 17–18

MAX WEBER (1881–1961)

Born Bialystok, Russia, April 18, 1881. Emigrated with family to New York, 1891. Studied: Pratt Institute, Brooklyn, New York, with Arthur Wesley Dow, 1898–1900; privately, with Dow, 1900–1901. Taught, public schools, Virginia and Minnesota, 1901–5. Studied, Paris: Académie Julian, with Jean-Paul Laurens, 1905; Académie Colarossi, and Académie de la Grande Chaumière, 1906–7; with Henri Matisse, 1907. Met Henri Rousseau, 1907. Returned to New York, 1909. One-man shows: Julius Haas Frame Shop, New York, 1909; Alfred Stieglitz's Photo-Secession Gallery, "291," New York, 1909, 1911; Murray Hill Gallery, New York, 1912; Newark Museum, New Jersey, 1913. Organized first Rousseau exhibition in the U.S., "291," 1910. First sculptures, 1910. Exhibited: "Younger American Moderns," "291," 1910; with Grafton group, Alpine Club Gallery, London, 1913; with Arthur B. Davies, Jules Pascin, Walt Kuhn, Charles Sheeler, Montross Gallery, New York, 1917. Published: *Cubist Poems* (London, Elkin Mathews), 1913; *Essays on Art* (New York, Rudge), 1916. Taught: art history, Clarence White School of Photography, New York, 1914–18; The Art Students League of New York, 1920–21, 1925–27. Retrospective, The Ehrich Galleries, New York, 1915. One-man shows: The Print Gallery, New York, 1915; Montross Gallery, New York, 1915, 1923; Galerie Bernheim-Jeune, Paris, 1924; J. B. Neumann's New Art Circle, New York, 1924–37. Member, Board of Directors, Society of Independent Artists, New York, 1917–19. Exhibited with Société Anonyme, The Brooklyn Museum, New York, 1926. Awarded Potter Palmer Gold Medal, 41st American Exhibition, and Garrett Prize, 52nd American Exhibition, The Art Institute of Chicago, 1928, 1941. Moved to Great Neck, New York, 1929. Retrospectives: The Museum of Modern Art, New York, 1930; Whitney Museum of American Art, New York, and Walker Art Center, Minneapolis, 1949; The Jewish Museum, New York, 1956; Pratt Institute, 1959; Newark Museum, 1959. One-man shows: The Dayton Art Insti-

tute, Ohio, 1938; Paul Rosenberg & Co., New York, 1942–45, 1947; Carnegie Institute, Pittsburgh, 1943. Member, The National Institute of Arts and Letters, 1955. Died Great Neck, October 4, 1961. Memorial exhibitions: The American Academy of Arts and Letters, and The National Institute of Arts and Letters, New York, 1962; Boston University Art Gallery, 1962. Retrospectives: Rose Art Museum, Brandeis University, Waltham, Massachusetts, 1966–67; The Art Galleries, University of California, Santa Barbara, and tour, 1968.

Bather. 1913.
Oil on canvas, 60½ × 24¼ inches
Signed and dated l. r.: "Max Weber 1913"

PROVENANCE:
Paul Rosenberg & Co., New York; Wright Ludington, Santa Barbara, California; Felix Landau Gallery, Los Angeles, 1961

EXHIBITIONS:
The Print Gallery, New York, January–February 1915, *Max Weber*
The Museum of Modern Art, New York, March 13–April 2, 1930, *Max Weber*, no. 30
Whitney Museum of American Art, New York, February 12–March 22, 1935, *Abstract Painting in America*, no. 117, frontispiece ill.
Whitney Museum of American Art, New York, April 9–May 19, 1946, *Pioneers of Modern Art in America*, no. 167
San Francisco Museum of Art, Summer 1948, *The Wright Ludington Collection*

REFERENCES:
Unsigned. "Nightmare and Pale Horse," *American Art News*, 13, February 6, 1915, p. 2

Spiral Rhythm. 1915, enlarged and cast 1958–59.
Bronze, 24 × 13⅜ × 13⅜ inches
Markings: back l. c. "Max Weber 1/3"

PROVENANCE:
Galerie Chalette, New York, 1960

EXHIBITIONS:
The Solomon R. Guggenheim Museum, New York, October 3, 1962–January 6, 1963, *Modern Sculpture from the Joseph H. Hirshhorn Collection*, no. 433, ill. p. 175
Whitney Museum of American Art, New York, February 27–April 14, 1963, *The Decade of the Armory Show*, no. 107, ill. p. 62; toured to City Art Museum of St. Louis, Missouri, June 1–July 14; The Cleveland Museum of Art, August 6–September 15; The Pennsylvania Academy of the Fine Arts, Philadelphia, September 30–October 30; The Art Institute of Chicago, November 15–December 29; Albright-Knox Art Gallery, Buffalo, New York, January 20–February 23, 1964
Whitney Museum of American Art, New York, September 28–November 27, 1966, *Art of the United States: 1670–1966*, no. 362

REFERENCES:
Arnason, H. Harvard. *History of Modern Art*, New York, Abrams, 1968, p. 435, ill. p. 434
Hunter, Sam. *American Art of the 20th Century*, New York, Abrams, 1972, ill. 416
Rose, Barbara. *American Art Since 1900*, New York, Praeger, 1967, pp. 240, 315, ill. 9–2
Rubin, William S. "The Hirshhorn Collection at the Guggenheim Museum," *Art International*, 6, November 1962, p. 35
Scott, David W. "Max Weber," *The Britannica Encyclopedia of American Art*, New York, Simon and Schuster, 1973, colorplate p. 587

Reading. 1935.
Oil on canvas, 31½ × 47¼ inches
Signed l. r.: "Max Weber"

PROVENANCE:
Associated American Artists, New York; Paul Rosenberg & Co., New York; Mrs. William Keighley, Paris, and California; M. Knoedler & Co., New York 1958

EXHIBITIONS:
Palace of Fine Arts, San Francisco, February 1940, *Golden Gate International Exposition*, no. 1499
The Pennsylvania Academy of the Fine Arts, Philadelphia, January 26–March 2, 1941, *One Hundred and Thirty-Sixth Annual Exhibition of Painting & Sculpture*, no. 134, ill.
Carnegie Institute, Pittsburgh, March 9–April 18, 1943, *Max Weber*, no. 42
City Art Museum of St. Louis, Missouri, February 5–March 13, 1944, *Thirty-Seventh Annual Exhibition of American Painting*, no. 72, ill.
School of the Museum of Fine Arts, Boston, May 10–31, 1945, *Paintings by Max Weber*, no. 9

REFERENCES:
Unsigned. "Followers Without Leaders Dominate Pennsylvania Academy Annual," *Art Digest*, 15, February 1, 1941, p. 5, ill. p. 6
———. *Max Weber*, New York, American Artists Group, 1945, ill.
Werner, Alfred. *Max Weber*, New York, Abrams, forthcoming, ill.

Still Life with Palette. 1947.
Oil on canvas, 30 × 36 inches
Signed l. r.: "Max Weber"

PROVENANCE:
Paul Rosenberg & Co., New York; The Downtown Gallery, New York, 1956

EXHIBITIONS:
Paul Rosenberg & Co., New York, October 27–November 15, 1947, *Max Weber*, no. 2
Whitney Museum of American Art, New York, February 5–March 27, 1949, *Max Weber Retrospective*, no. 80, ill. p. 55; toured to Walker Art Center, Minneapolis, April 17–May 29
The Pennsylvania Academy of the Fine Arts, Philadelphia, January 21–February 25, 1951, *The One Hundred*

and Forty-Sixth Annual Exhibition of American Painting and Sculpture, no. 148
California Palace of the Legion of Honor, San Francisco, January 24–March 2, 1952, *Fifth Annual Exhibition of Contemporary American Painting*, cat., ill.
American Federation of Arts tour, 1959–60, *Ten Modern Masters of American Art*, no. 30
American Federation of Arts tour, 1962–65, *Paintings from the Joseph H. Hirshhorn Foundation Collection: A View of the Protean Century*, no. 72

REFERENCES:
Farber, Manny. "Weber Answers Questions," *Art News*, 48, March 1949, p. 24, ill.
Genauer, Emily. "Private Collection Put to Public Use," *The New York Herald Tribune*, August 2, 1959, sec. 4, p. 6A
Goodrich, Lloyd. *Max Weber*, New York, Whitney Museum of American Art, 1949, p. 54, ill. p. 55
Reed, Judith Kaye. "New Webers Distinguished by Lyric Color," *Art Digest*, 22, November 1, 1947, p. 15
Unsigned. "Ten Modern Masters . . . ," *Columbia Museum of Art News*, South Carolina, 10, September 1959, ill. p. 1
Werner, Alfred. *Max Weber*, New York, Abrams, forthcoming, ill.

E. AMBROSE WEBSTER (1869–1935)

Born Chelsea, Massachusetts, January 31, 1869. Studied: School of the Museum of Fine Arts, Boston, with Frank Benson, and Edmund Tarbell, 1893–96; Académie Julian, Paris, with Jean-Paul Laurens, and Benjamin Constant, 1896–98. Settled in Provincetown, Massachusetts, 1900; traveled frequently to Jamaica, Bermuda, France, Spain, Italy. Exhibited: the Armory Show, 1913; Cage Gallery, Cleveland, 1913; Brooks Reid Gallery, Boston, 1913, 1914; Corcoran Biennial, 1914. Co-founded Provincetown Art Association, with Charles Hawthorne, and Edwin Dickinson, 1914; director, 1917–19. One-man show, Brooks Reid Gallery, 1916. Studied with Albert Gleizes, Paris, early 1920s. Included in "Paintings by the Provincetown Group," G.R.D. Studio, New York, 1930. Made painting and lecture tour through the U.S., 1930–31. Died Provincetown, January 23, 1935. Memorial exhibitions: Boston Art Club, 1935; Provincetown Art Association, 1950. One-man show, East End Gallery, Provincetown, 1962. Retrospective, Babcock Galleries, New York, 1965.

The Bridge. c. 1912.
Oil on canvas, 26 × 30¼ inches

PROVENANCE:
East End Gallery, Provincetown, Massachusetts, 1962

J. ALDEN WEIR (1852–1919)

Julian Alden Weir, born West Point, New York, August 30, 1852; son and pupil of painter Robert W. Weir (1803–1889). Studied: National Academy of Design, New York, with L. E. Wilmarth, 1870–71, 1874; with Jean-Léon Gérôme, Paris, 1873. Made painting trips: to The Netherlands, 1874; to Spain, 1876. Met James Abbott McNeill Whistler, London, 1877. Returned to New York, 1877; established studio; member, Tile Club. Society of American Artists, New York: founding member, 1877; exhibited, 1878–90. Taught, New York: Women's Art School, The Cooper Union for the Advancement of Science and Art, 1878; The Art Students League of New York, 1885–87, 1890–98. Traveled, with John Twachtman, to The Netherlands, 1881. National Academy of Design: associate, 1885; academician, 1886; Gold Medal, 1906; president, 1915–17. First one-man show, Blakeslee Gallery, New York, 1891. Exhibited with Twachtman, Claude Monet, Paul-Albert Besnard, American Art Galleries, New York, 1893. Co-founded The Ten (American Impressionists), with Childe Hassam, and Twachtman, New York, 1898. Member, The National Institute of Arts and Letters, 1898. One-man shows: Montross Gallery, New York, 1907 (watercolors), 1908, 1914 (watercolors); Albright Art Gallery, Buffalo, New York, 1911; Cincinnati Art Museum, Ohio, 1912. Twenty-five works included in the Armory Show, 1913. Received Corcoran Gold Medal, and First Clark Prize, Corcoran Biennial, 1914. Member, The American Academy of Arts and Letters, 1915. Died New York, December 8, 1919. Memorial exhibitions, New York: Century Association, 1920; The Metropolitan Museum of Art, 1924. Retrospectives: Babcock Galleries, New York, 1942; The American Academy of Arts and Letters, 1952; The Phillips Collection, Washington, D.C., and tour, 1972; National Collection of Fine Arts, Smithsonian Institution, Washington, D.C., and tour, 1972 (graphics).

The Bridge: Nocturne (Nocturne: Queensboro Bridge). 1910.
Oil on canvas, 29 × 39¼ inches
Signed l. r.: "Alden Weir"

PROVENANCE:
The artist; Dorothy Weir Young; M. Knoedler & Co., New York; The Milch Galleries, New York; Horatio S. Rubens, New York; B. J. Brotman, New York; M. Knoedler & Co.; Grand Central Art Galleries, New York; M. Knoedler & Co.; The Milch Galleries; M. Knoedler & Co., 1961

EXHIBITIONS:
Montross Gallery, New York, March 24–April 8, 1911, *14th Annual Exhibition of The Ten*
Carnegie Institute, Pittsburgh, April 25–June 30, 1912, *Sixteenth Annual Exhibition*, no. 330
The Corcoran Gallery of Art, Washington, D.C., February 6–27, 1919, *Ten American Painters*, no. 40
M. Knoedler & Co., New York, Summer 1919, *Twelfth Annual Summer Exhibition of Paintings by American Artists*, no. 20
Century Association, New York, April 4–26, 1920, *Memorial Exhibition of Paintings by the Late J. Alden Weir, N.A.*, no. 4
The Metropolitan Museum of Art, New York, March 17–April 20, 1924, *Memorial Exhibition of the Works of Julian Alden Weir*, no. 60, ill.
The Brooklyn Museum, New York, October 1937,

Leaders of American Impressionism—Mary Cassatt, Childe Hassam, John H. Twachtman, J. Alden Weir, no. 90

Babcock Galleries, New York, October 12–31, 1942, *J. Alden Weir,* no. 5

The American Academy of Arts and Letters, New York, February 1–March 30, 1952, *J. Alden Weir, 1852–1919, Centennial Exhibition,* no. 13

M. Knoedler & Co., New York, Summer 1961, *American Paintings, Watercolors, Drawings & Sculpture,* no. 21

Marlborough-Gerson Gallery, New York, September 27–October 14, 1967, *The New York Painter, A Century of Teaching: Morse to Hofmann,* p. 99, ill. p. 45

REFERENCES:

Brotman, B. J. *American Paintings as Contained in the Residence of Horatio S. Rubens, Deceased,* New York, n.d., no. 69

Clark, Elliot. "J. Alden Weir," *Art in America,* 8, August 1920, p. 242, ill. p. 237

Coffin, William A. *J. Alden Weir,* New York, The Metropolitan Museum of Art, 1924, p. VII

La Follette, Suzanne. *Art in America,* 1929; reprint, New York, Harper & Row, 1968, p. 214

Millet, J. B., ed. *Julian Alden Weir, an Appreciation of His Life and Works,* New York, Century Association, 1921, p. 137

Phillips, Duncan. "J. Alden Weir," *The American Magazine of Art,* 8, April 1917, p. 220

Preston, Stuart. *James Abbott McNeill Whistler,* New York, Abrams, forthcoming, ill.

Price, Frederick Newlin. "Weir, the Great Observer," *International Studio,* 75, April 1922, p. 126

Staley, Allen. *From Realism to Symbolism: Whistler and His World,* New York, Columbia University, 1971, p. 137

Townsend, James B. "Exhibitions Now On: 'The Ten's' Annual Show," *American Art News,* 9, March 25, 1911, p. 2

Unsigned. "130 Works in Weir Memorial Display," *Art News,* 22, March 22, 1924, p. 5

———. "The Passing Shows," *Art News,* 41, October 15, 1942, p. 27

———. "Weir Canvases Recreate Quiet of Past Era," *Art Digest,* 17, October 15, 1942, p. 9

Young, Dorothy Weir. *The Life and Letters of J. Alden Weir,* New Haven, Connecticut, Yale, 1960, pp. 201, 231, 258, 261

The Plaza: Nocturne. 1911.
Oil on canvas, 28⅜ × 39⅜ inches
Signed l. l.: "J. Alden Weir"

PROVENANCE:
The artist; Dorothy Weir Young; M. Knoedler & Co., New York; The Milch Galleries, New York; Horatio S. Rubens, New York; B. J. Brotman, New York; M. Knoedler & Co.; Grand Central Art Galleries, New York; M. Knoedler & Co.; The Milch Galleries; M. Knoedler & Co., 1961

EXHIBITIONS:
Albright Art Gallery, Buffalo, New York, May 21–September 2, 1912, *Seventh Annual Exhibition of Selected Paintings by American Artists,* no. 148

The Art Institute of Chicago, November 5–December 8, 1912, *Twenty-fifth Annual Exhibition of American Oil Paintings and Sculpture,* no. 288, ill.

Carnegie Institute, Pittsburgh, April 24–June 30, 1913, *Seventeenth Annual Exhibition,* no. 336

Macbeth Gallery, New York, January 2–19, 1914, *Group Exhibition of Six American Painters*

The Pennsylvania Academy of the Fine Arts, Philadelphia, February 8–March 29, 1914, *One Hundred and Ninth Annual Exhibition,* no. 134

The Corcoran Gallery of Art, Washington, D.C., December 17, 1916–January 21, 1917, *Sixth Exhibition of Oil Paintings by Contemporary American Artists,* no. 86

M. Knoedler & Co., New York, Summer 1919, *Twelfth Annual Summer Exhibition of Paintings by American Artists,* no. 22

City Art Museum of St. Louis, Missouri, September 14–October 28, 1919, *Fourteenth Annual Exhibition of Paintings by American Artists,* no. 160

Century Association, New York, April 4–26, 1920, *Memorial Exhibition of Paintings by the Late J. Alden Weir, N.A.,* no. 6

The Metropolitan Museum of Art, New York, March 17–April 20, 1924, *Memorial Exhibition of the Works of Julian Alden Weir,* no. 61, ill.

The Brooklyn Museum, New York, October 1937, *Leaders of American Impressionism—Mary Cassatt, Childe Hassam, John H. Twachtman, J. Alden Weir,* no. 89

Babcock Galleries, New York, October 12–31, 1942, *J. Alden Weir,* no. 6

The American Academy of Arts and Letters, New York, February 1–March 30, 1952, *J. Alden Weir, 1852–1919, Centennial Exhibition,* no. 15

The Phillips Collection, Washington, D.C., May 6–June 8, 1972, *J. Alden Weir,* no. 20, ill. 26

REFERENCES:

Benedikt, Michael. "New York Letter," *Art International,* 9, October 20, 1965, p. 41

Brotman B. J. *American Paintings as Contained in the Residence of Horatio S. Rubens, Deceased,* New York, n.d., no. 71

Clark, Elliot. "J. Alden Weir," *Art in America,* 8, August 1920, p. 242

La Follette, Suzanne. *Art in America,* 1929; reprint, New York, Harper & Row, 1968, p. 214

The Milch Galleries. *Important Work in Painting and Sculpture by Leading American Artists,* New York, c. 1920, ill.

Millet, J. B., ed. *Julian Alden Weir, an Appreciation of His Life and Works,* New York, Century Association, 1921, p. 137, ill.

Phillips, Duncan. "J. Alden Weir," *The American Magazine of Art,* 8, April 1917, p. 220

Price, Frederick Newlin. "Weir, the Great Observer," *International Studio,* 75, April 1922, p. 131

Townsend, James B. "Pennsylvania Academy Display," *American Art News,* 12, February 14, 1914, p. 4

———. "Seven Painters at Macbeth's," *American Art News,* 12, January 10, 1914, p. 6

Unsigned. "130 Works in Weir Memorial Display," *Art News,* 22, March 22, 1924, p. 5

———. "The Passing Shows," *Art News,* 41, October 15, 1942, p. 27

———. "Weir Canvases Recreate Quiet of Past Era," *Art Digest,* 17, October 15, 1942, p. 9

Young, Dorothy Weir. *The Life and Letters of J. Alden Weir,* New Haven, Connecticut, Yale, 1960, pp. 201, 261

The Bridge: Nocturne and *The Plaza: Nocturne* are two views of New York City from the artist's studio at Park Avenue and Fifty-eighth Street.

TOM WESSELMANN (b. 1931)

Thomas K. Wesselmann, born Cincinnati, Ohio, February 23, 1931. Studied: Hiram College, Ohio, 1949–51; University of Cincinnati, B.A., 1951–52, 1954–55; Art Academy of Cincinnati, 1955–56; The Cooper Union for the Advancement of Science and Art, New York, 1956–59. Served, U.S. Army, 1952–54. Exhibited, Judson Gallery, New York, 1959–60. One-man shows, New York: Tanager Gallery, 1961; The Green Gallery, 1962–65. Included in: "Recent Painting USA: The Figure," The Museum of Modern Art, New York, 1962; "Pop Art," The Pace Gallery, Boston, 1962; "Nouveaux Vulgarians," Galerie Saqqarah, Gstaad, Switzerland, 1963; "1st International Girlie Exhibit," The Pace Gallery, New York, 1964; "Pop Art and the American Tradition," Milwaukee Art Center, Wisconsin, 1965; "The New American Realism," Worcester Art Museum, Massachusetts, 1965; "Homage to Marilyn Monroe," Sidney Janis Gallery, New York, 1967; Documenta 4, Kassel, 1968; ROSC '71, Dublin, 1971; Whitney Biennial, 1973. One-man shows: Sidney Janis Gallery, from 1966; Newport Harbor Art Museum, Balboa, California, and Nelson Atkins Museum of Fine Arts, Kansas City, Missouri, 1970–71. Lives in New York.

Study for First Illuminated Nude. 1965.
Acrylic on canvas, 46 × 43 inches

PROVENANCE:
The Green Gallery, New York, 1965

JAMES ABBOTT MCNEILL WHISTLER (1834–1903)

Born Lowell, Massachusetts, July 10, 1834. Lived in St. Petersburg, Russia, 1843–49; returned to the U.S., 1849. Attended U.S. Military Academy, West Point, New York, 1851–54; discharged for demerits and deficiency in chemistry. Worked briefly, Winans Locomotive Works, Baltimore. Learned etching, while cartographer, U.S. Coast and Geodetic Survey, Washington, D.C., 1854–55. Moved to Paris, 1855; studied with Charles-Gabriel Gleyre, 1856. Exhibited with Henri Fantin-Latour, studio of François Bonvin, Paris, 1859. Moved to London, 1859. Exhibited: Royal Academy of Arts, London, 1860; Salon des Refusés, Paris, 1863. Met Claude Monet, Eugène Boudin, Charles-François Daubigny, 1865; became interested in Japanese prints and Chinese porcelains. Associated with Dante Gabriel Rossetti, and other Pre-Raphaelites. Exhibited: Salon des Beaux-Arts, Paris, 1867; American Section, Exposition Universelle de 1867, Paris; Royal Academy, 1872 (*Arrangement in Grey and Black No. 1: The Artist's Mother*). First one-man show, Flemish Gallery, London, 1874. Murals commissioned, Peacock Room, Frederick Leyland house, London, 1876 (now in Freer Gallery of Art, Smithsonian Institution, Washington, D.C.). Exhibited, Grosvenor Gallery, London, from 1877. Won libel suit against critic John Ruskin, 1878. Worked in Venice, 1879–80. Society of British Artists: member, 1884; president, 1886; voted out of office, 1888. Participated in first and second exhibition of Symbolist group, Les XX, Brussels, 1886, 1888. *Ten O'clock Lecture* published (London, Chatto & Windus), 1888. Légion d'honneur: chevalier, 1889; officier, 1891. Lived in Paris, 1892–1902. Directed own art school, Académie Carmen, Paris, 1898–1901. President, International Society of Sculptors, Painters, and Gravers, London, 1898–1903. Awarded Grand Prix for Painting and Etching, Exposition Universelle de 1900, Paris. Died London, July 17, 1903. Memorial exhibitions: Copley Hall, Boston, 1904; New Gallery, London, 1905; École des Beaux-Arts, Paris, 1905; The Metropolitan Museum of Art, New York, 1910. Retrospectives: The Arts Council Gallery, London, and M. Knoedler & Co., New York, 1960; The Art Institute of Chicago, and Munson-Williams-Proctor Institute, Utica, New York, 1968.

Girl in Black (Pouting Tom). 1902–3.
Oil on canvas, 20⅜ × 12¼ inches

PROVENANCE:
Private collection, France; Robert Dunthorne, London; Dowdeswell and Dowdeswell, London; M. Knoedler & Co., New York; Henry Harper Benedict, New York; Mrs. Henry Harper Benedict, New York; Sotheby & Co., London, Sale, November 21, 1962, no. 15, ill.

EXHIBITIONS:
New Gallery, London, February 22–April 15, 1905, *Memorial Exhibition of the Works of the Late James McNeill Whistler,* no. 6, p. 76

The Metropolitan Museum of Art, New York, March 15–May 31, 1910, *Paintings in Oil and Pastel by James A. McNeill Whistler,* no. 42

M. Knoedler & Co., New York, November 29–December 18, 1926, *Childhood in Art,* no. 28

REFERENCES:
Cary, Elizabeth Luther. *The Works of James McNeill Whistler,* New York, Moffat, Yard, 1913, no. 370, p. 212

Pennell, Joseph, and Pennell, Elizabeth Robins. *The Life of James McNeill Whistler,* London, and Philadelphia, William Heinemann, 1908

Pousette-Dart, Nathaniel. *James McNeill Whistler,* New York, Stokes, 1924, ill.

Sickert, Bernhard. *Whistler,* London, Duckworth, 1908, p. 172, no. 162

Unsigned. "'Childhood in Art:' A Selection of Paintings from the Exhibition Opening at the Knoedler Galleries Tomorrow," *The New York Times,* November 28, 1926, sec. 7, p. 3, ill.

———. "Exhibitions in New York: Childhood in Art: Knoedler Galleries," *Art News,* 25, December 4, 1926, p. 9

CHARLES WHITE (b. 1918)

Charles Wilbert White, born Chicago, April 2, 1918. Studied, School of The Art Institute of Chicago, 1937. Taught, South Side Art Center, Chicago, 1939–40. Included in: "Exhibition of Negro Artists of Chicago," Library of Congress (organized by Howard University), Washington, D.C., 1941; "American Negro Artists," Institute of Modern Art, Boston, and tour, 1943. Studied The Art Students League of New York, with Harry Sternberg, 1942. Received Julius Rosenwald Fellowship, 1942, 1943. Mural commissions: "History of the Negro Press," Negro Press, Chicago, 1943; "Contribution of the American Negro to Democracy," Hampton Institute, Virginia, 1943. Served, U.S. Army, 1944; hospitalized, 1944–47. Artist-in-residence, Howard University, 1945. Studied, Mexico City: Instituto Nacional de Bellas Artes, 1947; Taller de Gráfica (print workshop), with David Alfaro Siqueiros, and Leopoldo Mendez, 1947. One-man shows, New York: ACA Gallery, 1947–65; Hunter College, 1949. Received: The National Institute of Arts and Letters Grant, 1952; John Hay Whitney Fellowship, 1954. Moved to Los Angeles, 1956. One-man show, Heritage Gallery, Los Angeles, 1964. Co-founded Black Academy of Arts and Letters, New York, 1969. One-man shows: Forum Gallery, New York, 1970; Krannert Art Museum, University of Illinois, Champaign-Urbana, 1971. Has taught, Otis Art Institute, Los Angeles, since 1965. Lives in Altadena, California.

The Mother. 1952.
Sepia ink on paper, 28⅜ × 19 inches
Signed and dated l. r.: "Charles White '52"

PROVENANCE:
ACA Gallery, New York, 1953

EXHIBITIONS:
The Metropolitan Museum of Art, New York, December 5, 1952–January 25, 1953, *American Watercolors, Drawings and Prints,* pp. 8, 24, ill. p. 60

ACA Gallery, New York, February 9–28, 1953, *Charles White*

The Museum of the National Center of Afro-American Artists, Dorchester, Massachusetts, February 9–March 10, 1970, *Five Famous Black Artists,* cat., ill.

REFERENCES:
Loren, Erle. "Trial by Juries," *Art News,* 51, December 1952, p. 63

"In 1952 I returned from a lengthy stay in Europe. A trip that covered about a dozen countries, both the East and the West. The devastation and horror of World War II was still very much in evidence every place I visited. Such was the effect of this experience, I found it impossible to work during my stay. I could only react, think, absorb and re-evaluate. My values, my life-style, my socio-political philosophy and my art.

"On my return to the States, one of the first works I created was *The Mother.* To a degree it symbolizes the deep internal universal sorrow I saw, felt, and reacted to. Man's inhumanity to man.

"*The Mother* was a turning point in my conceptual approach. It triggered a direction that was far more personal and subjective than previously. A very simple drawing brought into focus the premise which my works are predicated on. Life and mankind must be wedded in dignity and beauty."

Statement by the artist, 1972

At the exhibition "American Watercolors, Drawings and Prints," 1952–53, *The Mother* received an Award for Excellence from The Metropolitan Museum of Art, New York.

JANE WILSON (b. 1924)

Born Seymour, Iowa, April 29, 1924. Studied, The University of Iowa, Iowa City, B.A., 1945, M.A., 1947; instructor in art history, 1947–49. Moved to New York, 1949. One-man shows: St. John's College, Annapolis, Maryland, 1951; Hansa Gallery, New York, 1953–57; Esther Stuttman Gallery, New York, 1958–59; Tibor de Nagy Gallery, New York, 1960–65. Included in: Whitney Annual, 1961, 1965, 1967; Corcoran Biennial, 1963. Received: Merrill Foundation Grant, 1963; Louis Comfort Tiffany Foundation Fellowship, 1967. One-man shows: Esther Bear Gallery, Santa Barbara, California, 1964; James Graham and Sons, New York, from 1968. Taught, Pratt Institute, Brooklyn, New York, 1967–69. Included in "The Artist and the American Landscape, 1908–1971," A. M. Sachs Gallery, New York, 1971–72. Lives in New York.

January: Tompkins Square. 1963.
Oil on canvas, 59¾ × 75⅛ inches
Signed l. r.: "Jane Wilson"

PROVENANCE:
Tibor de Nagy Gallery, New York, 1963

EXHIBITIONS:
Tibor de Nagy Gallery, New York, May 14–June 1, 1963, *Jane Wilson*

REFERENCES:
Unsigned. "Sold Out Art," *Life,* 55, September 20, 1963, colorplate p. 126

"I lived on Tompkins Square for ten years in all, but it was a good three years before the view across the street became internal enough to give back subject matter. I seemed to have absorbed it with early morning vacancy of mind, waiting at the window for the school bus. Winter was the most hypnotic time of the year because of the deep wet grays of the city, the bare trees always in some kind of motion at the top, the glare of the great

square sky over the park, and then, the upside-down brightness of the ground after a snow fall.

"I liked the enclosure of the park as a subject after having been involved in the on-and-on distances of landscape. Actually, cityscape, being so concerned with precisely limited depths, is a great deal closer to interior and still-life painting. I wanted to imply color rather than state it. I wanted to get at the color of the light *in* the city which is so entirely different from the light *around* the city.

"In trying to analyze what I was seeing and feeling, I found myself looking for a solidarity of verticals, horizontals, parallels and right angles, only to discover that they weren't there. Sidewalks sloped, streets arched, buildings leaned back, and have been settling slowly from their beginnings. The ground I stood on was not level, and the house I lived in was not immobile. Each thing had its own functional movement yielding an endless sequence of balances that were always transitory."

Statement by the artist, 1972

ISAAC WITKIN (b. 1936)

Born Johannesburg, South Africa, May 10, 1936. Moved to England, 1956. Studied, St. Martin's School of Art, London, with Anthony Caro, 1957–60. One-man show, Rowan Gallery, London, 1961. Assistant to Henry Moore, 1961–63. Taught, England: Maidstone College of Art, 1963; St. Martin's School of Art, 1963–65; Ravensbourne College of Art and Design, Bromley, 1964–65. Included in: "The New Generation," Whitechapel Art Gallery, London, 1965; 4ᵉ Biennale de Paris, 1965; Sonsbeek '66, Arnhem, The Netherlands, 1966; "Primary Structures," The Jewish Museum, New York, 1966. One-man shows: Robert Elkon Gallery, New York, from 1965; The Waddington Galleries, London, from 1966; University of Bridgeport, Connecticut, 1970. Retrospective, Robert Hull Fleming Museum, University of Vermont, Burlington, 1971. Artist-in-residence, Bennington College, Vermont, since 1965. Lives in Bennington.

Vermont IV (Spring). 1965.
Stainless steel and iron, 8 feet 9 inches × 6 feet 8¼ inches × 4 feet 2 inches

PROVENANCE:
Robert Elkon Gallery, New York, 1967

EXHIBITIONS:
Robert Elkon Gallery, New York, November 1–27, 1967, *Isaac Witkin*
Robert Hull Fleming Museum, University of Vermont, Burlington, July 15–September 15, 1971, *Isaac Witkin Retrospective 1958–1971*, no. 6, ill. p. 9

REFERENCES:
Brunelle, Al. "Reviews and Previews: Isaac Witkin," *Art News*, 66, December 1967, ill. p. 15
Kudielka, Robert. "New English Sculpture: Abschied vom Objekt," *Das Kunstwerk*, 22, October 1968, ill. p. 27

"The Vermont series are a group of four works done when I just arrived in America in 1965, and they are my first sculptures made in steel. Vermont was my first experience in living in the country, and I was much affected by the natural rhythms of the landscape and the violent changes of season. I think of these works as the 'four seasons.' There is in these four works a gradual unfolding of form as from a fist to an open hand In *Vermont IV (Spring)*, the elements have been fragmented from the previous pieces and reassembled in an open way, liberating the idea from the single form concept that closes in on itself. The form now opens up to interact with space and reaches outwards."

The artist, in *Isaac Witkin Retrospective 1958–1971*

WOLS (1913–1951)

Alfred Otto Wolfgang Schulze, born Berlin, May 27, 1913. Youth spent in Dresden. Studied music, and became an accomplished violinist; also studied photography, with Genga Jonas, 1931. Traveled to Berlin, to join Bauhaus, 1932; persuaded by László Moholy-Nagy to work independently. Settled in Paris, 1932; worked as photographer; taught German (to Alexander Calder, among others). Met Fernand Léger, Jean Arp, Alberto Giacometti. Drafted, 1933; took refuge in Spain; arrested and imprisoned for three months, 1935. Returned to Paris, 1935. Adopted the name Wols, 1937. Official photographer, Pavillon d'Élégance, Paris World's Fair, 1937. One-man show (photographs), Galerie Les Pléiades, Paris, 1937. Interned in French concentration camps, 1938–40; upon release, settled in Cassis, France; moved to Dieulefit, 1942; then to Paris, 1945. One-man shows, Paris: Galerie René Drouin, 1945, 1947; Galerie Nina Dausset, 1951. Included in Salon des Réalités Nouvelles, Paris, 1947. Died Champigny, France, September 1, 1951. One-man shows: Galerie Claude Bernard, Paris, 1958; Grace Borgenicht Gallery, New York, 1959; Galerie Europe, Paris, 1959–60; Gimpel Fils, London, 1960; Cordier & Warren Gallery, New York, 1962; Galerie Alexandre Iolas, Paris, 1965.

A Root (Une Racine). 1949.
Pen and ink and watercolor on paper, 7⅛ × 4½ inches
Signed l. r.: "Wols"

PROVENANCE:
Galerie Europe, Paris, 1962

Adversity of the Winds (Adversité des vents). 1950.
Watercolor on paper, 7⅛ × 6¼ inches
Signed l. r.: "Wols"

PROVENANCE:
Cordier & Warren Gallery, New York, 1962

EXHIBITIONS:
Cordier & Warren Gallery, New York, January 24–February 17, 1962, *Wols Watercolors*

FRITZ WOTRUBA (b. 1907)

Born Vienna, April 23, 1907. Worked as engraver, 1921–

24. Studied sculpture, Schule Anton Hanaks, Vienna, 1926. One-man show, Museum Folkwang, Essen, Germany, 1931. Associated with architect Joseph Hoffman; member, Wiener Werkstätte, Vienna, early 1930s. Included in Venice Biennale, 1932, 1934, 1936, 1950, 1952. Moved: to Zurich, 1934; to Paris, 1937; back to Switzerland, 1938–45; to Vienna, 1945. One-man shows: Venice Biennale, 1948; Musée National d'Art Moderne, Paris, 1948; Palais des Beaux-Arts, Brussels, 1951; Institute of Contemporary Art, Boston, 1955; Fine Arts Associates, New York, 1960; Galerie Claude Bernard, Paris, 1961; Museum am Ostwall, Dortmund, Germany, and tour, 1961–62; Marlborough-Gerson Gallery, New York, 1964; Haus der Kunst, Munich, and tour, 1967–68; Nationalgalerie, Prague, 1969. Has taught, Akademie der Bildenden Künste, Vienna, since 1946. Lives in Vienna.

Figure with Raised Arms. 1956–57.
Bronze (edition of two), 75¼ × 19¼ × 15 inches
Markings: back l. r. "FW"

PROVENANCE:
Otto Gerson Gallery, New York, 1961

EXHIBITIONS:
The Solomon R. Guggenheim Museum, New York, October 3, 1962–January 6, 1963, *Modern Sculpture from the Joseph H. Hirshhorn Collection*, no. 437, ill. p. 70

REFERENCES:
Arnason, H. Harvard. *History of Modern Art*, New York, Abrams, 1968, p. 531, ill. p. 530
Huyghe, René, ed. *Larousse Encyclopedia of Modern Art*, New York, Prometheus, 1965, p. 382, ill. 1057, p. 381
Read, Herbert. *A Concise History of Modern Sculpture*, New York, Praeger, 1964, no. 219, p. 305, ill. p. 202
——— (ed.). *Encyclopedia of the Arts*, London, Thames and Hudson, 1966, ill. p. 953

PAUL WUNDERLICH (b. 1927)

Born Berlin, March 10, 1927. Studied, Staatliche Landeskunstschule, Hamburg, 1947–51; taught graphics there, 1951–60. One-man shows: Overbeck-Gesellschaft, Lübeck, Germany, 1949; Künstlerclub, Hamburg, 1955; Dragonerstall, Hamburg, 1960; Galerie Niepel, Düsseldorf, 1961–65; The Print Club, Philadelphia, 1962 (Collins Prize), 1967. Included in: 1ᵉ and 3ᵉ Biennale de Paris, 1959, 1961; "German Prints at Mid-Century," Philadelphia Museum of Art, 1963; Documenta III, Kassel, 1964; "Phantastische Kunst in Deutschland," Kunstverein, Hanover, 1968; "Seven German Painters," II Triennale of Contemporary World Art, New Delhi, 1971. Lived in Paris, 1960–63. One-man shows: The Auckland City Art Gallery, New Zealand, 1967; Redfern Gallery, London, 1968; Staempfli Gallery, New York, 1970; Galleria Schwarz, Milan, 1971–72. Awarded Kamakura Museum Prize for Graphics, 9th Tokyo Biennale, 1968. Has taught, Staatliche Hochschule für Bildende Künste, Hamburg, since 1963. Lives in Hamburg.

Angel with Forefinger (Der Engel mit dem zeigefinger). 1967.
Oil on canvas, 63¾ × 51¼ inches
Signed and dated l. r.: "Paul Wunderlich 67"

PROVENANCE:
Redfern Gallery, London, 1968

EXHIBITIONS:
Redfern Gallery, London, May 14–June 14, 1968, *Paul Wunderlich*, cat.

Chair-man. 1968.
Chromed metal (edition of five), 53¼ × 17¼ × 18 inches

PROVENANCE:
Redfern Gallery, London, 1968

ANDREW WYETH (b. 1917)

Andrew Newell Wyeth, born Chadds Ford, Pennsylvania, July 21, 1917; son and pupil of noted illustrator N. C. Wyeth (1882–1963). First one-man show, Macbeth Gallery, New York, 1937. One-man shows: Doll & Richards Gallery, Boston, 1938–46; Macbeth Gallery, 1938–52; Currier Gallery of Art, Manchester, New Hampshire, 1951; M. H. de Young Memorial Museum, San Francisco, 1956; Santa Barbara Museum of Art, California, 1956; Wilmington Society of the Fine Arts, Delaware Art Center, 1957; M. Knoedler & Co., New York, 1958; Massachusetts Institute of Technology, Cambridge, 1960; Albright-Knox Art Gallery, Buffalo, New York, 1962. Included in: Pennsylvania Academy Annual, 1938–65; "American Realists and Magic Realists," The Museum of Modern Art, New York, 1943; Whitney Annual, 1946–67. The American Academy of Arts and Letters: Award of Merit Medal, 1947; member, 1955. The National Institute of Arts and Letters: member, 1950; Gold Medal for Painting, 1965. Retrospectives: M. Knoedler & Co., 1953; The Pennsylvania Academy of the Fine Arts, Philadelphia, and tour, 1966–67. One-man shows: Museum of Fine Arts, Boston, 1970; The White House, Washington, D.C., 1970. Wyeth Gallery, Brandywine River Museum, Chadds Ford, inaugurated, 1971. Since childhood, has lived in Chadds Ford, and has summered in Cushing, Maine.

Rail Fence. 1950.
Watercolor on paper, 21 × 29 inches
Signed l. r.: "Andrew Wyeth"

PROVENANCE:
Macbeth Gallery, New York, 1953

EXHIBITIONS:
Greenwich Gallery, New York, May 1–June 30, 1957, *Fifty Contemporary American Artists*, no. 49, ill. p. 109
American Federation of Arts tour, 1962–65, *Paintings from the Joseph H. Hirshhorn Foundation Collection: A View of the Protean Century*, no. 74

Waiting for McGinley. 1962.
Watercolor on paper, 14¾ × 21¾ inches
Signed u. r.: "Andrew Wyeth"

PROVENANCE:
M. Knoedler & Co., 1962

EXHIBITIONS:
Albright-Knox Art Gallery, Buffalo, New York, November 2–December 9, 1962, *Andrew Wyeth*, no. 98
Temple B'nai Sholom, Rockville Center, New York, March 31–April 3, 1963, *4th Annual Art Exhibit*, no. 39
The Pennsylvania Academy of the Fine Arts, Philadelphia, October 8–November 27, 1966, *Andrew Wyeth Retrospective*, no. 181; toured to The Baltimore Museum of Art, December 13–January 22, 1967; Whitney Museum of American Art, New York, February 14–April 2; The Art Institute of Chicago, April 21–June 4

REFERENCES:
Clifton, Jack. *The Eye of the Artist*, Westport, Connecticut, Fletcher, forthcoming, ill.

JEAN XCERON (1890–1967)

Born Isari Likosouras, Greece, February 24, 1890. Emigrated to the U.S., 1904. Studied, The Corcoran School of Art, Washington, D.C., 1910–16. Lived in Paris, 1927–37. Art critic: *Chicago Tribune*, Paris edition, 1929–30; *Boston Evening Transcript*, 1930. One-man shows: Galerie de France, Paris, 1931; Galerie Percier, Paris, 1933; Galerie Pierre, 1934; Garland Gallery, New York, 1935; Nierendorf Gallery, New York, 1938. Settled in New York, 1937. Fifteen paintings acquired by Hilla von Rebay for Guggenheim Foundation, New York, 1938–51. Included in "Art of Tomorrow," The Museum of Non-Objective Painting, New York, 1939; staff member of the Museum, from 1939. Member and exhibitor: American Abstract Artists, 1940–65; Federation of Modern Painters and Sculptors, 1944–65. WPA Federal Art Project, Mural Division, New York, 1941–42. Included in: Carnegie Annual, 1941–44, 1946–50; Whitney Annual, 1946–56, 1963–64; "The Classic Tradition in Contemporary Art," Walker Art Center, Minneapolis, 1953; "Cézanne and Structure in Modern Painting," The Solomon R. Guggenheim Museum, New York, 1963. Retrospective, University of New Mexico, Albuquerque, and tour, 1948–49. One-man shows, New York: Sidney Janis Gallery, 1950; Rose Fried Gallery, 1955–63. Retrospective, The Solomon R. Guggenheim Museum, and tour, 1965. Died New York, March 29, 1967.

Still Life No. 116. 1934.
Oil on canvas, 23¼ × 28¼ inches
Signed l. l.: "Xceron"

PROVENANCE:
The artist, New York, 1963

EXHIBITIONS:
Galerie Pierre, Paris, July 2–10, 1934, *Jean Xceron*

JACK BUTLER YEATS (1871–1957)

Born London, August 29, 1871; son of portrait painter John Butler Yeats (1839–1922); younger brother of poet William Butler Yeats (1865–1939). Lived with grandparents, County Sligo, northwestern Eire, 1879–87. Studied, London: South Kensington School of Art; Chiswick Art School; Westminster School of Art, 1887–88. Illustrator, *Vegetarian Messenger*, London, and Manchester, England, 1888–92; poster artist, Manchester, 1892–93. Included in Royal Hibernian Academy of Arts Annual, Dublin, 1895. First one-man show (watercolors), Clifford Gallery, London, 1897. Settled in Ireland, 1900. One-man show, Clausen Galleries, New York, 1904. Included in: Royal Hibernian Academy Annual, 1911, 1915–50; Salon des Indépendants, Paris, 1912; the Armory Show, 1913; Society of Independent Artists Annual 1921–26; Carnegie International, 1925, 1931, 1934–39. One-man shows: Arthur Tooth & Sons, London, 1926, 1928; Ferargil Galleries, New York, 1932; The Waddington Galleries, London, 1943–67; National College of Art, Dublin, 1945; Wildenstein & Co., London, 1946; Temple Newsam House, Leeds, England, and tour, 1948; Institute of Contemporary Art, Boston, and tour, 1951–52. Officier, Légion d'honneur, 1950. Died Dublin, March 28, 1957. Retrospectives: Venice Biennale, 1962; The New Gallery, Hayden Library, Massachusetts Institute of Technology, Cambridge, 1965; National Gallery of Ireland, Dublin, and international tour, 1971–72.

Tales of California Long Ago. 1953.
Oil on canvas, 36 × 48 inches
Signed l. l.: "Jack B. Yeats"

PROVENANCE:
The Waddington Galleries, London, 1961

EXHIBITIONS:
The Waddington Galleries, London, March 6–April 3, 1958, *Later Works by Jack B. Yeats*, no. 10
Willard Gallery, New York, March 6–31, 1962, *Jack B. Yeats*, no. 16; toured to Felix Landau Gallery, Los Angeles, April 23–May 12, no. 16
The New Gallery, Hayden Library, Massachusetts Institute of Technology, Cambridge, January 11–February 17, 1965, *Jack Butler Yeats*, no. 39

REFERENCES:
O'Doherty, Brian. "Art: Yeats the Painter," *The New York Times*, March 8, 1962, p. 28

JACK YOUNGERMAN (b. 1926)

Born Webster Groves, Missouri, March 25, 1926. Moved with family to Louisville, Kentucky, 1928. Studied: University of North Carolina at Chapel Hill, 1944–46; University of Missouri, Columbia, B.A., 1947; École des Beaux-Arts, Paris, 1947–48. Lived in Paris, 1947–56. Exhibited, Paris: "Les Mains Éblouies," Galerie Maeght, 1950; "Sept," Galerie Denise René, 1952. One-man show, Galerie Arnaud, Paris, 1951. Made three trips to Middle East, 1952–56. Designed sets and costumes: Georges Schehade's *Histoire de Vasco*, Paris, 1956; Jean Genet's *Deathwatch*, New York, 1958. Moved to New York, 1956. One-man shows, Betty Parsons Gallery, New York, 1958–68. Included in: Pittsburgh International, 1958, 1961, 1967, 1970; "Sixteen Americans," The Museum of

Modern Art, New York, 1959; Corcoran Biennial, 1959, 1962, 1963, 1967; "American Abstract Expressionists and Imagists," and "Systemic Painting," The Solomon R. Guggenheim Museum, New York, 1961, 1966; "Large Scale American Paintings," The Jewish Museum, New York, 1967; Whitney Annual, 1967, 1969. One-man shows: Massachusetts Institute of Technology, Cambridge, 1966; The Phillips Collection, Washington, D.C., 1968; The Pace Gallery, New York, 1971, 1972. Lives in New York.

September White. 1967.
 Acrylic on canvas, 9 feet x 7 feet 3 inches
 Signed and dated on back: "Youngerman 1967"

PROVENANCE:
Betty Parsons Gallery, New York, 1967

EXHIBITIONS:
Betty Parsons Gallery, New York, October 24–November 11, 1967, *Jack Youngerman*

ADJA YUNKERS (b. 1900)

Born Riga, Latvia, July 15, 1900. Moved to St. Petersburg, Russia, 1901. Studied, Art Academy, Petrograd, 1914–16. Served, Russian Army, 1916–18. Moved to Berlin, then Hamburg, 1919. First one-man show, Galerie Maria Kunde, Hamburg, 1921. Traveled in Italy, 1922–23. Lived in: Dresden, 1924; Havana, 1924–28; Paris, 1928–38; Stockholm, 1938–47. Edited and published magazines *ARS*, and *Creation*, Stockholm, 1942–45. One-man show, New School for Social Research, New York, 1946. Settled in New York, 1947. Taught: New School for Social Research, intermittently, 1947–56; University of New Mexico, Albuquerque, summers, 1948, 1949. One-man shows: Philadelphia Art Alliance, 1948; The Corcoran Gallery of Art, Washington, D.C., 1950; Kleemann Galleries, New York, 1950; Pasadena Art Museum, California, 1951; Grace Borgenicht Gallery, New York, 1952, 1953, 1955; Rose Fried Gallery, New York, 1957, 1958, 1968; André Emmerich Gallery, New York, 1959, 1961, 1963. Received: Guggenheim Foundation Fellowship, 1949, 1954; Ford Foundation Grant, 1959. Lived in: Corrales, New Mexico, 1950–52; Rome, 1954–56. Taught, New York: The Cooper Union for the Advancement of Science and Art, 1956–59, 1962–67; Barnard College, 1969–72. Included in: Whitney Annual, 1958, 1959, 1961, 1963, 1967; Pittsburgh International, 1958, 1961; "American Abstract Expressionists and Imagists," The Solomon R. Guggenheim Museum, New York, 1961. One-man shows: The Baltimore Museum of Art, 1960; Stedelijk Museum, Amsterdam, 1962; The Cleveland Museum of Art, 1966; The Brooklyn Museum, New York, 1969; Whitney Museum of American Art, New York, 1972. Lives in New York.

Tarassa X. 1958.
 Pastel on paper, 44 × 31 inches
 Signed and dated l. l.: "Yunkers 58"

PROVENANCE:
Rose Fried Gallery, New York; The New York Society for Ethical Culture, 1958

EXHIBITIONS:
Rose Fried Gallery, New York, April 1–May 3, 1958, *Adja Yunkers*
The New York Society for Ethical Culture, November 12, 1958, *First Annual Art Exhibition and Sale*, cat.
Arts Center, Fieldston School, Riverdale, New York, May 8–12, 1959, *Third Annual Art Exhibition*
The Baltimore Museum of Art, April 2–May 15, 1960, *Adja Yunkers: Recent Paintings*, cat.
Stedelijk Museum, Amsterdam, May 4–June 4, 1962, *Adja Yunkers*, no. 2

REFERENCES:
Johnson, Una E. *20th Century Drawings, Part II: 1940 to the Present*, New York, Shorewood, 1964, p. 85, colorplate 53

YVARAL (b. 1934)

Jean-Pierre Vasarely, born Paris, January 25, 1934; son of Victor Vasarely. Studied, École des Arts Appliqués, Paris. Exhibited, Paris: Salon des Réalités Nouvelles, 1955–57; Galerie Denise René, 1958. Co-founded Groupe de Recherche d'Art Visuel, Paris, with Julio Le Parc, François Morellet, Francisco Sobrino, Joël Stein, 1960; exhibited with group, in their studio, Paris, 1960. Included in: "Structures," Galerie Denise René, 1961; "L'Instabilité: Groupe de Recherche d'Art Visuel—Paris," The Contemporaries, New York, 1962; "Nove Tendencije 2 and 3," Galerije Grade Zagreba, Zagreb, Yugoslavia, 1963, 1965. Exhibited with Le Parc, and Sobrino, Galerie Aujourd'hui, Brussels, 1963. Included in: 3e–5e Biennale de Paris, 1963 (first prize), 1965, 1967; Documenta III, Kassel, 1964; "Mouvement II," Galerie Denise René, 1964; "Kinetic and Optic Art Today," and "Plus by Minus: Today's Half-Century," Albright-Knox Art Gallery, Buffalo, New York, 1965, 1968; "The Responsive Eye," The Museum of Modern Art, New York, and tour, 1965–66; "Lumière et Mouvement, Art Cinétique à Paris," Musée d'Art Moderne de la Ville de Paris, 1967. One-man shows: Howard Wise Gallery, New York, 1966; Galerie Rolf Ricke, Kassel, 1966; Galerie Denise René, 1969, 1972. With Vasarely, designed sets, Roland Petit's ballet *Kraanerg*, Ottawa, 1969. Awarded Gold Medal, II Triennale of Contemporary World Art, New Delhi, 1971. Lives in Paris.

Acceleration No. 18, Series B. 1962.
 Wood and plastic, 24½ × 23¼ × 3¼ inches
 Markings: back "Yvaral"

PROVENANCE:
The Contemporaries, New York, 1963

EXHIBITIONS:
The Contemporaries, New York, November 27–December 15, 1962, *L'Instabilité: Groupe de Recherche d'Art Visuel—Paris*

REFERENCES:
Judd, Donald. "In the Galleries: Groupe de Recherche d'Art Visuel," *Arts*, 37, February 1963, p. 45
Rickey, George. "The New Tendency (Nouvelle Ten-

dance—Recherche Continuelle)," *Art Journal*, 23, Summer 1964, ill. p. 272

OSSIP ZADKINE (1890–1967)

Born Smolensk, Russia, July 14, 1890. Sent to live with relatives, Sunderland, England, 1905; attended evening classes, local art school. Moved to London, 1906; worked as wood-carver. Studied, London, evenings: The Polytechnic, Regent Street, 1907; Central School of Arts and Crafts, 1908. Settled in Paris, 1909; studied, briefly, École des Beaux-Arts, with Jean-Antoine Injalbert. Met Guillaume Apollinaire, Alexander Archipenko, Jacques Lipchitz, Amedeo Modigliani, Henri Laurens. Included in: Salon des Indépendants, Paris, from 1911; Salon d'Automne, Paris, from 1913; Neue Sezession, Berlin, 1914; Allied Artists Exhibition, London, 1914. Served, French Army, 1915–18. One-man shows: Galerie Le Centaure, Brussels, 1919, 1924, 1927; Galerie La Licorne, Paris, 1920; Galerie Barbazanges, Paris, 1921, 1926; Galerie Schwartzenberg, Brussels, 1923, 1924; Galerie Druet, Paris, 1927; The Arts Club of Chicago, 1931, 1933, 1936; Palais des Beaux-Arts, Brussels, 1933, 1948; Whitworth Art Gallery, University of Manchester, England, 1935; Brummer Gallery, New York, 1937. Included in Venice Biennale, 1932, 1938. Moved to New York, 1941. One-man shows, New York: Wildenstein & Co., 1941; Buchholz Gallery, 1943. Taught, The Art Students League of New York, c. 1941–45. Included in "Artists in Exile," Pierre Matisse Gallery, New York, 1942. Returned to Paris, 1945. Conducted classes in his own atelier, and Académie de la Grande Chaumière; students included Kenneth Noland, Jules Olitski, Richard Stankiewicz, Harold Tovish. One-man shows: Stedelijk Museum, Amsterdam, 1948; Museum Boymans-van Beuningen, Rotterdam, The Netherlands, 1949; Gemeentemuseum, Arnhem, The Netherlands, 1954, 1962; The National Gallery of Canada, Ottawa, and tour, 1956–57; Musée des Beaux-Arts, Lyons, France, 1959; Städtische Kunsthalle, Mannheim, Germany, and tour, 1960. Retrospectives: Musée National d'Art Moderne, Paris, 1949; Maison de la Pensée Française, Paris, 1958; The Tate Gallery, London, and tour, 1961; Casino Communal, Knokke-Le-Zoute, Belgium, 1963. Awarded: Grand Prize for Sculpture, Venice Biennale, 1950; Grand Prix de Sculpture de la Ville de Paris, 1960. *The Destroyed City* commissioned as war memorial by city of Rotterdam, 1951; inaugurated, 1953. Died Paris, November 25, 1967. Retrospective, Hirschl & Adler Galleries, New York, 1971.

Mother and Child (Forms and Lights). 1918.
 Marble, 23½ × 16½ × 7½ inches
 Markings: l. r. side "Zadkine"

PROVENANCE:
G. P. Dudley Wallis, Manchester, England; Sotheby & Co., London, Sale, April 18, 1951, no. 103; Gimpel Fils, London, 1957

EXHIBITIONS:
Whitworth Art Gallery, University of Manchester, England, 1935, *Loan Exhibition of Paintings and Sculpture by Ossip Zadkine*
The Detroit Institute of Arts, and tour, 1959–60, *Sculpture in Our Time*, no. 208
The Solomon R. Guggenheim Museum, New York, October 3, 1962–January 6, 1963, *Modern Sculpture from the Joseph H. Hirshhorn Collection*, no. 438, ill. p. 72

REFERENCES:
Arnason, H. Harvard. *History of Modern Art*, New York, Abrams, 1968, p. 193, ill. 342
Goldwater, Robert. *What Is Modern Sculpture?* New York, The Museum of Modern Art, 1969, p. 146, ill. p. 47
Jianou, Ionel. *Zadkine*, Paris, Arted, 1964, p. 78, plate 39
Licht, Fred. *Sculpture: 19th and 20th Centuries*, Greenwich, Connecticut, New York Graphic Society, 1967, plate 237

JACK ZAJAC (b. 1929)

Born Youngstown, Ohio, December 13, 1929. Studied, Scripps College, Claremont, California, 1949–53. Received California State Scholarship in Painting, 1950. One-man shows, California: Pasadena Art Museum, 1951; Felix Landau Gallery, Los Angeles, 1951–70; Santa Barbara Museum of Art, 1953. Included in: Contemporary American Annual, University of Illinois, Champaign-Urbana, 1952, 1961, 1965, 1969; III São Paulo Bienal, 1955; Pittsburgh International, 1955, 1958, 1964; Festival dei Due Mondi, Spoleto, Italy, 1958; Whitney Annual, 1959, 1960. Received: Rome Prize Fellowship in Painting, American Academy in Rome, 1954, 1956, 1957; The National Institute of Arts and Letters Grant, 1958; Guggenheim Foundation Fellowship, 1959–60. One-man shows: The Downtown Gallery, New York, 1960; California Palace of the Legion of Honor, San Francisco, 1963; Pavilion Gallery, Balboa, California, 1965; Tyler School of Art, Temple University Abroad, Rome, 1968; Hopkins Center Art Galleries, Dartmouth College, Hanover, New Hampshire, 1970; Forum Gallery, New York, 1971; Galleria d'Arte Margherita, Rome, 1972. Artist-in-residence: American Academy in Rome, 1968; Dartmouth College, 1970. Lives in Rome, and in Jackson, Wyoming.

Big Skull II. 1964.
 Bronze (1/4), 30 × 42 × 20 inches

PROVENANCE:
Felix Landau Gallery, Los Angeles, 1964

EXHIBITIONS:
Felix Landau Gallery, Los Angeles, November 16–December 5, 1964, *Jack Zajac: Recent Sculpture*, no. 2
Forum Gallery, New York, April 17–May 7, 1971, *Jack Zajac Sculpture*, no. 12, ill.

Falling Water II. 1965–67.
 Bronze (2/4), 94 × 29 × 20 inches

PROVENANCE:
The artist, Rome, 1968

LAURA ZIEGLER (b. 1927)

Born Columbus, Ohio, March 16, 1927. Studied: Columbus Art School, 1942–43; Ohio State University, Columbus, B.F.A., 1943–46; Cranbrook Academy of Art, Bloomfield Hills, Michigan, summer, 1948. Taught, sculpture, Columbus Art School, 1948–49. Received Fulbright Grant, 1949; traveled to Italy. Returned to the U.S., 1951. Sculpture commissions, Columbus: cross, St. Stephen's Episcopal Church, 1953; *Burning Bush*, facade relief, Temple Israel, 1958. Moved to Rome, 1954. One-man shows: Galleria Schneider, Rome, 1955; Duveen-Graham Gallery, New York, 1956; Institute of Contemporary Art, Boston, 1958; M. Knoedler & Co., New York, 1958. Included in: Venice Biennale, 1956, 1958; "Contemporary Sculpture 1961," Cincinnati Art Museum, Ohio, and John Herron Art Institute, Indianapolis, Indiana, 1961. One-man shows: The Columbus Gallery of Fine Arts, 1967; Galleria Bruno Vangelisti, Lucca, Italy, 1968. Lives in Rome, and in Lucca.

Eve. 1958.
 Bronze, 70 × 23½ × 24 inches
 Markings: l. r. side "L. Ziegler 1958"

PROVENANCE:
The artist, Rome, 1962

EXHIBITIONS:
M. Knoedler & Co., New York, September 15–October 10, 1959, *Sculpture by Laura Ziegler*, no. 21
Cincinnati Art Museum, Ohio, January 13–February 5, 1961, *Contemporary Sculpture, 1961*, no. 52, ill.; toured to John Herron Art Institute, Indianapolis, Indiana, February 12–March 12

REFERENCES:
Tillim, Sidney. "In the Galleries: Laura Ziegler," *Arts*, 34, October 1959, p. 62, ill.

WILFRID ZOGBAUM (1915–1965)

Born Newport, Rhode Island, September 10, 1915. Studied: Yale University, New Haven, Connecticut, 1933–34; with John Sloan, New York, 1934–35; Hans Hofmann School of Fine Art, New York, and Provincetown, Massachusetts, 1935–37. Received Guggenheim Foundation Fellowship, 1937. Served, U.S. Army, 1941–42. Worked as photographer, mid-1940s; shared studio with Hans Hofmann. One-man shows (paintings): Alexandre Iolas Gallery, New York, 1952; Stable Gallery, New York, 1954, 1958. First sculptures, 1954. Taught: University of California, Berkeley, 1957, 1961–63; University of Minnesota, Minneapolis, 1958; Pratt Institute, Brooklyn, New York, 1960–61; Southern Illinois University, Carbondale, 1961. One-man shows (sculpture): Staempfli Gallery, New York, 1960; Obelisk Gallery, Washington, D.C., 1961, 1962; University Art Museum, University of California, Berkeley, 1962; Dilexi Gallery, San Francisco, 1962, 1963, 1966; Grace Borgenicht Gallery, New York, 1963, 1965. Included in: Whitney Annual, 1960–64; Pittsburgh International, 1962. Died New York, January 7, 1965. One-man show, Hansen-Fuller Gallery, San Francisco, 1969. Retrospective, San Francisco Museum of Art, 1973.

Bird in 25 Parts. 1962.
 Painted steel, 6 feet 10 inches × 8 feet 6 inches × 4 feet 8 inches

PROVENANCE:
Grace Borgenicht Gallery, New York, 1966

EXHIBITIONS:
Grace Borgenicht Gallery, New York, March 3–23, 1963, *Wilfrid Zogbaum*
Musée Rodin, Paris, June 22–October 15, 1965, *États-Unis: Sculptures du XXe Siècle* (The Museum of Modern Art, New York, International Circulating Exhibition), no. 69; toured to Staatliche Hochschule für Bildende Künste, Berlin, and Staatliche Kunsthalle, Baden-Baden, Germany

REFERENCES:
Ventura, Anita. "Field Day for Sculptors," *Arts Magazine*, 38, October 1963, p. 64, ill. p. 63

WILLIAM ZORACH (1887–1966)

Born Eurburg, Lithuania, February 28, 1887. Emigrated with family to Ohio, 1891. Worked for Morgan Lithograph Company, Cleveland. Studied: Cleveland School of Art, 1902–6; The Art Students League of New York, and National Academy of Design, New York, 1907–10; La Palette, Paris, with Jacques-Émile Blanche, 1910–11. Included in Salon d'Automne, Paris, 1911. Returned to Cleveland; worked as commercial lithographer, 1911. First one-man exhibition, Taylor Gallery, Cleveland, 1912. Moved to New York, 1912. Included in: the Armory Show, 1913; "The Forum Exhibition of Modern American Painters," The Anderson Galleries, New York, 1916; Society of Independent Artists Annual, 1917. Exhibited with wife, Marguerite Thompson Zorach: The Daniel Gallery, New York, 1915–18; The Dayton Art Institute, Ohio, 1922. First wood sculptures, 1917; stopped painting, 1922. One-man shows, New York: C. W. Kraushaar Galleries, 1924, 1928; The Downtown Gallery, from 1931. Commission, Schwartzenbach Silk Manufacturing Company, New York, 1925. Taught, New York: The Art Students League, from 1929; Columbia University, summers, 1936–39, springs, 1950–51. Included in "Painting and Sculpture by Living Americans," The Museum of Modern Art, New York, 1930–31. Awarded Logan Medal, International Watercolor Exhibition, The Art Institute of Chicago, 1931–32. Commissions: Radio City Music Hall, New York, 1932; U.S. Post Office, Benjamin Franklin Station, Washington, D.C., 1937; Mayo Clinic, Rochester, Minnesota, 1954; Municipal Court Building, New York, 1958. Retrospectives: The Art Students League, 1950, 1969; Whitney Museum of American Art, New York, and tour, 1959–60. The National Institute of Arts and Letters: vice-president, 1958; Gold Medal for Sculpture, 1961. Included in: Pittsburgh International, 1958, 1961, 1964; "Roots of Abstract Art in America 1910–1930," National Collection of Fine Arts, Smithsonian Institution, Washington, D.C., 1965. Died Bath, Maine, November 15,

1966. Retrospective, Bernard Danenberg Galleries, New York, 1970.

The Spirit of Silk. 1925.
Bronze (edition of three), 20½ × 4⅛ × 4⅛ inches
Markings: back l. c. "Wm. Zorach 1925"

PROVENANCE:
G. Contemporary Paintings, Buffalo, New York, 1961

According to the artist's son, Tessim, this figure is cast from one of three figures that were part of a clock on the facade of the Schwartzenbach Silk Manufacturing Company Building in New York City. Mr. Schwartzenbach, a successful, temperamental, and somewhat whimsical Swiss businessman, personally commissioned the original work. At noon each day, when the dwarf struck his anvil and the magician touched his wand to the door, *The Spirit of Silk* would emerge from the clock.

Setting Hen. 1946.
Maine granite, 14¼ × 16 × 13 inches

PROVENANCE:
The Downtown Gallery, New York, 1957

EXHIBITIONS:
Ten Thirty Gallery, Cleveland, May 1948, *William Zorach*
The Detroit Institute of Arts, 1959, *Sculpture in Our Time*, no. 212
The Solomon R. Guggenheim Museum, New York, October 3, 1962–January 6, 1963, *Modern Sculpture from the Joseph H. Hirshhorn Collection*, no. 443, ill. p. 170

REFERENCES:
Baur, John I. H. *William Zorach*, New York, Praeger, 1959, ill. 58

Schnier, Jacques. *Sculpture in Modern America*, Berkeley, and Los Angeles, University of California, 1948, plate 84

Eve. 1951.
Pink granite, 26 × 7¾ × 7 inches
Markings: back of base "ZORACH"
l. r. side "ZORACH"

PROVENANCE:
The Downtown Gallery, New York, 1957

EXHIBITIONS:
The Downtown Gallery, New York, October 2–27, 1951, *26th Annual Exhibition*, no. 28
The Downtown Gallery, New York, April 9–May 4, 1957, *Spring Exhibition*
The Detroit Institute of Arts, and tour, 1959–60, *Sculpture in Our Time*, no. 213, ill. p. 96
The Solomon R. Guggenheim Museum, New York, October 3, 1962–January 6, 1963, *Modern Sculpture from the Joseph H. Hirshhorn Collection*, no. 444, ill. p. 170
Joseloff Gallery, University of Hartford, West Hartford, Connecticut, November 8–December 4, 1964, *The Arts in Society*, no. 74

REFERENCES:
Baur, John I. H. *William Zorach*, New York, Praeger, 1959, ill. 72
Bruening, Margaret. "Birthday Downtown," *Art Digest*, 26, October 15, 1951, ill. p. 17
Burrows, Carlyle. "Art Exhibition Notes," *New York Herald Tribune*, April 20, 1957
Porter, Fairfield. "Reviews and Previews: Contemporary Americans," *Art News*, 50, October 1951, p. 45

LARRY ZOX (b. 1936)

Lawrence Ivan Zox, born Des Moines, Iowa, May 31, 1936. Studied: University of Oklahoma, Norman, 1955–57; Drake University, Des Moines, 1957–58; Des Moines Art Center, with George Grosz, summer, 1957. Taught: Cornell University, Ithaca, New York, 1961; Juniata College, Huntingdon, Pennsylvania, 1964. One-man shows: The American Gallery, New York, 1962; Kornblee Gallery, New York, 1964, 1966, 1970; Galerie Rolf Ricke, Cologne, 1968; Colgate University, Hamilton, New York, 1968; Dartmouth College, Hanover, New Hampshire, 1968. Included in: Whitney Annual, 1965–72; "Systemic Painting," The Solomon R. Guggenheim Museum, New York, 1966; Expo '67, Montreal, 1967; I Triennale of Contemporary World Art, New Delhi, 1968; Whitney Biennial, 1973. Received: Guggenheim Foundation Fellowship, 1967; National Council on the Arts Grant, 1969. Taught: University of North Carolina at Chapel Hill, 1967; The School of Visual Arts, New York, from 1967; Dartmouth College, 1969; Des Moines Art Center, and Drake University, summer, 1971. One-man shows: Akron Art Institute, Ohio, 1971; André Emmerich Gallery, New York, 1973. Lives in New York.

Diamond Drill Series—Trobriand. 1967.
Acrylic and epoxy on canvas, 9 feet 4¼ inches × 6 feet 8 inches

PROVENANCE:
Kornblee Gallery, New York, 1968

EXHIBITIONS:
Kornblee Gallery, New York, January 27–February 22, 1968, *Larry Zox*

CORRECTIONS TO THE CATALOGUE

Page 668 Bourdelle, *Head of Beethoven with Architecture* and Study for *Monument to Daumier*, artist's monogram should be:

⟡⟡ not ⟡⟡△

Page 686 Dubuffet, *Masks*, should be: *Robert Polguère* not *Polgure*
Markings should read: Robert Polguere not Polguère

Duchamp-Villon, *Horse: (Le Cheval)* not *(Le Chevel)*

Page 717 Manzù, *Young Girl on a Chair*, Feldman references: *Art as Image and Idea*, p. 151, ill. p. 152 not p. 140, ill. p. 139

Varieties of Visual Experience, p. 140, ill. p. 139 not p. 184, ill.

Page 726 Moore, commentary following *Three-Piece Reclining Figure No. 2: Bridge Prop*, should read: The artist, in Hedgecoe and Moore, p. 404 not The artists

Page 728 Nadelman, *Classical Figure*, dimensions: 34¾ × 15⅜ × 13⅝″ not 13⅝″

Page 757 Warhol, *Marilyn Monroe's Lips*: Left panel 82⅞ × 80¾″ not 80¾″

Index of Works

Acknowledgments

THIS, THE FIRST PUBLICATION of The Hirshhorn Museum and Sculpture Garden, has been made possible through the cooperation and assistance of many individuals. We have tried to include them all in these acknowledgments, and we apologize to those we may have inadvertently failed to mention.

We are grateful to Mr. and Mrs. Joseph H. Hirshhorn for responding generously to our repeated inquiries regarding their recollections of the artists and their works.

To the Smithsonian "family" we are indebted for the guidance and support which made this arduous task more of a celebration than a chore, and especially to Secretary S. Dillon Ripley, for his inspiring leadership as well as for his perceptive Foreword to this volume. Charles Blitzer, Assistant Secretary for History and Art, deserves a special mention for his wise guidance and his interest in the scholarly purposes of this book. The assistance of the Board of Trustees of The Hirshhorn Museum and Sculpture Garden has been unstinting and invaluable.

The participation of the six scholars whose essays appear in the volume is warmly acknowledged. Special thanks are due to the artists who patiently responded to research queries or contributed statements about their works.

Among the many individuals—scholars, former owners, heirs of the artists, and those in museum, library, and gallery positions—who have freely provided pertinent information, we wish to cite: Sally Avery; Hildegard Bachert; Philip C. Beam; Richard Bellamy; Bernard Black; Ruth Bowman; Erica Brausen; Rosalind Bengelsdorf Browne; Betty Burnham; Lawrence Campbell; Butler Coleman; Ralph Colin; Mrs. Mildred Davies; Harold Diamond; Tejas Englesmith; Richard Finnegan; Inge Forslund; Ilse Friesem; Marie Frost; Gabriel Garcin; Sidney Geist; Manuel E. Gonzalez; Lloyd Goodrich; Frances Archipenko Gray; Claude Bernard Haim; Daryl Harnisch; Anne Hecht; Gordon Hendricks; Grant Holcomb III; Paul Karlstrom; Leslie Katz; Lincoln Kirstein; Antoinette Kraushaar; Alicia Legg; Louise Leiris; Madeline Lejwa; Robert Lewin; Garnett McCoy; David McKee; Sara Mazo; Margaret Mills; Jean-Yves Mock; Mrs. John Nankivell; Ellwood C. Parry III; Casie Pfeifer; Phyllis Plous; Helmut Rippberger; Jean Sachs; Pat Sieminski; Louise Svendsen; Donna Swartz; Roberta Tarbell; David Vance; Barbara Volker; William Walker; Virginia Zabriskie.

The staffs of the following art libraries were particularly cooperative and resourceful: The Archives of American Art; The Frick Art Reference Library;

The Metropolitan Museum of Art; The Museum of Modern Art; National Collection of Fine Arts and National Portrait Gallery; The New York Public Library.

The preparation of this book has involved the collaborative efforts of the members of the Department of Painting and Sculpture of The Hirshhorn Museum and Sculpture Garden. Cynthia Jaffee McCabe was responsible for the chronological organization of the catalogue and for supervising its research. Inez Garson headed the research team whose other members were Emmie Donadio, Phyllis Rosenzweig, and Michael Shapiro. Anna Brooke, Frank Gettings, Fran S. Weitzenhoffer, and Francie Woltz also provided invaluable assistance. Joseph Sefekar's administrative support was most helpful.

We are grateful to the many professionals at Harry N. Abrams, Inc., who worked to produce this book: Ellen Shultz, our diligent editor; Nai Y. Chang and Dirk J. v O. Luykx, who designed the volume; Margaret L. Kaplan and Barbara Lyons; and, of course, Harry N. Abrams, Paul Anbinder, and the late Milton S. Fox.

Abram Lerner
Director

Photocredits

Brenwasser, New York: 91, 99, 100, 134, 139, 141, 155, 167, 168, 172, 177, 245, 261, 272–275, 278, 325, 333, 341, 403, 405, 406, 408, 410, 413, 434, 435, 437, 442, 457, 459, 465, 540, 561, 586, 616, 623, 624, 627, 653, 658, 663, 690, 813, 899, 901; Geoffrey Clements, New York: 48, 49, 52–54, 61–63, 65–69, 71, 77, 86, 93, 94, 102, 104–120, 129, 131, 133, 135–37, 138, 140, 143, 144, 146, 147, 150, 151, 157, 186, 187, 190, 196, 199, 210–243, 254, 266, 268–270, 289, 326, 344–367, 369–395, 397–399, 401, 404, 418–420, 425, 431–433, 443–445, 449, 452–454, 462, 470, 476–478, 485–488, 490–497, 499, 500–530, 534, 539, 541, 545, 546, 551, 552, 564, 565, 567, 569, 570–572, 574, 576, 578, 583, 605, 608, 613–615, 618, 619, 640, 646, 651, 659, 665, 666, 671, 672, 674, 691, 692, 694–697, 699, 700–708, 711, 713–733, 736, 738, 739, 741–743, 745–757, 759–765, 767–770, 781, 794, 799, 801, 805, 807, 808, 819, 828, 829, 835, 838, 847, 856, 858, 859, 861, 864, 868, 871–877, 890, 891, 893, 896, 905–907, 910, 911, 914, 919, 920, 925, 927–930, 932, 941, 942, 949, 951, 959, 960, 962, 963, 966–968, 970–996, 998–1002, 1004–1006, 1008–1019; S. Colten, New York: 72, 154, 193, 200, 415, 441, 448, 471, 472, 543, 575, 620; Abram Lerner, Washington, D.C.: 814, 815; Robert Mates, New York: 50, 51, 92, 96–98, 142, 145, 164–166, 173, 179, 244, 251, 252, 255, 258–260, 276, 277, 292–294, 300, 319, 320, 322, 323, 332, 335, 407, 436, 458, 463, 464, 469, 481, 482, 533, 536, 558–560, 577, 585, 588, 595, 597, 612, 625, 626, 633, 634, 636–638, 645, 648–650, 652, 655, 669, 678, 680, 773–777, 784, 787–789, 822, 823; Charles Mills, Philadelphia: 384; Otto Nelson, New York: 6, 9–11, 13–47, 59, 60, 64, 73–76, 79–85, 87–90, 101, 103, 121–127, 132, 148, 152, 159, 160, 163, 169, 174–176, 178, 180, 183, 201–204, 206, 207, 246, 253, 271, 279–285, 290, 296–299, 301, 305, 308–314, 321, 334, 336, 340, 342, 411, 412, 424, 426, 428, 438–440, 450, 456, 460, 466, 467, 483, 549, 554, 566, 573, 587, 590, 598, 599, 600–604, 606, 609–611, 617, 647, 664, 689, 710, 740, 771, 780, 785, 791, 792, 820, 821, 824, 830, 831, 834, 836, 837, 849, 852, 855, 860, 862, 865, 869, 870, 881, 882, 884–886, 897, 903, 904, 923, 931, 933, 936; Eric Pollitzer, New York: 205, 343, 796, 880; Walter Rosenblum, New York: 3, 7, 8, 130, 161, 171, 182, 185, 191, 208, 264–267, 288, 317, 318, 331, 337, 339, 368, 396, 400, 409, 447, 451, 474, 478, 489, 498, 535, 538, 555, 556, 580, 668, 681, 709, 744, 809, 812, 813, 818, 839, 842, 851, 909, 912, 943, 969; John Schiff, New York: 55, 56, 198

DATE DUE

Demco, Inc. 38-293